ALFRED HITCHCOCK

ALSO BY PATRICK McGILLIGAN
Cagney: The Actor as Auteur
Robert Altman: Jumping Off the Cliff
George Cukor: A Double Life
Jack's Life: A Biography of Jack Nicholson
Fritz Lang: The Nature of the Beast
Clint, the Life and Legend: A Biography of Clint Eastwood

EDITED BY PATRICK McGILLIGAN
Tender Comrades: A Backstory of the Blacklist (with Paul Buhle)
Six Scripts by Robert Riskin
Film Crazy: Interviews with Hollywood Legends
Backstory: Interviews with Screenwriters of Hollywood's Golden Age
Backstory 2: Interviews with Screenwriters of the 1940s and 1950s
Backstory 3: Interviews with Screenwriters of the 1960s
Backstory 4: Interviews with Screenwriters of the 1970s and 1980s
(forthcoming)

ALFRED HITCHCOCK

A LIFE IN DARKNESS AND LIGHT

PATRICK McGILLIGAN

!t

itbooks

AN IMPRINT OF HARPERCOLLINS PUBLISHERS

itbooks

The Library of Congress has cataloged the hardcover edition as follows:
McGilligan, Patrick.
Alfred Hitchcock: a life in darkness and light / Patrick McGilligan.—1st ed.
p. cm.
Filmography: p.
Includes bibliographical references and index.
ISBN 0-06-039322-X
1. Hitchcock, Alfred, 1899– 2. Motion picture producers and directors—Great Britain—Biography. I. Title.

PN1998.3.H58M38 2003
791.43'0233'092—dc21
[B]
2003046648

ISBN 0-06-098827-4 (pbk.)

12 13 BVG / RRH 10 9 8 7 6 5 4

WHEN ONE OF HIS FRENCH FOLLOWERS
SOLEMNLY ASKED ABOUT THE DEEPEST LOGIC OF
HIS FILMS, THE MASTER SHRUGGED, "TO PUT
THE AUDIENCE THROUGH IT."

—"The Man Behind the Body,"
Holiday, September 1964

CONTENTS

ALFRED HITCHCOCK

LONDON

THE ENJOYMENT OF FEAR

ONE

1899–1913

He might saw a woman in half, as one of his favorite real-life murderers did. Or, with a wave of his wand, scare a swarm of birds out from under his English gentleman's hat.

All of his tricks were in a single trunk plastered with travel stickers—his life, as it were. There were umbrellas, door keys, tiepins, rings and bracelets, a glass of poison, a ticking bomb, long kitchen knives and a host of other glittering stuff. Sometimes it seemed that he juggled only a handful of items with endless hypnotic variation. But just when you thought he'd shown you all he had, he reached into the deep bottom of the trunk and found something there to mesmerize you afresh.

Alfred Joseph Hitchcock was the ultimate magician of the cinema, an illusionist as pleased by his own mastery as he was by his audiences' reactions. He perfected a mask of jovial sangfroid, but he couldn't have been happier when the audience collectively sighed, laughed, screamed—or wet their seats.

His name was as English as trifle. The "Alfred" stood in honor of his father's brother. The "Joseph" was a nod to the Irish Catholicism of his mother—the name of the carpenter of Nazareth and husband of Mary.

The "Hitch" was a derivative of Richard, Coeur de Lion, most popular

of the Angevin kings. "Richard" was popular throughout the kingdom in variants, among them Dick, Rick, and Hick; the initial *R* was commonly nicked into *H*. The "Cock" meant "little" or "son of," as in "son of Richard," or "son of Hitch."

Little Hitch.

He shortened the name for friends and introductions. "It's Hitch," he drawled, relishing the trap about to be sprung, "without the cock." As he made a game of identity in his wrong-man movies, Alfred Hitchcock made a game of his identity in life.

Few directors forged their careers as resolutely, as self-consciously, as Alfred Joseph Hitchcock. Starting from boyhood, he was drawn slowly but steadily toward his métier—just as steadily as his family moved along East End suburbs, down the river Lea, in the last years of the nineteenth century, toward the greater opportunity of central London.

Leytonstone, where Alfred Joseph Hitchcock was born, was north of the Thames and south of beautiful Epping Forest, where Tennyson lived when he wrote "Locksley Hall." A hamlet attached to Leyton (Lea Town), Leytonstone (Leyton's Town) was once the fiefdom of rich merchants who built grand houses on estates that bordered country meadows and marshlands. Eventually the rich moved away, abandoning their mansions and estates to make way for vast numbers of cheap houses built by greedy developers for the nineteenth-century explosion of city workers. By the turn of the twentieth, the area was thriving commercially, booming with shops, churches, and schools, and fast losing its rural character. The population of Leytonstone doubled twice after the 1861 census.

Like Stratford, where Hitchcock's father, William, was born, and West Ham, home of his mother, Emma Jane Whelan, Leytonstone was part of the outer London county of Essex. The Essex boomtowns owed their existence largely to the Great Eastern Railway Line, which offered cheap "workmen's fares" to central London (about six miles from the Leyton station), and proximity to the river Lea. Down the Lea a tremendous variety of agricultural goods traveled through a series of locks leading to Regent's Canal, en route to the docks and warehouses of the Thames. The Hitchcocks owed their livelihood to the worker boom, the railway, the boats, and the river Lea.

William Hitchcock was born in 1862 to Joseph Hitchcock, a "master greengrocer" in Stratford. Part of West Ham, Stratford was separated from Bow in Middlesex by the Lea, over which stretched the Bow Bridge, the first stone bridge built in England. Joseph Hitchcock was already among the second generation of Hitchcocks to thrive in greengrocering. Besides William, Joseph Hitchcock had at least six other sons and daughters: Mary (known as Polly), Charlie, Alfred, Ellen, Emma, and John.

Polly, the eldest, married a man named Howe, and bore two children. Charles, the eldest son, fathered five, including Teresa and Mary, Hitchcock's cherished older cousins, whom he treated as aunts. Charles's son John, a Catholic priest, was known to all as Father John; he served as head of the parish of Our Lady and St. Thomas of Canterbury in Harrow, from 1929 to 1944, and is remembered there for doubling the size of the church and erecting a modern school.

Of the director's namesake, William's brother Alfred, not much is known, except that he was a bulwark of the family business. Alfred was to run a fish shop on busy Tower Bridge Road, immediately south of the Thames, and spearhead the London side of operations.

Ellen married a man from Cork and died giving birth to their third child. Her husband became legendary in the family as the first relation to emigrate to America, while the daughter who survived Ellen's death, also named Ellen, briefly moved in with the Leytonstone branch when the future director was a young boy.

Through shipping and intermarriage the Hitchcocks were well aware of the wider world, especially outposts of the United Kingdom. When she was just twenty years old, Emma left in 1899 for South Africa to marry James Arthur Rhodes. Taken off the boat in Durban harbor in a large wicker basket (like the kind that figures into the climax of *Torn Curtain*), Emma was then carried to safe ground on the backs of Zulu warriors. Like other Hitchcocks, Aunt Emma was a devout Catholic; she attended Mass for much of her life via rickshaw. The longest-lived and the farthest-flung, intrepid Aunt Emma became a favorite of young Alfred Hitchcock.

The baby of the original brood, John Fitzpatrick, had a pair of devilish eyes that twinkled in an angelic face. The burgeoning family fortune bought him education at the Douai School for Boys in Woolhampton; the priests who administered the school hoped that John might take the vows. Not to be: a financial wizard, John returned to the greengrocery trade to buy a string of stores near open street markets, which he turned into fish shops, often fronted by pavement stalls. These shops were then linked into a fish-greengrocery combine called John Hitchcock Ltd. Uncle John was married to a well-educated linguist who had taught English in France and Germany. Though childless, they doted on their nieces and nephews.

The circumstances of Alfred Hitchcock's childhood have been portrayed elsewhere as Dickensian, but the truth was closer to a vision of Frank Capra. Hard, hard work was necessary, expected and valued, but work was rewarded. The Hitchcocks were a jolly clan, full of fun. Uncle John could be coaxed into elaborate charades; he loved to play tricks on people. The Hitchcock women were "characters," some of them known to swear like troopers; the director's spinster aunts in particular inspired a multitude of Plainspoken Janes in Hitchcock films. The family adored gossip and scandal, risqué stories, Cockney humor. They attended sporting

events, music hall, concerts, plays, and, in time, moving pictures. They enjoyed parties where everyone drank too much and then got up to sing the sheet-music hits or the light operas of Gilbert and Sullivan.

"At family gatherings," Hitchcock reflected years later, "I would sit quietly in a corner, saying nothing. I looked and observed a good deal. I've always been that way."

The Hitchcocks were staunchly Catholic, but they showed irreverence for everything, including Catholicism. The Hitchcocks had a number of priests in the family; relatives or not, clergymen were in and out of the home, drinking, singing, laughing, and making mischief.

The Hitchcocks were not lower- or working-class; they were shop owners, their fortunes always on the rise. The home of Uncle John was the family locus: a posh Victorian, five bedrooms on three floors, located on Campion Road in Putney, and equipped with chauffeur, maid, cook, and part-time gardener. All the Hitchcocks gathered there to celebrate important birthdays and holidays. Every summer Uncle John rented a boarding-house in Cliftonville, a seaside town on the southeast coast, with rooms set aside for family members. Even after Hitchcock was famous, he still came to visit Uncle John on holidays and at summertime, sometimes staying at a local hotel with his wife and daughter. When he made a short film for a benefit in Cliftonville in 1963, Hitchcock's narration pointed out that he became class-conscious not in Leytonstone, but at the seaside, where he was struck, as a young boy, by the disparity between the locals and the vacationers.

Indeed, in direct contrast to much of what has been written about him, Hitchcock was part of a large, loving family, with whom he remained close throughout his life. The extended Hitchcocks knew him as "Alf" or "Alfie" (the English nieces and nephews called him "Uncle Alf"). Family members were encouraged to visit him at the various film studios, and especially in the 1920s were invited to gala functions with him, where they mingled with royalty and celebrity. Relatives came to stay with him in London, and later in California, for weeks at a time; he would pay their travel expenses, and whenever he was traveling arrange to meet up with them in distant places. He was always warm, welcoming, interested in catching up on news, no matter how busy, no matter if they were interrupted by journalists or fans. The famous Hitchcock phoned ordinary Hitchcocks regularly, and sent long, personable letters, thoughtful Christmas gifts, and substantial amounts of money when needed.

Uncle John, the tricky, flamboyant Hitchcock, inspired flamboyance in his nephew. Hitchcock's father, William, existed in the shadow of his younger brother's success and legend. There is a lasting impression that William

Hitchcock was a habitual drinker, and not always an efficient shop owner. On occasion, it is likely, he would have had to be bailed out by Uncle John.

Yet William married well, and his wife complemented his weaknesses with her strengths; their example of friendship and partnership reinforced Hitchcock's own feelings about marriage. Hitchcock's mother, Emma Jane Whelan, was second-generation Irish, Catholic, literate, the daughter of a policeman and one year her husband's junior. Hitchcock once described his mother as having "a cottage-loaf figure,"* which grew plumper as she grew older. When William was twenty-four and Emma was twenty-three, they were married and took over a greengrocery in Stratford.

Emma Jane Whelan Hitchcock has been described in her later years as "a smartly dressed, sedate person, very quietly spoken with an aristocratic manner." She had a black-Irish sense of humor, and could be sharp-tongued on occasion. She was very sensible, and likely kept the books for her husband, organizing the schedule and routine for a business that depended on timing and freshness.

In 1890, the third year of their marriage, Emma gave birth to a boy christened William Jr.; in 1892 she bore a girl the parents named Ellen, or Nellie. In 1896 the burgeoning family moved to Leytonstone, less than two miles north along the river Lea, where the Hitchcocks ran a greengrocery at 517 The High Road. On August 13, 1899, in the private rooms above the shop, Alfred Joseph Hitchcock was born.

That was the year "W. Hitchcock" took out an advertisement in the *Express and Independent Almanack* asserting the "NOTED QUALITY" of his "ENGLISH AND FOREIGN FRUIT," various kinds of potatoes, and other products. Customers were assured "ALL ORDERS PUNCTUALLY ATTENDED TO"—"FRESH EVERY DAY."

The more remote the years, the more difficult it is to be precise in reconstructing a life story—and speculation differs as to what sort of life Hitchcock led as a young child at 517 The High Road.

According to some published accounts, Hitchcock's father was a strict disciplinarian who could be stern and forbidding. Perhaps Hitchcock's most famous childhood story is this: William Hitchcock reportedly taught his son a lesson at a tender age, sending Alfred off to the local police station with a note that said the boy had been naughty. The policeman locked him in a cell, telling him, "This is what we do to naughty boys." Hitchcock said he always remembered "the clang of the door which was the po-

* A "cottage loaf" is the kind with a high-risen top in two sections, designed to be cut or torn in half. Hitchcock probably meant she had large breasts and a big bottom, with a tight-cinched belt between.

tent thing—the sound and the solidity of that closing cell door and the bolt."

After a few minutes—maybe five, maybe more—he was released.

Although his sister confirmed this incident to Hitchcock's official biographer, John Russell Taylor, she wasn't an eyewitness. And when Hitchcock told the story to interviewers, as he did relentlessly over the years, the story grew and mutated. The infraction changed. His age changed: sometimes he was as young as four, other times as old as eleven. "Hitch told it so often, and it was convenient for the press," said Robert Boyle, his production designer later in America; "he probably came to believe it himself."

Certainly his films believe it, and many times, in many ways, replay the scene.

It's worth remembering, however, that Hitchcock's maternal grandfather was a constable—and that in at least one version the policeman in the boyhood's story was a family friend, in on the joke. Police, like priests, were hardly strangers to the Hitchcock household. Still, Hitchcock always insisted the incident gave him a lifelong fear of arrest, jails, and policemen—a fear confirmed by many adult anecdotes.

Though policemen may have been thornily lodged in his subconscious, a stern, forbidding father is at odds with Hitchcock family lore. A kinder, gentler William Hitchcock is conjured by another Hitchcock anecdote, that Alfred was so well behaved as a boy, his father dubbed him "my little lamb without a spot."

William Hitchcock helped instill in the spotless lamb the boy's early passion for show business. He led the family to the nearby Borough Theatre in The High Road Stratford, one of Greater London's largest, a three-thousand-seat palace with playbills starring the likes of Beerbohm Tree, Henry Irving, and Ellen Terry. The Empire Theatre on Broadway also presented touring shows. The Theatre Royal on Salways Road, built by actor-manager Charles Dillon, began to project "animated pictures" between acts as early as 1897.

The first play Hitchcock recalled seeing, roughly in 1905, had its villain bathed in a "ghostly" green light accompanied by sinister music. The heroine was colored in rosy light. The boy was struck by such visual effects, and the man, directing films, would also dress and light people in symbolic colors. Think of Judy bathed in Madeleine's hues in *Vertigo*.

The family also made a habit of the symphony—"The Albert Hall on Sundays, and the Queen's Hall during the week." Asked once to choose his favorite orchestra pieces, Hitchcock listed Roussel, Elgar, and Wagner, Dohnanyi's "Variations on a Nursery Suite" ("because it opens like the most grandiose, huge, spectacular movie, probably by De Mille, and then reduces itself to a little twinkling on the piano; it always appealed to my sense of humor"), and Artur Rubinstein's playing of Schumann's "Carnaval."

The hardworking Hitchcocks loved all manner of entertainment and took special delight in carnivals and circuses. They always attended the annual Easter Fair in nearby Wanstead Flats, which had magicians and marksmanship contests and amusement rides.

Sunday mornings, William Hitchcock led the family to Mass, and after Mass sometimes on picnics to Epping Forest, with young Alfred dressed, according to one account, "in knee-length breeches, wide lace collar and straw hat." Later they might stop at the nearby Green Man, a local inn and pub that dated back to the seventeenth century, and once served as a refuge of such fabled highwaymen as Dick Turpin and Jack Shepherd.

Both parents were kind and loving. Although Hitchcock recalled that his mother used to ask him to stand at the foot of her bed every night and recount his daily activities, it would be rash to consider this purely in a negative light. Even calling this an "evening confession"—wasn't this, besides the language of Catholicism, the Hitchcock sense of humor? His nightly confession was no less than proof of a mother's abiding affection. "You know how families always spoil the youngest," the mother says in *Shadow of a Doubt,* speaking of the fatally spoiled Uncle Charlie (Joseph Cotten).

The family owned classic books: certainly *Grimm's Fairy Tales,* a favorite of Victorian illustrators, as well as a well-thumbed Bible. The Bible can't be bettered for gruesome stories, Hitchcock often said, and he routinely cited Hansel and Gretel and Little Red Riding Hood among the bedtime tales that made violence fascinating to him at an impressionable age. Imagine William or Emma Hitchcock reading their youngest to sleep. Or consider the possibility that father or mother was an enthralling raconteur who embroidered the familiar stories. Hitchcock, who spent his life in service of his urgent leanings as a storyteller, frequently likened the film director's job to that of a storyteller with a captive audience of children.

"When you tell that little boy the story on your knee, whether it's Red Riding Hood," Hitchcock explained once, "you've got to make it sound real."

"I put myself in the place of a child whose mother is telling him a story," he told François Truffaut in the course of their book-length interview. When "there's a pause in the narration, the child always says, 'What comes next, Mummy?' "

He often likened film to dreams in which reality mingles with imagination, akin to a bedtime story that continues into a nightmare after sleep. "Hitchcock realism," production designer Robert Boyle once explained, consisted of "his fairy tales played against a realistic environment."

He teased audiences with sly reminders they were in the grip of a manufactured dream.

Bedtime was on the second floor, in the rooms above the shop. The lights turned low, a boy's eyes darted to the doorway and the shadowy

banisters. "The night always exaggerates things, doesn't it?" Robert (Derrick de Marney) reassures Erica (Nova Pilbeam) in *Young and Innocent*. And staircases in Hitchcock films are often "the motor of drama," as Peter Conrad wrote in *The Hitchcock Murders*, leading "upwards to doom," or descending to creepy basements.

From the royal family down, almost every English house of the time had a dog, if only to ward off intruders. A faithful hound can be imagined lying on the floor as young Alfred, in bed, listened to the sleepy-time tales. Dogs proliferate in Hitchcock films, and sometimes, like Hogarth, who often put his dogs into paintings and etchings, they are his own pets. Dogs in Hitchcock films are invariably amusing, brave, and intuitive about the distress of their owners, and when a canine is killed, as in *Rear Window*, up is sent an ungodly "hue and cry," in Truffaut's words, "as if the death of a child were involved."

"Write what you know" is an old saw, often ascribed to Ernest Hemingway, although the sentiment must date back to antiquity. Hitchcock liked to say he wrote with the camera, but it was the same difference: he filmed what was familiar to him, what he knew about or researched. What he didn't know he didn't trust, and tended to avoid. His imagination "improved" on the familiar—as in the case of the jail anecdote.

Donald Spoto, in his "dark" biography of Hitchcock, chose to stress how the family "lived behind and over the crates and shelves of produce, and unless they went around through a back alley to a small rear door, they had to pass through the shop to reach the family rooms. In the middle of a small, dark and unsuccessful garden was the family outhouse. Privacy was even rarer than silence or sustained sunshine."

But when parents owned shops it was very common to enter by the front, and only wealthy people boasted luxurious indoor bathrooms at the turn of the century. Although Spoto harped on Hitchcock's toilet fixation, it's a *national* fixation, and one that's often wielded humorously. "Londoners are fascinated by excrement," pointed out Peter Ackroyd in *London: The Biography,* noting that Sir Thomas More could boast of knowing five Latin names for "shit." Especially in the 1930s and 1940s, the "toilet humor" of many British films (including Hitchcock's) provoked routine censorship when they were imported to America.

This familiar thread of English lives became creative grist. Hitchcock films delight in exploiting the taboo of bathrooms. "For Hitchcock, any task performed in there qualified as suspicious," wrote Peter Conrad. Traitors and criminals are always darting into toilet stalls; women are spied upon as they undress before mirrors; blood drips on shining fixtures.

Hitchcock certainly had the knack of introducing toilets into films—or

conversation. Even at age seventy-eight, working on the last script of his career, the director liked to recall Derby Day at Epsom Downs, where, as a boy, he noticed the enterprising children who dug holes in the ground and put up little tents, charging people for "the right to relieve" themselves. In Cockney singsong, Hitchcock digressed from scriptwork to imitate the twelve-year-old girls advertising, "Accommodations, one penny, accommodations, one penny," and the rougher sorts of boys who touted the same service for "A piddle and a poop, one penny." ("Of course, when the food was bad," Hitchcock told writer David Freeman, "they did quite well.")

Authorized biographer John Russell Taylor said that Hitchcock's childhood entailed mostly cozy memories. Pride of hard work and ownership, family togetherness, stockings at Christmastime that bulged with tangerines and nuts—characteristic of English Christmases.

The authorized view paints a shop less eerie, less of an obstacle course. "Right behind the house were the ripening sheds," wrote Taylor in *Hitch*, "and a vivid early impression is the scene inside them: with the great bunches of bananas ripening by the warmth of gas flares, the sight and the smell and the distinctive hiss. When he was a little older, he was allowed to go out with the deliveries of fruit and vegetables to grocers all over the Epping area, often a whole day round by horse-drawn cart. Another process which fascinated him was the husking of walnuts, which used to come into the shop still in their fleshy green outer coats and be husked ready for sale by the shop workers."

That seems closer to the mark. Although maybe it was both: a boyhood not all darkness, nor all sunshine, but like a Hitchcock film, a constant interplay of shadow and light.

Leytonstone was in the midst of thrilling upheaval. The Hitchcock greengrocery was in the middle of the block on The High Road, between Maywell and Southwell Grove Roads.

Coming out of the greengrocery, heading in any direction, were family butchers, bakers, shoe menders, tobacconists, clothiers, confectioners, drapers, hosiers, and more grocers and fishmongers. There were other Hitchcock relatives living and working in the neighborhood.

The buses (and later, electric trams) seemed never to stop running, and two train stations were nearby. Railway-mania is a phenomenon among the English, and romance and death ride on trains in many Hitchcock films, as well as on buses, planes, and ships—just about any form of transportation.

On The High Road the boy heard vendors shouting out the afternoon headlines "wet from the press"—as audiences hear them in *The Lodger,*

Foreign Correspondent, and *Frenzy.* Shop visitors arrived with the papers tucked under their arms, gossiping about lurid crime cases. It isn't too much to say that murder was serialized entertainment in England in that day and age.

Hitchcock liked to quote George Orwell, who, in a famous essay, "The Decline of the English Murder," concluded that the majority of English murder cases were adultery-related. Killing one's spouse was a means of divorce. Citing the respected Orwell was Hitchcock's way of defending himself against critics who were skeptical of his sordid subject matter. But Hitchcock films delved into marital murder, murder for money, political murder—all species of murder.

Often his murderers were just plain psychotic, which had a unique appeal for Hitchcock. Whitechapel was near Leytonstone, and that is where Jack the Ripper, beginning in 1888 and continuing for months, stabbed, mutilated, disemboweled, and slashed the throats of between five and a dozen female victims. The violence started and ended mysteriously. To this day the identity of the culprit is unknown, although many think he ended up in an asylum, in a small, spare room—like Norman Bates at the end of *Psycho.* Locals were still whispering about "the Whitechapel murderer" when Hitchcock was growing up. They whisper still today; the Ripper remains "an enduring aspect of London myth," in the words of Peter Ackroyd.

Adelaide Bartlett may or may not have poisoned her spouse with liquid chloroform over a decade before Hitchcock's birth, in 1886; a trial found her innocent. But Hitchcock knew all about the spectacular crime and delighted in recounting its particulars, perhaps because her victim, Edwin Bartlett, was a greengrocer, and her lover was a Wesleyan minister.

Another sensational murder, closer to home, also involved a greengrocer. Edgar Edwards of Leyton paid a visit to a small-town greengrocer one day in 1902, pretending to be interested in purchasing the operation. In the course of the visit he slew the owners and their baby, dismembering all three; then he took the bodies away and buried them in his garden on Church Road. When he tried again with a second greengrocery—that was his peculiar fixation—Edwards was caught and convicted. Mentally unbalanced, he told the judge that being on trial felt like being on stage; before being hung, he is supposed to have exclaimed, "I'm looking forward to this a lot!"—obviously with a Hitchcockian sense of humor.

The meek dentist Dr. Hawley Crippen, who decapitated and filleted his wife, then attempted to escape Scotland Yard by sea, accompanied by his mistress in the guise of a man, grabbed the headlines in 1910. The Hitchcocks, like many English families, enjoyed their evening supper, carving up the roast beef, doubly delicious when accompanied by talk of the Ripper, Adelaide Bartlett, Edgar Edwards, Dr. Crippen, and all the many others in

all their endless gruesome cornucopia. For the rest of his life Hitchcock was fascinated by real-life murders and murderers, and strove to evoke them in his films.

Of course, such suppertime talk wouldn't be at home in any Frank Capra picture, except perhaps *Arsenic and Old Lace*. Despite a generally happy, comfortable boyhood, Hitchcock was a sensitive lad who experienced the culture of murder fascination with fear as well as pleasure—or, as he liked to put it, linking the two, "the enjoyment of fear." He often said his films were about "ordinary people in bizarre situations," and he himself was the prototype. He was the ordinary man who imagined himself into murderous situations, enhancing his fantasies in the categories of suspicion, suspense, fear, and desire.

Writing in 1969 to a local reporter researching his roots, Hitchcock begged off any sweeping statements and said his only clear memory of Leytonstone was "the Saturday night when the first electric tram made its maiden journey" down the streets on an intensely cold December day in 1906. Shortly thereafter, when Hitchcock was only six years of age, the family moved down the Lea to Salmon Lane, Limehouse, in Stepney borough, taking over two existing stores, at 130 and 175 Salmon Lane.

The latter address stayed a fishmongery, while the Hitchcocks resided above 130, which doubled as a fish-and-chip shop. (It was quite common for fishmongers to double their business with such shops, which was a good way of getting rid of fish that was beginning to go off.) The two shops were about one hundred yards apart on opposite sides of the street, and only a long stone's throw from the town hall. William Hitchcock began to specialize in fish now, and left greengrocering behind.

Just as Hitchcock would later push his career toward the United States, his family's business constantly expanded toward wider markets. Not only did the Hitchcocks run two fish shops now—fresh and fried—they also bore some responsibility for dispersal of goods to ships and for the growing John Hitchcock Ltd. chain of greengroceries and fish and fried fish shops (now stocked by their own fish hatchery). The chain also included a number of poulterers, game dealers, butchers, and ice manufacturers. By 1925 John Hitchcock Ltd. would peak at a prodigious count of sixty-nine retail shops in the London area.

The boy's formative years, roughly from 1907 to 1915, were lived in the shadow of warehouses and wharves and the muddy, smelly Thames. Gliding constantly up and down the river were pleasure boats, fishing boats, tugboats, barges, and cargo ships. Picture a neighborhood not unlike where Marnie's mother lives: a street of densely populated buildings ending at the docks, with ships looming. The only grass that could be

found was between the cracks. It was a brick-and-mortar district, as one London chronicler noted, without stone lions or public monuments. Color the district gray, gray everywhere, with thronged shops, loud tramways, and the teeming streets and riverside.

The color was in the people. Fish-and-chips are a staple of English working-class life, and in Limehouse Hitchcock lived and breathed Cockney culture, soaking up the jokes, speech, and mannerisms of London's East Enders. But Salmon Lane was also a remarkably cosmopolitan neighborhood of immigrant Irish and Jews, with a Chinese quarter, incipient Communists, and outcasts and refugees from around the globe.

It was deep-dyed London, and proximate to all points in the city. Hitchcock soon became addicted to the city trams and rode them everywhere; he later boasted of riding to the end of every route by age eight, memorizing the stops and favorite places. (Years later in Hollywood, when the slate board reading 24–1 went up, Hitchcock would murmur, "Hampstead Heath to Victoria," that being the route of the 24 bus in those days.) The boy could take the bus to Ludgate Hill, visit the Old Bailey, and sit in the back rows of a courtroom and watch the latest murder prosecution unfold. And a few miles from the Old Bailey was Madame Tussaud's, with Jack the Ripper, and, in due time, Dr. Crippen among the constantly updated exhibits.

Another magnet was the West End, with its theaters, news shops, and bookstores for rummaging. Reading on his own began to supplant bedtime stories. Walter Scott (the bookworm daughter is reading *Ivanhoe* in *Shadow of a Doubt*), G. K. Chesterton, Arthur Conan Doyle, Wilkie Collins, John Galsworthy Mrs. Marie Belloc Lowndes, and John Buchan were among his favorites growing up. He also came under the influence of Edgar Allan Poe, who told "a completely unbelievable story . . . to the readers with such a spellbinding logic that you get the impression that the same thing could happen to you tomorrow."

An unabashed "trolley-jolly" in London, he was also a "timetable buff" for "imaginary voyages" to other lands. The boy hung a world map on his bedroom wall and bought *Lloyd's Register* and *Cook's Continental Tours,* embarking on pretend "trips on the Trans-Siberian Railway." The little colored flags he stuck on his map displayed the courses of ships at sea, and every day the boy moved them around to reflect the itineraries.

In Leicester Square Hitchcock found a shop that sold *Life* and *Judge,* two magazines that mingled literature with humor. From boyhood he explored America in these and other U.S. publications. "I would say that I was—if it is a word—Americophile," Hitchcock once averred.

As the youngest child, he was pampered and excused from shop work, leaving him plenty of time for reading. William Jr. had been targeted for the trade, and soon was running one of the Salmon Lane shops; eventu-

ally, Hitchcock's brother took over the Tower Bridge Road location from his uncle Alfred. While Hitchcock had affection and respect for his older brother, their nearly ten-year age difference kept them from being close. He said once that he had a keen memory of being the sibling too young to follow along when his older brother and sister took off on their bicycles in the afternoons.

He was closer to Nellie. He occasionally chaperoned his sister to dances, and accompanied her to stage plays or the new "animated pictures." The average motion picture lasted forty seconds in the year Hitchcock was born, lengthening to about eleven minutes by the time he moved to Salmon Lane. Up to that time, besides crude, flickering images sandwiched between revue acts, the Hitchcock family could have seen only "the new photoelectric marvel of Animated Photographs" shown in traveling bioscopes mainly at fairgrounds, church bazaars, disused shops, and boarded-up public baths.

But by 1907, picture palaces were thriving and multiplying. A few more years would pass before Hitchcock made a distinction in his mind between a good and bad picture, but from his earliest filmgoing in London, the pictures he remembered most vividly were those which took him on unforgettable journeys, which aroused his fears and desires, which defied logic.

He fondly recalled the "Phantom Rides," a spectacle featuring footage snapped from the cowcatcher of a train speeding through scenic locales, plunging through winding tunnels and up high mountains. He also remembered "Hale's Tours and Scenes of the World," a variant invented by an American fire chief, which sat the audience in an artificial train car, with scenery projected ahead of the "passengers" as the car weaved and emitted natural sounds to simulate a genuine railway ride. The London franchise of Hale's Tours opened on Oxford Street around the time of the Salmon Lane move, and broke precedent by charging all patrons the same price: sixpence. Each "train trip" was very short—several had to be spliced together to make a complete show—and comedy sketches were interspersed. One interesting thing about Hale's Tours was that it featured sights and monuments from around the world but, because it originated in the United States, highlighted visits to American locales and landmarks, such as the Black Hills.

Another early picture that Hitchcock recollected by specific title was "A Ride on a Runaway Train," which exhibited in London and the provinces in the summer of 1908, when he was only a lad of nine. One of a series produced by American showman Lyman Howe, "A Ride on a Runaway Train" also boasted a camera mounted on the front of a locomotive whizzing around mountains, but its footage was shrewdly undercranked so that "the motion accelerated when projected on the screen," in the words of film historian Charles Musser. The apparently runaway train met

its fate in "a plunge into a tunnel and a suggestion of destruction in a terrific accompanying crash," according to Musser. It's an ending that Hitchcock would reprise in *Number Seventeen* and, even more explosively, in *Secret Agent.*

When Hitchcock recollected "A Ride on a Runaway Train," he liked to throw in this Hitchcockian detail: audience members became so excited watching the thrill film that they peed themselves. Theater employees used to count the seats afterward, betting on how many wet seats they'd find. "The aim is," Hitchcock explained years later, describing his hopes for *Psycho* and *The Birds,* "there's not a dry seat in the house."

There would be many thrill rides in Hitchcock films, sometimes with his camera mounted on the cowcatcher. The effect of reality mixed with camera trickery, which first took his breath away with "A Ride on a Runaway Train," planted one important seed of his art.

"You do see yourself as a switchback railway operator?" an interviewer once asked him.

"I am possibly in some respects, the man who says, in constructing it [one of his films], 'How steep can we make the first dip?' " Hitchcock replied earnestly. "If you make the dip too deep, the screams will continue as the whole car goes over the edge and destroys everyone. Therefore you mustn't go too far, because you do want them to get off the switchback railway giggling with pleasure, like the woman who comes out of a sentimental movie and says, 'It was lovely. I had a good cry.' "

When Nellie took a job as a mannequin for a shop on Oxford Street, brother and sister stopped going to plays and pictures together. As a young lady, Nellie was very stylish and self-conscious about her looks. She used henna and curling tongs on her hair, and made a point of wearing the latest fashions. Nellie has been referred to as a "small" woman, but she was five feet ten. As the two grew into adulthood, she grew more unlike her famous brother: she didn't care much for travel, nor was she crazy about film or America. Her first husband, Jack Lee, ran the White Hart public house, half a mile from Salmon Lane, as early as 1915. But this early marriage failed, and so did a second, and over time Nellie became hypochondriacal and difficult.

Apart from his siblings, Hitchcock liked to say, he didn't have any playmates as a boy, and strictly speaking that may be true, especially considering how he moved around between homes and schools. It is certainly true that he was alone at home with his parents from age eleven. "My parents used to put me to bed at six o'clock so that they could go out and eat in a restaurant," he told Italian journalist Oriana Fallaci. "I used to wake up at eight o'clock, my parents weren't there, there was only that dim light, the silence of an empty house."

Motion pictures offered escape and fantasy. By eleven he was reading the London screen trade papers—the *Bioscope* and *Kinematograph and Lantern*

Weekly (or, in common parlance, the *Kine*)—that were carried by his favorite Leicester Square shop. Reading about the latest pictures—"long before they appeared," as he remembered—added to his sophistication, and became the first step in his infatuation with film, his self-education in the craft.

His formal education was bound up intimately with religion. Some have assumed that Hitchcock's Catholicism isolated him in Protestant England, and he himself said that it might have contributed to his "eccentricity." Yet he would have felt comfortable in Essex, which boasted an above-average percentage of Catholic residents and the highest attendance of worshipers of any county. Essex had schools, churches, businesses, community organizations, and huge areas that were entirely Catholic.

The Hitchcocks usually attended Sunday services in Stratford because that was where Father John, his father's nephew, said Mass. Hitchcock even briefly served as an altar boy; filming *I Confess* years later, he flourished his Latin and recalled the swinging of incense.

As a boy of six or seven, he may briefly have attended the public Mayville Road School in Leytonstone, where his sister Nellie took classes. It was conveniently close to the greengrocery on The High Road. But according to published accounts, Father Flanagan, a local priest, took the Hitchcocks aside one day and scolded them, saying that the boy ought to be receiving a proper religious schooling, and shortly thereafter he transferred to Howrah House in nearby Poplar.

The choice of Howrah House suggests a broad outlook on the Hitchcocks' part. A private convent school run by the Faithful Companions of Jesus, an order founded by a French missionary, it boasted spacious rooms, pleasant gardens, high academic standards, and an emphasis on music, painting, and drama. The students were mostly middle-class, although Howrah House accepted boarders from other countries, and even Jewish students, advertising that it did not interfere with competing religious beliefs. What Howrah House didn't have was very many boys: the school took male pupils only if not enough girls enrolled, and the son of a Catholic shop owner from the area would have been a preferred candidate.

Catholicism swirled around Hitchcock's boyhood the way London fog envelops *The Lodger*. He was inclined to say religion never had much effect on him, even though he remained a churchgoer and a steadfast Catholic throughout his life (priests were welcome visitors to his home as well as to his sets). But Catholicism pervades his films, albeit a brand of Catholicism spiked with irreverence and iconoclasm. It's there in characters and settings, in the small details and larger arc of the stories, in the symbols and motifs.

Think of the oft-sighted and sometimes lightheartedly juxtaposed nuns and

priests (a priest sitting across from a ladies' underwear salesman in *The 39 Steps*), or the many church buildings (even *Rebecca*'s Manderley is cathedral-like in appearance). It's there even in costumes and crucial props: bullets stopped by hymnbooks ("Hymns that have helped me," chirps Robert Donat in *The 39 Steps*), Henry Fonda's rosary beads in *The Wrong Man*.

It's there, emphatically, in his vision of romance. Hitchcock films believe in true love and marriage, but they are also cautionary, and warn of having sex with the devil. Hitchcock's devil is very Catholic—a ubiquitous devil, locked in an eternal struggle with good. The tension between crime and punishment in his films is almost always resolved, interestingly, by the criminal, not the police. Guilt usually forces a confessional ending, often a suicide, and at the end of nearly every Hitchcock film a kind of forgiveness, or absolution.

Today the Howrah House records are lost. But Hitchcock stayed there for at most two years, and then may briefly have attended the local Wode Street School, where the Faithful Companions also taught classes. After moving to Salmon Lane, however, the family found another enlightened situation for their son at the Jesuit-run Salesian College boarding school in Battersea. There are no records of him at Salesian College, however, because he was there fleetingly, perhaps as little as a week. Apparently hearing immediate complaints from his son, William Hitchcock investigated the school meals and promptly withdrew the boy. Not only was the food sub-par, but students were routinely given a distasteful purgative in their tea.

Whatever else he inherited from his father, Hitchcock developed an appreciation of good food, replete with quirky likes and violent dislikes. His father, for example, is said to have detested cheese and eggs, and Hitchcock shared the latter dislike, exploiting it to comic effect in his films. ("Poached eggs are the worst in the world," says Desmond Tester in *Sabotage*.) On the other hand, he learned to love steak (which must have been scarce in his fish-abundant household) and fresh Dover sole (which was standard shop fare).

By October 5, 1910, Hitchcock had been enrolled in St. Ignatius College.

Founded by Jesuit fathers in 1894, St. Ignatius College was a day school for "young gentlemen" at Stamford Hill. The eleven-year-old son of William and Emma Hitchcock had to get on the train to arrive daily by 8:45 A.M. for Mass before classes. The train ride from Limehouse stimulated the imagination. "The boys of my form would come armed with scissors and knives," Hitchcock recalled, "to cut up the seats and luggage racks."

By the time Hitchcock was enrolled as a "new boy" in the fall of 1910, the small original facility had been expanded into an Elementary School, New College, Church, and Chapel (the latter still under construction), and the enrollment was rising to nearly 250 students. They came from all back-

grounds. Although the Hitchcocks were able to afford the tuition, a growing number of board of education "free place" boys, the progeny of clerks, tailors, accountants, and laborers, joined the sons of solicitors and physicians.

Students attended classes in a jacket and tie, some with Eton collars; everybody wore a school cap marked with the letters *S.I.* on the front, leading local wags to refer to them as "silly idiots." Silly idiots they were not, however. With its rounded and liberal intermediate education, St. Ignatius guided some boys toward higher education while preparing others for technical or commercial careers. To this end the school had organized an ambitious curriculum emphasizing science, physics, mathematics, English and literature, and modern and classical languages. Latin was mandatory; Greek, French, and German were optional. Longfellow, Defoe, Dante, Dickens, and Shakespeare—committed to memory and performed annually in their entirety—were part of the curriculum.

Any boy who showed signs of religious vocation was sent to a seminary. Among the students during Hitchcock's era was John C. Heenan, who rose to become England's highest-ranking Catholic prelate, the archbishop of Westminster. Another was Ambrose King, later one of England's leading authorities on venereal disease and the author of a standard textbook on the subject. A third was Reginald Dunn, who went from schoolteacher to IRA assassin (of whom more later). A fourth, Hugh Gray, wrote essays and dabbled in film writing and later translated André Bazin's criticism. Among these only Gray was counted as a friend, someone Hitchcock kept up with until the end of his life, when Gray taught film at the University of California at Los Angeles (UCLA).

The prefect of studies from 1905 to 1914 was Father Charles Newdigate. According to the school's official history, Father Newdigate was unfailingly courteous and cheerful, "ever ready to see the best" in his boys, yet "almost too ready, perhaps, to be a good disciplinarian."

The Jesuit ethic of corporal punishment was a dubious tradition of the school. Archbishop Heenan described in his memoir how the teachers (mostly young Jesuits not yet priests) called out infractors to "receive the ferule" on the palms of their hands—or worse, on their knuckles. The ferule was like a flat ruler, yet "considerably more menacing," wrote Heenan. "It was, I believe, made of gutta-percha and caused a very painful swelling. The delinquent was ordered to receive three, six, nine, twelve, or for exceptionally serious offenses, eighteen (called, perhaps because it could be administered in two sessions, twice-nine)."

Students were usually allowed twenty-four hours in which to choose from one of two "tolley masters" assigned the duty of punishing boys.*

* "I do not know the origin of the word 'tolley,' " Heenan wrote. "I suppose it to be a derivative of toll, which is a measured stroke of a bell."

This "excellent system," wrote Heenan, "forbade a master who ordered punishment to be the executioner."

The beating (which could also be administered with a strap or wooden cane) was also ordered for poor scholastic performance, although Heenan said he was punished less than once a year during his time at St. Ignatius, and that end-of-day general amnesties were standard. And it's important to remember, added the archbishop, that "stupid boys in those days were beaten in every type of school almost as a matter of routine."

The effect on Hitchcock was more psychological than physical, he often said. Rarely did he violate the rules, so rarely, if ever, did he suffer the "tolley."

One notorious transgression was the "dangerous" practical joke presented by Donald Spoto as a tone-setting anecdote of his biography *The Dark Side of Genius*. As Spoto told the anecdote, Hitchcock and an accomplice grabbed a younger student named Robert Goold and hauled him off to the boiler room, immobilizing him for "a carefully planned psychological torture," ending when the two depantsed Goold and pinned a string of lit firecrackers to his underwear. That was certainly a deed calling for the tolley.

Goold told this entertaining story to Spoto and others over the years. Unfortunately, his recollection couldn't possibly be true; admission records show that Goold entered St. Ignatius a full term after Hitchcock departed. Confronted with the contradiction in 1998, Goold realized that he was "wrong in ascribing the incident to him [Hitchcock]."

Hitchcock could recall being summoned to receive the standard punishment only once, and that time he trudged into the room to face his "favorite priest, my friend"—whom he had chosen as his punisher. The priest, recognizing him, shook his head and said, "This isn't nice, is it?" "I said, 'No, Father,' " Hitchcock recalled, "And he took the hand and he let the instrument just drop on it. Very touching, of course."

Boys gathered outside the room to wait their turn and scrutinize the faces of the emerging culprits. "Yes, they were voyeurs," Hitchcock reflected in one interview. A boy could also choose the time of day for his punishment: morning break, lunchtime, midafternoon, or the end of the day; and putting off the punishment for as long as possible, Hitchcock decided later, was an early education in the power of suspense, like "in a minor way, going for execution."

Asked by the St. Ignatius College student newspaper in 1973 whether he would "regard [him]self today as a religious person," the school's most famous alumnus replied intriguingly: "Religious, that is a pretty wide term. It is a question of one's behavior pattern and a claim to be religious rests entirely on your own conscience, whether you believe it or not. A Catholic attitude

was indoctrinated into me. After all I was born a Catholic, I went to a Catholic school and I now have a conscience with lots of trials over belief."

The stern, bleak Catholicism of St. Ignatius shouldn't be exaggerated. Partly because it wasn't a boarding school, the school had a lively personality. There was a full complement of sports and athletics (fierce soccer rivalries, cricket matches with other colleges, an annual all-school tennis tournament). There was institutional interest in poetry, literature, music, and drama (the students mounted an annual operetta, and took field trips to the Old Vic and other productions). The annual Prize Distribution in Tottenham Town Hall was an especially gala occasion for the student body, with elocution and dramatic sketches, and parents performing music alongside students.

Apart from daily Mass, there was also a daily catechism drill and an optional Friday confession. There was an annual three-day all-school retreat for spiritual reflection: not optional. One popular priest of Hitchcock's time, Father Richard Mangan, used to give a well-remembered talk at these annual retreats, reflecting on death and dying, and exhorting students to be unafraid of their own deaths if they had lived decent lives.

Every classroom boasted its own altar of Our Lady, with flowers and candles. Every class was divided into two, row by row, Romans versus Carthaginians, with academic score books kept by designated class leaders. "Victory was celebrated with extra play," recalled the Reverend Albert V. Ellis, a fellow student during this period.

Certainly Hitchcock excelled academically, and it wasn't an easy curriculum. There was homework every night, and on weekends and holidays. Hitchcock told one interviewer years later that he always placed second or third in his classes, and that seems accurate. Twice he showed up on the irregularly published distinction lists. In 1911, he was ranked first out of five in mathematics. In 1913 he was listed as the second leader, without any subjects specified.

"We weren't allowed any latitude in our work," Hitchcock recalled. "Sometimes they were probably a little too zealous, especially when it came to giving us holiday tasks. When I was quite young—I must have been nine or ten—we'd be given something like Macaulay's *Horatius* to learn in the holidays.*

"Some kids don't care, others do. I was sensitive enough to care, and the last days of vacation were days of misery and fear, trying to learn this thing. As I remember it, they then kind of forgot to ask for it when we got back to school. It was very, very cruel."

* "Horatius," one of four long balladic poems in *Lays of Ancient Rome* by Victorian author Thomas Babington Macaulay, was learned by many British schoolboys during this era.

St. Ignatius wasn't only a school. It was a parish community thriving with family socials, jumble sales, holy day festivals, fund-raising bazaars, garden fetes, and holiday concerts. Yet the Hitchcocks, if they belonged anywhere, belonged to Father John's parish; taken along with his status as a "train boy," this may have set him apart, isolating him and contributing to a nature that was as shy, solitary, and contemplative as it was also urgently social.

It's tempting to envision Hitchcock on the fringe of the St. Ignatius theatricals or writing for the school paper, but there is no evidence; nor is there any evidence that he participated in sports. The impression he gave in interviews was that he kept to himself on the playground while others—even the scholastics and priests, their gowns tucked up—played soccer.

One sympathetic reason for his isolation was suggested by Ambrose King, who was in the same form as Hitchcock and rode the same train to school. Hitchcock was "a big boy who sat in the corner" of the train, recalled King. "He said little and was not easily engaged in conversation." But King remembered Hitchcock as "the subject of some idle conversation because he was considered odd." He and other St. Ignatius boys knew what Hitchcock's father did for a living and, with the cruelty of children, thought the Hitchcock boy "stank of fish" (a genuine occupational hazard for people who dwell in a fish shop).

Surely Hitchcock, who throughout life publicly poked fun at himself but privately was hurt by people's gibes, sensed the scuttlebutt and withdrew into himself.

For lunch at St. Ignatius, students could pick up snack food at a tuckshop, or bring lunches from home and take them down to the river Lea or out on the playground. Very often two friends huddled together, outside on the playground, munching their sandwiches as they watched the other boys form teams for games. They were "Alfie" and "Hughie"—Hitchcock and Hugh Gray, another unathletic, bookish, budding aesthete.

Gray told François Truffaut that he would always remember Hitchcock standing up against a wall, watching the other boys contemptuously. But that appears to have been mythmaking on Gray's part. He told his wife that the two usually sat together on a stone bench, somewhat forlornly.

Asked once by television interviewer Dick Cavett what he was like as a boy, Hitchcock replied, "Nice, very quiet, very dignified, kept to myself. I never fought other boys. I was very diligent."

To appreciate that nice, quiet boy, chubby, with soft brown eyes and a rooster's tuft of hair, sitting on a stone bench and watching others play as he chewed his lunch, we must "avoid the cliché." "Avoiding the cliché"—recognizing the familiar and using it to spring surprises—was Hitchcock's succinct mantra, oft-stated in interviews. It was his artistic credo.

Alfred Hitchcock the man in many ways belied his image. The origins

of Hitchcock's "wrong man" theme are there in that chubby boy on the stone bench, who allegedly stank of fish. He might have appeared thick to classmates, but he wasn't what he appeared. Appearances deceived, as he was fortunate to learn early in life. Self-knowledge was a crucial component of his character, and his films are insistent about discovering hidden depths, or eccentricities, in people.

Early on Hitchcock felt like an outsider, apart from other kids on Salmon Lane, or at St. Ignatius; later in America, even after his reputation was firmly established, he still felt apart from the Hollywood crowd.

The boy who sat on the stone bench, calmly observing and absorbing, found ways to enjoy himself. Hitchcock was more of a doer than people give him credit for, but he was also, from very early in life, a consummate watcher. He enjoyed himself immensely, watching.

He was at least two people: the watcher and the doer, the insider and the outsider, the image and the reality. He was the short, chubby cliché, but inside the "armor of fat," as he sometimes called it, he was sweet, sensitive, dashing, and wise. And tough. It was a hard, hard world, and he could be exceedingly tough in finding his way through life.

Inside the armor was a knight on a quest, whose sword would be a long silver ribbon of film.

TWO

1913–1921

Pressed by interviewers, Hitchcock said that at St. Ignatius he learned important things: "a strong sense of fear," how "to be realistic," and "Jesuit reasoning power." The fear, the realism mixed with fancy, the reasoning power and discipline of ordered thinking—these were the cornerstones of his art. No director was more disciplined, more ordered in his thinking. His unusually meticulous methods were key to his films and success, and also to his character.

There was a built-in paradox to Jesuit reasoning power—so powerful, Hitchcock knew, that it could prove the unprovable (the existence of God, for example). Hitchcock despised the "implausibles," those critics who faulted the holes in his films, for they had touched on one of his deeply embedded character traits. When forced to choose between reason or belief in his search for a cinematic effect, he wouldn't hesitate to suspend reason. "Film should be stronger than reason," he insisted in interviews. Or, as he told Oriana Fallaci, when a bomb or murderer is in the room "Descartes can go boil his head."

The implausibles just didn't get it: Hitchcock films reveled in their implausibility. Mr. Memory prompted to recite a supersecret formula onstage in front of hundreds of people in *The 39 Steps*. A man slaying his wife and

then chopping her up and burying her head in a communal garden, with windows open all around, in *Rear Window*. The entire story of *Vertigo*— desperately hard to believe, except for people who love Hitchcock films.

Compulsory education lasted only until age twelve in that era, and "Alfie" withdrew from St. Ignatius shortly before turning fourteen. Asked to declare his ambitions, Hitchcock said he thought he might become a navigator. With that half in mind, he enrolled in the autumn of 1913 in the London County Council School of Engineering and Navigation on High Street in Poplar. Hitchcock attended lectures in physics and chemistry, took all manner of shop classes, calculated nautical and electrical measurements, and studied the principles of magnetism, force, and motion. ("The worst thing was chemistry," he subsequently recalled. "I couldn't get on with that. Melting things in sulfuric acid. Who cares?")

The lessons and skills enhanced his résumé, and after a year of classwork Hitchcock was hired in November 1914 by W.T. Henley's Telegraph Works, a leading manufacturer and installer of electrical cables, on Blomfield Street. Hitchcock's lowly position involved calculating the sizes and voltages of cables.

He continued with night classes until December 12, when his father passed away at age fifty-two, from chronic emphysema and kidney disease. Of William Hitchcock's fatal illness not much is known; Hitchcock told Truffaut his father was "a rather nervous man," and John Russell Taylor said William Hitchcock struggled so hard to keep his emotions in check "that he suffered from various naggingly painful conditions of apparently nervous origin, like boils and carbuncles." On top of it all, father William was a drinker.

According to Taylor, fifteen-year-old Alfred was tracked down at school "and told the news by his brother" William Jr.; then he went over to his sister's to commiserate with her. Nellie was then working as a model for a department store and living on her own. Taylor said Hitchcock's sister greeted him strangely, "by saying almost aggressively to him, 'Your father's dead,' giving him a surreal sense of disassociation."

William Jr., only twenty-four, assumed management of both fish shops on Salmon Lane, and for the time being, the youngest member of the family continued to live above one shop with his mother.

England had been plunged into war earlier, in the summer of 1914, and London was increasingly choked with fear and rumors. Enemy submarines were spotted in the Irish Sea. Bomb-toting Germans were said to be planning sabotage in London. The newspapers were full of favorably slanted war news, although the lists of the casualties were long.

Hitchcock wasn't eligible for the draft until he was eighteen, and then it may not have been his weight that excused him from military service with a C3 classification. It may have been the combination of a glandular

condition, his relative youth, and his father's death. But as he would prove during World War II, what Hitchcock lacked in physical fitness he made up for in patriotism. He signed up for a cadet regiment of the Royal Engineers in 1917. He and a co-worker joined a corps of men receiving theoretical briefings in the evenings, while engaging in weekend drills and exercises. Their actual military stint was limited, however, to marching around Hyde Park in puttees, which, as he told John Russell Taylor, he never could get properly wrapped around his legs.

Afterward, Hitchcock said he and his friend would adjourn to a feast of poached eggs on toast. "Aha!" interrupted Taylor. "You said you never ate eggs." "Well," Hitchcock conceded, "I suppose I did eat one or two eggs when I was very young."

He once told a French interviewer that the first time he experienced genuine fear—as opposed to the enjoyment of fear—came when enemy bombs dropped on London. He was at home with other family members, and they all fell to the floor. His mother took refuge under a table and cowered there, murmuring prayers. But there was a Hitchcockian element of comedy in this terrifying scene, which he recounted, expertly mimicking his mother and other relatives. Despite the imminent danger, tea was still served, and his mother stopped her prayers long enough to say, "Only one sugar for me!"

Another time, Hitchcock remembered, he came home to Salmon Lane amid the shrill blare of sirens warning of a Zeppelin raid. (This must have been in 1915 or early 1916, the period of the most intense Zeppelin attacks.) "The whole house was in an uproar," he recalled, "but there was my poor Elsa Maxwell–plump little mother struggling to get into her bloomers, always putting both her legs through the same opening, and saying her prayers, while outside the window shrapnel was bursting around a search-lit Zeppelin—extraordinary image!"

His World War I memories mingled horror with comedy, much like his films. But living through wartime in his formative years deeply influenced a body of work that is filled with crazed assassins and spy plots, bombs that destroy innocents, and villains with German accents. And it reinforced a psychology that already understood life as fragile and arbitrary.

The war and his father's premature death, coming as Hitchcock embarked on his first job, formalized his break with the family profession, and put a grim seal on his boyhood.

Founded by William Thomas Henley in 1837, Henley's was an early manufacturer of electroplating apparatuses and insulated conductors, and later of telegraph and electrical cables, including both shore ends of the Atlantic cable as well as a Persian Gulf cable. Recently the company had shifted its

emphasis from telegraph cables to cables for light and power, and to production of all types of electrical distribution equipment. Besides home orders, Henley's had contracts and foreign branches around the globe, including in Europe, east India, China, Australia, and South America.

Hitchcock swiftly graduated to the sales section, where he honed his design and draftsmanship skills. There he would cultivate his habit of diligent planning, with notes, drafts, and multiple revisions. There he would also learn various means of publicity and promotion. No one ever had a better procedural grounding for film than Hitchcock did at Henley's. The job educated him technically, artistically, and commercially.

Henley's was a vast operation, with several hundred employees at the Blomfield Street office block alone. Like a film studio, the company was not only a business enterprise but a social enclave—a small world unto itself. The calendar of sponsored employee events included sports and dramatics, recreational clubs, company mixers, river trips, picnic parties, and other get-togethers.

Hitchcock liked to say that as a young man he was shy and solitary, but there he is at company outings, beaming in group photos. He liked to say he was a fat young man, but his weight fluctuated, and in some photographs he looks almost debonair, a round, sleek egg of a fellow. He still had hair, he affected a mustache, he sported bow ties on occasion, and in those youthful days he often wore a homburg.

Unlike at St. Ignatius, there is no question as to how Hitchcock fit in at Henley's: he was decidedly well known and well liked. "The only thing that matters," Hitchcock once wrote to his friend and producing partner Sidney Bernstein, "is who I work with day-to-day." He was speaking of the film world, but he might as well have been speaking of Henley's, where he first learned the importance of camaraderie on the job. Whatever his nature as a young boy, at Henley's he became the opposite of a loner: an inspired leader and motivator of people.

Throughout the war Hitchcock worked in the sales section, gradually realizing he didn't want to be an engineer. So, with the self-motivation that defined his character, he enrolled in art courses at Goldsmiths' College, a well-known, forward-looking branch of London University. The teachers sent him out to railroad stations to sketch people in various attitudes. He studied illustration and composition. Among his classes was a mesmerizing lecture presided over by the illustrator E. J. Sullivan, renowned for the detail and craftsmanship of his line drawings in newspapers, magazines, and books.

It was at Goldsmiths' that Hitchcock first began to pay attention to the history and principles of art: composition, depth of field, the uses of color, shadow and light. He began to frequent art galleries and museums, especially entranced by the French moderns.

Art courses sharpened his interest in theater and film. Hitchcock now became an inveterate "first-nighter," and the West End plays he saw during the years before he entered the film industry and in the 1920s made a lasting impression.

He saw *The Lodger* onstage in 1916, and John Galsworthy's *The Skin Game* a few years later. He always remembered that *Jolly Jack Tar* had a suspenseful bomb in the plot. The people in the theater were nervous about the bomb going off. A woman stood up in the gallery and shouted to the actors: "Watch out for the bomb!" More than one Hitchcock film could have had that as its advertisement: "Watch out for the bomb!"

He was bewitched in 1920 by James M. Barrie's *Mary Rose,* a sentimental ghost story set in a haunted English manor and on a mysterious island. He never forgot Fay Compton's stirring lead performance, and for the rest of his life he would dream of filming the play.

He often saw plays alone, and because neither his mother nor his sister had the same fascination with "pictures" (as he stubbornly called them for most of his life), he now went to many films alone too. "I did not miss a single picture," he later boasted to interviewers.

The British film industry was falling apart during World War I, and it would take a decade to recover its vitality. American pictures and stars dominated Hitchcock's calendar, and later, his memory: asked his opinion of the greatest chase ever filmed, Hitchcock would consistently cite the ice-floe sequence with Lillian Gish in D. W. Griffith's *Way Down East,* from 1920, along with Griffith's *The Birth of a Nation* ("the ride of the hooded men") and *Intolerance* ("the chase to save a man from the gallows"). He loved Chaplin, whom he would come to know personally, and fifty years after seeing *The Pilgrim* (1923) he could describe certain scenes shot by shot.

He grew to admire the "technical superiority" of American films. "While British films presented a flat image, background and foreground figures blending together," he noticed, thinking for the first time about the camera work and pictorial quality, "the American films employed back-lighting which made foreground figures or characters stand out in relief against the backgrounds."

Shuttling back and forth between plays and pictures, Hitchcock felt the first stirrings of ambition and a personal aesthetic. Attending the theater, he thought about film; attending pictures, he thought about stage plays. Although he adored theater and in his career adapted a number of plays into very good films, Hitchcock began to feel that film should be a different experience, almost "anti-theater."

Most film directors rely heavily on master shots and dissolves, but to Hitchcock these would come to feel like stage-bound techniques—like curtains opening and closing. He began to develop his own ideas about how

to tell a story visually, how to fill up what he called "the white rectangle." He even had his own musical language: High shots were like tremolos. A quick shot jumping in was a staccato movement. A close-up of a person (or the "big head," as he liked to call it) was for shock impact, or emotional value; that was more of a loud note, a sounding of brass.

Unusual for his time, Hitchcock rarely resorted to "camera coverage"; he rejected the safe convention of opening on a proscenium-type view, then shifting to a medium shot, before cutting to a close-up. Hitchcock wanted to control the perspective; he preferred to open with the big head, perhaps close with the master shot. And his camera hovered over the action—*he* hovered—as though he were onstage with the actors, breathing down their necks.

Plays depended on interesting talk and music. Film was silent, and depended on images—interesting pictures. Watching plays and films as he practiced and studied art, he found himself thinking more and more in pictures, and of how the "orchestration" of pictures might tell a story.

Although he remained responsible and attentive to his mother, by the time he was seventeen or eighteen Hitchcock had moved from Salmon Lane into a London flat that was owned by one of his uncles. By the time World War I ended, he had been mired in sales at Henley's for four years. He was nineteen.

Though he performed his duties well, Hitchcock had developed into "somewhat of a square peg in a round hole," according to W. A. Moore, the head of Henley's advertising department. "I was kind of lazy," Hitchcock admitted in an interview with Peter Bogdanovich forty years later, "so I'd pile them [requests for estimates] up on my desk and they'd go up to a big stack. And I used to say, 'Well, I've got to get down to this,' and then I polished them off like anything—and used to get praised for the prodigious amount of work I'd done on that particular day. This lasted until the complaints began to come in about the delay in answering. That's the way I still feel about working. Certain writers want to work every hour of the day—they're very facile. I'm not that way. I want to say, 'Let's lay off for several hours—let's play.' "

Moore befriended the "square peg," listening to Hitchcock's pleas to be transferred to another department. "Routine clerical work was never his great feature," Moore noted. "Art and strong imaginative work—creative work—were interwoven with his nature."

In late 1917 or early 1918, in accordance with his wishes, Hitchcock was sent over to advertising. His new job was more picture-oriented: designing, laying out, and pasting up the advertisements and brochures for Henley's products.

The tasks weren't always exciting, but there were lessons to be learned. "You will notice in many ads," Hitchcock reflected in a later interview, "the picture is contrapuntal to the words. You will see a shot of a locomotive rushing through the countryside and you'll find it's an ad for face cream. 'A smooth ride over your skin.' "

And there was opportunity for personal flair. "One example of his inventiveness," narrated John Russell Taylor, "was a brochure for a certain kind of lead-covered electric wire designed specially for use in churches and other historic buildings where it would be virtually invisible against old stonework. The brochure was upright, coffin-shaped, and Hitchcock designed it so that at the bottom of the cover was a drawing of an altar frontal, with two big brass candlesticks on top of it, and then above, at the top of the page, the words 'Church Lighting' in heavy Gothic type. No mention of electricity, and of course no indication of wiring, since the whole point of the selling line was the discreetness."

In the advertising branch Hitchcock found himself surrounded for the first time by artists and writers. The myth that Hitchcock was an odd loner—a fat boy aloof from others, contemptuous of ordinary activity—is disproved by what happened next. Not yet twenty, Hitchcock emerged as a leader, a young man who attracted collaborators, spurred teamwork, and united people to pursue a common goal.

It was no accident that within a year of his transfer Henley's launched a new magazine featuring, apart from company news and gossip, "Contributions—Grave or Gay": cartoons, short fiction, poetry, travel pieces, essays. *The Henley Telegraph,* which sold for sixpence ("By Post: Eightpence"), was beloved by employees and even hailed outside the company. The *Organizer,* a London business periodical, found it one of "the best written, best edited and best produced" of the city's house organs.

Not only was Hitchcock a founding editor, he also served as business manager, "very much to the despair of the chief accountant," according to Moore. Not only that, he was the *Telegraph*'s most prolific contributor.

Back at St. Ignatius there had been student publications, and Hitchcock may have tried his hand at writing, though the issues of those years are lost. Surely he learned about writing and literature from Father Richard Mangan, the same priest who gave that well-remembered exhortation about dying honorably. Mangan presided over an English curriculum that stressed Platonic and Chaucerian princples of dramatic literature. This included an emphasis on the logic, the structure, the internal symmetry and unity of ideas, what Galsworthy in *The Forsyte Saga* called the "significant trifle"—a detail which "embodies the whole character of a scene, a place, or a person"—and, when possible, a universality concerned with aspects of human nature and behavior.

A beloved theatrical instructor, Father Mangan was also known for his superb investigations of Shakespeare, and delighted students with his

spellbinding rendition of Macbeth's famous speech, rendered in a broad Lancashire accent: "Is this a dagger which I see before me?" He encouraged humorous as well as formal essays, contrary to tradition, and didn't mind if the two were blended.

Starting with his debut piece in *The Henley Telegraph*—in the premiere issue, volume 1, number 1, June 1919—Hitchcock also blended drama with dark humor:

GAS

She had never been in this part of Paris before, only reading of it in the novels of Duvain; or seeing it at the Grand Guignol. So this was the Montmartre? That horror where danger lurked under cover of night, where innocent souls perished without warning—where doom confronted the unwary—where the Apache reveled.

She moved cautiously in the shadow of the high wall, looking furtively backward for the hidden menace that might be dogging her steps. Suddenly she darted into an alley way, little heeding where it led—groping her way on in the inky blackness, the one thought of eluding the pursuit firmly fixed in her mind—on she went—Oh! when would it end?—

Then a doorway from which a light streamed lent itself to her vision—In here—anywhere, she thought.

The door stood at the head of a flight of stairs—stairs that creaked with age, as she endeavoured to creep down—then she heard the sound of drunken laughter and shuddered—surely this was—No, not that! Anything but that! She reached the foot of the stairs and saw an evil smelling wine bar, with wrecks of what were once men and women indulging in a drunken orgy—then they saw her, a vision of affrighted purity. Half a dozen men rushed towards her amid the encouraging shouts of the rest. She was seized. She screamed with terror—better had she been caught by her pursuer, was her one fleeting thought, as they dragged her roughly across the room. The fiends lost no time in settling her fate. They would share her belongings—and she—

Why! Was not this the heart of Montmartre? She should go—the rats should feast. Then they bound her and carried her down the dark passage. Up a flight of stairs to the riverside. The water rats should feast, they said. And then—then, swinging her bound body to and fro, dropped her with a splash into the dark, swirling waters. Down, she went, down, down; conscious only of a choking sensation, this was death.

—then—

*"It's out Madam," said the dentist. "Half a crown please."**

* The original English spelling and punctuation of *The Henley Telegraph* pieces have been preserved.

The Grand Guignol atmosphere and the beautiful woman in peril mark this as distinctly "Hitch," which is how he signed this first Hitchcock work and the rest of his *Telegraph* contributions.

A close-up of a woman's face swollen with terror became a Hitchcock staple, one of those images he teasingly reprised in film after film. The opening image of *The Lodger,* his very first popular success, is a woman screaming. (And it didn't always have to be a woman: in the opening shots of *Rope,* a man gets the same treatment.)

"Gas" has been published in other books concerning Hitchcock. Donald Spoto, in *The Dark Side of Genius,* found the story a sophomoric Poe imitation, plainly evidencing the Hitchcockian "images of sadism" (and of "the woman plunged into water") that were integral to Spoto's dark portrait of the director. As he did more than once when analyzing Hitchcock's career, however, Spoto overlooked the humor: the sadism is undercut by the twist ending, in which the reader's expectations are turned on their head.

One of the clichés about the English is their avoidance of dental care, and Hitchcock himself was notorious for stained, crooked teeth and foul breath. His very English trepidation about dentists is deployed to comic effect in "Gas"—and again and again in his films.

The first published example of one of Hitchcock's "twist" stories, "Gas" is ultimately more comic than sadistic. The woman isn't being confronted by any real danger, it turns out, but by a hallucination induced by the anesthetic. In his films Hitchcock was drawn to visualizing all types of what he called "phantasmagoria of the mind"—hypnosis, concussions, dizziness, drunkenness, dreams. But in this instance the particular anesthetic supplies another level of meaning: the standard anesthetic used by dentists at the time was nitrous oxide or "laughing gas," known to cause hilarity along with its hallucinations.

While "Gas" alone might suggest "images of sadism," the array of other pieces that Hitchcock penned for the *Telegraph,* brought to light for the first time during research for this book, reveals a more humane, playful, faceted sensibility. Hitchcock wrote for every issue of the *Telegraph* published during his tenure at Henley's. "His articles were always of the quaint, fantastic type," said W. A. Moore, and "reflective of his character."

His contribution to the second issue, in September 1919, was especially cinematic, and especially remarkable for anticipating the voyeuristic obsessions, the complex narrative architecture, and the psychologically subjective perspective of Hitchcock films:

THE WOMAN'S PART

Curse you!—Winnie, you devil—I'll——

"Bah!" He shook her off, roughly, and she fell, a crumpled heap at his feet. Roy Fleming saw it all. —Saw his own wife thus treated by a man who was little more than a fiend. —His wife, who, scarcely an hour ago had kissed him, as she lingered caressingly over the dainty cradle cot, where the centre of their universe lay sleeping. Scarcely an hour ago—and now he saw her, the prostrate object of another man's scorn; the discarded plaything of a villain's brutish passion.

She rose to her knees, and stretched her delicate white arms in passionate appeal toward the man who had spurned her.

"Arnold, don't you understand? You never really cared for her. It was a moment's fancy—a madness, and will pass away. It is I you love. Think of those days in Paris. Do you remember when we went away together, Arnold, you and I, and forgot everything? How we went down the river, drifting with the stream as it wound its way like a coil of silver across the peaceful pasture lands. Oh, the scent of the may and lilac blossoms that morning! The songs of the birds, the joy of watching the swallows sweeping across the river before us—Arnold, you have not forgotten? It was the first day you kissed me. —Hidden in that sheltered sweetness where only the rippling sunbeams moved upon the myrtle-tinted stream—Arnold, you have not forgotten!"

The man crossed the room, and leaned upon a table, not far from where she crouched, gazing down at her with a look from which she shrank away.

"No," he said bitterly, "I have never forgotten!"

Still kneeling, she moved nearer, and laid a trembling hand on his knee:— "Arnold, don't you understand? I must leave England at once. I must go into hiding somewhere—anywhere—a long way from here. I killed her, Arnold, for your sake. I killed her because she had taken you from me. They will call it murder. But if only you will come with me, I do not care. In a new country we will begin all over again—together, you and I." Roy Fleming saw and heard it all. This abandoned murderess was the woman who had sworn to love and honour him until death should part them. So this was—yes, and more than that. But Roy made no movement.

Was he adamant? Had the horror of the scene stunned him?

Or was it just that he realised his own impotence?

The man she called Arnold raised her suddenly, and drew her to him in a passionate embrace.

"There is something in your eyes," he said fiercely, "that would scare off most men. It's there now, and it's one of the things that make me want you. You are right, Winnie. I am ready. We will go to Ostend by the early morning boat, and seek a hiding place from there."

She nestled close to him, and their lips met in a long, sobbing kiss. And still

Roy Fleming gave no sign—raised no hand to defend his wife's honour—uttered no word of denunciation—sought no vengeance against the man who had stolen her affections. Was it that he did not care? No—not that, only—don't you realise? He was in the second row of the stalls!

This one was signed "Hitch & Co.," the first record of Hitchcock teaming up with closet collaborators, a practice that would become standard for his films. Though it may seem a little puzzling on first read, "The Woman's Part" makes sense once it's clear that it's written from the point of view of a husband watching his actress wife perform onstage. The "stalls" were the front stalls of a theater, downstairs, as against the less expensive "circle," upstairs. The husband is taking "the woman's part," thinking about his wife as he watches her emote, as Hitchcock often took "the woman's part" in his films, adopting her point of view with his camera.

The husband is remembering his wife at home before the performance, gazing down maternally at their child, even as he finds himself captivated by her transformation onstage, where she is impersonating an adulteress and murderess. Watching his wife as she confesses to the first Hitchcock murder, albeit one that takes place entirely within the frame of a proscenium, the husband finds his emotions strangely divided, and aroused.

"I'm a believer in the subjective," Hitchcock said in a later interview, "that is, playing a scene from the point of view of an individual." Subjectivity helped transfer emotions into the mind of the audience, and "putting the audience through it" was his basic credo, as he told François Truffaut. Hitchcock might have added that he always had to put *himself* through it first—in the writing, preparation, rehearsal, and, finally, direction. His grip on a film was always stronger, his grip on the audience surer, if he could empathize with a character or an actor. From this early story it is not far, for example, to Hitchcock's first-person camera entering the danger zone with Aicia Huberman (Ingrid Bergman), meeting Sebastian and Mama and the nest of Nazis in *Notorious*.

The structure of "The Woman's Part"—the idea within an idea, story within a story—is quite clever. If anything epitomizes the finest Hitchcock films, it may be that "Hitchcock operates on many levels," in the words of Andrew Sarris. His films aimed for simplicity and clarity—even clichés—on the surface, but with contrast and counterpoint undermining the clichés, and hidden depths of detail and sophistication. Like "Gas," "The Woman's Part" features complex interwoven layers of teasing, surprise, and hidden business. As Sarris wrote of Hitchcock's films: "The iron is encased in velvet, the irony in simplicity—simplicity, however, on so many levels that the total effect is vertiginously complex."

The main theme of "A Woman's Part" can be seen to relate to future

Hitchcock films like *Murder!, Stage Fright,* and the second *The Man Who Knew Too Much,* where the director also plays around with truth and lies in stories about actresses. It anticipates *The 39 Steps* or *Sabotage,* where the illusions onstage disguise a darker reality, and prefigures *Rear Window,* where a man with a Leica stares from a distance at a mysterious occurrence.

The third *Telegraph* story, from the February 1920 issue, was another twisted jest:

SORDID

"It is not for sale, Sir."

Through a friend I had heard of a Japanese dealer in Chelsea, who had a remarkable collection of English and Japanese antiques, and, being a keen collector, I had made my way to his shop to look over his curious stock.

The sword, a fine heavy specimen, with a chased blade and elaborate handle, was not very ancient, perhaps about twenty years old—but it had attracted me.

"I will give you a good price."

"I am sorry, but I do not wish to sell."

There must have been something unusual about it, and so I became more fascinated and determined to obtain the sword. After much expostulating and protesting, he agreed to sell on the promise that I would purchase other things in the near future.

"There is some history connected with this, is there not?" I asked.

"Yes, there is, and if you have time I will tell it to you."

At the time of the Russo-Japanese War, Kiosuma, his son, was an ambitious lieutenant in the Imperial Japanese Army. It chanced that once Kiosuma was charged with the despatch of documents to a destination back in Japan which took him near his home. On the journey he failed to notice that he was being followed by two men—Russian Agents.

His home was about an hour's journey short of his ultimate destination, so he decided he would call there first.

As he alighted from the train, a feeling of delight enveloped him when he thought of the surprise that he would give his parents. He made his way up the hill of the little village beyond which his parents lived, his path lying through a wood. He quickened his step with the excitement of anticipation, until—almost within sight of his house—he heard a step behind him. Turning, he saw an arm raised, then came oblivion—

It was night when he regained consciousness, and as he struggled to his feet he endeavoured to collect his dazed thoughts.

Then he remembered—the papers!

What should he do? With the papers gone—!

He staggered towards his house, the lights of which were discernible through the trees, and was met by his father.

"O son, from whence came thou?"

Kiosuma proceeded to explain with difficulty.

The brow of his father darkened, his eyes narrowed, and his face grew to that of a mask.

"Oh, unworthy one! Thou hast betrayed the trust of the great Nippon. Where now is thy honor?"

"But my father, they have not the code!"

"Thou dare to excuse thyself! Take the sword—thou knowest the only course."

Slowly, but fearlessly, Kiosuma proceeded to his room. He laid a white sheet on the floor, and placed a candle at each corner, then having robed himself in a white kimono, he knelt down and cast his eyes upwards.

He raised the sword, with the point to his heart and—

<p style="text-align:center">* * * * ***

I took the sword home and in the firelight continued to examine my purchase while I pondered over the strange tale of the afternoon.

I noticed that the handle was a little loose; perhaps it unscrewed. I tried it with success, and detached the blade.

Lowering it to the firelight I studied the unpolished surface and read—

Made in Germany, 1914!

This composition might be subtitled (to tweak a well-known Hitchcock maxim) "It's Only a Story." As in his films, the shocks and the comedy mingle and leaven each other in his *Telegraph* pieces. Of the seven he wrote, five have turnabout endings, and only two are bereft of any comedy. Hitchcock's irrepressible sense of humor suffused the company publication, which was generously sprinkled throughout with his puns, witty captions, and play-on-word titles like "Sordid" (or "Sworded," as it were.)

Before he entered film, Hitchcock was already well known at Henley's as a "natural humorist and clown," in the words of W. A. Moore. "He had a sparkling wit," said Moore, "but it was not only the things he said but the spontaneous and unexpected things he *did* which gave us aching sides and streaming eyes. On every outing to which he went he bubbled over with joyous fooling and sent us home stiff with laughter."

Not only did Hitchcock help run the *Telegraph*, but, as improbable as it seems, he also figured in Henley's recreational activities. He entered billiards tournaments and organized the Henley's soccer club. He followed boxing, tennis, racing, and soccer; years later, in Hollywood, he told asso-

ciates he subscribed to the London newspapers partly to monitor the West Ham club scores.

Hitchcock supervised Henley's soccer team for several seasons—quite possibly at a financial loss to himself, given his already established hatred of bookkeeping. "He never did value money and would always rather pay out of his own pocket than be worried with the keeping of records," remembered Moore.

Although he professed never to have had a bona fide date with a woman other than his wife (and there's little evidence to doubt him), at company-sponsored occasions Hitchcock did socialize freely with female employees. This included evenings at the Cripplegate Institute on nearby Golden Lane, a small hall that presented lectures, entertainments, and classes. He took waltz and ballroom dance lessons at Cripplegate, sponsored by Henley's: then, and later in life, Hitchcock was a surprisingly light-footed dancer, and he larded his films with memorable dance and ballroom sequences.

The dance lessons were presided over by a man named William Graydon, whose acquaintance with Hitchcock exerted a profound effect on the future filmmaker. At one time the Graydons lived quite near the Hitchcocks in Leytonstone, and the two families, both Catholic and theatrically inclined, may have known each other before Cripplegate. Graydon was the father of one Edith Thompson, who at times, along with her younger sister Avis, helped out with the Cripplegate classes. Edith also appeared in amateur productions in London, which, given Hitchcock's interest in the stage, he may well have attended. Certainly Hitchcock was acquainted with Edith, although he never admitted as much on the record. He spoke primarily of knowing her father.

In 1923, Edith Thompson was hanged along with her lover, Frederick Bywaters, after being found guilty of complicity in the murder of her husband. Though Bywaters did the actual killing, Thompson was alleged to have incited the crime. The controversial trial and execution made the case one of England's most sensational in the 1920s, dominating headlines and public debate for months. To have had such a close tie to this young woman, whom many believed to be falsely convicted, surely affected Hitchcock. Surely it influenced his view of crime and punishment, and the many Hitchcock plotlines in which women, if often murder victims, are rarely clear-cut killers.

In the 1960s Hitchcock discussed the Edith Thompson case with a British journalist who also prided himself on being a crime buff. Each boasted of having devoured all the sources. Hitchcock had read *A Pin to See the Peepshow,* the 1934 roman à clef about the celebrated crime, and attended *People Like Us,* a stage play based on the incident. (He knew the playwright, Frank Vosper, who acted in *Waltzes from Vienna* and *The*

Man Who Knew Too Much.) Both Hitchcock and the journalist professed to have inside knowledge of the execution; the journalist claimed that Thompson had grown so hysterical as doom approached that guards had to tie her to a small wooden chair before drawing the noose around her neck.

"Oh no, my boy," Hitchcock interjected, his eyes glinting. "That's not the way it was at all. She was hanged in a bosun's chair."

"What's that, Mr. Hitchcock?" asked the journalist, though he had some idea. (The dictionary describes it as a wooden board slung by a rope, to be used by sailors for sitting on while at work, aloft, or over the side of a ship.)

Demonstrating, Hitchcock took his right arm and crossed it to the inside of his left elbow, clasping it there. Then he leaned across to where the other man was sitting, grabbed the man's right arm, and crossed it likewise, pulling him closer to create a makeshift "chair" of connected limbs. The director had staged the action, making the journalist part of it. "That, my boy," said Hitchcock dryly, "is a bosun's chair." The director never mentioned, however, whether he had known Thompson personally.

Such was his sensitivity to the subject, however, that when Hitchcock read John Russell Taylor's draft of his authorized biography fifty years later, he requested only two minor deletions. One was Taylor's mention of the Graydon acquaintance. Hitchcock explained that his sister, Nellie, living in England, was still on friendly terms with Avis, Edith Thompson's sister. Hitchcock said he exchanged cards with Avis, and occasionally encountered her, when in England. The dark past never came up between them as an issue, he explained, and it was part of their bond that he pretended not to remember. The director didn't want the book to embarrass Avis.

In September 1920 another *Telegraph* was published, featuring a particularly elaborate Hitchcock short story that showed his propensity for subject matter that (given the venue) might have flirted with censorship:

AND THERE WAS NO RAINBOW

Robert Sherwood was "fed up"; of that fact there was not the least doubt. Time hung heavily, for he had exhausted his source of amusement and had returned from whence he had started—the club. He did not know what to do next: everything seemed so monotonous. How he had looked forward to these few days' rest! And now—well, there it was! He was fed right up!

While he was thus engaged in reviewing his present circumstances, in

strolled his pal, Jim. Now, Jim was married, so he was in a position to sympathise with him; although, mind you, Jim's life contract had not been the ultramodern kind—where you repent and eventually divorce at leisure. It simply happened that Jim had struck lucky, and he was content.

"Hullo, Bob, old fruit!"

"Hullo, Jim!"

"You don't look in the pink. Anything wrong?"

"Oh, I'm tired—and fed up!" And Bob unfolded his little drama.

"Why, I know the solution. What you want is a girl!"

"A girl?"

"Yes: a nice young lady—someone with whom you can share all your little joys and sorrows—and money!"

Bob shook his head. "No, that's no good; I'm not built that way. Besides, I don't know any girls."

"Listen to me. All you have to do is to go to one of the suburbs—say, Fulham—and keep your eyes open around the smart houses. When you have struck your fancy, just go up and—oh, well, you know what to say! Simply pass the time of day, etc."

Bob got up.

"I'll think about it. Can't do any harm, and in any case it'll pass an hour."

"Good man!" exclaimed Jim. "Let me know how you get on."

<p style="text-align:center">* * * * *</p>

It was pouring heavily, and, in consequence, Bob swore. If he had any special antipathy it surely was relations (all of the old and crusty sort) and duty visits. The latter was a demand of the present occasion, and he made haste to get the ordeal over. But the rain teemed down heavier, and, being without an umbrella, he slipped into a nearby doorway. Some minutes had passed without any abatement of the rain, when a cloaked figure made its way up the garden path towards the refugee.

"Oh!" exclaimed the newcomer, startled.

"Excuse me," said Bob, "but I am sheltering from the rain. I hope you don't mind."

"Not at all," she replied, inserting her key in the lock. "Oh, dear," she cried, "I can't get the key to turn."

"May I try?" volunteered Robert. Receiving assent, he continued the good work, but was equally unsuccessful. "The only thing to do is to force the door," he said.

"Oh, is there no other way?"

"I'm afraid that's the only solution. I find that one of the wards of the key has been broken off. You must have dropped it."

"I did—this afternoon, after I had closed the door. Well, as force is the only remedy, do you mind trying?"

A few heaves with his shoulder proved sufficient to send the door flying open.

"Thank you so much," she said. "In return for your kindness may I ask you to come in and sit down until the rain ceases?"

Bob hesitated for a moment; then he remembered Jim's advice, and assented, with thanks. Once inside, he lost no time in getting acquainted, and the end of thirty minutes saw the pair intensely interested in each other. Brainy man, Jim (thought Bob), to put me on a stunt like this. I shall never be able to thank him enough! He'll be glad to hear of my progress.

At the end of an hour he was all but engaged. Then came the sound of footsteps up the path.

"My husband," she gasped. "What shall I do? You must get out of the window—hide—or do something—quick!"

"Oh—hell!" groaned poor Romeo. "Here's a go!" To her he said quickly: "Switch out the light, and I'll slip out of the door when he enters!"

She sprang to the switch and the room was plunged into darkness.

But almost simultaneously her husband opened the door and turned on the light, finding Bob at his feet, ready to escape.

"Bob!"

"Jim!"

"You d—n fool!" he shouted. "I said Fulham—not Peckham!"

Here was Hitchcock's first suspenseful "love triangle." But it's also a triumph of comedic inference: "he lost no time in getting acquainted, and the end of thirty minutes saw the pair intensely interested in each other"— from a director who often got away with sly sexual innuendo while distracted censors fretted over the footage of violence.

Several of Hitchcock's *Telegraph* stories make obvious references to the world of theater. The extent to which the stage influenced his filmmaking has never been adequately assessed. Theatrical style and effects—bravura style and special effects—suffused his work.

Was Hitchcock involved with some sort of amateur theater group during this formative period? Henley's arranged for employees to subscribe to West End plays. The company also established a drama club, just starting up in 1920, which met to mount shows at the Cripplegate Institute. Hitchcock never claimed any such involvement, but one has the sense, in these early writings, of someone watching people perform, while dreaming up alternative realities.

One might speculate that in "What's Who?" his fifth bylined piece, Hitchcock was writing from his own vantage among just such a group. Published in December 1920, this story predicted one of the issues that troubled his own career: it poked fun at producers, who, to him and many other directors, could be a nuisance.

WHAT'S WHO?

"Now," said Jim, "the proposal I have to put forward is a novel one!"
We yawned.

Jim was the producer of our local amateur theatricals, you see, and beyond that description it is not in my power to make further comment. Jim is twice my size.

"In the next show each of you three," he continued, "will impersonate each other!"

I gasped.

"Now you, Bill," he said to me, "will be him"—pointing to Sid; "and Sid will be Tom, and Tom you. Then when—"

"Wait a minute," interposed Tom, "let's get this clear. Now I'm Sid—"

"No, you're not, you're me!"

"Well, who's you?"

"You are, you fool!"

"You're all getting into a muddle. Let me explain further," said Jim.

"Doesn't need any explanation," I replied, "it's all as clear as Tom—"

"What do you mean?" interrupted he. "If you're going to get personal about it, I'll chuck up being you before we start."

"All right then, you be Sid, and I'll be you."

"But!" yelled Sid, "you said you were me!"

"Well, so I am."

"You're not, you're him!"

"Look here," broke in Tom, "let him be you, and you be me, and I'll be him."

"Shut up!" screamed Jim above the din. "Why don't you all stick to my first arrangement?"

"All right, then," commenced Tom, "I'll be Sid."

"No, you won't. I'll be Sid."

"But just now you said you were me."

"Shut up, he's you."

"Well, who's me?"

"I don't know."

"Why, Sid is, of course," put in Jim. "Now let's start."

"When—"

"Wait," said Tom, "I can't be him; he's bandy."

"Who's bandy?"

"You are, you fool!"

"I'll punch your nose!"

"Don't start scrap—"

"Well, he—"

"Look at what—"

"I'm not, you idiot—"
Jim fainted.

"Hitch" claimed two entries in the December 1920 *Telegraph*. If the first seems a precursor to Abbott and Costello's "Who's on First?" shtick, the second is every bit as frivolous, an amusing disquisition on "pea eating" that could have been dreamed up only by the son of a greengrocer. This story looks forward to the many scenes in Hitchcock films which are centered on sustenance and libation. Sometimes the scenes reveal crucial story information. Other times, as in "The History of Pea Eating," they offer disarming comedy relief.

THE HISTORY OF PEA EATING

Modern science, with its far-reaching effects on the life of the community, has yet one more problem to solve to further the progress of the world—that of eating peas. Considerable speculation has been given to the methods employed in the early ages, and we read of the prehistoric man who simply buried his face in the plate of peas and performed practically an illusion by his act of demolishing the vegetables without the use of his hands.

One must admit, however, that this method may be described as crude, for one can hardly imagine the modern corpulent gentleman attempting the same feat, because of the danger of his excessive "adiposity" reaching the floor before his face reached the plate.

We are told that Sir Roger D'Arcy, in the early Middle Ages, found no great difficulty in the problem. All he did was to attach to the headpiece of his armor a double piece of elastic in the form of a catapult. He simply placed a pea between the piece of leather attached to the elastic and aimed towards his open mouth. But even this method brought inconvenience, for it was soon discovered that there were many gentlemen with a bad aim, and often a duel resulted from the fact that Sir Percy had badly stung the wife of Baron Edgar over the other side of the room. It is believed that an Act was instituted prohibiting the use of this method without a licence, and one had to pass a test to secure the necessary permission to adopt this very ingenious style of feeding.

These restrictions were responsible for the falling off in the popularity of peas, and after a time, they were practically non-existent as an edible vegetable. Many years later, however, their revival brought a great interest to the now famous pea-eating contests, the details of which reveal a further method of manipulation. It appears that each competitor was required to balance a certain number of peas along the edge of a sword, from which he was to swallow the peas without spilling any. Of course, in very exciting matches the contestants' mouths and faces were often cut. It is believed that the performance

*of sword swallowing was evolved from this feat, and that very large-mouthed
people of today are direct descendants from the champions of that period.*

*As is well known, many estimable people still practise this method on a
smaller scale.*

*Still further styles of deglutition were tried in late years, and the modern
boy's pea-shooter recalls the employment of pages to shoot the peas in My
Lord's mouth. Bad aim, of course, was reflected with dire results to the page.*

*We have yet to discover a really useful and satisfactory method of pea eat-
ing. A recent inventor evolved a process by which a pipe was placed in the
mouth and the peas drawn up by pneumatic means. But in the trials the in-
ventor unfortunately turned on the power in the reverse direction, with the re-
sult that the victim's tongue is now much longer than hitherto.*

*Another person suggested that they might be electrically deposited, but the
idea of the scheme was so shocking that it was not considered.*

*One of the most sensible ways which is at present in the experimental stages
is receiving the attention of a well-known market gardener, who is endeavour-
ing to grow square peas so as to eliminate the embarrassing habit which peas
have of rolling off the cutlery. It is to be hoped that the experiment will prove
successful.*

*In order to help on this very important scientific development, suggested
methods from our readers will be welcomed, and forwarded to the proper au-
thority. Please direct any suggestions to The Manager, THE HENLEY TELE-
GRAPH.*

Gainfully employed, creatively engaged, the young advertising man prac-
ticed a new persona in public, taking long lunches at posh West End
restaurants, adopting the uniform of businessmen and lawyers, slowly
reading his *Times,* fingering his first cigars.

In 1920 he turned twenty-one, voting age, and the age when a young
Englishman officially became an adult and was rewarded with "the key of
the door." The lunches grew longer. Hitchcock had been at Henley's for
six years now, and he was becoming bored, restless. His boss perceived
that his young protégé was ill-suited for any longtime sinecure, in adver-
tising or any other department.

Hitchcock "caused me much worry by his carefree lack of attention to
the essential details of an Advertising Department's organization," re-
membered supervisor W. A. Moore. "Printing blocks would be sent off
and no records kept. When they were again wanted, no one knew where
they were. Records were a thing outside his understanding—matters too
insignificant to bother about."

Hitchcock shuffled his creative options at Henley's the way he later
shuffled alternative versions of film scenes to accommodate a lowering
budget or threatening censors: "We could always get another block, or put

something else in if there was not time to get another," Moore recalled as Hitchcock's work philosophy. "I do not suppose 'Hitch' ever realized how much he worried me in that respect. He was always too lighthearted."

What really happened is that Hitchcock had fallen completely under the spell of motion pictures—just the field that might combine his technical and design prowess, his gift for gab and word pictures, his salesmanship and his leadership. More than once Moore came upon his employee furtively turning the pages of a screen trade publication. And in his spare time (he made no secret of it), Hitchcock was prowling around the film studios in the central city and suburbs, hovering on the sidelines of productions, waiting and watching.

Perhaps the twenty-one-year-old had already caught sight of the woman he one day would marry. Love at first sight was a cliché to which his films were not immune. Perhaps a glimpse of Alma Reville, busy on a film set, reinforced the young man's growing determination to leave Henley's. Hitchcock would not necessarily have said anything; he was a bider of time. Mrs. Hitchcock once told a journalist that it took her husband several years to speak to her, after first registering her existence. "Since it is unthinkable for a British male to admit that a woman has a job more important than his," Alma explained, "Hitch had waited to speak to me until he had a higher position."

Hitchcock's final piece in the *Telegraph,* published in March 1921, is short, and perhaps his most enigmatic contribution. Some of the detail is quite precise, however. Hitchcock is specific about the Bank, for instance, an underground station in the heart of the city, close to a busy street that runs along the river, the sort of place where a policeman stopping traffic for a girl would be exceptional. And the play to which the piece refers is almost certainly Harold Brighouse's *Hobson's Choice,* which Hitchcock had seen when it was first performed in 1916. The story of an illiterate bootmaker taken up by the old-maid daughter of his boss, and turned into a sort of tycoon after the daughter teaches him to read by copying out texts on a slate, the play was filmed by David Lean in 1954.

But who is the mysterious woman in Hitchcock's little story? There is no clue.

FEDORA

A play of a year or two back provided a situation of a little man seeking the goal of worldly greatness. In order that we should return home with a feeling of satisfaction, the author allowed the hero to attain his object, but not without the usual obstacles experienced by all great men. His earliest efforts included self-education, and I can clearly remember his model line for an ex-

ercise in handwriting. It was, "Great things grow from small." I believe this obvious aphorism was the pivot of the whole plot, and also of all our plots. Because every person has a plot (I don't mean allotment) and every plot is the same.

I don't know if you have ever seen a puny young nanny goat alone in a field in a rainstorm. If so, you have seen Fedora. Fedora is the heroine of this disquisition. She is small, simple, unassuming, and noiseless, yet she commands profound attention on all sides. People stop to observe her, and I believe it to be on record that one of the policemen on point duty at the Bank has held up the traffic—all for Fedora. You suggest she is beautiful—no, not definitely—I say not definitely, because I hold out hopes. Her appearance:—"Starting with the top," as the guide book says, there is an abundance of dark brown hair, under which peeps out a tiny perky face consisting of two greeny brown eyes, an aquiline nose (usual in these cases), and a faded, rose-bud lipped mouth. Her figure is small, possessing some of that buoyance of youth when walking with the aid of a pair of unassuming legs or, shall I say, to get away from the suggestion of artificiality, inconspicuously regular.

"Great woman labour leader hits out . . ." Can that be? I had hoped for better, but no worse. Perhaps an actress? I can see a storm of emotion exploding in the face of a helpless, juvenile lead . . . the fury of a woman scorned. Then the vociferous applause from all, except her victim. What will be his feeling? Perhaps he will be overcome by her dazzling personality. Dare he ask her to be his . . . wait, if our Fedora is to marry, surely she shall be a real wife, a worthy figure of womanly charm and grace—this, of course, depends upon the realisation of my hopes. Let me suggest the wife of the Mayor. Shall I put it, as it were, the power behind the chair. "My dear George the tram service lately has been disgusting, you must see that . . ."

"Yes, my dear, I will mention . . ." At functions she will be the recipient of bouquets from the daughter of the local contractor.

Sometimes, I imagine, she will write brilliant novels, profound essays and learned works. But it is all mere conjecture on my part. Whatever may be . . . but I am no prophet, neither is she. Time will tell.

Shortly before "Fedora" was published, Hitchcock read a bulletin in the trade papers: Famous Players–Lasky, the production arm of Paramount Pictures, was opening a branch studio in London. The American executives promised a multitude of jobs for English applicants, including openings for "captioneers," the writers and illustrators of the explanatory intertitles that gave silent film its voice.

The trade papers reported that the first property to be wholly produced in England by Famous Players–Lasky British Producers Ltd. would be *The Sorrows of Satan,* based on a book by the popular novelist Marie Corelli. Hitchcock promptly obtained a copy of *The Sorrows of Satan* and read it

cover to cover. W. A. Moore helped him prepare a portfolio of his designs, including sketchwork from his art classes, samples of his Henley's layouts, and a continuity of the Corelli novel laid out in title cards. ("It showed wrong-doers tempting a top-hatted Satan," Hitchcock recalled.) Moore turned a blind eye while others in the advertising section pitched in.

When Hitchcock presented his portfolio ("large, black, paper-covered board with this printed title"), he learned a reality of the business: *The Sorrows of Satan* had been indefinitely postponed. Yet the man in charge was impressed by Hitchcock's dedication in compiling an entire script of title cards, and he encouraged the young applicant to stay in touch. When a film based on the play *The Great Day* was announced, Hitchcock went back and prepared another series of intertitles, impressing Famous Players–Lasky with his "demonstrative persistence."

For a brief period thereafter, Hitchcock kept up his job at Henley's while moonlighting as a title artist, kicking back a portion of his earnings to boss and co-conspirator Moore. Until the day came when he was offered a permanent position with British Famous Players–Lasky, and on that day Hitchcock resigned.

"I must have been a bit of a psychologist," he recalled years later. "They offered me seven pounds a week, but I insisted that was too much, asked for less and told them to give me a raise later if it worked out." From his first niche in film throughout most of his career, Hitchcock took less salary while promising extra work, for love of the job.

His last day at Henley's was April 27, 1921. The first issue of the *Telegraph* published without a contribution from the young spark plug contained a blurb about Hitchcock's departure, slightly exaggerating the status of his new position, while allowing that the many friends he had made during almost seven years of employment at the company would miss him.

"He has gone into the film business, not as a film actor, as you might easily suppose," read the warm, regretful statement, probably written by Moore, but "to take charge of the Art Title Department" of "one of the biggest Anglo-American Producing Companies. We shall miss him in many ways, but we wish him all success."

THREE

1921–1925

Paramount's Famous Players–Lasky was then the leading film producer and dominated the business "as no company ever had or would," in the words of film historian Douglas Gomery. So there was tremendous excitement when, in April 1919, British Famous Players–Lasky, Limited, was established. Its stated goal was to produce pictures exploiting "the personality of British artists, the genius of British authors, the beauty and atmosphere of British settings and scenery," according to the press announcement, "with the advantage of that technical knowledge which the American cameraman has had exceptional opportunities of perfecting" after World War I.

Compared to Hollywood, the British industry was a perennially weak sister. English films were fewer in quantity, and generally considered inferior in quality. The production equipment and values were often second-rate. Even the *Bioscope*, which existed to promote English filmmaking, often complained that the films it covered were "devoid of merit."

Even if an English picture showed obvious merit, it led a beleaguered existence. Many English exhibitors and distributors supported their own industry only halfheartedly, preferring to book American films with American stars; and the plushest picture palaces were owned by U.S. companies.

Moreover, English films rarely penetrated the world's biggest market-place—America. Although Hollywood counted on England for extra profits, America did not reciprocate by showing English films in the United States. Americans found English films "too English," with their colloquialisms and "stars" unknown across the Atlantic.

The English film industry therefore endured a love-hate relationship with Hollywood. England's top talent was always defecting to Hollywood, and the exodus was so steady that wags referred to the deserters as a "Lost Legion," wandering in a parched culture.

The inequity of the relationship led to endless attempts at a fair adjustment. Again and again ambitious coproduction plans tried to address the discrepancies. British Famous Players–Lasky was one such partnership, intended to build London bridges to the land of Hollywood know-how.

It wasn't until October 1919 that Islington was pinpointed as the location of the new British Famous Players–Lasky studio.

Unpretentious Poole Street, which turned off New North Road in close proximity to the Canal Bridge, was the site of a dirty, dilapidated building surrounded by slums. Originally a power station of the Metropolitan Railway, more recently a tent and tarpaulin factory, this massive glass-roofed structure would lend itself to renovation. While the company might have preferred a less working-class address, press reports emphasized that Islington was only fifteen minutes by public transport from the West End.

The company signed an optimistic twenty-eight-year lease on the building; and then the architects and builders took over. They carved out two immense stages, publicized as the largest in England; a deep well tank for undersea filming; offices and workshops; and a restaurant, seating sixty, which offered West End–type meals at affordable prices.

Construction began in October 1919, and by the late spring of 1920, when the first production was inaugurated, the transformation was complete. The facility was trumpeted as thoroughly up-to-date, on par with the best of Hollywood. The cameras and lights were the most modern and expensive; the film was Kodak; the equipment and operators alike were brought over from America.

In spite of the English boosterism, there was an American tinge to everything. Moreover, the first scenes of the first British Famous Players–Lasky production were photographed not at Islington but on the Continent, where English filmmakers habitually fled to escape their foggy, soggy climate. English film already had a long-standing (one film historian says "obsessional") involvement with countries across the Channel, especially Switzerland, France, Spain, and Italy. The weather in those nations could be counted on, unlike in London, where the notorious "particular" could create darkness at noon.

This attitude about escaping to sunny, picturesque locations was embedded in English culture, and also in Hitchcock's sensibility. From youth, he had always been fascinated by travel. Now, going on location became essential to Hitchcock's filmmaking approach as well. Films had to go places. The studio was his laboratory, but shooting on location allowed Hitchcock to poach a little reality to blend into his studio-made dreamscapes.

It was an American, Hugh Ford, who crossed from Islington to Switzerland in late May 1920 to launch the first British Famous Players–Lasky production, *The Great Day*. Ford hailed from the stage and New York, where he had managed the Fifty-sixth Street studio of Famous Players–Lasky, U.S. He had also directed in Hollywood for D. W. Griffith's company. Although most of the top business echelon of Islington were Londoners, the key creative personnel were often Americans, or returning Lost Legionnaires.

The directors, in particular, came from Hollywood and Famous Players–Lasky, U.S.: The first batch included Donald Crisp (a native Londoner who advertised himself as a Scot, and another Griffith alumnus), John S. Robertson (a Vitagraph veteran born in London, but not the English London, the Canadian one in Ontario), George Fitzmaurice (Paris-born), and Paul Powell (American, who had directed Lillian Gish, Douglas Fairbanks, and Mary Pickford).

The first head of the scenario department also came from Hollywood. Tom Geraghty was a former *New York Herald* reporter who had written pictures for Dustin Farnum, Wallace Reid, and Douglas Fairbanks. His assistant was the Englishman Mordaunt Hall, who later moved to the United States and became the first bylined film critic of the *New York Times*.

Although Islington made a point of buying and filming English stories, the studio's scenarists were also usually from Hollywood, and often enough these writers were women. On more than one occasion, Hitchcock would point out that he was steeped in script philosophies he learned from the "middle-aged American women" who reigned at Islington.

Eve Unsell, an editor-scenarist who had written an estimated one hundred scenarios for such actresses as Elsie Ferguson, Marguerite Clark, and Mary Pickford, was the first important writer to arrive at Islington. In late 1920 she was followed by Margaret Turnbull, a novelist and playwright as well as prolific author of films. Scottish by birth (she had sailed with her parents for the United States at age two), Turnbull took over from Unsell as the chief continuity writer, then was joined in April 1921 by Mary O'Connor (who had worked with Powell), and the well-known Jeanie Macpherson, Cecil B. De Mille's close collaborator.

The first scripts Hitchcock read and helped produce, then, were written by Hollywood women versed in Hollywood ways. More so than in England, American films were centered on a glamorous star system, with stories that plunged beautiful heroines into crises or emergencies. Distaff

scenarists were often employed to help flesh out the characterizations of the leading ladies, to lend scripts the emotional nuances that were thought to appeal particularly to the female sector. From the beginning of his career Hitchcock learned to focus on actresses, emphasize the female characters, accent their performances, highlight their appearances. And he learned early to have women surrounding him to help toward that goal.

Although it's hard to confirm the credits, Hitchcock is believed to be responsible for the lettering and title illustrating for at least eight pictures in his first two years. These include *The Great Day* (directed by Hugh Ford, 1920), *The Call of Youth* (Ford, 1920), *Appearances* (Donald Crisp, 1920), *The Princess of New York* (Crisp, 1921), *Beside the Bonnie Brier Bush* (Crisp, 1921), *The Mystery Road* (Paul Powell, 1921), *Dangerous Lies* (Powell, 1921), and *Perpetua* (John S. Robertson, 1921).

At Henley's the advertising staff had been expected to write as well as draw, and that was precisely the job of the "captioneer," a combination writer and sketch artist. At Islington, Hitchcock's title cards featured "birds flying, hearts breaking, candles guttering," as he recalled in one interview. One that read "John's wife was worried about the kind of life he was leading" was accompanied by the drawing of a horizontal candle burning at both ends.

Hitchcock took his assignments from Norman Gregory Arnold, Islington's supervising art director and the man who hired him. Arnold's younger brother, Charles Wilfred Arnold, was another art director who became a Hitchcock friend. The head of the camera department was Claude McDonnell, whose frazzled air masked his competence. From these three men Hitchcock would learn all the ground rules of filmmaking. He was a fast learner. All three—both Arnold brothers and McDonnell—would end up taking orders from Hitchcock a few short years later, when he became a full-fledged director.

Sketching title cards was good training for an art director, whose job it is to sketch decor and sets. There is some controversy over just how accomplished a sketch artist Hitchcock was. "If I wanted to," he told film historian Charles Thomas Samuels, "I could draw every frame of the finished picture." It was especially true, early in his career, that Hitchcock drew shots for cameramen, and that his drawings could be expressive. But eventually he hired his own small army of artists, and by the 1960s his matte specialist, Albert Whitlock, who rarely saw this side of him, insisted that "Hitch was no real draughtsman and rarely attempted sketching."

In mid-1921, Hitchcock moved up the ladder. His first picture as art director was probably *Three Live Ghosts*, a comedy directed by George Fitzmaurice in late 1921, starring Clare Greet and Cyril Chadwick. Fitzmaurice was married to the scenarist Ouida Bergere, a former theatrical

agent and actress who had been in film since the days of one-reelers. Berg-ere was more than a writer; she was Fitzmaurice's muse. She slaved on all stages of her husband's films, even sitting beside him in the cutting room.

Fitzmaurice's favored cameraman, an American named Arthur C. Miller, recalled meeting Hitchcock when he was an enterprising young art director at Islington. "I went along with him to a rather shabby residence where he spent some time bargaining with the woman of the house for all her old furniture to be replaced entirely by new," said Miller. "He used her old furniture to dress the set he had designed at the studio."

"Success to our researches!" Sir John (Herbert Marshall) exclaims as he plays detective in *Murder!* Research was Hitchcock's detective work, and already a key component of his methodology. He relished the process of "putting himself through it" in preproduction, scouting out real-life set-tings and real-life counterparts for the characters. He compiled notes and sketches and photographs partly for authenticity ("I'm very concerned with the authenticity of settings and furnishings," Hitchcock told Truf-faut), but also as a springboard for his imagination. He always tinkered with the reality.

After *Three Live Ghosts* Hitchcock art-directed *The Man from Home* (another film by Fitzmaurice and Bergere) and *The Spanish Jade* (directed by Robertson), both shot in late 1921. For *The Spanish Jade,* cast and crew traveled to Spain. For *The Man from Home* Hitchcock visited France and Italy. He might have explored those countries earlier, on vacation from Henley's, but overseas travel became routine in the Islington years.

While art-directing his first films, Hitchcock also tried his hand at writ-ing his first script, adapting on a speculative basis a novella owned by the story department. He also performed spot directing on what were called "crowd days" at Islington, capturing faces among the extras, and he was occasionally "given odd jobs of going out to shoot odd little entrances and exits on interiors."

Though still an art director, Hitchcock later observed, he was already acting like a director, designing not only the sets but the camera angles. "I was quite dogmatic," Hitchcock said. "I mean, I would build a set and say to the director, 'Here's where it's shot from.' "

In all of film history only a small percentage of directors have come from the ranks of production design. This foothold gave Hitchcock a dis-tinct edge when thinking in pictures. From the start, the "right look"—for people and places—was integral to his vision.

At Islington, Hitchcock also found his soulmate, an Englishwoman among all those Americans, a woman who made a greater contribution to his films than any other person.

Alma Reville was born one day after Hitchcock, on August 14, 1899,

in Nottingham in central England. Nottingham was known for its lace, and Alma's father served as the London representative of a local lace firm; the family was comfortably middle-class, and Alma was educated at a private school for girls.

As a young teenager Alma took ill with chorea, or St. Vitus's dance, a nervous disorder that often follows as a complication of rheumatic fever.* She was forced to miss roughly two years of schooling, which she forever regretted. Regaining her strength and reacting against her childhood illness, Alma developed into a tomboy; she would always be more athletic than her husband, more drawn to exercise and physical activity.

As often as possible, but especially on weekends and holidays, Alma's mother took her recuperating daughter to picture shows. By the time she recovered her health, the Revilles had moved to Twickenham, west of London. There she cycled over to the Twickenham Studio, a former skating rink converted by the London Film Company, and watched the filming.

In 1915 sixteen-year-old Alma entered the screen trade, five years ahead of her future husband. The producer Harold Shaw, an acquaintance of her father's, secured a job for her in the cutting room of the London Film Company "because it was the only place where it would be possible to work without any experience," she once explained.

Editors in those days were called "film joiners." "Director" and "producer" were still interchangeable titles, and directors often did their own editing, called "cutting." Cutting-room assistants learned "continuity" by helping the director sequence the footage. An "assistant continuity girl" like Alma Reville was expected to type, file, and know shorthand; besides serving in the cutting room, she held the script during filming, ready to prompt the actors, while recording the shots and script changes. In a pinch, she was looked to for minor writing tasks, and as she gained experience she wrote more, and more often. Effectively, the standard "continuity" credit Alma received on her earliest films indicated that she was working as a combination cutter and script editor—a common career path for women in the silent era.

Twickenham was a busy studio in those years, and Alma worked on numerous pictures. She served as editor of a lavish *Prisoner of Zenda* (1915), directed by the American George Loane Tucker. Another picture she toiled on, at least according to her daughter, Pat Hitchcock O'Connell, was D. W. Griffith's *Hearts of the World* (1918), parts of which were shot in the vicinity using Twickenham personnel.

By 1920 Alma had established herself as "floor secretary," or first assistant director, to Maurice Elvey, one of England's silent film pioneers.

* Sydenham's chorea, not the incurable and hereditary Huntington's chorea.

Proving her pluck and resourcefulness, she also stepped in front of the camera for what amounted to the first "Hitchcock cameo," appearing in Elvey's *The Life Story of David Lloyd George* (1918), in which she portrayed the wartime prime minister's daughter.

Alma spent several years closely partnered with Elvey before moving over to Islington in early 1921. She then became the floor secretary to actor-director Donald Crisp. When she first laid eyes on her future husband, sometime in mid-1921, Hitchcock was but a lowly "editorial errand boy," in his words; Alma was an established cutter, continuity writer, and production manager.

Their first encounter was decidedly anticlimactic. "Newcomers who came into our world inevitably reacted with awe and bewilderment, but this one was different," Alma said. "He strolled across the set with a deadpan expression, stopped to ask me where the production office was, and when I pointed to the building, he nonchalantly disappeared into it without saying another word."

She noted his placid face and confident air, but their subsequent encounters went nowhere. "All I can remember about first seeing him," Alma said, "was that he was always walking round the studios with a large packet of drawings under his arm" and wearing "a rather draggy gray topcoat."

For Hitchcock, silence was often strategic: what seemed like caution was cunning. With his tranquil expression, the editorial errand boy watched and waited. Hitchcock said later that at first Alma seemed "a trifle snooty to me. I couldn't notice Alma without resenting her, and I couldn't help noticing her."

He couldn't help noticing that she was just five feet, petite, with bobbed reddish blond hair and hazel eyes. Pretty and vivacious—but for the hair color, almost the ideal woman he described in "Fedora." Yet she was his superior, and he would let three or four years go by before speaking to her again.

Alas, British Famous Players–Lasky did not last long. By the summer of 1922 the experiment was suspended, and rumors began flying that the American parent company had abandoned the idea of producing pictures in England. Although Paramount was proud of its handful of completed films, the Islington product was regarded as a hybrid, neither English nor American enough to succeed. Moreover, Famous Players had overextended itself by building a new studio on Long Island almost simultaneously with Islington. The company was backing away from grandiose plans for an additional plant in Bombay. On a visit to London, company founder Jesse L. Lasky claimed that the Islington shutdown was temporary, but issued a call for fewer, better pictures.

Months passed, and work was catch-as-catch-can at Islington. The payroll was trimmed, and Alma Reville was one of the people let go. Hitchcock must have worried over his own future, but he managed to stay on as part of the skeleton crew—and, characteristically, he perceived an opportunity in the unstable situation, and made himself indispensable. Working longer hours for less money, he thrived.

It was while the studio was in limbo that Alfred Hitchcock took his first turn at directing. *Always Tell Your Wife* was a two-reeler based on a theatrical sketch by the venerable actor-manager Seymour Hicks. A comedy about a philandering husband, his suspicious wife, and a blackmailing mistress, the story had been filmed before, in a 1914 production with Hicks in the lead; now, in January 1923, director Hugh Croise leased space at Islington to launch a new version, again starring Hicks. When Croise fell ill, Hicks looked around in desperation. His gaze fell on "a fat youth who was in charge of the property room," according to Hicks, a young fellow "tremendously enthusiastic and anxious to try his hand at producing."

Today, only one reel of *Always Tell Your Wife* survives at the British Film Institute in London. Its footage bears the dominant imprint of Hicks, its star, writer, and producer. The camerawork is static, the comedy broad. Yet one detail is surely of interest to Hitchcockians: this first "quasi Hitchcock" has pointed shots of a fluttering caged bird. Whether the picture was even completed or released is unclear; probably not.

Or perhaps the obscure *Number Thirteen*, shot during this same period, was the young aspirant's true debut. Hitchcock directed *Number Thirteen*, a.k.a. "Mrs. Peabody," sometime in late 1922 or early 1923. The story was about low-income residents of a building financed by the Peabody Trust, founded by American banker-philanthropist George Peabody to offer affordable housing to needy Londoners.

Number Thirteen was written by a woman employed at Islington, her precise identity unknown, whose background included a vague prior affiliation with Charles Chaplin. Hitchcock took on the directing and producing. The star was Clare Greet, the daughter of famed actor-manager John Greet and his wife, Fanny.* Greet knew Hitchcock from *Three Live Ghosts;* a popular older character actress, she had first appeared onstage before Hitchcock was born.

The most notable thing about *Number Thirteen* is that Hitchcock's uncle John invested in the picture; when the funds ran out, Greet also pitched in money. Still, filming was ultimately shut down with only two

* Knighted in 1929, John Greet toured incessantly in productions of Shakespeare and other English classics, bringing theater to a generation of Britons, especially schoolchildren.

reels completed. All that is known to survive of *Number Thirteen* are a few stills; it would rank high on anyone's list of important "lost" films.

The failure of *Number Thirteen*—and the loss of his uncle's investment—was "a somewhat chastening experience" that Hitchcock took deeply to heart. In the years that followed, preparation and preproduction would become all the more crucial to his methodology. Storyboarding—sketching all the scenes in advance of filming—became standard policy. He felt keenly responsible for making films efficiently, according to budget. He was proud to be a "commercial" director, one who would turn a reliable profit for his producers.

Greet's generosity was another gesture he never forgot. Hitchcock had a soft spot for onetime leading ladies of the stage, whom he often called on for eccentric supporting roles. Greet would turn up in future Hitchcock films more than any other performer.*

Undoubtedly there would have been an Alfred Hitchcock even if there had never been a British Famous Players–Lasky. But the director was forged in the crucible of Islington. His budding talent and buoyant, self-assured personality set him apart, and many of his signature ideas and techniques—not to mention long-standing relationships—dated to his first film job. Through thick and thin at Islington, Hitchcock slyly positioned himself at the very heart of the studio.

Quite apart from what befell British Famous Players–Lasky, the early 1920s marked one in a series of precarious junctures in English film history, with several studios showing huge losses and teetering close to bankruptcy. England never had the wherewithal of Hollywood—the massive capital, the domestic audience numbers, the global marketing organization. But times of crisis always attracted brave young blood, and in the spring of 1923 several people who would loom large in Hitchcock's future arrived at Islington.

Michael Balcon and Victor Saville hailed from Birmingham, with backgrounds in film rentals. Saville had handled Midlands sales of the D. W. Griffith epics *The Birth of a Nation* and *Intolerance*, and after World War I he joined with the brothers Charles and Herbert Wilcox in a cinema-booking partnership. Saville and Balcon then formed a company to make advertising films, and coproduced their first short feature with a promising up-and-comer—the exhibitor Sidney Bernstein.

One of Herbert Wilcox's friends was a Newcastle upon Tyne exhibitor

* Besides *Number Thirteen,* Clare Greet appeared in *The Ring, The Manxman, Murder!, The Man Who Knew Too Much* (1934), *Sabotage, Jamaica Inn,* and the Hitchcock-produced *Lord Camber's Ladies.*

named Jack Graham Cutts, another passionate D. W. Griffith promoter. When Wilcox made the plunge into feature production in 1919, he hired Cutts to direct his first picture, *The Wonderful Story*. Victor Saville was fortuitously married to the niece of C. M. Woolf, who owned England's largest rental operation, W & F (named for Woolf and his partner, John M. Freedman). When Wilcox and Cutts split up, Balcon, Saville, and Jack Freedman—John M.'s son—formed a new company, and snapped up Cutts as their marquee director.

Saville and Balcon were intelligent and well-bred. Over time Hitchcock would feel closer to Saville, a witty, artistic-minded kindred spirit who soon turned to directing, creating an underrated body of work in England and Hollywood. Balcon was more a born producer—after Alexander Korda, arguably the single most important in British film history—with an exemplary career that extended from Islington in 1923 to his final film in 1963. Cool and quick-witted, Balcon was a master businessman whose worldly salesmanship was sometimes at odds with his staunchly English (Michael Powell said "suburban") sensibility. Hitchcock owed a lasting debt to Balcon, although over the years their relationship would sometimes be rocky.

Not only did Balcon-Saville-Freedman find the financial backing they needed in England, they also traveled to the United States to pave the way for an American distribution deal with the Select Organization, run by Lewis Selznick. A scrappy motion picture production and distribution pioneer on the East Coast before World War I, Selznick had fallen on hard times by the early twenties, and was trying to reorganize. Eager for product, Select was willing to peddle inexpensive British features to a small eastern chain of U.S. theaters.

Selznick was the father of two go-getter sons. The younger, David, would later become a prestigious producer and give Hitchcock his first contract in America. But the older brother, Myron, was just as important to the director's future. Serving as his father's unofficial ambassador to London, Myron first shook hands with Hitchcock on a visit as early as December 1921; in time he would become Hitchcock's first agent in Hollywood.

When Balcon-Saville-Freedman became tenants at Islington, Balcon encountered Hitchcock, "obviously a live wire," a general handyman and draftsman eager to do more. The first-time producer engaged Hitchcock to act as Cutts's assistant director on *Woman to Woman*, a 1921 stage play slated as the new company's maiden film production. "At one of our earliest meetings," Balcon recalled, "I asked him if he knew of a good scriptwriter, as we had not yet turned the play into film form. Hitch replied immediately, 'Yes, me.' I asked him what he had done by way of scriptwriting, and he produced a script he had written but which had never been filmed. I read it and put Hitch to work at once."

Woman to Woman, in Hitchcock's words, was "the story of a man who

has a mistress in Paris, who bangs his head, loses his memory, and starts going with another woman, who gives him a child." He had to use his imagination in concocting such a story, he explained later, for at the tender age of twenty-three Alfred Hitchcock was still a virgin. He had never even been on a date, and was ignorant of "the mechanics of sex." "I'd never been with a woman," Hitchcock recalled in one interview, "and I didn't have the slightest idea what a woman did to have a child. I had even less idea what a man did when he was with his mistress in Paris, or when he was with another woman who was giving him a child."

But he must have had at least a *general* idea, since he had the benefit of a solid play from which to adapt—and the opportunity to collaborate with the playwright himself: Michael Morton. A Boston native living in London, Morton was a former actor and the brother of well-known Broadway playwright Martha Morton. The author of two decades' worth of London and New York stage hits, at fifty-nine Morton was old enough to be Hitchcock's father, and now he set about teaching the younger man the rules of dramaturgy.

Morton's play was about a young English army engineer's affair with a Moulin Rouge dancer in Paris, just before the outbreak of World War I. The Englishman goes off to battle, the dancer gives birth to an out-of-wedlock baby boy, and the soldier, wounded, suffers amnesia. Assuming a new identity, he marries a social butterfly, who denies him the sole wish of his life: a son. Years later, in London, he meets the mistress, an artistic dancer, now gravely ill. The title came from the climactic confrontation between the wife and dancer. After nobly offering to give her son up to the man's wife, the onetime chorine keeps a dancing engagement that imperils her life. The dance-suicide at the very end of the play (and film) was considered especially unconventional and thrilling; it became the first of a surprising number of "self-murders" to end a Hitchcock film.*

Woman to Woman called for a research trip to Paris, and off Hitchcock went with Cutts to do a little scouting, according to John Russell Taylor. Paris was already a kind of home away from home. Hitchcock loved the exhibitions (the art as well as vice museums), the restaurants, the street life, and risqué nightclubs.

The first thing Hitchcock did after arriving, according to Taylor, was attend Mass at the Church of the Madeleine. His next move, one might say, was equally Catholic: he toured Montmartre and visited the Moulin Rouge, the better to soak up the hedonistic atmosphere and create, in Hitchcock's words, "an exact replica" of the famous cabaret. Though en-

* Peter Ackroyd in *London: The Biography* makes a point of the London fascination with suicide, pointing out that the city was known as the "suicide capital" of Europe.

joying himself, his mind was also at work. "What's suggested is always more potent than what's shown," he said in a later interview, offering one of his theories on sex appeal. "Look at the girls that dance the can-can. They're covered in clothes, except for two provocative glimpses of flesh."

By now Hitchcock was officially serving as the assistant director *and* cowriter of *Woman to Woman*. Someone else had been slated as art director, but when he bowed out Hitchcock told Balcon he'd be happy to do that job, too. With all his accumulating responsibility he was obliged to hire a staff, and Alma Reville was rather astonished to receive a telephone call. Up to this time he had barely acknowledged her existence. Now he announced he was hiring for a new picture; would Alma be available as editor?

They had both worked at Islington, but this was the first time they collaborated on the same film. Working side by side on five Graham Cutts productions would cement their extraordinary lifelong partnership.

The romantic Englishman Clive Brook played the amnesiac, but Lewis Selznick insisted on an American leading lady—Hollywood stars were box-office insurance around the world. Victor Saville went to Hollywood to recruit Betty Compson, a stunning but down-to-earth blonde who had made the transition from vaudeville and comedy to serious dramatic parts. A star of her magnitude needed to be convinced she was not "making a mistake with a leap into the dark of a British studio," wrote Saville in his memoir. "I not only had to sell the screenplay but all the technical aids as well—did the studio use a Bell & Howell camera, had the cameraman a good track record, how experienced was the make-up man, and so on and so forth, right down to the efficiency of the wardrobe mistress."

Compson arrived in London in May 1923, and was lavishly feted at a press party at the Savoy. Hitchcock met the American actress there, and they struck up a fast friendship. He was grateful that such a big star would take more than passing note of a young nonentity, and he never lost touch with the actress. Seventeen years later, when she needed work to qualify for guild pension and benefits, he paid Compson back with one of her last roles, the minor part of Gertie in his comedy *Mr. and Mrs. Smith*.

When Hitchcock found something that worked, he remembered it and carried it forward. And in Betty Compson—the star of the first finished film he helped direct—he found the first Hitchcock blonde.

"No pains were spared in photographing the female star," Saville recalled. "Never less than an hour, and more often longer, was occupied in arranging the oh-so-many lamps and then deftly shading the light so that it only illuminated that part of the face to round the features and flatten out those creases that make-up had not successfully concealed." There was

always a patch of gauze in front of the camera lens; Compson was photographed as "a chocolate box perfection of beauty," in Saville's words.

Most of the filming took place at Islington in May 1923, but the company made a brief excursion to Paramount's branch studio at Joinville, France, where Hitchcock re-created the Casino de Paris in all its sin and splendor. They borrowed casino dancers from the current show, substituting Compson for the lead dancer. After the last performance on Saturday night, the dancers were transported to the studio, where they toiled for the cameras all night before returning to Paris in time for the Sunday matinee.

Hitchcock had stipulated replicas of the revealing casino costumes, but *Woman to Woman* was his first brush with the puritanical censorship he would battle relentlessly throughout his career. It was also a defeat. "We had to employ a group of needle women," remembered Saville, "to fit the chorus with brassieres—no French breast could be exposed on the screens of England or America."

Since Hollywood stars could be brought over to England only at considerable expense, it was standard practice for them to appear in two pictures back to back. As soon as filming on their first production was finished, then, Balcon-Saville-Freedman hastily assembled their next picture, advertised as featuring "The Same Star, Producer, Author, Hero, Cameraman, Scenic Artist, Staff, Studio, Renting Company as *Woman to Woman*." Once again Graham Cutts directed and Betty Compson starred (as twins); once again Claude McDonnell was behind the camera; once again Paris was the setting. And Alfred Hitchcock was once again the assistant director, "scenic artist," and coauthor with Michael Morton of the scenario, apparently based on an unpublished Morton novel.

The novel was called *Children of Chance*. One source tantalizingly summarized Morton's story: "Wild girl becomes possessed by soul of twin who died to save her life."

Woman to Woman met with acclaim when it was presented to the trade and press in the late fall of 1923. Lewis Selznick paid a reported record sum for the U.S. and foreign rights, and the first Balcon-Saville-Freedman production actually premiered in New York before London. It went on to become the rare English picture to score a commercial success in American theaters. Thereafter it was distributed by Select in Germany, where for too long English films had been hurt by postwar political antipathies. All the more miraculous, therefore, that in Germany *Woman to Woman* repeated its box-office triumph, and boasted "the distinction of being the first British film shown [profitably] in Germany since the war," according to the *Bioscope*.

English critics praised the film's expressive atmosphere and inventive

camera work, crediting director Cutts, then at the height of his reputation. But reviews also commented on the sturdy script; indeed, a version was published in the United States in *Representative Photoplays Analyzed* as a sterling example of scenario writing.

When *The White Shadow,* the film version of *Children of Chance,* followed quickly on *Woman to Woman*'s heels, however, the second film proved an unmitigated disaster. Critics and audiences hated it. Why? So many years later, it is impossible to say. No one can claim to have seen either of these long-lost films since their initial release in 1923 and 1924.

Whatever the cause, disaster mounted in the wake of the failure of *The White Shadow.* The Select Organization plunged into receivership. Selznick's troubles had little or nothing to do with the few English pictures he was handling; indeed, the canny bargain he struck with Balcon more or less guaranteed that all the American and German revenue went to Select. But after *The White Shadow* faltered, C. M. Woolf, the rental magnate who controlled domestic distribution, dealt the studio a death blow.

A former furrier who had made a fortune distributing Tarzan pictures and Harold Lloyd comedies, Woolf spent his career trying to impose his taste on a succession of film companies in which he invested heavily. He detested "artistic filmmaking," and blamed the failure of *The White Shadow* on too much "artistry"; when he withdrew his financing from Balcon-Saville-Freedman, the company was forced to disband.

Yet bankruptcies in the English film industry often yielded unexpected fruit. Scrambling to organize new backing, Balcon regrouped under a different directorship. He founded Gainsborough Productions, named for the eighteenth-century English portrait and landscape painter Thomas Gainsborough. Under Balcon, the smiling "Gainsborough Lady" in ruffled eighteen-century garb and feathered hat would become one of the film industry's glorious trademarks, signifying good taste and refined entertainment in English cinema.

The first Gainsborough production was announced in the spring of 1924: *The Passionate Adventure.* Graham Cutts was back as director, and Hitchcock returned as art director, coscenarist, and assistant director. This time the source was a novel by Frank Stayton, which had previously been produced as a play. Again, Michael Morton was Hitchcock's collaborator.

Clive Brook played the main character, an upper-class Londoner who sheds his stuffy straitjacket on weekends, abandoning his mansion and wife to pursue a mysterious double life in the East End tenements. The rebel gentleman attracts both friends (Lilian Hall-Davis) and enemies (Victor McLaglen) among the slum dwellers, and his double life arouses the suspicions of a high official of Scotland Yard (John Hamilton).

The Passionate Adventure was quickly shot and edited for a July 1924 premiere. Along with *Always Tell Your Wife,* it is the earliest quasi-Hitchcock film to survive, if only in archives. The art direction is impressive (Hitchcock re-created evocative canal settings on Islington stages), but the endangered woman and wrong-man intrigue of the script are even more distinctly Hitchcockian. So is the climax.

"Vicky screamed," Stayton wrote in the original novel. "Then, scarcely knowing what she was doing, she threw herself on Harris, plunging the knife beneath his left shoulder-blade. His fingers relaxed; he coughed, then fell backward on the floor between the table and the bed."

Hitchcock was already beginning to develop his storytelling philosophy, again with a language all his own. He looked for a "springboard situation" in a story source, and for any number of "dynamic situations" that might lend themselves to visual emphasis—that might be "ocularly interesting." He liked to start a film with an allegro or andante sequence, he said, something in a "leisurely tempo"; then he would give the audience a sudden jolt, followed by a series of jolts building to a "crescendo," or "high spot"—ending the story, perhaps, with a gentle, ambiguous coda.

This earliest Hitchcock film to survive contains the first known instance of the type of sensational crescendo he pursued throughout his career. During a violent struggle, a gleaming knife finds its way into the grip of tenement good girl Lilian Hall-Davis, and the endangered heroine plunges the blade into Victor McLaglen, saving the hero. This quintessential Hitchcock image came straight from the novel *and* the play; as good a reader as he was a watcher, Hitchcock always plucked out the dramatic elements that spoke to him, that best served his compulsion to tell his uniquely gripping stories. Then he found ways to stage these dynamic situations that would magnify their emotional impact.

For Hitchcock, his Islington apprenticeship confirmed the power of technique. But it also established the ideas, inspirations, and obsessions of a fifty-year career remarkable for its persistence of vision.

Two lesser members of the *Passionate Adventure* cast came from America. One was the understated actress Alice Joyce, who played the rich man's spouse; the other was winsome Marjorie Daw, playing her best friend. Daw, who had been featured in Douglas Fairbanks pictures, was still married to Hollywood director A. Edward Sutherland. But she was being heavily courted by Myron Selznick, who was scrambling to preserve his connections in Europe after his father's bankruptcy. Myron had promoted Daw for the part, and accompanied her to London for the filming, traveling on the *Berengaria.*

Myron was a short, barrel-chested man, a chronic drinker who over

time would become an oppressive drunk. But like all the Selznicks, he had willpower and drive and a magnetic personality. Myron knew how to make things happen, and on the set of *The Passionate Adventure* he began forging a chummy relationship with Hitchcock.

Michael Balcon, meanwhile, continued to lust after markets outside England. He made an optimistic deal with Germany's largest studio, Universum Film Aktiengesellschaft in Berlin, known as Ufa. The Ufa-Gainsborough coproductions, according to the agreement Balcon hammered out, would be owned and distributed by Balcon for English-speaking territories, with the German and European rights retained by Ufa.

Shortly after the premiere of *The Passionate Adventure*, Myron Selznick and Marjorie Daw accompanied Balcon to Berlin to smooth the way for Ufa-Gainsborough cooperation. Graham Cutts and Hitchcock, along with Alma Reville and a second assistant, arrived in September to prepare the first film under the new partnership. Cutts got busy with casting, while Hitchcock concentrated on the art direction and his first solo script, based on Raymond Paton's novel *The Blackguard*. Set in Paris and Russia, the story revolved around the career of an abused boy befriended by a philanthropic artist. The boy becomes a violin prodigy and falls in love with a princess, whom he saves from a revolution led by his former music teacher.

The first Gainsborough-Ufa coproduction would be more Ufa than Gainsborough—a "superproduction," boasting grandiose set pieces, including Parisian sights (already a recurring feature of Hitchcock films); symphony auditorium scenes; and, intriguingly, a dream sequence in heaven. This was all created on the stages of the vast, world-famous Neubabelsberg studio, which sprawled over forested acres on the outskirts of Berlin.

Hitchcock worked closely with Ufa cameraman Theodor Sparkhul, whom he later said resembled Harpo Marx. A onetime associate of Ernst Lubitsch, Sparkuhl knew as little English as Hitchcock knew German, so they communicated mainly via sketches and sign language.

Erich Pommer, Germany's preeminent producer, was acting as the production's nominal supervisor. German actor Walter Rilla was cast as the violinist, while Hollywood actress Jane Novak, a delicate blonde who had starred with William S. Hart and Harold Lloyd, was imported to play the Russian princess.

Others in the cast included England's Frank Stanmore as the philanthropist, and German character actor Bernhard Goetzke as the music teacher. Hitchcock had admired Goetzke's role as Death in Fritz Lang's *Der müde Tod,* and as the archdetective pursuing archcriminal Mabuse in Lang's epic two-part *Doktor Mabuse, der Spieler,* so he made a point of seeking out the formidable Goetzke and forging a connection with him.

The fall of 1924 was the glorious high-water mark of the German silent

era. In London it wasn't always easy to see foreign films, which rarely received widespread exhibition. But Hitchcock had gone out of his way to catch the early masterpieces of Fritz Lang, F. W. Murnau, G. W. Pabst, and E. A. Dupont. He was swept away by the controlling style and pictorial mood of German expressionism. Now he wandered around Ufa's famed Neubabelsberg lot, marveling at the magnificent sets for Lang's two-part film of *Die Nibelungen*. (With shooting just completed, Lang himself was away on his first trip to America.) Indeed, Hitchcock's design for one scene of *The Blackguard* called for demolition of the giant trees constructed for *Siegfried* (part 1 of *Die Nibelungen*). When Hitchcock insisted, the Ufa art department obeyed "tearfully," according to John Russell Taylor.

Hitchcock was able to observe Murnau, one of Germany's supreme masters, shoot an intricately arranged composition for a scene in *Der letzte Mann* (a.k.a. *The Last Laugh*), which starred Emil Jannings. The shot involved a complicated depth of field. A railway station platform had been set up with a real train carriage, behind which mock carriages receded in the distance; far away across the lot, barely visible, another real carriage could be seen, with actual passengers stepping on and off. The controlled illusion, with its forced perspective, impressed the Englishman. According to conflicting sources, Hitchcock either engaged Murnau in conversation, or overheard him tell others: "What you see on the set does not matter. All that matters is what you see on the screen."

Hitchcock never missed an opportunity to quote this remark, which became a cornerstone of his own approach: The reality didn't matter if the illusion was effective. He then emulated Murnau by hiring a slew of dwarves to stand far from the camera in *The Blackguard*, creating an artificial perspective for a crowd scene.

The writer of *Der letzte Mann*, Carl Mayer, was "one of the best film writers" ever, according to Hitchcock—because Mayer wrote pictures, not words, to accommodate the visual genius of Murnau. *Der letzte Mann* virtually dispensed with intertitles; it was "the prime example of expressing a story idea" as "told visually from beginning to end."

To Hitchcock's American indoctrination could now be added the visual influence of the Germans. German cinema was more architectural, more painstakingly designed, more concerned with atmosphere. The Germans shot the set, not the stars, and when they shot the stars they anatomized them into eyes and mouths and hands. The Germans loved shadows and glare, bizarre angles, extreme close-ups, and mobile camera work; the "floating camera" that became a Hitchcock trademark was first Murnau's. German directors were notorious for manipulating actors as though they were puppets, choreographing the action down to the last twitch. There was zero improvisation in a Fritz Lang film; F. W. Murnau didn't permit surprises.

Hitchcock could be maddening on the subject of other films and film-

makers. Publicly, he claimed never to have watched another director at work.* (Privately he complained that other directors never came to watch him.) He sometimes dodged questions about other directors and films. But his records prove that he diligently kept up with the best. Indeed, no director was a greater devotee; he saw as many films as time allowed, from the earliest animated photographs to daily screenings in the final months leading up to his death.

Although he could be evasive about his influences, when pressed Hitchcock would mention *The Cabinet of Dr. Caligari*, Murnau, Lang, even Lubitsch. And when asked in general about stylistic mentors, his reply was unflinching. "The Germans. The Germans."

Germany in 1924 was a nation at odds with itself, divided in elections and factionalized in street fighting, by political arguments at taverns and dinner tables. Nazism was still in the future. Hitler sat in a Munich jail, dictating *Mein Kampf* to Rudolf Hess. And Berlin was the center of luxury and squalor, decadence and vice.

Berlin was thrilling. As always when he traveled, Hitchcock mixed business and pleasure. When he wasn't working he was sightseeing, which was also work—for he was always taking mental notes. He attended the cabaret, concerts, plays, museum shows, and art gallery exhibits. He dined at the best restaurants. He made a point of meeting writers and actors with intriguing reputations, and made the rounds of agents and producers. When he wasn't sightseeing with Alma, he chummed around with Eddie Polo, an American serial action star making pictures in Berlin at the twilight of his career, and with Jane Novak, the second Hitchcock blonde. He remained friends with Polo until the actor's death in 1961, and was devoted to Novak: fifty years later he was still logging her birthday in his datebooks.

Some who knew Hitchcock think he was a man at war with himself over his sexuality: prurient by nature and instinct, repressed in his behavior. But purely as a watcher, not a doer, he was clever about logging kinky experiences wherever he went—including Berlin. Throughout his life he demonstrated such uncommon luck blundering into these experiences that his luck should truly be considered connivance.

One Berlin night, Hitchcock recalled, he was dragooned into accompanying Graham Cutts and an Ufa representative to a nightclub popularized

* Except once: Hitchcock said in one interview that he observed a director at Paramount during a tour of that studio on his first visit to Hollywood. Hitchcock said he was astonished to note that this man—who must have been Cecil B. De Mille, judging by the description—worked with a loudspeaker system. All the drama in the picture, he sniffed in a subsequent interview, seemed to be on the set.

by homosexuals. There they encountered two women, who volunteered to take the Englishmen to a private party that promised titillation. They stopped at a hotel and went upstairs to a room. Cognac was passed around. The women made "various propositions," in the words of John Russell Taylor, "which perhaps fortunately the terrified Hitch did not understand too exactly." He refused the offers, Hitchcock told François Truffaut, repeating, *"Nein, nein."* The two women then slipped into bed and launched into lovemaking in front of the others. "Hitch was surprised but fairly uncomprehending," wrote Taylor. Another member of the retinue, the young daughter of an Ufa executive, donned her eyeglasses in order to see better. "It was a *gemütlich* German family soiree," Hitchcock dryly informed Truffaut.

Although Taylor surmised that "it seems unlikely that this interesting and exotic experience had any very deep effect," he underrates the incident, not to mention Hitchcock's feigned innocence. Hitchcock films evince more than a passing curiosity in all manner of sexuality—straight, homosexual, and anything in between. (He once told Taylor that he himself might have become a "poof" if he hadn't met Alma.) The Jesuit in him was attracted by taboos and fascinated by sin—and sex ranked high in the Catholic pantheon of sins.

Sapphic overtones can be detected right from the first film Hitchcock directed, *The Pleasure Garden,* which, as Truffaut noted, features a scene of two girlfriends "who really suggest a couple, the one dressed in pajamas, the other wearing a nightgown." (Yes, Hitchcock told Truffaut, that scene was "inspired" by the Berlin incident.) The lesbian feeling between Rebecca and Mrs. Danvers was the boldest conceit of his first Hollywood foray—and trousered ladies turn up regularly in other Hitchcock films.

For all its enticements, though, Hitchcock's trip to Berlin wasn't completely blissful. Until now Hitchcock and Graham Cutts had been friendly enough; they vacationed together, played the occasional game of tennis. But now friction arose between the director and his all-purpose assistant.

Success had transformed Cutts into a drinker and extravagant womanizer. "Famed for such feats as having two sisters in his dressing room in the course of one lunch break," according to John Russell Taylor, Cutts in Berlin plunged into an affair with an Estonian dancer, while trying to keep that romance secret from another woman with whom he was cohabiting in his rented flat. (Cutts always insisted that the other woman was his wife, but Hitchcock suspected otherwise.)

Cutts's "erratic and unpredictable" comportment bothered Hitchcock only insofar as it affected his work; though he loved gossip about extramarital affairs, Hitchcock was rarely judgmental about them, in life or in his films. Unfortunately, Hitchcock (on the living-room sofa) and Alma (in a small bedroom) were cohabiting with "the Cuttses," and the assistants

were expected to aid and abet the great man's peccadilloes. Cutts would arrange a rendezvous with his Estonian girlfriend; Hitchcock and Alma were then expected to provide an alibi with "Mrs. Cutts." After a protracted evening on the town, all four would pile into a car to head home, and Cutts would insist on "just stopping off" at the girlfriend's place. While Cutts and his Estonian disappeared upstairs, Hitchcock and Alma waited—and waited—in the car. When Cutts finally reappeared, they'd hurry back "very late, to a heavy English meal prepared by Mrs. Cutts (steak-and-kidney pudding and such)," according to Taylor, "which of course they could not refuse without arousing suspicion, so that Hitch got to the point of regularly excusing himself from table to run out, throw up and return for the rest of the ordeal."

Though these charades put a strain on Hitchcock's relationship with Cutts, they also cemented his growing love affair with Alma. The unspoken bond between the first and second assistant, their glances mingling horror and amusement, were like those of Robert (Derrick de Marney) and Erica (Nova Pilbeam), trapped in the game of blindman's buff in *Young and Innocent*—their mission a shared secret. If anything summed up the Hitchcocks' kinship, it was this sense of unspoken communion, the mutual amusement and horror of a shared adventure.

Things went from bad to worse with Cutts, until one day the director fled Berlin with his Estonian mistress, bequeathing the few remaining scenes to his somewhat relieved assistant. *The Blackguard* wasn't completed until early December, but it might be considered another quasi Hitchcock. Seen today, the film has the scope and flavor of an Ufa spectacular, including stirring crowd scenes, magnificent sets, and passionate acting, with a hypnotic performance by Bernhard Goetzke.

Returning to London shortly thereafter, Hitchcock learned that Graham Cutts had retreated to Calais on the coast of France, where he was stranded with the Estonian, who lacked the proper papers to be admitted to England. The script Hitchcock was working on—the next planned Gainsborough film, *The Prude's Fall*, based on a play by Rudolf Besier and May Edginton—had to be messengered to Calais. The new film was slated to be shot in the winter of 1924–25, and Jane Novak was staying on salary.

To keep ahead of schedule, Cutts decided to photograph exteriors on the Continent, even as the script was still being written. This was common in the English film industry, and would become all too common in Hitchcock's career as well. Cutts led a small unit (including Hitchcock, Alma Reville, and Jane Novak) first to Italy, where they filmed exteriors around Lake Como and Venice, then on to St. Moritz, Switzerland. But the

weather was miserable everywhere they went, the Estonian was prickly, and Cutts was distracted by his romantic problems; they ended up collecting little usable footage. The lark turned sour, and the unit returned to England in general ill temper. Sans Estonian, Cutts was forced to shoot *The Prude's Fall* at Islington, and as expeditiously as possible.

After *The Blackguard, The Prude's Fall* was a disappointment. The last Cutts-Hitchcock picture reflected its troubled history, with a disjointed story line and scenes that looked hastily assembled for interior stages.

And the conflicts behind the scenes tolled the demise of the team. Cutts was fourteen years older than Hitchcock, and increasingly saw him as a rival. Behind Hitchcock's back, Cutts bad-mouthed the upstart. Years later, Alma said that Cutts "wasn't really a pleasant man; he knew very little, so we literally carried him." Hitchcock himself averred that in those days he was "running even the director," adding, "I used to whisper in his ear. I was the soul of discretion in asserting myself."

But Hitchcock always claimed to be oblivious of any tension between them. Years later, the once prominent silent-era director, down on his luck, applied for remedial work on *The 39 Steps;* by then the leading figure in English film, Hitchcock quietly arranged for Cutts to shoot close-ups of the film's star, Robert Donat. Later still, he gave Cutts's daughter an uncredited walk-on in *North by Northwest.*

In 1924, though, Cutts was still the big name, and it was up to Michael Balcon to devise a Solomonic solution. Balcon did just that. The Ufa deal had fallen through, but the producer had just negotiated a fresh agreement between Gainsborough and Emelka, a Munich-based competitor of Ufa. Balcon sent Hitchcock back to Germany as a bona fide director, and chose him to guide the first Gainsborough-Emelka coproduction.

Although he was a man who had always acted consciously and decisively, who had already directed, at least partially, a handful of film, and who once admitted that by 1924 "I was already toying with the idea of directing," Hitchcock usually gave credit for this turning point to Balcon. "Balcon is really the man responsible for Hitchcock," the director told Peter Bogdanovich. "I had been quite content at the time, writing scripts and designing." This statement seems all the more generous, considering the strong differences and misunderstandings that would arise over the years between the two.

Like Ufa, Münchener Lichtspielkunst was known by the phonetic reading of its initials, MLK, or "Em-el-ka." Formed in 1918 as a distinctly Bavarian alternative to Berlin's domination of the German film industry, Emelka was a leading proponent of mountain, *Heimat* (homeland), *Krimis* (crime), and other frankly commercial genres, as compared to Ufa's avowed artistic

mission. Michael Balcon's five-picture deal was intended to help Emelka surpass Ufa, in and outside Germany.

The first Gainsborough-Emelka coproduction was to be *The Pleasure Garden,* based on a 1923 novel by Oliver Sandys, the nom de plume of Marguerite Florence Barclay. The plot revolved around the friendship and intertwined fates of two nightclub dancers. One of the chorus girls is corrupted by success and marriage, while the other is betrayed by her husband, who leads a double life in a foreign land with a native mistress.

The film needed a recognizable star, "a name the public would know, which at that time meant it had to be a Hollywood name," in Michael Balcon's words. This time it was Virginia Valli, who had launched her career at the old Essanay Studio in Chicago in 1915, before achieving stardom with Fox and Universal. Valli would play the chorus girl with an unfaithful husband, while another American actress, Carmelita Geraghty—the daughter of former Islington story editor Tom Geraghty—would portray her ingenuous friend. Englishman Miles Mander was cast as Valli's unscrupulous husband. The smaller parts would be filled on location, with the bouillabaisse of nationalities that would become another Hitchcock trademark.

The scenario was by Eliot Stannard, who would remain an important colleague behind the scenes for the rest of Hitchcock's silent period. The cameraman, Baron Gaetano Ventimiglia, was a Sicilian descended from Italian nobility, but he had also worked in the United States for the Associated Press and the *Newark Times* before switching to film. He had shot pictures in Hollywood, Berlin, Nice, and, most recently, Islington.

From Hitchcock's point of view, though, the key member of his small band traveling from London to Munich late in the spring of 1925 was Alma Reville. Her official functions were as editor and assistant director, but her actual role was far more important. Over the brief time they had worked together, Hitchcock and his assistant had enjoyed total rapport. They loved food and art and music and theater. They shared a similar sense of humor. Alma complemented Hitchcock's ideas about storytelling and performance and decor. She was willing to listen at length to him, sometimes finishing his dangling sentences. Already Alma was his muse.

The arrangement with Emelka stipulated that interiors would be shot at the Geiselgasteig studio outside Munich on a clearing of fifty acres in a forested area dotted with thirty to forty permanent outdoor sets. Although the main story took place in England, the violent climax was set in an African outpost. The exteriors would be shot first in Italy while the nightclub and other sets were being constructed at Geiselgasteig.

Photography was set to start at the seaport of Genoa on the Italian Riviera. Alma journeyed ahead to Cherbourg to collect the two Americans, Valli and Geraghty, arriving on the *Aquitania.* She escorted them to Paris, where the stars insisted on stretching the budget and staying at the Clar-

idge on the Champs-Élysées. It was Alma who then took the women to Paris shops, selecting their frocks and arranging their hairdos.

After the farmer decides to marry the housemaid in Hitchcock's 1928 film *The Farmer's Wife,* he insists she must immediately change her hair and put on new clothes. "To mark the change," the farmer declares, "you must blossom out this very minute!" From the outset of his career, Hitchcock's actresses, to mark their transformation into leading roles, also had to "blossom out."

It's a mystery where his firm ideas in the wardrobe and hair department came from. Perhaps he dealt with models in art classes, or at Henley's; he may have learned something from his sister, Nellie, who was a model. But reshaping the look of his leading ladies, from head to heels, was also part of his process of arousal—"putting himself through it" before the audience. And, starting with *The Pleasure Garden,* Alma also helped to shape his aesthetic of feminine beauty.

The first Hitchcock film was a trial by fire. So much went wrong that the experience prepared him for all future disasters; he never tired of telling the anecdotes.

How simple life was in the silent era; how lightly a director and his company traveled! Hitchcock could recall the precise time he left Munich for Italy ("at twenty minutes to eight one Saturday evening"), accompanied only by Miles Mander (whom Hitchcock later admitted he disliked from the start), Baron Ventimiglia, and a "newsreel man" invited along to shoot the shipboard scenes in newsreel style. (This too became a typical Hitchcock gambit—engaging quick, adaptable, and inexpensive newsreel men to work independent of the primary unit, shooting filler scenes to his detailed instructions.)

Besides the main cameras, the small company carried little in the way of equipment. "No lighting, no reflectors, nothing else at all, except the film—ten thousand feet of it." Alma was still in Paris as they proceeded by train to Italy. According to Hitchcock, Ventimiglia told him not to declare their film stock to customs when they reached the Brenner Pass, to save on surcharges. The officials discovered the film, however, and "confiscated the lot." They had to pay a fine, and arrived in Genoa on a Monday morning "without any film and on Tuesday noon I had to shoot the departure on an ocean liner from the port," Hitchcock recalled. They had to send to Milan for a fresh supply.

The filming began in the last week of May 1925, though inauspiciously. The young German actress playing Mander's mistress had to be replaced when she informed Hitchcock she couldn't wade into the water for her big scene. *"Heute darf ich nicht ins Wasser gehen,"* she said, and the transla-

tion ("Today, I should not go into the water") supposedly baffled Hitchcock. Why, he later protested to interviewers, he had never even heard of menstruation! Scrambling for a replacement, the director finally enlisted the waitress of a local hotel. But the waitress was too plump; a series of retakes was necessary for the scene where Mander had to carry her into the water.

The budget had already been taxed by the Paris luxuries and the added film-stock expenses, and the crises mounted. Hitchcock had to wire to London for some of his own money; at one point, his wallet was even stolen. Hitchcock was kept busy with his least favorite pastime: bookkeeping. "Most of my evenings were spent translating marks into lira via pounds," he recalled. He borrowed small sums from the deep-pocketed stars. ("They weren't very nice about that," Hitchcock said.) Returning by rail via Belgrade, Vienna, and Zurich, they had to stint on meals. After paying a surtax on the Hollywood actresses' excess luggage, and another penalty for a window accidentally broken in the Zurich train station, Hitchcock returned to Munich—with only one pfenning in his pocket, he claimed, "the smallest German coin minted, worth considerably less than a farthing."

He wouldn't have gotten through it without his muse. Alma Reville caught up with them at the Villa d'Este on the shores of Lake Como, where they were shooting the picturesque honeymoon scenes. Feeling very much a beginner, Hitchcock found himself in a "cold sweat" staring at the famous Virginia Valli. "I was terrified at giving her instructions," he said. "I've no idea how many times I asked my future wife if I was doing the right thing."

Alma was a Rock of Gibraltar, staying close by Hitchcock's side for every shot on location, and then later in the studio. After photographing each take, Hitchcock would turn to her and ask, "Was it all right?" A satisfied nod, and he could move on to the next.

Back in Munich by the last week of July, they shot the nightclub dance numbers in a *Glashaus* (glass-roofed studio), under conditions made unbearable by the scorching summer heat. The dance sequences required intricate staging and endless retakes. Although by now Hitchcock had picked up a smattering of German—enough to fling colorful phrases around for years to come, lampooning the geniuses he had first observed at Ufa—the German trade publications noted that the Englishman needed a translator to give precise technical instructions.

Nonetheless, Hitchcock, whose sensitivity to budget and schedule was inculcated from childhood and reinforced by the rude exigencies of British film, finished photography by the end of August. Michael Balcon went to Munich for the first screening, proudly declaring that the young director's debut possessed an "American look," which was what Gainsborough and Emelka needed if the film was going to have any serious international

prospects. To anyone who sees *The Pleasure Garden* today, its "German look" (full of "witty angles and camera movements," in the words of Philip Kemp) seems equally acute.

In the meantime, Michael Balcon was busy raising money to take Islington over from British Famous Players–Lasky.

Charles Lapworth, a well-traveled Englishman who had worked as a journalist and as an agent in Hollywood, and then as a publicist for the Goldwyn organization in London, joined Gainsborough as its editorial director. Lapworth had written a story called "Fear o' God," which was announced as the second Gainsborough-Emelka production, and the second to be directed by Alfred Hitchcock. There was only a two-month interlude before the start of filming, but Hitchcock and Alma returned to London to consult with Eliot Stannard, who was crafting the scenario from Lapworth's story.

"Fear o' God" concerned a mountain-town schoolteacher who is first courted and then persecuted by a possessive justice of the peace, who drives her into the arms of a mysterious hermit. The hermit, dubbed Fear o' God, was to be played by Britain's Malcolm Keen; Bernhard Goetzke, whom Hitchcock had befriended on the set of *The Blackguard*, agreed to portray the judge. The schoolteacher would be played by Nita Naldi, the sexy vamp in Cecil B. De Mille's *The Ten Commandments* and the temptress opposite Rudolph Valentino in *Blood and Sand*. The casting, thus, covered the three target markets: England, Germany, and the United States.

The director returned to Munich early in November, to shoot initial exteriors while the script was still being completed. In need of "a nice thatched village with snowy mountains in the background and nice tree stuff in the foreground and no modern stuff," as Hitchcock recalled, the director spotted a postcard depicting picturesque Obergurgl in the Tyrolean Alps near the Italian border. The trip involved a long train ride to Innsbruck and then another long ride by automobile to Obergurgl. Upon arrival Hitchcock declared the setting perfect, and went to bed feeling fine. But it snowed heavily that night, and when Hitchcock and his crew woke up Obergurgl was blanketed in white. They switched to nearby Umhaus; then it snowed in Umhaus. It took all the director's powers of persuasion—and extra money from the beleaguered budget—to convince local firemen to get out their hoses and wash away the snow.

After a week or two of outdoor photography, Hitchcock hastened back to Munich to greet his leading lady, just then arriving from Hollywood. But when Nita Naldi stepped off the train, he recalled, "Munich quite audibly gasped." The heroine of the picture was supposed to be a "demure" schoolmarm; yet the glamorous Naldi was "dark, Latin, Junoesque, stat-

uesque,* slinky, with slanting eyes, four-inch heels, nails like a mandarin's, and a black dog to match her black swathed dress," according to Hitchcock. She was accompanied by an elderly gentleman who looked old enough to be her father; indeed, that is how she introduced him—as "Papa" (though Hitchcock had his doubts).

How to transform this glamorous vision into a rustic mountain woman? Of course the high heels, long nails, sultry makeup, and hairdo had to go. "Nita put up a magnificent fight for the appearance that had made her," Hitchcock recalled. She fought her new hairdo, her designated makeup and wardrobe, but lost every battle to the director. Alma took the star "round and made her buy cotton aprons instead of silk and compelled her to choose cloth instead of satin frocks," in Hitchcock's words.

This time the interiors were photographed at Orbis-Studio, also in Munich. A replica mountain town was designed and built by Willy Reiber, who had created the London settings for *The Pleasure Garden*. But there were rewrites, and other vexing delays; Hitchcock was learning to be philosophical about such problems. *The Mountain Eagle*, or *Der Bergadler*—as "Fear o' God" was retitled—was scheduled to finish filming by Christmas 1925, but it would be January before it wrapped.

For all the crises and emergencies of the Emelka productions, Hitchcock was having the time of his life. Filmmaking was never as fun: the crises seemed to invigorate him. In spite of his doubts, Naldi turned out to be "a grand person," a born trouper who ultimately did whatever Hitchcock asked, no matter how many takes were required. Keen and Goetzke were equally professional, equally grand.

The Mountain Eagle may have turned out an inferior picture ("a very bad movie," Hitchcock flatly told Truffaut), but the director's memories of that time were only fond ones. For years thereafter the Hitchcocks returned together to Lake Como, St. Moritz, and Munich; these were the places where he and Alma first made films, and where they fell in love.**

Returning to England after the filming, Hitchcock had reason to feel flushed with pride. "The career of this young man reads like a romance," his old Henley's boss, W. A. Moore, boasted. Only twenty-six, just four years out of the advertising department of Henley's, Hitchcock was now a film director with two pictures under his belt. He had done almost everything there was to do behind the camera, except step in front of it himself. (And of course, even that would come shortly.)

* She may have needed those heels to appear statuesque: if press materials can be trusted, Naldi was five feet four.

** Like Willie (Walter Slezak) in *Lifeboat*, Hitchcock could wax nostalgic about the pot roast in his favorite Munich restaurant.

Indeed, *The Mountain Eagle* marked a personal as well as professional milestone: Hitchcock had prevailed upon Malcolm Keen to bring over a ring the young director had secretly picked out in London, and by the time he and Alma left Munich Hitchcock had a private script planned out.

The return trip to England proved an unusually violent ride. A fierce storm shook the boat; the wind blew and roared, the swells ran high. Desperately seasick, Alma took to bed. "As I tossed fitfully on my bed of pain, there was a knock on my door of my cabin and Hitch came in," Alma remembered. "It was the first time I had ever seen him in a state of disorder, and the last time too. His hair had been blown about by the wind and his clothes had been soaked with ocean spray."

Born salesman and storyteller, Hitchcock was also a born actor. He had rehearsed the moment, with a few lines in his head. "Will you marry me?"

"I was too ill to lift up my head," recalled Alma, "but not so ill that I couldn't make an affirmative gesture."

"I thought I'd catch you when you were too weak to say no," Hitchcock told her.

Several versions of this anecdote have come down through the years, though their details vary. "It was one of my greatest scenes, a little weak on dialogue, perhaps, but beautifully staged and not overplayed," Hitchcock boasted on one occasion. "Alma's acceptance stood for complete triumph. I had wanted to become, first, a movie director and, second, Alma's husband—not in order of emotional preference, to be sure, but because I felt the bargaining power implicit in the first was necessary in obtaining the second."

Then again, maybe Alma was the instigator. "I married her, because she asked me to," Hitchcock told Oriana Fallaci on another occasion. "We'd been traveling around and working together for years, and I'd never so much as touched her little finger." That is certainly the way it plays in *Champagne,* a 1928 Hitchcock silent picture featuring a shipboard betrothal, with Betty Balfour proposing to woozy Jean Bradin.

Foreign Correspondent and *Lifeboat* also feature marriage proposals at sea, and there are shipboard romances in *Rich and Strange* and *Torn Curtain.* Hitchcock was among the most personal of directors, and autobiography with subtle variations was a staple of the archetypal Hitchcock story line. Even Alma's shipboard nausea would find its way on-screen: "I always get seasick," Ingrid Bergman complains in *Notorious*—and what is *Lifeboat* if not the ultimate seasickness film?

Back in England, Gainsborough completed the acquisition of Islington and announced an ambitious slate of nine pictures for 1926, with rental mag-

nate C. M. Woolf returning to the directorate and promising a fresh infusion of capital. Significant U.S. interest was reported in the reinvigorated company, and Michael Balcon and Charles Lapworth traveled to New York to firm up distribution. Nevertheless, Gainsborough's publicity emphasized that the studio program would be "British in every way save for the inclusion in each of one American actor or actress."

Parliament was already debating a "quota act" to limit the nefarious influence of Hollywood, and to stimulate native English filmmaking. Some form of the controversial 1927 Cinematograph Films Act would be in place up through the 1930s. The days of American stars and international coproduction were numbered—one reason the next decade would become known as Hitchcock's "most English."

For the moment, though, Alfred Hitchcock was England's most German director. Before the Emelka films were released, he was still relatively unknown outside the small realm of Islington. Indeed, Alma Reville was the bigger celebrity. She had been lionized in the trades as early as October 1925, in an article (with photograph) describing her as "clever and experienced," attesting that "she had much to do with the finish of all Graham Cutts's big pictures." In December 1925, Alma was featured in a full-page profile in the *Picturegoer.*

Hitchcock was still experimenting with his image. His caricature was drawn and identified as "A. J. Hitchcock" in *The Motion Picture Studio* in 1923, and he was promoted as "Alfred J. Hitchcock" in earliest publicity. He wore a duster's mustache for publicity stills, and still favored a bow tie. He toyed with a personal logo sketch linking his three initials. The exact billing and Hitchcock persona were still in formation, still fluid.

But Balcon had faith in Hitchcock, and he reserved one of Gainsborough's most prestigious projects of 1926 for the young Englishman fresh from his German triumph. In early December 1925 the trade papers carried this notice: "Almost immediately on his return Hitchcock will take up the megaphone on a third production for Gainsborough, *The Lodger* by Mrs. Belloc Lowndes."

FOUR
1925–1929

In Germany, Hitchcock had immersed himself in expressionism. Now, returning to London, partly through the newly organized Film Society of London, he grew equally attentive to Soviet film, and the theories of Dziga Vertov, Lev Kuleshov, Sergei Eisenstein, and V. I. Pudovkin.

"Film-art," wrote Pudovkin, "begins from the moment when the director begins to combine and join the various pieces of film."

Or "pure cinema," as Hitchcock liked to say, "is complementary pieces of film put together, like notes of music make a melody."

He familiarized himself with Kuleshov's experiments with editing, as described by Pudovkin. Hitchcock could precisely describe Kuleshov's famous experiment with a stage matinee idol, whose blank face Kuleshov intercut with a bowl of hot soup, a dead woman in a coffin, and a little girl playing with a teddy bear, obtaining different audience reactions with each new combination. Hitchcock knew the experiment so well he could pronounce the actor's name, and spell it for interviewers: Ivan Mozhukin.* He even demonstrated Kuleshov's idea during a 1965 television program, filming

* In France he became phenomenally successful under the spelling Mosjoukine.

himself with a suggestive smile, then intercutting the image first with tenderhearted footage of a mother and a baby, then with a beautiful young woman in a sexy bikini, winkingly making his point that the order and arrangement of the images—the editing—drastically altered the message.

Hitchcock was still in Munich in October 1925, when the Film Society launched its first official subscription event. The program featured comedy shorts by the nonconformist Adrian Brunel, a Western by "Bronco Billy" Anderson, and two celebrated German pictures—an experimental work by Walter Ruttmann, and the three-part *Waxworks* by Paul Leni.

German and Russian films were standard Film Society fare. Besides foreign films, the Sunday afternoon showings at the New Gallery and (later) the Tivoli also featured overlooked American pictures, controversial British works frowned on by government censors, and avant-garde films scorned by the official industry, which regarded the Film Society as anticommercial, artistically highbrow, and faintly communistic.

Although Hitchcock missed the premiere, he took enthusiastic part in the Film Society, and knew all the movers and shakers. These included Iris Barry, the film critic of the *Spectator;* Walter Mycroft, an editor and critic of the *Evening Standard;* the up-and-coming filmmakers Adrian Brunel and Ivor Montagu; actor Hugh Miller (from *The Prude's Fall*); the sculptor Frank Dobson; and Sidney Bernstein, then managing his family's chain of cinemas. Noel Coward and George Bernard Shaw also lent the luster of their names.

Montagu, the son of the banker Lord Swaythling, was the translator of Eisenstein and Pudovkin, and typical of the affluent, literate people spearheading the organization—the type of Cambridge- or Oxford-educated Englishmen Hitchcock preferred to associate with personally and professionally. (The nearest Hitchcock got to Cambridge was cropping his face into an alumni reunion photograph in *Dial M for Murder*—one of his best cameo chuckles.)

Hitchcock would benefit from collaboration with Montagu, and with Angus MacPhail, a red-haired Scot who briefly succeeded Montagu as film critic of the *Observer.* "Tall and thin and shortsighted," in the words of T. E. B. Clarke, MacPhail had such "a scholarly air, he might have been taken for a don." MacPhail desperately wanted to join the film trade; he would begin by hanging out on the set of *The Lodger*—and remain by Hitchcock's side, off and on, for three decades. The handsome, dapper Bernstein was another lifelong ally; Hitchcock would also work, with differing degrees of intimacy, with Mycroft and Brunel. They were all part of a small circle Hitchcock joined, who convened at Brunel's flat after screenings, holding what they dubbed "Hate Parties" to dissect what they had just seen.

Another Film Society and Hate Party regular was the somewhat older

writer Eliot Stannard. Born in 1888, Stannard was the son of novelist Henrietta Winter (who wrote as John Strange Winter); Winter's children's book *Bootle's Baby* accounted for Stannard's cuddly nickname: "Bootles." Whether Stannard was a onetime man of the theater or a former Fleet Street journalist is uncertain. Michael Powell described him as "a dark, wildly handsome, untidy man"; another Hitchcock collaborator, Sidney Gilliat, painted him with the "lantern-haggard, long-haired look of an unsuccessful touring actor."

This much is known: Stannard entered film in 1915 as the scenarist of *The Mystery of a Hansom Cab,* and between 1915 and 1922, when he turned up at Islington as the author of *Paddy the Next Best Thing*—a Graham Cutts picture sandwiched between the British Famous Players–Lasky dissolution and *Woman to Woman*—Stannard wrote roughly two dozen features. These included high-minded adaptations of plays and fiction by John Galsworthy, Arthur Wing Piñero, Henry Fielding, William Thackeray, Charles Dickens, and Robert Louis Stevenson, as well as many original potboilers. Stannard boasted a lengthy association with director Maurice Elvey; indeed, Alma Reville worked with Stannard on the Elvey productions, and may have recommended him to Hitchcock and Michael Balcon.

Steeped in literature and theater, Stannard knew most of the novels and plays that film producers were buying, in an era when best-selling books and West End hits were considered sure box-office bets. Known for his equable temperament, his admirable detachment from ego, and his perpetual air of resignation, Stannard was also recognized for his willingness to take on multiple assignments, turning them out with speed. "His method," in the words of Ivor Montagu, was "to sit down and tap it straight out on the typewriter as he thought of it, without change or erasure." Even more important to Hitchcock, he was just as proficient a talker. Stannard "could talk like an angel and forever," recalled Michael Powell.

Stannard was well established by the time he was partnered with Hitchcock on *The Pleasure Garden,* and, like W. A. Moore at Henley's or Michael Morton before him, he offered Hitchcock the wisdom of an elder. In addition to the two Emelka pictures, Stannard would work on the scenarios of seven other silent Hitchcock features; he would, in fact, write at least a part of every silent Hitchcock film. After him, no other scenarist would last as long with the director, who grew to be—to say the least—demanding of his writers.

Hitchcock liked to get close to his writing partners. He needed to feel an affinity with his closest creative collaborators, and in a sense he and a

given writer got "married" for the duration of a given project, spending all day, and then evenings and weekends, together. But the writer he trusted most from the start, the collaborator for whom he felt the greatest affinity, was the woman he would marry: Alma Reville. She was a constant, if somewhat mysterious, presence in the writing sessions—sometimes saying very little, though whatever she said counted. Hitchcock felt that it helped everyone to have a billiards-like "triangulated" discussion, to have "three Hitchcocks" in the room.

In later interviews Hitchcock said that *The Lodger* was the first property that he himself chose from the studio's available properties. (That was a proviso he often invoked when discussing his story choices—that he'd made the best choice possible "from the available properties.") But *The Lodger* was also a novel Hitchcock professed to love. The story of a psycho killer stalking London, it was the kind of material that struck a deep chord with him. And though in his later work he would often drastically change the novels he filmed, revising their stories to meet his own needs, in this first important instance he tried to be faithful.

Mrs. Marie Belloc Lowndes's novel, published in 1913, concerns a mysterious lodger suspected by his landlords of being the Avenger, a Jack the Ripper–style killer responsible for a series of "curious and brutal murders" in London. The novel had been a best-seller, and was followed by a well-received stage version, seen by Hitchcock, in 1916. The play was quite different from the book, tinged with comedy; it introduced the idea of the lodger wandering about at night in search of homeless people, presenting them with buns concealing gold pieces—an activity that is misinterpreted by Scotland Yard.

The film had its own reasons to depart from the book. For as keen as the director was on the novel, from the outset the three Hitchcocks were faced with two issues that dictated the singularities and peculiarities of the final script. Both involved their prospective star, Ivor Novello, a British boy wonder who had risen to the fore as a composer of popular wartime songs.

Michael Balcon had scored a coup by signing the Welsh matinee idol to a Gainsborough contract. Novello had made only a few films, including an American picture for D. W. Griffith, and he was principally a musical comedy performer. With his boyish grin and brilliantined hair, it is tempting to see Novello as Hitchcock's initial foray into "countercasting," or casting against type—the director's first golden opportunity to exploit a familiar persona to play off audience expectations. Novello might become the first dashing Hitchcock killer.

Yet Hitchcock was undermined, not for the last time, by a front-office decision: Novello had to be cleared, by the end of the film, of any wrongdoing. It was probably the dreaded C. M. Woolf who insisted that the success of *The Lodger* depended on Novello's female fans, who might be

repulsed if he proved to be the bloodthirsty Avenger. "It would never have done for Ivor's many fans to think him capable of villainy," wrote Novello biographer James Harding.

This went directly against the book Hitchcock prized, in which the lodger is revealed almost undoubtedly as the killer, a lunatic who is suffering from acute religious mania. At the end of Mrs. Lowndes's novel, the lodger even manages to elude police, who—in true Hitchcockian fashion—have been slow to evince "the slightest interest" in him as the obvious culprit. Then, just like Jack the Ripper, the Avenger disappears from public view, his ultimate fate unknown.

Hitchcock often said that if he hadn't become a film director, he might have become a lawyer. He was a master negotiator, and spent his career picking his way through minefields of casting, censorship, and front-office resistance to achieve ingenious compromises in his filmmaking. The way he solved the Ivor Novello problem in *The Lodger* became a reliable— though not perfect—blueprint for much of the rest of his career.

First, the three Hitchcocks made the telling decision to build up the part of young Daisy Bunting, the landlady's daughter. Daisy doesn't even *meet* the lodger until three-quarters of the way into Mrs. Lowndes's novel; there the story is viewed almost entirely through Mrs. Bunting's eyes. In Hitchcock's film, Daisy would become an equal lead character.

Just as telling: Daisy is described in the book as fair-haired, but in the film her character would become a "curly blonde"—a more specific detail that links her closely to the suspense, for curly blondes are said to arouse bloodlust in the Avenger. The book has an assortment of victims, but in the film all the Avenger's victims would be "curly blondes." It was the first instance of blonde fixation in a Hitchcock film—and an invention entirely his own.

Although hardly an icy, elegant Hitchcock blonde—in fact she's rather sweet and down-to-earth—Daisy has a charged sexuality that heightens her vulnerability. In one scene, Hitchcock has Daisy's boyfriend, the hapless policeman Joe, jokingly clap her in painful handcuffs—a prank intended to hint at "fetishism," as Hitchcock admitted to François Truffaut. He leaped at the chance to point out the obvious "sexual connotation" of handcuffs to his French colleague. "When I visited the Vice Museum in Paris," Hitchcock explained, "I noticed there was considerable evidence of sexual aberrations through restraint. You should try to go there sometime. Of course they also have knives, the guillotine, and all sorts of information."

The handcuffs aren't in Mrs. Lowndes's version; nor is another scene showing Daisy undressing for her bath, her pale skin glowing as though irradiated. (Hitchcock's beautiful women are never so beautiful as when they strip to their undergarments, unaware of being observed.)

As Daisy luxuriates amid the soap bubbles, the steam rising outside her

bath window is noticed by the lodger, lulling in his above-stairs flat. Aroused by the thought of Daisy (surely, the audience thinks, he is longing to clutch her by the neck and stroke those golden curls), the lodger creeps downstairs and stealthily tries the door handle of the bathroom. It's a remarkable scene that anticipates by thirty years Janet Leigh's stepping into the shower in *Psycho*. Up to this point the audience has been led to believe the lodger is the Avenger, and if Hitchcock had his druthers Novello might well have opened that door. But, no, in 1926 the door must be locked.

The three Hitchcocks had to make many changes from the book. Mrs. Lowndes had included a long scene toward the end of the novel in which Mrs. Bunting attends an inquest investigating one of the murders, and another involving a chance encounter between police and the lodger at Madame Tussaud's Chamber of Horrors. They were scenes the director might have enjoyed filming; he incorporated both inquests and famous museums into other films.

But the crucial chore was exonerating Novello, whose role was transformed into the first of Hitchcock's many wrong-man leads. The ending the writers came up with involved a mob pursuing the lodger and nearly lynching him; the lodger tries to climb down from a bridge, but is caught and beaten, dangling there when his handcuffs catch on a pike.* When the police arrive to save him (realizing that the real Avenger has struck elsewhere in the meantime), there has to be an explanation for the lodger's suspicious behavior throughout the story and it's a silly one: he has styled himself a good "avenger," stalking the evil one. The real Avenger, flashbacks reveal, has murdered the lodger's sister, one of the first curly blonde victims.

With the director whispering in his ear, Eliot Stannard wrote the script over the first two months of 1926; then Hitchcock went back over it one last time, breaking it down into several hundred master scenes, making notes and little sketches to guide each camera setup, "each one specifying the exact grouping and action of the characters and the placing of the camera," in his words. The script was always written with the flow of pictures in mind, but storyboarding was the final revision. Stannard was encouraged to suggest visual ideas, but again the more important contributor was the expert in continuity and cutting: Alma.

The script satisfied front-office concerns that Novello's character be proved innocent. But that left the second issue: Novello was a stiff, mannered actor, whose technique leaned heavily on his repertoire of tedious "handsome" poses. That was a challenge to be addressed in the directing, but one Hitchcock had already anticipated, incorporating into the shooting script a brooding visual design to eclipse Novello's flaws.

* Yes, it was an intentionally Christlike image, Hitchcock would admit ruefully to interviewers—but it was only meant as a small touch, he added, and perhaps a little indulgent.

* * *

In March 1926, *The Pleasure Garden,* which Hitchcock had finished film-
ing seven months earlier, was previewed—and greeted, in the words of the
Daily Express, as "an outstanding film." Even today, Hitchcock's direct-
ing debut remains impressive.

The very first sequence had showgirls gliding down a spiral staircase
onto the stage of the Pleasure Garden theater, ogled by elderly men slouch-
ing in the front row, glued to their opera glasses. There it all was in the
opening shots: show business and voyeurism, the sly Hitchcock mix.

The Pleasure Garden also boasted Hitchcock's first provocatively
staged murder. Miles Mander has a mistress who has outlived her useful-
ness.* They go wading in the sea, he tips her head back as if to baptize her,
then he strangles and drowns her.

And for the first time a film was signed—literally, with a scrawled au-
tograph—by Alfred J. Hitchcock, the formal billing he finally decided on.

The enthusiastic reception of *The Pleasure Garden* fanned the growing in-
terest in Hitchcock's new project. It didn't hurt that a stream of items de-
scribing *The Lodger* was being churned out by Cedric Belfrage, one of the
Cambridge circle, now Gainsborough's new publicity director.

The Lodger began photography in March 1926. Baron Ventimiglia re-
turned as Hitchcock's cameraman, shooting on the lavish sets (including a
multilevel lodging house) designed by C. Wilfred Arnold; Alma was the
film's assistant director and editor. Hitchcock cast Malcolm Keen in an-
other pivotal part as Daisy's boyfriend, Joe, the not-too-bright policeman
on the trail of the killer. (Joe's jealousy of Daisy's relationship with the
lodger was another "triangulation" original to the film.) Daisy's parents,
the landlords made nervous by their strange tenant, were played by Marie
Ault and Arthur Chesney, whose younger brother was actor Edmund
Gwenn. (Chesney and Gwenn "looked alike as two peas in a pod," in
Hitchcock's words.)

The curly blonde Daisy was played by June, the stage name of June
Howard-Tripp, a dancer and musical comedy headliner. Ivor Novello may
have asked for her; years earlier he and June had done a screen test, and
they had appeared together onstage. Then again, it may have been more
Hitchcock countercasting, as well as a chance to launch a new personality
into film. Like Novello, June was probably cast before the script was done:
Daisy was made to order for her blond, vaguely nubile looks.

* Often misidentified as Nita Naldi in filmographies, this was the overweight hotel waitress hastily re-
cruited for the role on location.

Hitchcock could be testy about his supposed fixation with blondes. "It's not my attraction to them," he told the BBC in one interview. "I think it's tradition. Ever since the beginning of movies, starting with Mary Pickford." After Pickford, blondes became "a symbol of the heroine," he said in another interview, or—one of his odd phrases—"the amplification of identification." He also liked to point out, with justification, that blondes photographed in sharper contrast, especially in black and white.

· On other occasions he admitted to being a gentleman who sometimes preferred blondes. More than once, he expounded on his favorite qualities in a leading actress. Above all, he invariably mentioned, she ought to be ladylike. During the English half of his career he described the ideal as sleek and petite. "Smallness is a definite asset," he wrote in a 1931 article. (They were taller in America.) If the actress was a blonde, well, she should be a frosty blonde, he said, evoking a snow-covered volcano, whose sexuality smoldered underneath. It was up to the film, and the director, to stir the dormant fires.

"I more or less base my idea of sexuality on northern European women," he said. "I think the northern Germans, the Scandinavians and the English are much sexier, although they don't look it, than those farther south—the Spanish, the Italians. Even your typical Frenchwoman, the provocative one, is not the epitome of French sex. The girl who lives in the country, always wears black on Sunday, is guarded by her parents, wrapped in her family—that's your typical French girl, and it's nothing like what they give the tourists."

Harping on blondes was an interview convenience. Actually, there was surprising variation among the Hitchcock blondes—and he also cast a number of intriguing brunettes. June herself was flaxen-haired; the curling was Hitchcock's idea.

Yet June helped set the mold for Hitchcock women, as Novello helped set the mold for the men. Hitchcock men could also hew closely to type. Like Novello, most were long, lanky specimens, with dark eyes, raven hair, perfect teeth. These were conventions of stage and screen, to be sure, but equally the wishful projection of a director who was short, fat, with sparse hair, and dubious teeth and breath. "I have always dreamed of being slim as a reed," Hitchcock once said. All the greatest directors dreamed themselves into their leading roles.

Gainsborough's publicity team celebrated the glamorous stars of *The Lodger;* the film itself was a celebration of beautiful camera work. Though Hitchcock liked the congenial Novello, he was wary of the actor because of his acting limitations and his homosexuality, unknown to his cult of female fans but no secret to those around him. As Hitchcock filmed Novello—and June—he took pains to work around those twin challenges.

Some of the film's most famous images were transferred dutifully straight from the novel—among them Novello's looming, Nosferatu-like appearance in the lodging-house doorway as a "tall, thin shadow of a man" with a "dark, sensitive, hatchet-shaped face" who is "clad in an Inverness cape and an old-fashioned top hat." But whenever possible the two stars were anatomized into body parts, latticed with light or shade—pictures drawn first in Hitchcock's mind, and then on paper, before they were transferred to film. *The Lodger* would be full of hands reaching, clutching; giant lips, wide, darting eyes, and cubist ears; treading feet and naked legs.

When Hitchcock's camera wasn't anatomizing, it was gliding restlessly, up staircases, into bathrooms, hovering from the rafters or rising even higher, as though the camera were perched in the heavens—as if to remind audiences that God was also watching. (Few directors resorted to overhead shots as insistently, as effectively, as Hitchcock.)

"Fresh from Berlin," recalled June, "Hitch was so imbued with the value of unusual camera angles and lighting effects with which to create and sustain dramatic suspense that often a scene which would not run for more than three minutes on the screen would take an entire morning to shoot." Once, she said, she was forced to carry "an iron tray of breakfast dishes up a long flight of stairs" some twenty times before Hitchcock was "satisfied with the expression of fear on my face and the atmosphere established by light and shadows."

The film's most bravura sequence—where the landlords fearfully listen to the lodger as he paces back and forth in his room overhead—was also plucked from the book, then masterfully planned and executed by the director. The lodger is seen from below, the camera pointing up through a glass floor. The landlords fret as the lights sway, and the hypnotic footfalls grow almost audible. The apparent stars of the sequence were Novello's feet—"restlessly walking up and down his sitting room" with "the cautious, stuffless tread of his rubber-soled shoes," in Mrs. Lowndes's words. But the real star was Alfred Hitchcock.

With Hitchcock meticulously collecting numbered shots and angles from his annotated script, photography was completed in six weeks. The editing took place concurrently, and by May the trade columns were already reporting that studio insiders who had previewed *The Lodger* thought it might be a masterpiece. But that was Cedric Belfrage's publicity speaking; inside Gainsborough, opinion was intensely divided about the picture, which had emerged more stylish and edgy than anyone had anticipated.

Graham Cutts—Hitchcock's former friend, now his diehard foe—continued to bad-mouth his onetime assistant; after seeing an early screening

of *The Lodger*, he told "anybody who would listen that we had a disaster on our hands," said Michael Balcon.

Another diehard was C. M. Woolf, who still held Hitchcock partially responsible for the fiasco of *The White Shadow*. He had opposed Hitchcock's promotion to director; now, paranoid that an "artistic" picture could not easily be launched into the maximum number of English theaters, Woolf convened a high-level screening. Hitchcock and Alma "couldn't bear to wait in the studio to know the results, and we walked the streets of London for an hour and a half." After hailing a cab back to the studio, they learned that Woolf had walked out, declaring he would shelve *The Lodger*. Bookings were canceled.

Between Woolf and Balcon, alas, hung a maddening gray zone of authority. Balcon equivocated, and time went by; then the producer appealed to Ivor Montagu, considered a statesman of the Film Society, though he wasn't yet intimately acquainted with Hitchcock.

The Lodger "was supposed to be highbrow, the most scarlet epithet in the film trade vocabulary," recalled Montagu. "Hitch, indeed, was deeply suspected by the distributors of this damning fault. Had he not even been trained in an art school, and entered the film world drawing the lettering and little decorative pictures on titles?"

The studio ran another private showing for Montagu, who "fell enthusiastically in love" with the embattled film. "Now, the hackneyed treatment of the plot and a weakness in characterization make it look primitive," Montagu reflected fifty years later. "Then, by contrast with the work of his seniors and contemporaries, all Hitch's special qualities stood out raw: the narrative skill, the ability to tell the story and create the tension in graphic combination, and the feeling for London scenes and characters."

Montagu went to work. There were too many intertitles—"in the region of 350 to 500"*—so he whittled them down. Montagu brought in another Film Society stalwart, E. McKnight Kauffer, an American who helped revolutionize British poster art, to design the main titles and cards. Kauffer's bold Neuland typeface would reinforce the German aesthetic.**

The final sequence, which finds an aroused mob pursuing the lodger through the streets of London, trapping and nearly pummeling him to death as he dangles by his handcuffs from a bridge, was more Soviet-influenced. But the sequence didn't build properly, in Montagu's estimation, and as a montage expert who had visited the Soviet Union and discussed editing ideas with Eisenstein himself, Montagu thought that per-

* This must be a wrongly remembered exaggeration.

** Kauffer also designed a poster for the film, ultimately rejected by Woolf as "too artistic."

haps Hitchcock should shoot some new footage to heighten the feverish effect.

What could Hitchcock—"five years older than I," in Montagu's words, and with "three pictures already tucked under his belt"—do or say when confronted by criticism from this novice, without a single film to his name? But Hitchcock's "It's only a movie" maxim was more than a clever quip—it was a statement of deep-seated philosophy.

To his surprise, Montagu found Hitchcock "ungrudgingly warm" and "eager to hear of anything that, even by chance, might make his work more acceptable." The retakes were filmed in August, and the reedited mob sequence was improved. It was mid-September before everybody felt satisfied, and Gainsborough hosted a press and trade screening.

It was a breakthrough screening. Iris Barry, who had joined the *Mail*, called *The Lodger* "brilliant"; going overboard, the *Bioscope* hailed it as possibly "the finest British production ever made."

The film was spellbinding for its time. Its eerie tension and periodic jolts of violence seemed perfectly calibrated. The story gaps—the false finger-points, the sugary ending that finds Daisy and the lodger engaged to marry—the director privately disdained, and most critics overlooked.

Four months later, in January 1927, *The Lodger* was released to the public, and Novello's rabid following made the film a hit across England. All of Woolf's dire predictions came to naught.

With *The Pleasure Garden* and *The Lodger* Hitchcock had arrived, full-blown, at the tender age of twenty-six. He was touted as the boy wonder of British film. Considering the industry's inferiority complex, he also loomed as a "Great White Hope," in June's words: a wunderkind who might grow up to bring maturity to British film, and drag the entire industry out " of its superannuated swaddling clothes" and "into long trousers."

With *The Lodger,* Hitchcock displayed his incipient mastery of something besides suspense: he was also a budding master of the press.

His relationship with journalists and critics developed in stages. During the first half of his career, until 1939, the bulk of Hitchcock's press coverage focused on his work and films. Before Hollywood, before the publicity lessons he learned from David O. Selznick, before his American television series, there was no Hitchcock cult of personality. In England, the publicity he received was normal for such an important director.

In these early years, moreover, Hitchcock wasn't unduly attracted to, or flattered by, press attention. Gainsborough's publicity department was in fact notoriously ineffectual, according to publicity director Cedric Belfrage, and the stars received most of its attention. In the case of *The Lodger,*

Hitchcock "was unconcerned when my efforts brought more newspaper space for Novello than for him. The director felt no need for artificial publicity, and was right," Belfrage recalled in notes for an unpublished memoir.

In England (and later in America), the film press crossed back and forth between Fleet Street and studio jobs, mingling incestuously. Hitchcock counted many journalists and critics among his friends, one reason he was usually comfortable with the press.

When he wasn't functioning as Gainsborough's publicity director, for example, Belfrage was also publishing bylined articles in film magazines extolling "Alfred the Great." Two of London's most powerful critics, Iris Barry and another woman, C. A. Lejeune of the *Observer,* were welcome visitors to Hitchcock's home. Not that friends (including Barry and Lejeune) weren't capable of disliking his films, but knowing critics demystified their opinions.

Hitchcock's colorful personality was an asset with the press. While a minority of journalists and critics may have been put off by him (as a vociferous minority were by his work), most found him as entertaining and provocative as his films. Drinks, dinner, and conversation with Hitchcock couldn't be bettered. He loved gossip and idle talk about show business. He saw the critics and journalists as sounding boards for his ideas. They were usually intelligent about film, and always brought gossip and news of their own.

Self-advertisement was a crucial step in Hitchcock's evolution. But when he first appeared on the screen in *The Lodger,* his cameo was intended as a wink at the press, rather than an attempt to launch himself as a public figure. It was a moment of self-advertisement for a small circle.

There is some debate about Hitchcock's initial cameo in *The Lodger*—indeed, over whether there might be two cameos. The first, early in the story, finds Hitchcock in a newsroom among the reporters; some people think the director can also be glimpsed at the end of the film, as a lout among the bystanders watching the lodger's near-lynching. "Once he said yes, it was he," recalled writer David Freeman, who worked on Hitchcock's last, unrealized project, "The Short Night." "The other time he said no, it wasn't."

Hitchcock told some interviewers that this first cameo was merely a matter of saving on schedule and expense by standing in for an actor. According to Ivor Montagu, Hitchcock offered a different, contemporaneous explanation at one of Adrian Brunel's Hate Parties. The director insisted that his "momentary flash appearances" were inspired by his admiration for D. W. Griffith, who took small parts in his earliest films, and by Chaplin's cameo in *A Woman of Paris.* Griffith and Chaplin always remained, for him, touchstones of quality.

One night not long after the opening of *The Lodger,* as Film Society

habitués mingled at Brunel's flat, someone asked, "For whom, primarily, do we make films? Whom is it most important to please?"

"The public" was considered too obvious an answer for Hitchcock, Montagu recalled. Equally unsatisfying was "the Boss"—the studio chief. "Hitch," said Montagu, "would have none of either answer."

Citing C. M. Woolf's qualms about *The Lodger,* which had delayed its release, people suggested that the proper party to please might be "the distributors"—acknowledging, in Montagu's words, "the validity of what they thought was Hitch's point that, unless the distributor liked and would push the picture, the public might never have a chance to give it a fair box office reaction, even if you had your own boss's support."

To all of these Hitchcock shook his head. "Hitch's deeper answer," Montagu recalled, was that "you make pictures for the press. This, he explained quite frankly, was the reason for 'the Hitchcock touches'—novel shots that the critics would pick out and comment upon—as well as those flash appearances that gradually became a trademark in his films. He went on to explain that, if you made yourself publicly known as a director—and this you could only do by getting mention in the press in connection with your directing—this would be the only way you became free to do what you wanted.

"If your name were known to the public, you would not be the prisoner of where you happened to be working—you could move on. Any newly founded company (there were many in the U.K. in those days) would be glad to have the cachet of your name as an asset in its prospectus. Any established company would like to sign you in order to score over its rivals."

This declaration astonished some present. But close Film Society friends recognized its unique truth for Hitchcock, who was farsighted in his dealings with the press.

"We all knew this was right," Montague wrote. "We all knew him well enough to know that while the fame and money of success might be to him a pleasant side-effect, it was not, could not be, his primary motive. He lived to make pictures. To make them better was his use for freedom. But we also knew he would never have admitted this, and so he spoke after his manner, dryly, sarcastically, cynically, teasingly, and we did not mind. He was the only one of us who might succeed in reaching his objective."

The joy was in the process—compromises notwithstanding. A film could be illogical, and still please—himself first and foremost, but also critics and audiences. The wrong-man theme was potentially a powerful one, even if its first clear outing in *The Lodger* was a practical solution to a script and casting dilemma. Art always involved practical challenges. The stars were always going to fall short of one's imagination.

Hitchcock was far from a perfectionist. When André Bazin interviewed him in 1954 on the set of *To Catch a Thief*, Bazin asked the director what ideal he pursued in filmmaking. Hitchcock answered: "The quality of imperfection." Bazin was baffled by "this rather oracular line," he later wrote. "My interpreter, Hitchcock and I spent a good quarter of an hour on this one point . . . but it never became perfectly clear." Bazin thought perhaps Hitchcock was jesting—but he was never more serious.

From his first films, he would learn to field front-office dicta, cope with forced casting and censorship, tinker with endings, and create different versions of Hitchcock films for different audiences.

As blithely as he accepted the imperfections of *The Lodger,* however, he resented its idiocies, and some critics have suggested that he spent much of the rest of his career trying in one way or another to remake it without compromise. As much as he recognized the value of compromise, he loathed second-guessing—the destabilizing effects of C. M. Woolf, who had nearly consigned his first major film to the dustbin, and of Michael Balcon, who had vacillated at a critical moment.

Time and again in his career, Hitchcock would break away from the easy path and take brave steps toward risk and independence. Time and again he met resistance and opposition with decisive action. The success of *The Lodger* came after he had directed only three pictures, but his confidence was already strong; he recognized that his name would mean something on any studio's prospectus.

And so he set about trying to divorce himself from Gainsborough.

Even as *The Lodger* was being reshot and reedited in the summer, a startling item appeared in the trade papers, announcing that "the brilliant young English director" had been signed away by a new production entity, British National Pictures, Ltd. Hitchcock still owed Gainsborough six months on his contract, but after that, it was reported, he would move over to a new studio being constructed on fifty acres on the outskirts of Elstree. Not much was known about the new studio, except that it had signed a U.S. distribution deal with Paramount.

As a man who prided himself on inside knowledge of his profession, Hitchcock realized that Gainsborough was in mounting disarray, losing money "through a series of unfortunate associations which made it a constantly moot point who was really in charge of things," in Cedric Belfrage's words. Charles Lapworth had left the directorate. Joining the board now was actor Carlyle Blackwell, who arrived with a financial portfolio (he was married to a diamond millionairess). But the studio's long-term financial fortunes could be secured only by successful films, and Woolf and Balcon were still vying for control of production.

Hitchcock waged an impressive power struggle with Gainsborough. The studio announced that his next directing project would be *The Silent*

Warrior, starring Blackwell. But Hitchcock refused, and the picture was reassigned to Graham Cutts. Hitchcock planted squibs in the press, reminding the industry that his future lay with British National. Then a series of other odd items appeared, repudiating "rumors . . . circulating in the trade" about Hitchcock projects. In a deliberate slap at budget-strapped Gainsborough, Hitchcock announced he was shaping four ambitious future films, two of which would "require locations on a big scale outside England."

Three months went by, after the triumphant press showing of *The Lodger,* with no activity from England's hottest director. Hitchcock was determined to let his contract run out.

He also had personal cause to be preoccupied. Alma Reville was taking Catholic instruction, and the Hitchcocks' wedding was scheduled for early December. He and Alma had been working and traveling together for almost four years now, and they had become inseparable. By day they went together to the studio; by night they went out to restaurants, premieres, nightclubs, gallery openings. In large and small ways they complemented each other: She drove; he read the maps. She watched the budget; he was a spendthrift. They never disagreed about anything important.

Now marriage would formalize the Hitchcock love story. At Brompton Oratory on Knightsbridge, the most fashionable church in London, they exchanged vows on December 2, 1926. Hitchcock's brother, William, stood up for him; Alma's younger sister, Eva, was maid of honor.

It has been speculated that Alma was obliged to convert to Catholicism at "the insistence of Hitchcock's mother" before any ceremony could take place, but this was not the case. As the church records where the ceremony was performed state uncategorically, "Dispensatione obtenta super impedimentum mixtae religionis."* The bride was not a baptized Catholic at the time of the nuptials; and although she was eventually baptized, her Catholicism failed to "stick" as the years went on, according to one of Hitchcock's private letters.

The newlyweds left England for their honeymoon, launching the "annual pilgrimage" they would follow at Christmas for most of their lives. First they stopped in Paris, spending a day with Nita Naldi, who was living there with her older gentleman friend; then they continued on to Lake Como and St. Moritz.

When they returned to London, the newlyweds took up residence on

* "By [or "With"] a dispensation obtained over the impediment of mixed religion."

the top two floors of a tall brick Georgian at 153 Cromwell Road, along a continuous line of fashionable houses west of the Victoria and Albert Museum. Their flat backed on to the Underground—"like a cliff," in the words of Michael Powell, "so that the thunder of the passing trains was distant like the waves on the pebbles of Sandgate beach."

The calendar now said 1927, and the nascent British National was looking less and less like a viable reality.

J. D. Williams, the new studio's dynamic managing director, had made his first fortune selling his First National circuit of several hundred theaters to Warner Bros. Williams signed D. W. Griffith star Dorothy Gish for the first three British National pictures, to be directed by Herbert Wilcox. But Williams soon alienated his business partners with his autocratic decision making and imperial lifestyle. He was fired in December, shortly after returning from a dealmaking trip to America, and the much-publicized Gish films were canceled. Wilcox, a founding partner, left to form his own studio. Rumors spread that British National was down for the count. And so, desperate to stall, British National lent Hitchcock *back* to Gainsborough.

When Gainsborough announced a new production called *Downhill* in early December there was no director attached, but by the end of the year Hitchcock had surfaced as a likely candidate. When the boy wonder returned from his honeymoon in January, it wasn't hard to convince him that, rather than stagnating, it made sense to follow *The Lodger* with another picture capitalizing on the rage for Ivor Novello—who, along with Constance Collier (under their pen name, David L'Estrange)—had written the hit play from which *Downhill* would be adapted.*

Novello was poised to re-create his West End role as a public school rugby hero who shoulders the blame for his friend, the son of a clergyman, when a girl becomes pregnant. In France (inevitably), the hero suffers disgrace, becomes a race driver, and worse.

Hitchcock had little choice but to reconcile himself to filming "a rather poor play," as he told Truffaut. But he could take satisfaction from the fact that his new overlords were able to farm him back to Gainsborough for a sum "exactly six times what he previously received," according to Cedric Belfrage. Although the difference between his former salary and the loan-out salary went to British National, not to him—an industrywide injustice

* *Down Hill* was two words as a play, one as a film. With his penchant for wordplay, Hitchcock often made subtle or "inside" changes in titles or characters' names, to differentiate the source material from the film.

the director suffered long before encountering David O. Selznick and Hollywood—Hitchcock did receive a fat starting bonus.

Shooting began as quickly as possible, on January 17. Once again Alma, now Mrs. Hitchcock, was his assistant director, with Claude McDonnell behind the camera. Besides Novello, the all-English ensemble included Isabel Jeans, once a leading lady of Harley Granville Barker's theater company, and Ian Hunter, in his first of three Hitchcock roles.

Working closely with Angus MacPhail, now head of the story department at Gainsborough, Eliot Stannard had crafted a straight-line adaptation. Some last-minute remedial work and "visualizing" was the extent of Hitchcock's contribution to the screenplay. (As if secretly relishing the script, however, he was fond of quoting Novello's fatuous lament upon expulsion from school: "Does this mean I won't be able to play in the Old Boy's match, sir?")

Though the actor was in his thirties, the early scenes required Novello to play a lad in his teens—a trick that worked better on the stage. Hitchcock didn't think much of the whole business. "Terrible!" he always muttered about *Downhill,* pointing out the ham-handed imagery of a scene in which Novello is tossed out of his home by his father and then heads "Down" an escalator into the Underground. As he often did when saddled with tedious drama, the director tried to lighten things up with Hitchcockian comedy; one scene he staged—a mock donnybrook—he would recall later as "ahead of its time." The studio thought so too, insisting that he cut it out, along with other comedy flourishes.

Hitchcock would often find more affection for his *memories* of making a given film than for the finished product. The "Down" sequence had to be photographed after midnight, Hitchcock recalled, after the last train had gone home. "We went to the theater first," the director said, "and in those days we used to go to a first night in white tie and tails and opera hats. So, after the theater, I directed this scene in white tie and top hat. The most elegant moment of direction I've ever had."

He always performed to the best of his abilities, however. Hitchcock was farsighted enough to perceive that impersonal studio projects would be counted as credit toward more ambitious and worthwhile films. And *Downhill* was far from worthless: scene after scene was enhanced by his imaginative staging, expressive lighting and composition, and unusual camera work.

One particularly inventive sequence began with a close-up of a man in evening dress—a swell, one judges, until the camera sweeps back to reveal that the man is a waiter. When a nearby couple begins to dance energetically, the waiter seems to join in, before the camera swoops farther back and around to reveal that the action is all part of a revue staged for a nightclub audience. This very Hitchcockian sleight of hand—"a sort of

Chinese box of illusion within an illusion," in John Russell Taylor's words—had nothing to do with the main plot. It was merely an opportunity to try something interesting.

For Hitchcock the storyteller, the means would always be as important as the end. The director didn't mind if a scene didn't quite work, if the tricks were worth trying. "It should be fun!" people remember him saying in his days as a boy wonder. "Fun!"

As long as it was fun.

The tricks could be internalized, Hitchcock knew, and the techniques streamlined for reuse in better films later on. Experimentation was the inevitable by-product of the director's constantly spinning mind.

Hitchcock was working at a restless clip. By the last week of March 1927 he was already in Nice and the Riviera for location work on his next Gainsborough picture, an adaptation of Noel Coward's *Easy Virtue*. In France he would shoot backgrounds and exteriors for the new project while polishing off final shots of *Downhill*, with Ivor Novello emoting in front of English backdrops on the rooftop of a French hotel.

A Noel Coward play was automatically an undertaking of higher quality and prestige than a work by "David L'Estrange." Coward, already among the royalty of show business, stopped by Islington to confer with Hitchcock during the making of *Downhill*; their subsequent friendship was more professional than personal, but would last for years. Yet Coward had little or nothing to do with the Hitchcock film. Once again Eliot Stannard adapted the 1925 play, with editorial input from Ivor Montagu and Angus MacPhail.

Four of the main players carried over from *Downhill*: Isabel Jeans as the persecuted victim of social hypocrisy who twice makes headlines in divorce proceedings; Ian Hunter as a lawyer; and Robin Irvine and Violet Farebrother as an upper-crust suitor and his mother.

Hitchcock could certainly feel comfortable with the play's theme, which indicted blind justice and conventional attitudes toward divorce. Yet as a silent picture, *Easy Virtue* limited Coward's brittle dialogue to the occasional intertitle—and the upshot was a thin shadow of the original.

Again, though, Hitchcock's touches kept it from being a terrible film. The director told François Truffaut that it contained the worst intertitle he ever wrote: Isabel Jeans, scarred from her treatment by the yellow press, cringes in terror every time she spots a newsman lurking with a camera. Her last line to picture snatchers covering the second divorce: "Shoot. There's nothing left to kill." (Again, Hitchcock's sly mention of it ensured that it wouldn't be forgotten.)

With Hitchcock, games involving lenses could be murderous, or simply

games. Another Hitchcockian highlight in *Easy Virtue* is the vignette of a divorce court judge peering at the plaintiff's counsel through his monocle—an ocular image followed seamlessly by a cut to a matching close-up. In those early days, that was an impossible special effect to achieve. "I had to make the monocle oversized so it would be in focus at close range," Hitchcock explained later. "Then I put a mirror in it instead of clear glass, and put the attorney character behind the camera, with a double for him in the long shot. And so when the monocle came up to the camera, you saw the man in close-up, without a cut."

Hitchcock not only dreamed up such unusual camera stunts, he took delight in figuring out how to execute them before the specialists did. He was like a brilliant symphony conductor who prides himself on knowing how to play every instrument in the orchestra.

Already, Hitchcock could boast more technical know-how than most directors accumulated in a lifetime. When Claude McDonnell took ill during the making of *Easy Virtue,* he gleefully took over, supervising his own lighting and camera setups. England's boy wonder was also a workhorse who filled in behind the lens more than once, in the silent era, when one of his cameramen took sick. He never lost a day on that score.

Easy Virtue, which was completed in May, would be Hitchcock's last film for Gainsborough. In June the director joined the newly reorganized, and renamed, British International Pictures, and undertook his third film in the first six months of the productive year 1927.

After its near financial collapse, British National had been forced to welcome a savior in the person of John Maxwell. A former solicitor from Scotland, Maxwell had been in film exhibition since 1912, heading up an expanding circuit of halls. Branching into rentals, he had built up Wardour Films as a rival to C. M. Woolf's empire. After J. D. Williams was ousted from the British National directorate, Maxwell effected a merger with Wardour, becoming chairman of the new company, British International Pictures, or B.I.P.

The *I* was important. In the year-end issue of the *Bioscope,* Michael Balcon, retrenching at Gainsborough, contributed an article entitled "Cutting Down Production Costs"; in the same issue, Maxwell wrote on "The International Film." Balcon was every bit the internationalist, but Maxwell had the fresh swagger and ambition to carve a niche out of foreign markets. Before the year was out B.I.P. would purchase a former Emelka chain as a foothold in Germany, make a deal with Sascha Films of Austria for distribution in eastern Europe, and sign with Pathé for France. Then came the announcement that B.I.P. films would be distributed by a new firm in the United States, headed by none other than J. D. Williams.

B.I.P. was initially willing to gamble more money on production, and Maxwell promised his directors creative freedom. At Borehamwood, near Elstree Station, the new B.I.P. studio boasted up-to-date facilities, including two enormous interior stages. All of this, as much as his salary increase, lured Hitchcock away from Michael Balcon and Gainsborough.

"Selling angle," one trade paper trumpeted as early as *Downhill,* "the name of Hitchcock."

His sixth film as director—and the first British International Pictures movie by any director—was first mentioned in the trades in April 1927, when the director told the *Bioscope* about *The Ring,* a grand-scale boxing drama he was planning. By then a draft of the script had already been completed. Eliot Stannard was reported as the writer, and Stannard's name was cited again as late as one week before photography commenced. But when Hitchcock and Stannard had a falling-out, Walter Mycroft, the newspaperman associated with the *Evening Standard* (and another stalwart of the Film Society), was brought in for touch-ups, and technical advice on the boxing sequences. The director also knew boxing; he could discourse knowledgeably on both the rules and the fighters, and routinely attended soccer and tennis as well as boxing matches.*

Boxing, like everything else, was grist. Hitchcock stored up observations and references like an academic. In 1937's *Young and Innocent,* Erica (Nova Pilbeam) employs rough first-aid measures that she explains (without elaborating) she learned in a boxer's dressing room. Forty years after *The Ring,* directing the final sequence of *Marnie*—an emotionally exhausting scene in which Marnie and her mother revisit the past—Hitchcock told Tippi Hedren the feeling was like two boxers who have fought to a draw. "He was pulling things out of his memory all the time," Hedren recalled.

Hitchcock's eventual credit as sole author of the original story and script—a credit unique in his career—underlines his proprietary feeling for *The Ring,* the picture he left Gainsborough to make.

The first act of *The Ring* takes place against the backdrop of a fairground, where One-Round Jack, an amateur pugilist, takes on all comers. A nattily dressed stranger flirts with Mabel, a comely ticket taker, and then decides to fight Jack. Mabel roots for Jack, who is her boyfriend, but Jack is beaten by the natty newcomer. The winner is revealed as the Australian heavyweight champion, Bob Corby. With one eye on Mabel, Bob invites Jack to take a job with him as his sparring partner, and train professionally.

The story then shifts to Hitchcock's own East End. After winning his

* Table tennis, too—for Ivor Montagu was a champion of the sport who enthusiastically dragged everyone to matches.

first professional match, Jack marries Mabel, and his fortunes rise. But his pride is dampened when he sees Bob aggressively wooing his wife at wild parties. Jack's jealousy leads to friction with Bob, and a violent confrontation with Mabel. Just as he and Bob finally are matched for a championship bout, Mabel leaves Jack. On the night of the showdown, Mabel is among the crowd. The audience must wait to see who will triumph.

Starting out at the new studio, Hitchcock had more leverage with the casting. He handpicked his lead actress, Lilian Hall-Davis, whom Hitchcock had admired as far back as *The Passionate Adventure.* ("An amazing girl," he once said of her. "On the set she suffered from an acute self-consciousness," but in private life "she possessed a terrific personality and amazing vivacity.") The actress was against type in his canon, a brunette playing a goodhearted, salt-of-the-earth character.

As One-Round Jack, the director cast Carl Brisson, a former Danish middleweight champion turned musical comedy entertainer. Brisson's only previous appearance on the screen had been in an obscure Danish picture; Hitchcock could thus claim to have launched Brisson into film, and this would be the more appealing of two leads Brisson would play for him.

Ian Hunter, from *Downhill* and *Easy Virtue,* was chosen to play Bob Corby, the Australian heavyweight, while Gordon Harker, who had begun his long career as a stage prompter in 1902, turned up as Jack's trainer and friend to the last. The son of Joseph C. Harker, a well-known stage scenic artist, Harker was a true Cockney—born, as they say, within the sound of Bow Bells.* He had played cheeky Cockneys in Edgar Wallace plays, and would supply similar comedy in several Hitchcock-B.I.P. films.

It may or may not be true that Claude McDonnell was slated to photograph *The Ring,* before illness felled him, or that McDonnell bucked about his salary and quit the production at the eleventh hour. Certainly it is not true, no matter what the director told Peter Bogdanovich, that Hitchcock "taught" photography to the eleventh-hour replacement—John Jaffray Cox, known as "Jack"—or that before *The Ring* Cox was any kind of "second" cameraman.

Jack Cox had worked in pictures since 1913, logging five years in the early 1920s as chief cameraman for Maurice Elvey, during which time, according to Duncan Petrie in *The British Cinematographer,* he had already demonstrated his promise as "one of the first important British cameramen." Alma would have known Cox from her stint with Elvey; he might have been another of her recommendations. In any case, when Cox succeeded Baron Ventimiglia and Claude McDonnell, it marked a clear division in the camera department between the Hitchcock films made at Gainsborough and those made at B.I.P.

* The pealing bell, that is, of St. Mary-le-Bow, in Cheapside, destroyed by bombing in 1941.

Cox was an "effects" cameraman—an expert in "blurred images, over-lays, dissolves and double exposures," in the words of Petrie. (His long-standing advertisement in the trade papers read: "Thoroughly experienced in Trick Work, etc.") That was more important to Hitchcock than fram-ing or lighting genius. Hitchcock really didn't need compositional advice; his staging within the frame was always strongly in his mind, and anno-tated in the script. What Hitchcock wanted was a cameraman who would take a dare. And even veterans like Cox were sometimes taken aback by Hitchcock's taunts and demands.

For the film's first fight scene, which takes place under a fairgrounds tent, Hitchcock insisted that Cox remove the usual array of kliegs and shoot the bout from a distance, with the only lighting a solitary bulb dan-gling over the ring. Not only that, he wanted the camera's point of view—Mabel's subjective point of view from outside a gap in the tent—heavily obstructed. In the foreground, shadowed figures in the crowd watch the fight, and like Mabel the movie audience is forced to peer at the action as if through a long-lens keyhole.

Hitchcock didn't teach Cox photography, but he did teach the old dog new tricks. Cameramen learned to trust Hitchcock's instincts; he not only stipulated the setups, but, with his art training, would whip out a sketch-pad, draw the image, and specify the focus.

"Hitchcock would draw it so wonderfully," recalled Bryan Langley, then an assistant to Cox, "that he could say, 'I want you to use a 50 mm lens' or a 35 mm lens or three-inch lens. He had drawn the perspective in, so the background was correct in relation to the foreground. I've never seen anyone else who can even approach doing that. Hitchcock was mar-velous in being able to draw what the camera could see. And it was like he was saying to the cameraman, 'If you get that, then I don't have to look through the camera.'

"There have been many stories [about Hitchcock] down the years. There was one cameraman, later on, who supposedly was given such a drawing, and he got the frame and foreground correct, but used a differ-ent lens [from the one specified], so the background was twice as large, or half the size. I heard that cameraman made a rapid exit."

Starting with *The Ring*, Cox would photograph all ten of Hitchcock's B.I.P. films during the prolific years between 1927 and 1932. Then, after an interval of several years, they would reunite on *The Lady Vanishes*. Eleven Hitchcock pictures: only Robert Burks, another virtuoso cameraman, whom Hitchcock found at Warner Bros. in America, would work with him more.

The filming took place in July and August 1927. The ample budget enabled a spectacular set, a full-scale fairgrounds built on the Elstree lot for the

film's establishing sequence. Hundreds of extras were hired. Hitchcock created a dream of a carnival glimpsed in twirling rides, common folk gorging themselves, games of chance and skill. The Germanic images go by in a Soviet whirl. Now and then there are odd close-ups of people and objects, images sometimes so extreme and distorted that they become modernist abstractions. (He would use this technique throughout his career: think of the lingering close-up of a ladder rung at the beginning of *Vertigo*.)

The boy wonder himself moved in a blur in these years. Colleagues and coworkers were struck by Hitchcock's perpetual motion, his boundless energy, his zest for the job. Michael Powell recalled the director vaulting up flights of stairs, ahead of everybody else. "It is amazing," wrote one journalist who stopped by to watch him stage the climax of *The Ring*, "how he manages to maintain his energy and keenness, considering that since the beginning of the year he has been on the [studio] floor, working practically every day."

The film's climactic Albert Hall match was a triumph of illusion, indebted to the recently invented Schüfftan process, first exploited by Fritz Lang in *Metropolis*, and which Hitchcock had brought home from Germany as his most valuable souvenir. The new process enabled him to stage scenes in public places, without the expense (or permission) of actually filming there, by blending live action in the foreground against miniatures, photographs, or painted scenery. Many of Hitchcock's most famous special effects were Schüfftan-style composites: real backgrounds mixed with re-creations.

Smoke and glare, images reflected in water and mirrors, crazily tilted framing, split-screen staging, and superimpositions were among the film's other Teutonic flourishes. One surreal sequence cuts back and forth between drunken revelers, fantastically elongated piano keys, and a hypnotically spinning long-playing record. Ultimately, *The Ring* is "the most Germanic in style of Hitchcock's silent films," as critic Jonathan Rosenbaum observed—a drama conventional in its story line, but shot in a dense, experimental style. Though in neither scope nor theme as sweeping as *Metropolis*, *The Ring* is as dark and velvety as a Fritz Lang epic.

A first-rate boxing saga, with all the ritual and well-observed detail of the sport, it is also a surprisingly intimate film. Unlike Lang (and other Germans), Hitchcock was adept at incidental humor (the carnival guests at the church wedding were a hilarious rehearsal for the circus freaks in *Saboteur*) and warmth. This was the young, uninhibited Hitchcock, who showed tremendous curiosity and feeling for his characters: fresh from his own marriage, he was sensitive to the tensions of fidelity. This is, too, the rare Hitchcock film without a single murder victim, a man falsely accused, or a woman living in dread of sex or violence.

With the speed characteristic of picture making in that era, the photog-

raphy was completed by summer's end, the footage was assembled by early September, and the finished film was screened later that month. The new Hitchcock film was swiftly hailed as another "masterpiece" by the *Observer,* and as "the greatest production ever made" in England by Iris Barry in the *Daily Mail.* "Mr. Hitchcock has done more for British pictures than a dozen acts of Parliament," opined the *Evening Standard.*

The *Bioscope* addressed Hitchcock presciently in a special editorial: "Our first hope is that you will long continue to make films in this country, because the producing industry—which owes you a debt of gratitude—can ill afford to be without your talent."

Another souvenir Hitchcock brought back from Germany was the playful tyranny in his persona; a tyranny that was very German, mingled with a playfulness that was very much his own.

At Elstree in the late 1920s emerge the first eyewitness accounts of a director who sometimes ruled the set like a führer, manipulating the people and the atmosphere the way he manipulated pieces of film—achieving darkness or light according to his mood.

To get what he wanted on film, he was capable of behaving like a dictator, or a circus clown. Like other tales of Hitchcock hubris, these stories have grown and been exaggerated over the years. The penchant for elaborate, sometimes borderline-ugly practical jokes was widespread during this era. Hitchcock was not the only practical joker at B.I.P. (or, later, Gaumont); the trend was industrywide. People say, for example, that whenever Monta Bell—an American who was "literary editor" of Chaplin's *A Woman in Paris* before turning director—was on the lot, the madness was rife.

Sometimes Hitchcock's "odd behavior" was simply good publicity. Teatime, for example, was a treasured afternoon break, and so it was fodder for the columnists when Hitchcock took to hurling crockery over his shoulder, signaling "Back to work!" after drinking his cuppa. "I always do it when I'm feeling good," Hitchcock explained one time. "I like to get up onto a high rostrum with a camera, and tip the tray over. Or push cups over the edge of a platform. Or just open my hand and let the whole thing drop. Wouldn't you?"

The first time he did it, Hitchcock told the press, one of his favorite crew members split his sides with laughter—a sure invitation to repeat performances. Soon he was expected to smash all his teacups. Such eccentricity woke people up, and made for an exclamation mark in an otherwise humdrum day. The crew relished it, which was sensible policy.

Hitchcock also hated uninvited visitors to the set, especially members of the general public on courtesy tours (ironic considering his later associa-

tion with Universal Studios, packager of the most lucrative studio tour in film history). So, when such tours materialized, Hitchcock would switch to German, shouting curses and obscenities—all the more amusing when the visitors were priests accompanied by ecclesiastical students.

Most of his practical jokes were innocent: hosting formal dinners with all the food tinged with blue coloring, placing whoopee cushions under the behinds of stuffy guests, plying uptight people with strong drink and watching as they came unglued. Some were elaborate and expensive: tying quantities of kippers onto the bumpers of a victim's fancy car, ordering a load of coal to be dumped on someone's front doorsill.

But practical joking was also a matter of one-upmanship—a game Hitchcock was driven to win at all costs. Assistant cameraman Alfred Roome recalled how the director used to poke fun at his posh, beetle-size Austin-Healey, and one day requisitioned the car for a conference with floor manager Richard "Dickie" Beville. Both hefty men, Hitchcock and Beville squeezed inside the vehicle, pointedly annoying Roome, who felt his private vehicle ought to be off-limits. Roome went in search of a smoke pot, found one in storage, placed it underneath the Austin-Healey, and then lit the fuse. "You never saw two fat men get out of a car quicker," recalled Roome. "Hitch never tried anything again on me. He respected you if you hit back. If you didn't, he'd have another go."

No question, some of his jokes had a bullying quality that disturbed people. Actors he didn't like or considered "phony" were special targets for sarcasm or pranks. Hitchcock said defensively in a 1972 televised interview that he never meant to harm or denigrate anyone. But everyone knew his jokes were at their worst when a film wasn't going right.

Oh, my son couldn't be a murderer, Bruno's mother (Marion Lorne) exclaims in *Strangers on a Train;* it must be one of his practical jokes. "Sometimes he goes a little too far," she sighs.

People reflexively cite the case of Dickie Beville. Beville always seemed to suffer the worst, most humiliating Hitchcock persecution. One notorious time, Hitchcock bet Beville he couldn't last a night in handcuffs. Before Hitchcock locked the cuffs, however, he tricked Beville into drinking coffee laced with a strong laxative. Even though there are wildly conflicting versions of this anecdote—the only consistent touch is the handcuffs—the story is widely accepted as gospel in English film annals. Poor Beville, it is said, spent a long diarrheic night, thanks to cruel Hitchcock.*

But many directors (not only Germans) enjoyed having court jesters on

* Typical of the wild, disparate versions, cinematographer Jack Cardiff wrote in his autobiography that the man's name was Harry, the laxative was in his beer, and after Harry was sodden and soiled he was pushed out of his car by Hitchcock "in the middle of nowhere," leading to Harry's arrest "on suspicion of being an escaped convict."

the set, and Alfred Roome, assistant cameraman on *The Ring,* insisted later that he knew "for a fact" that Beville and other underlings relished their immersion into "Hitchcockery." Roome said Beville willingly served as dupe, and as the director's beloved guinea pig he received bonuses and promotions for his suffering. Hitchcock considered him a friend; forty years on, ensconced at Universal in Hollywood, he sentimentally kept a small photo of Beville on his desk, amid his important awards and celebrity photographs.

Alma only half tried to temper his jokes. At home she was his best audience, her only complaint an occasional exasperated "Oh, Hitch!" But his staunchest ally during the B.I.P. years, his reliable straight man, was cameraman Jack Cox, who loathed pomposity as much as Hitchcock. Cox was a storied character: happy-go-lucky, a protean drinker, a sharp dresser, a ladies' man. Like Hitchcock he had a Cockney sense of mischief. They bantered ceaselessly on the set and conspired on many practical jokes, and when the worst, rottenest tricks were played, often there were only two people left laughing: Cox and Hitchcock.

Alma became pregnant in late 1927, and soon she was absenting herself more and more from the studio. A young woman—bright, attractive Renee Pargenter—was employed as the director's new secretary and script girl. The Arnold brothers continued as Hitchcock's art directors, while Emile de Ruelle supervised the editing of his pictures. Along with Cox, these people were the nucleus of the group that supplanted the Gainsborough team.

But Hitchcock and his staff weren't in London to read the complimentary notices for *The Ring.* Amazingly, the director was already immersed in his fourth production of the year, away on the coast of Devon shooting exteriors for *The Farmer's Wife,* a bucolic comedy about a widowed farmer sorting through local candidates for marriage. The Eden Phillpotts play had had a long run in 1924, and a popular 1928 revival. Eliot Stannard's adaptation adhered closely to the play, so closely that Hitchcock never felt right in claiming it. "It was a routine job," he told Peter Bogdanovich, "a stage play with lots of titles instead of dialogue."

That, to his credit, is how Hitchcock often described his "photographed plays." But *The Farmer's Wife* is much better than a routine job. Its nimble comedy, subtle camera work, and excellent acting make it the most unlikely and enjoyable of his silent films.

The trade papers took note of Hitchcock's adventurous casting: Jameson Thomas, the lanky, laconic actor picked to play the hayseed farmer of the title, wasn't associated with any of the stage versions. (In fact, the only member of the cast who played the same part on the stage was Maud Gill.)

Lilian Hall-Davis once again played a sympathetic figure—a housemaid, the soul of caring, who steals her way into the widower's heart. And Gordon Harker stole his scenes as Churdles Ash, the uncouth handyman.

The widower might be seen as a stand-in for the romantically bumbling Hitchcock, while the housemaid, who at one point declares, "There's something magical in the married state," might be considered an idealization of Mrs. Hitchcock—the perfect helpmate and model wife. Although the comedy sometimes borders on slapstick (a virgin spinster, whom the farmer chases around a table at a party, quivers as much as the gelatin mold she is carrying), the film is sweet and funny—an unabashed paean to true love and marriage.

What a triumphant year: Hitchcock directed four films in 1927, all of them successes.* With a showman's flair, he and Alma mailed out their first holiday cards as "the Hitchcocks," celebrating along with Christmas the first anniversary of their marriage. The card was designed as a small wooden puzzle: when assembled, it formed the increasingly familiar outlined profile of "Hitch."

Yet it wasn't necessarily great news when B.I.P. announced a new salary for their top director: seventeen thousand pounds annually, for twelve films over the next three years.

For one thing, the figure was an exaggeration. Young writer Sidney Gilliat recalled riding in a taxi late in 1927 with Hitchcock and J. A. Thorpe, a studio executive. Thorpe lowered his voice, warning Hitchcock that he'd better rein in the studio publicity or the tax bureau would try to collect on the inflated figure. Undoubtedly Hitchcock was making "very good money," said Gilliat—"top money, [but] it wasn't dizzy money."

But the public vote of confidence gave Hitchcock a brief, rose-colored opportunity to sketch his ambitions for the future. Whenever he was flush, or his slate was momentarily blank, he dreamed of atypical Hitchcock projects—subjects that would offer him a radical departure, a broader canvas—the kind of grandiose ideas that entranced him in the abstract but eluded him in practice.

While B.I.P. was making its announcement, Hitchcock was envisioning various future projects, including "two epic films dealing with the Mercantile Marine and the English railways." There was also loose talk of Hitchcock's chronicling England's general strike of 1926—a ten-day nationwide stoppage, generally regarded as a historic opportunity and dismal defeat for English labor—in a film that would depict "the fistfights

* *The Farmer's Wife* was released in early 1928.

between strikers and undergraduates, pickets, and all the authentic drama of the situation," in his words.

Already in preproduction, according to B.I.P., was an experimental "film symphony" called "London," which Hitchcock had written in collaboration with Walter Mycroft. This unusual project was said to be inspired by Walter Ruttmann's dazzling *Berlin: The Symphony of a Great City,* made in 1927. But his would not be merely "a mechanical film," according to the *Bioscope:* Hitchcock's "London" would offer a heaping slice of humanity.

None of these experimental, populist, or otherwise out-of-the-ordinary Hitchcock pictures would ever be made. The director's actual deal with B.I.P. included option clauses that hinged on his ability to churn out four B.I.P. productions a year, maintaining the staggering level of output he had managed in 1927. As fast as he was, Hitchcock couldn't keep up that pace and hope to make the kind of films that called for the studio to risk more time and expense.

Other factors also conspired against him. Although B.I.P. had strengthened its ties with Europe, the resistance to English films was still entrenched there, and John Maxwell had just about given up hope of extracting significant revenue from America. Instead he increased his number of domestic circuits, and turned his concentration to the home market.

What Maxwell really wanted to do in the foreseeable future was to consolidate his English audience. His twelve-picture, three-year deal with Hitchcock was part of a general speedup, and a studio policy that called for more—and cheaper—films to justify its overhead. Photographing English plays and books, with English actors, was front-office conservatism that took no account of Hitchcock's higher aspirations. And so the next several years at Elstree, from 1928 to 1932, would prove the busiest of Hitchcock's career, but also at times the least personal.

One key to the studio's accelerated production was Walter Mycroft, whom Hitchcock himself championed for hire at B.I.P. A short man with a hunched back, Mycroft quit the journalism profession in late 1927 and joined Elstree as the head of its story department. One of the founders of the Film Society, Mycroft had a reputation for seriousness and intelligence, though he was inexperienced as a scenario editor. It was Mycroft who came up with the inspiration for Hitchcock's next project, which began life as nothing more than a title: *Champagne.*

Though he often insisted that he'd never tasted a drop of alcohol until he entered the film business, by now Hitchcock was extremely fond of champagne, as he was of spirits of all kinds. Champagne, brandy, rum, and wine (Saint Paul is quoted approvingly on wine in *Shadow of a Doubt*) flow like a river through Hitchcock films.

Champagne had already been spotlighted in *The Ring*, served at the wedding of One-Round Jack and the Girl; later, a glass of bubbly slowly fizzles—in a clever dissolve—when the marriage goes flat. Then, when things look especially bad for Jack in his final fight with the champion, a splash of champagne revives him.

Now Mycroft wanted an entire film on the subject. Hitchcock, after thinking it over, said yes, why not? It was just the kind of challenge he found hard to resist.

He and writer Eliot Stannard tried taking the idea in a meaningful direction. They concocted a serious-minded story "about a girl who worked at Reims [the French champagne capital] in the cellars and always watched the train go off carrying champagne. Then she eventually gravitated to the city and became a kind of whore and was put through the mill and eventually went back to her job, and then every time she saw champagne go out, she knew, 'Well, that's going to cause some trouble for somebody.' "

But John Maxwell had gone ahead and signed a homegrown star as big as any in England: Betty Balfour, a talented but sunshiny actress of the Mary Pickford variety. With Balfour playing the lead, the studio insisted upon a purely bubbly *Champagne*. Partly because of his friendship with Mycroft, partly because he had little choice under the new rules, Hitchcock agreed to a quick rewrite, remaking the solemn drama as a blithe comedy.

Too quick: even though the start of filming was delayed until late February, while Hitchcock and Stannard raced to weave something new out of whole cloth, "they didn't really have a whole script" when the shooting started, according to assistant cameraman Alfred Roome. "They wrote it on the back of envelopes on the way to the studio. You never knew what was going to happen. It looked like it in the end. It meant nothing."

Balfour played a Wall Street heiress fleeing to Paris aboard an ocean liner, along with her boyfriend (Jean Bradin). Trailing Balfour was Theo Van Alten, a mystery man hired by her rich father (Gordon Harker) to teach the spoiled young heiress a lesson. Instead of a thematic commentary on the pitfalls of real life, the result was a film filled with references to champagne that were merely cute and fleeting—though the opening and closing images, shot through a champagne glass, would become one of Hitchcock's most celebrated effects.

"I was the one who had to focus through the bottom of the glass," remembered assistant cameraman Roome. "Hitch had it made specially by a glass manufacturer who put a lens into the bottom of a giant champagne glass, so we could shoot through it and get a clear picture of what was happening at the other end of the room. We all said it wouldn't work. Most people said that of Hitch's ideas, but they almost always did work."

One thing Hitchcock salvaged from *Champagne* was a relationship with a young photographer named Michael Powell. Powell had appren-

ticed in film with Rex Ingram (who had his own studio in Nice) and Harry Lachman (a painterly director admired by the Hitchcocks). Hired by B.I.P. to take still photographs, Powell saw his job as an opportunity to closely observe the eminent director of *The Lodger* and *The Ring*.

According to Powell, Hitchcock was so obviously upset about the casting of Balfour that he refused to let him or anyone else shoot stills of her. (One day Powell overheard Hitchcock refer to Balfour as "a piece of suburban obscenity.") Powell thought that was partly because Hitchcock had originally had his own leading lady in mind: a golden-haired actress named Anny Ondra, who'd made her name in Berlin cabarets and German and Czech films.

Whenever the studio's previous still photographer had ventured onto the Hitchcock set and tried to snap a photo of the action, Powell recalled, Jack Cox would yell, "Throw the breakers!" and the lights would go out. Then, suddenly, the director "would stumble and kick over the tripod of the clumsy eight-by-ten stills camera, which went down with a crash. This had been going on for a month. Nobody knew what to do about it."

Determined to succeed, Powell hefted a tripod and made "rather a noisy entrance" onto the stage. "It was a scene in a manager's office. Betty Balfour was applying for a job. Everyone looked at me, including Hitch, who was sitting in his director's chair twiddling his thumbs. He really was the fattest young man I had ever seen. He had a fresh, rosy complexion, his dark hair was sleeked back, and he was correctly dressed in a suit with a watch-chain across the waistcoat. He wore a soft hat. He observed me out of the corner of his piggy eyes sunk in fat cheeks. There was not much that Hitch missed with those piggy eyes."

The novice didn't get much encouragement from Hitchcock's "loyal and tight little unit." Twice, as the afternoon wore on, the director made a pretense of interrupting the proceedings and inviting the stills man to take his snaps. Twice the young photographer shook his head; the setup wasn't right for his needs. Twice Hitchcock and Cox exchanged dark looks. Around teatime, Powell spotted some appealing action and asked for a chance to shoot a few stills. Cox glanced at Hitchcock, who nodded. Then, while setting up, Powell wondered if he might change the lighting, lower the arcs. People gasped at his audacity.

"Mr. Cox," Hitchcock asked dryly, "do you mind if the stills man kills some of your lights?"

The sun arcs might be excellent for filming, Powell explained, but he didn't need them for his static photography. Hitchcock nodded sleepily. Then Powell asked for some backlight and a softer filter. Wide eyes all around, and more raised eyebrows from Cox and Hitchcock. Powell then proceeded to group the actors, telling them to go through their rehearsed paces, but to freeze their movements when he called out. As they did so,

he took one still, then another. "Could I have another, Mr. Hitchcock?" he kept asking.

"Very well, Mr. *Powell*," said Hitchcock, who had been watching intently. ("He had known who I was all along," Powell remembered. "I had underestimated him.") When the day's duty was done, the director heaved himself out of his chair and approached the young stills man. "Would you care to join Mr. Cox and myself in a beer, Mr. Powell?" Accompanied by Eliot Stannard, whom Hitchcock introduced to Powell as "the author of this dreadful film," they went off to a pub by the railway station to drink their fill of beer.

Forty years later Hitchcock's opinion of *Champagne* hadn't mellowed. "I thought it was dreadful," he often said of the Balfour film. But the luxury-liner comedy was diverting; the oceangoing scenes were useful rehearsals for later films; and the Paris nightclub scenes were invested with uncommon energy and zest. *Champagne* wasn't a bad picture, really, just predictable—leaving a sour taste for its director, who thrived on surprise.

The director was done with *Champagne* by July 1928, just as the Hitchcocks were expecting their first child. When Mrs. Hitchcock went into labor on July 7, her husband suffered a panic attack that reflected less than favorably on his character (though his behavior wasn't so peculiar for a young Englishman of his generation). He told the story on himself on occasion, but it was verified by his wife in a rare published account.

"I was having the baby at home, as most British women did in those days," Alma recalled in 1964. "I was expected to deliver early in the morning, but as the hours wore on without anything happening, Hitch found the apartment closing in on him. Suddenly he bolted out the door and disappeared until late afternoon. By the time he returned, I had a daughter for him and he had an exquisite bracelet for me. He had walked and walked, he said, and finally found himself in front of a jewelry store on Bond Street."

When Hitchcock returned to Cromwell Road, he was contrite. "I'd been wanting to get you a nice bracelet for some time," the director (whose films are full of such significant trifles) said. Alma recalled, "It was actually a peace offering to make up for deserting me at a crucial time."

The baby was a girl; the parents christened her Patricia Alma Hitchcock. "Pat" would be the family's only child. Although Mrs. Hitchcock still took occasional film jobs (she had just finished a script for *After the Verdict,* another Elstree production for the German director Henrik Galeen), the new mother increasingly stayed home. Her husband must have feared losing her: years hence, the memory of this time would trigger alarm bells whenever leading ladies deserted Hitchcock films for hus-

bands, and several Hitchcock films—*Rebecca, Lifeboat, Strangers on a Train,* and *I Confess*—would concoct crises out of ill-scheduled pregnancies or babies.

July was also the month that B.I.P. announced the cast for *The Manxman,* a drama concerning the complications of out-of-wedlock motherhood. A well-known novel by Sir Hall Caine, *The Manxman* was about a Manx village fisherman and a boyhood friend, who has since become a distinguished lawyer in line to become a "deemster" (a judge on the Isle of Man). The fisherman falls in love with a tavernkeeper's daughter, but the lawyer also has a secret love affair with the young woman, which leads to an illegitimate birth.

Although the novel is set on the Isle of Man in the Irish Sea (where Manx was the native dialect), most of the location filming was done in narrow-streeted cliffside towns along the Cornish coast, with only a brief excursion to the island. Hitchcock counted on the gorgeous windswept locations to help compensate for the overwrought ("banal," he told Truffaut) plot. Carl Brisson (the fisherman), Malcolm Keen (the lawyer), and Anny Ondra (the girl) play the characters whose fates cross so destructively.

Cast and crew were out of London in early September but back by the twenty-seventh, when Warner Bros. staged the premiere of Al Jolson in *The Jazz Singer* and other singing-and-talking short subjects, including a trailer for a forthcoming all-dialogue picture with all the artists making brief speeches "in such a natural manner that one forgot one was listening to a film," according to one contemporary account. (The trailer was rated a highlight on par with the Jolson film.) Although "talkies" had made their debut in the United States in 1927, the English were still skeptical about changing over to the new format. As late as August 1928, B.I.P. chairman John Maxwell was widely quoted dismissing talking pictures as a "fad."

Hitchcock was undoubtedly at the Piccadilly Theatre event, among the packed audience of government figures and show business celebrities whose storms of applause drowned out the words coming from the screen. What was England's foremost director thinking? What was his reaction? He left no record.

As it happens, Hitchcock's very next picture would be a talkie. But even if he had quit in 1928, he would still be remembered for stellar achievements. *The Lodger* and *The Ring* are his most widely heralded silent films. But contemporary critics, assessing the eight other films Hitchcock

mounted between 1925 and 1928, have found merit in the least of them, describing overtones of Griffith and von Stroheim in *The Pleasure Garden,* calling *The Farmer's Wife* among his "most underrated work," and praising even the problematic *Easy Virtue* as "inventive and cinematic."

By the end of 1928, the boy wonder was no longer boyish in the least; he was going on thirty, married, and a first-time father. He had come of age professionally as well, directing nine silent pictures since 1924. He would direct forty-four talking pictures over the next five decades.

The poetry of the medium, Hitchcock often told interviewers, suffered with the coming of sound. Too many subsequent films, he often complained, were composed not of pictures of an unfolding story, but of pictures of people talking. And he never lost his preference for pictures over sound.

In nearly every Hitchcock film to come, the most celebrated sequences—the remembered highlights—might as well be silent. If there was sound, it was music, natural noise, or screaming. (He loathed "cued music" that "merely confirms what you can see.") If there was dialogue, it was unimportant—even unintelligible.

The attempted assassination in Albert Hall in *The Man Who Knew Too Much.* Norman Lloyd toppling from the heights of the Statue of Liberty in *Saboteur.* The championship tennis match, followed by the fairgrounds sequence, climaxed by the crash of a carousel in *Strangers on a Train.* Edith Evanson, clearing the trunk in *Rope,* quietly observed by a camera eye that pays no heed to anyone else. Cary Grant dodging a crop duster in *North by Northwest.* Janet Leigh in the shower. The staircase murder in *Frenzy.*

To many directors who learned their craft in that era, silent pictures always stood as a symbol of a lost, innocent time. Many directors lamented the coming of sound. Acting and scripts in silent pictures were more "elemental," in Hitchcock's words—"no nuances or dialogue to be concerned with." There was always a relaxed, playful atmosphere on the set, with a three-piece orchestra (violin, cello, and piano) to enhance the mood. Everything was simpler, easier, more fun.

Among that generation, however, was only a small number resolved never to surrender entirely, and Hitchcock was one. He remained an extremist, stubbornly dreaming in pictures.

THE HEIGHT OF HITCHCOCKERY

FIVE

1929–1933

Hitchcock was an inveterate gambler on himself and always tempted by a technical dare. Despite his antipathy to "talkies," he took the challenge eagerly.

If the sound revolution intimidated America (and it did), it was even more daunting for England. There were so many disparate recording systems, and the costs of standardizing studio and theater equipment were exorbitant. For a long time, the leading artists, producers, and exhibitors of the English film industry were remarkably united—in trepidation.

After the September 1928 premiere of *The Jazz Singer,* though, resistance evaporated. Editorials in major newspapers declared that talkies had arrived, and even the *Bioscope* proclaimed the public demonstration a milestone. "Certain conclusions are inevitable," the trade paper averred, reversing its previous editorial opinion. "Sound has joined the pictures and the union is not a companionate marriage, but a permanent one. The new art will make film production more difficult, but will enormously increase the emotional and dramatic appeal of the well-made film."

At least one London studio was already producing "talking" short subjects, and others rushed to add brief dialogue scenes or musical background to completed silent pictures. The head of British International

Pictures, John Maxwell, notwithstanding his public statements to the contrary, forged connections with Pathé and De Forest Phonofilm to facilitate the swiftest possible switchover to synchronized sound. Elstree began soundproofing renovations.

Hitchcock couldn't be certain that sound would be in place in time for his next film. But right away he planned for contingencies. "Hitchcock," said Ronald Neame, an assistant cameraman on the director's next planned project, "was way ahead of the game. He just loved the idea of using sound."

Shortly after the premiere of *The Jazz Singer,* a writer named Garnett Weston, who had just signed to a contract with British International Pictures, arrived in London. Canadian by birth, Weston was considered a suspense specialist (he later became a mystery novelist). Fresh from a stint with Cecil B. De Mille in Hollywood, he was up-to-date on talkies. To the surprise of many in the trade, Weston was announced as Hitchcock's collaborator on the B.I.P. adaptation of *Blackmail,* a Charles Bennett stage play starring Tallulah Bankhead that had been a sensation at the Globe in 1928.

Eliot Stannard, who had worked on every one of Hitchcock's silent pictures, was thus unceremoniously dismissed. Whether Hitchcock and Stannard had quarreled again, or the silent-film writer was just considered too old-fashioned (fellow director George Pearson remembered that Stannard had the quaint habit of heading his master scenes "with a hint as to their mood, joyous, tragic, equivocal, etc."), Hitchcock left no clue. But this was the first signal that *Blackmail* would break with the past.

Stannard continued to write films, but after parting with Hitchcock he lost the stature he once enjoyed. He was still writing for Gaumont in 1944, a chain-smoking elder guru of the field; one colleague recalled him complaining vigorously that "Hitchcock took all the credit for writing *The Ring,* but at least fifty per cent of the most important ideas were mine." Stannard died later that same year.

The received history of the making of *Blackmail*—"the first British talkie"—is a *Rashomon* of conflicting accounts.

The Manxman was completed in September, but Hitchcock didn't launch photography of his next film until late February 1929. Hitchcock had a way of slowing down the pace of production for his most important films, and with Elstree taking baby steps toward sound, there was good reason to take his time.

Nearly everything Hitchcock did, he broke down into steps and components. And while he didn't always have the luxury of following each step, especially in England, Hitchcock liked to start with a fifty-to-seventy-five-word description of the story's kernel, or main idea, articulating its

through-line, or narrative thread. In Hollywood slang, this was known as a long "weenie."*

After the weenie came a lengthy prose treatment, of sixty to one hundred pages. Hitchcock liked to read the story in this prose form before launching into actual scriptwriting. The treatment was "scene by scene and action by action, without dialogue," according to the director. "The best way I can describe this outline—it's as though you'd looked at the film and cut the sound out."

At every stage of the scriptwriting Hitchcock liked to tell and retell the story, and have it told back to him by the writer or writers he was working with; it was a form of mental rehearsal that helped the director visualize key scenes, spot potential problems, and suggest emendations while changing the story into *his* story.

As treatment was transformed into script, the tellings and retellings continued. "I'm bringing the writer into the direction of the picture," Hitchcock once explained, "letting him know how I'm going to direct it." A Hitchcock script thus evolved in stages, with each stage indebted, obscurely, to the contributions of preceding writers. And each stage allowed Hitchcock to embroider his vision. "Oh, I make it [the film] before the script," he told one interviewer. "The script is the second stage."

Especially for his early sound pictures, and in an ongoing fashion throughout his Hollywood years, his favorite listener was also the author of the initial, lengthy treatment: usually it was Mrs. Hitchcock. At this time Alma became the true replacement for Eliot Stannard.

Hitchcock envisioned *Blackmail* as a splendid pretext for exploring the primal commingling of sex and violence that he had already marked as his territory in *The Lodger* and other films.

The plot concerned a triangle of cross-purposes: a young woman impulsively stabs an artist while fending off his sexual advances; an unscrupulous witness tries to blackmail the woman; her boyfriend, a police detective who is torn between duty to his profession and devotion to love, joins in framing the blackmailer for the murder.

Charles Bennett's play offered a solid foundation, but Hitchcock envisioned major changes for the film: opening up the settings, creating action, replacing the "third act."

The first team of "three Hitchcocks" on *Blackmail* included Garnett Weston, who contributed to the treatment before moving on. Often a writer left a Hitchcock project for no reason more sinister than a prior professional commitment; sometimes, however, it was poor chemistry. In

*The weenie stage of the process was less necessary if Hitchcock intended to follow a produced play strictly, as was the case with *Blackmail* and several films he made for B.I.P.

January 1929, Weston was shunted off to another B.I.P. assignment, and Hitchcock searched around the studio for a new writer.

Seeking a younger voice for a film he wanted to suffuse with a modern sensibility, Hitchcock didn't have to look very far. With his instinct for discovering young talent, he remembered Michael Powell, the young still photographer, whose magnificent career (as the director of *The Red Shoes* and the Hitchcock-like *Peeping Tom,* among other first-rate films) couldn't have been easy to foresee in 1929. But the twenty-three-year-old Powell was clever, thoughtful, a good talker and listener; Hitchcock liked him, and so did Mrs. Hitchcock.

Powell was befriended by the Hitchcocks and invited down to Shamley Green, a hamlet amidst the woods and lanes of Surrey, where the couple had established a half-timbered cottage for weekend escapes from Cromwell Road. There the director tended his flower beds (he was a passionate horticulturist), and they all took long country walks.

"They were kind to me," Powell recalled. "I never could understand what they saw in that moody, silent boy. I think that it was my association with great men [Rex Ingram and Harry Lachman] and great films. Something had brushed off. Like me, Hitch adored films and had great ambitions. Like me, he was impatient with the men who financed the struggling British film industry, looking inward instead of outward."

During the filming of *The Manxman* Hitchcock had handed Powell a copy of the Charles Bennett play, telling him that *Blackmail* was well crafted until the weak third act. Hitchcock liked fireworks for his third acts, the dramatic set pieces he called "crescendos," which topped everything that went before.

See what you think of the play, Hitchcock told Powell, and let me know how you think it might be improved for a film. It was the kind of remark Hitchcock often meant as a little test, but Powell passed swimmingly. He returned to tell Hitchcock he agreed with him—*Blackmail* would make a "swell movie." When Hitchcock then asked about the "rotten" third act, Powell said, "To hell with the third act. We'll make it a chase."

The original January start was postponed several times as the new three Hitchcocks went to work. By this point Anny Ondra had already been chosen to play Alice, the young woman who stabs the artist-seducer. Ondra had been luminous under Hitchcock's tutelage in *The Manxman,* a precursor to Ingrid Bergman, Grace Kelly, and Tippi Hedren in the long line of exceptional actresses who beguiled him. One of the secrets of his success—although it was an advantage he did not always have—was that signing the stars he wanted, early on, allowed him to build the script, and by extension the whole film, around their personalities.

As the writing team carried on, Powell was able to take long walks and get to know Ondra, who was also a regular guest of the Hitchcocks at Shamley Green. Besides the writing, Powell took "romantic still photo-

graphs of her charming face and body in the woods." Hitchcock often joined these woodland expeditions, "moodily" observing. "I am sure he wanted Anny as much as I did," Powell mused in *A Life in Movies*.

Hitchcock was incorrigible, recalled Powell, a "director" of people off as much as on the set. His provocateur's personality never relaxed. "You don't want to take all those solos [snapshots] of Anny," Hitchcock advised Powell on one occasion. "You want to get a boy with her in the hay and she's pressing up against him to feel his cock against her leg." ("He loved to talk bawdy," Powell remembered. "It made up for his gross, clumsy body.")

From Shamley Green to Cromwell Road, the script progressed. In London, Hitchcock rejoiced in his "researches": always, with crime films, paying visits to Scotland Yard, meeting with detectives, or visiting courts and prisons, collecting atmosphere and lore.

The film's procedural prologue grew out of the team's script talks and research. The prologue would feature a flying squad racing through London streets, an arrest, the interrogation and "identification parade," and the fingerprinting and jailing of a suspect. (The sequence then ends with a true Hitchcockian touch: a side trip to the policemen's washroom.)

As part of the director's by now standard operating procedure, Hitchcock and Powell also visited a series of typical settings where their characters might live and work. Powell was struck by the how the director, with his East End background, evinced a "peculiar and delightful" view of people and places "east of Temple Bar," while "toward the West End" Hitchcock seemed to fall back on "a more conventional approach because, to him, it only meant eating well in expensive restaurants, or going to the theater to see some actor or actress who had made a hit. But with the lower-middle-class Londoners of our film, shopkeepers, barrow-boys, hawkers, match-girls, hangers-on at the tails of the garment business, policemen, detectives, reporters, coppers' narks, thieves and pickpockets, he continually delighted me with the extent of his knowledge and the sharpness of his observation."

Hitchcock specialized in writers who reached for the spot that itched. At one script session, according to Powell, the director "broached an idea that I had been maturing for a while." *Blackmail* ought to conclude, Powell suggested, with an elaborate chase that takes place in "some bizarre location that is entertaining in itself."

"What do you mean?" asked Hitchcock, raising his eyebrows. "What do you think Michael means, Alma?" Right on cue, Mrs. Hitchcock gave Powell an encouraging nod.

Powell had been pondering his boyhood visits to the British Museum Reading Room, that hallowed edifice with its glass dome. "Let's have him [the blackmailer, pursued by police] slip into the British Museum at night," Powell offered, "and get chased through rooms full of Egyptian mummies

and Elgin Marbles, and climb higher to escape, and be cornered and then fall through the glass dome of the Reading Room and break his neck."

The Hitchcocks beamed. Years later, in his autobiography, Powell reflected that Hitchcock probably "had never been near the British Museum Reading Room," which was why Powell felt entitled to "make a modest claim to being the inventor of the Hitchcock Climax, unveiled to the world through the chase in *Blackmail,* and which led us all on many a delightful dance from Tower Bridge to Mount Rushmore, from the Statue of Liberty to you name it." What Powell overlooked was that he was hired expressly because the Hitchcocks recognized in him a kinship—in short, that he was "Hitchcockian" enough for the job, and just the kind of writer who might well come up with such ideas.*

The British Museum pursuit, and the toppling death of the blackmailer, were the film script's major innovations, but Alice's ultimate fate was another difference from the play. The stage version of *Blackmail* ended with a twist revelation: the artist hasn't been murdered by Alice after all—he has actually been felled by an undetected heart attack! (According to film historian John Belton in his study of Charles Bennett's work, the published play even differed from the produced play, for there Tallulah Bankhead insisted on having Alice surrender to police.)

Hitchcock tried to preserve Bankhead's version, with an ending that would have mirrored the prologue: After the blackmailer falls to his death, the detective boyfriend is forced to arrest and fingerprint his own girlfriend. The detective doesn't dare let on that he knows Alice, because he has been complicit. As he leaves the station afterward, another officer asks, "Well, what are you doing tonight, going out with your girl?" and he answers stonily, "No, not tonight."

Once again, though, the front office stymied Hitchcock. B.I.P. objected to the leading lady being arrested for murder at the end of the film; they didn't want Anny Ondra winding up behind bars, any more than Gainsborough had wanted Ivor Novello to be perceived as Jack the Ripper. They said it would be "too depressing," Hitchcock told Truffaut.

So the three Hitchcocks hastily revised the ending: The police would still trap the blackmailer on the roof of the British Museum, where he falls to his death. Discovering the blackmailer has a prior criminal record, the police are happy to close the books on the artist's murder. Tortured by guilt, however, Alice appears at the police station; she is on the verge of confessing—as guilty parties seem inevitably compelled to do in Hitchcock's films—when she is interrupted and hurried away by her detective boyfriend.

* Powell had also underrated the chase at the end of *The Lodger,* and the Albert Hall finale of *The Ring.*

It's far from a happy ending, as the actors' haunted looks convey. The detective has obstructed justice, and Alice is saddled with guilt. Hitchcock still thought the ending sugarcoated. "My life's full of compromises," he would sigh to Peter Bogdanovich when recounting the saga of the film years later.

The Islington brothers Norman and Charles Wilfred Arnold shared the art direction, and Jack Cox was the cameraman, when *Blackmail* started filming in February 1929.

Tall, handsome John Longden played Frank, the detective boyfriend; the shorter, less handsome Donald Calthrop played the blackmailer. (A character actor Hitchcock admired enough to use several times, Calthrop also appears in *Elstree Calling, Murder!,* and *Number Seventeen*. The director once said that Calthrop "could be compared with a Wurlitzer organ, which can give you everything from tremendous volume to the softest notes.") Cyril Ritchard, an elegant song-and-dance man from Australia, was cast against type as the ill-fated artist-seducer. Irish-born actress Sara Allgood, the tragedy queen of the Dublin theater, and music hall veteran Charles Paton portrayed Alice's parents.

Everyone still thought *Blackmail* was going to be a silent picture. That is what the studio told Hitchcock—which "bitterly disappointed" him, he said later. Ronald Neame, an assistant cameraman on the film and later a prominent director in his own right, observed in an interview that Ondra's casting proved that Hitchcock was expecting *Blackmail* to remain silent. "He wouldn't have cast Anny Ondra, because Anny was Czechoslovakian, and she was playing the part of a London girl. She had a strong accent, and there was no such thing as dubbing. I don't think he would have landed himself in that problem had he known he was going to do sound."

But Hitchcock loved to wave his magic wand over insoluble problems; throughout his career he gulled studios by consigning worries to the back burner while plowing ahead on his own terms.

In the helter-skelter tradition of English film, which he would carry on for the rest of his career, even in the stricter confines of Hollywood, Hitchcock shot the prologue with the second unit—and with John Longden, the only principal required—before the script was even finished. If the police rigmarole seems overdone from today's viewpoint, it held an inherent fascination for audiences of the time, and would have served a symmetrical purpose if Hitchcock had been allowed his original ending. Shot without sound, the prologue stayed silent—"a compendium of the art of the silent film," in the words of British film historian Tom Ryall.

Partly because Hitchcock often started with a second unit before the script was completed, there could be a surprising amount of tinkering

during filming, for a director who prided himself on careful planning. Another young man behind the scenes of *Blackmail* was Freddie Young, destined to become the illustrious cinematographer of *Lawrence of Arabia* and *Doctor Zhivago*. Young was delegated by Hitchcock to create a minor montage, and he recalled instructions as exacting as they were changeable.

Nowadays, each shot of a montage is photographed separately; then the sequence is folded together easily on a digital editing system. In the silent era, all the dissolves had to be created inside the camera. Before starting one had to know precisely how many feet of film to expose for each image, and the exact order of the images. "During filming it was often necessary to wind the film back or forward in the camera," Young explained, "and every time you did that you ran the risk of scratching it in the gate. If only one thing went wrong it would ruin the whole lot and you'd have to start all over again."

Hitchcock handed Young one page of the *Blackmail* script, "indicating—I forget the exact details—a shot of feet walking, followed by thunderclouds, a train, horses galloping." Young dutifully went off to create the prescribed sequence. "When I'd finished," recalled Young in his autobiography, "I showed it to him in the viewing room, and he said, 'That's fine, Freddie, but I've changed my mind. I'd like you to start with the train, then go to the feet and the horses' hooves, and finish with the clouds.'" Thus he had to start again from scratch.

Major and minor scenes of *Blackmail* were filmed in just such a fashion, shot by laborious shot, during February and March. Act One of the film climaxed with an especially bold sequence, in which Alice fends off the artist-seducer, finally stabbing him to death. It was a highlight carried over from the play, which Hitchcock restaged as pure cinema—pieces of film orchestrated into a series of viscerally thrilling chords.

In the scene Alice is quarreling with her detective boyfriend. She sneaks off for what is intended as a platonic tryst with the artist, and their date ends with him inviting Alice up to his flat to see his paintings. As they enter his apartment building, they are observed by the seedy Tracy (Donald Calthrop), lurking to collect a debt.

Upstairs in the flat, Alice is coaxed into putting on a tutu worn by the artist's models. She dances around like a flirtatious firefly, but when the artist steals a kiss, she stops cold; she decides to leave, but, still playfully, he hides her street clothing. Then he grabs her.

Lightness turns to dark. The struggle grows serious. They stumble around violently and slip behind a curtain. It's hard to tell what is happening: Hitchcock was always forcing his audiences to participate in the danger, to fill in gaps with their imagination.

Wrestling shadows. Writhing curtains. Alice's hand reaches out from

behind the drapery, just her hand—groping frantically—until her fingers finally close on a large table knife. The knife is pulled behind the curtain. Intense struggle, and then, after a beat, all movement ceases. The artist's arm pierces the curtain, lifelessly outstretched.

All of it was done very simply—a counterpoint to the British Museum climax, a more complicated, expensive, and decidedly Germanic highlight. Because the museum wouldn't allow a full cast and crew to occupy its premises (and the budget couldn't indulge the location work), the Hitchcock magic required the talents of the studio's effects wizards—and the Schüfftan process. According to Hitchcock, the studio knew "nothing" about the process, and officials "might have raised objections, so I did all of this without their knowledge."

As with *The Ring,* the famous backdrops were photographed first, and then the actors went through their paces separately; what the audience saw was a composite. Years hence, the director still reveled in the accomplishment, describing the technical challenges to a T. "You have a mirror at an angle of 45 degrees," Hitchcock recalled, "and in it you reflect a full picture of the British Museum. I had some photos taken with half-hour exposures—nine of them taken in various rooms in the museum—and we made them into transparencies so that we could backlight them. That is more luminous than a flat photograph. It was like a big lantern slide, about twelve by fourteen. And then I scraped the silvering away in the mirror only in the portions where I wanted the man to be seen running, and those portions we built on the stage. For example, one room was the Egyptian room—there were glass cases in there. All we built were the door frames from one room to another. We even had a man looking into a case, and he wasn't looking into anything on the stage. I did nine shots like this."

Meticulous staging and special effects sequences always took an inordinate amount of time, but Hitchcock seemed almost to dawdle during the filming. John Maxwell dropped by more than once to check the slow progress of *Blackmail.* Hitchcock and his complicit cameraman were ready for the B.I.P. boss. They arranged a dummy camera and lights on a nearby stage, on the pretense that they were photographing "a letter for an insert," in the director's words. Whenever Maxwell materialized, they started shooting the insert. The studio head grew bored and left.

By late March the weather had improved, and they could venture outdoors. One night, a screen trade columnist watched the filming at the Lyons Corner House, a well-known West End restaurant. Police tried to keep "the homegoing theater crowds" away, but the Saturday night throng refused to budge, watching Hitchcock shoot exteriors for the first scene between Alice and Frank, when they quarrel at dinner. The public was invited to merge with extras to form the crowd in the film, and it was "early

on Sunday morning [before] Hitchcock and Jack Cox were satisfied with the results," the columnist wrote.

As far as anyone knew, *Blackmail* was still officially a silent picture.

In early April came the news that B.I.P. had completed temporary sound-stages. The larger permanent facilities would not be ready until midsummer, but John Maxwell felt confident enough to announce an ambitious program of fifteen to twenty talking pictures for 1928–29. And the first of these, according to the trade papers, would be *Blackmail*—a newly scheduled "talkie version," with dialogue inserts already being hastily written by Hitchcock and Benn Levy.

Levy was a young Oxford-educated playwright who had just returned from Hollywood, and writing talkies there. (He would shortly marry the well-known American actress Constance Cummings.) Foreseeing the need for dialogue, Hitchcock had begun meeting with Levy in the spring, early enough that Levy's pages were ready by mid-April.

Maxwell only authorized the addition of "limited" sound to scenes already photographed. Yet, anticipating this cost-conscious approach, Hitchcock had shot key scenes with parts in mind that he could substitute out, and earmarked sections leading into or out of the silent scenes, "where sound could be tacked on afterward," in his words. According to British film historian Charles Barr, who compared both versions of *Blackmail,* "while shooting the silent version of the film sanctioned by Maxwell, Hitchcock was also shooting separate takes of each shot in order to prepare a negative for the sound version of the film."

"Since I suspected the producers might change their minds, and might eventually want an all-sound picture," Hitchcock told François Truffaut, "I worked it out that way."

Anny Ondra was the most delicate issue. Hitchcock adored her; by all accounts, everyone did. Besides being adorable, she was funny, intelligent, down-to-earth. The director preferred a leading lady he could flirt with, and the ones that flirted back fared best with him. Ondra was a flirt, but also a genuine friend. (Later in life Hitchcock would visit her whenever he passed through Germany.) Accent or no accent, he was going to stick with Ondra.

Ondra spoke with a thick Czech pronunciation, however, which wasn't right for an actress playing the daughter of a typically English newsagent. Hitchcock had had a potential solution in mind all along, but first he went to the bother of arranging a sound test for Ondra. The test would demonstrate the barrier of her accent—so that she would understand his dilemma.

The test footage, undated, survives in British Film Institute archives, and transcripts have been reprinted in books and documentaries about

Hitchcock. He is seen standing next to Ondra, reassuring her, prodding her to speak, while also teasing her mercilessly.

HITCHCOCK: Now, Miss Ondra, we are going to do a sound test. Isn't that what you wanted? Now come right over here.
ONDRA: I don't know what to say. I'm so nervous.
HITCHCOCK: Have you been a good girl?
ONDRA (*laughing*): Oh, no.
HITCHCOCK: No? Have you slept with men?
ONDRA: No!
HITCHCOCK: No?!
ONDRA: Oh, Hitch, you make me so embarrassed! (*giggling helplessly*)
HITCHCOCK: Now come over here, and stand still in your place, or it won't come out right, as the girl said to the soldier.
(*Anny Ondra cracks up completely*)
HITCHCOCK (*grinning*): Cut!

Lewd repartee was business as usual for Hitchcock during camera tests, according to those who worked with him. He liked to shout out at actresses, "Have you ever slept with anyone?"—a most unusual question in those days. Besides actually being keen to know whom his leading ladies were sleeping with, Hitchcock relished the chance to elicit a spontaneous reaction, look, or expression—a peek behind the professional mask.

Ondra's voice test, along with Hitchcock's "home movies" of *Blackmail,* confirm that she and the director had a warm, playful chemistry. There is footage of Hitchcock lifting up her dress and grabbing at her underwear, of her shooing him away through gusts of laughter. The director's leading men were treated much the same way. Actor Henry Kendall, for example, recalled that during his test for *Rich and Strange* Hitchcock "talked to me from behind the camera and would in the ordinary way have been asking me about my experience and for details of my career, but this time the conversation took a very Rabelaisian turn, and he kept me in fits of laughter so that I could hardly do more than stand in front of the camera and shake."

The test convinced Ondra, and voilà!—Hitchcock brought out his Alice-in-reserve: Joan Barry, a young British actress whose diction had been refined by study at the Royal Academy of Dramatic Art. Ondra would mouth her lines while Barry stood outside the framing of the camera and gave simultaneous voice to Alice's dialogue. (Never mind that Barry's upper-class accent was totally inappropriate for the character.) Hitchcock's solution meant more pressure all around—all three had to rehearse the exact timing of the scenes, every night after filming, in order to be ready for the next day.

The director's loyalty to Ondra carried the day, though her best scenes, as it turned out, are the silent ones without the distracting "voice double"—those that take place after the killing, when she is traumatized. But Hitchcock's fondness for Ondra didn't keep him from reducing her (as he had another favorite actress, Lilian Hall-Davis) to tears, until she gave him the suffering quality he wanted.

If there is one film, one character, one actress at the heart of Hitchcock's work, it is Anny Ondra in *Blackmail*. Hitchcock's male heroes generally do all right in the end, except for the guilt and shame. His women must kill or die, be humiliated, or endure a frustrating romance with an impotent hero on the run. One way or another the beautiful women always suffered.

Blackmail moved into B.I.P.'s new temporary soundstage: a padded house on the Elstree grounds.* The walls were cushioned with blankets. Draped felt was sandwiched under the corrugated-iron roof. The sound cameras were motor driven, and the motors made constant noise, so the cameras had to be encased in telephone-booth-like kiosks on wheels. The camera couldn't track or dolly without wheeling the entire booth around the room. Camera movement—already a Hitchcock trademark—basically ground to a halt.

The standard carbon arc lamps produced an incessant hum and splutter, so the cameramen began experimenting with five- and ten-kilowatt incandescents. This worked out well for illumination purposes, but created a near-suffocating heat inside the stage area—"like being in a bakehouse," as Freddie Young recalled. "In between calls, the actors lay down on the floor and napped as best they could in the sweltering heat."

The camera booth, a smaller confined space, was hellish—an even more punishing sweatbox. It was covered in front by a thick glass panel that had to be wiped clean constantly with alcohol. The crew even grabbed their tea breaks inside. "The operator was locked inside," recalled Young, who was assistant cameraman on another B.I.P. talkie (which actually preceded *Blackmail* in the temporary sound facility), "and there he'd stay until the end of the take, when he'd stagger out sweating and gasping for air."

"My first impression was of a largish room packed to capacity with a vast amount of junk," recalled Arthur Graham, a B.I.P. cameraman who

* The biggest sacrifice to the extended shooting schedule was Phyllis Konstam, who was playing the gossiping neighbor ("Knife! Knife! Knife!"). Konstam had to fulfill a previous stage engagement, and Phyllis Monkman stepped into her part, refilming the scenes with sound. To simplify the billing, neither actress was credited. In ads for the talkie *Blackmail*, as Charles Barr has pointed out, it is the "silent" Konstam who is shown.

dropped by to watch. "There were flats everywhere, cables snaking all over the place and a floor covered with a jungle of lamp stands."

Hitchcock, most of the time, was stationed in a separate recording booth that was every bit as hot and suffocating, wearing outsize earphones to monitor the audio quality.

"Utter chaos," thought cameraman Graham. Under the circumstances the director had to radiate confidence enough for everybody, but Hitchcock never lacked for confidence. It should have been embossed on his business card: Authority and Confidence. While every other British director was half paralyzed by the new equipment, Hitchcock methodically added not only key dialogue to the script, but incidental music and sound effects as well.

The effects specialists lined up on the sidelines, letting forth screams and laughter, making doors slam, horns honk, and birds sing—filling the film with noise.

The director sat Cyril Ritchard down at the piano and had him sing a snippet of a popular song just before his stabbing death. In another scene, where John Longden nonchalantly paced around a room, searching for clues, the director suggested that the actor whistle "Sonny Boy" from *The Jazz Singer*—the first American talkie, which was still the rage in British theaters. Longden thought that the cheekiest Hitchcock touch of all.

Hitchcock was quick to see sound as another means of editing, which could link images in novel fashion—as when he cut from the outstretched hand of a tramp Alice spies on the street to the scream of a landlady discovering the stiff, protruding limb of the dead artist.

He even deliberately distorted sound. The most audacious example comes after the murder, when Alice sits, trancelike, at the breakfast table with her parents, her secret weighing on her mind. Just behind them, a neighbor woman, standing in the family's news shop, loudly discusses the murder. She complains about the very "un-British" method of stabbing someone with a knife. "Now I would have used a brick maybe, but I'd never use a knife. A *knife* is a terrible thing. A *knife* is so messy and dreadful. . . ." Over and over the offending word is repeated, magnified, exaggerated, becoming, in Hitchcock's words, "a confusion of vague noises."

Hitchcock intercut this hilarious "knife" recitative with close shots of Alice, her eyes darting back and forth guiltily. The tension builds as Alice's father asks for a slice of bread. Alice's hand edges slowly toward the bread knife, until the word "knife" is heard one last sharply accusing time. She gives a start, and hurls the blade from the table.

There wasn't the budget to reconvene extras or rebuild entire sets in the padded building. For the Corner House supper shared by Frank and Alice at the beginning of the story, Hitchcock had planned ahead, and now restricted the new setup to one table, with the camera focused on the two

principals. Now and then Frank steps busily out of the frame, and Hitchcock cuts to shots of other diners from the silent version. The effects specialists furnished the dining-room clatter.

Their sly dialogue reminds the audience they are watching a film. Hitchcock's characters *go* to films; they *talk* about films; and in *Rope,* they even advertise another Hitchcock film. It's another one of the director's Chinese-box qualities.

In this scene Frank has invited Alice to the premiere of a new crime film (not unlike the one the audience is watching). When Frank mentions Scotland Yard, however, Alice stifles a yawn. "If it weren't for Edgar Wallace,* no one would have ever heard of it [the Yard]," she says. Frank insists that the picture should be amusing. "However, they're bound to get all the details wrong," Frank chuckles—a gibe at Hitchcock's own craft! While others were deep-thinking sound, Hitchcock was having fun.

Sound was Hitchcock's brand new toy. Chortling over his own cleverness, he handed his personal 16 mm camera to Ronald Neame, and guided him through the making of a backstage "home movie" about the filming of *Blackmail.* With his penchant for teasing the boundaries between artifice and reality, Hitchcock positioned Neame behind the curtain during the scene where Alice stabs the artist, urging him to get plenty of footage of the property man lathering blood on the knife.

All England sensed the historic moment. The duke and duchess of York (later queen to George VI, and then Queen Mother) visited the *Blackmail* soundstage in May. The duchess, known to be a motion picture fan, wanted to witness the making of a talkie. "I remember taking her into one of those camera booths," Hitchcock recalled, "and it was an awful crush, since they were very tiny." (She squeezed in with him, the cameraman, and the focus boy—"It was almost a matter of committing *lèse-majesté.*") Then the duchess visited the sound booth, where Hitchcock encouraged the royal visitor to do what, traditionally, royalty never did—doff her hat—and try on the earphones. That was just what she did.

After the sound footage was matched up with the silent stuff, the finished product had to be manufactured at low budget and top speed to beat any rivals to claim the title of the first British talkie. Still, some purists, and some eyewitnesses, insist that *Blackmail* really wasn't the first.

As noted, before Hitchcock, Freddie Young had already shot several "dialogue scenes" in the padded building for a picture called *White Cargo.* In his memoir Young argued that *White Cargo* deserved to boast of being

* Prolific British author Edgar Wallace, known as the "king of the thriller" for his suspenseful books and plays, often involving Scotland Yard.

"the first sound sequence to be filmed for a British feature." Another English director, Thomas Bentley, had already completed a "talking" two-reeler called *The Man in the Street,* and he sniffed in interviews that *Blackmail* was "only half-sound." Victor Saville's *Kitty* was another film trumpeted by some as the first British talkie, and maybe it was—except that only the last reels "talked" (the rest were scored with music), and the sound sequences were added in New York on an experimental stage owned by RCA.*

Other British talkies might have been shot first, but Hitchcock's exceptional planning translated into speed and efficiency in postproduction. The filming in the padded building was finished by late May, and the talkie *Blackmail* was ready for trade screening on June 21.

And there is something else: those rival first talkies have faded into obscurity, while *Blackmail* remains a milestone—not only a film at the forefront of sound, but a film whose subject and style were ahead of its time in every way. Arguably, it was Hitchcock's first mastery of suspense.

When the talkie *Blackmail* had its premiere at select theaters in July 1929, the London film critics were unanimous. The *Daily Mail* said the new Hitchcock film was "the best talking film yet—and British," while *Kine Weekly* described it as "a splendid example of popular all-talkie screen entertainment." The London reviewer for *Variety* noted that "silent, it would be an unusually good film; as it is, it comes near to being a landmark."

Yet *Blackmail* also existed as a silent film, and the soundless version was quietly released a short time later, drawing bigger crowds at the hundreds of English theaters not yet wired for talkies. In 1993, when the British Film Institute restored the silent version, commissioning a Jonathan Lloyd score to accompany a world tour, contemporary critics got a chance to see the "other" *Blackmail.* Most agreed that it stood up equally well.

Hitchcock had appeared in *The Lodger* and *Easy Virtue* (strolling past a tennis court in the latter), but *Blackmail* contained his most extended cameo to date. Alice and Frank, in one scene, are riding on the Underground. Among the passengers is the director, intently reading a book. A small boy leans over and jabs Hitchcock's hat, knocking it down over his eyes. He returns the poke, but cowers as the little nuisance approaches him again. The scene fades. Shot silent, the cameo remained intact and soundless in both versions.

Hitchcock was already a celebrity by the summer of 1929, and he had reason to feel on top of the world. But it was a small world—the world of

* *Kitty*'s dialogue was written, incidentally, by Benn Levy—probably where Hitchcock got the idea to hire him.

British film—and he had constant evidence of its fickleness. Late August brought one grim reminder.

With little warning, B.I.P. announced massive layoffs, firing nearly one hundred people, or roughly 20 percent of its personnel. The studio instituted severe budget restrictions and a general policy of retrenchment in production. The shock waves reverberated throughout the industry, and layoffs and cutbacks spread to other studios.

The mood was bitter at Elstree. Although the books continued to show profits, John Maxwell had tied up too much capital in "the round dozen of finished, dialogue, synchronized and silent pictures, at present in cold storage," in the words of one trade paper; and given the limited number of English venues ready to show them, B.I.P.'s expensive talkies couldn't make back their investment without conquering foreign markets. The United States continued its immunity to even the best English films, a phenomenon of which *Blackmail* became a sore example. The first British talkie was rejected outright for distribution in the U. S., according to film historian Paul Rotha, even though it was "infinitely better than any American dialogue picture of the same time." The reasons given were many and irritating, but the upshot was simple: Americans couldn't decipher the English accents.

The failure of the Hitchcock talkie in America, and outside of England generally, was counted a "hard blow" to the studio, according to Rotha. "Even the Dominions cold-shouldered" *Blackmail,* wrote the film historian. "Censorship authorities in Australia at first prevented the picture from being shown," though the ban was later reversed.

The burgeoning crisis gave Maxwell an excuse to get more personally involved in production decisions. He decreed new belt-tightening measures: Pictures would have to be made cheaper and faster, and now more than ever with English audiences uppermost in mind. Foreign stars simply did not justify their investment.* Costly and adventurous travel would be curtailed in favor of filming on studio stages, which were already figured into the overhead.

At the moment of his first great triumph, therefore, a pall was suddenly cast over Hitchcock's career. Regardless of whether *Blackmail* was the first British talkie, the verdict was that he had taken too long and spent too much money to produce the film. America was underwhelmed by his achievement, and censorship hurt prospects in the English territories. There are no reliable box-office figures from that era, but any profits from the film were modest.

It couldn't have helped his standing at B.I.P. that his budding mystique

* One foreign star Hitchcock never worked with again was Anny Ondra. She returned to Germany shortly after *Blackmail;* she married boxer Max Schmeling and later retired from film.

was creating something of a backlash: already his detractors had formed an "anti-Hitchcock" club. The earliest critics faulted his repetitive visual ideas more than his subject matter. Even in a favorable review of the mild-mannered *The Farmer's Wife,* the reviewer for the *Bioscope* felt compelled to complain that the "magnificent" picture had been undercut by Hitchcock's tendency toward "fantastic angles of photography." Even as he praised *Blackmail,* the London correspondent for *Variety* grumbled about the director's growingly familiar "staircase complex." ("Staircases are very photogenic," the director defended himself years later, in his interview with Charles Thomas Samuels.)

Although Hitchcock survived the August massacre, John Maxwell put him on notice. He needed to accelerate his productivity, diversify his subject matter, and direct commercially attractive films. Musicals—considered a perfect showcase for talkies—were extremely popular, so England's most important director was hastily assigned, in late August, to help out with the "all-dialogue, singing and dancing" *Harmony Heaven.* Hitchcock may have logged a few days on the production, but it couldn't have been much more.

Harmony Heaven was superseded by the announcement, in October, that Hitchcock had agreed to transfer the Sean O'Casey play *Juno and the Paycock* to the screen. After that, the director would film another crime story—more in the detective vein—with his adaptation of the Clemence Dane–Helen Simpson novel *Enter Sir John.*

This surge of activity was enough to satisfy Maxwell, and since the script for *Juno and the Paycock* was sacrosanct, Hitchcock would have extra time during filming to prepare the screenplay for *Enter Sir John.* The press had already noticed the director's inclination to alternate straight theatrical adaptations with more original, "purely cinematic" works, in the words of the *Bioscope.* Plays were simply easier to film; Hitchcock considered them "breathers" between subjects that involved more originality, expense, and risk.

Sean O'Casey's *Juno and the Paycock* was first produced in 1924 at the Abbey Theatre in Dublin; a year later it had opened in London, chalking up over two hundred performances in different runs before touring companies took it to the provinces. Hitchcock had seen it several times. "One of my favorite plays," he told Peter Bogdanovich.

The acclaimed *Juno* has often been described as a mixture of low comedy and sublime calamity. The main setting is a poor Dublin tenement, the home of the Boyle family. Captain Boyle is "Paycock," an arrogant, boozy clown, who takes his self-important seafaring honorific from his onetime stint on the Liverpool-to-Dublin coal run. Juno—named, O'Casey always said, not for the Roman hearth goddess but for the way the character's life is shaped by events that transpire during the month of June—is Boyle's wife, and the real head of the family. She is an exalted mother, Mother Ire-

land incarnate. Juno will endure any indignity for her beloved children. Mary is her sweet, devoted daughter; her son Johnny is a crippled victim of Irish politics, concealing a dark shame.

Captain Boyle is unexpectedly declared heir to a forgotten relative's bequest. The rise and fall of Boyle's legacy supplies the semifarce, while the fate of Johnny provides the tragedy. O'Casey had set his play against the backdrop of the 1921 North-South division of Ireland, and the settling of scores between Republicans and Free Staters. Johnny is revealed to have "shopped" a former comrade to his death. Disaster builds when fault is found with the bequest; Mary becomes pregnant and is deserted by her boyfriend (a law clerk handling the will); and militants arrive to exact their revenge on Johnny.

For B.I.P., *Juno and the Paycock* was a hit play sure to be a hit film. For the director, it was his first opportunity to explore how politics have corrupted history.

A remarkable percentage of Hitchcock films revolve around sabotage, espionage, or assassination. His villains in these stories tended to be ideological fanatics turned traitors or terrorists. Just as Hitchcock had a specific real-life case that haunted him when dealing with "marital murders" (to paraphrase George Orwell), the director's political films were shadowed by the true story of Reggie Dunn.

Dunn was no "wrong man"—he was a resolute killer, and another notorious criminal the director knew firsthand. During his time at St. Ignatius, Dunn had been one of the most popular, athletic boys at the school. After World War I, however, Dunn grew embittered about the policy of the British government toward Ireland. He joined the IRA and volunteered to become an assassin; he and an IRA comrade shot dead the former chief of the Imperial General Staff, Field Marshal Sir Henry Wilson, in London in 1922—the same year Edith Thompson was alleged to have plotted her husband's murder. Like Thompson, Dunn was caught and executed. (Unlike her, he proudly admitted his guilt.)

The character of Johnny would be a stand-in for Dunn, and *Juno and the Paycock* would be the first Hitchcock film to establish the theme that he carried over to later work—of ideological extremism as a spreading stain that distorts idealism and destroys innocents. This was also O'Casey's theme, and so the director (half Irish, after all, and his own mother a Juno of the Hitchcocks) felt completely in sync with the play— if not the playwright.

Hitchcock had occasion more than once to pay his respects to Sean O'Casey, who was a self-declared exile from Ireland after a bust-up with the Abbey Theatre, and then living at Woronzow Road, St. John's Wood.

A fiercely dogmatic man of the theater, O'Casey thought film was inferior entertainment. Even the best pictures offered "the glorification of insignificance," he felt, while the worst—well, the worst were nothing but "lurid ornamentation on a great big scab." But Adrian Brunel and Ivor Montagu, two of the more "intelligent fanatics for the movies," in O'Casey's words, had pursued the playwright with film-writing offers, and one day managed to lure him over to Elstree, where he first met Hitchcock. John Russell Taylor said this meeting transpired on the set of *Blackmail,* but according to O'Casey's recollection it must have occurred almost a year earlier, during filming of the more frivolous *Champagne.*

"There was hot haste and sonorous solemnity everywhere in the place," O'Casey recalled. "Producer, actor, actress, artisan and their allies behaved as if they were gods creating a newer world. Great doors opened onto wide, imposing steps leading down to an imposing room where a crowd of grandees appeared to be enjoying a sumptuous meal. Down these steps came Betty Balfour, escorted by a beau to the sound of drum and trumpet. This was repeated whenever the left foot of Betty Balfour was lifted too soon, or the right one came down too late. Hundreds of pounds were being spent to bring a Betty Balfour nicely down a flight of steps. I had had enough for the day. It was all furious and false."

The "furious and false" *Champagne* held little promise for any meaningful collaboration with Hitchcock on *Juno and the Paycock,* but the director and playwright met on several occasions, and initially seemed to get along. Important playwrights had contract clauses that stipulated a faithful rendering of their text, but O'Casey was prodded to write a brief new lead-in for the film, which took place in a bar following a riot and gunplay. The new scene would help open up what had been a single-set play—and give Hitchcock an opportunity for a bartender cameo.*

Urged by Brunel and Montagu, O'Casey even thought about writing an original script for Hitchcock. He began to formulate a story he tentatively called "The Green Gates," a broad canvas about daily life inside Hyde Park in central London—"the emotion of the living characters to be projected against their own patterns and the patterns of the park," in the words of O'Casey biographer Garry O'Connor. "It was to begin at dawn with the opening of the gates," as O'Casey put it, "and end at midnight as they closed again, to the twelve chimes of Big Ben striking softly in the distance."

It was exactly the sort of slice-of-life drama, digressive and widely revealing of humanity, that Hitchcock always dreamed of filming. So he and

* A publicity photo in the *Picturegoer* showed the director tending bar, though sadly the cameo was dropped from the final film, when Hitchcock had second thoughts about intruding on the famous play.

Alma (who was adapting *Juno and the Paycock*—it would be her first formal script credit on a Hitchcock film) came to dinner at Woronzow Road. The O'Caseys put on the ritz, bringing out their finest dinnerware and tablecloth, "one kept for state occasions," according to O'Casey, "for Sean and Eileen [his wife] had secret visions that this coming talk might bring money worries to an end."*

The playwright's recollection of this summit meeting was poisoned by his disappointment in what followed. "Hitchcock was a hulk of a man, unwieldy in his gait, seeming as if he had to hoist himself into every movement, like an overblown seal, sidling from place to place, as if the hard earth beneath couldn't give him a grip," O'Casey wrote later. "Seated at table, though quiet in his movements, he seemed to be continually expanding, while Mrs. Hitchcock seemed to contract, a stilly mind sitting silent but attentive, registering every gesture and every word. His sober lounge suit, straining at the buttons, seemed to want to let itself go, while her gayer dress seemed to tighten round her body, imprisoning the impressions her mind formed from the experimental talk of the evening.

"Hitchcock liked all the suggestions made by Sean," his account continues, "but Sean noticed that his wife kept a dead silence, merely answering quietly an odd question or two put to her by Eileen. Hitchcock blazed up about the power of the camera—it could take into itself all in heaven, on the earth, and in the sea under the earth; there was nothing beyond its scooping eye. But Sean felt that the camera could do very little. Keep moving was its cry, like a parrot-policeman. It could not pause to take a breath as the stage did."

After an evening of "experimental talk" about the Hyde Park subject, the film director departed "bubbling with excitement," leaving behind "a hearty invitation to come to dinner some day the following week, of which Mrs. Hitchcock would let them know."

But Mrs. Hitchcock never called back, and her husband never followed up on "The Green Gates." O'Casey, who later converted "The Green Gates" into a play, acidly ascribed the Hitchcocks' silence to the veto power of the director's "smiling and silent" wife.

Did Hitchcock, after leaving Woronzow Road, realize he couldn't possibly hope to make "The Green Gates" at such a time of constraint at the studio? Was the bubbling just polite table talk? Or did Alma warn her husband off a man so pigheaded against film?

The cast of *Juno and the Paycock* was a mix of contract players and names familiar from the stage productions. As Juno, Hitchcock cast the original

* In his account of Hitchcock's visit, O'Casey refers to himself in the third person.

Dublin actress, Sara Allgood (she was also a veteran of *Blackmail);* for Joxer, the wastrel in cahoots with Captain Boyle, he also obtained the prototype, ex–Irish Player Sidney Morgan. Perhaps because O'Casey was perpetually at odds with Barry Fitzgerald, the original Paycock, Hitchcock stayed away from the actor, who would later become a quintessential Irishman in many Hollywood films. Instead he gave Fitzgerald a vignette as a street orator, glimpsed in O'Casey's new opening scene.

For his Captain Boyle, Hitchcock tried to get Arthur Sinclair, who had ably portrayed the Paycock in London, but Sinclair was under contract to tour in the play. So he bestowed the lead on Edward Chapman, a Yorkshireman from the stage who would be making his screen debut. John Longden was the law clerk who seduces Mary Boyle (Kathleen O'Regan). A Scotsman, John Laurie, rounded out the cast as the ill-fated Johnny.

Most of the action would take place on the one-room set that was replicated from the stage production, allowing the director to shoot swiftly and inexpensively in November and December 1929. Being faithful to stage plays, and not exceeding his strict budgets, Hitchcock learned to embrace cramped sets—and to be stimulated by them.

In one scene, the Boyle family is talking things out; a recording can be heard in the background, and a funeral procession is wending by outdoors, when the rat-a-tat of machine-gun fire interrupts. Hitchcock had an idea: he wanted to try capturing it all in one fluid camera movement— incorporating all the dialogue and sound effects in a single long take with no cuts. Because of the still-primitive technology, all the speech and music and incidental noises had to be recorded simultaneously, while remaining somehow distinct and intelligible.

The stage at Elstree was packed on the day they shot that scene, the director recalled proudly years later. Hitchcock couldn't find the precise recording he wanted—so, off-camera, a small orchestra played "If You're Irish, Come into the Parlor," while a sound man sang the song with a clothespin attached to his nose for tinny effect. A group of people marched and chanted off to one side of the set, simulating the funeral procession, while an effects man beat on a sofa with two canes to evoke the gunshots. As the actors spoke their lines, the camera slowly dollied in to a close shot of the terror-stricken Johnny. On screen, it worked seamlessly—a bravura stunt for the young director, and a tryout for similar camerawork in the future.

On the strength of stellar acting and such dazzling flourishes, *Juno and the Paycock* was warmly received upon its release in the spring of 1930. James Agate in the *Tatler* declared that the O'Casey adaptation "appears to me to be very nearly a masterpiece. Bravo, Mr. Hitchcock!" Today, however, the reputation of Hitchcock's first "100% talking picture" is uneven: it's intense, rewarding in parts, but talky. The director himself, modestly, later said he was "kind of rather ashamed when it got terrific notices."

As for the embittered O'Casey, he always insisted he never actually saw the Hitchcock film—though that didn't stop him from taking potshots at the director for the rest of his life. Although he didn't reciprocate publicly, Hitchcock's reminiscences of O'Casey were "not untinged with malice," according to John Russell Taylor, and the prickly playwright helped to inspire "the character of the old bum prophesying the imminent end of the world in *The Birds.*"

And yet Hitchcock never lost affection for his version of *Juno and the Paycock.* "Were you bored with it?" Peter Bogdanovich asked him, referring to the obligation to be so faithful to O'Casey's play. "No," Hitchcock replied quickly to the baited question, "because the characters were so interesting."

Nineteen twenty-nine should have gone down as a banner year for the man who had steered the first British talkie to fruition. But instead it was a year of roller-coaster twists and turns.

Hitchcock did his best to stay in favor with the management. He wasn't above directing a ten-minute short in late 1929 called *An Elastic Affair,* which showcased two young aspirants who had just won acting scholarships and a tryout with the studio.

Nor, as Christmas neared, did he mind helping with *Elstree Calling,* a buffet film of variety acts that was being produced by Adrian Brunel. At least the gesture allowed him to satisfy the front-office clamor for a Hitchcock musical while adding a third production credit for 1929—not unimportant at a studio suddenly obsessed with cost efficiency.

Walter Mycroft, the head of the story department, and contract writer Val Valentine had collaborated with Brunel in stitching together the semblance of a story line spotlighting the best-known routines of vaudeville and radio personalities. The cast included radio star Tommy Handley, music hall star Lily Morris, musical comedy stars Cicely Courtneidge and Jack Hulbert, and a sprinkling of legitimate actors familiar to Hitchcock, including John Longden, Jameson Thomas, Donald Calthrop, and Gordon Harker.

Elstree Calling had been low-budgeted for a twelve-day schedule, starting a week before Christmas. At first Hitchcock guided only the unmusical framing segments, with Harker and Hannah Jones playing a couple who are trying in vain to tune in their primitive television set. They are reduced to hearing all about shows, secondhand, from neighbors.

Brunel was reaching for a bright, satirical quality, but when John Maxwell saw the rough assembly in the screening room, he found *Elstree Calling* a crashing bore. Brunel insisted that some of the humor was subtle, that it would all come into focus during the final editing. "Every shot

should be funny by itself," Maxwell declared, ordering retakes. Brunel tried to win over Mycroft. They met in secrecy, with Mycroft muttering paranoiacally that he couldn't appear to side with Brunel, or he would be reported to Maxwell by studio spies. There were many, Hitchcock included, who had begun to think Mycroft was the chief spy.

In the end, Mycroft sided with Maxwell; Brunel was relieved of his responsibilities, and the studio ordered retakes and reediting. Hitchcock was ordered back to work, fixing up the segments of other directors. He was obliged to reshoot Brunel's burlesque of *The Taming of the Shrew,* with Calthrop and Anna May Wong, and the comic sketch about a jealous husband (Jameson Thomas) who breaks into a flat and shoots the wrong lovers (not far from "And There Was No Rainbow," Hitchcock's early short story for Henley's).

Hitchcock claimed he worked on the picture for all of a day, but the retakes must have made it longer. Although he was a fan of radio and music hall, Hitchcock didn't feel it was his film, and it certainly wasn't counted when his final feature, *Family Plot,* was advertised as his fifty-third. When François Truffaut asked about *Elstree Calling,* Hitchcock discouraged any discussion. "Of no interest whatever."

Walter Mycroft also helped the Hitchcocks adapt *Enter Sir John*—the last time he served as any sort of "third Hitchcock." By 1930, Mycroft had ascended to lofty heights: he was not just the head of the story department, but the de facto head of production, answering only to the top boss—John Maxwell. Mycroft's importance was eclipsed only by his self-importance, and he was growingly despised as an arbitrary manager and a despot. He became the object of vicious practical jokes concocted by Hitchcock and others on the lot. "If you break Mycroft's back," Hitchcock cracked nastily, alluding to Mycroft's abnormal curvature, "you'll find chocolate inside, poisoned."

Enter Sir John owed its premise to a novel cowritten by Clemence Dane (the nom de plume of Winifred Ashton) and Helen Simpson. Dane was an actress turned playwright, best known for her 1921 stage hit *A Bill of Divorcement;* Simpson was a versatile writer from Sydney, Australia, convent- and Oxford-educated. Although Simpson's most famous novel, *Boomerang,* was still in the future, she was already regarded as a first-rate novelist of romantic history, psychological crime, and mysteries (sometimes in collaboration with Dane). Hitchcock would work with Simpson later on *Sabotage,* and in 1949 he would film her novel *Under Capricorn.*

Enter Sir John concerned the discovery of a dead woman in the flat of a young actress, who is caught standing over the victim, staring in shock, holding a bloodied poker. Both victim and apparent murderess are mem-

bers of a traveling troupe, yet no one else is suspected of the crime because of the telling circumstances. A jury convicts the woman, who insists she cannot remember exactly what transpired. A date is set for her execution. Puzzled by the case, and feeling guilty because he once rejected the defendant for his repertory ensemble, one of the jurors—Sir John, a Ben Greet–type knight of the theater—turns amateur sleuth, engaging two former troupe members to help him find the real killer.

Adapting a book always allowed Hitchcock more room for his quirks and conceits. Producers inevitably saw and remembered the plays, while they could be counted on never to have read the novels. Hitchcock thus got out of the business of adapting plays in England in the early 1930s, as soon as he could, in favor of transforming novels like *Enter Sir John*— whose most Hitchcockian scenes, not surprisingly, aren't in the book.

The first of Hitchcock's enhancements takes place early in the film, just after the dead body has been discovered and the circumstances of the murder established. The police embark on a prolonged excursion to the backstage of a theater, where they attempt to interrogate other actors in the troupe as they prepare for their entrances. The actors evince split personalities: they show one face while being questioned by police, then break off in midsentence and race onstage in character. As the play is seen and overheard from the wings, and the stage audience roars in delight, the policemen are left scratching their heads.

The film's memorable third act isn't in the book either. In the novel, Sir John's detective efforts lead him to suspect Handel Fane, a onetime member of the ensemble, who has murdered accidentally to hide the fact that he is a "half-caste."

First, Hitchcock tinkered with Fane himself. The book's Fane is a trapeze artist who doubles as a music hall clown. Hitchcock had just finished a film chock-full of music hall, though, so rather than repeating himself he switched to another pet venue—a circus. He found inspiration in Vander Barbette, a Texas-born trapeze artist who toured the world, wearing women's clothing in an act that ended with the revelation that he was a man. Man Ray had photographed Barbette, and Jean Cocteau showcased him in *Blood of a Poet*, putting him in a Chanel gown and having him applaud a card game that ends in a suicide.

In the last act of Hitchcock's film, Fane is tracked down at the circus, one of those arenas the director relished for their resonance with the public. Fane is risking his life nightly, performing in drag in a high-wire act. (In the cost-cutting spirit of B.I.P., the circus is a small, humble one, compared to the lavish fairgrounds of *The Ring*.)

But the film's crescendo is anything but humble. In the book, Fane escapes being apprehended, leaving his ultimate fate up in the air. But in Hitchcock's hand the story takes a more sensational turn. After Fane re-

alizes he's been found out—that he's fated for arrest—he takes his place high above the sawdust for the evening performance. In a long, silent film–style sequence, backed by pulsing circus music, the camera swings along with the trapeze. Multiple images are superimposed for a vertiginous effect. Suddenly Fane stops his routine; then, as though in a trance, he slowly takes a rope and knots it around his neck. The crowd and orchestra are silenced—and then screams erupt as Fane plunges from the heights.

The death of a villain in a Hitchcock film is always confessional, and this was one of Hitchcock's most thrilling—done with an expressiveness worthy of the early German masters.

Filming on *Murder!* (as *Enter Sir John* was retitled) was originally set to begin in January 1930, but it had to be delayed for a few months as B.I.P. prepared to add the film to its newest moneymaking scheme. The only foreign market John Maxwell hadn't given up on was Germany, and now he persuaded Hitchcock to direct a German-language version of *Murder!* concurrent with his English production. The studio was feverishly producing such foreign-language "bilinguals," as they were called, and so Hitchcock squeezed in a whirlwind trip to Berlin to meet with representatives of Sudfilm, B.I.P.'s new German partner. There he consulted on the casting of German leads, and met with Herbert Juttke (a London-born writer active in Berlin as a mainstream and expressionist scenarist) and Georg C. Klaren, Juttke's frequent writing partner.

Juttke and Klaren made an attempt to "Germanize" the script. "They proposed many changes that I turned down," Hitchcock said later. "As it happened, I was wrong."

The British cast was already chosen. Herbert Marshall, who had established himself as a suave lead of both English and American stage hits, was set to make his screen debut in a talkie as Sir John, while the director chose Norah Baring, heretofore best-known as the star of Anthony Asquith's *Cottage on Dartmoor* (1928), for Diana, the framed murderess. Edward Chapman from *Juno and the Paycock*, and Phyllis Konstam, who'd been deleted from the sound version of *Blackmail*, were cast as the Markhams, the colorful couple who assist Sir John's investigation. Miles Mander and Donald Calthrop also returned to work for Hitchcock as shady characters.

Every director of the era prided himself on launching stars. Hitchcock extended his pride to what he liked to call the "incidental cast," finding unusual secondary players—often stage actors—for eccentric or villainous parts. After all, the leads "are simple and immediately apparent characters with whom the audience quickly identifies itself," he reasoned in one interview. "The incidental cast, the character actors, are the complicated

personalities. I choose unfamiliar performers for these subsidiary roles so as to mystify the audience as well as the hero and heroine."

The prime example in *Murder!* was Esmé Percy, who had studied in Brussels at the Conservatoire and in Paris under Sarah Bernhardt, and who was closely associated with George Bernard Shaw's plays. For this, his screen debut, Percy would bring piquancy as well as a sympathetic quality to Handel Fane, the cross-dresser shamed by his half-caste heritage— Hitchcock's first sketch of a character later realized as Norman Bates in *Psycho.*

The film had a split personality when it finally went before the cameras in March. The German cast of *Sir John greift ein!* (the tentative German title) had to wait on the sidelines, ready to leap in and hit their marks after the English actors had executed scenes for *Murder!* The German Sir John was Alfred Abel, notably a leading player of Fritz Lang's *Metropolis;* Olga Tschechowa, a Moscow Arts Theater veteran who had been striking in F. W. Murnau's *Schloss Vogelod,* was Norah Baring's counterpart. Wherever possible, English actors who spoke passable German were employed for small parts. Alone among the English principals, only Miles Mander appeared in both versions, as the murder victim's husband.

One of the German-speaking Englishmen recruited for *Sir John greift ein!* was Charles Landstone, a London theater administrator and playwright, who'd been spotted in a minor role in a German-language play at the Arts Theater Club. The studio casting department rang his agent, asking if he would consider moonlighting in a bilingual. Feeling uncertain— he wasn't a full-time actor—Landstone headed over to Elstree, where, after rattling off a few German phrases, he was engaged as one of the jury. Landstone's memoir offers a window onto the filming, and a portrait of the young Hitchcock ruling the set.

The jury scene was "full of serious discussion," wrote Landstone, "and each man had to give his views—Norah Baring was being tried on a murder charge—and Hitchcock had the idea of planting each juryman with a solo shot that displayed his personality. The Englishman in my part was Kenneth Kove, quite a well-known feature actor of the day and a member of the famous Aldwych farce team. I watched him carefully as he went on the set, and thought that if I could copy him I might get through. When it came to my turn I did all the things that he had done, and I was through without being sacked as some of the others had been. I saw Hitchcock give me a knowing grin; he hadn't been fooled, but he didn't care. For the twelve days that the shooting of the jury scene lasted I followed the same procedure, carefully aping everything that Kove did. Nobody seemed to notice, not even Kove."

Hitchcock's behavior on the set sometimes seemed daft to Landstone.

The director "fooled about" ceaselessly between shots, he remembered, and took every opportunity to exploit the bilingual situation for laughs. "He had a clapper-boy named Harold, and he cast him in the role of the King's Jester. His cry would be 'Haro-old!', and when Harold dutifully came to heel he would be sent off on one fool's errand after the other. He made 'Haro-old' learn off by heart a sentence in German which he told him to go and repeat to the young actress who was Norah Baring's counterpart. I forget what it was exactly, but it was the sort of remark that one might expect in the most permissive of today's scripts. In 1930 it was outrageous. 'Haro-old' dutifully repeated it; the girl was startled out of her life and 'Haro-old' stammered: ' 'E told me to say it.' The actress, catching sight of Hitchcock roaring his head off, wagged her finger at him in admonition."

Yet there was a method to Hitchcock's madness, Landstone realized. The director transparently disliked Alfred Abel, a stuffy man who didn't share his sense of humor. Abel refused, for example, to wear the same tweeds-and-raincoat costume as the English star, Herbert Marshall, because it didn't suit his idea of formality. And he refused to follow Hitchcock's directions for the scene where a landlady's children climb over Sir John, who is trying to relax in bed while sipping his morning cup of tea. It is a memorable interlude in *Murder!* (experimenting with overlapping sound, Hitchcock has a baby bawling throughout), but it had to be restaged for Abel and *Sir John greift ein!* "Things that were funny to the Anglo-Saxon mind were not at all funny to Germans," Hitchcock said later.

Abel finally stepped into the crosshairs when he objected to Marshall's special lounge chair. No such privilege had been accorded the German lead. "Hitchcock didn't trouble to explain," wrote Landstone, "that Marshall was a 1914–18 war casualty and had a wooden leg, but simply said that provision would be made for the German to rest between the shots. He gave his orders to Haro-old, and after lunch a magnificent-looking armchair, far more luxurious than Marshall's, appeared at the side of the set. On it was Abel's name, and the latter thanked Hitchcock profusely. Noticing, however, the director's puckish grin, the German went over to the chair and touched it gingerly with his finger, whereupon the whole contraption collapsed to the ground. Hitchcock's roar of laughter filled the studio."

The double filming dragged on well into May; then the double editing took the bulk of the summer. Hitchcock admitted later that he overreached on this project. "Although I spoke German, I didn't know cadences of speech," he explained, "and I was lost on the set. The actors sounded colloquial to me, but I really couldn't understand what they were saying."

Not only was he experimenting with bilingual filmmaking, he had en-

couraged a rare degree of improvisation from the actors. "I would explain the meaning of the scene to the actors and suggest that they make up their own dialogue," he recalled. "The result wasn't good; there was too much faltering."

In the end the film suffered a mixed fate. The colloquial title *Sir John greift ein!* did not translate well in Germany, and even the name of the accused murderess had to be changed there from Diana to Mary—which became the German title. The secret of Fane's motive was also too English, so in the bilingual, Fane murders not because of his "half-caste" blood, but to conceal the fact that he's a prisoner on the run. The tampering was so drastic that the bilingual was barely recognizable as a Hitchcock film, and *Mary* achieved only a limited release in Germany.

Murder! did better when it was shown in London in the fall of 1930 (though it was "too sophisticated for the provinces," Hitchcock told Truffaut). The new Hitchcock film was hailed by the London critics as a sharp and entertaining advance in talkies. The director's camera, rooted to one spot for most of *Blackmail,* had been freed up, and it was now darting and whirling like a dervish. The aural experimentation, too, was incessant: actors overlapped their lines; there were interior monologues and constant background noise; music blared throughout.

These days *Murder!* has an unfairly slight reputation as just "another photographed stage play."* It is dated and stagy in parts, and at times Hitchcock's experimentation sticks out—as when the awed Markhams take a surrealistically spongy walk on Sir John's carpet. But it is also a film of style and intelligence, marked by two ideas central to the Hitchcock oeuvre. The first is that the machinery of justice cannot always be trusted. Like Sir John, his alter ego—the last holdout on the jury—Hitchcock himself couldn't countenance the idea that such a beautiful woman could be guilty of murder.

The second conceit is underlined by the coda the director added to the Clemence Dane–Helen Simpson story. Hitchcock's glorious climaxes would often be followed by just such "a tranquil coda to an exciting evening," as Doris Day's song is termed at the end of the second *The Man Who Knew Too Much.* Sir John and Diana are huddled in soothing conversation. The camera pulls back to reveal a proscenium arch, and an audience watching the last act of a play. As the actors utter their final lines, the performance—and the film—conclude together.

Another Chinese box, another paean to show business, another commentary on voyeurism—a suite of treasured Hitchcock ideas. He said it over and over again in his career, in interviews and in films: The world of

* *Murder!* is often cited as based on a stage play—but, as Charles Barr points out in *English Hitchcock,* if it was in fact written for the theater, it was never produced on stage.

pretend was separate from the real world. Theater and film offered an escape from reality—and sometimes, in the best plays and pictures, an insightful critique of that reality.

After a brief August vacation Hitchcock went back to work, this time to prepare a film of John Galsworthy's *The Skin Game.* The studio preferred plays to Hitchcock originals, but Hitchcock genuinely admired Galsworthy, whose novels he read and plays he never missed. He often said that Galsworthy ranked with Buchan as an influence on him. *Escape,* Galsworthy's 1926 drama about an escaped convict who protests his innocence, was a virtual template for Hitchcock's wrong-man films, and he had seen the original production of *The Skin Game* in 1920, then again in revival. He also saw *Hard tegen hard,* a silent Anglo-Dutch version made in Holland in 1920.

Like Sean O'Casey, Galsworthy was interested in film primarily for the added revenue—and like O'Casey, he didn't think much of the "faking power" of the medium. Even at his most accommodating, Galsworthy preferred silent film, sniffing at talkies as "silent film spoiled."

The director and playwright endeavored to forge common ground, meeting in September 1930 at Grove Lodge at Hampstead, and later at the playwright's baronial manor in Sussex in Bury House. Acting as their intermediary was Leon M. Lion, one of the last of the actor-managers who lived and breathed the theater. Galsworthy liked and respected Lion, who had acted in or produced several of his plays; Hitchcock considered him a nuisance.

One memorable visit to Bury House occasioned "the most cultured dinner table I ever attended," Hitchcock would recall. The dinner was presided over by Galsworthy in the role of chivalrous feudal lord, mandating every new subject of conversation. "Let us discuss words," the dramatist announced on this occasion. "Words in relation to their meaning and in relation to their sounds."

"One guest suggested the word 'fragile' as descriptive," Hitchcock remembered. "Another advanced the opinion that the French 'fragile' was even more delicate in its sound. A third stressed the claims of 'crepuscular' as being 'filled with the nuance of the twilight.' I sat amazed at the feeling the guests had for the sound-sense of the words."

Galsworthy, like O'Casey, had a B.I.P. agreement that outlawed, in his words, "dialogue except what is written and passed by me, and no tampering with the play's integrity." Hitchcock would be hemmed in on *The Skin Game* more than on *Juno and the Paycock.* Though he worked to open it up visually, he'd adhere very closely to the play—shooting most of the scenes with multiple cameras for a fluid sound track (they still "couldn't cut sound in those days").

Galsworthy felt strongly about casting, and he presented Hitchcock with a list of preferred actors, though his contract gave him no say in this matter. Yet in the end, the leads must have pleased the playwright. Edmund Gwenn had been the original Mr. Hornblower, the nouveau riche industrialist whose hard-driving tactics ignite a feud over a parcel of land between two families, one aristocratic and the other parvenu. Gwenn also played Hornblower in the silent film; now he would reprise his famous role for Hitchcock. And Helen Haye, another original cast member who had returned for the Anglo-Dutch silent, was back as the snobby Mrs. Hillcrist.

The rest of the ensemble was a mix of Hitchcock semiregulars and actors under studio contract. John Longden would play Hornblower's son Charles, with Phyllis Konstam as his wife, Chloe, whose tawdry past is exploited as a bargaining chip by the upper-crust Hillcrists. Edward Chapman was cast as Dawker, the family adviser of the Hillcrists. C. V. France was Mr. Hillcrist, while Jill Esmond (then wife of Laurence Olivier) played Jill, the sympathetic Hillcrist daughter. Frank Lawton was Rolf Hornblower, whose crush on Jill is overshadowed by the rivalry between the two families.

The filming took place in November and December 1930, largely on B.I.P. soundstages, and the dialogue-heavy script was more an actor's showcase than a director's. Still, Hitchcock was better with actors than he's been given credit for. He later admitted that it took him awhile to develop a conscious philosophy about actors, which he explained for a 1940s publicity article called "Actors Aren't Really Cattle."*

Where once he might have been snooty about actors, he wrote, "more and more, I have come to value responsiveness from an actor, hunt for it, cast with it in mind, nurture it.

"Silliest of all Hollywood arguments," Hitchcock wrote, "is between the school that claims to believe the actor is completely a puppet, putting into a role only the director's 'genius' (I am, God forgive me, charged with belonging to that school) and the equally asinine school of 'natural acting' in which the player is supposed to wander through the scenes at will, a self-propelling, floating, freewheeling, embodied inspiration."

He insisted that all the weeks he spent "thinking and sketching, preparing" a film were in part an attempt to "create an effective cinematic framework, and to mask within that framework every contrived aid—design, lighting, timing, camera angles, costume, even hairdo—that will aid the performer to whom he's given a hellishly difficult assignment."

* Although this was a ghosted article, it was "retyped from dictation" and has the ring of Hitchcock's own speech.

He admitted certain "garlic hates" among the profession:

"Actresses who, at shooting time, think of clothes, hairdos, camera angles. Experts are thinking of those for her.

"Actors, either sex, who apparently listen courteously and attentively to direction, and then do the scene their way.

"Actresses who let their emotions run away with them in front of the camera until their voices grow shrill, their work caricaturish.

"All 'temperament' not before the camera.

"Actors, either sex, who exercise their right to stop at six o-clock, regardless of whether a mood scene, after all day fumbling, is finally going right."

He listed an arsenal of options and strategies for dealing with actors. Any great director would cite "perfect casting" as the best line of defense, he confessed. Shouting "you old bitch" at actresses—"especially pretty young ones"—had its time and place. (This, Hitchcock admitted, was of less value once the actresses found out the insults came from a "genial fraud.") When nothing worked, why, of course, one simply hated the actor.

But Hitchcock loved Edmund Gwenn, and cast him again and again in his films. Later known as a specialist in elderly eccentrics, Gwenn, in *The Skin Game,* gives a ferocious, arresting performance as the socially wronged man. And the ensemble supporting him is equally superb.

The Skin Game surprises on several levels; today it seems more multi-faceted and gripping, more coherent, and ultimately a more personal Hitchcock film than *Juno and the Paycock.* Hitchcock may have felt more comfortable addressing English class hypocrisies than Sean O'Casey's Irish troubles. By the end of the film, when the despondent Chloe kills herself and Hillcrist shames his wife with the words "When we began this fight, we had clean hands—are they clean now? What's gentility worth, if it can't stand fire?"—Galsworthy's famous curtain closer has become the director's own cri de coeur.

Even in the confines of rigid adaptation, the director found opportunities for visual excitement. The country auction, where surrogates for both parties bid on the desired land parcel, is there in the original play; but the sequence in the film opens with a Hitchcockian joke: having the property praised in mumbling tones by an auctioneer so Milquetoast that nobody can quite decipher his words. Then, when the bidding begins, the camera work echoes the frantic bidding by darting, panning, and cutting among the crowd. The result isn't perfect, but Hitchcock had a penchant for auction scenes, and would refine the ideas in *The 39 Steps, Saboteur,* and *North by Northwest.*

Even before finishing *The Skin Game* in January 1931, though, the di-

rector was yearning to get away from the straitjacket of plays. He wanted his next film to be more ambitious, a Hitchcock original; he wanted to get out of the studio and take his camera to far locations.

In the first instance, getting out of the studio meant spending more time at home, where he could avoid Walter Mycroft and John Maxwell. He still put in regular studio hours, but stole time at home—where work could be freely interrupted by naps, parties, and outings. Home is where the Hitchcock originals were nourished, and his next film, *Rich and Strange,* would be his first wholly original project since *Champagne.*

Also spending a lot of time at Cromwell Road in late 1930 and early 1931 was the Australian-born novelist and travel writer Dale Collins. Slowly, this new edition of the three Hitchcocks fashioned what was intended as a picaresque tale of romance and mishap on the high seas.

Rich and Strange was officially "based on a theme" by Collins, whose books about long sea voyages invariably entailed complacent travelers encountering apocalyptic storms, shipwrecks, or pirates. Collins's popular novel *Ordeal* had been dramatized for stage and screen, and *The Haven* also had been filmed. Collins dabbled in film writing between voyages and books, and while living in London he had become friends with the Hitchcocks (he was an especially good-natured victim of the director's practical jokes).

As an avid voyager himself—imaginary and otherwise—Hitchcock was enthusiastic about Collins's story, involving young married Londoners who inherit a pile of money and follow their wanderlust to distant ports of call, experiencing dramatic reversals of fortune along the way. *Rich and Strange* was likely developed first as a lengthy treatment by Collins before he turned it into a 1930 novel, whose publication coincided with the film's release. After the treatment, the humorist, songwriter, and handyman writer Val Valentine took Collins's place, working with the Hitchcocks to put the story into script form.

Collins probably accompanied the Hitchcocks on the winter cruise they took in early 1931 to unwind after *The Skin Game.* The director liked his writers to augment the family and come along on working vacations, the better for brainstorming. With four-year-old Pat, the Hitchcocks sailed down the coast of West Africa, then across the Atlantic to the nearest islands of the West Indies. Then it was back to England, stopping off in Bathurst, Gambia, where their local guide, a priest, gave them a tour of a mission church in the jungle. Hitchcock told John Russell Taylor that the journey helped give him "a vivid sense of how rapidly cruise members, decent people all, get to hate one another after being cooped up a while on board ship" (a striking conceit, though it doesn't really figure in the film).

The Hitchcocks made a separate excursion to Paris, where they enjoyed

sneaking away on the slightest pretext. The director was planning to feature Parisian nightspots in the new film, and he was eager to refresh his researches. While attending the Folies Bergere, he inquired where he and Alma might go to observe some authentic belly dancing. He had the idea of showing "the heroine looking at a navel that goes round and round and finally dissolves to a spirallike spinning motion," he told François Truffaut. ("Like the main title of *Vertigo?*" asked Truffaut. "Yes, that's it," Hitchcock replied.)

The couple were borne by taxi to a strange place on a dark street. It wasn't until they were inside the building, according to Hitchcock, that they realized they had arrived at a brothel.

"We were sort of put in the position of the couple in the film," Hitchcock told the BBC years later. "We were two innocents abroad." After treating everyone to a round of champagne, they were escorted into a room and shown "a demonstration of two girls copulating." Afterward, the Hitchcocks bolted. *Rich and Strange* incorporates a tamer version of this anecdote, with the young married couple starting off their trip aghast at Parisian decadence.

Fortified by such personal adventures, Hitchcock made good progress on the script. But it wasn't good enough to satisfy the studio, so in the spring Hitchcock armed a skeleton-crew second unit with instructions and dispatched them, along with a few bit players and stand-ins, to capture local color on a voyage from Marseilles to the Red Sea, and then onward to the Indian Ocean.

The second-unit work was largely intended to reassure B.I.P.; come April the director still wasn't ready to launch principal photography, still wasn't satisfied with the script, which was being touted as a departure from everything he had done before.

Maxwell and Mycroft were convinced that Hitchcock was just procrastinating. The talkie revolution had nearly crippled the studio, and Hitchcock boasted the largest director's salary on the lot. Even as the trade papers were reporting that the script was "almost finished," Mycroft was reviewing the latest draft, demanding trims and deletions. Hitchcock made concessions, and even before the cameras rolled *Rich and Strange* was under attack.

By May, the casting was finalized. Joan Barry, Anny Ondra's "voice double" for *Blackmail,* was rewarded with the role of the young wife. She had just made a splash in Harry Lachman's *The Outsider,* which was co-scripted by none other than Mrs. Hitchcock. Henry Kendall, a West End leading man considered lightweight but charming, was picked to play her husband. The veteran Percy Marmont, often cast as a typical English gentleman, earned the first of his three Hitchcock roles as the passenger who woos Barry during the sea voyage, while Betty Amann was set to portray

the faux princess who flirts with Kendall. Music hall entertainer Elsie Randolph rounded out the main cast as the ship's busybody.

By June, Hitchcock had chalked up six months of scriptwork and planning.

Although Hitchcock had already mounted his share of chases and adventures in previous films, *Rich and Strange* was the first true antecedent of *The 39 Steps* and *North by Northwest.*

Its title came from *The Tempest:* "Nothing of him that doth fade / But doth suffer a sea-change / Into something rich and strange." The story concerns Emily and Fred, a humdrum suburban couple, who splurge their inheritance on a world tour. First they head to Paris, after which they board a luxury ship in Marseilles. Fred promptly becomes seasick. Emily embarks on a platonic affair with a Commander Gordon, while Fred, once recovered from his illness, is smitten with a princess.

Their ship travels from the Mediterranean to Port Said, from the Suez Canal to Colombo, the chief port of Ceylon. Under the strain of their flirtations Fred and Emily's marriage begins to fall apart, but in Singapore the two come to their senses. Emily abandons Commander Gordon and returns to Fred, who has learned that his crush is not a princess, but a shop owner's daughter from Berlin, who absconds with all their cash.

Now without funds, the couple must hitch a ride home on a steamer. The vessel crashes, or explodes, one night (in the first disaster at sea in a Hitchcock film). Trapped inside their cabin, they cling to each other in terror as the vessel sinks. They fall asleep entwined, but awaken in the morning still alive, and afloat on their upended boat. They are rescued by Chinese pirates, who expose them to a brutal life before finally dropping them off at a port, from which they wend their way back home to London. There, with a sigh of relief, they resume their steak-and-kidney-pie lives.

From the beginning Hitchcock had hoped to sail with cast and crew to film in nearby ports, or at least steal a few highlights in Paris. He hadn't filmed outside England since *Champagne,* and he was tired of painted scenery and Schüfftan-style composites. But the director had miscalculated his leverage; Walter Mycroft refused to approve travel expenditures, and throughout preproduction he chipped away at the scope of Hitchcock's plans.

In the end the budget spared only one day on location—at Clacton-on-Sea, a cut-rate resort in Essex for Londoners on holiday. "This involved a bathing scene which was supposed to take place at Suez," recalled leading man Henry Kendall. The bathing scene in question was shot on a "bitterly cold" morning, the actor remembered, "when I was shivering in my bathing trunks and almost blue with cold, and the result was so obviously not a bit like a gay dip in the Red Sea that it was cut from the film."

Kendall suffered a mysterious illness in the summer of 1931 that exac-

erbated the filming. The illness was serious enough to be reported in the press—a case of "blood poisoning" that resulted in several operations and a prolonged recovery in a convalescent center. (In his autobiography Kendall says it was "carbuncles.") For almost two months, Hitchcock photographed everything he could think of that didn't involve the presence of the leading man. By the time Kendall returned, Barry and Marmont had been called away on prior engagements, and Hitchcock was forced to shoot Kendall solo for the last takes. The production finally petered out at the end of August.

It had taken the director fully nine months to concoct and shoot this Hitchcock original, time that B.I.P. would have preferred he invest in adapting an established play. Postproduction also dragged on while Hitchcock tried to figure out how to fill out the film with as much second-unit footage as possible.

Rich and Strange was finally released in December 1931, to a critical response that could be summed up in one word: "interesting." Hitchcock—often his own harshest critic—later said he wasn't sure it was even all that interesting.

It was an only intermittently engaging film that never quite transcended its flaws. The stars, Hitchcock later complained, had negligible chemistry. Joan Barry was vivacious, but Kendall came off as flat; later, the director (uncharitably) blamed Kendall for being a "fairly obvious homosexual," in John Russell Taylor's words, who lacked any sexual charge with women.

Some of the most intriguing scenes were cut. Hitchcock told François Truffaut about a sequence he shot in a tank, in which Henry Kendall is swimming with Joan Barry, and she stands with her legs astride, daring him to swim between her legs. He dives, "and when he is about to pass between her legs, she suddenly locks his head between her legs and you see the bubble rising from his mouth. Finally she releases him, and as he comes up, gasping for air, he sputters out, 'You almost killed me that time,' and she answers, 'Wouldn't that have been a beautiful death?' "

Deleted—for reasons of length or censorship. And Hitchcock told Peter Bogdanovich about "an amusing sequence" at the end of the film. "Their cargo ship is wrecked and abandoned in the South China Sea, and they are rescued by some looters on a Chinese junk. Then, after it's all over, they meet me in the lounge. This is my most devastating appearance in a picture. They tell their story and I say, 'No, I don't think it'll make a movie.' And it didn't."

This "amusing sequence," Hitchcock's flash appearance, had its origins in Dale Collins's novel, where the "little fat man" the couple meet at the end of the story is actually the author. The cameo became another eleventh-hour deletion; falling prey to the mysterious jinx that surrounded *Rich and Strange,* the director left his own face on the cutting-room floor.

Contemporary critics have sparked a movement to reevaluate the film. Donald Spoto labeled *Rich and Strange* a fascinating "encoded autobiogra-

phy," while British film historian Roy Armes has hailed it as a "major work" that underlines "the complexity of Hitchcock's vision of his fellow men."

But Hitchcock encoded everything with elements of autobiography, and compared to later, classic films that learned from its lessons, *Rich and Strange* looks pinched and lackluster.

Walter Mycroft had to be obeyed, deceived, or defied—or maybe, as only Hitchcock could, all three combined. By 1931, Mycroft was widely detested as a tinpot dictator, according to contract writer Val Guest.

One day the head of production decreed a repainting of the Elstree lavatories. Afterward, these words were found scratched onto the newly painted wall of the men's room: MYCROFT IS A SHIT. People always suspected the culprit was Hitchcock, but years later he swore to Guest that it wasn't him or any of his confederates. ("Not that we didn't agree with the message," Hitchcock added.)

As *Rich and Strange* was being edited, Mycroft ordered Hitchcock to start work on a new project. He and Rodney Ackland, a young playwright, were assigned to adapt John Van Druten's *London Wall,* a white-collar love story that had been a West End success. When Hitchcock showed apparent interest in the change-of-pace material, Mycroft decided to take his insubordinate employee down a further notch. He shuffled *London Wall* off to another B.I.P. director, Thomas Bentley (who filmed the Van Druten play as *After Office Hours*), and reassigned Hitchcock to *Number Seventeen.*

"There is also the possibility," noted Frank Launder, a B.I.P. contract writer (and later the cowriter of *The Lady Vanishes*), "that Hitch preferred *Number Seventeen* and merely said he wanted to make *After Office Hours* in order to fool Mycroft into giving him *Number Seventeen.*"

The J. Jefferson Farjeon play was more in the Hitchcock vein, at least on the surface. A comic thriller set in an abandoned house with "No. 17" stamped over the front door, the play, though generally drubbed by critics, had proved to be one of the miracle hits of the 1925 season. *Number Seventeen* had spurred several revivals, a series of related novels, and, like *The Skin Game,* a European silent-film version, directed by Geza Von Bolvary in Germany in 1928.

The thin plot followed a series of mysterious figures who enter No. 17 at cross-purposes. One of the leads is a Cockney named Ben, a shamelessly hammy character played onstage and even in the German silent by Leon M. Lion, whom Hitchcock had suffered as his intermediary with John Galsworthy. If the play wasn't a bitter pill to Hitchcock, the detested Lion was. As producer and star of the original stage production, though, Lion was so identified with the play and role that he came umbilically attached

to the project. Hitchcock thought Lion an "awful old man." He claimed in later interviews that he had no special affection for the play, either.

But then again, maybe that was the appeal for Hitchcock—subverting Leon M. Lion and Walter Mycroft. Now he launched a scheme for "teasing the bosses," according to writer Rodney Ackland, who also switched over to *Number Seventeen*. Hitchcock, Ackland recalled, deliberately set out to turn the popular Farjeon play into "a burlesque of all the thrillers of which it was a pretty good sample—and do it so subtly that nobody at Elstree would realize the subject was being guyed."

All the coincidences and contrivances of the original, Hitchcock saw, could be wildly exaggerated. A dim-witted heroine would become literally dumb: a mute. And "as the climax of a thriller was invariably a chase (generally between a car and a train, at this period)," recalled Ackland, "*Number Seventeen*'s climax must be a chase-to-end-all-chases—its details so preposterous that excitement would give way to gales of laughter."

The "hilarious" script conferences retreated to Cromwell Road, "the atmosphere of which was considerably more stimulating than that of the studio," Ackland remembered. Evening sessions usually began with a round of the Hitchcocks' favorite cocktail, which seemed to change from film to film. For *Number Seventeen* it was the delicious white lady, a concoction of gin, egg whites, light cream, and superfine sugar. Day or night, white lady–inspired ideas for how to tweak the clichés arose "moment to moment," Ackland recalled.

Considering the dismal bind he was in at Elstree, it's no wonder that Hitchcock began to proclaim that all of the really hard work and most of the genuine fun of making pictures was in the writing—which, for him, optimally took place at home, with companionable writers and his beloved wife. No wonder Hitchcock began to adopt the attitude, exaggerated in his many interviews, that once the script was done, the directing was a chore, even a bore.

The three Hitchcocks stretched out the hilarity for several months, before their new script had to be handed in for filming in the winter of 1931–32. Besides Lion—the only actor carried over from the original cast—the ensemble included Anne Grey (The Girl), and Hitchcock veterans John Stuart (The Detective) and Donald Calthrop (playing yet another shady character).

Hitchcock gave Lion his mugging close-ups, but no real chance to shine; likewise he immersed the play in a froth of exaggerated special effects and hyperkinetic camera work. The play's well-known opening—the introduction to the characters and the mysterious house—Hitchcock turned into a Grand Guignol satire, with silly, creepy music, lurid shadows, and the camera lunging around and racing up stairwells to freeze on terrified expressions.

The ending of the film was the biggest change from the stage. The three Hitchcocks devised a wild sequence with a runaway train chased by detectives in a hijacked bus, ending with the train smashing into a waiting cross-Channel ferry. Hitchcock was an acknowledged master of miniatures, and he sold the idea to Mycroft on the theory that he could stage it all cheaply with models and figurines. But some people think he deliberately staged the wild crescendo so it simply looked cheap.

The director was fed up with the studio, and determined to burn his bridges. Bryan Langley, Jack Cox's co-cameraman, recalled that the budget was badly strained, and the director walked around griping that he was making good films "in spite of the management." With *Number Seventeen*, he simply tore up the play and tossed it into the air like confetti. Hitchcock was right in admitting, years later, that the result was "little better than a quota quickie." Although a minority of modern-day critics find it an exhilarating parody ("a sophisticated deconstruction of the mechanics of the thriller," wrote Charles Barr), most rank Hitchcock's last film for B.I.P. as among the least—a sour shrug of the shoulders from the director, and one huge practical joke on management.

Rich and Strange was still new to theaters and *Number Seventeen* was as yet unreleased in March 1932, when, to the surprise of many, B.I.P. announced that Hitchcock would supervise a "number of pictures" for the studio in 1933. "It is intended," according to B.I.P. publicity, "that these pictures will be made by new young directors, who will thus be enabled to develop their talent under the guidance and control of our most skilled craftsmen."

Superficially a promotion, the supervisory post was in reality a last-ditch effort by management to bring Hitchcock to heel, and extract a few extra films carrying his magical name. For Hitchcock, it offered one final opportunity to prove himself a company man.

Hitchcock tapped Benn Levy, the writer of the sound version of *Blackmail*, to direct the first project, based on an H. A. Vachell play, a crime drama called *Lord Camber's Ladies*. The film would have the distinction of starring the actor-manager Gerald du Maurier ("in my opinion, the best actor anywhere," Hitchcock told Truffaut), along with Gertrude Lawrence as his mysteriously poisoned wife. Hitchcock was expected to guide and assist Levy's directing debut.

Hitchcock and du Maurier were longtime friends and rival practical jokers; the director had once, famously, stuffed a dray horse into du Maurier's dressing room at the St. James Theatre. But *Lord Camber's Ladies* was a mutual low point in their careers, and they outdid themselves with fool pranks. "It was a wonder that the picture was ever completed at all," wrote the novelist Daphne du Maurier, the actor's daughter, "for hardly a

moment would pass without some faked telegram arriving, some bogus message being delivered, some supposed telephone bell ringing, until the practical jokers were haggard and worn with their tremendous efforts."

Levy felt upstaged by the practical jokers, and reacted obstinately to Hitchcock's suggestions. The two men bickered throughout the filming in the summer of 1932, and afterward didn't speak to each other again for years. "So my handsome gesture in offering him the direction," Hitchcock told Truffaut, "blew up in my face."

Hitchcock briefly nurtured two other projects for the studio. One was an ambitious, yearlong street-life film offered to John Van Druten, but when Van Druten mysteriously pulled out of the directing, and *Lord Camber's Ladies* fizzled, Hitchcock was finished at British International Pictures. Walter Mycrof terminated his contract, and suddenly England's most acclaimed, most famous film director found himself unemployed.

In the summer of 1932, earlier than has been reported, Hitchcock was already dreaming of America.

Actress Alice Joyce, who had appeared in *The Passionate Adventure*, had a brother named Frank Joyce, a Kansas City ex-vaudevillian who had made a killing in hostelries in New York and Florida before moving to Hollywood to manage his sister's financial affairs. The other Hollywood actress in that 1924 film, Marjorie Daw, got divorced and married Myron Selznick shortly after filming. Frank Joyce and Myron Selznick then formed the Joyce-Selznick Agency, one of the first talent agencies to focus on motion picture clientele.

After luring Ruth Chatterton, William Powell, and Kay Francis away from Paramount in the early 1930s, and then auctioning them to Warner Bros., the Joyce-Selznick Agency rocketed to prominence; before long they represented Hollywood's most glamorous and well-paid personalities. Myron Selznick flitted in and out of London, where the agency kept a branch office, run by Harry Ham, a native Canadian who had once been an actor in Islington films. Aided by Ham, Selznick courted Hitchcock, and the English director, despondent after the low point of producing *Lord Camber's Ladies*, started to listen.

Hitchcock didn't actually have an agent, a publicist, or any staff between productions, other than his wife and a continuing assistant who also served as his secretary. He had a business manager, J. G. Saunders, who advised him on his contracts, investments, and business dealings. British deals were relatively straightforward compared to Hollywood contracts, and Hitchcock wasn't immediately convinced that he needed representation by Joyce-Selznick. But he allowed the agency to float his name with U.S. producers.

The independent producer Sam Goldwyn, and Carl Laemmle Jr., the

head of Universal, were the first to declare interest. Some studios, Hitch-cock liked to say, were Cartiers, while others were more like Woolworths. He was "much more keen to go with" Goldwyn—a first-class producer who already had a reputation for combining entertainment with artistic values—than a Woolworth-type studio that "went in for what I call creak-ing door pictures and monster movies." But Laemmle was the more ag-gressive party, and Joyce-Selznick encouraged his offer. Laemmle was proud of importing foreign directors to America, and he had a special in-terest in Germany, where the Laemmle family had its roots. Hitchcock's experience in Anglo-German production counted with Laemmle.

When Myron Selznick cabled that Laemmle wished to discuss specific terms, Hitchcock replied that the lowest salary he could feel comfortable with was $1,750 a week for a guaranteed eight weeks on one picture, plus round-trip transportation. What he really wanted was $2,500 a week for twenty weeks and two pictures. A two-picture commitment, Hitchcock felt, would allow him to establish a solid footing in America. The first could be a studio project, while the second might be parlayed into a Hitch-cock original.

But this was still wishful thinking in 1932. Hitchcock's timing was un-fortunate. Hollywood, which had passed through the early years of the Depression virtually unscathed, was now headed into a terrible slump. The salary Hitchcock was asking would have put him among the industry's top-paid directors, and the Englishman's films did not yet have the box-office track record in America to justify the financial risk to Universal.

The head of Universal thought it over and wrote the Joyce-Selznick Agency that his plans had changed since first discussing Hitchcock, but he would "certainly keep him in mind for the future." Prophetic words: the first Hollywood studio to woo Hitchcock would be where he ended up, thirty years later, during the last phase of his career.

From bad to worse: Hitchcock tried teaming up with the enterprising Hungarian-born Alexander Korda—not yet "Sir" Alexander—who could be found in 1931 at Gaumont. Hitchcock signed a contract with the inde-pendent producer, who was trying to whip together an English version of a German picture with the working title "Wings over the Jungle." They spent nearly a year making plans—even posing for publicity photo-graphs—without succeeding. "It was not my fault," Hitchcock recalled. "Nor could Korda exactly be blamed. It was just one of those things." The project later evolved into *Sanders of the River* (1935), which Hitchcock had nothing to do with, except "some of the preparatory work."

Hitchcock was then approached by Tom Arnold, a well-known stage impresario who was making his first foray into motion pictures. Arnold hired

Hitchcock to direct *Waltzes from Vienna,* based on a sugary play about the romantic lives of composers Johann Strauss and his son Johann Jr.

It was a delightful play—and Hitchcock had been idle for too long. Others might have seen it as a desperate move, but not him. "Nothing to do with conceit," he told François Truffaut. "It was merely an inner conviction that I was a filmmaker. I don't ever remember saying to myself, 'You're finished; your career is at its lowest ebb.' And yet outwardly, to other people I was."

Waltzes from Vienna was going to be shot at Islington, where Arnold was renting studio space from Gainsborough. For any number of reasons, it was an awkward homecoming.

For one, Hitchcock did not get along with the film's predetermined star, Jessie Matthews, England's musical comedy queen, cast as the pastry cook with whom Johann Jr. falls madly in love. He should have gotten along splendidly with her: Matthews routinely played the lead in musicals of the type he relished, and she knew all the Cockney jokes and slang he loved—indeed, she had spoken with a Cockney accent until elocution converted her.

But Matthews had buried her Cockney past beneath a glossy facade, and didn't share Hitchcock's sense of humor—about herself, or the film. The director never got past the gaffe of trying, at the very first reading, to convince the self-important star to affect a more ironic interpretation. Hitchcock "was then just an imperious young man who knew nothing about musicals," according to Matthews. "I felt unnerved when he tried to get me to adopt a mincing operetta style. He was out of his depth and he showed that he knew it by ordering me around."

The "imperious young man"—who together with Alma adapted Guy Bolton's play—thought the material cried out for a sophisticated approach. "Instead of the romantic, rather serious story of the play," recalled Esmond Knight, the only member of the stage cast to turn up in the film (as Strauss Jr.), Hitchcock tried to convert "the whole thing into a light comedy, and his ideas for many of the sequences were extremely funny—on paper."

It didn't help that the leading lady fought him tooth and nail. The Hitchcock means of "taking the mickey out of an actor during rehearsal," in Knight's words, didn't work on Matthews. "He used to call me 'the Quota Queen' and send me up mercilessly," the actress recalled. Matthews said she could never give her best during a take because she was "always anticipating some ghastly practical joke" the director was about to play on her.

Some actors "laughed and entered into the fun," Knight admitted, but not him—like Matthews, Knight felt "continually on the *qui vive* for some elaborate leg pull at my expense, which automatically produced a feeling

of nervousness." One of the laughers was Fay Compton, whom Hitchcock had adored onstage in *Mary Rose* and engaged to portray the Countess. He also relied upon on the good-natured personality of Edmund Gwenn, playing Strauss Sr.

Those who didn't cooperate ran the familiar risk of being minimized by Hitchcock's camera work. Jessie Matthews, pointedly, ended up seeming "a not too important part of the film's design," as the critic for the *Times* later pointed out. Film scholar Charles Barr has described one such scene in the Countess's house, which Hitchcock cleverly staged in order to push "the possibilities of the long take"—while also abbreviating the screen time of its leading lady.

"His Excellency (her husband) gets out of bed, and the camera tracks back with him along the corridor as he reads some provocative love lyrics written by her, and goes to her room to confront her. From off screen left, behind a closed door, she replies that 'I wrote these verses to the river Danube,' thus mollifying him, though she will in fact be giving the verses to Schani [Strauss Jr.]. His valet enters from off screen right to call him for his bath, her maid enters from the left, and, after some by-play, the camera pans right with His Excellency as he goes across the corridor into his bathroom.

"After a moment, the valet emerges, and we pan back left with him as he joins the maid. This develops into a protracted close-shot embrace between the two servants, while they act as relay for a conversation between husband and wife, both of whom remain from now on in their respective off screen quarters. She calls out a question to the maid, who repeats it at close range to the valet, who calls it out to the husband, and so on, between the kisses. This take lasts two minutes, fifty seconds."

When *Waltzes from Vienna* was released in February 1934, prevailing opinion saw the latest Hitchcock film as an abysmal failure. Today it's among the rarest of Hitchcock films, not even available on video. Too bad: it's a deft, glittering imitation of a German light musical, chuckling more winningly than *Number Seventeen* at its own conventions.

And Hitchcock's Islington homecoming was awkward for another reason: hat in hand, he encountered an old friend, Michael Balcon, who had just been placed in charge of Gaumont. Gaumont was a new studio under the control of the banker brothers Maurice and Isidore Ostrer, who had acquired a holding interest in Gainsborough and C. M. Woolf's rental firm. Although Gaumont took over Islington, the enterprise was headquartered at Lime Grove in Shepherd's Bush, a facility dating from 1914, but recently upgraded into a state-of-the-art complex. The new main building, which opened in 1931, was a white, flat-roofed monolith almost ninety

feet high. The studio boasted five stages, a processing laboratory, three theaters, a hall for orchestra recording, and a six-hundred-seat restaurant.

Balcon was visiting the set of *Waltzes from Vienna,* ostensibly to say hello to Glen MacWilliams, the frequent cameraman of Jessie Matthews vehicles, when MacWilliams reminded him who was directing and brought the two men together. Hitchcock shook Balcon's hand uncomfortably, but as the two made small talk they gradually warmed up to each other. Balcon asked his old friend what he had next on his lineup. "Nothing yet," replied Hitchcock mildly.

Hitchcock told Balcon about a script he had begun to develop while still at B.I.P., in collaboration with *Blackmail* playwright Charles Bennett. The script was based on the Bulldog Drummond stories by Herman Cyril McNeile (a.k.a. "Sapper"). B.I.P. owned the rights to the novel, its many sequels, and all of Sapper's characters. Their initial treatment had Drummond, a debonair ex–war hero turned sleuth, stumbling onto an international spy ring while vacationing in Switzerland. The spies, in order to enforce Drummond's silence, kidnap his baby. Hence their working title: "Bulldog Drummond's Baby."

Their scenario had rung budget alarms with John Maxwell, who had killed the project. Balcon was intrigued. Could Hitchcock retrieve the rights? The director thought so, and promptly bought back "Bulldog Drummond's Baby" for £250—then resold it to Balcon at twice that sum. "I was so ashamed of the one hundred per cent profit," Hitchcock admitted later, "that I had the sculptor Jacob Epstein do a bust of Balcon with the money."*

Balcon had given him his first directing job; now he rescued him from embarrassing freelancing. Hitchcock was eternally grateful. "It's to the credit of Michael Balcon that he originally started me as a director," he told François Truffaut, "and later gave me a second chance."

Buoyed with optimism, the director signed a multipicture contract and took up new offices at Lime Grove. For Gaumont, from 1933 to 1938, he would have freer rein than ever before. Balcon still had approval over stories, casting, and budgets, yet now their relationship was reshaped by Hitchcock's reputation as England's most important director. Balcon still made the vital business decisions, but creatively he left Hitchcock alone.

* The New York–born, Jewish sculptor Jacob Epstein was vilified early in his career as a threat to the English art establishment, though in his lifetime he would come to be considered a modern master. Commissioning an Epstein bust of Balcon was a gesture eloquent in its generosity and as a statement of Hitchcock's artistic sensibility. Later, Hitchcock would also commission Epstein to create a sculpture of his daughter, Pat.

SIX

1933-1937

Enter Charles Bennett, the latest, some might say the greatest, of the third Hitchcocks. The director may have been the master of suspense, Bennett liked to boast, but suspense was his middle name.

Born in Shoreham-by-Sea in Sussex in the same month and year as Hitchcock, Bennett was the son of actress Lillian Langrishe Bennett. Once an actor himself—he was charming and handsome in the leading-man mold—Bennett turned playwright in 1927. *The Return* was his first produced play, *Blackmail* his second.

Bennett had had little to do with Hitchcock's film of *Blackmail*. But the two did meet during the production, and they struck up a friendship. Rakish, jovial, and sharp-witted, Bennett was boon company: a talker and a drinker. In the early 1930s, when the West End playhouses began to "tumble like ninepins," in Bennett's words, he joined the enemy: motion pictures.

Under contract at B.I.P. at the same time as Hitchcock, Bennett mainly wrote low-budget thrillers, often for director George King. His forte, like Michael Morton and Eliot Stannard before him, was organizing the cause and effect of suspense, the undergirding and sequencing of the drama. Once Hitchcock committed himself to a film project, this was the step of the process he plunged into first: laying out the continuity, usually in one

of the prose treatments that he found so useful. Adding context, refining the characters, and creating a proper script came later.

Hitchcock often said that playwrights or novelists, with their structural expertise, delivered the best first strike on film scripts—especially when it came to Hitchcock originals. Professional scenarists familiar with screen conventions were more useful, he felt, *after* the treatment or first draft. Hitchcock had a derisive, if affectionate, term for the professionals: "stooge writers." Bennett was both: a produced playwright but, by 1933, also a "stooge" seasoned in film. Hitchcock would come to call him "the world's finest stooge."

Their relationship would be dictated, nevertheless, by Hitchcock's formidable reputation, and by a subtle change in his attitude toward scriptwriting, which first manifested itself at Gaumont. Until now the director had shared writing credit for most of his films, but in the future Hitchcock would write only in a pinch, only crucial scenes, and he would never again take a script credit. Directing, he had grown to believe, took precedence over the writing. While he was forced to negotiate with producers throughout most of his career, he would always insist on dominating the writers he worked with.

"Without in any way detracting from the importance of the contribution made by the writer of either basic story material or screenplay," Hitchcock explained in an unusual deposition for the Directors Guild of America in 1967, offered to aid in a battle with the Writers Guild over possessory credits, "the writing is but a *single element* in the production of a film. It is the director who bears the primary responsibility to produce the integrated film and to edit it in such a manner that the various elements are perfectly combined.

"This has sometimes been referred to as 'creative magic,' but in every day terms it is not magic but tremendously hard work and effort on the part of the director which creates the film."

Just as Jack the Ripper inspired the many Hitchcock films featuring psychotic murderers, World War I—and its historical doppelgänger, World War II—loomed over his political films.

In January of the same year that Hitchcock joined Gaumont, Adolf Hitler became chancellor of Germany; a month later the Reichstag burned down mysteriously, paving the way for the Enabling Act that gave Hitler dictatorial powers. The world seemed to be igniting with hate and violence. The feeling extended even to America, where, the same month as the Reichstag fire, a crazed man tried to assassinate President Franklin Delano Roosevelt during a speech in Miami, missing his target but killing the mayor of Chicago.

The Man Who Knew Too Much was written in the shadow of these events.

After Hitchcock moved to Lime Grove, he and Charles Bennett began revising "Bulldog Drummond's Baby," their first order of business being to remove Bulldog Drummond (for Sapper's fictional hero still belonged to B.I.P.) *and* the baby.*

Hitchcock didn't like to drive, so he hitched a ride to the studio with Bennett most mornings. They always began with small talk, Bennett recalled; sometimes they were joined by the studio barber, who gave Hitchcock a shave and cut his increasingly sparse hair—"so there really wasn't much that went on before lunch at all," in Bennett's words. At 12:30 P.M., the two would adjourn to the Mayflower Hotel for lunch, after which they'd return to the studio, where Hitchcock usually stole a nap, according to Bennett. When the director woke up they'd talk some more; around five, they'd repair to Cromwell Road.

Bennett liked to make it sound as though it were all idle conversation, with the real writing left up to him. But for Hitchcock collaboration was always a seduction, its goal a productive marriage. Hitchcock set the tone with idle talk, which lowered his writers' defenses. He lured them with digressions, gossip, tasteless jokes. He would offer up preposterous ideas for Bennett to dismiss, and resist perfectly sensible ideas himself. He studied each new idea endlessly, and from all sides, as though it were a polyhedron. He insisted that his writers "fill in the tapestry."

Bennett boiled with ideas. And he fought for them, too, which the young, feisty Hitchcock liked—up to a point. "Hitch was, always, so exasperated [by Bennett] that he was stimulated to action—or counteraction as the case might be," recalled story editor Angus MacPhail. "Bang him, bash him, vilify him, and up he [Bennett] comes smiling."

Everybody at the studio seemed to boil with ideas. Hitchcock thrived on interaction with writers—the more, the merrier. He told and retold the stories of his films to anyone who would listen, filing away their reactions for future reference. Now at Lime Grove he was reunited with his old friends Ivor Montagu and Angus MacPhail; their involvement would become integral to the style and quality of the Hitchcock films over the next several years.

At B.I.P. he had sorely missed the sophistication and constructive criticism of Montagu, who had spent time in Hollywood after leaving Gainsborough, working at Paramount with the Soviet filmmaker Sergei Eisenstein. Their projects never quite jelled, however, and Montagu had

* The "baby" was a five-year-old boy in the treatment for "Bulldog Drummond's Baby"; in *The Man Who Knew Too Much*, the "baby" became a prepubescent girl—closer in age and spirit to the director's own daughter, Pat.

returned to England, disgusted with the film business and intent on staying out of it. Balcon coaxed him over to Gaumont as Hitchcock's supervisory producer.

MacPhail was still the head of Michael Balcon's story department, and Hitchcock trusted his expertise. Although MacPhail's "filmic knowledge was encyclopedic and his memory so good that he could find a parallel in almost any suggested story situation," according to writer T. E. B. Clarke, "this made him, as a writer, rather too prone to rely on film clichés" to be a good screenwriter; "but it equipped him to be a marvelous scenario editor." Personally, Hitchcock and MacPhail were even more the kindred spirits; MacPhail, too, was a lover of lowbrow music hall and high-minded theater, and an incorrigible, egregious punster. He was also among the few to humble the great Hitchcock, reminding him once a year in his Christmas card of the inane title cards of *Downhill*.

Although the heavy lifting was done by Hitchcock and Bennett at the studio, some of the best ideas for *The Man Who Knew Too Much* surfaced at night at Cromwell Road, where the director presided over an informal film society of friends and associates. Regularly taking part in these evening sessions, besides Bennett, Montagu, and MacPhail, was their hostess, Mrs. Hitchcock. Others stopped by. Dinner was served; drinks flowed.

The nights at Cromwell Road were deliberately playful, "a feast of fancy and dialectic," in Montagu's words, "a mixture of composing crosswords and solving them." The underlying goal might be serious, but the dedicated clowning oiled the gears of creativity. Hitchcock told lewd anecdotes, and played his favorite musical recordings (the director was in a Hungarian phase in the early 1930s, Bennett recalled, and forced everyone to listen to "Play, Gypsy, Play" ad infinitum).* People sang along with the recordings, or got up and danced.

The group dynamic made for scripts that were more decidedly topical, more freewheeling and densely packed with allusion, than the films Hitchcock had made at Islington or B.I.P. "The unfolding story was elaborated with suggestions from all of us," Montagu remembered. "Everything was always welcome, if not always agreed. Like anyone else, Hitch would sometimes reject an idea when it was put forward, sleep on it, and return with it next morning as his own; which by then it undoubtedly was, since it could only be incorporated when adjusted in his own head to make it fit."

If there was an overriding philosophy, it was symbolized by a little book called *Plotto* that Hitchcock flourished—a book boasting a compendium

* Hitchcock saved up Gypsy-style Hungarian accordion music for deep in the background score of *Rope*—as Brandon's (John Dall) "atmospheric music" for the guests.

of master plots with interchangeable conflicts and situations. Never mind that sometimes the inserts were implausible. "I'm not concerned with plausibility," Hitchcock liked to boast. "That's the easiest part, so why bother?" Or, as he put it on another occasion, "Must a picture be logical, when life is not?"

The daily newspapers were a constant source of inspiration. Although Hitchcock shied away from taking political stands himself, his circle was thoroughly socialist and antifascist, even including Communists like Montagu. (Montagu and Sidney Bernstein were among the earliest organizers of the British Committee for Victims of German Fascism.) The influence of this group affected the tough-edged world view of his Gaumont films.

Newspapers were good not only for headlines, but as a steady supply of tidbits in all categories. "We would search for ideas in books, in plays, odd scenes in the street. Not straight copying, usually, but ideas to prompt ideas," Montagu recalled.

With Bennett in charge of the main plot line, and the Cromwell Road friends chipping in, "Bulldog Drummond's Baby" evolved into *The Man Who Knew Too Much*—an action-filled thriller that was broader in scope and more politically charged than any previous Hitchcock film.

The story mirrored the fragile state of the world, with Hitchcock capitalizing, in small and large ways, on English fears of a resurgent Germany. The title character—the distraught father of the kidnapped child—is forced into the role of sleuth and hero when he intercepts a coded message, which reveals the planned assassination of a foreign dignitary on British soil. (In one pointed scene, a representative of the Home Office reminds the father of the consequences of inaction—mentioning June 1914 Sarajevo.)

The intercepted message is the film's Macguffin—the storytelling device that was MacPhail's mantra, if not his actual invention. Hitchcock, who adopted the Macguffin gleefully for this and other films, gave the standard explanation to François Truffaut: "There are two men," he related, "sitting in a train going to Scotland and one man says to the other, 'Excuse me, sir, but what is that strange parcel you have on the luggage rack above you?' 'Oh,' says the other, 'that's a Macguffin.' 'Well,' says the first man, 'what's a Macguffin?' The other answers, 'It's an apparatus for trapping lions in the Scottish Highlands.' 'But,' says the first man, 'there are no lions in the Scottish Highlands.' 'Well,' says the other, 'then that's no Macguffin.' "

The Macguffin in any Hitchcock film represented "the unknown plot objective which you did not need to choose until the story planning was complete," as Montagu put it. The final elucidation of Mr. Memory, just before he dies in *The 39 Steps:* that's the Macguffin. What is secreted in the wine bottle in *Notorious*? The Macguffin. Other spy pictures had inadvertently absurd plot goals; in a Hitchcock film, whether the Macguffin

turns out to be an assassination or a clandestine alliance (echoing World War I) or, often enough, a super-secret weapon, by the time it's clarified in the film it has become an absurdity—and deliberately beside the point.

Yet who hatched the first Macguffin for *The Man Who Knew Too Much*, or devised any particular element of his Gaumont films, is maddeningly elusive to pinpoint, considering—at Cromwell Road, as later in Hollywood—the complicated give-and-take of Hitchcock's creative process.

Hitchcock had set a previous climax in Albert Hall; now he thought of setting the assassination attempt in that massive building, beloved by Londoners for its concerts, charity balls, exhibitions—even, in bygone days, boxing. Someone suggested that the targeted foreign official might be attending the London Symphony. Someone else suggested that gunshots might be drowned out by drums, or a cymbal crash. They were all devotees of *Punch*; Hitchcock collected bound volumes of the humor magazine, and several times recruited writers from its staff. Now one of the group evoked "The One-Note Man" by H. M. Bateman, from a 1921 back issue—a panel cartoon depicting a musician whose job consisted of preparing all day to play a single horn note in the evening orchestra program.

That was enough for Hitchcock to roar to life—envisioning a sequence built around an original choral piece climaxing with cymbal crashes from the one-note musician. He gleefully planned a nail-biting sequence that would crosscut between the lurking assassin, the foreign dignitary, the mother of the kidnap victim (positioned to spot the crime and cry warning), and the cymbalist awaiting his cue.

That crescendo had to be followed by an even bigger one—it was a Hitchcock rule. The director would have to top the Albert Hall sequence with an exciting rescue of the kidnapped girl. Someone suggested a shootout between the kidnappers and police; then someone else mentioned a headline-making incident from 1911. Hitchcock remembered it from his youth: the Sidney Street Siege, in which then home secretary Winston Churchill directed a shoot-out by squads of police against a small group of Bolshevik anarchists holed up in a building.

Re-creating such a shoot-out on film could have been pro forma in other hands, but Hitchcock was inspired by the Sidney Street reference. He eagerly planned every moment, every shot of the sequence, building the action to a frenzied pitch, then topping it off with one of those symmetrical strokes that epitomize the best Hitchcock scripts: At the height of the shoot-out the kidnapped girl escapes her captors and flees across a high rooftop, chased by the same villain who bested the mother in target shooting earlier in the film. When the police marksman proves a shaky aim, the mother grabs the rifle and coolly shoots the man dead.

The ideas may have come from every direction, but there was no ques-

tion who was in charge of "the integrated film." After the script of *The Man Who Knew Too Much* evolved virtually "by consensus" over the winter of 1933–34, according to Montagu, "the scenes of course were finalized by Hitch, and his verbal texts then duplicated from the writer's [Bennett's] notes."

This kind of group writing, however, was competitive as well as collaborative. After the silent era, Hitchcock tended to stack up writer after writer on each new project; they were expected to augment and improve upon their predecessors' work. It was an approach more typical of producers—but Hitchcock had already begun to function as his own de facto producer, and he was expert at manipulating writers.

Hitchcock saw Bennett, "the world's finest stooge," as basically a carpenter, whose foundations and framing required sanding and ornamentation. That didn't bother Bennett as much in the carefree Gaumont era as it would later on, though it was always a disappointment for a Hitchcock writer when the director's seduction ended. A surprising number of scribes stopped by the studio or Cromwell Road, and joined the pool who added nuance to *The Man Who Knew Too Much*. The Australian composer Arthur Benjamin, who taught at the Royal College of Opera, was commissioned to compose the original cantata for the Albert Hall sequence; the well-known satirist D. B. "Bevan" Wyndham-Lewis, who wrote occasional poesy for his "Beachcomber" column in the *London Daily Express,* also did spot writing for the film, including the cantata lyrics.

The Cambridge-educated playwright A. R. (Arthur Richard) Rawlinson and the actor-writer Edwin Greenwood signed up for "additional dialogue." A close friend of the director's, Greenwood was one of the "multifaceted" types Mr. and Mrs. Hitchcock seemed to collect; himself a film director in the silent era, Greenwood now stayed busy as a character actor and as a mirthful crime novelist who was praised for his English atmosphere.*

Even as filming was about to start, the script touch-ups continued. Angus MacPhail phoned the Welsh actor and playwright Emlyn Williams to ask if he might add "zing" to a few scenes. He did—but Williams never even met with Hitchcock, such was the director's trust in MacPhail.

Pierre Fresnay, the Frenchman known for his appearances onstage with the Comedie Francaise and in Marcel Pagnol films (and later for his famous role in Jean Renoir's *Grand Illusion*), was starring in a London play with his wife, Yvonne Printemps. Hitchcock, who was in the audience on open-

* Greenwood's books include *French Farce, Miracle in the Drawing Room, The Fair Devil, The Deadly Dowager,* and *Old Goat,* the last of which is dedicated: "To Alfred Hitchcock ('Hitch'), Good Maker of Good Pictures, Good Judge of Good Things, Good Friend."

ing night, engaged Fresnay to play the small part of the secret agent whose murder triggers the plot—although, as the director later insisted to François Truffaut, "I didn't especially want a Frenchman. I believe that came from the producer's side."*

The well-known actor (and playwright) Frank Vosper was cast as the oily hit man Ramon, with Hugh Wakefield as Clive, the father's sidekick, who figures in the film's *Plotto*-comedy—a trip to a sinister dentist,** and then a visit to a church of supposed sun worshipers.

The Bulldog Drummond character had been downgraded from dashing to merely fatherly, but at the same time his wife had evolved into more of a heroine. Leslie Banks, in the early stages of a lengthy screen career ("Quiet, cultured and charming," Hitchcock said of him, "he plays his scenes with ease and without worry to the director"), and Edna Best, a respected actress married to Herbert Marshall, would play the parents of the kidnapped girl.

For the kidnapped daughter, Gaumont offered one of its youngest contract players: Nova Pilbeam, an appealing fourteen-year-old who had just finished a gripping film, *Little Friend,* in which she played a youngster driven to suicide by her parents' divorce. The combination of *Little Friend,* which broke box-office records (and audience hearts) across England, and *The Man Who Knew Too Much* would make Pilbeam one of the country's preeminent child stars. "Even at that time," Hitchcock said of Pilbeam, "she had the intelligence of a fully grown woman. She had plenty of confidence and ideas of her own."

But the masterstroke of the casting—cementing the script's political implications—was undoubtedly Hungarian-born Peter Lorre as the chief of the subversives. Lorre, who catapulted to fame in Brecht plays and as the child murderer in Fritz Lang's *M,* had fled Berlin and Hitler in 1933. He made pit stops in Vienna and Paris, where in September 1933 Ivor Montagu heard of his plight and joined forces with Michael Balcon and Sidney Bernstein to bring him to London. When he arrived, Lorre stayed at Bernstein's flat.

According to Lorre biographer Stephen D. Youngkin, the actor was an "afterthought" for Hitchcock's film, and was cast initially in the smaller role of Ramon, the hit man responsible for the Albert Hall assassination. When Hitchcock and Montagu met with him at London's Hotel Mayfair, the only English words the refugee knew were *yes* and *no,* but he shrewdly

* One wonders, therefore, why Hitchcock chose another Frenchman, Daniel Gelin, for the remake.

** Originally Hitchcock intended to shoot this scene in a barbershop, but that was before he saw a Hollywood movie he often cited among his favorites—Mervyn LeRoy's *I Am a Fugitive from a Chain Gang* (1932), with Paul Muni. *Fugitive* "had a scene just like it" in a barbershop, "so I transposed it to a dentist's office."

said yes to everything. "I had heard that he [Hitchcock] loved to tell stories and so I watched him like a hawk and when I was of the opinion he had just told the punch line of a story," recalled Lorre, "I broke out in such laughter that I almost fell off my chair."

Smitten by the man from *M*, Hitchcock decided Lorre would be better as the criminal mastermind Abbott, "unctuous but deadly" according to the script, willing to go to any lengths to achieve his diabolical ends. Lorre's role was then expanded in the ongoing rewrites; Hitchcock even inserted a subtle allusion to the Lang film, when Lorre, in his first scene, shows his chiming watch to Nova Pilbeam—and the girl, alone among the crowd, finds him repulsive. Lorre's performance so delighted the director that his role steadily continued to grow throughout the filming. In the end, though he was second-billed, it was Lorre's face that graced the poster, along with the tag line "Public Enemy No. 1 of the World."

Hitchcock's longtime assistant director Frank Mills, his editor Emile de Ruelle, art directors Norman and Charles Wilfred Arnold, and cameraman Jack Cox were under contract to B.I.P., and stayed behind. Now that he had landed at Gaumont, Hitchcock—as he would be forced to do so often over his long, studio-hopping career—had to organize a new team.

As his new assistant director, Michael Balcon offered up a twenty-year-old Eton and Oxford graduate named Penrose Tennyson. Once the boy wonder, Hitchcock now began to evince a marked pleasure in playing mentor to younger people. He took "Pen" under his wing, patiently explaining his thinking on each question that arose, as well as his more general theories on filmmaking. More than a few young Englishmen, schooled by him, informally dubbed themselves "Hitch's boys"—and Tennyson wasn't the only one who later graduated to director.

Balcon, meanwhile, had been laboring to make London attractive to all kinds of film-world refugees from Germany. The many émigrés he placed under contract would contribute to the German flavoring of Hitchcock's films in the 1930s. These included art directors Alfred Junge (who had designed E. A. Dupont's *Waxworks* at Ufa, and moved with Dupont to England) and Austrian-born Oscar Werndorff (who art-directed Dupont's *Variety* as well as, previously for Hitchcock, *Number Seventeen*) and cameramen Günther Krampf (who had shot *Pandora's Box* for Murnau) and the Czech-born Otto Kanturek and Curt Courant (cophotographers of Fritz Lang's *Die Frau im Mond*). Junge would be the art director for *The Man Who Knew Too Much*, and Courant the cameraman.

For his editor, though, Hitchcock wanted a native Englishman with whom he could communicate easily. He rarely deigned to spend five minutes in the cutting room, but he stayed in constant close communication

with his editors. For some scenes Hitchcock deliberately left few editing options, but for others, regardless of what his trusty storyboards showed, the director shot a handful of variations, which were typically shuffled and debated until the eleventh hour before a premiere. He usually made sure to include extra shots for the montages, not to mention alternative codas in case he wasn't satisfied with his first-choice ending.

Balcon offered up a junior cutter named Hugh Stewart, but first the twenty-three-year-old had to pass muster with Hitchcock. Muster had little to do with his editing ability, however. After he was hired, Stewart was asked over to Cromwell Road, where he joined a party in progress and was handed a glass of something that looked and tasted vaguely like orangeade. The drink was spiked with gin, but Stewart didn't notice until he'd imbibed so much that he was acting like a crazy man; by the end he was almost stupefied. The next morning, when the young editor blearily appeared on the set, Hitchcock made a point of halting the action and announcing, "Stop, everybody! Turn the lights on that man. This young fellow disgraced me last night!" Stewart took it all in good spirits—and thereby passed the test. Stewart kept on task, always grateful that Hitchcock had shown faith in him on his first film. Another of "Hitch's boys," he eventually became a producer.

Not least important, the director needed an intelligent, highly organized personal assistant, who according to industry custom was likely to be a charming young woman. At B.I.P., this job had belonged to Renee Pargenter, but, shortly after Hitchcock joined Gaumont, Pargenter got married and gave notice. Hitchcock placed an advertisement in the *Daily Telegraph* and other publications seeking a "young lady, highest educational qualifications, must be able to speak, read and write French and German fluently, by producer of films."

Twenty-six-year-old Joan Harrison spotted the ad and applied. Although she was a graduate of St. Hugh's and the Sorbonne, her résumé modestly boasted only college stints as a film critic and sales experience in a London dress shop. On her mother's advice Harrison wore a hat to the job interview. She found herself last in a long queue, and it was nearly lunchtime before she was beckoned into Hitchcock's office. The director stared at her momentarily, then asked her to take off her hat. She was revealed to be exactly the sort of well-bred young lady he was looking for.

Petite, with coiffed blond hair and flashing blue eyes—then, as always, immaculately dressed—Harrison was beautiful enough to be a leading lady. When Curt Courant first met her, he thought she ought to be in the film, not holding a script on the sidelines. The cameraman talked Hitchcock into giving her a screen test. (Well, it wasn't too hard to convince him: "Who have you slept with, Miss Harrison?!") But that is far as it went.

Could Harrison speak any German? Hitchcock needed her to bridge the communication gap with the art director and cameraman. No, she admit-

ted, but her French was not so bad. ("High honors" at the Sorbonne, according to Charles Bennett.) Well, Hitchcock sighed, his own German would suffice. Anyway, he was famished, he said; Harrison could have the job if she joined him in a meal.

At lunch, they talked easily. Harrison's uncle, it turned out, was Harold Harrison, keeper of the Old Bailey—the official who assigned cases to different courts for trial. She had taken to following the courts herself, and could recount the particulars of a succession of trials with superb recall and evident relish. Uncle Harry "was one of those uncles young girls adore," Harrison once recalled. "He not only took you to lunch, but he knew the grisly details of all the most shocking crimes. For years I've read the transcript of every interesting trial I could lay hands on."

She was every bit as much an aficionado of show business. In college, recalled classmate Rita Landale, Harrison was "always reading a play." She had an encyclopedic recall of actors. Although her formal film experience was limited to a few reviews in college and for the *Advertiser,* her father's Guildford, Surrey, biweekly ("when I was a girl, so I could get passes"), she was also an avid, knowledgeable moviegoer.

So Harrison was hired as Hitchcock's assistant, working informally in the same capacity for Mrs. Hitchcock as well, helping out with synopses and treatments. Right away she was given promising plays and novels and told to weed out extraneous matter and boil the stories down for possible screen adaptation. Right away she began to learn "continuity."

Starting with *The Man Who Knew Too Much,* then, Harrison got a crash course in every aspect of the film business from a master professor. At first Harrison was the lowliest member of the team, but swiftly she rose up; she would ultimately become as important to Hitchcock's career as anyone but Mrs. Hitchcock.

"I think you'll find the real start of my career was *The Man Who Knew Too Much,*" Hitchcock once said, and it's true: the film turned a corner for him, conclusively establishing his greatness.

Hugh Stewart always remembered how, on the first day of filming in June 1934, Hitchcock arrived on the set and made a show of slapping the script down on a desk and announcing, "Another picture in the bag!" It was Hitchcock back on top, confidence renewed—and the first recorded instance of his public credo that the job was done long before the cameras rolled.

As credos go, this one was mainly for show. "One of the reasons against that argument," explained Peggy Robertson, his longtime personal assistant in Hollywood, "is that the script was very seldom finished before we started shooting. We always had trouble with endings. 'What are we going to do? How is it going to end?' We'd have minute sketches of the tiniest camera movement, but how would the whole sequence end? He didn't know."

"He's a master of well thought out effects," colleague George Cukor mused in one interview, but not all the effects were manifest in the script or storyboards. Himself renowned as an "actor's director," Cukor knew Hitchcock personally and admired him professionally for, among other things, the extraordinary performances he often extracted. But "I'm not quite sure that he is telling the complete truth [about having everything planned so carefully in advance]. He must improvise with performances sometimes. . . . [And] he is hiding things from you; he doesn't say how he works, how he achieves effects—easier to say it was all planned in the script and the rest is mechanics."

One thing that didn't change when "Bulldog Drummond's Baby" became *The Man Who Knew Too Much* was the St. Moritz opening. Hitchcock made a habit of wielding such opening scenes in his films to lull his audiences into a false security. He often chose what he liked to call picture-postcard or sightseeing clichés to establish a setting. "Local topographical features," he said: Think of Holland, and you think of windmills. Think of Switzerland, and what comes to mind? Skiing and winter games.

This time, Hitchcock began with the guests of an exclusive hotel engaged in outdoor contests. Edna Best is a lovely sharpshooter distracted by her precocious daughter, Nova Pilbeam, during a skeet shoot. The audience would do well to remember the mother's skill with a gun.

That night, in the hotel ballroom, the rakish Pierre Fresnay whisks Best onto the dance floor, in a buoyant sequence that begins deceptively—with the two of them getting tangled up in a skein of yarn, which has been pinned to their clothing by Best's sulking husband, Leslie Banks. When an unseen enemy shoots Fresnay, the music muffles the gunfire; dying in Best's arms, the dashing Frenchman whispers the Macguffin.

He started the film that way, the director once explained, "to show that death comes when you least expect it." Light shifts into darkness, and the real Hitchcock dance begins.

Ironically, given John Maxwell's cost-conscious opposition to "Bulldog Drummond's Baby," the Gaumont films were among Hitchcock's cheapest. One of Hitchcock's unsung virtues as a director was his ingenuity at saving money, at creating the illusion of luxury under constrained conditions. Only small crews traveled to locations beyond England in the mid-1930s, so Hitchcock conjured up his beloved Swiss scenery out of bits and pieces of precisely stipulated second-unit footage and a few painted backdrops; the lavish-seeming Albert Hall and Sidney Street highlights were also modestly budgeted, ingeniously fabricated illusions.

For the first climax, Hitchcock returned to the Schüfftan process, which he had employed for *The Ring* and *Blackmail*. Gaumont couldn't afford hundreds of extras; nor, in any case, would the studio be allowed to take over Albert Hall for protracted filming. So Hitchcock had long exposures made of various angles of the auditorium, which were then blown up into

oversize transparencies. The Italian-born artist Fortunino Matania, a frequent contributor to all the finest London periodicals, made realistic paintings of the audience on each transparency. "We went back to the Albert Hall and set up the Schüfftan camera in exactly the same spots where the original photographs were taken," Hitchcock proudly explained to Peter Bogdanovich. "Now the mirror reflected this little transparency with a full audience, and we scraped the silvering here and there—a box near the entrance and the whole of the orchestra. Then in the box we had a real woman opening a program and so forth, and the eye immediately went to the movement. All the rest was static."

The Albert Hall scene remains an unforgettable mosaic, a shoo-in for any highlight reel of the greatest sequences in film history. Hitchcock's camera begins on the faces of the audience and the orchestra as the cantata begins and the searching mother arrives. As the haunting music swells, his camera returns to the mother, her despair growing ever deeper. From the mother he cuts to a gun barrel gradually protruding from behind the curtain; at first the image seems like an abstraction out of modern art, but as the gun slowly wheels to point toward the camera—and its target—the frightening image merges with the gunshot and the mother's scream.

As always with the best Hitchcock films, the director set aside privileged moments for his preferred actors—usually those playing the most innocent characters, or the most depraved. The director doted on Pilbeam, and his tenderness toward the sacrificial lamb of the story (the young, kidnapped daughter) is the beating heart beneath the film's essential cruelty.

The other actor who fascinated him was the sardonic, moonfaced Peter Lorre. Among other things the two men shared a malicious sense of humor. Lorre's first line, "Better ask my nurse," the director made him repeat over and over, mocking his pronunciation. ("What? Pederast my nurse?!" Hitchcock echoed incredulously from behind the camera.) Their banter switched back and forth from English to German slang. "That may have been a little Hitchcockery," editor Hugh Stewart said, "because nobody else except Lorre understood Hitchcock."

Hitchcock dubbed Lorre "the Walking Overcoat" for the long coat the actor habitually wore, which drooped down to his shoes. Evenings and weekends, Lorre and actress Celia Lovsky (whom he married during the filming) became frequent guests at Cromwell Road, along with others from the production. During filming, the Hitchcocks were eager hosts, rotating a guest list that included both stars and lesser members of the company. The parties served to bolster the on-set camaraderie, which could sag during the long, tedious days.

After hours, when sufficiently libated, the director of *The Man Who Knew Too Much* needed little coaxing to perform his most notorious shtick: the host doffed his shirt, wrapped a shawl around his shoulders,

and became a sexy belly dancer with enormous breasts, undulating to music and hysterical applause. Nobody laughed louder than Lorre.

The only thing that bored Hitchcock more than a straight hero was a bland villain. His villains could be as handsome and impotent as his heroes, but the best of them evoked pity. Lorre offscreen was a tortured soul, already saddled with a drug habit that would grow worse as he aged. He was the Reggie Dunn character of *The Man Who Knew Too Much*, but also the most personable, most fully human being in the film: Hitchcock's first great villain, before Bruno Anthony or Norman Bates.

The Sidney Street–style siege begins with an incisive succession of police vignettes. One officer, after boasting of his prospective overtime ("Looks like an all-night job to me!"), is sent to try the front door of the hideout, and promptly gunned down. Another, after similar side-of-the-mouth comments to ingratiate himself with audiences, props a mattress up in front of a window to shield himself from gunfire—he meets a predictable fate. That is when the action breaks out on several levels of the street and buildings.

The siege, like the Albert Hall sequence, is a stunning montage, a director's showcase. But it was also acted to the hilt by Lorre, who proved a tremendous asset to the film. His final scenes seal the magnificence of *The Man Who Knew Too Much*. First comes the two-shot of a smiling Lorre and his horse-faced adjutant ("nurse" Cicely Oates), just before she is sprayed with bullets. His reaction to her death tells us how much he loved her (despite the hints that she was very likely a lesbian). His implacability is shattered, and for just a moment we feel for him. Then, consumed by rage, Lorre finally grabs a gun and joins in.

Lorre is the only member of the gang to survive the chaotic shoot-out. We don't see him, hiding behind a door as the police edge into the room. That is the excuse for a small but marvelous Hitchcock touch: the chiming of his watch (heard at strategic moments throughout the film) signals his last act of bravado and self-destruction.

But Hitchcock loathed happy endings, and the last shot of the reunited family isn't very comforting. Our ultimate glimpse of the mother, after her deadeye rifle shot, reveals a face crushed by the realization of what she has done. The father will have a scar from his wound; the young daughter would surely be in therapy for the rest of her life.

The film was disturbing—so much so that its quality was not immediately apparent to studio officials. When Hitchcock previewed *The Man Who Knew Too Much* for Maurice and Isidore Ostrer, the banker brothers who presided over Gaumont's board of directors, he was baffled by their response. After the lights went up, the Ostrers scurried out of the screening

room without uttering a polite word. Sitting alone with editor Hugh Stewart, Hitchcock furrowed his brow. "Are they always like that?" he asked. "I don't think," Stewart replied diplomatically, "they know what to say."

The Ostrers thought *The Man Who Knew Too Much* might be "too artistic." They asked for a second opinion from an expert on films too artistic: C. M. Woolf, Hitchcock's old nemesis, still a fixture on the Gaumont board. As it happened, Woolf was virtually in charge of the studio while Michael Balcon was out of reach in the United States, making distribution and talent deals. After watching Hitchcock's film, Woolf summoned the director and told him it was appalling rubbish. Woolf ordered up a set of new, mild scenes to be shot and inserted by Maurice Elvey. "Hitch was practically suicidal," wrote John Russell Taylor, "and begged Woolf on his knees to let the film be shown as it was shot."

"Our personal suspense, Hitch's and mine, went on for days," said Charles Bennett. Hitchcock told Bennett that until the impasse was broken they might as well set aside their next project—*The 39 Steps*. Bennett switched to working on "a cheap original I knew would pay for the milk."

His suspicions piqued, Woolf asked to read the script for the next Hitchcock project—and tried to nip *The 39 Steps* in the bud too. Hitchcock and Ivor Montagu were called on the carpet. Woolf diagnosed the new script as "highbrow stuff" that would only give rise to "another piece of rubbish," and gave the director and associate producer one month to shape up or ship out. Worse yet, he ordered Hitchcock to develop a musical based on the life of music hall composer Leslie Stuart, best known for his turn-of-the-century hit *Floradora*. That was the sort of English picture that English audiences would flock to see, Woolf declared.

In the meantime, Hitchcock had been desperately trying to reach Michael Balcon; now his emergency telegrams finally got through—fortunately in time for Balcon to overrule Woolf. Such postproduction interference would never happen again, Balcon vowed—a promise he kept as long as he remained in charge at Gaumont. *The Man Who Knew Too Much* was then scheduled for release, and *The 39 Steps* was allowed to proceed. The Hitchcocks took Bennett and Joan Harrison with them to St. Moritz at Christmas to work on the script and take a much-needed holiday.

The Man Who Knew Too Much chalked up incomparable reviews in London ("glorious melodrama," raved the *Kinematograph Weekly*, "artless fiction, staged on a spectacular scale") and went on to tremendous popularity in England. Not only that: it became the first Hitchcock film to score with critics—and audiences—in the United States. Wherever it played in the world, people saw a film as enthralling as any other made in 1934.

C. M. Woolf never really relented where Hitchcock was concerned. The rental magnate insisted on booking *The Man Who Knew Too Much* into

his own chain as the lower half of double bills headed by routine Hollywood first features. Although the Hitchcock picture "broke attendance records for almost every theater it played," in Montagu's words, its percentage of the take was assigned to the first feature, and thus it earned only nominal fees. Woolf, who saw Hitchcock as a loser with audiences, recorded his film as a loser too.

A "B" movie in Hollywood budget terms—its entire cost was roughly forty thousand pounds—*The Man Who Knew Too Much* made a relative fortune over the years, and still plays widely in museums, in repertory, and on television. But in the short term, the experience finally taught Hitchcock the dangers of relying on a system so dependent on its distributors. Woolf could be kept at bay only so long. Early in 1935, Hitchcock resumed his flirtation with the Joyce-Selznick office, asking its London representative, Harry Ham, if he would again sound out American studios. This move was short-circuited, however, when Balcon found out about it, and warned Ham that Hitchcock had a Gaumont contract. Having just defended Hitchcock against a big investor, Balcon had no intentions of loaning him out.

The Man Who Knew Too Much was hailed by English critics as a fresh Hitchcock varietal, a politically urgent blend of comedy and suspense that minimized his usual aesthetic experimentation in favor of sweepingly entertaining set pieces. "At last he has thrown critics and intellectuals overboard with one of his incomparable rude gestures," declared C. A. Lejeune in the *Observer,* "and gone in for making pictures for the people."

It was true: at each stage of his career, he excelled at creating variations on familiar, favorite ideas. Before *The Man Who Knew Too Much,* spy-saboteur pictures weren't really Hitchcock's specialty. Now, suddenly, he discovered that they fit him like a second skin—and *The 39 Steps,* based on a John Buchan novel that dated back to World War I, gave him a chance to explore the genre further.

Hitchcock often commented that in his youth he had devoured the books of Buchan, the Scottish barrister and highly regarded author known for his adventures with debonair gentleman heroes. Buchan liked to refer to his novels as "shockers"—a word Herbert Marshall uses in *Murder!* to describe one of his crime plays, and a word Hitchcock adopted in interviews to characterize his own films. Hitchcock said that he identified with Buchan's "understatement of highly dramatic ideas," and told François Truffaut that "Buchan was a strong influence a long time before I undertook *The 39 Steps.*"

In truth Hitchcock was probably fonder of *Greenmantle,* the sequel to *The Thirty-nine Steps,* which follows lead character Richard Hannay on a

secret mission during World War I.* Hitchcock and Charles Bennett talked about adapting *Greenmantle* before opting for *The Thirty-nine Steps*, partly for practical reasons. *The Thirty-nine Steps* was a "smaller subject," in Hitchcock's words, set entirely in England, while *Greenmantle* would have called for German and Turkish scenes. *The Thirty-nine Steps*, in contrast, could be shot almost entirely at Lime Grove.

But Buchan's book, a thriller in 1915, was quaint by the 1930s—full of coincidences and uncinematic elements, as Hitchcock realized when he reread it for the project. "When I did so," he said later, "I received a shock. I had learned a lot about filmmaking in the fifteen-odd years that had elapsed" since his first reading. "Though I could still see the reason for my first enthusiasm—the book was full of action—I found that the story as it stood was not in the least suitable for the screen." He and Bennett launched a new treatment during the filming of *The Man Who Knew Too Much*, and then finished the first draft in the winter of 1934–35.

If any film supports Hitchcock's typical boast, that when he selected a book he felt free to extract what he pleased and throw out the rest, it was this alleged favorite, a book he insisted he loved—and which he transformed into arguably the grandest of his Gaumont films.

He reshaped *The Thirty-nine Steps* into a Hitchcock film that bore scant similarity to the book. The story was updated, and turned into a romance. Buchan scenes were dropped, Hitchcock scenes inserted. As usual, the director added not only major elements to the plot and characters, but many smaller, delightful touches throughout. Once again, work on the script was divided between the studio and Cromwell Road. Once again, though Alma and Charles Bennett were the main writers, an informal group congregated to help out with ideas, borrowing from other films, books, newspapers—whatever was handy.

Novelists never claimed the same control over film adaptations as playwrights—and Hitchcock was through with plays, for the time being. The West End was in its worst slump, so there was less available material anyway; but more to the point, Hitchcock had more power now, and he preferred the freedom of working with novels.

The differences between the book and film began with a subtlety in the meaning of the title. The "Thirty-nine Steps" of the novel refers to a flight of steps leading down to the sea from the headquarters of the German spy organization; in the film there are no such steps, and the title signifies the organization itself—"conducting information on behalf of foreign spies."

Buchan's "double chase" concerns a wronged man fleeing from police

* There is a slight difference between the published title of the novel and that of the film, with Hitchcock playing one of his word games. The Buchan book is *The Thirty-nine Steps*, while the Hitchcock film is *The 39 Steps*.

while racing against time to foil a foreign conspiracy; that much, at least, was carried over from the book. Remarkably, however, Buchan's novel is entirely devoid of a love story—indeed, of any character even faintly resembling Pamela (Madeleine Carroll). Pamela was Hitchcock's vital addition to the film: a train passenger who first betrays Hannay to the police, and then, when coincidence forces her to join him on the run, handcuffed together, falls in love with him.

Two of the film's most famous sequences were also original: the haunting interlude on an isolated farm with Hannay given shelter by a suspicious crofter (tenant farmer) and his fetching young wife; and the music hall finale, where Mr. Memory—on point of honor—spurs his own death by reciting the secret of "The 39 Steps."

John Russell Taylor said the crofter scene was consciously derived from "a slightly risqué story about a lustful wife, a watchful husband, a traveler and a chicken pie." In at least one interview the director referred to another inspiration, a novel about an authoritarian South African Boer, his young, sex-starved wife, and a handsome overseer who comes between them—Claude and Alice Askew's *The Shulamite*. Hitchcock often worked just this way, borrowing from two or more references, then patching the related ideas together and blending the whole into something wholly new, leaving only a hint of the original inspiration.

Charles Bennett insisted in later interviews that it was he who thought of Mr. Memory—the man "doomed by his sense of duty," in Hitchcock's words. But Mr. Memory had a real-life counterpart, an entertainer named Datas, a.k.a the Memory Man, well known in England for his mnemonic performances—and well-known to Hitchcock, who fondly recalled seeing his performances as a boy. "He always concluded his act by having a stooge ask when Good Friday fell on a Tuesday," he recalled. "He would then answer that a horse called Good Friday fell in a particular race on Tuesday, June 2, 1874." The Cromwell Road group passed around a copy of Datas's autobiography, and there on page 202 was the famous capper from his act—which in turn inspired Mr. Memory's climactic utterance in the film.*

Whoever thought of an idea, of course, in the end it was Hitchcock who chose whether to use it in the film. Bennett's job was to link up the *Plotto*-pieces, write it all down, and turn in a coherent draft. Then—in what was now an established Hitchcock tradition—came other writers to help polish the diamond.

On *The 39 Steps*, only one other was credited: Ian Hay (the pseudonym

* From *Datas: The Memory of Man:* "On Tuesday, December the 26th, 1899, which was Boxing Day, the horse fell at a fence in the Thornycroft Steeplechase at Wolverhampton, broke his leg and was shot on the course."

of Ian Hay Beith). Hay was a well-regarded light humorist whose novels and plays wittily skewered English life. Odd characters and colorful dialogue were his forte. This was the first of three instances where Hay, who seemed to be friends with everyone (including Bennett), made the final emendations on a Hitchcock script before shooting.

Everybody heard about what happened when cameraman Curt Courant, told by Hitchcock exactly what size lens to use for a particular scene of *The Man Who Knew Too Much,* didn't follow orders. When Hitchcock noticed the change in dailies, he was furious. "Applying his own opinions didn't exactly meet the story requirements," the director recalled. "So in a light but halting German I said a few things."

The director wanted a more accommodating cameraman for *The 39 Steps.* He chose Bernard Knowles, whom he'd known as far back as 1923, when Knowles assisted Claude McDonnell on Graham Cutts's *Flames of Passion.* A full-fledged cameraman since the late 1920s, with a reputation for fluidity and atmospheric lighting, Knowles would shoot *The 39 Steps, Secret Agent, Sabotage, Young and Innocent,* and (with Harry Stradling) *Jamaica Inn* for Hitchcock.

Hugh Stewart had moved on, so Hitchcock found another young studio editor, Derek N. Twist. (He, too, would later become a prominent director and producer.)

The casting was Hitchcockian all the way: The director chose Berlin-born Lucie Mannheim to play the exotic spy who attaches herself to Hannay during the ruckus and gunfire at the music hall, at the start of the film. Hannay scoffs at her tale of a secret network of foreign agents, until she is (rather implausibly) knifed by an assassin in his flat in the middle of the night. Hitchcock's generation could appreciate the subtext: Mannheim had been a prominent actress-director in Germany, and playing a character bent on saving England was her first job since fleeing Hitler; *The 39 Steps* launched a second career for Mannheim in English film.

Onetime matinee idol Godfrey Tearle, who had played Romeo in a silent film, was countercast as the sinister spy chief of *The 39 Steps,* who "can look like a hundred men" but cannot disguise the missing "top joint of his little finger." Wylie Watson was the unerring Mr. Memory. John Laurie was cast as the Scottish crofter, while Peggy Ashcroft, appearing nightly as Juliet opposite John Gielgud in Gielgud's production of *Romeo and Juliet,* accepted a rare screen role as the crofter's wife. Hitchcock "attended all her major stage performances and admired her boundlessly," according to her biographer, Garry O'Connor.

All along Hitchcock had envisioned a certain actor as the embodiment of John Buchan's gentleman adventurers. He had seen the handsome, mag-

netic Robert Donat onstage in Shaw's *Saint Joan,* in which he played Dunois, and in James Bridie's *The Sleeping Clergyman,* in which Donat famously acted a dual lead: a tubercular medical student and a doctor hero; and he had noticed the actor's "queer combination of determination and uncertainty." Recently, while under contract to Alexander Korda, Donat had made screen inroads in *The Private Life of Henry VIII,* which had been an unprecedented U.S. success for a British film, and then done well in Hollywood in *The Count of Monte Cristo.*

After making arrangements with Korda and Donat, Hitchcock looked around for a leading lady who might rival Donat in the looks and charm departments. His first choice was Jane Baxter, a genteel German-born English actress who had just finished making *The Constant Nymph.* But Baxter had made a "verbal promise" to appear in a play whose production dates clashed with the film; so Hitchcock thought next of Madeleine Carroll.

Carroll's acting expertise had been questioned by some critics, but her cool blond beauty—Hitchcock, with his "precise sarcasm," noted Ivor Montagu, described the actress's appearance as "glossy"—had made her one of England's top box-office attractions. The director had known her since the late 1920s, when Carroll was an up-and-comer playing smallish parts in lesser B.I.P. pictures, shot on the other side of the wall from Hitchcock's major productions. In person, he knew Carroll to have "a great deal of joie de vivre," in his words; she was amusing and unaffected. On-screen, though, her persona was icy, forbidding. When Carroll came in for a meeting, Hitchcock pointed out the discrepancy and gave her one of his favorite bits of acting advice: Be her natural self. (It was sensible advice, of course, but it often mystified actors: where was the acting in being yourself?)

The first trap was laid. Donat and Carroll weren't acquainted, and Hitchcock deliberately did not introduce them until the first day of photography in the studio, in the spring of 1935. Immediately after the two shook hands, Hitchcock handcuffed the two of them together for their scene on the moors—a brief, almost perfunctory scene, an odd choice for the first day of shooting. Then, after recording a few takes, Hitchcock announced that he'd lost the keys to the handcuffs. "I must find them," he muttered—and left the stage. Minutes passed—*hours,* according to some accounts—before he returned.

Handcuffs were a favorite Hitchcock prop—and had been added to Buchan's story for the same reason they were added to Mrs. Belloc Lowndes's. Freud was a hot topic at Cromwell Road, and Hitchcock counted on the sadomasochistic implications. The handcuffs "brought out all kinds of thoughts in [the audiences'] minds," Hitchcock explained in one interview. "For example, how do they go to the toilet was one natural, obvious question. And the linking together is a kind of—I think it relates more to sex than anything else."

As co-conspirator Dickie Beville pretended to go searching for Hitch-cock, the stars fidgeted, then grew flustered, then developed the very prob-lem Hitchcock had imagined: how to go to the bathroom. They were annoyed with Hitchcock, but also with each other—and before long they were acting not unlike their characters.

"There was nothing else to do, so we talked of our mutual friends, of our ambitions, and of film matters generally," Donat later recalled. "Grad-ually our reserve thawed as we exchanged experiences. When Hitch saw that we were getting along famously, he extracted the 'missing' key from his waistcoat pocket, released us, and said, with a satisfied grin, 'Now that you two know each other we can go ahead.' "

More traps were laid. Carroll's father was a distinguished professor of French at Birmingham University, and Hitchcock soon took to calling out, "Bring on the Birmingham tart!" The director was dead set on making every assault on her dignity he could, to prepare her for her on-screen in-dignities. "We deliberately wrote the script to include her undignified handcuff scene and being led out from under the waterfall looking like a drowned rat," recalled Ivor Montagu.

Adopting an attitude toward his actors that the story took toward their characters: it was a Hitchcock strategy rarely expounded upon; perhaps it was subconscious, but it was effective. Breaking down Pamela's frosty armor was one way of getting Carroll to "be herself." The handcuffs left her with some bruises; the jokes and sarcasm stung. But Carroll "took it all in grand spirit," Donat recalled, and Hitchcock responded by building up her part on the set, so "it turned out to be considerably more impor-tant at the end than we had originally intended."

Hitchcock wasn't often as tough on his leading men, and Donat was given a long leash. But the actor could be a bit of a clown, and during the crofter scenes Hitchcock had to apply the brakes rudely at one point when Donat and Peggy Ashcroft developed the giggles. After several attempts to restore order, the director exploded—smashing his fist into the bulb of a studio lamp. His violence startled them all, and they finished up soberly.

The iron fist was always there, lurking in reserve. But for all that, the crofter interlude was especially well done, a harrowing tintype of a young farm wife living in domestic captivity. The last shot of Ashcroft, poised in the doorway to follow Donat as he flees, then turning back inside with palpable regret, is as heartbreaking a shot as ever filmed. Markedly dif-ferent in tone from the rest of the high-spirited picture, the crofter section comes closest to achieving the director's stated ambition for *The 39 Steps* as "a film of episodes"—a rapid succession of turnabouts, sudden changes of pace, each, in his words, "a little film unto itself."

* * *

The last shot of *The 39 Steps* is striking. It's a particularly dense composition: backstage, as he lies dying, Mr. Memory delivers his last performance to the police, with chorus girls dancing and kicking onstage in the background (undoubtedly a process shot). Hannay and Pamela are viewed partially from behind, standing over the dying man. As the shot fades and the camera moves in close, they reach out to hold hands, Hannay's handcuffs still dangling from his wrist. Hitchcock had originally envisioned a different final moment, with Hannay and Pamela heading off in a taxi after getting married. Hitchcock shot that scene, but at the last minute decided against it.

There are people who insist that the two stars imitated their characters, falling in love during the filming. It's a rumor that's impossible to confirm at this remove—but Hitchcock enjoyed watching people fall in love on his watch, whether during one of his films or at one of his soirees. He was capable of matchmaking, or meddling brutally if he thought the pairing was wrong.

On camera, though, Robert Donat and Madeleine Carroll assuredly did fall in love. And *The 39 Steps,* a hurtling suspense story at its core, also works as a perfectly pitched romance. To Carroll, who shone as never before in this film, the director often paid his highest compliment, telling interviewers "the first blonde who was a real Hitchcock type was Madeleine Carroll." More than once he took "a great deal of credit" for launching her as a sex symbol.

Donat, who spent his "happiest months in a film studio" on *The 39 Steps,* according to biographer J. C. Trewin, was also launched into a new stratosphere. He emerged from his Hitchcock experience anointed as a man of the people, "the British equivalent of a Clark Gable or a Ronald Colman playing in a purely national idiom," according to C. A. Lejeune.

Even John Buchan was pleased. Appearing as a guest of honor at a banquet following the London premiere, the author publicly declared the Hitchcock film superior to his own book. The admiration was mutual: Buchan (Canada's newly appointed governor-general) and Hitchcock became occasional lunch partners, and for the next forty years the film director would flirt with adapting another Buchan novel.

When *The 39 Steps* was released, audiences flocked to see the new Hitchcock film. Critics hailed it—first in England, then in America ("one of the fascinating pictures of the year," Andre Sennwald rhapsodized in the *New York Times*)—as Hitchcock's best, most entertaining to date.

The interest from Hollywood was still percolating. Although Hitchcock continued to stay in touch with the Joyce-Selznick Agency (Donat was one of their clients), some job opportunities were rejected by Gaumont before he ever heard about them. American offers were "skillfully parried by [Michael] Balcon," wrote John Russell Taylor, "who felt understandably possessive about his protégé and liked to give the impression that he was

in fact Hitchcock's agent as well as producer and friend, all to keep him in Britain."

He still wasn't making dizzy money, but by 1935 the Gaumont contract had made Hitchcock prosperous. He had begun to accumulate an art collection, and maintained two homes. Cromwell Road was the home office, where Mrs. Hitchcock continued as her husband's closest collaborator and severest critic—the only critic, he liked to say, whose opinion he feared. Shamley Green was where friends and the extended family congregated on weekends—Hitchcock's mother, but often his brother and sister too.

Viewed by all as a well-mannered but precocious child, Pat Hitchcock turned seven the year *The 39 Steps* was produced; after finishing preschool, she began classes at Mayfield, a Catholic boarding school. With Pat in school, Mrs. Hitchcock could immerse herself more in her husband's films, although she no longer kept hours at the studio as before.

Between films there was always time set aside for rest and travel, regularly to Paris and the south of France, and often to Italy. After *The 39 Steps* the family made a trip to Rome, where, among other things, Hitchcock had arranged a private audience with the pope. The immediate family was often accompanied on vacations by Hitchcock's mother, and sometimes by his favorite relatives, Nellie and Teresa. Another frequent guest was Joan Harrison, by now the director's amanuensis and increasingly accepted as part of the family.

More than one close associate observed that Hitchcock preferred the company of women. Women surrounded him, assisted and insulated him professionally.

One difference between Hitchcock and so many other directors was that he was a staunch family man—a facet of his character that belies the image of a man obsessed with murder and evil. A surprising number of his films, especially in the first half of his career, were in one sense about true love, and protecting one's marriage and family.

Another difference is that directors in this era were so often notorious for exacting a form of droit du seigneur with actresses. Not Hitchcock: though there are gaps and ambiguities in his record. He was sometimes capable of questionable behavior.

At parties, if Alma was not there and he had drunk too much, he was capable of pawing a woman or grabbing at her behind. One of his tricks was to kiss a woman hello or good-bye, then surprise her by thrusting his tongue inside her mouth. He wasn't immune to crushes on young actresses, though never famous ones. Now and then he would escort a crush around the studio in fatherly fashion, waiting and watching—eternally waiting and watching.

There is no evidence Hitchcock ever engaged in a full-fledged affair. And certainly any fantasy of his promiscuity is suspect, given the fact that he was sexually impotent.

Before Masters and Johnson's groundbreaking *Human Sexual Response* in 1966, impotence—or "phallic fallacy," as they dubbed it—was a little-understood condition. Today its various causes, psychological and physical, are better known. Impotence can be triggered by a variety of circumstances, from poor circulation to alcoholic intake. Masters and Johnson were also careful to cite the possible "monotony of a repetitious sexual relationship" and "preoccupation with career or economic pursuits."

Any combination of these possibilities is applicable to Hitchcock—especially his weight, which was aggravated by excessive eating and drinking. In his era impotence, usually a source of major embarrassment, was not widely diagnosed or discussed.

Right around the time that Masters and Johnson published their study—the sort of book Hitchcock might have sought out in advance, in galleys—he began to drop public hints to interviewers about his impotence. He confided to more than one person around the time of *The Birds* that he had long been "chaste." He liked to say he'd only ever had sex once, to conceive Pat—and that he found the mechanics unpleasant. "I was so fat I had to conceive my daughter with a fountain pen!" was a joke he was fond of making, even in front of Alma.

"I know that Hitch was functionally impotent," said writer Jay Presson Allen, who became close to him on *Marnie*, "because of everything he said to me. I don't think it bothered him that much. I think he used it in his work. Everything was channeled into the work."

When François Truffaut asked Hitchcock why his love scenes were so charged with intimacy and passion, the director brushed off the question. "I don't get any particular kick out of doing that sort of scene myself," he replied. "I'm a celibate, you know. I'm not against it, but I just don't think about it very much."

"Yes, but your pictures are full of it," Truffaut persisted.

"Maybe that's the outlet, eh?"

Chaste and *celibate* were code words, adding a poignant subtext to all those voyeuristic men peering through binoculars and windows and key-holes in his films. Hitchcock wouldn't have been the first director with a seemingly happy marriage to chase after the occasional fling. But he felt himself to be odd-looking, and probably irretrievably impotent. The circumstances had to be perfect, as circumstances rarely are. He wasn't a chaser; he was a watcher and a waiter.

At least once, in the 1930s, he was fortunate in the circumstances. It was after a holiday gathering at Cromwell Road—as likely as not, just after *The 39 Steps*. After small gifts were handed round, the inebriated

guests piled into taxis to head off to another party. Mrs. Hitchcock was tired and stayed home, while the director chanced to sit snugly next to a young actress, whose gift had been a toy tin trumpet. They handed the trumpet back and forth, trying to get a squawk out of it, but Hitchcock, red-faced and squirting laughter, couldn't deliver. The actress said it was very simple; it was like a proper blow job. And how does one perform a proper blow job? the innocent inquired, laughing harder. Upon which the actress got down on her knees and demonstrated.

Only a few believed this anecdote, which Hitchcock saved for private on rare occasions, although it may have inspired the oft-stated public version: "An English girl, looking like a schoolteacher, is apt to get into cab with you and, to your surprise, she'll probably pull a man's pants open." Only a few believed a similar tale, later, involving Ingrid Bergman. But as his many published interviews demonstrate, Hitchcock was a relatively truthful man—sometimes an exaggerator, rarely a liar. And so even this story may very possibly be true.

Nearly all of *The 39 Steps* was shot within the confines of Lime Grove. One exception is the scene where Hannay escapes his pursuers by leaping out of a train speeding along what English audiences would have recognized as the main northeast rail line, stretching over the mile-and-a-half-long Forth Bridge, just north of Edinburgh. The day or two of location filming that scene required was all the budget could afford.

The Gaumont years were not luxurious, but undoubtedly they were Hitchcock's happiest in a studio. Lime Grove hummed like a college campus with the brightest students and youngest professors. And the work was Hitchcock's oxygen—he was always starting up his next film while finishing another. By the time *The 39 Steps* was showing in theaters, the script of his next project, *Secret Agent,* had made it through several false starts, and was nearly ready to go.

On the surface, the new film—based on a series of related Somerset Maugham short stories published as a book—was a third consecutive spy-saboteur story for Hitchcock. But the new one would take audiences down a different road. Success and stability in the director's life had a way of driving him toward darkness and depth in his films.

"The Traitor" and "The Hairless Mexican" were among the stories collected in Maugham's *Ashenden, or The British Agent.* Gaumont owned the rights to the book and also to an Ashenden play written by *Daily Telegraph* critic Campbell Dixon.

Again, Hitchcock would use the stories mainly as a springboard. He and Charles Bennett—still his chief constructionist—borrowed their two principal characters (Ashenden and the "hairless Mexican"), a locale (Switzer-

land, conveniently one of Hitchcock's favorite places), and the premise of "The Hairless Mexican" (that Ashenden, assigned to assassinate a foreign agent, kills the wrong man). Little else came directly from Maugham.

The writing was sometimes a struggle. Bennett wasn't the first or last writer to notice that Hitchcock had a store of dissociative techniques that helped alleviate the tension when the team was stuck for ideas. He interrupted dry spells with irrelevant gossip or long schoolboy jokes. One time he insisted they adjourn and reconvene on the roof of Croydon Airport, another time on a train bound for the Riviera, once at a bullfight in Barcelona.

During the writing of *The 39 Steps*, Bennett recalled, Hitchcock authorized Joan Harrison to hire a steamer with an orchestra on board "just for the three of us." The boat pushed out into the Thames, sailed to Greenwich and back, with just its three passengers. "This was supposed to be a story conference, but not a bit of it, not a bloody word was spoken about the story," said Bennett. Still, they returned feeling refreshed.

Hitchcock and Bennett made a good marriage. For one thing, Bennett was always up for any sort of Hitchcockery. The two took long drives together, alert for "anything weird" along the way, for Hitchcock was "always fascinated by anything out of the ordinary," in Bennett's words. One time, passing over a railroad bridge, the two hopped out to descend stairs and explore a derelict railway station. Another time, they sneaked into the generations-closed Princess's Theatre on Oxford Street, once the London base of the famous actor Charles Kean. They stood together on the stage of the vast auditorium, silently absorbing the spooky atmosphere. Bennett had no doubt that Hitchcock was storing it all up in his brain for some future use.

On another occasion, the collaborators drove and drove as they talked, and ultimately ended up at a pub somewhere in the depths of Cornwall, where they sat around drinking liberally and listening to Sophie Tucker, whose brassy voice emanated from the next room. They presumed it was a gramophone, but after a while realized it was the Red Hot Mama herself, sitting all alone at a piano and singing to herself. Any further work was out of the question. "Recognizing us," Bennett recalled in his unpublished autobiography, "she continued to sing—a beautiful one-woman performance before an audience of two."

More than once Hitchcock and his faithful writer checked into remote country hotels under pseudonyms. They booked rooms separated by a shared bath, and Bennett was amused and touched, mornings, when awakened by Hitchcock "dressed as a hotel servant as he infinitely politely announced, 'Your bath is ready, sir.'" And it was. Hitchcock himself had drawn and prepared his bath to temperature.

Together, they went to the phony "All in Wrestling" shows (which

Hitchcock loved), the opera (which the director also loved, though he was capable of snoring in full dress through a masterly performance of Wagner's *Die Meistersinger von Nürnberg*),* and Center Court at Wimbledon. They even played some tennis during breaks, with Hitchcock and Joan Harrison squaring off against Mrs. Hitchcock and Bennett. "But I never once saw Hitch go after a ball," recalled Bennett. "The tubby little man would just stand there and stolidly wait until the ball came directly to him. It never made for a very good game."

Stumped during the writing of *Secret Agent*, Hitchcock and Bennett flew to Basel, Switzerland, where Ivor Montagu was vacationing, collecting Montagu in a resort town and proceeding to the Lauterbrunnen Valley, to roam around its woodlands and waterfalls. "Amusing days, searching for ideas and locations," recalled Bennett.

After settling on their story's big finish, Hitchcock continued alone by train from Switzerland toward the Balkans so he could ponder how to visualize the finale—absent in Maugham—in which Ashenden and the "hairless Mexican" finally corner their target on a train. One of Hitchcock's wildest train rides, it ends in a splendid crash and explosion.

But the marriage to a writer was always a marriage of convenience, and after Bennett was done with his draft he was followed again, to his growing resentment, by fix-it writers who spruced up his pages. In this instance, two others were credited: the equable Ian Hay and Jesse Lasky Jr.—the son of the Paramount magnate, and a future writer for Cecil B. De Mille.

Photography was set to begin in October 1936. Hitchcock's cameraman was still Bernard Knowles, now joined by Charles Frend as his editor. Frend had been a lowly cutting-room assistant for *Lord Camber's Ladies* when Hitchcock (the producer) started grumbling over a poorly assembled sequence one day, saying he thought the bloody fool assistant could splice it better. Frend took up the gauntlet, and when Hitchcock moved on to *Waltzes from Vienna*, Frend got up the courage to phone and ask to be his editor. To his surprise, Hitchcock remembered the young cutter and invited him over to Cromwell Road for drinks.

"What makes you think you are experienced enough to cut a picture?" Hitchcock challenged Frend over cocktails.

"Well," admitted Frend, "I'm not really."

"You know what it'll mean, don't you? At the end of the day's work, when I'm exhausted I shall have to come to the cutting room and show you how to do it."

* He catnapped notoriously, even during plays in which he had invested money—for example, Rodney Ackland's adaptation of Hugh Walpole's novel *The Old Ladies*, starring John Gielgud. "If it's one he was very keen on seeing," Alma once explained, "but he has fallen asleep, then he asks me what happened."

"Yes, Mr. Hitchcock."

"Well," grunted the director, after staring at the young pup for what seemed to Frend an awfully long time, "as far as I'm concerned, you've got the job."

"Hitch could be very kind and thoughtful," remembered Frend. "He liked enthusiasm and I was certainly full of enthusiasm."

After *Waltzes from Vienna* was over, Hitchcock summoned Frend and asked if he had his next film job lined up. Frend said no. "You should stay here [with Gaumont]," Hitchcock advised. "You don't want to go back to B.I.P. with your tail between your legs, do you?" Then he picked up the phone and made a show of calling Michael Balcon's brother, S. C. "Chan" Balcon. "Chan," burbled Hitchcock, "Stapleton of B.I.P. has just been on to Charlie Frend. He wants him back. You're going to lose him if you're not quick."

Brother Chan was obliged to ask, "Charlie who?" He hadn't the slightest idea who Frend was. "My editor, Charles Frend," smoothly explained Hitchcock. "He's going back to B.I.P. You'd better grab him quickly." So friend Frend was fixed up with a solid contract at Gaumont, where he was immediately assigned to the next Jessie Matthews musical. Eventually Frend would edit three Hitchcock films: *Secret Agent,* then *Sabotage,* and *Young and Innocent.* He was another one of the informal club of "Hitch's boys," and after some years as an editor developed into a solid director at Ealing.

For the mistakenly targeted older couple, who turn out to be ordinary tourists, the director cast Percy Marmont (in his second Hitchcock film) and Florence Kahn, a.k.a. Lady Beerbohm—the wife of critic, caricaturist, and essayist Sir Max Beerbohm. Kahn, once famed as Richard Mansfield's leading lady, had all but retired from the theater, but Hitchcock saw her in a revival of *Peer Gynt* at the Old Vic. He coaxed her into her only screen appearance in *Secret Agent.* (Hitchcock proudly told interviewers that the stage actress had not only never visited a film studio before, "she had never before seen a film in her life.")

Robert Young was a curious choice for the German agent, but the versatile American actor had been imported at the behest of Michael Balcon, who hoped his name might help Gaumont push for wider U.S. bookings. (Young "is typical of the polished Hollywood actor," said Hitchcock. "He is easy to handle because of his long training in films.")

Peter Lorre was brought back from Hollywood, where he had settled after *The Man Who Knew Too Much,* brandishing his dementia in *Crime and Punishment* for Columbia and *Mad Love* for MGM. The Mexican General was the film's choice role: as Maugham wrote, "He was repulsive

and ridiculous, but you could not take your eyes from him. There was a sinister fascination in his strangeness." Hitchcock had earmarked the part for Lorre from the start, even referring to him as "Peter" in the working script.

Lorre wasn't Mexican, however, so the script had to explain that away; nor was he hairless, so Hitchcock ordered a makeover. A makeup artist joined the actor on the boat train to London, oiling and curling his hair— adding a narcissistic aura to Lorre's character.

Hitchcock also gave a nubile, slightly plump Lilli Palmer one of her first noticeable roles in *Secret Agent*, as a young woman ("Lilli") who is picked up by the Mexican General; he drops a chocolate down her dress, and by next morning has her set up in a hotel room. Lilli is the link to Karl (Howard Marion Crawford), her boyfriend, who works at a chocolate factory—Hitchcock shorthand for Switzerland. The chocolate factory is also spy headquarters.

Secret Agent featured a female agent who poses as Ashenden's wife, then falls madly in love with him; she wasn't in Maugham's stories, but dated to the Campbell Dixon play. The film script would build up the part for the lady of the hour: Madeleine Carroll.

The director was intending to reunite the two stars of *The 39 Steps*, Carroll and Robert Donat, seeing Donat as a perfect Ashenden. But Donat had other obligations, so the director turned to John Gielgud, already a stage legend; the curtain had just rung down on his famed production of *Romeo and Juliet*, in which Gielgud directed Laurence Olivier as Romeo while he himself played Mercutio, and doubled as the Chorus.

Thus far Gielgud had registered only weakly in motion pictures. The medium gave him shivers: he hated the endless waiting around for lighting and camera setups, and the discontinuous filming of facial expressions and bits of dialogue. Film confused his performance and sapped his confidence. Hitchcock thought he could give Gielgud a confidence transfusion, and he wooed the stage actor with compliments—and by describing the Ashenden part as "another Hamlet, only in modern dress," according to one Gielgud biographer, Ronald Hayman, "who cannot reconcile himself to the necessity of killing."

The peerless Shakespearean said yes, and even got involved in the casting, recommending actors for parts. Still, Gielgud turned up at Lime Grove on the first day feeling uneasy. His trepidation only mounted, for many of his scenes were with Lorre, whose angelic comportment during rehearsals evaporated once the camera rolled. Then the devil came alive, tossing off asides and stage business (a cigarette stuck precariously between his lips as he slurred his lines) that stole attention from anyone unlucky enough to share the screen with him. Gielgud was thrown—for him, a man of the theater, the script was bible—and when he looked to Hitchcock he met an inscrutable stone face.

The stone face was far from pleased. Lorre's morphine addiction, in check during *The Man Who Knew Too Much,* had spiraled sadly out of control. The actor had been hospitalized in the United States; now, in London, Gaumont was forced to help arrange his injections. And when they weren't conveniently arranged, as happened more than once, Lorre sneaked away between setups to satisfy his habit.

Other books uphold the legend that Lorre rivaled Hitchcock at practical jokes, at one point supposedly avenging himself by having fifty singing canaries delivered to Cromwell Road. "As the versions multiplied," Lorre biographer Stephen D. Youngkin wrote, "so did the flock of birds." Lorre's pranks and quirks had been amusing during *The Man Who Knew Too Much,* but his behavior on *Secret Agent* was self-destructive—worse, unprofessional. His increasingly bizarre antics "wore thin" with Hitchcock, Youngkin wrote. One day Lorre arrived at the studio wearing an "intricately woven waistcoat of many colors," which he showed off to everyone. When the actor strutted up to Hitchcock, though, the exasperated director made no comment; he simply upturned his coffee and spilled it all over the waistcoat.

At least Hitchcock didn't splash any hot coffee on Gielgud. But the stage legend was thoroughly discomfited by the director's demands: Gielgud spent hours in front of Lake Como back-projection scenery, with smoke machines blowing fumes across his face, and hours more lying under girders and rubbish, posing for inserts for the train-wreck finale.

All of Gielgud's cumulative wisdom seemed irrelevant to the task at hand, and Hitchcock's standard advice, that Gielgud "rub out everything and start blank," didn't help in the slightest. "Be yourself" was no kind of advice for Gielgud, an actor who worked by transforming himself into another person entirely. "Hitchcock has often made me feel like a jelly," Gielgud told interviewers at the time, "and I have been nearly sick with nervousness."

Secret Agent fell behind schedule, and in November Gielgud and Olivier returned to the stage to reverse their *Romeo and Juliet* roles. Some nights, Gielgud left the theater and returned to the studio after midnight to shoot remaining scenes.

Hitchcock's casting gambles were hardly infallible, and in the end Gielgud was neither the Hamlet nor the Romeo the film called for. His business with his "wife" (Carroll)—particularly the "morning after"—is amusing, but their scenes were never as romantic as intended (like Ivor Novello and Henry Kendall before him, Gielgud was miscast as a raging heterosexual). Disillusioned, Gielgud wouldn't act in pictures again for twenty years.

But *Secret Agent* has marvelous flourishes that are treasured by Hitchcock fans: the folk ensemble singing mournfully as they roll coins around in a big wooden bowl; the wrong-man killing (eerily observed through a

telescope as it transpires on a distant, snowy ridgetop); and the train-wreck finale, all low-budget shrieking noise, smoke, and distorted angles. These were highlights, certainly—yet coming after the sparkling *The 39 Steps,* Hitchcock's adaptation of Maugham was a letdown for audiences and critics alike.

Hitchcock, though, was the rare director who could stand to blame himself. In later years, he would admit on more than one occasion that he had committed mistakes, had never conquered the material. "I liked *Secret Agent* quite a bit," Hitchcock said. "I'm sorry it wasn't more of a success."

The director never worked with greater efficiency than at Gaumont, aided by the tight-knit fellowship of artists and aides who lent his films a marked continuity of subject matter and style.

By the time *Secret Agent* was ready for theaters, Hitchcock and Charles Bennett had prepared their adaptation of *The Secret Agent,* a Joseph Conrad novel and another spy-saboteur suspense story in the mold of *The Man Who Knew Too Much, The 39 Steps,* and *Secret Agent.* It was a natural choice for Hitchcock, though he knew from the start that Conrad's coincidental title—and much of his story—would have to be scrapped.

Conrad's cautionary tale about a ring of terrorists operating in London was first published in 1907, thus predating World War I, but Hitchcock saw immediately that, like John Buchan's novel *The Thirty-nine Steps,* the story could easily be updated to 1935 England.

If *Ashenden, or The British Agent* was minor Maugham, *The Secret Agent* was major Conrad ("a work of depth and genius considered one of his greatest," in the words of one literary critic). Even so, Hitchcock felt free to take his usual liberties with the material.

The film script did preserve three of Conrad's main characters (Mr. and Mrs. Verloc, and Stevie, Mrs. Verloc's young brother), but it dropped Mrs. Verloc's mother, another figure who serves an important purpose in the book. The script also retained a key plot situation—the unintended bombing that kills Stevie and precipitates Mr. Verloc's downfall—though in Conrad's novel Stevie's death comes from his stumbling against a tree, and is recounted by a chief inspector who brings the news. Hitchcock upped the status of the incident by putting Stevie on a crowded bus, and planning a piece of tour de force cinema.

Even before the script was finished, in fact, in November 1935 Hitchcock sent a second unit to photograph the Lord Mayor's Show—the annual procession to the Law Courts for the lord mayor's oath of office, which entails a parade and crowds. This newsreel-style footage would later be incorporated into the sequence that begins with Stevie running a seemingly innocent errand for Mr. Verloc, carrying the time bomb with him.

The settings, too, were more Hitchcock than Conrad. Long before *The Birds* the director showed a fondness for the winged creatures which crop up repeatedly in his films as harbingers of disaster. For his Conrad adaptation, Hitchcock envisioned a bomb-making headquarters masquerading as a pet shop specializing in birds; arriving there to pick up a timed explosive, as a ruse Verloc buys a pair of songbirds. "The birds will sing at 1:45!" the bomb maker merrily reminds him.

No such bird shop appears in the Conrad novel; nor in the book does Verloc meet with his terrorist contact in the unlikely public setting of the London Zoo Aquarium. In the film they hold a lengthy discussion in barely discernible tones, standing with their backs to the camera as they gaze upon giant sea creatures swimming around in a vast illuminated tank. After his contact departs, Mr. Verloc continues to stare at the water tank; Hitchcock dissolves from the fish to moving traffic in Piccadilly Circus, and then into a vision of the buildings crumbling and sinking as though from an imagined explosion.

Finally, nowhere in the book do we encounter an undercover agent named Ted, an impotent man of the law desperately in love with Mrs. Verloc. This was another Hitchcock invention, and a character written to attract a leading man such as Robert Donat, whom the director was still pursuing.

Mr. Verloc is one character who does originate with Conrad's novel, but Hitchcock made a telling change in his occupation. Conrad's Verloc owns a nondescript variety-goods shop; Hitchcock transplanted him to one of his Chinese boxes, making Verloc the proprietor of a movie theater in southeast London, which shows films that are a "bit too odd" (probably German expressionist). Like Lilian Hall-Davis in *The Ring,* Mrs. Verloc takes tickets out front. (The undercover policeman works next door to the movie theater at a greengrocer—"like a juxtaposition of Hitchcock's own formative milieux," in the words of Charles Barr.)

The movie theater setting prompts one of the film's highlights: the sequence that begins after Mrs. Verloc learns of Stevie's death and realizes the truth about her husband—that he is a saboteur who ineptly blows up innocent people, including her own brother. She stumbles into the aisles of the theater, just outside their living quarters, where a packed audience is rapturously watching a cartoon before the main feature. (The cartoon is a "Silly Symphony" by one of Hitchcock's favorite filmmakers—Walt Disney. He often said that Disney had the best breed of actors because he could always rub them out if he didn't like their performances.) Still in shock, Mrs. Verloc sits down among the crowd. Glancing up at the screen, she finds herself suddenly chuckling and laughing, a moment of giddiness that veers into darkness.

When the cartoon's Cupid slays Cock Robin with an arrow, it triggers the

186 | *THE HEIGHT OF HITCHCOCKERY*

pointed musical refrain: "Who Killed Cock Robin?" Mrs. Verloc gives a start, and sets her jaw to return for a showdown with her husband. The result: another famous Hitchcockian scene in the "knife, knife, knife!" vein.

If progress on the script was fitful, it was because the three Hitchcocks couldn't settle on a proper ending. Hitchcock agonized over his endings. There had to be a crescendo to top everything that came before, and then "closure"—a note of pointed ambiguity to round things off. Above all he wanted to avoid the kind of ending he called a "hat-grabber": he wanted to catch audiences before they fled up the aisles.

The ending to Conrad's novel features the despondent, guilt-ridden Mrs. Verloc committing suicide, throwing herself off a ferry bound for France. That was impossible, Hitchcock knew; the studio would never accept it, and for good reason—it would leave the audience without any hope. Someone came up with the idea of one of the bird-shop bombs destroying the theater, but how would they deal with the fact that Mrs. Verloc has already killed her husband?

When Hitchcock got stuck, he inevitably borrowed from his earlier work. ("Self-plagiarism is style," he was known to observe wryly.) He borrowed, quite transparently in this instance, from *Blackmail*. In the final scenes of *Sabotage*, the policeman, Ted, tries desperately to dissuade Mrs. Verloc from giving herself up for the killing. He loves her too much to sacrifice her to the whims of justice. "What chance would you stand with a judge and jury?" he asks.

She rushes up to another officer, managing only to gasp "He's dead!" before Ted cuts her off—just as another hopelessly enamored detective does in *Blackmail*. Then an explosion rocks the theater, burying Verloc and his bird-shop comrade. Afterward the second officer thinks over what she said, and muses, "She said it before—or was it after? I can't remember." And the blast has destroyed all the evidence—a nice touch.

When Bennett had completed his draft, Hitchcock called in the reinforcements: writers Ian Hay, Helen Simpson, and the multitalented E. V. H. "Ted" Emmett worked away polishing scenes as the autumn start of filming approached.

Before he met her, Hitchcock admired the American actress Sylvia Sidney, who was held in high regard for sensitive performances full of dignified suffering. He, in fact, had spoken with Charles Bennett about crafting an original story to showcase "the masochistic Sidney," and before *Sabotage* (as the Conrad film was retitled) they spent time compiling notes for a "Sylvia Sidney Subject" that would exploit her ability to "suffer every torture, then react with arresting and explosive assertiveness," according to Bennett. Their notes were tabled in favor of *Sabotage*.

On one of his Hollywood trips, producer Michael Balcon managed to sign the petite brunet star, who had just finished *Fury* for Fritz Lang at MGM. Hitchcock was so excited about the casting that he made the exceptional gesture of phoning the actress aboard her ocean liner via two-way radio as Sidney made the journey across the Atlantic. (Hitchcock relished protracted, expensive overseas phone calls and lengthy telegrams.)

The character of Mrs. Verloc's brother, Stevie, saw minor changes: around fourteen and "addled" in the novel, in Hitchcock's film he is merely boyish. England's leading boy actor, wavy-haired Desmond Tester, who looked younger than his seventeen years, got the part.

Peter Lorre would have been right for Mr. Verloc, if Hitchcock hadn't washed his hands of him. But the director snapped up another refugee passing through London—Oscar Homolka, a veteran of stage and screen in Vienna and Berlin, who may have lacked Lorre's sly, humorous quality, but at least evinced the same world-weariness.

Unquestionably, though, the greatest disappointment was the loss of Robert Donat. Donat had accepted the role of Ted and been announced for the film in the spring of 1936, but he suffered from chronic asthma, and when he came down with acute bronchitis, Hitchcock was forced by Sidney's arrival and the pressing schedule to proceed without him.

Hitchcock bore the actor no grudge. While Donat was recuperating, the director sent him joke gifts at the hospital: kippers, to coax back his ailing sense of smell. Over the years the two stayed friends, keeping up a warm, kidding correspondence, which often centered around reuniting for another film. Unfortunate timing of the projects, as well as Donat's chronic indecisiveness, managed to conspire against such a reunion.

At the eleventh hour, though, Hitchcock and his team were forced to rewrite the part for John Loder, a tall, dashing heartthrob under studio contract. Loder had film experience dating back to 1926, but he just wasn't "suitable" as Ted, as Hitchcock later told François Truffaut. Loder lacked the nuance—the emotional dynamism—of Donat, and his casting pushed the film toward a more single-minded solemnity. But when it came to casting his leads, even at the height of his reputation in England Hitchcock often had to compromise.

Unsuitable actors didn't bother Hitchcock as much as those who refused of their own accord to accommodate him—to do what he believed they were capable of doing. He couldn't have been more enthusiastic about Sylvia Sidney, which is why her contrariness came as a surprise.

The real problem, according to Charles Bennett, was that when Hitchcock and the leading lady met, they didn't hit it off. "Sylvia just wasn't Hitchcock's type," recalled Bennett. It was a problem for Hitchcock if he

didn't *like* an actress, particularly one who was going to be playing a deeply sympathetic character in one of his films.

Sidney's problem with Hitchcock took an odd form: although she ought to have known better—she'd been appearing in pictures since 1929—she behaved like a female Gielgud, unable to fathom the process of filmmaking in preordained shots and angles. "She could not piece together in her mind what Hitchcock was after, the meaning of separate shots and how the scene could be constructed from them," recalled Ivor Montagu. "She had always acted a scene right through, and she badly needed words, a single sentence or even a phrase, to start a mood off for her, as a singer needs a note to find the key.

"We were happy with her work. She felt uncertain and would not be reassured. As befits a great star, she had, in Hollywood fashion, been built a little tent on the [Shepherd's] Bush studio floor so that she could rest between shots from inquisitive eyes. Many were the times I was called up from my office, in which emergency of course it is the AP's [associate producer's] duty to embrace and comfort her as best he can."

It was almost a day-to-day struggle with Sidney. One of her most important scenes took place after the Disney-cartoon sequence—when, knowing that Verloc's bomb has killed her brother, Stevie, she returns to their living quarters to serve him supper.

This was one sequence that Hitchcock had faithfully extracted from Conrad:

"Her right hand skimmed slightly the end of the table, and when she had passed on towards the sofa the carving knife had vanished without the slightest sound from the side of the dish. Mr. Verloc heard the creaky plank in the floor, and was content. He waited. Mrs. Verloc was coming. As if the homeless soul of Stevie had flown for shelter straight to the breast of his sister, guardian and protector, the resemblance of her face with that of her brother grew at every step, even to the droop of the lower lip, even to the slight divergence of the eyes. But Mr. Verloc did not see that. He was lying on his back and staring upward. He saw partly on the ceiling a clenched hand holding a carving knife.

"It flickered up and down. Its movements were leisurely."

In the novel Verloc is reclining on a sofa; the director restaged it, putting Verloc at a table waiting for his evening meal. Mrs. Verloc brings a plate of food to him and begins to serve the roast. The knife she is carrying appears to act "as a magnet," in Hitchcock's description. "It's almost as if her hand, against her will, is compelled to grab it. The camera frames her hand, then her eyes, moving back and forth between the two until suddenly her look makes it clear that she's become aware of the potential meaning of the knife."

The sequence was pure Hitchcock—"closeups and inserts, eyes, expres-

sions, forks, potatoes, cabbages," in Montagu's words. Yet the scene required not a word of dialogue from Sidney, and it wasn't long before the exasperated actress, feeling irrelevant, broke into tears, threatening to quit. "Would you give us a few more hours," Montagu pleaded, "until you see the rough cut?"

The sequence was pulled together in a hurry, and Hitchcock, Montagu, and editor Charles Frend joined Sidney in the screening room. The actress couldn't help but be impressed by the rough cut—it was a powerful montage, destined to become one of the most famous sequences in Hitchcock's oeuvre. The actress emerged from the projection room, shaken. "Hollywood must hear of this!" she declared, appeased.

Yet the truce was only temporary. Sidney took offense at Hitchcock's sense of humor, his way of summoning young Desmond Tester to the set: "Where's the testicle?"* The director teased Tester for general "amusement of the cast and crew," Sidney said later, to the "total mortification of the kid." Perhaps—Hitchcock wasn't above mortifying a "kid" if he was in the mood. But this kid was also seventeen years old, and the character he was playing was the buffoon of the film. Tester himself insisted in subsequent interviews that he enjoyed working for Hitchcock "because he was funny" and played "lovely practical jokes."

The truce finally collapsed when Hitchcock called for retakes in the carving-knife scene. He needed more close-ups of Sidney's hands. She asked for rehearsal. Calmly, Hitchcock assured Sidney, "You don't need any rehearsal in this shot, darling, you've already killed him!" But she couldn't be mollified, and tried to pull rank. After all, she was the star, and making a higher salary than the director (or so she insisted, in later interviews). "I went right to Lord so-and-so [Balcon] who was the producer and told him, 'This man is impossible. I can't do a scene when we haven't come to that part in that scene. I can't look down, terrified, when there is nothing to be terrified about. And he just wanted to shoot my hands. Lord so-and-so listened patiently and then said, 'Sylvie . . . you have to trust him . . . he knows what he is doing.' And no matter how much money I was making, neither Hitchcock nor the producer could be moved, and I ended up looking down with my hands out in front of me."

Sidney lived to a ripe age, and gave other interviews that sniped at Hitchcock, helping to stoke the myth of a man who regarded actors as cattle.

And the director, for his part, returned the favor. Hitchcock claimed that even Sidney's hands were disappointing, that he cheated with close-ups of another actress's. He found it difficult to get "any shading" into her

* Not far removed from "Hitch, without the cock."

face. (He wasn't the only director with such complaints; Fritz Lang, who used Sidney in three films, once fired off a gun near the actress without warning, so desperate was he to disrupt her customary placid expression.) "On the other hand," Hitchcock conceded to François Truffaut, "she had nice understatement."

No matter what day-to-day problems he might have endured, Hitchcock had been shielded for several years by Ivor Montagu and Michael Balcon. All the sadder, then, that a disagreement with the two producers caused friction during the filming of *Sabotage,* and that because of this—and a mounting studio crisis—Hitchcock never again worked with either man.

The director had asked to build a facsimile tram for the scene where Stevie is crammed on a slow-moving public transport, unwittingly carrying Mr. Verloc's time bomb. Citing the deteriorating financial situation at Gaumont, Montagu said no. Building a tram and laying tracks would drive up the budget, and the footage was expected to consume less than a minute of screen time. Montagu thought that a simple bus would do as well.

Hitchcock insisted that a tram would communicate "London" to American audiences in a way that a mere bus would not. He tried going over Montagu's head, but Balcon backed Montagu. Regardless, Montagu asked to be released from Hitchcock's unit, feeling he had lost the director's respect over the issue. Years later Montagu insisted he carried no grudge, and added, in retrospect, that Hitchcock had probably been right about the tram.

But Montagu was right about the financial emergency. Just after photography on *Sabotage* was completed, in December 1936, Isidore Ostrer arrived at Lime Grove with a list of cost-saving dictates, including people to be fired—starting with well-paid executives like Montagu and Balcon. Balcon had been feuding with the Ostrers, and Montagu was merely expendable. The Ostrers announced drastic cutbacks in production, and Gaumont was reorganized under Balcon's former assistant, Edward "Ted" Black.

Hitchcock remained intermittently cordial with Balcon over the years, and he saw Montagu at least once more, after World War II, when he was making a film in England. Montagu and Angus MacPhail joined the director for dinner in his Claridge's suite. "He was as humorous, amiable and affable as ever," recalled Montagu. "A splendid evening."

Although today *Sabotage* is considered a near masterwork, the Joseph Conrad adaptation upset some critics in 1936, with its bleak vision of misguided politics.

C. A. Lejeune, the reviewer for the *Observer*, felt betrayed, angrily confronting the director after the premiere ("with clenched fists held in the air," according to Hitchcock) and reproaching him for callously blowing up the boy, Stevie, in full view of the audience. As Lejeune later reported in one of her columns, they had "a very acid talk on that occasion, and for quite twenty-four hours we didn't think well of each other."

Hitchcock had a sophisticated attitude about critics. He thought they had a job to do, and sometimes they wrote foolish things, but he prided himself on never having written "a letter of protest over a bad review to a paper or magazine in my whole lifetime." Sometimes, too, they wrote well, and what they wrote stayed with him. Lejeune was a friend and frequent visitor to Cromwell Road. "As a family man" he took her comments personally, and "apparently brooded," said Lejeune. "I have his own word for that, and his wife's, and his secretary's."

"Aside from a few scenes" he could take pride in, *Sabotage* turned out "a little messy," Hitchcock reflected in later interviews. He often said that if he'd had it to do all over again he would stage Stevie's death differently, going for gradations of suspense rather than a shock effect. Probably, he allowed, Stevie's death should have taken place offscreen.

Ironically, in the United States, where the gloomy social context was less threatening—and where *Sabotage* was retitled *The Woman Alone*—the film found more appreciative critics. After years of having his work weakly distributed, snipped by censors, or underrated by reviewers, Hitchcock was finally making an impression in the States. Though his films were still shown mainly in houses that catered to foreign-language or "art" films (indeed, the *New Yorker*, assessing the vogue for Hitchcock films, declared it was "mainly a local phenomenon" confined to Manhattan), *The Woman Alone*—following *The Man Who Knew Too Much*, *The 39 Steps*, and *Secret Agent*—solidified the director's growing reputation, becoming his fourth Gaumont film to rack up critical praise.

The *New York Times* had written that if *The 39 Steps* had "any single rival as the most original, literate and entertaining melodrama of 1935, then it must be *The Man Who Knew Too Much*," released in the United States the same year. "A master of shock and suspense, of cold horror and slyly incongruous wit," wrote Andre Sennwald in the nation's most important newspaper, "he [Hitchcock] uses his camera the way a painter uses his brush, stylizing his story and giving it values which the scenarists could hardly have supposed."

One of the most thoughtful American critics, Otis Ferguson of the *New Republic*, declared that *Secret Agent* elevated the Englishman to "among the best" directors in the world. Now, reviewing *The Woman Alone* for the *Nation*, Mark Van Doren agreed with that opinion, extolling Hitchcock as "the best film director now flourishing" in the English language,

"a master" with "the simplest, the deepest, and the most accurate imagination."

As troubling to English audiences as it was to English critics, *Sabotage* was one Hitchcock film to which the English public never warmed. The Ostrers watched its failure with a jaundiced eye. The director had survived the Christmas massacre at Gaumont, but only because he still owed the studio two pictures. Already in the hopper—and now under the stewardship of Ted Black—was Hitchcock's adaptation of *A Shilling for Candles,* a 1936 mystery by Scottish writer Josephine Tey (pseudonym for Elizabeth Mackintosh).

The man who replaced Michael Balcon, fortunately, turned out to be— surprisingly, to some in the trade—every bit a first-rate producer. Less well known than his older brother George, who ran a string of music halls including the London Palladium, Ted Black had served as a theater circuit owner and manager until 1930, when he switched over to the film production side. He started out by managing the studios at Islington and Lime Grove for Balcon.

If Balcon was the very image of a producer, Black was more the working ideal. Nowadays relatively unsung (he died prematurely in 1948), Black was "one of the very best producers I ever worked for," recalled Val Guest, who started out as a contract writer under Black at Gainsborough and Gaumont. "Ted Black was a solid, hardworking producer. You could go to Michael Balcon with a problem and Michael would put you on to somebody else to solve the problem. Ted would solve it."

If Balcon hobnobbed with the elite, Black was more a regular fellow— "one of the gang," according to Guest, "whereas you could never call Mickey Balcon one of the gang." Balcon reveled in the glamour and publicity, while the down-to-earth Black was notorious for skipping the parties and galas, eschewing the press, and giving intellectuals wide berth.

If Balcon prided himself on being cosmopolitan, Black was as English as they come, and he made no bones about it. He had a mandate from the Ostrers to make English films for English audiences, and "like his brother George at the London Palladium," according to Robert Murphy in *Gainsborough Pictures,* "Ted had an almost superstitious faith in his ability to divine popular taste and was wary of involving himself with anything that might dilute it."

Rather than pining after Hollywood names, Black placed his bets on English personalities. Rather than cobbling together star vehicles, he promoted a solid script as the basis of a well-made film. The script was for Black "the be-all and the end-all," in Frank Launder's words. Unlike Balcon, Black delighted in script conferences and went in for them "whole-

sale," according to Launder, joining in the general critique and tossing out ideas without his ego running rampant.

Best of all, Black was an unabashed Hitchcock fan. He and his brother were both longtime acquaintances of the director; now Black made it his business to be helpful, clearing all obstacles from Hitchcock's path and stretching the budget wherever possible. He took over as Hitchcock's buffer with the Ostrers. The two films Hitchcock made with Black as his producer are among his most enjoyable. Indeed, having gotten brooding out of his system with *Sabotage,* now he came up with his most happy-go-lucky story.

The script for *A Shilling for Candles* had benefited from input from Ivor Montagu before he left the studio, and from initial construction by Charles Bennett. The Hitchcocks, Bennett, and Joan Harrison vacationed at St. Moritz at Christmas 1936, interspersing brainstorming with skiing. (Well, Bennett, Joan Harrison, and Alma went skiing; the director simply stuffed himself into skiwear and sat on the veranda, reading.) When a telegram from Myron Selznick arrived, offering Bennett a contract with Universal in Hollywood, Bennett decided to leave the project. Hitchcock threw the bon voyage party.

The script was far from finished, however, and somehow Hitchcock had to compensate for the loss of the world's finest stooge. He did so in characteristic fashion, melding drafts and contributions from a slew of other stooges, including his friend Edwin Greenwood, the *Punch* humorist Anthony Armstrong, and rising young playwright Gerald Savory. Loosely presiding over the procession of scribes was Hitchcock's friend and story editor Angus MacPhail, still at Gaumont. Counting Montagu, Bennett, Harrison, and both Hitchcocks, that added up to eight or nine writers on this script—a not atypical number over the course of his career.

Tey's novel starts with the discovery of a woman's body washed up on a beach. The victim is a famous actress; the only clue to her murder is a button entangled in her hair. Suspicion is directed at a young man, acquainted with the deceased, who cannot account for a missing button on his mackintosh. Protesting his arrest, he escapes the police and sets out to clear himself, aided by a detective's daughter who believes in his innocence.

Hitchcock kept the dead body on the beach (with gulls circling overhead in brief, haunting slow motion), the young man on the run (his profession changed, amusingly, from "unemployed waiter" to unproduced screenwriter), and the policeman's daughter (who becomes much more important than Tey's series detective, Alan Grant of Scotland Yard, whom Hitchcock eliminated). The film thus opened up what was a straight-ahead murder mystery into a blend of chase, comedy, and romance, rendering the initial crime almost irrelevant.

The point of the film, after all, is not the missing clue, or the mystery detection, but the irresistible attraction between the wronged man and the policeman's daughter. (Only the barest hint of any romantic chemistry exists between the two characters in the book.) And, as usual, the very best scenes—the blindman's buff at a child's birthday party (darkly reprised in *The Birds*) and the stunningly choreographed hotel ballroom crescendo that reveals the killer's identity—have no counterpart in Tey's book. In the end, the novel was altered so drastically that the studio looked kindly upon Hitchcock's new title: *Young and Innocent*.

Hitchcock's returning cameraman was Bernard Knowles, and his editor again was Charles Frend. Ufa alumnus Alfred Junge, busy elsewhere since *The Man Who Knew Too Much,* would return to oversee the spectacular sets (all the more spectacular for being manufactured on a strict budget): one of Junge's triumphs is the collapsible mine shaft, down which plunges the escaping couple's car, along with their sole witness.

In keeping with Black's policy, the stars were English. Although the story was episodic and the settings were multiple, the leading man and lady—the writer on the lam and the tagalong who falls in love with him—would appear, singly or together, in virtually every scene.

For the wronged man, the director cast Derrick de Marney, conventionally handsome and lightweight in the emerging Hitchcock tradition, who had been onstage since a teenager and in pictures since 1928. For the constable's daughter Hitchcock could have had anyone in England, but he returned to sweet Nova Pilbeam, now eighteen and blossoming.

After this production, Hitchcock would have only one picture remaining on his Gaumont contract, and that was never far from his mind during the filming of *Young and Innocent*.

It hasn't generally been appreciated what obstacles he endured in his career. His first film as director was halted for lack of money. He was one of a handful who survived the massive layoffs at Islington in 1923. *The Lodger* was all but stolen away from him in postproduction. At B.I.P. he went within weeks from acclaim for making the first British talkie to dodging another round of mass firings. Within months of *Blackmail,* he was making virtual "quota quickies." At the peak of his fame in the early 1930s, he was discharged in England and cold-shouldered in Hollywood, forced into freelancing on fly-by-night pictures. Now, in the summer of 1937, his sixth or seventh professional crisis was bearing down on him.

One could see it in his weight, which had swollen grotesquely. One could see it in the first published accounts of the director nodding off to sleep on the set. Derrick de Marney had no compunction about telling the press that Hitchcock stole catnaps between takes, and rushed him and his

costar at least once through a scene at "express train tempo." When the take was over, however, Hitchcock did open his eyes "with difficulty," according to de Marney, in order to consult his watch. "Too slow," the director murmured; "I had that scene marked for thirty seconds and it took you fifty seconds. We'll have to retake."

One could see it, too, in the upsurge of pranks and defensive sarcasm that marked Hitchcock's behavior during these months. De Marney complained to the press that the director subjected his actors to "merciless ribbing." Not all the cast: one he exempted was Nova Pilbeam, who was indeed a young and innocent actress—playing a constable's rebellious daughter (a little like Hitchcock's mother) who happens to be a whiz with automobiles (a little like Hitchcock's wife). With Pilbeam, Hitchcock seemed remarkably "deferential," de Marney said a little resentfully, "both on and off the lot."

Better than deferential: years later, Pilbeam still recalled *Young and Innocent* as "quite the sunniest film I was involved with." Yes, she conceded, "one was rather moved around and manipulated, but, having said that, I liked him [Hitchcock] very much."

Hitchcock went out of his way to spoil his young star: Her character had a pet dog in the story, she recalled, and both she and the director doted on the animal. When the dog finished its scenes, a handler stood by to take it away. "We were both so upset," Pilbeam said, "that Hitch decided to write him another sequence, so we kept him for another five or six days."

Hitchcock could be tender—or he could be merciless, if the scene he was shooting brought that out in him. Pilbeam recalled that when the car driven by Robert (de Marney) crashes through the floor of an abandoned mine, Robert and Old Will the Hobo (Edward Rigby) manage to leap to safety, but Erica (Pilbeam) just barely hangs on between the collapsing vehicle and the edge of the pit. Crawling toward her, Robert reaches out and grabs her hand. "I was terrified!" recalled Pilbeam. "But Hitch had this quirky sense of humor and made that scene go on and on, so that I thought my arm would come out of its socket."*

The mine-shaft sequence is thrilling, but it's topped by the film's final, brilliant crescendo, which takes place at a thronged *thé dansant* in the ballroom of a seaside hotel. In this sequence, Erica and Old Will have staked out the ballroom, searching for the elusive killer. They only have one clue: the man's eyes twitch uncontrollably—a detail that isn't in the book, of course; it's a classic Hitchcock touch.

They sit at a table and survey the crowd. Couples are dancing to a band

* It surely reassured Pilbeam, and amused Hitchcock (who liked to use his inside knowledge of actors for or against them in a scene), that the hands he actually photographed—the man who actually grabbed the actress and kept her from falling—belonged to assistant director Pen Tennyson. Hitchcock knew that Pilbeam had a crush on Pen, and indeed shortly after making *Young and Innocent* they were married.

playing a song first heard over the opening credits. The musical refrain is insistent: "He's right here, it's the Drummer Man . . ." Hitchcock made the song as specific to the scene as the camera work. The music and pointed lyrics were assigned to three Americans in England: Sammy Lerner, Al Goodhart, and Al Hoffman.*

The tour de force shot Hitchcock planned required a special camera boom and lens, and then two days to block and shoot the elaborately re-hearsed action. The camera starts high on a crane above a chandelier at the far end of the dance floor, then lowers itself onto the floor and ma-neuvers past whirling dancers to gradually approach the bandstand, where the musicians are finally seen—performing in blackface. The camera creeps closer to the faces, finally halting only a few inches from the drum-mer's eyes. An extreme close-up reveals the "drummer man"—the killer—his white eyes madly darting and twitching.

"At that moment," Hitchcock told François Truffaut thirty years later, "I cut right back to the old man and the girl, still sitting at the other end of the room. Now, the audience has the information and the question is: How are this girl and this old boy going to spot the man? A policeman outside sees the girl, who is the daughter of his chief. He goes to the phone. Meanwhile, the band has stopped for a break, and the drummer, having a smoke outside in the alley, sees a group of police hurrying toward the rear entrance of the hotel. Since he's guilty, he quickly ducks back inside to the bandstand, where the music resumes.

"Now the jittery drummer sees the policeman talking to the tramp and the girl at the other end of the ballroom. He thinks they're looking for him, and his nervousness is reflected in the drumbeat, which is out of tune with the rest of the band. The rhythm gets worse and worse. Meanwhile, the tramp, the girl, and the police are preparing to leave through an exit near the bandstand. In fact, the drummer is out of danger, but he doesn't know it. All he can see are those uniforms moving in his direction, and his twitching eyes indicate that he's in a panic. Finally, his beat is so far out of rhythm that the band stops playing and the dancers stop their dancing. And just as the little group is making its way out the door, he falls with a loud crash into his drum.

"They stop to find out the reason for the commotion, and the girl and the tramp move over to the unconscious man. At the beginning of the story we had established that the heroine is a Girl Scout and an expert on first aid. In fact, she and the hero first got together when he fainted in the po-lice station and she took care of him. So now she volunteers to help the

* Hoffman had been a real-life "drummer man" in vaudeville and nightclub bands, while Lerner, most fa-mous for his ditty "I'm Popeye the Sailor Man," would write similar specialty material—ersatz folk songs and dances—for *The Lady Vanishes*.

unconscious drummer, and as she leans over him, she notices the twitching eyes. Very quietly she says, 'Will someone please get me a wet cloth to wipe his face off,' at the same time beckoning the tramp to come over. A waiter hands her the towel—she wipes the man's face of its black makeup and looks up at the tramp, who nods and says, 'Yes, that's the man.' "

This justly celebrated sequence is followed by a quick, tenderhearted coda. The vindicated Erica proudly drags Robert over to reintroduce him to her father, the chief constable, who has chased him futilely throughout the film. As the policeman and the wronged man awkwardly shake hands, the camera inches back to frame the trio standing together. Erica beams as her gaze shifts ambiguously from her father to her new beau.

Pilbeam was never pluckier. No Hitchcock heroine was ever treated as gallantly. De Marney, sometimes as off balance on the screen as he must have felt on the set, was nonetheless winning. The cops are Keystone, the tone almost that of a screwball comedy. Such pleasures abound in *Young and Innocent,* a clear, confident gem of Hitchcockery, yet one that was created under duress by a director who was gazing upon an uncertain future.

SEVEN
1937–1939

Michael Balcon was snapped up by MGM in mid-1937 to head its new studio in London, an operation largely intended to fulfill the English "quota laws" that forced U.S. companies to invest in English film production. Balcon immediately tried to recruit Hitchcock to MGM-British, offering the seeming security of a two-year, multipicture contract. The majority of the films would have to be shot in England, but the offer included the possibility of loan-outs to MGM proper in Hollywood. A tempting offer it was, and given Balcon's long, fruitful association with Hitchcock, MGM-British was optimistic about signing the director.

But the temptation of America had become irresistible. And after the Christmas 1936 massacre, and a fresh rash of bankruptcies that swept the film industry, Hitchcock was resolved to leave England.

Hitchcock often said that London's gloomy weather was his signal motivation. "The sky was always gray, the rain was gray, the mud was gray, and I was gray," he told matte artist Albert Whitlock. (Even the kindly old diplomat visiting London in *Foreign Correspondent* complains about the fog and rain.)

In February 1937, Hitchcock penned an article for the *New York Times* complaining that the "greatest difficulty we have in making films in England is to combat the climate." He described his discouragement one

night as he waited for the rain to stop and the sky to clear, in order to shoot an outdoor scene for *Sabotage*. "The cameras are covered up, the microphone is shrouded," the director wrote. "The crowds stand huddled against the shops. I crouch, muffled up and chilled to the marrow, in a temporary shelter; my stars, Sylvia Sidney and John Loder, wait desolate and frozen in a doorway. And why? Because it is raining as it has never rained before, rain which drips off my hat and down my collar and which has held us up till tempers are frayed for three nights running."

The climate fueled his discontent, but the perpetual woes of the English film industry were just as important an impetus behind increasingly public hints that he wanted a U.S. contract. In America, after ten years as a relative unknown, his Gaumont films had finally conquered the critics and compelled the attention of Hollywood producers—even though his films still boasted only modest revenue, their distribution limited to select theaters in big cities.

Myron Selznick resumed his intensive lobbying on behalf of the Englishman in the spring of 1937. Frank Joyce, after a year's illness, had died in 1935, leaving the new Selznick Agency—"the biggest talent agency in Hollywood," in the words of one trade publication—under Myron's sole stewardship. Myron piqued the interest of two independent producers: Walter Wanger and David O. Selznick.

Wanger, whose films were financed and released through United Artists, knew Hitchcock from time he'd spent in England in the early 1920s, when the young executive had been a theater administrator in London for Paramount. A versatile, respected producer inclined toward serious material, Wanger had supervised pictures by Frank Capra, Rouben Mamoulian, and Fritz Lang, among other leading directors. Now he expressed his willingness to meet with Hitchcock and strike a deal, if the terms could be worked out.

Wanger's rival was another respected producer, this one with ties to the Selznick Agency that were hard to beat. Myron's younger brother David O. Selznick had just separated from MGM and founded his own company, Selznick International Pictures. In his mid-thirties, DOS (the acronym by which he was widely known) was more inclined toward glossy films aimed at female audiences, often adapting middle-class literature with high-class craftsmanship. Wanger and DOS were both consummate salesmen of their films.

But from the moment he joined the competition for Hitchcock, DOS claimed the inside track. Besides being Myron's brother, he was married to Irene Selznick, the daughter of MGM production chief Louis B. Mayer. DOS had connections with several studios, and close friendships with New York investors who facilitated his grandiose ambitions. By the spring of 1937, DOS had elbowed Wanger aside, declaring his intention to bring Hitchcock to Hollywood. But it would be fully two years before he succeeded.

Hitchcock's financial predicament was more complicated than has been previously understood. He needed a high salary to offset the taxes he would have to pay to live and work as a nonresident alien in the United States. Selznick Agency memos estimated that the director could expect to pay at least $9,000 in U.S. taxes on a potential $50,000 annual income, or slightly more than $6,000 if he were to accept a $40,000 annual salary.

In England, Hitchcock was now making in the neighborhood of $35,000–$40,000 yearly. (When, for example, Balcon tried to sign Hitchcock to a contract with MGM-British, offering £15,000 annually, the offer was initially rejected purely on salary terms, which one Selznick memo dismissed as "ridiculously low.") Still, it wasn't dizzy money, especially by Hollywood standards, and if Hitchcock didn't extract a substantial raise over his current wage, he would actually suffer a loss of income in Hollywood, after relocation expenses, American taxes, and British surcharges.

All the negotiations between Hitchcock and Hollywood were framed by two important considerations. The first was the salary issue. Hitchcock and the agency decided the minimum amount he could accept for directing one picture was $50,000. This was still less than was earned by other name directors in Hollywood, but Hitchcock was aware that he didn't yet have the U.S. box-office record of, say, Frank Capra or Howard Hawks.

The trickier issue was that Hitchcock was determined not to abandon England for a single-picture deal. Otherwise he would have taken the MGM-British offer, with its built-in likelihood of a loan-out to MGM-Hollywood. He was practical enough to know that he would have to prove himself to an American producer by making at least one contract film. But Hitchcock the artist was anxious to ensure that any deal he made would preserve his ability to make Hitchcock originals.

Though he realized that he would be closely tied to his benefactor at first, what Hitchcock really wanted was two years of opportunity on American soil, and the freedom to work outside of his contract when an opportunity arose. From the first discussions with both Wanger and DOS, then, Hitchcock asked for a multipicture, multiyear agreement, with an escalating salary, to ensure that any temporary loss in income or professional standing would be offset by the long-term chance to prove himself.

He said he would accept $50,000 for the first year, but only if guaranteed $75,000 for a second. And from the start he insisted on his right to approve his assignments, or any loan-outs arranged by his producer.

Hitchcock was a canny negotiator. He understood that all these demands—the multipicture contract, the salary escalation, and the project-by-project veto privilege—made him a hard sell, so he took the lead in shaping the arguments on his own behalf, sweetening the proposition for potential buyers.

From the earliest negotiations he emphasized that his wife and creative

partner, Alma, would work on all the Hitchcock films without taking any salary. He said he would toil beyond what was expected of the typical director and outside the normal time frame of involvement. He promised to steep himself in script development, scouting, and research, preparation in every category of preproduction, vowing to work without salary for up to eight weeks "previous to starting production," in the words of one agency memo—no big sacrifice for Hitchcock, according to the memo, as he preferred "to work and write on his own stories" anyway.

This offer of free scriptwork actually may have backfired as a bargaining chip. Hitchcock didn't yet appreciate that he was negotiating with a system where, as a matter of policy, scripts were developed not by directors, but under the firm control of producers.

Sabotage, renamed *The Woman Alone,* was just opening in New York, and Gaumont had booked a miniretrospective of *The Man Who Knew Too Much, The 39 Steps,* and *Secret Agent* into revival houses. To publicize the films, Gaumont agreed to defray the costs for a trip to New York. The Selznick Agency urged the director to seize the moment.

As soon as *Young and Innocent* was finished, the Hitchcocks (including nine-year-old Pat) boarded the *Queen Mary* for America. They were accompanied by Joan Harrison.

The crossing took six days, but boat travel soothed Hitchcock. He happily lounged on deck, watching the waves and the passengers with equal pleasure. Whenever asked to define perfect happiness, Hitchcock answered: a blue sky without any clouds. "A clear horizon," he told television host Tom Snyder in 1974, "not even a horizon with a tiny cloud bigger than a man's fist."

According to a subsequent account in *Life,* the Englishman astonished his fellow passengers "by reciting the ports of call and times of arrival and departure of all ships sighted at sea."

One fellow passenger was the actor Cedric Hardwicke, whom the Hitchcocks had admired in West End plays (he was Churdles Ash in the original stage production of *The Farmer's Wife*). Hardwicke's friendship with the family was cemented on the voyage; Hitchcock later cast him in pivotal roles in *Suspicion* and *Rope,* and several times in *Alfred Hitchcock Presents.*

Talking with François Truffaut years later, Hitchcock wondered aloud why he had waited so long to visit a country he had followed since boyhood, like a favorite sports team. "I was meeting Americans all the time and was completely familiar with the map of New York. I used to send away for train schedules—that was my hobby—and I knew many of the timetables by heart. Years before I ever came here, I could describe New

York, tell you where the theaters and stores were located. When I had a conversation with Americans, they would ask, 'When were you over here last?' and I'd answer, 'I've never been there at all.' "

Ostensibly the Hitchcock party was on vacation, as the director insisted in interviews. But anxious to settle on a new project, he, his wife, and Joan Harrison spent their spare time brainstorming stories. Hitchcock told the press they were working on a script called "False Witness," intended for *Young and Innocent* star Nova Pilbeam, which involved "her con-man father and alibis." If that didn't work out, he had another film in mind, "based on a pet theme of his." He said he'd nurtured "a long-felt desire to take a comic situation and suddenly switch to tragedy—to experiment on the effect of slapstick under fairly sane conditions." He thought he might open a film "with a half-dozen Keystone cops crawling out of a tunnel, while a thug stands over the exit with a club and hits each one coming out. Wouldn't it be interesting to show a close-up of the sixth cop with blood trickling down his face—comedy suddenly turned sober—and then cut to a picture of his family in agony over his misfortune?"

Of course the real reason for the trip was to further Hitchcock's American ambitions. The Hitchcock party was met at the docks by Katherine "Kay" Brown, an eagle-eyed talent and literary agent who worked for David O. Selznick in New York. (Brown was the scout who first recommended Margaret Mitchell's Civil War epic *Gone with the Wind* to Selznick.) While Hitchcock busied himself with interviews promoting *The Woman Alone,* arranged in advance by Gaumont's U.S. publicity director, Albert Margolies, job interviews were set up by the Selznick Agency.

Hitchcock lost no time making an impression with David O. Selznick's associates. The director and his family spent a weekend on the beach at the East Hampton home of Kay Brown, who had a daughter Pat's age; he lunched with John Hay "Jock" Whitney, scion of an old-line family—a sportsman, millionaire, and show business investor.

Both of these trusted Selznick advisers were won over by Hitchcock in person—a good thing, since DOS was stuck in California, preoccupied with plans to film the Margaret Mitchell novel, the most expensive production he had ever undertaken. But Selznick spoke with the director at least once—their first known personal contact. Walter Wanger, similarly preoccupied with one of his films in progress, also phoned Hitchcock.

But this first conversation with Selznick wasn't quite what the director had hoped. DOS had been apprised of the MGM-British offer, and startled Hitchcock by recommending that he grab the MGM deal. If Hitchcock signed with MGM-British, he could still work with Selznick on a loan-out through MGM, with whom DOS had an ongoing relationship, while saving Selznick the risk and cost of bringing Hitchcock over entirely on his own. DOS seemed oblivious of Hitchcock's own urgent needs and desires; there was no discussion of any specific project, or any attempt to negotiate.

Myron Selznick's staff went to work massaging MGM and Selznick International, trying to connect and concretize the loan-out options. Though his discussions with Hollywood producers remained largely offstage, Gaumont publicist Al Margolies made sure that the rest of his Cook's Tour of the East Coast was well documented by the press.

Typical tourist sightseeing was always on a Hitchcock itinerary, and the English visitors made a quick side trip to Washington, D.C., where they took a VIP tour of the U.S. capital. With little time to spare, they glimpsed the Jefferson Memorial, the Washington Monument, and other sites from the windows of a limousine, just like Farley Granger in *Strangers on a Train,* or the Soviet defectors in *Topaz.*

The English visitors also traveled to Saratoga Springs, New York, where Whitney took them to the races, a lifelong Hitchcock pastime. They gawked at the high-society spas and resorts with their rocking-chair porches. "I pointed them out to my wife," Hitchcock later told a journalist, "and we stood and looked at them. If we have rocking chairs in England it is only as curiosities. But here you have them in real life as well as in the movies."

Thinking ahead to *Saboteur,* they visited Rockefeller Center. With the eye toward authentic crime detail he would later put to use in *The Wrong Man,* Hitchcock dropped in on a police lineup and scrutinized the suspects.

He was coaxed by one journalist into visiting the theater where *The 39 Steps* was showing. Although the *New York Times* would report that he slept through his own masterpiece, the newsman who actually accompanied him, William Boehnel of the *New York World-Telegram,* insisted the director *stood* through the show, commenting only once, "and that was to complain because of the way a particular sequence he liked very much had been cut." Afterward, outside the theater, Hitchcock was pleasantly surprised to encounter a swarm of film fans holding up glossy photos of him for his autograph.

While they were in New York, the Hitchcocks made the beaux-arts St. Regis on Fifth Avenue and Fifty-fifth Street their headquarters. Hitchcock stayed in luxury hotels wherever he roamed, and in years to come he would adopt the St. Regis as his New York home away from home.

In his suite, between phone calls and interruptions, Hitchcock regaled the fourth estate. Mrs. Hitchcock ("a petite blonde, who doesn't look as if she tipped the scales at more than 100," according to one press account) flitted in and out on errands, while Pat ("a gracious little lass who curtsies prettily and says how-de-do") was throwing a ball against a wall and trying to catch it on the bounce. Margolies ushered in the interviewers, including a man from the *New York Times,* Eileen Creelman of the *New York Sun,* and Janet White of *Picture Parade.* The director went on U.S. radio for the first time, interviewed by Radie Harris for *Gertrude of Hollywood.*

As canny as Hitchcock was with critics and journalists, he was learning

the game in America. As open and comfortable as he was with the press, at times he could be too open, too comfortable—and end up hurting himself.

Up to this time, the American coverage of Hitchcock's career had been scant, limited to a few interviews and brief items in New York and Los Angeles newspapers. His British coverage, of course, was far more expansive, but it had focused on his filmmaking techniques and the films themselves. England hadn't yet developed the same appetite for celebrity gossip that prevailed with Hollywood personalities (though rarely, in truth, with directors).

It would have been unheard of in 1937 for the British press to dwell on a physical description of Hitchcock, or to sling gibes about his weight. But that quickly became the routine in America. The U.S. press was awed by his size, reported now at 250 pounds. Interviews often took place during dinner or drinks, and American reporters wrote down not only what he ate, but the jokes he made about his weight too. One paper described him as looking like "one of those jolly Sultans in an *Esquire* cartoon," while even the staid *New York Times* found him "Falstaffian"—"a walking monument to the principle of uninhibited addiction to sack and capon, prime beef and flowing ale, and double helpings of ice cream."

The press was delighted at what good company Hitchcock proved to be— and how infinitely "quotable" he was. In this first round of American interviews, it's palpably clear that a star was being born. He held forth not only on film, but on anything that came up. His trip coincided with the heavyweight championship bout between American Joe Louis and Tommy Farr, the Welsh coal miner who was the British Isles underdog. Farr battled hard for the full fifteen rounds but ended up losing the decision, which many considered unfair. It's unclear whether the director of *The Ring* took in the bout in person, or listened on the radio, but Hitchcock could extemporize. "Before last Monday night [the day of the fight]," according to one newspaper, "Mr. Hitchcock didn't think much of Farr's chances. 'Just popped up out of nowhere,' he said. After Monday he didn't think so much of our Brown Bomber, but Farr had gone up a couple of notches with him." *

Speaking of boxers, Hitchcock mentioned that former British and Commonwealth Heavyweight Champion Joe Beckett, "whom somebody in the room ungraciously referred to as the Human Pancake," was running a pub somewhere, and that Bombardier Billy Wells, another former champ ("Strawdin'ry man, Billy. Great style, but no guts. Knock a fellow silly and then stand back as if to say, 'My, My! Look what I've done!'"), had performed fight scenes in *The Ring*.

The "21" Club on West Fifty-second, where the rich mingled with the

* Joe Beckett was British and Commonwealth Heavyweight Champion from 1919 to 1923. Billy Wells, British and Commonwealth Heavyweight Champion from 1911 to 1919, also acted small roles in films, sometimes billed as Bombardier Billy Wells, Incidentally, he is the man who bangs the gong at the beginning of all the Rank films.

literati, was *the* place to dine—and Hitchcock moved in, giving interviews. Dining there with columnist H. Allen Smith of the *New York Herald-Tribune,* Hitchcock was reported to have eaten three of the club's famous steaks, followed by three of its famous vanilla ice cream desserts, followed by a pot of its justly unfamous English tea. (Afterward, Hitchcock said he was sorely tempted to fling the teapot to the floor, as was his wont back in England.) Instead, the director puffed upstairs three flights to examine the choice meat cuts hanging in "21"'s cooler.

Smith's interviews could be fanciful; a screwball newspaperman known for his practical jokes, he once "kidnapped" Albert Einstein to keep him away from a dinner in his honor; and his popularity as a humorist would soon rival that of his friends James Thurber and Robert Benchley. But he presented this superb performance with a straight face, and so did Hitchcock.

It was hardly negative publicity; still, it was the first whiff of a Hitchcock caricature that would soon become the director's public face, for better and for worse. And heading home on the *Georgic* in the first week of September, Hitchcock felt disheartened. The talks with Hollywood producers had proved inconclusive, and the "fat" articles had wounded his vanity. The *Hollywood Reporter,* quoting London sources, reported that Hitchcock returned "rather disconcerted" that "the American press boosted him as an expert on food instead of Britain's ace director."

"Learning from experience" could have been a motto for Hitchcock, though, and in time he would take the American fascination with his looks and personality and turn it to tremendous professional advantage. In time this puckish figure, a genial curiosity to the American press in 1937, would become the most interviewed, most profiled, and most written about and analyzed Hollywood director of all time.

For the moment, he was still a foreigner looking for an American home. The Selznick Agency tried once more to talk him into signing with Balcon and MGM-British as a surefire entree to Hollywood via David O. Selznick. All of Hitchcock's instincts told him to decline. Balcon "was very possessive of me," the director told François Truffaut, "and that's why he was very angry, later on when I left for Hollywood." But Myron Selznick succeeded in at least one crucial respect: he had convinced Hitchcock of his diligence. At last, the English director signed the papers to become an official client of the American agency.

Alfred Hitchcock was by any measure a self-made man. But even he had happy accidents that lifted him up at critical junctures in his career. Michael Balcon appointing him director of *The Pleasure Garden* was one such fortuitous event, if that anecdote is to be believed. *The Lady Vanishes* was another.

The Lady Vanishes was based on the 1936 suspense novel *The Wheel Spins* by Ethel Lina White, a contemporary Welsh author who specialized in mysteries featuring endangered heroines. Producer Ted Black had bought the screen rights and commissioned a script in 1936. Second-unit photography actually started under an American director, Roy William Neill, in August of that year, with a few exteriors in Yugoslavia, but the filming encountered problems and the production was temporarily shelved.

The novel concerns an English socialite who takes a European holiday and is befriended by an elderly English governess during a long train journey. The governess disappears in the middle of the train trip, but not a single passenger will admit to having laid eyes on her. The socialite suspects a conspiracy, or foul play. When no one listens to her, and the facts prove elusive, she begins to doubt her own sanity.

The adaptation by Frank Launder and Sidney Gilliat had turned a dramatic and somewhat monochromatic novel inside out; the result was an eccentric and hilarious script in the Hitchcock style, even before Hitchcock himself became involved. Launder and Gilliat added a pair of Englishmen more curious about cricket scores than the fate of the vanished governess, and a blossoming romance between the socialite and a folklore scholar, the only train passenger who believes her tale. Then everything was tied into a web of politics and spies.

Launder and Gilliant were at the beginning of their remarkable hyphenated careers. Earlier scripts for pictures like *Rome Express* (1932) had already demonstrated their penchant for ripping train adventures, but largely on the strength of *The Lady Vanishes* they would be catapulted behind the camera, jointly writing, directing, and producing such classic English films as *Night Train to Munich, Millions Like Us, The Young Mr. Pitt, The Happiest Days of Your Life, Geordie,* and *The Belles of St. Trinians*.

Launder was an ex–civil servant turned actor and playwright, Gilliat the son of the managing editor of the *Evening Standard,* and a protégé of Walter Mycroft. Entering the film business as Mycroft's assistant, Gilliat rode to his first day of work at Elstree in 1928 in the same taxicab as Mycroft, and rode home the same day with Mycroft and Alfred Hitchcock in the director's car.

Gilliat started out as a low-level reader for Mycroft, sifting through the B.I.P. "tripe pile" of stories. He knew Hitchcock only in passing from those days. Hitchcock, Gilliat recalled, relished sending the worst "penny dreadfuls" over to the story department for Mycroft's consideration; more than once, Gilliat said, he sent Hitchcock back a report on a submission ("without reading it, of course"), trumpeting an embryonic *Madame Butterfly*. He took pleasure in tweaking the great director, conjuring a love story with heroine attracted to hero by "the healthful glow of his countenance," and ending with the two passionately "sharing the same kimono."

According to Gilliat, Hitchcock was in distinctly bad odor with Gaumont when he returned from the United States, because of negative reaction to *Young and Innocent* at studio previews. "The Ostrer brothers who owned the outfit," Gilliat recalled, "were ready to settle Hitch's contract, pay him off and not make the last one. He was never regarded by the more commercial end of the business as particularly good box-office. They told Ted Black this and he said, 'He's got one picture to do.' The Ostrers asked Black if Hitchcock had a suitable subject and Ted said, 'I think I have.' Hitch hadn't found one on his own."

The director's nose twitched as he read Launder and Gilliat's blend of comedy, romance, and suspense, with all the Hitchcock ingredients: a missing body, a speeding train, a young man and woman linked by distrust and danger. If he hadn't yet read the Ethel Lina White novel, he certainly recognized its inspiration. The legend of an ailing elderly lady who vanished from a hotel in the place de la Concorde during the Paris Exposition of 1889 had been fictionalized by Mrs. Marie Belloc Lowndes in her 1913 novel, *The End of Her Honeymoon*, and retold by Alexander Woollcott in "The Vanishing Lady" in his book *While Rome Burns*. Changing the film's title to *The Lady Vanishes* was a nod to Woollcott, one of the writers Hitchcock devoutly read in his favorite U.S. magazine, the *New Yorker*.*

Even though there was already a script, there is nonetheless debate over what Hitchcock contributed to the Launder-Gilliat draft, which had already been stamped with front-office approval a year earlier. According to Gilliat, Hitchcock approached their script the way he would a play, restricting his tinkering mainly to the beginning and ending.

Launder "agreed some new scenes with Hitch," recalled Gilliat on one occasion, and "because Ted Black admired Hitch, they had decided to put a little extra in the budget, so they were able to extend the ending, which Frank rewrote. They also knocked off the opening, so, essentially, the parts that were 'authored' by Hitch were the beginning and the end. There were odd alterations in the middle, which Frank did with Hitch."

Yet that doesn't do credit to the scope of the tinkering, which involved not only Hitchcock, Launder, and Gilliat, but others at the studio. It was "all in the family," according to Val Guest. Guest and Marriott Edgar (known as George) interrupted their work on Will Hay vehicles to kick in ideas. "We always used to wander in and out," recalled Guest, "and Hitchcock used to wander in and out, and he would ask, 'Got a better line for this?'"

The new opening was one of Hitchcock's andantes: A revolving-door

* A copy of the *New Yorker* floats by amid the other debris during the opening credits of *Lifeboat*. Once in Hollywood, Hitchcock would recruit several writers from the magazine's masthead.

introduction of guests crowding into a small inn on the night before the train departs. ("Originally, I had written a much longer opening which took place on a lake steamer in the Balkans," recalled Gilliat.) And the original Launder-Gilliat script ended, according to the director, "when the lady is removed on a stretcher." Instead, Hitchcock came up with a shoot-out between border police and train passengers committed to defending the elderly lady. The former established the setup and characters ("rather like jumping half a reel into the picture, in comparison to the original," in Gilliat's words), while the latter provided the big-bang finish.

Along with these crucial changes—without which it's hard to imagine the film today—there were those "odd alterations in the middle." It was always Hitchcock's policy to build up the supporting characters. In this case, he enlarged the parts of the cricket-obsessed Englishmen—he already had the actors in mind—and transformed a banker, who in the Launder-Gilliat draft shared a compartment with the socialite and governess, into a stage illusionist whose "Vanishing Lady" specialty would add to the conceit.

The original script was full of allusions to foreign ministers of propaganda and "England on the brink," but the rewrites also strengthened the sly political commentary. The absurd Macguffin (a coded song) is linked to the meddling of a fictional Mittel European nation (Bandrieka, "one of Europe's few undiscovered corners"), replete with its own pretend language. Audience members would have fun guessing at the real Bandrieka.

The train shoot-out reinforced the politics. The hero and heroine try to rally their countrymen away from teatime, but the English passengers are stubbornly complacent: "They can't possibly do anything to us, we're British subjects!" One Englishman—an adulterer, and worse, a heel—declares himself neutral, and steps from the train waving a white flag. He is promptly shot dead. The message is clear: England is kidding itself to think it can appease Hitler.

Especially in light of the bad feeling that developed between him and the two scenarists, it must be said conclusively that Hitchcock (or, rather, both Hitchcocks, for Alma was credited with "continuity") put his stamp on *The Lady Vanishes*—as a writer, before he'd even set foot on the set.

The Lady Vanishes would be a reunion with cameraman Jack Cox, and one last Hitchcock film produced at Islington. Cox had to summon his old resourcefulness on the once-grand soundstages, now small and threadbare compared to Lime Grove. The pictures shot at Islington during this era were conveniently set in train compartments and lighthouses and cramped prison cells. Alex Vetchinsky, the resident designer, had become an expert

at that sort of inexpensive single set, and his influence is conspicuous on *The Lady Vanishes.* Hitchcock was encouraged to make abundant use of his full arsenal of back-projection, trick shots, and miniatures to maintain the illusion of a real train in constant motion.

Naunton Wayne and Basil Radford (Nova Pilbeam's uncle in *Young and Innocent*) were teamed up by Hitchcock as the cricket-mad Englishmen. The two actors had never performed together, but their rapport was so instantaneous that their parts grew during filming, and *The Lady Vanishes* cemented them as a team for other films.

The duplicitous brain specialist was Paul Lukas. Cecil Parker and Linden Travers were the adulterous couple. Philip Leaver was the magician Doppo, and Catherine Lacey was memorable as the accomplice whose high heels clash with her nun's habit—another Hitchcock touch. The frumpy "vanishing lady," Miss Froy—"rhymes with joy"—was a part for Dame May Whitty, a stage star on both sides of the Atlantic since the turn of the century.

Launder and Gilliat didn't want a regulation hero, so they had changed Ethel Lina White's dam engineer into Gilbert, a folklore scholar. It was probably Hitchcock who nudged the character further along this path into "a scholar of folk music"—which allowed for the comedy sequence that introduces Gilbert, and the tune that will save the world (self-plagiarism from *The 39 Steps,* where the tune inside of Robert Donat's head finally reminds him of Mr. Memory).

Ted Black urged Hitchcock to test Michael Redgrave, who had carved his reputation in classics on the stage (he was then appearing nightly in the Chekhov play *The Three Sisters*). Although inexperienced in film—and as wary of the rival medium as John Gielgud—Redgrave was persuaded by the generous long-term contract proffered by Gaumont.

For Iris, the producer championed Margaret Lockwood, a pert brunette rising in audience polls who had never met her costar before she was cast in *The Lady Vanishes.* "We were introduced at a charity film ball at the Royal Albert Hall, where we danced together and were photographed in a tight embrace which suggested that, to say the least, we knew each other quite well," Redgrave recalled in his autobiography.

Characteristically, the director was counting on an awkwardness between them. Hitchcock was up to his usual tricks, choosing the first day of filming to shoot the scene where Gilbert and Iris "meet cute." The folk-music scholar has collected members of the hotel staff in his room to noisily reproduce a local dance. The dancers are making too much commotion for Iris, who is trying to go to sleep in the room just below; she convinces the hotel manager to evict Gilbert. Gilbert then vengefully barges into her room, booming out the march later used famously in *The Bridge on the River Kwai.*

"It is possibly the gravest disadvantage of acting for the camera," Redgrave later reflected, "that one must do an important scene with someone one has never acted with, perhaps never even met, or, as with Margaret Lockwood and myself, met only briefly and in somewhat artificial circumstances. After some initial parrying, Margaret and I got along well, though we remained suspicious of each other for some time."

In the film, as Hitchcock well knew, the two characters also meet at a disadvantage and remain suspicious of each other for some time—their romance developing stealthily.

"Something of an intellectual snob," in his own words, Redgrave harbored suspicions of Hitchcock and film in general. The director's slashing brand of humor Redgrave never got used to: he couldn't understand why, at one cast party at Cromwell Road, Hitchcock poured drink after drink for Mary Clare (the aunt in *Young and Innocent,* the baroness in *The Lady Vanishes*) until, to his obvious satisfaction, the actress got roaring drunk.

Like others before him Redgrave couldn't understand Hitchcock's "shock tactics," in his words—his fallible belief "that actors take themselves too seriously, and that those who have an infinite capacity for taking praise will sometimes perform better if they are humorously insulted. He evidently thought that I had a romantic reverence for the theater, and he could see that I had the newcomer's disdain for the working conditions of the studio."

The writers begrudged Hitchcock. The leading man regarded him warily. The budget was shoestring. The director was fat and pale, his future gray and cloudy.

The months spent making *The Lady Vanishes* were filled with nervousness and difficulty, and once again there were published reports of a fatigued director stealing forty winks during filming. "He was a dozing, nodding Buddha with an enigmatic smile on his face," recalled Lockwood. Once again there were reports of a Hitchcock, literally backing away from confrontations with people—standing as far away against a wall as he could, staring sullenly at someone who had trapped him, stabbing a finger at him.

It's a curious fact, but nobody has been able to date the origins of that most notorious of Hitchcock pronouncements: "Actors are cattle." The director himself recalled that he might first have said something along those lines in the late 1920s, thinking of stage actors who took a snobbish attitude toward motion pictures. The purity of theater was a pretension that Hitchcock, himself a theater aficionado, couldn't abide. "I do not know whether his famous 'Actors are cattle' remarks was coined for my benefit, but I well remember his saying it in my presence," Redgrave remembered.

"When we started," Hitchcock recalled, "we rehearsed a scene and then I told him [Redgrave] we were ready to shoot it. He said he wasn't ready.

'In the theater, we'd have three weeks to rehearse this.' 'I'm sorry,' I said, 'in this medium, we have three minutes.' "

The leading man was subsequently taken aback when fellow actor Paul Lukas, whom he "greatly admired and liked," wondered aloud why Redgrave didn't even seem to be *trying* to fit into the film world. Redgrave felt chastened: he *hadn't* been trying. Hitchcock had advised him to "do as I was told and not worry so much." When Redgrave finally decided to follow this advice, he finally started to relax—and began to like the director.

It is a virtue to know one's solace, and Hitchcock found ways of nurturing his spirit in the worst of times. As striking as any anecdote of friction or unpleasantness on the set of *The Lady Vanishes* is the one about an event the director orchestrated for an important visitor. One day, at lunchtime, he had the stage cleared. Mood lighting was ordered, and a small group of studio musicians on the sidelines struck up an arranged playlist. He had a favorite menu drawn up, and juice served in champagne glasses. Then he and nine-year-old Pat, just father and daughter, ate a special lunch aboard the dining car of the mock train.

Even while he was making *The Lady Vanishes,* Hitchcock kept one eye on America. The Selznick Agency was working to reignite interest in bringing him to Hollywood. Producer Bob Kane seemed eager to employ the director for the new London unit of Twentieth Century–Fox, and RKO in Hollywood floated a long-term producer-director pact. Most promising of all, independent producer Sam Goldwyn reentered the competition.

The new prospects were encouraged by the Selznick Agency mainly to heat up the lukewarm discussions with David O. Selznick. The agency went so far at one point as to wire DOS in his drawing room aboard the Santa Fe Chief, advising him that it was "really urgent" for him to focus on the matter "as propositions are coming up for Hitchcock elsewhere."

But DOS, consumed with preparations for *Gone With the Wind,* couldn't seem to think ahead. He couldn't focus on Hitchcock. When Jock Whitney and Kay Brown dined with the director at the Connaught Grill in London at the end of November 1937, they were again impressed with the man in the ample flesh. When Whitney took in *Young and Innocent* at a subsequent preview, however, his reaction was dismay. His transmission to DOS warned that the latest Hitchcock "establishes new low for both Pilbeam and himself. Please see it before further negotiation." Brown didn't learn of this rash, mistaken verdict for several weeks; when she did, she weighed in belatedly: "Regret do not agree with Jock."

Yet Brown, along with Jenia Reissar—Selznick's talent and literary scout in London—also warned DOS repeatedly that Hitchcock was reputed to be a "slow worker." Bob Burnside was another Selznick adviser who informed

his boss crudely that Hitchcock was "a fat man and a little lazy." These reports—unfair to Hitchcock's true efficiency and productivity—gave DOS pause. Furthermore, whenever DOS asked about the director's present salary, he was told a sum equal to less than forty thousand dollars. He couldn't figure out why Hitchcock was asking for so much more.

When DOS himself finally saw *Young and Innocent* in February 1938, he emerged from the screening to proclaim Hitchcock "the greatest master of this particular type of melodrama."* Yet the Hollywood producer continued to balk at the salary the Englishman was requesting, and continued to prefer a one-picture contract; and DOS didn't want to sign any contract until he knew what the first Selznick-Hitchcock production was going to be.

Halfway through the filming of *The Lady Vanishes,* his last commitment under the Gaumont contract, Hitchcock still didn't know what his next project was going to be. So he was nearly frantic when he met with Charles Laughton in the spring of 1938.

After his break with producer Alexander Korda, and following the disaster of the unfinished Josef von Sternberg film *I, Claudius,* Laughton had gone into business with German émigré Erich Pommer to set up Mayflower Films. There had already been two successful Mayflower productions, and the next was going to be *Jamaica Inn,* based on a 1936 novel by Daphne du Maurier, and Laughton wanted Hitchcock as his director. Set in the nineteenth century, *Jamaica Inn* concerned a band of cutthroats who wreck and plunder ships off the Cornish coast, under the secret leadership of a local vicar (the starring part earmarked for Laughton). Their piracy is threatened by a young, upstanding maiden—the niece of one pirate—and an undercover naval officer.

It was while considering Laughton's proposition that Hitchcock also read the latest Daphne du Maurier novel in galleys. *Rebecca* was a gothic suspense thriller about the English lord of a manor who is haunted by the memory of his first wife, the never-glimpsed Rebecca, who has perished in a mysterious boating accident before the story begins. The book's narrator is his new wife, who must unravel the horror of the past.

Hitchcock promptly tried to option *Rebecca,* but flinched at paying the asking price himself. This, finally, spurred DOS into some semblance of action. Jenia Reissar, who had started in the business working for Gerald du Maurier, set about acquiring the book for the American producer, which the Selznick Agency considered the first step toward a contract with Hitchcock. But DOS optioned many properties, and his talk was still vague.

* *Young and Innocent* was feebly retitled *The Girl Was Young* for the United States—and, as usual for Hitchcock, suffered cuts (often for censorship, but in this case, inexplicably as a means of reducing its running length). It would be interesting to know if Selznick saw the unfortunately truncated U.S. version, with the blindman's buff scene at the children's party deleted.

In the spring of 1938 Hitchcock told a London columnist, "If I do go to Hollywood, I'd only work for Selznick." But he was merely keeping the hook baited. Not until the final days of *The Lady Vanishes* did he receive the equivalent of a nibble. DOS telegraphed his brother's office in London, proposing a Hitchcock film "TO BE BASED UPON AND CALLED QUOTE TITANIC UNQUOTE." There was no script, but Hitchcock could name his preferred writer, the producer's telegram said, and go straight to work. Filming could be under way by mid-August.

While DOS typically gave himself an out ("PLEASE DISCUSS THIS FRANKLY AND THOROUGHLY WITH HIM MAKING DOUBLY SURE THAT THERE WILL BE NO DISAPPOINTMENT IF I SHOULD DECIDE AGAINST IT"), Hitchcock's reply was an unequivocal yes. The "Titanic" project offered him a splendid opportunity to make a human drama on the grand scale, and he had already demonstrated his aptitude for shipboard suspense in earlier films. Harry Ham's return telegram pledged Hitchcock's interest, adding, "AND BELIEVES HAS VERY GOOD IDEAS ON SUBJECT AS HAS CONTEMPLATED DOING ROUGHLY THE SAME THING HIMSELF."

Hitchcock said he could make himself available to DOS inside of two weeks. But he cautioned that August would be too soon to develop a suitable script. He reiterated his current salary demand: he required fifty thousand dollars to make the one picture over a six-month timetable, plus round-trip transportation and expenses for him and his wife. After thinking it over, Selznick agreed that August was foolishly optimistic, to Hitchcock's relief. But the producer offered no alternative timetable—and worse, he said he wouldn't pay the sum of fifty thousand dollars for six months and one film.

A dispirited Hitchcock met with Dan Winkler of the Selznick Agency in Paris to talk things over. Winkler tried to reassure him. Winkler is said to have coaxed him to a ringside table at the Casino de Paris (which probably didn't take much coaxing). Hitchcock is said to have fallen asleep, amidst "the noisiest show in the world, nude women dancing right next to his table," according to Winkler. (Probably it was with one eye fluttering open.)

Hitchcock's Hollywood prospects at this point were still iffy; his English possibilities, on the other hand, seemed firm, immediate. Sometime during the impasse, Hitchcock agreed to direct the Laughton film, setting a September 1 start date for *Jamaica Inn,* and then squeezed in quick meetings with writer Sidney Gilliat, engaging him for a major "repair job" on playwright Clemence Dane's first draft. Hitchcock even held discussions with the debonair song-and-dance man Jack Buchanan for a musical picture to follow *Jamaica Inn.*

But his next move was more surprising—even to the Selznick Agency. Hitchcock announced that he would return to America, traveling to Hollywood at his own expense to meet with DOS and other producers. The week after *The Lady Vanishes* wrapped, that is what he did, sailing with

Alma aboard the *Queen Mary* in the last week of May. On June 6, they were met on the New York docks by Kay Brown.

Once again, Gaumont publicity director Albert Margolies had set up interviews for Hitchcock, and before he set off for Hollywood the director met with New York journalists, some of whom were familiar from the previous year.

This time, dining with Eileen Creelman of the *New York Sun* at "21," Hitchcock stressed in his interview that he was dieting on doctor's orders. ("Mustn't get too heavy, you know," he said. "You've read those advertisements: 'When I meet a girl she always passes me by.' ") After a year of constant work and a rigid, sacrificing diet of one meal a day, Hitchcock said he was down to 179 pounds. Creelman reported his dinner consisted of broiled lamb steak, which Hitchcock ordered by drawing a sketch for the waiter of a chop "with lots of meat and very little bone." Cantaloupe preceded; fresh pineapple followed.

After sampling a New York Yankees game—Basil Radford, perusing the scores in the *International Tribune,* sounded his disapproval of the great American pastime in *The Lady Vanishes* ("Children play it with a rubber ball and a stick")—the Hitchcocks caught the train to Chicago. There they boarded the Super Chief, the "Train of the Stars," which departed on a Tuesday and sped through the Southwest to arrive in Los Angeles by early Thursday. It was a forty-hour magic-carpet ride through Middle America that, advertisements boasted, sacrificed only one business day.

What were his thoughts as Hitchcock peered out the window at the American landscape streaking by? The Super Chief made only one fleeting stop in Kansas City during its transcontinental trip, and future Hitchcock films would for the most part—like the Super Chief—also bypass Middle America (This neglect would make the rare stops—the desolate highway in *North by Northwest* or Mount Rushmore in the same film—all the more memorable.)

Train travel was different in America, Hitchcock mused in later interviews. The trains were spacious and air-conditioned, and first-class passengers rode in roomy private berths. There was little of the forced crowdedness and social intermingling of English trains. The new high-speed diesel engines also seemed less cinematic than the old locomotives, he reflected; he said he didn't think he could ever make a film like *The Lady Vanishes* on an American train. (Yet he did find ways to create high drama on American trains, several times.)

"Palm trees! Sunshine! Lovely!"—that's how Marlene Dietrich describes California in Hitchcock's *Stage Fright.* Yet it wasn't all sunshine and loveliness for him on this first visit.

As was customary for Hollywood celebrities, the Hitchcocks were met at the Pasadena station by his agents, Myron Selznick and Dan Winkler. Winkler, the junior agent who would drive the English director to some of his appointments, was also an expert on Los Angeles restaurants and nightclubs, having formerly partnered with *Hollywood Reporter* publisher W. R. Wilkerson in the operation of the Trocadero.

But when the Hitchcocks visited the local clubs and eateries on this first trip to Hollywood, it wasn't to sneak their names into the gossip columns. There was little of the press clamor that characterized their New York visits; Hitchcock gave no interviews from his suite at the Beverly Wilshire Hotel. There was no Gaumont publicity. This leg of the trip was all business, and the secretive, Machiavellian Myron Selznick took charge.

The summer of 1938 was dry and hot in Hollywood, and warmhearted films were the fashion. Among the films being produced around town, Frank Capra was shooting the Kaufman-Hart play *You Can't Take It with You* over at Columbia; MGM was making *Boys Town,* with Spencer Tracy in priest's robes; Bette Davis, Anita Louise, and Jane Bryan were playing siblings with husband troubles in *The Sisters,* which was under way at Warner Bros.

David O. Selznick was busy producing *The Young in Heart,* a wacky comedy cowritten by Hitchcock's old friend and collaborator Charles Bennett. The casting of Clark Gable as Rhett Butler had just been announced for *Gone With the Wind.*

Some accounts have contended that DOS was the only Hollywood producer who seriously courted Hitchcock (one account reports Selznick's subsequent boast to Frank Capra, that Myron "could not get bids for [Hitchcock] at the time I signed him"). But that is an oversimplification. The agents who worked for Myron were accustomed to navigating the gray zone that existed between the brothers. They knew how Myron liked to lord it over his younger brother, parry and thrust with David until he drew blood; then, only then, would he triumphantly deliver the goods.

The agents had done their best to set up meetings at all the studios. And while DOS was understood as the main target, some agents felt that Hitchcock was an attractive client who could be peddled to other producers, to everyone's greater benefit.

Myron's brother came first, however, and Hitchcock's introduction to the producer was set for June 15, the day after his arrival. That summit meeting was so anticlimactic that afterward the director didn't know what he ought to think. In person, the producer was nothing like his bulldog brother. DOS was a bookworm in thick eyeglasses. He was warm and solicitous; his ego was diffuse. Most important, Hitchcock liked him.

DOS was harder to pin down, even, than his brother. The producer

seemed in no hurry to decide the things that mattered most to Hitchcock. He tended to bulldoze or derail the conversation. He rambled. He equivocated. He chain-smoked—taking phone calls, and talking to Hitchcock and the caller at the same time. He startled the director by appearing to wave off the "Titanic" project, which the director had crossed the Atlantic to discuss. Instead, he said, he had been thinking Hitchcock might excel at directing an Edward G. Robinson vehicle. The producer had always wanted to make an Edward G. Robinson picture. But there was no script, DOS felt obliged to add—no script, no story, and come to think of it, no Edward G. Robinson.

There was one bright bit of news: the producer had just consolidated the option for *Rebecca*, which he knew would tantalize Hitchcock. *Rebecca*, DOS mused, might very well become the second Selznick-Hitchcock film . . . after the first one . . . which might or might not be "Titanic."

Hitchcock retained his composure. But Noll Gurney, the senior Selznick agent who accompanied him to the meeting, picked up on the Englishman's crushed reaction. He took the director to dinner in an effort to cheer him up: DOS's plans were necessarily elastic, Gurney explained, and Hitchcock "should not take David's ambiguity as emanating from a source of disinterest in him."

Gurney was one of the cabal of agents (Winkler was another) who unequivocally admired Hitchcock, and wondered if he was being delivered too easily into the arms of Myron's brother. "I have personally felt for a long time that Hitchcock is about the only director in England who can in any way match our 'A' directors here," Gurney explained in one memo, "and it must be remembered that he has had to work under conditions in England which have been most difficult. . . . I would like to see Hitchcock get an opportunity here comparable to that given our average top director—I am confident he would not fail."

Sam Goldwyn had been lined up to share a possible two-picture contract with DOS, and to Gurney and others he seemed the more appreciative customer. Again escorted by Gurney, Hitchcock met Goldwyn face-to-face on his second full day in Hollywood. Goldwyn expressed eagerness to split a two-picture deal with Selznick International; he already had a subject and title—"Scotland Yard," exploiting Hitchcock's Englishness and crime-film reputation. Goldwyn was raring to go: "Scotland Yard" could be produced first, if a decent script could be thrown together and the arrangement was okay with DOS. "Or of course David's picture might come first and Sam's second," in Gurney's words.

Gurney knew, however, that DOS wasn't likely to launch a Hitchcock project in earnest until after *Gone With the Wind* was completed. That was a problem because Hitchcock was in a hurry for a commitment. The director wanted assurances that he could go to work on his first American

film immediately following *Jamaica Inn*. But the Goldwyn film couldn't be scheduled first without offending DOS, so the diplomacy became knotty.

"Sam wanted to talk deals immediately," Gurney said. "I told him that Hitchcock did not want to do anything definite until he was convinced, first, that he wanted to do 'Scotland Yard,' and secondly, he was confused about the situation with Selznick International."

After his initial encounters with Selznick and Goldwyn, Hitchcock was confused indeed. He was slated to meet with other producers, but now said he was embarrassed to be "hawked about town" like a bargain from the bin, without being able to tell possible employers when he was available for work. Gurney managed to coax him to appointments with Adolph Zukor at Paramount, with executives at Warner Bros., and with Walter Wanger at RKO, but the Englishman was increasingly restive in these situations, since he got the clear impression that everyone was waiting for clearance from DOS.

To a certain extent, Gurney was operating at cross-purposes with his boss. Myron had rock-solid faith in an eventual agreement with his brother. More than once the superagent had to rein in his subordinates before they pushed Hitchcock too hard with other prospects. At one point, a Selznick agent was tracked down by Myron's secretary while en route to RKO to promote Hitchcock for a deal there, and ordered to return to the office and "hold off on discussion until they finish with DOS," according to an agency memo.

Such labyrinthine maneuvering, during Hitchcock's first week in Hollywood, opened his eyes. It made him feel less secure and prompted him to review his demands. He had been asking fifty thousand dollars per film; now, recognizing that working in Hollywood would put him at the whim of whimsical producers, he suddenly upped his price to sixty thousand, taking the agency by surprise. He also asked for additional expenses, elevating the total price to seventy-five thousand. "He quite realizes that at one time he felt he was able to get through on fifty thousand dollars," Gurney explained sympathetically in a memo, "but on refiguring his taxes and expenses sixty thousand dollars is the only figure that will give him the net that is the equal of what he now gets in England, and he intends to ask more there after the Laughton picture."

The Selznick Agency was forced to advertise a new figure: Hitchcock's requirements were now sixty thousand dollars for sixteen weeks of production, with fifteen thousand extra for expenses over the same time span. Hitchcock took pains to point out that "for this figure he intends to give a good deal more time than is usual," in Gurney's words. The English director promised to supervise all preliminary work and research, free of charge. He wouldn't take money for any preproduction work he performed before January 1, 1939, when his contract and salary would begin.

Mrs. Hitchcock's involvement, he continually reminded everyone, came free of charge. He overoptimistically vowed to start photography on his first film by March 1, 1939, and to launch preproduction of the second "not later than between June 1st and 15th."

Hitchcock presented another fresh stipulation: Joan Harrison was his "secretary and script girl," and he wanted her $150–$200 weekly salary etched into any deal. "Hitchcock says that this girl has worked for him for years," explained Gurney, "and is invaluable to him in connection with his 'peculiar system' of writing, his shooting schedule, camera angles etc."

Unlike some Hollywood producers (an RKO official took his studio out of the Hitchcock bidding with the words "You will have trouble with us at that price"), Goldwyn didn't fret over the escalating demands. He continued his avid pursuit of the English director, and they shared a long lunch on June 23. Goldwyn liked Hitchcock, and was impressed that a man of such stature was paying his own way to America to apply for a job.

The second Goldwyn-Hitchcock meeting went swimmingly—even better than the first. "Goldwyn put on his usual act with Hitchcock," Gurney reported back to the agency. "I mean that first of all he established himself as the director's greatest friend on earth and then proceeded in an attempt to make an office boy out of Hitchcock. In other words, to tell him step by step what he should do in connection with preparing a story on 'Scotland Yard,' but Mr. Hitchcock quietly upset all of Mr. Goldwyn's ideas and Goldwyn then became very praiseworthy of Hitchcock's great ability and attainments."

Hitchcock thought it would help if he did what he often did in England: employ the same writer on both his first, presumably Selznick, production and his second, presumably for Goldwyn. To save time and money, one or more writers could work on both scripts simultaneously, consulting with him while he was filming *Jamaica Inn.* "Hitchcock says there must not be any apprehension about his ability to assist these writers whilst he is making the Laughton picture," Gurney explained, "because outside of actual shooting, the Laughton picture is so well prepared that it is more or less a mechanical procedure now to 'get it into the camera.' "

Who ought to be the main writer? Goldwyn wondered aloud. Hitchcock "stressed the importance of his having an English writer and one with whom he could work," in Gurney's words. Goldwyn was the rare Hollywood producer who encouraged compatibility between a writer and director; he was the sponsor, for example, of the long partnership of Lillian Hellman and William Wyler. Goldwyn suggested that Hitchcock might reunite with Charles Bennett, who was presently under contract to DOS and therefore could be easily integrated into the bargain. Hitchcock awkwardly explained that "Bennett would be ideal for him on the story construction, but that later on he would have to have a dialogue writer," Gurney reported.

Goldwyn wasn't going to lose sleep over details. They "came to the

point of discussing a deal," said Gurney, before Goldwyn again invoked the protocol. "He could go no further until David Selznick 'cleared the way,' as DOS had the first call on Hitchcock."

But Gurney knew the agency was flirting with Goldwyn primarily to arouse DOS, who the cabal believed was less likely to share Hitchcock with Goldwyn—his equal or even his better as an independent producer— than with anyone else in Hollywood. So the Goldwyn talks ground to a halt while everyone waited for a signal from DOS.

Three weeks after Hitchcock's arrival in Hollywood, everyone was still waiting. The director had been wined and dined. He had done a modicum of sightseeing, but he was too distracted to enjoy himself. He spent most of his time on the sidewalks between the hotel and the agency in Beverly Hills. And still there was no firm word from DOS.

And by the end of June, Hitchcock was apoplectic. He found himself somehow tied to the indecision of his agent's brother, without any guarantees, schedule, or definite project on the table. On June 30 the director spent two hours at the agency, irately complaining that he appreciated DOS was having some difficulty arriving at a final decision—but "still he would rather have the answer of 'no' than none at all, so that we may know how to proceed with Goldwyn or any other producers who might be interested in him," according to Gurney.

Myron, though, could be as charming a bulldozer as his brother David. He convinced Hitchcock to stay calm just a little longer. DOS was about to see the light. After talking with Hitchcock, Myron took command; he visited his brother and delivered an ultimatum. Sure enough, on July 2, Selznick International finally made Hitchcock an offer.

An extremely disappointing offer: the proposed contract would guarantee only one Selznick-Hitchcock production, along with four years of option clauses permitting the producer to extend his supervision of Hitchcock films, one per year, through 1943. The arrangement would begin, at the producer's discretion, between January 15 and April 15, 1939. Preliminary language specified the first project as "Titanic," although DOS had the right to substitute any other film. (The final language would delete any mention of the ship-disaster project, fast disappearing from DOS's radar screen.)

Moreover, the offer was for only fifty thousand dollars for the first Selznick picture, encompassing at least twenty weeks of production (the other weeks of the year would be free and clear to Hitchcock). Only after he had directed four additional films for Selznick International, over four years, would Hitchcock's salary rise to seventy-five thousand dollars. "All of the time that Hitchcock devotes to the story between now and the actual starting date is to be gratis," the offer stipulated.

In his book *Hollywood: The Movie Colony, the Movie Makers,* Leo Rosten researched the earnings of Hollywood filmmakers in 1938, listing

thirty-four directors (out of sixty-seven voluntary respondents) making salaries of $100,000 or more, and sixteen who earned over $150,000.* The latter group included such studio contract journeymen as Roy Del Ruth, Norman Taurog, Archie Mayo, and Wesley Ruggles.

Not only did Hitchcock's proposed contract rank him below Del Ruth, Taurog, Mayo, and Ruggles, but it tucked all of his and Mrs. Hitchcock's scriptwork into his salary (other directors were routinely paid extra for any scriptwork). Plus, it made no allowance for sharing of profits or of gross revenue, which was gradually becoming standard for top directors. No allowances were made for coproducing, which also boosted other directors' income. There were travel and relocation set-asides, but even these were less than Hitchcock had wanted. And DOS did agree to pick up the moving expenses and salary of Joan Harrison.

Myron assured a disconsolate Hitchcock that it was the best contract he could get under the circumstances; that DOS was superior in every way to Goldwyn; that it was a matter of cachet to work for Selznick International, and this cachet would help Hitchcock obtain a higher salary on his loan-outs. He could direct his one Selznick production a year, and then feel free to direct one or more additional pictures for other Hollywood producers—including Sam Goldwyn if he wanted. In other words, the contract was an open door to America.

Hitchcock accepted. On July 6 Myron hosted the Hitchcocks for a celebratory dinner at his house, with Dan Winkler, Clark Gable, and Carole Lombard the only other guests. Selznick clients both, Gable and Lombard were the uncrowned (and yet unmarried) king and queen of Hollywood. The screwball comedienne was a down-to-earth "Hitchcock blonde" who delighted in risqué humor. Gable laughed hardest whenever the apple of his eye was laughing.

Hitchcock, charmed by Lombard, was also in a laughing mood. Ever the practical artist, he was convinced that everything was probably for the best. And with his high-spirited dinner, Myron sent his client home from Hollywood on a high note.

Furiously left out in the cold was Sam Goldwyn, who had waited patiently for Hitchcock to conclude a deal with the Selznicks that ultimately locked him out. Determined, the producer made one last-ditch effort to contact the Englishman and sign him for at least one Goldwyn production, sometime—anytime—in 1939. Because DOS's calendar was so "elastic," Myron knew better, and ordered the agency not to facilitate any communication.

* Of course the most famous and best-paid Hollywood directors did not volunteer information about their salaries.

On July 8, the Hitchcocks returned by train to New York. The director finished off an extended sit-down with Russell Maloney for the *New Yorker,* and spoke on WNYC radio about "The Making of Melodrama" with *New Republic* film critic Otis Ferguson. Hitchcock "held forth about the possibilities of enterprising B-features as a field for experiment," reported John Russell Taylor, "using offbeat stories by writers such as O. Henry or Edgar Allan Poe—a curious anticipation of what he was going to do with his television series years later."

Then the Hitchcocks sailed on the *Normandie* back to England, and again the director sprawled in a deck chair, basking in the blue skies, watching the people, and catching up with his reading. He carried with him, according to London's *Daily Telegraph,* "a trunk full of books, articles and contemporary illustrations" about the *Titanic* disaster. This time his fellow passengers included novelist Theodore Dreiser, actor George Sanders, *New York Post* entertainment columnist Leonard Lyons, and William Paley, the head of CBS radio—who would one day air *Alfred Hitchcock Presents* on his television network.

David O. Selznick announced his prize acquisition on July 12, the eve of Hitchcock's departure for England. The news was carried in the *Los Angeles Times* and film columns nationwide, but the items were brief—partly because DOS couldn't elaborate on "Titanic," reported as the first Selznick-Hitchcock project ("Quite obvious what the last two reels will be," Hitchcock told one New York newspaperman. "Beyond that nothing"), and partly because Hitchcock's name meant almost nothing to the general public in America.

In England, the loss of this "national institution," in C. A. Lejeune's words, was bigger news. As long feared, England's onetime boy wonder, its greatest director, was joining the Lost Legion of Hollywood. The applause was tinged with bitterness.

For one thing, the Gaumont films, which had stirred deep admiration from some critics, also added others to the anti-Hitchcock club. Graham Greene was one who detested the illogic and Macguffins of some of Hitchcock's greatest English films. Commenting on *Secret Agent* in the *Spectator,* for example, Greene wrote, "How unfortunate it is that Mr. Hitchcock, a clever director, is allowed to produce and even to write his own films, though as a producer he has no sense of continuity and as a writer he has no sense of life." John Grierson was another well-known critic who rarely lost an opportunity to accuse Hitchcock of squandering his talent.

Noting that Hitchcock intended to leave London as early as January 1939, after finishing *Jamaica Inn,* Herbert Thompson, the editor of the fan magazine *Film Weekly,* wrote: "I do not always applaud these Hollywood

captures, but in Hitchcock's case I am sure experience of Hollywood's mass-production methods will improve his work. Hitchcock, still probably Britain's most talented director, certainly the most individualist, has suffered for too long from being unchallenged in his own field and from being allowed to make his pictures almost exactly as he pleases. There is a strain of willfulness in Hitchcock, which has become more and more apparent with every picture he has made.

"He is a man with a cold and sardonic eye. He sees the grotesque side of his fellow men. And he is always more than ready to include one scarifying, impish touch, even at the risk of sacrificing the mood of a scene or a whole picture. He pleases himself."

In spite of all that, Thompson arrived at a hopeful conclusion: "There is a suggestion that Hitchcock may decide to remain in America after he has made his 'Titanic' film. I doubt the truth of that. Hitchcock is one of our few directors who can be called essentially British.

"When he returns he will, I predict, be a finer and more popular director than ever."

Hitchcock didn't care a fig about *Jamaica Inn;* he had agreed to direct it largely out of desperation. But he did have an affectionate regard for Charles Laughton, and thought he would enjoy directing the oft hammy, always charismatic actor, whose physical bulk rivaled his own. Hitchcock and Laughton had known each other since the late 1920s, when they lunched together occasionally. A frequent guest at Cromwell Road and Shamley Green (he had his own cottage in the vicinity), Laughton was as chimerical in private life as he was flamboyant and arresting on-screen (he had already played Claudius, Rembrandt, and Henry VIII, winning the 1933 Oscar for *The Private Life of Henry VIII*). Hitchcock found him to be "a very charming man," in his words, "very nice and also very troubled."

Laughton's partnership with Erich Pommer, who in Berlin in the 1920s had supervised the Ufa masterpieces of Fritz Lang, F. W. Murnau, and G. W. Pabst, had been launched with fanfare. Pommer's résumé certainly commanded respect, but Hitchcock knew the producer only glancingly from his time in Berlin and "hadn't seen him since." Now a refugee from Hitler, Pommer was in many ways an edgier man. Reduced to supervising one film at a time, not several simultaneously, Pommer was no longer as laissez-faire in his approach. He hovered over all the decisions, feeling the need to reestablish his reputation outside Germany. He and Hitchcock renewed their acquaintance with instant mutual dislike.

By the time Hitchcock returned from America, the *Jamaica Inn* script, which had been bequeathed to Sidney Gilliat and Joan Harrison, had come

under Pommer's influence. With one eye on the U.S. market, the producer had sent the Clemence Dane version to the New York office of the Production Code Administration, which "had refused to allow a clergyman to be the villain," in the words of Gilliat. Although that was the whole point of the novel, Pommer had taken the Production Code to heart, and insisted the clergyman be turned into a justice of the peace. On this and any other dispute, Laughton—concerned about his investment, loyal to Pommer, and insecure about his own judgment—sided with his partner, usually by making himself invisible. In Hitchcock's absence, Pommer had cracked the whip on a revised draft that produced "unashamed characters who were melodrama," in Gilliat's words.

With a deep sigh, the director had to acquiesce when Pommer and Laughton now insisted on employing J. B. Priestley, widely revered for his prodigious output of plays and novels, to toil on the star's part and dialogue, lending period flavor and "Regency touches," in Gilliat's words. Priestley churned out "scenes more or less straight out of Ashden's *End of the 18th Century,* a famous source book," according to Gilliat, while the resigned Hitchcock let Laughton develop them almost as apron speeches*

Hitchcock showed only a mild interest in the *Jamaica Inn* script anyway, according to Gilliat. On this film, almost all the pleasure was in the storyboarding. The director focused particularly on "the first scene which was the coach arriving at the Jamaica Inn—all raging surf, whistling wind and violent shadows," in Gilliat's words.

The Mayflower partners sought an unknown to play the lead female character, Mary, the young niece who opposes the pirates. Maureen O'Hara had apprenticed with the Abbey Theatre in her native Dublin before playing inconsequential parts in British films, but after an inconclusive screen test the redhead, just eighteen, met Laughton and bewitched him. O'Hara had signed for the role well before Hitchcock agreed to direct.

Leslie Banks, who played the father of the kidnapped girl in *The Man Who Knew Too Much,* was cast as Joss, the leader of the gang of rogues; his wife, the well-named Patience, would be portrayed by Marie Ney. Rugged Robert Newton was the government infiltrator, flushed out by the pirates and rescued by Mary. Among the gang of rogues, whimsically, the director planted two actors who had also served as writers of Hitchcock films, Emlyn Williams and Edwin Greenwood.

* * *

* The film's strangest scene takes place in a dining room and involves a horse. Donald Spoto blames this scene on the director—"the appalling exaggeration of a sadistic scene in which the deranged Laughton, protesting how much he is in love with Maureen O'Hara, binds and gags her"—but Priestley wrote it straight from the novel.

By the time filming began in October, Hitchcock felt he was in the clutches of a two-headed monster. It would be too strong to say he ceased to care, but he knew a futile struggle when he saw one, and he stepped back and let Erich Pommer and Charles Laughton dominate. Looking ahead to America, he had already left *Jamaica Inn* behind. "Realizing how incongruous it was," he later told François Truffaut, "I was truly discouraged, but the contract had been signed."

His detached attitude allowed him to preserve his friendship with the star. It was an unusual problem for Hitchcock: directing an actor he liked and admired, but who wouldn't listen to him. Laughton was really the first Method actor he had encountered. One scarcely directed Laughton, other than telling him where to stand for the camera angle. "The difficult actor" (as he is dubbed in one biography) carried on most of the debate inside himself—to the exclusion of anyone else. "Laughton versus Laughton" is how the frustrated director described the process. "He frets and strains and argues continuously with himself. And he is never satisfied," Hitchcock declared in one interview.

From the start of filming, Laughton was thwarted by his inability to deeply communicate what he felt was the core of his character, Sir Humphrey (to get as close as "the sweat in a whore's bed," as he declaimed one night at Ciro's). Laughton insisted Hitchcock frame him only in close or medium shots, for example, until he learned how Sir Humphrey ought to walk. This lasted about a week, until he heard a snatch of the film's score—from Weber's *Invitation to the Dance*—being arranged by composer Eric Fenby. "I've found it!" Laughton yelped, whistling the waltz rondo as he proudly demonstrated his peculiar walk. Now, the actor declared, Hitchcock could open up his angles.

One day later in the schedule, they worked for hours to get a close-up of Laughton viciously tying up O'Hara, her hands behind her back. Hitchcock couldn't get the expression he wanted from the actor, however, and at one point Laughton sat down in a corner and began to weep. Hitchcock went over and consoled him, patting him on the shoulder. Laughton looked up and said, "Aren't you and I a couple of babies?" ("I wanted to use a Goldwynism and say, 'Include me out,' " Hitchcock recalled, telling the anecdote, years later.) After a few more takes, Hitchcock finally got what he wanted. "You know how I got it, don't you?" asked Laughton proudly. "No, Charles, how?" "I thought of myself as a small boy of ten, wetting my knickers." ("That's inspiration for you, isn't it?" Hitchcock liked to top off the story, a smile spreading across his face.)

Laughton exasperated everyone. But "I think to be fair to Laughton," Sidney Gilliat recalled, "none of us had a completely clear picture of the squire." The star, explained Gilliat, "could be very fine indeed when he trusted his instinct, but as soon as he got a scene right by instinct—and

knew it—he would then try to repeat it by intellect. Now his instinct was sounder than his intellect, but he distrusted the one and cultivated the other."

It was a torturous production, with Laughton torturing himself, and the entire cast and crew tortured by the torrents of machine-blown wind and water that sent everyone home at night suffering shivers and colds.* Hitchcock perfected his standing-against-the-wall routine, which could be as deceptive as his catnapping habit: sometimes it was a feint, other times it was exactly what it seemed—abject retreat. The director stood against the wall a lot while directing Laughton in the J. B. Priestley scenes, according to Gilliat. And he grumbled more than usual to the press: "Directors can't direct a Laughton picture. The best they can hope for is a chance to 'referee.' " Or: "The hardest thing to photograph are dogs, babies, motor boats, and Charles Laughton. Motorboats because they never come back for take two."

All things told, though, *Jamaica Inn* was surprisingly well refereed.

Under Hitchcock, Maureen O'Hara gave a fiery performance that established her as a rising star. The director found tenderness in the relationship between Leslie Banks and Marie Ney, and encouraged mugging and colorful behavior from the gang of pirates.

Hitchcock found a surprising tenderness in Charles Laughton's character, too. At the end of *Jamaica Inn*, Sir Humphrey has gone mad. Kidnapping Mary, he tries to escape; mumbling like a lunatic, he climbs a ship's mast surrounded by gawking crowds. As constabulary swarm, he leaps to his death—another Hitchcock villain who dictates his own confessional fate. Besides his softhearted niece, the only person who grieves for him is his much-abused manservant, Chadwick (Horace Hodges). The eerie coda of the film is a final shot of this dazed retainer, Sir Humphrey's shrill "Chadwick!" still ringing in his ears.

The announcement that Hitchcock had signed a contract with Selznick International may have provoked mixed feelings in England, but the long article about the director in the *New Yorker* stirred up a real hornet's nest, and caused permanent repercussions in his relationships with writers.

"A Hitchcock picture is, for better or for worse, about 99.44 per cent Hitchcock," wrote Russell Maloney. "Hitchcock selects all his stories, and

* Edwin Greenwood, playing a pirate named Dandy, died prematurely shortly after the filming. Sidney Gilliat, in a later interview, didn't hesitate to blame Greenwood's death on Hitchcock. "Hitch could easily have sent him home, as you didn't really see the individual characters in the middle of those rolling waves and wind machines; but Hitch went on shooting and poor Edwin went down with pneumonia and died shortly afterwards. I felt that could have been avoided and that Hitch was to blame for what happened."

is the leading figure in the adaptation, writing of the dialogue, and preparation of the shooting script."

At the outset of each project, according to Maloney, Hitchcock "engages a writer, preferably an extrovert who is prolific in ideas and situations rather than in fine writing." Then he convenes daily story conferences for a couple of months around the dining-room table of his flat, attended by the writer, Mrs. Hitchcock, and Joan Harrison.

"First they reduce the story to a bald half-page outline, which sets forth the main situation and the principal characters. Hitchcock next asks himself (and his colleagues), 'What are these people? What is their station in life? What do they work at? How do they act when they are at home?' The outline is expanded into a treatment of sixty or seventy typewritten pages. This covers the story scene by scene and action by action, but without dialogue. The dialogue is done by a second writer, who takes over each installment of the treatment as fast as it is turned out by Hitchcock and his idea man. Then Hitchcock and his wife convert the dialogue into the final shooting script, a task for which Hitchcock gallantly allows her exclusive program credit, under her maiden name."

Published in the September 10, 1938, issue, the article was made available earlier for publicity purposes. It came at an embattled time for screenwriters in England and the United States. In both countries, film writers were busy organizing guilds to demand fair payments and accreditation, and to unite their profession against the high-handed practices of producers.

While Hitchcock was quoted sparsely, and most of the phraseology was Maloney's (calling the director "the leading figure" in the script development, for example), the *New Yorker* account was relatively accurate. But the slant in favor of Hitchcock cast his writers in a diminished light, and suggested that sentiment orginated with the director himself.

It is unclear whether Charles Bennett, busy trying to reposition himself in Hollywood, learned what Hitchcock had told Sam Goldwyn about him—that he was primarily a constructionist. At least this remark, which Bennett's agent—Myron Selznick—also wished he could expunge from the record, was made in private. Now the able scenarist of *Blackmail, The Man Who Knew Too Much, The 39 Steps, Secret Agent, Sabotage,* and *Young and Innocent* read, between the lines of America's most prestigious magazine, that the director did not think he was a truly "fine writer," and that Mrs. Hitchcock, Joan Harrison, and sundry dialogue specialists were required to bolster Bennett's scripts.

A deeply dismayed Bennett wired Hitchcock: "APPARENTLY HARMLESS STATEMENT YOU MADE TO NEWSPAPERS WAS ACTUALLY NOT PLEASANT FOR ME . . . IN ALL INNOCENCE YOU NEARLY PUT YOUR FOOT IN IT FOR ME."

Although Hitchcock swiftly wired an apology for the misunderstanding, the writer felt mortally wounded. Almost certainly the combination of

what was said to Goldwyn and what appeared in the *New Yorker* torpedoed any likelihood that Bennett would write Hitchcock's first American film.

Frank Launder and Sidney Gilliat, who were militant in support of writers, were doubly outraged—on Bennett's behalf, but also their own. They, not Hitchcock, had "selected" *The Lady Vanishes*. Their initial script, which the director had praised, was written without any input from him. They regarded the article as self-aggrandizement at their expense.

Even before the *New Yorker* hit newsstands, Hitchcock must have realized that the article overstepped some bounds, because he tried a preemptive maneuver. One day he and Gilliat were discussing the *Jamaica Inn* script at Cromwell Road, according to Gilliat, when Hitchcock mentioned with elaborate casualness that a forthcoming publicity profile of him in an American magazine cited him as claiming that he wrote "99.44 per cent" of all his scripts. Hitchcock assured Gilliat that "that doesn't apply to people like you and Frank, who I regard as real writers." That ham-handed compliment bothered Gilliat all the more.

But Hitchcock himself gave a copy of the magazine to Gilliat, and no more was said for the time being. Controversy was stirred anew in December, however, when snippets were recycled in Viscount Castlerosse's widely read column in the *Sunday Express*.

The occasion was the opening of *The Lady Vanishes*. The new Hitchcock film had begun to collect rhapsodic reviews, and Gilliat couldn't help but feel that critics were giving the director what he and Launder regarded as undue credit for *their* screenplay. Upset by the reviews and by Castlerosse's exaggerations, Gilliat told Hitchcock, "I think you ought to cover us over that." The director pleaded, "It's not my fault." Gilliat insisted, "I'm not saying it is your fault, but I'd be terribly grateful if you would correct it with regard to *The Lady Vanishes*."

But the director issued no public corrections, even after the recently formed Screen Writers Association wrote him a formal letter protesting the now widely published assertion that he was the closet writer of all the Hitchcock films. Launder sent him a caustic telegram: "I DON'T LIKE OUR 0.8 PER CENT BEING BELITTLED." The director then tried to make light of the whole brouhaha, sending back a series of joking telegrams signed by his mother, pointing out the dubious origins of the statements and how his words had been widely distorted. Launder struck back with another barbed telegram, this one addressed to Emma Hitchcock, saying, "MY SON FRANK SAYS THAT HE WON'T PLAY WITH YOUR SON ALF ANY MORE BECAUSE HE'S A BIG BULLY WHO STEALS ALL THE MARBLES. SIGNED ETHEL LAUNDER."

Although he made jokes himself about being a "big bully," Hitchcock detected the veiled reference to his weight, and the barb stung. According to Gilliat, Hitchcock was "very insulted," and the issue was dropped with

bad feelings all around. Hitchcock subsequently offered Gilliat a chance to come to Hollywood with him and write *Rebecca,* but Gilliat declined— partly, he said later, because he disliked the book, partly because he nursed a grudge. (In any event DOS said no to paying for some chap named Gilliat he'd never heard of.)

In later interviews, Gilliat would consistently misrepresent this incident and blow it out of proportion, while disparaging Hitchcock as an odd, "very destructive character." Bennett, who found it difficult to forgive Hitchcock, made similar comments. Because they both lived long lives and gave numerous interviews, they helped further the idea that the director thought all writers were cattle too—another persistent phantasm in the Hitchcock legacy.

Meanwhile, Joan Harrison, whom Hitchcock was cultivating as a writer, earned her first on-screen credit as coscenarist with Sidney Gilliat on *Jamaica Inn*—a gesture intended to pave the way for her to launch her career in Hollywood. Alma Reville also worked on the script, receiving her now customary credit: "Continuity."

The postproduction of *Jamaica Inn* was left to Erich Pommer; Hitchcock certainly wasn't sticking around for its release. Yet the film proved surprisingly successful with audiences, and even with critics—though more so in the United States, where Hitchcock was on a roll, than in England, where his departure for Hollywood left a sour taste with reviewers.

As with *Waltzes from Vienna,* the experience of *Jamaica Inn* reminded Hitchcock that at heart he was a poet of the present day who got lost whenever he tried to muck about in a make-believe past. He vowed never to make another costume film, though it was a vow he usually forgot whenever a new costume story came along to tempt him.

For the moment, Hitchcock was anxious to settle the question of his first American project. For a long time, David O. Selznick remained maddeningly undecided between the "Titanic" film or *Rebecca* . . . or a third tantalizing possibility that never quite formed on his lips. One bulletin from Selznick International had Hitchcock directing an adaptation of *The Flashing Stream,* a London play regarded as a likely vehicle for Carole Lombard. When Hitchcock cabled to ask what had happened to "Titanic," DOS cabled back that he was postponing it, but that Hitchcock should not tell the press: "DO NOT WANT TO GIVE IMPRESSION THAT WE HAVE RELAXED PLANS FOR TITANIC LEST SOMEONE ELSE BE ENCOURAGED GO AHEAD WITH IT."

Hitchcock had hoped to start work on the "Titanic" script as early as August, but Selznick's vacillation forced him to tread water instead with exploratory research. As of September 21, *Variety* was still reporting *Re-*

becca as Hitchcock's *second* Selznick project, with "Titanic" probably the first; as late as November 2, Hitchcock was visiting the Board of Trade in London to assure skeptical officials ("they seem to think that if I recapture all the horror and violence of the situation it will stop people going on cruises") that his "Titanic" picture would glorify British seamanship and heroism, and promote recent advances in lifesaving measures.

By the time DOS decided conclusively on the first Selznick-Hitchcock production, it was mid-November—and the decision was *Rebecca*. Although Hitchcock might have been happier with "Titanic," by then he was glad for any go-ahead. After Gilliat recused himself, and before filming on *Jamaica Inn* was complete, Hitchcock put the initial continuity in the hands of Alma and Joan Harrison; they were joined by Michael Hogan, a onetime actor with Granville Barker's and Tyrone Guthrie's troupes, who was married to actress Madge Saunders.

Hogan was known for playing the father on *The Buggins,* the first, hugely popular "radio family" on English airwaves, and for collaborating with the show's creator, Mabel Constanduros, on various radio and theater material. An actor attuned to dialogue and characterization, Hogan was the proverbial "extrovert who is prolific in ideas and situations" (in the words of Russell Maloney) whom Hitchcock liked to have as his sounding board. Hitchcock paid Hogan out of pocket at first, hoping to get the jump on *Rebecca*. Besides, the Hitchcocks liked the Hogans' company; they all went out together to the theater and nightclubs.

Hitchcock also tried to push ahead with the casting, since knowing the actors would help with writing the characters. He thought Maureen O'Hara, fresh in his mind from *Jamaica Inn,* might be the right young actress to play the new wife whose existence is overshadowed by the dead Rebecca. But DOS had never heard of O'Hara, and the producer cabled Hitchcock: "MUCH TOO EARLY TO ADVISE CASTING."

For Selznick it was much too early for anything; he was still completely absorbed with making a film out of *Gone With the Wind.* The costs of that production were ballooning out of sight, and the last thing DOS wanted to do was to siphon off money and energy to another film. Hitchcock, on the other hand, coasted to a finish on *Jamaica Inn* in late November, and expected to sail for America after the first of the year. He counted on drawing his salary from Selznick International beginning in January.

When the producer informed him that he wouldn't be able to concentrate on *Rebecca* until late February at the earliest, Hitchcock was incensed. That would mean weeks of idle, unsalaried time, but not enough time to squeeze in another film in either England or the United States. When he asked DOS to pinpoint a date, DOS wired him back: "SORRY CAN'T BE OFFICIAL OR DEFINITE." After thinking it over, DOS said unhelp-

fully that he didn't think he could focus on *Rebecca* "much before March or April."

With such vague noises from DOS, the director angrily insisted that Myron Selznick find him another quick job—immediately. Hitchcock sorely wanted to reduce his "NONEARNING PERIOD BETWEEN JAMAICA INN AND COMMENCEMENT SELZNICK CONTRACT," according to the telegram he sent his agent in Hollywood.

Other Hollywood producers, meanwhile, hovered in the wings. Arthur Hornblow Jr. at Paramount stepped up to offer Hitchcock a rock-solid March 1 start date on a studio-approved project. Hitchcock was inclined to say yes—but it turned out that he *couldn't* say yes without DOS's consent; furious to be pushed on a point of pride, Selznick insisted that he, and only he, would produce the first Hitchcock picture in America.

What finally broke the logjam, and lit a fire under DOS, was not Hitchcock's mounting pique, or the offers of other producers. It was the naming of Hitchcock as Best Director of 1938 in late December by the New York Film Critics. His latest film to reach America, *The Lady Vanishes,* struck the New York critics of that year—as it strikes most viewers today—as a total delight, as inventive a creation as any Hitchcock film to date.

Alarmed that his open-ended agreement with the year's Best Director might allow Hitchcock free rein to freelance for his rivals, the producer volunteered amended terms that would make Hitchcock *exclusive* to Selznick International for two pictures a year, one of which *could* be a loan-out—though only if circumstances were agreeable to both parties. Added value to Hitchcock came in the form of an increased annual (as opposed to per-picture) salary, which would kick in automatically in April regardless of any further postponements by Selznick. The built-in raises also improved on their previous agreement.

Hitchcock consented to this very quickly, by telephone, and happily finalized his departure. With some awkwardness, he managed to extricate himself from the Jack Buchanan picture he had tentatively agreed to direct. For tax purposes his association with J. G. Saunders was liquidated, though Saunders would continue as his English accountant for the rest of his career. The director arranged to lease his flat on Cromwell Road and the cottage in Shamley Green. Furniture was placed in storage.

Hitchcock had twiddled his thumbs for over two months. Now— sooner than DOS wanted him, but later than Hitchcock might have wished—he, his family, and Joan Harrison sailed from England on March 4, 1939. The bon voyage party that enlivens the beginning of *Foreign Correspondent* gives a hint of the scene: a crowd of friends, drinks and toasts, and the funny tender moment when his mother kissed him good-bye and wished him good luck.

HOLLYWOOD

FEAR AND DESIRE

EIGHT
1939–1941

This time, as Hitchcock crossed the Atlantic for good, there were clouds on the horizon that he couldn't ignore. War clouds. Professional clouds. He was on the verge of forty, of middle age; and now, halfway through his life and career, he had to start over in a country that still felt alien to him.

The Lost Legion of British film industry exiles had filled Hollywood with actors and actresses who made cozy salaries playing European types in American films. A small group of British-accented actors even became stars. But few Englishmen before Hitchcock had managed to carry successful directing careers to the Hollywood system.

And Hitchcock would discover early that films about murderers were considered another lowbrow specialty in Hollywood—partly because "in America," as he observed in interviews, "crime literature is second-class literature."

He moved to Hollywood, he said later, fully realizing that he was "a minor figure in a vast film industry made up of entrepreneurs who headed the studios." It was a system dominated by producers, not directors, and by the stars under studio contract who reigned at the box office. The studios supervised the writers and scripts; they calibrated the glamour of their leading ladies; they designed the "look" of their productions. Directors

weren't expected to second-guess production designers or cameramen. They weren't expected to think like writers or editors.

When Hitchcock, a quintessential Englishman, came to Hollywood, he was entering an industry that was quintessentially American. On the boat to the United States, as he tried to relax, he must have wondered if he was doing the right thing. If he had stayed home, he knew, he would easily have reigned for years as the greatest filmmaker in all of England.

His welcome was orchestrated by Selznick International and Albert Margolies, who was now retained personally by the director to handle his East Coast publicity. A guest lecture was arranged at the Yale School of Drama, where Hitchcock reportedly impressed the students with his knowledge of English theater; in another event at Columbia, he addressed a class on the "History of Motion Pictures."

Presiding over a press dinner at "21," over champagne and steaks Hitchcock was asked to name his ten favorite films. The list, which readers were assured he "thoughtfully selected," included two Cecil B. De Mille films. De Mille's *Saturday Night*, a 1923 feature starring Leatrice Joy, he ranked his overall favorite. It was followed by *The Isle of Lost Ships* (Maurice Tourneur, 1923); *Scaramouche* (Rex Ingram, 1923); *Forbidden Fruit* (De Mille, 1921); *Sentimental Tommy* (the 1921 version of James Barrie's novel, directed by John S. Robertson); *The Enchanted Cottage* (the 1924 version of Arthur Wing Pinero's romantic drama, also directed by Robertson); E. A. Dupont's *Variety* (1925); Josef von Sternberg's *The Last Command* (1928); Charles Chaplin's *The Gold Rush* (1925); and the depression-era drama *I Am a Fugitive from a Chain Gang* (Mervyn LeRoy, 1932). All but the last title—a socially conscious wronged-man story, which Hitchcock liked enough to praise again in the *New York Times* ten years later—were silent pictures, made before 1928.

The Hitchcocks took time for a ten-day visit to Florida and the Caribbean, leaving New York by train on March 16, and flying from Miami to Havana, then at the height of its mystique as a hot spot for international high society. Wherever he went his films were bound to follow, and Hitchcock would include nods to Cuba as a fascist haven in *Saboteur* and *Notorious*, and make Castro-era political intrigue a centerpiece of *Topaz*.

The director and his family returned to New York via rail on March 27, and departed for California four days later. They passed through Chicago, then crossed Middle America to arrive at the Pasadena depot on April 5. Myron Selznick was among the official greeters, though after a round of pleasantries they were turned over to Dan Winkler.

The Selznick Agency had leased for the family a three-bedroom apart-

ment in the Wilshire Palms on Wilshire Boulevard in Westwood, a new high-rise with a view of the mountains and ocean. The Selznick International studio was only ten minutes away by car. Joan Harrison was installed in a suitable apartment in the same building.

Although Hitchcock later insisted he "wasn't in the least interested in Hollywood as a place," he eagerly settled in. Eight-millimeter home movies, which he shot from the open seat of a convertible as they toured the city, capture the English family's exultant mood.

"The only thing I cared about was to get into a studio to work," Hitchcock told François Truffaut, and by Monday, April 10, he was rested and anxious. On that day he reported to the Selznick International lot on Washington Boulevard in Culver City, a mile east of Metro-Goldwyn-Mayer. There stood a white colonnaded mansion modeled after Mount Vernon and erected by Thomas Ince during the silent era, now owned by RKO and leased to Selznick, for whom it served as both headquarters and distinctive logo. To the rear of the main building sprawled eight soundstages and a forty-acre back lot, with vegetation that could be artfully disguised as any exterior in the world.

On the first floor was the spacious, well-appointed sanctum of the head of the studio. On David O. Selznick's desk was an omnipresent jar of cookies to alleviate his hypoglycemia; dangling from one wall was a photograph of his father, Lewis J. Selznick, whose fall from grace was never forgotten by his sons, and whose roller-coaster fortunes had even affected Hitchcock back in his Islington days. The Selznick executive advisers Daniel O'Shea (financial) and Henry Ginsberg (production) occupied adjacent niches. Hitchcock and Joan Harrison were assigned a comfortable suite with kitchen and bath in an outlying bungalow, where they resumed their work on the *Rebecca* script.

Michael Hogan had moved to Hollywood ahead of the Hitchcocks to write *Nurse Edith Cavell* for producer Herbert Wilcox, and now Hitchcock paired him up with Philip MacDonald to complete a draft of *Rebecca*. A leading figure in detective fiction, the British MacDonald had lived in Hollywood since 1931; until this point his film credits were unexceptional, though notable among them were a number of installments for the Mr. Moto series starring Peter Lorre.*

MacDonald was given the job of organizing the chain of suspense, while Hogan filled in with scene-by-scene ideas. On the page and in person both writers were witty, sophisticated personalities; they didn't flaunt

* MacDonald's many novels include *The List of Adrian Messenger,* filmed by John Huston in 1962.

their egos, and they forged a deferential camaraderie with Hitchcock. Mrs. Hitchcock, the director's uncompensated wife, joined with Joan Harrison and the newly hired hands to comprise five Hitchcocks collaborating on the script.

Selznick, meanwhile, was so overwhelmed by *Gone With the Wind* that he gave little thought to *Rebecca*. The filming of the Civil War epic had begun on December 10, 1938, with the extravagant burning of Atlanta, and then consumed a record four months of photography; the final take—before retakes, that is—was recorded in April 1939, the month Hitchcock started work. Some seventeen writers and five directors had been deployed on *Gone With the Wind*. The unprecedented costs eventually soared above $4 million.

Postproduction on *Gone With the Wind*, though, had just begun. The dubbing and looping, color values, optical effects, sound and musical scoring, editing, retakes and reediting—these were the producer's real obsession, his chance to revel in eleventh-hour fine-tuning. A month into his contract, even Hitchcock was asked to ponder a reel of *Gone With the Wind*.

"As I outlined on the evening of the 3rd of May," he reported back, "I feel that the lack of suspense in this reel arises out of the fact that it is deficient in three main essentials.

"(1) That the audience should be in possession of all the facts appertaining to Butler's, Ashley's, etc., efforts to get into the home which is surrounded by Union soldiers.

"(2) That the audience should be shown surreptitious exchange of glances by the pseudo-drunken Butler and the character Melanie.

"(3) That the end of the tension should be sufficiently marked as the Union soldiers depart with their apologies.

"I suggest that these things can be remedied by the following method:

"(a) To play the reel up to the commencement of the reading of David Copperfield and, instead of the LAP DISSOLVE to the pendulum, CUT AWAY to some location that has the house in sight and there show the desperate group of Butler, the wounded Ashley, etc. Establish that in the distance they can see that the house is surrounded; their bewilderment as to what manner they can pass the cordon; then, suddenly Butler has an idea. On this, we CUT BACK into the house and proceed with the reel until the family hear the arrival of the drunken group. Then, CUT outside to the drunks coming toward the house. Show Butler lift a sober eye in the midst of his mock inebriation, and from his eye-line show the military preparing to arrest their advance.

"(b) Once inside the house it should be essential to see an exchange of meaning glances between Butler and Melanie in order that we know that she is in possession of the fact that they are only pretending to be drunk.

"After the military has gone, there should be a slight movement, but Butler

should hiss them to silence for a moment while he crosses to the window; and then, turning, give the all clear. From this tableau of arrested motion, the whole room-full break into feverish movement around Ashley, etc."

Hitchcock even supplied an ordered list of shots that might improve the sequence. Hal Kern, the editor of *Gone With the Wind,* digested his notes and reported to DOS that the Englishman "has a great mind and better picture ideas than anyone I have met in months."* The producer could not help but be pleased by his new employee.

At least through June, *Gone With the Wind* demanded Selznick's unflagging attention. Hitchcock and his clique of writers were free to shape *Rebecca.*

The casting began before the script was finished—in Hitchcock's mind, at least.

Indeed, just off the train on April 5, Hitchcock dashed off a cable to Robert Donat, urging him to consider the part of the aristocratic Englishman, Maxim de Winter ("his face was arresting, sensitive, medieval in some strange inexplicable way," wrote Daphne du Maurier), who cannot shake the curse of Rebecca. Aware that such a notion was premature and bound to offend David O. Selznick, who prided himself on his casting acumen, Dan Winkler sent the wire, but only under protest.

Donat had just finished *Goodbye, Mr. Chips,* giving a performance that would eclipse Clark Gable's in *Gone With the Wind* to win him the Best Actor Oscar for 1939. Yet DOS quickly scotched the idea of Donat, saying it would be impossible to get MGM-British to loan him to Hollywood—though he didn't try very hard. Selznick's preferred list included Walter Pidgeon, Leslie Howard, Melvyn Douglas, and William Powell. Among these names, only Powell, who specialized in gentlemanly comedy, intrigued Hitchcock Casting Powell as de Winter—that would *really* be casting against type. The English director had loved Powell in *Libeled Lady,* and met and liked the self-effacing star at one of Myron Selznick's parties. Hitchcock was tempted by Powell, and his thoughts would return to him.

Before leaving England, Hitchcock had said in interviews that the ideal leads would be Ronald Colman as de Winter and Nova Pilbeam as the second Mrs. de Winter. Colman was an actor DOS and Hitchcock could agree on—and another Myron Selznick client to boot. Hitchcock launched a concerted campaign to woo the mellow actor, whose debonair qualities

* Ultimately, none of Hitchcock's "better ideas" was adopted by DOS for this scene; the entire scene was reimagined and reshot, changing drastically from the version Hitchcock saw and critiqued.

had made him Hollywood's romantic vision of an Englishman. Hitchcock made at least two visits to Colman's home in May 1939. Although he was on pleasant terms with Colman—whose wife, Benita Hume, had played a tiny part in *Easy Virtue* and a more substantial one in *Lord Camber's Ladies*—the actor refused to be pinned down. At first, Colman said, he relished the idea of starring in a Hitchcock film. But then he had second thoughts. He worried aloud about playing a wife killer, however sympathetic. In the end, Colman effectively demurred by signing for other roles in 1939, taking him off the roster of available leads for almost a year—longer than Hitchcock or Selznick could be expected to wait.

The talk then turned to Laurence Olivier—the authoritative English actor, highly regarded for his interpretations of Shakespeare and the classics onstage, who had catapulted to stardom in Hollywood after his Heathcliff in *Wuthering Heights*. Though Powell was still in the running, Olivier gained the edge; in performance he was very much like de Winter—a riddle—and casting Olivier would also resolve a thorny issue for DOS, who wanted to keep Vivien Leigh, his Scarlett O'Hara, content during the long months of *Gone With the Wind* postproduction that he knew would last the summer and into the fall of 1939. Olivier and Leigh's extramarital romance had fueled a scandal during *Fire over England,* and their love story was continuing, with "dirty weekends" away from the press as they sought divorces from their respectives.

After Olivier signed on as de Winter, Leigh became the leading candidate for the second Mrs. de Winter, the nameless narrator of the book and film, who must solve the mystery of Rebecca's demise and conquer her husband's demons. A "raw ex-schoolgirl, red-elbowed and lanky-haired," in du Maurier's words, the second Mrs. de Winter is really the story's central character. Almost desperate to claim the role opposite her future husband, Leigh agreed to audition for the part, with Olivier himself reading de Winter's lines off-camera (a special consideration he didn't afford to any of the other candidates). Leigh's tests were a disaster, though, and according to David Thomson in *Showman,* DOS concurred with Hitchcock and director George Cukor, who helped with testing, that "she doesn't seem at all right as to sincerity or age or innocence."

But who would be right in age and innocence? Hitchcock, early on, had voted with apparent sincerity for Nova Pilbeam, the English actress who had beguiled him in *The Man Who Knew Too Much* and *Young and Innocent.* Other accounts insist that the director, in private communications with DOS, questioned Pilbeam's maturity, her ability to "handle in love scenes." But to this day Pilbeam believes Hitchcock desired her for the part; he may even have disparaged her as a way of piquing Selznick's interest. In the end, though, DOS said no to importing a nonentity.

The auditions went on and on, through May and June. The process was a test of wills, but there was also genuine, torturous indecision. Hitchcock

and DOS screened footage of top-tier leading ladies such as Margaret Sullavan and Loretta Young, as well as long shots like costume-drama blonde Anita Louise, and even sixteen-year-old Anne Baxter.

Hitchcock had a monumental tolerance for sitting through screen tests. He would call for them less often in Hollywood, where they were more of a producer's tool, and he preferred to meet with people informally rather than test them himself. But without the constant West End theatergoing that had stimulated his casting ideas in England, he was obliged to rely on tests; and he prided himself on an archival memory for all those he watched.

But Selznick was more addicted to screen tests; in truth, the producer cared far more about casting than the English director, who preferred to get it over with. "I think he [DOS] really was trying to repeat the same publicity stunt he pulled in the search for Scarlett O'Hara," Hitchcock said later. "He talked all the big stars in town into doing tests for *Rebecca*. I found it a little embarrassing, myself, testing women whom I knew in advance were unsuitable for the part."

Cukor and another American director, John Cromwell, both long accustomed to the Selznick routine, conducted some of the auditions. Watching test after test, Hitchcock's mood soured, and his comments, especially about the more incongruous possibilities, could be caustic. Jean Muir, who never had good luck in Hollywood, he described as "too big and sugary," while the unknown Audrey Reynolds was deemed "excellent for Rebecca who doesn't appear."

Gradually, he divined the producer's favorite: Joan Fontaine. In June 1938, at a dinner party at Charlie Chaplin's, DOS had found himself seated across the table from the delicate blond ingenue. This "owl of a man," in Fontaine's words, sat up straight when the actress mentioned that she'd just read a thoroughly gripping novel called *Rebecca*. The producer introduced himself, and confessed that he'd just bought the film rights—would Fontaine like to test for the lead?

It's easy to chuckle at this implausible fairy tale—after all, Fontaine was the dinner date of George Cukor, a Machiavellian insider. The important thing is that the producer was smitten. A coquettish creature, not quite twenty-one, Fontaine was born in Tokyo to English parents; her older sister Olivia de Havilland—their feud was one of the liveliest in Hollywood—was better established, including her role in *Gone With the Wind*. Up to this point Fontaine was best known for a few quietly memorable roles, fumbling with charming ineptitude as Fred Astaire's dance partner in *A Damsel in Distress,* keeping the home fires burning in *Gunga Din.* "Olivia de Havilland's kid sister" hadn't yet emerged as every Lothario's vision of an English lady who could chill any man with frosty words, but whose expression hinted at naughtiness in the bedroom.

Although it seemed obvious to everyone that DOS had fallen in love

with Fontaine—from the end of June 1938 into early 1939, David Thomson says, the producer contrived to see her on almost a daily basis—their love supposedly remained platonic. And because she was more of a young cutie than the kind of major star Selznick had in mind for *Rebecca,* the producer dithered about signing her for the part.

Hitchcock dithered too. After directing Fontaine's first audition, John Cromwell announced that the search was over. Later, Hitchcock would insist that he had agreed with Cromwell, but at the time he was noncommittal. Selznick's obvious crush on Fontaine made him nervous. Hitchcock "observed how much the gestation of *Rebecca* in David's mind had had to do with his feelings for Joan Fontaine," Thomson wrote.

After reviewing Fontaine's test footage, Selznick adviser Jock Whitney said he wasn't convinced she should play the part—which carried weight with DOS. Nor was Alma Reville won over—which carried weight with her husband. Mrs. Hitchcock found Fontaine's manner "coy and simpering," her voice "extremely irritating." In the end, though, the final decision was up to DOS; after a while the testing ceased, and everyone waited.

Although Selznick had warned Hitchcock to stay faithful to Daphne du Maurier's book, it is doubtful whether the producer himself had read more than a synopsis of the novel by the summer of 1939. Honor thy expensive source: it was a routine commandment for the producer—but an ironic one for Hitchcock, who already had the reputation of waving his wand over books and making them disappear.

In early June the director turned over a lengthy treatment of *Rebecca,* and the document "shocked" DOS "beyond words." Hitchcock and his writers had dared to tinker with du Maurier, introducing all kinds of new elements: from flashbacks depicting Rebecca, to an opening showing de Winter on a ship smoking a cigar and making his fellow passengers cigar- and seasick. The director had added a suspenseful car ride along a high rim, along with a host of comic incidents, and "well-observed moments of English domestic life," according to Leonard Leff in *Hitchcock and Selznick.*

Not too shocked to dictate a lengthy memo, DOS expounded on "the filmmaker's responsibility to a popular novel." The producer not only admonished Hitchcock—"We bought *Rebecca* and we intend to make *Rebecca*"—but, even more remarkably, also wrote to du Maurier behind Hitchcock's back, reassuring the novelist that he had "thrown out the complete treatment," and that he intended to force Hitchcock to film "the book and not some botched-up semi-original such as was done with *Jamaica Inn.*"

DOS hated Hitchcock's comic additions, and targeted them all for dele-

tion—particularly the Hitchcockian seasickness, which the producer judged "cheap beyond words." Selznick films were solemn entertainment, and the du Maurier novel certainly was humorless. Too bad that a Hitchcock film characteristically mingled light with darkness.

Also targeted for deletion were the flashbacks. It was a little awkward that the whole novel was a flashback, from the opening line—"Last night, I dreamt I went to Manderley again"—forward. And there was no way around de Winter's account of Rebecca's death, which had to be some kind of flashback, didn't it? But Selznick didn't care for flashbacks, and he hated the ones Hitchcock had devised—especially those portraying Rebecca, who never makes an appearance in the book.

Worst of all, Hitchcock had tried to make the second Mrs. de Winter bright and amusing—a spunkier character, less of a victim. DOS insisted that Hitchcock return to the tone of the book, however, and carry over all of "the little feminine things which are so recognizable and which make every woman say, 'I know just how she feels . . . I know just what she's going through' . . . etc." As for de Winter, Selznick thought the character earmarked for Laurence Olivier as yet possessed "no charm, no mystery and no romance."

The conventional wisdom, relying largely on the voluminous memoranda in the Selznick archives, holds that the producer's intervention immensely improved the film of *Rebecca*. David Thomson argues that the initial Hitchcock script was "crass and vulgar—Hitchcock was not a good reader, and he did not always grasp the depths of Daphne du Maurier's writing." Leonard Leff conversely notes that the director was a "voracious reader," and one, moreover, who was worried about the static quality of the novel.

Bad reader, or voracious one? Hitchcock was a keen reader for his own needs, and in truth the treatment was relatively faithful to du Maurier. His innovations were arguable but modest. The comedy, the shipboard and car-ride scenes, the English ambience, the newly plucky leading lady's part were characteristic Hitchcock touches he might have been expected to bring to any film.

But the Englishman was on trial in Hollywood, and he knew how and when to bend to producers. The five Hitchcocks went back to work, freshly aware of the dangers of deviating blatantly from the du Maurier original.

They produced a one-hundred-page draft by late June. Again DOS responded with detailed criticism, and again a new draft was crafted to his specifications. Once again the producer ordered reinstatement of original du Maurier elements: the second Mrs. de Winter had to be even more girlish, more of a nail-biting bumbler. Another draft emerged by the end of July, followed by more DOS memos; only then was Pulitzer Prize–winning

dramatist Robert Sherwood hired for the final revision—the first of several writers Hitchcock drew from the famed Algonquin Round Table and the corridors of his beloved *New Yorker*.

Taking a break from *Gone With the Wind*, DOS now freed himself up for regular script conferences with Hitchcock and Sherwood (and the omnipresent Joan Harrison). On sunny days, they convened aboard his yacht; at nights—for the producer loved to work long past midnight—they met at Selznick's house. "Naturally Selznick dominated the scene—pacing up and down, apparently oblivious to those around him who were nodding off," remembered Hitchcock, "and he did not even notice that the long, lanky Mr. Sherwood, having imbibed somewhat, was trying unsuccessfully to sail a small boat in the swimming pool. By dawn, of course, nothing much had been accomplished, but that was the producer's way."

Although the producer's goal was to adhere to the book, not every issue—Rebecca's mysterious fate, for example—could be resolved thus. In the novel, for example, it is revealed that de Winter shot Rebecca after she goaded him with the possibility that she might be pregnant with another man's child. DOS knew better than Hitchcock that crime always met with punishment in Hollywood. If de Winter killed Rebecca (and there was no book or film if he didn't), then he had to be punished. Otherwise, *Rebecca* could never hope to be passed by the Production Code, the clearinghouse of Hollywood censorship.

Not until the last possible script stage did they hit on the solution: In the film it would be explained that Rebecca, secretly ill with a deep-rooted cancer, has died accidentally. She lies about her pregnancy by another man in order to provoke de Winter, who causes her to fall and strike her head on a heavy piece of ship's tackle. ("I *suppose* I struck her . . . she stumbled and fell.") Sherwood wrote the dialogue, but Hitchcock saw an opportunity to employ a characteristic visual device, which enabled him to avoid the flashback imagery. As de Winter confesses, the camera tells its own story, moving from object to object in the room—tea table, divan, cigarette stubs—hinting at certain details, but forcing the audience to fill in with its imagination.

By the end of summer the script was finished, except for the nit-picking. Although Sherwood, the first and most important writer's name on the screen, was undoubtedly the highest paid, the yeoman's work had been done by everybody else. The producer's main contribution was to restore the book's precise dialogue whenever possible. Hitchcock, for his part, had long since accepted that few of his personal story ideas would make the cut in this, this first American film. He took consolation in his many small triumphs "off the page": intimations brought out in the direction, visual flourishes he could indulge without compromising Selznick's mandate to follow du Maurier to the letter.

One scene that was carried over from the book was ingeniously transformed in the filming. In this scene the second Mrs. de Winter tells her husband that she has broken a precious china cupid, hiding the shards of the figurine in a desk drawer out of fear of the imposing housekeeper Mrs. Danvers. Mrs. Danvers is summoned and given an awkward explanation; de Winter snipes at his wife for her timidity.

DOS had insisted on preserving du Maurier's dialogue. But Hitchcock made a change in the staging, which scarcely affected the lines. The director, who had lately inaugurated his new life in America with his own home movies, has de Winter and his wife similarly occupied with 8 mm footage. As the scene begins, the pair are gazing at movies of their honeymoon, projected on a far wall. De Winter and his wife sit in the foreground, their faces strobed with light. Their enjoyment is interrupted by Mrs. Danvers, and the projector is shut off while Mrs. De Winter awkwardly explains about the figurine. After Mrs. Danvers departs, de Winter snaps at his wife, then apologizes brusquely, and restarts the projector. But the lingering tension in the room now contrasts with the carefree mood of the couple in the home movies.

In desperation, Mrs. de Winter asks if her husband is happy. "Happiness is something I know nothing about," he replies coldly (a du Maurier line). "Oh look," he adds, pointing to the wall, "there's the one where I left the camera running on the tripod, remember?" (A Hitchcock line.) From her crushed look, the camera pans to the home movies, where the honeymooners are still cavorting. It is far and away the purest Hitchcock moment in *Rebecca*.

The summer of 1939 passed almost uneventfully as Hitchcock made steady progress on his first Hollywood film. The family settled into an American rhythm. They found a place of worship at the Good Shepherd Church in Beverly Hills, and a school for Pat in Marymount, a private academy for girls run by the Marymount order of nuns, on Sunset Boulevard in Bel Air. The family Austin was traded in for a new Chevrolet. Though Hitchcock pooh-poohed driving, insisting to interviewers that he didn't even know how, he often chauffeured his daughter to school at Marymount, and for a long time drove her to Sunday Mass.

In their heady early days in Hollywood, the Hitchcocks frequently attended premieres and nightclubs and the best restaurants—Perino's, Romanoff's, and Chasen's. They were already well known to most film folk in the British colony, and were welcome guests wherever expatriates gathered. One of the persistent misconceptions about Hitchcock is that he was aloof from Hollywood's English community. In truth he was friendly with many of them, and he and Alma were hosted regularly by the Cedric Hard-

wickes, the Reginald Dennys, and the Basil Rathbones (Hitchcock had known Rathbone's second wife, Ouida Bergere, as far back as Islington, when she was married to George Fitzmaurice).

Although David O. Selznick and his wife were known as fabulous party hosts, Hitchcock didn't spend much time socializing with the couple after hours. Leonard Leff suggests that Irene Mayer Selznick never warmed to Hitchcock, though judging by their correspondence over the years they were cordial. One memorable evening that Hitchcock and DOS spent together was part business—attending the premiere of *The Wizard of Oz* in August 1939. Afterward the pair dined and drank, talking up a storm. "He's not a bad guy, shorn of affectation," DOS wrote his wife, "although not exactly a man to go camping with." (Not that DOS was known for roughing it.)

The brothers Selznick competed socially, too, and Hitchcock was taken under Myron's wing after work hours. It was Myron who introduced the director around, made certain he met other producers, and got Mr. and Mrs. Hitchcock (along with Joan Harrison) added to the buffet-style supper-party circuit and more intimate dinners thrown by stars and VIPs on the agency's client list; Myron also invited them to Arrowhead Lodge for weekends. In their first months in Hollywood, the English newcomers kept up an intense get-acquainted schedule and befriended a regular circle of Selznick Agency clients, including actress Loretta Young, director Leo McCarey, the William Powells, and Carole Lombard and Clark Gable.

Under the watchful eye of Selznick International, Hitchcock also met the Hollywood press. DOS prided himself on his salesmanship, and especially on the West Coast it was he who took charge of Hitchcock's publicity. Hitchcock's initial press coverage was low-key, but most of the director's quirks are there in the first American newspaper and magazine articles about him. He liked to read history, biography, and travel books—not mysteries or thrillers. (A white lie, but good for publicity.) He did the eating, Alma did all the cooking. (Ditto.) He didn't drive, because he was afraid of police. (Ditto.)

Hungry for colorful details, the press seized on Hitchcock's reputation for telling raunchy stories at elegant dinner parties, or falling asleep between courses. At one party, according to some accounts, Hitchcock caught forty winks amid an unscintillating conversation between novelists Thomas Mann and Louis Bromfield. Another time, regardless of his glamorous dinner partners—Loretta Young and Carole Lombard—the director dozed off at Chasen's. "No one was ever quite sure how far these naps were genuine and how far he staged them impishly to test other people's reactions," wrote John Russell Taylor. Was it a defect in his makeup, or just part of the publicity?

By August, the Hitchcocks were thoroughly integrated into Hollywood

life. Increasingly uncomfortable in an apartment, they decided to lease a house. Carole Lombard mentioned that she happened to be vacating the house she was leasing at 609 St. Cloud Road in Bel Air, and moving into Gable's ranch house in Encino. The Hitchcocks knew and liked the Lombard place, a furnished English-style cottage, and they made plans to move in in October.

Hitchcock jousted with Selznick over *Rebecca*'s cameraman. He wanted Harry Stradling, who had shot *Jamaica Inn* with Bernard Knowles. But DOS wanted a cameraman loyal to the producer, and vetoed Stradling. (Hitchcock got Stradling later for *Suspicion*.) From Warner Bros. the producer borrowed George Barnes. There was nothing wrong with Barnes, who photographed many prestigious Hollywood films, save that his forte was a gauzy look that didn't have much in common with Hitchcock. But DOS was a believer in the gauzy perfection of his leading ladies.

The art director would be Lyle Wheeler, the editor Hal Kern. They were longtime Selznick associates and part of the *Gone With the Wind* production team.

Working for Selznick had its good and bad points, but Hitchcock made lasting friends at Selznick International, especially among the women. He cultivated long-term relationships with Anita Colby, the tall blond model known as the Face, who consulted on fashion and beauty for Selznick (she was known as the "Feminine Director of the Selznick Studio"); Barbara Keon, a key assistant on *Gone With the Wind,* who now was acting as a liaison between Hitchcock and Selznick; Margaret McDonell, a British editor in the story department; and Kay Brown, who proved a walking index of New York writers and actors.

It was Brown who pushed for Judith Anderson, then appearing on Broadway as the Virgin Mary in a religious allegory called *Family Portrait,* to play the insidious Mrs. Danvers: "tall and gaunt," in Daphne du Maurier's words, "dressed in deep black, whose prominent cheekbones and great hollow eyes gave her a skull's face, parchment-white, set on a skeleton's frame." Onstage Anderson had played Gertrude to John Gielgud's Hamlet, but she had appeared in only one previous film, 1933's *Blood Money*—an improbable gangster drama in which Anderson played a tough, gutsy character. Hitchcock, who had admired Anderson in plays for years, also remembered that film role, in which there was more than a hint of a potential Mrs. Danvers.

Hitchcock himself tested one Florence Bates, a plump, middle-aged former lawyer whose previous acting experience was limited to shows at the Pasadena Playhouse. Though she was an amateur in Hollywood terms, Hitchcock gave Bates the part of Mrs. Van Hopper, the vain American

dowager who employs Fontaine's character as her traveling companion—
"her fussy, frilly blouse a complement to her large bosom," "her voice
sharp and staccato, cutting the air." Bates's scenes have a humor and bite
absent from the rest of the film.

The film's other featured parts were filled by members of the Lost Le-
gion. George Sanders was cast as Rebecca's bounder cousin Favell ("a
big, hefty fellow, good-looking in a rather flashy, sunburnt way," in the
book); other roles went to Gladys Cooper, Nigel Bruce, Reginald Denny,
C. Aubrey Smith, Melville Cooper, and Leo G. Carroll.

With September looming, the final script was approved by the producer,
and photography was slated to begin. Yet there was still no word on the
leading lady. Vivien Leigh was hoping against hope, while Joan Fontaine
had given up altogether. She had impulsively decided to marry English
actor Brian Aherne, and her August 19 wedding, combined with the press-
ing start date of *Rebecca,* jolted Jock Whitney and David O. Selznick into
action. A telegram reached Fontaine on her honeymoon in Oregon, con-
gratulating her, and ordering her to report for wardrobe fittings right after
Labor Day.

Before calling action on the first take of *Rebecca* Hitchcock was already
scheming to get away from David O. Selznick for his second American
film. He had already sized up the producer's cautious approach, his need
to dominate directors, and he knew that any breakthroughs he might hope
to achieve in Hollywood would have to be achieved away from Selznick.

He also grasped the less obvious fact that Selznick International
wouldn't have a new project immediately ready for him to develop after
he finished *Rebecca.* Selznick was still preoccupied by *Gone With the
Wind,* immersed now in planning its massive publicity and advertising
campaign. At this rate, the director knew he couldn't possibly grind
out another Hitchcock-Selznick production within the first year of his
contract.

The escape clauses in Hitchcock's contract had been carefully crafted by
Selznick to place control firmly in the producer's hands. If the director's
weekly salary paid the Englishman as little as a third of what his best-
respected colleagues were making, that didn't seem to bother Hitchcock—
at least not at first. What did bother him were the restrictions on his ability
to make films for other producers.

Under Hitchcock's contract, DOS could approve or reject any loan-
out—or invoke an annual layoff period. The contract obliged Hitchcock
to make two pictures a year to earn his salary—two Selznick films, or
one Selznick and a loan-out. But if DOS rejected the loan-out, as he had
every right to do—and if no substitute assignment was mutually agreed

to—then Hitchcock could be laid off, and would forfeit a portion of his salary.

Even if Hitchcock managed to knock off two pictures inside of twelve months, DOS had the right to suspend his weekly paycheck for up to twelve remaining weeks each year.

By the end of the summer, Hitchcock knew he was looking ahead to two or three months of photography and then postproduction on *Rebecca*. He knew he couldn't possibly squeeze in a second film in the allotted months of contract time unless he shot another film from a producer's fully prepared script, which he was loath to do. And he was desperate to know his next project, for "his financial position is such that he cannot afford a layoff," as Dan Winkler advised Myron Selznick. By the time Selznick International yielded to common sense, granting Hitchcock permission to entertain proposals from other producers, the Selznick Agency had already spent months making covert contacts for him.

Among the people who showed interest in the English director even before he finished his first Hollywood film were Loretta Young, who had struck up a rapport with him at parties; the former silent star Harold Lloyd, who operated a production unit at Paramount; and Walter Wanger, whose interest in Hitchcock had persisted since 1937.

Wanger was the one with the most active program, and he wanted to produce a Hitchcock film as soon as possible. Primed by Myron Selznick, he had met with Hitchcock casually; now, in mid-September, with *Rebecca* entering its second week of photography, the director received Dan O'Shea's official permission to talk with Wanger.

As a directing prospect, Hitchcock had one curious shortfall: he didn't own or possess any literary properties. He had never had the time, the inclination, or the financial wherewithal to keep a back file of stories or scripts to wave in front of producers. It wasn't practical, and it wasn't his style. He had always been a working professional under contract, who reviewed the available studio properties and then chose the project that best matched his sensibility.

Starting over in Hollywood, when producers asked him what *he* wanted to do next, he found himself taking a shortcut and offering to remake one of his best-known English films, transferring the English settings and characters to America. A remake of a proven Hitchcock success was attractive to Walter Wanger. Lunching with Wanger in September, the director discussed transplanting *The Man Who Knew Too Much* to America. Or, if the producer preferred, Hitchcock could take *The 39 Steps* and craft a surefire sequel to it, using John Buchan's second Richard Hannay novel, *Greenmantle,* which he had always favored anyway. Hitchcock even ventured that Robert Donat might be willing to reprise his role.

Wanger was intrigued by *Greenmantle,* but knew it would take some

time to negotiate the screen rights with the Buchan estate. Perhaps *Green-mantle* could be their second film together, Wanger suggested, already hoping for a long-term collaboration. In the meantime, the producer said, Hitchcock might consider taking over a troubled project called *Personal History*, whose off-and-on status had been splashed all over the trade papers.

Personal History was a memoir by Vincent Sheean, an American newspaper correspondent who had chased headlines in foreign capitals during the 1920s. Ever since its publication in 1935, the producer had been piling up flawed scripts, trying unsuccessfully to turn the book into a Walter Wanger production. Wanger said he would be happy for Hitchcock to take over the challenge; for all he cared, as long as the story had an American foreign correspondent, Hitchcock could do anything he wanted—even change the book into a sort of *The Man Who Knew Too Much*, or an informal remake of *The 39 Steps*.

Hitchcock didn't need much convincing. Once he'd accepted, Wanger went after a deal with Selznick International. Wanger agreed to pay Selznick International $5,000 a week, only $2,500 of which would go to Hitchcock as his regular salary. But Wanger also agreed to employ Mrs. Hitchcock for an additional $2,500 weekly, which Alma Reville could earn free and clear of Selznick, to whom, after all, she was not under any signed contract. Soon thereafter, as the director concentrated on *Rebecca*, Mrs. Hitchcock and Joan Harrison plunged into *Personal History*.

On September 1, 1939, Hitler invaded Poland and annexed Danzig; two days later England and France, which had mutual defense treaties with Poland, declared war on Germany. America, President Franklin D. Roosevelt announced, would abide by its Neutrality Act, which had been passed by Congress in the mid-1930s to keep the United States out of foreign wars.

The war headlines shook the cast and crew of *Rebecca*. The director frantically phoned his mother, Emma Hitchcock, trying to convince her to come to the United States; but Mrs. Hitchcock refused to be uprooted, proud of having survived World War I in London. Alma was more successful with her family, and arranged to bring her mother and sister to America.

Five days after Hitler's invasion, Hitchcock commenced filming on *Rebecca*.

Most of, the cast were professionals with sterling credentials. Hitchcock could trust their instincts, especially those of Laurence Olivier, just coming off his Oscar nomination for *Wuthering Heights*. Although his role in *Rebecca* was sketchier than that in *Wuthering Heights,* Olivier was always self-assured, even intimidating in performance.

Hitchcock typically devoted more attention to his actresses, and that was true even in the case of Judith Anderson, whose charge it would be to convey—subtly enough to elude the censors—the peculiar closeness between Mrs. Danvers ("Danny") and Rebecca. Daphne du Maurier had implied a protosexual bond between the women; two weeks before filming, the implication remained intact in the script. And now the Production Code office, known informally as the Hays Office, strenuously objected to "the quite inescapable inferences of sex perversion" in the film script.

In Hollywood it was rather expected of the best directors that they buck censorship, but Hitchcock would buck the Hays Office with exceptional tenacity in the American phase of his career, pushing the boundaries of sex and violence in film after film. And he usually did so deviously, rather than in direct confrontation—stalling, surrendering by degrees, swapping off one cherished transgression for another.

The Production Code had been written by a Jesuit priest and a crusading Catholic layman, and it existed partly as a check against the proliferation of local and civic censorship groups across America. These included the Legion of Decency, the Church's official—and even more stringent—ratings board. Catholics ran the Hays Office in Hollywood. Hitchcock met frequently and ungrudgingly with head censor Joseph Breen, and his assistant, Englishman Geoffrey Shurlock. He had an ease with them that others lacked, and they were as amused as they were alarmed by his ability to sneak "inescapable inferences" past them.

Even after the sins of a Hitchcock script had been washed away by the Hays Office, such inferences often remained. Although the censors gradually eliminated any dialogue that suggested an improper relationship between Rebecca and Mrs. Danvers, Hitchcock got around the problem by clever atmospherics and intimate two-shots, with Mrs. Danvers hovering over the second Mrs. de Winter while stroking Rebecca's lingerie, recalling their precious closeness. (Mrs. Danvers's line about Rebecca's underwear being handmade by cloistered nuns probably looked chaste on paper, but what a hoot: of course it's a Hitchcock line, not in the book.)

To help Anderson with her performance, though she was an actress acclaimed for interpreting Shakespeare and the classics, Hitchock assumed the character in rehearsals and showed Anderson how to position herself for optimum camera effect. "I knew I was in the presence of a master," she said afterward. "I had utter trust and faith in him."

But *Rebecca* would have to rise or fall on the shoulders of its least seasoned player. Nearly every scene revolved around the second Mrs. de Winter, Joan Fontaine. Hitchcock had to play Pygmalion with Fontaine: slathering the young actress with support and advice while at the same time isolating her from the other actors and whispering against them (reminding Fontaine constantly that Olivier disliked her, hinting that she was

in danger of being replaced). Hitchcock built up his power over Fontaine while keeping her nervous and vulnerable enough to enhance the nervous, vulnerable character she was playing.

She was not, it must be said, all that popular. Olivier, still smarting over the fact that Fontaine had beaten out Vivien Leigh, treated his costar with transparent disdain. Olivier's "attitude helped me subconsciously," Fontaine later conceded in *No Bed of Roses*. "His resentment made me feel so dreadfully intimidated that I was believable in my portrayal."

Hitchcock encouraged these tensions as grist for the scenes between his two stars. When, during the first week of shooting, Fontaine expressed shock after Olivier used a four-letter word, Hitchcock stepped in. "I say, Larry old boy, do be careful," he cautioned. "Joan is just a new bride." When Olivier asked who the husband was, Fontaine replied that she had married Brian Aherne. "Couldn't you do better than that?" he flung over his shoulder before striding off imperiously. The retort demolished her; Aherne was a lightweight, often typecast as an English gentleman, and Fontaine said later that she could never look at him with the same eyes again. (An impulsive marriage to begin with, it would also be a short-lived one.)

Not just Oliver, but the entire cast, behaved like a "cliquey lot." United by their superiority and their purer Englishness, they sneered at the least-seasoned player behind her back, or so Fontaine believed. Hitchcock took advantage of this, too, drawing on Fontaine's insecurity to inform her performance in *Rebecca*. Ordering Fontaine to the set on her day off, the director surprised the actress by throwing her a birthday party. She was equally surprised that the important cast members didn't bother to show up; they stayed in their dressing rooms. Hitchcock could have summoned them—but their absence suited his strategy.

It wasn't really a matter of "Divide and Conquer," as Fontaine described it in her autobiography. It was Hitchcock forcing a novice actress to *become* her character, by treating Fontaine like Mrs. de Winter. The actress felt as alone, as terrified, as de Winter's young bride felt in Rebecca's world.

This was one of the director's techniques, but there were others. Fontaine recalled Hitchcock drawing for cameraman George Barnes a sketch of one shot that featured her character, cringing in an oversize wing chair, the light slanting across her face so that only her frightened eyes peered out. The sketch proved helpful to the cameraman, but also to the actress. "We all could see precisely what he wished to photograph," Fontaine said.

If sketches didn't work, Hitchcock was capable of ruder measures: In one scene, Fontaine was supposed to break down into tears. (Selznick's fidelity to the book meant that Fontaine's character would spend many scenes on the verge of tears.) After multiple takes, Hitchcock still wasn't satisfied. The

actress pleaded that she was all out of tears. "I asked her what it would take to make her resume crying," recalled Hitchcock. "She said, 'Well, maybe if you slapped me.' I did, and she instantly started bawling."

The only other person Hitchcock had to manipulate was the producer. In England producers made self-important visits to sets, but those visits were ceremonial, and easily tolerated. David O. Selznick had a different habit: he made ostentatious on-set appearances to monitor his directors, and often insisted on approving the staging of key scenes *before* they were filmed.

In England, producers were master businessmen in charge of financial decisions. In Hollywood, producers regarded themselves as creative forces. Selznick's droit du seigneur as a creative producer had sometimes extended to firing directors when they clashed with—or disappointed—him. Although the director's contract made his firing unlikely, once he had launched photography, Hitchcock recognized the wisdom of following local custom.

"Would you say Selznick was a producer who interfered?" Peter Bogdanovich asked Hitchcock. "Oh yes," he replied. "Very much so. In fact, the big shock I had was after I had rehearsed a scene and said, 'Well, let's go,' and the script girl said, 'Oh, wait a minute—I have to send for Mr. Selznick.' Before a scene was shot, he had to come down."

Selznick's visits to the set of *Rebecca* tapered off rather quickly, however. For one thing, Hitchcock made his displeasure clear. For another, the first preview of *Gone With the Wind* took place shortly after *Rebecca* began filming; after that, Selznick's calendar was taken up with retakes and reediting, and the producer's grandiose promotional plans. "It was my good fortune that he was extremely busy," Hitchcock said later. Watching *Rebecca*'s dailies became Selznick's main involvement, and there the producer swiftly discovered that Hitchcock didn't direct like any other director he had under contract—or like anyone in Hollywood.

Blanket "coverage" was an orthodoxy in Hollywood: DOS expected a full complement of close-ups, medium shots, establishing shots, angles, and two-shots of virtually every page of script, allowing the producer to have every conceivable option in the editing room. In Hollywood, directors may have presided on the set, but producers ruled the editing roost.

If the scriptwriting had been a game of checkers for Hitchcock, with producer and director jumping and kinging to a draw, the filming was chess with a champion. Hitchcock called the shots with the camera. And although there was usually extra coverage and alternative takes on a Hitchcock film, the director would shoot as little extra as possible on *Rebecca*.

Watching the dailies, Selznick tore his hair out. He didn't understand

"my goddamm jigsaw method of cutting," in Hitchcock's words, or what the director was doing with Joan Fontaine, giving Olivier the day off while an off-camera script girl fed de Winter's lines to the already jittery actress for her close-ups. Convinced that Fontaine was underplaying her role, DOS advised Hitchcock to strive for "a little more Yiddish Art Theater, a little less English repertory theater" in his approach. Selznick eventually grew worried enough that, in early October, he considered closing down the filming, getting more involved, and bearing down on Hitchcock (as he'd done with other directors). And yet, when he showed Hitchcock's cumulative footage to his wife, Irene, she assured him it was superb.

The producer continued worrying aloud in his memos: wasn't Hitchcock taking too much time with rehearsals, with lights, with his elaborate setups? But the most taxing delays weren't the director's fault: actors blew their lines, Fontaine came down with the flu, the technicians' union held a wildcat strike. It's a myth that Hitchcock ate up inordinate time on his first Selznick production, but it was a myth that proved useful to DOS—who gleefully adopted it and spread it via his staff.

The producer's memos grumbled that he was getting "less cut film per day" than he expected from "a man who shoots twice as many angles" as other Hollywood directors. Hitchcock was shooting only what he intended to use. Checkmate: whenever the producer made a suggestion that the director was forced to adopt, whenever he ordered retakes, even then Selznick found himself subverted. "Rather than minimize Selznick's additions," wrote Leonard Leff, "Hitchcock actually enhanced them."

When, for example, Selznick insisted that a dinner-table scene between Olivier and Fontaine be reshot because Fontaine seemed "more self-conscious in this scene than in most others," Hitchcock complied. He refilmed, incorporating Selznick's dialogue changes faithfully. Yet he also restaged the scene, obliterating the dialogue by having his camera sweep back dramatically away from the couple at the table. "In the act of withdrawal, a movement duplicated elsewhere in the film," in Leonard Leff's words, "the camera contributes to the young bride's feelings of unworthiness and abandonment."

Toward the end of *Rebecca*—when Rebecca's body is discovered, and questions arise about why de Winter earlier misidentified his wife's corpse—an inquest ensues. This is followed by a visit to Rebecca's London doctor, who reveals her cancer diagnosis. De Winter is cleared—and the film ends with the crescendo scene from du Maurier's novel, in which, rather than accept her new mistress, Mrs. Danvers burns Manderley (and herself) to the ground.

The battle between producer and director extended even down to the film's final image. DOS wanted the flames to form the letter R. "Imagine!" Hitchcock sniffed in later interviews. They argued about it throughout the

filming, until Hitchcock finally prevailed with his own variation: the camera pushing slowly into the burning bedroom to show flames licking at Rebecca's initialed pillow.

DOS won the script and lost the filming. After the last take in December, the director, already looking ahead to his next, more Hitchcockian film, left *Rebecca* in the hands of the producer, who did his best to reassert his authority and apply "the Selznick touch." DOS had Fontaine extensively rerecorded; he supervised remedial retakes; he fooled with the editing. He also supervised the score, adding music to underline nearly every scene.

The film's running time indicates that the producer utilized every available scrap of footage, arriving at 130 hand-wringing minutes, the longest Hitchcock film to date. Hitchcock's films did expand in length in Hollywood, but in his body of work that time is exceeded only by another Selznick collaboration, *The Paradine Case* (132 minutes), and by *North by Northwest* (136 minutes).

The length was one of Selznick's small victories. "The lesson of working with Hitchcock," David Thomson wrote, "was that no matter how much the producer involved himself, there were secrets of craft, nuance, and meaning that only a director controlled. It was a war from which David [Selznick] emerged not just beaten, but demoralized."

Even with everything Selznick could think to do to "improve" *Rebecca,* the film was ready for a sneak preview on the day after Christmas. The audience reacted with "great acclaim," wrote Thomson, and *Rebecca* was slated to open in U.S. theaters in March 1940.

The Hitchcocks celebrated their first American Christmas at their leased St. Cloud Road home, opening presents and sharing egg nog with former tenants Carole Lombard and Clark Gable, who regaled them with tales of the Atlanta premiere of *Gone With the Wind.*

By Christmas, the Hitchcocks and Joan Harrison had fashioned a fresh approach to *Personal History,* incorporating their nationality and politics. Vincent Sheean's memoir lacked a linear plot; the events of the book took place entirely in the 1920s, with long chapters set in Chicago, Paris, Rome, Madrid, Tangier, Tehran, Moscow, and Shanghai. The first thing the three Hitchcocks did was narrow the focus to London, barely glimpsed in the Sheean book. London, the Hitchcocks' home, became the film's home.

Although in England the director had been routinely praised for his "gentleman adventurers," for his first Hollywood original Hitchcock would consciously replace this hero with an American John Doe—"the man in the street," as he sometimes put it. The foreign correspondent

would even boast a generic name, Johnny Jones.* A street-savvy New York newspaper reporter, Jones is described as having a reputation for toughness (he once beat up a policeman in the line of duty). At the beginning of the story the reporter is posted overseas because the other foreign correspondents are viewed as too namby-pamby to expose certain European leaders as the gangsters they really are. The fact that England was at war with Germany was very much on everyone's minds, so upon his arrival in London, the naïve American would be thrust into the middle of a global conspiracy intended to force England into war.

Although the hero was a marked change, the treatment, penned by Alma and Joan Harrison, was generously sprinkled with ingredients "in line with my earlier films," in Hitchcock's words: spies and traitors, a kidnapping and attempted assassination, a love story mingled with wrong-man comedy—all climaxed by the downing of a transatlantic airliner and its crash into the ocean. Since Hitchcock had been rereading *Greenmantle,* the script also borrowed at least one item from that novel—the involvement of a faux peace organization, echoing Buchan's bogus League of Democrats Against Aggression.

The politics of the film would have been even more explicit if not for the Neutrality Act and the Hollywood censors. Unwilling to write off the German-speaking market (in or outside of Germany), the Hays Office objected, for example, to the villains speaking identifiable German. Borrowing a note from *The Lady Vanishes* then, Hitchcock converted the language of the villains to a made-up vernacular. The enemy, for whom the main villain is spying, is offhandedly identified as "Borovian"—another country on Hitchcock's fictitious map of Europe, bordering, one suspects, on Bandrieka.

The proposed storyline was audacious, going so far as to make the Neutrality Act part of its message, placing the legislation squarely in opposition to the Bill of Rights. At the very end of the film, the American captain of the ship that rescues the airliner's passengers would cite neutrality in refusing to allow the foreign correspondent to report the disaster from sea. But this violates freedom of the press, the reporter argues (and then tricks the captain by shouting his argument—and the news—into a transatlantic phone call).

Walter Wanger heartily endorsed the three Hitchcocks' bold approach. Wanger was more laissez-faire than Selznick, and didn't constantly second-guess his directors. From the outset of the project, the director and his new producer got along like co-conspirators.

The contrast with DOS was thrown into relief when Wanger schemed

* In the quasi-comic opening sequence, his editor, striving for a more distinguished byline, impulsively renames Jones "Huntley Haverstock."

with Hitchcock *against* Selznick International. A naïf financially, Hitchcock had lived reasonably well from film to film, but the move from England had been costly. Hitchcock had no investments, his savings were modest. His reserves were still in London banks, and the new British Defence Finance Regulations barred transfers of currency out of the country. (Not until well after the war would Hitchcock get his hands on his London savings.)

The director's financial problems were behind his peripheral involvement in a minor Walter Wanger production, *The House Across the Bay,* in January 1940. George Raft, the star, was unhappy with the climactic scenes, and wanted someone other than Archie Mayo, who had guided the rest of the film, to direct an alternative ending. Wanger called in Alfred Hitchcock, who dazzled Raft by outlining a pepped-up crescendo, with brief scenes that he himself would write and supervise. Wanger phoned DOS on the spot to get approval for Hitchcock to interrupt progress on *Personal History* and devote a few days to retakes.

Wanger then bestowed a small sum of money on Hitchcock, and Dan Winkler of the Selznick Agency approached DOS and argued that, having come up with a "story twist" everyone endorsed, Hitchcock deserved a bonus. But DOS thought otherwise; any Hitchcock income, he claimed, was owed directly to Selznick International.

After the creative tug-of-war over *Rebecca,* here was another taste of how tight the Selznick straitjacket would be. Hitchcock was upset about turning his bonus over to DOS, but Myron said he could do nothing about it. Fed up with this and other frustrations, Winkler quit the agency and took an associate producer's post at RKO.

In February, at Hitchcock's behest, Walter Wanger engaged Charles Bennett at one thousand dollars a week for four weeks—the amount of time Hitchcock thought he would need to transform the treatment into a decent script. Old misunderstandings between Hitchcock and his once and favorite stooge were set aside as Bennett, the capable constructionist who had worked with the director on seven of his best-known films in England, bent to the task of organizing the elements and ideas into coherent suspense. Recreating their past formula, the two worked in as genial and leisurely a manner as possible. "If we got stuck on the plot," recalled Bennett, "we'd take a drive to Palm Springs or somewhere."

Bennett was a security blanket for Hitchcock. The director had enlisted him partly for auld lang syne, partly because the revamped *Personal History* needed his English background, and partly because Bennett could be counted on to reinforce the antineutrality *politique* that was at the story's core.

Shortly after the war broke out, a small group of British expatriates in Hollywood began to meet to devise ways to confront American neutrality and promote England's cause. Congregating regularly at the office of Cecil B. De Mille, this group felt obliged to keep its existence secret, not only because the Neutrality Act made prowar agitation illegal, but because of political tensions within the film industry. Hollywood mirrored America with its split between citizens anxious to join the fight against Hitler and those—a peculiar alliance of America Firsters and Communists abiding by the Hitler-Stalin pact—who preached isolationism.

For two years, this small expatriate group would operate as a virtual cell of British intelligence, with the goal of nudging America toward involvement in the war. Its key figures included actors Boris Karloff (whose brother John Pratt was in the London office of MI6) and Reginald Gardiner, directors Robert Stevenson and Victor Saville, and Charles Bennett. Either Bennett or Saville, the group's informal leader, brought Hitchcock to meetings.

The new Hitchcock project was developed in the midst of this stealth campaign on England's behalf, and indeed in March 1940—the month that Bennett handed in his draft—the Hollywood cell group set in motion another quasi-Hitchcock film: an unusual charity production designed to glorify England. Hitchcock joined Saville, Cedric Hardwicke, and Herbert Wilcox in sending out a general call to British natives in Hollywood. Actors, writers, and directors were asked to show their patriotism by donating their services to an anthology picture whose earnings would be pledged to war-related causes.

Pledges of support were quickly received from Ronald Colman, Errol Flynn, Charles Laughton, Vivien Leigh, Laurence Olivier, Herbert Marshall, Ray Milland, Basil Rathbone, George Sanders, Merle Oberon, and many others. Hitchcock was named to the Board of Governors of Charitable Productions producing the anthology film and distributing its proceeds. He also agreed to direct one of its five segments. The proposed story of *Forever and a Day,* as the picture was to be called, would follow two families, masters and servants, living in a London house over the course of thirty years (1899–1929).

Hitchcock also volunteered to cochair, with Dame May Whitty in London, a drive to raise funds to evacuate children from the Actors' Orphanage in England, to safe havens in Canada and the United States.

What was true in England still obtained in Hollywood: after Charles Bennett completed his four weeks, Hitchcock went looking for other writers to shore up the script. This time, however, when Bennett left Hitchcock's employ he left it forever. The two stayed cordial, meeting over the years

for lunch or drinks. But the fact that Hitchcock never again called on him as a writer puzzled and hurt Bennett; he lived to the age of ninety-five, granting interviews about Hitchcock that reflected his wounded pride.

It may have been that Hitchcock, over time, needed a constructionist less. Or it may have been that Bennett was coming increasingly under the influence of the politically conservative Cecil B. De Mille in the 1940s, eventually developing into an anti-Communist zealot, which offended Hitchcock's mild brand of socialism. Just as likely, it was that the films of De Mille, once one of Hitchcock's idols, began to decline in quality around the time Bennett joined his staff; the De Mille films written by Bennett—*Reap the Wild Wind, The Story of Dr. Wassell, Unconquered*—were the object of private ridicule in Hitchcock's camp.

After Bennett left the fold, a slew of credited and uncredited writers joined Hitchcock and Joan Harrison in the script relays. Another fellow Englishman, James Hilton, the best-selling author of *Lost Horizon* and *Goodbye Mr. Chips* (and screenwriter of such quality films as George Cukor's *Camille*) put in the longest stint, and was undoubtedly the highest paid.

The humorist Robert Benchley was also among the writing platoon. A Myron Selznick client, and the second *New Yorker* and Algonquin writer to be drawn into collaboration with Hitchcock, Benchley had appeared mainly in acclaimed comedy shorts, and Hitchcock guaranteed him a part in the film: from the earliest drafts, one of Johnny Jones's colleagues, a dipsomaniacal American reporter stationed in London, was dubbed "Benchley."

"My part is still very nebulous and quite unnecessary," Benchley wrote his wife in a March 27, 1940, letter, "and right now the picture itself seems to be in pretty sloppy shape." The script would almost certainly have to "rely on the Hitchcock touch," he added, with what must have been an audible Benchley sigh. "The story has absolutely nothing to do with the book and never did have. We are now trying to think up a new title. It is an out-and-out melodrama like *The Lady Vanishes* or *39 Steps,* only not so good."

Hitchcock got along so splendidly with Benchley that his small role, while remaining nebulous and unnecessary, kept growing in the script—and the director then encouraged him to improvise during filming; even after Benchley had finished his written scenes (as he complained to Myron Selznick), Hitchcock still wouldn't let him go. He was paid to stick around, just in case.

The young writer Richard Maibaum* was borrowed from Paramount

* Maibaum was later a prolific writer for the James Bond film series.

at the eleventh hour, uncredited, for extra work on the most Hiltonian of the dramatis personae, the kidnapped elderly idealist Van Meer. ("I feel very old and sad," he says when questioned about Europe's political crisis, "and very helpless.") Van Meer is the only man in Europe who knows the secret "Clause 27" of the endangered peace treaty.

"It's not very logical," Maibaum told Hitchcock after reading the latest script draft.

"Oh, dear boy," the director responded with a grimace, "don't be dull. I'm not interested in logic, I'm interested in effect. If the audience ever thinks about logic, it's on their way home after the show, and by that time, you see, they've paid for their tickets."

As the writing was being completed, the design and second-unit teams raced along their parallel tracks. Operating on his philosophy that foreign locales called for signature sights, Hitchcock set a handful of scenes among London tourist stops, including Waterloo Station and Westminster Cathedral, and also in Holland (barely mentioned in Vincent Sheean's book), in a countryside of windmills and in the Rembrandtsplein, one of Amsterdam's public squares. A British unit was delegated to photograph these sites for design and back-projection purposes.

In America, sets were meanwhile constructed under the supervision of William Cameron Menzies. In the last week of February 1940, Menzies had won the Oscar for Best Art Direction for *Gone With the Wind;* a legend among production designers, now Menzies oversaw the creation of an array of new sets on the Goldwyn soundstages, including a field of windmills, facsimiles of the public square in Amsterdam, Waterloo Station, a high lookout on the tower of Westminster Cathedral, and a full-size airplane and fuselage. Hitchcock hired as his cameraman Rudolph Maté, born in Cracow, whose distinguished record included European films with Alexander Korda, Carl Dreyer, Fritz Lang, and René Clair.

Give Walter Wanger credit: as a producer, he had convictions and guts. He okayed all expenditures as the budget crept above $1 million and then, during shooting, to almost $1.5 million, "more than double Wanger's average negative costs," in the words of Wanger biographer Matthew Bernstein. All this with *Rebecca* still untested at the box office. More decisive and expeditious than Selznick, Wanger also admired Hitchcock more unreservedly, and he accepted the expensive sets and special effects as the cost of doing business with the Englishman.

With principal photography scheduled for mid-March, the casting had to hurry to keep pace. From the start in Hollywood, Hitchcock was eager to shake the label "British director," and it was evidence of his ambition for the new film that he had crafted his leading roles for Gary Cooper and

Barbara Stanwyck—magical, all-American casting that would have followed closely on the pair's starring in Frank Capra's *Meet John Doe*.

But having signed to play Capra's John Doe, Cooper had little appetite for a John Doe film for Hitchcock—or, as the director preferred to put it, "I think the people around him advised him against it." When Hitchcock referred in interviews to certain Hollywood stars who looked down their noses at "my type of film," he was thinking of this first incident—and of the many others that followed. Bad timing may also have been a factor: Cooper was heavily booked, and *Meet John Doe* would tie him up from July through September of 1940. Finally, Wanger might not have been able to squeeze enough money out of his strapped budget to afford the star's salary, reputedly the highest in Hollywood.

Cooper's rejection was a blow. Hitchcock had to settle for tall, lanky Joel McCrea, who was versatile and well liked, but "a second choice Cooper," by McCrea's own admission. At least, Hitchcock hoped, McCrea's casting would clinch Barbara Stanwyck, the actor's frequent costar. And Stanwyck was agreeable to McCrea—but her schedule was also intractable; she was available after *Meet John Doe*, but not before. *Personal History* couldn't wait, and all the other top actresses were also tied up.

Wanger needed a decision by the end of February, and he lobbied hard for Laraine Day, an MGM actress best known as Nurse Mary Lamont in the *Dr. Kildare* series. Hitchcock watched a few of her films, then skipped a screen test in favor of an informal meeting. Day made a good impression when she came to his office; she was bright, pleasant, and unassuming, and Hitchcock cast her as McCrea's love interest. Still, "I would like to have bigger star names," he said ruefully years later.

The rest of the cast were Hitchcock recidivists: Herbert Marshall, the well-respected star of *Murder!*, would play Stephen Fisher, the head of the fraudulent Universal Peace Party and the film's smooth-talking villain—Laraine Day's father. George Sanders would portray Scott ffolliott (the two small *f*s are a running joke), another correspondent on the truth trail—a less sinister and better part for Sanders than his turn in *Rebecca*. The ever agreeable Edmund Gwenn was fifth-billed as Rowley, the hit man who flubs McCrea's assassination from the heights of Westminster Cathedral.

Jane Novak, whose friendship with Hitchcock dated from *The Prude's Fall* and *The Blackguard*, was also given a small part. Novak is the blond woman traveling on the plane with her mother, at the end of the film; later she's seen hysterically trying to open the hatch while oil splashes across the window, then drowning as the water rises to the ceiling.

The director dipped into his German file for Van Meer, the film's symbol of hope. Albert Basserman was hired to play the elderly diplomat, kidnapped and tortured (with jazz recordings!) into divulging the secret treaty clause. ("Our Macguffin," the director proudly told Truffaut.) That

Basserman was a veteran of Max Reinhardt's theater and German silent film, and a refugee newly arrived from Nazi Germany, doubled the symbolism. (He had written the ministry of propaganda in 1933, saying he refused to perform in a country where his wife, a Jew, was a second-class citizen.) In his mid-seventies, Basserman invested his well-written role with unusual dignity, and in the end was nominated for an Academy Award.

Promoted by the Selznick publicity department as "the master of melodrama," Hitchcock took a break before filming to give interviews promoting the release of *Rebecca*.

When Hitchcock's first American film opened at the end of March, the reviews were spectacular. "Artistically," proclaimed *Variety, Rebecca* was "one of the finest productional efforts of the past year." "A splendid job," according to *Time*. The *Hollywood Spectator* singled out the "brilliant direction," and the *New Yorker* found the film of *Rebecca* "even more stirring than the novel." *Theatre Arts* said it was "a piece of suspenseful Hitchcock magic," while Frank Nugent in the *New York Times,* though he praised Hitchcock's guiding hand, noted disapprovingly that the Englishman had become "less individualized" by Hollywood.

The audience numbers were very good, if not also spectacular, with an eventual $700,000 profit recorded for Selznick International. ("Only two of more than one hundred RKO releases between 1939 and 1949 earned over $700,000," according to Leonard Leff.) Hitchcock had never had such figures in England, or comparable publicity, advertising, and distribution. It was a quantum leap in the magnitude of his success.

Though justly proud, his pride was tempered by his feeling that *Rebecca* was more David O. Selznick's package—so much "the supreme Hollywood package," in the words of latter-day critic Leslie Halliwell, that any top contract director (say, Victor Fleming) could have done it. Hitchcock was poised, in 1939, to become Selznick's next Victor Fleming: an all-purpose master of any kind of melodrama for the producer. Only his individuality prevented it.

"Well, it's not a Hitchcock picture," Hitchcock told Truffaut. "It's a novelette really." As if genuinely bemused by *Rebecca*'s success, he added, "It has stood up quite well over the years. I don't know why."

With Joel McCrea instead of Gary Cooper, the director may have lost some interest in the John Doe of *Foreign Correspondent*, as *Personal History* was renamed halfway through filming. The production went smoothly—so smoothly that anecdotes have emphasized the overweight Hitchcock all but sound asleep most of the time. But he had just finished

an arduous year: moving to a foreign land and absorbing a new system of production; coping with the added activity and anxieties engendered by the war; working hard for months on *Rebecca,* followed by similarly unrelieved toil on *Foreign Correspondent.*

Behind the scenes, his financial difficulties were mounting. Even as the cameras rolled on his first Walter Wanger production, Hitchcock was desperately trying to convince David O. Selznick to let him line up a second Wanger project, lest he find himself with idle—that is, unsalaried—time. He was working days, nights, weekends; he was drinking more heavily than usual, and his weight had reached an all-time peak of around three hundred pounds.

McCrea recalled in an interview how Hitchcock liked to imbibe a pint of champagne at lunch, then doze off during the early afternoon's filming. One afternoon, after uttering a mouthful of dialogue, McCrea looked to Hitchcock for approval, expecting to hear, "Cut!" The director was "snoring with his lips sticking out," in McCrea's words. So instead the leading man yelled, "Cut!" and that woke the master up. "Was it any good?" Hitchcock inquired. "The best in the picture," replied McCrea. "Print it!" declared the director.

The pint of champagne is probably an exaggeration; and if the actor remembered Hitchcock as disengaged, perhaps it was because of their lack of rapport. Born and raised in California, a laid-back actor who was entirely a product of the studio system, McCrea, from Hitchcock's point of view, lacked credibility as the street-smart New York reporter he was playing. ("He was too easygoing," Hitchcock told Truffaut.) Hitchcock never gave him enough credit; McCrea's talent was entering its stride, and, after a fitful start, his performance in *Foreign Correspondent* grows—as even Hitchcock's camera seems to notice.

Was the snoring partly an act? Laraine Day recalled Hitchcock falling asleep after lunch nearly every day, but she said he *never* closed his eyes while a scene was being rehearsed, or filmed. Hitchcock dozed only until the cameras and lighting were ready; then an assistant director nudged him awake for the actual photography.

She also recalled the director laboring to create a camaraderie on the set. Hitchcock made bad jokes and pulled pranks, though they were mostly old-fashioned ones—nothing overboard like in the old days.

Was he snoozing and snoring because he could direct *Foreign Correspondent* with one hand behind his back? Because on most shooting days there was little to rouse his instincts?

One of the most electrifying sequences in his body of work is the plane-crash climax at the end of *Foreign Correspondent.* This sequence begins with Fisher (Herbert Marshall) and Carol (Laraine Day) fleeing to America aboard the transatlantic flight. Father and daughter face each other

awkwardly across their seats. Feeling Carol's silent accusation and shame, Fisher delivers a heartfelt apology for lying to her, for what he has done and how he has done it—"for using the tactics of the country I grew up with."

They are joined by Jones (McCrea) and ffolliott (Sanders), who have been sequestered in the rear cabin. Ffolliott tells Fisher that he will be arrested upon his arrival in New York, and Johnny proclaims his love for Carol. Suddenly the plane, which has been mistaken for a bomber by a German destroyer, is fired upon from below, and a mad scramble ensues among the passengers.

Then and now, critics rotely praise this sequence for its technical wizardry. But as was so often the case with Hitchcock, bravura technique disguised remarkable content. The violence in a Hitchcock film could be randomly cruel—killing women, children, even a passing cyclist during the Van Meer assassination. In his political films, tellingly, the innocent victims really added up.

The hysteria, as the plane plunges toward the ocean, is chilling. A well-dressed Englishwoman haughtily refuses to don a safety vest, stands up in the aisle, and demands to see the British consul—only to be cut down by flak. When the plane hits, the water slowly rises in the cabins as the trapped occupants desperately grope toward the steadily lowering ceiling.

Hitchcock devised one particularly moving vignette that comes after the plane has all but submerged, with only a handful of survivors clinging to the wreckage. A pilot (the picture of American pluck) bobs up from beneath the waves and climbs on top of the sinking tail section, waves exhaustedly, then jumps into the roiling sea to swim exhaustedly toward the others. One passenger mutters that they don't have enough life preservers—they'd better not help the pilot or they'll be swamped. Facing arrest and his daughter's shame, Fisher overhears the remark, then silently unbuckles his life preserver and slips off the wreckage into the sea. His daughter spots him, screams in anguish. Jones jumps in to save the father . . . but fails.

The crash was certainly the film's most technically audacious sequence. Hitchcock had the well-known stunt pilot Paul Mantz fly out over the Pacific and execute nosedives with a camera affixed to the front of his plane, pulling out of the dives at the last instant so the plane almost grazed the water. Then the director had a glass-fronted cockpit built, in which the two actors playing pilots were suspended above a huge water tank. The Mantz footage was projected onto screens in front of the men as the plane plunged downward on rails. The plane's wings were rigged to break away; two dump tanks with chutes were concealed from view by screens of rice paper, and at the crucial instant a button was pushed and hundreds of gallons of water tore through the screens for the crash effect.

Some critics argue that Hitchcock had more feeling for technical wiz-

ardry than for the emotional truth of situations, and the director himself fostered this impression by dwelling, in publicity, on his vaunted techniques. He did spend less time communing with actors as time went on— less in Hollywood than in London, when he was younger and freer with people. Sometimes he could even let an entire film go by without saying very much to principal performers. Yet he knew when the emotional truth was the indispensable element—as it was in such a scene.

To Robert Benchley, whose heavy lids veiled his expression, Hitchcock gave only one morsel of advice: "Come now, Bob, let's open those naughty little eyes." With the female star of *Foreign Correspondent* he was also stingy with direction, starting Laraine Day off in her scenes with McCrea before he'd even introduced them properly. (Yet Day realized later that this created a freshness between her and her costar, whom she barely knew at the outset of filming—a freshness that was integral to their developing relationship in the film.)

Only once during the filming, Day recalled, did Hitchcock give the actress specific pointers. He paused in the midst of setting up an intricate water-tank shot for the aftermath of the plane crash, and took the actress aside. He quietly explained the feeling she ought to convey in her tear-filled close-up, which lets the audience know that her character has admitted to herself that her father was a traitor—and that she accepts his redemptive suicide.*

In that final moment Hitchcock's film, deceptively light throughout, turns irremediably dark.

All but the coda of *Foreign Correspondent* was completed by mid-June 1941, when, in utter secrecy, Hitchcock and Joan Harrison departed for a quick, unpublicized trip to England.

In Canada they had to wait for berths on a ship traveling in a convoy across the Atlantic, according to John Russell Taylor, and then sleep in crowded spaces with a shortage of bathrooms. But Hitchcock was a man who traveled intrepidly all his life and often on punishing timetables, and he wanted to see his mother and try one last time to persuade her to come to the United States. When Emma Hitchcock refused, Hitchcock helped to resettle her at Shamley Green; according to Taylor, she was later joined there by his brother William, "bombed out of his south London fish shop in the blitz."

Checking on the availability of his English funds was another matter of

* Worth recalling is the fact that Herbert Marshall had an artificial leg. Usually he covered up the handicap, but a scene like this posed special difficulties. The ceiling of the plane was paper, and Hitchcock had the water actually rise over the heads of the actors before letting them break through. Marshall's leg made this problematic, so he stood in a special cylinder while everyone else was inundated.

urgency—he had begun to suffer embarrassing overdrafts in Hollywood. He also needed to ship his furniture and belongings to America, now that the Hitchcocks had moved into a house.

There were also business motives for the trip. After the success of *Rebecca*, it seemed that every studio in Hollywood wanted him to direct a picture. But the two DOSs at Selznick International—David O. Selznick and chief financial officer Dan O'Shea—seemed to block his every preference.

Selznick and O'Shea had a good cop–bad cop routine. The producer made all the charitable gestures: he allowed Hitchcock to pick up guest fees on radio programs; he authorized expenses for a week in Palm Springs, so Hitchcock and Charles Bennett could spend a working holiday there during *Foreign Correspondent;* and after *Rebecca* opened, he instructed O'Shea to bestow a five-thousand-dollar bonus on the director. Yet these were seen as mere crumbs by the director, who quipped that all the money was fast funneled into a "Fund for Starving Hitchcocks." Indeed, the producer's "extras" were intended as crumbs; it was Selznick's philosophy (privately expressed in memos Hitchcock never saw) to keep his studio employees "economically dependent upon us in order to be better able to control them," in the words of O'Shea. When it came to bigger money matters, Selznick deferred to O'Shea, who then weighed in negatively.

Selznick refused to approve a second Wanger-Hitchcock production after *Foreign Correspondent,* insisting on reviewing all the other offers piling up. It was a game DOS loved to play, setting rival buyers against each other to drive up the value. At the same time, an increasingly nervous Hitchcock would be less likely to resist his final decision.

Well into June, with the bulk of *Foreign Correspondent* in the can, Walter Wanger was still hoping for a future with Hitchcock. Wanger liked the Englishman enough to stipulate a bonus and profit participation for the next Wanger-Hitchcock project. More reluctantly, the producer even agreed to take over any Selznick-imposed layoff period, putting Hitchcock at ease by promising to keep him on continuous salary after *Foreign Correspondent* was completed—even though the two men had not yet agreed on their second subject.

Once again Hitchcock raised the idea of a sequel to *The 39 Steps*—the adaptation of *Greenmantle* with Robert Donat—and once again Wanger was perfectly amenable. Hitchcock went so far as to contact Donat, but the actor couldn't commit to coming to America, and besides, the Buchan estate was still asking for too much money.

Wanger was coming to the end of his distribution deal with United Artists, and he had to find a niche at another studio. Hal Wallis at Warner Bros. seemed eager to sign up Wanger and Hitchcock for several pictures, until Wallis backed out over the expense projections for *Greenmantle.*

Wanger then took the Hitchcock-*Greenmantle* package over to Twentieth Century–Fox, where Darryl Zanuck expressed initial enthusiasm. But Zanuck also voiced concerns over the budget estimates, and asked for other ideas.

What Hitchcock really treasured in the evolving deal with Wanger was a prospect DOS firmly vetoed. The director pleaded to make his second Wanger film "off contract"—in effect setting the Selznick clauses aside for a period of several months while working exclusively for Wanger and taking home all the remuneration. This, Hitchcock explained, would give him a chance to catch up with his financial crises. But DOS didn't intend to give Hitchcock time or money off his contract; he insisted not only on the letter of the contract, but on being cut in on anything else Wanger was whispering about—bonus money or profit participation. Weighing in, Myron Selznick said the agency also was entitled to its 10 percent of any off-contract monies.

Hitchcock was outraged. He groused freely around Hollywood about the unfairness of it all, which did nothing to improve his relations with either Selznick. When, in mid-1940, O'Shea officially informed him not to expect any of the concessions he so sorely desired—no abrogation of the layoff period, no profit participation without DOS drawing half, no "immediate outside picture"—O'Shea unofficially warned Hitchcock that his "chances of getting anything above your contract are not bettered by remarks attributed to you concerning collusion to your detriment between David and Myron."

Wanger felt a mounting frustration with the Selznick brothers; so Hitchcock, ever practical, started meeting with other producers. He lunched with Charles "Buddy" Rogers, the former actor now married to Mary Pickford, and with Arthur Hornblow Jr., an emissary from Paramount. He talked several times with Benny Thau about an MGM deal. These people eagerly sought his services, and he would stay friendly with Hornblow and Thau for the rest of their lives.

MGM had a script about a scarred lady criminal who undergoes cosmetic surgery, yet is haunted by her shady past. *A Woman's Face* was ready to be filmed. Hitchcock was open to the possibility, although he objected to the penciled-in star, MGM diva Joan Crawford. He also objected to the studio-appointed producer, Lawrence Weingarten, and asked for "a noninterfering producer like [Sidney] Franklin" rather than Weingarten. MGM tried to meet his demands. The studio tentatively agreed to Margaret Sullavan (Hitchcock's suggestion) or Olivia de Havilland as the film's leading lady, while drafting Hitchcock's friend Victor Saville as the producer. The studio also agreed to consider *Greenmantle* as the second picture in a longer-term Hitchcock contract, and to pay the salaries of his assistant director, Eddie Bernoudy (who had worked on *Rebecca* and *Foreign Correspondent*), secretary Carol Shourds, and Joan Harrison.

When the two DOSs spoke to MGM, though, the terms ballooned. Selznick International demanded the loan-out of a top studio name in exchange for Hitchcock—a James Stewart or King Vidor. (Selznick International placed similar demands on Warner Bros. and Universal.) But MGM wasn't easily deterred, and just kept asking: How soon before Hitchcock could start at the studio? How long before he could begin filming?

The amount of time Hitchcock preferred to spend on a project was always glossed over in negotiations. Ideally, the director preferred to start at the script stage and be paid straight through to the end of postproduction. MGM and other studios typically didn't care about having him for the script stage; they wanted Hitchcock to be available for a prescribed number of weeks *after* a script was already approved in-house, its cast and budget okayed. That is why MGM pushed *A Woman's Face,* while Hitchcock characteristically asked for a two-picture deal. He gambled on preparing a second, personal film while directing the studio package.

Hitchcock was overoptimistic in estimating the amount of time it would take him from start to finish on a film, but so were the two DOSs—because it behooved them to *imply* that Hitchcock could wrap up an entire film inside of ten weeks rather than risk the "tip-off," as O'Shea put it, that with the customary delays it would take at least fifteen, probably more.

The studios, with their approved projects, maintained an edge over Wanger, who didn't yet have a Hitchcock-style property at the ready. Developing a script for Wanger would take four to six months. Wanger was willing to pay Hitchcock's salary over that time, but Selznick preferred to see his top director helming two studio films, rather than developing one Hitchcock original for a rival independent producer. Higher productivity would make Hitchcock more valuable to Selznick International. DOS thought Wanger had "spoiled" Hitchcock by letting him spend so much time and money on *Foreign Correspondent.*

Just as MGM was encountering turbulence, though, another studio entered the competition with a similar two-picture offer. In late spring Hitchcock lunched with Harry Edington, the new production head of RKO. Dan Winkler was at RKO now, and he had joined an internal campaign to recruit Hitchcock. Edington, a former talent agent, had once represented such stars as Greta Garbo, Marlene Dietrich, Joel McCrea, and Cary Grant, with whom he had a particularly close relationship. Edington knew Hitchcock from the Islington days, when he had been a unit manager for MGM in Europe; his Canadian-born wife, Barbara Kent, once Harold Lloyd's leading lady, was part of Hollywood's British colony, and involved with Hitchcock in war-support activities.

Although he had scant producing experience, Edington had been ap-

pointed to fill the vacancy created by the sudden resignation of Pandro S. Berman. RKO was busy putting out the welcome mat for Orson Welles and *Citizen Kane,* and the freedoms guaranteed to Welles had Hollywood buzzing. Walter Wanger would ultimately end up at RKO, and Jean Renoir also had an upcoming project there. Studio head George Schaefer was cultivating a reputation for the studio as a haven for émigrés, outsiders, and iconoclasts.

RKO had a comedy script, tentatively titled "Mr. and Mrs.," in which Carole Lombard had agreed to star, ideally opposite Cary Grant—but only if the picture could be shot inside of five weeks, and only if her friend Hitchcock directed. Her box-office clout had elevated her to the status of de facto producer.

Yet there was a second, more intriguing RKO property, which Edington mentioned during his lunch with Hitchcock: an English suspense novel called *Before the Fact* by Francis Iles, about a charming cad planning to murder his wife for inheritance money. The director's ears pricked up. Of course he was familiar with the 1932 suspense novel, now considered a landmark of crime fiction. Hitchcock had mentioned Iles admiringly to interviewers, and said he'd like to film one of his books—they would make precisely "his type of film."

As much as he adored Lombard, however, Hitchcock stubbornly resisted the first project, "Mr. and Mrs." Screwball comedy was a dauntingly American genre, and the studio didn't want him to so much as tinker with the script.

He still preferred *Greenmantle,* and tried selling Edington on making *Before the Fact* first for the studio, then the Buchan film. But of all the studios, RKO was the least interested in *Greenmantle.* What Edington really wanted was for Carole Lombard to be happy, and what Lombard wanted was to be directed by Hitchcock in "Mr. and Mrs."

Edington sent the "Mr. and Mrs." script over to Hitchcock early in May, but a month later the director had to admit he still hadn't cracked it open. When Hitchcock finally did get around to reading the script, he confessed that he found the humor awfully familiar; perhaps, he ventured, Mrs. Hitchcock might write a better comedy, a Hitchcock *original* for Lombard. But "Mr. and Mrs." was already bought and accepted, and RKO said no.

Warner's sent over *The Constant Nymph,* an intense love story that had been filmed twice before, once in England—and with a script by Alma Reville. The intended star was another incentive for Hitchcock: Joan Fontaine.

Twentieth Century–Fox proposed the anti-Hitler *Rogue Male,* while Columbia producer Sam Briskin wooed Hitchcock with "Royal Mail," also to star Cary Grant. Hitchcock hedged on *Male* and "Mail"; the latter

was "a costume picture," he explained in a memo, and he was "a modernistic director." But he did express a firm interest in working with Grant.

Hitchcock knew that Columbia owned James Hilton's *And Now Goodbye,* which revolved around a nonconformist English clergyman, an unlikely romance, and a train wreck. That kind of material, he said, would interest him more than "Royal Mail"—perhaps with Laurence Olivier as the clergyman. Perhaps he could direct *And Now Goodbye* as his first Columbia picture, *Greenmantle* as his second. Columbia was open-minded; Hitchcock even visited the studio to pitch the two films, and explain how he'd handle the "censorable angles," according to memos.

Except for the not unimportant fact that he didn't want to miss a payday between *Foreign Correspondent* and his next assignment, in truth Hitchcock wasn't very excited about any of the "go" projects the studios had at hand. He cared more about the *second* film in any contract—the kind of project he could develop himself—and about whatever subsidiary clauses might boost his income.

Indeed, so many scripts and offers piled up, and so confusing were the constantly shifting array of prospects, that just before he left for England in early June, the Selznick Agency asked the director to rank the studios and projects that appealed to him most. Hitchcock listed *Greenmantle* first, then *A Woman's Face*—undoubtedly because he nursed hopes of directing both for MGM, the Cartier of Hollywood studios. Third was *Before the Fact,* followed by *The Constant Nymph* or—his own surprising last-minute addition—a remake of *The Lodger.* Then, in descending order of interest: *Jupiter Laughs* by Scottish author A. J. Cronin, a play set in a sanatorium; *And Now Goodbye; Rogue Male,* which Hitchcock admitted he hadn't yet read in book or script form*; and lastly, "Royal Mail."

Note that "Mr. and Mrs.," pushed hardest by RKO, Carole Lombard, and both Selznicks, didn't even make the list. Note also that Hitchcock's idea to remake his silent-era hit *The Lodger* came in at number four. He had never really liked the original, Hitchcock told American producers. Maurice Elvey had made a sound version in 1932, also starring Ivor Novello, but Hitchcock would give Mrs. Belloc Lowndes's story a fresh cachet by shooting it in color: the American *Lodger* would be the first Hitchcock film in color. He announced his intention to coproduce the remake—paying for half the rights, sharing half the risk and profits.

Lately he had been thinking quite a bit about color—reaching typically iconoclastic conclusions. Color would always be subtle in a Hitchcock film, as deliberately coded as everything else. "Color should be no different from the voice which starts muted and finally arrives at a scream," he

Rogue Male was later filmed by Fritz Lang as *Man Hunt.* "Royal Mail" was never produced.

declaimed in one interview. "Color should start with the nearest equivalent to black and white," he said on another occasion. Or, as he put it another time, "Color for reason, not just color to knock people's eyes out. Make color an actor, a defined part of the whole. Make it work as an actor instead of scenery."

He foresaw "natural color used naturally," not "all those outdoor things with long ranges of smoky blue mountains and violent ground hues and a staring blue sky, they're wrong. They are postcard in effect." A color version of *The Lodger,* he said, would be more painterly than postcard; Hitchcock vowed, for example, to definitively capture the dense yellow fog that blanketed London. "I want to show how street lamps seem to drop deeper yellow tears into that swirling mess of vaporous sulfur," he rhapsodized.

He described how he might photograph "a London family in a dismal basement dining room, all browns and grays and blacks when suddenly the plaster in the ceiling gets first damp, then pink, then red, and a drop of red falls down and splashes onto a white tablecloth and spreads out as another drop joins it. When we rush upstairs, expecting the worst, we find a man has upset a bottle of red ink and it is dripping through his floor and the ceiling below. I can even see a closeup of two murderous eyes, the white of the eyeballs stained by crimson veins, inflamed eyes. Not makeup, actually inflamed eyes."

Hitchcock first tried this mesmerizing pitch on Walter Wanger, who was intrigued by the notion of remaking *The Lodger*. But when David Selznick heard about it, he decided that if Hitchcock was going to remake one of his silent hits, it ought to be a Selznick International production. Inquiring about the rights, DOS learned from his London representatives that Mrs. Belloc Lowndes was reluctant to sell them to any producer connected with Hitchcock, for she had detested the silent film version. The price she was asking was high: twenty thousand dollars. Hitchcock himself contacted Mrs. Lowndes to iron out their differences, explaining that the idiocies of the 1926 film weren't his fault. But her price didn't budge.

Half nobly, half opportunistically, Myron Selznick stepped forward, volunteering to pay half of the twenty thousand dollars and coproduce the film with Hitchcock. Myron had produced films in the 1920s, and now he was itching to best his brother in that arena, too.

One attraction of remaking *The Lodger* was the prospect that Hitchcock might be able to draw on his frozen English funds to pay his ten thousand dollars. But the director's liquid assets didn't run to ten thousand dollars, not even after he tossed in the value of his life insurance policy. Ultimately Myron had to *loan* Hitchcock his half of the rights fee, while Edmund Gwenn exchanged English currency for U.S. dollars to lessen the surcharges.

The Lodger waxed, even as *Greenmantle* waned. Walter Wanger finally dropped out of the running, exhausted by all the hemming and hawing. DOS simply didn't want to encourage a relationship with a producer who guaranteed bonuses, profit participation, and creative free rein. Shortly thereafter Wanger struck a bargain with Fritz Lang, setting up the type of close partnership with an illustrious director that he had originally sought with Hitchcock.

DOS prided himself on knowing what was best for Hitchcock; he vetoed some offers out of hand. MGM, Warner's, Twentieth Century–Fox, Universal, and Columbia—each discouraged for different reasons—were forced to push ahead with their immediate projects, sans Hitchcock.

That left only RKO. RKO had the inside track with both Selznicks, and even Hitchcock wanted to please Carole Lombard. In mid-June, O'Shea approved a contract with the studio that gave Hitchcock one hundred thousand dollars per film for two sixteen-week productions. The first four-month period took into account "Mr. and Mrs.," but also the extra weeks the director thought he would need to develop a proper scenario for the second Hitchcock-RKO production—which was specified in the contract as Francis Iles's *Before the Fact.*

As an incentive for Hitchcock to agree to the loan-out, O'Shea granted Hitchcock a $250 per week raise, bringing his salary to $110,000 a year. He was promised a bonus of $15,000 if he finished the two RKO films within one year's time. (Selznick International would meanwhile earn a 100 percent–plus profit on Hitchcock's RKO salary.)

While traveling to England, Hitchcock could begin discussing the adaptation of *Before the Fact* with Joan Harrison. But there was something else on his agenda, another project left over from the list the director had drawn up in May: *The Lodger.* Hitchcock carried with him the English currency he had managed to scrape together, intending to option the remake rights from Mrs. Belloc Lowndes. And that is what he did.

England in June 1940 was anxiously awaiting the feared Luftwaffe, which was busy installing itself on airfields within easy striking distance of London. Mothers and children were being evacuated from the cities as the men rehearsed for the Battle of Britain with blackouts and air raid sirens. Rationing was introduced. And it was in June that Winston Churchill made his dramatic plea for American aid; as film historian Mark Glancy notes in *When Hollywood Loved Britain,* the coda of *Foreign Correspondent* is "a subtle, filmic representation" of the same. "In God's good time," the prime minister declared, the New World, "with all of its power and might," must step forth to rescue the Old.

In London, Hitchcock met with his old friend Sidney Bernstein, who

had just resigned the chairmanship of Granada Theatres and other directorships for an unpaid appointment as adviser to the Ministry of Information. At Bernstein's behest the director agreed to make war propaganda films for England. He also helped to arrange the evacuation of orphans, and on the way back from England, passing through Ottawa, met with officials to "snip governmental red tape and complete arrangements to bring sixty youngsters from the Actors' Orphanage in London to a safe haven on this side of the Atlantic," according to published accounts.

Of all the Britishers in his Hollywood cell group, ironically, it was Hitchcock—avowedly the least political among them—who found the earliest opportunity to "do his bit." The tense atmosphere in London stiffened his spine, and influenced the new ending he would shoot for *Foreign Correspondent*—though Hitchcock's RKO contract indicates that an up-to-the-minute ending, a postscript to the main story, had been discussed before his trip.

Immediately upon his return, Hitchcock and Walter Wanger met with Ben Hecht to brainstorm the ringing speech that Joel McCrea delivers into a radio microphone at the end of the film, with bombs dropping on London and the broadcasting booth plunged into darkness. Hecht, one of Hollywood's best-known, highest-paid writers—also among the speediest—took only a day to pen the curtain-closer, which cribbed from Churchill:

"All that noise you hear isn't static, it's death coming to London. Yes, they're coming here now. You can hear the bombs falling on the streets and the homes. Don't tune me out—hang on awhile—this is a big story—and you're part of it. It's too late to do anything here now except stand in the dark and let them come as if the lights are all out everywhere except in America.

"Keep those lights burning, cover them with steel, ring them with guns, build a canopy of battleships and bombing planes around them. Hello America, hang on to your lights, they're the only lights left in the world!"

It was a speech "out of key with your kind of picture," Peter Bogdanovich told Hitchcock, fishing for confirmation that it was forced upon him by the politically active producer.

"It's all right," replied the director blandly. "It worked."

"Don't you think it was the wrong package for all your fine thriller ideas?" asked Charles Thomas Samuels, in his equally extensive interview with the director.

"Got me a telegram from Harry Hopkins!" responded Hitchcock.

No wonder he remembered that telegram—proof that *Foreign Correspondent* was seen in the highest circles, by President Roosevelt himself, and his cabinet.*

* *When Hollywood Loved Britain* author Mark Glancy cited another government leader who recognized the power of *Foreign Correspondent*. Nazi Germany's Minister of Propaganda Joseph Goebbels admired the Hitchcock film as "a masterpiece of propaganda."

* * *

The coda was finished by the end of the first week of July, and the swift postproduction—rarely protracted on a Hitchcock film—was completed in time for an August 16 opening.

The reaction of audiences in the summer of 1940, when the war dominated American and British headlines, cannot quite be appreciated at this remove. Though the political context of *Foreign Correspondent* was artfully disguised (the Germans never identified as Germans), the contrivance was so clever, as Mark Glancy notes, that "audiences in 1940 would have had no problem in decoding the story, and they may not have noticed that they had to decode it."

The film's courageous immediacy, its "mingling of realism and fantasy" (*New York Sun*), elevated it into "easily one of the year's finest pictures" (*Time*). *Commonweal* found Hitchcock's new work "brilliant." The perceptive Otis Ferguson, writing in the *New Republic*, said that *Foreign Correspondent* provided "a seminar in how to make a movie travel the lightest and fastest way, in a kind of beauty that is peculiar to movies alone." By contrast *Rebecca* was "fooling around," wrote Ferguson, "not really a bad picture," but inferior to *Foreign Correspondent*, and soaked with "a wispy and overwrought femininity."

The blitz attacks launched by Germany on England on September 8 made the ending especially prescient—a "flash forward," with McCrea's radio address eerily presaging Edward R. Murrow's famous broadcasts from a blacked-out London.

All the more peculiar, then, that only a week after *Foreign Correspondent* opened in the United States, producer Michael Balcon was quoted in London and New York newspapers denouncing the "famous directors" of England who had elected to hide out from the dangers of the war in Hollywood, "while we who are left behind shorthanded are trying to harness the films to our great national effort." Although Balcon didn't mention Hitchcock by name, he made no bones about citing "a plump young junior technician" who the producer said had been promoted upward "from department to department" by Balcon himself.

Balcon's comment was one part of "a particularly virulent campaign of abuse," as Sidney Bernstein's biographer Caroline Moorehead put it, in which the absent Hitchcock was more than once smeared in the English press. Back in May 1940, Seymour Hicks had aimed a volley at expatriates "gallantly facing the footlights," and proposed a film titled "Gone With the Wind Up," to star Charles Laughton and Herbert Marshall, with Hitchcock behind the camera. And J. B. Priestley, just a few days after Balcon, took part in a shortwave broadcast that made similar accusations against the British in Hollywood.

Balcon, Hicks, Priestley—they had all had past creative differences with Hitchcock. But Balcon had been a friend, and his widely circulated remarks were an especially low blow, with their shameless dig at Hitchcock's weight. According to John Russell Taylor, both Hitchcocks felt "deeply upset," but what could the director say? That he was doing everything he could behind the scenes? That, with *Foreign Correspondent,* he was flouting both the Hays Office and the Neutrality Act? That Selznick had him shackled to his contract and returning to England was inconceivable? That, having gone broke moving to Hollywood, he could hardly afford to move back? That he was overage and, yes, sadly overweight?

That Lord Lothian, Britain's ambassador to the United States, had publicly declared in July that "all British actors of military age"—up to thirty-one—should return home, but that older Englishmen "should remain at work until new regulations about military age were issued"?

Balcon should have known about Lord Lothian's statement—as he should have known about a gathering in Hollywood earlier in the summer, when the British consul told Hitchcock and other Britons that it was "not desirable," in the words of actor Brian Aherne, who attended, "that we should all rush back to England, which had plenty of manpower for the foreseeable future but not equipment." Members of the British colony were asked, temporarily, to contribute to war charities and to make themselves available for speeches or public events. Only a small number—David Niven, for one—actually did return and don combat uniforms.

Balcon should have known about *Forever and a Day,* the upcoming charity film Hitchcock had signed on for. If he'd been better friends with Hitchcock, he might have known that the director had already volunteered to make war into films for England's Ministry of Information.

In truth, Hitchcock conducted himself admirably during World War II, doing war work steadily, often secretly, and never grandstanding. In spite of his own financial concerns, he gave time and money in generous amounts to wartime causes. From the very beginning of the war, he was wholeheartedly involved, and to the end of his life the full extent of his involvement was never publicized.

Pressed by the Selznicks—and Mrs. Hitchcock—the director felt obliged to issue an uncharacteristic press statement saying that Balcon's remarks were inspired by jealousy "colored by his own personal experiences in Hollywood, which have invariably wound up unfortunately for Balcon. He's a permanent Donald Duck." Hitchcock added pointedly in the press release, "The manner in which I am helping my country is not Mr. Balcon's business."

Yet Balcon did not relent immediately. In fact, he and other prominent Britishers took surprising umbrage at *Foreign Correspondent* when it was released in England. Balcon, Dilys Powell, Paul Rotha, and other promi-

nent figures signed a letter in the *Documentary News Letter* following the English premiere, denouncing McCrea's staunch radio speech as the blatherings of "an irresponsible American news-hound" whose call to U.S. arms was "an insult" to the English "army of civilians" who would inevitably turn the tide.

According to John Russell Taylor, only a short time later Balcon was "unofficially informed" of Hitchcock's various contributions to the war effort, and "soon regretted" his very public remarks. "The harm had been done," wrote Taylor; the insinuations of Balcon and others have left a lingering impression of Hitchcock as a shirker.

Both Hitchcocks were hurt, and "Alma especially found it hard to forgive a number of the things which had been said about Hitch in Britain during the early days of the war," wrote Taylor. The controversy hardened her "resolve to stay permanently in their new home."

The Hitchcocks celebrated the success of *Foreign Correspondent* by putting down a deposit on their first American home, in northern California. They had become friends with Joan Fontaine's parents, the G. M. Fontaines, who lived in Los Gatos near Santa Cruz. After hearing of their interest in viticulture, the Fontaines recommended a search in the Vine Hill area. The search led to a nine-room Spanish-style house and estate known as the Cornwall Ranch, or "Heart o' the Mountain," first built in 1870. At the end of Canham Road near Scots Valley, the two-hundred-acre property overlooking Monterey Bay was shaded by giant redwoods and included tennis courts, stables, and a winery across Highway 17. The purchase price was forty thousand dollars.

The summer of 1940 was crowded with activity. Besides the trip to England and the purchase of a new home, the completion of *Foreign Correspondent,* and the start of his contract with RKO, Hitchcock was endeavoring to launch himself as the host of a national radio series.

The director had been a fan of English radio, but found it easy to transfer his affection to American radio programs, which he listened to whenever he had free time in the evening. He enjoyed the musical presentations but also the dramatic series. American radio was in its golden age, and the nighttime shows were a sort of campfire of the airwaves, around which unseen friends gathered for evocative storytelling. Hitchcock listened to the shows for relaxation, but also to pick up ideas for writers, actors, and stories.

With his capacity for what is nowadays called multitasking, Hitchcock thought he could preside over a radio series practically in his spare time. Radio would mean excellent publicity, not to mention added income.

The idea of putting Hitchcock on the radio had originated in the publicity department of United Artists, which distributed Walter Wanger's

films, back in January 1940. It was United Artists who first facilitated contacts with New York advertising agencies and producers, who thought Hitchcock might "more or less do a 'De Mille,' " pointing to Cecil B. De Mille's regular stint as host of the *Lux Radio Theater*.

Wanger endorsed putting Hitchcock on radio mainly for the promotional value—at that point he and Hitchcock were talking about a long-term association—whereas the Selznick Agency was motivated by the financial considerations. Myron's brother David, as usual, was the chief skeptic. Wasn't radio déclassé? Wouldn't a radio series take too much of Hitchcock's time—time better spent on prestigious Selznick films or better-paying loan-outs? And if Hitchcock did apply himself to radio, wouldn't DOS be entitled to his usual cut?

Throughout the spring of 1940, the director squeezed in meetings and phone calls and memos, dreaming up an Alfred Hitchcock radio series. Radio producer Joe Graham saw Hitchcock as emcee of a weekly anthology program presenting the favorite detective stories of famous people; the first episode, hypothetically, might be based on a story of President Roosevelt's choice. But Hitchcock told Graham he wasn't a fan of detectives per se—he was generally more interested in the victims and criminals—and the concept evolved, after a few meetings, into a series of mystery melodramas of Hitchcock's choosing, with him introducing and producing. The series would be called *Suspense*.

But the meetings and preparatory work were suspended after DOS decided he didn't want his director wasting valuable energy on a radio program over which Selznick International exerted no control, and for which it was unclear who would receive the payment. Myron tried to budge his brother—this is one instance where the agency aggressively pursued Hitchcock's wishes—but, as was becoming typical, without effect. DOS was adamant: No radio series. Because the contract with DOS was ambiguous when it came to nonfilm activity, Hitchcock wasn't convinced it was the producer's prerogative. But lawyers for the director and the agency warned him repeatedly against skirting the contract.

Shrewdly, then, Hitchcock floated an idea: What if he exercised his newly acquired rights to *The Lodger* for radio? Not only would that help him establish a foothold in the broadcast medium, but a well-done radio show would enhance his prospects of remaking the film.

DOS reluctantly okayed a radio production of *The Lodger* as a onetime experiment. Hitchcock borrowed two of the main actors from *Foreign Correspondent*: Herbert Marshall as Mr. Sleuth (the Lodger) and Edmund Gwenn (whose English currency had helped secure the rights) as the landlord. (This was an in-joke: his brother Arthur Chesney had played the part in Hitchcock's silent film.) *The Lodger* was broadcast as an audition in the *Forecast* series on July 22, 1940.

The ending of the radio show, like the novel, left open the question of whether the Lodger was the killer stalking London. Before the end of the show, an actor playing Hitchcock interrupted the presentation and asked viewers to write in and vote on the ending—and the Lodger's true identity. Viewers were also urged to write NBC to request a regular Hitchcock series, but despite an "overwhelming" number of letters, according to Martin Grams Jr. in *Suspense: Twenty Years of Thrills and Chills,* the series didn't make it on the fall 1940 schedule. DOS had absolutely refused to give his permission. The *Suspense* concept was shelved until 1942, then revived without Hitchcock; it would enjoy an acclaimed twenty-year run on American radio.

From that initial flirtation with radio, however, Hitchcock took away a stubborn yearning to shape a suspense series for national broadcast. Around this time he also made his first contacts with New York publishers and agreed to edit his first book of suspense stories. Last but not least, a New York adman working on the radio series had come up with the idea of dubbing Hitchcock "the Master of Suspense." That was snappier than "the Master of Melodrama," as Selznick had promoted him for *Rebecca,* and more accurate.

By late August, the newly christened Master of Suspense was over at RKO, directing a most unsuspenseful screwball comedy. Over the summer Cary Grant had dropped out of the project, and Robert Montgomery, a reasonable facsimile, became Carole Lombard's costar.

Screenwriter Norman Krasna had written several highly-regarded films, including the Oscar-nominated *The Richest Girl in the World, Hands Across the Table* (another Carole Lombard comedy, and a hit), and a pair of films for Fritz Lang—the antilynching *Fury* and a quasi musical called *You and Me.* Yet Krasna was also a frustrated playwright who sometimes slighted film in favor of periodic assaults on "serious" theater. Famous for his verbal sales pitches, Krasna dazzled in meetings, but didn't always deliver a script that lived up to his pitch.

"Mr. and Mrs." concerned a Park Avenue couple who learn their marriage has been voided by a technicality, a discovery that triggers what are intended to be madcap complications. As Hitchcock realized when he finally got around to reading the script in June, it was less than Krasna's best. But because of the schedule—and because Lombard was so gung ho about it—Hitchcock had to accept the script as it was.

As Hitchcock later told François Truffaut, he undertook *Mr. and Mrs. Smith,* as the film was retitled, as a "friendly gesture" to the leading lady. But it was equally true, as he told Truffaut, that he accepted the assignment at a "weak moment" in his career. "Since I didn't really understand

the type of people who were portrayed in the film," Hitchcock explained forthrightly, "all I did was to photograph the scenes as followed [in the script]."

Hitchcock was eager to honor his RKO contract, with its promise of a second film, and so he put on the happiest possible face during the six weeks he spent directing *Mr. and Mrs. Smith* in the early fall of 1940. On the set, he and his leading lady had a kidding relationship that kept spirits high. The director chalked up lines for the "screwball blonde" on an "idiot board," while the lead actress (and ex officio producer) turned the tables on him, directing the customary Hitchcock walk-on—and gleefully driving him through repeated takes.

One day, Lombard famously twitted Hitchcock by setting up a miniature cattle pen on the set. The pen enclosed three young heifers, adorned by ribbons, that were emblazoned with the names of the three stars: Lombard, Montgomery, and Gene Raymond (playing the husband's rival). The prank was intended to generate widespread publicity, and it did, helping to make his maxim "Actors are cattle" as well known in Hollywood as it was in England.

But directors sometimes feel like cattle too. One attraction of the RKO contract was its built-in bonus structure, and almost as soon as he started filming, Hitchcock began bombarding Myron Selznick with pleas that he wangle from his brother the fifteen thousand dollars he had been promised for completing two RKO films inside of a year. Dan O'Shea complained that the agency harassed him almost daily on the subject.

Again feeling pinched for cash, Hitchcock even started grumbling in public. On one celebrity radio appearance he thanked the show for compensating him, saying he had suffered "extraordinary relocation expense." This infuriated David O. Selznick, who seethed in a memo, "Hitchcock had better not make himself ridiculous by such statements."

After *Gone With the Wind*, Selznick had plunged into a midlife crisis from which he would never quite recover. DOS moved to Connecticut in the summer of 1940, then to New York City, then back to California. Most of the time he was "unreachable," but when Hitchcock's pleas for the extra fifteen thousand dollars finally did reach him, DOS declined; no bonus would be paid until after completion of both RKO films. Hitchcock threatened the only Selznick he could find, telling Myron he might be forced to sell his half of *The Lodger*. Myron didn't blink.

Desperate to supplement his income, Hitchcock asked Sig Marcus in the Selznick Agency's London office if some kickback scheme might be cooked up, whereby compensation for some nominal service in Hollywood might be channeled back to his older brother, William, in England. William, through Hitchcock's accountant, could then option stories for filming, independent of Selznick. A flabbergasted Marcus informed the director that

such a conspiracy only spelled legal trouble—and he warned the agency that Hitchcock seemed to be under terrible strain.

The director's anxiety was stoked further by Carole Lombard and Dan Winkler, who reminded the director over and over during the filming of *Mr. and Mrs. Smith* that he was getting a raw deal from the Selznicks, and that what he really needed to do was break his Selznick International contract and join RKO permanently.

All this may not have been conducive to lighthearted farce. When *Mr. and Mrs. Smith* was released in January 1941, though, critics found it "chucklesome" (*New York Times*) and "extremely funny in spots" (*Newsweek*); and at the box office the Hitchcock comedy coasted to profits on the strength of Lombard's popularity. If there were a few sharply negative reviews ("as commonplace a film as one may find anywhere," John Mosher wrote in the *New Yorker*), they didn't hurt Hitchcock in Hollywood, where duty and versatility were expected of a director.

Hitchcock had already switched his focus to *Before the Fact*. Author A. B. (Anthony Berkeley) Cox was an Englishman of Hitchcock's generation, who wrote detective stories under the pseudonym Anthony Berkeley, and crime novels under the name Francis Iles; it was these last—and eliminating the whodunit aspect in favor of an intense identification with the murderer or victim—that many critics believed his greatest accomplishment. The first Francis Iles book, 1931's *Malice Aforethought,* had announced the intentions of its murderer on the first page, and came to be considered a masterpiece of its type. Its follow-up, 1932's *Before the Fact,* once again let readers know from the outset that the victim-to-be's husband intended to slay her.

RKO had owned the rights to Iles's novel since publication, but the studio had failed over the years to produce a script that satisfied the Hays Office. The crime of murder always had to meet with punishment in Hollywood films, yet it was a central conceit of *Before the Fact* that a ne'er-do-well husband cheerfully succeeds in murdering his rich father-in-law and wallflower wife.

And Iles had a story twist that posed an even worse challenge to censorship: after the devoted wife realizes that her husband intends to murder her, she stages her own death as a suicide, to spare her husband punishment for the deed. (Hence the title, referring to the legal phrase "accessory before the fact"—since the wife proves an accessory to her own murder.) Suicide was also explicitly condemned by the Production Code when it offered "a means to an end, escape from justice, disgrace, etc.".

Successful murderers and willful suicides were taboo in Hollywood. But telling Hitchcock what he *couldn't* do exerted a kind of aphrodisiac effect

on his creativity. He had evoked lesbianism in *Rebecca,* and staged not only Rebecca's quasi suicide but Mrs. Danvers's self-immolation. He had even flouted the U.S. government itself with his swipe at the Neutrality Act in *Foreign Correspondent.*

Now he smoothly assured RKO that he would tell *Before the Fact* "through the eyes of the woman and have her husband be villainous in her imagination only," in the words of John Russell Taylor—even though this turned the very crux of the novel, the springboard which so appealed to him, on its head. At the same time he was busy courting Cary Grant, who had rejected *Mr. and Mrs. Smith* because it smacked of typecasting, telling him the Iles story would be a great chance for Grant to break out of his rut, and play a murderer. Hitchcock figured he could develop a working script, assuage the censors with petty concessions as the drafts progressed, and then slip Grant as a murderer past the authorities just before the closing bell.

The first treatment fell to Mrs. Hitchcock and Joan Harrison. After they finished in November, Samson Raphaelson was called in to develop the full script. Apart from being another Myron Selznick client, Raphaelson was a topflight dramatist, whose play *The Jazz Singer* had been made into America's first talking picture. In Hollywood, Raphaelson had subsequently enjoyed collaboration with Ernst Lubitsch on several sparkling films. Arriving from New York in early December, Raphaelson met daily with the director (and usually Joan Harrison), often at St. Cloud Road, where RKO had given them permission to work. Raphaelson did most of the actual writing at the nearby Riviera Country Club, where he was staying, sending fresh pages over to the Hitchcock house by limousine.

Raphaelson recalled the Reville-Harrison treatment as incomplete, with "dummy" dialogue, and rather "long-winded" at that. Its main accomplishment was in paring down the book's characters and subplots. (In the novel, both the cad of a husband and the wife-victim have extra lovers, who would gradually be excised as a sop to censors.) Right off, Raphaelson told Hitchcock that the treatment "didn't agree at all with the way I would get at it [the film]," and asked if he could try his own ideas, adding, "If you don't like what I write, we'll fight it out." To his surprise, Hitchcock—almost matter-of-factly—said yes.

"That story broke more easily for me than anything I have ever written," Raphaelson reflected years later. "Everything I brought to him [Hitchcock], he'd read instantly and it was fine. I drank more than I ever drank in my life. He was drinking a lot then. He was very fat. I would come to his home in Bel Air, he would be behind the bar, shaking orange juice and gin, and he'd say, 'Have a drink, Rafe. Got it with you?' I'd put some pages of script down and while I was having the drink, he would

lean over the edge of the bar and turn the pages. You'd think he was scanning it. Then he'd say, 'That's fine, that's fine, Rafe.' "

Hitchcock rarely offered any criticism of his pages, Raphaelson recalled. Once in a while, the director would warn the writer, "We've got to be careful with this scene, it's censorable," and Raphaelson would put on the brakes a bit. Or Hitchcock would point to a line of dialogue and say, "I'd like a little more something here, because when I photograph it I'd like to have the wind blowing through her hair."

At night, Mr. and Mrs. Raphaelson (the actress Dorothy Wegman) went to dinner, parties, and premieres with the Hitchcocks, and soon the initially wary Raphaelson grew to like "this odd, weird, little faggish man and this sweet little boyish woman."

Hitchcock was still falling asleep at dinner parties, and one night Raphaelson and Mrs. Hitchcock contrived to turn the tables with a little joke of their own. They slipped a Benzedrine into his cocktail; the other guests received sleeping tablets. "The dinner ended," said Raphaelson, "with Hitch wide awake and all his guests asleep. Hitch couldn't go to sleep, and spent the evening trying to find something to amuse himself. Finally he was able to arouse the guests sufficiently to send them yawning on their way home. Mrs. Hitchcock slept peacefully the rest of the night, and the rising sun found Hitch still wide awake."

When Raphaelson finished his draft, Hitchcock asked the writer, rather timidly, if he would mind if Mrs. Hitchcock—who, again, was being paid separately by RKO for her contribution—was given the continuity credit that had been customary on his English films. "It pleases her," he explained. "Good God," answered Raphaelson, "I couldn't care less." Then Hitchcock broached the issue of his assistant, explaining that Joan Harrison was like "family" to him. "You know, Rafe," explained the director, "Joan is very ambitious and she wants the credit in order to get other jobs. Of course she doesn't want to stay with me forever. Do you mind if I add her name to yours?" Again, Raphaelson didn't mind.

After a five-week stint Raphaelson returned to New York; for the rest of his life he would recall collaborating with Hitchcock as "the easiest and most pleasant" experience he ever had in the film industry. The two couples remained close, exchanging visits, letters, and phone calls over the years. "We had a much more affectionate relationship with Hitch and his wife," Raphaelson recalled, "than we had with Lubitsch."

While the script was being refined, the sets built, and the cast and crew finalized—over the winter of 1940–41—Hitchcock stole time to keep a promise he'd made to Sidney Bernstein.

One of Bernstein's documentaries, *Men of the Lightship,* had been offered

to Twentieth Century–Fox and RKO, but both studios refused to distribute the short war film, "chiefly because the commentary and voices were unsuitable for those markets," according to Bernstein. Bernstein cabled Hitchcock to ask how much it would cost to alter the narration, engage American actors in Hollywood, and redub everything in Yankee vernacular. Hitchcock said money was no object; he would pay the cost out of his pocket.

So he enlisted Robert Sherwood from *Rebecca* for the rewrites and Robert Montgomery from *Mr. and Mrs. Smith* as narrator. And then Hitchcock himself supervised the reediting and dubbing. Cost: $4,428. There is no evidence he was ever reimbursed.

Men of the Lightship was subsequently accepted by Fox, and retitled *Men of Lightship 61.** Hitchcock declined any credit. He would perform the same function later that year for *Target for Tonight,* a Ministry of Information film about an RAF bombing raid on Germany that earned a special Oscar. Again, his contribution went uncredited.

Meanwhile, the director's burgeoning relationship with Cary Grant led to the announcement that Grant would star with Ida Lupino in the planned Hitchcock segment of the pro-British anthology film *Forever and a Day.* Between stints on *Before the Fact,* Hitchcock sandwiched in meetings with Alma and Charles Bennett to prepare the episode, in which Queen Victoria's funeral procession passes by a wealthy home, and the camera picks up the handyman (Grant) and housemaid (Lupino)—a couple dreaming of escape to America. This was scheduled to be shot after *Before the Fact,* in the late spring or summer of 1941.

Unfortunately, *Before the Fact* was destined for delays and crises, and in the summer of 1941 the Hitchcock episode had to be handed off to French director René Clair, considered an "honorary member" of the British colony because he had directed a few pictures in England in the mid-1930s. Brian Aherne replaced the equivocating Grant. Yet the Aherne-Lupino segment of *Forever and a Day* might be considered another "quasi Hitchcock," for he developed the story, which is distinguished from the rest of the film by its Anglo-American spirit.

Before he began filming *Before the Fact,* Hitchcock also took time out to attend his first Academy Awards.

Rebecca led the field in 1940 with a remarkable eleven nominations: Best Production, Director, Actor and Actress (Laurence Olivier, Joan Fontaine), Supporting Actress (Judith Anderson), Adapted Screenplay (Robert E. Sherwood, Joan Harrison), Cinematography (George Barnes),

* Incidentally, Hitchcock's Jesuit school classmate Hugh Gray was credited with the original script of *Men of Lightship 61.*

Interior Decoration (Lyle Wheeler), Original Score (Franz Waxman), Editing (Hal C. Kern), and Special Effects (Jack Cosgrove).

One of *Rebecca*'s rivals for Best Production, ironically, was Hitchcock's other film from 1940, *Foreign Correspondent,* which garnered five other Oscar nominations: Original Screenplay (Charles Bennett, Joan Harrison), Supporting Actor (Albert Basserman), Cinematography (Rudolph Maté), Black-and-White Interior Decoration (Alexander Golitzen), and Special Effects (Paul Eagler, photographic; Thomas T. Moulton, sound).

But 1940 was among Hollywood's finest years, and the list of other Best Picture candidates was impressive: *All This, and Heaven Too, The Grapes of Wrath, The Great Dictator, Kitty Foyle, The Letter, The Long Voyage Home, Our Town,* and *The Philadelphia Story.* One other director, John Ford, had two Best Picture nominees, although managing to pick up two in his first year of Hollywood residency made Hitchcock's the more astounding achievement. (Indeed, it would be over thirty years—with Francis Ford Coppola's 1974 Best Picture nominations for *The Conversation* and *The Godfather, Part II*—before the feat was repeated.)

With four out of the ten Best Picture nominees directed by either Hitchcock or Ford, one of the two seemed bound to win as Best Director. Ford's stirring adaptation of *The Grapes of Wrath,* John Steinbeck's Pulitzer Prize–winning novel about Okies vacating their dust bowl homes, was considered the Hollywood favorite, while *Rebecca* had the edge in national critics' polls (receiving 391 first-place votes over 367 for *The Grapes of Wrath* in *Film Daily*'s annual poll of 546 professional critics).

"*Rebecca* had been out of circulation for several months," according to Mason Wiley and Damien Boa in *Inside Oscar,* "so the day after the nominations were announced, Selznick held a second gala 'premiere' for *Rebecca* at the newly-opened Hawaii Theater on Hollywood Boulevard. At this second premiere, Selznick read a joint resolution he had managed to wangle from the governor of California and the mayor of Los Angeles, temporarily changing the name of Hollywood Boulevard to 'Rebecca Lane.' He also unveiled an extremely large seat that had been installed in the Hawaii with the inscription 'Reserved for Alfred Hitchcock.' "

On February 27, 1941, the Hitchcocks attended the preceremony banquet at the Biltmore Hotel, joining David O. Selznick and Joan Fontaine at the table reserved for *Rebecca. Foreign Correspondent* producer Walter Wanger, the then president of the Academy of Motion Picture Arts and Sciences, hosted the actual ceremony, which was broadcast nationally on radio and preceded by an address from President Roosevelt.

Almost to the end of the evening, Hitchcock and his two nominated pictures threatened to be among the also-rans* (Indeed, *Foreign Correspon-*

* The only early *Rebecca* winner was cameraman George Barnes, whose hiring had been dictated by DOS.

dent didn't win a single award.) When the time came to reveal the Best Director winner, presenter Frank Capra invited the nominees up to the podium, suggesting they "shake each other's hands for jobs well done. Warily, George Cukor, Alfred Hitchcock, Sam Wood and William Wyler followed orders," according to *Inside Oscar*. John Ford was conspicuously absent; earlier, he had crustily informed reporters that he and Henry Fonda (a Best Actor nominee for *The Grapes of Wrath*) would be fishing off the coast of Mexico. Ford insisted he didn't care about Oscars ("a trivial thing to be concerned with at times like these," he told writer Dudley Nichols). But the American director was widely recognized as Hollywood's greatest—and Ford was the leading contender each of the five times he was nominated in his career.* Moreover, *The Grapes of Wrath* was distinguished Americana, as opposed to *Rebecca*'s vision of haunted England. So it was hardly surprising when Ford won for *The Grapes of Wrath*.

One of the unfair myths about Hitchcock is that he wasn't generous toward his colleagues. It's true that he didn't often sing the praises of fellow directors in print, believing in part that naming some would omit others. But he prided himself on keeping up with the best films and filmmakers, and especially in the 1940s, when there really was a community of directors in Hollywood, Hitchcock was very much part of it, attending dinners and parties with William Wellman, Leo McCarey, George Cukor, and others whose company he enjoyed.

Cukor and Ford were two he especially respected, and Cukor would become a real friend over the years; Hitchcock knew Ford only in passing. Ford was directing *The Long Voyage Home* for Walter Wanger at the Goldwyn studio at the same time that Hitchcock was finishing *Foreign Correspondent* for the same producer. Joel McCrea remembered that Ford made a point of stopping by the Hitchcock set on the day they were shooting the film's broadcast coda. According to McCrea, Ford even volunteered "a kind of reading" of his lines, a gesture that amused—and flattered—Hitchcock.

For a Directors' Guild booklet after Ford's death, Hitchcock handwrote a tribute to the man who bested him in his first Oscar race—a gesture so rare for Hitchcock as to be almost unique. "A John Ford picture was a visual gratification—his method of shooting, eloquent in its clarity and apparent simplicity," Hitchcock wrote. "No shots from behind the flames in the fireplace toward the room—no cameras swinging through chandeliers—no endless zooming in and out without any discernible purpose. His scripts had a beginning, a middle and an end. They are understood all the world over and expand as a monument to part of the land he loved: Monument Valley." Never mind that Hitchcock didn't care for most Westerns,

* Ford won four of the five Best Director awards for which he was nominated.

and never tried to make one himself. (He liked to say he didn't know what people ate in frontier times, or where they went to the bathroom.)

Like Ford, Hitchcock feigned indifference to the Academy Awards. He would also be nominated for Best Director five times: for *Rebecca, Lifeboat, Spellbound, Rear Window,* and *Psycho.* Unlike Ford—in a measure of his outsider status—he never won.

Hitchcock sincerely believed he didn't make the kind of pictures rewarded by Academy voters, and he was never a contract director with a major studio and the guaranteed voting bloc of its employees. Except for his time with Selznick—and then again, at the twilight of his career, at Universal—he never enjoyed the benefit of lavish award campaigns.

When the final Academy Award of the evening was given out, however, the Best Production nod went to *Rebecca.* The trophy itself, of course, went home with the producer, David O. Selznick.

So Hitchcock had good reason to be cynical about the Academy Awards, even though *Rebecca*'s Oscar meant that his stock in Hollywood took a sharp rise. And once again the pattern held that, as one Hitchcock production started filming, the director was already agitating behind the scenes for his next assignment. Once again Hitchcock was panicked about the twelve-week layoff period DOS might invoke at any time.

All of a sudden, Hitchcock didn't expect, or want, any extension of his relationship with RKO. The controversy over *Citizen Kane,* and the failure of the Orson Welles film at the box office, had sent shock waves through the studio, and the supportive climate that had surrounded Hitchcock during the making of *Mr. and Mrs. Smith* had changed.

Immediately after the Oscars, in March 1940, the Selznick Agency went into action, trying to sell Hitchcock to another studio. Once more, the agency tried to convince DOS to suspend the director's normal contract, so he could maximize his market value on at least one film independent of Selznick International. But again DOS said no, reiterating that he intended to approve any outside work—the terms *and* the subject matter.

Over at Universal, Frank Lloyd, a Myron Selznick client who had directed 1935's Best Picture, *Mutiny on the Bounty,* had just formed a new unit with producer Jack Skirball. Skirball (more than Lloyd) liked and was impressed by Hitchcock, and was receptive to producing two pictures with the Englishman. The director told Skirball that a color remake of *The Lodger* was his first preference, and after that, he could deliver a Hitchcock original. The Universal producer told Myron Selznick he'd meet any fair price for Alfred Hitchcock.

The English atmosphere, the fragile wife cringing in dread of her husband's secrets, the suicide-murder twist ending: it was as though Hitchcock were

trying to remake *Rebecca,* without Selznick's arch embellishments and concessions.

Once again, the director drew his supporting players from the British colony, many of them already Hitchcock alumni: Cedric Hardwicke would portray General McLaidlaw, the father of Lina; Dame May Whitty from *The Lady Vanishes* would be Mrs. McLaidlaw; Nigel Bruce from *Rebecca* was Beaky, Johnny's old crony who dies a mysterious death; Isabel Jeans from *Downhill* and *Easy Virtue* was the flirtatious Mrs. Newsham; and Leo G. Carroll from *Rebecca* was back as Captain Melbeck, from whom Johnny embezzles funds.

The know-it-all mystery writer Isobel Sedbusk, who befriends Lina, was a character who required special Hitchcockian casting. A onetime leading lady of the English stage, now the director of John Van Druten's plays, Auriol Lee would make her only American film appearance in the role—depicted in the novel as a pinprick parody of Dorothy Sayers.*

One happy byproduct of Lee's casting was that it led to Pat Hitchcock's Broadway debut. Lee had plans to direct Van Druten's new play, *Solitaire,* in the fall of 1941, and she was looking for a youngster to play one of the leads—the neglected daughter of well-to-do parents, who forms a friendship with a middle-aged tramp. Twelve-year-old Pat, who had performed in school plays, was the right age and type.

At the center of Hitchcock's English cast for *Before the Fact,* meanwhile, was one of Hollywood's sexiest Englishmen—who, as it happens, had just taken American citizenship. Rising steadily in talent and popularity throughout the 1930s, Cary Grant really began to spread his wings when cast as a darkly humorous romantic lead in comedies for directors Leo McCarey, George Cukor, and Howard Hawks. A driven and enigmatic man offscreen, Grant wasn't complacent in his stardom. When in the mood—and he was exceedingly moody—he enjoyed taking risks with his image, and his career.

Grant arrived for the first day of filming, on February 10, 1941, thrilled at the opportunity of starring as a cold-blooded killer—a seductive creep. Johnny's twinkling eyes, his "infectious, intimate smile" on a face "the merriest" ever seen (according to the novel), evoked nothing so much as Grant's own screen persona.

* *Before the Fact* as a book had been acclaimed by critics for its wealth of nuance about the empty life of the English upper middle class, with the type of barbed satire the director deployed effortlessly in his Gaumont films. Yet in spite of the heavily English casting, the Dorothy Sayers satire and other "authenticity" would be missing from Hitchcock's adaptation of the Francis Iles novel. And where, in the case of *Rebecca,* Selznick had striven to preserve an Englishness the director felt to be false, here the director took measures to minimize it. Even so, in later interviews he often complained about RKO's faux British production design, "the elegant sitting rooms, the grand staircases, the lavish bedrooms and so forth," as he told Truffaut. "Another weakness is that the photography was too glossy."

Hitchcock knew Grant socially, but this was the first time the two had contrived to work together. Grant was the biggest Hollywood name yet to appear in a Hitchcock film. A complex performer, Grant was equally credible as a lover or a bully (in *Notorious* he does a convincing job of punching Ingrid Bergman in the face). By agreeing to star for Hitchcock—where, for example, Gary Cooper had balked—Grant once again displayed the instincts that shaped a remarkable career. And by helping himself, he helped Hitchcock, validating him in Hollywood's eyes.

And in Grant the director found the first leading man since Robert Donat with whom he felt a profound connection. Grant was the same general type as Donat, as attractive as he was entertaining. Yet Grant also had a bitter, ruthless streak, ordinarily suppressed on the screen, that set him apart from a Donat—or, say, a Joel McCrea. Those other stars told audiences all about themselves; with Grant, there was always ambiguity. Grant withheld information, struck a distance, kept people guessing, off and on camera. Like Hitchcock, he kept guarded the doors to his psyche.

When asked about the star of *Suspicion, Notorious, To Catch a Thief,* and *North by Northwest,* Hitchcock often described him in familial terms. "One doesn't direct Cary Grant," he liked to say. "One simply puts him in front of a camera. He enables the audience to identify with the main character. He represents a man we know. He's not a stranger. He is like our brother."

Although this was a cliché for interviewers, there was also a degree of truth to it: Grant felt like family to Hitchcock, but he also served as an alter ego, someone the director could like and admire, and a dashing rake with whom he could vicariously trade places. With Grant (and later, with James Stewart) the heroes began to deepen in Hitchcock films, and the films deepened with them.

If Hitchcock and Grant had a fast but edgy rapport (Grant "whistled to work," wrote John Russell Taylor, "and Grant says he thinks they got on so well right away because they both remembered licorice allsorts"), the director had a different relationship with RKO's appointed leading lady.

The Lina that Hitchcock originally wanted was Michèle Morgan, well known in France but newly arrived in Hollywood as a refugee from Nazi occupation. Her French accent didn't bother him, but it worried RKO. The studio preferred Joan Fontaine for box-office insurance, and now the second Mrs. de Winter leaped at the chance to star in a second Hitchcock film. She scribbled a note after he sent her a copy of the book, vowing to play Lina "for no salary" if necessary.

After *Rebecca,* Fontaine had become one of the most sought-after actresses in Hollywood, but she still looked up to the director who had remade her image and guided her to her first Oscar nomination. This time, however, as she complained to RKO officials, Hitchcock seemed to pay her less attention dur-

ing filming. In fact, at times her old mentor seemed to neglect her altogether. Hitchcock surely realized, if Fontaine did not, that she was already well rehearsed for what was essentially a reprise of her role as the second Mrs. de Winter.

If Hitchcock was fond of Fontaine, Grant was not—which was all to the good. Behind the leading lady's back, the star told close friends that he had a genuine impulse to strangle Fontaine—an enmity that informed his mercurial performance. The romantic chemistry between the two was perhaps the film's greatest illusion. (One of Hitchcock's signature camera movements—a hypnotic 360-degree pan—does most of the work for their most romantic kiss.)

Although Fontaine was in virtually every scene, the film was shaped more around Grant—and intended for Grant as *his* showcase. "My villain?" coos a disapproving Isobel Sedbusk when Lina interrogates her about the murderer in her best-seller. "My hero, you mean! I always think of my murderers as my heroes." Just what Hitchcock might have said: with Grant, the director was hoping finally to cross a line that had long eluded him: dropping the standard monstrous villain, in favor of a handsome, grinning one with irresistible sex appeal.

Unfortunately, RKO was self-destructing even as *Before the Fact* was being shot, and all of Hitchcock's clever strategies for gulling the studio and fooling the censors went awry.

Although Harry Edington had left Hitchcock pretty much alone during the writing of the script, the studio official never lost track of the censorship concerns. Besides the problematic ending, the novel is loaded with sex. Johnny (Grant's character) is not only a murderer and philanderer in the book, but also the father of an illegitimate child conceived with the housemaid. The director knew he had to forgo this, and so he did, with the usual show of reluctance.*

What about the ending? Edington kept asking. The wife couldn't end up dead. Cary Grant couldn't end up a cheerful wife murderer. How was Hitchcock going to punish all the wrongdoing?

This conundrum was at the front of Samson Raphaelson's mind as he wrote the script. He and Hitchcock toyed with different endings, which they hoped might appease the studio. Raphaelson wrote at least one "temporary" version, which neither he nor Hitchcock thought was quite right; Raphaelson preferred the ingenious one the director himself dreamed up, which did

* The housemaid Ethel (Heather Angel) is still in the film, but platonically, even though the mink stole Johnny gives her seems left over from the philandering in an early draft.

not skirt the issue, but cheated it. Years later Raphaelson still remembered Hitchcock's solution, without being sure whether it was actually shot.

Here is how it happens in the book: Lina, the suspicious wife, is brought to despair by the realization that Johnny intends to murder her—even though she is pregnant with his child. (In the film, of course, she *isn't* pregnant—another bone tossed to the Hays Office.)

In the book *and* the film, Johnny brings Lina a glass of poisoned milk as she lies in bed. (The glass of milk was one of those novelistic details Hitchcock seized on; he had it lit from within by the effects specialists, highlighting its vile contents.) Then, just as in the book, Johnny is seen slowly ascending the long staircase to Lina's bedroom.

Lina has two nicknames in the book—"Letterbox," "in pleasant allusion to her mouth" (a nickname that didn't make it into the film), and "Monkeyface" (which did). "Letterbox" must have given Hitchcock the idea Raphaelson so admired. In this version Lina writes her mother a letter revealing the truth about Johnny; when it is read after her death, Johnny will be caught and punished, and society will be protected from his future crimes. In the Hitchcock version, just before she drinks the poisoned milk, Lina would ask Johnny, "Will you mail this letter to Mother for me, dear?" "Fade out and fade in on one short shot," as the director told François Truffaut; "Cary Grant, whistling cheerfully, walks over to the mailbox and pops the letter in."

But the letterbox ending was nixed. At the eleventh hour, Edington, who had become a scapegoat for RKO's downward spiral, was fired by studio president George Schaefer. Dan Winkler was also discharged, and with that the two men who had signed Hitchcock were gone. Then, against all common sense, Schaefer hired none other than the lord high censor of the Production Code, Joseph Breen, as RKO's temporary production boss.

If Hitchcock had ever hoped to release *Before the Fact* with an ending that faintly resembled the original, that hope now vanished. Alma Reville and Joan Harrison, who had taken over the script from Raphaelson, wrote and rewrote the ending, and at least two variations were filmed. The one that was shown to preview audiences, in mid-June 1941, had Lina putting Johnny to the test by drinking the glass of milk that she believes is poisoned; then, when she realizes she isn't dying, she goes into the next room just in time to keep a guilt-ridden Johnny from drinking the poison himself.

It was a disaster. "Trial audiences booed it, and I don't blame them," the director told the *New York Herald Tribune*. "They pronounced the girl stupid to willfully drink her possible destruction. With that I don't agree. But I did agree that the necessary half-reel of explanation following the wife's survival was deadly."

In late May, with most of the photography completed, Hitchcock met with Raphaelson in New York to ponder their last-ditch alternatives. On

Cape Cod in June, where his wife was appearing in summer stock, Raphaelson received a phone call from Hitchcock, who told him, "Joanie [Harrison] and I have written a new ending." Raphaelson's secretary took the scene down over the phone; he read it, made some notes, and phoned back.

The ending as it stands—indeed the entire film—can't be understood without this background. As with *The Lodger,* another book about a serial killer, in the end Hitchcock was forced to surrender the very things that had intrigued him most about *Before the Fact.* The script had yielded to many of the censorable issues, but as film scholar Bill Krohn noted, an "unusually large number of scenes" were also filmed that had to be "completely eliminated" during the editing. What remained, alas, was fluff: Cary Grant as more a scamp than a cad.

The ending that Hitchcock and Joan Harrison wrote had a terrified Lina announcing that she's going away to spend time with her mother. Johnny insists upon driving her to her mother's house, and they embark on a wild, Hitchcockian car ride on a high coast road. Convinced that Johnny is trying to kill her by deliberately smashing the car on the winding road, Lina desperately tries to leap out of the vehicle—only to be grabbed by her husband at the last instant. Whereupon Johnny confesses that he's been acting erratically not out of any desire to hurt her, but because he is consumed by guilt and financial woes. In fact, he confesses, *he* is the one who has been contemplating suicide! Sobbing with relief, Lina declares she won't go to her mother's after all. Their car circles around on the road to head home, and the film closes with the two driving off, Johnny's arm around his wife.

"I think," Hitchcock reflected years later, "it would have been better if I'd shown them both driving and he's just looking back over his shoulder regretfully—because he didn't push them over."

Hitchcock and Cary Grant had to swallow the bitter pill: a vapid ending, and an inexplicable reversal of the main character's villainy just before the final fade-out.

Yet even that wasn't enough of a concession for the new bosses. When Hitchcock traveled to New York in late June, a producer named Sol Lesser, who had just been named second-in-command under Breen, stepped in to confiscate the footage and splice together a condensed version of *Before the Fact* that eliminated *all* the homicides and erased *all* suspicion of Johnny's crimes. The condensed film would offend nobody—and run less than an hour! When Hitchcock returned, his cry of anguish was heard 'round Hollywood, with the Selznick brothers joining him in a rare display of family unity. After furious protest the director's cut was restored; and Lesser, whose tenure at the head of RKO (along with Breen's), set a Hollywood record for brevity, left the studio leadership to return to producing B pictures.

The final indignity was the new title. The preview audiences couldn't

grasp the meaning of *Before the Fact,* which Hitchcock preferred as a title. He always said he admired the novel, and, rare for him, praised it publicly as "a masterpiece." Yet he also understood that the ironies of the title had been rendered meaningless by the censorship compromises. As an alternative he proposed "Johnny"—happy to draw attention to his leading man. But the studio settled on *Suspicion,* a word that crops up in the second paragraph of the book. Hitchcock never lost an opportunity to say how much he hated the "cheap and dull" title.

But the title suited the film, which somehow transcended its flaws to become an amazing crowd pleaser—a box-office sensation that drew surprisingly rhapsodic reviews ("This is a far finer film than *Rebecca,*" wrote Howard Barnes in the *New York Herald Telegram*). Today movie fans still love *Suspicion,* and a small group of critics even find depths in its flaws. Mark Crispin Miller has described it as one of Hitchcock's masterpieces, precisely *because* of "the distortions of subjective vision," while the abrupt happy ending has been strenuously defended in *Cahiers du Cinéma* on the grounds that its patent absurdity forces audiences to wonder if Johnny will try to murder Lina again *after* the credits.

Joan Fontaine managed to stay friends with Hitchcock, and eventually picked up an Academy Award as the year's Best Actress. (*Suspicion* was also nominated for—and lost—Best Picture and Best Muscial Score.) Everyone in Hollywood, including Fontaine, suspected her Oscar was really for *Rebecca*. Her performance in *Suspicion* was not as strong, her characterization neither as consistent nor as complicated.

Cary Grant was nominated for Best Actor only twice in his career, for *Penny Serenade* and *None but the Lonely Heart;* like Hitchcock, the consummate actor never won a competitive Oscar. But it was Grant who made a lasting impression on the director: *Suspicion* would be Hitchcock's final outing with his Oscar-winning blonde, but to his dark, complex leading man he would be drawn again and again, as to a half-open door.

NINE
1941–1944

If, thus far, he had not yet matched his best English films, Hitchcock could nevertheless take comfort in the notion that he was building up credit and security for his long-term Hollywood career. Yet the Selznicks continued to cast a shadow over the short term; this time it was older brother Myron who stood in his way, blocking his remake of *The Lodger*.

Hitchock had talked Universal producer Jack Skirball into buying the rights for $35,000. But Myron demanded $50,000, along with 10 percent of any eventual profits, "the whole deal subject to approval of all budget elements," in the words of agent Sig Marcus, who was trying to piece together the deal. Moreover, Myron demanded that he be credited on the eventual film as coproducer.

The stiff terms gave Skirball pause. He had been trying to appease Hitchcock, but he thought the $50,000 price tag was outrageous. It was Hitchcock who was pushing to remake *The Lodger,* after all, not Skirball, and now the director's own agent was souring the deal with his demands.

Hitchcock implored his agent to take $30,000 of Universal's $35,000 offer, giving Myron more than his half of the stipulated $50,000; Hitchcock agreed to accept only $5,000 up front—a 50 percent loss on his $10,000 investment (though this was partly a loan from Myron). But

Myron wouldn't sell his half without coproducer and profit-participant status.

And when the brothers Selznick talked it over, they stood united, finally, on at least one subject: Jack Skirball was a novice producer who would probably ruin a remake of *The Lodger*. Myron and David wondered if perhaps they shouldn't just coproduce the remake themselves, making it a joint Selznick brothers' production. Of course, they could afford to muse about it endlessly. Not Hitchcock.

Drawn by *The Lodger* into speculating about what was best for his contract director, DOS spoke almost wistfully about getting back into producing, and supervising the next Hitchcock film. His appetite whetted, DOS told Myron he would be willing to buy Hitchcock's share of the rights to *The Lodger* if the director would consent to develop the project under his aegis. DOS then could absorb the remake into his program, and produce it as a Selznick-Hitchcock film—or ultimately sell it off to someone like Skirball, multiplying his profit.

Hitchcock had a series of dinners with Selznick to talk things over. Hitchcock liked David—better, as time went on, than he did Myron. Hitchcock and DOS were both talkers and dreamers. One night at dinner they spoke dreamily about the Swedish actress Ingrid Bergman, whom Selznick had brought to Hollywood. Since *Intermezzo,* her first American film, Bergman had become just another high-priced Selznick loan-out. DOS thought Hitchcock should direct Bergman in a Selznick film. Hitchcock thought so too.

Subsequently, Hitchcock spun "a very interesting, if rather erotic story," according to Selznick, which the director said that he and Joan Harrison had hastily whipped up for Bergman. The scenario would be loosely based on a true account of a couple who were kidnapped and chained together. "The young wife of a military attaché or something of the sort," Selznick wrote in a memo, "and a close male friend, after being kidnapped, were chained together by Chinese brigands for six months. I can understand the appeal of this to Hitchcock." Hitchcock had improvised the pitch—and apparently, Selznick didn't recognize it as a reheated blend of *Rich and Strange* (Chinese pirates) and *The 39 Steps* (handcuffs).

That "rather erotic story" may not have appealed to Selznick, but nevertheless he and Hitchcock were finally finding a kinship, rehearsing ideas aloud to each other. At one dinner Hitchcock rehearsed the notion of remaking *The Man Who Knew Too Much* instead of *The Lodger*. DOS liked that possibility so much that he assigned John Houseman, new to his staff as a producer, to brainstorm with Hitchcock over how to transplant the story to America. When it became clear that Hitchcock didn't actually own the rights to the original film, though—they were still tangled up with Gaumont back in England—the idea was swiftly dropped.

The Lodger kept bobbing up, partly because DOS liked hearing Hitchcock talk about it. How would the story be dramatized differently than before? Hitchcock improvised: maybe they could Americanize the story somehow. Hitchcock talked up a storm, until DOS said he'd like to read a solid treatment before making up his mind. Fine, replied the director; Mrs. Hitchcock could craft a scenario for twenty thousand dollars. Too bad, responded DOS, reminding Hitchcock that Alma's services came free to him with her husband's Selznick contract.

Strictly speaking, Myron told Hitchcock, David was right. As long as *The Lodger* was developed as a Selznick project, Alma couldn't be paid. Hitchcock was enraged, claiming he'd never been informed of such niceties before signing his contract. Anxious to smooth everything over, Myron tried to mollify his client over a series of dinners. But Myron wore on Hitchcock: his unctuous hospitality when it suited his mood, his hardshelled attitude the rest of the time; his drinking and bellicose rants.

Finally, in the late spring of 1941, the director decided to set *The Lodger* aside for the time being and move on. DOS was chimerical, and at the moment neither Selznick seemed serious about producing. Jack Skirball, on the other hand, was eager to let Hitchcock try almost anything.

Skirball had been urging the director to switch gears and turn his attention to what they had always referred to as "Hitchcock #2." This would be a Hitchcock original: a wrong-man chase, like *The 39 Steps*, but set in America. The wrong man would be another John Doe American, mistaken for a saboteur. Hearing about this, DOS agreed to let Hitchcock develop "Hitchcock #2" under Houseman; DOS could monitor the script progress, and then decide later whether to produce the film himself or sell it for easy profit.

DOS placated Hitchcock by raising his salary to $3,000 weekly, beginning in July 1941; the director would now be making $120,000 yearly. Myron also tried to placate his client by hiring Alma for $10,000 to write a first treatment for *The Lodger* remake. But since Hitchcock was a half partner in the rights, he had to vouch for half of Alma's salary out of any future earnings on the property. (The agreement Hitchcock signed with Myron also obliged him to direct the remake, unless incapacitated.)

The annual raise and script commission were a salve to his pride, but the director balked at Myron's request to re-sign with the agency for another seven years. His first contract with the Selznick Agency was coming up for renewal—but by now Hitchcock blamed Myron even more than his brother for the maze he was in.

Though DOS was still pretending he might eventually produce the saboteur project, Hitchcock assured Skirball that the film would end up at Universal. Even before the contract details were resolved, then, the Hitchcocks and Joan Harrison went to work on the story, moonlighting at

night, on weekends, even on the set of *Suspicion*. By midsummer, with *Suspicion* in postproduction, Hitchcock was holding his first meetings with John Houseman.

The war and filmmaking went hand in hand. In August 1941 Hitchcock made a quick trip to New York to consult with Sidney Bernstein, who had flown to the United States aboard a Liberator bomber. On behalf of the Ministry of Information, Bernstein was en route to Hollywood, where he hoped to establish a cooperative relationship with studio executives.

Returning ahead of Bernstein, Hitchcock and Victor Saville helped arrange his appointments. While meeting with studio moguls Harry Warner and Louis B. Mayer, among others, Bernstein stayed with Hitchcock at St. Cloud Road. Bernstein's goal was to convince the studios to attach various MOI wartime short subjects to their major releases, and incorporate into their future programs features that celebrated British history and heritage.

This activity still ran counter to the Neutrality Act. Pro-British activity in Hollywood was under scrutiny by American intelligence operatives, as well as by pro-German elements in the film industry. Although many U.S. citizens wanted to do everything possible to side with England, the government's official policy was to do nothing, so America Firsters had law enforcement on their side. *Foreign Correspondent*—and now the saboteur project—were precisely the type of "message pictures" that isolationist Senators Burton K. Wheeler (D., Montana) and Gerald P. Nye, (R., North Dakota) inveighed against in widely publicized speeches, denouncing "alien" influences in Hollywood.

Indeed, in the fall of 1941, Saville was among those publicly branded a British agent in Senate Interstate Commerce Committee hearings led by Wheeler and Nye, with testimony alleging that in Hollywood, Saville entertained "lavishly and that each of his guests is served a full course of British propaganda." *Foreign Correspondent* somehow escaped the list of Hollywood pictures targeted by the committee (Hitchcock's propaganda was that slippery), and anyway, the hearings were brief—the investigation was cut off by the events of December 7.

Pearl Harbor suddenly freed Hitchcock to be more explicit with his subject matter in the new film—now called *Saboteur*. Although work on the story had been ongoing since the early summer, a series of crucial revisions would occur after America went to war.

John Houseman had taken DOS's place supervising Hitchcock, though neither Houseman nor anyone else operated under the illusion that *Saboteur* would end up a Selznick production. "Early in the proceedings, he [DOS] said, 'I'm not going to make it anyway,' " wrote David Thomson.

Born Jacques Haussmann in Bucharest to an Alsatian father and an English mother, Houseman was educated in England; transplanted to New York by the early 1930s, he produced the Gertrude Stein–Virgil Thomson avant-garde opera *Four Saints in Three Acts* before joining forces with Orson Welles in a tempestuous partnership that spawned the Negro Theater Project, the Classical Theater Project, and the stage and radio productions of the Mercury Theater. When Welles moved to Hollywood, Houseman went with him as the unofficial supervisor of *Citizen Kane,* but endless friction with his partner led him to accept a contract with Selznick.

DOS hoped to leverage Houseman's British background, "as well as my cultivation and charm," in Houseman's words, "to establish good personal relationships with Hitch and to cajole and encourage him into conceiving and preparing an original screenplay."

"I had heard of him as a fat man given to scabrous jokes," Houseman wrote later, "a gourmet and an ostentatious connoisseur of fine wines. What I was unprepared for was a man of exaggeratedly delicate sensibilities, marked by a harsh Catholic education and the scars from a social system against which he was in perpetual revolt and which had left him suspicious and vulnerable, alternatively docile and defiant."

Though they had met before, Houseman got his first close-up of Hitchcock on this project, and according to film historian Leonard Leff, he found himself "mesmerized."

"His passion was for his work, which he approached with an intelligence and almost scientific clarity to which I was unaccustomed," Houseman recalled. "Working with Hitch really meant listening to him talk—anecdotes, situations, characters, revelations and reversals, which he would think up at night and try out on us during the day and . . . the surviving elements were finally strung together into some sort of story in accordance with carefully calculated and elaborately plotted rhythms."

The first three Hitchcocks did most of the initial scutwork at St. Cloud Road. One day, a visiting reporter observed Mr. and Mrs. Hitchcock and Joan Harrison "rushing into different rooms with typewriters and manuscripts, taking over tables, chairs and lounges and at once starting to work feverishly, paying no attention to anybody but themselves." The progress was punctuated, the reporter observed, by delivery of "huge goblets of Strawberries Romanoff, a concoction of ice cream, fruit and liqueurs," upon which Hitchcock gorged, "then dozed off as the frenetic activity continued around him."

After making crucial contributions to the story, Harrison decided to leave the project to strike out on her own in Hollywood. While Hitchcock had expected her to leave eventually—indeed, in interviews, predicting her eventual success away from him—he panicked at losing Harrison at

this juncture, and tried to extract extra money from DOS to entice her to stay. When Selznick refused, Hitchcock stormed out of the office. Houseman the diplomat quelled the emergency; then, after things settled down and Harrison had vacated, a young man named Peter Viertel came to the rescue.

As a junior writer under contract to Selznick, Viertel would keep the first-draft costs down. Barely twenty-one, Viertel had received glowing reviews for his first novel but as yet had no screen credits (nor, for that matter, did Houseman). But as the son of two illustrious figures—the Viennese poet, playwright, and film director Berthold Viertel, and the Polish-born actress Salka Viertel, well known as Greta Garbo's confidante and scenarist—he came with a pedigree. Hitchcock liked mixing precocious writers with famous ones, and the well-bred Viertel was his sort of eager beaver.

At their first meeting, Viertel confessed he didn't really know how to write a script. "I'll teach you, my dear boy," Hitchcock cooed, "in about twenty minutes." The director then launched into an elaborate explanation of the difference between establishing shots and close-ups; using musical terms, he said that long establishing shots were like long overtures (not always necessary) and close-ups were like cymbal crashes used for dramatic effect. He urged Viertel not to worry about writing lengthy descriptions or too much dialogue ("no speeches, please"). "The main thing," Hitchcock said, "is to get a script together to get the whole project moving."

The second shift of three Hitchcocks took over—Viertel, Houseman, and the director. Mrs. Hitchcock absented herself, accompanying Pat to New York for rehearsals and performances of the John Van Druten play *Solitaire.* (Dudley Digges had replaced Auriol Lee as director, after Lee was killed in a car accident heading back east after *Suspicion.*) Pat would earn unqualified praise from theater critics; but the play opened just a few days after Pearl Harbor, and lasted only three weeks before closing. Immersed in *Saboteur,* her father never saw her Broadway debut.

The new three Hitchcocks did their best to keep abreast of the headlines throughout that fall of 1941. The saboteur script raced ahead of widespread fears that Nazi-sympathizing fifth columnists might try to sabotage U.S. heavy industry. The hero became a California munitions worker, falsely accused of sabotage, who eludes arrest and flees cross-country, trying to prove his innocence. Dragged along with him on this "double chase" is a blond billboard model (a tweaking of Hitchcock's friend, the model and beauty consultant Anita Colby). One of Hitchcock's ideas, which dated from the earliest days of work on the story, was the climax—with the real saboteur, cornered by his pursuers, falling from the upraised torch of the Statue of Liberty.

Nobody pretended the latest Hitchcock film was going to be anything

but a pastiche of old ones, mixing scraps of John Buchan with *Foreign Correspondent* (itself a pastiche). But there was one big difference: "*Saboteur* was the first picture he was to make in America about America using America as a background," in Viertel's words. (Hitchcock himself was already describing it as an "American picaresque.") Besides the Statue of Liberty, the film would visit Hoover Dam, Rockefeller Center, Radio City Music Hall, and the Brooklyn Navy Yard. There would even be side trips to a western ranch and ghost town.

Hitchcock was comfortable recycling himself—too comfortable, sometimes. In one session with Viertel, he said he thought the fifth-column leader might bear a physical flaw: an eye twitch, or missing finger, perhaps. Dreaming up the New York scene in which the heavy mingles with guests in the ballroom of a grand mansion, the director instructed Viertel to write a long dolly shot past the waiters and people in dinner jackets and all the beautiful women, coming to rest on a close-up of a hand lacking one digit. Viertel said, "I think you used the missing finger in *The 39 Steps,* Hitch, and the long dolly shot in *Young and Innocent*." "Hmmm," purred Hitchcock, "well, I'll think of something else." (He eventually dropped both ideas.)

Or maybe that was a little test. Was Viertel up on his Hitchcock studies? Writers were expected to know his films; if they didn't, he'd order up screenings for them.

With Houseman adding his two cents, Viertel cranked out pages and pages. The director acted "supremely confident that he would make many more films and that an occasional failure would do little harm to his reputation," recalled Viertel. "With the possible exception of *Rebecca,* he seemed to know that his films would inevitably be labeled 'Hitchcock movies,' so his vanity was never involved in our exchange of ideas."

As usual, gaps and implausibilities barely broke his stride. In one instance Viertel painted himself into a corner, locking the John Doe character in a storeroom. How could he be sprung? Hitchcock suggested he might hold a lighted match to a sprinkler alarm system, followed by a quick cut to him standing outside the building, watching a fire brigade arrive. But wouldn't the audience scratch their heads, Viertel wondered, trying to piece together how he managed to get out? "They'll never ask!" Hitchcock crowed.

Especially after Pearl Harbor, with the script overtaken by the war, *Saboteur* couldn't help but evolve into a "message picture." Regardless, Hitchcock shied away from dead-on dialogue. "Too on the nose" was his harshest criticism. As a man with one foot always in the silent era, he preferred not to articulate every last meaning with words.

When, however, Viertel broke the "no speeches" rule and wrote what he thought was a rather explicit fascist monologue, to be delivered by the

leader of the fifth columnists—who sneeringly refers to "the great masses . . . the moron millions"—Hitchcock said nothing. He read the speech, and allowed it to stay in the script. Later, after one of those studio previews the director hated, with their idiotic audience response cards, he walked out with Viertel. "The great masses," Hitchcock muttered, linking his appreciation for Viertel's dead-on dialogue with the irksome preview cards, "the moron millions."

These three Hitchcocks had camaraderie; what they lacked was time and money. DOS wanted a quick script to save on costs, and Hitchcock wanted a quick script to get out from under DOS. When Viertel finished his "rough first draft," the young writer regarded it with chagrin. "It wasn't very good, as you can well imagine," Viertel recalled. But after reading it, Hitchcock chortled, "It's no worse than a lot of others and it'll get me away from Selznick!"

Though the Universal deal was pending, Hitchcock and Houseman were obliged to troop around town, pitching the package to other studios—all part of the grand scheme to tout the Selznick name, and drive up the eventual price. Hitchcock felt "like a pimp, divided between humiliation over these performances and the pleasure he always felt at trying out his gimmicks on a new audience," a sympathetic Houseman observed. Selznick's asking price for Hitchcock and the script augured a profit of roughly 300 percent. "This grievance over what he quite rightly regarded as the exploitation of his talent became so deep that it finally affected the quality of the picture," reflected Houseman.

But Skirball kept the faith, and *Saboteur* was inevitably delivered to Universal as the first of a two-picture contract with Hitchcock. For the script alone, which Selznick could and did advertise as a "Hitchcock original," the studio was forced to pay the remarkable sum of $120,000—$70,000 upon signing, plus $50,000 after the picture had grossed more than $500,000. DOS would earn 10 percent of the gross receipts, provided (as per contract) that Hitchcock didn't exceed the $750,000 production budget.

The steep terms were "onerous" to *Saboteur* coproducer Frank Lloyd, David Thomson wrote in *Showman*. And besides the budget ceiling, there were especially taxing rush clauses. The second Universal film—"Hitchcock#1"—had to be completed before June 1942 in order to inaugurate the next cycle of the Selznick contract.

Whatever the conditions may have been, though, the Universal films are more Hitchcockian than those he made for RKO—in part because he was allowed to create his own stories, in part because he was making strides in adapting to America, and in part because of his uniquely benign producer.

Jack Skirball was a rare commodity in Hollywood: both a producer and an ordained rabbi. Born in Pennsylvania, Skirball had attended the University of Chicago before becoming a rabbi in Cleveland, Ohio, and Evansville, Indiana, in the 1920s. He drifted into film exhibition and started producing educational films, including a documentary called *Birth of a Baby* that stirred national controversy in 1938. In Hollywood since the late 1930s, he first served as an officer of the flea-budgeted Grand National and Arcadia Pictures. Teaming up with Frank Lloyd in 1940, he earned his first A credit: *The Howards of Virginia,* a Cary Grant vehicle.

Skirball was a "pleasant, non-aggressive producer, who was a fan of Hitch's," recalled Peter Viertel. "He was of slight build, wore glasses, and did not interfere with the creative efforts of Hitch and any of the writers." And right away, Skirball, like Walter Wanger before him, understood the depth of Hitchcock's bitterness over how he was being treated by the Selznicks; even before filming began, Skirball went out on a limb to contrive a voluntary bonus for Hitchcock of 10 percent of all gross receipts for *Saboteur* after "170% of negative cost." Hitchcock insisted that this bonus, Skirball's own extracontract gesture, was his and his alone. This infuriated both Selznicks. If the director got paid separately, neither Myron nor David received their percentages. (Later, thinking the low rate DOS had been paying Viertel was equally "outrageous," Skirball bonused Viertel, too.)

Right away, Skirball authorized spending more of the precious budget on the best writer money could buy: Dorothy Parker, the third member of the *New Yorker* and Algonquin Round Table to be recruited for a Hitchcock script. The celebrated short-story writer and humorist honed a number of scenes before the approaching start date in December.

Parker, for example, fixed up the scene where Barry Kane (Robert Cummings) hitches a ride with a truck driver, turning it into a satire on fashionable proletarian melodramas like *They Drive by Night*. The driver's a gum-chewing lumpen who keeps up a running monologue about his wife driving him crazy, always buying hats and going to movies—hats, movies, hats, movies. Kane is idly whistling Beethoven. "Hey," says the truck driver, "catchy tune." (Typical of Hitchcock, the truck driver returns, strategically, later in the story.)

Parker also wrote the exquisite scene with the billboard model's blind uncle, an idealist reminiscent of the elderly diplomat in *Foreign Correspondent*. The uncle, who lives in a mountain cabin, shelters the fleeing wronged man from police, and provides a peaceful interlude when he plays a snatch of "Summer Night on the River" on the piano. (The English composer of the piece, the uncle notes, was Delius—also a blind man.)

Another Parker contribution supplied a witty microcosm of the world in turmoil: While fleeing police, Kane and Pat Martin (Priscilla Lane) leap inside a painted wagon trundling along the road. Inside dwell a troupe of

circus freaks: a truculent midget, a gentle-hearted bearded lady, Siamese twins who disagree sharply, an ambivalent fat lady, and the group leader, the skeletal Bones. When police search the caravan, the troupe argue heatedly over whether to turn the refugees over to the law, or to heed their consciences. The democratic-minded Bones successfully insists on putting the issue to a vote. Parker wrote the scene as a hilarious "parallel to the present world predicament," as Bones himself overtly comments. The midget, of course, represented Hitler; Bones was FDR. The other freaks were internally divided European nations. The scene encapsulated the plight of refugees from war and fascism. "Some of her [Parker's] touches, I'm afraid were missed altogether," Hitchcock lamented in his interview with François Truffaut. "They were too subtle."

Hitchcock paid Parker the ultimate compliment: he shared his cameo with her. The writer appeared in the first version of the scene, in which a car drives past the wronged man and the billboard model on a desert highway. Hitchcock drove (a play on his claim that he never drove), with Parker beside him in the passenger seat. When they spotted Kane grappling with the billboard model, trying to muffle her cries for help, the car slowed down. "My," went the quip Parker wrote for herself, "they must be terribly in love."

After watching the dailies, however, Hitchcock decided the cameo was too intrusive, and so the brief scene was refilmed with professional actors. The director tried another cameo, later in the film, as a deaf-mute outside a drugstore in the New York scenes (standing next to his secretary, Carol Stevens). But Universal thought this might offend people—so, ever practical, he cut his usual walk-on to an eyeblink.

Although Jack Skirball's avowed goal was to let Hitchcock make a Hitchcock film, Universal was the Woolworth of Hollywood studios—arguably the least endowed, the least prestigious of the major production companies, a studio without A budgets or stars. All the glamorous people were under contract elsewhere, and any big names Hitchcock might hope to borrow were booked months in advance. By the time *Saboteur* landed at Universal, only a few weeks were left for preproduction and casting before the start date.

The Peter Viertel draft had been rushed over to Barbara Stanwyck and Margaret Sullavan, two leading ladies Hitchcock courted repeatedly over the years. He met personally with both, pouring his charm over the weaknesses of the script. Either would have pleased him as Pat, the billboard model, who is forced to aid and abet the wronged man.

Barry Kane was really the central character, and Hitchcock chased Henry Fonda—John Ford's Tom Joad—to play his first all-American

wronged man.* The director met with Bill Goetz and Darryl Zanuck at Twentieth Century–Fox, and also with Eddie Mannix at MGM, trying to persuade these executives to disrupt their hallowed schedules by loaning out Fonda, or an equivalent star.

Quite apart from the scheduling problems, Hitchcock's star quest was undercut by budget strictures. Universal couldn't squeeze top dollar from a budget that had already absorbed high payments to Selznick. So the director shifted to the B list.

He met with Joel McCrea, who was happy to appear in another Hitchcock film, even at the modest salary offered by Universal. But McCrea wasn't available right away either, so Hitchcock turned to Robert Cummings, a genial actor better known for airy romance and bumbling comedy (though he had just appeared in the serious *Kings Row*). Hitchcock would later tell Truffaut that Cummings was merely a "competent performer" who belonged to "the light-comedy class of actors," listing, among his failings, the fact that "his features don't convey an anguish." But at the time he privately preferred him over McCrea—and later he would cast Cummings again, in *Dial M for Murder*. Perhaps it was Cummings's stage training that won over Hitchcock—but then again, it may have been that the two enjoyed each other's company off-camera.

Casting Cummings killed any slim hopes of securing Stanwyck or Sullavan, though, "because they will not support an actor of lesser importance than themselves, in a role of greater importance than their own," as a Selznick Agency memo observed. So in mid-November, within a few days of engaging Cummings, Hitchcock also accepted an equivalent leading lady: Priscilla Lane, the youngest of three sisters who had appeared as siblings in *Four Daughters*. The blue-eyed blonde, a former big-band vocalist, was getting a star buildup from Warner Bros., and the terms of her loan-out guaranteed that she would be billed over Cummings. Though she was given the impression that Hitchcock had personally requested her, the director told others that Lane was "imposed" on him by coproducer Frank Lloyd from a list of lesser, affordable actresses. Cute and sweet, "she simply wasn't the right type for a Hitchcock picture," he said later.

The villain of *Saboteur*, the leader of the fifth columnists, was an important role. The script showed a sophisticated understanding of the pro-Nazi camp in America, "who called themselves America Firsters and who were, in fact, American Fascists," as the director noted in later interviews. Now Hitchcock sought an actor who wouldn't imply "sinister, slinking, foreign-looking men," but someone "outwardly clean and patriotic in ap-

* Barry Kane, the character's name, dated from the first script sessions with John Houseman—Hitchcock's tease on *Citizen Kane*.

pearance." He tried for a hundred-percent American: Harry Carey, often a decent, though not saintly, figure in John Ford films. Someone like Carey would act as a "counterpoint element" and give audiences a jolt, Hitchcock thought. When he asked Carey to play the out-and-out traitor, though, the actor was offended (and his wife indignant); Carey joined the burgeoning club of actors who turned up their noses at a Hitchcock film.

The director also approached the suave John Halliday, who had semiretired from the screen after playing Katharine Hepburn's father in *The Philadelphia Story*. But Halliday was living in Hawaii, and after Pearl Harbor he was hemmed in by travel restrictions. Finally, because of the timetable and studio pressures, the director was forced to accept Otto Kruger, a suave, capable contract player, but nonetheless an oily "conventional heavy," in Hitchcock's words, who would spring no surprises on the audience.

Hitchcock tested a whole slew of actors before casting Vaughan Glaser as the blind uncle. Short, soft-spoken Alan Baxter would lend an epicene quality to the fascist functionary who drives Cummings cross-country ("When I was a child, I had long golden curls."). Onetime leading lady of the stage Alma Kruger—best known as the head nurse of the Dr. Kildare and Dr. Gillespie series—was a counterpoint choice as the pro-Nazi high-society dowager.

The saboteur—the Macguffin personified—afforded a small but choice part for a newcomer. In New York for the premiere of *Suspicion* in December, Hitchcock tested several stage actors, including a young Canadian named Hume Cronyn. John Houseman suggested that he should meet with Norman Lloyd, who had been sensational in Shakespeare productions for the Mercury Theater. Lloyd visited Hitchcock at the St. Regis.

"It impressed me, as I came into his presence," recalled Lloyd in *Stages*, "that he was the definition, in one's imagination, of an international motion picture director. I don't mean in the cliché Hollywood style, or as in a George S. Kaufman comedy, but in the sense of a director one felt to be a major figure in the contemporary entertainment world. He told me what he had in mind and said that he would have me tested; he didn't do the tests, because he had to go back to Los Angeles. I was to select a scene with a character who was like the character in the film, which he described to me."

Lloyd got the part, and even before he came to Hollywood he went to work with Hitchcock's second unit. A crew led by special-effects cameraman John Fulton came East to photograph Radio City Music Hall (for the sequence where a chase and gunfight fells an innocent in the audience, laughing hysterically at the comedy on-screen), the launching of a liberty ship in New Jersey, and the Statue of Liberty. Following strict instructions from Hitchcock, Fulton shot still plates and action from a portfolio of sketches.

Lloyd and several dozen extras, including a stand-in for Priscilla Lane, were photographed at the Statue of Liberty's ferry ticket office, ascending the gangplank, on the deck of the ferry, and then arriving on Bedloe (now Liberty) Island in New York Harbor. The statue's upraised hand, the giant torch, and the ledge under the torch were also photographed, and then later re-created to scale on Universal stages. The mock-up doubled for the national monument, and stuntmen doubled for Lloyd when, at the end of the film, the saboteur trips over the side and is caught by Robert Cummings, one hand clutching his unraveling sleeve. For his "fall," Lloyd actually spun on a wire in front of a black cloth inside the studio; the background was matted in, with the actor miming his plummeting as the camera pulled away. It was a spectacular effect achieved by meticulous planning over months—one of Hitchcock's most famous dangling-man sequences. Scant dialogue; no music; only natural sound—the wind gusting, the coat ripping, a woman's scream.

Hitchcock, Lloyd recalled, had an amazing instinct for turning the freshest headlines to his advantage. After the French ocean liner *Normandie* was swept by fire in the second week of February 1942, the director swiftly dispatched a Universal newsreel unit to film the ship, which was lying keeled over in New York Harbor.* He told the crew to photograph the beached liner as though from the window of a speeding car, and then to get some additional footage of a taxi hurtling down the West Side Highway, the elevated road that runs along the west side of Manhattan. In Hollywood, meanwhile, Hitchcock positioned Lloyd in the backseat of a mock-up taxi and told him, "When I cue you, look to your right as if you see the *Normandie*."

In real life, initial suspicions that the *Normandie* was sabotaged were later ruled out. But audiences of the time, watching Hitchcock's crafty composite of newsreel and staged fiction, experienced the intended frisson. This "shows a man [Hitchcock]," reflected Lloyd years later, "who was really on his toes and aware of any opportunity to create something for his film: to take history at the moment and incorporate it into a script—in character, story and action."

Ironically, "the U.S. Navy was incensed at the *Normandie* shots and demanded that they be removed," wrote film historian George Turner, and the sabotage implication was omitted until the 1948 reissue.**

* The newsreel unit became part of the film's story, too—as the Trojan horse decoy that delivers the saboteurs to their target.

** The management of Radio City Music Hall also objected to the chase and gunfighting (and killing) on its premises—so, according to Turner, "it had to be severely cut to avoid identification of the theater," clearing the way for the eventual premiere of *Saboteur* at that New York showcase.

* * *

Even as principal photography began, a week before Christmas 1941, the director returned to the script. Peter Viertel came back on the job, conferring with Hitchcock "every evening, while he was shooting, lunching with him on weekends and spending Sundays together working out the scenes and trying to make them better under his tutelage," according to Viertel.

Hitchcock's life at the time, the writer recalled, was "very spartan—work, the cutting room, home." There were no vacations, or open-door parties of the sort that had characterized his life in London. Sunday was the only day he wasn't at the studio, and on that day Viertel visited St. Cloud Road for script sessions, followed by lunch. Mrs. Hitchcock had grown alarmed over her husband's weight, and he was again dieting. Yet Viertel was convinced that, except when striking a pose for publicity, Hitchcock wasn't really given to stuffing himself. Viertel was not the only close associate to believe Hitchcock may have had a glandular condition that caused him to retain weight. Hitchcock believed so himself, and kept regular appointments with his Beverly Hills physician, Dr. Ralph M. Tandowsky, for diuretic (and B-vitamin) shots.

The director owned a book of famous menus from which he liked to read aloud, sighing ruefully, for example, over a glorious repast served to King George on a state visit to Paris in 1914. "The menu was full of succulent delights," recalled Viertel, "and Hitch would get his kicks just out of reading it, but then lunch would be spartan, maybe a salad with a side of lamb. Hitch ate, but not an astonishing amount. He didn't really drink that much, and you never saw him drunk."

In spite of budget constraints and casting disappointments, Hitchcock seemed positively ebullient now that he was on his own at Universal, far away in miles and spirit from the Selznick penitentiary. He had collected a new team, including a young art director, Robert Boyle, whose abilities as a sketch and design artist recommended him to Hitchcock for the future. His cameraman was the highest paid on the lot: Joseph Valentine, who filmed the slapstick comedies and Deanna Durbin musicals that were Universal's bread and butter. (Valentine had also shot *The Wolf Man,* an atmospheric horror picture Hitchcock particularly admired.)

His stars may have been compromise choices, but he didn't mind so very much. He saw them as bargains. "All that stuff about him saying, 'Actors are cattle'—I'm sure that was just publicity," recalled Priscilla Lane. "He was very exacting—unswervable in getting you to do exactly what he wanted. But he was always pulling little gags to keep the set a happy place."

Hitchcock didn't speak to the actors very much about acting anyway, according to Viertel—except in the case of Otto Kruger, who just couldn't

please him. Kruger never fit his picture of the villain, no matter how hard Hitchcock prodded him. ("I think you should do it a little more *pointedly*, Otto.") In general, Hitchcock "worked with actors against the Stanislavsky or Group Theater method," said Viertel. "He let them, very much like John Huston, do the scene in a rehearsal, and then most any direction he gave had to do with timing." The director believed he could solve any acting problem with camera work, and his solutions were often ingenious—as when he filmed the villain's lengthy soliloquy with Kruger seated on a sofa and the camera fixed an eerie distance from the actor across the room.

Universal grew "alarmed at the 50-odd sets Hitchcock ordered," reported George Turner, "especially a vast Stage 12 desert, a reconstruction of a part of the turbulent Kern River including a waterfall, and the grand ballroom of a Park Avenue mansion." Hitchcock assured Skirball that he would cut some corners, though, and Skirball in turn reassured the studio. Hitchcock budgets were like Hitchcock's weight: he might prefer to gorge himself, but he was a genius at shedding pounds—a master of scrimping, happy to film only a *corner* of a building set to avoid having to construct the entire facade. Strapped for cash, Hitchcock would all the more resort to mattes, miniatures, and background plates, blended masterfully by the effects wizards.

The film's mansion set was built onto a stairway left over from a Deanna Durbin vehicle. A back-lot storage building ("an old scene dock with big sliding doors that happened to be there," in Boyle's words) was easily transformed into an aircraft factory. When the doors opened and a crowd of workers poured out, the audience would glimpse a vast dark interior with rows of airplanes under construction—actually a scenic backing. Hitchcock knew "the chances that almost any shot will not hold longer than five seconds," according to art director Boyle, "and that a matte in particular is going to be on for no more than five seconds. Then the audience doesn't have time to find the problems."

For the actual sabotage, the film needed some kind of impressive explosion—and even that Hitchcock managed to pull off on the cheap. He visualized it as a simple, eerily effective shot, with black smoke gradually billowing under the sliding doors of the factory, followed by a tremendous bang and roar. "Hitch made a drawing," Boyle remembered, "in which he drew just the big doors and then he did a big scribble. He said, 'There will be an explosion.' And I thought that scribble was more illuminating than the finest drawing you could make."

Scene after scene stimulated his creativity. The night sequence involving the circus caravan gave Hitchcock the opportunity to quote from F. W. Murnau, creating a variation on the lesson he had learned on the set of *The Last Laugh* in 1925. "We had a shot from the back of this long train

in which we had a full-size truck, and then a smaller truck," Boyle re-
called. "After that we began to get into miniatures, and finally, as we got
way off in the distance, we got into just cutouts. Now the problem was the
people, because the police were searching the whole train, which meant we
needed people all the way back. We had full-size people in the foreground
truck, smaller people behind, and still smaller people behind that. For the
first three trucks we used people of regular heights, from six-footers down
to five-footers. After that we went into midgets. Then way in the back-
ground were small, articulated, cutout figures whose arms could be
worked like puppets, and we had tiny flashlights on their hands. I don't
know many directors nowadays that would stand still for that; they're
afraid of it. Hitchcock was never afraid to try anything, and if it didn't
work exactly as he wished it didn't bother him that much, as long as he
got the sensation correct."

Rarely in his career did Hitchcock enjoy the luxury of an unrestricted
budget. Yet if *Saboteur* was hurried and inexpensive; if the script was
flawed ("I would say that the script lacks discipline," Hitchcock, again his
own harshest critic, told Truffaut, and "the whole thing should have been
pruned and tightly edited long before the actual shooting"); if the stars
were bland—well, none of it mattered. Audiences were dazzled. Edited
and released quickly in the spring of 1942, *Saboteur* soared at the box of-
fice. While today it may not have the same electrifying immediacy, the film
is still full of vigor and panache. Then as now, critics regarded it as minor
Hitchcock, but in 1942 Hollywood saw it differently. *Saboteur* was the
first film by the English director that truly looked American.

Although *Saboteur* ultimately inched over budget (by roughly three
thousand dollars), Skirball fought for Hitchcock's bonus anyway—and
ended up deducting the extra money from his own profit share. Hitchcock
received an extra fifteen thousand dollars, directly from the producer. It
was a victory all around.

As usually happened, while making *Saboteur* the director was already pre-
occupied with finding a subject for his second film under the Universal
deal. "During that period," said Peter Viertel, "he was always starting on
another one right away."

Once again Hitchcock harked back to John Buchan, proposing yet again
to adapt *Greenmantle,* this time with Cary Grant and Ingrid Bergman in
mind. His backup choice was *No Other Tiger* by A. E. W. Mason, the au-
thor of *Four Feathers,* an adventure that begins during an Indian tiger hunt
before shifting to British high society. "Hitch enthused particularly,"
Selznick story editor Margaret McDonell reported, "about the climax
where the beautiful dancer is found hanging from the chandelier."

But rights to the Buchan novel were as elusive as ever, so he returned to another persistent idea. Though stymied from remaking *The Lodger*, he thought about crafting a Hitchcock original about a more modern serial killer. Steeped in crime lore since boyhood, Hitchcock had well-honed reflexes when fashioning such a film. These stories were so deeply rooted within him, so instinctual, that he gave them a name: "run-for-cover" films.

"Whenever you feel yourself entering an area of doubt or vagueness," he once said, "whether it be in respect to the writer, the subject matter, or whatever it is, you've got to run for cover. When you feel you're at a loss, you must go for the tried and true."

Margaret McDonell was married to the British-born author Gordon McDonell, whose adventure stories and crime novels, influenced by James M. Cain, were often sold as film material. When McDonell told her husband that Hitchcock was anxious to find a run-for-cover crime story, McDonell reminded his wife of a yarn he had dreamed up in 1938, when their car broke down and they were stranded in Hanford, south of Fresno in California's San Joaquin Valley, waiting for repairs. Hitchcock agreed to hear the story over lunch at the Brown Derby.

In the first week of May 1942, Hitchcock first heard the bare bones of the story McDonell was calling "Uncle Charlie." It concerned a "handsome, successful, debonair" man, in McDonell's words, who arrives in a California town to visit his sister's family. The family—middle-aged parents, a nineteen-year-old son, and an eighteen-year-old daughter—haven't seen Uncle Charlie for ten years. The daughter is Charlotte, young Charlie, named in her uncle's honor—his favored niece, and a young woman with "great potentialities of charm." But young Charlie begins to suspect—rightly—that Uncle Charlie is a serial murderer on the run from police; when he realizes she knows the truth, he decides to kill her to protect his secret. McDonell's original story concluded at a country picnic, where, lunging at his niece, Uncle Charlie topples off a cliff.

A debonair serial killer in small-town America: this was pure run-for-cover. Years later the director told crime historian Jay Robert Nash that "Uncle Charlie" instantly reminded him of the notorious 1920s trial of Earle Leonard Nelson, who traveled from coast to coast in America, slaying matronly types. Another time he said it evoked the case of mass murderer Henri Landru, a Parisian confidence man and killer who murdered at least ten women and a boy between 1915 and 1919, and whose trial was held in 1921. (Landru's case later inspired Chaplin's *Monsieur Verdoux*.) The more real-life echoes a crime story had for Hitchcock, the bigger his pool of references, the greater his enthusiasm.

Before he could start on "Uncle Charlie," though, Hitchcock had to patch together a new agreement with Selznick International. He couldn't make "Uncle Charlie" for Universal fast enough to finish filming inside of

the one-year time frame of his contract, and thus he would be unable to fulfill his obligation to Selznick of two pictures per year. This was the constant subtext in his dealings with Selznick; over time it had proven the most troublesome clause in his contract. At Hitchcock's urging Myron Selznick even consulted outside lawyers to see if he could get around the problem, but the lawyers weren't confident, and Dan O'Shea refused to budge.

Once again the labyrinthine, patched-over Selznick contract prevailed, and on May 7, after meeting with Gordon McDonell, Skirball approved a memorandum specifying "Uncle Charlie" as the second picture of the Universal contract—in conjunction with Selznick, extending Hitchcock's availability to the studio into the late fall of 1942. McDonell supplied a six-page synopsis of his story. Although Hitchcock asked him for a lengthier treatment, the author didn't want to interrupt the novel he was writing, and never augmented the six pages.

It was up to Mr. and Mrs. Hitchcock to brainstorm the initial "Notes on Possible Development of Uncle Charlie Story for Screen Play," which they did on May 11, 1942, outlining the director's formative vision for the film. Although McDonell had posited "a typical small American town" with "little people, leading unimportant little lives," Hitchcock was worried about that word "typical," wary that it suggested a cast of stock figures. So he and his wife modified the town into a place invaded by modern evils ("movies, radio, juke boxes, etc.; in other words, as it were, life in a small town lit by neon signs"), with a sympathetic, individualized family whose members would lend themselves to plenty of comedy—especially "from the characters 'not in the know.' "

Working without Joan Harrison for the first time in nearly a decade, and needing to flesh out McDonell's brief story, Hitchcock wanted a writer with more experience than Peter Viertel. Just as he sprinkled his films with American landmarks, Hitchcock liked to add a dash of literary prominence to their credits—and now he went looking for "the best available example of a writer of Americana," as he later put it. Miriam Howell, producer Sam Goldwyn's literary agent in New York, made a suggestion: Thornton Wilder.

Fond of casting against type, Hitchcock sometimes tried it with writers too. Wilder was best known for the Pulitzer Prize–winning drama *Our Town,* a panorama of life in a small, bucolic New England town, as viewed by the dead in the local graveyard. Hitchcock, who had seen and admired the play, fired off a one-thousand-word telegram synopsizing "Uncle Charlie," and asking Wilder if he would be interested in writing a Hitchcock film that would be the dark underbelly of *Our Town.*

Despite the apparent folksiness of his work, Wilder was a sophisticated writer with a sure technique rooted in Greek and Roman drama. He had

won his first Pulitzer with the novel *The Bridge of San Luis Rey*, which was later adapted into a film; when *Our Town* was adapted in 1940, Wilder collaborated on the screenplay. When Hitchcock wired him, Wilder had just completed *The Skin of Our Teeth*, destined to become another stage classic.

Wilder had one free month before he was due to join army intelligence. Though he was intrigued by the prospect of writing a Hitchcock film, he complained to his friend, the famous journalist Alexander Woollcott, that the story idea sounded "corny." Yet Wilder also wanted to make some quick money to tide over his mother and sister while he was in the army. His agent requested fifteen thousand dollars for the script, payable in increments for five weeks of work. It was a princely sum, but Wilder was a princely name, and Jack Skirball immediately authorized the contract. On May 18 Wilder boarded a train; three days later he was meeting with Hitchcock, staying at Hollywood's Villa Carlotta and commuting to Universal.

The director and his bard of Americana seemed to find the same wavelength at once. Openings were as important as endings to Hitchcock, and he wasn't sure yet how he wanted to open the film. In McDonell's sketchy version of the story Uncle Charlie isn't introduced until he materializes in the small California town. Hitchcock wanted some kind of prelude that would show Uncle Charlie before his arrival, already frantic and on the run.

Most comfortable with East Coast settings, Wilder proposed an opening sequence showing Uncle Charlie holed up in a New Jersey boardinghouse. The police are shadowing him, and he is pondering his next move. "There's this short story by [Ernest] Hemingway," suggested Wilder, "where a man is lying in bed in the dark, waiting to be killed. That would make a good opening." Hitchcock was taken aback. The great Wilder was a practical craftsman, it turned out—just like him—not above a little pilfering to get the job done. The New Jersey opening would give the film a more national scope. And that is just how *Shadow of a Doubt* would begin, with a tacit nod to Hemingway's well-known story "The Killers."

Hitchcock knew that his style and methods weren't familiar to everyone, so just as he had with Samson Raphaelson, the director screened his earlier work for the writer, showing *Suspicion* and other Hitchcock films to Wilder, "whispering technical procedures in Thornton's ear," according to biographer Gilbert A. Harrison. Mornings were for discussion; in the afternoon Wilder wrote, usually by longhand on notepaper. "He never worked consecutively," said Hitchcock, "but jumped about from one scene to another, according to his fancy."

Sparking off each other, the two made galloping progress. "In long story conferences," Wilder wrote to Woollcott, "we think up new twists

to the plot and gaze at each other in appalled silence: as much to say, 'Do you think an audience can bear it?' "

"Work, work, work," Wilder wrote to his sister on May 26. "But it's really good. For hours Hitchcock and I, with glowing eyes and excited laughter, plot out how the information—the dreadful information—is gradually revealed to the audience and the characters. And I will say I've written some scenes. And that old Wilder poignance about family life [is] going on behind it. There's no satisfaction like giving satisfaction to your employer."

They began by tinkering with young Charlie's family. Gordon Mc-Donell had presented the mother as a "semi-invalid social climber," according to film scholar Bill Krohn in *Hitchcock at Work*, while Uncle Charlie was posited as a kind of "fairy godfather" who brings momentary hope and change to the family's drab existence. Gradually, under Wilder (and later, Sally Benson), the family characters became more positive, more engaging.

Ultimately, the teenage brother would disappear entirely from the script. Instead, young Charlie got a kid sister and an even younger brother—the better for comedy. Hitchcock also decided to eliminate young Charlie's scapegrace boyfriend, "a John Garfield type," according to McDonell. Instead, a police detective would nurse a crush on young Charlie. ("A commercial concession, really," Hitchcock later told Charles Thomas Samuels.)

The Hitchcocks' notes had hinted at an incestuous relationship between the niece and uncle—"her being attracted to him"—creating tension between the mother and daughter. Now, in Hitchcock's work with Wilder, safer "twinship" motifs emerged—like the doppelgängers of German expressionism. Wilder wrote the relationship ("We're like twins," Uncle Charlie tells his niece, "you said so yourself"), while Hitchcock's camera visually linked the two Charlies: introducing Uncle Charlie, lying on his bed, before he flees police and leaves for California; then showing young Charlie posed similarly on her bed, her mood suddenly lifted by the premonition that Uncle Charlie is about to reenter her life.

The script gradually took on the feeling of a dark parable—darker even than *Saboteur*. Uncle Charlie became an American Satan—and another Hitchcock villain who uncharacteristically spoke "on the nose," in his unsettling showdown with young Charlie in a Main Street tavern:

"There's so much you don't know. So much. What do you know, really? You're just an ordinary little girl living in an ordinary little town. You wake up every morning of your life, and you know perfectly well that there's nothing in the world to trouble you. You go through your ordinary little day, and at night you sleep your untroubled, ordinary little sleep, filled with peaceful stupid dreams. And I brought you nightmares . . . or did I? Or was it a silly, inexpert little lie? You're a sleepwalker blind! How

do you know what the world is like? Do you know the world is a foul sty? Do you know if you ripped the fronts off houses, you'd find swine? The world's a hell! What does it matter what happens in it?"

This was Wilder at his best, strengthening a persistent Hitchcock theme: evil might dwell next door in Hitchcock's world, or in one's own household; there really is no sanctuary. Yet the director always stubbornly refused to philosophize, and whenever he was queried about the deeper meaning of *Shadow of a Doubt* (or any of his films), his replies were maddening. "There is moral judgment in the film," Hitchcock said. "He's [Uncle Charlie] destroyed at the end, isn't he? The niece accidentally kills her uncle. What it boils down to is that villains are not all black and heroes are not all white; there are grays everywhere."

On one occasion, interviewed for the *New York Times* in 1951, Hitchcock explained that most of his films, even *Shadow of a Doubt*, were basically chases. "The chase makes up about 60 per cent of the construction of all movie plots," he mused. He added that *Hamlet* could probably be considered a chase, "because Hamlet is a detective."

"Wouldn't *Macbeth* be a chase," the interviewer asked, "Macbeth being the evildoer who is pursued by fate?"

"Well, yes," Hitchcock said, retreating, "but the moment you make fate the pursuer you're getting a little abstract."

By the end of May, Hitchcock and Wilder had thirty promising pages. "Each step is complicated plotting and of course that gets denser and more complex as it goes on," Wilder wrote his sister. "But I like it." They interrupted work, flying north to scout out the town of Santa Rosa. Gordon McDonell had originally situated "Uncle Charlie" in the San Joaquin Valley, but Hitchcock had settled on this place in Sonoma County, about fifty miles north of San Francisco. *Shadow of a Doubt* would become the first of several Hitchcock films set near his northern California home.

Santa Rosa was then a sleepy hamlet, population 13,000, built around a central square. Working at Universal had already afforded Hitchcock a new measure of freedom, and now the war created an unexpected advantage: the U.S. government had placed a ceiling of five thousand dollars on new set-building costs. Making a virtue of necessity, Hitchcock convinced his amiable producer that they could shoot much of *Shadow of a Doubt* on location in Santa Rosa, saving on sets while displaying a picturesque town straight out of Norman Rockwell. Hitchcock was excited, looking forward to "reverting to the 'location shooting' of early movie days," according to Universal publicity.

"Beautiful countryside," he told Hume Cronyn later on. "Miles and miles of vineyards. After the day's work we can romp among the vines, pluck bunches of grapes and squeeze the juice down our throats."

Hitchcock, Wilder, Jack Skirball, and art director Robert Boyle toured Santa Rosa, meeting with city officials and roaming city streets. The local library, the train station, the telegraph office, the American Trust Company bank—all were postcard perfect. Hitchcock stopped in front of a private residence on McDonald Avenue, hailing it as the kind of house where young Charlie and her family would live. (Wilder disagreed, insisting that the large house suggested an income bracket above the station of young Charlie's father, a bank clerk. They checked, and Wilder was right: the house belonged to a physician. But the reality didn't matter to the director, and Hitchcock used the house.)

Researching reality always invigorated Hitchcock. Once back in Hollywood, he and Wilder plotted the remainder of the script with renewed zest.

"My god, I'm not only getting money, but I'm getting pleasure," Wilder wrote at the end of a long day of work, at midnight in mid-June. "Seventy pages of the script went to the typist's today—20 more tomorrow. It only has to be 130. Today and yesterday Hitch and I devised the ending. Honest, I think it'll be an awfully absorbing picture."

But the script wasn't quite finished by the end of Wilder's fifth week in Hollywood, when he had to head back east for army duty. When Wilder left by train on June 24, he was accompanied by Hitchcock and Skirball— the better to squeeze out the final pages. Somewhere between Los Angeles and New York the script was completed—and then Hitchcock did the unimaginable. He told the American dramatist he wasn't completely satisfied with the script, that he wanted another writer to take a pass at it.

The structure of the suspense story was solid, Hitchcock explained, but the characters needed shoring up; they were too quaint. "I feel the script needs a polish," the director told Wilder. "The only way I can describe it is that the Santa Rosa in our story is like a town without neon signs. Its history, its warmth, its people and characters—they're all there. But I would like a tinge of the modern in it, just a little sharper here and there."

Surprisingly, Wilder agreed with Hitchcock. He suggested Robert Ardrey, who had been his playwriting student at the University of Chicago; Ardrey's first screen credit was 1939's *They Knew What They Wanted*, a Carole Lombard–Charles Laughton picture set in the same wine-growing region as *Shadow of a Doubt*. But Hitchcock felt that Ardrey—who later switched to anthropology, writing the groundbreaking books *African Genesis* and *The Territorial Imperative*—was too solemn for the task.

Besides, eager to add humor to the script, the director already had a replacement in mind. After he and Wilder parted ways, he met in New York with Sally Benson, then in the midst of an annus mirabilis. *Junior Miss*, her collection of stories about the foibles of a twelve-year-old girl—and the Broadway play based on her book, which delighted Hitchcock when he saw it—were huge hits in 1941. Her short fiction was highly regarded for

its skilled depiction of youth and its knowing satire; besides adding comedy and modern tinges to *Shadow of a Doubt*, Hitchcock wanted her to add freshness to his family portrait. Benson became the fourth writer from the *New Yorker* (where she also reviewed mysteries and occasional films) to be recruited by Hitchcock.*

At first Benson worked from New York, her pages integrated into the continuity by Mr. and Mrs. Hitchcock. Then, just before the late-summer start of production, she came to California and spent two weeks writing on the set. "The rewrite greatly improved Wilder's very rough draft," according to film scholar Bill Krohn.

Counting Gordon McDonell and both Hitchcocks, five writers worked on *Shadow of a Doubt*. Make that six: up on location, actress Patricia Collinge, who played young Charlie's mother, contributed to her own characterization—removing all traces of the "rather silly woman" of the shooting script, according to Krohn. She also touched up the romantic interlude in the garage between young Charlie and the police detective, which takes place after Uncle Charlie seems to have been cleared.

In the end, only four writers were credited on the screen: McDonell, Benson, Wilder, and Alma Reville. Being rewritten by Sally Benson—or a supporting actress, for that matter—didn't alter Wilder's favorable view of the experience; nor did it detract from Hitchcock's opinion of Wilder. Indeed, the director gave Wilder an unusual citation, which ran in the credits just before Hitchcock's own name: "We wish to acknowledge the contribution of Mr. Thornton Wilder to the preparation of this production."

"[In America] I was turned down by many stars and by writers who looked down their noses at the genre I work in," Hitchcock later explained. "That's why it was so gratifying for me to find out that one of America's most eminent playwrights was willing to work with me and, indeed, that he took the whole thing seriously.

"It was an emotional gesture," Hitchcock said of the unusual credit. "I was touched by his qualities."

Coming off his positive experience with Thornton Wilder, Hitchcock was in an unusually upbeat mood when he lunched with an emissary from Myron Selznick's agency on July 9, shortly before filming began on *Shadow of a Doubt*. Sig Marcus reported back that Hitchcock was "most affable and pleasant." *Saboteur* had already earned 170 percent of its gross, and a check for 10 percent was being processed as a bonus to the

* *Shadow of a Doubt* was Sally Benson's first film job; her later credits would include *Meet Me in St. Louis* and *Anna and the King of Siam*.

director. And now the head of Twentieth Century–Fox, Darryl Zanuck, was knocking on the door, eager to give Hitchcock a studio contract after he completed his Universal obligations.

Zanuck had met with Hitchcock several times since his very first visit to Hollywood, and wouldn't give up on trying to find a niche for the Englishman. The stumbling block was always a matter of the right material—Hitchcock had his pet projects, Zanuck had his—but there also was the dodgier issue of creative control. An intelligent, sometimes courageous producer, Zanuck gave leeway to important directors, but he also kept a firm hand on the creative elements of his studio's product.

Hitchcock was still pining for his *Lodger* remake, but Zanuck, after thinking it over, finally said a firm no. Even this news, delivered by Marcus, couldn't deflate the buoyant director. *Shadow of a Doubt* amounted to a kind of American *Lodger* anyway, and despite the time, money, and emotion he'd invested in the idea of a remake, Hitchcock now announced he was ready to give up his interest in the property. He told Marcus he would be willing to sell his half share of the rights to *any* other producer, and urged him to mention the newly available project to Jack Skirball's partner, Frank Lloyd. But Lloyd only sniffed, "No, thanks, that's not for me—that's something suited to the peculiar talents of Mr. Hitchcock."

The Lodger seemed a lost cause. But Zanuck was bent on bringing Hitchcock to Twentieth Century–Fox.

While back east, before the script or casting for *Shadow of a Doubt* was final, Hitchcock was nonetheless shrewdly looking ahead. His friend Sidney Bernstein was in from London; when they met up (Bernstein finding his old friend "fat as ever"), Hitchcock agreed to travel to London later in 1943 and direct two films for the Ministry of Information.

With certain scenes of *Shadow of a Doubt* already clear in his mind, Hitchcock called in Universal's newsreel division again, leading a crew to Newark, New Jersey, where he shot the opening sequence—though he still didn't know who would play Uncle Charlie, the film's central character. In June he had spoken with William Powell, the comic gentleman whom Hitchcock was still eager to lure into darkness. Powell had always hesitated before, but now Hitchcock's string of successes helped convince him to say yes. However, MGM was feeling protective of Powell's good-guy image, and the studio refused to lend him out, insisting he was all booked up.

As usual, David O. Selznick urged Hitchcock to borrow someone under contract to him. Joan Fontaine would make an appealing young Charlie, DOS said. Hitchcock agreed, and early script treatments even described the niece as a "Fontaine type." By late May, though, the director had

turned his eye to Fontaine's older sister. Over dinner with Olivia de Havilland, Hitchcock regaled the actress with the story, and a hypnotized de Havilland said yes. But she had already signed to start shooting *Princess O'Rourke* for Warner's in midsummer, and wouldn't be available until September. Though he tried several times, Hitchcock never managed to work with de Havilland.

With shooting looming, Hitchcock was still without his Charlies, old or young. So Hitchcock shot the film's Hackensack River backgrounds and other New Jersey setups with Actors' Equity day players. He staged the Hemingway-inspired opening on a residential street, with two detectives staking out the boardinghouse where Uncle Charlie is cornered. Among the footage he captured was a series of high, haunting long shots over empty lots and dark deserted alleys: a bleak urban setting to contrast with the first image of Santa Rosa—an avuncular cop spreading his arms to shelter local citizens who are crossing the street.

To cover all contingencies, Hitchcock shot the sequence, showing Uncle Charlie multiple times, using "three different men: tall, medium and short," as the director later told journalist Charles Higham. "So when Cotten was cast I used the shots with the tall man."

Hitchcock's tall man was Joseph Cotten, the Mercury Theater player whose debut in *Citizen Kane* had made him a household name. (Cotten had just finished his second Orson Welles film, *The Magnificent Ambersons,* which Hitchcock ordered up and watched before release.) A Virginian by birth, Cotten was a new addition to the Selznick stable; he boasted the refinement of William Powell without the latter's permanent air of bemusement. Casting Powell might have given Uncle Charlie a different coloring and a certain shock value, but Cotten was a strong second for the character Wilder had described as in his mid-forties, "very well-dressed," wearing "a red carnation in his buttonhole. His face is set in fatigue and bitterness."

Cotten was eager to work with Hitchcock, but he worried about playing a man "with a most complex philosophy, which advocated the annihilation of rich widows whose greedy ambitions had rewarded their husbands with expensive funerals." He asked for the director's advice. How did the character think and behave? Off they headed to talk about it over lunch at Romanoff's, with Cotten behind the wheel. (Hitchcock was still playing his old I-don't-drive game: "Matter of fact, taught my own wife and my daughter to drive," he told Cotten, "but inside my own private driveway. Whenever I see a policeman, I simply go all to pieces.")

Cotten wondered what would go through the mind of a habitual criminal like Uncle Charlie when he spotted a policeman. Fear? Guilt? "Oh, entirely different thing," answered Hitchcock, warming to the subject, though even in private he was more likely to be flippant than deeply philo-

sophical. "Uncle Charlie feels no guilt at all. To him, the elimination of his widows is a dedication, an important sociological contribution to civilization. Remember, when John Wilkes Booth jumped to the stage in Ford's Theater after firing that fatal shot, he was enormously disappointed not to receive a standing ovation."*

After parking the car, Hitchcock suggested they stroll along Rodeo Drive. He told Cotten to let him know when he spotted a likely murderer. "There's one with the shifty eyes," Cotten said, "he could very well be a murderer." "My dear Watson," Hitchcock countered, "those eyes are not shifty, they've simply been shifted. Shifted to focus upon that pretty leg emerging from a car." With that, the director's glance shifted too, as his camera might in a film, anatomizing his target. "The rest of Claudette Colbert," Cotten noticed, as he wrote in *Vanity Will Get You Somewhere,* followed "the pretty leg to the pavement."

A light went on in Cotten's head. "What you're trying to say is, or rather what I'm saying you're saying, is that a murderer looks and moves just like anyone else."

"Or vice versa," Hitchcock dryly returned. "That completes today's lesson."

They proceeded to Romanoff's, where Hitchcock ordered a steak and the actor an omelette. ("Never ate an egg in my life," Hitchcock deadpanned. Well, he amended himself, "I suppose eggs are in *some* of the things I eat, but I never could face a naked egg.")

As Cotten drove the director home afterward, Hitchcock mentioned—almost as though he had just thought of it—his plan to use a snippet from Franz Lehar's well-known "The Merry Widow Waltz" as a leitmotif in the film. A recurring image of spinning dancers, underscored by this familiar melody, would subtly remind the audience of Uncle Charlie's true nature (the press has dubbed him "the Merry Widow Murderer").

Getting out of the car at St. Cloud Road, Hitchcock offered Cotten one last bit of serious advice. "I think our secret is to achieve an effect of contrapuntal emotion. Forget trying to intellectualize about Uncle Charlie. Just be yourself. Let's say the key to our story is emotive counterpoint; that sounds terribly intellectual. See you on the set, old bean."

The actress finally cast as young Charlie also received a director's pep talk—though of a different sort. Gracious-mannered, soft-spoken Teresa Wright, a Goldwyn contract player, had been nominated for an Oscar for her screen debut as the young daughter in *The Little Foxes.* Just as important, however, may have been understudying Emily in the Broadway pro-

* True crime and history were always among Hitchcock's recreational reading, and famous assassinations, which combined the two, were of high interest. In this case he had obviously been reading *The Man Who Killed Lincoln* (1939), Philip Van Doren Stern's re-creation of the historical event, in which Booth, in his hotel room before the act, imagines "he heard people of the South acclaiming him. . . . No actor in all the world's history ever had such an ovation."

duction of *Our Town;* Thornton Wilder had rhapsodized over her sensitivity as an actress. With Olivia de Havilland out of the running, Wright rose to the fore, and Sam Goldwyn agreed to loan her out to Hitchcock.

When Hitchcock met with Wright in late June, however, he didn't audition or interview her; nor did he analyze the character she would be playing. With actresses he was more likely simply to tell them the story of the film, at great length—watching their reactions and reveling in his audience of one. "To have a master storyteller like Mr. Hitchcock tell you a story is a marvelous experience," Wright said. "He told me everything, including the sounds and the music. When I went to see the film after it was all over, months after it was completed, I watched it and I thought, 'I've seen this film before.' I saw it in his office that day."

The rest of the cast coalesced during July. Up in Santa Rosa, Hitchcock had spotted ten-year-old Edna May Wonacott skipping down the street with her mother. Wonacott had a girlish look: freckles, pigtails, spectacles—a mirror of Hitchcock's own daughter, Pat, at that age. It was probably mere coincidence that Wonacott was the daughter of a local grocer, a distinction she shared with the director, but Hitchcock brought her to Hollywood and tested her, asking her to read aloud and yawn like a bored schoolgirl. She won the part of Wright's bookworm sister, an addition to Gordon McDonell's original family.

Dublin-born Patricia Collinge, who would play young Charlie's mother, was also plucked from *The Little Foxes*—not the last William Wyler film Hitchcock would watch for casting and other inspiration. Collinge was another distinguished lady of the stage, and Hitchcock had followed her career dating back to West End appearances before World War I. *The Little Foxes*, for which Collinge was also Oscar-nominated (in a role she first played on Broadway), had been her screen debut, too.

Inept police were fixtures in Hitchcock films, and Wallace Ford and MacDonald Carey played the two detectives added during script development. (Carey played the one nursing a crush on young Charlie.) Veteran character actor Henry Travers was cast as young Charlie's father, the bank clerk who keeps up a Hitchcockian running conversation with his next-door neighbor about the latest gruesome murder cases, as juicily reported in the newspapers and pulp periodicals.

A *middle-aged* next-door neighbor: not an obvious part for Hume Cronyn, just thirty years old. Canadian by birth, married to the acclaimed English stage actress Jessica Tandy (who played Ophelia to Gielgud's Hamlet, Cordelia to his Lear), Cronyn was destined to become a good friend and part of the director's emerging brain trust in America. Although established on Broadway, Cronyn had not yet made any mark in pictures. But he had already been camera-tested by Hitchcock, and when the director spotted Cronyn at Romanoff's one night, he was reminded of the test.

Cronyn was summoned to meet Hitchcock, who awaited him "with

arms folded, tilted back in his chair," the actor remembered. "He wore a double-breasted blue suit; four fingers of each hand were buried in his armpits, but his thumbs stuck straight up. He weighed close to three hundred pounds and looked remarkably like a genial Buddha."

Hitchcock began by extolling the splendors of northern California. Cronyn knew he was there to talk about a film role, but waited and waited for the director to get around to mentioning it. Finally, after apparently exhausting his spiel, Hitchcock stared out the window for what seemed a very long while, then looked Cronyn over and murmured, "We'll have to mess around with a little makeup—some gray in the hair perhaps—and glasses. We start shooting in about three weeks. Will you stay here or go back to New York?"

Cronyn was in. So was cameraman Joseph Valentine, having passed muster on *Saboteur*. Dimitri Tiomkin, the Russian-born composer, would write the score, though his task was already circumscribed by Hitchcock's choice of a "Merry Widow" theme. For this, the first of his four Hitchcock scores, Tiomkin distorted the familiar melody "into a sinister tone poem much in the style of Maurice Ravel's 'La Valse,' " in the words of film historian George Turner.

On July 30, 1942, less than three months after reading the six-page "Uncle Charlie" synopsis, the Hitchcocks, including fourteen-year-old Pat, headed off to Santa Rosa. Joseph Cotten's wife accompanied the actor to northern California, and author Niven Busch, who had just married Teresa Wright, added to the familial mood with his extended location visit. "There was very much a family feeling," recalled Wright. "When you are on location you are much closer to each other than when you are in the studio, coming from your own home to work. All of that lent itself to the film. A lot depends on things that go on behind the scenes."

Behind the scenes, location work with a family in tow could also breed chaos. On location in Santa Rosa, Hitchcock was vexed by the weather, which played tricks with the light, and by curious crowds, who pursued the Hollywood folk everywhere. (Whenever possible, locals were hired for bit parts and extras.) Hitchcock had to change some day scenes into night; and as in the silent days in London, he sometimes had to work past midnight in order to close down and take control of the streets.

This was the first time the American press streamed to a Hitchcock set, lured by the novelty of the location angle and by interviews with an always quotable director. Universal may have been a lowly studio in some regards, but its publicity department was among the best. Reporters from *Life,* the *New York Times,* and Los Angeles, Chicago, and San Francisco newspapers, and from the screen trade publications, as well as wire-service repre-

sentatives, were all invited to watch. Publicity for *Rebecca,* orchestrated by Selznick International, had lionized the producer and director equally; now Universal focused its publicity on Hitchcock, and the clippings boosted his growing celebrity outside New York and California.

Hitchcock had an impressive ability to compartmentalize—to deliver an entertaining interview to a reporter amidst the tumult, then snap to attention and jump from his chair to zero in on a detail. Outside the controlled conditions of a studio, away from pesky producers—and despite the vicissitudes of location work—Hitchcock was a man often more relaxed and expansive than he could be in Hollywood. On weekend nights in Santa Rosa, he presided over elaborate dinners for a rotating list of guests at the Occidental Hotel, where he and his family were staying. Martinis preceded a menu he specially ordered; the lamb, he directed, had to be pink.

"The martinis, the meal, his immense weight, to say nothing of the day's work, would take their toll until Hitch's chins would rest on his chest and he would start to snore gently," Cronyn recalled. "Alma would reach out her forefinger and, with the gesture of someone lifting the latch on a garden gate, chuck him under the nose. It always seemed to me like a frightful indignity, but Hitch never seemed to mind. He would smile, reach for a toothpick, and with his free hand coyly cover his mouth while picking his teeth. Eventually he would catch the thread of conversation and rejoin us."

After a month on location, cast and crew returned to Universal to shoot interiors, which had been replicated from photographs and Robert Boyle's sketches, on stage 22. The *New York Times* called the sets "quite a phenomenon," with their breakaway walls and several prop dinner tables of different sizes, allowing the camera to exploit unlikely angles in the family scenes. As much as Hitchcock was drawn to locations, he usually saved his greatest Hitchcockery—his pure-cinema highlights—for inside the studio, where the storyboards ruled, and the conditions could be manufactured.

The actors didn't always understand Hitchcock's sleight of hand, at least not during the shooting. Seated at the family dinner table for one scene, Hume Cronyn was supposed to react in surprise at something young Charlie (Teresa Wright) said. Hitchcock told him to rise abruptly—which the actor did, pushing off his chair and stepping back.

"That's all right, Hume," said the director, "but rise and step *in*."

"*Toward* Teresa?"

"Yes, step in and lean forward."

"But she's just said something very offensive."

"I know."

"But . . . yes sir."

Cronyn made the move as directed, he later recalled, "and it felt terri-

ble, completely false." When Hitchcock asked for another take, Cronyn repeated his original movement, stepping back. You've done it wrong again, the director said. "I know," muttered Cronyn, "I'm terribly sorry. It just feels so uncomfortable."

"There's no law that says actors have to be comfortable," purred Hitchcock ominously. "Step back if you like—but then we'll have a comfortable actor without a head."

After Cronyn mastered the move, Hitchcock took the screen novice aside and consoled him. "Come and see the rushes," the director urged. "You'll never know which way you stepped. The camera lies, you know—not always, but sometimes. You have to learn to accommodate it when it does."

Cronyn went to the rushes, and of course Hitchcock was right.

The actors Hitchcock took a special interest in became the sympathetic focus of his most expressive camera work. One day Teresa Wright had a question about the scene where she walks down a flight of stairs wearing a ring taken from one of Uncle Charlie's victims. Preparing to deliver a toast, Uncle Charlie spots the incriminating ring, instantly realizes her implicit threat, and changes his toast: "Just in time—I'm leaving tomorrow!" Wright understood the import of the scene, but couldn't figure out why it was taking so long to prepare the shot. Hitchcock sat down and patiently explained the technical challenges involved in sending a camera speeding into a close-up of her ring as she descends.

The resulting shot was a classic Hitchcock moment, of a kind he repeated, with variations, in countless other films. The director enjoyed the technical challenges of such bravura camera work, but it was also designed to serve the story—in this case, immersing the audience in the tension, guiding them subjectively from "the general to the particular," in the words of screenwriter David Freeman, "the farthest to the nearest."

The "two really spectacular shots" in *Shadow of a Doubt,* in Wright's words, were both created in the studio, and both were designed around her character. One was the scene where she confronts Uncle Charlie with the damning evidence of the ring. The other was a shot of young Charlie at the town library late one night, researching her uncle's crimes. When she reads an article that confirms the terrible truth, the camera pulls back dramatically into an impossibly high crane shot. As young Charlie runs abjectly from the library, the God's-eye view casts pity on her torment and solitude.

Shadow of a Doubt had begun with its focus on Uncle Charlie, but the production gravitated to young Charlie—as the director was drawn to the engaging innocence Wright brought to the role. At the end, at Uncle Charlie's funeral, where young Charlie is consoled by the smitten detective (who has arrived late to the finish, as usual with Hitchcock's police), the

director allowed her a final moving soliloquy about all the good there is in the world—an idealistic statement, rare, perhaps even unique, in a Hitchcock film.

Casting a cloud over the final weeks of filming was news from England: Hitchcock's mother was gravely ill. On September 26, 1942, just as *Shadow of a Doubt* wound down, Emma Hitchcock passed away at the Shamley Green cottage. At her bedside was her firstborn, William, and a physician who recorded her death, at age seventy-nine, from acute pyelonephritis, an abdominal fistula, and an intestinal perforation.

Donald Spoto has hypothesized that young Charlie's mother was named Emma in honor of Hitchcock's mother, and that the character, conceived during her final months of life, was "the last benevolent rendering of a mother figure in Hitchcock's films." He cites the scene where young Charlie's mother shouts into the telephone, evoking Emma Hitchcock's similar "amusing habit," which dated from "early days in Leytonstone."

But shouting into the telephone was common comedy at the time, in British and American films alike. Hitchcock must have known that his mother was failing, and it is possible he shaped Charlie's mother as a kind of tribute. His close friends and relatives insist, however, that he never uttered a harsh word about his mother, neither publicly nor privately. "Hitch *adored* his mother," insisted his longtime assistant Peggy Robertson.

Did Hitchcock really turn against mothers in his films after the death of his own? It certainly is true that Hitchcock later created a number of monstrous mothers. Perhaps Emma Hitchcock's death liberated this side of him; perhaps, as a loving son, he'd avoided any chance of offending her with such characters when she was alive.

But Hitchcock's most notorious monster-mothers—in *Psycho* and *Marnie*—come straight from the books. And at the same time his parade of winning or ultimately sympathetic mothers never really ceased, as *Stage Fright, To Catch a Thief, The Trouble with Harry, The Man Who Knew Too Much, The Wrong Man, North by Northwest,* and *The Birds* attest.

Darryl Zanuck was still pursuing Hitchcock. Although the head of Twentieth Century–Fox was eager to bring the director into his fold, Hitchcock wasn't keen on any of the studio's properties. Nor, immersed as he was in *Shadow of a Doubt,* had he found time to develop new projects of his own.

Another draw on his time was his continuing ambition to host a radio series. In September and October Hitchcock met with representatives of an advertising agency, trying to package a new *Suspense*-style series, with Arch Oboler as writer and producer. Hitchcock met and got along well

with Oboler, one of the wizards of the airwaves. This time, Hitchcock insisted, he himself would emcee (not some actor portraying him); to allay concerns of sponsors and underwriters, he even agreed to submit to a "voice audition."

A pilot program was produced at the Pabst Blue Ribbon Theater in early September, but Hitchcock was still busy shooting *Shadow of a Doubt,* so he could only drop in after hours to observe portions of the taping. An actor stood in for him during the original taping; the director then made his own tape to be spliced into the final recording. Everyone was impressed. "His voice came over well and with a great deal more authority and charm than the actor that was used in the original audition," reported producer Joe Donohoe.

If the series received the go-ahead, Hitchcock would stand to gain an additional $1,500 weekly for use of his name and for his host duties. Yet both Selznicks insisted on their share of the sum, still furious that Jack Skirball had managed to hand-deliver Hitchcock a direct bonus for *Saboteur* without a penny going through Selznick hands. They weren't about to see the same thing happen again with a radio contract.

After *Shadow of a Doubt* wrapped, Dan O'Shea delivered a threat: Selznick International would lay Hitchcock off for twelve weeks unless he took Zanuck's offer to come to Twentieth Century–Fox. That ultimatum, plus the fact that Zanuck had vacated the studio to make government war films, finally persuaded Hitchcock. He took a one-picture deal with Twentieth Century–Fox—with a second-picture option—that put the kibosh on the radio series.

On November 19, 1942, Hitchcock moved from Universal to his new offices at Twentieth Century–Fox. Nobody knew when Zanuck was expected back. After lobbying for an appointment as a colonel in the Signal Corps, the producer had been posted to Gibraltar, where he was waiting to fly to Algiers for the Allied invasion of North Africa. William Goetz had been left temporarily in charge of production, and he immediately placed Hitchcock under the aegis of staff producer Kenneth MacGowan. And now, with Zanuck gone, Hitchcock was primed to act.

It was some time during the spring of 1942 that Hitchcock first had the idea for a "lifeboat film," which would take up where the sea-ditching climax of *Foreign Correspondent* had left off. If he would never get the chance to make a film about the vast scope of life in a great metropolis, or one day in a park from dusk to dawn, or a doomed ocean liner carrying a cross-section of humanity, at least he could study a small group in a lifeboat: the world adrift, in microcosm.

That spring newspapers and magazines were filled with articles about

lifeboat rescues. Production designer Robert Boyle recalled Hitchcock brandishing one such clipping during the making of *Shadow of a Doubt,* and teasing him with the idea: "It's a small space, like a closet, isn't it?" Cramped spaces were a visual and technical challenge, and while crossing the Atlantic by boat and plane he had often thought about the fate of people stranded at sea.

He had mentioned the lifeboat idea to Jack Skirball before they settled on "Uncle Charlie." Skirball wasn't enthusiastic; he thought the subject fell outside the director's customary forte, and anticipated (correctly) that it would require prolonged scriptwork.* Hitchcock also tried the idea on David O. Selznick, but the producer wouldn't nibble. He deliberately hadn't mentioned the idea to Zanuck, but on his first day at the new studio he had it on the tip of his tongue for William Goetz. He pitched a story concerning a handful of survivors of a torpedoed freighter. *Lifeboat,* as Hitchcock was already calling the proposed film, would be "laid entirely in and around" the boat, with the most provocative notion being that "to provide dramatic action and suspense, the last person picked up should be the captain of the German U-boat that had sunk the vessel to which the lifeboat and its people belonged," according to MacGowan.

On that first day at Twentieth Century–Fox, Hitchcock made it clear that *Lifeboat* would be an allegorical story. It would be shaped by his love-hate relationship with the German nation. As a young man in London he had been deeply affected by Germany's role as aggressor in World War I; then early in his career, he had found surprising happiness in Berlin and Munich, working for Ufa and Emelka. He had been vitally influenced by German expressionism. And now, the world was experiencing the horrors of Hitler. The German U-boat captain of the story would represent the Germany of yesterday and tomorrow, Hitchcock told William Goetz: both a leader and a traitor of humanity.

Within half an hour of speaking to Goetz, Hitchcock was turned over to MacGowan, with Goetz's endorsement. Harvard-educated, a onetime drama critic, MacGowan had been Eugene O'Neill's partner at the famed Provincetown Playhouse in the 1920s. In Hollywood since 1932, he had supervised noteworthy pictures by Rouben Mamoulian, Fritz Lang, and John Ford. A producer with artistic ambitions, MacGowan liked Hitchcock and identified with his aspirations. At one of their first meetings the two fell to discussing the Swiss painter Paul Klee, whom they both revered.

* During the making of *Shadow of a Doubt,* Skirball split up with his partner, Frank Lloyd, and moved over to United Artists. He and the Hitchcocks stayed friendly, and Alma subsequently made one of her rare script contributions to an American picture that her husband didn't direct—*It's in the Bag,* a Fred Allen comedy produced by Skirball for United Artists in 1945.

One of Hollywood's noted art collectors, MacGowan would go on to help Hitchcock build his growing art collection, including abstracts by Klee.

Having started out in Hollywood as a story editor, MacGowan was also helpful in devising the story's initial characters and situations in collaboration with Mr. and Mrs. Hitchcock—the latter working "on a voluntary basis in these preliminary stages," in MacGowan's words. As Alma herself later recalled for the studio legal department, these first conferences among the latest three Hitchcocks were "general in nature, tossing the story idea around between us, and discussions as to possible writers, the development of characters—the same kind of conversations we have had for years about every story in which Mr. Hitchcock was interested."

The lifeboat project was leaked to columnists before Christmas; it was described then as the story of the passengers of a merchant marine ship, sunk by a Nazi submarine, who are "thrown into the ocean at the same time with a single life boat between them." This led to a letter from a merchant marine official, offering to assist the project, and to mistaken reports in later accounts of how *Lifeboat* originated with the merchant marine. Taking up the cue, however, Hitchcock called on the merchant marine for research and authenticity, and his office began to fill up with accounts of ship disasters and rescues.

Before Christmas the lifeboat passengers were only tentatively described, but they already included two ship's officers, a Canadian nurse, and, significantly, a "moderately well-to-do woman with her maid"—the former a character intended as a starring part for a name actress—and the enemy captain rescued after his German submarine explodes.

After the initial brainstorming, who should write the script? At first Hitchcock thought of James Hilton or A. J. Cronin. But then, fresh from his happy collaboration with Thornton Wilder, he thought of another leading American author: Ernest Hemingway. MacGowan had a long acquaintance with Hemingway, whom the studios were always trying to woo to Hollywood. The producer authorized an offer that would meet any conditions ("WITHIN REASON") stipulated by the author of *The Sun Also Rises* and *For Whom the Bell Tolls*.

Late in December, MacGowan and Hitchcock sent Hemingway a lengthy cable at his winter home in Finca Vigia, Cuba, inviting him to write "A DRAMATIC NARRATIVE" of the lifeboat idea. The cable made it clear: "THE WHOLE STORY TAKES PLACE IN THE LIFEBOAT WITH THE CONFLICT OF PERSONALITIES, THE DISINTEGRATION OF SOCIAL INEQUALITIES THE DOMINANCE OF THE NAZI ETC." Hemingway could name his price, and work from Cuba if he pleased. Hitchcock would be glad to meet with him at intervals in Miami. Whatever Hemingway wrote, MacGowan and Hitchcock felt certain, would be valuable; and, however much they used or discarded, Twentieth Century–Fox could look forward to exploiting the Hemingway name in advertising.

* * *

Christmas was celebrated in a new home: "a snug little colonial," in Alma's words, the director's forty-third-birthday gift to his wife. The Hitchcocks had begun looking for a house of their own after Alma grew dissatisfied with what she considered the steep terms of their lease on the Carole Lombard place. More prudent financially than her husband, she had tried to get the owner to lower the monthly rate, and when that failed, Mrs. Hitchcock started house hunting. After a while she managed to find a house she liked: a story and a half, with painted white brick and gray-brown shingles, paned windows, and a porch and patio, just across from the Bel Air Country Club golf course. When Alma showed it to her husband he gave her a practiced look of indifference. But on location for *Shadow of a Doubt,* where they jointly celebrated their birthdays, Hitchcock gave his wife a new handbag; inside was a gold key to the front door of 10957 Bellagio Road.

The forty-thousand-dollar purchase price was secured by Hitchcock's bonus for *Saboteur,* and by the money he received for finally selling his share of the rights to *The Lodger.* In the end Hitchcock was bought out by his partner, Myron Selznick, who then turned around and sold the book to a studio that had all along resisted the property—Twentieth Century–Fox. (Briefly a candidate for Hitchcock's second film at the studio, *The Lodger* was ultimately remade by director John Brahm, with a cast that included Merle Oberon, George Sanders, Cedric Hardwicke, and Laird Cregar. Hitchcock was not credited in any capacity.)*

The first week of 1943 brought unexpected sad news. Hitchcock's older brother, William, died on January 4, following his mother to the grave by less than six months. William Hitchcock's death, at age fifty-two, came at his home in Guildford. The coroner's report attributed his passing to "congestive cardiac failure, probably contributed to by the taking of paraldehyde, thus aggravating the cardiac failure and precipitating death." (Paraldehyde was a nervous system depressant used as a sedative, and given to alcoholics to induce calm or sleep.) Based on an interpretation of the coroner's report, biographer Donald Spoto calls the death an "apparent suicide"; moreover, because Hitchcock was absent from his mother's and brother's deathbeds, he asserts that "some of the filmmaker's associates felt there was nagging and gnawing guilt festering" in his soul. Yet surviving family members say that Hitchcock's brother was a heavy, melancholic drinker who mixed alcohol and pills, dying accidentally as a result.

* "I saw it at Fox," Hitchcock later told *Psycho* author Robert Bloch, "and they remade it so crudely . . . no suggestion in it . . . it was all just laid on the nose."

When John Russell Taylor wrote his authorized biography of Hitch-cock, the director asked for only two minor but revealing changes in the text. The first dealt with his personal acquaintance with convicted mur-deress Edith Thompson; the second concerned his brother's drinking. When Taylor wrote that William's death was hastened by alcoholism, Hitchcock asked him to take it out. "Do you really need that?" he asked gently. He didn't see why William's memory should be besmirched. The reference was deleted.

One repercussion from William's death was Hitchcock's suddenly vehe-ment determination to curtail his own eating and drinking. He had begun watching his calories, but cheated whenever he felt like it. One day, how-ever, Hitchcock fell on his arm while running to catch a train, and he was shocked by the tremendous pain caused by his own massive weight crash-ing down on him. Hitchcock also told interviewers that he had received a jolt of a different kind one day in Santa Rosa filming *Shadow of a Doubt,* when he glanced at his reflection in a shop window, and saw a grotesquely swollen man staring back at him.

He hovered around three hundred pounds. His back ached constantly. Now his physician, Dr. Ralph Tandowsky, a nationally recognized au-thority on cardiology and cardiovascular disease and a pioneer in the di-agnosis of heart problems, joined Mrs. Hitchcock in imploring the director to stop cheating, and to take his diet seriously.

So for 1943, Hitchcock made a New Year's resolution: From now on, he would eat and drink sensibly. He liked to tell interviewers that his weight-loss diet consisted of only a cup of coffee for breakfast and lunch, and a steak and salad for dinner. It wasn't always that ascetic, but his re-solve to lose one hundred pounds in record time was proof of tremendous willpower, and he swiftly lost enough to unveil the new "thin" Hitchcock for *Lifeboat.* How would the director contrive to squeeze his expected cameo into a film set entirely at sea, in a lifeboat? Even Hitchcock was stumped for a while, until the solution dawned on him. He would immor-talize his profile in a before-and-after newspaper advertisement for the Reduco Obesity Slayer corset. "My favorite role," he crowed to François Truffaut.

January was also the month that *Shadow of a Doubt* premiered in the-aters. The new Hitchcock film was seen by most critics, at the time, as a modest crime thriller. Bosley Crowther in the *New York Times* found it ex-citing, but also specious and bathetic. In England the director's reputation had predictably declined, with a general feeling among critics that Holly-wood had not only robbed England of Hitchcock, but Hitchcock of his in-dividuality. His "cinematic construction has had to be subordinated to

pseudo-romantic conflicts involving the highlighting of principal players," wrote Paul Rotha. When *Shadow of a Doubt* was shown in London, it didn't impress Hitchcock's old friend C. A. Lejeune of the *London Observer,* who subscribed to the general English disparagement of his Hollywood work.

Lejeune's review, unflatteringly headlined "Stout Fellow," compared Hitchcock to another sometimes overweight director, Orson Welles. "The overlapping dialogue, unrelated conversation carried on between several people at one time, is common to both directors. So is the tendency to shoot a scene from the ceiling, the cellars, or the plumbing. So is the presence of Joseph Cotten in the leading role." Lejeune charged Hitchcock with settling for the constraints of "run for cover" crime films—and claimed that, unlike Welles, he had "conspicuously failed" at everything else. "Statisticians who are interested in the relations between avoirdupois and the study of crime," Lejeune sniffed, "may care to observe that the falling curve of his waistcoat has been followed by a corresponding fall in the curve of his films."

Since 1943, however, *Shadow of a Doubt* has grown and keeps growing in critical esteem. Eric Rohmer and Claude Chabrol, in their pioneering 1957 appraisal of the director's oeuvre, called the film brilliant, ascribing its few defects to its caricatured secondary characters (ironically, these were mainly of Hitchcock's own devise). In *The Murderous Gaze* William Rothman found some of the dialogue worthy of Samuel Beckett. Even *Sight and Sound*'s Lindsay Anderson, who like other English critics embraced little of what Hitchcock did after he left home, called it the director's "best Hollywood film."

Hitchcock maintained his own inner compass. In interviews he did little to help critics distinguish between his best and worst, any more than he might expound on the hidden meaning (if any) of his films. He liked to call *Shadow of a Doubt* a "most satisfying picture"; more than once, he called it his favorite. But "favorite" wasn't quite the same as best; and, speaking for posterity, he pointedly told François Truffaut it *wasn't* his favorite, and told Peter Bogdanovich it was merely "*one* of his favorites."

Among his best it certainly was, and is. But equally important to Hitchcock were the fond memories he had of making *Shadow of a Doubt.* He had a productive collaboration with Thornton Wilder, and began long friendships with Hume Cronyn and Joseph Cotten. Working on location, he had made a film with more independence than he had yet managed in Hollywood. As physically unfit as he was at the time, Hitchcock was in prime creative condition. Making *Shadow of a Doubt* was a proud memory that never dimmed.

* * *

Drubbed by some critics for losing his artistry in a layer of "fat," Hitchcock was busy thinning—and launching a film no one could dismiss as a run-for-cover proposition. Any hopes that Ernest Hemingway might write *Lifeboat,* however, were dashed by a cable the writer sent Kenneth MacGowan in early January, saying that other work precluded his involvement. "THANK HITCHCOCK FOR ASKING ME STOP PERHAPS WE CAN WORK TOGETHER ANOTHER TIME BEST REGARDS."

Hitchcock immediately began casting in other directions. John Steinbeck, at that time ranked as Hemingway's peer among American novelists, was suggested by Nunnally Johnson, who had adapted Steinbeck's Pulitzer Prize–winning *The Grapes of Wrath* into an Oscar-nominated Best Picture for Twentieth Century–Fox in 1939. Though he lived much of the time in northern California, near his hometown of Salinas, Steinbeck was between books, and leasing a house in Hollywood. He knew the sea, owned a ketch, and spent time sailing and fishing; he'd also just finished a novel for 1942 that explored similar terrain to what Hitchcock had in mind. The story of a prototypical European small town invaded by a fascist force, *The Moon Is Down* was another cautionary wartime allegory.

Like Hemingway, Steinbeck had never written expressly for Hollywood, but his name was golden at Twentieth Century–Fox, where he visited to meet with MacGowan and Hitchcock. Their first two-hour meeting took place in MacGowan's office.* Hitchcock briefly outlined the lifeboat story, and Steinbeck said he liked the idea. The author offered to launch a prose treatment over the coming weekend; he would write a few pages, and destroy them if he was dissatisfied with what he wrote. If the writing clicked for him, he would accept the assignment and write the treatment as a short story.

Over the weekend, as it happened, Steinbeck turned out "quite a number of pages," according to MacGowan's recollection—and then kept writing until the short story evolved into what he called a "novelette." His contract would eventually stipulate two hundred pages of manuscript, with a clause that reserved Steinbeck's right to publish the eventual novelette as a Steinbeck book. That was fine with MacGowan and Hitchcock, who thought a Steinbeck book tied into the picture would make great publicity.

As Steinbeck raced ahead of the contract, though, he was also racing ahead of Hitchcock. He met with Hitchcock and MacGowan only once more; all Steinbeck could recall about that second meeting, when deposed later by

* The studio legal department, trying later to reconstruct the sequence of events, was never able to pinpoint the date of the first meeting among Steinbeck, MacGowan, and Hitchcock, but decided it must have taken place between Wednesday, January 6, and Tuesday, January 12, 1943.

lawyers, was that Hitchcock "was interested in dramatic incident and technique, and most of his suggestions had to do with that," in his words.

Steinbeck recalled only one specific suggestion that Hitchcock made: The well-to-do female passenger in the lifeboat—the lead character Hitchcock had envisioned from the beginning—ought to be wearing a diamond ring, the director said, which the other boat passengers are forced to use as a fishing lure. That was the director's "usual irony of using a fabulous thing" as a physical detail, Steinbeck said. MacGowan recalled Hitchcock also stressing that the German in the lifeboat should deceive and betray the other survivors. But the director was diplomatic, saying Steinbeck should think his suggestions over.

Remarkably, by the second week of January—still with no signed contract—Steinbeck had churned out more than one hundred triple-spaced pages. Reporting to Hitchcock, he announced that he had elected to tell the story through the eyes of a single character—an ordinary seaman. "My reason for using this method is to focus the film through a human eye, a single human eye and a human brain which is as nearly the camera eye as anything we imagine," Steinbeck explained. The author said he wasn't trying to write "stock characters" but "on the other hand I haven't the slightest intention of going out of my way to make them unusual." Steinbeck recommended unfolding the entire story in flashback, and using hallucinatory effects to show the progress of starvation. "The overtone of the whole story will be misty, almost dreamlike—actually a memory pattern, as will be described in the beginning of the story of the film," said Steinbeck.

One ordinary seaman's subjectivity, a life-and-death drama recounted wholly in flashback, hallucinatory sequences: it wasn't quite what the director had in mind, but it could work. Hitchcock didn't panic. Anything Steinbeck wrote was bound to be workable.

After completing most of the first draft of his novelette, Steinbeck headed for New York, where he was preparing to travel overseas as a war correspondent for the *New York Herald Tribune*. Mr. and Mrs. Hitchcock followed him there on January 14, convening two weeks of script conferences and revisions. The Hitchcocks stayed at the St. Regis, Steinbeck at the nearby Beekman Tower. Although Hitchcock and Steinbeck spent a concerted amount of time together—joining Alma for lunch at "21"—their meetings were hampered by the fact that Steinbeck already considered the bulk of his job done.

In Steinbeck's "dramatic narrative," Willie, the German rescued and squeezed into the lifeboat, was the story's pivotal figure, as Hitchcock had wanted. But Steinbeck left it unclear whether or not Willie was a Nazi, whether or not he was an officer of the submarine that torpedoed the ship. Steinbeck's Willie was an enigma, his true nature an issue raised but never resolved by the author. The other passengers can't communicate with him,

for he doesn't even speak English. Where Hitchcock had envisioned a story that hinged on concrete deceit and betrayal, Steinbeck offered only a general atmosphere of distrust and paranoia.

As intriguing as this might be, it wasn't what Hitchcock wanted. But asking Steinbeck to change Willie's characterization was problematic: Steinbeck had no time for a wholesale rewrite, and besides, he was confident of what he had written. One thing Hitchcock asked for was a new crescendo—not the relatively benign conclusion of the novelette, but a culminating episode of "dramatic violence" of some sort. "Whether his suggestion or mine, I don't know," recalled Steinbeck later for lawyers; "we agreed to put in the ending of the destroyer and the German ship which hadn't been in my original idea. I had wanted to end by having the boat picked up."

Later, when *Lifeboat* stirred up controversy, Steinbeck would complain that Hitchcock was "one of those incredible English middle-class snobs who really and truly despise working people." But his animus seems to have been inspired less by Hitchcock himself than by resentment over the substantive changes Hitchcock made to his version of the lifeboat story. The two men may not have cozied up the way Hitchcock and Wilder had, but they got along professionally, and spent very little actual time together.

By the time he returned to California, however, Hitchcock realized that *Lifeboat* needed a fresh writer, one with a better understanding of his kind of storytelling. Even before Steinbeck had finished the revisions to his novelette, Hitchcock was meeting with MacKinlay Kantor, an acclaimed author of short stories and novels about America in wartime (his novel in free verse *Glory for Me* would become the basis of *The Best Years of Our Lives*, and he'd win a Pulitzer Prize for *Andersonville*). As a kind of audition, Hitchcock asked Kantor to work with Alma on devising the opening scenes of *Lifeboat*.

Mrs. Hitchcock, who returned to the project on salary, and Kantor then drafted an opening set in a movie theater, featuring a sailor and his girlfriend on their last date before he ships out to sea—one of Hitchcock's Chinese-box conceits, reminding audiences they were watching a piece of fiction. This segued into a seaboard sequence introducing the other characters just before the ship is sunk by a German torpedo. But Hitchcock didn't feel a connection with Kantor; "I didn't care for what he had written at all," he recalled. Kantor was dismissed inside of two weeks.

That was toward the end of February 1943, almost simultaneous with Steinbeck's submission of the revised novelette. By March 1, Steinbeck was done with *Lifeboat*. Yet in the credits Steinbeck alone was listed for the film's "Original Story"; he was even nominated for an Oscar, and his contribution has been routinely praised ever since.

In fact, Steinbeck's contribution to *Lifeboat* was like that of dozens of other Hitchcock writers over the years, whose official credits simplified a

complicated collaborative process. His case has engendered decades of misunderstanding. Articles in the *Steinbeck Quarterly* have argued that Steinbeck was principally responsible for the "allegory of a world decimated by global warfare," and that his original story was profoundly ironic and broadly humanitarian, while the eventual Hitchcock film was "suspensefully dramatic but morally empty." *Literature/Film Quarterly* has also contributed to the prevailing impression that Steinbeck wrote a "more realistic, meditative" story, compared to the "clichés, stereotypes and simplistics" of the Hitchcock version.

"Actually, Hitchcock's idea was to do a movie on the merchant marine," Jackson J. Benson wrote in *The True Adventures of John Steinbeck, Writer*. "It was Steinbeck, long before he was brought into the project, who had the lifeboat idea, and it was he who wrote the original screenplay. His work was then doctored to make it slicker and less allegorical."

But incontrovertible evidence buried since the 1940s in studio and legal files proves these claims to be false. It's true that Steinbeck did augment and amplify Hitchcock's story in his novelette. But what he wrote, besides having a point of view that was introspective and uncinematic, was hardly up to his own best standards. Even his own agent and editor, Annie Laurie Williams and Pat Covici, regarded the novelette as "very inferior Steinbeck, however good it might be for pictures," in the words of one Twentieth Century–Fox memo. Indeed, it was Williams and Covici, not the studio, who successfully pressured Steinbeck *not* to publish the novelette. Chagrined by Steinbeck's decision, the studio offered a bogus magazine version co-bylined by Hitchcock and a studio publicist.

There was a false start with another writer (who made at least one suggestion Hitchcock incorporated, changing the wealthy woman's ring into a Cartier diamond bracelet) before *Lifeboat* was inherited by one of Hollywood's finest stooges.

Jo Swerling was a cigar-chomping ex-newspaperman and playwright from New York, lured to Hollywood in 1929 to help cope with talkies. He wrote notable films for Frank Borzage, Rouben Mamoulian, William Wyler, and John Ford, and was a regular scenarist—frequently in combination with Robert Riskin—for Frank Capra. (The finishing writer on *It's a Wonderful Life* was Swerling.) Although unknown to the general public (especially compared to John Steinbeck), Swerling was regarded inside the industry as the consummate pro, a self-effacing and companionable expert at comedy and drama.

Swerling shook hands with Hitchcock for the first time in the office of Kenneth MacGowan, who had recommended him as the best available man under contract. Swerling never met or spoke with Steinbeck. Later, when there was a lawsuit against the film by a third party alleging plagia-

rism against Hitchcock and *Lifeboat,* Swerling recounted in a deposition how little he valued Steinbeck's novelette.

"I read the [Steinbeck] script," recollected Swerling, "and decided that I would take the assignment only with the consideration that I would not have to follow the script, the reason being that Steinbeck had written it entirely from the point of view of the mental reaction of an individual, which would be exceedingly difficult to dramatize with a camera. And there were other elements in the lineup that I did not like. Thereupon it was agreed that we would start from scratch, using the basic idea. After the first reading that I gave to the Steinbeck story, I never again referred to it, nor did anybody else working on the picture."

Asked how a writer of Steinbeck's stature could have failed to produce a satisfactory script, Swerling explained, "The industry could give you thousands of examples of an original idea being given to first-rate writers, men of national reputation, who thereupon, to use a vulgar term, 'bitched' them, and which ideas were subsequently handed to professional screen writers, without national reputations, who thereupon made acceptable screen plays out of them."

At times, in his deposition, Swerling made deprecating comments about the Steinbeck novelette which, he hastened to add, were "not for publication." Steinbeck hadn't really shirked the task, Swerling insisted. He had done precisely what he had been paid to do. His name was an asset to the film, and the studio wanted to preserve it as an asset.

Swerling didn't claim the final script he turned in was particularly original, or brilliant. "The formula of *Lifeboat* is a standard formula," he cheerfully admitted. "Sometimes the people are segregated on a desert island, as in the case of *The Admirable Crichton.* Sometimes they are in a hotel, as in the case of *Grand Hotel.* Sometimes they are in a doomed submarine. The locale changes, but the principle is the same. The principle is that you get a group of people in the environment which forces them to be together.

"We claim no originality, and I imagine that Hitchcock would claim no originality in the conception of the idea itself, excepting insofar as it related in this particular example to the War."

What message, lawyers asked Swerling, was the average moviegoer supposed to derive from *Lifeboat?*

"He was supposed to say to himself, 'Beware of the Nazis bearing gifts,' " replied Swerling. "After the War, when you meet these people, remember that they are likely to turn right around and do the same thing over again."

The best thing about *Lifeboat,* Swerling stated—and the only really original thing about the film—was the Hitchcockian theme of "the world in minuscule—something that Steinbeck completely fell down on." That

was an idea the director had touted, Swerling said, from the first moment they met.

Indeed, the true author of *Lifeboat* wasn't Steinbeck, Swerling insisted in his deposition—but neither was it Swerling himself. Every character, every dramatic incident, scene after scene, was largely or "entirely" Hitchcock's. "Every move in the story basically was Hitchcock's move," Swerling said, "In other words, I would say that Hitchcock was entitled to the credit 'Original Story by Alfred Hitchcock,' provided he had chosen to make a claim to it."

Not once in Hollywood did Hitchcock take screen credit for a story or script. Indeed, he bent over backward to exclude himself in favor of all other eligible writers, with the interesting exceptions of *Strangers on a Train* and the remake of *The Man Who Knew Too Much*. Any of his scenarists would have understood his taking a cocredit; one way or another, he picked the stories, guided the script meetings, articulated the characters, visualized the key situations, and edited the drafts. When absolutely necessary, he even wrote dialogue. Paradoxically, it was his modesty as a writer, and his generosity with credits, that opened the door for complaints from writers who felt his very silence on the subject was a way of stealing their thunder.

Both Hitchcocks were humble about their writing, and throughout the late spring and early summer of 1943 Alma Reville rejoined the project, attending meetings with Hitchcock, Jo Swerling, and producer Kenneth MacGowan to hash out the final script.

Since Hitchcock wasn't keen on MacKinlay Kantor's material, and as Steinbeck's novelette unfolded entirely in flashback, the team started over on the film's opening scene. While toying with different openings, Hitchcock made a point of seeing the new Warner Bros. war drama *Action in the North Atlantic,* and the morning after the preview announced that *Lifeboat* had to avoid any obvious similarities by starting its story immediately *after* the explosion, introducing the individual characters as they clamber aboard the lifeboat. "This saved the company $150,000, and made a much better opening," recalled Swerling.

Steinbeck's "dramatic narrative" was actually an interior monologue, devoid of real action or conflict—which was surprisingly undramatic. The author himself admitted to lawyers that Hitchcock carried over only one specific dramatic incident of his from the novelette—the plight of the drowned baby and despondent mother, which crops up early in the film.

Revamping the characters, Hitchcock improved on their personalities and relationships, tying them closer to the drama. Steinbeck's "ordinary seaman" Bud, who had narrated the novelette in a "dese, dem, and dose" vernacular,

now became Kovac, and the script abandoned his point of view, making him a secondary character. Hitchcock returned the film's focus to the characters who intrigued him the most: the well-to-do Connie Porter, and Willie the German.

Though Kovac became less of a proletarian, he also became, arguably, less cardboard. "Practically a Communist," in Hitchcock's words, Kovac in the film becomes a more nuanced symbol of lumpen *politique* whose conflict with Rittenhouse is depicted as a miniparable of management versus labor. And Steinbeck had presented Rittenhouse, blandly, as the owner of an airplane factory; the film made him a gleeful capitalist with leadership qualities—"more or less a Fascist," Hitchcock told François Truffaut. It is Rittenhouse who presciently anticipates a boom after the war and forecasts China as an expanding market, and Rittenhouse who is friendliest with Willie.

Steinbeck had woven "very little love interest" into his novelette, as the author himself conceded to lawyers, and no hint of any budding romance between Kovac and Connie Porter. Yet in the film their animal desire for each other is a key component of the tension. ("Dying together's even more personal than living together," Kovac declares, grabbing Connie Porter and kissing her when it looks as though the lifeboat is about to sink.)

Porter had been described by Steinbeck as a onetime stage actress ("kind of pretty when she's fixed up") who got elected to Congress on an antilabor Republican platform. This was too on the nose for Hitchcock, who had his leading lady in mind before Steinbeck's name was ever mentioned. So now he, Alma, and Jo Swerling remade Connie Porter into a flamboyant newspaper correspondent, a Dorothy Thompson type, worldly and cynical.

The German in the lifeboat had been Hitchcock's conception from the first. He wanted Willie to be an über-German, fluent in English, and—the most inspired twist—the smartest, strongest person in the boat. Hitchcock's Willie conceals a flask of water and a compass (all details that were added by Hitchcock, Steinbeck told lawyers). He's also a doctor, and saves the seaman Gus's life by crudely amputating his leg, a Hitchcockian scene that juggled comedy and tragedy. Then the German takes over, rowing the boat toward the enemy as the other passengers lose their strength and wits under the blazing sun. When a dazed Gus spies Willie sipping water, Willie throws overboard the man whose life he has saved, drowning him. This, the most Hitchcockian scene in the film, was absent from the novelette.

There was no such Willie in Steinbeck's narrative, nor was there any Gus. There was a character who metamorphosed *into* Gus, but "nobody like him, really," Steinbeck admitted to lawyers. These were all Hitchcock's characters, fleshed out by Swerling. Steinbeck told lawyers he *detested* Hitchcock's version of Willie.

Later, during his own deposition for the plagiarism lawsuit, Hitchcock

was obliged to answer a series of questions to establish the origins of the film's characters, scenes, main incidents, and ideas. His answers establish how precisely he kept track of the tangled authorship of one of his typically tangled scripts—and how, privately, he viewed his own contribution.

Who, the attorneys asked, thought of the character of the Nazi captain?

"I did."

"The character of the colored man."

"John Steinbeck."

"The incident of the colored man conducting the burial at sea."

"As far as my recollection goes, it was MacKinlay Kantor."

"The character of Gus Smith, the sailor."

"I think Jo Swerling."

"The incident of the amputation of Gus Smith's leg and his thirst for drinking salt water."

"Jo Swerling."

"The characters of the crazy woman and her baby."

"I would say Steinbeck."

"The activities of the crazy woman with her baby in the lifeboat."

"I would say Steinbeck."

"The idea of the Nazi captain having a compass concealed on his person."

"Myself, in conjunction with Swerling."

"The idea of the Nazi captain being pushed off the lifeboat."

"To my recollection, Steinbeck and Swerling."

"The idea of the Nazi captain being beaten to death with the shoe from the foot of the amputated leg."

"Myself."

"The character of Connie Porter."

"Steinbeck and Swerling."

"The incident of fishing with a diamond bracelet as bait."

"I do not remember."*

"The incident of the colored man playing the flute."

"Steinbeck."

"The incident of Kovac taking charge of the boat, directing its course and the rejection of the Nazi captain for this job."

"I do not recall. That was in conference with many people."

"The idea of constructing a tattered sail for the lifeboat."

"I do not recall."

"The character of Rittenhouse, the wealthy man, and his activities in the lifeboat."

* But he did remember: Elsewhere, Hitchcock went off the record about the diamond bracelet to explain that the idea had come from a writer who worked very briefly with him, but who wouldn't agree to a contract. Since that was the writer's only contribution to survive in the final film, Hitchcock said, he preferred not to mention his name.

"Steinbeck and Swerling and myself."

Even in private, fighting a charge that he'd misappropriated another's work, Hitchcock took few pains to claim authorship; like Swerling, he also made no claims to originality.

"There were [many] survivor stories, and survivor books published in the newspapers and magazines," Hitchcock told the lawyers matter-of-factly. "In other words, it [the film] wasn't the most unique idea."

Fishing with a shiny bracelet for bait? "Read any kind of lifeboat story," Hitchcock advised the lawyers. "They all try to fish. . . . no originality in that at all."*

That business in the film about Gus trying to drink salt water? "That's in the Bible," his attorney interjected. "I would say in roughly 3,782 lifeboat narrations," Hitchcock remarked.

Some writers have contended, absurdly, that Hitchcock fretted about Steinbeck's "political baggage" (the author sided with progressive causes). If they had any political quarrels, they were over speechifying, which bored the director in private and on-screen. Jo Swerling was as liberal as Steinbeck, if not more so. Under Hitchcock, the film became less pedantic; the labor versus capital motifs were strengthened (Connie Porter sarcastically dubs Kovac "Tovarich," and reminds him of his responsibility to the Comintern); the references to fascism and the political prisoners were introduced ("Some of my best friends are in concentration camps"); and in the end the film leaned further left politically than Steinbeck's novelette.

Swerling finished by late July. Then Hitchcock reviewed the shooting script one last time with MacGowan, pushing back the start date as cuts and improvements were made.

From his very first meeting with Kenneth MacGowan, Hitchcock knew whom he wanted for his leading lady. To play the flamboyant reporter, who somehow materializes in the lifeboat looking like she has stepped out of a fashion layout—mink coat, jewel case, portable typewriter, and Brownie 16 mm camera intact—he wanted a living legend. He was only passingly acquainted with Tallulah Bankhead, who had taken London by storm in 1923 when she appeared in *The Dancers*, a play by Gerald du Maurier and Viola Tree; of course, he had admired her in the stage production of *Blackmail*, too. (He had even slipped a compliment to her into *Murder!*, when a character praises another actress as "pure Tallulah.")

Bankhead was a legend, only on the stage; she was notorious for her

* No matter that the shiny bracelet was Hitchcock's "usual irony," as even Steinbeck recognized, of using a significant trifle to define a character, and that as the script developed, the bracelet became increasingly important as a symbol of Connie Porter's superficiality.

lack of success in film. Moreover, by 1943 she was forty years old, hardly a young, glamorous Hollywood leading actress. That was undoubtedly part of her appeal for Hitchcock, who liked contrary casting, and the like-minded MacGowan approved the idea.

The director sent one of the earliest treatments to the actress, who signed on at once, allowing Hitchcock to ensure that her colorful personality could be written into the role. According to Bankhead, "He kept making my part like me and I kept saying: 'Don't make me say "dahling," they'll think I'm playing myself,' but I did what he told me." Later, after she came to Hollywood for the filming, Hitchcock told the actress that Connie Porter was the least likely sort of person he could think of plunking into the lifeboat, and Bankhead was "the most oblique, incongruous bit of casting I could think of."

Burly William Bendix, who specialized in playing good-natured American joes, was cast as Gus, the sailor with a gangrenous leg. Henry Hull, a veteran of films since 1917, was cast as Rittenhouse, while Hitchcock gave English actress Heather Angel the small but memorable part of the mother who drowns herself. (Angel also had portrayed the maid in *Suspicion*.) A young actress under studio contract, Mary Anderson—who had played a small part in *Gone With the Wind*—was cast as the Red Cross nurse Alice.

The role of the Negro seaman, Joe, was assigned to Canada Lee, who had played Bigger Thomas in Orson Welles's vaunted stage production of *Native Son*. Hitchcock spotted Lee, who had appeared in only one minor film, in a screen test sent over by Metro-Goldwyn-Mayer. His casting was a subtle indication of how Hitchcock saw the character. Lee, who had only a brief screen career—ending with his blacklisting and premature death in 1952—could be counted on to bring strength and dignity to any performance.

If the part of Connie Porter grew in the script drafts, Kovac—the narrator of Steinbeck's novelette—lost ground. Yet he remained important as the only man who poses any physical risk to the German, and the post-Steinbeck rewrites would accent his sexual attraction to Connie Porter—although their chemistry is fractious, as much instinctual hate as eventual love. The actor feeding lines to Lee in the MGM test was John Hodiak, a square-jawed ex-radio actor with minor screen experience. By now Hitchcock knew what trouble he'd have coaxing Gary Cooper or Henry Fonda into his lifeboat, and so Hodiak, a relative unknown with a correspondingly affordable salary, was cast as Kovac.

The single character added to the film after Steinbeck's novelette was the ship's radio operator, who pursues a tender sideline romance with the nurse. (In the frustrated-hairdresser fashion of other characters in Hitchcock films, he is always fiddling with the ribbon in the nurse's hair.) It was a part especially created for Hume Cronyn, who had a growing friendship with the director.

Spies and traitors—Germans or Nazis, often enough—were among Hitchcock's stock-in-trade, and the part of Willie called for a supervillain as engaging and irresistible as he was loathsome. Perfect for the part was Walter Slezak, once a dashing figure on the German stage and in films, who had gained poundage and become, literally and figuratively, an imposing heavy. Having admired him in two recent anti-Nazi films, Leo McCarey's *Once Upon a Honeymoon* and Jean Renoir's *This Land Is Mine,* Hitchcock gave Slezak the role.

Lifeboat was slated to be shot almost in its entirety in a water-filled tank on the back lot at Twentieth Century–Fox. The tank had four corner chutes that propelled water toward the lifeboat, which would be held relatively stable by a maze of underwater wires. For scenes that required ocean backgrounds, a second boat was suspended on a mechanical rocker against a process screen, on which were projected the shifting moods of the sky and sea.

The cameraman would have to come from the studio roster, but the director knew his choice: Glen MacWilliams, with whom he had crossed paths on *Waltzes from Vienna.* A journeyman whose work dated back to the silent film era in Hollywood, MacWilliams would turn in his most impressive photography under Hitchcock on *Lifeboat*—and earn the only Academy Award nomination of his career.

Before filming started in August, there was a last-minute crisis when Darryl Zanuck, immersed during the first half of 1943 in Signal Corps activity in Washington, D.C., returned to his post as head of production just in time to critique the finished *Lifeboat* script.

Lifeboat would have been an unusual, ambitious film at any studio, but at Twentieth Century–Fox it could have been developed only in Zanuck's absence. The studio boss was aghast that ten months had been spent on the film—and that the result was a script that posed serious budget and censorship issues.

Zanuck pointed to an Office of War Information letter complaining that *Lifeboat* presented "more serious problems than any script of yours which has been reviewed by this office for years." Accurately predicting the antipathy that would descend on the Hitchcock film upon its release, the OWI letter said "the group of Americans in the lifeboat present a picture which the Nazi propagandists themselves would like to promote."

The OWI saw Connie Porter as a "selfish, predatory, amoral, international adventuress," while Rittenhouse was assessed as an unfairly unsympathetic businessman. Kovac seemed "fairly decent," although he had Communist leanings, and the script implied he cheated at poker. Joe, the Negro, shouldn't be a "former pickpocket," and, by not participating in

balloting on the fate of the German, he "implies that he is not accustomed to the franchise and prefers not to exercise it." ("Do I get to vote too?" Joe asks sarcastically.)

Worst of all, the OWI report concluded, "The only hero is the Nazi"— and the spectacle of Willie murdering Gus by shoving him overboard was positively disgusting. (That certainly wasn't in the novelette, Steinbeck hastened to tell lawyers—it was Hitchcock's coup de grace.) Disgusting, too, that Willie should then be beaten and drowned in a burst of mob outrage. (Willie drowned in Steinbeck's version, too, but getting beaten with Gus's shoe, taken off his amputated leg—that was pure Hitchcock.) "They're like a pack of dogs," Hitchcock said in describing the scene to François Truffaut. To the OWI, the scene was "an orgasm of murder."

To Zanuck's credit, he issued no harsh commands, no formal response to the OWI complaints. Having arrived late in the game, he found himself in an awkward position: he still hoped Hitchcock might direct a second picture for Twentieth Century–Fox, and he was as tough an opponent of censorship as any studio head. In the end, he simply informed Hitchcock that while he did not agree with all the criticisms, he felt they should be taken into account.

Even more offensive to Zanuck than Willie's character was the scene where the lifeboat passengers tie up the distraught mother to keep her from throwing herself overboard, only to discover her body drifting at the end of the rope the next morning. The head of the studio hated the whole theme of the drowned baby and suicidal mother, and urged Hitchcock to delete the sequence. Hitchcock resisted, and prevailed. Zanuck also strongly advised trimming the comic-relief card game and baseball small talk between Kovac and Rittenhouse; Hitchcock made minor changes.

Worried about a budget that had already escalated during the long preproduction, Zanuck asked his subordinates to time the script with a stopwatch. Their report, delivered to him in the third week of filming, warned that, at Hitchcock's current rate of progress, *Lifeboat* might run as long as two hours. Zanuck dashed off a memo, urgently delivered to the director on the set, which insisted that Hitchcock speed up and make wholesale cuts in the script. "You're not going to get your eliminations by cutting out a few lines here and there in each sequence," Zanuck wrote. "You are going to have to be prepared to drop some element in its entirety."

Hitchcock could be steely with writers or actresses, but it wasn't often that he confronted the top bosses with his rage. But he had spent nearly a year coaxing *Lifeboat* through the shoals of scriptwork and casting, and he wasn't about to scuttle the film now for Darryl F. Zanuck.

His reply, dated August 20, 1943, was remarkable, considering that Hitchcock was addressing the studio's highest executive. "I don't know who you employ to time your scripts," the director wrote, "but whoever

has done it is misleading you horribly. I will even go so far as to say disgracefully. In all my experience in this business, I have never encountered such stupid information as has been given you by some menial who apparently has no knowledge of the time of a script or the playing of dialogue."

Hitchcock went on to state that he based his calculations on indisputable facts ("facts that come from persons of long experience"). They were shooting in sequence, and already up to page 28 of the script ("which includes a fair amount of silent action"); Hitchcock estimated the existing footage would run fifteen minutes. On the basis of a 147-page script, and allowing for the storm sequence, he predicted a final running time of eighty-four minutes or "7560 feet, which, in my opinion, is considerably inadequate for a picture of this caliber and importance."*

Hitchcock insisted he was making reasonable progress, no matter what Zanuck's foolish subordinates thought. Just now he was busy shooting a nine-page sequence "which will take approximately two days—which is exactly one day under the allotted time in the production schedule." Hitchcock closed: "Dear Mr. Zanuck, please take good note of these above facts before we commit ourselves to any acts which in the ultimate may make us all look extremely ridiculous by giving insufficient care and notice to these considerations."

Zanuck took a deep breath, and had the script retimed. The new estimates made him realize the film wasn't so "bad off" schedule-wise, after all. The head of the studio backed off any showdown with Hitchcock, conceding that the initial timing "was not done by an expert" and that the pacing of certain hard-to-time scenes hadn't been taken into account. (To producer Kenneth MacGowan, Zanuck admitted, "For your confidential information, the damn fool who timed the script also timed all of the descriptive reading.")

This early backstage face-off, with Hitchcock demonstrating his superior knowledge of production minutia, had the effect of strengthening the director's hand—though throughout the filming Zanuck continued to plead for the elimination of "nonessentials." Hitchcock made a show of small excisions in minor scenes, but nothing significant was endangered. *Lifeboat* still belonged to the director.

Everything about *Lifeboat* challenged the conventional wisdom, from its subject matter to its casting to the way it was filmed. The script centered on ten people in a lifeboat, none of them stars with any track record with audiences. At the helm was a German superman. Among the highlights of the story were the drowning of an infant, the suicide of a crazed young

* Hitchcock was closer: the final running time was ninety-six minutes.

mother, and an onboard amputation endured by the character who most closely evoked an ordinary American.

The cast had to submit to three months of huddling together in a mock lifeboat, rolling and pitching in relentless surf simulated by wave-making machines. They were constantly doused by water, and had to struggle to keep their balance or risk being heaved overboard. The actors were "frequently wet, cold, and covered with diesel oil," Hume Cronyn recalled. Even during scenes that took place in a "flat calm," he said, "there was a large demand for anti-seasickness pills among the actors."

Cronyn cracked two ribs one day, he recalled, when he was whipped about by the water and hurled into the gunwale. Tallulah Bankhead wrote that she was "black and blue from the downpours and the lurchings." Suffering under "the heat, the lights, the fake fog and submersions followed by rapid dryings-out," the leading lady came down with bronchial pneumonia, halting production for several days. (It was one of many such delays.)

A prima donna playing the part of a prima donna, Bankhead set everyone's teeth on edge. She was "a compulsive talker with a reputation for wit," recalled Cronyn. The actress was also a compulsive name-dropper, with a vocabulary bristling with obscenities. "Listening to her constant talk was like a Chinese water torture," said Walter Slezak. "She told us she'd given up drinking for the duration of the war about seventy-two times a day."

There was this storied sidelight: Bankhead eschewed undergarments, and freely exposed her private parts. Some people, including Slezak, were offended. "In order to step into the boat we had to go over a little ladder," Slezak recalled. "The first day she lifted her skirt to under her arms—with nothing underneath. She carried on that tired joke for about fifteen weeks, while I was on the picture. Every day, three, four, or five times, she showed she wasn't wearing panties. Maybe I'm a prude, but I don't like vulgar women."

Not Hitchcock: One day, according to Cronyn, a visiting lady journalist from a women's magazine took umbrage at Bankhead's exhibitionism, and complained to the publicity department. The publicists pressed the issue with production manager Ben Silvey, who passed the buck to Hitchcock. Joseph Cotten vouched for what happened next: he was visiting the set when he noticed cameraman Glen MacWilliams slide over to Hitchcock and whisper that whenever Bankhead spread her legs, the shot was ruined.

The director lifted up his stomach, stuck out his bottom lip, and pronounced loud enough for everyone to hear, "This is not for me to handle. We shall call the hairdresser." *

Bankhead behaved snobbishly, and worse, toward her lowly Holly-

* There are several versions of this anecdote. Among the funniest: "Should I call wardrobe, makeup, or hairdressing?" Not as widely recounted is the capper: After filming was over, Bankhead reportedly made a point of apologizing to production manager Ben Silvey for causing him so much publicity trouble. Wearing a loose skirt, she then stood on her head with her limbs in the air to give him his own private show.

wood colleagues, according to all accounts. One day she lashed out at Henry Hull, whose advanced age gave him some trouble memorizing his lines. "You goddamned old ham," Bankhead snarled. "The company was paralyzed," wrote Cronyn. "Hitch quickly went to the water-cooler. He hated confrontations."

Apparently unable to distinguish the actor from the character, Bankhead nurtured a near hatred for Walter Slezak, referring to him on- and off-camera as a "goddamned Nazi." On the day word reached the set that the Italians had capitulated and Mussolini had fled, Slezak said something like, "Well, thank God that part's over. Perhaps it will spare more unnecessary bloodshed"; according to Cronyn, Bankhead turned on the actor, hissing, "I hope they spill every drop of German blood there is. I hate them all! And I HATE YOU!" There transpired a "deathly hush, followed by Walter's reasonable voice: 'I'm sorry about that, Tallulah.' "

Hitchcock, defending Bankhead in subsequent interviews, insisted she wasn't serious about Slezak: "Only semiserious." The director liked her diva personality—her imperial style of acting (he later quipped that she acted like the capital of Siam: Bang-Cock), her lack of inhibition. Such a personality suited Connie Porter—the toughest person in the lifeboat, who intimidated all the others.

When Bankhead tried to intimidate the man in charge, however, seeking to interpret a given scene according to her own lights, she was told by Hitchcock, "very quietly with that wonderful dead-fish face of his," in Walter Slezak's words: "No, do it my way."

Hitchcock was very "gentle" with her throughout the filming, according to Bankhead; he could be gentle—or firm—with any actress, as needed. Oft quoted is his rude riposte to Mary Anderson, who made the mistake of fishing for a compliment from the director. "Mr. Hitchcock, what do you think is my best side?" "My dear," he is said to have replied, "you're sitting on it."

Anderson tried Hitchcock's patience—especially after he caught her stuffing Kleenex into her bra. But even she benefited from his direction. When she came to her big emotional scene, Hitchcock waited and "waited for her to get into the mood," according to Slezak, then finally threw up his hands and started issuing orders. "Look, child," the director exclaimed, "we haven't got that much time! First of all you will drop your voice about three notes. You will then take one long deep breath and begin talking. At that line [he pointed to the script] your breath will give out— but you will keep on talking, even if I can't hear a word of what you are saying! Let's shoot!"

"They did the scene in one take," Slezak remembered. "At the exact line where Hitchcock had predicted, her breath gave out, but she kept on mouthing the words. And suddenly you had a feeling, that there was a girl

who was completely spent; her parched lips, after forty-two days on the open sea, quivered and trembled. She didn't have the strength to make them heard but you understood everything she said. Hitch knows more about the mechanics and the physical technique of acting than any man I know."

Two weeks before Thanksgiving, the filming wrapped. Although *Lifeboat* was the first Hitchcock film to consume an entire year of production, and although it cost close to $2 million—although, as one film historian claims, "the aftermath left everyone feeling betrayed," including Darryl Zanuck—the truth is that when the head of the studio saw the first cut in mid-November, internal studio memoranda confirm that Zanuck raved about *Lifeboat* as an outstanding film with awards potential. Despite the costs and the disagreements over the director's first Twentieth Century–Fox film, Zanuck still wanted to keep Hitchcock at the studio.

The reluctant partner again was Hitchcock. His contract dangled the possibility of a second Twentieth Century–Fox production after *Lifeboat,* but the agreement hinged on finding mutually acceptable subject matter.

Stalling the decision gave Hitchcock leverage during the making of *Lifeboat.* Beginning in the spring, Twentieth Century–Fox tried to nudge him along on the option clause. The director told the studio he was leaning toward filming an adaptation of J. M. Barrie's play *Mary Rose,* the subtle, enigmatic tragedy with *Peter Pan* echoes that he had first seen on the stage in 1920. Hitchcock informed the studio that he intended to purchase the rights himself, and coproduce the film with Kenneth MacGowan.

This desire was partly quashed by the Barrie estate, which demanded an exorbitant sum for the story rights, and partly by Zanuck, who had an adverse reaction to the project. Zanuck regarded *Mary Rose* as a pure fantasy, too whimsical for U.S. audiences and for a suspense director like Hitchcock. MacGowan backed Hitchcock, but when MacGowan announced he would be leaving the studio after *Lifeboat,* all hope of *Mary Rose* vanished.

Instead, the studio gently pushed the idea of adapting another property: *The Keys of the Kingdom,* A. J. Cronin's novel about a Scottish missionary in nineteenth-century China. Although Hitchcock said he liked the book, he refused to commit to the project, even after Zanuck had penciled him in as director and *Keys of the Kingdom* was scheduled for filming in the fall of 1943. Seeing the move as a ploy intended to move *Lifeboat* along, Hitchcock continued to equivocate, and *The Keys of the Kingdom* was handed over to studio contract director John M. Stahl.

With Thanksgiving looming, Hitchcock's next picture was still up in the

air. He hadn't enjoyed his small taste of Zanuck's authority, and David O. Selznick also weighed in against extending the Twentieth Century–Fox contract. According to Leonard Leff's study of Selznick and Hitchcock, DOS saw Zanuck as another producer who had not supervised the English director properly; leaving Hitchcock to his own devices, DOS believed, had only freed the director to gleefully run up the "inordinate costs" and filming schedule of *Lifeboat*—behavior DOS feared might ruin Hitchcock's reputation and diminish his value on future loan-outs.

DOS staved off other inquiries—Hal Wallis at Warner's, Sam Goldwyn again. After cornering Hitchcock for a talk in late 1943, Goldwyn received a sharp reprimand from DOS: Goldwyn couldn't hope to understand a man like Hitchcock, his producing rival lectured.

If anything, though, professional distance had improved Hitchcock's relationship with Selznick. DOS was grateful when, as a personal favor, Hitchcock took a break from *Lifeboat* to shoot a War Bonds trailer with Jennifer Jones, the young actress with whom Selznick had fallen in love. Now DOS was sounding serious about producing films again, and about wanting his next production to be directed by Hitchcock. That was fine with Hitchcock, who wanted nothing more than to fulfill—and be done with—his Selznick contract.

The most urgent item on his agenda after finishing *Lifeboat,* though, was to go to England and keep his commitment to Sidney Bernstein. A series of cables had kept him in touch with Bernstein's plans at the Ministry of Information. In the spring of 1943 the director had agreed to the subjects of two war films he would supervise in London, and Bernstein had begun developing the stories, while trying to nail down the director's availability for later in the year.

For Hitchcock, the best time for a London trip was after *Lifeboat,* and before he launched another project. He tried to convince Dan O'Shea to let him go to England for twelve weeks, even agreeing to accept this as his annual layoff period—provided he could subtract the twelve weeks from future time owed to DOS. But O'Shea refused, preferring to categorize the time as a "suspension" so that Hitchcock would still owe the time to DOS, carrying the obligation over to the next contract cycle.

DOS, as usual, was torn. He resisted the idea of Hitchcock's going to England and doing war films with Bernstein, who looked to him like another potential rival becoming too friendly with his ace director. Indeed, DOS took every opportunity to belittle Hitchcock's friend. When Bernstein showed one of his proudest Ministry of Information films to Selznick, the producer expended five pages of criticism in a telegram, blasting its unsuitability for U.S. exhibition.

As a way out of this impasse, Hitchcock had begun tempting Selznick with a book by Francis Beeding (pseudonym of Hilary Aidan St. George Saunders and John Leslie Palmer) called *The House of Dr. Edwardes,*

which concerned a madman taking over an insane asylum during the superintendent's absence. Hitchcock said the obscure 1927 novel would offer the pretext for a powerful thriller dramatizing the mystery and dangers of psychiatric investigation. He himself had optioned the rights inexpensively, and offered it to Selznick International at a bargain rate. He improvised a starring role for Ingrid Bergman, and ventured that he could develop a treatment during his layoff in England—working with his old friend Angus MacPhail, who was going to produce the war films.

He guessed correctly that the story's psychiatric milieu would appeal to DOS, still deep in the throes of his midlife crisis (obsessed with Jennifer Jones, he had broken up with his wife). The producer was in regular analysis, and could talk about nothing but. DOS okayed the project—but said the layoff was a technicality under O'Shea's jurisdiction.

O'Shea refused to budge, though—and Myron Selznick was proving an increasingly useless go-between. The director's contempt for his agent had poisoned their relationship, and Hitchcock still stubbornly refused to remit any commissions on non-Selznick bonuses paid to him directly; he also refused to repay the ten thousand dollars Myron had paid Alma for her draft of *The Lodger*. (To Myron's annoyance, the draft never materialized.)

The diplomat of the agency, Sig Marcus, visited Hitchcock on the *Lifeboat* set in October to wave a white flag and parley. He told the director that Myron was hurt by rumors that Hitchcock was shopping around for a new agent, meeting with Dan Winkler over at the Feldman-Blum offices. The director's agreement with the Selznick Agency had expired in June of 1943, and he had refused all entreaties to re-sign with Myron.

Marcus reported back: Hitchcock insisted he respected Myron and was going to stick with the agency, at least through the end of his Selznick International contract. But he would not sign another contract with the agency, and again he refused point-blank to give the Selznicks any percentages of his Universal bonuses, no matter how "patiently" Marcus explained to him that this was standard operating procedure throughout Hollywood.

"The entire conversation was so friendly," said Marcus, that the agent feared Myron would think he was "carried away by Hitchcock's charm." After all, Marcus had failed to get any straightforward answer from the director, never mind any actual commitments or concessions.

Hitchcock had made up his mind. He had no choice but to accept O'Shea's definition of the layoff period. Visitors to his office at Twentieth Century–Fox were told he was preparing a three-month business trip, and his secretary dodged questions. When Hitchcock left for London after Thanksgiving, his future at the studio, and his status with the agency, were up in the air.

Mrs. Hitchcock, who stayed behind, was delegated by her husband to oversee postproduction on *Lifeboat,* including working with composer Alfred Newman. Hitchcock was always wary of traditional studio scores, and, as he would do later with *The Birds,* he envisioned a unique sound track composed almost entirely of naturalistic sounds. He approved only sparse music to run under the opening credits and the end title cards.

Zanuck, who had been stewing over his various defeats during filming—not to mention his failure to re-sign Hitchcock—proposed tender music for the romantic Hume Cronyn–Mary Anderson scenes. Hitchcock, through Alma, stood firm: no music. But Zanuck had his revenge, making minor cuts in these and other scenes wherever he could—and then rushing prints east for the release before Hitchcock returned from England.

"I knew that if I did nothing [to aid England] I'd regret it for the rest of my life," Hitchcock said later. "It was important for me to do something and also to get right into the atmosphere of the war."

In August 1943 Angus MacPhail left Ealing to join the Ministry of Information, and planning for the Hitchcock films began in earnest, with MacPhail as producer and "story saboteur," in his words. "I'm going to suck up to you by evolving a story which begins with a Senegalese falling dead from the gallery of St. Paul's," his old crony wrote to Hitchcock in Hollywood.

Sidney Bernstein hadn't wanted Hitchcock dealing with issues pertaining expressly to wartime England, a subject reserved for resident English directors such as Anthony Asquith and Michael Powell. But Hitchcock would be perfect for two projects paying tribute to the French Resistance—to be shot in French and subtitled in English. For Hitchcock, who started out his career with location forays to the Continent, the war was really about the places he knew firsthand. Germany and France were personal; Japan and the Pacific theater were conspicuously absent from mention in all his films, wartime or otherwise.

By November, the ministry had received budget and story approval for two three-reelers to be shown to the general population in the free territories of France.

The first was *Bon Voyage,* which involved a downed British pilot whose escape from France has been aided by the Resistance. This story had an initial treatment by writer V. S. Pritchett, but MacPhail stalled the final draft. "I've already warned Sidney about the dubious value of confronting A. Hitchcock with completed scripts," MacPhail wrote the director.

The second was *Aventure Malgache,* which concerned the internal affairs of Vichy-controlled French Madagascar. Both films were going to entail "a lot to do in the way of settling the political line, clearing [it] through Security or any Government Departments involved," according to Ministry of Information memos. That is another reason Hitchcock was chosen

for these subjects: Bernstein felt he could trust the director's political sophistication.

Flying across the Atlantic from New York to London, which remained under intermittent aerial bombardment, was still not a simple matter in late 1943. In the best of situations, it meant fourteen hours of nerve-racking discomfort in the air. "I flew over in a bomber, sitting on the floor," Hitchcock later recalled, "and when we got halfway across the Atlantic, the plane had to turn back. I took another one two days later."

He arrived on December 3, 1943. Though he was earning only a token salary, Hitchcock took a suite at Claridge's, his favorite London hotel, and met there with writers. In the case of *Bon Voyage,* the scenarist was Arthur Calder-Marshall, a biographer and fiction writer who had worked briefly in Hollywood under contract to MGM. *Aventure Malgache* would be written by J. O. C. Orton, a veteran of British films. MacPhail assisted on both scripts, and a number of French Resistance members and show business exiles living in London consulted on matters of authenticity.

"The slightest error, they feared, might hold the picture up to ridicule," Hitchcock recalled in a contemporaneous interview. "I couldn't show a scene where cigarette butts are lying around. French audiences would simply laugh off such a preposterous sight. You must remember that where people are limited to four cigarettes a day, as they are in France now, there is no such thing as an unclaimed cigarette butt. People take a few puffs on a cigarette and stuff the butt into a match box, taking it out later for another puff."

In another scene, he continued, "I showed a restaurant. Ordinarily you would never think about the look of a table where a meal has been finished. But in representing a French restaurant of today, you do. There are no crusts of bread left on the table. If I permitted anything like that, it would simply mean to future French audiences that the people who made the picture didn't know what they were doing."

Both scripts acquired intricate flashback structures and last-minute story twists under Hitchcock's care. In *Bon Voyage,* a Polish prisoner appears to have aided the downed RAF pilot during his escape from France; but a Free French colonel, debriefing the pilot in London, retells the adventure from a different point of view, revealing (by clever restaging of events) that the Pole was actually a Gestapo agent trying to flush out the Resistance.

Aventure Malgache became the more controversial of the two stories, largely because Hitchcock noticed political bickering among the French consultants, and incorporated these tensions into the film. "We realized that the Free French were very divided against one another," he said, "and these inner conflicts became the subject."

Aventure Malgache begins in Chinese-box fashion with a troupe of actors slowly donning their makeup before a show. Ex–Resistance fighters

who have escaped to London from the French territory of Madagascar, they now carry on the struggle by performing patriotic plays. The actors recall events in Madagascar, including political differences and incidents of craven collaboration with the enemy. At the end of the film, the island's turncoat police chief, hastily preparing for the arrival of the British navy, hides away his bottle of Vichy water and photograph of Pétain, substituting Scotch and a wall portrait of Queen Victoria.

MacPhail had warned Hitchcock back in October that his budget would be bargain-basement, but the director lined up composer Benjamin Frankel, who often worked with Noel Coward, and former Murnau cameraman Günther Krampf, who had worked in England since 1931. For the ensemble of *Aventure Malgache* Hitchcock hired the Molière Players, an ad hoc troupe of exiled French actors, some of whom also appeared in *Bon Voyage*.

By January 20, Hitchcock was fast at work at the venerable Welwyn Studios in Hertfordshire, now part of British International Pictures and used principally for the production overflow from Elstree. The three-reelers were shot and edited quickly; Hitchcock was done by February 25, and booked to return to America on March 2.

Only a short time later in 1944, the twenty-six-minute *Bon Voyage* was distributed in liberated France and Belgium. But the thirty-one-minute *Aventure Malgache*, originally planned to salute the heroism of French resisters, had grown under Hitchcock into an exposé of domestic traitors— and so it was held back. The fact that the two films received such limited circulation is another reason Hitchcock's war work seemed invisible.

Still, the director took considerable pride in *Bon Voyage* and *Aventure Malgache*. He was fond enough of the former that he later explored expanding it into a feature film, rescreening it as late as 1958 while under contract at Paramount.

In the early 1990s, when the MOI films were unearthed and released on video, they were seen as supplying a vital link in the director's career. Both were revealed as "very Hitchcockian," as Philip Kemp wrote in *Sight and Sound*—surprisingly complicated narratives with expressive camera work, characteristic levels of humor and irony, and strong themes.

While ensconced at Claridge's, Hitchcock and Angus MacPhail found time to discuss the adaptation of *The House of Dr. Edwardes;* together they cranked out a solid treatment. According to Leonard Leff, David O. Selznick had asked for a theme about "the healing potential of psychiatry." This was a leap, since the novel was almost a country-house mystery; but if ever Hitchcock threw a book out the window, this one flew far, far away.

Even Leff, often skeptical of Hitchcock, concluded that the treatment

neatly gutted the novel, while establishing "the structure and several of the major incidents for the film eventually called *Spellbound*." It strayed so far from the book—but was of such intriguing quality—that DOS wondered privately if Mrs. Hitchcock had helped out, "ghosting" from Hollywood.

During the brief time he spent in London, Hitchcock hosted get-togethers with Ivor Montagu, Alexander Korda, and other old friends. Several times he visited his sister, Nellie, who was living at Shamley Green with other family members. His relationship with Sidney Bernstein deepened, and they talked about going into business together after the war.

He experienced the rationing, the drills, the blackouts. The worst of the blitz was over, but there was a flurry of bombings—a "baby blitz," as some called it. Hitchcock was vastly amused when, while he was dining with his spinster cousins at Claridge's, German planes flew over, provoking a noisy antiaircraft barrage, and his cousins virtually ignored it all—except for one remarking to the other, "You know, my dear, the guns sound different here than they do at our house, don't they?" But the threat of incendiaries and parachute mines dropping from the skies was real, and the war darkened his mood.

Especially late at night, when Hitchcock found himself stranded at the hotel, he felt helpless. "I used to be alone at Claridge's Hotel," Hitchcock wrote to Alma, "and the bombs would fall, and the guns, and I was alone and didn't know what to do."

TEN

1944–1947

Lifeboat opened in American theaters in January 1944, while Hitchcock was still in England. His most controversial film up to that time, it divided reviewers—even against themselves.

New York Herald Tribune columnist Dorothy Thompson wrote a piece conceding that *Lifeboat* was "from the point of direction and entertainment, brilliant," while condemning the Hitchcock film as a work which "translated into German, could be presented in Berlin as a morale builder for the Nazis' war, with only minor changes." (Did Thompson notice that she was the prototype for Tallulah Bankhead's character? She didn't say.)

Manny Farber of the *New Republic* wrote that *Lifeboat* "both irritates and holds you effortlessly to its exposition." James Agee wondered in the *Nation* if Hitchcock had lost "some of his sensitiveness to the purely human aspects of what he is doing," and then speculated that the film's insensitivities resulted from *Lifeboat*'s being "more of a Steinbeck picture than a Hitchcock." Bosley Crowther, who was just beginning his quarter-century reign as lead critic for the *New York Times,* found the Hitchcock film "a consistently exciting and technically brilliant drama of the sea," which nonetheless repelled him by its injudicious—perhaps, he thought, inadvertent—elevation of the superman ideal.

After his initial review, Crowther's opinion hardened; he wrote two Sunday articles reiterating the "appalling folly," the "shocking political aspect," the "insidious" nature of *Lifeboat*; and the *New York Times* also devoted a section to pro-and-con letters (including one from the producer Kenneth MacGowan patiently explaining the film's theme). While at first Crowther had attempted to divide the responsibility for the film equally between Hitchcock and Steinbeck, he got hold of the novelette, and in his second Sunday piece noted that the film was a "radical departure" from the Steinbeck story. It was now his opinion that Hitchcock had "preempted" the "conscientious" writer. Steinbeck was responsible for all that was good about *Lifeboat;* the director was to blame for all the bad.

Steinbeck, alarmed by the controversy, had authorized his agent, Annie Laurie Williams, to send the unpublished novelette to Crowther. Steinbeck had also received a letter from the National Association for the Advancement of Colored People (NAACP) complaining that Joe, the Negro character, was a stereotype. Although Joe was Steinbeck's creation, the author was concerned about the appearance of racial prejudice, and after seeing *Lifeboat,* he wrote to his agent that he agreed with the civil rights group. Hitchcock had taken his dignified race representative and turned him into "a stock comedy Negro," in his words, or "the usual colored travesty."

As Steinbeck later attested in depositions, Joe is "a colored man, not religious—a very proud man" in his novelette, "and in no way wanting not to do anything with decisions. In fact he makes many decisions. It is quite an opposite character [from the film's]." Steinbeck's Joe not only heroically tries to save the mother and baby when the two are floundering in the water, but also tries to save Willie after the German is pushed overboard. And Joe is an accomplished flautist who moonlights in a chamber orchestra.

He plays the flute in the film, too—but it's more of a recorder, and the music he plays is equally humble. In this and other ways, Hitchcock stripped Joe down: the Negro character makes only a single rescue (the mother and child), his musical talent is modest (he's no chamber musician), and he has a pickpocket past (the element that really inflamed the civil rights organization). The film also makes Joe deeply religious, a change Steinbeck hated because he saw it as stereotypical. (Joe is the only passenger who, praying for the soul of the dead baby, can recite the Bible from memory: "He leadeth me beside still waters . . .")

Hitchcock could never be mistaken for a civil rights pioneer. Black characters are few and far between in his films, which take place in the Anglo-Saxon world where he felt most comfortable. Before *Lifeboat* one has to go back to 1927's *The Ring*, the last Hitchcock film based on the director's own original story, to find another prominent black character—an ap-

pealing trainer who is a friend of the hero. But the script credited solely to Hitchcock also includes a title card referring to a "nigger" boxer.*

The man never mentioned publicly in the Steinbeck-Hitchcock debate was Jo Swerling. Yet it was Swerling who took the lead in reshaping Joe as a character, according to legal documents—Swerling, who was as liberal politically as Steinbeck. And under Swerling, although Joe became a less idealized Negro—he lost his job as a chamber musician and added ex-pickpocket to his résumé—the character acquired other symbolic value. When the anti-German storm finally bursts, for example, it is Joe alone who refuses to join the mob bloodletting—and his decency, his disgust at what the others have done, provides a sharp allusion to Negro lynching that was especially pointed in the 1940s. Hitchcock's Joe is a character who looks better and better over time.

The newspaper articles were just the tip of the controversy. Behind the scenes, individuals and organized groups complained to Twentieth Century–Fox about the film's pro-Nazi propaganda value. And almost from the premiere Darryl Zanuck was pressured to withdraw advertising and support. After a good blastoff at the box office, *Lifeboat* began sinking—and that, along with Hitchcock's anger that Zanuck had taken nicks out of the film behind his back, ended any lingering hopes that he might direct a second film for the studio.

Zanuck had been right about one thing: *Lifeboat* did attract awards at the end of the year, and Tallulah Bankhead was a front-runner when the New York Film Critics assembled to name the year's Best Actress. Still, it took six ballots for her to obtain the majority of votes and defeat Ingrid Bergman, for the less controversial *Gaslight*. Hitchcock didn't receive a single Best Director vote for *Lifeboat*.

Lifeboat did better with Academy voters in Hollywood, where making the sea ordeal believable on a soundstage was recognized as a remarkable achievement. Hitchcock's direction was Oscar-nominated, along with the original story (Steinbeck), and the black-and-white photography (Glen MacWilliams). Hitchcock lost to Leo McCarey, who was the big winner that year, having also been named Best Director in New York. (McCarey won two Oscars for *Going My Way*, for the story and directing, while Joseph LaShelle's camera work won for *Laura*.) Bankhead, the Best Actress in New York, did worse in Hollywood, where she wasn't even nominated.**

* Incidentally, that offensive word is never used in Hitchcock's *Lifeboat*—although the narrator of Steinbeck's novelette had referred to Joe repeatedly as a "buck nigger."

** In her autobiography Bankhead reasonably attributed the slight in part to the fact that she wasn't a contract player who could count on studio bloc votes.

Yet hers is a magnificent performance—and, *Lifeboat* remains under-rated. "Wow!" Connie Porter exclaims when a German ship bears down on the lifeboat in Hitchcock's crescendo, narrowly cutting across its bow—a thrilling, mesmerizing process shot. The entire film is as dazzling as that one moment. Fluid and symphonic in its pacing, *Lifeboat* is as original and searching as any picture made in Hollywood during World War II. Hitchcock made only tough, visceral films about the war—and with his toughest films he braced himself for second-guessing. He deliberately pushed his audiences, and courted critical rejection. "They all thought it was pro-German," he shrugged in an interview two decades later, "which was idiotic." But the fate of *Lifeboat* scarcely affected his momentum.

Returning from England through New York City in mid-March 1944, Hitchcock was a subdued man. He told friends that although he felt patriotic about England, he no longer felt quite like an Englishman. Yet the bombing of London, the food shortages, and the terror he'd experienced firsthand—all these humbled him, and put his troubles with the Selznicks in perspective. Without further protest he accepted Dan O'Shea's definition of his absence as a suspension, meaning he would still owe those twelve weeks to Selznick International. In London he had begun discussions with Sidney Bernstein about a new venture, a partnership to produce films after the war. And now he felt hopeful about seeing the light at the end of the tunnel.

The death of Myron Selznick on March 23 was another sign of changing times. Myron had tried many "cures" for his alcoholism, but his drinking finally caused an abdominal hemorrhage that sent him into a fatal coma. His brother David was at his bedside when Myron passed away in a Santa Monica hospital. Once the most powerful agent in Hollywood, he was only forty-six.

Yet Hitchcock didn't rush back to California to attend the funeral. In truth, he had grown to despise Myron, and to blame him for all his contract problems. After Myron's death, he informed the agency that he felt under no future obligation to it; he would fulfill his responsibilities to Selznick International, and pay the agency its commissions on that contract; but in the future he would handle his own business, and he reiterated his refusal to pay any percentages on past bonuses, or on future income outside of Selznick productions.

The Selznick Agency threatened to sue over the bonuses and outside income, and for the first time Hitchcock consulted independent attorneys. He wasn't alone in fighting the agency at this time; under erratic leadership, the agency had fallen into disrepute. Some clients sued to void their contracts; others simply walked away. Hitchcock's dispute with the agency wasn't settled for several years, and he never did pay the contested monies.

On his "word of honor," Hitchcock assured DOS that he would direct

the two pictures that remained on his Selznick International contract—if the number *was* two, that is. The contract had been amended and extended so often that its patchwork was mystifying. But nobody in Hollywood would dare employ Hitchcock until it was cleared with DOS, so the director had little choice but to meet his obligations while counting down to freedom.

The first of the two pictures would be *The House of Dr. Edwardes*. As previously agreed, Hitchcock lingered at the St. Regis in New York, working on a first draft of the script with writer Ben Hecht, who was then living in nearby Nyack. David O. Selznick trusted Hecht to craft "a well-constructed emotional story on which to hang all of Hitchcock's wonderful gags," but the director trusted Hecht for his own reasons.

Hecht had bailed Hitchcock out with the coda for *Foreign Correspondent;* some sources believe he also consulted on *Lifeboat*. The director and writer were two of a kind. At the top in their fields, both shared a jaundiced view of Hollywood and the world. They knew Hollywood preferred box office to art, and they didn't kid themselves: in order to satisfy Selznick, *The House of Dr. Edwardes* would have to strike a plausible psychiatric pose—a pose that both recognized as, in Hitchcock's phrase, "pseudo-psychoanalysis"—but the bottom line was creating a mystery with a pair of sexy stars that would clean up at the box office.

With DOS safely at arm's length on the West Coast, Hitchcock and Hecht began, as Hitchcock preferred, by touring the reality that would seed the fiction. They went trawling for verisimilitude in mental hospitals and psychiatric wards in Connecticut and New York before settling down to revise and expand the Hitchcock-MacPhail treatment. They were under no obligation to follow the book, hardly a memorable best-seller, and one Selznick may never have read; they even knew who their two stars were going to be.

At least they thought they knew. With a virtual lock on Ingrid Bergman, who was under contract to Selznick, they began tailoring for her the role of psychoanalyst Constance Petersen, who falls in love with the new superintendent of the mental institution, Anthony Edwardes. The writing team incorporated in-jokes to please Bergman when she read the script: when the troubled Dr. Edwardes starts to act strangely, and he and Petersen decide to seek the advice of Dr. Brulov, her psychiatric mentor, they travel to Rochester, New York—where Bergman would have felt at home, having lived there between films with her husband, Petter Lindstrom, as he studied for his medical degree.

For the character of Edwardes—eventually revealed by psychoanalysis to be an impostor suffering from amnesia, tormented by a dark secret in his past—Hitchcock was hoping for Cary Grant, as he often did. Alan Osbiston, editor of the MOI films, visited from London to consult with

Hitchcock, and observed one session with Hecht. "I spent all my time sit- ting with them watching them," recalled Osbiston. "It was a staggering experience. Hecht would come in with a few pages of script and read it to Hitchcock and then Hitch would read it back to him, then they'd act the parts. Hitch would say, 'OK, you're the girl. I'm Grant. Now, we move from here to there.' And they'd move all around the hotel suite acting and playing their lines. Hitch would say, 'I'll come from over here . . . no, that doesn't work because, you see, our camera is over here. I want that dia- logue to come over here. Ben, you've got to pull that line up to here so that I can play it in front of the camera here.' The whole thing was worked out in the most minute detail."

With Ingrid Bergman and Cary Grant in prospect, the love story was para- mount. Hecht, who had undergone analysis, came up with psychiatric expla- nations for the plot twists as well as suggestions for actual imagery—a corridor of doors swinging open when the two first kiss, for instance, "sym- bol for the beginning of love between two people," in Hitchcock's words.

Although Hitchcock and Hecht swapped roles back and forth while re- hearsing the script, the director was really more like Edwardes, who in the film declares, "I don't believe in dreams. That Freud stuff is a lot of hooey." The director wasn't unfamiliar with Freud's writings, having first browsed them in the 1920s, when Freud cast a shadow over all art and lit- erature; and he was more than capable of expounding, for example, on symbols (preferably sexual) and artifacts. Hitchcock even enjoyed regaling friends with his own dreams—which ranged from prosaic to vivid, some- times vividly erotic—soliciting their interpretations. But he didn't take the subconscious too seriously, and in his private life studiously avoided doc- tors of the mind.

In any event, he and Hecht both realized that *The House of Dr. Ed- wardes* wasn't going to end up as a thoughtful investigation of psycho- analysis. For Hitchcock, the primary allure of the film was the opportunity to give cinematic life to the dreams that help to unravel the amnesiac's identity. Although Salvador Dalí's name didn't surface officially until late spring, from the outset Hitchcock envisioned turning the dreams over to the famed surrealist—holding back on the idea until the script gained acceptance with Selznick. By late spring the latest draft was describing one dream that plainly evoked 1928's *Un Chien Andalou,* one of two cele- brated surrealist films designed by Dalí and directed by Luis Buñuel. The opening of *Un Chien Andalou* shows an eyeball sliced with a razor; the Hitchcock script featured a man cutting painted eyes in half with a giant scissors.

Hitchcock felt confident that the prospect of a Hollywood job would tempt the extravagantly mustachioed Spanish artist, and he counted on Dalí's spicing up the film with his unique fantasies. "Traditionally, up to

that time," he explained later, "dream sequences in film were all in swirling smoke, slightly out of focus with all the figures walking through this mist, made by dry ice with smoke pumped across the top. It was a convention. I decided to do these hallucinatory dreams in his style, which was just the opposite of the swirling misty dreams. I could have chosen [Italian surrealist Giorgio] de Chirico, Max Ernst—there are many who follow that pattern, but none as imaginative and wild as Dalí."

For two months, March and April, Hitchcock and Hecht stuck to the East Coast. Myron Selznick's death had plunged his brother into "a deep depression," according to David Thomson, and it wasn't until the two arrived in Hollywood in May that the usual whirlwind of meetings and memos commenced.

As usual, Selznick spouted criticisms like a geyser. Hitchcock and Hecht had fashioned a documentary-style opening depicting actual psychiatric techniques; the procedural montage echoed the prelude to *Blackmail,* but Selznick found it tedious. The early drafts poked fleeting fun at psychiatry—with one intriguing highlight of the Hitchcock-MacPhail treatment being a production by psychiatric inmates of *The Way of the World,* William Congreve's masterpiece of Restoration comedy—but as with *Rebecca,* Hitchcockian humor was unwelcome in Selznick's world.

One of the Hitchcock-Hecht versions opened teasingly with two men sharing a train compartment. One grabs a fly and pulls its wings off, and the other says, "Oh, I wouldn't do that, if I were you." One of the two men is a psychoanalyst, and the other is a new patient, but the audience has "to figure out which was the crazy man," according to Hitchcock. Alas, few such "wonderful gags" would survive Selznick's blue pencil.

Meanwhile, to authenticate the film's psychiatric content—and give *Dr. Edwardes* an official seal of respectability—Selznick called in his own psychiatrist, May Romm, a motherly Freudian who made a specialty of treating celebrities. (She would be credited on-screen as "Psychiatric Advisor.") Romm's advice "significantly improved" the script, according to Leonard Leff—although, as usual, Hitchcock didn't care about tedious authenticity, and the final film's depiction of psychoanalysis never really rose above the level of simplistic vulgarization.*

Hitchcock's attitude toward the Selznick-vetted final script, despite his best efforts with Hecht, was less than satisfied. "I used to tell him [Hitchcock] that I got so many really awful scripts that I got so mad I'd throw them at the wall and say I just couldn't stand it," recalled Ingrid Bergman

* In the *Journal of Applied Psychoanalysis,* Volney P. Gay observed that Hitchcock's similar attitude toward psychoanalysis in *Vertigo*—where, according to Midge's psychiatrist, Scottie needs a shock equal to what caused his vertigo in order to cure it—amounts to "folk beliefs about mental illness."

in an interview. "Anyway I got this script from Hitchcock and he said, 'Remove your husband and child before you throw it at the wall!' "

Like Hitchcock, Ingrid Bergman was obligated to David O. Selznick; she was in no better position to throw the script against the wall than he was. Regardless, the director met with the actress several times to allay her concerns that the love story was illogical and the psychologizing just so much folderol. Don't worry, Hitchcock assured the actress, love isn't logical. (Or, as Dr. Brulov says in the film, "The mind of a woman in love is operating on the lowest level of the intellect.") Nor, he said, was he intending to make a documentary—so she should forget all about any pretensions to realism.

Almost from their first meeting, Hitchcock developed an unusually intense friendship with the sensual Swedish actress. (In his biography of Bergman, Donald Spoto describes it as an "acute, unrequited passion.") They were kindred spirits. They shared the belief that Selznick contracts had trapped them in an "absolute prison," in Bergman's words. Both saw themselves as outsiders in Hollywood, and pined for the culture and sophistication they'd left behind in Europe. Both were refreshingly earthy personalities, with blunt senses of humor. Even more than Salvador Dalí, Bergman was sufficient reason for Hitchcock to make *Spellbound,* as the adaptation of *The House of Dr. Edwardes* was now retitled.

Cary Grant was another story. Grant could toss an unpromising script whenever he wanted, and often did. His own boss, Grant declined *Spellbound.* Selznick didn't mind; he wasn't looking forward to paying Grant's sky-high salary, when Hitchcock could just as easily use one of his contract players. Joseph Cotten was Hitchcock's preference from the Selznick stable, but the producer nominated a tall, darkly handsome younger man with "a rather rugged face"—as Bergman describes him in *Spellbound.* Gregory Peck had appeared in only two pictures, but he had been catapulted to stardom with his Oscar-nominated role as a saintly missionary in *The Keys of the Kingdom.*

Hitchcock shrugged, and accepted Peck in the role of the mentally unbalanced Edwardes. Like Joel McCrea, Peck was a California native, and perhaps for that reason Hitchcock initially saw him as "kind of rough around the edges, a small-town American boy." (In truth, Peck was no such thing: from medium-size La Jolla, he was formally trained in the Stanislavsky Method and had acted on Broadway.)

But the director tried to treat Peck like one of "Hitch's boys," mentoring him. He showed him how to comport himself like a gentleman—à la Cary Grant. "I was given to wearing brown suits," Peck recalled in one interview, "but he pointed me toward gray and dark blue and black. 'One

wears brown in the country, you know, but gray or navy in the city,' he told me one day. Well, I did what he said. But then one day I showed up in a blue suit with brown shoes. They were dark brown, and I thought they looked pretty good. 'Oh, Gregory, don't ever wear brown shoes with a blue suit!' he scolded me in his avuncular way."

Uncle Hitch also offered instruction in fine wines and spirits. "He did a wonderful, generous thing, by the way, which he later tossed off," Peck recalled. "He sent me a case of twelve assorted bottles of wine, each a fine vintage, and on each one he had attached a handwritten label: 'this is best with roast beef'; and 'this is best with filet of sole'; and 'this is desert wine.' All of them were Lafite-Rothschild, or Montrachet, or something equally good."

Selznick got his preferred leading man; Hitchcock concentrated on the supporting cast. Another Selznick actress, Kim Hunter, stood in for Bergman during the numerous test scenes with actors up for the role of Fleurot, a rakish psychiatrist. Hunter recalled how Hitchcock addressed each candidate at inordinate length, "giving them a gorgeously articulate, detailed description of who they were, what their character wanted, what was going on in the scene, what the whole film was about. . . . It couldn't have been clearer."

At the end of "each magnificent offering to the actor," in Hunter's words, the director would turn to her and elaborately inquire, "Do you agree, Miss Hunter? Do you think that's right?" Hunter recalled, "I think he took an evil pleasure in seeing me blush scarlet and stammer some inanity in reply. He teased me unmercifully. But it didn't for one minute accomplish what I presume he also had in mind, to put the chaps who were testing at ease. At my expense, of course. It just made them more frightened."*

John Emery, one of Tallulah Bankhead's ex-husbands, ended up with that part. But who would play the third-billed Dr. Murchison, the head of the clinic, who has murdered the real Dr. Edwardes on the ski slopes? During the rewrites, DOS kept trying to inject jealousy into the relationship among Dr. Murchison, the Edwardes impostor (Peck), and Dr. Petersen (Bergman), while Hitchcock—who was probably just being contrary—kept resisting any such triangulation. When Hitchcock chose Leo G. Carroll, the decidedly unsexy Englishman from *Rebecca* and *Suspicion,* the hint of romantic tension among the three all but vanished.

The actor Hitchcock cast as Dr. Brulov, Bergman's mentor, was Michael Chekhov. The Russian-born nephew of the famous playwright, Chekhov

* Although Hunter did not appear in *Spellbound,* Hitchcock remembered her dutiful screen-testing and successfully recommended her to Michael Powell for his classic 1946 film *A Matter of Life and Death* (known in the United States as *Stairway to Heaven*).

had run acting schools in London and New York before settling in Hollywood. Although well regarded as a mentor of performers, Chekhov had acted on-screen only twice in America, in *In Our Time* and *Song of Russia*.

Predictably, DOS bolstered his hand with a crew whose loyalty would be primarily to him—art director James Basevi, editor Hal C. Kern, and cameraman George Barnes, all veterans of *Gone With the Wind* and *Rebecca*. Hitchcock regarded Barnes as almost an enemy, "a woman's cameraman," in his words, "whose whole reputation and living was built on the demand for his services by certain stars." During the filming Barnes antagonized Hitchcock—insisting, whenever possible, on diffusing his lens to achieve his signature soft look. Hitchcock fought him, scene after scene.

With Selznick's permission, Hitchcock engaged Budapest-born composer Miklós Rózsa, who often wrote lush violin themes over rich strings—music that throbbed with gypsy wildness. His music for Billy Wilder's *Double Indemnity,* released earlier in the year, was the most admired score of 1944. (Wilder was another director whose films Hitchcock watched religiously.) Hitchcock gave the composer very "precise" instructions for *Spellbound,* according to Rózsa, including "a big sweeping love theme for Ingrid Bergman and Gregory Peck and a 'new sound' for the paranoia which formed the subject of the picture."

Filming began in the first week of June 1944.

Selznick, meanwhile, was brooding over postproduction on *Since You Went Away,* his first picture since *Rebecca* four years earlier and his first to star actress Jennifer Jones. Though dizzily in love with Jones, he was also stewing over his divorce. His brother's recent death had plunged him into depression. Most of the summer DOS spent "out of Hollywood," wrote Leonard Leff—away from Hitchcock and *Spellbound.*

During *Rebecca,* Hitchcock had been forced to suffer the occasional humiliation of the producer hovering over the filming, judging him with his watchful eyes. The rare times Selznick materialized on the set of *Spellbound,* Hitchcock reverted to his old English tricks, staging a phony mechanical failure. Although Selznick monitored dailies and wrote memos, "this didn't perturb Hitchcock," recalled Ingrid Bergman. He "just said, 'That's too bad' if he didn't agree. The movie was his." Even if the script was again shaped by Selznick's dictates, what happened on the set was the director's exclusive province, and Hitchcock could direct such mumbo jumbo in his sleep.

And sometimes it certainly seemed he was sleeping. Hitchcock was "constantly nodding off," recalled Gregory Peck. "He would sit in his canvas chair with his four chins drooping, sound asleep while they finished up the lighting. The first assistant, who was very tactful, would stand alongside him and jiggle him to wake him."

Yet a sleeping Hitchcock could be a deceptive, dangerous Hitchcock. When he woke up, said Peck, he seemed to know "exactly what was going on. He had the entire picture in his head, in his mind's eye. Every shot and every frame was rolling through his head."

It took Peck and Bergman a while to adjust to working with a man who appeared to have every image in his head, right down to the actors' gestures and intonations. Norman Lloyd was playing a small role in *Spellbound*, as a mental patient who insists he has murdered his father. His first scene was with Bergman; it was also the first scene in which Hitchcock directed the actress. Lloyd watched their battle of wills with fascination. Bergman wanted to play the scene according to her instincts, to speak and move in her own way. But Hitchcock, whose ideas for a scene grew more rigid whenever he was working under strain—or didn't yet trust a performer—wouldn't budge.

"He would sit patiently," Bergman recalled years later, "and he would listen to my objections that I couldn't move behind a certain table, for instance, or that a gesture on a certain line was awkward. And then when I was finished complaining to him and I thought I'd won him over to my point of view he would say very sweetly, 'Fake it!' This advice was a great help to me later, when other directors wanted something difficult and I thought no, it was impossible. Then I would remember Hitchcock saying to me, 'Fake it.' "

Peck made the mistake of inquiring about his motivation in a particular scene. What were his character's inner life and feelings? What should he be thinking? "My dear boy," Hitchcock drawled, "I couldn't care less what you're thinking. Just let your face drain of all expression." Peck's "soul-searching and . . . lack of ready technique," in the actor's words, tested Hitchcock's patience. The inexperienced leading man hungered for guidance. Much of the time Peck felt adrift, vulnerable—rather like the character he was playing. Although the drained expression was a guise, it also suggested the reality of an uncertain actor.

Spellbound was not a film, however, in which Hitchcock required the stars to deliver immortal performances. The Bergman-Peck love story had been carefully mapped out in advance by the director as mainly a feat of camera work. Their hypnotic attraction to each other would be defined by some of his most sensuous, gliding camera moves, and by gorgeous, lingering close-ups that externalized her longing and his tortured doubt.

He may have dozed, but the director didn't dawdle. Principal photography was over by late August, and then it was on to the matter of Salvador Dalí's dreams.

Selznick had been slow to authorize the hiring of Salvador Dalí. "I think he didn't really understand my reasons for wanting Dalí," Hitchcock said

later. "He probably thought I wanted his collaboration for publicity purposes." The producer considered the surrealist's initial asking price too high: five thousand dollars for approximately ten drawings and paintings, from which Hitchcock would derive his dream sequences. While the two DOSs negotiated with Dalí's agent, Felix Ferry, the producer commissioned a poll to determine whether his hiring would be worth the expense—and if Dalí's name signaled "art" to the general public—which DOS thought might be a bad thing.

It wasn't until early August that Hitchcock was able to convene his first meeting with Dalí, his agent, and the special-effects experts. The meeting went well. The director told Dalí the entire story of *Spellbound* "with an impressive passion," in the words of the surrealist, who afterward declared Hitchcock "one of the rare personages I have met lately who has some mystery." But Dalí refused to start drawing until his contract was finalized.

Dalí now said he was willing to accept four thousand dollars for his art, but he insisted on retaining ownership of all his sketches, as he felt they would have long-term value. Since he was paying for Dalí, though, DOS felt *he* should own the art. The final negotiations during filming led to a Solomonic solution: cut the baby in half. Dalí agreed to split the artwork "down the middle," according to Dalí biographer Meredith Etherington-Smith, with the producer reserving the first pick of half the sketches, and the rest going to the artist.

By the time the producer approved Dalí's terms, however, "there was not much time to prepare. The various arguments leading up to Dalí's hiring had left little time for the actual work," according to James Bigwood in his definitive account of the production.

Dalí's contract spelled out four distinct dreams: "1. The Gambling Sequence, 2. Two Men on a Roof, 3. The Ballroom Sequence, 4. The Downhill-Uphill Sequence."

Dream 3, the Ballroom Sequence, was slated to go before the cameras first, on the last two days of August. Dalí's conception for that dream had Bergman as a stone statue with ants crawling out of the cracks, "representing life taking refuge inside the statue," in his words. Hitchcock nixed the ants, an image he felt was too identified with the artist. But the statue was okay; and the production crew began a race against time to turn Bergman into one, and construct the ballroom.

As usual, Hitchcock found himself hurting for time *and* money, for Selznick, resenting the size of Dalí's fee, elected to compensate by scrimping on the length and budget of the dream sequences. Determined to have his Dalí dreams, Hitchcock insisted he could pull everything off with, if necessary, "no sets whatsoever—with possibly some miniatures but with somewhere between 80–100 [thousand dollars] per painting." Instead Selznick slashed the entire dream budget—from the original plan of $150,000 to $20,000.

Originally, Hitchcock had hoped to shoot "in the open air so that the whole thing, photographed in real sunshine, would be terribly sharp," in his words. Now he beat a retreat to the soundstages. At first, in order to create the impression of a nightmare, with "heavy weight and uneasiness" hanging over the guests in the ballroom, Dalí had envisioned hanging "fifteen of the heaviest and most lavishly sculpted pianos possible" from the ceiling and swinging them over the heads of cutout dancers "in exalted dance poses" who "would not move at all, they would only be diminishing silhouettes in very accelerated perspective, losing themselves in infinite darkness." Saving time and money, Hitchcock substituted miniature pianos dangling over the heads of live dwarfs.

No one had bothered to inform Dalí of the changes. Arriving at the studio to observe the filming on August 30, the artist was "stupefied at seeing neither the pianos nor the cut silhouettes." He was assured that tiny pianos and dwarfs "would give perfectly the effect of perspective that I desired. I thought I was dreaming. They maneuvered even so, with the false pianos and the real dwarfs (who should be false miniatures). Result: The pianos didn't at all give the impression of real pianos . . . and the dwarfs, one saw, simply, that they were dwarfs. Neither Hitchcock nor I liked the result and we decided to eliminate this scene. In truth the imagination of the Hollywood experts will be the one thing that will ever have surpassed me."

Meanwhile, in order to turn Bergman into a statue, the actress had a breathing pipe placed in her mouth. A papier-mâché mold was constructed around her, and then she was draped in a Grecian gown, with a crown on her head and an arrow through her neck. When action was called, she burst out of the mold; when the film was run backward, the actress seemed to metamorphose into a statue.

With Dream 3 completed, they had to wait a week before Dream 1 was ready, with its giant scissors and painted eyes. Dalí himself chalked up "the jagged path that he wished the giant scissors to follow," cutting the eye-adorned curtains, according to Bigwood. "As specified in Dalí's sketches and notes, metronomes embellished with cutout eyes (a twenty-year-old image borrowed from Man Ray) were set in motion 'precisely synchronized in opposing directions' on tables with human legs. His plan to have a 'cockroach with an eye glued onto its back moving across the blank cards' was politely rejected, as was his suggestion that 'the eye could reappear and serve as a dissolve into the wheel in the chimney scene' " for the still-unfilmed Dream 2.

Flitting around a nightclub and kissing all the gamblers in this scene was a lady sprite, or "kissing bug," wearing "hardly anything." (The gamblers are wearing weird stocking masks and playing distorted card games.) Dalí himself created the costume for kissing-bug Rhonda Fleming by

spending two hours with a large scissors cutting a four-hundred-dollar Dior negligee into shreds. When his creation was shown to the Hays Office, however, the censors insisted on additional shreds to cover her exposed midriff, thighs, and breasts.

Two dreams down, two to go: Hitchcock moved on to numbers 2 and 4. The Two Men on a Roof and Downhill-Uphill converged in a murder committed on a snowy rooftop, with one man sporting an insecure beard and another clutching a limp wheel—a Dalí trademark.

By the end of the month the dreams were done, assembled, and shown to the producer. But Selznick was unimpressed. His notes ordered retakes, optical work, newly dubbed dialogue, and fresh editing of all sections of the dreams—adding significantly to the costs. "Selznick's hopes for an inexpensive dream sequence were history," wrote Bigwood.

Hitchcock had compromised, he had cut corners, he had labored mightily—and it was no longer any fun. After finishing the rough cut, he spent only one more day in the studio, according to Leonard Leff. Then the director abandoned *Spellbound* and his Dalí dreams for England, where he had agreed months earlier to meet with Sidney Bernstein.

Selznick was glad to let him go. The Dalí dreams were bothering DOS—he questioned even the merit of the art—and now he could tinker freely with them. The producer ordered another art director, William Cameron Menzies, to begin retakes stripping away Dalí's background for the statue dream, and refilming Bergman sitting in a "weird deserted place." Menzies shot new close-ups of the man cutting the giant eye. "Though the scene had been originally shot using a double, Norman Lloyd did the honors in the closeup," according to Bigwood. "His presence in the dream (as well as Rhonda Fleming's) was a subtle clue to the mystery, as both appeared elsewhere in the film. The fact that they are both unrecognizable in the finished sequence somewhat diminishes the clue's value."

The retakes spilled into December. There was so much reshooting, recutting, and redubbing that Selznick decided the dreams were no longer Dalí's—they were Dalí's with "other work, not by Dalí, being mixed in." He explored the possibility of lowering the size of, or changing the wording of, the famed surrealist's screen credit. But the credit was mandated by contract: "Dream Sequence Designs—by Salvador Dalí."

Later interviews with Bergman have given rise to the idea that the dreams were originally "a wonderful twenty-minute sequence that really belongs in a museum"—that Selznick hacked the Hitchcock-Dalí vision to bits. This is pure myth, according to Bigwood. On-screen, the dreams totaled slightly under three minutes. "The sequence was indeed originally intended to be longer," Bigwood explained. "Never twenty minutes long— Ingrid Bergman exaggerates a bit—but certainly forty or fifty seconds

longer than it finally wound up." The only one of the vignettes to be dropped entirely was that of Bergman as a statue, along with the "weird deserted place" as its background.

The dreams may not have been hacked to bits, but Selznick had fought them from the beginning, and then starved the budget, reshooting, recutting, and finally attenuating Hitchcock's vision. The director blamed Selznick, but he blamed the surrealist equally. The famed artist was "really a kook," Hitchcock told Charles Higham years later, whose notions were too bizarre for Hollywood.

When Dalí finally saw the finished *Spellbound,* he too was disappointed. "*Les* best parts in Hitchcock *que* I like he should keep," the surrealist was quoted, "that much was cut."

En route to London, the director stopped in Boston to attend the preview of a new play. His daughter, Pat, now sixteen, had landed another part in a Broadway-bound comedy drama called *Violet,* adapted from a series of *Redbook* stories about a young Miss Fix-it who helps untangle her father's love life. Having missed his daughter's professional debut during *Saboteur,* Hitchcock had no intention of missing this play for *Spellbound.* He proudly congratulated Pat backstage.

The producer of the play was Albert Margolies, who had been Gaumont's publicity chief in the United States, and then Hitchcock's East Coast press agent after the director moved to America. The playwright was Whitfield Cook, a Yale-educated author who had published short fiction in *American Mercury, Story,* and *Cosmopolitan.* (Cook's *American Mercury* story won an O. Henry "Best First-Published" award in 1943.)

Mrs. Hitchcock had read *Violet* and asked to meet Cook, who was working in Hollywood under contract to MGM. He was also going to direct the play. She liked the playwright as much as his play, and helped with some structural suggestions for the final revisions.

Read-throughs and rehearsals were in September, and once again Alma accompanied Pat to New York, staying with her at the Wyndham. Alma wrote home about the time they spent with Joan Fontaine after the premiere of *Frenchman's Creek* and the plays they attended, like Samson Raphaelson's latest—the Hitchcocks always kept up with the careers of people they knew personally. Her letters also make it clear how much the New York cost of living worried her ("things are dreadfully expensive here, much higher than L.A."). She asked about the family dogs (one had been left in the care of Joan Harrison), and fretted about her husband's weight, which was always burgeoning. She knew Hitchcock had a habit of stalling his checkups with Dr. Ralph Tandowsky, and urged his secretary to remind him to make a doctor's appointment when he returned to the

United States. New York weather was "very dreary and humid," she said. "I miss the house and garden so much, and Mr. H.," Alma wrote her husband's secretary, "I don't think I can do this again."

Following out-of-town previews, *Violet* opened at New York's Belasco Theater in October, but Pat's second Broadway play did little better than the first, closing after twenty-three performances. *Violet* earned "dreadful notices," Alma lamented, reporting back to California. "Pat has taken it all splendidly—her only concern is for Whit. I nearly cried on the second night. My view on actors has changed considerably—they all put on such an act of gaiety and went on the stage giving better performances than they'd ever given."

Hitchcock was still in London, where he and Sidney Bernstein were rolling up their shirtsleeves to plan a film company that would link their friendship and their dreams across the ocean under the name "Transatlantic Pictures." While the director was busy planning films that might be as artistic as they were commercial, Selznick oversaw the postproduction of *Spellbound,* continuing to chip away at its length. The film may have lost less than a minute of Salvador Dalí, but Selznick robbed it of up to twenty minutes of Hitchcock.

Hitchcock was in England for nearly two months: the new partners had much to talk about. Transatlantic Pictures, as its name suggested, would exploit the best available talent from England and America, dividing the creative and business operations equally between the two nations. Of course, this was a dream that dated back to Islington—a dream that might be said to have a long, distinguished history of failure—but Hitchcock and Sidney Bernstein thought they were the ones to make it work.

The Transatlantic chapter in Hitchcock's life has been inadequately reported, and misunderstood. In order to make the new company successful, the principals—there were only ever two (not counting Alma, who was ex officio), and never more than a handful of employees—had to parlay a start-from-scratch operation into a fully competitive enterprise, following a model that had never before been successful. And one of the principals was busy directing films, while the other had no real production experience.

Transatlantic's first challenge was to find investors. The company had to raise production capital by negotiating low-interest loans from banks on both sides of the Atlantic. They needed a major Hollywood studio to share the financial risks—and, just as important, to implement the distribution of Transatlantic films in America and around the world. (Bernstein would handle distribution in England through his chain of cinemas.)

And in order to establish credibility with banks and a Hollywood studio, the new company had to have stories and stars that would reassure its in-

vestment partners. Each of these needs was inextricably linked to the other, but a first priority was to option and develop stories that would attract box-office names. Finding these properties was actually more difficult than finding investors, because Transatlantic—a two-man operation—was in ceaseless competition with the major studios in London and Hollywood, which made it their habit to snap up everything that had been published or performed, while simultaneously employing armies of writers to think up suitable originals.

The hunt for financial partners would be led by Bernstein; as the businessman of the pair, he would naturally guide the business decisions. Hitchcock would be the creative head of Transatlantic, but the initial plan was that he and Bernstein would woo other directors and creative artists to join their dream. After two months spent planning the future, they were optimistic about their chances. But Hitchcock and Bernstein were also hardheaded about the film industry, and they knew their success would depend on good luck as much as hard work.

Returning from London through New York, the director sat down with Ben Hecht to hash out the script of his next film. He had an informal two-picture understanding with Hecht, and if *Spellbound* was the Selznick film, *Notorious* would be the Hitchcock original.

In midsummer Hitchcock had signed an extension of his Selznick contract, settling on the disputed number of films he owed the producer—now agreed as two—in exchange for a backdated pay raise. Transatlantic, the director realized, was going to take a while to gestate, and he wanted to keep working; he also wanted to work with Hecht again.

Hecht also owed a Selznick picture, and while developing *Spellbound* he and Hitchcock had discussed a second project, originating with a musty *Saturday Evening Post* serial from 1921 called "The Song of the Dragon." Written by John Taintor Foote, the serial concerned an American theatrical producer approached by federal agents; they want to hire an actress, with whom the producer was once infatuated, to seduce a monocled English gentleman living on Fifth Avenue. The monocle man is actually German, the leader of a "small army of bomb planters and incendiaries" trying to sabotage U.S. industry.

A few basic elements of "The Song of the Dragon" were eventually carried through in the development of *Notorious* (its lead female character is an amateur Mata Hari recruited into the pretense of romance with a German agent). But the *Saturday Evening Post* serial was mainly an excuse for Selznick to use a property he owned, and for Hitchcock and Hecht to lull the producer into complacency while they went about changing the story so radically that its origins were unrecognizable.

The real inspiration of *Notorious* was closer to home. In Hollywood during World War II, several of Hitchcock's friends gathered intelligence on behalf of England's Ministry of Information. More than once, amateur English spies had been asked to seduce suspected German operatives. Charles Bennett wrote in his unpublished autobiography about one such incident; though married, Bennett claimed he was assigned to romance a suspected female double agent in order to ascertain her true loyalties. Actor Reginald Gardiner was another Hitchcock friend drafted by MOI into a furtive relationship with an actress believed to be a Nazi sympathizer—a liaison that came to cloud his marriage.

While "The Song of the Dragon" took place in New York City during World War I, the first thing Hitchcock did (as he often did) was to move the setting and time frame forward—not to Hollywood, but to Miami in 1946, *after* World War II. Even as the war was winding down, Hitchcock and Hecht grew obsessed with the future of the Nazis and their sympathizers. Hitchcock had predicted the repatriation of the Vichyites in *Aventure Malgache;* the year before *Notorious,* Hecht had written a play called *A Flag Is Born* attacking the "British barbed wire" surrounding Palestine, the Jewish homeland. (Zionism provoked Hecht's blacklisting in England, but his anti-British reputation doesn't seem to have given Hitchcock the least pause.)

As was his wont, Hitchcock had begun planning *Notorious* while still filming *Spellbound.* In August he and Hecht had mapped out a treatment, focusing the new story on pro-Nazi scientists outside of Germany regrouping for another try at world conquest. Hitchcock was far enough along in his thinking to (presciently) propose South America as the main locale. And once again they were hoping for Ingrid Bergman and Cary Grant.

In December, after Hitchcock returned from England, they worked on fleshing out the lead characters: Grant would play the American intelligence agent trying to penetrate a ring of fascists-in-exile. Ingrid Bergman had tentatively agreed to portray the woman of "loose morals" whose father has been convicted as a traitor—linking her character, in this last of Hitchcock's four World War II films about spies and saboteurs, to that of Laraine Day in *Foreign Correspondent.* Exploiting her guilt over her father, Grant would coerce Bergman into an undercover assignment, which she accomplishes so credibly that the South American Nazi proposes marriage. Despite the growing attraction between Grant and Bergman, the agent urges her to accept the marriage, leading to her endangerment.

The Hitchcock-Hecht story conferences were "idyllic," observed Frank Nugent in the *New York Times.* "Mr. Hecht would stride about or drape himself over a chair or couch, or sprawl artistically on the floor. Mr. Hitchcock, a one hundred and ninety two pound Buddha (reduced from two hundred and ninety five) would sit primly on a straight-back chair, his

hands clasped across his midriff, his round button eyes gleaming. They would talk from nine to six; Mr. Hecht would sneak off with his typewriter for two or three days."

The casting helped drive the writing. Grant's Devlin would become a coldhearted government operative gradually thawed by the more selfless Alicia (Bergman). (In "The Song of the Dragon," it was the other way around.) But what should Alicia's mission be? What were those South American Nazis up to? This was the film's Macguffin, but it was as elusive to Hitchcock and Hecht as it is to Devlin in the film. The two sketched in the idea of the German refugees setting up a secret army in mountain camps, knowing all along that this was just a temporary solution.

Then, taking a break from the scriptwork, Hitchcock volunteered for his own secret government mission. In early December, he and Hecht agreed to create, for the U.S. State Department and Office of War Information, a ten-minute film looking ahead to postwar foreign policy, touting world unity while laying the groundwork for American participation in a "world security" organization. This unusual project was personally authorized by Secretary of State Edward Stettinius Jr.

On the day after Christmas, 1944, the two men traveled to Washington, D.C., and "sat up most of the night" of December 26 "roughing out a script," in Hecht's words. The original idea was simply to film a six- or seven-minute speech by Stettinius, weaving it together with newsreel footage. But Hitchcock and Hecht preferred to dramatize the need for a world-security organization. They urged outlining "the proposed international organization in dramatic form by projecting into the future and telling the story of its operations in stopping an unnamed potential aggressor about the year 1960," according to Stettinius memos.

When Hecht outlined the script ideas they had brainstormed to a group of State Department officials on December 17, everyone present, including the secretary of state, agreed "that it was a very dramatic and effective presentation." Although there was talk of an actor narrating the film, Hitchcock insisted that "for dramatic effect it would be necessary for the Secretary to carry the entire narration."

But as usual with Hitchcock's war work, his ideas were too hard-hitting. The projected script's blunt warning about "a future belligerent attack by a world power, threatening peace in the futuristic world," in the words of film scholar Sidney Gottlieb, alarmed U.S. officials, who were hoping to build postwar relationships with former enemy nations. Sensitive policy points were overlooked, even trampled, by the "combined imaginations" of Hitchcock and Hecht, according to one memo.

Although some published sources indicate that Hitchcock may eventually have shot a couple of scenes for the short film, ultimately titled *Watchtower over Tomorrow*, John Cromwell was credited as director. Whether

it was ever shown publicly is uncertain. As with his war work for England, this quasi-Hitchcock film for the U.S. State Department not only bucked conventional politics, but went unreported for years.

In *A Child of the Century,* Hecht bemoaned the whole interlude as a waste of time, dismissing the secretary of state and all his colleagues as a "vacuous wagonload of politicos." He and Hitchcock were in Washington for only a few days; they returned to New York in time for Alma and Pat to join the director for the holidays. And the trip had other creative pay-offs: while in D.C. Hitchcock soaked up the top secret atmosphere—and came away with an intriguing idea for a *Notorious* Macguffin.

By the time they got to Hollywood in January, Hitchcock and Hecht had fifty pages of *Notorious.* Selznick had asked to see their progress by February 1.

"Selznick remained an extraordinary editor," Leonard Leff writes in *Hitchcock and Selznick.* "He read the *Notorious* first draft, criticized the occasionally precipitous story turns or mediocre treatment of certain plot points, and scribbled double question marks and triple exclamation marks in the margins."

One early draft, according to Leff, had Alicia speaking in "Tallulah fashion," which Selznick lambasted as "horribly coarse without being witty," complaining that it consisted of "jokes and words that date back to Hecht and MacArthur's *Front Page.*" According to Leff, "Noting the omnipresence of Hecht in the treatment, Selznick cried, 'More Hitch.' "

This notion of DOS as an editor extraordinaire of Hitchcock scripts is itself extraordinary, although it is presented as all but gospel in other books as well. Hitchcock and Hecht, both grizzled veterans of a practiced Hollywood regimen that routinely involved multiple drafts (and multiple writers over the course of many months), didn't need Selznick to tell them their first draft was formative. "The script writing moves thru a molasses covered paper," Hecht wrote to his wife early in 1945, "but it moves."

Hitchcock didn't need Selznick to tell him to add his personal stamp to a script, either. After Selznick's comments, in fact, Hitchcock and Hecht spent another four months working alone, without the producer. It wasn't until May that they got down to regular late-night meetings with Selznick. Hitchcock and Hecht would hunker down at Romanoff's beforehand; Selznick didn't expect them until 11 P.M. Then "for four hours," wrote Leff, "the producer would pace, discourse, and digress, then at three in the morning finally turn to the project at hand."

Hecht's letters to his wife make it plain how much he enjoyed Hitchcock's company. They dined together "like two Edwardian dandies," he wrote. And he also appreciated Selznick's notes, "that extra twenty per cent" worth of fine-tuning, as Hecht put it.

But neither he nor Hitchcock was blind to the fact that Selznick didn't seem very enthusiastic about their pet project—or that much of his advice didn't suit their higher ambitions for the film. Aware of the producer's short attention span, and the fact that his costly production of *Duel in the Sun* starring Jennifer Jones was then spiraling out of control on location in Arizona, they listened patiently to Selznick, nodding to him and each other. And then they simply went ahead with their own plans.

The producer was of little help on the most stubborn plot point: What was Alicia's mission? What was the plot objective? By March 1945 Hitchcock and Hecht were itching to reveal their solution: Hecht's letters began referring to his son as "the little atomic bomb," and by April even the press had been informed of their "secret researches," in the words of Thornton Delahanty in the *New York Herald Tribune*.

It was a variation on an idea that Hitchcock had nurtured over most of his career. "Big Bomb Sensation!" Hitchcock's newsboys scream in *Sabotage*. Russell Maloney of the *New Yorker* had told the director about rumors of a secret government project in New Mexico; then, during their trip to Washington for *Watchtower over Tomorrow,* Hitchcock and Hecht had picked up further tantalizing hints of the revolutionary weapon of mass destruction being developed by a team of U.S. scientists. "A bomb," the director liked to tell scriptwriters, "is always good." The biggest bomb sensation in history? That would be very good indeed.

Musing aloud with Hecht, the director—who prided himself on being a wine connoisseur—said he thought the vital component to such a bomb might be hidden in the wine cellar of the German agent's mansion. Rooting around for clues in the cellar, Alicia or Devlin might accidentally break a bottle of 1934 Pommard, only instead of burgundy, out spills sand— pitchblende, uranium ore being mined by the fascists.

Donald Spoto calls Hitchcock less than honest for claiming he consulted an expert on the subject of atomic weaponry. But it's exactly the sort of thing the director was wont to do. In the spring of 1945, probably in mid-March, Hitchcock and Hecht visited Dr. Robert A. Millikan, the first American-born physicist to win the Nobel Prize, at his offices at the California Institute of Technology in nearby Pasadena. Millikan was known for his radiation and nuclear-energy research and for application of that research to military problems.

According to Hitchcock, Millikan vaulted out of his chair and warned the director against inquiring into such high-level secrets. Although Millikan's appointment book doesn't prove the visit, contemporaneous newspaper accounts allude to it, and attest that California Institute of Technology scientists were "pretty leery" about talking to the Hollywood duo.

The Macguffin would cause the director almost as much grief back at the studio as he claimed it did in Millikan's office. Selznick doubted the

plausibility of Hitchcock's idea, and his own research staff backed him up; no one except science fiction authors had ever heard of a mass weapon spawned from uranium. The uranium bomb gave Selznick an excuse to temporize about the script: The uranium might be a good idea, or then again it might not. In any event, he would have to study it further. DOS wanted to make pictures for average Americans. Wouldn't such an unfamiliar idea baffle audiences?

By this point Hitchcock and Hecht had chalked up more than six months of writing, and the producer was starting to regard *Notorious* as "the most expensive script in the history of my career." But the director wouldn't surrender the idea of wine-bottled uranium as the film's Macguffin—and Selznick's vacillation only gave him more time to polish the script.

At one point, a frustrated Selznick even threatened to sell the whole kit and caboodle to producer Hal Wallis. Acting in collusion, Hitchcock and Ingrid Bergman swiftly agreed—startling Selznick. Their willingness to abandon him was "a blow to my ego," Selznick admitted. So he did offer *Notorious* to Wallis, who had been trying for years to coax Hitchcock over to Warner Bros., but Wallis ended up rejecting the package—because of the uranium in a wine bottle. As one of Wallis's assistants later told Hitchcock, "The bomb was a goddam foolish thing to base a movie on."

Wallis's rejection reinforced Selznick's skepticism—and yet never were cautious producers so foolish. Uranium was indeed a fissionable component of the bombs that were dropped on Hiroshima and Nagasaki just a few months later. Even stupider, neither Selznick nor Wallis seemed to realize that the wine-bottle uranium was merely an intriguing footnote to a film that was shaping up as one of Hitchcock's greatest love stories.

The spring of 1945 passed pleasantly. Well paid at last, finding spare time for his own projects at last, Hitchcock was moving in several directions at once. He read stories for Transatlantic and dabbled again in radio, producing another audition show, this time a dramatization of Francis Iles's "Malice Aforethought," which was offered as yet another series pilot.

Ingrid Bergman and Dr. Petter Lindstrom were frequent dinner guests at Bellagio Road. Alma liked the actress and her dentist husband as much as Hitchcock, and after dinner, Donald Spoto wrote, the couples often rolled back the carpet and danced to the radio, or to recordings.

Whitfield Cook had become a regular guest, and Joan Harrison also often came to dinner, sometimes accompanied by her date, Clark Gable. Another frequent guest was Ben Hecht, who was in and out of town; Hecht had a fierce reputation, but Cook was surprised by his "quiet gentleness" while off-duty at the Hitchcocks'. When there wasn't dancing

after dinner, there might be Scrabble or other board games, or perhaps a stroll across the golf course. The Hitchcocks' London habits continued, as the couple made excursions to local theater or road shows. In the spring of 1945, the Hitchcocks organized a group outing to see Paul Robeson in *Othello*.

In late March, taking the train up to Santa Cruz for the weekend, Hitchcock told Cook the entire story, thus far, of *Notorious*. (On this trip Cook heard the title for the first time.) Swiftly becoming a regular visitor to "Hitchcock North," Cook discovered that the host also was surprisingly unfierce off-duty. Work was discouraged at the Hitchcock home overlooking Monterey Bay (although stories came up, and the director meditated on his projects in his enormous marble bathtub). The director had an extensive collection of gardening books, and puttered endlessly in the garden. Shedding his usual uniform, he roamed the estate in shirtsleeves and shorts, and visitors were invited along on the country walks he took with Alma. The director read and dozed in the sun; he and Alma sat for long spells on a bench at the top of a hill, gazing at the ocean. On Sundays, Cook drove Hitchcock and Pat to church.

Weekends up north, Hitchcock was "hilariously funny," thought Cook. His old stunts were revived for new friends. He greeted guests in the mornings in mock-butler mode, offering a newspaper and champagne in glass-bottomed pewter mugs. On occasion he could even be induced to perform his long-dormant "breast ballet." Once, Cook recalled, Hitchcock had to return to Los Angeles early, and Alma, Cook, and other guests saw him off at the train station. The director entered his sleeping car, drew up the shades, and started a striptease "with all the mannerisms of burlesque," in Cook's words. Alma shrieked with laughter, "Oh Hitch, stop it! Stop!" "There was a lot of fun in him," recalled Cook.

In June 1945, David O. Selznick decided to postpone *Notorious* indefinitely. He wanted to bring in a new writer to work on the script while he shopped the package around to other studios besides Warner's. Hitchcock didn't so much as blink.

Delay was perfectly acceptable to Hitchcock; after all, according to the latest amendments to his contract, DOS had to pay his salary regardless. Hitchcock didn't care to rush *Notorious,* and he had other pressing commitments. As he had agreed back in February, Hitchcock was heading to London in mid-June 1945 to make one final government war film for Sidney Bernstein: a documentary about the horrors of the Nazi concentration camps, intended for distribution to German audiences.

The idea for such a film had originated early in 1945, when Bernstein was among those in the Allied command structure who were stunned by revelations emerging from the newly liberated camps, and proposing "a systematic record" of the concentration camps, using footage provided by

military and newsreel photographers accompanying the British, American, and Russian forces sweeping across Europe. The supreme commander officially ordered the documentary film in April, but progress had slowed over the question of which government (and which director) would ultimately organize the sensitive content.

Other eminent directors—Carol Reed and Billy Wilder among them—were approached about compiling the documentary. But Hitchcock was the only one who could set aside time in the summer and guarantee a month of availability. "It was a great tribute to Sidney that Hitchcock agreed to come," wrote Bernstein biographer Caroline Moorehead, for even though the end of the war was in sight, conditions for travel were still neither safe nor predictable. Air passage proved impossible, and once again the fastidious Englishman had to sacrifice creature comforts to travel aboard a crowded ship, sleeping "in a dormitory with thirty other people," in his words.

By the time Hitchcock arrived in London, in fact, the United States had withdrawn its support for the project, deciding instead to produce its own documentary about the camps. In early July, the Psychological Warfare Division of the Supreme Headquarters Allied Expeditionary Force (SHAEF) dissolved, eliminating the other Allies as well.

But the British, spurred by Sidney Bernstein, decided to go ahead and produce their own documentary. It would be one of the last acts Bernstein—a tireless antifascist and crusader against anti-Semitism—would perform before relinquishing his SHAEF and Ministry of Information posts.

In late June, Hitchcock checked into Claridge's, immediately meeting with two writers who had witnessed the atrocities of Bergen-Belsen firsthand. Richard Crossman (later a Labour member of Parliament, and a minister in Harold Wilson's government of the 1960s—his book *Diaries of a Cabinet Minister* was a sensation in its time) contributed a treatment, while Colin Wills, an Australian war correspondent, wrote a script that relied heavily on narration.

The director had committed himself to the project early enough to give Hitchcockian instructions to some of the first cameramen entering the concentration camps. Hitchcock made a point of requesting "long tracking shots, which cannot be tampered with," in the words of the film's editor, Peter Tanner, so that nobody could claim the footage had been manipulated to falsify the reality. The footage was in a newsreel style, but generally of high quality, and some of it in color.

"One of the big shots I recall," said Tanner, "was when we had priests from various denominations who went to one of the camps. They had a Catholic priest. They had a Jewish rabbi. They had a German Lutheran and they had a Protestant clergyman from England. And it was all shot in one shot so that you saw them coming along, going through the camp, and

you saw from their point of view all that was going on. And it was never cut. It was all in one shot. And this *I know* was one of Hitchcock's ideas."

The footage spanned eleven concentration camps, including Bergen-Belsen, Dachau, Buchenwald, Ebensee, and Mauthausen. The filmmakers ended up with eight thousand feet of film and newsreel, some of it shot by Allied photographers, the rest of it impounded. It was to be cut and assembled into roughly seven reels.

At the MOI theater on Malet Street, Hitchcock watched "all the film as it came in," recalled Tanner, although the director "didn't like to look at it." The footage depressed both of them: the piles of corpses, the staring faces of dead children, the walking skeletons. The days of looking at footage were long and unrelievedly grim.

The concentration camp film, like *Watchtower over Tomorrow,* was expected to perform the miracle of excoriating Nazi brutality while holding up optimism for postwar Germany. But by early August, shortly after Hitchcock returned to the United States, funding was suspended with only five or six reels finished. "The military command, our foreign office and the U.S. state department, decided that the Germans were in a state of apathy and had to be stimulated to get the machine of Germany working again," Bernstein recalled bitterly years later. "They didn't want to rub their noses in the atrocities."

Despite Bernstein's protests, the unfinished fifty-five-minute film—without completed sound or narration—was dumped into the Imperial War Museum, under the title of its archival file number: "F3080." It wasn't unearthed and shown to the public until 1984. Then, like Hitchcock's other wartime contributions, "F3080"—or "Memory of the Camp," as it has come to be known—was discovered to be no Hitchcockian flight of fancy, but an extremely hard-nosed, politically farsighted, totally unflinching look at the nightmare truth—"truth," as Norman Lebrecht wrote in the *Sunday Times,* "at its most naked."

Hitchcock's belief in *Notorious,* fortified first by his trip to Washington, D.C., was only strengthened by the stark footage in London. Back in Hollywood, though, David O. Selznick was losing faith in a film that had never really interested him.

The project still posed all kinds of problems to Selznick. The producer preferred Joseph Cotten, his contract player, over Cary Grant, who would come with ego and salary demands. The Macguffin still bothered him. As *Duel in the Sun* drained his resources, *Notorious* looked increasingly like a millstone he ought to unload.

Hitchcock seemed remarkably indifferent as Selznick opened negotiations with RKO—perhaps because he had already met with RKO pro-

ducer William Dozier several times back in the fall of 1944, pitching him a not-dissimilar story of "a woman sold for political purposes into sexual enslavement." Thanks to Hitchcock, Dozier—on the verge of marrying Joan Fontaine—was already an interested customer.

An amiable, laissez-faire producer, Dozier wound up paying the astronomical price of $800,000 for a package that included Hitchcock, Ingrid Bergman, and the script, as well as agreeing to cede 50 percent of any net profits to Selznick.* When Selznick stipulated that *Notorious* must undergo one final revision as a condition of the sale, Hitchcock was obliged to agree. But when Selznick spoke up against Cary Grant, who wasn't available right away—urging RKO to go ahead with Joseph Cotten—Hitchcock invoked a subclause in the deal that prohibited any further interference by Selznick.

The deal was all but signed by August 9, by which time the United States had dropped its atomic bombs on Hiroshima and Nagasaki—putting to rest any doubts about Hitchcock's Macguffin. And after Japan surrendered on August 14, ending the war, the script seemed all the more propitious, as it anticipated the fears—suddenly pervasive in the press—that diehard fascists would hide out and conspire after the peace.

RKO scheduled the filming of *Notorious* for later in the fall, giving ample time for the final rewriting and casting, and for Hitchcock to undertake a personal mission. At the end of the summer he and his wife set time aside to escort their daughter Pat to visit Marymount College in Tarrytown, New York, just outside of Manhattan. With Cary Grant unavailable until October, and Hitchcock away on the East Coast, Group Theater playwright Clifford Odets slugged away at a revision. During September and October, only minimally advised by Hitchcock, Odets took an unsatisfactory pass at the final script.

After Odets was paid and dismissed, after Selznick had been taken out of the loop, Ben Hecht returned to the project. Hecht was a notorious gun for hire, and it was becoming rare for him to care enough to see a film through from start to finish.

All along, DOS had used possible Production Code and government objections as arguments against the script; now this buck was passed to RKO. Not only was *Notorious* as politically provocative as Hitchcock's war propaganda films—imagining an alliance of U.S. fifth columnists and unregenerate Nazis at play in South America—it was also angling to be as sexually explicit as any Hollywood film to date.

* Hitchcock told Truffaut that *Notorious* cost $2 million to make, but grossed $8 million.

Hitchcock was his own best ambassador, meeting repeatedly with studio and Production Code officials, lulling people with the shifting script and his wry reassurances. The director planned one scene that would blatantly skirt the guidelines of the code, which forbade any "excessive and lustful kissing, lustful embraces, suggestive postures and gestures." Unofficially, screen kisses were limited to just a few seconds, but in this scene, set on the terrace of Devlin's apartment, Grant and Bergman would kiss passionately for much longer—their kissing interrupted by a ringing telephone, and then, as they moved inside toward the phone, by their nuzzling as they walked. The lines in the script were revised to the satisfaction of the censors, though it was the staging and the close camera work that stretched the code ("metaphorically," Hitchcock said later, "the camera had its arms around them").

The two stars worried about how strange it felt. Walking along, nuzzling each other with the camera trailing behind them, seemed "very awkward" to the actors during filming, according to Bergman. "Don't worry," Hitchcock assured her. "It'll look right on the screen."

It looked so right that it sneaked past censorship. "We kept moving and talking, so that the seconds were always interrupted," recalled Bergman.

It wasn't just the kissing that should have troubled the censors. What about the portrait of Alicia as a heavy drinker, hungover in the morning (plucking a hair out of her mouth), sleeping around on behalf of the government? "You can add Sebastian's name to my list of playmates," she bitterly informs Devlin after dutifully "mating" with Sebastian. But somehow Hitchcock slipped it all by the Code.

Hitchcock rarely managed to pull together a dream cast for any of his 1940s films, but *Notorious* was a glorious exception. Neither cool nor a pure blonde, Ingrid Bergman was by this time a close friend, a fellow intriguer in the great conspiracy against Selznick and Hollywood. Knowing her as well as he did, he could write her feelings and personality into the character of Alicia. Bergman was tired of playing saints, and in *Notorious* she got her chance to play a shame-ridden boozer, willing to sleep with the devil in order to wash away the stain on her conscience.

Just as Alicia was written to accommodate a humanized Bergman, the part of Devlin, a "fatheaded guy full of pain," was tailored for Cary Grant—not the sleek, witty Grant of screwball comedies and manly adventures, but the slick, tortured Grant who intrigued Hitchcock. In *Suspicion* Hitchcock had tried to turn him into a wife killer, and failed; but Devlin was even closer to Grant's own deep ambivalence. The triumph of the script was its love story, which took a boozy tramp and made her dou-

bly appealing by the fatheaded cad struggling to uphold his defenses against her.

For *Saboteur,* Hitchcock had tried unsuccessfully to get a prototypical American hero as his fifth columnist. For *Notorious* he needed a sophisticated actor with a foreign accent, and he landed Claude Rains, who had made a specialty of fatally flawed characters in a series of Oscar-nominated parts—*Mr. Smith Goes to Washington, Casablanca, Mr. Skeffington.* Rains had been established in American film since 1935, after acting in repertory with the Theater Guild in New York, but before that Hitchcock had admired him on the London stage in the 1920s. (The first Mrs. Rains, Isabel Jeans, had acted in *Downhill, Easy Virtue,* and *Suspicion.*) Now a short, middle-aged man, Rains was, like Alex Sebastian, vulnerable about his age and appearance in a sympathetic way.

Louis Calhern was cast as Cary Grant's boss, the dapper intelligence chief. Hitchcock, who targeted German Nazis in film after film during the war, also gave real-life German antifascists some of their best Hollywood roles. That was certainly true of Reinhold Schünzel, cast as a mild-mannered doctor among the fascist circle. Schünzel had been a reputable actor and director in Berlin; the transvestite comedy *Viktor und Viktoria* was the high-water mark of his directing career, before his flight from Hitler. Among the other uncommon faces were ex–ballet dancer Ivan Triesault as the killer Eric, and stage actor-director Eberhard Krumschmidt as Emil, who dooms himself by panicking over a wine label.

Undoubtedly it was Hitchcock's private joke that British diplomat Charles Mendl—the husband of ex-Broadway star Elsie De Wolfe—graced the film's first party scene as a playboy yachtsman sailing to Cuba. (He invites Alicia along with him, but instead she chooses South America with Devlin.) Mendl was active in Hollywood intelligence circles, and Hitchcock must have enjoyed watching him play a fascist on the run.

The character of Alex Sebastian's mother called for a combination of Nazi and dragon lady—a she-devil to rival Judith Anderson in *Rebecca.* Hitchcock had the inspiration of casting Czechoslovakian-born Leopoldine Konstantin, a charmer on the Berlin stage in the 1920s, now an older, more intimidating actress. Though she had appeared in German pictures before her flight from Hitler, this was Konstantin's only appearance in an American film.

The director had the pick of the RKO lot for his production team. He chose as his cameraman Ted Tetzlaff, who had photographed early Frank Capra pictures at Columbia and Gregory La Cava and René Clair comedies for Paramount. (Tetzlaff resisted Hitchcock a little during filming, but the Englishman stared him down.) The editor was Theron Warth, a journeyman who turned in his finest work under Hitchcock. Although Hitchcock was famous for his electrifying montages, his editing—especially of

love scenes—could be delicate. Scene after scene of *Notorious* is cut in a subtle, unobtrusive style that looks modern even today. When Alicia slides over in her airplane seat for a first glimpse of Rio de Janeiro, for example, she unconsciously leans into Devlin, and Hitchcock catches his eyes as they widen—as though, for the first time, he has caught her scent. This charged shot quietly dissolves into the next scene.

The production design was by Carroll Clark and Albert S. D'Agostino, two consummate art directors who later reigned at the Walt Disney studio in the 1960s. The special effects were by Vernon L. Walker and Paul Eagler, including a Rio de Janeiro evoked entirely through back projection. One of Selznick's last contributions was to insist on sending *Citizen Kane* cameraman Gregg Toland to Brazil to capture authentic scenery to blend in with Hitchcock's studio footage—a feat every bit as convincing as *Lifeboat*. Toland filmed an entire horse race, which the director used as a reflection in Bergman's binoculars; for another scene, where Grant and Bergman appear to be seated at a sidewalk café, Hitchcock simply filmed the actors on a soundstage in front of Toland's authentic footage—perfecting an illusion that he had first practiced as far back as the restaurant scene cobbled together from two versions for the talkie *Blackmail.*

Notorious also marked the beginning of Hitchcock's long collaboration with Hollywood's premiere costume designer. David O. Selznick had been fussy about the look of his leading ladies, but Hitchcock had his own longstanding ideas in that department; now, with RKO's permission, he made a point of borrowing Edith Head from Paramount, where she had supervised wardrobe for Preston Sturges and Billy Wilder films.

Head always said that of all the directors she worked with, Hitchcock was the most precise. "Every costume is indicated when he sends me the script," Head wrote in her memoir. "There is always a story reason behind his thinking, an effort to characterize." On another occasion, Head said, "He spoke a designer's language, even though he didn't know the first thing about clothes. He specified colors in the script if they were important. If he wanted a skirt that brushed a desk as a woman walked by, he spelled that out too."

When Devlin meets Alicia for the first time, in the scene where she is partying to excess, Ingrid Bergman would be dressed in stark contrast to everyone else in the room—"a zebra-skin print blouse with her midriff exposed," in Head's words. Later on, Alicia had to wear more demure clothing; as an infiltrator, Hitchcock cautioned, she needed to blend in, not stand out. He did away with any ornate jewelry, furs and feathers, silly hats—the kind of showoff accoutrements Bergman had worn at Selznick's behest in *Spellbound.* Costuming Bergman for Hitchcock was "an education in restraint" for her, said Head.

 Although Selznick had written associate producer Barbara Keon into the RKO contract to watch over his interests, by now she was basically in Hitchcock's camp. And William Goetz was as deferential as Jack Skirball. After twenty-five years in the business, it was Hitchcock's first official film as his own producer, with nearly the power that came with the title. With the *Notorious* script finally finished, and the cast and crew finalized, the filming was ready to start on October 22—after more than a full year's preparation.

From beginning to end, the filming of the dark-spirited *Notorious* was suffused with a positive glow. In November, champagne was popped on the set to celebrate the release of *Spellbound,* which had been launched by one of Selznick's all-out publicity campaigns (ranging from fashion layouts to airplane skywriting). From the majority of critics—*Newsweek* hailed it as "a superior and suspenseful melodrama"—to the lines of moviegoers who spent upward of $7 million on the picture at the box office, the new Hitchcock film exceeded all expectations. Its success was later crowned by six Academy Award nominations, including Best Picture and Hitchcock's third as Best Director. *Spellbound* was also nominated for Best Supporting Actor (Michael Chekhov), Black-and-White Cinematography (George Barnes), Scoring of a Dramatic or Comedy Picture (Miklós Rózsa), and Special Effects (Jack Cosgrove).

 The only nominee to collect an Oscar, however, was Rózsa. In his autobiography Rózsa complained that Hitchcock never even called to congratulate him—but Hitchcock had left *Spellbound* behind in postproduction, and one of its stupidities, in his opinion, was the otherwise stirring theme music that Selznick poured like syrup over too many scenes. In his sessions with François Truffaut, Hitchcock complained vigorously about the scene where Ingrid Bergman meets Gregory Peck for the first time. "Unfortunately, the violins begin to play just then," said Hitchcock. "That was terrible!"

 Any success was a dividend, but Hitchcock didn't kid himself. He didn't think much of *Spellbound.* "Just another whodunit," he informed an interviewer in 1946. "The whole thing's too complicated," the director told François Truffaut—and all those eleventh-hour plot explanations were "very confusing."

 Notorious, on the other hand, was a consummate Hitchcock film, in every sense filled with passion and texture and levels of meaning.

 The director adored his cast. He and Claude Rains were extremely friendly; Rains was born on the wrong side of the Thames, and his sophistication concealed a Cockney boyhood—he knew the same vernacular, even the same jokes, as Hitchcock. The director let Rains decide whether

he would adopt a strong German accent (the decision was no); the actor even managed to retain his good humor when Hitchcock mentioned "this business of you being a midget with a wife, Miss Bergman, who is very tall." Standing five feet seven—at least according to official publicity—Rains understood Hitchcock's point. If Bergman (who stood roughly five nine, but looked taller) towered over him in their romantic scenes, the effect might be inadvertently comical.

So for the scenes where Alicia and Alex strolled together hand in hand, Hitchcock built ramps for Rains that were unseen by the audience. The rest of the time, he told Rains, the actor should try elevated shoes. Hitchcock asked Rains to buy a pair and get used to wearing them. "Walk in them, sleep in them, be comfortable in them," the director urged Rains.

"In the close shots," Hitchcock explained to Truffaut, "the difference between them was so marked that if I wanted them both in a frame, I had to stand Claude Rains on a box. On one occasion we wanted to show them both coming from a distance, with the camera panning from him to Bergman. Well, we couldn't have any boxes out there on the floor, so what I did was to have a plank of wood gradually rising as he walked toward the camera."

Rains liked the elevated shoes so much he adopted them for personal use. Cary Grant didn't need extra height, but working with the enigmatic star was always a negotiation. The battle was half won once he was lured to the set; but even with a script he had approved, Grant was susceptible to mood swings, and always trying to rewrite his dialogue. Though Grant was open to direction, he didn't really require it from anyone, including Hitchcock.

Grant came to *Notorious* full of bounce, though—enough that he was able to coach Bergman through her initial period of adjustment. It was Grant, as much as anyone, who helped the actress through her second Hitchcock film—rehearsing her the way Devlin rehearses Alicia. "One morning, when we were working on *Notorious,* she had difficulty with a line," Grant recalled. "She had to say her lines a certain way so I could imitate her readings. We worked on the scene for a couple of hours. Hitch never said anything. He just sat next to the camera, puffing on his cigar. I took a break, and later, when I was making my way back to the set, I heard her say her lines perfectly. At which point Hitch said, 'Cut!', followed by 'Good morning, Ingrid.' "

More in control on *Notorious,* Hitchcock also had more flexibility than he had enjoyed with *Spellbound*. He was more tolerant of Bergman the second time around, and allowed the actress to try her own ideas and moves.

Indeed, he had grown exceptionally fond of Bergman, and there is little reason to doubt biographer Donald Spoto's assertion that the actress confided in the director—about her ongoing love affair with Robert Capa, for

example (who photographed the production for *Life*), or, later, about her crush on Italian neorealist filmmaker Roberto Rossellini, for whom she left her husband. The Hitchcocks were among the first to know about Rossellini, and although they liked Dr. Petter Lindstrom, they stayed loyal to Bergman.

Hitchcock liked to tell a story that Spoto scoffs at as the delusion of a repressed personality: one day the director arrived at home, according to Hitchcock, to find Bergman waiting for him, enticing him toward the bedroom, pleading for a tryst with her adored Svengali. Hitchcock told this tall tale to writer John Michael Hayes and other close associates, only slightly varying the details. (Sometimes it happened in his home, sometimes in hers.)

Or was it such a tall tale? It only happened "once," he always maintained. Hitchcock never dated the anecdote, but it's tempting to believe it occurred during *Notorious,* when Bergman was under a romantic spell and in the mood for sex, rather than on *Spellbound* (a trial run) or the later *Under Capricorn* (a fiasco). Although most people doubt Hitchcock's anecdote, why wasn't such a thing possible? Don't actresses fall in love with their directors all the time? He was no longer so grossly overweight—and wasn't he devilish and charming? Didn't Bergman have affairs with her other directors, notably Victor Fleming? Was Rossellini, later, such a dashing physical type? Doesn't the story Hitchcock told sound about right, for such a sly innocent?

Can anyone watch Bergman talk about the director, the night of the American Film Institute Life award in 1979, one year before his death, without feeling the love between them?

Whatever happened off the set of *Notorious,* Bergman described the filming as the "happiest experience" of her three Hitchcock credits, and that happiness—for all of them—translated into one of the director's greatest films: richer, more seductive, psychologically and politically darker than the far more commercially successful *Spellbound.*

Notorious was completed in January, the same month Sidney Bernstein visited Hollywood for his first talks with studio heads about Transatlantic Pictures. With both Transatlantic partners making such a confident impression in business meetings, getting American banks behind the new company was almost a snap. The partners struck up a fast relationship with Security National Bank in New York City and Southwest Trust and Savings in Los Angeles. Both were financial institutions with farsighted loan officers, Alex Ardrey in New York and George Yousling in California, who took the lead in investing in postwar independent production.

Ardrey and Yousling were not only reasonable about financial policy;

both were Hitchcock fans. The director grew particular close to Ardrey, sometimes phoning the banker after hours just to chat, relating scary bedtime stories to be passed on to Ardrey's children. When Hitchcock received the Irving G. Thalberg Award at the Academy Awards ceremony in 1967, his brief acceptance speech mentioned Ardrey, probably mystifying the audience—possibly it was the first time a banker had ever been thanked from that podium.

Bank loans made Transatlantic more attractive, but still, some studio had to share the risks. Which would offer the best combination of gross and profit percentages, office and studio space—and, not to be underestimated, the highest degree of creative autonomy?

From the first, Jack Warner at Warner Bros. emerged as most likely to succeed. The fact that Hitchcock had never worked at Warner's was an advantage; the head of the studio, eager to sign a three-time Best Director nominee, was like a suitor who'd waited all evening for a dance. Warner wanted Hitchcock to direct one Warner's picture for every Transatlantic film. Though Warner insisted on script and casting input on studio *and* Transatlantic productions, Transatlantic could develop its own packages autonomously—once the subjects were approved.

Warner was eager to get Hitchcock working on a Warner's film right away, but naturally the partners wanted to launch Transatlantic with a Transatlantic production, a property that gave them the advantage of ownership. Although all the stories were subject to approval by the banks and Warner's, it was up to Transatlantic to find its own material.

The time and expense typically involved in that process were extraordinary. MGM, for example, held weekly staff meetings at which a dozen story and production officials discussed between ten and twenty possible subjects that had been submitted by a wide array of scouts, agents, and editors. These stories—originals as well as adaptations, older books and plays as well as newly published ones seen before publication—were presynopsized, rated, and ranked by readers. Only if they passed muster were they read in their entirety by experienced in-house story editors. Each was then analyzed in terms of potential box office, critical or awards value, budget liability, and appropriate contract actors, writers, and directors. This laborious process could consume weeks before a decision was made—a tentative decision, and always subject to reevaluation, starting the process all over.

In the case of Transatlantic, Hitchcock had big eyes at the start, and once again he began rhapsodizing aloud about the kind of big-canvas, slice-of-life picture he'd always dreamed of making. "Whenever I have used New York in a picture," he told the *New York Herald Tribune* in 1945, "I have been licked by it. It's too big, too hard to get at with the camera. It would be wonderful to do a story entirely about New York in

color. What I mean is not the New York as it exists to the tourist or the casual observer, but inside New York, a behind-the-scenes, backstage New York, something that would show the inner life of the city, like the things that go on in the kitchens of big hotels.

"I would begin the story at four o'clock in the morning and end it at two the following morning," he continued. "I'd like to open with a scene in the Bowery showing a bum drowsing in a saloon, a fly walking on his nose: starting with the lowest form of life in the metropolis. And I'd end up, ironically of course, with the highest form of life, a scene the following morning in a swank nightclub, with well-dressed drunks slouching over their tables and passing out. I don't know what the story would be in between. That's the problem."

Almost from Bernstein's first visit to Hollywood, though, the partners were forced to scale back their ambitions. The real problem was that the partners didn't have the time or money to develop such an artistically ambitious film, when Warner's was clamoring for something commercial and modestly budgeted. Reluctantly, they decided to inaugurate a Transatlantic story department, although they could afford to hire only one person, in Hollywood, to sift through a pile of properties and submit reports. Their limited resources gave them little choice but to concentrate on obscure or first-time authors who might have been overlooked by the aggressive major studios. They gravitated to English novels in part because such books were more affordable and less likely to have already been sold to the Americans.

When Hitchcock wasn't dreaming of grand-scale epics, he was recalling past ideas that had eluded him. One story that intrigued Hitchcock harked back to his boyhood, and the inn in Leyton that had once been a hideout for famous highwaymen. Off and on over the years he returned to the notion of filming the saga of Jack Sheppard, the eighteenth-century English highwayman whose numerous jailbreaks made him a folk hero. He also talked over the years about mounting a version of *Lorna Doone,* the oft-filmed romance between a farmer and rebel's daughter, set in seventeenth-century England. Both of these projects were presented to Bernstein, who reminded the director of his vow to avoid costume pictures; but Hitchcock wasn't easily dissuaded—in fact, the challenge of overcoming his Achilles' heel seemed to tempt him all the more. The partners usually compromised by commissioning an inexpensive treatment, though the scope and expense of these costume subjects generally relegated them to the back burner.

One of the first books Transatlantic tried to option was *The Dark Duty* by Margaret Wilson, a novel Hitchcock had coveted since its publication in 1931. Its story concerned the harrowing hours leading up to the hanging of a murderer in England, and the injurious effects of the death sentence not only on the falsely accused man, but on the governor of the penal institu-

tion and his wife. An aficionado of the grisliest murder cases, Hitchcock was also an aficionado of executions—though he opposed capital punishment, and always thought that *The Dark Duty,* a propaganda novel about the execution of a wrong man, offered a welcome platform for his views.

But Transatlantic learned an early lesson in economics when the agents for Wilson, an Iowan transplanted to England who had won a Pulitzer Prize for *The Able McLaughlins* in 1924, learned that the film's director would be Alfred Hitchcock. The forgotten fiction's price went up, up, and up, until it was almost out of sight. Once again the partners compromised, throwing a pittance at the project, taking the shortest-term option, and authorizing a treatment—several steps ahead of real money, or a real commitment.

Among the authors the partners discussed was Helen Simpson, the cowriter of *Enter Sir John,* who had also helped out on the script for *Sabotage.* Simpson had died during World War II when German planes bombed the hospital where she was recovering from surgery. One of her admired novels, *Under Capricorn,* struck Hitchcock as a possible vehicle for Ingrid Bergman—even though, as Bernstein pointed out, it was yet another costume drama, set in Sydney, Australia, in the mid-nineteenth century.

Remakes were always on Hitchcock's mind, and the partners mulled a new version of *The Man Who Knew Too Much,* and discussed the possibility of expanding *Bon Voyage* or *Aventure Malgache* into features. While the partners read material and searched for the right property—at the right price—to use in launching their company, Jack Warner waited. Sorting things out would take time, and Transatlantic would need to have not just one project, but a whole roster of story material, before it could cement the best extended terms with the studio.

Meanwhile, David O. Selznick had been galvanized into action. With Hitchcock spending so much time in meetings at other studios, his prize director appeared to be slipping away from him. Anxious not to lose Hitchcock, the producer made an unexpected offer to renew his contract. It was an offer unheard of in Selznick annals: the director would remain under contract indefinitely, but *nonexclusively*, as long as he agreed to direct one Selznick production per year, at a guaranteed one-hundred-thousand-dollar salary plus a percentage of gross and profit receipts.

Hitchcock was tempted, if only momentarily. He had only one Selznick film left on his eternally amended contract, and now the onus was on the producer to decide what that film would be. Now, finally, it was Hitchcock who could afford to bide his time. Selznick was paying him five thousand dollars weekly to while away his time planning the future of Transatlantic.

Digging frantically into his sorely depleted story files, Selznick came up with a 1933 novel by English author Robert Hichens, purchased by MGM years before as a possible vehicle for Greta Garbo. Among the prolific author's many other books was the well-regarded *The Garden of Allah,* which had been adapted for stage and then filmed twice—once as a silent, and in 1936 as one of the first Selznick International pictures.

Critics had found *The Paradine Case* one of Hichens's better books. The story concerned a Danish woman, Mrs. Ingrid Paradine, who is accused of poisoning her husband, a blind war hero. Mrs. Paradine's lawyer, Keane, falls in love with her, jeopardizing his happy marriage and prosperous career. The judge hearing the case, Lord Horfield, is a bitter enemy of the lawyer, and Keane defends Mrs. Paradine too strenuously. When Mrs. Paradine reveals in court that she has had an affair with her husband's manservant—which provoked her husband's murder—Keane's humiliation is complete. Mrs. Paradine is found guilty.

Hitchcock could have turned the project down, but he was ready to move on with his career, and didn't mind the Hichens novel, with its heroine named Ingrid, its London atmosphere, and its Old Bailey climax. (Mrs. Paradine's story reminded him once more of the Edith Thompson case, although the fictional murderess admits her guilt.) Clinching his interest, DOS agreed to let Hitchcock scout and conduct research and lead a second unit in London, where he could spend more time moonlighting on Transatlantic on Selznick's dime.

Hitchcock wanted to tinker with the novel, though. One thing he anticipated changing was Mrs. Paradine's fate. Rather than submitting her to the executioner, as Hichens did (a move the censors wouldn't allow anyway), Hitchcock conceived of a different ending that would hint at her contrition while reflecting disapprovingly on capital punishment. Defeated in court and shamed by the truth, Mrs. Paradine would kill herself.

So the director said yes, and Selznick sent over the previous drafts of the *Paradine* script—a pile rising "eighteen inches high from the floor," according to Hitchcock. In March he and Alma collaborated on a new "dialogue treatment for budget purposes," working at home on Bellagio Road. Selznick's proxy-on-the-spot was again Barbara Keon, although Selznick privately grumbled to Dan O'Shea that Bellagio Road had evolved into a "country club," with Keon the latest "charter member."

Another figure informally drafted into the long-term brainstorming sessions was MGM contract writer Whitfield Cook, who was becoming Alma's sounding board when her husband wasn't around. Up in Santa Cruz on weekends, while Mr. Hitchcock dozed in the sun, Mrs. Hitchcock took walks with Cook and discussed their respective projects.

The Hitchcocks had renovated their kitchen and dining rooms, adding an outside dining area with a heated tile floor, and a large wine cellar. (His vineyard he donated to a nearby Catholic seminary; the grapes were har-

vested annually by priests-in-training.) Although their German cook some-times came north, Alma supervised the important meals, while Hitchcock played the sublime host. Generous gifts followed guests home: a first edi-tion, bottles of expensive wine, a box of Havana cigars placed on the seat of a departing car.

Ingrid Bergman and her husband, happy to escape the stuffiness of Hol-lywood, came for weekend stays. ("Both very nice and simple and fun," Cook noted in his journal.) The standoffish Cary Grant was more likely to turn up at Bellagio Road, not Santa Cruz. Bergman had promised to star in at least one Transatlantic picture, but Grant always turned himself into the object of a campaign. During *Notorious* Hitchcock had talked with the star about forming a partnership, either independent from or in conjunc-tion with Transatlantic. In a series of long lunches at Lucy's, a Mexican restaurant across from RKO, they worked at developing a story called "Weep No More." A young writer, Bess Taffel, was borrowed from the studio to organize the script, which originated in material Hitchcock had drawn from studio files. "But he could have taken anything out—it all re-volved around Hitch's ideas," recalled Taffel.

After they had brainstormed "Weep No More" for several weeks, Taffel recalled, the director asked her one day to retell the story back to him. She did so, emphasizing, as she later realized, characterizations at the expense of the plot. The director listened impassively. "That's all very interesting," he responded dryly after she was finished. "But what I want to hear from you now is this: Let's say the movie has opened, is a big success, and is playing at all the big theaters. And Mrs. Jones says to Mr. Jones, 'Are you playing cards again tonight?' He says, 'Yes, I am.' She says, 'Then I think I'll go to see a movie with Cary Grant.' When she comes home that night, he's lost a lot of money, and he doesn't want to be asked about it, so he says—'Did you see the movie?' She says yes. He says, 'What was it about?' And . . . what she tells *him* is what I want you to tell *me*."

Grant was skittish about "Weep No More" and also about the part-nership with Hitchcock. He didn't enjoy long lunches at Lucy's as much as the director, and didn't speak up much about the script, according to Taffel. Still, one day the star did ask Taffel to do something for the char-acter he was going to play: "Give him some zzzzz," he said, leaving Taffel free to interpret the request as she might. She interpreted it as "pizzazz." (That's the quality Tippi Hedren is said to bring to the Rutland household in *Marnie*.)

Twice in the first half of 1946—in February and May—Hitchcock flew to New York aboard Howard Hughes's private plane, along with Cary Grant and Hughes himself. The February passenger list also included Ed-ward G. Robinson, Paulette Goddard, and William Powell. Arriving in New York, the celebrities shot off to the Sherry-Netherland Hotel for

"elaborate wining and dining," according to Grant biographer Charles Higham. Hitchcock had his own agenda: interviews, business meetings, the usual sightseeing and theatergoing.

In late May, Bergman accompanied the two aboard Hughes's plane. Grant spent part of the trip in the cockpit, helping Hughes fly the plane. This time Hitchcock spent a week in New York, bringing his two stars to meetings to boost the prospects of Transatlantic. Influenza plagued him the whole week—and the return trip only made matters worse.

"We thought we were as good as home," recalled Hitchcock, "but then [Hughes] began to make stops. In Chicago, I believe, for a change of clothes. Then in St. Louis to go to a nightclub. The problem was, as difficult as it was to get commercial passage from New York to Los Angeles, it was all but impossible from anywhere else. So there we were, dropping in on some cabaret in Denver, or a restaurant in Nevada."

In between these two flights, on April 11, 1946, word leaked to the press that Hitchcock and Sidney Bernstein were organizing a new company to produce independent pictures in London and Hollywood. The first production, it was reported, would be *Under Capricorn*, with Ingrid Bergman in the starring role. Surprisingly, the second was announced as a contemporary *Hamlet*, starring Cary Grant.

Hamlet had arisen almost out of desperation. With Grant losing interest in "Weep No More," Hitchcock had scrambled for an alternative to keep the star on the hook. He went over to Warner Bros., where Grant was shooting *None but the Lonely Heart*, and pitched him the idea of a modern-day *Hamlet*—receiving Grant's tentative endorsement.

The notion was "to take the Shakespeare text and transcribe it into modern English," in Hitchcock's words, presenting the classic "as psychological melodrama." Hitchcock thought about finding an English professor to create a modern-language adaptation, which he and Mrs. Hitchcock would then convert into a cinematic treatment reinterpreting "the situations in a modern idiom." Their treatment could then be converted into a full script, Hitchcock assured Bernstein, by any Hollywood "stooge writer." And *Hamlet* had the added advantage of being cheap: Shakespeare, after all, was in the public domain.

After Mrs. Hitchcock submitted a 195-page revised version of *The Paradine Case*—basically an edited compilation of the many earlier drafts—Hitchcock prevailed upon the producer to hire the very opposite of a stooge: the preeminent Scottish playwright James Bridie (pseudonym of Dr. Osborne Henry Mavor).

Bridie, once hailed by J. B. Priestley as "the most undervalued dramatist of his stature," had had his first play produced in 1928, and wrote

over forty others in his career, including satires on the middle class, light fantasy, biblical and poetic allegories, and searching dramas. *Storm in a Teacup, A Sleeping Clergyman* (with Robert Donat as the original lead), *The Black Eye,* and *The Anatomist* are among the Bridie plays that remain in British repertory even today. A physician who never left his profession (he was always addressed in person as Dr. Mavor), Bridie set many of his plays in a medical context.

Things started out on the wrong foot, though, when Bridie flew from England early that summer to confer with Hitchcock, expecting to be met at the New York airport by a Selznick representative. When no one materialized, Bridie, "a very independent man," in Hitchcock's words, tore up his contract and flew home. Fortunately, Hitchcock, who had flown ahead for scouting and research, was waiting at the London airport to greet him.

But Bridie refused to return to America, and Hitchcock had to choose between discharging a man he respected, or collaborating from a distance with Bridie, who lived in Glasgow. An unreserved admirer of Bridie's work, he chose the latter—knowing that keeping the writer at a distance from Hollywood also shielded Bridie from Selznick.

Up to this time Bridie hadn't had much experience or luck writing for film, and the director had to compensate for their distance with lengthy phone calls and cables, laboriously explaining his ideas and methods, specifying the story's action and dialogue on a scene-by-scene, incident-by-incident, even line-by-line basis. One typical cable ran thirty pages, taking over thirty minutes to transmit.

Selznick had cautioned Alma to adhere to the book; now the director relayed the same advice. The one major change Hitchcock had proposed fell swift victim to the producer's anxiety about censorship. Neither America nor England would allow Mrs. Paradine's execution on the screen, but she couldn't commit suicide either—that was equally forbidden. How, then, should *The Paradine Case* end? What ending could possibly substitute for the original, or compare to the suicide crescendo Hitchcock had imagined?

Hitchcock focused on the climactic courtroom sequence. Perhaps Keane's rhetorical flourishes against the manservant might provoke Mrs. Paradine into openly confessing—a kind of emotional suicide that would rock the courtroom. With the lawyer devastated, the focus could then switch to Keane, and his crushing defeat. It bothered Hitchcock, though, this idea of finally unmanning the hero. "Do you think this could be written without making Keane too much of an ass?" he asked Bridie in one cable.

Almost from the inception of the project, Hitchcock had to feign his interest in many parts of the story. He never believed in Mrs. Paradine as a coldhearted murderer, and he never understood the mystery being parsed

in the courtroom. What exactly happened on the night in question? How exactly did Mrs. Paradine commit the murder? And why?

Though he directed more than a handful of films set in grand mansions, Hitchcock admitted in more than one interview that he himself felt lost and disoriented in such surroundings. Movie mansions—like the one RKO had forced on him for *Suspicion*—were always *too* grand. When it came to *The Paradine Case*, he confessed that he couldn't figure out how the rooms connected with each other, an issue that bears directly on Mrs. Paradine's guilt—and the explanation is forbiddingly complicated in the final film. The director mused in more than one interview that he couldn't figure out where the people went to the bathroom in such mansions. The camera in Hitchcock films liked to peek into the bathroom, just to make such things clear.)

And he never did resolve the crux of his problem with the book: why would such a beautiful woman kill her husband for such a mangy lover? Hitchcock understood handsome men committing murder, yes—but, less so, beautiful women. He needed a beautiful woman he could believe in, not one who murdered.

Consequently, his focus gradually shifted to the only true innocent of the story. Hitchcock told Bridie to build up Keane's wife, Gay, as an emotional counterweight, and to focus on the scene after Keane's courtroom debacle, that showed Gay and her husband behind closed doors. He wanted that scene to be a reaffirmation of marriage, the film's real crescendo—"a moving scene of reconciliation without any necessary physical embrace," in the director's words.

Over the summer of 1946, at his home in Glasgow, Bridie wrote and wrote.

From May on, Hitchcock spent much of his time overseas. After squaring his thoughts with James Bridie and Sidney Bernstein in England, he flew to Paris, where he gave interviews for the premiere of *Spellbound,* followed by an excursion to Nice for the first Cannes Film Festival, where *Notorious* had been entered in competition.*

Returning to England, Hitchcock was fascinated to read about the arrest of Neville Heath, a former Royal Army Service Corps officer who turned out to be a particularly nasty murderer; his two female victims were viciously beaten, whipped, and sexually mutilated. (His last words before he was hung were reportedly, "Come on, boys, let's get on with it!")

* An American film won the Grand Prize at Cannes that first year—Billy Wilder's *The Lost Weekend,* which also defeated *Spellbound* for the Best Picture Oscar. *Notorious's* chances at Cannes were not improved by the fact that some of its reels were projected in the wrong order.

Heath became the first postwar Jack the Ripper logged into Hitchcock's pantheon.

Scouting locations ahead of the *Paradine* script, he toured mansions, visited Holloway Prison for women, and reacquainted himself with one of his old haunts—the Central Criminal Court, known as the Old Bailey. The keeper was persuaded to let a crew photograph the courtroom, so the Hollywood re-creation could be exacting.

The judge in the story, Lord Horfield—who suggests a composite of real-life Lords Rayner Goddard and Travers Humphreys, both capital-punishment advocates who had figured in sensational murder cases*— called for special research on the part of the director. Hitchcock consulted with official wig- and robe-makers, attended several court sessions, and sketched the judge in action. "As I watched the judge," he noted in an interview, "I even knew what lens I would use to photograph him."

"Casting became a battleground," wrote David Thomson in his Selznick biography. First the producer tried for ideal casting: Greta Garbo, who had been on sabbatical since 1941. But Garbo became the latest Hollywood star to turn up her nose at Hitchcock; she didn't care to make her comeback as a murderess. Then the director set his hopes on Ingrid Bergman, but in spite of their friendship she refused to get involved in another Selznick production.

While in Paris and Nice, Hitchcock met with French actresses, but Selznick wasn't interested. The producer's insistence on selecting his own leads "screwed up all the values" of *The Paradine Case*, as the director later told Peter Bogdanovich. "Unfortunately," in Hitchcock's words, Selznick had just signed the sultry Italian Alida Valli, whom he was trumpeting as "another Bergman." Valli was on the verge of stardom in Italy before the war, when she quit rather than make fascist pictures. Hitchcock liked Valli when he met her, so much so that in Hollywood she was added to both his dinner-party and Santa Cruz guest lists. (In later years, whenever he passed through Rome, he made a point of visiting her.) But in the end Valli wasn't Garbo or Bergman, and Hitchcock felt she was less than star material. "She was too impassive and didn't know her English too well, which is a tremendous handicap," he told Charles Higham.

* Hitchcock was also an aficionado of famous judges. The most controversial case presided over by Lord Goddard, lord chief justice of England from 1946 to 1958, was probably that of two youths accused of murdering a policeman during a warehouse burglary in 1953. The young man who fired the fatal shot could not be executed because of his age, but his accomplice, who was actually under arrest when the killing occurred, was found guilty and hanged. This incident was later turned into the film *Let Him Have It* (1991). Lord Humphreys was a junior solicitor in the Oscar Wilde case, the Dr. Crippen murder trial, and the trial that found Frederick Bywaters and Edith Thompson guilty of the murder of Thompson's husband. As a judge he later tried many famous cases, including that of John George Haigh, the acid-bath murderer.

All along, Selznick had envisioned Gregory Peck as Keane. By now Peck was the producer's biggest star, his most trusted moneymaker. Hitchcock had declared openly, in meetings and dinner parties, his preference for someone more in the mold of Laurence Olivier or Ronald Colman. In the end, though, it was Peck. "I don't think that Gregory Peck can properly represent an English lawyer," Hitchcock was still complaining years later.

For the manservant, Hitchcock wanted the kind of rough-hewn personality called for in the novel ("With horny hands, like the devil!" he told Truffaut)—someone like Robert Newton, for sharp contrast with the ladylike Mrs. Paradine. Being a theater man, Bridie had his own casting notions, and suggested a rough-hewn French actor. But by mid-August the manservant was also a fait accompli; Hitchcock wrote Bridie that he was stuck with a different Frenchman, a Selznick commodity who could hardly be called "earthy," but who had "sufficient mood," he hoped, "to provide us with all the mysterious elements connected with his association with Mrs. Paradine."

That was Louis Jourdan—a rakishly handsome young actor Selznick had met and done cartwheels over. Valli, Gregory Peck, and now Louis Jourdan—all three leads chosen by Selznick, all mistakes in Hitchcock's eye. Though he ended up liking Jourdan, too, the director always maintained that the Frenchman was "the worst flaw in the casting"—his elegance misplaced in a part that cried out for "a manure-smelling stable hand." And Selznick even heightened Jourdan's elegance, capping his teeth, elevating his heels, styling his hair. "A pretty-pretty boy," Hitchcock called him, rolling his eyes in one interview. He "destroyed the whole point of the film," he said in another.

As usual, Hitchcock found his consolation in the ensemble. He remembered Ann Todd from West End hits in the 1930s, and now sought her out for Keane's true-blue wife. In London, he took the actress to dinner and told her she would be "the most exciting person in the film." And he surely tried to make it so, though in the end, in spite of all the rewrites on her scenes, her character was "too coldly written," Hitchcock later admitted.

If policemen or detectives didn't much interest him, Hitchcock was fascinated by judges, whose lives and exploits he followed as avidly as he did criminals'. Judge Horfield and his wife, Lady Sophie Horfield, were especially savory parts. Judge Horfield was first offered to the sympathetic villain of *Notorious,* Claude Rains, but he rejected the job as not his sort of dish. So Charles Laughton, who had hammed it up in *Jamaica Inn,* got a second chance in a Hitchcock film, and Horfield's wife—a faithful sufferer, who must endure her husband's constant verbal abuse and fawning over other women—was handed over to Ethel Barrymore, the only performer to emerge from the film with an Oscar nomination.

Reliable veterans Charles Coburn and Leo G. Carroll (appearing in his

fourth Hitchcock film) portrayed Keane's partner and the prosecuting attorney, respectively. The "best characters in the picture are some of the secondary figures," the director informed Truffaut.

By the end of August 1946 all the research and second-unit work was done, the casting was firm, James Bridie's script had been handed in, and Hitchcock was awaiting the go-ahead. None was forthcoming. Probably none was expected. Long before Bridie submitted his draft of the script, Selznick had decided it would be inadequate. The producer wanted to supervise his own final revisions, but it was hard to set aside the time he needed. He was immersed in postproduction for *Duel in the Sun* and preproduction for *Portrait of Jennie*—his twin Jennifer Jones showpieces. His debt steadily mounting, Selznick was floating around on uppers and downers. "I am on the verge of collapse," he confided to Dan O'Shea.

Hitchcock thought Bridie had done a better than acceptable job under the circumstances, and he stayed in contact with the writer about *The Paradine Case* long after his draft was done. He relied upon Bridie, particularly, for fine points of British legal rigmarole ("the only serious bloomer I can find," Bridie wrote after perusing one later draft, "is the use of the Scots Law word PRECOGNITION instead of DEPOSITION"). And Hitchcock even tried to hire Bridie to start the script of *Under Capricorn* for Transatlantic. The Scottish playwright declined. "I don't mind helping to turn *The Paradine Case* from a bad book into a good film," Bridie explained, "but it is another story when the book is a good book but based on a philosophy of life that means nothing to me. If you get the right script writer, *Under Capricorn* ought to be really memorable. But it is not up my street."

Meanwhile, Ben Hecht—still in the good graces of Selznick and Hitchcock alike—was recruited, at his usual extraordinary expense, to turn out the final draft. Mrs. Hitchcock also returned to the job, holding conferences with her husband and Hecht that were sporadically attended by Selznick. In November and December the producer became a more regular participant, but even after Hecht finished, Selznick still wouldn't approve the script.

By now it was clear: Selznick was teaching Hitchcock a lesson. The producer was the supreme power when it came to his own productions, and the script was the supreme act of creation. Long a frustrated writer, Selznick had begun signing his names to scripts (*Since You Went Away* and *Duel in the Sun* were the first). Now he took over the writing reins himself.

Well, Hecht certainly didn't want his name on the screen, and off in Scotland, Bridie—not a member of the Writers Guild—cared even less. To make himself all the more important, DOS even toyed with omitting Mrs.

Hitchcock from the credits ("even though," he admitted, "she was a contributor to the early scripts, which were thrown out, and was helpful editorially in conferences"). But in the end Alma's involvement was too pervasive to ignore, and Selznick was obliged to take the gracious road and give her credit.

Just as Hitchcock's practicality and equanimity always preserved him as a creative force, David O. Selznick's manic intensity destroyed him. The financial state of the Selznick organization was "dreadful," according to David Thomson, and the producer was gambling its future on *The Paradine Case*. Filming finally began on December 19, and almost instantly fell behind. Already bloated by a year of preproduction, the budget continued to swell and groan.

The Paradine Case was an uneven battleground. For Hitchcock, it would be one last exercise in professional subservience. The producer had anointed the stars and, at the eleventh hour, commandeered the script. DOS did everything he could to second-guess the camera work. All of this Selznick had done before with Hitchcock, but never to such an extent, never so thoroughly and destructively.

Fussing with the script, page by page, Selznick fell so far behind the production schedule that he had to stay up all night, some nights, dictating to his secretary the line changes for the next day's shooting. The new pages had to be rushed to the studio for the director and cast to read and study, and then by limousine to the Hays Office, where last-minute adjustments were de rigueur. Hanging fire until this process was completed, the first shot of the day was sometimes delayed until after lunch.

Although Ben Hecht and Mrs. Hitchcock tried to offer assistance, Selznick shouldered most of the burden—a burden that amounted, after all, to satisfying his own ego. One lesson the producer was reteaching Hitchcock was fidelity to the book. But DOS's scriptwork suffered, ironically, because the writing was "too novelistic," wrote Leonard Leff. Indeed, in scene after scene, the producer simply transcribed the novel. Turning the pages of the book as he wrote, Selznick restored whole stretches of Robert Hichens's wordy dialogue, drowning the drama in a sea of verbiage.

Forced to wait for his daily ration of script, Hitchcock lost the only power he ever had over Selznick: control of the set, and of his preplanned vision of the film. Pages that arrived freshly baked from the producer's oven seemed to him merely warmed-over, and more than once the director was overheard muttering, "What am I to do? I can't take it anymore."

"The dialogue was invariably worse, not better," recalled Gregory Peck. As the filming dragged on, according to Peck, Hitchcock "seemed really

bored with the whole thing, and often we would look over to his chair after a take and he would be—or pretended to be—asleep. Something was troubling him even more than during *Spellbound*, I think." But as Hume Cronyn pointed out in one interview, Hitchcock hadn't done much falling asleep in public since he lost weight during *Lifeboat*. The truth was, he was disconsolate. And more than once his frustration turned to anger—at himself, or anyone in the vicinity.

Hitchcock feuded furiously with cameraman Lee Garmes, a first-rate veteran who came highly recommended; Garmes was a favorite of Selznick's, but also of Hecht's, having photographed and helped direct the brash Hecht and Charles MacArthur films. Trapped between Hitchcock and Selznick, Garmes couldn't find a middle ground.

In spite of everything, the director strived to implement the Hitchcock style—fluid camera movements and a mingling of darkness and light, his trademark chiaroscuro. But Selznick insisted on shots to break up the camera fluidity and on soft Hollywood glamour. The evil people, in a Hitchcock film, were always warped somehow. It bothered Hitchcock that the producer decreed such beautiful photography and costuming for Mrs. Paradine. "People in Arizona have got to know you're rich," Selznick told Alida Valli.

The producer ordered Garmes to crank up the lighting. After seeing the prison visiting-room scenes, he decreed retakes. He wanted a Selznick leading lady idealized in every scene.

At several points in the story, Hitchcock had planned his most elaborate tracking shots to date. In the courtroom sequence there were often four cameras trained on the principals, which created a bramble of equipment and wires underfoot. Faced with constantly changing dialogue, the actors felt doubly under the gun, forced to deliver Selznick's awkward lines while they walked through Hitchcock's virtual obstacle course.

In one scene, as Ann Todd recalled in her memoirs, a camera tracked her smoothly as she entered the front door of her house, called to her husband (Peck), doffed her coat and kicked off her shoes, ran upstairs two flights, entered her sitting room, and made a long telephone call, all the time speaking nonstop to Peck, "who was off screen with his feet up reading his few lines." Thereupon—with the camera still rolling—Peck entered the frame, and "we had a long and elaborate love scene to play. . . .

"We had to film all this 35 times! First the front door kept sticking," the actress recalled, "then there were many difficulties with the camera crane that had to follow me all the way up the stairs, then the trouble for camera, microphone, etc., getting through the doors—either I went too quickly or the camera was too slow, and various people on the set had to crouch on the floor to pull away the furniture as the camera and I passed. Last of all, on the twentieth take, I started to forget my lines and we had to go right back to the beginning again. I think it was a marvelous notion

of Hitchcock's because it gave a flow of continuity to the scenes. Unfortunately it was mechanically very nearly impossible to hold for so long."

Also unfortunately, the producer hated it. After seeing the dailies, Selznick stormed down to the set screaming, "We're not doing a theater piece!" The Hitchcockian approach was ordered reshot "conventionally." For this and other attempts at bravura camera work, the producer took pains to curtail Hitchcock's vision during filming and editing.

Hitchcock's favorite effect, he told Charles Higham, had been planned since the inception of *The Paradine Case*. Keane (Peck) and Sir Simon Flaquer (Charles Coburn) walk toward the camera as they enter Lincoln's Inn, part of the venerable fourteenth-century London law complex. The two are seen entering the building, closing the door, walking up the stairs, turning the corner, heading along a landing into an office, and then continuing into the office, all without a single cut. It was one of Hitchcock's signature composites, using background projection and a treadmill, elaborately planned and prepared in advance by his second unit in London. Opposed to the long take, and oblivious of the significance of Lincoln's Inn, Selznick deleted the shot.

Indeed, Selznick threw out so much of Hitchcock's second-unit footage that any sense of English atmosphere the film might have boasted was lost. In every way he could manage, the producer, in the throes of the tragic psychodrama that ruined his career, sabotaged his own film.

Curiously, right up through the end of the filming—even as he persisted with his script "improvements," directorial second-guessing, and memos ever darkening in tone—Selznick was still trying to sign Hitchcock to a contract extension: offering to split his annual workload with Transatlantic, boost him to six thousand dollars weekly, even offering him a seat on the Selznick directorate.

"Hitchcock may have written the picture off in his own mind," wrote David Thomson. "Perhaps he was allowing disaster to mount." Perhaps—but given his nature, Hitchcock was more likely trying to stave off disaster, while looking beyond *The Paradine Case*.

The stars knew a disaster was happening around them, but they were left to fend for themselves. Most of the director's goodwill flowed toward the subsidiary cast. Ann Todd, playing the one character who captured Hitchcock's attention, found the director kind and helpful to her. "He takes the trouble to study his actors quite apart from what they are playing," Todd said, "and so is able to bring hidden things out from them. He always realized how nervous I was and used to wait for the silence before 'Action' and then tell a naughty, sometimes shocking story that either galvanized me into action or collapsed me into giggles."

But at times Hitchcock erupted in bursts of strange behavior that couldn't be easily explained—except by the nonstop tension swirling around the production. One time, Todd recalled, she was preparing for a scene in her bed, reclining in an elegant dressing gown, when all of a sudden, to her amazement, he "took a flying leap and jumped on me, shouting "Relax!' For a moment I thought he might have broken my bones."

Records, not bones, were broken when the filming finally ground to a halt on May 7, with the budget estimated at $4.258 million, "or nearly exactly the cost of [Gone With the] Wind," in Thomson's words. Ninety-two days of principal photography: that was a Hitchcock record.

So was the initial three-hour version of The Paradine Case eventually approved by the director. Hitchcock conducted a few retakes in early summer, but only after demanding and receiving one thousand dollars per day. Then Selznick took over, supervising Hal Kern's intrusive editing, Franz Waxman's overdone score. The producer made final trims to bring the picture to 131 minutes, in time for its premiere on the last day of 1947.

The last Selznick-Hitchcock production was stillborn, a lifeless picture critics rightly blamed on the producer. Audiences stayed away, and by June 1950 it was in the books as a permanent loser. Worldwide income as of that date: $2.119 million. Once asked which of his pictures he'd like to burn, Gregory Peck replied without hesitation: The Paradine Case.

THE TRANSATLANTIC DREAM

ELEVEN

1947–1950

Transatlantic's search for stories that it could purchase cheaply and quietly—stories that might appeal equally to English and American moviegoers, to bank loan officers, Warner Bros. executives, and Hollywood stars—continued to be problematic. Ingrid Bergman's commitments forced *Under Capricorn* to be reslotted as the second Transatlantic production, but strong candidates for the first remained elusive. One project that met a fast demise was the idea of a Hitchcockian *Hamlet* starring Cary Grant. For one thing, a professor who had written a contemporary novel based on Shakespeare's play began threatening a lawsuit after reading of Hitchcock's similar idea in Transatlantic's inaugural announcement. The new company couldn't open for business under a cloud of litigation. Besides, the partners concluded, transplanting *Hamlet* to modern America was easier said than done.

Scrambling to find another vehicle for Cary Grant, Hitchcock turned to a provocative drama that had intrigued him ever since it was first staged at the Ambassadors Theater in 1929. The plot of Patrick Hamilton's play *Rope* was billed as "suggested by Thomas De Quincey"—Hitchcock enjoyed quoting his *Murder Considered as One of the Fine Arts*—but drew its more obvious inspiration from a notorious American crime of 1924.

Hitchcock had followed the newspaper stories about Nathan Leopold and Richard Loeb, a pair of reportedly brilliant University of Chicago students and homosexual lovers who were obsessed with the superman theories of Nietzsche. In order to prove their superior intellects, Leopold and Loeb had committed a completely motiveless killing—murdering a young acquaintance just for the thrill of it. Their "perfect crime" was marred, however, by a series of stupid mistakes that led to their arrest. Despite being defended by famed attorney Clarence Darrow, the two were found guilty and sentenced to life in prison.

Hitchcock had seen and admired Hamilton's play about two similarly well-bred friends who murder a classmate for sadistic reasons and stash his body in a trunk in the living room of their London flat. Inviting the victim's parents and others to a get-together at the apartment, the killers then entertain their guests in the presence of the corpse.

The director had always talked about actresses as dormant volcanoes, but over the years he had found himself saddled with actors who curiously resisted smoldering in love scenes. Several of them—Ivor Novello, Henry Kendall, John Gielgud, and Michael Redgrave—were homosexual or bisexual in real life, and notably diffident about women. *The Lodger, Rich and Strange, Secret Agent,* and *The Lady Vanishes* had been, to some extent, hampered by their unromantic performances. Hitchcock had already shown, with Handel Fane in *Murder!,* a fascination with blurred sexual identity; and now, by making that idea the cornerstone of a Hitchcock film, he took a bold leap in his thinking.

Hitchcock had been thinking about *Rope* for several years; he mentioned the play to Peter Viertel while working on *Saboteur,* suggesting that it might lend itself to being shot in continuous, carefully planned single-shot takes. He had tried that technique on *The Paradine Case,* only to be stymied by Selznick. Now, during one of their Transatlantic meetings, Bernstein happened to mention his feeling that the most important West End plays ought to be filmed just as they had been staged, preserving them as landmarks of English culture. Hitchcock seized the opportunity to raise the idea of filming *Rope.*

Hamilton's play had thus far scared off film producers, the director observed, so the rights would probably be inexpensive to obtain; and the play had been performed on Broadway, so American audiences would recognize it. As Hamilton had transplanted the Chicago case to London, Hitchcock saw no problem in moving it back to New York. Cary Grant could play one of the major roles. And the idea of filming it in sequential long takes, he perceived early on, would yield side benefits in both costs and publicity.

By early 1947, with *The Paradine Case* still slogging through production, the idea had gained momentum. Hitchcock was already telling close friends he was planning to shoot his next film within the confines of a sin-

gle stage set, and entirely in continuous nine-and-a-half-minute takes. Cary Grant was penciled in as the star. Bernstein convened script conferences with the playwright in Transatlantic's Wardour Street offices in London.

Warner Bros. was encouraged to see *Rope* as a run-for-cover crime film. Eager to set their first Hitchcock film in motion—starring Cary Grant, after all—the studio accepted the director's hasty assurances that he could overcome any censorship objections, and the project was formally slated as Transatlantic's first production.

Preoccupied by the more immediate project, Warner's also overlooked another property the partners had cheaply optioned and were touting as the third Transatlantic film, to follow *Under Capricorn*. This was *Nos Deux Consciences* ("Our Two Consciences"), a 1902 French play written by Paul Bourde, a man of letters and editor of the daily paper *Le Temps*, under the pseudonym Paul Anthelme. Hitchcock had seen the play in London in the early 1930s; now, after meeting with French playwright Louis Verneuil, who was peddling the rights in Hollywood, Transatlantic commissioned a translation and film treatment from Verneuil.

Hitchcock didn't encounter much competition in procuring rights to the 1902 play—especially given the fact that its protagonist was a priest who is executed for a crime he didn't commit. At the start of Anthelme's story, the priest hears a murderer's confession, but when questioned by police is forced to abide by his vow of secrecy. The priest then becomes the chief suspect; unable to explain himself, he is arrested, tried, and executed. It was a bold premise, one to which few other directors might have been drawn. But daunted by *The Dark Duty*, Hitchcock saw the French play as an opportunity to make an anti–capital punishment thriller without paying too much money for the rights.

The wrong-man priest seemed a dubious premise to Warner's, but Hitchcock pitched it as another run-for-cover crime film. There wasn't any treatment (much less a script) to object to, and at studio meetings it was the least pressing subject. Again Hitchcock boasted of how cleverly he would handle the censorship obstacles, and of his intention to snare the biggest, most unlikely star imaginable to play the priest. Cary Grant, Cary Grant, Cary Grant, the director cooed, and the Warner's officials were lulled into complacency.

At least *Rope* and the wrong-man priest could be rationalized as Transatlantic pictures. What really mattered to Warner Bros. was the projects that Hitchcock had promised to direct for the studio. The first of these was also penciled into the deal by the end of 1947: Transatlantic had optioned a British crime novel called *Running Man;* about to be published in England, it would see U.S. publication a year later as *Outrun the Constable*. The novelist, Selwyn Jepson, had little American reputation, so once again the rights weren't costly.

With its London-based story of a young woman forced to play detective in

order to rescue a man wrongly accused of murder, the property looked appealing to Warner's. It would be their *own* Hitchcock run-for-cover—without any thrill-seeking killers or doomed priests. And so *Rope* and *Under Capricorn* for Transatlantic, and *I Confess* (the wronged-priest film, also for Transatlantic), were now joined by *Outrun the Constable* (for Warner Bros.) as the projects on Hitchcock's future agenda over the summer of 1947.

Patrick Hamilton was invited to try his hand adapting *Rope* to the screen, but the playwright distrusted the medium of film, and without Hitchcock at his side Sidney Bernstein couldn't guide their talks to success. "Neither Sidney nor Hamilton," wrote Caroline Moorehead, "could see a way of transforming one of the clues, a ticket for the theater, which on stage could be handled in conversation, into a realistic shot on camera."

The ever obliging James Bridie offered a few ideas, but by mid-March Hitchcock had nominated a left-field substitute: Hume Cronyn. "Why me?" Cronyn, the able actor from *Lifeboat* and *Shadow of a Doubt,* wondered. "I had no screenwriter credits. A couple of my short stories had been published; I'd written and sold a screenplay that was never made and that I doubt he [Hitchcock] ever saw. Perhaps he just wanted someone to talk to."

Why not? Cronyn was intelligent; he had an easygoing friendship with the director. Hitchcock must have read at least one sample of his writing— a published account of the filming of *Lifeboat*. And Cronyn was familiar with New York, the new setting for *Rope*. This would become the first of several important Hitchcock films to adopt the setting of America's greatest metropolis—its London.

Hitchcock and Cronyn began by talking, simply jawing their way through the script at Bellagio Road. "Then I would go back to North Rockingham Avenue [where he lived] and put it all down on paper," recalled Cronyn. "We did not meet every day; I was too busy scribbling for that. When we did meet, there were certain hazards to be avoided; one of the most severe was that I should not get drunk. Hitch was a great believer in a relaxed approach to work, and before lunch the wine bottle would appear and he would descant on the vineyard, the vintage, and the nature of the grape as he poured and poured again. . . .

"Early on in the working relationship I discovered a curious trick of his," said Cronyn. "We would be discussing some story point with great intensity, trembling on the edge of a solution to the problem at hand, when Hitch would suddenly lean back in his chair and say, 'Hume, have you heard the story of the traveling salesman and the farmer's daughter?' I would look at him blankly and he would proceed to tell it with great relish, frequently commenting on the story's characters, the nature of the humor involved, and the philosophical demonstration implied. That makes it sound as though the stories might be profound or at least witty.

They were neither. They were generally seventh-grade jokes of the sniggery school, and frequently infantile."

One day, Cronyn asked the director challengingly: "Why do you do that?"

"Do what?" asked Hitchcock.

"Stop to tell jokes at a critical juncture."

"It's not so critical—it's only a film."

"But we were just about to find a solution to the problem. . . . I can't even remember what it was now."

"Good. We were pressing. . . . You never get it when you press."

Cronyn said later that he never forgot "that little piece of philosophy" Hitchcock offered, "either as an actor or as a sometime writer." Or another tidbit Hitchcock disgorged one day, during an argument about a story point. Seizing a pad and pencil, the director sketched a circle.

"This is the pie," Hitchcock said. "We keep trying to cut into it here." To illustrate, he carved a wedge into the circle's perimeter. "What we must try to do is *this*—" Hitchcock said, his pencil racing around to the opposite side of the circle and digging out a different wedge.

"What does that mean?" asked Cronyn. "Turn day into night? Color into black and white? Change our antagonist into our hero?"

"Maybe," answered the director. "What we're doing is so . . . expected. I want to be surprised."

Sometime in April, Arthur Laurents, another dark horse, joined the rotation, even as Cronyn continued developing the treatment. Sidney Bernstein flew to New York to meet Laurents and approve the hire, telling the new writer, "Every line must be a gem, my dear boy. Literature, that's what we want, literature!" (This intimidating advice—the very opposite of Hitchcock's approach—was one reason that the director would keep his partner at arm's length during the development of future scripts.)

Laurents was a young, bright, bitterly funny New Yorker whose second play, a flop called *Heartsong,* had been backed by David O. Selznick's ex-wife Irene, now a Broadway producer. Laurents had just finished his first Hollywood experience, rewriting *The Snake Pit.* Although he wouldn't be credited for his work on the Anatole Litvak film, Laurents came with high recommendation from Litvak and Irene Selznick.

And he was homosexual—not unimportant among his credentials. Even Laurents suspected that Hitchcock had hired him because *Rope* "was to be filmed as a play and I was a playwright, and because its central characters were homosexual and I might be homosexual." Not only that: Laurents was also having an affair with Goldwyn contract actor Farley Granger, whom Hitchcock already foresaw as Phillip, the weaker-willed of the two killers.*

* In the play the two characters are Charles Cranillo and Wyndham Brandon. In the film Cranillo, the weaker of the two, became Phillip (Farley Granger), and the other became simply Brandon (John Dall).

In April, Laurents had not yet moved in with Granger, so Laurents doubted whether the director knew for certain they were lovers. Yet their affair was open gossip in Hollywood—and the sort of show business whispering that Hitchcock, a connoisseur of gossip, would have relished. Still, neither Laurents nor Hitchcock ever mentioned it.

"At Warner Brothers studio in Burbank where *Rope* was shot, homosexuality was the unmentionable, known only as 'it,' " Laurents recalled in his memoir. "It wasn't in the picture, no character was 'one.' Fascinating was how Hitchcock nevertheless made clear to me that he wanted 'it' in the picture. And of course, he was innuendoing to the converted. I knew it had to be self-evident but not so evident that the censors or the American Legion would scream. It's there; you have to look but it's there all right."

While Cronyn served as a sounding board, Laurents began working independently on the actual script—the kind of awkward overlap that wasn't uncommon with Hitchcock, or Hollywood in general. While Cronyn wrote, Hitchcock met with Laurents, but Laurents was "never shown what Hume [Cronyn] did"—which helps explain why he spent the rest of his life insisting that Cronyn had done little or nothing.

At the start of the summer, Hitchcock envisioned the soulful Granger as Phillip, the rising star Montgomery Clift as Brandon, the mastermind of the murder, and Cary Grant as Rupert Cadell, the former prep-school master who introduces the students to Nietzsche—"the one man alive," says Brandon in the film, "who might have seen this thing from our angle, that is, the artistic one." Rupert is the story's pivotal character—obviously another homosexual, thought Laurents—"probably an ex-lover of Brandon's." The trio would amount to "dream casting," from the writer's point of view.

As their meetings progressed, Hitchcock slyly began inviting Granger to join him and Laurents for dinners. "It was very Hitchcock," explained Laurents. "It tickled him that Farley was playing a homosexual in a movie written by me, another homosexual; that we were lovers; that we had a secret that he knew; that I knew he knew—the permutations were endless, all titillating to him, not out of malice or a feeling of power but because they added a slightly kinky touch and kink was a quality devoutly to be desired."

Transplanting the setting and characters was an underrated Hitchcock move. It was laborious, tricky business, even in this simple story with its handful of characters and single setting. (It was more heroic with *Vertigo*.) The transplant had to be seamless and credible, and with every scene the director intended to block out the action and his camera work as never before, mapping out each of the uninterrupted takes. Hitchcock, now rid of David O. Selznick, seemed in no great hurry. He met with Laurents regularly over the summer, endlessly talking it over.

Father Hitchcock and his youngest son, Alfred Joseph, curiously dressed and formally posed in front of the W. Hitchcock greengrocery on 517 The High Road, Leytonstone. The date is circa 1906, the future director not yet seven years old.

The employees of Henley's on a river trip to the launch at Sudbury Lock.

Hitchcock's uncle John, the family financial wizard and his early backer, with the two Emma Hitchcocks: the director's South African aunt Emma (seated) and his own English mother.

A mustachioed Hitchcock when he still played a keen game of tennis. (Later in life, writer Charles Bennett complained, he'd refuse to budge from a fixed spot unless the ball was hit straight to him.)

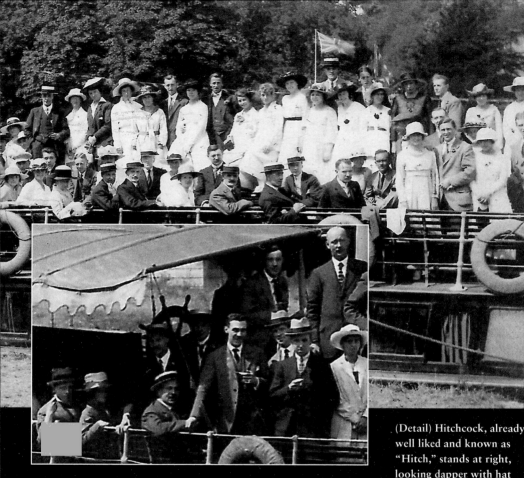

(Detail) Hitchcock, already well liked and known as "Hitch," stands at right, looking dapper with hat and cigar. At far left is W. A. Moore, Hitchcock's boss at Henley's and probably closet collaborator on his first title-card submissions for British Famous Players–Lasky.

Joke publicity: Reading the trade papers while on vacation in Shoreham. From left are Jack Cutts, a man identified as "George," Hitch, and Ada—who called herself "Mrs. Cutts," though she may or may not have been.

Newly clean-shaven, surrounded by . . . birds, the scenarist, art director, and assistant director of
The Blackguard—Hitchcock by name—visits Berlin with Jane Novak, the American actress imported
to star in the Gainsborough–Ufa coproduction. Novak was one of the first Hitchcock blondes; they
remained lifelong friends.

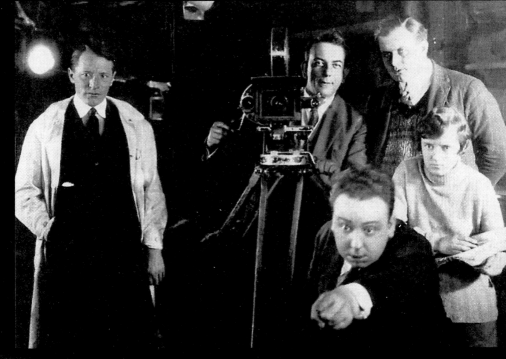

Calling "Action!" on the first Hitchcock film, *The Pleasure Garden* (1926). Alma is at his side, holding the script and watching intently.

Working hard in the snowy Alps, capturing a scene for *The Mountain Eagle* (1926) with Alma once again faithfully monitoring the continuity.

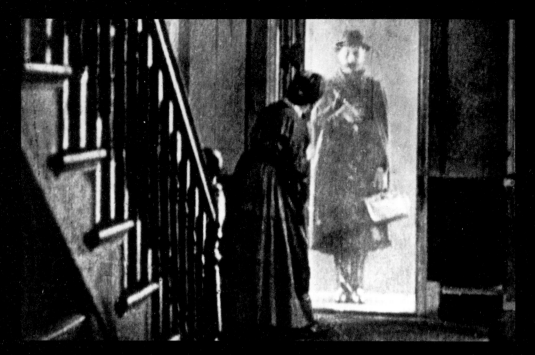

Battling the front office all the way, Hitchcock made *The Lodger* his first great triumph with critics and the public. Here Ivor Novello makes his first appearance in the film—an image straight from Mrs. Belloc Lowndes, whose book Hitchcock had read and loved.

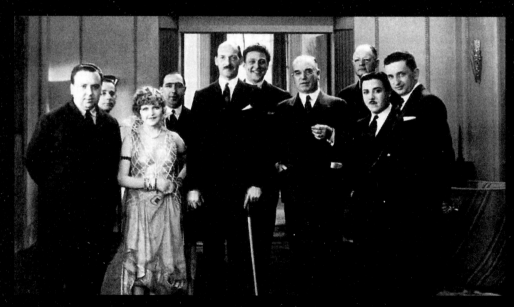

British International Pictures group portrait from the late 1920s. From left: Hitchcock, J. Grossman (studio manager), Betty Balfour (star of *Champagne*), two unidentified figures, Carl Brisson (star of *The Ring* and *The Manxman*), studio boss John Maxwell, another unknown, and fellow contract directors Monty Banks and E. A. Dupont.

Hitch (with earphones) and Anny Ondra coping with sound on the set of *Blackmail:* "PLEASE KEEP AWAY FROM FRONT OF **CAMERA**."

Hitch's cameo in *Blackmail:* not the first, but the first written in as comedy, it set the memorable pattern

A wronged fugitive and a glossy blonde skeptical of his innocence, joined by handcuffs: Hitchcock with his perfect costars Robert Donat and Madeleine Carroll on the set of *The 39 Steps* (1935), still ranked among the greatest British films of all time.

December 2, 1926: The joyous wedding day.

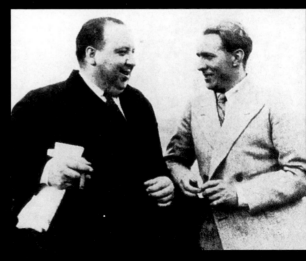

Elliot Stannard, who worked
on more Hitchcock films
than any other writer—
writing part or all of every
silent Hitchcock feature

With Charles Bennett, "the world's greatest stooge," who,
after Stannard, wrote the most Hitchcock films—seven of the
very best, starting with *The Man Who Knew Too Much*.

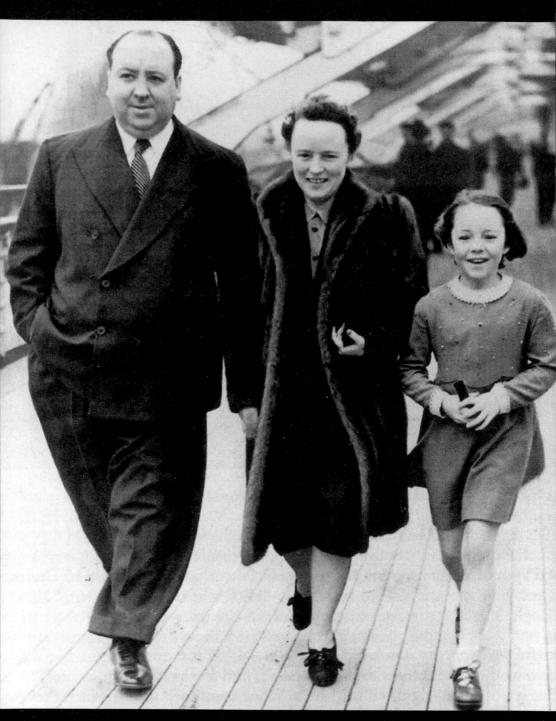

The real three Hitchcocks: Father, mother, and daughter, with a joyful bounce in their lockstep, on the *Queen Mary* bound for America, March 1939.

Hitchcock's cameo as a newspaper reporter in *Young and Innocent:* one of his Chinese-box jokes, poking fun at himself as a sly, camera-toting voyeur.

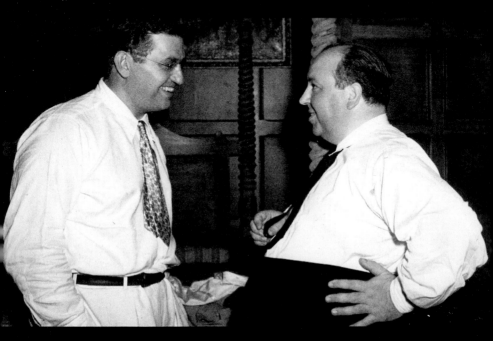

The irresistible force and the immovable object: David O. Selznick and Alfred J. Hitchcock

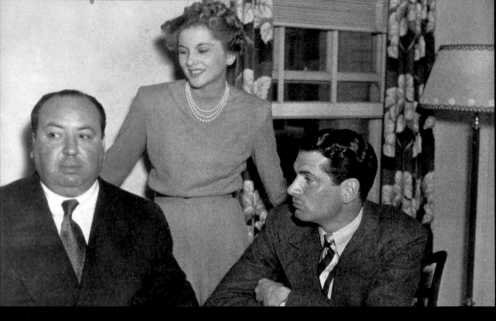

With Joan Fontaine and Laurence Olivier, the romantic leads of *Rebecca* (1940); their chemistry was better on screen than off.

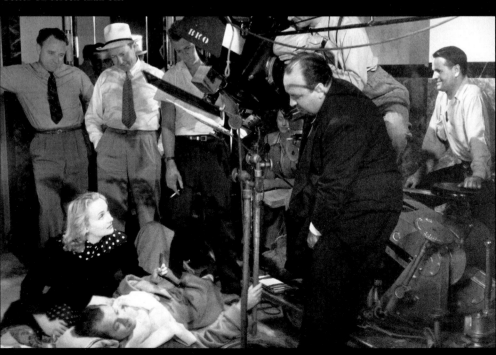

Even in a trifle like 1941's *Mr. and Mrs. Smith*, Hitchcock managed to work his Germanic angles—here with a luminous Carole Lombard and Robert Montgomery.

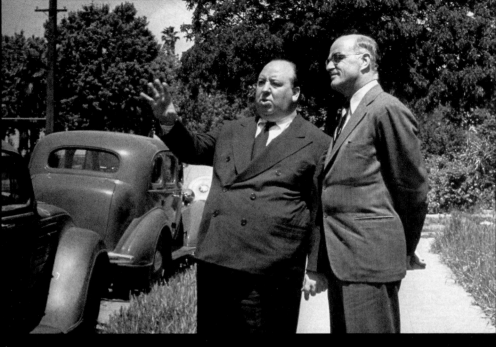

Hitchcock relished the chance to work with distinguished collaborators—from the worlds of arts and letters alike. Here he appears with Thornton Wilder on their June 1943 jaunt to Santa Rosa, scouting locations for *Shadow of a Doubt* ...

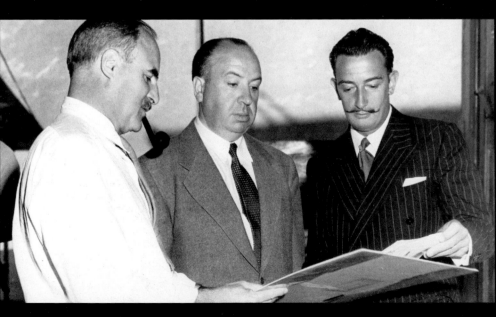

... and with Salvador Dalí, looking over the Spanish surrealist's sketches for *Spellbound* (1945). Dalí's contribution was ill-fated: "*Les* best parts in Hitchcock *que* I like he should keep," Dalí later said, "that much was cut."

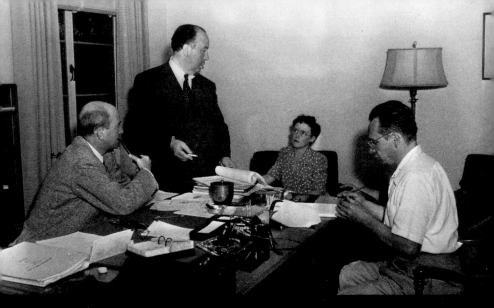

ohn Steinbeck got the Oscar nomination, but the true writers of *Lifeboat* (1944) are seen here at work at Twentieth Century–Fox. From left: producer Kenneth MacGowan, the newly svelte Hitchcock, Alma Reville, and one of Hollywood's great contract writers, Jo Swerling.

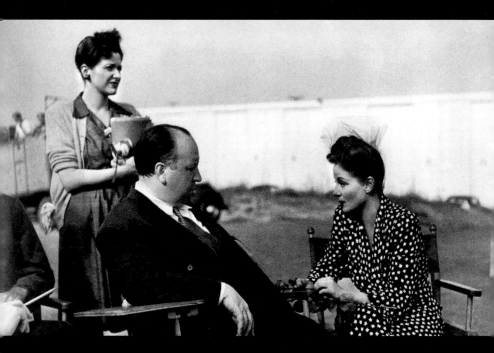

With Tallulah Bankhead on the set of *Lifeboat*. He envisioned the leading role for her, shaped the

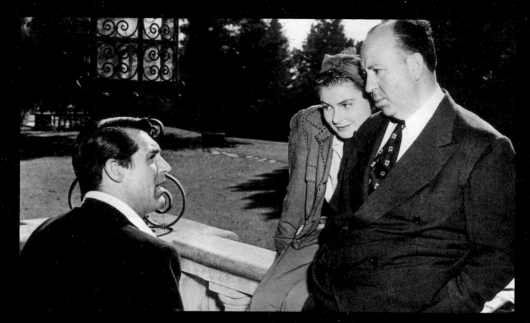

His favorite collaborators, though, were his cast—and no film was more happily cast than *Notorious* (1946), with Cary Grant and an affectionate Ingrid Bergman. It was Hitchcock's greatest triangulation.

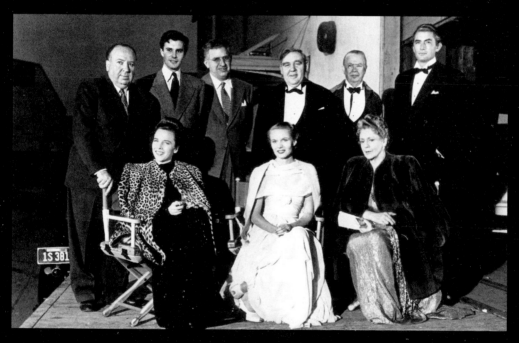

The Paradine Case (1947), the other side of the coin. From left (seated): Alida Valli, Anne Todd, Ethel Barrymore; (standing): Hitchcock, Louis Jourdan, Selznick, Charles Laughton, Charles Coburn, Gregory Peck. Of all his films, Peck later chose this as the one that should be burned.

With two important allies in his transitional years: his lifelong friend Sidney Bernstein, who shared his Transatlantic dream . . .

. . . and Jack L. Warner, who offered an important studio berth after Hitchcock left Selznick. Among the moguls, Warner was the one he got to know best.

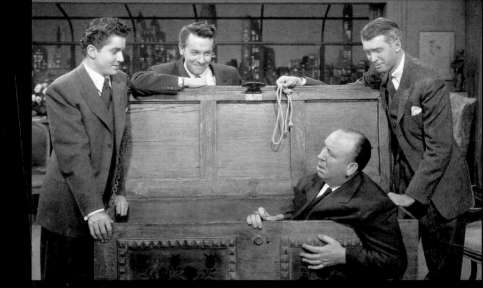

Joke publicity: Rising from the deadly trunk, surrounded by the three leads of *Rope:* Farley Granger (left), John Dall, and Hitchcock's friend and frequent partner James Stewart.

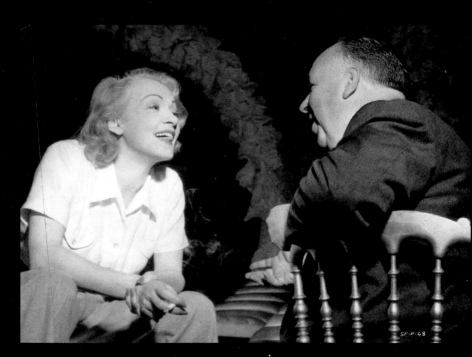

Hitchcock adored Marlene Dietrich and fashioned *Stage Fright* for her persona the way he had shaped *Lifeboat* for Tallulah Bankhead. Privately Dietrich thought him "a strange little man"; here she seems to glow with affection.

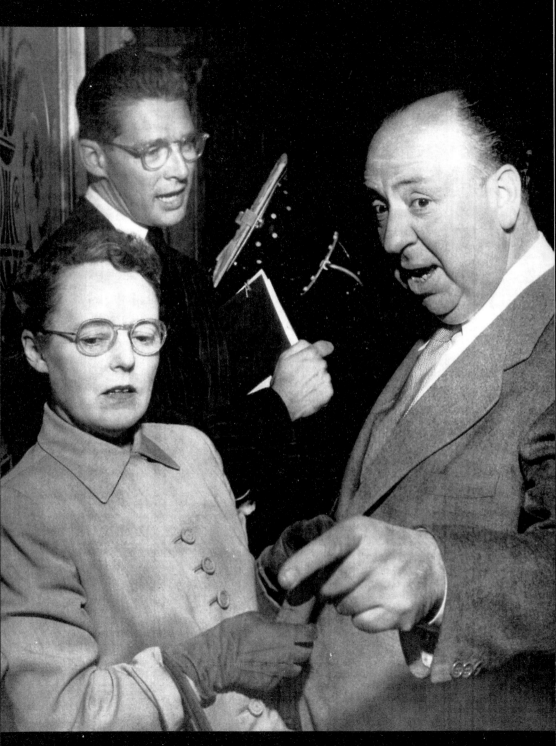

With Whitfield Cook: the "three Hitchcocks" who wrote *Stage Fright* and *Strangers on a Train* (1951). Alma's affection for Cook spilled into passion.

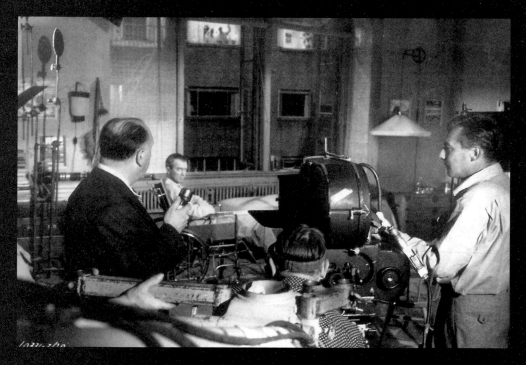

Filming *Rear Window* (1954): Hitchcock (with walkie-talkie), cameraman Robert Burks at right, James Stewart in his wheelchair, and the remarkable, multilevel set in the background.

On the *Rear Window* set with a wary-looking John Michael Hayes, who wrote four of Hitchcock's greatest 1950s films—but didn't always get along with the director.

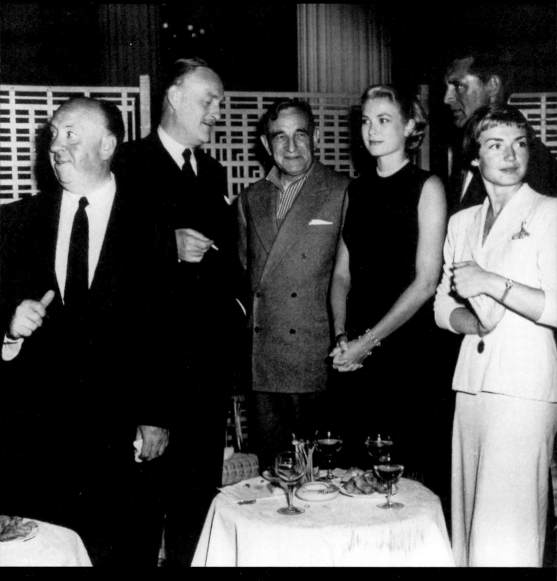

Cast soiree during *To Catch a Thief*: from left, Hitchcock, John Williams, Charles Vanel, Grace Kelly, Cary Grant, and French actress Brigitte Auber, whose daughterly relationship with the director nearly spiraled out of control.

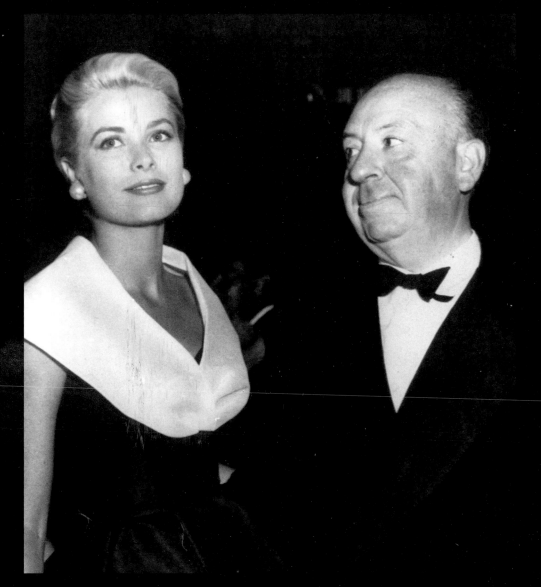

Hitch gazing admiringly at Grace Kelly: the definitive Hitchcock blonde, she was also a hardworking actress, ideal in his view for any role. He never stopped hoping for her comeback.

Hitchcock during the exceptionally difficult living room scene with Kim Novak in *Vertigo* (1958). James Stewart waits patiently in the background.

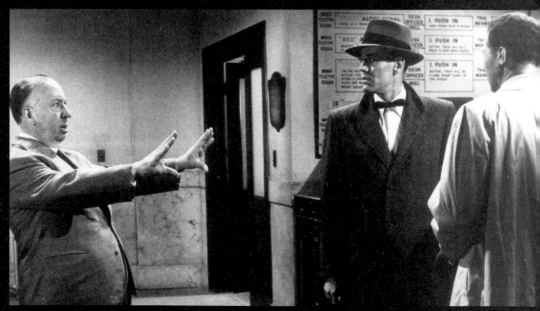

(Left) An imperfect experiment in neorealism, *The Wrong Man* (1956) was a chance for Hitchcock to work with Henry Fonda, whom he had coveted since arriving in Hollywood, and to launch his first "personal star," Vera Miles.

Who's in that crop duster? Why would anyone lure Cary Grant to a desolate rural crossroads, just to kill him by air attack? No matter: Hitchcock's bravura sequence in *North by Northwest* (1959) is endlessly delightful—as a lesson in cinematic storytelling, or for pure enjoyment.

If *North by Northwest* gave Hitchcock (with Eva Marie Saint) as light, inventive, and Kafkaesque a romantic comedy as anything he'd ever done . . .

. . . *Psycho* (1960) was just the opposite: a stark and haunting film whose lead actress (Janet Leigh) was dead within twenty minutes. Its imagery (and music) would be among the director's most lasting contributions to popular culture.

By the late 1950s Hitchcock was able to revel in every aspect of his career. With *Alfred Hitchcock Presents,* he exulted in presenting . . . himself (here with Vincent Price and James Gregory).

His rapport with Anthony Perkins enhanced *Psycho,* an unforgettable portrait of an ineffably human serial killer who is never quite judged—indeed, almost pampered—by the director.

By the late 1950s, Hitchcock's "brain trust" included longtime assistant Joan Harrison, who took over producing the television series; she was a trusted script and casting adviser for both film and TV . . .

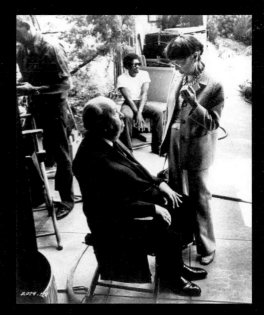

. . . the brilliant yet difficult Bernard Herrmann, whose scores for *Vertigo, North by Northwest,* and *Psycho* are considered definitive movie music . . .

. . . and the celebrated Hollywood designer Edith Head, who complemented and fulfilled Hitchcock's own strong ideas about women's hair and wardrobe.

First and foremost, even after she no longer signed contracts or took credits, his chief adviser and critic was always Alma Reville—here on a trip to Milan in 1960 for the Italian opening of *Psycho*.

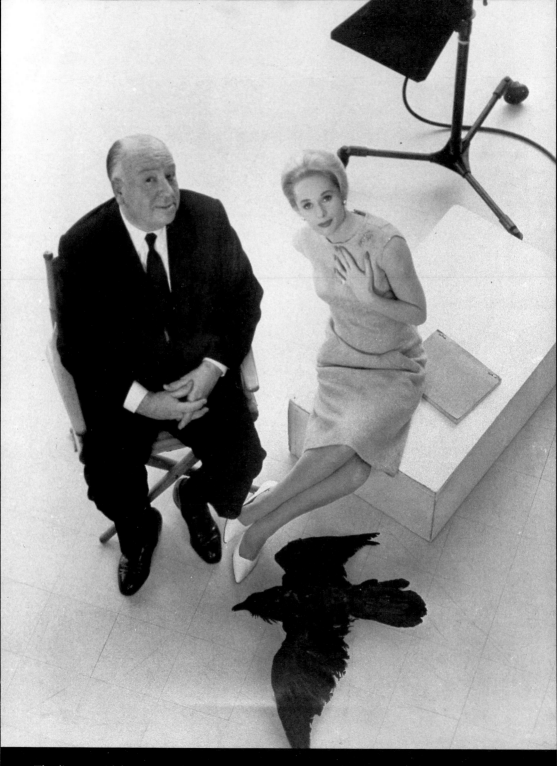

The director with his newest "discovery," Tippi Hedren, in a publicity shot for *The Birds* (1963).
The overhead shot was part of Hitchcock's standard visual vocabulary; the bird of doom—like the glacial
blonde—a lifelong favorite motif.

Trying to guide Paul Newman and Julie Andrews through the lackluster *Torn Curtain* (1966).

Hitchcock with French New Wave director François Truffaut in the 1970s. Truffaut championed Hitchcock from his earliest days as a film critic, interviewed him definitively for a book about his films, and helped raise Hitchcock's auteurist stature around the world.

Bruce Dern and Barbara Harris delighted the director during the shooting of *Family Plot* (1976), and he subtly nudged the film to focus on their characters. "Hitchcock's 53rd," it would also be his last.

On November 16, 1972, Hitchcock was invited to a luncheon honoring Spanish filmmaker Luis Buñuel at director George Cukor's house. From left (standing): Robert Mulligan, William Wyler, Cukor, Robert Wise, unknown, and Louis Malle; (seated): Billy Wilder, George Stevens, Buñuel, Hitchcock, and Rouben Mamoulian.

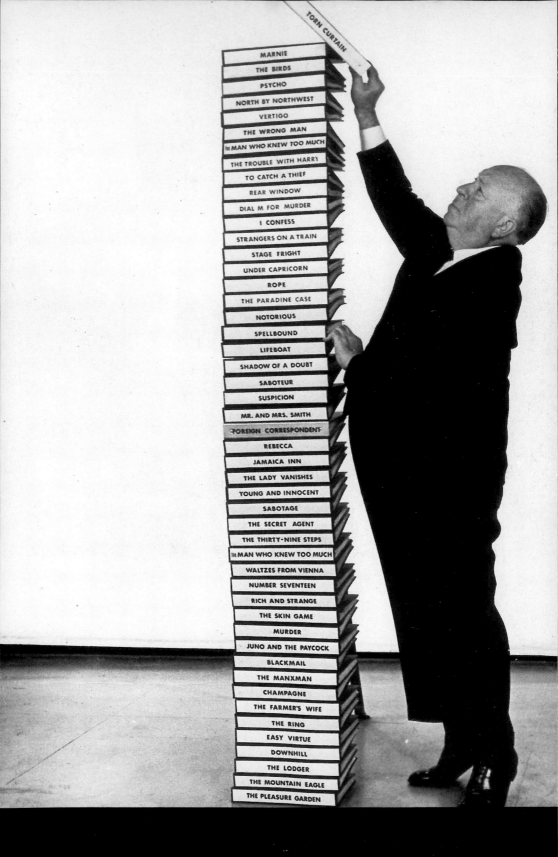

* * *

Thus the summer of 1947 passed slowly and pleasurably. In early June, the Hitchcocks celebrated Pat's high school graduation with a party at Bellagio Road—a lavish affair for them, with more than fifty guests. Among those congratulating Pat were Alida Valli and her husband, composer Oscar de Mejo; Whitfield Cook and his writing partner, Anne Chapin; Hume Cronyn and Jessica Tandy; Arthur Laurents and Farley Granger; and Ingrid Bergman and Cary Grant.

Sidney Bernstein was still in London, but he and Hitchcock had begun speaking at length by phone every Sunday morning, a habit that waxed and waned over the years. Sometimes they talked business, other times they traded gossip or family stories. Alma was a doting godmother to Sidney's son David.

It was Bernstein's job to build the future, and he went about entreating other talented people to join the fledgling Transatlantic operation. Hooks were baited, but the fish swam by. Frank Launder and Sidney Gilliat, by now a highly successful writing, directing, and producing duo, met with Bernstein and considered signing with the company. According to Caroline Moorehead, when Launder asked Bernstein who had "final say" over major decisions, he or Hitchcock, the producer replied, "I do . . . because otherwise we could find ourselves in a situation where nothing got done." After which Bernstein forthrightly added, "But I'm well aware of the fact that the moment I exercise it, it's the end of our partnership." Launder and Gilliat declined. Bernstein tried hard to attract other luminaries, but while the Hitchcock name may have pleased bankers, fellow filmmakers were wary, suspecting Transatlantic was a one-man show.

In late summer Bernstein moved his family to Beverly Hills and rented a house on Palm Drive, overseeing the final stages of preproduction for the maiden Transatlantic production at Warner Bros. The partners—often augmented by Victor Peers, a universally liked production manager who was their chief lieutenant—had an office at the studio, but also held informal meetings at Hitchcock's house. Between their planning sessions the two friends managed to have "a great deal of fun," according to Moorehead's biography. "When Sidney was told by an employee that Jack Warner, the more tycoonlike and aggressive of the brothers, with his small mustache and dapper appearance, received a copy of every Western Union telegram dispatched from his studios, he and Hitchcock started inventing joke ones calculated to perplex and tease him."

The partners often worked all day and into the night. One evening, taking a dinner break at the Bel Air Hotel, they encountered the caustic novelist Evelyn Waugh, who had "a ferocious and inexplicable hatred for Hitchcock," in Moorehead's words. "Let's pretend we're having a really

funny time," Bernstein suggested. "Whatever I say, you laugh and I'll do the same." Once started, they couldn't stop laughing, and from a nearby table, Waugh, "his face purple with loathing, sat glaring at them, in silence," according to Moorehead.

It wasn't until the waning days of summer that the *Rope* casting bubble burst. Although the sexuality of the three leads had not been explicitly defined by Hitchcock, in script or production meetings, there were clear implications in the script. (Brandon wears cologne; his mother is mentioned pointedly.) Both Cary Grant and Montgomery Clift understood, and both were leery. "Since Cary Grant was at best bisexual and Monty was gay," recalled Arthur Laurents, "they were scared to death and they wouldn't do it."

Hitchcock and Grant got into a heated argument, and the star of *Suspicion* and *Notorious* backed away not only from *Rope* but also from plans to formalize any association with the director. "Hitch swore he would never work with Cary again," recalled screenwriter Bess Taffel, who never finished "Weep No More," the script intended to launch a Hitchcock-Grant partnership.

Losing Grant and Clift was a terrible letdown, but Hitchcock didn't have to look far for his new Brandon. He kept running into John Dall at Chasen's and Romanoff's. Dall was Columbia-educated, with experience at the Pasadena Playhouse, and in his first screen role, as the coal miner taught by aging spinster Bette Davis in *The Corn Is Green*, he had been nominated for an Oscar as Best Supporting Actor. While not as popular or magnetic as Clift, Dall was a powerful actor—and a homosexual willing to play it subtly that way.

Granger was signed on as the other killer, but that left Rupert, the third focal character. With Clift and Grant out of the equation, Hitchcock needed a star of a certain magnitude, and he now cast his eye in a very different direction.

The casting of James Stewart as Rupert is still a matter of debate among critics of *Rope,* but the normally folksy actor had endured a grim firsthand experience of World War II and returned a changed man. "Stewart was in fact thinking of quitting Hollywood and going back to Pennsylvania to run his father's hardware store," wrote Joseph McBride in *Frank Capra: The Catastrophe of Success*. During the making of *It's a Wonderful Life,* Stewart told Lionel Barrymore that after what he'd seen in the air force, he wasn't sure acting was a job for a man. Hitchcock picked up on this new, disillusioned Stewart, now looking for meatier roles.

Their go-between was Lew Wasserman, a man as important as any other in Hitchcock's life story. After the death of Myron Selznick in 1944, Hitchcock had stayed wary of, even hostile to, the idea of formal repre-

sentation. Since his next long-term contract was with Transatlantic—an equal partnership with his best friend—Hitchcock had no urgent need for an agent.

After Myron's death, the Selznick Agency had been purchased by Leland Hayward, the New York–based talent and literary agent who had roomed with Myron and David during their salad days in Hollywood, and who had longtime business ties with both Selznicks. Kay Brown switched over to the new Hayward agency, and so did most of Myron's remaining clients; the Selznick agents who joined the new entity included Nat Deverich, who had been one of Hitchcock's champions behind closed doors. Deverich became manager of the Hollywood office, which became known as the Hayward-Deverich Agency.

The newly constituted Hayward-Deverich Agency represented the crème de la crème of Hollywood, including Billy Wilder, Lillian Hellman, Dorothy Parker, Ben Hecht, Myrna Loy, Judy Garland, Ginger Rogers, Gene Kelly, Fred Astaire, Henry Fonda, and James Stewart. The agency represented Hitchcock only nominally, but Hitchcock and Hayward (who was married to the actress Margaret Sullavan) moved in the same circles, and the two men were quite friendly. In 1945 Hayward quit the agency business to become a Broadway producer; he and Deverich sold out to a rival, the Music Corporation of America, and MCA absorbed their rolls— including James Stewart and Alfred Hitchcock.

Wasserman was one of the rising lights of MCA, a company that had its origins in the popular music field. Originally from Cleveland, where he had started out in the 1930s booking nightclubs and doing low-level publicity, Wasserman had developed into one of show business's most committed go-getters. Transferred first to New York and later to Hollywood after MCA branched out into the motion picture business, Wasserman had unmatched energy, and devotion to his clients. Tall, thin, bespectacled, always immaculately tailored, he had "an air of complete confidence with a penumbra of wisdom and assurance," in the words of Dore Schary, one of his clients.

Hitchcock sized up Wasserman as someone like himself, a son of modest beginnings who was reinventing himself as a man of the future. Unlike most agents, Wasserman was as good a listener as he was a talker, eyeing people intently as he listened to them; he had built a reputation as a sensible man who talked big but nonetheless delivered. He was a visionary in his field, a powerful figure whose power was still growing.

Wasserman was the matchmaker between Hitchcock and Stewart. It wasn't an easy match: disappointed at the loss of Cary Grant, the banks refused to lend Transatlantic as much money as the company hoped for, mindful that Stewart couldn't match Grant's international box-office draw. Still, Stewart was one of America's leading box-office stars, and his price

tag was almost as daunting as Grant's; to broker the deal, Wasserman had to persuade Stewart to waive his preferred fee in lieu of a percentage of box-office returns.* It was high-level matchmaking—and a breakthrough for Wasserman, who proved himself a man Hitchcock could trust.

In the original play, however, Rupert is a poet (read: homosexual). In the film, he would become a publisher of philosophical texts. The script, written with Cary Grant in mind, required few changes after Stewart took his place. But with the folksier American playing Rupert, any implication of a homosexual triangle among the three leads was lost—first of all on the star. "John Dall and Farley played Brandon and Phillip's sexuality truthfully and that took courage," Laurents reflected. "I don't know whether it ever occurred to Jimmy Stewart that Rupert was a homosexual. Hitchcock didn't say anything but it wouldn't have mattered if he did."

During the fall Arthur Laurents completed most of the script back east. Although critics then and now rotely refer to the first play Hitchcock had filmed in fifteen years as a faithful adaptation, the stage version was altered markedly—enough that when Patrick Hamilton finally saw it in London he felt bamboozled, and privately denounced Hitchcock.

The locale switch from London to New York entailed both reupholstering the plot and changing the cast of characters. Hitchcock replaced the play's too subtle incriminating clue (the theater ticket) with Rupert being handed the wrong hat—the victim's monogrammed fedora—when he leaves the party; the hat bolsters his hunch that the missing man has been murdered. At the end of the play Rupert fends off the two killers with a sword concealed in his walking stick, but in the film Rupert grabs a gun away from Brandon and fires it out the window to alert police.

Hitchcock and Laurents also altered the play's guests, who congregate for drinks around a storage chest concealing the dead body of David Kentley. Onstage, these include Kentley's father, the father's sister, and a vapid young man and woman with only a passing connection to the victim. A French-accented manservant is around to serve food and drink.

The only character from the play to survive relatively intact was Mr. Kentley, a role earmarked for Hitchcock's friend Cedric Hardwicke. His dialogue, updated from the play, made him the conscience of the film. When Brandon sneeringly decries "inferior beings whose lives are unimportant anyway"—a line that linked Nietzsche with Hitler—the senior

* Stewart, who had only recently become a free agent, was earning somewhere in the neighborhood of $175,000–200,000 per picture. Ultimately, he would clear $300,000 in percentage fees for his services on *Rope*.

Kentley angrily rebukes his "contempt for humanity." In more than one postwar film, Hitchcock scattered such reminders of something he never forgave: the evil of Nazi Germany.

In Hitchcock's film, Mrs. Kentley is reported to be ailing in bed. So Mr. Kentley has brought along an uninvited guest, his visiting sister-in-law, Mrs. Atwater—who becomes one of those showboat females prevalent in Hitchcock's world. She offers astrology and comic relief, sparking a conversation in which the guests discuss a handful of movie stars and try to recollect the titles of recent pictures they all have seen . . . "the wonderful something" (a nod to Stewart's recent showcase, *It's a Wonderful Life*).

The lines are similar in the play; Hitchcock simply replaced the names of 1920s stars such as John Gilbert and Joan Crawford with those of his Hollywood friends. Donald Spoto cites the film's mention of Ingrid Bergman as evidence of Hitchcock's hopeless crush on the actress ("Oh, I think she's lovely!" one guest comments), but it's really an excuse for self-advertisement on the director's part; the guests are trying to recall the title of her most recent film: *Notorious*! (A female guest declares "I'll take Cary Grant myself"; and though Mrs. Atwater concurs, she says she likes Errol Flynn just as much.) Hitchcock counted on his friend, actress Constance Collier—who made her screen debut as *Lady Macbeth* in 1916 and later cowrote *Downhill* with Ivor Novello—playing Mrs. Atwater to the hilt.

The vapid young man and woman of Hamilton's play were transformed into Kenneth (Douglas Dick) and Janet (Joan Chandler), who arrive for Brandon's party separately but with closely intertwined backstories. Former lovers, Kenneth is another old school chum, and Janet is a health and beauty columnist—both ultimately reveal themselves as characters of substance. Brandon has invited them to the soiree in another manifestation of his "warped sense of humor," in Janet's words. And Hitchcock has invited them into the film—Brandon boasts that he broke up with Janet *before* Kenneth (a hint to moviegoers, already attuned to the swirling subtext, that Brandon may be bisexual)—to deepen the cross-tensions.

Even the dead man was subtly made over by Hitchcock. David Kentley is never glimpsed in the stage play, but Hitchcock insisted, over Laurents's heated protests, on strangling the character in the opening shots, so the audience would squirm uncomfortably with the recollection of the killing. For the film, David Kentley becomes Americanized as a Harvard graduate, and dialogue that emphasized his only-child status would heighten sympathy for his parents.

The French manservant was dropped in favor of one of Hitchcock's beloved "old maids": an actual maid, Mrs. Wilson, played to mousy perfection by Edith Evanson. Mrs. Wilson harbors a crush on Rupert, natters on about pâté, and prods along the suspense by wondering aloud why

Brandon would spontaneously decide to bring the food into the parlor and set the table on large trunk ringed with candles, as if it were a "ceremonial altar."

Her character helped Hitchcock open up the play, which had only a single drawing-room set. The film, too, was basically one set, but Hitchcock created depth of field by adding an adjacent dining room and kitchen. In one remarkable scene, which comes after everyone has eaten, Hitchcock stands his camera close by the trunk (where the victim's corpse is hidden) while keeping his lens fixed on Mrs. Wilson as she clears the food and dishes. The housemaid removes the objects one by one, sweeping in and out through a series of open doorways leading to the other rooms. The audience watches and watches, waiting for her to finish clearing the table—and then, finally, to lift the lid and discover the body. No one else is even in the protracted shot; only Rupert's shoulder is glimpsed, and only chatter is heard.*

If Rupert's character didn't change drastically from the play, Hitchcock's film does take the crucial step of making him the former housemaster of all four young men—David, Kenneth, Phillip, Brandon—and thus, effectively, their surrogate father. It is Rupert who remembers that Brandon had a "chest complex" as a boy, a weakness for bones in bloody chests in his fireside stories; it's Rupert's suspicious scrutiny that reduces the swaggering Brandon to stuttering guilt; and it's Rupert who offers the film's thoughtful, Hitchcockian articulation of goodness ("an obligation to the society we live in") and evil ("something deep inside you from the very start").

Long after *Rope* and *Under Capricorn*—the two films he chose to shoot in maximum-length takes—Hitchcock was at a loss to explain what had come over him. The technique was an attention-getting "stunt," he admitted once. "I really don't know how I came to indulge in it," he said.

Was he trying to prove something to himself, or to Hollywood? Was he trying to prove to the American film industry that such a thing even could be done—a bravura gesture of artistic commitment, in defiance of the machine-line production system? Were the long, uninterrupted takes intended to maximize his control over the final film, deflating his actors and curtailing any producer interference? Or was the technique mainly his way of distracting journalists and censorship from subject matter as daring and provocative as anything he had done?

A complete reel in those days ran approximately 950 feet, or for

* In one of his symmetrical career strokes, all but irrelevant to general audiences, Evanson would play a small role in another Hitchcock film—an office charwoman in *Marnie*—for the film's most elaborately staged sequence, which plays similar games with her character and doorways and silent suspense.

roughly nine and a half minutes. Patrick Hamilton's original play ran one hour and thirty minutes; the film was timed for less than nine reels, or about eighty minutes.

To make the challenge even harder, *Rope* was slated to be a Technicolor production. Hitchcock had long hoped to make his color debut with a remake of *The Lodger* (with red blood dripping on white flower petals, he often told interviewers), but that ambition had eluded him. Now he would take the occasion of the first Transatlantic production to make his first color film. As would be characteristic of him throughout the rest of his career, he chose a generally subdued palette. He set about planning light and hues—inside and outside the apartment—that would gradually darken to build the tension.

He borrowed cameraman Joseph Valentine from Skirball Productions, and editor William Ziegler from Warner Bros. But the actual "cutting" of *Rope,* the first of three Hitchcock films edited by Ziegler, was closely determined in advance by the director, according to official studio publicity. The only genuine cuts were dictated by the length of a film reel, with the breaks between reels usually disguised by an actor passing in front of the camera just as the footage ended. (Ziegler, according to publicity, helped plan the action by removing the roof from his daughter's dollhouse, rearranging the rooms to approximate the set, and then moving chess pieces around as stand-ins for the actors.)

On a Warner Bros. soundstage, Hitchcock had a special floor built a few inches above the permanent floor and lined with felt. This became the floor of art director Perry Ferguson's New York penthouse apartment, consisting of kitchen, dining room, hallway, and living room—with collapsible walls hanging on overhead tracks that could be slid aside to allow the camera to follow the actors through doors. Outside the living-room window hung a reproduction of the New York skyline, complete with miniaturized buildings and clouds of spun glass hung on wires, to be moved between reels to simulate a shifting sky. The film starts in daylight and ends at nightfall; the incremental shadowing of the sky, with stars, lights, and neon signs twinkling on, would coincide with the action.

To inaugurate the first Transatlantic production—and belatedly celebrate the Hitchcocks' birthdays—Pat Hitchcock joined Arthur Laurents and Whitfield Cook in organizing a party at Bellagio Road on December 6. Besides Sidney Bernstein and his wife, the guests included the John Hodiaks, Ingrid Bergman, and Cary Grant. Rehearsals were about to begin for *Rope;* filming was scheduled to commence on January 12, 1948.

Sidney Gilliat once recalled the glow on Hitchcock's face upon the first release of *The Lady Vanishes* in England, at the sight of a marquee with his name floating above the title. After ten years in Hollywood, he finally re-

claimed that "possessory credit," calling for his new film to be released as "Alfred Hitchcock's *Rope*." He would receive the same credit by contract as producer of all the Transatlantic–Warner's films. (Later, at Universal, Lew Wasserman would arrange for his client's name to appear in "a size type 100% of the title.")

"I consider the possessory use of my name above the title of a film as of extraordinary value to the producing company as well to myself," Hitchcock asserted in his 1967 deposition, aiding the Directors Guild lawsuit against the Writers Guild. "I have always considered my name and reputation to be the most valuable property right owned by me." He added proudly "that not more than fifty directors to my knowledge have ever been granted possessory production or presentation credit, although there have literally been thousands of persons who have directed motion pictures during the past sixty years."

Alfred Hitchcock's *Rope* was rehearsed for several weeks with every action and corresponding camera move diagrammed on a blackboard. Crew members had to practice moving walls and furniture out of the path of the huge camera boom (the size of "a little Volkswagen, practically," in the words of Farley Granger), while the cast had to memorize up to eleven pages of dialogue and business per reel.

All this put a certain strain on the Hollywood contingent, who were accustomed to shorter takes, briefer passages of dialogue to memorize, and simpler instructions sketching out their moves. Before filming started, the studio threw a huge press party, where Hitchcock expounded on the elaborate rehearsal and preparation. "The only thing that's been rehearsed around here," cracked a nervous James Stewart, "is the camera."

Normally Hitchcock shot out of continuity, but *Rope* demanded sequential staging and filming. The opening scene, which was the first to be photographed, shows the two killers strangling David (Dick Hogan), then stuffing his body into the trunk. John Dall and Farley Granger were flawless for eight minutes, speaking their lines as they moved about between rooms, amid a flurry of rising and lowering walls. When the camera followed them back to the living room, there—"right in camera focus," as Hitchcock later told François Truffaut—"was an electrician standing by the window!" So the whole production began with a ruined first take.

Many more such false starts followed, including a number of near-disastrous collisions with the formidable camera boom. Uncertainty and exasperation set in early, but Hitchcock was all assurance, undaunted by imperfection. The director of England's first talkie had been through all this sort of thing before.

"We couldn't use the sound that was recorded while he was filming," Stewart recalled. "He made the walls and furniture with rubber wheels so they wouldn't make any noise, and the sound people said, 'No, you can't

make it; it just sounds exactly like it is—a wall moving on rubber wheels.' It didn't bother Hitchcock. He said: 'We'll do the first take for the camera, and take all the microphones out.' Then he took all the walls and furniture out and put in about twenty microphones all over the set, and we did it for sound. And there were only about five or six places where we had to redub, because of timing and everything."

The oldest pros, Cedric Hardwicke and Constance Collier, didn't mind the rehearsal or memorization; for them, the approach was akin to performing in the theater. "They were the most fun on the film really," recalled Granger. "They thought it was a hoot." After initial "nightmares, the kind I had not known since my first days in the theater," Stewart also embraced the process as "pure joy because it was like returning to the stage where action is continuous for a full act and you either do or die."

"Jimmy, never do anything you don't feel like doing," Hitchcock told the star. "If it doesn't feel natural, then we'll work on it till it does." This advice was somewhat complicated by the limp the director insisted that Stewart adopt; the limp was called for, Hitchcock explained, to forewarn audiences that this was "a different sort of characterization" for Stewart. (A leftover from the play, the limp is explained differently in the film. "Rupert got his bad leg in the war for his courage," explains Mrs. Wilson; which contrasts sharply with Brandon's smart-aleck remark, "Good Americans usually die young on the battlefield.")

If Stewart eschewed any homosexual implications, if his limp wasn't very convincing, if Stewart wasn't entirely at his case as an armchair philosopher extolling "the art of murder," and if in the end his good-guy persona did evince limitations, then Hitchcock would learn those limitations and put that knowledge to good use in *Rear Window, The Man Who Knew Too Much*, and *Vertigo*. And Stewart nonetheless gave a compelling performance.

"Jimmy Stewart was Jimmy Stewart," Arthur Laurents reflected, "which meant not a whiff of sex of any kind. He does dominate the picture, though, with ease and authority. His Rupert is intelligent, attractive, laced with humor—teasing, though, rather than sardonic."

Journalists flocked to the set during the filming, and so did a few celebrities: Noel Coward and Ingrid Bergman came out of friendship, but also to boost publicity—and in Bergman's case, because Hitchcock was planning to duplicate the long-take methodology with his next film, *Under Capricorn*.

Sidney Bernstein was a prince of a producer. He never interfered, only facilitated. At night the Transatlantic partners studied the rushes, then headed to Bellagio Road to talk things over with Mrs. Hitchcock. The Hitchcocks enjoyed tempting Bernstein with rich soufflés, wrote Caroline Moorehead. "When Sidney succumbed, Hitchcock would eat half of it, and next morning complain bitterly that his diet had been broken."

The filming was completed by February 21; Truffaut reported that it took eighteen shooting days, while *American Cinematographer* said the number was thirty—a discrepancy that depends in part on whether at least nine days of refilming are included. Joseph Valentine, who delivered exquisite black-and-white photography for *Saboteur* and *Shadow of a Doubt,* either wouldn't or couldn't achieve the gradually darkening color scheme Hitchcock desired; Bernstein finally had to replace him—and Hitchcock reshot scenes where the color was too lurid. Valentine was officially reported "ill," and a Technicolor consultant aided cameraman William V. Skall, who finished the film, sharing the credit.

In the fall of 1947, a series of events conspired to alter the future of both Hitchcock and Hollywood.

In October, the House Committe on Un-American Activities (HUAC) began a set of hearings in Washington, D.C., that launched fifteen years of blacklisting. Intended to cleanse American film of Communist influences, the blacklist weakened the industry by purging talent and rendering many controversial subjects off-limits. Many in Hitchcock's circle were affected, including Arthur Laurents, who was among the leftists driven out of town; Hume Cronyn, whose screen career was also ruptured (Cronyn's left-liberal politics would be investigated by the HUAC later in the 1950s); Whitfield Cook, who was outraged by Hollywood's capitulation to HUAC and soon would switch to fiction; and Sidney Bernstein, who opposed the inquisition and donated money to support the legal defense of accused "Reds."

Television was another purgative draining the film business. Although NBC had been on the air with regular programming since 1939, the year 1948 is generally seen as the unofficial birth of national prime-time broadcasting. That was the year the three networks mounted competing full nightly schedules, and the year that the number of television stations and television sets in the country started to skyrocket.

In a journal he kept during these years, Cook suggests that the anti-Communist crusade sickened everybody in the Hitchcock circle, and that the director openly fretted over the encroachment of television—a medium that rivaled and threatened to undermine the film industry. Later, Hitchcock would find cause to rethink both these issues.

For the moment, though, Mrs. Hitchcock and Hume Cronyn were finishing a treatment for *Under Capricorn,* slated to begin production in London immediately following *Rope.* In Glasgow, James Bridie launched into a script, communicating with Hitchcock by telephone and telegram. Victor Peers returned to London to organize the preproduction.

The third Transatlantic project was also shaping up. After talks with Hitchcock, Louis Verneuil had finished a first treatment of the story that would eventually become the film *I Confess*. The treatment transposed the turn-of-the-century French play to a small town outside San Francisco—the second time (after *Shadow of a Doubt*) that Hitchcock had gravitated to comfortable home territory. Verneuil's second treatment incorporated an even more adventurous idea of the Hitchcocks', revealing the wrong-man priest to be the father of an illegitimate baby.

When columnist Jimmy Fidler leaked news of the wronged priest project, however, Warner Bros. and bank officials reviewed the treatments and expressed concern. But concern was premature, Hitchcock insisted; though Cary Grant was now out, he had discussed the film with James Stewart, who would very likely take over the role. In any event, the director assured everybody, Verneuil's treatments were just one step in the film's evolution. Now Mrs. Hitchcock would write a new treatment, changing everything. Meanwhile, Hitchcock said, *Outrun the Constable*—seen by the studio as the less controversial run for cover—could be moved ahead of *I Confess*, giving Warner's its own Hitchcock film way ahead of schedule. This maneuver kept the peace.

Whitfield Cook went to work on *Outrun the Constable*, collaborating on a treatment with Alma, who was toiling more or less simultaneously on all her husband's nascent projects. Although Joan Harrison, off producing films on her own, remained close to the Hitchcocks, Cook now took Harrison's place as a constant presence among the family—the latest third Hitchcock. In late December 1947, for example, Cook accompanied the couple to the premiere of *The Paradine Case*. Toward the end of production on *Rope*, when Mr. and Mrs. Hitchcock were asked to a formal dinner party at Constance Collier's, with a guest list that included the Chaplins and the Aldous Huxleys, Cook was invited along.

On the weekend that *Rope* wrapped up filming, Cook and Hume Cronyn were guests of the Hitchcocks in northern California. With his partner, Anne Chapin, Cook was also working on an MGM picture about a navy rescue, but the talk easily drifted among all the Hitchcock projects: *Under Capricorn, Outrun the Constable, I Confess*. "Alma, Hitch & I take long walks in the afternoon in rain and old clothes," Cook wrote.

On March 20, 1948, the three ate dinner at Romanoff's, joined by Joan Harrison and Sidney Bernstein. While they dined, the Hitchcock party kept up with radio accounts of the Academy Awards. It was the first time in eight years that Hitchcock had neither a film in release nor an Oscar nominee in some category. A week later, when the Hitchcocks sailed for London, they both phoned Cook from the *Queen Elizabeth*, and Alma sent wires about *Outrun the Constable*, which the writer would continue to develop in their absence.

* * *

What was it that attracted Hitchcock to the idea of filming *Under Capricorn,* the novel set in Australia by Helen Simpson? Was it that the rights were inexpensive (according to Donald Spoto, costing a single token dollar)? Was it the subject's inherent interest to English moviegoers—balancing out its predecessor, *Rope,* which Hitchcock had reshaped to appeal to American audiences? Or was it that Hitchcock had a soft spot for the author, who had contributed to *Murder!* and *Sabotage?*

Simpson's 1937 novel concerns the shared secret of a married couple who live in nineteenth-century Sydney, a boomtown populated largely by convicts and soldiers. The husband is a "ticket-of-leave" man, a former prisoner who is now a coarse-mannered landowner and businessman. His crime—killing his wife's brother—took place in Ireland, with his dipsomaniac wife as the only eyewitness. (It turns out she's the actual killer.) Smitten by her beauty, a handsome, well-bred newcomer to Sydney sets out to rehabilitate her.

Well regarded in its day, *Under Capricorn* was the kind of historical fiction Hitchcock claimed he read habitually in his free time—unlike crime novels, which he said felt too much like work. But he had "no special admiration" for the Simpson novel; only on rare occasions would he even admit to "liking" it. Alma liked it more, and it's possible that Ingrid Bergman saw in Lady Flusky—the wife of the "emancipist"—her specialty of noble suffering.

Did anyone involved think it was a potential masterpiece? Reminiscing about *Under Capricorn* to Truffaut, Hitchcock claimed that Bergman "only wanted to appear in masterpieces. How on earth can anyone know whether a picture is going to turn out to be a masterpiece or not?"

From the earliest Transatlantic publicity, Bergman's name had been touted as an asset to the project—a guarantee of box-office voltage. But there was also a downside to her star power. For one thing, Bergman knew her value and demanded a commensurate salary—$200,000, plus 25 percent of the profits. And unlike James Stewart, she wasn't willing to defer any of her salary in exchange for a profit-sharing agreement.

As the film's director, Hitchcock was offended by her salary requirements, and thought his payment should be just as high, or higher. Therefore he gave himself a raise on *Under Capricorn* to $250,000—along with 30 percent of profits. When Bergman heard of the move, she complained, and was granted an equal 30 percent. Neither would ever collect a dime under the arrangement.

Years later, Hitchcock admitted that his ego had run amok from start to finish on *Under Capricorn.* "I made the mistake of thinking that to get Bergman would be a tremendous feat," Hitchcock said. "It was a vic-

tory over the rest of the industry, you know. That was bad thinking, and my behavior was almost infantile. All I could think about was: 'Here I am, Hitchcock, the onetime English director, returning to London with the biggest star of the day.' I was literally intoxicated at the thought of the cameras and flashbulbs that would be directed at Bergman and myself at the London airport. All of these externals seemed to be terribly important."

Hitchcock's "confusion," he told Truffaut, started *before* Bergman— with the choice of story ("If I'd been thinking clearly, I'd never have tackled a costume picture"). The team of John Colton and Margaret Linden had done an early adaptation. A well-respected playwright whose plays were often transferred to the screen, Colton had dramatized Somerset Maugham's *Rain* and also *The Shanghai Gesture,* which became a Josef von Sternberg film.

Colton and Linden expunged the book's casual racism, and restricted the action to the mansion; they deleted a protracted subplot sending the newcomer Adare deep into the Australian interior in search of gold. After completing the adaptation, perhaps initially intended for the stage, Colton died suddenly in 1946.

Hitchcock invited Arthur Laurents to write the film version, but after absorbing the book, which didn't excite him, Laurents said no. "Later in the day, Sidney [Bernstein] put his arm around me and friend to friend, for my sake, tried to persuade me to recant," Laurents recalled. "I had hurt Hitch. I had offended him by my disloyalty. Loyalty was an unquestioning yes; no was ingratitude. For me, however, recanting would not be an act of friendship, it would really make me disloyal. Hitch didn't see it that way. I never sat at his table at Romanoff's again. A hard, early lesson in friendship: we had never really been friends."

Hume Cronyn, who had also toiled on the script of *Rope,* was then recruited to collaborate on *Under Capricorn,* working first with Mrs. Hitchcock in Hollywood, before traveling to England with the director to finish the assignment. Cronyn was again chosen because he was a "friend," Hitchcock told Truffaut, "a very articulate man who knows how to voice his ideas."

James Bridie, meanwhile, was teaming up from his home in Glasgow. Although Bridie had earlier excused himself from adapting Simpson's book, unlike Laurents he admired the novel, and he was finally won over by Hitchcock's vow to preserve as much of its flavor as possible. While Hitchcock and Cronyn plotted out the continuity, Bridie fleshed out the characters and wrote dialogue; Alma read and edited the drafts. This was not the close group dynamic of Cromwell Road, however, this was the scattered contributions of four creative minds who were seldom, if ever, in the same place at the same time. Looking back on the process, Hitchcock

never quite decided who was the weakest link in the chain; he tended to blame Cronyn, the Johnny-on-the-spot, who was suited to adapting the small-scale *Rope* (which exploited his familiarity with the stage and New York) but lacked "sufficient experience" for this, more sprawling, period drama.

Spring in London was always welcome; it painted the future in a sunny glow. Having pulled off the technical challenges of *Rope,* Hitchcock was feeling proud and optimistic. Between script conferences with Sidney Bernstein and Hume Cronyn, the director finalized the cast and crew for *Under Capricorn,* and oversaw the ambitious sets being constructed at Elstree. He'd be filming in the old Amalgamated Studios, now maintained by MGM-British, which had used its American financial backing to build modern, Hollywood-style facilities—and the best studio restaurant.

It was Mrs. Hitchcock's first trip to England since 1939, and the couple took time to renew friendships and introduce their grown-up daughter to relatives. *Outrun the Constable* was set in London, and that gave Alma a professional and personal incentive to tour the city with Pat. Nurturing her acting ambitions, Pat was hoping to join the Royal Academy of Dramatic Art (RADA), the leading drama school in England. So mother and daughter visited RADA on Gower Street, and Pat was enrolled for the fall term.

Although Hitchcock poked fun at Pat's avocation in interviews, she was the center of her parents' world, and they supported her goals. "I don't think they wildly encouraged her but they didn't discourage her," recalled Whitfield Cook. "They were with her all the way."

Alma brought up the idea of incorporating RADA and the backstage world into *Outrun the Constable.* One of the main characters in the Selwyn Jepson novel is a glamorous older woman, almost a diva type. The young woman trying to solve the murder must don a maid's disguise to go under cover and pin the crime on the diva. The novel's young woman has no real occupation, so Alma suggested making her a RADA student—an aspiring actress like Pat. In the same vein, the diva could be an *actual* diva of the theater. The amateur then would have to conquer the diva with her sleuthing *and* her acting. The Hitchcocks talked it over enthusiastically; the doubling and deepening of theatrical motifs would ultimately pervade the script and lead to a new title.

It was a bad sign that the director's *next* film already seemed to be interesting Hitchcock more than the one he was working on. No matter how much he and Cronyn flogged the *Under Capricorn* script, bolstering Ingrid Bergman's scenes, the second half of the story remained thin and lumpy; its sole interest derived from a jealous housekeeper. The story had no real

crescendo, so ultimately the writing team turned its attention to the love triangle between Flusky, Lady Flusky, and Adare, conjuring up a violent altercation in which a gun is fired accidentally, Adare nearly dies, and Flusky is brought to the brink of arrest, scandal, and ruin.

Hitchcock always sensed when script talks were going poorly; he knew the auguries. He spent session after desultory session with Cronyn, brainstorming without inspiration. Before long he was violating his own credo, and rushing the solutions.

One morning in the Transatlantic offices, Cronyn recalled, "Hitch suddenly reared back in his chair, scowling like an angry baby, and announced, 'This film is going to be a flop. I'm going to lunch.' And he stalked out of the room, pouting. I was appalled; Sidney [Bernstein] was immediately solicitous. 'Now, Hume, don't be upset. You know Hitch: he'll have a good lunch, come back, and everything will be serene.' It was true; I'd seen Hitch suffer these tantrums before. He never had them on the set. But during a film's preparation he could become very mercurial, his emotional thermometer would soar to over a hundred degrees in enthusiasm, only to plunge below freezing in despair."

That night the director and writer shared a long, lavish dinner at the Savoy, with Hitchcock insisting they order two expensive bottles of a rare vintage, Schloss Johannisberger and Fürst von Metternich. The evening restored Hitchcock's "benign humor," and the daytime conferences resumed in a more optimistic mode. "The trouble was," wrote Cronyn, "I had the awful, nagging suspicion that Hitch's premonition was accurate."

In the second week of June, Hitchcock returned to Hollywood for a week to approve the postproduction of *Rope* and help fashion the trailer for its fall release. He was still in good spirits, and all he could talk about were his high ambitions for *Under Capricorn*. He was going to take the innovative single-take method of *Rope* one step further—shooting on multilevel sets and even some exteriors. The fluid camera had become a bug with him; this time, though, the bug would prove fatal. *Rope* may have been a forgivable indulgence, he said later, but filming *Under Capricorn* that way was patently stupid.

But there was a hidden agenda behind Hitchcock's enthusiasm for the fluid camera. He was desperately trying to cast a spell over Ingrid Bergman. He wanted his leading lady to be as excited as he was, to visualize along with him how seamlessly the camera would weave through every scene of *Under Capricorn*. Flush with overconfidence, the director ran *Rope* for the actress and Whitfield Cook in a Warner Bros. screening room. "I liked it," Cook wrote in his journal. "She didn't much."

Neither did executives of Warner Bros. Behind the scenes the management

recoiled in horror—not at the long takes, but at what *Rope* was really "about." The homosexual subtext was suddenly transparent, though somehow until now it had eluded all the studio officials and censors. Hitchcock had pulled it off: with all his talk about technique, he'd distracted them all long enough to make the film *his* way, right under their noses.

The ears of Barney Balaban, the New York–based president of Paramount, pricked up when he heard about *Rope,* and he wrote privately to Jack Warner, urging him to divorce Warner Bros. from the unsavory Hitchcock film. Balaban warned Warner that the film too closely evoked the Leopold-Loeb case, with its portrait of two killers clearly homosexual and, worse, Jewish.

"I have talked to Alfred Hitchcock," the head of Warner's swiftly (and privately) replied, "and he emphatically told me that it has nothing whatsoever to do with the Loeb-Leopold case. Furthermore, the action takes place in New York and no Jewish characters are portrayed in the picture." Warner added, "Very confidentially, Barney, had you or someone else called my attention to the resemblance between the case and this picture before the picture was made, Warner Bros. would not have made any deal to release the picture. . . . I also want to impress upon you that it is not our property and that we only have a small financial interest in it and are chiefly concerned with the picture's distribution."

Letters echoing Balaban's came pouring in from the Anti-Defamation League, film betterment councils, and other citizen organizations. In cities and states across the country the Hitchcock film was forbidden, or passed by local censorship boards only after "eliminations" in certain scenes—often including the strangling scene that opens the film. The National Board of Review consigned *Rope* to "mature" audiences—over the age of twenty-one—the kiss of death for wide commercial prospects.

By the time *Rope* was released in September, its box-office fate was sealed by both the internal reaction of the studio and the external pressure of censorship groups. Warner's, quite capable of mounting vigorous campaigns on behalf of its own productions, advertised and distributed the Transatlantic picture with scant enthusiasm. Although *Rope* made an initial box-office splash in New York, receipts quickly dwindled across the nation. And there was no consolation overseas: in Canada the film was snipped; in England the Americanization was met with puzzlement ("it is hard to understand let alone justify the violence he has done to the text," wrote the *Times*) or pillory (Lindsay Anderson said it was the "worst" of Hitchcock's career); in France and Italy *Rope* was banned outright.

American critics split their verdict between superlatives and pejoratives. While Howard Barnes hailed *Rope* as "the work of a master" in the *New York Herald Tribune,* Bosley Crowther in the *New York Times* called it "possibly one of the dullest pictures ever made."

Ironically, Hitchcock had employed his single-take technique so smoothly, so imperceptibly, that it proved a negligible factor in reviews. The technique was a success, the film a failure. Yet in the end *Rope* succeeded on Hitchcock's own terms, as one of those pictures in which he challenged everybody, including himself. It was, he foresaw, a film for posterity, which has marked it with an asterisk. *Rope* is a near masterwork, not without flaws, not for all tastes, but the singular experiment of a ceaselessly questing artist.

The fate of the first Transatlantic film, however, would spell trouble for the future of the fledgling company, and Hitchcock had to fight his sinking feelings about *Under Capricorn.*

For the part of Sam Flusky, a former Irish stablehand the novel describes as a coarsely spoken "flabby bulk" of a man, Hitchcock sought Burt Lancaster, who he thought might credibly play a "horny, manure-smelling stable hand" locked into a fatal chemistry with Ingrid Bergman. But Lancaster cost too much, and for the moment he was booked up anyway—and Hitchcock knew that if Transatlantic's schedule fell behind, the banks would start calling in their loans.

Enter Joseph Cotten. Hitchcock's friend, he was available ("by arrangement with David O. Selznick") for the part, though as a southern gentleman he didn't smell much like manure, and he was leery of the Irish accent. Cotten would do his best, but he was "wrong" for the part, Hitchcock conceded later, and asking audiences to accept him as a former farmhand feared by civilized Sydney as a "violent brute" was asking too much.

The director needed at least one English star for a film purporting to be "Transatlantic" in appeal, so he went to lengths to woo Michael Wilding for the third-billed Adare, the newly arrived Irishman who falls in love with Mrs. Flusky. Wilding was a name only in England, where he'd served as a lightweight leading man opposite Anna Neagle. ("A British version of [Jimmy] Stewart" was how Marlene Dietrich thought of him.)

The English actor had his first meeting with Hitchcock in New York earlier in the spring. "Do you know New York well?" Hitchcock asked after they shook hands and ordered drinks in his St. Regis suite. When Wilding said it was his first visit, Hitchcock exclaimed, "Oh, we must remedy that." With the director as guide they launched a three-day tour, from Harlem to the Empire State Building. The whirlwind ended with a ferry trip from Staten Island to the Statue of Liberty; Hitchcock gazed up at the national shrine that had starred in *Saboteur*, then handed over his field glasses to Wilding and remarked, "Take a look at the lady's anatomy. Can't you guess that a Frenchman had a hand in constructing those bosoms?"

Wilding enjoyed the sightseeing, but began to wonder when Hitchcock

would mention *Under Capricorn,* "or, even more important open up about his attitudes to filmmaking. But he did let one remark slip about his approach to directing: 'The secret of suspense in a film,' he told me, 'is never to begin a scene at the beginning and never let it go on to the end.' "

At last Hitchcock did bring up the pending job, and Wilding got the part. Alone among the principals, Wilding would maintain enough good humor throughout filming to preserve their rapport. Like the character he played, the actor didn't take himself too seriously. There wasn't "enough humor" in *Under Capricorn,* Hitchcock ruefully told François Truffaut, but what little there was—on- and off-camera—came from Wilding.

The remaining cast and crew openings were filled out by English personnel. Margaret Leighton, prominent on the stage in the reborn Old Vic, was cast as Milly, the psychopathic maid who plies Mrs. Flusky with drugged drink; Jack Watling was Flusky's secretary (a character more prominent in the book); Cecil Parker, ignoble in *The Lady Vanishes,* was the Governor.

As his cameraman Hitchcock secured one of England's finest: Jack Cardiff, who'd served as an operator on *The Skin Game.* Cardiff had a reputation for his sensual color photography of Michael Powell films, and earlier in the year had picked up an Oscar for *Black Narcissus.* Hitchcock beamed as he screened *Rope* for Cardiff. The cameraman couldn't help but admire the vision, and gamely accepted the "daunting challenge" of shooting *Under Capricorn* in single takes—all the while thinking it was "rather crazy."

Ingrid Bergman's salary was not the only drain on the budget, which would eventually soar above $2 million. Set design and construction costs rose beyond all estimates. The Flusky mansion boasted two floors and a half dozen rooms, and had to be built in sections that could slide open electronically to allow giant camera cranes to float through doorways and walls. It covered the largest Elstree stage.

Hitchcock's cast was ready for action by mid-June, but construction lagged behind, and then a wildcat technicians' strike forced an additional delay. The strike cost not only money but goodwill; when Ingrid Bergman first visited the set, she was stunned by the "hostile feeling" emanating from the crew.

The script also lagged, and it never jelled into a satisfying whole. Cronyn was inexperienced, and although James Bridie wrote for Hitchcock several times, he "was a semi-intellectual playwright and not in my opinion a very thorough craftsman," the director reflected years later. The ending of *Under Capricorn* remained anticlimactic—a rare failure for Hitchcock. "On thinking it over later on," said the director, "I realized that he [Bridie] always had very good first and second acts, but he never succeeded in ending his plays."

July 1 arrived. The leads grew restless. Bergman, whose inflated (financial and script) importance had already thrown Hitchcock off stride, had time to kill. She ate, drank, gained weight—and she stewed. The Irish lilt required by Lady Flusky worried her. Characteristically, the director told Bergman not to worry, but to her, Hitchcock seemed worried about everything—the script, the set, the elaborate camera work—*except* her.

Bergman was in a personal and professional muddle. Her marriage, weakened by her love affairs, was falling apart. She had grown to loathe Hollywood's factory-line production system, and was anxious to move in a new direction and reinvigorate her career. After seeing *Open City* and *Paisan,* she found herself swept away by the truthfulness of Italian neorealism. In April, she wrote a letter to filmmaker Roberto Rossellini, declaring her eagerness to break away during *Under Capricorn* and meet him and discuss the possibility of working with him in the future. These plans did not escape Hitchcock's notice.

Joseph Cotten dined nightly with the Hitchcocks and Bergman. To him, Hitchcock seemed on edge, complaining about the rationing that was still in effect in England—and, it seemed, "all things British."

Not until July 19 did Hitchcock call the first take of *Under Capricorn*: Ingrid Bergman's introductory scene—where Lady Flusky enters the dining room, barefoot, drunk, and disheveled, to meet her husband's guests and exchanges meaningful dialogue with Michael Wilding about their common Irish past. Bergman sailed through, Irish accent and all. When Hitchcock called "Cut!" there was relieved applause.

Bowing to Bergman's nervousness, Hitchcock shot the actress's first scene without resorting to a maximum-length take. Bowing to Sidney Bernstein's, the director had already modified his vision and started breaking up a few scenes for planned cuts and camera angles. But the very resistance Hitchcock had encountered while touting his fluid camera ideas had also hardened his resolve to shoot the key scenes in long takes.

The long takes were a "technical nightmare," according to cameraman Jack Cardiff. As with *Rope,* all the actors' movements had to be chalked on the floor, amid the miles of cable that lay underfoot. As the cast spoke their lines, the camera had to move and the walls disappear; electricians had to rush lamps on dollies into place, then scramble out of view. Hitchcock was kept busy shouting to the cast and crew "like the captain of a fishing fleet exhorting his crew to pull in the nets," according to Michael Wilding.

Prolonged rehearsal was again necessary, once more testing his stars' rusty memory skills. The extraordinary physical effort required by Hitchcock's technique also taxed the crew's patience, and technical glitches ru-

ined take after take. When the actors finally got a scene right, they had to perform it all over again, sans camera, to record the dialogue.

They would rehearse one day and shoot the next, recalled Cardiff. "Good recorded sound was impossible: the noise was indescribable. The electric crane lumbered through sets like a tank at Sebastopol, whole walls cracked open, furniture was whisked away by panting prop men and then frantically replaced in position as the crane made a return trip. The sound department did exceptionally well just to get a 'guide track' (picking up dialogue above the din so that the correct soundtrack could be matched to it later). When we had made a successful ten-minute 'take,' everyone had to leave the studio except the sound people, Hitch, the script girl, and the cast, who would then go through the motions with dialogue without the camera. Amazingly, by sliding the sound tape backwards and forwards it all came together."

Under the circumstances, Hitchcock had to violate his own principles and pay more attention to the words than to the pictures—to the *sound* of the acting rather than the acting itself.

"I watched him once, during a ten minute take," Cardiff remembered. "He had his back to the actors, aimlessly looking down at the floor, and at the end, when he had said 'Cut,' he made only one comment to my camera operator Paul Beeson: 'How was that for you, Paul?' On Paul's nod, he would signal his acceptance of the whole reel."

Pained by such pressures and problems, Hitchcock got his only "pleasure out of doing those camera tricks," according to Ingrid Bergman. One filming anecdote is curiously poignant: Hitchcock was guiding a quiet interlude between Bergman and Wilding, watching them intensely as they were photographed, when suddenly he let out a howl. Then, in a gentle tone, he said, "Please move the camera a little to the right. You have just run over my foot." The enormous camera had indeed broken Hitchcock's big toe.

The camera afforded pleasure and pain to the director—but only pain to the cast, Bergman especially. "The prop men had the job of moving all the furniture while the camera was rolling forward and backward, or from this side to that," remembered the actress, "and the walls were flying up into the rafters as we walked by, so that huge Technicolor camera could follow us. It just drove us all crazy! A chair or a table for an actor appeared the minute before a cue. The floor was marked with numbers and everybody and every piece of furniture had to be on the cued number at the right moment.

"What a nightmare! It's the only time I broke down and cried on a movie set."

Her last Hitchcock film, *Notorious,* had been pure joy. But now, even more than on *Spellbound,* their first film together, Bergman questioned Hitchcock's judgment, his authority. "The other day I burst," the actress

wrote to a friend. "How I hate this new technique of his. How I suffer and loathe every moment on the set. My two leading men, Michael Wilding and Joe Cotten, just sat there and said nothing, but I know they agree with me."

One day, frustrated by a long-take scene in which she traipsed around the mansion, trying to recall pages of dialogue as the huge camera crane relentlessly pursued her, she erupted with expletives, telling off Hitchcock. "I said enough for the whole cast," Bergman said. "Little Hitch just left. Never said a word. Just went home . . . oh dear . . ."

"Later on," Hitchcock told Truffaut, confirming the incident, "someone called to inform me that she hadn't noticed my departure and was still complaining twenty minutes after I'd gone."

There was one other confrontation—although "confrontation" is the wrong word, for Hitchcock had perfected his disappearing act. One night after a particularly rough day of filming, the director was sitting having a drink with his three main players in a restaurant. Bergman started in with her griping. Once her back was turned, Hitchcock simply rose from the table and left. "That's the trouble with him," she told her fellow actors; "he won't fight."

Cotten was as miserable as Bergman. He was no less intimidated by the perpetual-motion camera (which he dubbed "the Monster"), and by the Irish accent that permanently eluded him.* Like Bergman, he too was having personal troubles; during the filming, his wife actually tried to commit suicide after learning of Cotten's affair with an actress back in the United States. The incident was hushed up by Transatlantic.

Hitchcock, who hadn't really wanted Cotten, tried to be sympathetic, and at one point went so far as to summon James Bridie from Glasgow to address the actor's concerns about specific dialogue ("no word, no punctuation of which was ever changed" without Bridie's "conference and approval," the actor recalled). Although he hated London, Bridie boarded a train to meet with Cotten, Hitchcock, and Sidney Bernstein at the studio.

"I hear you are having trouble with the speech about your background," Bridie began, lighting up one of the flat Turkish cigarettes he preferred.

"Oh no, not at all," replied Cotten reassuringly. "It's a beautiful speech, a pleasure to learn, and I look forward to reciting it."

"Well, exactly what are we talking about?" asked Bridie, glancing with puzzlement at Hitchcock and Bernstein.

* All three principals slurred their Irishness. "I saw the film again recently on television," wrote Michael Wilding in his memoir, "and we certainly made a strange-sounding trio—Joe with his American accent, my own clipped English and Ingrid's Swedish-Irish." But mingled nationalities had long been accepted in Hitchcock's films—and this was hardly the worst thing about *Under Capricorn*.

"It's only the first five words," said Cotten. "I simply find it impossible to say them with any conviction."

"What are the first five words?" prodded Bridie.

"I was born in Dublin."

"Where *were* you born?" asked Bridie.

"Virginia," said Cotten hesitantly.

"Well, change the line to read, 'I was born in Virginia,' " declared Bridie.

Later that day, however, Cotten, who had grown to dislike his character and the film intensely, made a slip of the tongue in front of Hitchcock and Bridie, referring to *Under Capricorn* as "Under Cornycrap." Eyebrows were raised, but nothing said. Cotten later regretted the gaffe, and blamed it for the fact that Hitchcock never invited him to act in another film.*

Over time, the atmosphere gradually improved. Hitchcock did his best to spread cheer, reviving his old prankishness. He found kindred souls in Wilding, who was always laughing, and sound mixer Peter Handford, who had the difficult task of trying to record all the dialogue at the proper levels. Handford shared with Hitchcock a love of trains, which they discussed during the breaks. They had a set routine: Hitchcock tugged off the sound mixer's headphones, whispering something obscene in his ears; then, when Handford broke into laughter, the director would announce huffily, "Well, when the sound mixer is *ready,* we'll start shooting."

As of old, Hitchcock found a court jester in stuffy assistant director Cecil Foster Kemp, who was the butt of his jokes for general amusement. But the jokes were mild, and tonic. Sidney Bernstein left the director to his own devices on the set, but after hours the producer was a helpful diplomat, smoothing ruffled feathers and holding a nightly open house (or, as Hitchcock called it, "open office"). Cotten served as bartender for the ice-cold martinis handed around.

Eventually the patience, the jokes, and the martinis won out. Bergman flew to Paris late in August, met Roberto Rossellini, and soon fell in love. Although this started her on a road that led deep into scandal and controversy, and away from Hitchcock and Hollywood, for the time being it left her feeling happier and revitalized. At last, Bergman too relaxed.

Early in the shooting Hitchcock had been unusually tentative with the actress, and in this, their third film, his camera work is the least intimate. But Mrs. Flusky's "confession," Bergman's key scene, had been scheduled for late in the filming, in September. The confession was cursory in the novel—only a few lines, nothing more—but the script stretched it out into a cathartic scene, a showcase for the actress. This time Hitchcock stuck to

* But they stayed good friends off-camera, and Hitchcock eventually buried the old grudge by calling on Cotten to star in the premiere episode he planned for *Alfred Hitchcock Presents.* (It was later broadcast second.)

his guns and filmed the scene as one protracted take. It would be one of the few such takes to survive the final cut.

To her surprise, Bergman had grown accustomed to the camera stalking her. "I talked all the time," she wrote to a friend. "The camera never left me and it worked fine. I must say much better than being cut up and edited."

The result is one of the highlights of a film with few to recommend it.

The original plan had been to finish by early September. But Michael Wilding took ill with pleurisy, causing further delay. The problems plaguing *Under Capricorn* never really abated.

The delays and postponements sent Mrs. Hitchcock back to America in the third week of September, ahead of her husband, who had three weeks to go before wrapping up photography in England. A number of exteriors were then slated to be filmed at the Warner's ranch. Alma returned alone, leaving her daughter in the care of her husband's favorite spinster cousins, with whom Pat would reside while attending RADA.

It is impossible to know all we'd like to know about Alma Reville Hitchcock's state of mind, then or ever. If Mr. Hitchcock was notorious among even close friends for guarding his innermost thoughts and the secrets of his heart, Mrs. Hitchcock surpassed him. Alma offered only one image to the world: that of a happily devoted spouse. She gave interviews, but they were almost entirely about her husband; she didn't expatiate on her own feelings. His career was her career. His friends were her friends— and one of those mutual friends was Whitfield Cook.

If Hitchcock was sexually impotent, what about Alma? He could make wisecracks about his impotence, his lack of sexual activity, but how did Alma feel?

He could flirt with or try to kiss an actress, but what about Alma?

Wasn't she a perfectly normal woman, with a sexual appetite that wasn't being satisfied? Didn't Mrs. Hitchcock entertain her own normal fears and desires?

Mrs. Hitchcock and Whitfield Cook had begun to meet for lunch and dinner at restaurants which, if not quite obscure or out of the way, nonetheless fell outside the regular beat of Hollywood columnists. For the next three weeks, she and her cowriter enjoyed quiet get-togethers at the Ready Room and LaRue's, discussing the script they were developing.

Did Hitchcock believe that Cook was homosexual? It might have been reasonable for Hitchcock to assume as much; though Cook would later marry, at the time he was a bachelor with homosexual friends. Did Hitchcock believe Cook was therefore "safe" as a regular companion for his wife? Or did the director guess that the two felt an attraction, and sympathetically allow the flirtation to progress? Might Hitchcock even, under

the circumstances, have approved of the direction their closeness was taking? After Alma came home from England, she appears to have seized the opportunity of her family's absence to open her heart to Cook. On the evidence of his journal, she said some thing to him on September 20 that took him by astonished surprise. If she told him of her feelings, he would have been astonished indeed, for according to his journal he spent as much time with men as with women.

Over the next week, meeting purportedly to discuss the script they were collaborating on, Mrs. Hitchcock continued talking. Although there may be other explanations, a fair reading of Cook's journal suggests that she was pressing her case for a different relationship. Cook sincerely liked Alma; he liked her enormously. But he must have been torn. He counted himself a friend of Hitchcock, and wouldn't want to jeopardize that friendship, nor the work relationship they shared.

What could Alma say to convince him? That if they planned everything out, her husband would never know? Or maybe that Hitch already knew, and it was all right with him?

It appears that, on October 1, after a cozy dinner at a restaurant, they began making love, probably at Bellagio Road. According to Cook's journal, their sexual foray was "complicated by an overseas call." A Hitchcockian scene: it must have been the husband himself, phoning at the most vulnerable, dangerous, inopportune time. Probably nothing was confessed; and it was perfectly normal for Cook to be keeping Alma company.

Whatever happened, though, must have reinforced Cook's better instincts. Over the next week, the two saw each other constantly. They went to restaurants, and to dinner at Constance Collier's. They drove to Santa Barbara for steaks at Talk of the Town. It appears from Cook's journals that Alma wept during one of their meetings, perhaps bereft over her friend trying to distance himself. Whether she ever broached the idea of lovemaking again is unclear. But the two intensified their pace on the script, and Mrs. Hitchcock and Cook were inseparable for months to come.

Hitchcock wasn't done in England until the first week of October. He returned to Hollywood to handle what shooting remained, a few exteriors and a handful of pickup and process shots. Sidney Bernstein would supervise the initial editing and postproduction in London.

On November 2, the Hitchcocks hosted Whitfield Cook and Hume Cronyn for dinner at Bellagio Road, and they crowned the evening by listening to the national election returns on the radio. The election was a cliffhanger, but all of them, politically liberal, rooted for the eventual winner, Harry Truman, who ascended to the presidency after President Roosevelt's death and had pledged to continue FDR's policies.

On Thanksgiving weekend, the Hitchcocks and Cook drove up to Santa

Cruz. The day was clear and beautiful, and the three Hitchcocks took long walks together.

If Hitchcock wrote off someone as a fool, that was one thing. But he wasn't one to hold grudges against people he really liked, and Ingrid Bergman (still accompanied by her husband), the Joseph Cottens, and Arthur Laurents were invited to Santa Cruz for weekends in the fall of 1948. Pat returned to the United States for the Christmas holidays, and Bernstein flew in and out of the country, consulting with Hitchcock about the editing of *Under Capricorn*.

Christmas Eve 1948 was celebrated in Santa Cruz with an excursion to midnight Mass. Cook and his mother were the only overnight guests. Christmas Day was rainy, and Hitchcock made a big fire in the hearth. Laurents and Joan Harrison arrived by plane about noon, and there was gift giving and champagne toasts followed by dinner. The next day it was still raining, and everybody played backgammon and Monopoly.

The following week, Cook threw a lavish New Year's Eve party in Hollywood, and the Hitchcocks were among a star-studded guest list—the Chaplins, Arthur Laurents and Farley Granger, Sally Benson, Shelley Winters and director Joseph Losey—ushering in 1949. Thereafter the three Hitchcocks drove to Palm Springs, which had become a favorite winter getaway—a St. Moritz of desert and Joshua trees, where they mixed relaxation with script talks. The director knew many of the Hollywood holiday seekers who gathered at the Racquet Club, hosted by former silent screen star Charlie Farrell and his wife, retired actress Virginia Valli—who had played the lead in Hitchcock's 1926 film, *The Pleasure Garden*.

But the commercial failure of *Rope* had dealt Transatlantic a harsh blow, and now, in London, Sidney Bernstein struggled with the editing and post-production of *Under Capricorn*. Anticipating that Transatlantic would need to retrench, Hitchcock volunteered in the fall of 1948 to put the Selwyn Jepson novel, to be renamed *Stage Fright*, on the fast track for filming in London in the spring of 1949. That was great news for Warner's, which was still wary of *I Confess*.

Stage Fright was shaping up as a cozy return to the English thrillers that were Hitchcock's safe haven. Although the author wasn't widely known outside of England, Jepson's work was nonetheless of reliable quality. Jepson had a prolific career—novels, short stories, radio plays, and films (even directing one)—but he became best known for his series of crime novels starring Eve Gill as his detective.

In *Man Running*, the first of the series, Eve Gill is the daughter of a scalawag smuggler. One night in London she notices a man named Jonathan Penrose on the street. Penrose is fleeing from constables, and "without conscious thought" Eve kisses him to deceive the law enforcers

and to "protect this man from the hated police who were our enemies as well as his." Impulsively, Eve decides to hide Penrose, who is hopelessly in love with a society figure, Charlotte Greenwood.* Greenwood has accidentally killed her husband (or so Penrose believes); suspecting otherwise, Eve disguises herself first as the lady's maid, then as an actress, to detect the real murderer. A modest but beguiling policeman joins her on the case.

A wrong-man suspect, a beautiful young woman torn between love and justice, theatrical motifs, and English humor—Jepson's novel had Hitchcock written all over it.

Alma and Whitfield Cook had finished a film treatment by the end of 1947, but the real scriptwork didn't begin in earnest until after the holidays. As it was going to be a Warner Bros. production, the studio asked Hitchcock to work with its top writer, Ranald MacDougall, whose credits included the Oscar-nominated *Mildred Pierce*. But Hitchcock hedged on MacDougall; saying he wanted a lengthy prose version before proceeding to a script, he held out for Cook, who had virtually moved in with the Hitchcocks. Perhaps, too, he didn't want to sacrifice independence by using a man beholden to Warner Bros.

The three Hitchcocks didn't launch daily script conferences until after Cook was approved by the studio, in mid-January 1948. One of their goals was to maximize the backstage milieu. They would invent a minor role for RADA student Pat Hitchcock, playing a friend of Eve's with the sly name of Chubby Banister (the first of the memorable small parts she took in her father's films). Hitchcock wanted a number of splashy scenes for Charlotte, and envisioned a glamorous star playing the diva character.

The team also worked to enlarge the part of Eve's colorful smuggler father, the Commodore, who is only a passing character in the book. At the urging of James Bridie, whom the director was expecting to polish the dialogue, the three Hitchcocks watched Sidney Gilliat's *Dulcimer Street* for the scene-stealing performance of Alastair Sim. (Sim had appeared in several Bridie plays.) The Commodore was then tailored for Sim—though later, during filming, the ebullient actor drove Hitchcock crazy, mugging without restraint.

In their script talks Hitchcock was "definitely the leader," Cook recalled. But Mrs. Hitchcock was "the world's best critic." If Hitchcock and Cook worked out something on their own together, and Alma didn't seem to react one way or another when it was told to her, inevitably her husband would ask, "What do you think, kiddie?" Cook didn't quite catch the nickname, and thought Hitchcock was calling her "kitty." One day he

* The diva's name in the book is changed to Inwood in the film.

asked the director, "Why do you call Alma 'kitty'?" "Not kitty," Hitchcock replied, "*kiddie,* because she was such a young little thing and so small when she started working with me in England."

In Jepson's book the climax involves a surreptitious tape recording at a cottage in the woods; Hitchcock took the essentials of that scene and transplanted them to a London theater. But the loudest script debate was over Penrose's reversal of guilt at the end of this scene. In the book Penrose is utterly innocent, the pawn of the scheming Charlotte and her manager, Freddy Williams. Hitchcock wanted to try something structurally unusual: Penrose would relate a sympathetic version of events to Eve, in flashback, at the beginning of the film; but then a twist ending would reveal that his version of events to have been a lie. In the final moments, a dying Penrose would confess to being the killer.

And this idea made for an even more unusual situation: the Hitchcocks disagreed with each other over it. Mrs. Hitchcock and Cook banded together to fight for Penrose's innocence, while Hitchcock insisted on trying it his way. Mrs. Hitchcock and Cook—joined against the director as writers, but also in their deepened relationship—never wavered in their conviction that a false flashback lied not only to Eve, but to the audience, who would feel cheated.

When, on March 24, Jane Wyman won the Best Actress Oscar for *Johnny Belinda,* a Warner's tearjerker in which she portrayed a deaf-mute, she became queen of the Burbank lot. Shortly thereafter, Hitchcock asked for Wyman to play Eve Gill. It helped that her agent—who also represented her husband, Ronald Reagan—was Lew Wasserman.

There was never any question but that the good-humored Michael Wilding would return to play Lieutenant "Ordinary" Smith, the detective who falls in love with Eve—a much better part for Wilding than the one in *Under Capricorn.* Dublin-born Richard Todd was almost an afterthought for Penrose, though Todd had been nominated for an Oscar as Best Actor for his ailing patient in *The Hasty Heart,* a Warner Bros. film that Hitchcock watched for Ranald MacDougall's script.

The most important part, from Hitchcock's point of view, was the diva Charlotte Inwood. The part called for a genuine diva, and once again Hitchcock thought first of Tallulah Bankhead. But Jack Warner balked at Bankhead, remembering *Lifeboat'*s box-office fate. Next the director suggested Marlene Dietrich. To Dietrich—almost fifty, but still a goddess— Warner said an enthusiastic yes.

In early April, Hitchcock sent a treatment of the script to Dietrich at her residence at the Hotel George V in Paris. She wrote back directly, saying that although she recognized the treatment as rough, "I like it very much,

knowing that you are going to do it," adding, "I being quite an Erle Stanley Gardner* admirer would love to ask you a couple of questions but I will wait with that until I know more through the script or until I see you."

Her agent extracted a salary of ten thousand dollars weekly, for ten weeks of filming. In the last week of April, when the Hitchcocks and Cook passed through New York on their way to England aboard the *Queen Elizabeth,* Dietrich flew in from Paris to meet with them. Hitchcock invited her to lunch in his suite at the St. Regis. "She came in," recalled Cook, "looking so ravishing, her hair done back smoothly on her neck and in a plain black dress. Just the most beautiful person in the world. And we had a lovely time, drinks and funny conversation."

After a whirlwind of theatergoing—running the gamut from *Death of a Salesman* to *South Pacific* and *Kiss Me Kate*—the three Hitchcocks sailed for England on April 28.

"There must be a lot that doesn't appear on the surface," Eve (Jane Wyman) muses in *Stage Fright*. "Who knows what goes on in a woman's mind? I mean, like wheels within wheels."

Both the scripts Alma worked on during her dalliance with Whitfield Cook involved women torn between two lovers. In *Under Capricorn,* the audience would be kept guessing until the end as to Lady Flusky's true feelings—which lie, incidentally, with her husband. In *Stage Fright* the audience must similarly bide its time to learn whether Eve will stick with the dull Penrose or fall for the appealing Lieutenant "Ordinary" Smith. Marriage decisively wins out in *Under Capricorn,* while the ending of *Stage Fright* is drastically different from the book The book leaves Eve with tender feelings for Penrose; for the film, Hitchcock had insisted upon something that he had never done before: the "wrong man" turning out, in fact, to be guilty.

Did Alma's intermittent romance with Cook persist? It's impossible to know. Arriving at Southampton, and then proceeding by boat train to London, the Hitchcock party registered at the Savoy; that evening, they joined Pat Hitchcock, the Sidney Bernsteins, and Al Margolies (who was handling publicity for Transatlantic) for dinner.

Cook had finished a draft of the script during the crossing, but Hitchcock suffered an attack of the flu, and took to bed at the Savoy. Largely from his bed, by phone and telegraph, he then ordered up changes and touch-ups from James Bridie in Glasgow and Ranald MacDougall in Hollywood. MacDougall, working as a favor, refused credit.

* The author of the Perry Mason mystery novels.

It was Cook's first visit to London, and Alma took it upon herself to escort the writer to bombed-out areas of the city, and to Chelsea, Hyde Park, and Covent Garden market. She took him to favorite pubs, and the pair attended plays and music hall in Islington.

The first weekend of May, the three Hitchcocks repaired to Bernstein's farm at Kent, where life was peaceful and dull. Still nursing a sore throat, the director spent part of the weekend in bed, but he rose for a screening of Bob Hope's new *Sorrowful Jones,* which Bernstein had arranged, and which everyone found hilarious.

The cast was shaping up, and the script was coming along. There were none of the unpleasant harbingers of *Under Capricorn.* Old friends could be found at Elstree: George Cukor, for one, was there directing Spencer Tracy in *Edward, My Son.* Cukor invited the Hitchcocks and Ingrid Bergman to dinner in his own suite at the Savoy. The two directors swapped Selznick horror stories, laughing as they tried to top each other.

Hitchcock also feasted on the English newspapers and the latest crop of headline killers. John Haigh was arrested in February 1949 for the acid-bath murder of a wealthy widow, which, as the Scotland Yard investigation revealed, was his last in a series of gruesome murders purely for profit. (Well, not purely; he confessed to drinking the blood of his victims.) The trial was in July, the hanging in August; the case riveted the British public.

Later in 1949, when *Stage Fright* was in postproduction, the arrest of Timothy Evans for strangling his wife and child also drew lurid coverage. Although Evans at first confessed, he withdrew his confession at trial, insisting that the deed was done by a meek middle-class neighbor named John Christie. Evans was hanged in 1950, but sure enough, a couple of years later Christie was found out and arrested for the murders of his wife, neighbors, and a series of prostitutes and working girls, whom he stuffed in the closet and under the floorboards of his house at the ever-after sinister address of 10 Rillington Place. All during 1949, Hitchcock read about Haigh and Evans and Christie, filing his fascination with these horrific killers away for the future.

After he recovered from the flu, the Hitchcocks went out several times to nightclubs, for dinner and dancing; when Hitchcock danced with his wife, Cook danced with Pat. On May 15, Cook flew to Paris and Italy for three weeks of vacation. By the time he returned in mid-June filming had started, and Alma met him at the airport.

"Miss Dietrich is a professional," Hitchcock was widely quoted as saying after *Stage Fright.* "A professional actress, a professional cameraman, a professional dress designer."

Hitchcock biographer John Russell Taylor said that the director's comments were sincere evidence of his professional regard for her, and that an unspoken affinity existed between the two screen legends. The truth was, Dietrich tended to dominate any film that she starred in. She came with all sorts of personal and professional baggage. Still, Hitchcock accepted her for the way she was: as with Tallulah Bankhead, Dietrich's reputation for manipulative behavior preceded her, and she was in the film precisely because she was a known quantity.

Her contract, for example, stipulated her wardrobe; she had to be adorned in Christian Dior dresses—expensive outfits that she could take home afterward. But Hitchcock, always controlling about what his leading ladies wore, had a clause that allowed him to approve the designs: the marabou, white fox, black tights, diamonds galore.

In fact, once Dietrich accepted the role of the diva, the character of Charlotte was rewritten to reflect her particular persona. In Selwyn Jepson's novel the character is said to be an ex-actress, but not a singer; with Dietrich, though, it became imperative to incorporate a song or two into the script, and that was one priority of the revisions.

Hitchcock volunteered a few song suggestions of his own. One of his ideas was a 1927 Cole Porter tune, "The Laziest Gal in Town." Though its composer was famous, the song was obscure, having been recorded only once. The director recalled hearing the number at the Biltmore Hotel, where saxophonist Frankie Trumbauer led the house band on NBC radio during the summer of 1938, the year of Hitchcock's first trip to Hollywood.

Dietrich countered with Edith Piaf, one of her friends (and some say lovers). She got Piaf's permission to sing her famous chanson, "La Vie en Rose." It wasn't a bad choice, and Hitchcock knew Dietrich could pull off a Piaf song. But he was planning to stage one of the production numbers in its entirety, and for that purpose he wanted a song less familiar to audiences—and more to his taste. Dietrich wasn't thrilled about ceding a song choice to Hitchcock, but he held fast. After sifting through numerous possibilities, she finally surrendered to "The Laziest Gal in Town."

Dietrich also had ideas about the script. Hitchcock listened respectfully, and the May and June rewriting continued to enhance her role. But her scenes weren't stretched out of proportion, as they were for Ingrid Bergman in *Under Capricorn*. It was more as though a spotlight swept down over her in scenes, illuminating an icon.

Bridie and MacDougall both labored over Dietrich's scenes, giving her much of "the picture's best dialogue," in the words of Steven Bach in his biography of the star. That included her curtain-call soliloquy, after Charlotte is found out as an accomplice to the murder and waits to be taken to jail. Talking to a police guard as she smokes a cigarette backstage, she

complains obliquely about pet dogs, who don't return their owners' affections. "When I give all my love and get back treachery and hatred," she hisses, "it's—it's as if my mother has struck me in the face." It was a great speech expressly tailored for Dietrich.

"Do you think that, as it is Marlene Dietrich playing the part," Hitchcock had asked Bridie as filming approached, "we could round her off [at the end] a little more strongly than we have done at the moment? I wondered if you could give her something with a little philosophy. I know that Dietrich herself (who is no fool) would like to go out of the picture not feeling sorry for herself as she is doing at the moment. Naturally it doesn't call for any profundities, but something a little longer than we have now. It might be possible, do you think?"

Even as filming on *Stage Fright* began, Hitchcock continued to "rough in" his own changes to Dietrich's dialogue, asking Bridie to critique his tinkering. It wasn't until mid-July, midway through photography, that work on her lines ceased. Bridie said he heartily approved of Hitchcock's "cuts and alterations." Bridie added, "Charlotte particularly at last comes to life. In neither the Alma–Whitfield version nor in mine was she worth a damn."

The best available man, Wilkie Cooper (who had shot *The Hasty Heart*), was the cameraman when photography began on June 1, and the largely English cast included Kay Walsh (then married to David Lean) as Charlotte's mercenary "dresser," and toothy comedienne Joyce Grenfell, who runs the shooting gallery at the theatrical garden party.

In the book, Eve has no mother, just an aunt. One character Hitchcock created expressly for the film was the Commodore's estranged wife, a role earmarked for the preeminent stage actress Sybil Thorndike. Mrs. Gill is depicted as a vague, distracted character, not without charm, who never quite catches up to what is going on. Speaking to *Films in Review* shortly after the New York opening of *Stage Fright* in 1950, Hitchcock made a point of calling the film's characters "quite normal people," and remarking that "I know the kind of people." Moreover, he added, "the heroine's mother," Mrs. Gill, was "like my mother"—the only time he ever compared Emma Hitchcock to one of his fictional characters.

"Casting is characterization," Hitchcock often said, and once again the characters he liked were the actors he liked, a fact borne out on the screen. He never got past Richard Todd's personality, which disappointed him off- and on-camera. ("Nice but nothing there," Dietrich decided.) Todd wondered why the director seemed so "cold and diagrammatic in his approach" during filming, "as if he were not really very interested in the picture." He certainly didn't seem very interested in

Todd—whose importance, already tainted by the script debate, dwindled—except for Hitchcock telling Todd that he possessed "expressive eyes," and then squandering "a lot of time doing shots on me where only the eyes were lit."

If the film's putative hero disappointed the director, so, alas, did the heroine. According to Hitchcock, Jane Wyman burst into tears when she first saw herself in homely drag in the rushes, for the scenes where she is disguised as Dietrich's maid. Not only did Dietrich have better dialogue in the film, the older actress looked ten times more beautiful. Eve's disguise is a fundamental conceit of the novel, and had been dutifully written into the script as part of the reality-versus-illusion theme. Yet after seeing the dailies, Wyman insisted on spiffing herself up in obvious ways. Hitchcock spoke to the actress about it more than once, in his suite and in her trailer, yet she persisted—with the backing of Warner's, which saw no advantage in having one of the studio's marquee attractions look drab and feel worse.

"The lack of reality" in her character hurt the film, Hitchcock said later. "She should have been a pimply-faced girl. Wyman just refused to be that and I was stuck with her."

In reaction, the director turned his gaze to someone who wouldn't let him down. Just as Hitchcock had indulged Tallulah Bankhead, allowing her to tyrannize the cast of *Lifeboat,* now he stood back while Marlene Dietrich "directed" *Stage Fright*. She mothered the ensemble. She rehearsed her production numbers to a fault. She advised the director on her lighting.

"La Vie en Rose" is heard twice in the film, both times incompletely. "The Laziest Gal in Town," the song Hitchcock forced on Dietrich, is heard in full—with Dietrich giving a full-throttle performance, before an auditorium of rapt extras whose presence she demanded. The extras gave her a standing ovation. Hitchcock's camera is fixed on her throughout the song. Vincente Minnelli couldn't have filmed it more simply, or effectively. A highlight of the film, the Cole Porter song entered Dietrich's permanent repertoire.

Singing or acting, her hypnotic performance holds the film together. Dietrich played only a handful of important roles after World War II, but *Stage Fright* is one of the best. Although the film was Hitchcock's homage to Dietrich, still he "frightened the daylights" out of her, the actress told John Russell Taylor. "A strange little man," she told her daughter, Maria Riva. "I don't like him. Why they all think he is so great, I don't know. The film is bad—maybe in the cutting he does all his famous 'suspense' but he certainly didn't do it in the shooting."

Hitchcock "knew exactly what he wanted," Dietrich conceded in her in-

terview with Taylor for his biography, "a fact that I adore, but I was never quite sure if I did it right. After work he would take us to the Caprice restaurant and feed us with steaks he had flown in from New York, because he thought they were better than the British meat, and I always thought he did that to show that he was not really disgusted with our work."

So Hitchcock didn't cuddle with Dietrich. That was a job for Michael Wilding, the self-effacing third-billed star, who was swept up in an affair with the diva. Wilding had the sneaky feeling that as their romance heated up, so did his value to Hitchcock and the film. "At her suggestion my role was greatly enlarged," Wilding said, "and without being the least bit patronizing, she started giving me helpful suggestions, which brought out the best in me."

Wilding was putty in Dietrich's hands. The Hitchcocks, silently observing, were amused.

Whitfield Cook flew back to America on June 25. Alma, who initially stayed behind to help monitor the dailies, "wrote me letters about what was going on in the cast," Cook recalled, "who was sleeping with whom." When Mrs. Hitchcock returned to Hollywood on August 9 ahead of her husband, Cook met her at the airport. The next week the two enjoyed each other's company in Santa Cruz, swimming and taking long walks in sublime weather. With her editorial instincts, Alma enjoyed listening to Cook's story ideas and giving him advice.

But she was apprehensive about the forthcoming release of *Under Capricorn*. During postproduction Sidney Bernstein had convinced Hitchcock to abbreviate some of the long takes he had persisted in filming, but early screenings hadn't generated enthusiasm for the film's style or its subject matter. Mrs. Hitchcock blamed herself—her initial championing of the story, and her early role in the development of the script.

Under Capricorn opened at Radio City Music Hall in mid-September, while the director was still occupied overseas. Although the film was a disappointment from Ingrid Bergman and Hitchcock, the critical reaction was mild. Howard Barnes of the *New York World Telegram* wrote, for example, merely that Hitchcock had "stumbled."

Regardless of reviews, Transatlantic was counting on Bergman to draw in audiences. But dramatic events had overtaken her life. Bergman had joined Roberto Rossellini in Italy, and by the end of the summer of 1949 their romance was news, her out-of-wedlock pregnancy a growing scandal. Catholic organizations were quick to condemn her morals; a few congressmen even got into the act, excoriating Bergman on the floor of the House. And across the United States, exhibitors shrank from booking *Under Capricorn*.

Upset at the blackening of her name, Bergman refused to do publicity for Hitchcock's film, refusing even to appear at its London opening. "I don't intend ever again of my own free will to see the press and answer questions," the actress wrote Sidney Bernstein from Stromboli. Hitchcock was mystified; he might have been jealous that Bergman had left him and Hollywood for a different sort of career, but he really didn't care whom Bergman was sleeping with. What bothered him more was that she was shirking her responsibility to the film.

The London reviews were worse, and *Under Capricorn* soon became a debacle outstripping even *Rope* or *The Paradine Case*. The banks moved to repossess it; more galling, the second Transatlantic film was then handed over to Dan O'Shea, who thought he might be able to squeeze additional revenue out of it as a Selznick release. Hitchcock suspected O'Shea of bearing him a permanent grudge, and neglecting *Under Capricorn;* indeed, when the Museum of Modern Art presented its Hitchcock retrospective in 1963, O'Shea refused to loan the film. To this day, it remains the least widely seen film of Hitchcock's American period.

And it's not a terrible film. Though strange and awkward, it's stylish and heartfelt at its center, with a loyalty between the married Fluskys that ultimately is stirring. In France *Under Capricorn* claims a cult reputation, and Hitchcock himself never lost his fondness for it. "I would have liked it to have been a success, even outside of commercial considerations," he told François Truffaut. "With all the enthusiasm we invested in that picture, it was a shame that it didn't amount to anything." The French appreciated the film, the director told Peter Bogdanovich, "because they looked at it for what it was and not what people expected."

In Santa Cruz, where she and Cook had repaired for the weekend, Alma read the notices. Cook was astonished at how distraught she was. Alma wept and wept. He could not console her.

TWELVE
1950–1953

Alma Reville was never again credited with writing a film. Although she remained the gatekeeper of all Hitchcock's films—from choice of story to a film's final cut—she never officially wrote another script.

Years later, the Hitchcocks both went to lengths to deny that Mrs. Hitchcock had ever written scripts at all. When in 1974 an author asked to include her in a book about "The Women Who Wrote the Movies," her husband shielded her by declining on her behalf, insisting that Alma was never a *real* writer. Early in her career she had been obliged to "make notes on the set," Hitchcock explained, "and afterwards her main job would be to cut and assemble the film for the first showing to the director." She evolved into a "technical writer," merely "cutting it up into shots and so forth," he said, but "never a creative writer in the sense we know it today."

But Mrs. Hitchcock's involvement with her husband's films was far deeper than that suggests, on both a creative and an emotional level. If a Hitchcock film failed it was painful to Alma, while her husband was capable of shrugging off reviews or box-office failures. Once asked "the secret of his serenity," Hitchcock replied, "I always try to look at things as though I were remembering them three years later." He always did look ahead. After a film was done, it was "gone," recalled Whitfield Cook,

"and he was interested in the next thing." In spite of what has been written about him, Hitchcock was far from a perfectionist. He didn't set out to make masterpieces. He was a master of accepting flaws, papering over them, and moving on.

Once, in an interview, film historian William K. Everson asked the director if he would like to remake certain of his pictures and correct their faults. Hitchcock quickly replied, "I don't think I would care to do that," adding, "I'll go further. I wish I didn't have to make them" in the first instance. After the script has been finished, the director explained, "sixty per cent of the original conception" was all he ever dared hope to realize on the screen.

Then why make the films at all? Everson asked. Well, "there's some fun," Hitchcock admitted. "There's tempo involved, and size of image"— and then there's the cutting, one last chance to "get it right."

Before the failure of *Under Capricorn,* Alma had produced a fresh treatment for *I Confess,* transferring the setting from San Francisco to Quebec. But after she said she didn't want to write any more scripts, the project needed a new and deft writer, for the bulk of the task remained of moving the nineteenth-century French play across the Atlantic, and forward to a contemporary time.

After meeting with Hitchcock in London during the making of *Stage Fright,* Lesley Storm—a.k.a. Mabel Margaret Clark, the novelist and dramatist, who cowrote the Carol Reed film *The Fallen Idol*—was engaged for the job. Everyone felt encouraged when Storm brought her notes and pages to Paris for a script conference with Hitchcock, Sidney Bernstein, and Victor Peers. The project seemed finally on the verge of a breakthrough—until Storm went incommunicado for weeks, leaving Bernstein and Hitchcock angry and mystified as they awaited her revised treatment. Ultimately, Storm was discharged.

Hitchcock had a stubborn faith in *I Confess.* Priests intrigued him; he found it amusing when the ones he met confessed their enjoyment for his sexiest, most violent films. The director had casual friendships with faculty members of the Catholic Marymount College (later Loyola Marymount), and a longtime friend in Father Thomas James Sullivan, whom Hitchcock met at the time of *The Paradine Case,* and then stayed in regular touch with for thirty years. Priests found Hitchcock a willing donor to Catholic charities, and although it became well known that he contributed a generous amount (twenty thousand dollars) to building a new chapel at his alma mater, St. Ignatius College, in 1962, less reported is the fact that several times the Hitchcocks were benefactors of new chapels and churches scattered around California.

I Confess was steeped in Catholicism as well as Hitchcockery, and he

was reluctant to let go of either. He stubbornly refused to abandon the story's most controversial elements: the illegitimate child whose existence the priest is unaware of; and the ending where the priest is hanged. Even though Bernstein supported whatever Hitchcock wanted to do, he also warned the director repeatedly that censorship in England as well as America would zero in on these, his pet ideas for *I Confess*.

Showing himself fearless where writers were concerned, Hitchcock made a stab at hiring another renowned novelist with ambivalent views of the cinema. Graham Greene, a Catholic convert whose thrillers were often suffused with religious and political themes, rarely worked directly for film and loathed most of the screen adaptations of his fiction. A harsh critic of Hitchcock during his stint as a reviewer for the *Spectator* and *Night and Day* in the 1930s, Greene had denounced the director in his heyday for his "inferior sense of reality," and more than once said that he vastly preferred the films of the "German Hitchcock"—Fritz Lang.

After Storm let Transatlantic down, Hitchcock thought of Greene, whose talent, prestige, and deep-dyed Catholicism might yet salvage *I Confess*. The director spoke directly to Greene's agent; then Bernstein followed up with a formal offer, to which Greene replied that he didn't write pictures for hire. "It is a resolution I made some years ago," Greene wrote, "and I don't want to break it, even for Hitchcock. Thank you very much, however, for asking me."*

Shortly thereafter Hitchcock visited Samson Raphaelson in Bucks County, Pennsylvania, and performed his bedtime-story routine, enthusiastically telling the writer the whole story of the film (thus far). Perhaps the writer of *Suspicion*, which had been hampered by the Production Code, might be tempted by another Hitchcock film full of opportunities for even more flagrant code breaking. When Raphaelson sniffed that *I Confess* wasn't his type of material, the director went away cross, and stymied.

This was shortly after the East Coast previews of *Stage Fright*. It was on the train back to California that the director was reading a new book by a first-time author named Patricia Highsmith. He was accompanied by Mrs. Hitchcock and Whitfield Cook, who passed around the galleys. Highsmith's story concerns two people who meet accidentally on a train. One is a psychopath who enunciates his theory of a perfect crime: swapping murders with a total stranger.

Turning the pages of the new book excitedly, the three Hitchcocks began to talk about how easily *Strangers on a Train* could be transformed

* Not that the incident changed Greene's mind about Hitchcock. In a new introduction to a collection of his film essays in 1972, Greene wrote, "I still believe I was right" in the 1930s to be irritated by Hitchcock's " 'amusing' melodramatic situations," full of "inconsistencies, loose ends, psychological absurdities."

into another run-for-cover crime film, allowing for yet another postpone-ment of *I Confess.* The screen rights wouldn't be very expensive, for High-smith was still an unknown commodity—and the story would lend itself to being photographed in black and white, inside the studio on a modest budget, even without major stars.

What Hitchcock really coveted was the springboard situation: the criss-crossing of two passengers on a train, one with murder on his mind. Oth-erwise, he thought the rest of the story was pretty expendable. Even before the rights had been sewn up, then, as the three Hitchcocks crossed the country by train and talked among themselves, they began replotting the story for film. With Alma eschewing actual writing, Cook got the job of integrating the torrent of ideas into a coherent treatment.

The major changes to Highsmith's story began with the two main char-acters. In the book, the strangers—Bruno and Guy—actually *do* swap murder victims. Bruno, the psychopathic instigator, slays Miriam (Guy's estranged wife), and afterward hounds Guy into killing his father. Bruno later dies in a boating accident, while a guilt-ridden Guy is finally cornered by a dogged detective.

Highsmith's Bruno is a physically repugnant alcoholic, but now the three Hitchcocks began to reimagine him as more of a Hitchcockian killer—dapper and charming, at least on the surface. The homoeroticism that Highsmith hinted at in Bruno's idolization of Guy would be pre-served. Just as he had with *Rope,* Hitchcock would make Bruno's sexual-ity a fascinating subtext of the film, for anyone who cared to notice it (as long as that someone wasn't a studio or censorship official). Whitfield Cook knew how to code the signals from his circle of friends, and in his hands the film's Bruno became a dandy, a mama's boy who speaks French, and who professes ignorance of women.

Guy really got the bigger makeover. In Highsmith's novel Guy is an ar-chitect; but tennis was a sport Hitchcock had played and observed for years, and so for the film Guy became a top amateur tennis player with as-pirations for political office. (Bruno has avidly followed his athletic career and rocky love life in the newspapers.) To head off the censors, Guy be-came a decent guy who *refuses* to carry out his part of the crazed bargain, killing Bruno's father.*

But there was also a subtext to Guy, hinted at in the film's relocating of key action to Washington, D.C. The politically left-leaning Cook was the second writer drafted by Hitchcock expressly because he was comfortable with sexually ambiguous characters. Cook used Guy to make the film a parable "quietly defiant of the Cold War hysteria sweeping America," in

* A Hitchcockian detail: Guy is supposed to shoot the father with an old German Luger from a San Fran-cisco pawnshop.

the words of film scholar Robert L. Carringer. That hysteria was targeting homosexuals along with Communists as enemies of the state. Concurrent with the House Committee on Un-American Activities' ongoing probe of Communists in Hollywood, and Senator Joseph McCarthy's attacks on Soviet moles in the State Department, the U.S. Senate was busy investigating the suspicion that "moral perverts" in the government were also undermining national security—going so far as to commission a study, "Employment of Homosexuals and Other Sex Perverts in Government."

In his analysis of *Strangers on a Train*, Carringer persuasively argues that the film was crucially shaped in part by these Cold War events. The very blandness and decency of Guy, wrote Carringer, made the character a stand-in for victims of the antihomosexual climate. "To all appearances Guy is the all-American stereotype," Carringer writes, "an athlete, unassuming despite his fame, conservatively dressed." Guy is "a man of indeterminate sexual identity found in circumstances making him vulnerable to being compromised." Guy's decency also sets him up for Bruno's revenge, which becomes the excuse for Hitchcock's spectacular crosscutting between the two sequences he had in mind to climax the film.

Besides Washington, D.C., which isn't in the book, Hitchcock envisioned other settings different from the Highsmith book. The novel had long sections set in the Southwest and Florida, but Hitchcock planned to stick to the corridor of East Coast cities linked by rail, which figure only fleetingly in the novel. One of Highsmith's settings, however, was a Connecticut amusement park, and Hitchcock homed in on that favorite locale—changing the particulars for Bruno's fairgrounds murder of Miriam, and then staging Bruno's return to the fairgrounds as the film's crescendo.

These changes and new ideas first coalesced in the treatment Cook began to work up on the train—"not a treatment exactly," in the words of Czenzi Ormonde, the final scriptwriter of *Strangers on a Train*, but something "called a 'step line' and it was in great detail."

On this run-for-cover project, Hitchcock raced ahead of everyone: the script, the cast, the studio. Already on this auspicious train trip, pieces of the film were dancing like electrical charges in his brain. He moved quickly in sewing up the rights for a pittance, and in getting the go-ahead from Warner Bros. to substitute *Strangers on a Train* for *I Confess*. To a studio still concerned about the director's preoccupation with Catholic priests and capital punishment, the Highsmith novel looked like a return to a more familiar, more comfortable brand of Hitchcock suspense.

While Hitchcock developed *Strangers on a Train*, Sidney Bernstein could further develop *I Confess*. In London, the Transatlantic producer engaged Paul Vincent Carroll—a cofounder, along with James Bridie, of the Glasgow Citizens' Theatre—for another treatment of the wrong-priest story.

* * *

After finishing his treatment, Whitfield Cook moved back east to concentrate on novels, and once again Hitchcock went shopping for a writer—a name author, like Steinbeck or Thornton Wilder, who could lend prestige to the film. Like first-rank actors, however, prestigious writers turned Hitchcock down more than once in America. Weeks turned into months as Cook's treatment for *Strangers on a Train* circulated around Hollywood. A host of writers dismissed Hitchcock's distasteful little drama. "Eight writers turned me down," Hitchcock told Charles Thomas Samuels. "None of them thought it was any good," he told Truffaut.

One of these was the hard-boiled novelist Dashiell Hammett. By midsummer, though, Raymond Chandler, second only to Hammett in the pantheon of American crime fiction, had surfaced as an alternative. Chandler lived in nearby La Jolla, and occasionally dabbled in film: the script he had recently cowritten for Billy Wilder's *Double Indemnity* had even been nominated for an Oscar. Approached through his agent, Ray Stark, Chandler read the Highsmith novel and the Whitfield Cook treatment, and agreed to take the assignment, though privately he sided with the other notables who had deemed it "a silly enough story." But Chandler would do it partly for the money and "partly because I thought I might like Hitchcock, which I do."

Chary of Hollywood, Chandler refused to drive to Burbank for meetings at Warner Bros., but that didn't seem to bother Hitchcock. Starting in early August, he and Barbara Keon—late of Selznick International, now working as Hitchcock's associate producer—made several limousine trips to the house in La Jolla, where Chandler was living with his semi-invalid wife.

Chandler avoided studio appointments largely because he distrusted lengthy discussion about scripts. As much as Hitchcock enjoyed talking and socializing, Chandler preferred to get down to the writing. At first appreciative of the director ("a very considerate and polite man"), he soon grew tired of their meetings, which were like the tennis matches in the film—full of fast and furious volleys. "Every time you get set," Chandler wrote to one intimate, "he jabs you off balance by wanting to do a love scene on top of the Jefferson Memorial or something like that."

Surprise of surprises, Chandler proved one of those dread "plausibles" who wanted all the film's characters to have motivations, and every plot twist an airtight explanation. He wanted to spell things out with *words*, rather than leave any of the writing to the camera. He was underwhelmed by Hitchcock's digressions—his anecdotes about *Champagne,* for example, which were intended to convey his visual philosophy, but which were Greek to Chandler.

Hitchcock was too ready "to sacrifice dramatic logic (insofar as it exists) for the sake of a camera effect," Chandler griped in one letter. He preferred a man "who realizes that what is said and how it is said is more important than shooting it upside down through a glass of champagne."

The trips to La Jolla yielded diminishing returns. The personal chemistry between the two men evaporated, and Chandler's behavior turned odd and belligerent. All Chandler wanted to do, it seemed, was debate what Hitchcock had decided must be done. The crime novelist argued that Highsmith's original story was superior to Hitchcock's version, and kept trying to restore the book. The tension was heightened by the fact that Chandler drank heavily, and spent some of their meetings either tippling or fighting off a hangover. That kind of unprofessionalism irked Hitchcock. But he couldn't fire Chandler—who had a firm contract—without alarming Warner's.

Hitchcock decided to make one last trip to La Jolla, but resolved to avoid an argument with Chandler if the author's obnoxious attitude persisted. Upon arrival, the director sat down in his usual chair, taking his usual posture. Chandler, in his cups that day, began a scathing rant about why Hitchcock should stick to the book and forget all of his devious plot and camera tricks. The director let him go on . . . and on. Barbara Keon had to speak up during the silences, when it became embarrassingly clear that Hitchcock wasn't going to utter a word.

At the peak of Chandler's oration, the director simply stood up, opened the door, and left the house. Keon hastily assembled her belongings and raced after him to where his car was waiting, the door held open by a driver who had been alerted to stand by. An amazed Chandler followed, shouting at Hitchcock. The director paused to let Keon plunge into the backseat of the car first, then tried to squeeze his bulky body into the vehicle as fast as possible.

In an uncontrolled stream of invective Chandler called Hitchcock a fat bastard, and worse, as they drove off. The remarks "were personal," recalled Czenzi Ormonde, who heard about the incident from Keon, "very personal." Hitchcock kept his poker face until they had safely escaped; even then, he gazed out the window for a long time as the limousine clocked the miles. Halfway back to the studio he finally turned to Keon and said simply, "He's through."

It wasn't Chandler's finest hour. But in his alcoholic haze, the writer seems not to have realized the damage he had done. He settled down to five weeks of scriptwriting, griping to his agent, the head of the Warner's story department, and anyone who would listen that Hitchcock never again spoke to him. "Not even a telephone call," he complained to Warner Bros. "Not one word of criticism or appreciation. Silence. Blank silence."

Hitchcock never even acknowledged receipt of Chandler's script, which arrived at the studio at the end of September.

In late August Hitchcock had to shoot the first backdrops back east before the script and cast were finalized. He personally supervised the second-unit work, including at the Davis Cup competition in Forest Hills, where they amassed footage of every imaginable backhand and serve. ("I remember asking them would they mind moving that Davis Cup out of the way, please?")

He would make use of this footage in two splendidly staged tennis matches in *Strangers on a Train*. The first contains the unforgettable image of the spectators swiveling their heads from side to side as they follow the intense volleys, while Bruno's head (and gaze) remains conspicuously fixed on Guy.

The second match is the one Guy must win—as fast as possible—in order to slip away from police and foil Bruno's attempt to frame him with evidence planted at the fairgrounds. (The Hitchcockery included doubles as well as newsreel footage, and a specially created machine that shot the balls just under the camera, to make it look as if Guy is hitting straight into the lens.) This second tennis match is magnificently intercut with a "game" every bit as tense: Bruno "playing" inside a storm drain, reaching and stretching his fingers as he struggles to retrieve an initialed cigarette lighter (the significant trifle which will incriminate Guy).

Back east, Hitchcock also shot establishing footage of Penn Station and the national monuments of Washington, D.C. He had to use a stand-in for Bruno, who posed as a shadowy figure on the distant steps of the Jefferson Memorial—symbolic, wrote Donald Spoto, of "a malignant stain . . . a blot on the order of things." The second-unit footage was precisely the kind of sightseeing scenes that Raymond Chandler, busy writing an irrelevant draft, most vehemently opposed.

Chandler's version was delivered in late September, and filed away. The new writer Hitchcock then hired, in October, was not a famous author but a Hollywood stooge—not even famous among other stooges. If there is a perfect example of Hitchcock's instinct for finding compatible writers, it is this unfamous lady with an exotic name: Czenzi Ormonde.

Ormonde was American-born, of Dutch and Bohemian ancestry; she and Hitchcock had met during his first month in Hollywood, and their paths continued to cross over the years. Ormonde had been working for David O. Selznick, doing research for *Gone With the Wind,* and she ended up in Barbara Keon's office, helping writers with script drafts. Later, she went to work as a dialogue writer for Sam Goldwyn. "I wrote on many, many pictures, for which I received no credit, just probing and sharpening the dialogue," Ormonde recalled.

Publicity photographs show her to be a fair-haired beauty with long shimmering hair. In interviews the director sometimes obliquely referred to Ormonde as "Ben Hecht's assistant," leading other books about Hitchcock to describe her as one of Hecht's "ghostwriters." In truth, she assisted Hecht on research for *Gone With the Wind* (hence Hitchcock's remark) and then stayed close friends with the Hecht family, taking over the lease on Hecht's house whenever the writer was east. But it would be more accurate to call her Keon's assistant.

In 1950, Ormonde had just published *Laughter from Downstairs*, a collection of her short stories culled from *Cosmopolitan*, depicting the life of a Bohemian-American family from the point of view of a nine-year-old girl. (The dust jacket said "parts of it were written with the aid of a flashlight tied on the end of a belt before the advent of electricity at her farm.") But although she had recently finished an assignment for Twentieth Century–Fox, Ormonde couldn't boast a single big-screen credit.

Hitchcock liked Ormonde, though, which automatically ranked her ahead of Chandler. She was a young free spirit who preferred to live away from Hollywood on a ranch. Through the years she had been an occasional dinner guest at Bellagio Road ("An exchange I heard between Mrs. H. and the daughter Pat Hitchcock proved to me she was a wonderful, clear-thinking and tender mother," Ormonde recalled). Furthermore, Ormonde, who came inexpensively, was ready to go to work. Dispensing with Chandler was awkward, but ruffled feathers were smoothed by the fact that Ormonde was also a Ray Stark client. (That really annoyed Chandler; "it's bad enough to be stabbed in the back without having your agent supply the knife," he wrote.)

At their first conference, Hitchcock made a show of pinching his nose, then holding up Chandler's draft with his thumb and forefinger and dropping it into a wastebasket. He told the obscure writer that the famous one hadn't written a solitary line he intended to use, and they would have to start all over on page one, using Cook's treatment as a guide. The director told Ormonde to forget all about the book, then told her the story of the film himself, from beginning to end.

Hecht had less than Chandler to do with the final script of *Strangers on a Train;* the true credit belongs to Alma Reville, Whitfield Cook, Barbara Keon, Czenzi Ormonde, and—of course—Hitchcock. The director knew Ormonde was the right choice after she wrote a handful of informal tryout pages for the first scene between Bruno and his daffy mother—a scene that finds Bruno lounging in a silk robe in the family mansion, getting a manicure from his mother before his father arrives to rail in the background. The chirrupy Mrs. Anthony appears ignorant of her son's vices. She is blithely devoted to her hobby of painting badly—"such a soothing pastime." (Former St. Ignatians might have gotten an extra chuckle out of the portrait Bruno's mother is painting: a grotesque modern-art smear that

she insists is Saint Francis.) Under Ormonde, Mrs. Anthony had emerged as an ultimate Hitchcock mother.

As the director read over Ormonde's first pages he grew excited: the character brought to mind a certain actress. He got on the phone to England and arranged to hire Marion Lorne, an American stage actress managing theaters in London with her husband. Lorne, making her screen debut, would make Mrs. Anthony one of the film's memorable characters—both touching and absurd.*

Ormonde was one of many people who witnessed a Hitchcock performance that attested to his fear of policemen. So many similar anecdotes have been told about him that they amount to one of two things: either evidence of a bona fide complex, or a lie so smooth and practiced that no one ever saw through it. One day, according to Ormonde, the two were driving to the studio through heavy traffic, when a motorcycle cop suddenly appeared behind them, following their car (a scene, incidentally, echoed in several Hitchcock films). Ormonde—who of course was doing the driving—assured the panicked director that she had been proceeding legally, under the speed limit. Then, at a traffic stop, the motorcycle cop swerved up ominously beside them. "I saw you and Mr. Hitchcock leave the studio," the policeman exclaimed, pushing his helmet up with a grin, "and want to tell him I never miss a Hitchcock film. They're the greatest!"

Ormonde glanced over at Hitchcock, who wasn't responding. He seemed to be in a trance. "He did not care what was said, perhaps had not heard it," Ormonde said. "Fists were clenched, face was pale, his eyes stared ahead. Visibly this was a very frightened man."**

Mrs. Hitchcock once explained that her husband was "afraid of any brush with the law," not merely because of the boyhood incident in which he was briefly locked in a jail cell, but because the director once "swerved slightly over the white line in England and was stopped by an English bobby who took down the particulars. Hitch drove everyone around him crazy for days, worrying whether or not he was going to get a summons."

After two weeks of meetings with Ormonde and Barbara Keon, Hitchcock switched to preproduction full-time, leaving the writing to the two women. "We were dominated by time, and time meant everything to us," said Ormonde. Keon, who had already been through it once with Chan-

* Except for a bit part in *The Graduate*, it was Lorne's only screen appearance. On television the actress became widely known, later, on the *Mr. Peeper* series and as Aunt Clara on the long-running *Bewitched*.

** It must have happened to him with peculiar frequency, judging from a host of similar eyewitness accounts. "One time I was taking him home—in those days I had a Volkswagen Bug," recalled art director Robert Boyle. "We were going down a street, and as we stopped at the stop sign, a motor cop came by on his motorcycle. Hitchcock was rigid. His palms were sweating."

dler, guided the drafts through revision. The two women often worked until four in the morning, trying to make pages in time for the planned late-October start date. Keon knew "exactly" what Hitchcock wanted. "She'd take two or three scenes and condense them," recalled Ormonde.

These two women wrote the script of *Strangers on a Train*—crafting all the famous highlights (the stalking and strangling of Miriam, the tennis duel, the carousel explosion), the crisscross and doppelgänger conceits, all the symmetrical touches that knit the film together. Hitchcock was absent for long stretches, and later he would complain to Truffaut that the final script evinced "weaknesses." Ormonde wasn't privy in any case to all his thinking; indeed, as she insisted in an interview for this book, she wasn't aware of the slightest homoerotic undercurrent between Bruno and Guy; Hitchcock certainly didn't mention it, and in her opinion it doesn't exist in the script or the film.

The writing was left to Keon and Ormonde, while Hitchcock raced toward the start date. "When I took this assignment," Raymond Chandler was still complaining to Warner's, "I was told by Mr. Hitchcock that there was no hurry—no hurry at all; no pressure—no pressure at all. About halfway through it I heard from his factotum [Barbara Keon] that there was a shooting date of October 1, because Mr. Hitchcock had to go East before the leaves fall and he would have to have, or at least very greatly desired, the completed script some little time before that; and that there was even the possibility . . . that if a page marked 'The End' was not received by the studio by the end of October 1, then Mr. Hitchcock might not be allowed to begin shooting."

The Ormonde-Keon version wasn't completed until November. A courtesy copy was sent to Chandler, who angrily informed his agent that his draft was "far better than what they finished with." He demanded that Warner Bros. remove his name from the credits. When it came to listing writers on the screen, Hitchcock usually included everybody, but in this case he agreed with Chandler. His preference? Drop the famous name, and credit only Whitfield Cook and Czenzi Ormonde.

But the studio wouldn't budge. Just as with John Steinbeck and *Lifeboat,* Warner's wanted Chandler's name for its cachet, though inevitably his name overshadowed Cook's and Ormonde's. About the only thing Hitchcock ever said publicly about the hard-boiled novelist was that "our collaboration was not very happy." Privately, the director always insisted that he had done everything possible to erase Chandler from *Strangers on a Train.**

* * *

* Years later, Universal publicist Orin Borsten, working on *Topaz,* noticed two first editions of a Chandler novel among Hitchcock's office library. He asked if he might have one. Take them both, Hitchcock said.

Leading off the 1950s—the decade of his most sustained creativity—*Strangers on a Train* was a deceptive Hitchcock film: a run-for-cover that became one of his definitive masterworks.

Behind the scenes, Hitchcock now assembled a photographic unit that would anchor his films for years to come. Low-key, mild-mannered Robert Burks was a Warner Bros. cameraman in the Jack Cox tradition: a versatile risk-taker with a penchant for moody atmosphere. Burks was an especially apt choice for a film destined to be Hitchcock's most Germanic in years: the compositions dense, the lighting almost surreal, the optical effects demanding.

As his editor Hitchcock once again called upon William Ziegler, who had proven himself on *Rope*. The climactic carousel explosion was a particular marvel of miniatures and background projection, acting close-ups and other inserts, all of it seamlessly matched and blended under Ziegler's eye.

Dimitri Tiomkin, a favorite of the studios, was hired to compose another Hitchcock score (his first being *Shadow of a Doubt*). But the Hitchcock films are not Tiomkin's best; the two simply never developed much of a kinship. Scenes without any music (or with handpicked songs) were still a more personal sound track for Hitchcock, and surely it was the director's idea to insert into the first fairgrounds scene the calliope number, "The Band Played On," as Bruno and his victim ride wooden horses. ("But his brain was so loaded it nearly exploded / the poor girl would shake with alarm . . .")

As much as possible the studio wanted Hitchcock to use its own contract players. Ruth Roman was cast as Anne, Guy's trusting fiancée; Hitchcock complained later that the bristling actress was foisted on him, that she lacked sex appeal. While he treated her scenes almost as filler ("Anne was always a bit of a stick," Raymond Chandler complained after seeing the film, "but now she's a piece of spaghetti"), the role of her father gained in importance, becoming a U.S. senator. A favorite actor from outside the studio, Leo G. Carroll in his fifth Hitchcock role, became, like Cedric Hardwicke in *Rope,* the film's voice of decency. (Upbraiding his family for joking about the fairgrounds killing, he says of Guy's murdered wife, "She was a human being.")

Warner's liked Hitchcock's bold idea for an actor to play Bruno. Robert Walker was the husband Jennifer Jones had left for David O. Selznick. After that humiliation, Walker suffered a series of breakdowns, and then, after a brief marriage to Barbara Ford (John Ford's daughter), spent time in the Menninger Clinic for alcoholism. Walker was not quite a major star; film audiences knew him, characteristically, as an endearing boy-next-door type—including as Jones's soldier boyfriend in Selznick's tear-jerking *Since You Went Away*. But Hitchcock was aware of Walker's tormented side, and he would revamp his image with his inspired countercasting.

In contrast, the studio balked at Hitchcock's choice for Guy. William Holden was a bitter dramatic actor, not yet a major star, fresh from playing a psychotic killer in *The Dark Past*. But hiring Holden would entail a complicated loan-out from Columbia and would tax the film's budget. The studio countered with Farley Granger, whom Hitchcock had directed in *Rope*.

The director got Walker; the studio got Granger—but Granger's casting changed a key idea of Hitchcock's. Bruno's homosexuality is implied in the script, but there's no question of Guy's heterosexuality: he's in the middle of a messy divorce and has a girlfriend. If Guy had been portrayed by a man's man like William Holden, Hitchcock believed, Bruno's attraction to him would really make Guy (and audiences) squirm. But as it was, the director had to accept an odd crisscross in the casting: a straight actor (Robert Walker) playing a homosexual, who comes on to a "super-straight" (to borrow Robert L. Carringer's word) played by a homosexual (Granger).

It added an unintended layer to *Strangers on a Train* that Hitchcock scholars are still trying to unravel—and on-screen Walker delivered a mesmerizing performance, overpowering Granger's. His Bruno is on par with the best of the Hitchcock villains for pure creepiness.

As for Granger, he did an earnest job in his role. Hitchcock could be unkind when reflecting on certain actors, and Granger was another he decided he didn't especially care for—"too easygoing," à la Joel McCrea. Unsurprisingly, Granger found the director "emotionally detached" during the filming, more interested in the effects than the performers. It was certainly true that Hitchcock had lost interest in Guy, who "should have been a much stronger man," he was still insisting years later. "The stronger the man, the more frustrated he would have been in the situation." He never forgot his preference for William Holden.

If *Strangers on a Train* was Teutonic in its camera work, it was Russian in its montage wizardry. As with *The Ring* in 1927, Hitchcock ordered up a small amusement park, and the film's first visit there—when Bruno strangles Guy's wife, Miriam—had a tour de force moment, with the killing refracted through the victim's eyeglasses, which have fallen to the ground. Hitchcock put as much effort and planning into that single shot as some directors put into entire films, and how it was done serves as a paradigm of his genius.

Although he sometimes told stars the entire story of the film, other times he deliberately withheld information from actors; as with his writers, Hitchcock briefed actors on a need-to-know basis. Laura Elliott, the Paramount contract player hired to portray Miriam, was ordered to wear

glasses so that she would resemble Anne's bespectacled younger sister, Barbara. The glasses she was given were so thick "I literally could not see the blur of my hand passing in front of my eyes," Elliott recalled. "If you can imagine this, all I could see was just a little bit out of the sides, on either side. And that was the pair Hitchcock wanted me to wear, because in reverse they made the eyes look very small—very 'pig-eyed,' as he called it. I did the entire film without being able to see. I could not see Farley Granger's face when I looked at him. I could not see the merry-go-round when I was trying to jump on—I could not see! And Hitchcock insisted that I wear those glasses even in the long, long shots, out of doors."

For the strangulation scene, Hitchcock first shot the exteriors with the other actors; then one day Elliott was summoned alone to a large, bare soundstage for her part in the puzzle. "Hitchcock had this big, round, like two-and-a-half, three-foot diameter, concave-type mirror sitting on the concrete floor of the sound stage," the actress recalled. "The camera was on one side, shooting down at the mirror, and Hitchcock said, 'Now go to the other side of it and turn your back.' I did, and my reflection was now in the mirror. He said, 'Now, Laura, I want you to float to the floor. Float backwards to the floor.' Like I was doing the limbo, bending backwards under a stick. He said, 'Float to the floor,' and I said, 'Yes, Mr. Hitchcock.'

" 'Okay, roll 'em,' he said, and I started learning back and back and back. But you can only get so far until, suddenly, THUNK—you drop two feet to this concrete floor! He'd say, 'Cut! Laura . . . fllloat to the floor.' [in a despairing voice] 'Yes, Mr. Hitchcock.' And we'd do it again and I'd get just-so-far, and go THUNK on the cement floor. Seven takes but on the seventh take, I literally floated all the way to the floor. And he said, 'Cut. Next shot.' "

What happened next was an ingenious feat of double printing, one Hitchcock boasted about to François Truffaut: the floating shot was photographed in a concave mirror, and then printed into the lenses of the girl's glasses frames. It was the kind of shot Hitchcock had been tinkering with for twenty years—and Robert Burks captured it magnificently. In the end, *Strangers on a Train*'s single Oscar nomination went to its director of photography.

Strangers on a Train would be a film of stunning visual effects. Yet like other great Hitchcock films, it contained layers of subtle meaning at every level, from the script and the imagery to the actors themselves.

One other actress who came from outside the Warner Bros. roster was none other than Pat Hitchcock, who played Anne's younger sister, Barbara. The biggest, most devious of the roles Hitchcock's daughter played in one of her father's films, Barbara was presented as a cheerful crime aficionado. She is Guy's biggest booster, and her physical resemblance to his dead wife is evoked in the flame of Guy's lighter—one of Hitchcock's

throwaway flourishes. Indeed, Barbara resembles Miriam so closely that Bruno blacks out from shock after noticing her at the senator's party, and then nearly asphyxiates a matron he is prankishly pretending to strangle. Later, Barbara is closely integrated into the climax, when she and her sister conspire to fool the gullible police and help Guy escape from the tennis stadium.

Pat Hitchcock said in interviews that she had to audition for roles in her father's films just like any other actress, and that he treated her like anyone else on the set. But it is inconceivable that Hitchcock didn't invent Barbara, a character absent from the book, purely for Pat.

And he *did* treat her like a daughter on the set. Studio publicity had fun with the father-daughter angle, cranking out a release saying that she was afraid of heights (like her father), and that one day the director dared his daughter to ride the Ferris wheel on the set. When Pat took him up on the dare he stopped the Ferris wheel with her at the top, leaving her dangling in total darkness for an hour, and only then, according to the publicity, Hitchcock allowed his "trembling daughter" to be lowered and released.

This was good stuff for press agents paid to stir up thrills, and it has been repeated in other books to bolster the idea of Hitchcock's sadism. But the Ferris wheel incident took "all of three minutes," Pat has insisted tirelessly in interviews; far from being alone, she was flanked by the two actors who played Miriam's friends; and afterward they all "had a good laugh about it."

Pat reveled in the Hitchcockian sense of humor, and indeed shared it. While she was growing up, she has said, her father would sneak in and paint a scary face on her as she slept, giving her a start when she woke up and looked in the mirror. The director's daughter doubles the joke in a film full of mirrored meanings—acting like a kind of Greek chorus in *Strangers on a Train,* a constant reminder that behind the camera her father is chuckling.

Filming on *Strangers on a Train* was completed by Christmas. The Hitchcocks booked a twenty-fifth anniversary return to St. Moritz, Switzerland, where they were joined by family friends, including Whitfield Cook. Hitchcock had lost a fair amount of weight—he was back down to 225 pounds—and insisted on squeezing into ski pants, which took "about half an hour," Cook recalled. After which the director sat on the veranda and read, while his wife and Cook went skiing.

Hitchcock, astonishingly, hadn't had a bona fide vacation in more than ten years. His few studio contracts hadn't included paid-vacation clauses; his efforts to build a name for himself in America had kept him busy—and his work ethic, his dedication to planning and making his films, also set

him apart. Since moving to Hollywood in 1939, he had directed fourteen feature films, plus a handful of war propaganda films. In the 1940s, Alfred Hitchcock directed more films, for example, than either Howard Hawks or William Wyler.

But the nonstop activity wasn't healthy; it had begun to wear him down. Ever since finishing *Stage Fright,* friends and associates had been pleading with him to take some time off. Hitchcock wasn't sure what film he would be directing next, anyway. The latest treatment of *I Confess,* by Paul Vincent Carroll, still missed the mark. Warner's, pleased with *Strangers on a Train,* agreed to let him take a sabbatical during the first half of 1951.

Pat had accepted a featured role in her third Broadway play, a murder mystery called *The High Ground*, set in a convent. The Hitchcocks leased John Houseman's apartment on West Ninth Street in Greenwich Village for their daughter, and in between bouts of editing and postproduction on *Strangers on a Train,* they traveled back and forth between the coasts, visiting with Pat, and stealing long weekends in Santa Cruz when they could.

The idea of an extended vacation outside the United States grew on him, and after Pat's play closed (she liked to joke that she was "queen of the three-week run"), Hitchcock announced that the family was going to Europe for an "indefinite stay." At the end of March they booked passage on the Italian line, shipping a car ahead to Naples. Alma did the driving to Capri and then Rome, where they stayed at the Hotel Excelsior.

"We saw a great deal of Ingrid [Bergman]," Mrs. Hitchcock reported back in a letter. "The baby is just sweet! [Roberto] Rossellini was in Paris, thank goodness. Ingrid is very thin, almost gaunt. Smartly dressed, jewelry etc., so on first appearance she strikes you as being hard. She seemed very pleased to see us and once the first strain was over, it wasn't so bad. She seems to talk incessantly and speaks Italian fluently."

From Rome the Hitchcocks drove to Florence, and then to Venice, where they rendezvoused with Broadway scenic designer Lem Ayers and his wife. North of Venice they made a sentimental stop at Lake Como, checking into the same Villa d'Este where they had stayed during the filming of *The Pleasure Garden* twenty-five years earlier. From Italy they headed to Innsbruck and Bavaria, taking a tour of Hitler's residence, and then visiting Munich, where they were chastened to see the still-bombed-out places they remembered from 1925, when they had lived in the German city for months.

In mid-April, after passing through Berlin, the Hitchcocks arrived in Paris, their favorite city in the world. The weather was gorgeous—though letters home suggest that, in spite of all his success, Hitchcock was still worrying about financial security. Alma, who held the purse strings, said they were "counting the pennies and really watching our step."

That is why Hitchcock quarreled with Sidney Bernstein in London, where they decamped after Paris. Because of substantial losses on Transatlantic's first two films, Hitchcock had not been paid the final twenty-five thousand dollars he was owed for directing *Rope*. When Bernstein insisted that sacrifices were necessary, Hitchcock replied that any sacrifices ought to be made by future agreement, without amending past agreements. He wanted the money on the spot, and in the end he extracted it; the situation was awkward for both of them.

"Have spent most of the time in London looking for stories," Hitchcock wrote his secretary in mid-May. "Some are possible but not certain." Then it wasn't until late May, after nearly two months abroad, that the Hitchcocks flew home—via Canada, where he got back into a working frame of mind by touring Montreal and Quebec City. Hitchcock later told interviewers that he chose Quebec City as the setting for *I Confess* because it was the only North American city where priests walked around out of doors in their cassocks. But Quebec was also a convenient substitute for the Paris he loved. The sprinkling of Gothic churches gave it an Old World quality that made it a cinematic natural. The Canadian Cooperation Project had launched an entente with Hollywood, and just recently Otto Preminger, for one, had journeyed there to shoot his film *The 13th Letter*.

Once again the Hitchcocks' car had been shipped ahead, and they drove down the Maine coast through Boston to New York City in time for the June premiere of *Strangers on a Train*. With this and other Warner Bros. films, the studio took full advantage of Hitchcock's easy relationship with the press; displaying instincts inherited from her father, Pat Hitchcock also gave interviews, joining her father in a mini–publicity tour of the East Coast.

Forever after, Hitchcock reflected that this two-month vacation in 1951 was one of the most sensible things he ever did—and in the years ahead, he made room annually for similar long vacations and world travel between films. As a parent, he also knew he would never again spend as much concerted time with Pat, for on the crossing to Italy their twenty-two-year-old daughter met and fell in love with a young man named Joseph E. O'Connell Jr.

O'Connell, from Newton, Massachusetts, was educated at Georgetown Prep in Garret Park, Maryland, and served in the navy during World War II. He was the treasurer of the Thomas M. Dalby Mills for children's clothing, part owned by his family—an entrenched, well-to-do Catholic family. Indeed, Pat's beau was the grandnephew of Boston's late Cardinal William O'Connell.

* * *

In London, Hitchcock and Sidney Bernstein had finally settled on another Transatlantic project: a 1948 novel called *The Bramble Bush* by David Duncan. At its core this was another wrong-man story, about a fugitive from police who is forced to adopt the identity of a murder suspect. But the intriguing thing about *The Bramble Bush* is that it signaled a political shift for Hitchcock. The wrong man of *The Bramble Bush* is a disillusioned Communist agitator; increasingly in the coming years, as the international political climate changed, Hitchcock would leave behind Hitler and Germany as his reference points for evil, and find a new villain in the Soviet Union.

It had been almost three years since *Under Capricorn,* and Bernstein was itching to produce another film. *The Bramble Bush* was intended to follow *I Confess;* but since both required development, whichever script developed fastest would be the next Transatlantic production.

Hitchcock decided to work simultaneously on both projects during the second half of 1951, while Sidney Bernstein in London aggressively optioned other properties for the future. The director took Bernstein's advice to stay away from the office and indulge in "a spell of living at home"— at Bellagio Road, but also as much as possible up in Santa Cruz.

When the Hitchcocks made up their minds, they moved like the wind, and at home the most important business was planning for Pat's wedding. Friends say that Hitchcock was initially taken aback at the whirlwind romance, but always supported his daughter's decisions and grew fond of his prospective son-in-law. Mrs. Hitchcock took the lead in organizing the nuptials, and the wedding took place in the Lady Chapel of St. Patrick's Cathedral, New York City, on January 17, 1952. Afterward, a breakfast reception was held on the roof of the St. Regis. As tradition dictated, Hitchcock was the first to dance with his daughter, and after the celebration the newlyweds left for their honeymoon in Havana.

Two writers—whose collaboration involved working closely with Hitchcock but never actually with each other—worked on *I Confess* and *The Bramble Bush* simultaneously.

William Archibald, born in Trinidad, had sung and danced professionally before turning playwright. His play *The Turn of the Screw,* an adaptation of Henry James's novel, was one of the hits of the 1950 season. (It later became the 1961 film *The Innocents.*)

George Tabori, born in Budapest, was a journalist in London before serving in the British army during World War II. His fiction was suffused with European history, and often fixated on the German national character. His novel *Original Sin* was a crime story and when Hitchcock found him, his first play, *Flight into Egypt,* about concentration-camp refugees, was about to open on Broadway.

I Confess was Hitchcock's personal priority, and therefore, much to Warner's chagrin, the wronged-priest project achieved momentum. First Archibald worked on a new story line; then, in the late winter of 1951–52, Tabori followed up with a dialogue draft that finally satisfied the director. According to Tabori, throughout their several months of close association he and Hitchcock got along splendidly. They held fruitful discussions, and then Hitchcock "left me alone," he said, to write the script. It was only after Tabori had finished the revisions to Hitchcock's apparent satisfaction that the director went ahead and "changed the whole thing," for reasons the writer never understood.

It wasn't because of the Catholic Church. In April 1952, Hitchcock, Tabori, and Sidney Bernstein visited Quebec to receive assurances of local cooperation, soak up the atmosphere, and recruit Quebecois actors for secondary roles. Bernstein took the lead in talks with religious authorities, seeking their approval; and surprisingly the Canadian Church found *I Confess* profoundly Catholic—for the priest, in spite of his illegitimate child and execution, was greatly ennobled by the script. The Transatlantic partners wisely employed a local priest with a doctorate in theology, Father Paul La Couline, as "technical consultant"; and Father La Couline bridged the discussions with the Church, reading the script to authenticate the ecclesiastical reality and recommending trims to avoid censorship.

It was Warner Bros. that finally rebelled. For years Hitchcock had staved off the studio's nervousness, hoping somehow to slip his ideas onto the screen. But as the midsummer start of filming loomed, Hitchcock was forced to circulate the latest script by Tabori, and studio officials were shocked to discover that the wrong-man priest *still* had an illegitimate child in the story—and *still* was destined to be executed at the end of the film. In late April, the studio put its foot down: it couldn't produce such a film, which was bound to provoke an overwhelming outcry in America.

James Stewart was no longer being touted by Hitchcock as the major star who could make the priest film palatable to the studio. Trying to find maneuvering room, Hitchcock now floated the possibility of Laurence Olivier, but Warner's said no, thank you. Even after the objectionable elements were purged from the script, the studio insisted on having an American lead.

In April, Hitchcock for the first time suggested a refugee from *Rope*—Montgomery Clift. Clift was at the height of his popularity; having just completed *A Place in the Sun* (for which he garnered his second Best Actor nomination), he would have a brief availability for *I Confess* before appearing in *From Here to Eternity* (which would bring him his third). Clift was willing to play the wronged priest, named Father Michel in the Tabori script (later renamed Father Michael Logan, as one of the *Boys Town* touches Warner's demanded). Clift even looked like a priest, possessing, his costar Karl Malden observed, "the face of a saint but when you looked

into the eyes you saw a tortured soul trying to make its way out of utter bewilderment."

Playing a noble priest was a better career move than playing a homosexual killer: Clift said yes, and was happily accepted by Warner Bros. It so happened that the actor was friendly with a French monk who lived in a cloistered monastery in Quebec, and he was glad to spend a week there before filming. Unfortunately, it was the Tabori script that won Clift over, illegitimate child, wrong-man execution, and all. Only when he arrived in New York for camera tests—when it was too late to back out—did the actor discover that that version would never make it to the screen.

Hitchcock was finally forced by Warner Bros. to gut from the script the very ideas that had most interested him in the first place. The studio called on him to drop not only the out-of-wedlock child—his and Mrs. Hitchcock's invention—but the wrong-man execution, which dated from the original play. He worked feverishly alongside the faithful Barbara Keon to create a new subplot: Father Logan (Clift) and his old girlfriend (the character eventually played by Anne Baxter) are blackmailed for having slept together one stormy night. True, it's an extramarital fling for the girlfriend, but she doesn't *tell* the priest that she is married—and he isn't even a priest yet! That took care of the illegitimate baby (there just isn't one), while the execution was removed in favor of the priest's trial and acquittal, a last-reel chase, and cornering of the true villain.

Archibald polished the Hitchcock-Keon rewrite of Tabori's ill-fated draft. Counting a Canadian writer recruited to hang around the set and contribute "Quebec atmosphere," upwards of a dozen writers toiled on *I Confess* over the years; it was a dispiriting record for a Hitchcock film.

Back when his spirits were high, the director had courted Olivia de Havilland for the leading-lady role—that of the priest's "girlfriend." But as that role changed in the rewrites, it declined in credibility and actual screen time, and a star of de Havilland's importance (and salary) had to be discounted. Hitchcock backpedaled with Warner Bros., arguing for a hitherto unknown actress. He proposed Suzanne Cloutier—Orson Welles's Desdemona in *Othello*—or perhaps the German actress Ursula Thiess, who had not yet appeared in Hollywood films.

Jack Warner's desire to reconquer European markets sealed off by the war was always part of the Transatlantic–Warner's bond, and now it enabled Hitchcock to get away with signing Anita Björk, a protégée of the great Swedish director Alf Sjoberg. Björk had just given an intense performance as the title character of *Miss Julie*, Sjoberg's masterful adaptation of Strindberg's play which had tied for the Grand Prize at Cannes in 1951.

The filming of *I Confess* was scheduled to begin on August 21, in Quebec, and on July 23 Hitchcock traveled ahead to New York for camera tests with Clift and Björk. When Kay Brown greeted Björk at the airport, however, she found the Swedish actress accompanied by her lover—the poet, novelist, and playwright Stig Dagerman—and their illegitimate baby daughter. (Björk was estranged from her husband in Sweden.) Instantly aware that this spelled trouble, Brown alerted Hitchcock, who told Bernstein, who phoned Jack Warner.

On July 24, Hitchcock gamely went ahead and shot a day of wardrobe, makeup, and other tests with Clift and Björk, while Bernstein sparred with the head of the studio. Warner Bros. had just spent weeks expunging the priest's girlfriend and his illegitimate child from *I Confess;* now the leading lady had shown up in America flaunting her own out-of-wedlock baby. "You simply can't do this," Jack Warner told Bernstein, "not again. Not with *another* Swedish girl." Warner recommended that Björk obtain a quickie divorce and marry the child's father, a proposal reportedly relayed to the Swedish actress—and hotly refused. Warner then insisted that Björk be replaced and simply paid off; Hitchcock protested, but was overruled.

Willing, under the circumstances, to assume all liabilities, the studio offered to buy out Transatlantic and make *I Confess,* at this eleventh hour, a 100 percent Warner Bros. production. All the fight went out of Bernstein; he had never felt comfortable with Warner Bros. (he had sued the studio over advertising rebates from *Rope* and *Under Capricorn*), and was aghast at the latest predicament. Bernstein "felt that there were too many compromises involved," according to his biographer Caroline Moorehead, and resigned from the film.

Hitchcock had a different dilemma. He had spent years, including almost the entirety of 1951, preparing a film that was suddenly on the brink of cancellation. He was above all a professional; he had never quit a production, never at the last minute, or in the midst of shooting. He had thirty years of experience with studio vicissitudes; he had experienced and withstood worse indignities. Walking away from *I Confess,* Hitchcock knew, would cause an irreparable breach with Warner Bros. and inflict damage on his reputation in Hollywood.

Surrendering *I Confess* to the studio was the only course to take. Moorehead reported that Hitchcock and Bernstein parted "amicably," and that Hitchcock was "far too deeply committed to the film to pull out." Transatlantic intended to stay together for *The Bramble Bush* and future films, but for the moment the fledgling company was put on hiatus.

Hitchcock felt Björk was an extraordinary actress, and he wasn't overjoyed by the phone call from Jack Warner informing him of her replacement—the more ordinary Anne Baxter. Baxter had won a Best Supporting Actress Oscar for her role as a dipsomaniac in *The Razor's Edge* in 1946,

and was nominated again for *All About Eve* in 1950. And Hitchcock knew her socially (her husband was John Hodiak). But he never spoke to the actress about *I Confess* before she arrived in Quebec a week before the start of filming. After ordering her bleached blond hair dyed even blonder ("I felt I wasn't as pretty as he wanted a woman to be in his films, and as he wanted me to be," Baxter told Donald Spoto), Hitchcock rushed the new leading lady before the cameras so fast that the costumes designed for Björk were simply altered to fit the Hollywood actress.

"When you compare Anita Björk and Anne Baxter," Hitchcock said ruefully to François Truffaut, "wouldn't you say that was a pretty awkward substitution?"

The cast and crew stayed at the Château Élysée, with the Hitchcocks at the more elegant Château Frontenac. Most of the exteriors were filmed in Quebec City, and a number of scenes were shot at the house of parliament and city hall. St. Zephirin-de-Stadacona was the main church.

Robert Burks was again Hitchcock's chosen cameraman. Rudi Fehr was the editor. The score was another by Dimitri Tiomkin, but one of his more interesting, including some elements of a mock-Gregorian chant.

The secondary characters included the pivotal married couple who work in the rectory—the killer who confesses to the priest, and his abused wife. In Tabori's draft they became German émigrés—"displaced persons," in Hitchcock's words. The director cast O. E. Hasse, a powerful character actor trained by Max Reinhardt who had started his screen career as an extra for F. W. Murnau, as the killer; Dolly Haas, a popular German star of the early 1930s before fleeing Hitler, was cast as his wife. Hitchcock remembered Haas fondly from the British remake of D. W. Griffith's *Broken Blossoms,* where she acquitted herself in the Lillian Gish role.

Karl Malden, a close friend of Clift's who had just won the Best Supporting Actor Oscar for *A Streetcar Named Desire,* was cast as the detective who stubbornly tries to pin the crime on Father Logan. The studio knew enough to be concerned about Clift, already a notorious drinker and troubled soul, and hoped that Malden would keep him steady.

Brain Aherne didn't become the Crown Prosecutor until the last minute. Besides his fleeting status as Joan Fontaine's first husband, Aherne was an even-tempered professional whom Hitchcock knew dating as far back as the West End production of *Rope,* in which Aherne played the original Brandon, the dominant partner in the killing. The director phoned his old friend from Canada and asked him to come and play a role in *I Confess*— for less than his customary salary, Hitchcock apologized, because the budget was already overspent.

Dozens of journalists descended on Quebec City to cover the filming, which was plagued by inclement weather (nonetheless augmented for story purposes by wind machines and fire hoses) and observed by huge crowds. Eight thousand people watched Hitchcock shoot the scenes with Clift and Baxter on the promenade overlooking the St. Lawrence River.

Accounts disagree as to whether Clift began to drink heavily in Canada, or later on in Hollywood during the studio filming. Haas thought the star was usually sober on the set, but "mighty unhappy about something." Malden thought Clift's erratic behavior had very little to do with the script or Hitchcock; and that the actor was "tragically beginning to fall apart."

Drunk or sober, Clift was "very neurotic and a Method actor," according to Hitchcock, and couldn't relax under the director's stony gaze. Clift resisted Hitchcock's preordained camera setups, while trying to draw inspiration from "obscure" sources. "I remember when he came out of the court [in one scene]," Hitchcock recalled. "I asked him to look up, so that I could cut to his point of view of the building across the street. He said, 'I don't know if I would look up.' Well, imagine. I said, 'If you don't look up, I can't cut.' "

Clift had his drama coach, Mira Rostova, close by at all times; she had been made part of his contract, and was umbilically attached to his performance. Rostova rehearsed with the sensitive actor daily, and then stood just out of sight whenever the cameras rolled. Clift waited for *her* nod of approval, not Hitchcock's, before moving on.

Malden thought Rostova's presence created "a deep division and tension" on the set, a gulf between the star and the director—but if so it remained a largely unspoken gulf. Hitchcock left Clift and Rostova alone. What would be gained otherwise? Wasn't everything about *I Confess* a fait accompli? If anything, Hitchcock was extraordinarily patient, exceptionally polite, as he went about collecting his shots and angles.

The director realized that, if anything, Rostova helped the production by soothing Clift's wounded psyche. Although Hitchcock dubbed her the "little pigeon," he treated the drama coach with elaborate courtesy, and made a point of including her in the cast dinners he hosted at the Château Frontenac in August and September, and later at Bellagio Road.

Holding court at the cast dinners up in Canada, Hitchcock steered the conversation toward a recent trial in a Quebec courtroom: a Quebec jeweler had wanted to murder his wife so he could collect on her insurance policy and marry his mistress. His girlfriend's brother made a bomb with a timing device, and the mistress express-mailed it on an aircraft carrying the wife. It was timed to explode over the St. Lawrence River, theoretically destroying evidence of the crime, but instead blew up forty miles outside Quebec at seven thousand feet, killing the wife and twenty-two others. The man and his accomplices were arrested and convicted, and in 1950 they were hanged—all for a ten-thousand-dollar policy.

With the disheartening prospect of *I Confess* all around him, he distracted himself with talk of how a bomb on an airplane might make an exciting Hitchcock film.

Inevitably, *I Confess* suffered from its patched-together script ("lacking in humor and subtlety," as Hitchcock told François Truffaut) and disappointing leads. Montgomery Clift proved a disappointment not only to the director, but also to his friend Karl Malden. Malden and Clift had a falling-out during the filming: Malden thought the star was trying to upstage him in their scenes together, and he became convinced that Clift and Rostova were whispering against him. Silently seething, Malden felt betrayed by Clift's behavior. After he was invited to view a rough cut of *I Confess*, Malden realized that Hitchcock must have seen and understood everything that passed between them. The editing subtly favored Malden. When Malden thanked him, Hitchcock murmured, "I thought you'd like it." ("I felt it was his way of offering me a little prize for staying cool about Monty and Mira," wrote Malden.)

Anne Baxter never had much of a chance: the final absurdity of the script was her character leaving the grand ballroom on the arm of her husband (Roger Dann), even before the violent denouement of *I Confess*. Her character's scenes were rewritten one last time on location; by then Hitchcock felt hamstrung by the casting. His camera preferred the exquisite Dolly Haas, playing the sympathetic character named for his wife, Alma.

I Confess smolders without ever catching fire. Hitchcock is most comfortable with the secondary characters (the Brian Aherne scenes are especially playful), the brooding Quebec City and Catholic atmosphere, the dreamlike flashbacks. (These silent interludes, depicting the idyllic prewar romance between the priest and his girlfriend, seem almost to achieve the kind of hyperrealism Hitchcock had wanted from Salvador Dalí for *Spellbound*.) Perhaps the best part of *I Confess* is the Hitchcockian ending—"which is liturgically and thematically right (transference of guilt healed by confession)," in film scholar Bill Krohn's words—although it was virtually imposed by the studio as an alternative to hanging the priest.

The ending finds Father Logan, after being acquitted in the courtroom, met outside by hostile reporters and a mob of angry people.* The killer's wife can't stifle her conscience any longer, but when she tries to shout the truth, her husband pulls a gun and (somewhat illogically) shoots her. Pan-

*Filling out the tapestry for Hitchcock, conspicuously standing in front of the mob, is a fat woman munching an apple as she glares at the priest—an idea the director proudly singled out as his own, in his conversations with François Truffaut. "I even showed her how to eat the apple."

demonium erupts. The priest and police then chase the man through descending levels of the Château Frontenac. Defiantly clutching his gun, the killer winds up—like the Drummer Man or Mr. Memory before him—alone on a stage at the far end of a grand ballroom.

Father Logan dares to approach the killer. The jittery man makes a threatening gesture, and the police shoot him. The killer collapses in the priest's arms—another villain who has improvised his own self-murder in a Hitchcock film. "I am alone as you are," he murmurs to Father Logan, pleading for forgiveness. The priest closes his eyes and whispers a prayer over the dying man. Hitchcock was usually compassionate toward his sinners, but this is his most compassionate ending to his most Catholic film.

The time Hitchcock had taken off in 1951 paid off in dividends for the decade ahead.

Unusually for him, by the time *I Confess* went into postproduction, Hitchcock knew what his next several film projects were going to be. After *I Confess,* he planned to direct *The Bramble Bush* for Transatlantic; after that he was going to direct another Transatlantic property, an adaptation of a novel called *To Catch a Thief.* He had read the book in galleys, and Sidney Bernstein had optioned it on his behalf. They sent it to Cary Grant, who in 1952 tentatively committed to playing the lead, a retired jewel thief living on the Riviera.

While in New York in the fall of 1952, Hitchcock saw a play called *Dial M for Murder,* a hit imported from London; he filed it away in his mind as a possible run-for-cover subject. He met with Leland Hayward, who wanted to sell him on a Cornell Woolrich short story, which Hayward had optioned in partnership with Josh Logan. Logan, a Broadway director who wanted to move into film, had written a treatment of the story. Hayward wanted Hitchcock to produce the Cornell Woolrich film, with Logan directing James Stewart in the lead; alternatively, Hitchcock might direct the film, from Logan's script. Around this time Hitchcock also had the idea of Stewart starring in the long-bruited-about remake of *The Man Who Knew Too Much,* and he asked Bernstein if he could pin down the rights for Transatlantic.

In his spare time, he was already scribbling notes for an unusual film, based on a book by Jack Trevor Story. It wasn't a well-known book: not *What Happened to Harry?*, Hitchcock kept having to correct Bernstein, but a scenic little novel called *The Trouble with Harry.*

And to journalists who interviewed him on the press tour for *Strangers on a Train,* Hitchcock had spoken for the first time about a future film, in which he envisioned a wrong-man hero—someone like Cary Grant—hiding inside Abraham Lincoln's nostril atop Mount Rushmore. What the

hero was doing there, or how he got there, the director didn't have the slightest notion.

In New York, Hitchcock shared drinks at "21" with Otis Guernsey of the *New York Herald Tribune.* His eyes lit up when Guernsey said he had an idea for a film about an "ingenuous American" saddled with a mistaken identity—the "highly romantic and dangerous identity" of a "masterspy"—being pursued by assassins. Hitchcock turned Guernsey over to Kay Brown, who eventually extracted a treatment from the newspaperman that even Guernsey felt evinced too many "faults of a) logic b) corn or c) overcomplicated devices." But Hitchcock didn't mind the faulty logic, the corn, or the overcomplicated devices—and he paid for the sketchy treatment.

Bernstein spoke with Ben Hecht about expanding the wrong-master-spy idea into a vehicle for Cary Grant, but Hecht was too busy, so Hitchcock set it aside. Guernsey's idea bore obvious similarities to *The Bramble Bush,* with its politics and wrong-man conceit, yet it offered a fallback if the other project bogged down. "The Man in Lincoln's Nose" was Hitchcock's joke title for the idea, which almost a decade later became *North by Northwest.*

The consent decree that forced the major studios to divest themselves of their theater chains, the surge of television, and the shadow of the blacklist had combined to hobble Hollywood at the beginning of the 1950s. Production was down drastically, and in late 1951 Hitchcock noted in a letter to Bernstein, not without pity, that the much-admired Michael Curtiz had just been cashiered by Warner Bros. after twenty-six years as a contract director. Hitchcock suddenly found himself one of only a handful of filmmakers under long-term agreement—suddenly he was the studio's star director.

Hitchcock, who had started out in the business writing intertitles for silent pictures, took stock of the dubious trends sweeping the industry, in his letters to Bernstein. He dryly disparaged the quick fixes of Cinema-Scope, Magnascope, Cinerama, 3-D, and "road show" pictures—the official alternatives to television. Warner Bros., Hitchcock knew, was about to jump on the 3-D bandwagon. The veteran director was skeptical of fads, but thought at least they had the merit of distracting the bosses from watching him too closely. While the bosses panicked, Hitchcock crackled with confidence. While they had forgotten how to entertain, he was refining his ideas. Hollywood was adrift—but his films would sail through the gaps.

Hitchcock was fascinated by Darryl Zanuck's high-wire act amid nervous stockholders at Twentieth Century–Fox, and amused to observe Jack Warner's sudden pique whenever a Zanuck triumph was reported in the trades. Except for David O. Selznick, who was nominally independent of

the major studios, Jack Warner was the mogul Hitchcock got to know best, and the only one still as firmly in control in 1950 as he was when Hitchcock first visited Hollywood. Hitchcock's letters indicate that many of the final, touchy decisions involving his Warner Bros. films were settled privately between him and the top man.

Most directors who started out in silent pictures were winding down, just as Hitchcock was charging full blast into the coming decade. Jack Warner could take pride in having such a man under contract—at a time when there was little else the studio could point to with pride. *Rope* and *Under Capricorn* may have been box-office failures, but Warner's only handled the distribution on these films; Transatlantic absorbed the losses. *Stage Fright* and *Strangers on a Train,* on the other hand, had proved economical and surprisingly profitable. For Warner Bros., Hitchcock was a triple achiever: a man with an audience track record, a consistent awards contender, and a publicity asset.

It was at Warner's that Hitchcock first began to consult closely with the studio about the promotion of his films, and that the publicity began routinely to refer to him as "the Master of Suspense." Hitchcock made appearances for the studio at premieres outside of New York and Los Angeles, doing minitours of regions and markets, familiarizing himself with influential local critics and columnists. (When Irv Kupcinet traveled to London in 1953, Hitchcock was able to write ahead, informing Bernstein all about "Kup," advising that a "tiny red carpet" be thrown for the *Chicago Sun Times* columnist, who also hosted his own television show.) During his time at Warner Bros., Hitchcock added to his list of friendly media contacts and cultivated a wider network of relationships.

Although the publicity tropes had originated in an earlier time, Hitchcock's image was cemented during this era. Warner Bros. publicity incorporated all the now familiar Hitchcock anecdotes: a man afraid of police because of his boyhood brush with them; a dictator of actors who regarded them practically as cattle ("Of course there are some very nice cattle," he often quipped; or sometimes he'd protest, "I didn't say they were cattle, I said they should be *treated* like cattle"); a typecast director growingly concerned about his typecasting ("If I should make a film of another sort, people would come out asking, 'Well, where was the suspense?' ").

Hitchcock cheerfully abetted his publicity, which he knew added to his value to a studio. There was always some truth in the published clichés. In making his point about being typecast, for example, he publicly complained that Hitchcock pictures were prejudged by critics—and this was indeed a source of real and growing resentment, privately. When *I Confess* was released in England, Hitchcock read over a batch of reviews he'd received in the mail from Bernstein. "Not bad on the whole," he com-

mented. But he added, "By God, I am typed though, what with the label 'thriller' and the search for 'suspense.' "

The U.S. notices were not good, but also "not bad on the whole," when *I Confess* was released in March 1953—premiering in New York during Holy Week. ("A nice Lenten date!" the director joked in one letter.) And the third Hitchcock–Warner Bros. film also swiftly turned a profit.

Though the Legion of Decency slapped it with a rating of "Morally Objectionable for Adults," the film's Catholicism was not really controversial—the watered-down script and appreciative reviews in the Catholic press took care of that ("an enormously interesting film," wrote Robert Kass in *Catholic World*, "thoughtful, adult drama"). But as the director later conceded, one unanticipated weakness of *I Confess* was that non-Catholics did not feel very strongly involved in the fundamental premise: that priests have a sacred obligation to keep secret the revelations of the confessional.

The final surprise of the censorship saga occurred in Canada. In Quebec, at a cocktail party preceding the world premiere, Hitchcock seemed to be in an upbeat mood; but afterward, at the reception, the director was furious. That is because an obscure member of the government Censor Bureau had insisted on cutting out Anne Baxter's explicit declaration of love for Montgomery Clift, and that part of the flashback where it is made clear they spent the night together: almost three minutes of footage. After taking pains with the archdiocese, and being forced to give in to the studio, the insult left him livid. "There will be one version for the province of Quebec," he told a Canadian Broadcasting Corporation interviewer angrily, "and one version for the rest of the world."

But as confirmed by his letters, he paid more attention to box office than to censors or critics, and in spite of its drawbacks *I Confess* was a success for Hitchcock and Warner Bros.

In the winter of 1952, the director plunged back into developing *The Bramble Bush*. He felt he squandered too much time with George Tabori, who came back to Hollywood, met with the director, then went away and wrote a version that was completely different from what Hitchcock expected. In his late-1952 and early-1953 letters, Hitchcock expressed outrage over the "disgraceful" behavior of the independent-minded Tabori, which threw the project off stride, and off schedule. Hitchcock had to wait weeks for William Archibald to become available as Tabori's replacement, and then to restart the script.

Although he felt more compatible with Archibald ("a good worker [with] sound views of character, etc."), he faced pressure from Warner's, which was chagrined by the start-and-stop progress of the project. The

studio wanted to have its next Hitchcock film within a year of *I Confess*. And the director faced growing internal doubts about whether he could give *The Bramble Bush* "a distinction beyond an ordinary chase story." Writing to Sidney Bernstein, Hitchcock said he was being urged to speed up, though the script still needed "many weeks" of revising. "It is even quite possible for me to have to tell Warner's," Hitchcock wrote in January 1953, "that I cannot lick it and ask them to accept another subject."

Meanwhile, he asked Bernstein to engage an English writer to launch a treatment of *To Catch a Thief* "so that I can have something to work from" as soon as he finished *The Bramble Bush*. "I have been losing a lot of time waiting to complete one film entirely, before starting to think about another," Hitchcock explained. "This I would like to correct. I could easily have some preliminary discussions with a writer (unless of course one runs into a Tabori who ignores everyone's ideas) and then he could go to work on a first draft even while I am still shooting another picture. Huston and other Independents have been doing this."

That is when the Cornell Woolrich project popped up again. James Stewart agreed to star in the film, but only if it could be produced later in 1953, and only if Hitchcock would direct. Hitchcock was inclined to say yes, "assuming I was able to do it [*Rear Window*] after *Thief*," in his words. He awaited Bernstein's opinion.

Not the least important of several events that occurred in early 1953, Bernstein had departed on a monthlong Far East trip, a dream vacation announced as an ostensible "fact-finding trip" for future Transatlantic productions. But in truth the vacation spelled the demise of Transatlantic; when he returned from his vacation, Bernstein realized that he simply didn't want to produce motion pictures. Transatlantic was mired in debt, and Hitchcock's partner was tired of the risks and pressures of the business. Bernstein was constantly on call to Hollywood, but he felt more at home in London. Anxious to simplify his life, he decided to resign from the company.

There was no Transatlantic without Bernstein. But Hitchcock took the news calmly; he had half expected it, and he accepted the decision as temporary. Yet Bernstein's retreat led directly to Hitchcock's. He soberly reevaluated *The Bramble Bush*, which had begun as a Transatlantic project. Its story opened in Mexico, but most of the film was to be set near San Francisco, making for an expensive and challenging production. And if Bernstein bowed out, *The Bramble Bush* would have to become a Warner Bros. film, with Hitchcock wondering "whether it will make an important enough picture for these doldrum days."

Warner Bros. didn't care much about *The Bramble Bush*. The studio was in a frenzy over 3-D, the stereoscopic photography that simulated a three-dimensional effect. The studio's 3-D *House of Wax* was drawing

crowds and setting box-office records across America. Jack Warner wanted Hitchcock to try the new format. Though initially dubious, the director believed Warner's had short-shrifted *I Confess* in its advertising and publicity. All the support had gone to the "new toy," in his words—the studio's new 3-D pictures. Warner Bros. would take a different attitude toward a 3-D Hitchcock, and *The Bramble Bush* was too political for 3-D; the Mexican and San Francisco locations would be impossible in 3-D.

Better to hit the soundstage. In early April, Hitchcock asked the studio's permission to drop *The Bramble Bush* and switch to the stage play *Dial M for Murder,* which he thought could be quickly and cleverly filmed in 3-D. Hitchcock told Bernstein he intended to shoot *Dial M for Murder* as a Warner Bros. film at Elstree in late summer and fall, then direct *Rear Window* for Paramount, following that with *To Catch a Thief* for Transatlantic in the spring of 1954. Cary Grant was still attached to *To Catch a Thief,* and Hitchcock left the door open for Bernstein to change his mind and return to producing. Otherwise he would carry on alone.

Dial M for Murder was a story about an English marriage gone stale. The caddish husband, discovering his wife's affair with a visiting American, decides to stage her perfect murder in order to speed up his inheritance. Everything goes wrong; the wife, lured to the phone where a hired killer awaits her, fights back. She stabs the intruder to death (a famous scissors-stabbing scene in the play, which Hitchcock intended to turn into the best 3-D flourish of the film). The husband must frantically cover his tracks and organize the clues to fool the police and frame his wife. Only the American lover and a dogged police official refuse to believe the evidence, which is enough to convict her.

The play had originally opened in London in June 1952. Hitchcock did not see the show there, but Sidney Bernstein did so right away and gave it a good report. Hitchcock attended the Broadway production shortly after completing *I Confess,* and returned at least once after deciding to make a film version. Producer Alexander Korda, who had snapped up the rights to the play, profited by reselling them to Warner Bros.

Dial M for Murder was a decidedly run-for-cover play, right down to its London setting. Indeed, Hitchcock hoped to shoot as much of the film as possible at Elstree, integrating second-unit footage from around London, but Jack Warner quickly vetoed that idea. Warner claimed he didn't want to send the studio's only 3-D cameras overseas, but "I personally think the real reason is that he will create a bad impression by making a picture abroad when the studio is virtually at a standstill," Hitchcock told Bernstein.

The modest budget and tight schedule dictated Hitchcock's expeditious filming decisions. Unlike with *Rope,* the only other play he adapted in Hollywood, Hitchcock had little time to rewrite *Dial M for Murder,* so the

film's setting would remain London, its characters all British. The script-work for *Rope* had proven how long Americanization could take.

The film's script was really "not a great problem," Hitchcock wrote Bernstein, because the playwright, Frederick Knott ("quite a bright boy"), closely cooperated with Hitchcock. The film "will have to follow the play very closely," the director explained, "because if any attempt is made to open it up the 'holes' will show, so I am treating it in a modified *Rope* style. After all, its great success as a play has been its speed and 'tightness.' "

Of course one reason Hitchcock had hoped to shoot the film in London was to minimize Warner Bros. intrusions. "One cannot show modern London exteriors on the back lot," Hitchcock informed Bernstein, yet "the [Warner's] front office could see no difference between the Brownstone N.Y. street and Randolph Crescent, Maida Vale!" The story's single, recyclable set was attractive to Warner's, but even on interiors Hitchcock had to be on faux-English alert. His first fight, he reported to Bernstein, was over the "shocking taste of the set dresser" (adding, he's "a contract man, so he's a must").

Although *Dial M for Murder* was planned for 3-D, Hitchcock didn't foresee any outrageous effects. "No spears or chairs to throw at the audience," he assured Bernstein. He would stage it all quite simply, letting his camera glide fluidly around the furniture to add subtle depth of field. A good thing too, for—just as Hitchcock had anticipated—by the time *Dial M for Murder* went before the special cameras in August, the 3-D fad had faded. During filming it became common knowledge that, as Hitchcock informed Bernstein, "it is quite possible that *Dial M for Murder* may even go out as a flattie." *

One of Hitchcock's secret motives for switching to *Dial M for Murder* was that, at his urging, Cary Grant had seen the play, and was "very, very keen to play the lead"—at last fulfilling his ambitions to play a wife killer for Hitchcock. But Jack Warner vetoed that idea, too, saying he did not think it was "possible to overcome [the] public being used to Cary as a light comedy type," in Hitchcock's words. Privately, the director thought the real reason was that Grant had asked too high a salary, as well as a percentage of the gross; with *House of Wax* a smash hit in theaters during the negotiations, Warner believed any 3-D Hitchcock stood to earn a "big gross and he obviously thinks that Cary's ten percent of the gross is too much to pay." **

So instead Hitchcock engaged Ray Milland, an Oscar winner for *The*

* Indeed, *Dial M for Murder* did go out as a "flattie," playing only select theaters in major cities in 3-D.

** In addition, that is, to the director's own guarantee of 10 percent profits, on top of the 3–5 percent of negative cost that had to be set aside for 3-D inventors Milton and Julian Gunzberg.

Lost Weekend (and Best Actor at Cannes that year, beating Cary Grant in *Notorious*). Milland was a hardworking actor, but without Grant's charisma. "Cost," Hitchcock dryly informed Bernstein, "$125,000."

The cast of the Broadway show yielded two actors for the film who needed little rehearsal in reprising their roles. John Williams had played the Inspector and Anthony Dawson was Lesgate, the crooked ex-classmate blackmailed into handling the murder. Hitchcock had tried to promote the countercasting of suave Louis Hayward as Lesgate—the part he was still calling, in silent-film parlance, the "heavy." But Hayward asked for $10,000, which taxed the studio's bargain budget of $805,000 (before overhead), a ceiling already burdened by the $150,000 and percentages passed to Korda for the screen rights. Dawson, a Scot, was less of a name to American moviegoers, and he also required less of a salary, earning a mere $8,000 for his role. Savings to the budget: $2,000.

Robert Cummings seemed the best man available for the second lead, the American crime writer Mark Halliday. Hitchcock had a soft spot for the self-effacing star of *Saboteur,* a periodic guest at Bellagio Road. Besides, Cummings took a low salary of $25,000.

For Margo, the victim of her husband's jealousy and greed—and the only lady in the cast—Hitchcock couldn't afford a top star. But here he turned his limitations to advantage.

The budget needed an unknown, or at least an actress who wouldn't demand an inordinate salary. Hitchcock remembered a discarded Twentieth Century–Fox screen test, in which he had seen a young hopeful portray an Irish immigrant girl. Her accent was wrong, but the actress was irresistibly photogenic. John Ford's *Mogambo* was being shown around Hollywood, and Hitchcock was able to watch the young actress in her latest film—the breakthrough role for this twenty-four-year-old, whose electric charm and sensuality were not so evident in her first two films. Still a relative newcomer in the spring of 1953, Grace Kelly was not yet in demand. MGM, which owned her contract, was willing to loan her out for only $14,000.

The quick script (polished and done by the end of July), the streamlined casting, and rapid preproduction—all these not only served the budget, but allowed Hitchcock to intersperse what he called intense "bouts" of preparation for the project that was being quietly lined up as his next film— another intended "breather" before *To Catch a Thief.* Lew Wasserman closed a $40,000 deal transferring Cornell Woolrich's short story, which would become the film *Rear Window,* from Leland Hayward and Joshua Logan to Hitchcock: $25,000 for the rights, $15,000 for Logan's treatment. After *Dial M for Murder,* Hitchcock would direct the Woolrich story for Paramount, with James Stewart as his star. In return for certain distribution rights, Warner Bros. agreed to loan Hitchcock out to the rival studio, where Stewart had a multipicture deal and a window of availability in the fall.

* * *

At their first meeting, Hitchcock looked Grace Kelly up and down, and proceeded to lecture her on what she would wear in *Dial M for Murder*. He had one of his color-coded ideas: initially, Margot would be clad in a bright wardrobe; then, gradually, as she is victimized by events and indicted for murder, she'd go to "brick, then to gray, then to black." Except for the red lace dress she wears in the first scene, they would buy everything off the rack of department stores.

Kelly listened politely until Hitchcock told her she would wear a velvet robe for the scissors-stabbing highlight. At which point the young actress disagreed; her character wouldn't don a fancy robe in the middle of the night, she said, just to answer a ringing telephone.

"Well, what would you do?" Hitchcock asked. "What would you put on to answer the phone?"

Kelly said she wouldn't put anything special on. She'd be wearing her nightgown. She had trumped him, and that was part of their bond. A nightgown it was.

Born to wealth and connections in Philadelphia high society, a former model who had studied acting at the American Academy of Dramatic Arts, Kelly was the Hitchcock fantasy woman come to life—a dream blonde as ladylike as Madeleine Carroll, but as earthy and wanton as Ingrid Bergman. Kelly didn't mind Hitchcock's abruptness, or his despotism, which amused her. She wasn't shocked by his oft-crude sense of humor. Having attended a girls' convent school, she had heard every conceivable crudeness before she was thirteen.

A naughty girl herself, Kelly juggled two or three affairs during the filming of *Dial M for Murder,* much to the director's delight. "That Gryce!" Hitchcock was wont to exclaim privately. "She fucked everyone! Why, she even fucked little Freddie, the writer!" Her hand-holding with the playwright (and screenwriter) appeared in the entertainment columns, and her dalliance with Anthony Dawson was also grist for the rumor mill. And published accounts agree that Kelly and Ray Milland carried on an especially torrid affair, which almost broke up Milland's long-secure marriage.

Hitchcock the voyeur couldn't have been more delighted. And as *Dial M for Murder* was being shot, he was already shaping his next film to showcase this prepossessing young actress.

"All through the making of *Dial M for Murder,*" Kelly recalled, "he sat and talked to me about it [*Rear Window*] all the time, even before we had discussed my being in it. He was very enthusiastic as he described all the details of a fabulous set while we were waiting for the camera to be pushed around. He talked to me about the people who could be seen in other apartments opposite the 'rear window,' and their little stories, and how

they would emerge as characters and what would be revealed. I could see him thinking all the time."

"I could have phoned that one in," Hitchcock liked to say about *Dial M for Murder*, making a bad pun out of his modesty. He insisted that he did very little with the film, creatively. He merely cast the film well, turned on the cameras, and documented a taut, well-made play.

But in spite of its humble reputation (Robin Wood refers only briefly to the film in his book, and in the Truffaut book Hitchcock cursorily dismisses it), *Dial M for Murder* ended up as more than just another photographed play. The script was intentionally laced with Hitchcock's "familiar ironic humor," as Peter Bordonaro noted in his definitive article in *Sight and Sound;* and on a thematic level the adaptation introduced "subtle shifts in Knott's characters and in the arrangement of dialogue in order to express" Hitchcock's own ideas about "the nature of human relationships" and "sexuality in general." Scene after scene was made cinematic, with editing, high-angle shots, and recurring motifs (including the phallic implications of certain household objects).

And with Grace Kelly's affecting performance at the heart of its suspense, *Dial M for Murder* drew crowds, grossing $5 million worldwide—the fourth hit in a row for Hitchcock and Warner Bros.

PARAMOUNT

THE GLORY YEARS

THIRTEEN
1953–1955

"Palaces are for royalty," Francie (Grace Kelly) tells John Robie (Cary Grant) in *To Catch a Thief*. "We're just common people with a bank account." Kidding with friends, the film's director put it another way: "We can all be millionaires, and still only eat two lamb chops."

The financial shortfalls and anxieties Alfred Hitchcock had experienced during the 1930s and 1940s were over and done by 1954. His salary was rising steadily, and had been augmented for the first time at Warner Bros. by profit-sharing arrangements on *Stage Fright, Strangers on a Train, I Confess,* and *Dial M for Murder*. Yet it wasn't until he signed a contract with Paramount that he truly began to make dizzy money.

The Hitchcocks didn't live in a palace, and they never indulged in extravagant habits. Food, wine, and travel were luxuries the couple shared with friends and relatives. He arranged for his sister and other family members to visit him in the United States, hosting his cousin Theresa on several expeditions she made to Hollywood; on one trip she created a scene worthy of *Number Seventeen,* when she was accidentally left behind at a train station in the Southwest and had to jump into a taxi and race along the tracks to catch up.

Having failed to lure his mother to America, he took special care to provide

for other kin. ("There are precious few of us left!" his South African aunt Emma wrote him in 1956.) His account books indicate that he remained attentive to his family, and when his brother William's widow entered a sanatorium in England fifteen years after her husband's death, Hitchcock quietly instructed his accountant to pay her bills and provide a weekly allowance.

The Hitchcocks often received special shipments of gastronomic delicacies from England and Europe, and during filming had them delivered on location and served at the cast dinners Hitchcock grandly presided over. The director bought quantities of expensive wine for himself and for others as gifts, and prided himself on his vast collection of vintages; the one major addition the couple made to Bellagio Road was a wine cellar.

It was no accident that the stylish furnishings in his films were echoed in the aesthetic of his own homes: more than once he asked the art director of a film to suggest ideas for interior design. Visitors—to one of his houses, or to the homes of his screen characters—did double takes at the modern art on the walls. Hitchcock hated wallpaper, preferring walls of simple vanilla, with maybe a dash of color—a Utrillo here, a Picasso there.

Art was probably his most expensive indulgence, and Hitchcock's small but noteworthy collection divided its loyalties between the English and the French. Especially at Bellagio Road, the walls were hung with postimpressionist favorites—Maurice Utrillo, Chaim Soutine, Raoul Dufy, Maurice de Vlaminck, Amedeo Modigliani. He had three paintings by Paul Klee, the Swiss fantasist to whom he sometimes obliquely compared himself. "I'm not self-indulgent where content is concerned," he once said. "I'm only self-indulgent about treatment. I'd compare myself to an abstract painter. My favorite painter is Klee."

Two of his Klees—*Odyssey 1924* and *Strange Hunt*—are allegories of Nazi persecution, according to film scholar Bill Krohn, who has written definitively about Hitchcock's art collection; the third, *Mask and Scythe,* is the one that Hitchcock told John Russell Taylor he wasn't sure he could afford when he purchased it for six hundred pounds in 1938, to celebrate the success of *The Lady Vanishes.*

The first image to greet visitors stepping into the foyer of Bellagio Road was Georges Rouault's *La Suaire,* which depicts the face of the Redeemer as imprinted in blood on Christ's burial shroud. *Eclipse of the Moon* by Darrel Austin, a campy supernaturalist, decorated the director's study. Sprinkled around the house over the years were a number of drawings by Walter Sickert, a disciple of Degas known for his low-life subjects;* the sensuous, semiabstract nudes of Claude Garache; and a variety of Chinese figurines.

The Jacob Epstein bust of Pat Hitchcock was displayed in the courtyard

* Sickert, it would have amused Hitchcock to know, was "proved" to have led a double life as Jack the Ripper, according to a recent book by American mystery author Patricia Cornwell.

entry of the house overlooking Monterey Bay, while the rose garden featured a mosaic by Georges Braque. The etchings, caricatures, and paintings of Thomas Rowlandson, known for his evocations of crime and punishment (especially London hangings), set a more satirical mood inside the house. Equestrian art in the entrance hall was complemented by a Rowlandson painting, *The Last Gasp, Toadstools Mistaken for Mushrooms*, described in one catalog as "a macabre scene of a doctor ministering to a family, whose tongues—long, swollen and white—are telling him that they aren't long for this world."

The dining room featured two Rowlandsons that spoke to Hitchcock's brand of social satire. *Fast Day* shows clergymen "preparing to stuff themselves on a day of fasting and self-mortification," in Krohn's words, with a painting of Susanna and the elders on the wall behind them. *Sympathy* is an engraving of a prison guard about to flog a female prisoner at Bridewell, while a judge looks on sympathetically. Two of Rowlandson's "wrestling women" hung in the dining room, while *Pigeon Hole*—showing a horde of poor patrons jammed into the gallery at the Drury Lane—was in the guest room.

Visitors didn't get to inspect all the Hitchcocks' art: A set of evocative drawings of a nude man and woman by Henri Gaudier-Brzeska* hung in the master bedroom. And appearances could be deceiving: matte artist Albert Whitlock told Krohn that Hitchcock asked him to forge several of the most famous paintings he owned, so that copies of the valuable works could be hung at his vacation home up north, as a safeguard against burglars.

Nevertheless, it was a modest collection by Hollywood standards. Others in the film colony owned enough paintings and sculptures to fill warehouses. Perhaps the most valuable work Hitchcock owned, the *Rue des Abbesses* by Utrillo, was appraised in 1970 at forty-five thousand dollars.

The dizzy money began in 1954, courtesy of Lew Wasserman, MCA, and Paramount.

Sidney Bernstein's advice helped Hitchcock build his art collection, but Wasserman and MCA did wonders for his stock portfolio. By 1954, thanks to Wasserman, Hitchcock was well invested in oil, and the animals to which he often compared actors: cattle. His in-laws guided him to aluminum and metals. His investments profited him so considerably that he could joke about occasional losses. "The hell with new in-laws!!" Hitchcock wrote to Bernstein in late 1953 after taking a twenty-five-thousand-dollar hit on Canadian shares.

* The sculptor whose life is depicted by Ken Russell in the film *Savage Messiah* (1972).

Wealthy by most measures, Hitchcock would be made immeasurably richer by his new contract with Paramount, which Wasserman mast1erminded. The contract had begun as a simple single-picture loan-out from Warner Bros., but swiftly evolved into a long-term agreement with the Hollywood studio whose parent company had run Islington, where Hitchcock first entered the business in 1921.

One of Wasserman's many talents was his ability to sense when the revolving door of Hollywood might present a fresh opportunity for MCA clients. During the early 1950s Paramount underwent a sweeping change in management; now, prodded by Wasserman, the new bosses offered Hitchcock a lucrative and innovative multiyear package that the thriftier Jack Warner didn't even try to match.

Paramount was in the process of switching over from a traditional system, built on salaried producers who operated under strict studio management, to outside production units, dominated by a director, producer, or star lured to the lot by promises of independence and profit sharing. Don Hartman and Y. Frank Freeman were the two men spearheading the revolutionary transition, which had demonstrated early success.

A former Wasserman client, Hartman had worked as a screenwriter and then an associate of Dore Schary at MGM, before joining Paramount as an executive in 1951. The courtly, soft-spoken Freeman, a former Georgia exhibitor, was the New York boss. While Hartman, in the words of *Variety,* "gave exclusive thought to the 'art' values" of Paramount films, Freeman supervised the budgets and profits, concerning himself with "the 'art' as an inherent part of the commerce." Despite the industry's early-1950s malaise, Paramount was prospering because of this "click combination."

Paramount had always been a "country club" studio, snobbish about its pictures and willing to spend more to uphold its prestigious reputation. And now directors George Stevens, William Wyler, and Cecil B. De Mille had units at the studio. Producer Hal Wallis had just moved over from Warner Bros. The offices of Bob Hope, Barbara Stanwyck, Humphrey Bogart, Kirk Douglas, Burt Lancaster, and James Stewart were on the lot. Jerry Lewis and Dean Martin had Paramount contracts, and Elvis Presley would arrive in 1956.

Hartman and Freeman were unabashed fans of Hitchcock's films, and from the start Wasserman had them eating out of his hand. Wasserman had been forced to accept the basic terms of the Transatlantic–Warner Bros. deal, which predated his relationship with Hitchcock. But the Warner's contract stretched back to 1947, and the years since had been fruitful for the director. With Paramount, Wasserman was able to escalate all the terms, protecting Hitchcock's independence and autonomy; improving his salary, expenses, and perks; and implementing profit and (finally) gross percentages that put Hitchcock on a par with any director in Hollywood.

Wasserman was a secretive operator, and the full details of the Para-

mount contract have never been made public. The contract covered nine pictures: five directed and produced by Hitchcock, and four produced by the studio, with Hitchcock simply directing. Hitchcock would earn a reported $150,000 salary for each studio project, with 10 percent of the profits after twice the budgetary costs; presumably he took a lesser salary but a higher gross percentage for the films he produced *and* directed. And he was paid substantially more for the first four films specified in the contract: *Rear Window, To Catch a Thief, The Trouble with Harry,* and *The Man Who Knew Too Much*—stories whose rights Hitchcock controlled.*

But Wasserman's real coup passed almost unnoticed in 1954: a pioneering reversion clause that gave Hitchcock *ownership* of the five pictures he produced and directed, eight years after their initial release. The future implications of this clause would be astronomical.

Mrs. Hitchcock had consulted on the script of every Hitchcock film up through *Stage Fright;* even thereafter, she helped develop *I Confess,* and assisted in the crucial brainstorming stages for *Strangers on a Train.* Starting in 1954, although Alma could be coaxed into advising her husband on a scene-by-scene basis, she walked away from her traditional daily involvement in his films.

Starting on *Rear Window,* Hitchcock was challenged to fill a daunting void—and he met the challenge, quite unexpectedly, by altering his practice of relying upon multiple writers and third Hitchcocks, and handing over his trust to a single man. In doing so, it might be said, he was putting his trust in himself above all. With almost a full decade of films mapped out before him, he charged ahead with increased confidence and maturity: the clarity of his vision resulted, in the 1950s, in some of his deepest scripts and greatest Hitchcock films.

John Michael Hayes was another pipe-smoking stooge who wasn't yet especially well known in Hollywood. Hayes was in his early thirties, from Worcester, Massachusetts; after college, he worked on newspapers and radio stations, then spent time writing and editing daytime radio shows before World War II. After serving in the army, Hayes hitchhiked to California and found a niche at CBS radio, writing comedy for Lucille Ball's *My Favorite Husband* and drama for Howard Duff's *Sam Spade,* as well as other top programs. One show Hayes regularly wrote for was *Suspense,* the series Hitchcock had helped to originate (and still a favorite of his); Hayes's name was mentioned frequently on the air.

Hayes knew Hitchcock's work, some of it especially well. During the

* It is worth pointing out that two of these projects—*To Catch a Thief* and *The Trouble with Harry*—had earlier been rejected by Paramount's story department when they were read in galleys.

war, while stationed in the Aleutian Islands, he projected films for service-men, and he claimed to have seen *Shadow of a Doubt* some ninety times. By 1953 he had written several films himself, though his credits were mod-est. "I doubt if Hitch had gone to see *War Arrow* or *Red Ball Express,*" Hayes said in one interview. But Hitchcock would have seen *Thunder Bay,* written by Hayes, which starred James Stewart. Still, his most important job qualification was probably his work on *Suspense*—and the fact that he was represented by MCA.

The story that became *Rear Window* first appeared in *Dime Detective Magazine* in February 1942, under the title "It Had to Be Murder," where it was credited to one of Cornell Woolrich's pseudonyms, William Irish. Woolrich was a prolific writer of pulp thrillers that were frequent fodder for both Hollywood filmmakers and the producers of *Suspense.* Hitchcock kept up with everything Woolrich wrote. Joan Harrison had produced the Robert Siodmak film *Phantom Lady* in 1944, based on a Woolrich story, and as early as Hitchcock's third book collection of crime stories Woolrich was already a regular contributor.* The screen rights to "It Had to Be Murder" had been optioned shortly after publication by producer Buddy DeSylva, and sold after his death to Leland Hayward and Joshua Logan.

"It Had to Be Murder" told the first-person story of a man named Jeff, confined to the back bedroom of a hot and stuffy Manhattan apartment with a broken leg. With nothing to do all day and no one to talk with ex-cept a black houseman, Jeff stares out his bay window at his neighbors across the courtyard. They include a married couple, the Thorwalds, whom Jeff sees quarreling before Mrs. Thorwald disappears. Thorwald claims that his wife is on vacation, but Jeff convinces his best friend, a homicide detective, to investigate his hunch that Mrs. Thorwald has been murdered.

Hitchcock would retain much of Woolrich's vision, but the genius of the script, according to Woolrich biographer Francis M. Nevins Jr., was to make explicit what was implicit, fusing "new and genuinely Woolrichian elements" into "not a patchwork but a beautifully unified film."

Right from its inception, the director had ideas for transforming what was really a low-budget mystery into another *Lifeboat*—another "small universe," in his words, evincing "a real index of individual behavior." Al-though the story's plot would remain more or less intact, Hitchcock began his makeover by building on the treatment Logan had written in a failed attempt to parlay the story into his directing debut.

In Woolrich's original story, Jeff doesn't even have a girlfriend. The girl-

* "After-Dinner Story" by William Irish appeared in *Alfred Hitchcock's Fireside Book of Suspense* (Simon & Schuster, 1947).

friend first appears in Logan's treatment as an actress, already deeply integrated into the story line: drawn into Jeff's suspicions about Thorwald, she volunteers to snoop in his apartment, placing herself in harm's way—an idea that would become a key element of the film.

Hitchcock began his script talks by focusing on the two main characters—or, more precisely, on the actors playing them. When the director first shook John Michael Hayes's hand, at the Warner's studio in the spring of 1954 as he was preparing *Dial M for Murder*, Hitchcock told the writer that James Stewart and Grace Kelly were going to play the leads. Before Hayes wrote a word of *Rear Window*, he knew that Stewart would be his man with a broken leg, and Kelly his girlfriend. Kelly "has a lot of charm and talent," Hitchcock told Hayes, "but she goes through the motions as if she is in acting school. She does everything properly and pleasantly, but nothing comes out of her. You've got to bring something out of her, bring her to life. Would you spend some time with her?"

Not only did Hayes know his stars before he started writing, he knew their characters' professions. Hitchcock wanted Lisa Carol Freemont (Kelly) transformed from an actress into a top fashion model. In a later deposition related to a copyright-infringement suit, Hitchcock said he based the character on a longtime friend—former cover girl Anita Colby, once among the highest-paid models in America. Colby had become a successful businesswoman, and she and her husband often dined with the Hitchcocks. (Hitchcock's lead female characters were often actresses or models.)

At the director's behest Hayes "spent off and on a week" with Kelly, and then modeled Lisa "partly out of Grace Kelly and partly out of my wife," model Mel Lawrence. "I knew some of the patois of that business," Hayes explained. Patois—or "sophisticated dialogue"—was his stock-in-trade. In radio, Hayes had learned to "move very quickly to set up your characters by what they say." Dialogue was his admitted "strong point, rather than construction."

Lisa was a wholesale addition. Jeff was revamped into a character more Hitchcock's than Woolrich's creation. In the original story, Jeff doesn't have a stated occupation; in the Logan treatment, he is a sportswriter. But Hitchcock remade L. B. Jefferies (Jeff's new name in the film) into a Robert Capa–type photojournalist, addicted to a restless lifestyle of covering hot spots and photographing celebrities for national magazines—making him all the more bored and frustrated by his immobility. Hitchcock introduces this conceit beautifully with a sweep of the camera across the walls of Jeff's room, adorned with awards and glamorous magazine covers (including one of Lisa), ending with a shot of a racing car cartwheeling toward the camera—the shot that broke the photographer's leg.

Making the character a professional photographer was a Hitchcockian masterstroke. Jeff could become a voyeur—as filmed by a voyeur director,

and watched by a voyeur audience. Woolrich actually described Jeff as a "Peeping Tom" in his story, but the long-lens Leica in Jimmy Stewart's lap deepened and doubled the meanings—not only articulating the voyeuristic subtext, but providing the actor with useful stage business.

As always, Hitchcock also worked hard to improve the secondary characters. Forced to replace Woolrich's black houseman (a character tinged with condescension in the original story), he thought of making the character a middle-aged woman, an insurance company nurse. He had the actress in mind: wisecracking Thelma Ritter, who was under contract to Paramount. Hayes did the rest.

"One of the things that I told Hitchcock," Hayes recalled, "was that I always had the feeling that pictures did not work to unite the audience at the beginning. Hitch asked me what I meant, and I told him, 'When people come into a theater, they're all strangers. They don't know each other. Somebody has your armrest, the lady in front of you is wearing a hat that's too big, the man to your right has been eating garlic, and somebody behind you is whispering or crunching popcorn. You'd like to see the picture by yourself. . . .' I said to him, 'What somebody should do is to unite that audience right away, the way a great orator does.' "

Hitchcock asked, "How would you do that?" and Hayes supplied the right answer: "With comedy." Stella was written to evince a "broad, coarse vaudeville kind of humor," according to Hayes, and she also served as one of Hitchcock's Greek chorus characters. After the audience "had laughed together," Hayes said, "they could gasp together, they could clutch the seats together, and they could scream together. We have them working as an instrument." Hayes was speaking Hitchcock's language.

The Thorwalds were perhaps the least changed characters, but even with them Hitchcock added a host of small touches, for his own enjoyment and that of his eagle-eyed fans. In Woolrich's story, for example, Thorwald has poured his wife's body into a new cement floor; in the film he decapitates her and stores her headless body in a trunk (and her head in a hatbox). Hitchcock borrowed the decapitation from the Patrick Mahon murder case, and Thorwald's saving his wife's wedding ring for his mistress from Dr. Crippen.*

In his original story, Woolrich merely sketched in the other neighbors that Jeff spies on, which include a widow coping with a young child, and

* The notorious English murderer Patrick Mahon killed and dismembered his mistress in a seaside bungalow in April 1924, stowing the body parts, including her head, in the mistress's trunk, before trying to burn them. Dr. Crippen ultimately had been arrested when he slipped up by transferring his wife's jewelry to his lover. Later, in his interview sessions with Hitchcock, François Truffaut noted the subtle thematic echo of the search for Mrs. Thorwald's missing ring in the film (a significant trifle which is absent from the Woolrich story). The clue Lisa desperately seeks, Truffaut pointed out, symbolizes the marital commitment she yearns for from Jeff.

newlyweds keen on jitterbugging. Hitchcock banished the widow in favor of a childless couple who dote on their pet dog ("The Dog Who Knew Too Much," James Stewart quips after the animal's mysterious death), and a lovelorn old maid on the verge of suicide. The newlyweds stayed basically the same, though the jitterbugging was handed off to another character; Hitchcock accented their lovemaking, however, and the new wife's insatiable sexual appetite is one of the film's running jokes.

Woolrich's story is missing the shapely "Miss Torso" who limbers up and dances in a seemingly constant state of undress, as well as the lady sculptor and the song composer, who complete the "little stories" (Hitchcock's words) that are glimpsed through Jeff's binoculars.

Although Hayes insisted in later interviews that "Hitch left it up to me to create the scenes and he liked what I created," assistant director Herbert Coleman, who was present for their initial meeting and others, recalled Hitchcock describing the scenes at great length, and with his usual wealth of detail. The director worked with Hayes, on *Rear Window* and their other films, the way he always worked: outlining the story scene by scene, generating specific visual or dialogue instructions. "Hitchcock walked around the office dictating the story as he had it in his mind," said Coleman, "and John Michael Hayes sat at a typewriter and typed what was dictated. Hitch told everything, every camera move, everything but the dialogue. When it came to the dialogue, he'd say, 'Now, Mr. Hayes, the dialogue must convey this meaning.' "

While Hitchcock shot *Dial M for Murder* and tended to preproduction for *Rear Window*, Hayes went away and wrote the greatest script of his career. One of the things Hitchcock liked about Hayes was his no-nonsense efficiency. Although Hitchcock's time would be less constrained in the years ahead, the director nonetheless kept up a furious pace, and he valued a writer who could keep up with him. Hayes's seventy-six-page treatment was completed by September 1953, and the full script began to arrive in sections in October. Even after that, Hitchcock and Hayes continued "writing by camera," according to Hayes. "We went over it line by line and page by page. What we did then was try to break it up into shots. Now Hitch wanted to set them up into actual camera angles. He had a large sketch pad on which he sketched out each camera setup."

Hayes was initially signed to write three pictures for Alfred J. Hitchcock Productions, but the director was so pleased with the first job that his contract was torn up and another film was added. Including *Rear Window*, Hayes would be paid fifteen thousand dollars a week to write four Hitchcock films over the next three years.

By September, Hitchcock was busily assembling his new team at Paramount. The only collaborator he brought with him from Warner Bros. was

his invaluable cameraman, Robert Burks—though Burks also took along his team, including camera operator Leonard South, who stayed with Hitchcock up through *Family Plot.*

George Tomasini, a young editor under Paramount contract, was a find. He had only a handful of credits, but they included Billy Wilder's *Stalag 17,* and Hitchcock admired Wilder's films. Tomasini would edit every one of Hitchcock's films from *Rear Window* through *Marnie* (with the sole exception of *The Trouble with Harry*)—nine Hitchcock pictures, more than any other editor.

Paramount also reunited Hitchcock with Edith Head, who had designed the costumes for *Notorious,* and who, from now to the end of his career (sometimes uncredited), would watch over the hair and wardrobe of his leading ladies.

Hal Pereira has routinely been credited with the production design of the films Hitchcock directed at Paramount. But Pereira was the department head, and the real work was done by key subordinates behind the scenes. The creator of the *Rear Window* set was a Selznick veteran, Joseph MacMillan Johnson, who had been an artist on *Gone With the Wind* and later shared an Oscar for special photography on *Portrait of Jennie.* Paramount also meant a reunion with John P. Fulton, who had helped Hitchcock achieve the special effects for *Saboteur.* Now under contract to Paramount, Fulton—and John Goodman, the art director of *Shadow of a Doubt*—would work on the Hitchcock films of the 1950s.

The set was a proud accomplishment. Most of the close photography would center on Jeff (James Stewart), sitting in a single room with a window that looked out onto a crowded courtyard. The courtyard, as seen from his window, contained multileveled apartments, gardens, trees, fire escapes, smoking chimneys, and an alley leading to a street with a bar, pedestrians, moving traffic—all of it capped by a Manhattan skyline. There were thirty-one apartments in all, twelve fully furnished. The set had to be elaborately prelit for day and night, with remote switches controlling the lighting. Although most of the film's shots were taken from the vantage point of Jeff's apartment, the other dwellings and occupants had to be identifiable in long-range shots that would deliver both clear definition and adequate depth of field. (Their coded costuming helped their identification; Miss Lonelyhearts, for example, would be the only character always to dress in emerald green.) The faraway actors carried tiny microphones, through which they received instructions, walkie-talkie–style, from Hitchcock. All this demanded innovation from the camera and sound experts.

Hitchcock's intermediary with Paramount, and his top deputy on *Rear Window,* was a Kentucky native who had started at the studio as a driver in 1927. Herbert Coleman had just finished working as assistant director

to William Wyler on *Roman Holiday;* now the studio assigned him to assist Hitchcock. Coleman picked C. O. "Doc" Ericksen to be the production manager—and Hitchcock immediately dispatched Ericksen to New York for photographs and sketches of Greenwich Village courtyards of the sort he had noticed while visiting John Houseman's apartment earlier in the 1950s. Coleman and Ericksen both lasted with the director throughout the Paramount years, Hitchcock's most cohesive decade.

Besides being together constantly during preproduction and photography, Coleman and Ericksen met with Hitchcock between the films and often traveled with him. They admired him ("Mr. Hitchcock" seemed his due, and they initially felt awkward when urged to call him "Hitch"), and considered him a warm, humorous, equable taskmaster, even a friend. Their can-do attitude was one of the positives of the Paramount years. Hitchcock would miss them when they were away, and interrupt whatever he was doing and beeline over to see them when they showed up. "Herbie and I smiled as much as anyone could imagine," said Ericksen. "We were always upbeat."

Hitchcock assembled another sparkling supporting cast—starting with Thelma Ritter as Stella, the comedy-relief nurse. Reliably funny with sharp-tongued characters, Ritter had entered films in 1947 and racked up four Academy Award nominations in six years. Another Paramount contract player, dependable Wendell Corey, was lined up as the detective: pinpointed as a World War II buddy of Jeff's, he would play a larger role than his character did in the original Cornell Woolrich story.

Although they have no scripted dialogue and are glimpsed only from afar through their apartment windows, future *Chipmunks* creator Ross Bagdasarian (the composer), Judith Evelyn (Miss Lonelyhearts), and Georgine Darcy (Miss Torso) made even the film's minor characters memorable. And Raymond Burr, who was still specializing in heavies at this stage of his career, was picked to play Thorwald. Hitchcock had Burr made up in short curly hair and spectacles, and then costumed in white button-down shirts. His chain-smoking was the last Hitchcockian nuance—all, the director told later interviewers, to evoke David O. Selznick.

Hurdling the Production Code seemed increasingly easy for Hitchcock. Luck was with him during the Paramount years, and, besides, the rules of censorship were finally changing.

Production Code administrator Joseph Breen, who had been Hitchcock's nemesis since *Rebecca,* criticized the first draft of *Rear Window* on every imaginable count: for its leering depiction of Miss Torso; for the scene in which Miss Lonelyhearts welcomes to her apartment a young man whose "hand is doing something with the slide fastener at the back of her

dress"; for Stella's toilet humor ("When General Motors has to go to the bathroom ten times a day, the whole country has to let go"); for the newlywed couple caught up in the "sexual aspects of a honeymoon"; for the constant dialogue that suggested a sexual relationship between Jeff and Lisa; and especially for the lines that implied Lisa was going to stay overnight in Jeff's apartment—a fact that becomes plain as sin in the film when she shows off a sexy negligee.

Paramount wasn't as prudish as Warner Bros., though, and allowed its autonomous units to take the lead in fending off the Code. First finding an ally in Luigi Luraschi, the studio's liaison with censorship authorities, Hitchcock invited Code officials to Paramount to marvel at the set. Treating them like royalty, he smoothly reviewed the objectionable elements. Almost everything they saw as an issue, he explained, would be staged far away from the camera—too far to matter. "Having seen the extraordinary set, and noting that the action in the surrounding apartments would be photographed from the viewpoint of the protagonist's apartment," wrote Steven DeRosa in *Writing with Hitchcock: The Collaboration of Alfred Hitchcock and John Michael Hayes,* "many of their concerns had been eliminated."

Hitchcock then filmed Miss Torso several different ways: once topless from behind, once in white lingerie, and once in black, playing the racy versions off against each other for Code officials. He made minor compromises in scenes, exaggerating their importance, but "in spite of Breen's objections," wrote DeRosa, "many of these elements remain, verbatim, in the finished picture."

Timing was on his side: after twenty years as the top cop of Hollywood morality, Joseph Breen was nearing retirement by the time *Rear Window* went before the cameras. No one followed through on many of his objections to the script. And Breen was replaced by the Englishman Geoffrey M. Shurlock, who was more open and liberal in his attitude, more open (and resigned) to the idea that screen values were moving with the times.

Some directors create their best films out of angst, cheap budgets, impossible schedules, and stars or projects that inspire in them conflict or indifference. But Hitchcock found his greatest inspiration during times of security and contentment, filming stories that took a leisurely amount of time to germinate, and which delved deeper into familiar, favorite themes. He could be marvelous on a shoestring, but he made his greatest films with first-class budgets.

By the time he began filming *Rear Window* in October, Hitchcock was an almost svelte Master of Suspense. He had dieted down from his all-time high of some 340 pounds to his all-time low of 189. He had "sel-

dom been happier," wrote John Russell Taylor. "I was feeling very creative at the time," Hitchcock told François Truffaut. "The batteries were well-charged."

Hitchcock had been credited as producer of the Transatlantic and Warner Bros. films, but Paramount gave him more power and authority, with fewer strings attached. And greater purse strings: after *Rear Window*—which was planned from the start as a soundstage-bound film, as much for the challenge as anything—Hitchcock was allowed to splurge on travel. It wasn't simply that he was enamored of location work, which involved a certain amount of risk; but going places, adding dashes of local flavor, was vital to Hitchcockery. And there were more personal considerations: Alma had stopped coming into the studio, but she adored travel, and if Hitchcock was working on a location she would accompany him, and even follow him to the set from time to time. The Paramount films went to places the Hitchcocks wanted to visit together.

For seven years, Jack Warner had balked at paying what he considered the stratospheric salaries of Cary Grant and James Stewart. Actors under studio contract came cheaper, made no special demands, and didn't skim off percentages. But Paramount was willing to structure Hitchcock's budgets so the director could afford Stewart and Grant.

The two stars were as different in their professionalism as in their on-screen personas. While Grant could be a royal pain, fussy and demanding in his approach to a film, Stewart punched into work like a guy carrying a tin lunch box. Stewart was more of a partner, and the Hitchcock-Stewart films were organized as partnerships, with Stewart's company sharing a percentage of the gross and profits—and risk. As with *Rope,* Stewart paid himself a reduced salary, taking the chance of making more money on the back end. The director knew from experience that such an arrangement wouldn't work with Cary Grant, but after *Rope,* Stewart would be involved this way in each of his other three films with Hitchcock, from the script stage through to the end of production.

Hitchcock and Stewart had a peculiar friendship; they were intimate but also proper with each other, close but also businesslike. Stewart wasn't much of a gossiper, a chuckler at dirty stories, or a practical joker. He attended at least one "blue dye" dinner party at Bellagio Road, where Hitchcock served blue martinis, blue steak, and blue potatoes to the guests, but thereafter he was a rarer visitor to the Hitchcock houses, in Bel Air or up in Santa Cruz. (It worked the other way around; Hitchcock visited Stewart, often at his vacation home in Hawaii.)

In meetings or on the set they didn't talk much. They had more of an unspoken communion, sharing amused glances—like Mr. and Mrs. Hitchcock.

Here is Stewart, tongue half in cheek, on the director:

"I never once saw him look through a camera. Uh, maybe he couldn't get up. He'd make a little screen with his hands and the poor cameraman, whoever he was, had to get back there and look at it, and Hitch would say, 'This is what I want.'

"I don't think Hitch paid much attention to a 'star image.' I never heard Hitch discuss a scene with an actor. He never did with me. I heard him say that he hired actors—you know, the 'cattle' as he referred to them—because they were supposed to know what they were doing. When he said 'Action,' he expected them to do what he hired them to do.

"Every once in a while after shooting a scene Hitch would get out of his chair and come up to me. Then he would very quietly say, 'Jim, the scene is tired.' He would then go back to his chair and sit down, and you would know exactly what he meant, that the timing and the pace were wrong."

For Hitchcock, Stewart had already played mentor to a pair of killers in *Rope*. In the years ahead the folksy star would play even more dysfunctional roles. In *The Man Who Knew Too Much* he'd find himself at the mercy of an international conspiracy. In *Vertigo* he'd suffer a fear of heights, a nervous breakdown, and sexual obsession. Now, in *Rear Window*, he would be impotent in a plaster cast, with Grace Kelly almost sacrificing her life for him. Indeed, *Rear Window* could be "interpreted as a picture of impotency," as Peter Bogdanovich suggested. "It could be, yes," Hitchcock joked, "the impotency of plaster."

But it's easy to overlook that two of these films boast parts as romantic as any Stewart ever got to play. One of the most magical entrances in cinema is the shadow of Lisa (Grace Kelly) spreading over Jeff, as she silently enters his apartment and bends down to kiss him awake. Hitchcock made the kiss unique: a close-up lingering in seeming slow motion. "These are pulsations that I get by shaking the camera by hand," Hitchcock explained to Truffaut, "or dolly backward and forward, or sometimes by doing both."

Hitchcock finally found his American alter ego in Jimmy Stewart; while in Grace Kelly he discovered the perfect blonde to gaze upon rapturously—never murderously.

"Too talented, too beautiful, too sophisticated, too perfect," Jeff complains about Lisa—and that was Grace Kelly. Perfect women were always perfectly dressed in a Hitchcock film, and just as the script started with the actress, the directing started with her look. Kelly probably looked perfect in dungarees, but for *Rear Window* Hitchcock told Edith Head she ought to evoke "a piece of Dresden china, something slightly untouchable." Head would garner an Oscar nomination for her costuming of the film, including Kelly's black-and-white dress, with beaded chiffon skirt, that she wears in her magical entrance; and the sheer peignoir she wore later (which Kelly herself thought made her look like a "peach parfait").

Hitchcock even had ideas about the perfect bosom; aware that Kelly was on the flat-chested side, he decided that a pleat in her peignoir was contributing to that impression. "He was very sweet about it," Kelly recalled. "He didn't want to upset me, so he spoke quietly to Edith. And then everything had to stop." Hitchcock thought perhaps she should don falsies, but alone with Head in her dressing room, Kelly cheated. "We quickly took it up here," Kelly explained, "made some adjustments there, and I just did what I could and stood as straight as possible—without falsies. When I walked out onto the set Hitchcock looked at me and at Edith and said, 'See what a difference they make?' "

Kelly could get away with almost anything with Hitchcock. His adoration of the actress was another thing he had in common with his leading man, his partner. "We were all so crazy about Grace Kelly," James Stewart said. "Everybody just sat around and waited for her to come in the morning, so we could just look at her. She was kind to everybody, so considerate, just great, and so beautiful." Assistant director Herbert Coleman concurred: "Every man who ever was lucky enough to work with Grace Kelly fell in love with her, me included. Even Hitchcock—although he only was in love with two people, and that was Alma and Pat."

The affection the director had for his two stars was borne out in a filming experience that was carefree, and reflected in an ending to the actual film that is rare, if not unique, for Hitchcock.

After the killer Thorwald is caught, he is all but forgotten in *Rear Window*'s tidy coda, which is almost Capraesque in its feel-good optimism. The struggling composer is seen to have finally finished his pop song; the suicidal Miss Lonelyhearts has found a promising suitor; Miss Torso's beau shows up (a good joke: he's a too short nerd in army uniform); and the courtyard community springs back to life . . . even as Lisa, coyly turning the pages of a ladies' magazine, watches over a dozing Jeff (with a new broken leg).

François Truffaut told Hitchcock that when he first watched *Rear Window* in his days as a critic, he found it "very gloomy, rather pessimistic and quite evil," but after reseeing the film, in preparation for their talks, he found its vision "rather compassionate." "What Stewart sees from his window," said Truffaut, "is not horrible, but simply a display of human weaknesses and people in pursuit of happiness. Is that the way you look at it?"

"Definitely," replied Hitchcock.*

* But when Peter Bogdanovich pressed the director about the future of Jeff and Lisa—would they get married and live happily ever after?—Hitchcock wouldn't nibble. Too philosophical a question. The glow of that happy period had worn off by the time of the interview, and Hitchcock was too hardheaded to speculate about imaginary people. "Oh, I don't know," he replied. "I never bothered about that very much. I would doubt it myself. He'd be off on some job, you know."

Always cunning, always operating on as many levels as he could plumb in a story, Hitchcock was at his most byzantine with *Rear Window*. Its obvious voyeurism was wrapped up with sympathetic humanism; its grisly crime story offered sharp-eyed character study and aching romance. Crafted entirely in the studio, claustrophobic in its staging, *Rear Window* was also Hitchcock's greatest demonstration of Kuleshov's theories of how editing affects perception—and by his own lights "my most cinematic" film. One of his simplest, "smallest" films, it is also among his most complex and universal.

Hitchcock's rift with John Michael Hayes really began on their second film. *To Catch a Thief* was a 1952 novel by David Dodge, an American who wrote whimsical humor (*20,000 Leagues Behind the 8-Ball, How Lost Was My Weekend*), mystery adventure (*Plunder of the Sun, The Long Escape*), and volumes of travelogue. When Sidney Bernstein officially bowed out of future filmmaking, Transatlantic transferred the story rights—which had cost the company a mere $15,000—to Paramount, for $105,000.

The author lived part of the year on the Côte d'Azur, which gave the novel its setting. The first attraction for the director was undoubtedly France and the Riviera, among the Hitchcocks' favorite places in the world, which they couldn't visit often enough in film or in real life. Dodge's book also touched on the internecine politics of the French Resistance, which had intrigued the director before, in *Bon Voyage* and *Aventure Malgache* (though treatment of the subject is light in the book—and even lighter in the film).

To Catch a Thief tells the tale of a notorious cat burglar named John Robie, nicknamed Le Chat (the Cat), who during the war forsakes crime and becomes a Resistance hero, then retires to live comfortably on the French Riviera. A rash of high-society jewel thefts that imitate his honorable methods ("he was never known to employ violence or carry a weapon") forces the Cat to seek the help of old comrades, stake out likely targets, and set traps in order to catch the copycat and clear himself with police.

In such a synopsis the novel sounds quite similar to Hitchcock's film, but in fact the book and film are entirely dissimilar. As the author himself wryly admitted some years after the film was made, "All that survived [of the book] in the end were the title, the names of some of the characters and the copyright, which was mine."

Once again Hayes had the luxury of writing for specific stars, and tailoring the characters to their personalities. And when Hitchcock learned that Hayes had never been to the Riviera, he sent the writer and his wife on a quick trip there while postproduction continued on *Rear Window*.

The Hayeses stayed at the Carlton Hotel in Nice, familiarizing themselves with a primary setting of the story. By the time Hayes returned to Hollywood, Hitchcock was ready to "get involved in the script work every day, which had not been true of *Rear Window*," as Hayes explained to Donald Spoto. "The work was a pleasure for most of the time. What made us a good team was that he had such brilliant technique and knowledge of the visual, and ego and conviction; and I think I was able to bring him a warmth of characterization."

Robie (Cary Grant), the sexy Texas tourist Frances "Francie" Stevens (Grace Kelly), her world-weary mother (Jessie Royce Landis), the enigmatic French girl Danielle (Brigitte Auber), Robie's ex-Resistance pal Bertani (Charles Vanel), and the insurance agent H. H. Huston (John Williams)—all these characters are present in David Dodge's novel.* But Hitchcock would fiddle with them all, ratcheting up the romance between Robie and Francie, and injecting the plot with more suspense and comedy than Dodge had brought to the book.

Hitchcock and Hayes held almost daily script conferences through the late winter and early spring of 1954. Frequently these meetings were at Hitchcock's house, where the director relaxed in a sweater, or an open shirt with no tie. Their lunch was prepared and served by the director's German cook. One scene in *To Catch a Thief* takes place at Robie's villa, where Robie (Cary Grant) and Huston (John Williams) share lunch and a humorous disquisition on quiche Lorraine, served by Robie's cook. That scene was inspired by a quiche Lorraine lunch served at Bellagio Road.

The quiche scene, though, also spurred friction between the director and writer. Hitchcock was "preoccupied with strangulation," according to Hayes, and he wanted the scene to end with the insurance man praising the delicate crust of the quiche, and the "exceedingly light touch" of Robie's cook, who quietly serves it around. Robie concurs, adding, "She strangled a German general once, without a sound."

Hayes objected to such morbid comedy, but Hitchcock said too bad; he was the boss, and the line stayed in. The scene was pure Hitchcock—and also served as one of several that expanded on the role of the insurance agent, which he had earmarked for a favorite actor.**

Hitchcockian flavoring of a different kind was sprinkled over the scene where Robie escorts Francie down a hotel corridor. Though she has previously evinced little interest in him, when she stops at the door to her room

* Bertani and Huston have different names in the book.

** Ironically, André Bazin, though he praised *To Catch a Thief*, singled this scene out as a sign of "Anglo-Saxon ignorance of French manners and customs"—for quiche Lorraine "is not a specialty of southern France."

she suddenly turns and passionately kisses him. According to Hayes, Hitchcock insisted that one night in New York he was walking Grace Kelly back to her hotel room, when she kissed him in just such a fashion. That's all— just a perfect kiss, and then the door closed. True, Joan Fontaine does much the same with Cary Grant at the doorstep in *Suspicion*; but apocryphal or not, the Hitchcock anecdote went into the script.

Hayes always insisted that Mrs. Hitchcock never sat in on a single one of their conferences, or ventured any suggestion in his presence; that the director never said anything that expressly reflected his wife's opinion, except once: "Alma liked your script." It was his highest compliment— though people didn't always take it well.

Mrs. Hitchcock was busy these days being a grandmother; Pat Hitchcock had given birth to her first daughter, Mary Alma O'Connell, in 1953, followed by Teresa (called Tere) and Kathleen. Hitchcock's letters didn't often agonize about the reviews of his films, but he fretted consistently over Pat's health during each of her pregnancies, and he doted on his grandchildren.

If Mrs. Hitchcock was no longer working openly on scripts, she was still quietly reading them, and offering advice on key scenes. According to Herbert Coleman, the Hitchcocks were very precise about settings they knew from experience, which they wanted for the backdrops in the south of France. It was Alma, the driver in their marriage, who took the lead on mapping out the Grand Corniche sequence, where Francie and Robie are pursued in her car by Sûreté nationale agents. Alma had the curves of the road memorized, according to Coleman, and told him where the second unit should perch on the perpendicular cliffs overlooking the small town of Eze.

The car-chase sequence excited Mrs. Hitchcock so much, according to Coleman, that she joined one of their Sunday afternoon meetings, outlining the action shot by shot. She suggested photographing much of the Grand Corniche chase from a helicopter flying over the two cars racing along the high road—an audacious idea in those days. Alma then brainstormed the whole continuity: Francie driving wildly, Robie nervously clutching his knees, the screeching wheels, the sharp curves of the road, and the plunging precipices. The scene would reprise (even improve on) similar ones from *Suspicion* and *Notorious*. Hitchcock said less than usual, just sat there beaming at his wife.

The director came into the office the next Monday morning in an exultant mood. Mrs. Hitchcock, he told everybody, had diagrammed out the best scene in the picture. Later, when *To Catch a Thief* was released, an interviewer asked Hayes explicitly about the scene, and he commented innocently, "I got carsick writing it." Recalled Doc Ericksen: "This pissed off Hitchcock pretty good." The director walked around the office, shak-

ing his head. "Alma and I did that," he protested. "We worked on it all Sunday afternoon."

But the full script never achieved the same rounded feeling as *Rear Window*. In one sense, it was never really completed—for even after Hayes finished the draft they took to France, where there were endless alterations dictated by the budget, location, censorship, and the actors.

For example, Hayes's script called for a wild chase through Nice, with Robie dodging police amid a carnival procession of floats, ultimately climbing inside the head of King Neptune. As he had done with the Lord Mayor's Show for *Sabotage,* the director expected to film the actual annual carnival parade, and later re-create key incidents as inserts inside the studio. But after Paramount placed a $3 million ceiling on the budget, the carnival chase seemed too expensive; so in mid-April, on the eve of departure for France, Hitchcock simply deleted the sequence. The film's flower-market chase was cheaper (and tamer).

And to no one's great surprise, the Production Code had expressed repeated alarm over the script. The Code's officials fretted over the beachwear, Robie's unapologetic criminal past, the persistent sexual innuendo in the dialogue, the scene where Robie drops a casino chip down the cleavage of a woman gambler, and the "pointed" symbolism of the fireworks exploding as Francie seduces Robie—which was deemed "totally unacceptable." Down the line, Hitchcock promised, he'd resolve it all to the censors' satisfaction.

In France, the script would have to adjust to the censorship concerns, the locale and climate, and the expected interpolations of an international cast—not to mention Cary Grant, who could be counted on to fool around with his lines.

Catching Cary Grant for *To Catch a Thief* took three years of patience and diplomacy.

Grant hadn't appeared on-screen since starring with Deborah Kerr in *Dream Wife* in 1952. After that production, the mercurial star had announced his retirement. "It was the period of the blue jeans, the dope addicts, the Method, and nobody cared about elegance or comedy at all," he explained later. After a world cruise Grant returned to Hollywood, but rejected script after script. Hitchcock had kept him apprised of *To Catch a Thief* from the moment the book was published, luring him along with tales of the sophisticated comedy he was planning, finally adding Grace Kelly—the epitome of elegance—as the coup de grace of his sales pitch.

As often happened, Hitchcock was willing to make personal sacrifices to realize his vision of *To Catch a Thief*. He even took a cut in salary to

accommodate the leading man he preferred above all others: under the agreement that transferred rights to the film to Paramount, Hitchcock agreed to take his 10 percent of profits on this film only *after* the studio had subtracted Grant's 10 percent from the gross.

Grace Kelly's star had continued to rise, thanks to the popularity of *Rear Window*. Only five Hitchcock films were listed among the top ten in the year of their release.* The first two were *Rebecca* and *Spellbound,* but *Rear Window* ranked behind only *White Christmas* and *20,000 Leagues Under the Sea* among the top films of 1954. (*North by Northwest* also hit the top ten, and *Psycho* soared the highest, becoming the number two film of 1960.)

Elia Kazan had offered Kelly the lead opposite Marlon Brando in *On the Waterfront,* but she preferred to travel to the south of France to reunite with the director she trusted from *Dial M for Murder* and *Rear Window*. The actress didn't have that far to go to match Francie's description in the book ("she had a good figure and the kind of Irish attractiveness that goes with blue eyes," David Dodge wrote, with "a fair skin" and—the only difference—"dark hair"). Knowing his star, though, Hitchcock had enhanced her character's scenes with mischief and naughtiness.

The European locale gave Hitchcock a chance to draw on a varied talent pool for his supporting cast, another bouillabaisse from a recipe only he could have devised. Charles Vanel was a magnetic Frenchman who had started his career in the silent era and made noteworthy appearances in Jacques Feyder, René Clair, and Marcel Carne films—most recently starring in Henri-Georges Clouzot's *Wages of Fear* and *Diabolique,* watched repeatedly (and admired) by Hitchcock. Although Paramount was dubious, the director was determined to cast Vanel as Bertani, leader of the gang of former thieves who now run a catering cabal. (Bertani's occupation was a Hitchcock touch; in the book his character is a black market wheeler-dealer trading in real estate, insurance, imports and exports—everything except food.)

Jessie Royce Landis had been on Broadway since 1926, acting in everything from Kaufman-and-Hart to Shakespeare to Jo in *Little Women,* and occasionally directing plays, as well as appearing in occasional films. She would portray Francie's dyspeptic mother. The nimble John Williams, from *The Paradine Case* (where he can be glimpsed on the prosecution team) and *Dial M for Murder,* would play the insurance agent from Lloyds of London—"a thin, elderly man with white hair and a fierce white guardsman's mustache," according to the novel. Hitchcock

* This is the top ten according to U.S. and Canadian rental revenue as reported by the distributors, considered a more reliable indicator than total receipts at the box office.

expanded the role to exploit Williams's twinkling English-gentleman charm.

The director had seen tomboyish Brigitte Auber in Julien Duvivier's *Sous les Ciels de Paris* and marked her down for Danielle, a sturdy French girl capable of climbing all over villa roofs ("nineteen or twenty, as pretty as a flower," according to the book, "slim and small-breasted"). The fact that Auber had real circus training was a happy accident.

The Paramount team of Robert Burks (cameraman), Joseph MacMillan Johnson and John P. Fulton (special effects), George Tomasini (editor), Edith Head (costume design), and Herbert Coleman (assistant director) was carried over intact from *Rear Window* to *To Catch a Thief*.

Reaching for another antidote to television, Paramount imposed a wide-screen process on Hitchcock for the first time. Although VistaVision was a viable alternative to CinemaScope, producing a sharp, wide, horizontal image with excellent depth of field, it never gained much popularity outside of Paramount. Hitchcock said later that he wasn't enamored of what he called "oversized screens"—the format replicated as letterbox nowadays—but at the time such formats were sweeping the industry. "It leaves you with a good deal of empty space that causes the audience to wonder what it's there for," he once explained. "I happen to own a Dufy that was painted on a long, narrow canvas; but the subject is a harbor and therefore suitable. Filmmakers, on the other hand, are bound by the screens available throughout the world. You can't compose for a New York screen only; you've got to think, say, of the screen in Thailand." As with 3-D, though, Hitchcock went along with the trend, accepting Vista-Vision for *To Catch a Thief* and all his future Paramount films—even borrowing it for *North by Northwest*.

The real trouble with VistaVision was in the close-ups. When Vista-Vision lenses focused on near images, the backgrounds—all that gorgeous scenery for which they were traveling to France—were blurred. Indeed, after screening Hitchcock's initial dailies from location, Paramount sent the director emergency telegrams urging him to shoot "rear projection plates" of all the scenery, and save the close-ups for Hollywood. Doc Ericksen carried the telegrams around in his pocket for a day or two, trying to decide how best to tell Hitchcock that the studio was advising him to proceed basically as a second unit. Finally, after dinner and drinks one night, Coleman handed him the telegrams. Hitchcock took one look, stuffed them in his back pocket, and said, "Okay, now you've shown them to me."

But as he often did, Hitchcock took the compromise as a challenge—shooting both close-ups and rear projection plates on location, and then back at Paramount shooting alternative close-ups against the plates. The final blend of reality and artifice was left to postproduction, and to

Robert Burks, Joseph MacMillan Johnson, and John P. Fulton. Throughout the 1950s the demands of VistaVision would force Hitchcock to rely on this old-fashioned method of matching close-ups with process plates—and thereby create an almost accidental consistency between his British and American films, one that has intrigued critics over the years. In the English half of Hitchcock's career, it was a technique largely dictated by climate and budget; during his U.S. peak, ironically, these "canned" backgrounds were a holdover dictated by the need for widescreen clarity. According to associates, although such process shots became a hallmark of his style, Hitchcock hated having to constantly resort to them.

Hitchcock's schedule was arranged to allow him to promote the British release of *Dial M for Murder* in London, and to bring *Rear Window* to the annual Cannes Film Festival on his way to Nice in the last week of May. John Michael Hayes was already registered at the Carlton, revising against the clock. "The condition of the script is not good," Doc Ericksen reported to a Paramount official in Hollywood. Hitchcock wanted better dialogue; there were last-minute emendations for Bertani, and an important improvement for the scene where Robie and Danielle swim out to the hotel float for a talk. Francie was brought into the scene for her only confrontation with Danielle—a highlight of the film, adding comedy and triangular tension.

The first shots of Hitchcock's British *The Man Who Knew Too Much* featured travel posters for Switzerland. Brochures advertising Naples, Venice, Paris, and Monte Carlo told the audience where Cary Grant and Joan Fontaine honeymooned in *Suspicion.* And now the first shot of *To Catch a Thief* would show the sidewalk window of a travel bureau. "If you love life, you'll love France," one slogan beckons. *Rear Window,* the director's experiment in microcosm, would be the last film for a long time that Hitchcock would craft entirely inside a studio. Paramount was the first studio to let him—and his films—do what he had always wanted: roam the world.

If *Rear Window* was an intentionally serious film, *To Catch a Thief* was a deliberately larky one—an opportunity for Hitchcock to put the world's finest cuisine on the studio tab while he and the audience enjoyed "travel folder heaven" (as John Williams describes the surroundings in the film); an excuse for audiences to luxuriate in the sight, every bit as heavenly, of Cary Grant and Grace Kelly in prime condition, circling each other romantically. It was a showcase of "beautiful people, beautiful scenery, a love story and suspense"—the unofficial philosophy of Hitchcock's Paramount films, according to Herbert Coleman.

Having eschewed the Method of Elia Kazan for the "personality act-ing" of Hitchcock, Kelly continued to blossom as an actress, more than holding her own in playful love scenes with Cary Grant, who had been at the job much longer—almost a quarter century. "I was awed by her," said Grant later. "We all loved her very much."

More than in *Rear Window,* even, Hitchcock's camera seemed in love with Kelly. The stunning actress worked and played hard, both virtues the director admired. She had her acting coach, Elsie Foulstone, on location, and rehearsed her lines over and over. Whatever went on beneath the sur-face, she radiated serenity during filming—and after hours made time for fashion designer Oleg Cassini, with whom she was engaged in a torrid af-fair. Though everyone held their breath, off-camera she didn't even flirt with Cary Grant.

Cassini sometimes joined Kelly, the Cary Grants, and the Hitchcocks for dinner after a day of shooting. The director "had one of the most cu-rious eating habits," Cassini recalled in his autobiography. "His diet con-sisted of one spectacular meal each day. He would fast until evening, drinking only water during the filming. Then he would take a bath and we would gather for dinner at the restaurant of his choice, for the precise meal of his choice."

Cassini was just passing through; Edith Head was the film's costume designer, and *To Catch a Thief* was a "costume designer's dream," in her words. Again, Hitchcock gave her precise instructions for what Kelly should wear, but advised her to leave the leading man alone. "Hitch trusted me implicitly to select my own wardrobe," Grant recalled. "If he wanted me to wear something very specific he would tell me, but gener-ally I wore simple, tasteful clothes—the same kind of clothes I wear off screen."

Hitchcock wouldn't allow a revealing bikini, any more than censors, so Head was instructed to buy tasteful knockouts in Paris swimwear shops. Kelly's polka-dot bathing suit is straight out of the novel—one of the de-tails Hitchcock had mentally underlined in the reading.

The annual *fin de saison* Bal de Biarritz is also noted in the novel, though in only a brief mention. Hitchcock turned the gala occasion into the film's extended climax, which weaves together the various threads of the story: the Resistance cabal on the spot, catering to the idle rich in masquerade; the insurance agent drawn into the intrigue; and the final jewel heist, which forces Robie to chase down the real culprit on a rooftop.

It didn't escape the director that an eighteenth-century-themed costume ball would give Head the chance to garb his leading lady in something eye-popping. He envisioned Kelly in shimmering gold ("Hitchcock told me that he wanted her to look like a princess," said Head), and Head came

up with the delicate gold-mesh dress, wig, and mask that helped get her an Oscar nomination in 1954—an award Head always felt, bitterly, she should have won.*

To Catch a Thief was a blend of genres—comedy, romance, suspense— and the leading man was also an unclassifiable blend. Hitchcock's roles for Cary Grant always drew on his ambivalence toward women. In *Suspicion*, Grant plays an apparent cad who wants to kill his wife; in *Notorious*, he can't bring himself to believe in love. Now Grant was cast as a lone wolf, a man every bit as tense, self-absorbed, and narcissistic as the actor himself. That's the way Robie is in the book, but even more so in the film, where he is so preoccupied by the copycat thefts that most of the time he doesn't even pretend to like Danielle or Francie. ("What a signal girl!" he says sarcastically of the latter. "A jackpot of admirable character traits.") The romantic comedy was twice as funny coming from such a grudging lead.

For Grant, each film role was a possible dirty trick that was being played on him, a dubious opponent that had to be outmaneuvered. The handsome star knew his value to Hollywood, to Hitchcock, and to *To Catch a Thief*. Hitchcock "likes me a lot, but at the same time he detests me," he confided to costar Brigitte Auber. "He would like to be in my place. He'd very much like to be in my place, because he can *imagine* himself in my place."

His "place" included privileges above the other actors. Grant's contract called for an air-conditioned limousine—either Lincoln or Cadillac—with liveried chauffeur, specially ordered from England and delivered to France. The arrival of the car then had to be timed ceremoniously to coincide with the star's own arrival on location, so Grant could make a show of flattered surprise. After a week or two of the limousine, however, Grant complained to Doc Ericksen that the car made him appear pretentious; suspecting that his fellow cast members were starting to resent him, he demanded a roadster with a young driver in street clothing. The limousine was returned, the roadster with driver requisitioned. After a week or two with the roadster, Grant came back to the production manager and demanded, "Where's my limousine?" At great expense, the limousine was airlifted back.

Grant's demands were incessant, and finally Ericksen went to Hitchcock to complain. The director listened, with sympathy. Grant drove him crazy too, Hitchcock admitted. For example, the star wanted the company to stop shooting every day precisely at 6 P.M. so he could have dinner at a

* The masquerade ball was staged at Paramount in Hollywood toward the end of filming. Kelly took forever to be stuffed and sewn into her magnificent constume, and when she finally arrived on the set the sight of her prompted everyone to gasp. Hitchcock's relief that she wouldn't appear flat-chested prompted one of his classic bon mots: "Grace, there's hills in them thar gold." (Incidentally, Head's costume design was beaten out for the Oscar by Charles Le Maire's for *Love Is a Many-Splendored Thing*.)

civilized hour. Well, fine, Hitchcock preferred to quit on time—but that was one thing in the studio, quite another on location. Grant was compulsively punctual, however, and his quitting time was in his contract.

"Don't worry," Hitchcock told Ericksen confidentially, "I'll take good care of Mr. Cary Grant. On the last day of the picture, I intend to tell him off once and for all."

One thing about locations—they are a unifying experience. The rain delays, the shifting sun and clouds and winds, the prying photographers and noisy crowds—they became the common enemy. Kelly's good humor was contagious, and even Grant loosened up, mamboing with Auber in her trailer during breaks. For his amusing cameo on a bus, Hitchcock was revealed in a panning shot, seated next to the difficult star (and a caged bird).

When the cameras were turned on, Grant was worth any amount of bother. Everyone agreed that "it wasn't a very good scenario," in Auber's words, and some scenes that were filmed were later deleted; others were tinkered with on the set, still others changed in the postsync stages. Grant was at his freewheeling best with ad-libs and stage business. "Every now and then Hitch would say, 'Where is Cary? Let's change this scene,' " recalled Auber. "And sometimes Cary would say, 'I can't say this line,' and he would change it on the spot."

One of the film's wittiest scenes occurs on a ridgetop where, after eluding police pursuers, Robie is dragooned into a picnic with Francie. Dipping into her picnic basket, Francie asks, "Do you want a leg or a breast?" With an indescribable Cary Grant–look, Robie replies, "You make the choice." The stars spontaneously added such bits, "in a cheerful, silly mood," according to John Russell Taylor, carrying on the fun even after Hitchcock called cut.

Spontaneous and as hardworking as anyone, Grant brought craft and dedication to every role—along with the marquee value Hitchcock prized. Toward the end, once they were back in Hollywood, Ericksen reminded Hitchcock of his vow to tell off the star. "Well, I don't know," the director hedged, rubbing his chin. "I might want him for another picture."

They wrapped up location work on June 25, and then resumed interiors in Hollywood after July 4. Herbert Coleman stayed behind in France to supervise the second unit, collecting the road and aerial footage for the Grand Corniche sequence, from precise storyboards. The footage was then rushed to Hollywood, where Hitchcock watched rushes and wired back remarkably detailed notes for retakes. "In present shot," the director pointed out in a typical memo, "only half the bus appears on the screen. This I realize arises out of fact that you are veering out of its way. . . . This latter fault could be corrected by keeping camera panned well over to left so that as camera car swerves the camera pans over at same time from left to right."

With all the script jiggling, the location hitches, the outright refilming, *To Catch a Thief* eventually fell almost a month behind schedule. August 13, 1954, Hitchcock's fifty-fifth birthday, was celebrated as birthdays often are on film sets, by champagne and cake. "Ladies and gentleman," the director's very English secretary announced, "would you all come into the other room, please, and have a piece of Mr. Hitchcake's cock?"

The general camaraderie on location didn't improve tensions between Hitchcock and John Michael Hayes, however. On location, the director and writer skirmished several times over scenes, with you-know-who always emerging the winner. Hayes tried showing his preferred version of pages to the two stars behind Hitchcock's back. The director ordered Hayes to cease and desist.

The film's coda was a particular sticking point. The ending kept changing from draft to draft, and the final version was Hitchcock's, over Hayes's protest. A cute coda: Francie chases Robie back to the villa, throws her arms around him on the terrace, and then, after Robie surrenders to her kiss, looks over her shoulder at the beautiful view and exclaims, "Mother is going to love it here." (Leaving just enough film in the reel for one of Grant's patented looks.)

Never entirely plausible, the script became even less so on location, and during postproduction. That bothered Hayes; not so Hitchcock. Who has set up Danielle's father, pushing him over the cliff to his death? It's a mystery never clarified in the film. The actress playing Danielle demanded to know. But Hitchcock told Brigitte Auber, "It doesn't matter."

The sex-drenched scenes were one element of the script that survived remarkably intact, however. Francie, in particular, always speaks while flashing bedroom eyes.

"Tell me," Robie asks her at one point, "what do you get a thrill out of most?"

"I'm still looking for that one," she replies.

Hayes's dialogue was so slippery (his marvelous double entendre was almost entirely an invention of the script), and Hitchcock guided things so cleverly, with the two stars all but winking at the camera, that the Production Code found it hard to pinpoint their complaints.

The sexiest scenes had been red-flagged at every stage. From the first draft, code officials targeted the fireworks erupting in the sky as Robie and Francie embrace—urging that "the love scene between Cary Grant and Grace Kelly, in Miss Kelly's hotel room . . . be terminated by a dissolve before the couple lean back toward the corner of the sofa." To the Code—and Hitchcock—the fireworks signified "pure orgasm," as he later told Peter Bogdanovich, "just as the tunnel at the end of *North by Northwest* is a sexual symbol."

Focusing on the fireworks, the censors overlooked the very next scene, which takes place later that same night. After the fade-out, Francie is seen bursting into Robie's room, accusing him of stealing her mother's jewels. She goes off to phone the police; her mother is left briefly alone with Robie, and takes his side—she likes him and finds him attractive. Undaunted, Francie returns to advise Robie that she has spoken to the police and told them *exactly* what he was doing all night. "Everything?" Robie asks, with a raised eyebrow. "Oh, the boys must have enjoyed that down at headquarters."

Hitchcock stacked up the violations, then traded cunningly—with Paramount and the censorship authorities. Studio head Don Hartman objected to one running gag, in which the two French plainclothesmen, during surveillance breaks, scrutinize nudie postcards. After first making a show of resistance, the director then made an equal show of surrender—cutting the nudies. "Why would you take that out? It's charming," the film's composer, Lynn Murray, complained to Hitchcock. "The picture doesn't stand or fall on one little shot," the director explained. "Besides, if I take that out they won't complain so much about the fireworks scene."

Murray initially wrote "very sensuous" music for the fireworks scene—a smoky tenor saxophone to accent the romantic mood—but the director suggested he try again with music "in a more conventional way, like with strings." Murray did so, and the result tempered the "orgasm" effect, just enough to win the day with the censors. Another Hitchcockian trick, another hard-won victory.

Postproduction was in general a nightmare. On location, the sky had changed moods swiftly and dramatically, making it difficult to maintain a visual continuity. Hitchcock had tried various experiments, including using filters for night shooting, but the night images disappointed everyone. Robert Burks would miraculously win the Oscar that year for ravishing camera work that was partly a marvel of special effects.

Gusty winds and constant background racket also forced heavy dialogue rerecording. Music was sometimes the solution. "For example, in a scene on the beach at Cannes with Grant the wind is whipping the umbrellas and the canvas on the cabanas," remembered Murray. "He said there would be absolutely no sound track in this scene—just music."

Dubbing also helped smooth things over for the French actors who spoke broken English. For the part of Danielle, Brigitte Auber's pidgin English proved charming. But for the others it often sounded plain wrong. "In the interest of schedule and budget [on location]," recalled George Tomasini's assistant, John M. Woodcock, "Hitch okayed many imperfect takes, knowing that the French cast was due to travel to the U.S. for additional shooting. He figured that, with coaching and looping, their performances could be improved."

Dubbing and redubbing: in January 1955, months after calling the last

take at Paramount, Hitchcock returned to Nice for what he hoped was a final bout of studio rerecording for *To Catch a Thief*. Ultimately, the sound editors had to insert 250 "loops" of corrected sound—something of a record for the time, according to Woodcock.

Ironically, Charles Vanel came off the worst. Hayes trimmed his dialogue, "shortening speeches and, in the process, sacrificing characterization," in the words of Steven DeRosa. Elsie Foulstone coached him from the sidelines; his lines were even phonetically chalked on a blackboard. But, as a last resort, Hitchcock began to shoot him with his back to the camera and his hand over his mouth. Vanel's English was so incomprehensible that ultimately he had to be redubbed almost entirely by another Frenchman. In the end, the grand old man of the French cinema would be seen in *To Catch a Thief*, but not heard—and the plausibility of his character naturally suffered.

But plausibility, holes in the plot, bodies without voices—none of it mattered. *To Catch a Thief* proved nearly as popular as *Rear Window* when it was finally unveiled almost a year after its filming, in August 1955. While *Rear Window* continues to inspire serious analysis and to support Hitchcock's artistic reputation, *To Catch a Thief* remains unabashedly escapist. The fabulous scenery, the deceptive humor, the romantic alchemy—the director somehow pulled it all off, conjuring a film that begs comparison to the work of Ernst Lubitsch.

In London for the premiere, he gave an interview explaining that *To Catch a Thief* was merely "a woman's picture." "It's important that filmmakers should have a sense of responsibility for the stability and continuity of their industry," Hitchcock said. "And, if sometimes you have to make corn, try at least to do it well."

The Hitchcock property that thrilled Paramount the least was the offbeat black comedy: *The Trouble with Harry,* which the director was determined to do "just for fun and for relief from what he was doing regularly," according to John Michael Hayes. But the studio stuck to its bargain.

Published in 1949, Jack Trevor Story's first novel was slight, just over a hundred pages. Its whimsical plot revolves around a little boy's discovery of a dead body in rural woods, and the reactions of several local townspeople who all believe they have killed the man accidentally. Little is known about the stranger, except for his name: Harry. "A nice little pastorale," Hitchcock called the story.

While on location for *To Catch a Thief*, Hayes started developing the script, meeting with Hitchcock between setups and on weekends. Hitchcock had been visualizing *The Trouble with Harry* ever since reading it in galleys; Hayes tried to convince him to add some action or suspense, but

the director showed little inclination to deviate from a book he had read over and over. "In truth," conceded Steven DeRosa, "Story's short novel reads rather like a detailed film treatment," with "pithy dialogue and aural descriptions" that betrayed Story's background (like Hayes's) in radio.

Hitchcock always said he was attracted by the subversive sense of humor that pervades *The Trouble with Harry*. But the story also has the undertow of romance that balanced his best films. In fact, it boasts a double love story: a sweet courtship between an older couple, a shy spinster and a retired gentleman, which is paralleled by the spicier attraction between a perky, husbandless mother and a tortured artist.

From book to the screen, characters and subplots had to be eliminated, but little was added: the single new character is Mrs. Wiggs's son Calvin, a deputy sheriff whose investigation into the killing provides a modicum of suspense, as well as the police thickheadedness expected in a Hitchcock film. And little was added in the way of dialogue, which remained "almost religiously faithful" to the book, according to DeRosa.

The major change was in making the film transatlantic—transplanting the story from the English countryside setting to Vermont. The Americanization was easier to do than with *Rope* because all of the novel's local references were superficial. Hayes had lived in Vermont as a boy, and his background came in handy, although in the end the film claimed only the merest whiff of Yankee authenticity.

The Hitchcocks had enjoyed their trip through New England in 1951, and now the director wanted to shoot in Vermont during the peak of fall ("to counterpoint its macabre elements with beautifully colored scenery," he told Charles Higham). With the efficiency and organization that marked the Paramount years, he worked until 5:30 P.M. on Saturday, September 4, on *To Catch a Thief,* before leaving for the train east.

Paramount was gulled along by Hitchcock's shell game of casting. Although *The Trouble with Harry* was decidedly more of an ensemble piece than his recent pictures, the director talked up Grace Kelly for the part of Jennifer, the young mother—who turns out to be Harry's estranged wife—until Kelly became embroiled in a contract dispute with MGM.

When Kelly proved unavailable, Hitchcock considered carrying over a different actress from *To Catch a Thief*—Brigitte Auber, who was a relative unknown in America. "She had a casual way of wearing a blouse," John Michael Hayes noticed in France, "which exposed her bosom frequently. And Hitch, of course was delighted." Hitchcock had struck up a friendship with Auber; now that Pat was married and busy with her own family, he behaved with the French actress as though she were his daughter. (Indeed, Auber's father had recently died, and she came to look upon Hitchcock as a surrogate father.)

But all the headaches with French accents during *To Catch a Thief*

helped put Hitchcock off the idea of Auber, and even en route to New England Hitchcock still didn't have his leading lady. Producer Hal Wallis had rhapsodized about a twenty-year-old dancer who stepped in for the lead one night in the Broadway musical *The Pajama Game*. The dancer had made a screen test for Wallis, which Hitchcock watched appreciatively. Coleman then visited the understudy backstage in New York on the director's behalf, noting her lithe tomboy looks (quite like those of Auber). Coleman told the understudy Hitchcock was looking for a "suitably fey creature" to play the lead of his next picture.

Meeting with Shirley MacLaine (no blonde) for the first time at the St. Regis, the director had a few questions: What movies had she done? Could he see any television film on her? What Broadway roles had she acted? None, nothing; she was only a chorus girl, an understudy. "Suddenly," MacLaine recalled, "his leg shot up, his foot came down heavily on the seat of a chair, and his elbow came to rest on his knee, all in one lightning motion."

"That makes you about the color of a shamrock, doesn't it?" said Hitchcock.

"Yes, sir, I suppose so," she replied, standing up. "Should I go now?"

"Of course not. Sit down. All this simply means that I shall have fewer bad knots to untie. You're hired."

She fell back into her chair.

"I shall need you on location—in Vermont—in three days. Can you make it?"

It was okay to have a nobody as the perky, young mother—if Hitchcock could boast a marquee attraction as the tortured artist. Early on, he had teased the front office with the idea of Cary Grant, but Grant's salary and percentage demands were escalating out of sight, and Hitchcock was determined to keep *The Trouble with Harry* a "little" picture. Moreover, Grant could be a nuisance: rewriting the part to please him would be a headache, and might change the flavor of the story beyond recognition.

William Holden was Hitchcock's real preference, and once again the director hotly pursued the actor. But whether for budget or loan-out reasons, or because of the accelerated schedule, Holden vanished from the horizon even as Hitchcock was passing through New York. The director had a reasonable average with Cary Grant, but his repeated attempts to coax Holden into a Hitchcock film were unsuccessful.

In New York, Hitchcock met with John Forsythe, who agreed to a ten-week leave from playing Captain Fisby in *Teahouse of the August Moon* to appear in *The Trouble with Harry*. A debonair actor with a reserve of quirkiness, Forsythe had appeared in several undistinguished films, but his Broadway credits were prestigious and his radio work extensive (including multiple appearances on Hitchcock's beloved *Suspense*).

That's how reflexive his instincts were, how fast Hitchcock was moving. As late as September 14, when his arrival in Vermont was splashed across the *Barre Daily Times*—shaking hands with Governor Lee Emerson at the airport—official publicity was still insisting that Hitchcock's star for *The Trouble with Harry* was William Holden.

Not only did Hitchcock cast a former understudy and a no-name as his two leads, but the true star of *The Trouble with Harry* was an octogenarian friend of the director's. The central character of Jack Trevor Story's novel is the aged, retired captain of a Thames barge, who believes he may have shot the stranger accidentally while hunting. (In the film he is the retired commander of an East River tugboat.) All along, Hitchcock had envisioned this role for the English actor Edmund Gwenn, whom he had previously directed in *The Skin Game, Waltzes from Vienna*, and *Foreign Correspondent*.

The winking humor of *To Catch a Thief* spilled over to *The Trouble with Harry,* and some of John Michael Hayes's sexiest double entendres ever came from the mouth of the octogenarian. "Do you realize you'll be the first man to cross her threshold?" Sam (John Forsythe) teases the Captain (Edmund Gwenn) in their first scene together, referring to his courtship of the spinster, Miss Gravelly. "It's not too late, you know. She's a well-preserved woman," replies the Captain defensively. "I envy you," Sam says. "Very well-preserved," the Captain muses, "and preserves have to be opened some day."

From the first draft, Paramount and code officials noticed this exchange; Hitchcock promised to do something about the lines—but, once again, found a way to keep them in the film.

The other members of the cast weren't going to help the box office much either. Mildred Natwick, an accomplished interpreter of Shakespeare, Shaw, O'Neill, and Ibsen and a semiregular in John Ford films, was cast as Miss Gravelly. Mildred Dunnock, who had been poignant as the wife in *Death of a Salesman* on Broadway and then on film, would play Mrs. Wiggs, the country-store proprietor, village postmistress, and agent for Sam's unsalable art. Tall, craggy-faced Royal Dano, Elijah in John Huston's film of *Moby-Dick,* became the deputy sheriff, while seven-year-old Jerry Mathers—later the star of TV's *Leave It to Beaver*—had a rascally part, enhanced from the book, as the little boy who first discovers the body.

Herbert Coleman and Doc Ericksen had scouted ahead to find a quaint Vermont village with plenty of atmosphere and mountain scenery, settling on the vicinity around St. Johnsbury, a place where sidewalk repairs were reported on the front page of the newspaper. Unfortunately Hurricane Carol blew through on September 1, spending itself out in Canada and

New England, including parts of northeastern Vermont and St. Johns-bury—followed a week later by heavy electrical storms that washed out local roads.

Hitchcock had been looking forward to filming the brilliant autumn leaves of New England. Instead the trees were down everywhere, the streets were littered with storm wreckage, and tree branches were naked. John Michael Hayes probably didn't mind; he was still polishing the script, on location. Coleman and Ericksen, on the other hand, had to scramble to relocate. Initial photography was delayed until the end of the third week of September, but the bad luck never abated. It was colder and wetter than average that year in Vermont.

Alma traveled with her husband, joining him frequently on the set to watch the filming. To observers, the director seemed in fine fettle. The location difficulties didn't perturb him; he waited out clouds and rain by shooting a few interiors, and then, when close-ups of the foliage proved disappointing he filled in with long-distance vistas. By mid-October, though, it was clear that inclement weather had settled in for the winter, and the company was forced to abandon Vermont for Hollywood, leaving a skeleton crew behind to shoot stand-ins against the landscape.

It was time for a little Hitchcockery. The director had leaf samples sent back to Hollywood ahead of his arrival to help the craft departments re-create the Vermont countryside on a soundstage. Paramount art director John Goodman had to weave wonders with artificial trees and leaves, while effects specialist John P. Fulton and cameraman Robert Burks had to match the studio lighting and colors to the location footage.

The Trouble with Harry troubled even less with the niceties of logic and reality than *To Catch a Thief*. But Hitchcock completed his second film of 1954—by any measure a very good year—in time for Christmas. Once again the Hitchcocks celebrated by flying to Europe, making stops in St. Moritz, Paris, and London before returning home to America.

The winter of 1954–55 was devoted to postproduction on *To Catch a Thief* and *The Trouble with Harry*, more or less concurrently.

When *To Catch a Thief* proved a mess of looping, dubbing, and laboratory effects, and George Tomasini got bogged down in the editing room, Hitchcock had to grab another studio editor, Alma Macrorie, to cut *The Trouble with Harry*. And when *To Catch a Thief* started to lag behind, so did composer Lynn Murray, and Hitchcock found himself in need of someone else to create the music for *The Trouble with Harry*. Murray recommended his friend Bernard Herrmann.

Trained at Juilliard, influenced heavily by Debussy and Ravel, Herrmann was a composer of ballets and opera, and an orchestra conductor who sup-

ported his "serious" musicianship by writing music and conducting for films and CBS Radio. In 1941, his first year in Hollywood, Herrmann had been nominated for two Academy Awards—winning the Oscar for *The Devil and Daniel Webster* over his more famous score for Orson Welles's *Citizen Kane.* He also contributed brooding, experimental, atonal music to *The Magnificent Ambersons, Jane Eyre, Hangover Square, The Ghost and Mrs. Muir, The Day the Earth Stood Still,* and other films—and lately, among his myriad activities, he had been scoring episodes of *Suspense* for radio.

Although Hitchcock had often inserted select pieces of music into his films, up to this time he hadn't been able to control the overall scores—so the scores inevitably disappointed him. Even *Rear Window:* he often said that one flaw of that film was the conceit of the pop song, which is being composed throughout the story, and then is heard with a flourish at the end as played by an entire orchestra. Franz Waxman, who had also scored *Rebecca* and *Spellbound,* couldn't deliver the kind of pop tune Hitchcock wanted. "It didn't work out the way I wanted it to, and I was quite disappointed," he told Truffaut.

Arrogant, contentious, moody, Herrmann seemed an unlikely Hitchcock soulmate. Even his best friends thought the brilliant composer was sometimes his own worst enemy. Yet when Hitchcock met with him in January 1955, they discovered they shared "a great unanimity of ideas," in Herrmann's words. Both were practical artists who felt most comfortable collaborating with people they liked or admired. "Many directors can make one or two good movies," Herrmann said in 1968, even after he and Hitchcock had had a bitter parting of ways, "but how many can make fifty great ones like Hitchcock? Somerset Maugham once said, 'Anyone has one good novel in him—it's the second one I'm interested in.' "

Beginning modestly with what film music scholar Royal S. Brown has described as his "bantering and scherzo-like music" for *The Trouble with Harry,* Herrmann's scores would immeasurably enhance Hitchcock's greatest films to come. His music would contribute an "affective depth" to those films, wrote Brown, "precisely what Hitchcock's cinema needed, what, in fact, it had sorely lacked even in certain masterpieces of the early 1950s, such as *Strangers on a Train.*"

That affective depth was there instantly in their relationship, so after *The Trouble with Harry* Hitchcock began to bring Herrmann in, according to the latter, "from the time of script. He depends on music and often photographs a scene knowing that music will complete it." The director also brought the composer into every stage of the editing, according to Herrmann, because "if you're using music, he'll cut it differently."

* * *

At the same time that he was busy with postproduction of *To Catch a Thief* and *The Trouble with Harry,* Hitchcock launched into scriptwork on the remake of *The Man Who Knew Too Much.*

Almost from his initial trip to Hollywood he had been thinking about Americanizing *The Man Who Knew Too Much*—first describing the North African bazaar scene, with the smudge coming off the face of a murdered secret agent, in his *New Yorker* profile in 1938. Then as early as 1940, his second year in Hollywood, Hitchcock had pitched the idea to David O. Selznick—who had briefly encouraged it.

The remake was always linked to Hitchcock's friendship with Angus MacPhail, who had been pivotally involved in the original; and it was after Hitchcock and MacPhail got back together to collaborate on *Bon Voyage* and *Aventure Malgache* during World War II that Hitchcock renewed his pursuit of the rights. Sidney Bernstein finally secured a deal, for Transatlantic.

MacPhail had been productive at Ealing for some years after the war, contributing to the scripts of *Whisky Galore* (1948) and *Train of Events* (1949). But always a genial alcoholic, he gradually drank himself into a physical and financial state from which he seemed unable to rebound. He wrote to Hitchcock from Nice in February 1953, explaining that he was neurasthenic, in debt, and unable to pay his hotel bill. Hitchcock immediately wired some money, and later subscribed to an informal group of MacPhail friends who paid his back taxes so he could return to England, and then furnished an allowance to keep him afloat.

To employ MacPhail and help rehabilitate him was part of what motivated Hitchcock to press forward with the remake. Not only could MacPhail help update the script, he could obtain an American screen credit that would legitimize his membership in the Screen Writers Guild, whose health and insurance benefits could ease his future financial burdens.

MacPhail came to Hollywood shortly after Christmas, staying at a hotel near the Hitchcocks on Wilshire Boulevard. Hitchcock and his old friend and story editor then took the lead in revamping the 1934 film for James Stewart, whose involvement gave the project momentum. Stewart had agreed to star in the remake, and he had set aside a block of time in the summer of 1955. Leslie Banks had been excellent as the "man who knows too much" in the original version, but Banks was hardly magnetic, and that film was more of an ensemble piece. The new script had to create more of a star part for Stewart—Hitchcock's partner.

As Stewart was only credible as an American, Hitchcock decided to incorporate the star's familiar persona and turn the British tourist couple of the original into the McKennas, an "old married couple" from the Midwest. Knowing already that he wanted to shoot scenes in Marrakech, Hitchcock and MacPhail made Ben McKenna (Stewart) a physician fresh

from a medical conference in Paris, who takes his family along on a senti-mental side trip to North Africa, where he served during World War II. Just as in the original, the McKennas witness the murder of a spy, a Frenchman who has befriended them; their child is kidnapped, and they are propelled into an international conspiracy and a race against time.

The first *Man Who Knew Too Much* had capitalized on the headlines and tensions of the early 1930s, especially the rise of Hitler and Nazism. For the remake, it made sense for Hitchcock to draw on the political fis-sures of the 1950s. Germany was fast being rehabilitated, and the Soviet Union loomed as the new totalitarian evil in the world. Although he dis-approved of the excesses of the Cold War, Hitchcock felt increasingly at home in Eisenhower's America, and the second *Man Who Knew Too Much* marked his continuing shift toward anti-Communism.

Hitchcock had devoured the news of Klaus Fuchs's confessions of espi-onage in 1951, which was followed by the disappearance of Fuchs's collegue—Italian-born nuclear physicist Bruno Pontecorvo—and Ponte-corvo's presumed defection to Russia. Pontecorvo was a naturalized British citizen and admitted Communist sympathizer: it was his example that inspired Hitchcock and MacPhail to substitute British Communists for the implicitly German ring of kidnappers and assassins of the original film.

MacPhail—who, though basically apolitical, scorned British Commu-nists—reinforced this drift. His notes from January and February 1955 in-dicate that the shaping of the remake was also influenced by the crisis in Hungary. Hungarian Prime Minister Imre Nagy, who rose to power in 1953, replacing a Stalinist, was behaving in unexpectedly liberal fashion, introducing nationalist policies that alarmed his Soviet sponsors. Out of this Hitchcock and MacPhail developed the idea that a Nagy-type prime minister might be targeted for death by the Russians during a trip to Lon-don, with the deed manipulated to look as though it had been ordered by the Americans. Once again the assassination attempt would occur during a symphony performance at the Albert Hall; once again it would be foiled by the mother's scream—a sequence from the original that Hitchcock felt he couldn't improve upon. (Among the attractions of the remake, for Hitch-cock, was not only the chance to shoot on location in Marrakech, but to re-make the orchestra climax, in color and with hundreds of extras, in the actual Albert Hall—two impossibilities in the parsimonious Gaumont era.)

In February, the two friends hammered out other key plot points. This included the new opening in Marrakech, where, on a bus, the McKennas' son, eight-year-old Hank, accidentally yanks off a Muslim woman's veil, nearly provoking a riot among the passengers. The riot is forestalled by a mysterious stranger, Louis Bernard—a secret agent who has mistaken the McKennas for the British Communist couple he is trying to trace.

As early as February, Hitchcock anticipated that Doris Day would be

playing Jo McKenna, Stewart's wife—and already the notion had emerged to make Jo a retired, world-famous vocalist. MacPhail actually wrote the first version of the scene that replaced the shoot-out in the original, with Jo rescuing Hank in the (implicitly Soviet-bloc) embassy by singing a song she has taught him. Hank reveals his hiding place by whistling the melody back in reply—an idea Hitchcock and MacPhail consciously borrowed from a Richard the Lionheart legend.*

Together, Hitchcock and MacPhail also came up with an alternative to the quasi-comic sequence in the original where Leslie Banks and Hugh Wakefield visit a sinister dentist looking for clues, and wind up at a sun worshipers' temple—a blind for the gang's hideout. They sketched out a scene that would send Ben McKenna in search of "Ambrose Chappell," a name whispered by the dying Louis Bernard. Alone and paranoid on London streets, Ben hears the sound of menacing footsteps, but it's a false alarm—and so is "Ambrose Chappell," who turns out to be a taxidermist without the slightest inkling of spies.

Meanwhile, an agitated Jo is stuck in a hotel room with old show-business cronies when she suddenly realizes that "Ambrose Chapel" is a London church (more Protestant than in the original film), where the British couple holding her boy hostage are posing as clergy. And off she rushes to the rescue. . . . All this was in the greenhouse by the time John Michael Hayes, who had been kept busy on another Paramount project, joined the script in late February. Hayes stated in later interviews that he never even saw the original film. However, to bring Hayes "up to speed on the story," reported film scholar Bill Krohn, "Hitchcock rented a 16 mm copy of the first *Man Who Knew Too Much* and screened it for him."

Whether or not Hayes ever saw the original, Hitchcock certainly sat him down for one of his patented walk-throughs, spieling out the new Americanized version, including all the ideas he and MacPhail had incorporated so far. Hayes claimed in later interviews that he never read anything MacPhail had written down—one of the reasons he believed MacPhail "never did any writing." It was a misunderstanding that would fester over time.

Hayes's draft—though incomplete, and breaking off after the Ambrose Chapel sequence—was ready for Hitchcock's perusal inside of a month. "To say that Hayes fleshed out the characters would be to slight his contribution," Krohn noted. "Up until this point there were no characters, only an increasingly refined structure for provoking suspense worked out

* Richard I was captured by the King of Austria while returning from the Holy Land; his favorite minstrel, "going from castle to castle singing a song Richard had composed," in film scholar Bill Krohn's words, "finally heard his master joining in the refrain from inside the fortress where he was imprisoned." Richard I was freed, just as Hank is in the remake.

by a couple of veteran plot wizards. Hayes brought Ben, Jo and Hank to life, although Hitchcock was less satisfied with his handling of Louis Bernard, the Draytons, the very English Secret Service man and other details of the film's foreign locales."

According to Krohn, Hayes's treatment of the McKennas' marriage was perhaps "his most important contribution" to the script. Hayes had Jo yearning to return to the stage now that Hank was growing up, with the couple ("so secure that they can afford to quarrel," according to MacPhail's original description) bickering about an offer she has received for a comeback. Contradictorily, Jo also hints that she wouldn't mind having another child. Hitchcock, however, found the conflict between career and home life "old hat," and urged Hayes to make the marriage, wherever possible, "satirical and comic."

Hitchcock kept trying to insert comedy into the remake. He wasn't satisfied with the soap-opera quality of certain scenes either, and judiciously edited a key scene in the script that Krohn attributed to Hayes: Ben tricking Jo into taking a sedative before telling her about Hank's kidnapping. "In Hayes's first draft," Krohn wrote, "Jo tells off Ben in no uncertain terms for drugging his own wife, sobbing as she loses consciousness that she hates him with all her heart for what he has done. When filming, Hitchcock did away with all the hand-wringing, rightly judging it to be 'melodramatic,' but kept the heart of the scene."

The director was a genius at dividing his attention, but he was extremely busy in the spring of 1955, and the script wasn't yet completed by the time he left for London in late April. Hitchcock left behind notes "often very specific, indicating the need to change a single word, an entire speech, a description of action, or a camera direction," according to Steven DeRosa.

But on April 20, 1955, before Hitchcock went to London, there was a significant interruption in his daily routine. Mrs. Hitchcock was already an American citizen, and more unabashed than her husband in her enthusiasm for America. In the 1950s, along with many Americans, she switched to the Republican Party and voted for Dwight Eisenhower for president. Hitchcock also admired the former general, although there is no evidence he ever voted, and in the 1960s, associates say, he switched back to admiring Democrats—Kennedy and Johnson.

Sidney Bernstein hosted a dinner in London in 1955, with Hitchcock and Charles Chaplin, in which the conversation turned on the subject of patriotism. Chaplin, also a native Englishman, had been hounded out of Hollywood by anti-Communists and morality crusaders; while traveling to London for the premiere of *Limelight* in 1952, the gentleman tramp had

had his passport voided by the attorney general. Chaplin now said he was glad he had never adopted U.S. citizenship; involuntarily exiled, he considered himself a citizen of the world. Hitchcock said that although he didn't condone what had happened to Chaplin, if a person was going to live and work in a country, he ought to accept the full responsibility of citizenship.

Lew Wasserman had been urging Hitchcock to become an American citizen—after all, there were tax benefits; and over the years Mrs. Hitchcock also had repeatedly tried to convince her husband to take the plunge. Everyone recognized that it was a sensitive issue with him; whenever he was pressed on the issue, he begged off with the halfhearted excuse that he couldn't find the time on his crowded schedule. "If only we could get a judge to come to the studio and swear me in," Hitchcock would say.

On April 20, however, Herbert Coleman drove him downtown to take the oath. Hitchcock and his assistant producer usually amused themselves while driving with word games, giving the director a chance to show off his Cockney rhyming slang. Today, though, Hitchcock gazed out the window somberly, saying nothing. "Hitch, are you having second thoughts?" Coleman asked. "No, Herbie," he replied, "but the Hitchcock name goes back almost to the beginning of the British Empire and you can imagine what a serious thing it is for me to break away."

In downtown Los Angeles the courtroom was thronged with prospective Americans, and Hitchcock held up his hand and gave his pledge of allegiance while standing among a crowd of immigrants. One of the director's MCA agents, Arthur Park, was one of Hitchcock's two official witnesses; the other was longtime friend Joseph Cotten.

"You're like an American character in an English movie," Grace Kelly tells Cary Grant in To Catch a Thief, mocking his composite nationality. In England in his youth, Hitchcock had thought of himself as an "Americophile," but nowadays he was like an English character in a Hollywood movie. He was proud to be American, yet English at his core.

The name Alfred Hitchcock was already famous by 1955, especially in England and America, where his face was easily recognized. But now the seeds of even greater fame were being planted—a wider recognition that would make Hitchcock, like Chaplin, a citizen of the world, and the director who surpassed all others as the real star of his films.

One of these seeds had been sown during the filming of To Catch a Thief. The south of France is where the influential cineastes of Paris first flocked to make the director's acquaintance. Paramount had enterprising publicists in Paris, as it happened, and they encouraged the French to meet and study the man as they studied his films.

The formidable Jean-Luc Godard had written, of Strangers on a Train, that it was imbued with "lofty ambition," and classed Hitchcock with Lang and Murnau—hailing him as "the most German of transatlantic di-

rectors." Claude Chabrol and François Truffaut, two enthusiasts with dreams of becoming filmmakers themselves, attended a press gathering for the director in a Paris hotel room in 1954, and then later visited the studio at St. Maurice, where Hitchcock was supervising the postsynchronization of *To Catch a Thief.*

Chabrol and Truffaut interviewed the director for *Cahiers du Cinéma,* an important new film journal; so did André Bazin, an influential critic and author of a book about Orson Welles, who journeyed from Paris to Nice to watch Hitchcock direct the flower-market scene with Cary Grant and John Williams. In the summer of 1956, Henri Langlois, the founder of the Cinémathèque Française in Paris, included a dozen of the rarest Hitchcock titles (including several silents) in a monthlong retrospective of British cinema. In September of that year, *Cahiers du Cinéma* would accord Hitchcock the rare honor of devoting an entire issue to him.

Initially, it must be said, Hitchcock took a bemused attitude toward his "intense" French acolytes, who primarily focused on the underappreciated artistry of his Hollywood films. The director was flattered, but not overwhelmed. Of course he knew as well as anyone that there were subtleties and levels to his films. But Hitchcock was truly astonished by "every last morsel of meaning," in the words of Bazin, that the French had managed to wring out of his work. "Sometimes I wonder if they are talking about me" at all, he liked to say with a wink.

Truffaut, for example, insisted that the snakelike bracelet Lilian Hall-Davis wears as a gift from her secret admirer in *The Ring* must be a reference to original sin. Perhaps, Hitchcock shrugged. When Truffaut insisted that *The Trouble with Harry* was shot in the fall, the season of decay, for symbolic reasons, Hitchcock had to agree. "I couldn't very well disillusion him, could I?"

No matter how much Bazin probed, he had to concede that Hitchcock's bemusement and astonishment seemed sincere. Bazin, in between setups that day in Nice, desperately tried to persuade the director to discuss the "constant and profound message" that French cineastes had detected in his life's work. Hitchcock preferred to talk about technical means and methods. Bazin wanted to talk about art; Hitchcock replied, in Bazin's words, that "it was easy to make an 'artistic' film, but the real difficulty lay in making a good commercial film."

Bazin took consolation in forcing Hitchcock to take note of at least one recurrent theme in his films, "that, because of its moral and intellectual level, surely went beyond the scope of simple 'suspense'—that of the identification of the weak with the strong." As the director listened to him, Bazin listed examples from *Shadow of a Doubt, Strangers on a Train, I Confess*—good and evil linked by names, train tickets, the confessional, etc.

"The translation of such a subtle argument was not very easy," recalled Bazin in his article. "Hitchcock listened to it with attention and intensity.

When he finally understood it I saw him touched, for the first and only time in the interview, by an unforeseen and unforeseeable idea. I had found the crack in that humorous armor. He broke into a delighted smile and I could follow his train of thought by the expression on his face."

The French critic and essayist noted, however, that "the relatively serious nature of my questions undoubtedly had little in common with what he was accustomed to in American interviews, and the sudden change in critical climate may have upset him."

The critics of *Cahiers* and *Positif*—an equally serious rival French film journal—began to redefine Hitchcock as an artist in such a persuasive, assertive fashion that the rest of the world was ultimately forced to take notice. Foremost among the voices leading that charge were the young French critics he met in 1955: Bazin (the mentor of the "auteur" movement, although his own approach was more eclectic), Godard (the first aggressive champion of Hitchcock), Chabrol and Eric Rohmer (who teamed up to write the first book about him), and Truffaut (who would reenter Hitchcock's life some years later and definitively shape his legacy).

Another, even bigger seed was being planted in America, where Lew Wasserman watched over his client's interests. It was supposedly Wasserman who had the idea—and whoever had it, it was a hell of an idea—to put Hitchcock on television.

Hitchcock always said it was Wasserman's idea, just as he always said it was Michael Balcon's idea that he should try directing. But it was also true that he had spent years trying to launch a national radio series, and just as true that he was already choosing favorite suspense stories, writing introductions, and lending his name as editor to an anthology series of books.

However it transpired, Hitchcock made a show of reluctance when Wasserman brought up the idea in the spring of 1955. He himself wasn't a big TV watcher (he liked quiz shows, he told one interviewer, and public affairs programs "of an international nature"). He saw the epidemic popularity of television as a threat to the film industry, to which he was unreservedly loyal. And no other director of his caliber had dared defect to the small screen.

Yet it hadn't escaped his notice that MCA was a growing power in television, packaging programs with talent and advertisers. Or that a year earlier, in mid-1954, Sidney Bernstein had played a role in formulating England's Television Bill, and had then won an independent television contract, adding broadcasting to his Granada empire (permanently closing the door on any future Transatlantic films in the process). When Wasserman suggested (or so Hitchcock always said) that another old friend, Joan Har-

rison, might help with a Hitchcock series, it sealed his interest. Although it was important that Hitchcock himself supervise the launch of the series, Harrison could shoulder much of the day-to-day work.

Harrison had moved to New York to produce *Janet Dean, Registered Nurse,* starring Ella Raines, for syndication. Hitchcock's onetime protégée had actually entered television before him, after one of her film partners, director Robert Siodmak, left Hollywood to return to Germany, and the other, actor-director Robert Montgomery, jumped to prime time with his own series. Now Harrison returned to Hollywood, joining the television project as associate producer.

With Wasserman oiling the gears, CBS offered Hitchcock a state-of-the-art contract. He would lend his name to the series, serving as host and producer and directing a set number of episodes. His salary would be higher than he received for many of the feature films he had directed—reportedly $125,000 per episode. And in one of those clauses that were Wasserman's specialty, all rights to the series would revert to him after first broadcast.

A separate production company—named Shamley Productions, for Hitchcock's English country cottage—was duly incorporated. Planning began for the first season.

MCA would help with the stories, the writers, and the casting. With Wasserman powering its growth, the firm was evolving into a superagency, an octopus with long tentacles. "I am entering television," Hitchcock joked to the *Los Angeles Times,* "because I am the tip of a tendril. I am a slave to MCA." But *Alfred Hitchcock Presents* would boost the director's fame and wealth in ways neither he nor Wasserman could have guessed.

The late spring and summer were taken up with filming *The Man Who Knew Too Much.*

The director met in London with Angus MacPhail, who had preceded him there, and together they flew to Marrakech in the second week of May. MacPhail was more sophisticated than Hayes when it came to foreign locations, and in Marrakech he was expected to serve as Hitchcock's Johnny-on-the-spot, performing minor script touch-ups ("to edit and make notes on the script pages as they were sent by Hayes," according to DeRosa's book) while also brainstorming the gags and bits of comedy that were supposedly his specialty.

Hayes stayed away from Marrakech, and knew only vaguely how MacPhail, whom he thought of as a charity case, had preceded him on both versions of *The Man Who Knew Too Much.* This was the first time Hitchcock had forced Hayes, who hadn't shared credit with anyone on *Rear Window, To Catch a Thief,* or *The Trouble with Harry,* into a shotgun marriage with another writer. He hadn't experienced the director's

long-standing custom of crediting as many writers as it took to finish the job—often including Mrs. Hitchcock.

Hayes had just been nominated for an Oscar for *Rear Window*,* and couldn't help but see what was happening to him now as devaluing his name and reputation. When his completed draft was delivered by air to Marrakech, with a cover page that proclaimed "Final Screen Play by John Michael Hayes," with no reference to MacPhail, Herbert Coleman knew there was going to be trouble. He stalled handing the script over to Hitch-cock, who took one look at the cover page and "blew his top," in Cole-man's words. This was a betrayal that struck at MacPhail's genuine contribution, and at Hitchcock's effort to aid an old friend. "Call the boys," said Hitchcock—meaning MCA—"and tell them to fire that man right now."

But Coleman didn't call the boys, and MCA wasn't ordered to fire Hayes right away. Instead, Hayes was officially cautioned by Coleman, in a studio memo, not to sign or describe any script as "final" until Hitch-cock had first approved of the pages. Everyone in the know hoped it was a misunderstanding that would blow over. When Hayes, still blithely con-fident of his standing, showed up for final revisions on location in Lon-don, he perceived that he was in bad odor, but wasn't sure why.

These three Hitchcocks—Hayes, MacPhail, and the director—convened awkwardly in a London hotel room in early June to revise the Albert Hall and embassy sequences under the gun. "We wrote during the day, mimeo-graphed at night, and brought it to the set the next morning," recalled Hayes. "I don't know whether it suffered or not."

The script was done by the time the company returned to Hollywood for interiors later in June. Certainly Hayes was done. The writer didn't speak with Hitchcock for the rest of the filming, and Mr. and Mrs. Hitch-cock (quietly and without credit) made "minor editorial changes," in the words of DeRosa. And though it had its virtues, the script did suffer.

Until late 1954, Hitchcock had held out a faint hope of reteaming Grace Kelly with James Stewart in the remake of *The Man Who Knew Too Much*. Reunited, these two stars might have given the "old married cou-ple" that playful hint of sexual chemistry that is hinted at in the film, when Louis Bernard declares it is too bad that Jo McKenna, who has been singing a bedtime song to her son, has been interrupted in midrefrain. McKenna mutters, "I had that same feeling myself many times." Stewart's

* *Rear Window* was also nominated for Best Direction, Best Color Cinematography (Robert Burks), and Best Recording (Loren L. Ryder), but failed to win in any category.

eyes twinkle when he speaks that line, but the meaning was different with Doris Day—and Hitchcock's camera veers away.

New York film critics had voted Grace Kelly Best Actress of the Year in 1954, for three pictures: *Dial M for Murder, Rear Window,* and *The Country Girl.* None of these were produced by Metro-Goldwyn-Mayer, which owned her contract, and her dispute with the studio had persisted with a suspension. MGM lifted the suspension in the spring of 1955, in time for Kelly to accept the Best Actress Oscar for her deglamorized star turn in *The Country Girl,* but the Oscar-winning actress stayed inactive for another six months while she continued to reject what she considered inferior MGM vehicles. Thus it became clear that Hitchcock's favorite leading lady would have to be crossed off his list if he wanted to shoot his film in the summer of 1955. Then at the Cannes Film Festival in May, where the actress was heading the American delegation, Kelly met Prince Rainier III of Monaco. . . .

The rest, as they say, is history.

Doris Day was usually typecast as a Little Mary Sunshine, but Hitchcock had been intrigued by her performance in *Storm Warning,* in which the singing actress had a rare nonmusical role as a waitress whose truck-driving husband is a Ku Klux Klan enforcer. Encountering the actress at a Hollywood party after seeing the film, Hitchcock told her, "You can act. I hope to use you in one of my pictures."

Or perhaps he was just being polite. According to songwriter Jay Livingston, who wrote the theme song for *The Man Who Knew Too Much,* Day wouldn't have appeared in the remake if not for pressure from MCA, which represented Hitchcock and the actress. "His agent, MCA, said he couldn't have [James] Stewart unless he took Doris Day," recalled Livingston. "He told us he didn't want Doris Day, but he had to take her. He was very happy with her later."

When Day signed on in the spring of 1955, her persona forced a change in the evolving script. Anything other than a wholesome type seemed a stretch for Day—and for her loyal audiences. In the original *Man Who Knew Too Much,* the mother-character is a flirt who dances with Louis Bernard; not in the remake, where she chiefly shows suspicion toward the Frenchman. And when the McKennas tour the Marrakech bazaar in the remake and Jo notices an Arab woman with an infant slung over her back, she astonishes her husband by blurting out, "When are we going to have another baby?" This raises a subtext—thwarted sexuality, or motherhood—that is never revisited.

Although Jimmy Stewart would assume his well-rehearsed rube persona for the film, in real life it was Day who more closely resembled the "typical American." At the time of *The Man Who Knew Too Much,* she had never been outside the United States; she was petrified of airplanes, trav-

eling whenever possible by boat. Arriving in Marrakech, she found the climate "ungodly hot," and was shocked by the "poverty and malnutrition." There wasn't much she could do about the poverty, but as an animal lover the star used her clout to demand that all the hoofed and feathered creatures used in the production be well fed on the film budget.

On-screen it was Stewart who fumbled his way through the Moroccan dining experience, but off-camera it was Day.* "The diners filled their plates from a community pot *with their hands!*" she wrote in her memoirs. "Well, D. Day is a lady of rather simple, hygienic eating habits and there was no way I was going to dig into the couscous or anything else." Although Hitchcock hosted the occasional rescue dinner with food flown in from Paris, Day was miserable in Marrakech, taking to her bed for days with pleurisy.

She waited in vain for the great director Alfred Hitchcock to step up and *direct* her. "I loved him personally," Day recalled. "We would go to dinner and laugh, and he was warm and loving, just really sweet. But I didn't understand him on the set." Did Hitchcock even approve of the way she was performing her role? She had no clue. Left to her own devices, the actress feared she was floundering. When Day complained about Hitchcock to Stewart, her costar tried to reassure her: "That's the way he is."

In other films Day could be a deft comedienne, but in *The Man Who Knew Too Much* the on-screen bumbling was shifted almost entirely to the leading man. Hitchcock had always minimized the aw-shucks side of Jimmy Stewart, but now he encouraged the star to improvise for laughs. Yet Stewart's fish-out-of-water antics as he struggles to learn Moroccan table manners are feeble (and illogical, considering that his character might have learned something about the culture during World War II). The British tourists of the original are sophisticates; the remake Americans seem blithely ignorant of the cuisine, language, and customs of their hosts.

The scene where Stewart gets into a comic scuffle with a taxidermist (getting his hand bitten by a stuffed tiger) had been deliberately underwritten to allow for impromptu creativity on the set; but this, too, became a weak scene—and a particular mistake, as Hitchcock conceded in later interviews, considering the hilarity of the dentist scene from the original that it replaced.

Stewart was curiously better in high drama for Hitchcock; he doesn't reach his best in *The Man Who Knew Too Much* until after the kidnap-

* Of course the stars ate only at the finest restaurants in Marrakech, and in the film the McKennas stay and dine at the Hotel de la Mamounia—where, off-camera, James Stewart and Doris Day also stayed and dined.

ping, when his character is reduced to impotence and desperate action. Surprisingly, for one of Hollywood's gifted gabbers, Stewart was better for Hitchcock when he *wasn't* talking; he was better watching and agonizing—as in the Albert Hall sequence. After one run-through, Hitchcock told Stewart to forget all about the script, and then he wiped out his dialogue on the sound track; the actor's mouth works furiously throughout the scene, but all that can be heard is the orchestral score.

All the time they were in Marrakech and London, Doris Day felt like a "lost soul." She related to Hitchcock personally, but yearned for him to engage with her professionally. "Not once, in any situation, did A. Hitchcock say a word to me that would have indicated that he was a director and I was an actress," she wrote in her memoir. "I had an eerie feeling that I wasn't even being recorded on the film—that when the rushes were shown all there would be was Jimmy Stewart and some invisible presence who moved glasses around and opened doors, like Topper."

After returning to Hollywood, Day summoned her agent and demanded a "heart-to-heart" with Hitchcock before they went ahead with the really "difficult scenes" that were scheduled to be filmed on Paramount stages. An emergency meeting was called in the director's office. Present: Hitchcock, Day, and MCA agent Arthur Park (his agent and hers).

"I wanted to have a frank talk with you about the picture," Day began. "I don't know why it is. I've gotten to know you pretty well and I like you so much, but I really feel like I'm not pleasing you."

"What makes you say that, my dear?" asked Hitchcock, apparently astonished.

"Well, you're not telling me what to do, and what not to do, and I just feel like I've been thrown into the ring and left to my own devices. We have all of our big scenes coming up and I want to please you, and do my best, but I just want you to feel free to say whatever you want to say to me because I want us to have a good rapport so that we can make a good movie."

"But, dear Doris, you've done nothing to elicit comment from me."

"What do you mean?"

"I mean that you have been doing what I felt was right for the film and that's why I haven't told you anything."

"Gosh, I wish you had told me that—it would have made all the difference. You see, I'm kind of, well, frightened of you in a way, and insecure."

"Everyone's frightened."

"Don't tell me you are."

"Oh yes, I am. I'm always frightened. When I walk into the dining room at Paramount I'm as insecure as everybody else."

"Honestly?"

"Everybody's frightened and insecure, and the ones who appear not to be are just appearing not to be. Deep down, they're as frightened as the next fellow, maybe even more so."

"Well, Hitch, I'm not frightened anymore and I feel that you and I can talk about anything. And if I'm not giving you what you want in a scene—"

"Of course I'll tell you—you'll be the first to know!"

Shortly after this master class—which should be excerpted in the chapter in directing manuals headed "On the Handling of Nervous Actresses"—Day's biggest scene came up on the schedule. It was the scene, by happy circumstance, where her character's nerves have been stretched to the breaking point—the scene where, before her husband tells her that her son has been kidnapped, he insists on sedating her with pills. Upon hearing the terrible news, she cries out and attacks him, and he restrains her as her strength ebbs. A tough, tough scene.

The two stars went through the blocking once for the camera, then broke for lunch. The actress spent the entire lunchtime nervously preparing, "doing the whole scene, every detail, every line of dialogue in my head, which is the only place I like to rehearse." Then Hitchcock shot the difficult scene in one take—and it became the acting highlight of the film.

Ultimately, the second *Man Who Knew Too Much* belongs to Day more than Stewart, just as the first belongs more to the mother. Stewart's performance improves in the second half, but hers reaches a level of real, affecting depth, climaxing in the Albert Hall scene. As the cymbalist reaches for his brass instruments, and the assassin slips into the shadows in order to strike, the look on Jo's face when she realizes what is about to happen— as she writhes futilely and sobs uncontrollably—fulfilled Hitchcock's every hope for Day's performance.

The director hadn't thought about a pop song for this film, any more than he had initially wanted Day, composer Jay Livingston insisted. At least that's what he told the songwriters—"which didn't make us feel too good," Livingston recalled. But MCA wanted a song for Day, so Hitchcock met with Livingston and Ray Evans, fellow MCA clients, who had won previous songwriting Oscars for "Buttons and Bows" and "Mona Lisa" (the latter heard in the background of the *Rear Window* sound track). Hitchcock told them, "I don't know what kind of song I want," but said it must be simple enough for a child to sing also—and that it would be heard twice in the film. (The first time is in Marrakech, as Jo tucks Hank into bed; the second is during the embassy sequence, when she sings it to a ballroom of guests, her voice soaring upstairs to be heard by the kidnapped boy.)

Livingston had just seen *The Barefoot Contessa*, in which Rossano

Brazzi takes Ava Gardner to his ancestral home in Italy, where these words are engraved on a stone: "Che Serà Serà." The lyricist had jotted the words down in the dark, later changing them to the more universal (Spanish and French) "Que Será Será." "We wrote the song very quickly," recalled Livingston, who penned the lyrics while Evans wrote the music, "but we waited two weeks to let him feel that we had taken a lot of time. When I sang it for him, he said, 'I told you I didn't know what kind of song I wanted. *That's* the kind of a song I want,' and walked out."

Shades of Marlene Dietrich and *Stage Fright:* Day didn't like the number at first, and resisted recording it for one of her albums, convinced that it was really a song for children. When Paramount and MCA applied pressure, she did record it, but refused to do more than one take. Afterward she declared, "That's the last time you'll hear that song." But "Whatever Will Be, Will Be (Que Será, Será)" won the Oscar for Best Song of 1956; it became Day's biggest-selling single, and in time she would embrace it as her signature tune.

The world of Hitchcock fans can be divided into people who prefer the original *The Man Who Knew Too Much,* and those who find the remake superior. The former may be the majority, but the latter make up a noisy faction.

The remake has a solid supporting cast of players rarely glimpsed in Hollywood films. They include Daniel Gelin (a veteran of films by Jacques Becker, Sacha Guitry, and Max Ophuls) as the foreign agent, Louis Bernard. The duplicitous English couple are played by Bernard Miles (a pillar of the British stage, also active in film) and Brenda de Banzie (she was the eldest, rebellious daughter in David Lean's film of *Hobson's Choice*). And Hitchcock immortalized Reggie Nalder, whom he plucked from obscurity, as the film's assassin; his advice to the Viennese dancer and stage actor for the Albert Hall sequence: gaze at your victim as if you're gazing at a beautiful woman.

The first film runs a galloping 85 minutes, the second an overlong 120. Even Arthur Benjamin's "Storm Cloud Cantata" was elongated for the remake: Benjamin was hired to compose an extra minute and a half of music for the American version. As though unwilling to trust the moron millions of Americans who hadn't seen the original, the director stretched out the suspense, adding several reminder shots of the cymbalist. ("In the audience there are probably many people who don't even know what cymbals are," Hitchcock explained to Truffaut.) Bernard Herrmann appeared on-screen as the conductor, but the rest of his score—rising and falling arpeggios— was the least distinctive of his contributions to Hitchcock films.

The original was made at a time when the world was living in dread of

Hitler. The remake looked to the Cold War for its drama, making various allusions to Communism, but Paramount was nervous about offending foreign markets, and Hitchcock's political references were tamped down by censors. The studio insisted that all references to Hungary and the Soviet Union be deleted. Hitchcock was an old hand at coding his politics; for the remake, the target of assassination would hail from a nameless nation, the embassy would be generically Eastern European, and the crypto-Communist couple would be only faintly defined—derisively, by the diplomat who has manipulated them—as "intellectuals."

The 1950s were not the 1930s, however, and British Communists could never carry the same frisson as Peter Lorre's evil embodiment of Germany. Above all, the remake suffers from the absence of the magnificent Lorre, and of the spectacular crescendo of the original, in which Lorre and his gang shoot it out, and the kidnapped daughter's safety is assured by her mother's cool marksmanship.

Yet the musical ending of the remake has its own cathartic emotion, its defenders insist. "Middle aged academics are not supposed to admit they burst into tears every time Doris Day begins 'Que Será Será,'" wrote Robin Wood, "but in my case it's a fact." Audiences certainly embraced the remake—and *The Man Who Knew Too Much* did well at the box office for Hitchcock and Paramount.

Interviewing Hitchcock, François Truffaut insisted that "the remake is by far superior to the original," but Hitchcock countered with a statement that is widely quoted in studies of his career, if not always appreciated for its double-edged meaning: "Let's say that the first version is the work of a talented amateur and the second was made by a professional."

Speaking to film historian William K. Everson some years after Truffaut's book was published, Hitchcock was asked to explain this ambiguous statement. "I think, actually," the director amended himself, "the difference would be in the original *The Man Who Knew Too Much* I wasn't audience-conscious, whereas in the second one, I was."

By late summer Hitchcock could turn his focus to an enterprise that might have consumed a full year's attention for a man less well organized, less brimming with ideas and energy. But less than six months after it was conceived, *Alfred Hitchcock Presents* premiered in October 1955.

Other books about Hitchcock have maintained that he had little to do with the day-to-day management of the series that bore his name, often quoting his own publicity to that effect. But the publicity was rooted in Hitchcock's desire to divert credit to Joan Harrison; the fact is that he worked very hard to establish the show, especially in the first two seasons. He involved himself closely in all the story and personnel choices, and met

frequently with network and ad agency representatives to apprise them of his decisions.

The Hitchcock name had been on storefronts in his boyhood, and he had made it an asset to film companies in England well before he reached Hollywood. He did rely heavily on Harrison, once his secretary and protégée, whose judgment he knew he could trust. Once again they worked together easily, if not quite as equals, certainly as kindred professionals. But from the outset, setting the tone and style, it was Hitchcock's show in name and spirit.

"A television show, like a soufflé, reflects the taste of the person who selects and mixes the ingredients," Hitchcock said years later in one of his public speeches. "It matters a great deal, for example, whether onions or garlic are used and when the arsenic is added."

"Selecting the ingredients" meant, first of all, taking care with the stories and scripts. With thirty-nine episodes to be produced each season, Hitchcock had to cast a wide net for material. Over the years, he had amassed a fund of favorite stories, and had also built relationships in the publishing field. "I have always wanted to work in the short story," he told the *Los Angeles Times*. "The small, simple tale of a single idea building to a turn, a twist at the end. A little shocker. The story that's lost, when stretched to the length of a movie."

The tone of the series was at first decidedly English with only a thin coating of Hollywood, and its British accent would persist throughout the run of the series. No other U.S. television show could claim quite the same pedigree, drawing on stories by a British Who's Who of authors including H. G. Wells, A. A. Milne, Rebecca West, Julian Symons, V. S. Pritchett, Eric Ambler, and John Mortimer. Roald Dahl and Stanley Ellin were probably the most frequently adapted, and more than once Hitchcock returned to authors whose novels he had already filmed, Mrs. Belloc Lowndes, Ethel Lina White, and Selwyn Jepson among them.

Another major source for early episodes was stories previously dramatized on radio, especially on the *Suspense* series—and its televised counterpart, which ran from 1949 to 1954.* Previous publication wasn't "a rigid policy," said Norman Lloyd, who joined Hitchcock's show as associate producer in 1957, "but rather a pragmatic one. Hitch liked to know that a story had been published first, because he always felt that if a story had been published, you had something to begin with. He was not one for developing stories, as is mostly done today."

The bulk of the stories involved murder under suspicious or peculiar circumstances. Episodes were sometimes darkly comic, sometimes stark or

* The TV version of *Suspense* returned, after a decade's hiatus, for one season in 1964.

mordant, and most of the episodes had twist endings. Among the first season's highlights was the story Hitchcock once cited as an inspiration for *The Lady Vanishes*—"The Vanishing Lady" by Alexander Woollcott (with Pat Hitchcock as the daughter of a woman who vanishes at the 1899 Paris World Exposition). The first season would boast adaptations of Dorothy Sayers, Anthony Armstrong, and John Collier. But *Alfred Hitchcock Presents* also had its share of American writers, and the first season featured stories by *Rear Window* author Cornell Woolrich (who never wrote directly for the program, though again and again his stories were adapted) and Ray Bradbury, who wrote originals as well as adaptations throughout the run of the series.

Television scripts called for a brevity and economy similar to the demands of radio, and many of the scriptwriters also had cut their teeth in radio. The most prolific were *Suspense* alumni: Harold Swanton, James P. Cavanagh, Louis Pollock, Mel Dinelli. Francis Cockrell—who wrote all four of the episodes Hitchcock directed in 1955–56, and seven of the twenty shows Hitchcock directed for television—was a southerner who wrote humor, short stories, novels, and films, often with his wife, Marian.* The Cockrells and Joan Harrison had collaborated on 1944's *Dark Waters,* a Hitchcockian frightened-lady film.

Besides directing a handful of shows, Hitchcock was contracted to introduce each episode, and at the conclusion provide a wrap-up. He also agreed to hawk for the advertisers, which was standard practice on television in the 1950s. But it was clear, from the very first discussions, that this was no burdensome requirement: Hitchcock relished the opportunity for these mischievous cameo performances.

His brief appearances called for a ghostwriter uniquely attuned to his sensibility. MCA once again rode to the rescue, with James Allardice. Born in Ohio, Allardice was a former newspaperman who had drawn on his war experiences for his first Broadway play, later adapted into the Dean Martin–Jerry Lewis comedy *At War with the Army*. He then wrote a Francis the Talking Mule picture as well as other vehicles for Martin and Lewis. Having drifted into television, Allardice had just won an Emmy, in 1954, as part of the team who wrote monologues for the highly rated *The George Gobel Show*.

Allardice and Hitchcock were a perfect match. At their first meeting, Allardice told Hitchcock about a high school play he had written, in which he displayed an electric chair under which hung the sign: "You can be sure if it's Westinghouse." "Hitchcock loved this," according to John McCarty

* On her own, Marian Cockrell wrote another of the shows that Hitchcock directed.

and Brian Kelleher in their book on *Alfred Hitchcock Presents* "and accepted Allardice enthusiastically, putting him under exclusive contract."

It was also standard practice for a television series to have a recurring title sequence with theme music. For the underlying music Bernard Herrmann suggested "Funeral March of a Marionette," written by Charles Gounod in 1872, a classical novelty Herrmann had used on *Suspense* and later recycled as a temporary sound track for *The Trouble with Harry*. Hitchcock, who matched up songs with Marlene Dietrich and Doris Day, finally had his own trademark music. "Even when people hear the music today," wrote McCarty and Kelleher, "what they usually think of is Hitchcock's silhouette countenance merging with the odd little line drawing that he had sketched of himself for the show's logo."

After the titles and "Funeral March," the curtain metaphorically rose, and the host appeared to greet the viewers. Hitchcock's first costume was ordinary, the speech concise:

Good evening, I am Alfred Hitchcock. Tonight I'm presenting the first in a series of stories of suspense and mystery called, oddly enough, Alfred Hitchcock Presents. *I shall not act in these stories, but will only make appearances, something in the nature of an accessory before and after the fact, to give the title to those of you who can't read and to tidy up afterwards for those who don't understand the endings.*

But after the premiere, it was off to the races. The voyeur was also an exhibitionist. Sensing Hitchcock's eagerness to perform—his willingness to show off and poke fun at himself—Allardice wrote wildly. By the third episode Hitchcock was twirling a gun; his weight was already a running joke; and, most astonishing, he had begun to skewer advertisers:

Tonight's story is about a man named Perry and follows after a minute called tedious.

Our story will continue following this calculated but confusing interruption.

Our play tonight is a blend of mystery and medicine. It follows this one-minute anesthetic.

The cameos were sometimes vignettes of low comedy; other times they were extremely witty. Hitchcock was willing to take any Allardice dare: he donned a mustache to play his own twin brother, impersonated a genie lurking inside a bottle, became a scarecrow in a cornfield, even affected a mop top as one of the Beatles. The host set the tone as much as the stories

themselves, commenting on the absurdity of what audiences were about to witness, thereby ameliorating its subversive excesses.

The tone was also set, that first season, by first-class actors. They included familiar faces from Hitchcock films (Joseph Cotten, Barry Fitzgerald, Patricia Collinge, Robert Newton, Isobel Elsom, Thelma Ritter) and edgy newcomers (including, in the first season, John Cassavetes, Charles Bronson, and Joanne Woodward). The casting was often heavily English, and Hitchcock favorites abounded. John Williams, from *The Paradine Case*, *Dial M for Murder*, and *To Catch a Thief*, might hold the record. The dapper, self-effacing Englishman "was the definitive Hitchcock actor," recalled Norman Lloyd. "Everything in his style served Hitchcock's purposes: the underplaying, the subtle humor, the indirect approach he had."

The directors were likewise topnotch. Hitchcock and Joan Harrison recruited many old acquaintances dating back to England—among them Robert Stevenson, Ida Lupino, and John Brahm. Robert Stevens, who guided more episodes than anyone (he was the only *Alfred Hitchcock Presents* director to win an Emmy, for the second season's "The Glass Eye"), was another Englishman—and a veteran of *Suspense*.

But the show was also open to up-and-comers, and young Americans like William Friedkin, Robert Altman, and George Stevens Jr. (the son of the well-known director) held their first important jobs on the series. Hitchcock was as closely involved in choosing the directors as he was with the stories and stars. Paul Henreid, the stalwart Warner Bros. actor known for his roles in *Casablanca* and *Now, Voyager*, was surprised one day by a call from Hitchcock himself, complimenting the only film he had directed—*For Men Only*, a low-budget college drama—and inviting Henreid to join the roster.

"But—but the blacklist . . . ," stammered Henreid, who believed that his left-leaning politics had gotten him "graylisted" in Hollywood.

"I think that's over, Mr. Henreid," said Hitchcock, "and high time." Indeed, it was: Henreid thereafter got steady work directing episodes of *Alfred Hitchcock Presents*.

Bottom-billed in the cast of *For Men Only* was a beautiful blonde named Vera Miles, who had represented Kansas in the Miss America contest of 1948. After spotting the actress in Henreid's 1951 film, Hitchcock ordered up a more recent John Ford film, and was impressed by Miles as Jeffrey Hunter's pining sweetheart in *The Searchers*. He originally hired the actress for just one episode in the first season—a particularly audacious episode that involved fragile sanity, an implied rape, and a mistaken-identity murder.

"Revenge" would feature Miles as former ballet dancer who, after suf-

fering a nervous breakdown, moves to a trailer park with her husband (Ralph Meeker). One day, while the husband is at work, she is attacked by an unknown assailant. The attack leaves her traumatized. The police, as usual in a Hitchcock story, are clueless, so her husband vows to get revenge himself. Driving through a small town, the wife suddenly spots a man walking on the street and cries, "That's him!" The husband pulls over and follows the man into a hotel, surprising him in his room and bludgeoning him to death. Getting back into the car, the husband reassures his wife, and they drive on. Then she spots another man walking. "That's him!"

Hitchcock tried to draw a line between his television and film companies. They were supposed to be distinct operations, even headquartered in separate locations—the film offices at Paramount, the television shows produced on Revue stages at Universal. But inevitably the two spilled back and forth, and during the making of "Revenge" Hitchcock grew so excited about Miles that he signed her to a five-year contract, making her exclusive to him, for television *and* film. Miles was not only a shapely knockout (she photographed suggestively, ripe to burst in a sunsuit, in "Revenge"), but her acting was subtle and sensitive. With Ingrid Bergman off in Italy and Grace Kelly being a princess in Monaco, Hitchcock wanted Miles in his future.

The director's enthusiasm for Miles, and for "Revenge," led the host to make a last-minute decision: he made her episode the series debut—bumping "Breakdown," with Joseph Cotten, which was rescheduled for later. Both were quintessential Hitchcock stories—anthologized together in Hitchcock's 1949 collection, *Suspense Stories**—but "Breakdown" was a minimasterpiece, with all the "pocket universality" of *Lifeboat* or *Rear Window*.

Cotten starred as a ruthless businessman finishing a Miami vacation. Firing an employee by phone, he expresses disgust at the weak emotions of the man, who pleads and weeps for a second chance. While driving back to New York from Florida, his car, which has stopped for a prison road gang, is smashed into by a construction vehicle. He awakes to find himself pinned under the steering wheel of his wrecked car, completely paralyzed except for the ability to wiggle one finger. The escaped prisoners come and strip away his clothes and belongings, and when the police arrive everyone interprets his shocked stare as a mask of death. Ending up in a morgue, he is desperate to let people know he is alive. Just as a coroner is about to zip him into a body bag, he starts to weep, and someone finally notices his tears.

The main dialogue in the twenty-two-minute segment is Cotten's inte-

* "Breakdown" had also been dramatized for the *Suspense* radio series.

rior monologue, delivered as a voice-over. Most of the episode is composed of close-ups of his face, his immobility emphasized by extreme camera angles. It was "frozen film," according to Hitchcock; "you optically repeat the last frame—that's how you get a still." It was also extraordinary television, a taste of pure cinema for the small screen—in critic Robin Wood's words, a parable of "a systematic stripping away of all the protective armor of modern city man."

Of the four episodes Hitchcock directed for 1955–56, "Revenge" and "Breakdown" were the best. The other two were "Back for Christmas," with John Williams burying his nagging wife in the basement, then vacationing in California; and the oddball "The Case of Mr. Pelham," with Tom Ewell as a man whose doppelgänger gradually takes over his identity.

Although the series would take a year to build its regular audience and climb into the top ten, it was an instant hit with television critics—and more than one thought that "the best thing about *Alfred Hitchcock Presents*," in the words of John Crosby of the *New York Herald Tribune,* "is Alfred Hitchcock presenting." Leo Mishkin, writing in the *New York Morning Telegraph,* agreed: "That wide-eyed innocence he displays on the twenty-one inch screen, that pudgy physique with its hanging lower lip, those soft accents of his speech all but annihilate the very image of suspense and terror he has tried so carefully to build up."

He was already a star among moviegoers, but it's no exaggeration to say that television provided a quantum leap in the magnitude of his celebrity. Or that 1955 was another very good year for the director: *To Catch a Thief* was a hit in theaters, he finally achieved his remake of *The Man Who Knew Too Much,* and his name adorned a suspense series.

The Hitchcocks liked to vacation at Christmas, but it hadn't always worked out that way. The holidays had meant mass firings at Islington, Gaumont, and Gainsborough. Christmas was dodgy during the Selznick years, too; the producer used to drive Hitchcock crazy, giving him his annual bonus in war bonds that couldn't be immediately cashed in.

But a grateful Paramount gave him the Christmas present of a world tour at the end of 1955. Mr. and Mrs. Hitchcock departed on the *Queen Mary,* on December 12, for a monthlong itinerary including Tokyo, Bangkok, Hong Kong, Calcutta, Delhi, Bombay, Cairo, Rome, Paris, and London. At each stop Hitchcock visited studio outposts and conducted publicity for his films, spreading his name and face around the globe. He was never happier than when he stood on the Ginza in Tokyo, gazing up at a billboard with his giant face painted on it. He chortled at what he saw: a Hitchcock with Asian eyes.

FOURTEEN
1956–1958

One person who never wrote for *Alfred Hitchcock Presents* was John Michael Hayes.

When Hitchcock returned, refreshed, from his monthlong trip around the world in January 1956, he had his next four projects lined up ahead of him, enough to fill out the decade. Paramount had optioned two books for him: *Flamingo Feather,* a big-budget jungle adventure set in South Africa, and *D'Entre les Morts* ("From Among the Dead"), a French thriller by Pierre Boileau and Thomas Narcejac. *Flamingo Feather* was intended as a Paramount film, like *To Catch a Thief; From Among the Dead* would be an Alfred J. Hitchcock production. The third project was a true wrong-man story based on a *Life* magazine article by Herbert Brean. The fourth was "The Man in Lincoln's Nose"—the idea hadn't grown much beyond Otis Guernsey's brief treatment, but the concept still intrigued Hitchcock.

Hitchcock wasn't yet sure in what order he would make the four films; it all depended on how easily the scripts and other elements came together. But in January 1956 it still seemed possible that Hayes might write one of the films. The trade papers had even announced "The Man in Lincoln's Nose" as a "Hitchcock-Hayes production." That kind of shared attribution really irked the director, believed Hayes, who after the success of *Rear*

Window was feeling a little irked and underpaid himself. Hitchcock and Hayes were both MCA clients, and the writer believed their separate agents were colluding to keep his salary low. "They were all in on it because Hitchcock was their big client," Hayes said bitterly, years later.

Whenever Hayes complained about his salary, his agent urged patience: "Stick with Hitch and you'll get a diploma from Hitchcock University, which will be extremely valuable in the future." When the bonus Hitchcock promised Hayes for *Rear Window* never materialized, the sore point was aggravated. Yet even Steven DeRosa, in his book celebrating Hayes, discovered that the writer's salary "doubled" after *Rear Window*; and Hitchcock considered Hayes's all-expenses-paid trips to France for *To Catch a Thief*, to Vermont for *The Trouble with Harry*, and to London for *The Man Who Knew Too Much* as bonuses of a different kind.

But the personal chemistry between the director and his longtime collaborator was never strong. Hayes complained in one interview that Hitchcock never invited him and his wife up to their second home in northern California, and even in Hollywood the Hitchcocks didn't socialize after hours with the Hayeses.

The director's ego couldn't accept Hayes's role in shaping several of Hitchcock's most important successes, the writer believed. Hitchcock found a reason to skip the Mystery Writers of America banquet the year Hayes received the Edgar Allan Poe Award for *Rear Window*, and afterward made light of the award when Hayes showed it to him: "You know, they make toilet bowls out of the same material." (Even DeRosa says Hitchcock was probably joking, but Hayes didn't appreciate the humor.)

After giving published interviews that annoyed Hitchcock, Hayes was ordered to refrain from personal publicity without prior approval. It wasn't an extraordinary demand in Hollywood, but Hayes detected the insecurity of a director who "wasn't going to be Barnum and Bailey," as he frequently put it, in later interviews. "He was Alfred Hitchcock, Genius. He was the Creator, the Master; it was an Alfred Hitchcock film and nothing else. It was not an Alfred Hitchcock film written by John Michael Hayes."

According to associate producer Herbert Coleman, though, Hayes was the real grandstander, from the point of view of the Hitchcock circle. It was Hayes who flaunted the "oversized ego," in Coleman's words. It was Hayes who was capable of boasting in print, saying in subsequent interviews that he crafted "the whole construction and treatment and screenplay [of *Rear Window*] on my own," or that "most of *To Catch a Thief* was again my creation."

Hitchcock's view was that *Rear Window* was handed to Hayes on a silver platter—not only the story but the main characters and the stars playing them, along with detailed discussion of every scene. The same with *To*

Catch a Thief, on which Mrs. Hitchcock had made a significant contribution, not to mention the emendations on location and during postproduction. As for *The Trouble with Harry,* Hitchcock had practically memorized the book, and the film followed it closely.

But the latest conflict between them would prove the worst. Who ought to be officially credited for the screenplay of *The Man Who Knew Too Much*? When Hitchcock insisted that Hayes share credit on the screen with Angus MacPhail, Hayes appealed to the Writers Guild of America; after reviewing all the written material, their arbitration panel ruled in favor of Hayes. A staunch member in good standing with the Hollywood organization, the American trumped the Englishman, who was viewed suspiciously as an arriviste and personal friend of the director's.

Hitchcock was furious that Hayes had gone over his head, and felt that MacPhail had been unjustly usurped. Film scholars such as Bill Krohn, and insiders of the period, agree. "As far as I'm concerned," Herbert Coleman believed, "the credits ought to read: script by Alfred Hitchcock, Angus MacPhail and John Michael Hayes."

In spite of the tension between them, Hitchcock put off any showdown with the writer until his return from his holiday vacation, hoping that Hayes might yet reconcile himself to working amicably with MacPhail, who had since moved to Hollywood semipermanently to serve as de facto story editor of Hitchcock Productions.

As the only one of the four upcoming projects that wasn't based on previously published material, "The Man in Lincoln's Nose" needed the most development, so Hitchcock slotted it last. Likewise, the novel *D'Entre les Morts* offered the director a basic plot and characters to build upon, but needed substantial work—first a translation, then a transplant to contemporary America.

Flamingo Feather and the true wrong-man case, Hitchcock decided, could be written simultaneously by MacPhail and Hayes, trading off on rewrites in Hitchcock's customary fashion. MacPhail was asked to take the lead on *Flamingo Feather* because of its British Empire overtones, while Hayes was expected to concentrate on the other script, which Hitchcock felt was more up his crime alley. Set entirely in New York City, *The Wrong Man* would be scheduled first.

First Hitchcock had to arrange a leave from Paramount because *The Wrong Man* belonged to Warner Bros.; the studio had signed a contract with the actual wrong man in the New York incident. But Hitchcock also told Lew Wasserman that he was directing the film for Jack Warner because he wanted to make good on the single picture still outstanding on his 1947–54 contract. Over the years he would tell interviewers the same thing repeatedly. And it's possible he was telling the truth; Hitchcock took contracts seriously.

But did he really owe Warner Bros. anything? It's far from clear. And Warner's was actually ambivalent about *The Wrong Man* until Hitchcock offered to waive his salary, an offer calculated to win him the go-ahead to make the picture. It's hard to think of very many other directors in Hollywood history who have volunteered to work for free this way, at the peak of their success. Yet such a gesture was entirely in character for Hitchcock, who had often ignored money to make the films that interested him.

Hayes didn't have that option. When it came to *The Wrong Man,* Hitchcock insisted that Hayes agree to collaborate with MacPhail, even stipulating in advance that they must share credit on the finished film. According to Hayes, Hitchcock even demanded that, like him, the American writer work "for nothing"—no salary. There is no proof of this astonishing gambit other than Hayes's recollection—astonishing because Hitchcock must have known full well that the Writers Guild, which insisted on minimum fees for any script commissioned by a producer, would never allow such an arrangement, even if Hayes agreed.

Hayes believes that Hitchcock never really expected him to take the bait; the director knew "that I couldn't do it," in Hayes's words. "If you don't come to Warner Brothers with me," Hayes quoted Hitchcock as saying, "I'll never speak to you again." Hayes refused—and that was the end of their relationship. Hitchcock—a "registered coward," as Hayes liked to say—sent "emissaries" to tell the writer he'd been discharged. More accurately, the writer wasn't "renewed"; with his four-picture contract fulfilled, Hayes was kicked out of Hitchcock University.

They did speak again, however, if only once, when Hitchcock ran into Hayes at the ballet a few years later. Hitchcock acted "very cordial" to him, Hayes recalled. But despite sporadic efforts by associates to reunite them, the director refused ever to work again with the scenarist of four films considered among Hitchcock's greatest.

Herbert Brean's June 29, 1953, article in *Life* had recounted the facts of *The Wrong Man* case, and there was even a television reenactment, produced by Robert Montgomery, which aired on NBC in February 1954.

Earlier in 1953, Manny Balestrero, a jazz bassist and father of two young children, was accused of stealing $217 from an insurance company in Queens. Protesting his innocence, Balestrero was arrested, jailed, and brought to trial. He was temporarily freed after a juror inappropriately spoke out from the jury box, causing the judge to declare a mistrial. Then, before Balestrero could be retried, the real criminal was caught robbing a delicatessen—but not before Manny's wife, Rose, suffered a mental breakdown from the strain.

Although Hitchcock always insisted he made *The Wrong Man* because

it was "the available project," it was also precisely what he'd been after for some time. Partly by circumstance, his passion for research and authenticity had been overshadowed in recent films by artifice and Hitch-cockery, and now he wanted to sink his teeth into a neorealistic subject.

In interviews, Hitchcock sometimes disparaged what he (and some critics) called "kitchen sink" neorealism, telling the press that he and his Italian housekeeper watched Vittorio De Sica's *The Bicycle Thief* in San Francisco one day, and that his housekeeper was half bored by the masterpiece. He didn't always describe his own reaction, but he was impressed by the film, and once told the *New York Times* that *The Bicycle Thief* was a perfect double chase—physical and psychological. Hitchcock's love for Italy was genuine; and he kept up with the postwar cinema there, paying special attention to Roberto Rossellini's films—in part because Rossellini's latest featured Mrs. Rossellini, Ingrid Bergman.

The ideal film, in the words of neorealist theorist (and scenarist) Cesare Zavattini, was "ninety minutes of the life of a man to whom nothing happens." The Italians were developing a vision of film as a documentary-style snapshot of real life, with storytelling that was antidramatic. They valued nonprofessional acting and visual simplicity, eschewing suspense and camera trickery in favor of insights into society and a humanistic vision. Italian neorealism had already crept into the American films of Fred Zinnemann, George Stevens, and William Wyler, and now Hitchcock was drawn by its tenets and aesthetic.

The Wrong Man offered Hitchcock a real-life incident—involving an Italian American—that would enable him to continue his lifelong critique of the judicial system. It gave him an opportunity to adopt an "unmistakably documentary" approach, in his words—a radical challenge for the director. And it would mean a script credit for his friend Angus MacPhail.

Once Hitchcock parted ways with John Michael Hayes, he needed another writer to complement MacPhail, and once again he reached beyond Hollywood for a quintessential American. Maxwell Anderson, like Thornton Wilder and John Steinbeck before him, rarely wrote directly for Hollywood, and most of his screen credits—such as the most recent, *Joan of Arc* starring Ingrid Bergman—were based on his acclaimed stage work. Insistent in their moral stance, Anderson's Broadway plays ranged from experimental verse drama to satire and musicals. And one of his most famous historical dramas, *Winterset,* concerned two Italian American immigrants who may have been wrongly executed: Sacco and Vanzetti.

Anderson said yes, and by February 1956 Hitchcock, MacPhail, and Herbert Coleman were living at the St. Regis in New York, scouting locations and holding meetings with the writer, who commuted from his home in nearby Stamford, Connecticut.

Although in some ways it was the opposite of everything Hitchcock had

ever done, fidelity to life was Hitchcock's unusual, almost compulsive goal in making *The Wrong Man.* He wanted to tell the story *exactly* as it had transpired, with minimal dramatic or cinematic embellishment. To that end, the New York team tried methodically to retrace Balestrero's footsteps, his habits and experiences. Coleman himself rode the 3:30 A.M. subway train Balestrero had taken home after finishing his Stork Club gig on the night of his fateful arrest. MacPhail ate breakfast at the café where the musician had dined that morning, and both visited the delicatessen where the real criminal was apprehended, quizzing the deli owners.

Coleman and MacPhail interviewed the actual judge in the case, the defense attorney, the prosecutor, and Rose's psychiatrist. Along with Hitchcock, they visited the actual jail and observed how prisoners were booked and handled. They visited the actual psychiatric rest home.

They tried as much as possible to retrace the police procedures, but were stonewalled by the current New York police commissioner, who wanted nothing to do with a film highlighting a false arrest. Writing to Anderson, Hitchcock complained that police officials were acting as though "grave secrets might be given away if we asked a detective whether he blew his nose loudly or softly while interrogating a suspect." As devious with police commissioners as he was with Production Code officials, Hitchcock simply switched gears, enlisting retired policemen as consultants. (Later he got his own revenge, insisting on dropping any mention of New York police from the screen acknowledgements.)

On the other hand, a number of incidental figures in the case offered their assistance, and Hitchcock even hired some to portray themselves in the film. (This was a common practice of Italian neorealism, engaging nonprofessionals; but Hitchcock had rarely done it to such an extent.) Wherever possible, Hitchcock then staged their scenes in the actual locales.

Everything, Hitchcock insisted, ought to happen just as it had happened to the real Manny Balestrero. By phone and letter, Hitchcock kept Anderson abreast of the ongoing research as the latter wrote in Connecticut. When Anderson placed the scene where Manny is booked and fingerprinted too early in the script, Hitchcock gently reminded the writer of "the actual order of events." When Anderson wrote a speech in which a juror interrupted the proceedings to admit he has reached a guilty conclusion before hearing all the evidence, Hitchcock praised Anderson's writing, but said he couldn't use the speech in the film. Anderson had taken too much license, and the speech as written was fictitious—"a major contradiction of the actual events, and could be so easily used in hostile criticism."

Whenever the team hit a dry spell, they returned to the actual people, reinterviewing them for new ideas. They were amused to learn, for example, that when the real holdup man was arrested, he cried out, "Let me go!

My wife and kids are waiting for me." Hitchcock told Anderson to drop that line into his working draft. "I loved that line," he told François Truffaut, "it's the sort of thing you wouldn't dream of writing into a scenario."* In the somber prologue he substituted for his usual cameo, Hitchcock would claim proudly (though with exaggeration) that "every word" of the script was drawn from real life.**

The leads were locked in from the start. *The Wrong Man* was tailored for Henry Fonda and Vera Miles, two additional reasons for Hitchcock to be excited about the project. He had coveted Fonda since coming to Hollywood, trying to hire him first for *Foreign Correspondent* and later for *Saboteur.* Along with Gary Cooper and James Stewart, Fonda was one of the great John Does of the American cinema, and might be expected to bring echoes of Tom Joad to his portrayal of Manny Balestrero.

The Wrong Man would also launch Hitchcock's "first personal star." The phrase, used in Hitchcock's publicity, wasn't strictly accurate: Hitchcock had signed actresses to exclusive contracts as early as the silent era. Nor could he claim to have "discovered" Miles, for others had spotted and used her first. But until the 1950s, with Paramount's backing and the power of a network television series under his belt, he hadn't been in a position to have Hollywood actresses under contract. Miles was the first American he tried to build into a major star. "The latest in a famous line of cool [Hitchcock] beauties," *McCall's* called the actress, pointedly noting that she was being touted as "the new Grace Kelly."

Miles may have been beautiful, but she wasn't as well-bred as Kelly, and Edith Head was brought in to consult on her look and wardrobe for public appearances. "She's an extraordinarily good actress," Hitchcock advised the costume designer, "but she doesn't dress in a way that gives her the distinction her acting warrants." Miles wore "too much color," Hitchcock observed, yet she was obviously the kind of person who was "swamped" by color. The decision to shoot *The Wrong Man* in black and white was in line with Italian neorealism, but was also reinforced by the director's opinion that bright colors put Miles at a disadvantage. Head organized her "complete personal wardrobe" of blacks, whites, and grays, and then, when Miles arrived in New York in March, the first thing she

* In the film, it's "Let me go! I've got kids!"

** In fact he had filmed himself in a scene with Henry Fonda, but Hitchcock ultimately cut this cameo from *The Wrong Man,* deferring to the realism he was striving for. Instead, a striking soundstage long shot opens the film, with the director in shadowy silhouette addressing the camera soberly: "This is Alfred Hitchcock speaking. In the past I have given you many kinds of suspense pictures, but this time I would like you to see a different one. The difference lies in the fact that this is a true story, every word of it, and yet it contains elements that are stranger than all of the fiction that has gone into many of the thrillers that I've made before."

did was follow the Hitchcocks to a department store, where they picked out the kind of dresses her character should wear.

The shell-shocked woman Miles portrayed in the series premiere of *Alfred Hitchcock Presents* was a kind of rough sketch for Rose, Manny's traumatized wife; especially after Manny's jailing, Hitchcock wanted to switch the film's focus to Rose's fragile psychology. As it turned out, Manny presented disappointingly few complexities to the scriptwriters, so it was all the more vital to build up the character being played by Hitchcock's first personal star. In both cases, it proved difficult to be cinematic while remaining true to events.

The pivotal scene was Manny's second visit with his attorney, where both he and his lawyer realize Rose is undergoing a breakdown. Hitchcock kept in touch with the real-life Balestreros in Florida, where they had moved after Rose was placed in a sanatorium.* For this and other scenes the team communicated repeatedly with the couple, asking how Rose remembered feeling, but they were consistently discouraged by the couple's responses. The Balestreros had only mild anecdotes. Far from flooding him with intriguing details, reality let Hitchcock down.

Hitchcock had spent his entire career creating drama out of his imagination, sprinkling fiction with bits of reality; now he strained to replicate a rigorous reality, without the slightest concession to fantasy. Again and again, the team's research showed that the couple had endured everything with a surprising lack of "any particular emotion," in Hitchcock's words. The director agonized over a script that seemed doomed to end up "underwritten," alternating many "slow passages" that echoed the reality with more satisfying scenes that seemed, to Hitchcock, "over-cinematic." Again and again the director appealed to the Balestreros for tidbits; again and again he returned empty-handed, and wrestled with the urge to enhance the scenes—to improve reality.

Angus MacPhail made a solid contribution to the script, and would stay at the director's side throughout the filming. Hitchcock borrowed his key team from Paramount: Herbert Coleman (associate producer), Bernard Herrmann (music), George Tomasini (editor), and Robert Burks (photography). Telling Burks he intended to shoot the film in black and white for a journalistic look, Hitchcock warned the cameraman that *The Wrong Man* might not be his kind of subject. But Burks stayed on, and once again

* A crawl at the end of *The Wrong Man* reassures audiences that the actual Rose had made a complete recovery and left the mental institution, though Hitchcock pointedly told Truffaut, "She's probably still there."

Hitchcock benefited from his expressive camera work. Burks switched effortlessly, making "this film of winter," in the words of Claude Chabrol and Eric Rohmer, a tonal companion piece to *I Confess*.

The weather was wintry indeed that spring in New York. Warner's insisted on developing the footage in California, so dailies were delayed—and refilming was thus minimized, just as the studio intended. When the actor playing the judge couldn't remember his lines, he was hurriedly replaced; when the actress portraying the attorney's wife gave Hitchcock "attitude," according to Harold J. Stone, who was playing the arresting officer, she was simply cut out of the film. (The attorney's wife is heard only on the telephone, taking a message for Anthony Quayle.)

Regardless of the weather, script deficiences, or the failings of bit players, Hitchcock was upbeat. He had long since learned to accept a film's imperfections. Feeling right at home in his favorite New York hotels and restaurants, the director delighted in his two stars. "Didn't he feel that actors were cattle?" *Playboy* asked Henry Fonda some years later. "Not Hitch, no," Fonda answered. "He was funny all the time. Hitch would come in and tell a funny story just before he'd say 'Roll 'em' into a serious scene. I loved working with Hitch. He blueprinted every scene he did carefully with the production man and the assistant director and the script supervisor, so that any one of the four of them could have lined up the shot and shot it."

The man playing Manny Balestrero glided through the film, giving a sensitive, thoughtful performance—while the director bore down on the actress playing his wife. Donald Spoto writes that Hitchcock put his first personal star through "the poignant scenes of her breakdown over and over until she was nearly sick with exhaustion." But exhaustion was part and parcel of the role, and the same process had worked wonders with, say, Joan Fontaine.

Spoto also writes that behind the scenes, Hitchcock behaved in "strangely ardent" fashion toward his leading lady—attention Spoto says she resented. (Miles herself is not quoted.) There is no question that Hitchcock took a kind of Pygmalion approach, often his technique with actresses he regarded as under his tutelage; no question, too, that Hitchcock sometimes bestowed gifts and flowers on his lead actresses, courting them with the gestures of a lover—all the better that they might respond to the ardent gaze of his lens. And no question that he stood around, waiting and watching with his penetrating gaze.

But Hitchcock was always aboveboard with Miles, associate producer Herbert Coleman insisted in an interview for this book. The director was flirtatious with beautiful actresses, he remembers, and the vivacious Miles flirted with lots of people, Hitchcock included—a give-and-take that might have been misunderstood by outsiders. "Hitch had an obsession with her,

sure," said Coleman. "But it never went beyond imagining. Anyone would want to be a lover of Vera Miles."

Miles was a free spirit, and to some extent she resisted Hitchcock's hovering attention, his Svengali makeovers. Her resistance did lead to friction between them. But in *The Wrong Man,* under his strict guidance, Miles also gave a haunting performance.

And pretending to be a Cyrano in love with his leading lady may have been the only fun on a film that was saddled with bare facts and sketchy characterizations. Rose Balestrero and the other characters could have used some of the old Hitchcockery, but the neorealist mantle proved something of a straitjacket for the director. Although the French rank *The Wrong Man* among his neglected, underrated works, and the film makes an eloquent plea for the rights of the ordinary accused (indeed, it prefigures the Miranda ruling), ultimately its impact was dampened by the neorealistic approach. Slow, somber, remarkably restrained, it's one Hitchcock film that doesn't hold up very well for modern audiences, to whom Manny's ordeal can seem almost mundane.

When François Truffaut asked him about *The Wrong Man,* Hitchcock declared that it ought to be filed under "the indifferent Hitchcocks." Fidelity to fact hurt the script; everything was "anticlimactic." Truffaut liked it better than the director did, and he asked Hitchcock to defend the film. "Impossible," Hitchcock replied. "I don't feel that strongly about it."

One part of the film he did feel strongly about was the scene toward the end, after Rose has been institutionalized and Manny, facing retrial, has begun to lose hope. His mother urges him to pray to God for strength and deliverance. (All along Manny has carried rosary beads in his pocket.) As Manny (and the audience) stare at a picture of the Savior, and his lips murmur in prayer, a double exposure reveals the real killer walking down a street; his face gradually fills the same frame until it is superimposed over Manny's close-up. More than once in interviews Hitchcock apologized for this violation of reality, but just as often he admitted that it was one aspect of *The Wrong Man* that for some reason he liked. The one thing he liked was a cinematic intrusion that violated neorealism—a moment that provided a moving reaffirmation of his faith that, in a just world, God wouldn't condemn a wrong man.

Preparing to leave the world of New York realism behind for something far more exotic, the Hitchcocks received yellow fever shots on May 18, 1956. After the premiere of *The Man Who Knew Too Much* on May 22, the director left George Tomasini behind to edit *The Wrong Man* and Bernard Herrmann to work on the music, and joined his wife, Herbert Coleman, and Doc Ericksen on a flight to London. From there they flew

to Swaziland, Rhodesia, and the Republic of South Africa to scout locations for *Flamingo Feather*.

Flamingo Feather was an almost conventional adventure story written by the unconventional Laurens Van der Post, the leading South African novelist, travel writer, and memoirist, better known for more elegiac explorations of the beauty and mystery of Africa past and present. Van der Post's novel shared an anti-Communist angle with several other Hitchcock projects of the 1950s, with a white South African anthropologist foiling a Communist conspiracy to foment a rebellion of jungle natives.

James Stewart had agreed to star in *Flamingo Feather*, and the filming had been announced for the late fall or winter, in Africa. Again Hitchcock hoped to reunite Stewart with Grace Kelly, though as Princess Grace of Monaco she had temporarily retired from acting.

When the small advance party arrived at Jan Smuts Airport in Johannesburg in the first week of July, Hitchcock told reporters he was visiting "for atmosphere, just atmosphere." He expected to make a three-week tour of possible sites, but also to meet with Van der Post. Paramount was eager to avoid stirring up political controversy, so Hitchcock downplayed the novel's anti-Communist slant, describing instead "a sort of John Buchan real adventure, with good, sophisticated stars." He laid out his plans to build up the romance (nonexistent in the book) and disguise the Communists, perhaps transforming them into agitators with faux dialects. "Politics is bad box office anywhere," Hitchcock told the *Cape Times*. "Love, yes. Van der Post agrees with me that there should be a stronger love interest."

The director still had close relatives in South Africa, and that undoubtedly was part of the appeal of the project and the trip. He stopped off in Durban to catch up on old times with his father's sister, Emma Rhodes—always known in the family, because she had the same name as Hitchcock's mother, as the "South African Emma."

The sightseeing and reunion with his aunt led Donald Spoto to describe the trip as a studio-paid holiday, "which is very likely what Hitchcock wanted all along." Doc Ericksen thought the trip was some kind of "scam," but Herbert Coleman scoffed at that word, saying they conducted earnest preproduction in South Africa. Hitchcock could well afford to travel at his own expense, Coleman points out, and often did.

What really set *Flamingo Feather* back was a parade of logistical roadblocks: the idea of Princess Grace (a mirage), the politics (a turnoff for Paramount), and the budget (a potential sinkhole). And Hitchcock didn't like what he heard in Africa about the available actors and extras and equipment. After touring the famed Valley of a Thousand Hills in Natal, he realized that the hills and valleys could be replicated outside Los Angeles. Why bother with Africa?

Up to this time, Hitchcock had fewer unrealized projects on his balance sheet than most major directors. It wasn't until Warner Bros. and Paramount that he was even allowed to second-guess himself—allowed to write off the time and money he'd put into a project—whenever the situation proved "confusing," the word he used when describing the fate of *Flamingo Feather* to François Truffaut.

By the time the Hitchcocks arrived back in America, *Flamingo Feather* was all but moot. Now "From Among the Dead" was moved up on the director's schedule.

Nobody blamed Maxwell Anderson for the flaws of *The Wrong Man,* which he had written to order, and swiftly. Before Hitchcock went to Africa, he left in Anderson's hands the task of working up the first treatment of what would become—almost two years and several writers later—*Vertigo.* In Nairobi, the director received a telegram saying that Anderson would have roughly fifty pages ready for him when he passed through New York. The two met for lunch, and Anderson handed his progress over to Hitchcock.

The Pierre Boileau–Thomas Narcejac novel was set in Paris and Marseilles during World War II. The story revolved around a forcibly retired detective whose shameful fear of heights has accidentally led to the death of a colleague. The detective is employed by an old acquaintance, a successful businessman he loathes, to follow around the man's wife—who is said to be under an ancestral curse luring her toward suicide. As he follows the wife around, the detective becomes obsessively attracted to her. In the book and film, the wife's name remains the same—Madeleine—as does her appearance: her hair in a tight bun, her figure wrapped in a "smart gray suit" cinched tight at the waist.

When Madeleine leaps to her death from a country church tower, the detective goes into a mental tailspin, unable to get the woman out of his mind or accept that she's dead. After the war ends, while peering at faces in a newsreel, he spots a woman who resembles Madeleine. He tracks her down in Marseilles, and though she claims to be a complete stranger, he talks her into letting him re-create her as Madeleine—buying her a gray suit, changing her hair. Gradually it's revealed that the Marseilles woman was the mistress of the Parisian businessman, and that her suicide was staged to cover up the man's murder of his wife. Even though the detective succeeds in transforming the Marseilles woman back into Madeleine, he is driven insane by his confused love. The novel ends with him strangling her, convinced that only her death will bring the first Madeleine back to life.

Before Anderson wrote a word, he knew the major changes Hitchcock wanted from the novel. The decision had already been made to modernize

the story and relocate it to San Francisco. The location, as usual, was so basic to Hitchcock's vision that two round-trip plane tickets for Anderson and his wife were attached to the writer's June 1956 contract. The playwright was even instructed to visit specific sites, including San Juan Bautista and Mission Dolores; these had already been correlated with similar scenes in the novel. (Hitchcock had picked the Mission Dolores for its picturesque quality, even though the church didn't have a bell tower. The way his mind worked, he was already planning simply to matte a tower in.) Hitchcock urged Anderson to preserve the spirit of the book, while transplanting its plot and characters.

The treatment Anderson handed over to Hitchcock in New York was formative. It was bookended with incidents of death on the Golden Gate Bridge, and portrayed Judy, the mistress who impersonates Madeleine, as a daughter of wealth who is haunted by her guilt. The dialogue was "awful" and the "set pieces overworked," according to Dan Auiler in his book about the making of *Vertigo,* but that may be unfair to an early draft. Hitchcock certainly treated Anderson well, telling the writer in a subsequent letter that he was going to commission a new continuity, yet blaming himself for not following Anderson's "original suggestion to have completed the structural layout even as far as a temporary script before you did the dialogue."

For this all-important "structural layout," he met again with his trusted compatriot Angus MacPhail. In August and September the two old friends talked over the Boileau-Narcejac story. MacPhail, according to some sources, was beginning to drink again; he was also feeling like a square peg in Hollywood, and wanted to return home to England. Although he recognized *Vertigo* as a "fascinating story," in his words, MacPhail quit the project in September, telling Hitchcock the script needed "a real big imaginative contribution," which he "simply couldn't provide right now."

Before MacPhail left, however, the two produced a new two-page outline, which began as the film does with the rooftop chase that introduces the detective and the *Vertigo* motif. Although this scene, absent from the French novel, was written in Hitchcock's hand, Bill Krohn attributed the outline to the Hitchcock-MacPhail synergy. As Krohn wrote in *Hitchcock at Work,* MacPhail likely made "an important contribution to the film's evolution." (The American detective's nickname, Scottie, lingers as a nod to the Scot—MacPhail.)

It was now imperative to bring in another "fresh writer," and Joan Harrison suggested Alec Coppel. That was fine with the boys at MCA, as Coppel was also an agency client. In his mid-forties, Coppel was from England by way of Melbourne, and had been in Hollywood since the early 1950s. His name is absent from most reference books, probably because his work as a novelist, playwright, theater director, and writer of teleplays

and films spans three continents and so many different fields. By 1956, Coppel was familiar to Hitchcock: as an ongoing contributor to *Alfred Hitchcock Presents* he was already in the Bellagio Road circle, and internal memos suggest that he also did spot writing for *To Catch a Thief*.

A superb dramatic constructionist, Coppel was also a jocular man whose novels, plays, and films tended toward light humor. During Hitchcock's time at Gaumont, Coppel had adapted his West End success *I Killed the Count* into a 1938 film for the studio, with Ben Lyon and Terrence de Marney (brother of Derrick) among the cast.* The 1953 film *The Captain's Paradise,* based on another Coppel play, was particularly successful, and it starred Alec Guinness as a skipper with a wife in two different ports, to match his split personality. Coppel's original story secured him an Oscar nomination.

At their first meeting to discuss *Vertigo*, Hitchcock gave Coppel "four typed notes about key matters such as the opening rooftop chase, and dictated a list of the twenty-three sequences he already had in his head," according to Bill Krohn. The two then met regularly through the fall of 1956, with Coppel charged first with developing a lengthy continuity consisting of "numbered paragraphs with no dialogue," in Krohn's words. This would be followed by a full script, hopefully in time to start filming in December 1956.

Besides ordering up a minifestival of Hitchcock films, the director screened *Diabolique* for Coppel; thereafter, joined by members of his staff, Hitchcock watched the 1955 French film several more times throughout the second half of 1956. If *The Wrong Man* had been Hitchcock's attempt to emulate the Italians, with *Vertigo* he would go French all the way—trying for a film more dreamy, more romantic, its atmosphere more doom-laden than anything Hitchcock had previously done. Henri-Georges Clouzot's film was also based on a Boileau and Narcejac novel—and its story, like *D'Entre les Morts,* was also about a murder and a haunting.

With *Flamingo Feather* deferred, Hitchcock needed to start lining up other projects for the future. So in the late summer of 1956, Lew Wasserman brought him an offer from Metro-Goldwyn-Mayer.

That summer, almost before it happened, Wasserman found out that MGM's board of directors had ousted the studio's production chief, Dore Schary. A former Wasserman client, Schary had presided over MGM's plummeting production and revenue since 1948. Once Hollywood's

* A three-part version of *I Killed the Count* was later aired on *Alfred Hitchcock Presents*—the only instance of a "serial" in the show's history—over successive weeks in March 1957. Anthony Dawson and John Williams were in the cast, while Francis Cockrell wrote the teleplay.

biggest, most powerful studio, MGM was now in a state of turmoil and despair. A journeyman producer, Sol Siegel, was appointed the new head of production, and Siegel would make almost any deal with Wasserman to be able to tell stockholders he had a Hitchcock film on his schedule. He agreed to give Hitchcock top salary and budget, a percentage of gross earnings, and—in a meaningful first for Hitchcock—a clause in his contract giving the director final cut.

MGM wanted Hitchcock to develop a valued property: *The Wreck of the Mary Deare,* based on the Hammond Innes best-seller about an inquest into the mystery of a freighter found abandoned in the English Channel. Gary Cooper, whom Hitchcock had always admired, was mentioned as the likely star, and Bernard Herrmann recommended an MGM contract writer: his friend Ernest Lehman, a former Broadway publicist and radio writer. Lehman had adapted *Sabrina* for Billy Wilder and had just finished *Sweet Smell of Success,* based on his own scorching novel about press agentry, for Burt Lancaster's production company.

Hitchcock and Lehman met in the studio commissary on the last day of August. Lehman's strength was humor and dialogue, and he was wary of the courtroom-heavy *Wreck of the Mary Deare.* He was busy with other assignments, and told Hitchcock he didn't want to commit himself. But Hitchcock instantly liked Lehman, who was sophisticated and effortlessly funny. Chuckling through lunch, he urged Lehman to read the book and reconsider. They could always have another lunch.

In the meantime Alec Coppel met periodically with Hitchcock, and worked at home on a new continuity for *Vertigo.* Hitchcock was busy through the late summer and early fall preparing the 1956–57 season of *Alfred Hitchcock Presents.* He preferred to shoot the bulk of his hosting vignettes, and at least two of the shows he was slotted to direct, before Christmas, leaving the winter for preproduction of a feature film. Eight or nine of Hitchcock's presentations could be polished off in two days of nonstop filming (three or four times a season); directing an episode required two days of rehearsal, followed by three of photography.

With one successful season safely accomplished, Hitchcock was already able to cut back on the time he gave to the series, delegating more authority and responsibility to Joan Harrison. He directed only three episodes for 1956–57, and Harrison was promoted to full producer in the credits.

Hitchcock made it a policy to direct the season premiere, and for 1956–57 it was "Wet Saturday," a droll suspense story by John Collier, featuring Cedric Hardwicke and John Williams; the second episode he directed was "Mr. Blanchard's Secret," a mild satire of *Rear Window,* about a murder mystery writer (Mary Scott) who jumps to erroneous conclusions about next-door neighbors. The third was the season highlight:

"One More Mile to Go" featured David Wayne as a henpecked husband who bludgeons his wife to death, and then drives around on the highway with her corpse stuffed in the trunk of his car, trying to decide how best to get rid of the body. A motorcycle policeman, who has noticed his blinking rear light, repeatedly pulls him over. Latter-day Hitchcock scholars have noted how this tour de force of macabre humor and suspense foreshadows scenes in *Psycho* (the ominous highway patrolman) and *Frenzy* (the dead woman's body in a potato sack, rolling around in the rear of a lorry).

After the success of the first season, the publicity for *Alfred Hitchcock Presents* snowballed; while a press junket every September took care of the national columnists, the requests for interviews with the host became a stream that never abated. Hitchcock's publicity, once timed to the annual release of his films, became virtually nonstop.

When Gloria Stewart insisted that her husband, James, who was slated to star as the obsessed detective of *Vertigo*, take some time off before his next film, the late-fall start was postponed. Paramount agreed to carry the pre-production team on salary, and the filming was rescheduled for early 1957. Meanwhile, the second unit could continue to shoot location plates; Hitchcock could supervise wardrobe tests for Vera Miles, who had been cast as Madeleine/Judy; and Alec Coppel could take extra time on the script.

Coppel was improving on Maxwell Anderson's spadework, especially when it came to the love story, which was changing and evolving. Coppel's version already visualized one of the film's famous scenes: Scottie kissing Judy in her hotel room, a kiss that plunges him back in time to the moment when he kissed Madeleine in the stables of San Juan Bautista. Coppel's script, developed during extensive discussions with Hitchcock, even had the camera whirling deliriously around the couple, with Scottie experiencing the memory as an ecstasy.

Among the peculiarities of the latest draft, though, was the explanation for Scottie's fear of heights—Coppel made it the result of a bad parachute jump in his backstory. And although Madeleine is haunted by a mysterious ancestor in the Boileau-Narcejac novel, Coppel had left that key idea out of his version, while retaining Anderson's depiction of Judy (Madeleine's double) as a wealthy woman (and guilt-ridden accessory) from the East Coast.

The longer Hitchcock dwelled on a story, the more deeply he was likely to explore its mysteries. But Coppel wanted to move on—he was preoccupied by a play he was writing—and so the project needed yet a third writer. (The play, *The Gazebo,* produced by the Playwrights' Company in 1958, includes a character very much like Coppel—a television writer working on a play—who phones Hitchcock and asks him for advice about how to stage the murder scene.) Hitchcock and Coppel parted friends.

At the end of November, Hitchcock wrote Maxwell Anderson to say that he now had a suitable springboard for a shooting script, and invited him to rejoin the project. "This construction has taken many weeks of work between Mr. Coppel and myself," Hitchcock wrote, "and I still wonder that after all the years of one's experience why construction is such a hard job." His long letter reminded Anderson that "an audience sitting there looking at this picture has no idea at all that this is a murder story." The film should be "a strange mood love story," wrote Hitchcock, with the woman falling in love with the detective just as tragically as the detective falls in love with her. "I am really anxious to get mood," he said, "but not necessarily somber mood" and not "heavy-handed." As an example of such a mood, Hitchcock cited the "fey quality" of a favorite play, *Mary Rose*—another story about a haunting woman.

They arranged to meet a few weeks later, when Hitchcock would be in New York doing publicity for *The Wrong Man*. But when Anderson showed up, he told the director he'd thought it over—and wished to decline. Hitchcock was taken aback. He phoned Kay Brown immediately to ask about other writers—telling the agent "with remarkable clarity," according to Herbert Coleman, "the story [of the film] in a very few minutes." Brown thought of Sam Taylor, a playwright whose Broadway hits included *The Happy Time* and *Sabrina Fair*. (The latter had been adapted for film by Ernest Lehman, another writer being pursued by Hitchcock.) Serendipitously—it was one of the reasons Brown thought of him—Taylor had been educated at Berkeley and had lived in the San Francisco area for several years.

The early-1957 start date was pushed back again. Even so, the script might have been rushed—and *Vertigo* might have been less of a film—if events hadn't further delayed the production.

Shortly after the first postponement of *Vertigo*, the director suddenly dropped his fork during lunch, hugging his stomach. Although the pain went away, Hitchcock knew it was his navel hernia. His physician, Dr. Ralph Tandowsky, insisted that he have the operation he had been stalling for years. The January surgery was expected to be routine, but turned out more serious when colitis was discovered. Hitchcock took to bed for a few weeks.

It was while recuperating at home that Hitchcock held his first meetings with Sam Taylor to discuss the *Vertigo* script. "We discovered as soon as we met that our minds worked alike," the writer remembered, "and that we had a rapport. It seemed to be a rapport that didn't have to be announced. So, when we worked, especially at his house, we would sit and talk. We would talk about all sorts of things—talk about food, talk about wives, talk about travel. We'd talk about the picture, and there would be

a long silence, and we'd just sit and contemplate each other, and Hitchcock would say, 'Well, the meter is still running . . .' And then all of a sudden we would pick up again and talk some more."

In the middle of the night on March 9, however, Hitchcock woke up in extraordinary pain, and was rushed to Cedars of Lebanon in an ambulance. He was wheeled into an operating room for a second operation, this time to remove obstructing gallstones, and this time lingering in the hospital for a month. At first his visitors, and phone calls, were restricted. Soon he rebounded, and within a week he was conducting interviews from his bed, expounding on his favorite murderesses: Madeleine Smith, Adelaide Bartlett, Edith Thompson. . . .

Yet for the first four months of 1957, Hitchcock was hospitalized or bedridden at home. "For one who has always boasted of never having been sick, I really hit the jackpot this time—Hernia, Jaundice, Gall Bladder removed—and two internal hemorrhages—all in 12 weeks," he wrote to Michael Balcon, who used the widely reported news of Hitchcock's illness to seek a rapprochement. "I am now busily restoring my blood count," he added cheerfully, "in order that I may resume at least in three weeks more lucrative 'operations' such as two feature films, 30 one-half hour television shows and 10 one-hour shows!"

Released from the hospital on April 9, Hitchcock spent another month at home, taking it easy. Not until the end of April did he return to work at Paramount, and keep a pressing lunch date with Lew Wasserman, MCA agent Herman Citron, and James Stewart. Stewart, a full business and creative partner on *Vertigo*, as on all his films with Hitchcock, had continued meeting with Sam Taylor during the precarious months of March and April. The star's willingness to explore emotions he had never bared before—his instincts for drama and performance—helped Taylor deepen Stewart's role.

The character of Scottie was safe in Stewart's hands, then; it was the part of Madeleine/Judy that was suddenly up in the air. That was the crisis facing the four men at the end-of-April lunch. When the director's gallstones had forced yet a third postponement of *Vertigo*, Vera Miles had telephoned Coleman in a panic. "She was not the calm, thoughtful Vera I knew so well," recalled Coleman. "Her voice revealed a troubled young lady"—because, as Miles informed Coleman, she was pregnant.

During the filming of *The Wrong Man*, Miles had married Gordon Scott, an actor who portrayed Tarzan in several 1950s movies. Their marriage had in fact aggravated the tensions between Miles and Hitchcock, for he had a history with actresses being distracted by new husbands, and he was especially opposed to a marriage if he didn't think much of the husband.

And marriage inevitably produced babies. Now Miles was pregnant, which mandated either another postponement of *Vertigo* or a new leading lady. Although Hitchcock's first personal star might have been able to fi-

nesse the role earlier in 1957, she knew she couldn't disguise her pregnancy on a midyear shoot; besides, she wanted to take time off to be with her baby. That news ended her conversation with Coleman, he recalled—"together with Hitch's dream of making Vera a major star."

Coleman was the bearer of the tidings, bringing the news to Hitchcock when he was still in the hospital. The director didn't curse or scream; he simply let out a long, weary sigh. First Ingrid Bergman, then Anita Björk, now Vera Miles. Actresses falling in love, and their ill-timed pregnancies, seemed to haunt his career. Though he tried to stay cordial with Miles, casting her in *Psycho* and as the lead of his only hour-long color telefilm, he "lost interest" in making the actress a star, Hitchcock later admitted. "I couldn't get the rhythm going with her again."

All along, Lew Wasserman had preferred a different actress, someone more glamorous and well established at the box office—someone like Kim Novak. Wasserman and Stewart had spoken enthusiastically about Novak, a twenty-four-year-old actress who had made her screen debut with a walk-on in a 1954 Jane Russell vehicle. Hitchcock had in fact looked at test footage of Novak while casting *The Trouble with Harry*. Although at first she seemed an obviously manufactured personality, and the critics loved to snipe at her, by 1957 Novak had not only made strides as a performer, but been named by *Box-Office* as the most popular star in the United States Best of all, she was a sexy blonde with ethereal looks—like Madeleine's.

Novak was an MCA client but under contract to Columbia, where she was a pet protégée of studio head Harry Cohn. After Hitchcock agreed, Wasserman walked into the office of Harry Cohn and arranged a swap: James Stewart would consent to appear in a future Columbia production with Novak, in return for the studio loaning her to *Vertigo*. At lunch, the four men decided on a new start date: June.

Though still unfinished, the script of *Vertigo* was evolving as a jewel, the four men agreed. Taylor had improved scenes and dialogue throughout, although his only real innovation was coming up with the character of Midge, a college friend of Scottie's with an unrequited crush on him, who would function as one of Hitchcock's Greek chorus characters early in the story. Taylor even had an actress in mind for the part—his friend Barbara Bel Geddes, who had been nominated for an Oscar for *I Remember Mama,* but who worked mainly on Broadway.

Taylor's first substantial conference with Hitchcock since the second hospitalization came the following week, the first week of May. It was then that Hitchcock, who had just spent weeks in bed brooding over *Vertigo,* broached a major departure from the novel. Judy's involvement in the real Madeleine's death, suggested the director, ought to be revealed to the audience two-thirds of the way through the film, rather than at the de-

nouement as in the book. The truth would be made clear to audiences through Judy's memories as she wrestles with her role in deceiving Scotty.

Taylor was "shocked" by the idea, Hitchcock later told Peter Bogdanovich. But the writer remembered things differently. "I kept saying to Hitchcock that there's something missing," Taylor said. "Then one day I said to him, 'I know exactly what's missing'—I said, 'It's really a Hitchcockian thing.' I was naturally being 'Hitchcock' with him. I said, 'This is not pure Hitchcock unless the audience knows what has happened,' and he agreed.

"The trouble was, I didn't know exactly how to write it because I thought originally of [having a] scene between Judy and Elster, in which he is preparing to go east and she is saying, 'What will become of me?' That would've revealed it to the audience, but I came to the conclusion— not I alone, but Hitch and I talking about it—we came to the conclusion that [that] would strangely rob Scottie. It was just an instinct with us both.

"We finally fastened on what we did, which is the writing of the letter and the flashback. I always felt that it was a weakness that we had to do it that way."

As Hitchcock and Taylor continued refining the script, a minor crisis postponed the production once more: furious at Harry Cohn for profiting on her loan-out, Kim Novak refused to report to work. Cohn and Novak haggled throughout the summer. *Vertigo* was ultimately rescheduled to start filming in October 1957, almost a year from its original start date. With all that time to put to productive use, "the screenplay was written in great detail, as it should be directed," noted Dan Auiler, "down to the camera directions and even the commentary on the music."

The delays deepened and darkened the script. For the first time, a Hitchcock love story would end pathetically, with the abject failure of the hero and the death of the leading lady.

Over the summer, as Hitchcock pressed forward with *Vertigo,* he also met with Ernest Lehman, whom he had coaxed into writing *The Wreck of the Mary Deare.* Most of their time was spent gossiping over enjoyable lunches. In spite of the fact that Hitchcock had a signed deal, he didn't seem eager to film the Hammond Innes best-seller. "Every time I brought up *The Wreck of the Mary Deare,*" Lehman recalled, "I saw looks of anxiety cross his face and he would adeptly change the subject."

Lehman was likewise indifferent. All he managed to sketch out was "a powerful opening image of a ship drifting, deserted, in the English channel" and a tentative ending. He thought "the rest" was doomed to be "a boring courtroom drama" with manifold flashbacks. He waited and waited for Hitchcock to arrive at a similar conclusion, as their delightful lunches continued. Finally one day Lehman announced, "I give up. I just cannot see a way of dramatizing this book *properly*. Please get yourself another writer."

"Don't be silly," responded Hitchcock, shaking his head. "We get along so well, let's forget this one and think of some other picture to do together."

"I think he sensed that he'd be 'safe' with me," Lehman told Donald Spoto. "He cast those around him very carefully, based on his unconscious readings of their potential behavior—whether they'd be threatening to him, perhaps the type who could leap up and show anger. I was quiet, respectful, interested, maybe even interesting, and obviously one who would easily fit the role of 'sitting at the feet of the master.'"

Lehman sat at the master's feet for a few more weeks, kicking around ideas. Forgetting, once again, his vow to stay away from costume pictures, Hitchcock revived the idea of filming the life of eighteenth-century highwayman and escape artist Jack Sheppard. But Lehman wasn't keen on Jack Sheppard, either, so eventually they fell to musing about what Hitchcock called "a sole provocative idea with which I had long been obsessed." The idea for "The Man in Lincoln's Nose" concerned a nonexistent master spy who has been set up as a CIA decoy. The man would be mixed up in an assassination at the UN, and the climax would be the decoy dangling from a presidential nose at Mount Rushmore—"a unique predicament" in the director's mind "before even one word of the script was written," in Hitchcock's words.

Hitchcock had carried around the germ of *North by Northwest* for seven years, talking about it with friends and associates and other writers. "We used to discuss it every time we had a chance," recalled John Michael Hayes, now banished from Hitchcock's employ.

Hearing the director sketch this ultra-Hitchcockian story—wrong-man suspense mingled with comedy and romance—Lehman grew excited. They brainstormed some ideas. The decoy agent, whose name was Thornhill from the earliest draft, was "probably a traveling salesman" in Otis Guernsey's original synopsis. Hitchcock saw him as a New York businessman, and now, talking to Lehman, thought he might be an American supersalesman—a highly successful ad executive. Lehman had a Madison Avenue background, so why not?

There was only one hitch: MGM thought Hitchcock was busy developing *The Wreck of the Mary Deare*. No problem, the director told Lehman. He set up a meeting at MGM, and informed officials there that it was going to take him quite a while to lick the Hammond Innes novel, and he said he could knock off another MGM picture in the meantime. "Which delighted them," recalled Lehman, "because they thought they would get two films instead of one."* So MGM got a two-page outline of a story called "In a Northwesterly Direction."

* In the end, MGM got only the one Hitchcock film. *The Wreck of the Mary Deare* was passed to author Eric Ambler (husband of Joan Harrison), who wrote the script. Michael Anderson directed Ambler's script, and Gary Cooper was ultimately the star.

* * *

It's tempting to date the personal crescendo Hitchcock had in his relationship with actress Brigitte Auber to the summer of 1956, when he was still preoccupied with *Vertigo*.

He had at least two friendships with actresses go awry in similar fashion during this period, the mid-1950s. Both involved young actresses, foreign-born, who saw the director as a father figure. Only Auber would go on the record for this book. She can't remember the exact dates, only that something happened about two years after *To Catch a Thief*. Hitchcock was in and out of London and Paris constantly, and the two had stayed in touch. When they got together, he treated her with "parental tenderness," in her words.

His pursuit of her evokes *Vertigo*—with its story of a man pursuing an elusive fantasy creature. Auber felt that she and the director had a special friendship. If she found out that Hitchcock was in London, she had her favorite wines sent to his hotel. When he came to Paris he brought wine from his own cellar; they brought the wine with them to French bistros, where the chefs came out from the kitchen to taste from the director's private reserve. Hitchcock seemed to know all the chefs by name. "He passed his life in restaurants," Auber said.

He talked vaguely of starring Auber in a film he said he was planning: the story of an American serviceman who meets a French girl during World War II, then brings her home with him to the United States, where her illusions about him are rudely stripped away. She never saw anything on paper; he simply told her the story, embroidering it over dinners.

The director told Auber more than once an anecdote about a famous, beautiful actress throwing herself at him. He didn't boast, or tell the story crudely; he refused to give the name of the star, or any details about what had happened between them. The French actress wasn't sure whether or not to believe Hitchcock, but he talked about the incident so earnestly that she wanted to believe him. She thought perhaps it really had happened.

One night, after a dinner in Paris, Auber offered to drive him back to his hotel, but Hitchcock said he would walk back from her place. So she drove to where she lived with her boyfriend, a Spanish dancer. It was late at night; they parked in her small car and talked.

During a lull in the conversation, to her amazement, Hitchcock suddenly lunged at Auber, trying to kiss her "full on the mouth." "I shied away immediately," recalled the actress. "I said, 'It's not possible.' Someone had once told me that, if a woman was ever [put] in this position, she must say, 'No, I am faithful. I have a faithful temperament.' "

Hitchcock accepted her explanation that she felt the need to be faithful to her boyfriend. He appeared mortified by the incident. Over the years he

contacted her a few times, asking if they might patch up their friendship, but the bond was broken. The actress told Hitchcock she felt betrayed.

"One never imagines that someone like that has a crush on you," the French actress said. "It was an enormous disappointment for me. I had never imagined such a thing. The quality of our relationship was entirely different." Reflecting on what had happened between them, Auber said she thought Hitchcock felt ugly, and that this ugliness was a wall between him and women. "The poor cabbage had a wonderful soul, I know," she added.

Once again in the summer he divided his time between film and television. As Hitchcock had explained in his letter to Michael Balcon even before the news was made public in the United States, the success of *Alfred Hitchcock Presents* had generated a lucrative offer from NBC. The network was preparing a new series called *Suspicion,* for which it sought his imprimatur. The financial incentives were attractive, but so was the hourlong format. Hitchcock reached agreement with the network before his second hospitalization; then, after recovering, he plunged into shaping a second television series, and directing the premiere. Shamley Productions signed to produce at least ten episodes of *Suspicion.*

In that busy first week of May 1957, Hitchcock met with Joan Harrison and Francis Cockrell to discuss the first *Suspicion* episode, based on a Cornell Woolrich story called "Three O'Clock." Over the summer he then met repeatedly with Harrison.

It took him one week, in mid-July, to direct the Woolrich-inspired drama—retitled "Four O'Clock"—with E. G. Marshall as a man who rigs a time bomb in his cellar to murder his wife (Nancy Kelly), whom he suspects of infidelity. Unfortunately, thieves break into the house and bind and gag the man next to his ticking bomb. "It is one of Hitchcock's best televisual efforts," wrote J. Lary Kuhns in a definitive article about Hitchcock's television career, "rigorously done, without any atmospheric score, and climaxing in a stunning montage sequence." The second half might be seen as "a companion piece to 'Breakdown,'" wrote Kuhns, "with the internal monologue acting as a counterpoint to the visual."*

Norman Lloyd joined Shamley Productions in the summer of 1957 to assist with its burgeoning operations. After acting in Charles Chaplin's *Limelight,* Lloyd had moved back to New York in 1952 to work in theater and television, but he felt stalled professionally. When Hitchcock called to offer him a job as an associate producer on *Alfred Hitchcock Pre-*

* Alas, "Four O'Clock" is the rarest of all Hitchcock-directed television episodes nowadays; *Suspicion* lasted only a year on the air, and the series was rerun only once, in the summer of 1959.

sents, Lloyd was surprised. Hitchcock was taking a chance on the actor's moving behind the camera, but he liked Lloyd and trusted his intelligence. When Lloyd came out to Hollywood, he left his family in New York at first, joining Shamley on a six-month tryout. He started as an assistant to Harrison.

Yet Hitchcock still approved the stories and writers, helped with script problems, discussed the major casting of all the television shows—even working on Sundays when his weekdays were crowded. He regularly met with James Allardice to cook up his monologues, and watched all the finished episodes before they were aired, although his postproduction suggestions were usually diplomatic. His television duties were sandwiched into an appointment book never more crowded than in 1956. And whenever there was spare time, he had lunch with Ernest Lehman.

Hitchcock's chagrin over losing Vera Miles kept him from going wild over Kim Novak.

Novak annoyed him, even before he met her. At her first wardrobe meeting with Edith Head, the actress informed Head that she was disposed to wearing any color "except gray"—which was the color of Madeleine's suit in the book *and* film. Head recalled: "Either she [Novak] hadn't read the script, or she had and wanted me to think she hadn't. I explained to her that Hitch paints a picture in his films, that color is as important to him as it is to any artist." Her assistant stuck "the sketch of the gray suit off to the side so she wouldn't see it," while Head showed her "some of the other designs."

After Novak left, the costume designer called Hitchcock, "asking if that damn suit had to be gray, and he explained to me that the simple gray suit and plain hairstyle were very important, and represented the character's view of herself in the first half of the film. The character would go through a psychological change in the second half of the film, and would then wear more colorful clothes to reflect the change. Even in a brief conversation, Hitch could communicate complex ideas. He was telling me that women have more than one tendency, a multiplicity of tastes, which can be clouded by the way they view themselves at any particular moment. He wasn't about to lose that subtle but important concept."

"Handle it, Edith," Hitchcock said, "I don't care what she wears as long as it's a gray suit."

Coming to lunch at Bellagio Road in late June, Novak persisted with her conditions. She didn't care for Madeleine's prescribed hairstyle or color; she didn't wear suits in real life or on camera—especially gray suits.

Hitchcock didn't blink. "Look, Miss Novak," he said, "you do your hair whatever color you like, and you wear whatever you like, so long as it conforms to the story requirements." (As Hitchcock later told Truffaut,

"I used to say, 'Listen. You do whatever you like; there's always the cutting-room floor.' That stumps them. That's the end of that.")

Sam Taylor was also present for the Bellagio Road lunch. To Novak's consternation, Hitchcock steered the discussion toward "everything except the film—art, food, travel, wine," the writer remembered, "all the things he thought she wouldn't know very much about. He succeeded in making her feel like a helpless child, ignorant and untutored, and that's just what he wanted—to break down her resistance. By the end of the afternoon he had her right where he wanted her, docile and obedient and even a little confused."

At her next meeting with Head, Novak seemed chastened. Brunet hair (for Judy) and a gray suit were now acceptable. There was one point of principle she refused to surrender, however: the buxom actress often preferred to go without a brassiere in life, and wanted to do the same in some scenes on screen. Though he preferred to dictate ladies' underwear too, that was all right by Hitchcock.*

August and September were taken up with final script meetings, scouting up north, casting featured parts, wardrobe, and camera tests. The days were filled with meetings at which Hitchcock reviewed all the design and storyboard sketches. He watched all the second-unit footage, looked at photographs, and approved all the locations.

The film would visit several Bay Area landmarks, including Fort Point, where Madeleine attempts a watery suicide; the Palace of the Legion of Honor, where Madeleine sits transfixed before the portrait of Carlotta Valdes; Golden Gate Park, where Scottie and Judy take their most romantic stroll; the church at San Juan Bautista, whose bell tower would be matted in; and the cliffs and redwood forests of Big Basin, where Scottie kisses Madeleine.

Besides Barbara Bel Geddes, the supporting cast included Tom Helmore (who had played a liaison officer in *Secret Agent*) as the duplicitous Gavin Elster, and the Russian-born Konstantin Shayne as Pop Leibel, the bookshop proprietor and local-history buff who relates the legend of Carlotta Valdes.**

After almost two years of scriptwork and preparation, the filming began in San Francisco on September 30. The first scene photographed dated back to the original novel and Maxwell Anderson's initial script: the scene where Scottie follows Madeleine as she visits the grave of Carlotta Valdes at the Mission Dolores, one of San Francisco's oldest structures. (In

* When, in their first interview sessions, François Truffaut complimented Novak's "animal-like sensuality" in the film, Hitchcock gave her credit for that, at least—linking Truffaut's comment with her refusal to wear undergarments. "As a matter of fact, she's particularly proud of that," he said.

** Shayne was married to Leopoldine Konstantin, the actress who played Claude Rains's dragon-mother in *Notorious*.

the novel the site is the Cimetière de Passy in Paris.) The first day's work had been estimated in advance by script supervisor Peggy Robertson at two minutes and forty-nine seconds of screen time. "In a testament to Hitchcock's efficiency and planning," Dan Auiler wrotes, it's "within seconds of the duration of the finished sequence."

Everyone agrees that Hitchcock approached *Vertigo* with an unusual air of seriousness.

"We could all tell," screenwriter Sam Taylor recalled, "that this was a very important project for Hitch, and that he was feeling this story very deeply, very personally."

"The atmosphere of the film, and of the shooting," concurred John Russell Taylor in the authorized biography, "was so strange and intense it seemed to affect everyone."

It was true even of the leading man who usually made things look easy. James Stewart, who stayed with the Hitchcocks at their Santa Cruz home during the location work, driving to and from the set with his friend—his partner, his director—he too caught the intensity. This, his fourth Hitchcock film, would elicit Stewart's darkest high-wire act of vulnerability, passion, and rage.

The leading man was wont to plunge "deep inside himself to prepare for an emotional scene," Kim Novak remembered. "He was not the kind of actor who, when the director said, 'Cut!' would be able to say, 'OK' and walk away. I was the same way. He'd squeeze my hand and we'd allow each other to come down slowly, like in a parachute."

Stewart spent a lot of time squeezing Novak's hand, and defusing tensions between the leading lady and director. Her costar "looked after me," Novak said. "He was like the boy next door, my father, and the brother I wished I had. He had a natural kindness and sensitivity. I was nervous at first with Hitchcock. I kept saying to Jimmy, 'What do you think he wants me to do?' Jimmy put a gentle arm on my shoulder and said, 'There, there now, Kim. It will be fine. Now, if Hitch didn't think that you were right for the part, he wouldn't have signed you to do it in the first place. You must believe it for yourself.' "

Novak never enjoyed the same rapport with Hitchcock. He thought the actress was full of herself, and stubborn about her bad ideas. Novak had arrived on the set, Hitchcock explained later, "with all sorts of preconceived notions that I couldn't possibly go along with." They retreated to the privacy of her dressing room, where he told her to blank out her emotions for the camera. "You have got a lot of expression in your face. Don't want any of it. I only want on your face what you want to tell to the audience—what you are thinking.

"Let me explain to you," Hitchcock continued. "If you put in a lot of redundant expressions on your face, it's like taking a sheet of paper and scribbling all over it—full of scribble, the whole piece of paper. You want to write a sentence for somebody to read. If they can't read it—too much scribble. Much easier to read if the piece of paper is blank. That's what your face ought to be when we need the expression."

Early in the schedule, according to John Russell Taylor, the actress raised a question about a certain line of dialogue. "Might it not be better," Novak wondered, "if the character's inner motivation was brought out by changing this line or extending that?" Hitchcock replied with a stone face. "Kim," he said, "this is only a movie. Let's not go too deeply into these things."

"It's only a movie," Hitchcock's standard reassurance, paralyzed some actors, while freeing others. "I don't say that he [Hitchcock] has not gone more deeply into things beforehand, in his preparation," once mused Stewart. "But he takes the responsibility for all that off the actor's shoulders."

Novak wasn't liberated. She felt imprisoned. Her character even had to walk in a certain way, trapped and cinched into clothing she had disdained. Novak couldn't be sure if Hitchcock "ever liked me," the actress reflected years later. "I never sat down with him for dinner or tea or anything, except one cast dinner, and I was late to that. It wasn't my fault, but I think he thought I had delayed to make a star entrance, and he held that against me. During the shooting, he never really told me what he was thinking."

Hitchcock molded the look and behavior of Novak, the way Scottie molds Judy—he trapped her with his attitude. Madeleine/Judy also feels trapped, and most critics believe that the director drew out Novak's greatest performance for *Vertigo,* helping her transcend her limitations.

After two weeks of filming in the San Francisco vicinity, cast and crew returned to Hollywood, where the ensuing two months of soundstage work at Paramount would push *Vertigo* over its allotted schedule by nearly three weeks and over its planned budget (already bloated by the protracted preproduction) by a quarter of a million dollars.

Hitchcock kept up a remarkably crowded schedule, hosting an *Alfred Hitchcock Presents* party at the Coconut Grove on November 4 for TV-page editors, and then a chuck-wagon dinner at Republic Studios on November 6 for one hundred columnists. Some of *Vertigo*'s soundstage delays and overages can be chalked up to Barbara Bel Geddes, who struggled with her part. Her "scenes seemed to be the hardest to get right," Auiler wrote. Multiple retakes were required for the scene where Scottie rebuffs

Midge's awkward attempt at comedy ("It's not funny, Midge"), followed by Scottie's leaving in a pique, and Midge bitterly chiding herself for poking fun at his obsession ("Stupid, stupid, stupid . . ."). A dissatisfied Hitchcock made the actress try it again and again.

On November 14, shortly before Bel Geddes was done (Midge vanishes from the last section of the film), the director invited the actress to lunch and offered her a starring role in an *Alfred Hitchcock Presents* episode he'd been talking about ever since inaugurating the series. "Lamb to the Slaughter," based on a short story by Roald Dahl (who also wrote the teleplay), was about a devoted wife, spurned by her louse of a husband, who clubs him to death with a frozen leg of lamb. As detectives scour her house for clues to the crime, the lamb cooks delectably, ultimately becoming their supper.

Although Bel Geddes had a thankless role in *Vertigo*, the director rewarded her with the lead in his best-remembered television show. Her wounded innocence, affecting in the film, was deployed to comedic perfection in "Lamb to the Slaughter," which Hitchcock directed early in 1957.

The studio scenes focused on the two stars of *Vertigo:* James Stewart and Kim Novak.

The October and November filming included what Dan Auiler calls "the notorious Scene 151"—Scottie and Madeleine's first conversation, in Scottie's apartment, after Madeleine's suicidal jump into the bay. The eleven script pages began with a gradual pan from Scottie, seated on the sofa, to his bedroom across the apartment, where Madeleine is glimpsed, stirring naked under bedcovers. "In passing we see Madeleine's clothes drying in the kitchen," wrote Auiler. "The camera stops on his bedroom; through the open door, we see Madeleine sleeping, and we hear her murmuring something."

The staging warranted subtle adjustments in the camera work, and the dialogue was lengthy. Hitchcock watched the rushes, then reshot the scene again and again. The blocking, the acting, the lighting, the camera moves—everything had to be better. "Almost all of the [filming] delay can be ascribed to this one stubborn scene," according to Auiler.

The film's famous "revolving kiss" wasn't on the schedule until December 16. This is the scene near the end that follows the moment when Judy emerges from her bedroom, wearing Madeleine's exact clothing and hairdo, as Scottie has insisted. In the cemetery, wearing the gray suit, Madeleine had been bathed in a green light; now, as the transformed Judy stepped into view, she too was bathed in green, emanating from the hotel's neon sign outside the window—the same "ghostlike quality" that Hitchcock remembered from theatergoing as a boy.

Seeing her finally changed into Madeleine, Scottie sweeps Judy up into an embrace, kissing her fervently, releasing his memories. The "big head" close-ups (in Hitchcock parlance) fill the screen as the camera appears to whirl around them (though it was actually the scenery rotating). Scottie is transported into the past, back to the stable where he kissed Madeleine before she dashed from his arms and (apparently) leaped to her death. When the camera (and revolving stage) completes its circle, he is back in Judy's room.

It was difficult to photograph because the actors had to embrace at an extreme angle as the camera circled very close to them; they had to lean together in such a way that they eventually could slide down out of sight. On the second take Stewart slipped and fell, and filming had to be interrupted for an hour while he visited the studio doctor. When he returned, this exquisitely romantic, despairingly beautiful shot—one of the most beautiful of Hitchcock's canon—was finally captured by the end of the day.

Very often on a Hitchcock film pivotal scenes waited for the end of the schedule, when the creative juices were flowing and actors were primed. Hitchcock waited until December 18 before shooting the opening: Scottie dangling by his fingertips from a rooftop. The following day was the last, with a few pickup shots assigned to the second unit. Finally, around lunchtime, Hitchcock's cameo was staged near the Paramount paint shop.

"Sc. 21. Ext.: Shipyard. Mr. Hitchcock walks camera left to right & out passing Scottie entering. Scottie pauses to speak to Gateman who gestures & Scottie walks on & out."

Only one take required.

As was often the case, Hitchcock had worked right up to Christmas. The years of missing out on an annual break were over, however, and after the last takes on *Vertigo* the Hitchcocks left for Miami and Montego Bay, with a gambling side trip to Cuba, joined by the Lew Wassermans.

Ernest Lehman stayed behind to work on "In a Northwesterly Direction." With all the instructions Hitchcock had given him, Lehman felt he'd been given a treasure map with a whole array of Xs to explore. He took a two-week tour of New York, Chicago, and Mount Rushmore to get a feeling for the locales Hitchcock had specified. He visited the United Nations, underwent a mock arrest in Long Island (where the master villain of the story occupies a grand mansion), and toured Mount Rushmore with a forest ranger. Lehman sent the first sixty-five pages of script to Hitchcock in Jamaica, and on the very day the director returned to Hollywood, February 3, they met for the first time in weeks.

Rubbing his hands gleefully, Hitchcock said he liked what he had read—so far. In interviews Lehman sometimes sounded defensive when claiming credit for *North by Northwest;* the director had been dreaming

up the story for years, after all; and there would be another six months of talks and writing with Hitchcock before the script was done.

Curiously, Lehman remembered that one of the things Hitchcock liked to talk about endlessly was the *logic* of the plot and characterizations—even in the case of the exuberantly illogical *North by Northwest*. It was partly a defensive maneuver, for Hitchcock was always being pilloried by his nemeses, "the plausibles." But it also gave the director an excuse to explore the boundaries of a film's logic and decide just how far he could stretch things.

For a while they considered having the film's protagonist, Roger Thornhill, pass through Detroit just so Hitchcock could shoot a scene he had always wanted to put in a film: Thornhill would visit an automobile plant, where he and a factory foreman have a long, whispered conversation as they stroll alongside an assembly line. Behind them a car is being assembled, piece by piece. Just as they finish their talk, the car is done, ready to be driven. The two men glance at the shiny new car and exclaim, "Isn't it wonderful!" They open the front door, and out slumps a corpse. But the idea had to be squelched because "we couldn't integrate it into the story," said Hitchcock. So Thornhill bypassed Detroit.

Hitchcock shut the filming down for "a whole day" at a later point, according to Lehman, because he couldn't figure out how to explain a plot detail that was crucial to how he visualized a scene in the Chicago train station. Eve, Vandamm's sexy henchwoman (and Thornhill's love interest), is glimpsed inside a phone booth talking with her co-conspirator Leonard, who, as revealed by a beautiful camera glide, is on the phone to her from a nearby booth. But how did Eve know what booth Leonard would be in, and how did they know each other's phone numbers? Hitchcock and Lehman were both stumped. Work was halted "until somehow or other he came up with an answer that satisfied him," said Lehman. Then and only then, after arriving at some internal explanation (never, incidentally, elucidated in the film), did filming resume.

Hitchcock said later that with *North by Northwest*, he had gone beyond explanations. Even the Macguffin was finally irrelevant. What is the master villain, Vandamm (James Mason), up to? It's even murkier than usual. He's an "importer and exporter of government secrets," the Professor (Leo G. Carroll) explains, though when he elaborates on this to Thornhill, Hitchcock drowns out the conversation with the noise of an airplane propeller. ("My best Macguffin," the director told François Truffaut, referring to *North by Northwest*, "and by that I mean the emptiest, the most nonexistent, and the most absurd.")

The Macguffin is maddeningly elusive until the film's final moments, when it is revealed as a spool of microfilm tucked inside a pre-Columbian

figurine. In one of the film's throwaway laughs, Thornhill wryly dubs it "the Pumpkin," a mocking allusion to the Alger Hiss case.*

In the winter of 1957, as the script took shape, Lehman thought he was writing for James Stewart—and the more Stewart heard about the next Hitchcock film, the more he wanted to play the man inside Lincoln's nose. The three friends—Hitchcock, Stewart, and Lew Wasserman—got together for lunch at least once a week, but the director kept hedging about the start date; the script still needed work, he said. *North by Northwest* might also have been rushed into production—and James Stewart might have played Thornhill—if, in the spring, three crises hadn't slowed Hitchcock's progress again.

The first was the sudden passing, on March 26, of Paramount's Don Hartman, whose death at age fifty-seven from a sudden heart attack was a shock for Hollywood. Hartman had recently switched over to being an independent producer at Paramount, but he still maintained an office and presence on the lot. Hartman and Y. Frank Freeman had been the leadership team that gave Hitchcock his greatest freedom and independence; Hartman's death set in motion a chain of events that would eventually lead the director away from the studio.

The second blow, more personal and devastating to Hitchcock, followed in April. During a routine physical, Mrs. Hitchcock was diagnosed with cervical cancer—which, in 1958, almost automatically carried a death sentence. Hitchcock was staggered by the news, more shaken by Alma's illness than by his own the preceding year.

Mrs. Hitchcock opted for an experimental radiation treatment involving an injection of small particles of radioactive colloidal gold into the parametrial tissue. Some patients had died from this new method of attacking cervical carcinoma, while others had suffered debilitating side effects and major complications. But the radiogold treatment also had a promising survival rate, and Alma scheduled the operation for April 14.

That was the same week her husband was scheduled to direct "Dip in the Pool" for *Alfred Hitchcock Presents* over at Universal. Norman Lloyd proposed to take over the directing, but Hitchcock balked. That would be

* Starting with *Strangers on a Train*, Hitchcock had sneaked digs at the Red Scare into several of his films. In *To Catch a Thief*, Jessie Royce Landis tells Cary Grant she suspects him of merely *pretending* to be an American. "You never mention business or baseball or wage freezes or Senate probes," she says accusingly. "All the things I left America to forget," Grant mutters. In *The Man Who Knew Too Much*, the Marrakech police chief, interrogating an uncooperative James Stewart, reminds him snidely of HUAC—"you Americans sometimes find it desirable to betray confidences."

unprofessional—and bad luck. Alma was already in the hospital when Lloyd drove home with him to Bellagio Road to discuss the issue.

It was extremely hot that day, Lloyd recalled, and the director took off his jacket, "which is rare. He was in his shirtsleeves and tie and we sat in his garden. He started to talk about Alma. No one knew if she would live through this. And he started to weep." According to Lloyd, Hitchcock, who was never philosophical ("the nearest he has ever come to a statement of his life's philosophy," wrote John Russell Taylor, "is 'The day begins at 9 A.M.' ") talked philosophically that day about Alma meaning "all the world" to him.

"What is it all about?" he said, weeping uncontrollably. "What would it all mean, without Alma? After all, everything I do in film is secondary to what is really important."

"Dip in the Pool" was rescheduled for after the operation, and Hitchcock, the consummate professional, materialized on the set "regular as clockwork," according to John Russell Taylor, "rehearsing and shooting with his usual humorous impassivity, so that no one there knew anything was wrong. Then he would drive straight to the hospital, weeping and shaking convulsively all the way, and on arrival would put on his cheerful face again and spend the evening talking with Alma as though this were the most usual thing in the world."

Some time passed before it became clear that the radiogold treatment had succeeded, that Mrs. Hitchcock had beaten the cancer. But her strength returned in time for her to take a July trip to London with her husband, and all the signs were hopeful.

Cancer, which had touched their lives, would become foremost among their charities; the director gave generously of money but also of his time. One of his first contributions was appearing on *TACTIC*, an educational program produced by NBC, the American Cancer Society, and public television, that aired early in 1959. Introduced on the show as a "fear" expert, Hitchcock "directed" an impromptu skit with William Shatner as a doctor who reassures a young model diagnosed with breast cancer (Diana van der Vlis), that her fears of permanent disfigurement after an operation are irrational.

The third crisis involved *Vertigo*, which was in postproduction during the first months of 1957.

Scottie's (Jimmy Stewart) "vertigo" was Hitchcockery—the sort of hallucinatory special effect the director had been trying to perfect in films for years. "I always remember one night at the Chelsea Arts Ball at Albert Hall in London," Hitchcock told François Truffaut, "when I got terribly drunk, and I had the sensation that everything was going far away from

me. I tried to get that into *Rebecca* [in Joan Fontaine's fainting scene], but they couldn't do it."

The studio warned him that it would cost $50,000 to construct a special set with a crane apparatus to suggest the dizzying perspective of "vertigo." As it was the character's point of view, and Jimmy Stewart wasn't really in the shot, Hitchcock proposed using a miniature of the stairway, laying it on its side, and then achieving the shot by dollying away from the stairs while zooming the focus forward. "That's the way we did it," he said proudly, "and it only cost us $19,000."

Artist John Ferren had created the sketches and paintings supposedly drawn by John Forsythe's character in *The Trouble with Harry;* now he helped with the expressive nightmares suffered by Scottie after Madeleine's "suicide." And for the first time, Saul Bass, who had created imaginatively animated credits for Billy Wilder and Otto Preminger, put his unique stamp on the title sequence of a Hitchcock film, with a distinctive prologue that juxtaposed images of eyes with dizzying Lissajous spirals (invented by a nineteenth-century Frenchman to express mathematical formulas).

When pondering the musical score for *Vertigo*, Hitchcock was again reminded of *Mary Rose*, and sent to London for a copy of the original sheet music and an archival recording of the stage production, passing them along to Bernard Herrmann for inspiration. Although he trusted Herrmann enough that he preconstructed certain sequences to accommodate the composer's musical backing, Hitchcock also gave him meticulous notes clarifying the mood he wanted for each scene.

For the revolving kiss—the scene where Scottie embraces Judy after she is transformed into Madeleine—Hitchcock told Herrmann, "We'll just have the camera and you." Only minimal dialogue was scripted. Herrmann's cathartic theme—later compared by some critics to another favorite Hitchcock piece of music, Wagner's "Liebestod" ("Love Death") from *Tristan und Isolde*—would carry the scene.*

At least twice, Mrs. Hitchcock was involved in crucial editing decisions. The first time was very early on, when the Hitchcocks saw the initial cut upon returning from Jamaica. George Tomasini met them in New York and ran the picture for them. Alma told her husband afterward she thought it was going to be a marvelous film—but he had to get rid of that awful shot of Kim Novak running across the square where you could see her fat legs.

"I don't know which shot you mean, Alma."

* Herrmann's score for *Vertigo* is considered the apogee of his film career—before *Psycho*—but curiously, it is the only Herrmann score for a Hitchcock film that was actually conducted by someone else. A U.S. musicians' strike forced the music to be recorded in Vienna, under the baton of Muir Mathieson.

"The one where her legs looks awful."

"Well, I'm sorry you hate the film, Alma."

"I didn't hate it, I loved it. I thought it was wonderful. Just that shot."

Alma had an appointment at Elizabeth Arden's, so Hitchcock joined Tomasini and Peggy Robertson for lunch. Hitchcock was disconsolate, in the "depths of despair," recalled Robertson. Alma hated the film. How could he get rid of that shot?

He stewed about it all during lunch. Afterward, they dropped Tomasini off at the cutting room. Getting out of the cab at his hotel, Hitchcock leaned back into the open window and said, "By the way, Peggy. Tell George to take that shot of Kim out."

"Take it out! How can he do that?"

"Oh, it's perfectly all right. She will just leap from one side of the square to the other, but nobody will notice it because we will cut from big head to big head."

There was always more vacillation during the editing of a Hitchcock film than the director cared to admit, and there was more on *Vertigo* than usual. The shooting script contained a fair amount of exposition that was shot but ultimately abandoned during cutting. Originally, for example, the silent sequences of Scottie following Madeleine in his car had voice-over narration; Hitchcock even shot an explanatory coda, in Midge's apartment, with Scottie listening to a radio, announcing a police manhunt for Elster, who is wanted for murder.

"Sc: 276: Int: Midge's Apartment. 50 mm [lens size]. Variable diffusion. Midge listening to giant radio CRANE FORWARD & JIB DOWN as Scottie enters & goes to window. She gives him drink and sits. Tag end."

This too was discarded during editing, so that the last image of the film would be Scottie, his arms spread in a despairing, Christlike pose, standing atop the bell tower. Judy has been startled by a nun and backed off the ledge, re-creating Madeleine's fate by toppling to her own death. No further explanation necessary; any further police investigation is forgotten, and as far as the audience knows the original murderer has escaped.

Paramount even commissioned a "Vertigo" pop song by Jay Livingston and Ray Evans, the team behind "Que Será, Será," thinking that lyrics explaining the meaning of the abstruse title might be helpful to moviegoers. A "demo" version was recorded, and the studio even plugged the song in advertisements—but Hitchcock ultimately decided against using it.

Throughout postproduction, Hitchcock made many such choices, refining his vision of a film as he never had before, reediting, stripping away the elements that made the story explicit, allowing for longer stretches for Herrmann's music, and in the process completing the transformation of *Vertigo* from an everyday murder mystery into a haunting emotional allegory.

Was he uncertain, indecisive? Or was *Vertigo* simply deeper business

than usual? More than once Hitchcock asked Jimmy Stewart for *his* opinion of cuts and changes in the film's evolving form. Stewart did have opinions—which, unlike Cary Grant's, had to be honored—but unlike Grant, Stewart usually chose to soft-pedal his views, to encourage Hitchcock to do whatever felt right.

The postproduction ultimately got hung up on Hitchcock's radical structural innovation: the flashback that finds Judy in her hotel room writing a good-bye letter to Scottie, which reveals her "secret" to the audience. Judy is seen rushing up the ladder of the church tower ahead of Scottie, emerging from the trapdoor just as Elster hurls the real Madeleine off the ledge.

When the first preview was held in San Francisco on May 9, that scene was still in the film—but Hitchcock was uncertain whether it should remain. He told Herbert Coleman he was thinking of taking it out, and then he did just that; he removed the scene and held another screening for close confidants, including Joan Harrison. She jumped up afterward. "Hitchy! How could anyone want your picture to be seen any different from this!"

Coleman was furious. He disagreed, and resented having to counter the influence of the television staff, which was supposed to keep its distance from the films. Coleman told Hitchcock he was making a huge mistake. "We began to argue," recalled the associate producer, "face to face, our voices rising. Finally, he'd had enough and gave me the first direct order he ever gave me in all the years we had worked together: 'Release it just like that.' "

James Stewart was there for the argument, calm and tactful as usual. "Herbie," Stewart whispered, "you shouldn't get so upset with Hitch. The picture's not that important."

Coleman went ahead and stipulated the necessary recutting and rescoring, with "less than perfect results," and ordered five hundred prints of the new reel to be shipped to exchanges for distribution. Stewart may have whispered in Hitchcock's ear too. But overruling them all was the New York head of Paramount, Barney Balaban, who had been present at the San Francisco preview—and who practically shouted his opinion. After hearing about the last-minute changes from Coleman, Balaban phoned Hitchcock and argued with him to restore the scene.

Even then, Hitchcock might have refused, and everyone would have deferred to him. Was it loyalty and professionalism that made him yield, or was he finally won over by their arguments? For that matter, aren't doubt and despair among the powerful qualities of the film?

One final vote was likely cast. "The decision [to restore the sequence] was made during the week of April 24th," Auiler wrote in his book; "Alma returned home [from the hospital] on the 25th. It is no secret that,

in story crises like this, Hitchcock would often turn to his wife for guidance. Did Alma argue to keep the scene? As happened so frequently in their working relationship, it may well have been her judgment that Hitchcock followed."

Shortly after Alma returned home, Hitchcock phoned Balaban. He came out of his office afterward, staring through his secretary's cubicle at Coleman, who was sitting in his office. "Put the picture back the way it was," he barked, before going back in and shutting the door.

When *Vertigo* was released at the end of May 1958, the reaction from audiences and critics was underwhelming. There were some positive reviews, but the negative ones came from prominent venues. "Farfetched nonsense," declared John McCarten in the *New Yorker* (while the *New York Times* thought it "devilishly farfetched"). *Newsweek* said the director had "overdone his deviousness, overreached the limits of credibility, and, in his plot-twists, passed beyond the point of no return." *Time* found *Vertigo* just "another Hitchcock-and-bull story in which the mystery is not so much who done it as who cares."

The latest Hitchcock film was hardly acclaimed as the searching masterpiece that, almost universally, critics have since come to acknowledge. "In its complexity and subtlety, in emotional depth, in its power to disturb, in the centrality of its concerns, *Vertigo* can, as well as any film, be taken to represent the cinema's claims to be treated with the respect accorded to the longer-established art forms," wrote Robin Wood.

Hitchcock never lost a few reservations about the final product—especially about Kim Novak. "She doesn't ruin the story," he deadpanned to *Time*.

After having screened the film during the preproduction of *Psycho*, writer Joseph Stefano told Hitchcock that Vera Miles was a greater actress but Novak was better casting. Hitchcock's reply was that he would always feel a disappointment with the film, as Novak wasn't the Madeleine he had imagined.

Still, he recognized *Vertigo* as one of his greatest films. Years later, when Charles Thomas Samuels asked him, "What do you think about the prominence that *Vertigo* has assumed for your European critics?" Hitchcock replied unhesitatingly, "I think they understood the complexities of the situation."

FIFTEEN
1958–1960

On June 2, 1958, Hitchcock officially began work at MGM. Ernest Lehman was putting finishing touches on the script of the new film, which they were still calling "In a Northwesterly Direction." On August 20, they left to begin location filming in New York, Chicago, and Rapid City, South Dakota.

Early that summer, James Stewart had honored his commitment to appear opposite Kim Novak in *Bell Book and Candle,* the Columbia picture owed to Harry Cohn in return for Novak's loan-out to *Vertigo.* Thus Stewart diplomatically bowed out of "Northwesterly," but by then he must have realized that Hitchcock had his sights set on another star. Only Cary Grant could play the sexy Thornhill that Hitchcock and Lehman were conjuring up—the man who elicits a swooning double-take from a hospital patient when he steps through her window in one scene, her frightened command to "Stop!" softening, when she gets a closer look at the handsome specimen, into a huskier plea: *"Stop . . ."*

Vertigo's weak box office may have been the deciding factor in the director's mind when he finally turned against the possibility of Stewart. "In private," François Truffaut revealed after Hitchcock's death, "Hitchcock attributed the commercial failure of *Vertigo* to Stewart's aging ap-

pearance." Hitchcock would continue to mention Stewart in connection with future projects throughout the 1960s, but none ever materialized, and the star of *Rope, Rear Window, The Man Who Knew Too Much,* and *Vertigo* never again appeared in a Hitchcock film. In spite of their friendship, which never really abated, isn't it likely that Stewart's vanity was wounded?

Hitchcock "had a clear view of the value of the stars he employed," recalled *North by Northwest* actor James Mason. The director "told me for instance that the name of James Stewart on an Alfred Hitchcock film could be relied on to bring in one million dollars more than that of Cary Grant. He said this without any disrespect to Grant who, he was quick to point out, would obviously be more valuable than Stewart in other contexts. But he wanted to hit the big markets of middle America, an area of which Stewart was the darling."

But *Vertigo* had failed in those markets, and now Hitchcock looked for Grant to give a different sort of boost to the new film, even with its most memorable scene set in Middle America. As with *To Catch a Thief,* Grant's presence would add to the film's foreign prospects ("other contexts") while making it more of a draw as a "woman's picture." All along Grant had been waiting in the wings to be tapped on the shoulder by the director he trusted. The seduction was completed by a contract giving the star $450,000 in salary, plus a share of profits.

Not only would Hitchcock sacrifice Middle America for Cary Grant, he'd also sacrifice the peace of mind with which he preferred to work. And sure enough, immediately after signing his contract, the film's new star began to question the script, his part—the whole project. Indeed, Grant tried to renege. "Suddenly all Cary could think about and talk about was how desperately he wanted out of the movie," said Lehman. "The role was all wrong for him. The picture would be a disaster, etcetera, etcetera. Apparently Hitch was accustomed to this sort of thinking from Cary, so he just shrugged his shoulders and held fast." Grant abandoned his protests.

With the dashing Grant as Thornhill, who was going to portray Eve Kendall, the American Mata Hari with whom he falls in love? MGM, favoring its own roster, proposed the leggy dancer Cyd Charisse. Hitchcock temporized, considering other glamorous ladies, including Elizabeth Taylor. He spoke with Princess Grace, who said she might consider a comeback. By July, however, he had rejected all the studio names, and it had become obvious that Princess Grace wasn't going to leave Monaco for Hollywood—at least not yet.

As the start date approached, Hitchcock announced a surprising selection: Eva Marie Saint. Surprising because, although Saint was an exceptional actress, she wasn't regarded as particularly sexy or mysterious. Indeed, the actress had been quite the opposite of Mata Hari in her Oscar-

winning performance as Marlon Brando's noble, salt-of-the-earth girl-friend in *On the Waterfront.*

When Saint came to lunch at Bellagio Road in the first week of August, Hitchcock joked about changing her image in *North by Northwest.* "You don't cry in this one," the director told Saint. "There's no sink" (as in "kitchen-sink neorealism"). Unlike with Kim Novak, however, he instantly felt comfortable with the good-humored, unpretentious actress, as well educated and well trained as she was beautiful. Saint went away from lunch thinking "one of his greatest gifts as a director was that he made you feel you were the only perfect person for the role and this gave you incredible confidence."

She placed herself trustingly in Hitchcock's hands, and he rewarded that trust. MGM prepared an expensive wardrobe for her; Hitchcock rejected the designs. "I acted just like a rich man keeping a woman," he later boasted. "I supervised the choice of her wardrobe in every detail—just as Stewart did with Novak in *Vertigo.*" They visited Bergdorf Goodman and picked out her clothing from the latest styles for sale.* "I suggested," Hitchcock recalled, with impressive exactitude, that she "be dressed in a basic black suit (with a simple emerald pendant) to intimate her relationship with [James] Mason; in a heavy silk black cocktail dress subtly imprinted with wine red flowers, in scenes where she deceived Cary; in a charcoal brown, full-skirted jersey and a burnt orange burlap outfit in the scenes of action."

The intention, Hitchcock explained, "was that she be dressed brightly while the mood of the scene was subdued—and quietly while the mood was exciting." While filming in New York, he boasted, "I've done a great deal for Miss Eva Marie Saint. She was always a good actress, but [in *North by Northwest*] she is no longer the drab, mousy little girl she was. I've given her vitality and sparkle. Now she's a beautiful actress."

But it was true enough, and her transformation served as much to fix his own mental image of her as it did to help the actress find her character. Even off-camera: one day during a lull in the filming, Saint, decked out for the auction scene in her cocktail dress, wandered off the set for a cup of coffee. Spying her standing around with a Styrofoam cup in her hand, Hitchcock was taken aback and admonished her. "Eva Marie, you don't get your coffee," the director told her bluntly. "We have someone get it for you. And you drink from a porcelain cup and saucer. You are wearing a $3,000 dress, and I don't want the extras to see you quaffing from a Styrofoam cup."

The rest of the cast was almost ideal. Wisecracking Jessie Royce Landis,

* Edith Head may have acted as consultant on Saint's wardrobe, but only unofficially; quite remarkably, the credits for *North by Northwest* unspool without crediting any costume designer.

who'd stolen her scenes in *To Catch a Thief*, was back as Grant's scornful mother. (It was an in-joke flattering to Grant's perpetually young persona that, in real life, Royce was very nearly the same age as the man playing her son.) Leo G. Carroll would make his sixth appearance in a Hitchcock film as the tweedy chief of the U.S. counterintelligence agency.

Yul Brynner was Hitchcock's original choice for the heavy—Vandamm, the importer and exporter of government secrets, and the betrayed lover of Eve Kendall. When Brynner proved elusive, Hitchcock went for James Mason, whom he had seen on the London stage early in his career—Mason played the lead, for example, in a famous revival of *Escape*. Mason was underrated as a suave leading man, while always creepy as a villain. (He is one actor all the guests in *Rope* agree on: "So attractively sinister!")

Vandamm has a young, fiercely devoted, implicitly homosexual ("Call it my woman's intuition, if you will") attaché, a part for a newcomer—Martin Landau. Hitchcock had seen Landau onstage with Edward G. Robinson in the Los Angeles road show production of *The Middle of the Night*. Like Saint, Landau had studied with the Actors Studio, but while Saint was flexible in her approach, the younger actor's Method was more tortured—and contrary to Hitchcock's approach. Mason watched the director have malicious fun undercutting Landau in his first scene, where Thornhill is kidnapped and brought to meet Vandamm.

Landau had persuaded himself that it was "an important scene," according to Mason, who shared the scene with him. "He had given it much thought and, with a sense of something already achieved, said to me, 'There is a very clear progression for me in the course of this scene and, step by step, I have planned exactly what I must do with it.'"

When Hitchcock arrived to take charge, the director asked his assistant, Peggy Robertson, to remind him of the order of the setups. She consulted her notes, and said he had planned to shoot the high-angles first, then the other shots. According to Mason, the scene had been deliberately cut up, "so Landau never had a chance for his clear progression." Mason admitted he himself wasn't particularly stimulated by his villainous role. He liked Hitchcock, enjoyed his films, but found him a director who used actors like "animated props."

The first footage for *North by Northwest* was captured in front of the United Nations on August 27, 1958. UN officials had (understandably) refused Hitchcock permission to shoot an assassination on-site, so cameraman Robert Burks hid inside a carpet-cleaning truck and stole a master shot of Cary Grant leaping out of a taxi and crossing the street to the entrance. "Then we got a still photographer to get permission to take some colored stills inside," Hitchcock later recalled, "and I walked around with

him, as if I were a visitor, whispering, 'Take that shot from there. And now, another one from the roof down.' We used those color photographs to reconstitute the settings in our studios."

Establishing scenes were also photographed on Madison Avenue, at Grand Central Station, and on Long Island; then the company headed to Chicago for filming at LaSalle Station and the Ambassador Hotel; and from there to Rapid City, South Dakota, for the story's climax at a National Park Service cafeteria, a mythical Frank Lloyd Wright–type house, and airstrip atop Mount Rushmore, ending with the famous chase across the presidential faces.

What happened at the United Nations was reprised in Rapid City. Although he knew full well what was called for in the script, the location manager had to promise there would be no depiction of violence atop the "Shrine of Democracy," or even on the slopes, in order to secure the necessary filming permissions from the National Park Service. When the cast and crew arrived, the Hollywood folk gave interviews, and Hitchcock cheerfully dissembled. "When they say we'll do something on Lincoln's nose, this is very bad," he was quoted upon landing at the Rapid City airport. "We wouldn't dream of it. In fact, it would defeat the purpose for which we are using Mount Rushmore in the film."

One reporter then asked specifically "about the chase scene," according to Todd David Epp, writing for *South Dakota History*. "Hitchcock, ever the showman, handed the journalist a napkin with the presidents' heads drawn on it and a dotted line purporting to show the chase path. The Rapid City newspaper printed the story and a picture of the napkin. Citing 'patent desecration,' the Department of the Interior (the Park Service's parent agency), summarily revoked Hitchcock's original permit and prohibited the filming."

Hitchcock's schedule for Mount Rushmore filming was cut back to only two days—and then only in the park cafeteria and parking lot, and on the terraces that afforded views of the memorial. But two days—along with permission for still shots of the stone presidents, which, as ingenuously reported in the *Rapid City Daily Journal,* would help in creating a full-scale replica "for additional closeup scenes back in Hollywood"—was enough.

Meanwhile at MGM, production designer Robert Boyle was busy creating a glorious fake, where everything forbidden could take place: spy planes landing on Mount Rushmore, bad guys firing guns, actors climbing over the stone faces. After viewing *North by Northwest* a year later, Department of Interior officials felt "hoodwinked," according to Epp. Authorities wrote incensed letters to MGM, and South Dakota senator Karl Mundt demanded the filmmakers be penalized. The park service succeeded only in having its screen acknowledgment deleted.

Fine by Hitchcock.

* * *

Where the actors were concerned, Hitchcock was the ultimate stone face. As the years passed, he addressed actors less frequently; he consistently pared down their unnecessary dialogue; and for this film—the opposite of kitchen-sink drama—what he really required from the actors was an attitude, rather than any in-depth exploration of humanity.

Eva Marie Saint already felt transformed by her handpicked wardrobe. She recalled that all Hitchcock offered her were three simple instructions: "Lower my voice; don't use my hands; and look directly at Cary Grant in my scenes with him, look right into his eyes. From that, I conjured up in my mind the kind of lady he saw this woman as." He must have been right: Saint's performance—the epitome of playful chic—stands up for all time.

Cary Grant didn't require Hitchcock to pick out his wardrobe. Cary Grant *gave* grooming tips, and Hitchcock usually told him just to "dress like Cary Grant." And like Jimmy Stewart, Grant didn't need acting advice, either; he picked his roles to fit him like his custom-made Saville Row suits.

During the location work in New York, Grant hid out in a suite at the Plaza Hotel, the very place where Thornhill is spotted by the thugs who mistake him for a spy. One day, the actor was summoned from his suite for the quick shot where Thornhill strolls across the hotel lobby. After he came down and did his bit, a visiting journalist, interviewing Hitchcock, wondered aloud how Grant could play the scene without conferring with the director. "Oh," Hitchcock quipped, "he's been walking across the lobby by himself for years!"

Grant had been effortlessly walking across the screen for almost thirty years. The friction on his last film with Hitchcock had been negligible, and by now was forgotten. But the star had always maintained an edgier relationship with Hitchcock than James Stewart had. "There was something between them that wasn't always quite right," recalled production designer Robert Boyle. "Hitch and I had a rapport and understanding deeper than words," Grant liked to boast. Asked by a reporter how he communicated with Hitchcock, Grant replied, only half kidding, "All I have to do is disregard everything he says. But I guess what's in his mind, and then I do just the opposite. Works every time, and I find it very pleasant."

Grant didn't need acting tips, but other coddling was called for. Although his image was one of utter poise and self-assuredness, the reality, according to costar James Mason, was an actor "conscientious, clutching his script until the last moment." And, more than usual, Grant clutched the script of *North by Northwest*. The dapper actor complained incessantly that he really couldn't make head or tails of the film's implausible plotline. He told writer Ernest Lehman that he was afraid Hitchcock didn't have a suitably light touch for the comedy—saying this, incidentally,

within earshot of Hitchcock himself, while they were on location in New York. (The director, noted John Russell Taylor in his book, was "furiously offended.")

Grant was still complaining in mid-September, as they returned from their whirlwind travels and location work for interiors at the MGM studio. The bulk of scenes remained to be filmed—among them the Oak Room, the Long Island mansion, the police station, the UN, the Chicago hotel room, the auction, and Grant's scenes with Saint aboard the train. Hitchcock had mapped out a comic rendition of *Vertigo*'s famous revolving kiss, with Thornhill and Eve kissing in medium close-up, twisting and squeezing up against the walls of a train compartment. This time the lovemaking was claustrophobic, however, and it was the camera that remained fixed as the stars spinned and groped. (The extra joke is that they're responding not only to each other, but to the train rounding a bend.)

The Mount Rushmore crescendo also had to be filmed, as well as the intricate crop-duster sequence, which had been scheduled for near Bakersfield, at the south end of the San Joaquin Valley. Over the years Hitchcock had often driven by the flatlands there en route to Santa Cruz, playing variations of the scene in his mind. Now, on location to film the scene, Hitchcock found himself barely speaking to either the star or writer of *North by Northwest*. Grant was still kvetching; meanwhile Lehman had developed misgivings about the next Hitchcock film, called *No Bail for the Judge*—misgivings strong enough that he had refused to work on the project.

It was "110 in the shade," according to Lehman, on the day Hitchcock staged the sequence where Thornhill, keeping a rendezvous at a crossroads in the middle of nowhere, is attacked by a crop duster diving down at him from the sky, forcing him to take temporary refuge in a field of corn.* Hitchcock stripped down to shirtsleeves to oversee the laborious maneuvers of the stunt airplane. Between takes, there was plenty of time for Grant to sit and brood inside his air-conditioned limousine. The star beckoned Lehman inside to gripe about the (nonexistent) logic of the scene they were filming.

Hitchcock no longer even pretended logic. "I don't even know who was in that airplane attacking Cary Grant," he said later. "I don't care. So long as that audience goes through that emotion."

"Grant and Lehman found themselves quarreling with one another," according to John Russell Taylor, "with Grant claiming it was really a David Niven script and it was lousy anyway because he didn't understand

* Originally it was a wheat field, but after research indicated that wheat wasn't grown close to Chicago, Robert Boyle had planted a cornfield.

what was going on and he doubted if anyone else would. They were both aware, of course, that they were taking out their worries on each other because they could not manage to quarrel directly with Hitch."

The director set these distractions aside while he stoically collected his shots in blistering heat: The stationary high-angle of the bus arriving to deposit Thornhill at an isolated stop; the ground-level view of Thornhill looking around in vain for his mysterious contact; an automobile arriving to disgorge a stranger (Malcolm Atterbury); the hilarious two-shot of the stranger and Thornhill staring suspiciously at each other from opposite sides of the highway; the stranger remarking, before he climbs on a bus headed in the opposite direction, on the peculiarity of a crop duster glimpsed in the distance, buzzing low over land where there are no crops; the crop duster wheeling and circling around, heading slowly toward Thornhill, and then diving at him and ultimately chasing him off the highway, into the rows of corn; the crop duster banking low and coming in for another attack, spraying chemical fertilizer that spreads through the rows of cornstalks, driving Thornhill back out of hiding . . . and then onto the highway.

The result was the justly celebrated sequence that includes the shot—one of the most recognizable in all of film—of Cary Grant racing frantically down the highway in all his sharp-suited splendor (toward the camera), with the murderous plane swooping down on him from behind.

The sequence ends with Thornhill standing in the middle of the road, defying an oil tanker that is roaring toward him, flattening himself beneath the truck just as it brakes; then sliding out from under, just as the crop duster misjudges and crashes into the tanker, exploding in a fireball. This—along with the shower scene in *Psycho*, the most famous of all Hitchcock crescendos—the director achieved under enormous duress and arduous weather, orchestrating elaborate stunts and effects, and finessing a star and writer who were snapping at each other just to keep from picking a fight with him.

Grant's persona is central to the scene, but the net effect is all Hitchcock's doing: a master blend of location plates and mattes, real scenery and fake, actors and doubles. On location the plane dove for Hitchcock, and the star of *North by Northwest* jogged for the director—but never in the same shot. And when Grant flopped to the ground, he flopped inside the studio—his full extension in the shot part of its beauty—in front of a prephotographed back projection.

All of it was then spliced together into a textbook montage that will be studied and enjoyed as long as cinema exists. The crop-duster sequence is a perfect Hitchcock short story—with almost no dialogue, only natural noise, and none of Bernard Herrmann's music. One of Hitchcock's grandest illusions, it couldn't have been realized without the farsighted prepara-

tion and hard, hard work that characterized the whole saga of *North by Northwest*.

Approaching sixty, Hitchcock had already experienced intimations of mortality. In the past he had shrugged off disappointing films, but making them was now more than ever a struggle, and now each one felt important. In November, principal photography wrapped and the editing began. Bernard Herrmann started on his wittiest, most underrated score. Sam Taylor arrived, replacing Ernest Lehman on *No Bail for the Judge*, slated as a Paramount film to be directed by Hitchcock. (*To Catch a Thief* was the only other such arrangement to date.)

Meanwhile the budget of *North by Northwest* had risen steadily, from its original estimate of $3 million to somewhere in the lofty neighborhood of $4.3 million. By contract Cary Grant had to be paid $5,000 extra per day beyond the contracted period, as retakes and second-unit work continued. Studio chief Sol Siegel kept up a barrage of memos urging the director to stop spending money, but Hitchcock ignored them. As late as April, he was still shooting additional retakes and ordering more second-unit work.

Budgetary pressures may have opened the door for Saul Bass to create another one of his signature title sequences. All along Hitchcock had envisioned a different prologue: a series of office vignettes, establishing Thornhill in his ad-agency milieu. Although Grant uncharacteristically offered to act in such a title sequence for *free*, it was finally faster and cheaper to job out the animation of the titles to Bass, who surpassed himself with his arrows "forming a tilted graph," which "become a skyscraper with traffic reflected in its all-glass surface," in the words of Bill Krohn.

Hitchcock had joined another cat-and-mouse battle with the censors, managing once again to stay ahead of the cat. He fought a "running battle" with Production Code officials throughout January and February, according to Krohn, meeting repeatedly with the censors, patiently noting their qualms and reassuring them. The censors were particularly alarmed by Leonard's effeminacy and the mention of Thornhill's several divorces, and of course by the train-compartment overnights, which implied sexual relations between Thornhill and Eve.

One line that bothered Code officials at every stage of the script occurred during their dining-room encounter, when Eve suggestively informs Thornhill, "I never make love on an empty stomach." Yet that's how the director shot it. Ultimately Hitchcock agreed to overdub the line, though his solution let him have it both ways. Eve now said, "I never discuss love on an empty stomach," but lip-readers everywhere could decipher Hitchcock's version.

He traded away the dubbed line for the later implication that Thornhill and Eve had spent the night together. He even accepted dialogue offered by the head of the Production Code for the film's coda. Geoffrey Shurlock suggested that Grant might say something like, "Come along, Mrs. Thornhill," before he pulls Eve up into his compartment bed, indicating that the two have been married after the Mount Rushmore mayhem. That line was added in February, long after the scene was filmed, "looped over a closeup of Eve from the cafeteria scene," according to Krohn, "with the background removed."

Shurlock was so pleased that he overlooked the final shot: the train, bearing Thornhill and Eve in their upper berth, plunging into a darkened tunnel in markedly suggestive fashion. The shot wasn't in Lehman's script, nor in any draft the studio or censorship officials ever saw. Hitchcock added this very satisfying image at the last possible moment, in mid-March. The tunnel had been scouted by subordinates; the shot was sketched by Hitchcock, and the train was photographed from the rear by a pickup crew. It was "the most explicit depiction of the bottom-line facts of the sexual act ever pulled off under the Production Code," in the words of Krohn—and it gave Hitchcock the last laugh.

And he tricked everybody into his title. Nobody had liked the working title, "In a Northwesterly Direction." Along the way the director had tweaked it to *North by Northwest,* and then made sure that in one scene Thornhill tarried at a Northwest Airlines counter, offering a quick visual cue. Studio research reported that "north by northwest" was not an actual compass point, and the Title Committee was divided on its merits. Hitchcock shrugged, and said it was up to the committee—leading them to insist upon it.

"Do you know your *Hamlet*?" Sir John (Herbert Marshall) asks Markham (Edward Chapman) in *Murder!* "Every word of it," Markham replies. Even Ernest Lehman was fooled into thinking that the Shakespearean reference was accidental:

Act II, Scene 2
HAMLET: . . . my uncle-father and aunt-mother are deceived.
GUILDENSTERN: In what, my dear lord?
HAMLET: I am but mad north-north-west: when the wind is
 southerly I know a hawk from a handsaw.

Like all Hitchcock writers, Lehman operated purely on a need-to-know basis, and he didn't need to know that the director had studied and memorized *Hamlet* ("every word of it") back in his Jesuit school days. He didn't realize that Hitchcock had turned to Shakespeare before in search of titles (*Rich and Strange*). Nor was he up on the many references to Shakespeare plays in other Hitchcock films (even Peter Lorre quotes the

Bard in *The Man Who Knew Too Much*). Though few besides the director and his star would have known it, Hitchcock had once even tried to turn Cary Grant into Hamlet. He never got closer than when making *North by Northwest.*

When Hitchcock approved an unusually lengthy final cut of *North by Northwest,* MGM balked. Long films meant fewer showings per day, and less projected revenue. Sol Siegel ordered a screening of the Hitchcock film for the entire board of directors, on April 29, 1959.

Afterward, although the board was generally impressed, Siegel insisted that Hitchcock cut out the quiet interlude in the forest clearing between Eve and Thornhill after Thornhill's staged "death" in the Mount Rushmore visitors' center. The scene gives Eve the long-awaited opportunity to "explain" herself—but cutting it out would save several precious minutes of running time.

The director could have compromised; *North by Northwest* might have survived the loss. Instead, just as he battled Darryl Zanuck when *Lifeboat* was threatened, he fought back more fiercely than the MGM lion. On May 7 Hitchcock had a long lunch with his San Francisco lawyer, asking him to review his contract—the best he'd ever had in terms of leverage and autonomy, and the first to grant him final cut. Later that day he met with Siegel to deliver his reply: No, thank you. His tact and positive relationship with Siegel smoothed over any awkwardness, and MGM wisely backed off. Plans for last-minute postproduction touches, an amusing trailer (with Hitchcock promising "a vacation from all your problems . . . as it was for me!"), and an all-out publicity campaign went ahead unimpeded.

On July 1 *North by Northwest* had its premiere in Chicago, followed by national openings. "Suspenseful and delightful," A. H. Weiler wrote in the *New York Times. Newsweek* found it shiny, colorful and "slick, slick, slick." Hollis Alpert of *Saturday Review* called it funny and macabre and "much the best Hitchcock that has come along in years." It was a tremendous hit, taking in $6 million in rentals in North America alone.

Shortly after the opening, Hitchcock was eating lunch in the MGM commissary when Cary Grant strolled in and spotted the director. The two had not been on the best of terms during the filming, but now, with all eyes upon him, the dapper star walked over to Hitchcock's table, knelt down on the floor, and salaamed the director exaggeratedly.* Why? Take a look at *Operation Petticoat,* a perfectly entertaining film made in the same year

* Grant had recently found a new "peace of mind" through lysergic acid diethylamide (LSD). In publicity articles timed to coincide with the release of *North by Northwest,* Grant for the first time revealed that, in addition to hypnosis, yoga, and mysticism, after working with Hitchcock he had begun taking the synthetic, hallucinatory drug for psychotherapeutic reasons—and, he assured interviewers, it was working.

as *North by Northwest,* but one in which Grant is reduced to mannerisms. Not only were Grant's Hitchcock films among his very best, no director gave him better roles, and extracted livelier performances.

Often self-deprecating about his films, Hitchcock had no reason to be modest about *North by Northwest.* "It's the American *39 Steps,*" he told Peter Bogdanovich.

Sam Taylor had come to California before Christmas 1958 and then accompanied the Hitchcocks on their annual getaway to England and Europe. Stopping over in London, they scouted locations for *No Bail for the Judge;* in Paris, they conducted publicity for *Vertigo.* At St. Moritz, they celebrated the holidays and brainstormed on the new script.

No Bail for the Judge was a novel by Henry Cecil (born Henry Cecil Leon), an English judge who wrote fiction, nonfiction, and plays dealing with crime and the law. The novel concerned a lady barrister whose father is a well-known judge at the Old Bailey. Injured while on his way home one evening, the judge is assisted by a warmhearted prostitute, who takes him to her flat to recover. He likes her, and decides to stay at her place for a time. One night he arrives to find his rescuer dead, a knife in her back. The compromising circumstances lead to accusations of murder. His barrister daughter blackmails a gentleman thief into helping her find the person really responsible for the crime.

The Old Bailey milieu, the wrong man with his fingerprints on a knife, a heroine who clashes with an unjust legal system—all this suggested a run-for-cover crime film, but with enough variations and differences to keep Hitchcock interested. A big budget was anticipated to cover making the film in England—as well as the salary of Audrey Hepburn, Paramount's leadingest lady ("over the decade" of the 1950s, wrote David Shipman, "she would often seem the only female star worth a light"), who had agreed to play the judge's daughter.

Although Hitchcock liked to complain about England—and the English film industry—he was looking forward to shooting his first film entirely in London since *Stage Fright* in 1949. Taylor didn't officially go on salary until the end of January 1959, but by then he was already deep into the script with Hitchcock. Their main concern was enlarging Hepburn's role in the story; by April, after sessions at the studio and weekends up at Santa Cruz, there was a continuity treatment and partial draft.

Even before the April screening of *North by Northwest* for the MGM board, Hitchcock, Taylor, Herbert Coleman, and production designer Henry Bumstead had paid a second visit to London, finalizing the locations and the largely English cast. Although his appointment book suggests that Hitchcock interviewed Richard Burton for the part, Laurence

Harvey was ultimately selected to play the gentleman thief, and John Williams would have had his most important role yet for Hitchcock, as the judge, Hepburn's father.

Paramount seemed happy about the project, until executives learned of the director's intention to push the boundaries of the subject matter. In Hitchcock's revamping of the story, the female barrister would masquerade as a prostitute to investigate the murder, and then find herself under attack in Hyde Park, dragged into the bushes and fending off a rape. This scene (with its echoes of *Blackmail*) took the studio—and perhaps Audrey Hepburn—by surprise, for it didn't exist in the book.

Among the Paramount officials who loathed the rape scene was associate producer Coleman. He took the lead as the studio's intermediary, trying to pry it out of the script, arguing that Hitchcock was straying from the "beautiful people, beautiful scenery" credo of his Paramount films. His leading lady would be repelled by the rape scene, Coleman argued, reminding Hitchcock that Hepburn had just finished playing a saintly missionary in the Belgian Congo in *The Nun's Story*.

But Hitchcock dug in his heels. He relished shaking up the star's decorous image, as he had with other actors throughout his career—a career also spent pushing the cinema closer to unflinching depictions of violence. Hepburn wouldn't exactly be raped, he argued; she would fight off the rape. He insisted that the scene could be—would be—filmed in such a way as to satisfy Hepburn, Paramount, and the Production Code. By now, though, Paramount understood that Hitchcock's assurances were slippery where censorship was concerned, and the studio was reluctant to let him go to England with a script that hadn't been vetted.

According to Coleman, Hepburn herself read the script and objected to the scene; other books, including Barry Paris's authoritative biography of the actress, concur that Hepburn was "notoriously squeamish about violence," and nervous about the Hitchcock project. Armed with Hepburn's qualms, Coleman made one last unsuccessful attempt to convince Hitchcock to drop the scene. Finally, on behalf of the studio, Coleman shelved the script, and halted the production.

But the official explanation—the one Hitchcock offered in subsequent interviews—is just as plausible. Hepburn had just learned that she was pregnant. She had suffered miscarriages in the past, and was desperate to bear a child. Considering his history with pregnant actresses, Hitchcock would have been quick to read the writing on the wall. The birth of Hepburn's son Sean Ferrer on July 17, 1960, bears out this timetable. And until he officially left Paramount, Hitchcock continued to mention Hepburn and *No Bail for the Judge* in interviews, as though in his mind the project was only just temporarily postponed.

Either way, the decision came to a head soon after the men returned

from their final scouting mission to England. *No Bail for the Judge* wouldn't have the same allure for Hitchcock if it had to be made without Hepburn—or without the rape scene. Once again, as with *The Bramble Bush* and *Flamingo Feather,* he set aside a film. As Hitchcock later explained, preproduction had cost Paramount $200,000—but after he warned studio officials that continuing the troubled project would risk the loss of another $3 million, "they asked no further questions."

In any event, Hitchcock told the studio, he had another project in mind, an American run-for-cover that he could whip together quickly. He might not have canceled *No Bail for the Judge* so agreeably if he hadn't had a ready alternative. As Paramount waited to learn more, at home on June 3, 1959, after talking it over with Lew Wasserman, Hitchcock convened the initial production conference for *Psycho.*

Six months earlier, on December 18, 1958, MCA had taken a historic step, entering the film production business by purchasing Universal International and its 367-acre lot for $11.25 million. MCA's takeover of Universal cemented Lew Wasserman as the most powerful man in Hollywood, at once the head of the biggest talent agency and the head of a major studio (albeit one fallen on hard times). Immediately after making the acquisition, MCA started signing its clients to Universal contracts—an activity that intensified the Justice Department's ongoing investigation of the agency's strong-arm practices. The cancellation of *No Bail for the Judge* opened the door for Universal to recruit Hitchcock, which was Wasserman's goal. But Wasserman had to accept *Psycho;* that was Hitchcock's clever gamble.

Psycho may well be the most overly familiar motion picture in history. There are innumerable essays, books, college courses, academic symposia, fan clubs, and Web sites devoted to extolling and analyzing the film. But when Hitchcock first presented *Psycho* to his agents, his staff, and Paramount, he framed it as a simple, low-budget American shocker, in the style of his TV series, which would provide a breather from more lavish, grandiose productions.

Galleys of Robert Bloch's novel had circulated at Paramount back in mid-February 1959, but the weird yarn about a psycho killer who runs a lonely roadside motel was promptly rejected by studio readers as too ghoulish and posing insurmountable problems for censorship. Hitchcock's office routinely saw all the reader reports, but the director's antenna shot up when Anthony Boucher, in his *New York Times* crime-fiction column of April 19, 1959, praised the novel as "chillingly effective." Hitchcock, a devotee of Boucher's column, asked his assistant, Peggy Robertson, to get him a copy of the book.

Bloch, a Wisconsin author little known outside pulp-fiction circles, had been inspired by the real-life case of Ed Gein, a Plainfield, Wisconsin, farmer arrested in 1957 for grave robbing, cannibalism, and murder. A search of Gein's property revealed the remains of an indefinite number of female victims who had been cut up, eviscerated, and cannibalized; their skins, skulls, and body parts were displayed throughout his home. The investigation revealed that Gein, who adorned himself in garments made from the flesh of his victims, had had a tormented, perhaps incestuous relationship with his mother, whose death triggered his spree.

The basic facts of the Gein case were spun by Bloch into a macabre suspense story about a fat, lonely middle-aged tippler who has killed his mother and stuffed her corpse. One rainy night, a young woman who has stolen forty thousand dollars arrives at the motel he runs; he rents her a room, then spies on her through a peephole as she prepares for a shower. Dressed grotesquely in his mother's clothes, he surprises her with a visit.

"Mary started to scream, and then the curtains parted further and a hand appeared, holding a butcher's knife. It was the knife that, a moment later, cut off her scream."

Hitchcock liked to boast about playing the emotions of audiences as though they were notes on a organ, but when he read *Psycho* he must have recognized his own inner music surging through him. It was *The Lodger* as the Landlord of a motel; it was a phantasmagoria with a scary mansion, stairwell, and dark basement; it was a Peeping Tom and a screaming Jane; it was the world's worst bathroom nightmare, mingling nudity and blood; it was a plunging knife in the muscled grip of a man dressed, bizarrely, as his own mother. It is no exaggeration to say that Hitchcock had been waiting for *Psycho*—working up to it—all his life.

Late in April, MCA quietly arranged to option the screen rights—so quietly that the author had no idea who the buyer of his book might be. Only later did Bloch learn that *Psycho* was going to be immortalized by Alfred Hitchcock; like some other authors of books used for Hitchcock films, he always resented the price: a low, blind bid of nine thousand dollars.

Psycho would be the ultimate *Alfred Hitchcock Presents,* the director told his staff: gruesome and scary and darkly humorous. He might even save a little money by shooting the film with his television crew. Shooting it in black and white would also keep costs down (and besides, he added in later interviews, "in color, the blood flowing down the bathtub drain would have been *repulsive*"). All the filming could be done in the studio—on a quick, TV-style schedule.

With such a run-for-cover project Hitchcock could move fast, and he did. At Joan Harrison's suggestion, he met with James P. Cavanagh on May 12. At this point Cavanagh was mainly a writer for television, including *Alfred Hitchcock Presents;* he had won the Best Teleplay Emmy

for his 1956 episode, "Fog Closes In," and for the 1956–57 season had written the *Psycho*-inflected episode called "One More Mile to Go." Cavanagh was given a pep talk, a copy of Bloch's novel, and eight pages of handwritten notes "in which the director laid out precise camera movements and sound cues for certain key sequences" of the film, according to Stephen Rebello in his authoritative *Alfred Hitchcock and the Making of Psycho*.

When a story spoke to Hitchcock, it was because certain scenes were so specific, so resonant, so Hitchcockian, that he could visualize the pictures instantly. This is how, in this very first script conference with Cavanagh, Hitchcock was already describing Marion Crane's hours of driving before she finds herself on an unfamiliar road and pulls over at the Bates Motel: "The long traffic-laden route along Route 99—the roadside sights—the coming of darkness. Mary's thoughts about Monday morning and the discovery of her flight with the money. The rain starts."

If Paramount was concerned about Audrey Hepburn getting raped in *No Bail for the Judge,* though, *Psycho*—as Hitchcock (and Lew Wasserman) had foreseen—really threw studio officials into a tizzy. A flurry of meetings followed, involving Hitchcock's lawyer, MCA agents, and studio head Y. Frank Freeman. Freeman was aghast; he was Hitchcock's friend and ordinarily his ally, but Freeman had also just accepted the position of president of the Motion Picture Association of America, which administered the Production Code. *Psycho*—with its nudity, violence, transvestism, and bathroom scenes—loomed as Hitchcock's most direct challenge to the Code.

It was certainly a challenge to Paramount, but Hitchcock vowed to leap the censorship hurdles and said he was determined to make the film. Paramount's corporate president, Barney Balaban, flew out from New York in early June for another high-level meeting, expressly to discuss *Psycho*—but also to confront Freeman. After twenty-six years at Paramount, Freeman was then ushered out as head of production. Publicly, Paramount explained that Freeman was in ill health, but privately Balaban felt the studio had been foundering without Don Hartman, and that Freeman was proving unable to handle problems like *Psycho*. Balaban was anxious to shift the studio's focus toward family musicals like Warner Bros.'s *Auntie Mame* and MGM's *Gigi,* which had been the big box-office winners and dominated the Oscar race in 1958. Freeman was abruptly replaced by Jacob H. Karp, previously in charge of legal affairs, who joined Balaban in opposing *Psycho*. They were willing to revise Hitchcock's debt to the studio—and Wasserman was ready with an innovative proposal.

Psycho, he suggested, could become another Alfred J. Hitchcock film—not a Paramount production. The director would defer his salary ($250,000 by now), and direct *Psycho* absolutely *free of charge,* while keeping the budget (charged to Paramount) to an agreed-upon shoestring. In exchange,

Hitchcock would claim 60 percent ownership of the film until Paramount earned a set amount of money drawn from a guaranteed percentage of the gross, after which all revenue and ownership would revert to the director.

Further distancing the parent studio from the unseemly shocker, Wasserman proposed that Hitchcock shoot *Psycho* over at Universal, leasing the soundstages and renting the equipment to Paramount. Later the Justice Department would investigate the theory that *Psycho* was part of a clever kickback to the new MCA-Universal management, and Hitchcock himself was deposed by the government. Although nothing was proved, it was certainly true that Wasserman, with breathless speed, had snatched his number one client from a competitor and sold him back to himself, making money on both ends of the deal.

Money was rarely Hitchcock's motive, however. Once more he was setting his established salary aside, and putting his reputation on the line, for something he wanted to try—against all opposition. Few in his own circle were enthusiastic about the unsavory *Psycho*. His associate producer over six years and seven films, Herbert Coleman, had been hoping to establish himself independently as a producer, and he took *Psycho* as his cue to quit Hitchcock's staff. But Coleman was also Paramount's supervisory link with Hitchcock, who was now, therefore, effectively on his own. Though sorry to lose Coleman, the director gleefully forged ahead.

James Cavanagh had the summer of 1959 to work on the script for *Psycho*. Hitchcock took the time to tend to *Alfred Hitchcock Presents*, directing his 1959–1960 episodes and performing all his introductions for the upcoming season. In July he directed "Arthur," a black comedy about a chicken farmer who grinds his murder victims into feed, starring Laurence Harvey (left over from *No Bail for the Judge*). In August he filmed "The Crystal Trench," about a woman who loses her husband in a mountain-climbing accident, spends years pining for him, and then is stunned by a twist in the story when, in her old age, his perfectly preserved corpse emerges from a glacier, bearing a revelation.

Alfred Hitchcock Presents had developed a split personality: half the shows were stubbornly English; but as the series progressed, it increasingly explored the dark side of the American Dream—the artificiality, hypocrisy, neuroses, violence, and evil that lurked in boardrooms and bedrooms across the United States. *Psycho* would be the culmination of this trend in Hitchcock's thinking.

Cavanagh finished a draft in August. According to Norman Lloyd, the writer wrote one key scene that departed from what Hitchcock had explicitly outlined, and the director got no further in his reading than that scene; then he closed the script angrily, and discharged Cavanagh.

According to Stephen Rebello, "Much of Cavanagh's script has a

sketched-in, tentative feel" and "straddled episodic television," but at the same time Rebello's review of the various drafts reveals that much of Cavanagh's foundational work found its way into the final film. This included "elaborate details of the heroine's harrowing car trip; the poignant, impactful supper conversation between Bates and Mary [Marion in the film]; the obsessive cleanup by Bates after the shower murder; and the swamp's gobbling [Marion's] car. Even the shower murder sequence anticipates the intricate camera movement that ends in a close-up of blood mingling with shower water gurgling down the drain."

Psycho needed a new writer, but as with so many Hitchcock projects, casting and preproduction raced ahead of the script. Over the summer of 1959, Hitchcock held preliminary meetings with Saul Bass and Edith Head. And already he had tapped his leading man—changing Norman Bates in the process from the middle-aged slob of the novel into a character who could be played by slender, handsome twenty-seven-year-old Anthony Perkins.

Hitchcock had made the all-important decision to hire Perkins way back in early summer, before there was any script. Perkins, who had made his screen debut in 1950, had the facade of a "bobby-soxer's dreamboat-with-a-brain," in Rebello's words; he even recorded pop music albums. But Hitchcock liked Perkins as soon as he met him: he was a sensitive, intelligent actor eager to take a dare and play a cross-dressing serial murderer. Although it was never mentioned between Hitchcock and Perkins—repeating the pattern set by *Rope*—the actor's homosexuality was an open secret in Hollywood, and Perkins as Norman Bates couldn't help but draw on that subtext. More conveniently, the actor owed Paramount a film on a previous contract, and was available for a salary of only forty thousand dollars.

By July, Cavanagh knew he was writing for Anthony Perkins—and at the end of the summer, his successor was able to start with that knowledge as well as a solid draft to build on. MCA agent Ned Brown had been pitching Hitchcock on a client of his, a newcomer to screenwriting named Joseph Stefano. A composer in his late thirties who had written for George Shearing, Eydie Gorme, and Sammy Davis Jr., Stefano had recently written a couple of well-regarded scripts: a *Playhouse 90* episode called "Made in Japan,"* and a Paramount film, *The Black Orchid,* with Sophia Loren and Anthony Quinn.

Back in May, Hitchcock had watched about five minutes of *The Black Orchid* before shutting it off and opting for Cavanagh. But Brown was still

* "Made in Japan" had won the Robert E. Sherwood Award given to emerging artists by the Mark Taper Forum, one of the theaters making up the Los Angeles Music Center.

promoting his client, and Hitchcock had a soft spot for songwriters. So on September 1, Brown brought Stefano to Paramount for a brief meeting with Hitchcock. From Philadelphia, with only a high-school education, Stefano turned out to be "exuberantly cocky, volatile and streetwise," in the words of Stephen Rebello, the kind of colorful, entertaining personality Hitchcock would look forward to spending time with. "He found that I was very funny and we had a lot of laughs together," Stefano recalled.

A week later Stefano came to the studio for lunch with Hitchcock, who hired him at first on a week-to-week basis. It didn't seem to bother the director that, like so many other writers he had encountered over the years, Stefano wasn't jumping and cheering about his assignment; in fact, Stefano finished the Robert Bloch novel feeling oddly disappointed. To him the story was tawdry and depressing. Where was Cary Grant and all the glamour?

Hitchcock set about wooing his audience of one. He regaled Stefano with the whole story of *Psycho*—never showing him Cavanagh's script, but integrating the best parts of it into his working version of the story. He played up the oddball casting of Perkins as Norman Bates, and revealed his plans to enlarge the part of the shower victim for a major star.

The shower scene occurs in the third chapter of the book; Hitchcock's twist idea was to cast a marquee name, then shock the audience with her sudden, early demise. That made it all the more vital to play up Marion's few scenes. How, without damaging the integrity of the film, could Marion's part be enhanced? Stefano's suggestion spoke Hitchcock's language: "I'd like to see Marion shacking up with Sam on her lunch hour."

"The moment I said 'shack up' or anything like that," Stefano recalled, "Hitchcock, being a very salacious man, adored it. I said, 'We'll find out what the girl is all about, see her steal the money and head for Sam—on the way, this horrendous thing happens to her.' He thought it was spectacular. I think that idea got me the job."

The week-to-week job lasted roughly three months. They usually began with a morning meeting, often not starting until 11 A.M. because Stefano was undergoing regular psychoanalysis—which, he later reflected, probably influenced the "Freudian stuff" that gradually permeated the final script. *Psycho* would be influenced by television, by Anthony Perkins, and now by Freud—and it was also another chance for Hitchcock to emulate *Diabolique*.

Back in May Hitchcock had described *Psycho* to the *New York Times* as a story in "the *Diabolique* genre." He told Stefano that the French film had influenced his decision to shoot *Psycho* in black and white (like *Diabolique*). Their afternoon meetings were leavened by screenings; and *Diabolique* was shown more than once to Stefano and others on the staff. Stefano was also encouraged to order up his own private festival of Hitchcock titles. Afterward, the director patiently answered all questions about

each film. Stefano's favorite, he told Hitchcock, was *Vertigo*. The compliment "brought him to near-tears," Stefano recalled.

Hitchcock seemed happy for interruptions. He broke almost daily to visit with Lew Wasserman, who usually stopped by to chat about stocks and bonds. Hitchcock loved to digress; "usually not more than ten or fifteen minutes [of each day] would be directly concerned with *Psycho*," according to John Russell Taylor. The ten or fifteen minutes might be devoted to a major scene, or as likely to a passing fancy of Hitchcock's— such as his idea that Stefano should write scenes for rooms with lots of mirrors.

"He was not interested in characters or motivation at all," Stefano reflected in later interviews. "That was the writer's job. If I said, 'I'd like to give the girl an air of desperation,' he'd say, 'Fine, fine.' But when I said, 'In the opening of the film, I'd like a helicopter shot over the city, then go right up to the seedy hotel where Marion is spending her lunch hour with Sam,' he said, 'We'll go right into the window!' That sort of thing excited him."

In mid-October, Hitchcock flew to Paris and London for two weeks to promote *North by Northwest*. The tone-setting opening of *Psycho* was delegated to Stefano during his absence—a kind of informal tryout. When Hitchcock got back and read the pages, he paid Stefano the ultimate compliment: "Alma loved it!"

Stefano's script would stay fairly faithful to the basic sequence of events in Robert Bloch's novel, but he introduced many improvements in minor incident and characterization. And Stefano's boldest innovation—the tone-setting opening, with Marion and Sam finishing up their lunch-hour sexual tryst—might never have been suggested by an experienced Hollywood screenwriter, glancing over his shoulder at the Production Code.

Hitchcock always told his writers to write bravely, and let him be the one to worry about the censors. Another place where Stefano deliberately flouted censorship is the scene where Marion, after eating supper and talking to Norman, decides to repent of her thievery. Then before taking a shower, Marion mentally calculates how much money she has spent and will have to repay to wash away her crime. Although this scene is in the book, it needed to be visualized somehow for film, so Stefano had Marion calculate the sum on a piece of paper. Then: "I would like Marion to tear up a piece of paper," he said to Hitchcock, "and flush it down the toilet and see that toilet. Can we do that?"

Stefano recalled: "A toilet had never been seen on-screen before, let alone flushing it.* I thought if I could begin to unhinge audiences by show-

* Of course, there was one director whose camera had been darting into bathrooms on-screen ever since *The Lodger* in 1926: Hitchcock.

ing a toilet flushing—we all suffer from peccadilloes from toilet proce-dures—they'd be so out of it by the time of the shower murder, it would be an absolute killer." Hitchcock raised an eyebrow before replying, "I'm going to have to fight them on it."

According to Rebello, these "risqué elements" were, as usual, Hitch-cock's deliberate "ruse to divert the censors from more crucial concerns." And sure enough, when Paramount submitted Stefano's draft, Code offi-cials said it would be impossible to approve such a film, predicting that if Hitchcock did not modify the objectionable scenes—especially the lunch-hour tryst, the toilet flushing, and the shower scene—*Psycho* would also be condemned by local censors and the Catholic Church's Legion of Decency.

Yet Stefano's script was thoughtful as well as intentionally provocative. One example is the crucial supper scene, the only time Norman and Mar-ion have a meaningful interchange and forge a connection. Norman talks about his hobby of taxidermy and voices qualms about his mother, yet takes offense when Marion suggests that perhaps Mrs. Bates should be put in an institution. "She's not crazy!" he blurts angrily.

The book and film versions of that scene aren't vastly different, except Stefano's script puts the characters in an office den, a room eerily presided over by Norman's collection of stuffed birds. "The [stuffed] owl, for in-stance, has another connotation," Hitchcock informed Truffaut. "Owls belong to the night world; they are watchers, and this appeals to Perkins's masochism. He knows the birds and he knows that they're watching him all the time. He can see his own guilt reflected in their knowing eyes."

But the conversational "duet" between Norman and Marion is longer in the film, more substantive, and it boasts some of Stefano's finest dia-logue—helping to lift *Psycho* out of the category of cheap horror almost into the realm of philosophy.

When Norman tells Marion she doesn't look as though she's had many empty moments in her life, she insists she's had her share. "I'm looking for a private island," Marion admits ruefully.

"You know what I think?" counters Norman. "I think that we're all in private traps, clamped in them, and none of us can ever get out. We scratch and claw but only at the air, only at each other, and for all of it, we never budge an inch."

Marion says yes, but (thinking of the money she has stolen) adds that sometimes people deliberately step into their own traps. Norman replies that he was born into his trap, but doesn't mind anymore. Marion says he *ought* to mind, and asks gently, wouldn't it be better to put his demanding mother someplace safe?

"But she's harmless!" insists an agitated Norman. "She's as harmless as one of those stuffed birds."

Apologetically, Marion says she meant no offense.

"People always mean well," Norman continues resentfully. "They cluck their thick tongues and shake their heads and 'suggest,' oh so very delicately. It's not as if she were a maniac—a raving thing. She just goes a little mad sometimes. We all go a little mad sometimes. Haven't you?"

In September, Hitchcock also made changes in his team for *Psycho*. He would carry Saul Bass (titles), Bernard Herrmann (music), and George Tomasini (editing) over to Universal for the new film, but over the summer cameraman Robert Burks and production designer Robert Boyle were assigned to other Paramount projects. Their absence gave Hitchcock an opening to shed his familiar skin and attain an edgier look.

He raided *Alfred Hitchcock Presents* for John L. Russell, who had photographed features (including Orson Welles's version of *Macbeth*) but was also the cameraman for nearly every TV episode Hitchcock directed; quick, high-contrast photography was his forte. Assistant director Hilton A. Green, also from the series, replaced Herbert Coleman as Hitchcock's first lieutenant. (Green would share a title card with Saul Bass, who is actually credited twice—once for titles, and again, as "Pictorial Consultant" for the storyboards he created for key sequences.) For his production designers, Hitchcock recruited Joseph Hurley and Robert Clatworthy from Universal. The latter had been an assistant to Robert Boyle on *Saboteur* and *Shadow of a Doubt,* and then graduated to art director on productions ranging from the glossy *Written on the Wind* to the seedy noir of Orson Welles's *Touch of Evil*.

The shower victim in the book is a brunette, but Hitchcock wanted Marion Crane to be a blonde—a very particular blonde. Janet Leigh was the front-runner early enough that Hitchcock mentioned her name to Stefano at their first or second meeting. After starting out in wholesome, perky roles, the onetime MGM contract actress had consciously expanded her range, most recently demonstrating a surprising sexiness in *Touch of Evil*. Leigh was an MCA client under contract to Universal, and Hitchcock liked her personality; mixing socially with her and her husband, Tony Curtis, he found a warmth and ease with Leigh.

In October Hitchcock sent the actress a copy of the Robert Bloch novel, assuring her that even though her character would be vividly murdered in the first half of the film, Marion Crane would "be improved upon [from the book] and, of course, the descriptions of the characters will be completely different." Leigh understood that he wanted "a name actress because of the shock value, but he also wanted someone who could actually look like she came from Phoenix," in her words. ("A perfectly ordinary bourgeois," Hitchcock said.) "I mean, Lana Turner might not be able to look like someone from there," Leigh said. "He wanted a vulnerability, a softness."

Leigh accepted the requisite invitation to lunch at Bellagio Road, where Hitchcock encouraged the serious-minded actress to deep-think her character. "His deportment was cordial, matter-of-fact and academic," Leigh wrote in *There Really Was a Hollywood*. "He outlined his modus operandi. The angles and shots of each scene were predetermined, carefully charted before the picture began. There could be no deviations. His camera was absolute. Within the boundary of the lens circumference, the player was given freedom, as long as the performance didn't interfere with the already designed shot."

"I hired you," Hitchcock told Leigh reassuringly, "because you are an actress! I will only direct you if A, you attempt to take more than your share of the pie, or B, if you don't take enough, or C, if you are having trouble motivating the necessary timed motion."

At that first lunch he was already brimming with ideas for her wardrobe. Hilton Green and a crew had visited Phoenix and taken still photographs of typical residents and city streets; finding a Marion type, they "photographed everything from her closet, her bureau drawers, her suitcases," in the words of wardrobe supervisor Helen Colvig. After absorbing the research, Marion's wardrobe was then plucked off the rack at the Beverly Hills boutique JAX. Hitchcock was specific about Leigh's wearing "good wool," recalled *Psycho* costume designer Rita Riggs (who had also costumed Hitchcock for his TV intros), "because it takes light so beautifully and photographs a very rich gray."

The scenes where Marion wore only lingerie were a unique challenge for the costumers: what kind of undergarments should they be, and how racy could they be without offending the censors? There was some talk of having the actress's bra and slip made to order, but the director scotched that. Marion's undergarments would send a clear message to the female sector. "That just won't work for the character," Hitchcock told the costumers. "We want that underwear to be identifiable to many women all over the country."

"There was great equivocation," recalled costume designer Riggs, "about whether Janet would wear a black or white bra and slip in the opening. It went on and on. We had each ready, of course, and not until we were almost ready to shoot did Mr. Hitchcock finally choose white for the opening, black for after she steals the money. It was strictly for character statement. He had an obsession for the 'good' girl or the 'bad' girl.' "

Actually, the script would have *two* leading ladies, just as the film itself would fall into two halves. Part 1 was the theft and flight leading to Marion's murder; part 2 involved the investigation of her disappearance and the story's steady progress toward its climax and Norman Bates's arrest. There were almost two separate acting ensembles, in the view of some involved in the production.

Vera Miles was still under contract to Hitchcock, and Rebello's book claims that Miles seethed at being cast as Marion's older sister, Lila, the lesser star of part 2. Dressed according to Hitchcock's instructions, Lila looked "like a dowdy old-maid schoolteacher," in the words of Rebello. That may have been a sly form of Hitchcockian revenge—"some of his perversity coming through," in costumer Rita Riggs's words—but it is also true that the director wanted to ward off any distracting hints of romance between Sam and Lila.

Hitchcock took a while to decide on the only male performer, besides Anthony Perkins, who would bridge both halves of the film. Marion's lover, Sam Loomis, was described in Joseph Stefano's script as "a good-looking, sensual man with warm humorous eyes and a compelling smile." The director watched numerous screen tests and films, before gravitating to Stuart Whitman, whose ruggedness was tempered with a certain sensitivity. But MCA and Lew Wasserman preferred John Gavin, an MCA client and Universal hunk. "I guess he'll be all right," muttered Hitchcock, according to Rebello, after suffering through *Imitation of Life,* a Douglas Sirk tearjerker in which Gavin falls impossibly in love with older woman Lana Turner.

No matter: Sam was always a subordinate character in Hitchcock's eyes. The director kept reminding Stefano that Sam and Lila were stick figures for the audience. *Psycho* really belonged to Anthony Perkins and Norman Bates. Whenever Stefano tried to breathe some extra life into Miles's or Gavin's roles, writing "purely a character scene" between them for part 2, Hitchcock found an excuse to cut it out.

The dogged detective Arbogast, whom the script describes as flashing "a particular unfriendly smile," was also a second-half character, and after watching *Twelve Angry Men* Hitchcock cast Martin Balsam in the role. One character who wasn't in the novel at all was the chatty secretary played by Pat Hitchcock O'Connell. Busy as the mother of three, Pat had all but retired from acting; she kept busy editing her father's mystery magazine. Her father created a memorable walk-on for her in the scene where the oilman (Cassidy) visits the real estate office and boasts about putting a wad of cash down on a house for his newlywed daughter. Although Pat talks a blue streak, the lecherous Cassidy barely takes notice of her, too busy ogling the sexier Marion. "He was flirting with you!" Pat whispers to Marion, chin up. "I guess he must have noticed my wedding ring."

Hitchcock was unusually specific about his daughter's wardrobe too: green silk shantung. And as a point of pride, "his bit of sentimental whimsy," in costumer Riggs's words, the director was also specific about his own outfit for his cameo appearance, which he inserted near Pat's scene; he can be glimpsed outside the real estate office, wearing a cowboy hat.

The subsidiary parts were deliciously written, and after running a

television series for five years, Hitchcock was never more attuned to the available talent. *Psycho* would boast pinpoint performances from Frank Albertson as Cassidy the oilman, Mort Mills as a menacing California highway patrolman (Hitchcock insisted on his eerie dark glasses), John Anderson as a prototypical used-car salesman, John McIntire as an avuncular sheriff (wrong about everything, as usual), and Simon Oakland as the psychiatrist at the end of the film who fascinatingly diagnoses Norman's deviant behavior for the benefit of audiences—and, as Hitchcock calculated, for the benefit of the Production Code. (Oakland was a kind of stand-in for the director, drolly explaining everything away at the tag end of his TV show.)

On November 4, the team trooped over to Universal to look for the *Psycho* house among the standing sets, doctoring one into a blend of Charles Addams and Edward Hopper. ("California Gothic, or, when they're particularly awful, they're called California Gingerbread," Hitchcock told François Truffaut.) On lower ground the Bates Motel would be constructed.

"I must say that the architectural contrast between the vertical house and the horizontal motel is quite pleasing to the eye," remarked Truffaut.

"Definitely," replied Hitchcock, "that's our composition: a vertical block and a horizontal block."

On November 16 he moved to Universal offices. On November 17 and 19 he approved final sets and locations, based on the scouting in Phoenix and Fresno, which had included detailed requests for photos of a "shoddy hotel exterior, with the street outside with taxis and passersby"; "the interior and exterior of a real estate office, including a bank"; and "exterior of a small house in which two girls live, including a two-car garage and street; a bedroom of the same house."

"Hitchcock wanted to know things," Hilton Green told Rebello, "like *exactly* what a car salesman in a small town in the valley would be wearing when a woman might come in to buy a car. We went up there and photographed some salesmen against a background. He wanted to know what people in Phoenix, Arizona, looked like, how they lived, what kind of people they were. He wanted to know the exact route a woman might take to go from Phoenix to central California. We traced the route and took pictures of every area along the way."

"Putting the writer through it" was the first order of business. Putting the actors through it was the second. Putting himself through it was the sum of the process. And putting the audience through it was the ultimate goal.

From his first day in Hollywood, Hitchcock had sought to bring an American authenticity to certain films, and he had incrementally built up this quality in his work over the years, especially after leaving Selznick International. From his writers and stories to his stars and settings, from

Saboteur, Shadow of a Doubt, and *Strangers on a Train,* to *Rear Window* and *North by Northwest,* the director proved increasingly adept at conveying a trenchant vision of his adopted homeland. By the end of the 1950s the soaking-up process was complete—and no film would be more quintessentially American, or Hitchcockian, than *Psycho.*

In his new Universal office the director made notes on the script, studied his storyboards, and hung up a road map with pushpins tracing Marion's travel route.

Hitchcock "had reached a point in his professional life when he was ready for a totally different kind of picture," Joseph Stefano reflected later. "In his previous films he told things about himself he thought were true, but in *Psycho* he told more about himself, in a deeper sense, than he realized. He had been very concerned about his health, and I think he made the picture at the very time he was grappling with his own mortality. After all he had been very ill in 1957, and Alma had been very ill in 1958. And then in 1959 along came this murderous film. I think it was the sudden-death aspect that involved him emotionally."

After handing in his final draft at the end of November, Stefano met with Hitchcock one last time at Bellagio Road. They stole an extra day "to break down the shooting script," according to Stephen Rebello, brainstorming ideas for close-ups and angles. At lunch they toasted the script for *Psycho* with bubbly on the rocks (the director apologized for "such a terrible solecism" in his home, wrote John Russell Taylor, "merely because they had no champagne properly chilled"). All of a sudden Hitchcock "looked very sad," recalled Stefano, "and said, 'The picture's over. Now I have to go and put it on film.' "

The photography began on November 30, 1959. If, in hindsight, people talked about the filming of *Vertigo* as being an experience heavily suffused with brooding and tension, the making of *Psycho* seems to have been a crisp, clockwork affair.

Now—and for the rest of his career—Hitchcock would be working with a significantly younger generation of actors and actresses. He was old enough to be their father. They listened to his instructions reverently (from now on, for example, *he* chose the lingerie). They knew him primarily as a Great Director, a celebrity. They knew the public image, not the human being. It was at this stage that Hitchcock really became the embodiment of his image, a man who walked onto the set just as he did at the opening of his television show, moving to fit his India-ink caricature. Everyone accepted common truths about him—even if those truths were superficial.

He used to complain that actors who insisted on quitting after an eight-hour workday were "my hate of hates." Nowadays, however, the director himself arrived promptly at 8:30 A.M., and tried to call an end to filming

at 5:30 P.M. Everyone knew that Hitchcock stopped a little earlier on Thursdays, the night he and Alma customarily went to dinner at Chasen's, a once trendy restaurant now growing a little old-fashioned. (Chasen's made no effort, for example, to keep up with new culinary trends such as health food.)

He had almost always worn a black or blue suit and tie, never any ornamentation—no jewelry or wristwatch. Now that costume was expected of Mr. Hitchcock. All the articles commented on the array of similar suits that hung in his closet, offering a variety of fittings for his fluctuating weight. Between setups in Hollywood, he solemnly read the *London Times*. Hitchcock had so often commented that directing was boring, that now he felt obliged to act bored. His presence on the set intimidated many people, and not all the younger folk caught his dry jokes and subtle humor.

He had always gravitated to his favorite players, and his favorites on *Psycho* were Anthony Perkins and Janet Leigh—the two actors the script and camera also favored. After Marion's demise, the second half of the film switched its focus to Arbogast, and to Sam and Lila; and the script made a cursory effort to transform Lila into an avenger. But the scenes with Sam and Lila paid little heed to their feelings or personalities. Hitchcock's interest was in getting to the crescendos.

Hitchcock got along wonderfully with Perkins, whose guarded personality intrigued him. The actor suggested aspects of his boy-next-door wardrobe, and it was Perkins's idea for Norman Bates to munch candy corn. Even Perkins's requests for extra takes were indulged, and at one point, when he approached the director to ask haltingly about making a few minor changes in his dialogue, Hitchcock, ruffling his newspaper, looked up.

"Oh, they're all right—I'm sure they're all right. Have you given these a lot of thought? You've really thought it out? And you like these changes?" When Perkins assured him he did, Hitchcock said, "All right, that's the way we'll do it." Norman Bates was accustomed to pampering, and part of the strange power of *Psycho* comes from the fact that the serial killer isn't harshly judged by Hitchcock, but is allowed to live and breathe—is even pampered—by the director.

Hitchcock was less enthusiastic about the film's conventional lead, John Gavin, whom he is said to have referred to privately as "the Stiff." Gavin also offered input on his costume and characterization, but his ideas pained the director. Costumer Helen Colvig remembered a scene where "John conveyed through the assistant director that he wanted to come through a door in a certain way. Hitchcock looked askance and told the assistant, 'Don't worry, we'll just cast a shadow over his face. We can knock him out in no time.' I think John was trying really hard to impress Hitch, but he was just irritating him."

The opening tryst between Sam (Gavin) and Marion (Leigh) was crucial

in establishing their characterizations—and the audacious atmosphere of the film. For some reason the scene embarrassed Gavin, who resisted playing it with his shirt off. Hitchcock fobbed the actor off on writer Joseph Stefano, who was on the set. "Stefano persuaded him by encouraging him to use that very embarrassment as part of the scene," according to John Russell Taylor's book, "particularly when having an argument while half undressed."

The embarrassing nature of the scene was aggravated by the fact that it was the first one Gavin acted with Leigh—and unlike, say, *The 39 Steps*, he and she were not supposed to be "meeting cute." "It isn't easy to say, 'Hello, nice to see you again,' and then hop in the sack and make love, remembered Leigh. "We were bound to be somewhat awkward. I thought we had begun to warm up and were progressing fairly well. . . ."

After some lackluster takes, Hitchcock beckoned the white-lingerie-clad actress over and complained, "I think you and John could be more passionate! See what you can do!" (According to Rebello, Hitchcock actually instructed Leigh "in discreet but descriptive terms" to "take matters in hand, as it were. Leigh blushed, acquiesced, and Hitchcock got a reasonable facsimile of the required response.") Then, almost as an afterthought, the director strolled over to Gavin and whispered something in his ear, too, tantalizing each performer by giving the other secret advice. "I wouldn't have put it past him to pull my chain, and then to pull John's chain," said Leigh, "just to get the desired results."

Give Gavin credit: he was struggling with his role. Years later, when Leigh was researching her book *Psycho: Behind the Scenes of the Classic Thriller*, Gavin told her that his chances weren't improved by the odor he detected on the set. Hitchcock's body odor? he wondered. Or perhaps the director's breath? Or maybe his cigar, as Hitchcock sat there, puffing placidly away, mere inches away from the performers pretending a love scene. And that's the way the tryst opening of *Psycho* plays: audacious but awkward, provocative but cold, sexy with a whiff of BO.

"In a strange way," Leigh argued later, Gavin's passivity "worked for the suspense. Real passion would have justified Marion's theft. But the lack of the complete abandon with Sam might have led some audience members to think, 'I wonder if he really loves her that much?' It made Marion even more sympathetic, which Hitch was very concerned about her being."

During the filming, however, those who watched the dailies thought they were seeing way too much of the back of Gavin's head, according to Rebello's book, whereas, under Hitchcock's more sympathetic tutelage, Leigh was exposing unprecedented parts of her anatomy—while achieving her most immortal performance.

Leigh was a good sport, who got a kick out of the director's off-color limericks, puns, and pranks. Kim Novak had arrived on the set of *Vertigo*

on the day of her seminude scene (waking up from her "suicide attempt" in Scottie's apartment), to be greeted by a plucked chicken hanging from her dressing room; her unamused disgust undoubtedly wrecked any second chance Hitchcock might have been giving her. The worst jokes on Leigh seemed to come just moments before her most important scenes—and she found most of them terribly funny.

Hitchcock had one running gag involving Leigh and Mrs. Bates—Norman's mother—as he tested the various mummified skeletons created by the effects department. The director "relished scaring me," Leigh wrote in her memoir. "He experimented with the mother's corpse, using me as his gauge. I would return from lunch, open the door to the dressing room, and propped in my chair would be this hideous monstrosity. The horror in my scream registered on his Richter scale, decided his choice of the Madam."

Hitchcock *cared* about Leigh (and the character she was playing), a concern reflected in the way he helped her out, even *acting* from the sidelines, during the protracted car-driving interludes. In those scenes Marion wears "a troubled, guilty face," according to the script, and the director "completely articulated for me what I was thinking," Leigh recalled. " 'Oh-oh,' he'd say, 'there's your boss. He's watching you with a funny look.' "

The shower stabbing—Leigh's most demanding scene—was scheduled for the week of December 17–23, just before Christmas. "During the day," recalled Leigh, "I was in the throes of being stabbed to death, and at night I was wrapping presents from Santa Claus for the children."

Darkness and light: Mrs. Bates's knife was a retractable prop. The bathroom, at the director's insistence, was lined with "blinding white tiles" and shining fixtures. Plenty of chocolate syrup, in a squeeze bottle, supplied the dark blood. A professional dancer stood by for the more intimate shots (Hitchcock had thrown a publicity lightning bolt when he announced he was planning a "rearview scene of Miss Leigh"), but Leigh herself appeared in most of the shots, wearing flesh-colored moleskin, though it occasionally peeled away under the watery onslaught.

"Hitch and I discussed the implications [of the scene] at great length," remembered Leigh. "Marion had decided to go back to Phoenix, come clean, and take the consequences, so when she stepped into the tub it was as if she were stepping into the baptismal waters. The spray beating down on her was purifying the corruption from her mind, purging the evil from her soul. She was like a virgin again, tranquil, at peace."*

In addition to the scene of Arbogast climbing the stairs to meet Mother,

* The "shower as baptism" was an idea Hitchcock extrapolated from Robert Bloch's novel, where Mary Crane decides "that's what she was going to do right now, take a nice, long, hot shower. Get the dirt off her hide, just as she was going to get the dirt cleaned out of her insides. Come clean, Mary. Come clean as snow."

Saul Bass had storyboarded the shower sequence, sketching the "high shot with the violins, and suddenly the big head with the brass instruments clashing," in Hitchcock's words—the cuts coming staccato and furious, each lasting mere seconds. The montage conjured up complete nudity and savage violence, even though, as the director tirelessly explained in interviews, it was all an illusion—giving "an impression of a knife slashing, as if tearing at the very screen, ripping the film," in the words of the script.

Blond dripping hair, dark gaping mouth, blood spattering everywhere.

It took seven days to collect the individual shots—seventy-eight pieces of film (Hitchcock could stipulate the exact number for interviewers). Pat Hitchcock O'Connell has said that her mother conceived the precise order of the images. Saul Bass later claimed that he was on the set and actually *directed* the scene, though of course he didn't—yet it was possible, if unprovable, that Bass was nearby (it would have been like Hitchcock to keep him around).

The hardest shot was the last one of Marion, dead, "starting with the eye in full frame and gradually easing back to disclose the draped body still clutching the torn curtain, the running water, the entire bathroom," in Leigh's words. They filmed it some twenty times before Hitchcock was satisfied—and then during the postproduction, according to legend, Mrs. Hitchcock detected a blink from the actress, and a freeze shot was ordered.

Norman Bates, of course, was Marion's costar in that scene. But Anthony Perkins had been let off for the week; he was safely on the East Coast when the shower scene was filmed. The knife-wielding Mother was actually a costumed "double"—stuntwoman Margo Epper. Hitchcock deployed slow motion to cover Leigh's breasts—"the slow shots," the director told François Truffaut, then "inserted in the montage so as to give an impression of normal speed." Leigh's lifeless eye was optically enlarged in postproduction, according to Rebello's book, "so that orb appeared to be a perfect 'fit' in the bathtub drain as his camera spiraled down the drain." All of Hitchcock's long experience and magicianship went into these, his most spectacular forty-five seconds of terrifying illusion.

After a Christmas break filming resumed on the second half of the film, with Arbogast going to meet Mother and meeting his maker instead, and Lila stumbling upon Mother in the basement.

Mother herself was a piece of elaborate Hitchcockery. For the film to work, audiences had to think Mother was alive, right up to the climax. Paul Jasmin, an actor friend of Anthony Perkins, offered up his talent for doing an old-lady, Marjorie Main kind of voice; when Mother spoke, sometimes it was Jasmin, sometimes lines that had been looped by actresses Virginia Gregg or Jeanette Nolan (John McIntire's wife). Hitch-

cock spliced and melded the voices together, keeping moviegoers guessing until Mother's actual "appearance" as a mummified corpse in a rocking chair. That bit of stagecraft was even more troublesome than the shower sequence.

"First of all it was very difficult to get Mother to turn," Hilton Green recalled. "A prop man had to be squatting down on the back of his heels, out of sight, turning the chair in unison with the hitting of the light bulb, in sync with the movement of the camera. Trying to get all of that in one precise moment proved extremely tough. Oh, I've never seen Hitch so furious. He looked at the dailies and it wasn't the way he wanted." They had to try it again.

Only the last voice, with Bates sitting forlornly in jail, his mind subsumed by Mother, is entirely female: "Virginia, with probably a little of Jeanette spliced in," according to Jasmin.

Hitchcock paid more attention to Mother, some people involved in the production thought, than to Lila and Sam. Joseph Stefano kept arguing that the stars of Part 2 of *Psycho* deserved "a few seconds of silent memory" at the end, reflecting on what had happened to Marion, but the director was reluctant to stir the ashes. In order to keep the pace moving he cut dialogue Stefano had written for the pair, expressing their feelings of loss.

That may be one defect of *Psycho,* and especially of the final scene (among the last Hitchcock filmed, in late January 1960): the psychiatrist's monologue dissecting the psyche of Norman Bates. The scripted version of that sequence included exteriors outside the police building, a television crew broadcasting news of Bates's arrest, and a patrolman holding crowds back. Inside, an errand boy brings take-out coffee into the office of the Chief of Police. Sam asks Lila, "It's regular, okay?" and Lila answers pointedly, "I could stand something regular," followed by small talk that would give audiences a chance to decompress.

But Hitchcock didn't want the audience of *Psycho* to decompress. He wanted the final crescendo, then a quick coda. He shot the coda sequence virtually as scripted, before deciding to eliminate the atmosphere and small talk and focus purely on the psychiatric explanation of Norman's pathological relationship with his mother. Sam and Lila received only terse cutaways. After Simon Oakland, a smooth, authoritative actor, breezed through his lines, Hitchcock brought two months of photography on *Psycho* to a close on February 1, 1960.

Once filming was completed, the big question was how Hitchcock and *Psycho* would fare with the Production Code. American society was at a turning point, and the country was shaking off the Eisenhower decade and moving on to the bright new era of the Kennedys. Hollywood censorship

was in transition. The director correctly gauged that he had fans and friends among Code officials—chief among them Y. Frank Freeman, who had retained his position as liaison between producers and Code authorities, and Geoffrey Shurlock, the more liberal Englishman who had succeeded Joseph Breen as chief enforcer.

Two scenes involving Janet Leigh really stuck in the craw of the Hollywood censors: most of the focus, in March and April, was on the postcoital opening and the shower stabbing. Censorship officials couldn't decide which was worse: the opening, with Leigh in her undergarments, or the murder of a seemingly nude Leigh in the shower. Hitchcock approached the negotiations, as usual, like a poker game, shuffling and reshuffling his hand.

Right from the moment he recruited her, Leigh recalled, Hitchcock had alerted the actress as to "how he planned all along to manipulate the censors, by deliberately putting things in so bizarre, he could come back to them and say, 'Tsk-tsk. All right, I'll take that out, but you've got to give me this.' He deliberately inserted more questionable shots in the script, knowing quite well they would be unacceptable," she said, "but with each disallowed one he gained leverage in his bargaining for the ones he had really wanted all along."

Hitchcock successfully convinced censors, for example, "that the unprecedented shot and sound of a toilet flushing was a vital component of the plot," in Leigh's words, because when Lila found the scrap of paper it substantiated the crime, and proved that Marion had been at the Bates Motel.* Similarly, he insisted that "Marion's half-clad appearance in the opening shot with her lover Sam was necessary to prove the furtiveness and futility of the affair, which prompted her theft," said Leigh, while "the mixed blood and water gurgling down the drain was the necessary chilling substitute for any blood spurting or bloodstains."

The censorship board seesawed back and forth over the opening, but went unanimously "berserk" over the shower scene, according to Rebello. Yet they couldn't agree among themselves about what it was, exactly, that upset them. "Three censors saw nudity," Rebello reported in his book; "two did not. Memo from Shurlock office to the Hitchcock office: 'Please take out the nudity.' " The censors demanded a second viewing, and *Psycho* was returned to them for additional scrutiny. "Now the three board members who *had* seen nudity the previous day did *not* and the two who did not now *did*."

The rear shot of Leigh, which he had trumpeted so loudly in the press, was Hitchcock's wild card. The overhead shot of "the lifeless body of Janet

* Not quite true, as the film makes clear, for Norman has already admitted that she stayed there.

Leigh, sprawled over the bathtub, her buttocks exposed," in Rebello's words, was preordained as a casualty. "A perfectly heartbreaking shot," recalled Stefano, who championed the shot after seeing an early version of *Psycho,* "so poetic and hurtful." When Hitchcock admitted to Stefano that he was dropping the shot to mollify the censors, the writer was infuriated.

Hitchcock ultimately charmed the Production Code officials, and wore them down. His final maneuver was volunteering to reshoot the opening if he could leave the shower sequence alone—adding the stipulation that the censors had to show up on the set for the reshoot because he was confused as to how to satisfy their objections. The story—perhaps apocryphal—is that the reshoot was scheduled, but the censors never materialized, so nothing was changed. "And," script supervisor Marshal Schlom said, "they finally agreed they didn't see the nudity in the shower sequence which, of course, was there all the time."

The Production Code, in the end, voted its approval, and Paramount held its breath for the Catholic Church. The Legion of Decency issued a B—"Morally objectionable in part for all"—which was as low as could be tolerated. But in deference to the Code, the Legion had stopped short of condemning *Psycho,* and so the Legion's rating amounted to another victory for Hitchcock.

While the censorship battle was raging, George Tomasini did his brilliant editing, and Bernard Herrmann composed what many regard as his quintessential score. Herrmann's frenetically paced all-strings orchestration— what one critic called "screaming violins" and another "pure ice water"—would set the all-time standard in film music. The main *Psycho* theme is "repeated so often and at such musically strong points that it seems to be not only a point of departure but a point of return as well," according to film music scholar Royal S. Brown. The musical backing went beyond any previous Hitchcock theme "in its array of jarringly dissonant chords, the bitonality of which reflects on the film's ultimate narrative theme."

Although the director originally intended the shower scene to be one of his silent short stories, he changed his mind after hearing the piercing music. So Marion's ordeal would begin with "an extremely high-pitched string passage," in the words of film scholar James Naremore, "punctuated by Marion's screams and a series of notes that are like whistles," abruptly shifting, after Mother has stopped stabbing and fled, "into a loud but slow sequence of bass chords in a minor key." Only after Mother leaves the room does the music fade away, as a staring Marion slides down the wall. The final shot of her lifeless eye is complemented only by the natural noises of running water and a drain gurgling.

* * *

While the film was being edited and scored, Hitchcock convened a series of meetings in Lew Wasserman's office to plan the publicity, advertising, and release strategy for *Psycho*.

It was a campaign Hitchcock had really begun *before* the filming, making a series of provocative statements about the intentional shocker he had planned—complete with nudity, bloodshed, and transvestism—and then closing the *Psycho* set to journalists.

This created an aura of supersecrecy that extended even to the cast members. According to Vera Miles, the ensemble actually had to raise their right hands and swear not to divulge the plot twists of the film. That Hitchcock actually took such self-serving pains was unlikely, as was the rumor that the director bought up all copies of the book in Los Angeles. *Psycho* was a popular novel that hasn't gone out of print since its original publication.

One thing Hitchcock *did* buy was the book's original cover design, from artist Tony Palladino, ordering the poster to be modeled after the book jacket. (Since early in his career, Hitchcock, who started out in design, had consulted on his titles and advertising, but this was the first time he was able to dictate the style. Harold Adler, who worked with Saul Bass on the title sequence—"nervous, balletic horizontal and vertical bars that expanded and contracted in mirror-image patterns," in Stephen Rebello's words—noticed that Hitchcock's office "contained more art books and current magazines on graphics than I owned.")

Having agreed to direct the film for a deferred salary, Hitchcock was a major investor in—and co-owner of—*Psycho*. At one of the early advertising and publicity meetings, Barney Balaban objected to Hitchcock's promotional ideas, insisting they would never work, but Wasserman flourished Hitchcock's contract, reminding Balaban of the director's rights.

All his life Hitchcock had been a student of publicity; now he could take all the lessons he had been learning since Islington—lessons he had mastered with his television series—and apply them to *Psycho*. He hired his witty amanuensis James Allardice to write the *Alfred Hitchcock Presents*–type trailers, with the director himself offering a guided tour of the Bates Motel, lingering in the bathroom, flushing the toilet, and rolling his eyes.

"All tidied up," Hitchcock says ruefully. "The bathroom. Oh, they've cleaned all this up now. Big difference. You should have seen the blood. The whole, the whole place was, well, it's too horrible to describe. Dreadful. And I tell you a very important clue was found here [pointing to the toilet]. Down there. Well, the murderer, you see, crept in here very silently—of course, the shower was on, there was no sound, and uh . . ."

At which point, the director whips the curtain aside, and Bernard Herrmann's screeching violins are heard. There crouches an undressed blonde (not Janet Leigh, but the accommodating Vera Miles in a wig) emitting a bloodcurdling scream. It was one of the world's great trailers.

With the exception of the Selznick productions, Hitchcock had never enjoyed the big promotional and advertising budgets that came with studio affiliation. That was a continual gripe about his deal with Warner Bros.; Paramount was better, but some of his Paramount films—like *Vertigo*—received surprisingly modest press attention during filming, and only average budget support upon release. Now, with Paramount keeping to the shadows, Hitchcock had the opportunity to mastermind a film's release as never before.

It was Hitchcock himself who made the unprecedented decision to exclude critics from advance showings (supposedly to prevent them from giving away the ending in reviews), and to advertise, "No one . . . BUT NO ONE . . . will be admitted to the theater after the start of each performance." As Rebello points out in his book, the latter gambit was not unique (Paramount had tried the same angle with *Vertigo*), but it never worked as well as with *Psycho*.

Exhibitors were forced to comply. Publicity kits advised theater owners how to handle long lines and surging crowds, and cautioned them, in a recording from Hitchcock himself, "to close your house curtains over the screen after the end-titles of the picture, and keep the theater dark for half a minute. During these thirty seconds of stygian blackness, the suspense of *Psycho* is indelibly engraved in the mind of the audience, later to be discussed among gaping friends and relations. You will then bring up houselights of a greenish hue, and shine spotlights of this ominous hue across the faces of your departing patrons."

The postproduction gloss and release plans were then left to trusted subordinates as the Hitchcocks embarked on a two-month global vacation. They departed on the *President Cleveland* on April 3 for Honolulu, and from there traveled to Tokyo, Hong Kong, Singapore, Sydney, Rome, Paris, and London, as usual mingling publicity with pleasure.

In Tokyo, he later told Andy Warhol, he was escorted by an "extremely sedate" Japanese representative to a press club and steak dinner. Afterward they trooped upstairs, where Hitchcock had the kind of accidental encounter with undressed women that he also had been mastering since Islington days. He wasn't expecting pornography: "Awful films . . . American ones, French ones . . . and then [after the films] they had two live girls sticking a brush between their 'legs' and writing on white paper in Japanese characters."

*　　*　　*

The Hitchcocks wouldn't return to Hollywood until mid-June, just before the national opening of *Psycho*. It was Lew Wasserman who urged booking the film into hundreds of theaters directly following its weeklong prerelease liftoff at two New York City showcases, the De Mille and the Baronet, and the Hollywood Theater in Los Angeles. As Wasserman had hoped, box-office records were shattered first at the deluxe theaters, and then at neighborhood venues across the nation, before reviews and controversy could catch up with the film.

Despite controversy everywhere (British censors, for example, gave the film an "X"), *Psycho* set new attendance records around the world, grossing over $9 million in the United States and another $6 million overseas. In 1960 that remarkable figure was second only to *Ben-Hur*—and since that film's budget was $11 million, *Psycho* was really the year's most profitable film. (Hitchcock always insisted that he had never envisioned such moneymaking—for him, a "secondary consideration" to making the film.)

Psycho became a genuine phenomenon. Letters to the *New York Times* debated whether the film was "morbid" and "sickening," or "superb" and "truly avant-garde." There were "faintings. Walkouts. Repeat visits. Boycotts. Angry phone calls and letters," wrote Stephen Rebello. "Talk of banning the film rang from church pulpits and psychiatrist's offices."

There was every manner of critical response, including a handful—like Wanda Hale of the *New York Daily News*—who immediately embraced the film (giving it four stars). More common was the kind of backlash handed out by Dwight Macdonald in *Esquire,* who vehemently diagnosed *Psycho* as "a reflection of a most unpleasant mind, a mean, sly, sadistic little mind," or Robert Hatch in the *Nation,* who was "offended and disgusted."

Other critics, unable to make up their minds, had to see the film more than once and vote both ways. *Time* thought it was "gruesome," a heavy-handed "creak-and-shriek movie," but by 1965 was praising another film, Roman Polanski's *Repulsion,* as in "the classic style of *Psycho*." Similarly, Bosley Crowther of the *New York Times,* who had been qualified in his reaction to Hitchcock's films for over two decades, initially described *Psycho* as unsubtle and even "old-fashioned"; but the controversy over the film led him, as he had done with *Lifeboat* almost twenty years earlier, to reappraise the Hitchcock film in a Sunday piece—this time upgrading his opinion (*Psycho* was now "fascinating" and "provocative"). By the end of the year, the *New York Times* critic had decided *Psycho* was among the year's Ten Best—"bold," "expert," and "sophisticated."

One perceptive assessment came from V. F. Perkins, writing in England's *Oxford Opinion*. Reacting to *Sight and Sound*'s verdict that *Psycho* was "a very minor work," Perkins disagreed, and prescribed repeated viewings to prove his thesis. "The first time it is only a splendid entertainment, a

'very minor film' in fact," Perkins wrote. "But when one can no longer be distracted from the characters by an irrelevant 'mystery' *Psycho* becomes immeasurably rewarding as well as much more thrilling." Perkins went on to praise the "spectacularly brilliant" acting and "layers of tension" in the film, concluding that the subject matter was "fit only for a tragedian. And that is what Hitchcock finally shows himself to be."

Up to that time no film boasted as many return viewings. *Psycho* capped ten years of sustained creativity for Hitchcock. And, along with his other 1950s films that crisscrossed a dangerous land, it showed him to be an American tragedian indeed—tragedy delivered, as always, with a wink.

CITIZEN OF THE WORLD

SIXTEEN
1960–1964

Once, standing in the middle of a square in Copenhagen, the director heard a siren blaring and spotted an ambulance heading straight for him. The ambulance screeched to a halt, and out jumped a man, crying, "Autograph, please!" Hitchcock scrawled his autograph, the man jumped back into the ambulance, and off it went, siren blaring. "I don't know if the autograph was for the patient or the driver," he mused later.

Another time, stepping off a plane in Tel Aviv and heading down an escalator, Hitchcock was spotted instantly, and the whole airport seemed to pause and look up at him, showering him with applause as he descended. "That was very nice," he admitted.

When he traveled to Tahiti for a vacation, choosing such a remote place partly in order to escape his fame, even children recognized him, clustering around him on the beach. When he toured the Vatican, the Papal Guards standing around quietly hummed his television theme song.

It can be said without exaggeration that by 1960 thanks to the boost from *Alfred Hitchcock Presents* and *Psycho,* the short, portly film director was indeed a citizen of the world.

* * *

Psycho was nominated for four Academy Awards: Joseph Hurley, Robert Clatworthy, and George Milo for Best Black-and-White Art Direction and Set Decoration; John L. Russell for Best Cinematography; Janet Leigh for Best Supporting Actress; and Hitchcock for Best Director.*

The favorite that year, with ten nominations, was Billy Wilder's *The Apartment*. Wilder was at the peak of his reputation and enjoyed widespread industry support whenever he was nominated, attracting votes from both the Writers and Directors Guild memberships. The controversy over writing credits for *The Man Who Knew Too Much* (a story that had become common knowledge in the Writers Guild) no doubt hurt Hitchcock at Oscar time, even at this high point of his career; but he was probably hurt more, ironically, by his proud refusal to take a writing credit. Wilder's unique cachet came from being a writer *and* director. (Like Hitchcock, he also produced his films.) Hitchcock certainly could have claimed to have cowritten *Psycho,* but on principle he didn't.

Hitchcock admired the cynical, sophisticated Wilder as much as any director, always privately screening the latest Wilder film. He may even have voted for Wilder himself. Philip K. Scheuer wrote a sympathetic piece in the *Los Angeles Times,* trying to spark an underdog campaign: If Hitchcock won Best Director, he mused, all Hollywood would be shocked, and it would be "not so much for *Psycho* as to atone for having left the Master at the post the four previous times."

On April 17, 1961, Mr. and Mrs. Hitchcock sat up front at the Academy Awards ceremony at the Santa Monica Civic Auditorium. Alas, there were no surprises during the evening: not a single *Psycho* nominee went home with an Oscar. That night the Best Set Decoration and Best Editing honors went to *The Apartment*, and the Best Script, Best Director, and Best Picture Oscars went to one man—Billy Wilder.**

Psycho would be Hitchcock's last Best Director nomination. In his offices at Paramount and later at Universal, an increasingly crowded wall featured his many international awards, plaques, and trophies—including five certificates of Best Director nomination. He would point out the latter to visitors and shake his head ruefully, saying, "Always a bridesmaid, never a bride." The statue is just a fancy doorstop anyway, he'd note, adding, "The studios run those things." But his joking, close friends say, masked a deep private disappointment.

He said little publicly about the Oscars. Once, when a BBC interviewer asked him directly if he was disappointed at having never received the Best

* Among the spectacular omissions: Anthony Perkins, scenarist Joseph Stefano, editor George Tomasini, and composer Bernard Herrmann.

** I. A. L. Diamond shared the Best Script Oscar with Wilder.

Director prize, he replied, "We're on dangerous ground here. I won't talk about myself," and quickly changed the subject.

"Oscars aren't the end-all of our business," John Ford once crustily told an interviewer who pursued the same line of questioning. "The award those of us in this profession treasure most highly is the New York Film Critics Award. And those of us in the directing end treasure the Directors Guild of America Award. These are eminently fair."

But Hitchcock, despite being named a "finalist" and "quarterly winner" on occasion, never won Best Director from the Directors Guild of America, either. He was nominated a record *eight* times from 1948 to 1960: for *Strangers on a Train, Dial M for Murder, Rear Window, The Man Who Knew Too Much, The Trouble with Harry, Vertigo, North by Northwest,* and *Psycho.** And he fared little better with the New York Film Critics, who, after honoring him for *The Lady Vanishes,* shut him out of further awards for the rest of his career.

Almost by default it had fallen to the French to lionize Hitchcock, and the young cineastes of *Cahiers du Cinéma* and *Positif* had been turning up the volume. Hitchcock's incomparable run of films during the 1950s, climaxed by *Vertigo, North by Northwest,* and *Psycho,* made him an exemplar of "auteurism"—their theory that described directors as the true authors of the consistent ideas and themes of their films. The incessant French "propaganda" (Truffaut's words) gradually took root in America among the younger critics.

Foremost among the young American auteurists was Andrew Sarris, not only the U.S. correspondent for *Cahiers du Cinéma,* but a critic for New York's alternative weekly, the *Village Voice.* Writing in the *Voice,* Sarris compared Hitchcock to Orson Welles, and hailed *Psycho* as the "first American movie since *Touch of Evil* to stand in the same creative rank as the great European films." In 1962 Sarris went further, comparing Hitchcock to a French filmmaker widely regarded as an artist, and boldly stating that he was "prepared to stake my critical reputation, such as it is, on the proposition that Alfred Hitchcock is artistically superior to Robert Bresson by every criterion of excellence." The lionization spread, and would give Hitchcock solace even as the Oscar receded from his grasp.

"What will you do for an encore?" Lew Wasserman is said to have asked after *Psycho* earned controversy, acclaim, and the greatest box office a Hitchcock film ever enjoyed.

* Hitchcock's eight DGA nominations during this period tied with Billy Wilder—who finally won for *The Apartment.*

In fact, for nearly a year after *Psycho* was released, Hitchcock himself didn't know the answer. He busied himself in the second half of 1960 supervising the publicity and distribution of *Psycho* outside the United States, dubbing the film in several languages (a process that Hitchcock, unlike most Hollywood directors, personally oversaw), giving numerous interviews to foreign outlets, and touring England and the Continent for five weeks in the fall.

Hitchcock's only production meetings in the fall concerned the coming 1960–61 season of *Alfred Hitchcock Presents,* for which he was slated to direct two episodes, "Mrs. Bixby and the Colonel's Coat" and "The Horseplayer." (The latter was a piece of black comedy, with Claude Rains as a church priest who has two problems: a leaky roof that costs too much to fix, and a parishioner whose luck at betting on horses improves with prayer.)

The man who introduced his television shows with such flair was also becoming a toastmaster at public events unrelated to film. In the early and mid-1960s Hitchcock was invited to address college students at graduation ceremonies, businessmen's clubs, organizations of writers and editors, even presidential inaugural events. Each time an invitation was accepted, James Allardice would troop into the office to discuss Hitchcock's speech; the more important occasions usually demanded several drafts and revisions, with the director going over the lines as meticulously as if he were preparing a scene in a Hitchcock film.

These were time-consuming distractions, as were the protracted negotiations with Paramount that would enable Hitchcock to move his offices to Universal later in 1962. The biggest, best bungalow was being set aside for him on the Universal lot, including offices for his design staff and a writer; adjoining rooms with editing equipment; a separate office for his assistant, Peggy Robertson; a kitchen, cocktail lounge, and bathroom attached to his spacious private office; a dining room; and a projection room seating eight.

With several film projects competing for his attention, Hitchcock spread the assortment out on his desk like travel brochures, trying to decide where he wanted to go. In midsummer he talked with Ernest Lehman about an original story called "Blind Man," which would have starred Jimmy Stewart as a blind jazz pianist (referred to in script notes as "Jimmy Shearing," a combination of Stewart and pianist George Shearing, on whom the character was loosely based). The pianist regains his sight after an operation in which he obtains the eyes of a murdered man, and then develops strange memories and "disturbing feelings towards a man he meets who proves to be the murderer of his doctor," according to film historian Greg Garrett. "The musician and the murderer play a game of cat and mouse that leads them both aboard an ocean liner. Disneyland was also to be an important setting," as Garrett pointed out, "a vastly expanded carnival in the tradition of *Strangers on a Train.*"

Among Hitchcock's "crazy ideas" for "Blind Man," according to Lehman, were a scene where "the heavy throws acid in Jimmy's face and dies, blinding him for life, and he winds up just where he started"; and an opera with Maria Callas witnessing a murder while onstage singing—the note she is singing would then become "a scream which the audience applauds," in Lehman's words.

Lehman signed a contract for the project in December 1960, but it didn't help when the overcommitted Stewart backed out, leaving the blind pianist to become "a David Niven type." Or when Walt Disney publicly declared that he wouldn't let his children watch *Psycho*, "nor would he allow Hitchcock to make a movie about Disneyland," according to Garrett. The death blow, however, came the day Lehman appeared at Hitchcock's office and announced he wished to quit, finding himself unable to solve the plot problems. Canceling "Blind Man," Hitchcock vowed furiously never to work with the capricious Lehman again.

He told the press he might film *Trap for a Solitary Man,* a French play by M. Robert Thomas about a wife who disappears while on holiday in the French Alps—then resurfaces only to find her husband doesn't recognize her. In interviews he insisted that he might still film *No Bail for the Judge,* with Audrey Hepburn and Laurence Harvey.

Novels were still the most reliable source of potential material, and Hitchcock considered several as the encore to *Psycho*. One was Paul Stanton's *Village of Stars,* a cold war suspense story that leaves the pilot of a plane stranded in the air, with an atom bomb rigged to detonate at a low altitude.

Ultimately, though, Hitchcock chose *Marnie,* the latest novel by the English writer Winston Graham. Though Graham was best known as the author of the Poldark series about Cornish life in the eighteenth century, *Marnie* was a contemporary English story about a frigid kleptomaniac who is blackmailed into marriage by a man she has robbed. To cure her, he tries everything from forcing himself on her during their honeymoon to subjecting her to psychoanalysis, which traces the roots of her unhappiness to a sordid childhood.

Reviewers had praised the book for its psychological suspense from a woman's point of view; *Marnie* offered Hitchcock the chance for an informal remake of *Spellbound,* reversing the doctor-patient roles so that the man's unconditional love cures the woman. This time Hitchcock wouldn't have to contend with David O. Selznick. Until he embraced *Marnie* it had been unclear whether Hitchcock would direct another film for Paramount, but a skeptical Lew Wasserman accepted *Marnie* largely in order to finalize the move to Universal—reassured by Hitchcock's promise that the Winston Graham story would be Grace Kelly's comeback.

Hitchcock had been in touch with Princess Grace in Monaco. He told her about *Marnie,* though he didn't want her to read the book; he thought

it would be better to send her a detailed treatment, with the story already transplanted to America. With Stefano, who had done such a splendid job on *Psycho*, and Kelly to bring her charm and energy to the character of Marnie, Hitchcock at first envisioned a movie laced with more black comedy than the final film suggests.

For three months, starting on March 1, 1961, Hitchcock met daily with Stefano, trying to develop an Americanized version of *Marnie*, even dummying in dialogue for certain scenes to give Kelly "the best possible explanation of the movie she was coming back to," in Stefano's words.

As Kelly was from Philadelphia (like Stefano), that and other East Coast cities became the story's new terrain. In the book there are two male cousins competing for Marnie's affections, but Hitchcock wanted to make the film more a story of two women fighting over the same man. So the script invented a beautiful sister-in-law suspicious of Marnie. Marnie's affinity for horses comes from the novel (she rides them, Hitchcock slyly informed one interviewer, "as though she were cleansing herself"), as does the very English foxhunt. Partial to the pastime (there's also a foxhunt in *The Farmer's Wife*), Hitchcock planned to preserve Marnie's love of horses, while shifting the foxhunt to Philadelphia high society.

But Hitchcock and Stefano were still working in June, when word arrived from Monaco that 1962 was an impossible year for Grace Kelly. If Hitchcock waited for her, Kelly assured him, she would gladly appear in *Marnie* in 1963 or 1964. Hitchcock was willing to wait, and since nothing else was ready, he and Stefano parted amicably, and the partial draft of *Marnie* went into the files. The Hitchcocks took a longer-than-usual trip to New York later that month, meeting up with the director's sister, Nellie, and his cousin Teresa, who were in from London; the family took in the hot-ticket musicals together, and paid a visit to Washington, D.C.

In July, he took longer than usual for the only episode of *Alfred Hitchcock Presents* he would direct for the 1961–62 season—and the last of the half-hour shows he directed. "Bang! You're Dead" was a taut suspense story about a boy (Billy Mumy) who roams his neighborhood with a seeming cap pistol, which nobody realizes is a real gun loaded with bullets. As he did now and then, Hitchcock introduced this episode with an atypical lead-in, gravely intoning a warning about the danger of keeping firearms in the home.

Throughout the summer, he sifted through other stories. One novel he considered, interestingly, was *The Mind Thing*, a work of science fiction by Fredric Brown about an alien visiting earth who is able to possess living creatures. At the end, the alien assaults the hero "in an isolated cabin [with] a variety of animals that the alien is using as weapons, ranging from a bull to a dive-bombing chicken hawk," as Bill Krohn recounted in *Hitchcock at Work*. "Clearly," wrote Krohn, "Hitchcock wanted to make a film

in which Nature declares war on the human race." From *Village of Stars* to *Marnie* to *The Mind Thing:* the diversity bespoke a remarkable range of imagination for a man in his sixties. Hitchcock refused to ossify or be pigeonholed.

It wasn't until nearly August 1962, some eighteen months after he had completed *Psycho,* that Hitchcock settled on a new project, one with noticeable similarities to *The Mind Thing.* As usual, the choice was triggered by a number of factors, including coincidence: he had read in the newspapers of an August 1961 incident in Capatolla, California, when thousands of seabirds swarmed down from the sky, wreaking havoc—and that reminded him of a Daphne du Maurier novella.

Du Maurier's *The Birds* was first published in *Good Housekeeping* in 1952; Hitchcock had reprinted it in his 1959 anthology, *My Favorites in Suspense.* Du Maurier's moody novella concerned an epidemic of murderous bird attacks on a quiet Cornish village, as told from the point of view of a peasant farmer, his wife, and their children.

Jamaica Inn, Rebecca, and now *The Birds:* for the third time Hitchcock would film a du Maurier story, although he was sensitive to that fact, and insisted in later interviews that he had no special affection for the author. Indeed, as Hitchcock told François Truffaut, in a comment that he asked be excised from their published interviews, "I only read the story once. . . . I couldn't tell you what it was about today." Yet there was something that drew him to du Maurier's fiction, even as he felt compelled to slight it in public.

Once he had decided, he moved rapidly to recruit a writer. Stefano had taken other work, so Hitchcock met first with James Kennaway, who had written the acclaimed novel *Tunes of Glory,* made into a picture in 1960 with an Oscar-nominated script. "I see this film done in only one way," Kennaway told him. "You should never see a bird." Out! Hitchcock also interviewed Wendell Mayes, who had written Otto Preminger and Billy Wilder films, but didn't feel right about Mayes either. So he offered the job to Ray Bradbury, now established in science fiction but also a regular writer for *Alfred Hitchcock Presents.* (Bradbury had also written John Huston's acclaimed film of *Moby-Dick.*) Bradbury was enthusiastic about the du Maurier story, but when he told the director he couldn't start right away—ironically, he was busy with assignments for *Alfred Hitchcock Presents*—the impatient Hitchcock decided he couldn't steal him away from Joan Harrison.

Instead he picked a New York novelist who had less screen experience than any of them. Evan Hunter's first novel, 1954's acclaimed *The Blackboard Jungle,* had been made into a compelling film, though the Oscar-nominated screenplay was written by director Richard Brooks. Hunter had also sold a short story to *Alfred Hitchcock Presents,* "Vicious Circle,"

which was broadcast in April of 1957—though Hunter didn't write the teleplay either, and Hitchcock himself didn't direct the episode. It wasn't until 1959 that Hunter was hired by Joan Harrison to work directly for the series, adapting a Robert Turner story called "Appointment at Eleven."

"Appointment at Eleven" was about a man sitting in a bar, nursing a drink, and watching the clock. As the story unfolds we learn that his father is scheduled to be executed in a nearby penitentiary, at 11 P.M. Hitchcock didn't direct this episode, but it spoke to his opposition to capital punishment, and the host abandoned his customary tongue-in-cheek lead-in to introduce the show by saying the story's importance spoke for itself.

Hunter had dealt exclusively with Joan Harrison until the late summer of 1959, when the author came to California to adapt his novel *Strangers When We Meet* into a film for Kirk Douglas and Kim Novak, and to develop *87th Precinct,* based on his detective series under the nom de plume Ed McBain, as an NBC television series. By this time Hunter had a solid reputation.

Harrison invited Hunter and his wife over to the Revue screening room at Universal to view "Appointment at Eleven," and afterward they were escorted onto a soundstage where the host of *Alfred Hitchcock Presents* was directing a scene for "The Crystal Trench." The scene required an actor to lie beneath a block of ice, Hunter recalled; "the ice was resting on a narrow wooden ditch into which the actor had crawled. Another actor was supposed to rub his gloved hand over the ice, until the face of the actor below was gradually revealed."

Hunter was not the first or last writer to feel that his wife was an asset to his résumé where Hitchcock was concerned. Anita Hunter was then "all of twenty-nine years old, an attractive, russet-haired woman with green eyes, a warm smile, and a smart New York Jewish Girl sense of humor," Hunter recalled in *Me and Hitch*. Hitchcock "took an immediate liking to her, which was somewhat surprising considering his predilection for glacial blondes," and proceeded to ignore Hunter, guiding his wife around, "explaining pieces of equipment, introducing her to his cinematographer and his assistant director."

The crew was beginning "to get a bit frantic," noted Hunter, "because the huge block of ice seemed to be melting under the glare of the lights and Hitch still showed no intention of wanting to direct the scene. Finally, after the plaintive words, 'Mr. Hitchcock, sir, we're ready to go now sir' had been repeated a half dozen times, he cordially bade us goodbye."

Flash forward two years, to late August 1961, when Hunter received a telephone call from his agent asking if he'd be interested in adapting Daphne du Maurier's novella into a Hitchcock film. "Why me?" the author wondered. Had Hitchcock finally remembered him, or his charming

wife, Anita? "I told my agent I would have to read the story before I decided," Hunter recalled. "In truth, for the chance to work with Alfred Hitchcock on a feature film, I would have agreed to do a screenplay based on the Bronx telephone book."

After reading *The Birds,* Hunter told his agent he would like to take a shot at it, and Hitchcock phoned him to talk that very day. They had several phone conversations discussing ideas before he left the East Coast for California. Hunter signed a contract for seven weeks; Hitchcock warned that it might turn into a three- or four-month stint, and perhaps he should bring his lovely wife and children to California for the duration.

If Hitchcock read the Daphne du Maurier novella only once, his memory for the arc and details of the story was remarkable. Besides the pattern of birds "attacking, retreating and massing to attack again," in the words of Bill Krohn in *Hitchcock at Work,* and the "vivid descriptions of bird attacks," several key incidents in the film are lifted directly from du Maurier. These include the discovery of a neighbor found dead with his eyes pecked out, and the climax, with the family barricaded inside a house as the birds rally their final attack—followed by "the complete absence of explanation for the catastrophe," in Krohn's words.

But the script also deviated radically from the book, and once again the first order of business was "transatlantic"—moving the story and characters from Cornwall to an America familiar to Hitchcock. The farming village in southwest England would become the seaside hamlet of Bodega Bay, sixty miles north of San Francisco.*

Characteristically, this location was established before the writer signed his contract, and one of the first things Evan Hunter did was tour San Francisco and Bodega Bay, with Hitchcock as his guide. As usual, the reality inspired the director: a small lake ringed by a road gave him staging ideas, and the local schoolhouse prompted the imagining of a particular frightening scene, with a swarm of birds pursuing young, screaming children.

The pair then launched into daily script conferences, with rituals that Hitchcock had been following for almost forty years. "During our first exploratory week of getting to know each other and our individual styles," Hunter recalled in *Me and Hitch,* "I arrived in time for breakfast with him in the morning and we worked together till noon, when he broke for lunch."

* Bodega Bay was actually three municipalities—Bodega, Bodega Bay, and Bodega Head—rolled into one for the film. "I was making *Shadow of a Doubt* when the local Chamber of Commerce brought me on a rather undignified outing up here," Hitchcock recalled in one interview, "and I remembered it as being thoroughly beautiful in a haunting kind of way, just the place for this story."

"Tell me the story so far . . . ," Hitchcock always began.

"Hitch shot down two ideas I'd brought out with me. The first of these was to add a murder mystery to the basic premise of birds attacking humans, an idea I still like. But Hitch felt this would muddy the waters and rob suspense from the real story we wanted to tell. The second was about a new schoolteacher who provokes the scorn of the locals when unexplained attacks start shortly after her arrival in town. In the eventual movie, the schoolteacher survived (but not for long) in the presence of Annie Hayworth. In the movie, the town's suspicion and anger surfaces in the Tides Restaurant scene. But Hitch did not want a schoolteacher for his lead; he needed someone more sophisticated and glamorous."

Someone like . . .

"Well, Grace, of course," the director sighed. "But she's in Monaco, isn't she? Being a princess. And Cary [Grant] for the man, of course, whoever or whatever the character may turn out to be. But why should I give Cary fifty per cent of the movie? The only stars in this movie are the birds and me." Almost as an afterthought, Hitchcock cast a wicked glance at his writer and added, "And you, of course, Evan."

In lieu of the princess, Hitchcock studied the field of up-and-coming actresses. On September 26 he tested Pamela Tiffin, who had been adorable in Billy Wilder's *One, Two, Three*. He also screened footage of Yvette Mimieux, Carol Lynley, Sandra Dee. It wasn't until October 16—still only a month after the script had started—that the director sat in a projection room and watched 16 mm footage of an obscure ash-blond model.

So obscure that the director's appointment book misspelled her name: "Hedron," instead of Hedren. Born Nathalie Hedren in Minnesota, the model went by the professional name of "Tippi"—an affectionate Swedish nickname meaning "little girl." Tippi Hedren had established herself first with the Eileen Ford agency in New York before moving to California to try acting; once married, now divorced, she was the mother of a little girl, four-year-old Melanie—who would grow up to be the actress Melanie Griffith.

The Hitchcocks had seen Hedren in a commercial for Pet Milk on the *Today* show—nothing much, but it had a cute moment where Tippi whirled to acknowledge a boy's wolf whistle. Hitchcock asked MCA to track her down.

The agency contacted the model, asking her to come in for an interview, and bring along photographs and film footage of herself. "No one told her who exactly was interested," wrote John Russell Taylor, "though the office was full of pictures of Hitchcock." After a few days passed (while Hitchcock digested the photographs and footage), she came again, met with Herman Citron, and was offered a seven-year, five-hundred-dollar-weekly personal contract with Hitchcock. No mention was made of *The*

Birds; she signed the contract, assuming it was for *Alfred Hitchcock Presents.*

Still, Hedren didn't meet Hitchcock until lunch on October 24. Typically, the director kept the young model in the dark with idle talk of travel, food, clothing—"almost everything but" why he had engaged Hedren, as Taylor wrote. What he was doing was sizing her up. He liked her attentive face, her sophisticated manner, her statuesque looks. "Hitch always liked women who behaved like well-bred ladies," explained Robert Boyle. "Tippi generated that quality. He was quite taken by the way she walked."

Besides Hedren, at least two other young actresses boasted current contracts with Hitchcock: Joanna Moore and Claire Griswold. They all were put through the same regimen: wardrobe fittings, hair makeovers, long discursive lunches with the director, and tutorial viewings of his best-known films. Each made camera tests, reenacting scenes from Hitchcock films. Moore appeared in only a couple of Hitchcock TV shows before leaving to make her mark independently, while Griswold stayed on salary, simultaneous with Hedren.

For several weeks, as Hedren underwent this crash course, she had no idea that she was being considered as the possible leading lady of *The Birds.* She watched *Rebecca, Notorious,* and *To Catch a Thief;* then, at home with the Hitchcocks (Alma was usually in the room, observing but saying little, according to Hedren), she rehearsed the very same scenes Hitchcock had famously directed with Joan Fontaine, Ingrid Bergman, and Grace Kelly. The week before Thanksgiving, Hitchcock scheduled an expensive color screen test. Martin Balsam flew out from New York to be her leading man for the occasion, and Robert Burks was behind the camera for the three-day shoot, which cost in the neighborhood of thirty thousand dollars.

Still no one mentioned *The Birds,* until one night Hedren was invited to join the Hitchcocks and Lew Wasserman for dinner at Chasen's. There, Hitchcock presented her with a pin with "three golden birds with seed pearls, in flight" and asked her to play Melanie, the young woman whose visit to Bodega Bay coincides with the murderous onslaught of birds. "Well, I cried," Hedren recalled, "and Alma, Hitch's wife, cried—even Lew Wasserman had tears rolling down his face. It was a lovely moment."

All the script sessions began with Hitchcock adopting the manner of a boy hearing installments of a favorite bedtime story. He would come into the office every morning, recalled Evan Hunter, "and he would sit down in a big wing-back chair, and his feet scarcely touching the floor, and he was always dressed in a very dark blue suit and a tie and a white shirt and black shoes and black socks. And he would sit there and he would say,

'Tell me the story so far.' And in the beginning that was easy. But as it went on and I had to tell him the story from the beginning, it got to be a rather lengthy exercise and he would pick holes in the story so far, and say: 'Why does she do this? Why does she do that?' "

Musing about the lead characters, they jokingly dubbed them "Cary" and "Grace," or "the Girl"; though they eventually renamed Hedren's character Melanie, after Hedren's daughter. Hitchcock had initially sketched Melanie in as a San Francisco socialite who visits "a strange town which is attacked by birds shortly after her arrival," in Hunter's words. There she encounters "Cary," who lives in the strange town, as does "Cary"'s ex-girlfriend, a schoolteacher, a tad frowsy, still pining for him—just as Barbara Bel Geddes pines for James Stewart in *Vertigo*.

Why does Melanie decide to visit the strange town? As Hunter tells it, after their daily lunch he had the habit of taking a walk while Hitchcock napped. One day on his digestive stroll the writer came up with the idea for which he took "full credit—or blame, as the case may be." *The Birds*, the writer decided, ought to begin with "Cary" and "Grace" meeting cute, so the audience is lulled by a seeming "screwball comedy that gradually turns into stark terror."

Some critics think a number of Hitchcock films—from *The 39 Steps* to *Strangers on a Train* to *North by Northwest*—qualify as almost-screwball comedies. Didn't Hunter's idea prove that Hitchcock still had the knack for picking writers who reached for the spot that itched?

Before Hunter ever met Tippi Hedren, Hitchcock was already shaping scenes for the newcomer, his latest "personal star." As Melanie, Hedren would make her entrance precisely the way she had in her TV commercial, crossing a San Francisco street and coolly acknowledging a wolf whistle. Then, on a visit to a pet shop, Melanie encounters "Cary"—renamed Mitch Brenner in the film. A lawyer, Mitch enters the shop to order love-birds for his young sister; Melanie pretends to be a clerk knowledgeable about birds. Although he recognizes her as a socialite notorious for prac-tical jokes, he plays along—a light scene, until a caged bird escapes and foreshadows the strange events to come.

After putting the bird back in its cage, Mitch tells Melanie, "I'm put-ting you back in your gilded cage, Melanie Daniels," a sentence Hitchcock said he added "during the shooting because I felt it added to her charac-terization as a wealthy, shallow playgirl"—and because it corresponded with the later scene where she is trapped by gulls in a glass telephone booth. "Here the human beings are in cages," Hitchcock told François Truffaut, "and the birds are on the outside. When I shoot something like that, I hardly think the public is likely to notice it."

Each time they met to discuss the story, Hitchcock "would ask ques-tions about it, and I would try to answer them, and then accommodate

them," recalled Hunter. "In this way, he edited the script before any of it was actually written, commenting on character development and comic effect in these early scenes of the film. We knew that once the bird attacks started, the audience was ours. But would we be able to keep them sitting still while a Meeting Cute romance between an impetuous young woman and a somewhat staid San Francisco lawyer developed?"

How staid? Why was "a man of Mitch Brenner's age," in Hunter's words, "still effectively living at home with his mother and kid sister"? To explain this away, the script noted his father's recent death, and then Annie (the frowsy schoolteacher) described "the mother's possessive behavior in a heart-to-heart talk with Melanie, who at this point in the script seemed to be in more danger from Lydia Brenner than from any of the still quiescent birds."

From the outset, Melanie was the main, subjective character through whose eyes audiences would experience the horror of *The Birds,* and from the outset Hitchcock and Hunter struggled with her characterization. Neither the director ("True, I wasn't too keen on the girl's story") nor the writer ("I realize now that I was uncomfortable with the character of Melanie Daniels from minute one") ever felt quite satisfied with their creation.

Also from the outset, they debated the impetus behind the bird attacks. In du Maurier's story there is a "complete absence of explanation," in Bill Krohn's words; as the novella ends, the birds are regrouping for another strike. Hunter initially favored some attempt at a logical connection. "Do the townspeople have something to hide?" the writer mused, seeking the solution. "Is there a guilty secret here? Do they see this stranger [Melanie] as a messenger of revenge? Are the birds an instrument of punishment for their guilt?"

As usual, provocative ambiguity enticed Hitchcock more than stark explanation. But he brooded about the options. He and Hunter toyed with blaming the attacks on a Russian conspiracy (a dash of Cold War humor), or on ornithological revenge for human abuse. Eventually Hitchcock set the issue aside, leaving it for Hunter to grapple with as he wrote the first draft, without supervision, in his rented home.

The director left Hunter alone but phoned Mrs. Hunter every day, "and chatted with her on the phone, asking if she'd yet found a tennis partner or a good hairdresser," according to the writer. "Never once did he ask her how the screenplay was coming along. Nor on our frequent social outings did he ever ask me how things were progressing."

For Halloween, Hitchcock brought over signed copies of his new book, *Alfred Hitchcock's Haunted Houseful,* for the three young Hunter sons. The Hitchcocks and the Hunters often socialized after hours, and the two couples went to the racetrack together, at the director's behest. (He tried

to hand them each a hundred-dollar bill for betting; taken aback, the Hunters declined.) The two couples dined out together, and more than once dined in at Bellagio Road, sharing Saturday night supper around the kitchen table.

"After he'd had too much wine," Hunter recalled, Hitchcock "would take Anita's hand between both of his and pat it, and tell her he was nothing but a big fat slob." But Hitchcock and Hunter seemed to be enjoying their collaboration. And after he handed in his first draft, Hitchcock, in the glow of the moment, said perhaps Hunter could also write his next film—*Marnie*.

Reviewing Hunter's draft in a five-page letter dated November 30, 1962, Hitchcock listed his key concerns: Melanie and Mitch were still "insufficiently characterized," and Hunter had written too many "no-scene scenes." The director explained: "By this, I mean that the little sequence that might have narrative value but in itself is undramatic. It very obviously lacks shape and it doesn't within itself have a climax as a scene on the stage might."

Deemed expendable, and removed from the script, were "a scene between Melanie and her father in his newspaper office; two scenes in Bodega Bay, where Melanie goes to buy some temporary overnight clothes and later tries to rent a room at a fully booked hotel; and lastly, a scene inside the local church, where she runs into Mitch again," in Hunter's words.

"In a long and masterfully detailed paragraph," according to Hunter, "Hitch went on to suggest how we could begin foreshadowing the bird attacks from the very beginning of the film. Lastly, he wondered whether we shouldn't start thinking about giving the script a stronger thematic structure, and wrote, 'I'm sure we are going to be asked again, especially by the morons, "Why are they doing it?" ' "

In mid-December, Hunter handed in revised pages, including a new scene between Melanie and Mitch which at last spelled out a possible reason for the bird attacks. The scene began, in lighthearted fashion, with Melanie proposing "that this all must have started with a malcontent sparrow preaching revolution," according to Hunter. After they both laugh at her little joke, an awkward silence descends. After more flat jokes, "there is the chill of horror to Melanie's words when she says those finches came down that chimney in fury—as if they wanted everyone in the house *dead*," in Hunter's words.

Then, suddenly frightened, Melanie and Mitch fall into an embrace, kissing fiercely. "From what I understand," wrote Hunter, "Hitch shot this scene. But he never used it." He "suppressed" it, the director himself explained in later interviews, because it crucially slowed the momentum of

the story. Its absence ("sorely felt") became one of the writer's eventual grudges against the film.

Hitchcock responded to Hunter's revised draft with four pages of notes, just before Christmas. Mindful of the approaching holidays, he joked, "Perhaps it would be nicer if you took this letter and put it under the tree and then on Christmas Eve you could pull it out and say, 'Oo look, a present from Hitch.' P.S. People are still asking, 'Why did the birds do it?' "

Then Mr. and Mrs. Hitchcock flew to St. Moritz for the holidays, where Marlene Dietrich was celebrating her birthday onstage at Badrutt's Palace, and there the Hitchcocks greeted the star of *Stage Fright* after the show.

Hunter's final draft, arriving in mid-January, tightened the dialogue and proposed several new scenes, including the conversation between Melanie and the schoolteacher about Mitch and his mother, and the scene in the Tides Restaurant, where the owner and patrons—Melanie, but also a traveling salesman, an amateur bird expert named Mrs. Bundy, a barstool drunk, and a mother and her children made increasingly jittery—discuss the growing crisis. This last, thought Hunter, was probably his best-written scene.

Melanie is on the phone to her father in San Francisco, trying to describe the attacks. "I don't know, Daddy," she says in exasperation, "is there a difference between crows and blackbirds?"

"There is very definitely a difference, Miss," interrupts Mrs. Bundy, standing nearby, who has overheard.*

Mrs. Bundy lights a cigarette, then delivers an exegesis. She tosses off the Latin names of the species, while insisting that—in her opinion—neither crows nor blackbirds would boast "sufficient intelligence" to launch a massed attack, simply because their brain pans are not big enough.

"Ornithology happens to be my avocation," Mrs. Bundy explains. "Birds are not aggressive creatures, Miss. They bring beauty to the world. It is mankind—"

"Sam! Three southern fried chicken. Baked potatoes on all of them!" a shouting waitress interjects in the background.

Melanie hangs up on her father, and dials Mitch.

"It is mankind rather," Mrs. Bundy continues huffily, "who insists upon making it difficult for life to exist upon this planet. Now if it were not for birds—"

Over her shoulder Melanie says she doesn't care what Mrs. Bundy says. Birds are attacking.

"Impossible!" scoffs Mrs. Bundy.

* It strengthens the Hitchcockian flavor of the scene that Mrs. Bundy is elderly, inexplicably British-accented, and memorably acted by Ethel Griffies, a screen veteran since her debut in an Adrian Brunel silent picture.

"It's the end of the world!" cries the drunk at the end of the bar (the character, Hitchcock told Truffaut, who was "straight out of an O'Casey play").

Still grappling to satisfy Hitchcock, Hunter included in his final draft a broadcast Mitch hears on the car radio toward the end of the film, as he prepares their escape. "It appears that the bird attacks come in waves with long intervals between. The reason for this does not seem clear yet." Hunter had thus explained the attacks by pointing out that they were *inexplicable,* but in Hitchcock parlance, he had also hit the nail on the head—articulating the obvious.

Hunter suggested the final shots: birds swarming, scenes of wholesale destruction with victims lying everywhere, frightened faces peering out of windows. Melanie, Mitch, Lydia (Mitch's mother), and Cathy (Mitch's young sister) slip into their convertible and race down the road, just ahead of hundreds of birds. "Mitch?" asks Cathy, tears streaming down her face, as the car pulls slightly ahead, "will they be in San Francisco when we get there?" Then the script called for one last attack on the cloth-topped car as they race away.

One day, as Evan Hunter waited outside Hitchcock's office for their daily meeting, the door popped open, and out Hitchcock darted to greet a woman standing down the hall, "in her favorite one or two poses from the movie," in Hunter's words. Coming back, the director matter-of-factly informed Hunter that the new arrival was their Melanie. Hunter stared.

"Who is she?"

Tippi Hedren.

"What is she?"

She had done hair commercials on television, he said.

"Do you think she has the range to play the comic scenes that we need at the beginning and then the terror at the end?"

"Trust me, Evan."

Hunter had to trust him, and so did Lew Wasserman, but Hedren most of all had to put her faith in Hitchcock—and his confidence in her gave her confidence in herself.

Ever since the days of *The Lodger* and *Blackmail,* Hitchcock had been shaping films around favorite actresses and launching leading ladies. More recently, Vera Miles, in spite of disappointments, had served him well on television and in two feature films. With *The Trouble with Harry,* he had discovered a star in Shirley MacLaine, and in his three films with Grace Kelly he had sealed her image forever in the public mind. He had confidence in his star-making instincts.

Everything still began, for him, with the look of the performer—which had to be the look of the character in his mind. As he had done for nearly forty years, he started with Hedren by making her over. In the first months

of 1962 he convened a series of meetings to define Melanie's hair, makeup, and wardrobe, followed by a parade of camera tests to judge the result. In consultation with Edith Head and Rita Riggs (for wardrobe), and Virginia Darcy and Howard Smit (hair and makeup), Hitchcock selected Melanie's jewelry (a bracelet, ring, and single strand of baby pearls), her clothing (the mink coat and soft, cool green suit that Hitchcock thought hinted at a personal reticence), and her hairdo (swept back off her face).

The actress was subordinate to the look, and the look would inform the acting; Hitchcock would see to the rest. He said very little to Hedren *about* acting during *The Birds,* she recalled later, though he did suggest that Melanie might be compared to the character Tallulah Bankhead had played in *Lifeboat*—each "starting out as a jaded sophisticate and becoming more natural and humane in the course of her physical ordeal."

"Melanie Daniels is *his* character," she reflected later. Hitchcock "gives his actors very little leeway. He'll listen, but he has a very definite plan in mind as to how he wants his characters to act. With me, it was understandable, because I was not an actress of stature."

As part of her learner's permit, Hedren was expected to attend many of the production meetings from which an actress might normally be excluded. During January and February Hitchcock met almost daily with his staff, and Hedren, silently sitting in, was made to feel like an integral part of the process. The actress said she "probably learned in three years what it would have taken me fifteen years to learn otherwise."

Hitchcock counted on her learning, but he also counted on the expertise of his trusted cameraman Robert Burks, editor George Tomasini, and production designer Robert Boyle. The scenes involving hundreds of birds offered a unique technical challenge, and the unsung heroes of the film would include dozens of bird handlers and Universal scenic artists.

Among the key assistants to Robert Boyle were storyboard artist Harold Michaelson, who later became a top art director in his own right, and Albert Whitlock, a British-born matte painter who had sketched backgrounds for Hitchcock films in London back in the 1930s, before ending up at Universal in Hollywood. Michaelson created key storyboards based on Boyle's scene and compositional sketches, while Whitlock's atmospheric matte paintings would supply the aerial and establishing views of *The Birds*.

After a series of failed experiments with mechanical birds, Hitchcock decided to use real birds as much as possible, superimposing them on film with the actors. Hitchcock's crew undertook a frenzied campaign to round up birds of various species by contacting professional handlers. Trainer Ray Berwick, a former writer for TV's *Lassie* and a trainer for *Birdman of Alcatraz,* supervised the care and training (when possible) of thousands of gulls, ravens, crows, sparrows, finches, and buntings. The real birds were used for foregrounds, and dummy birds and optical illusion for the mass scenes and distance shots.

Hitchcock now hired Ub Iwerks, a legendary animator and photographic expert associated with Walt Disney since the early 1920s, to oversee the optical printing for *The Birds*—using a sophisticated sodium vapor process Iwerks had devised. Iwerks, who had received a special Oscar in 1959 for his advancements in optical printing, would be the film's "Special Photographic Advisor."

Bernard Herrmann was still on call, but might have been disappointed to learn that his role would be circumscribed. Hitchcock had the radical idea of giving the film a sound track composed only of natural bird sounds, with no recognizable music. He wanted the birdcalls and noises performed on an advanced instrument he first encountered on Berlin radio in the late 1920s—the electroacoustic Trautonium, invented by one Dr. Friedrich Trautwein and developed further by Oskar Sala. Sala and Remi Gassmann, a Trautonium composer, lived in Germany, and they agreed to collaborate with Herrmann on a unique sound track mingling natural and electronic bird effects.

By late January, the square-jawed Australian Rod Taylor and New York stage–trained Suzanne Pleshette had been cast as Mitch and Annie. Hitchcock settled on Taylor as his reasonable Cary Grant substitute after watching *The Time Machine;* Pleshette had caught his eye in her first Universal films. (A personable underachiever, Pleshette would later find lasting success on television.)

Before there was even a script, Hitchock had zeroed in on Jessica Tandy to play Mitch's overprotective mother. Born in London, Tandy had been admired in England for her classical acting, before her career took off in America; she had played a version of Blanche du Bois in the Los Angeles one-act forerunner of *A Streetcar Named Desire*—directed by her husband, Hitchcock's longtime friend Hume Cronyn. Tandy made only infrequent screen appearances, but *The Birds* would benefit from her performance—icy and forbidding initially, though her character grows sympathetic as the film progresses.

An unknown lead actress. Thousands of real and animated birds. No music. At $3.3 million, his biggest budget yet. Hitchcock had often set extraordinary goals for himself: placing one film entirely within the confines of a small boat, making *Rope* entirely in uninterrupted sequential takes, taking a chance on 3-D and quality television, taking a stab at neorealism with *The Wrong Man,* pushing the envelope with a low-budget shocker like *Psycho.* But *The Birds* was his grandest experiment yet.

As the start date grew near, there was a palpable excitement among Hitchcock's staff, but also an undercurrent of uncertainty and apprehension. Only Hitchcock was confident of his leading lady. No one could say whether all the birds and visual effects would merge credibly on-screen. Everyone understood that Hitchcock was reaching for something unusual, something daunting—something even he was groping to express.

"It was a little scary for all of us and probably for him," production designer Boyle recalled. "The antagonists were birds, you know, it wasn't a distant country that's trying to do us in, it wasn't a murderer or a rapist. It was something . . . strange. And it was hard to get hold of."

Hitchcock kept telling the staff they weren't making a science fiction film. So one day matte artist Whitlock, feeling "a bit shaky" about the project, asked the director, "Well, what are we making, Hitch?" "And he didn't know," Whitlock recalled.

In later interviews Hitchcock, maintained that he never lost sleep over the daunting special effects required for *The Birds*. "Never dared face them [the special effects challenges] at the outset," the director said later. "Otherwise the film never would have been made. I played it by ear."

What continued to worry him was the script—and how to conclude the story.

Assessing the various drafts, film scholar Bill Krohn reached a conclusion that speaks to the whole course of Hitchcock's career. After Evan Hunter finished his version, according to Krohn, *The Birds* was plunged into an elaborate production process, which resulted in a flurry of pink-sheet additions, modifications, and—most extraordinarily—a significant amount of last-minute improvisation by Hitchcock on the set. The changes occurred not only in the dialogue but, in scene after scene, in visual ideas that increasingly focused Melanie's subjective viewpoint. By the end, the basic draft was altered so substantially that it had evolved into what amounted to an informal final draft—for which only one man could claim true authorship.

After Hunter finished and moved on, Hitchcock continued to hone the script, a process that was perfectly natural to him. He solicited input from his staff and other writers, among them Hume Cronyn, whose wife now had a role in the film. Cronyn wrote the director, suggesting that there was "still room for improvement in the development and relationship of the principal characters. The implied arrogance, silliness, and selfishness of the early Melanie may need heightening, so that the change to consideration, responsibility, and maturity are more marked—and more enduring."

Another old acquaintance Hitchcock consulted was V. S. Pritchett—a struggling writer when they first knew each other in England, now a distinguished man of letters, teaching at the University of California, Berkeley. Pritchett came to discuss the story over dinner several times, in both Bel Air and Santa Cruz, and during filming Hitchcock had him ceremoniously chauffeured to the set. A fan of Pritchett's short fiction, Hitchcock liked to tease the author that what his acclaimed story "The Wheelbarrow" really needed was a murder ("which left me aghast," admitted Pritchett). If Pritchett added a murder, Hitchcock said, he might even film it.

In private letters to his family, Pritchett noted that Hitchcock reminded him of "a ripe Victoria plum endowed with the gift of speech," but the celebrated author was flattered to be courted by the director. "My father always spoke of Hitchcock with enormous fondness," recalled his son Oliver Pritchett. Quietly, Hitchcock employed the author to write a "destructive criticism" (in Pritchett's words) of Hunter's script for *The Birds*; as Pritchett later reported to his son, "I did so and he [Hitchcock] seems to think it's useful."

As usual, however, Hitchcock took only what resonated with his instincts. For example, Pritchett praised the scene where President Kennedy's State of the Union address is overheard on the radio as Mitch is boarding up the Brenner house for the climactic bird attack. In the speech, Kennedy extols America's role as "the great defender of freedom in its hour of maximum danger." Although Pritchett appreciated the Cold War irony of this passage, Hitchcock eliminated it during final editing.

Pritchett expressed concern that the "two different stories—in this case a light comedy and a terror tale" might not "weld together," but the author's suggestion to "link the two stories more closely" by turning Melanie into "someone who causes disasters because of her 'wildness,' having even killed someone inadvertently with one of her practical jokes," was rejected. In fact, it was pointedly countered in Hunter's favorite scene—when the hysterical mother advances on Melanie at the restaurant: "They say that when you came here, this started. I think you're the cause of this. I think you're evil. Evil!"

Whereupon Melanie slaps the hysterical mother, once and for all eliminating from *The Birds* any hint of "Melanie-as-jinx," in Bill Krohn's phrase.

Pritchett's most important influence, though, may have been in calling for an ending different from Hunter's. Pritchett deserved "the credit (or blame) for urging that the film end on a gloomier note, with the people in the car looking backwards at the village with fear, rather than forward to the hope of escape," thought Hunter. Hunter resented this as well as the other script changes made after his departure—whether by a celebrated author or persons anonymous. "Hitch allowed his actors outrageous liberties with what I had written," Hunter complained in one interview; "he juggled scenes and cut scenes and even added one scene."

The wholesale addition was inserted during the children's blindman's buff birthday party. In a brief interlude, Mitch and Melanie wander up the sand dunes carrying a martini pitcher and two glasses. They pour drinks for themselves, and Melanie opens up to Mitch, revealing that she has never known a mother's love; her own mother, she explains, abandoned her at the age of eleven to run off "with some hotel man in the east."

Hunter didn't learn about this vignette until it was about to be filmed,

and when he did he was infuriated, excoriating it as a "pointless piece of exposition." Not realizing that the scene was a kind of suite of Hitchcock tropes—blindman's buff, martinis, a rotten mother, an absentee father— he suspected that the ideas must have originated with Pritchett. Wondering who could have written such "inane dialogue," he complained vociferously, but Hitchcock shot the new pages anyway.

Only later did Hunter learn that "Hitchcock himself had written it." Besides the tropes, the scene exhibited the kind of depth of characterization and literary symmetry that Hitchcock always strove for in a script; it gave Melanie, whose father dotes on her, a heartless mother—in contrast with Mitch, whose father recently has died, and whose mother is clinging. Not insignificantly, the new dialogue also gave Melanie a rare sympathetic moment in the film.

Years later, reflecting on his collaboration with Hitchcock, Hunter promoted a version of events that emphasized the director's desperate need to be recognized for his artistry. Hunter recalled Hitchcock boasting that "he was entering the Golden Age of his creativity. He told me *The Birds* would be his crowning achievement." Hunter's very hiring lent "respectability" to that aim, the writer believed, because he was the author of *The Blackboard Jungle*—which, Hitchcock must have noticed, "had received serious critical appraisal."*

Hitchcock tried in interviews "to justify" *The Birds* "as a great work of art," Hunter insisted, claiming that "the Girl" represented "complacency" and that "people like Melanie Daniels tend to behave without any kind of responsibility, and to ignore the more serious aspects of life. Such people are unaware of the catastrophe that surrounds us all. *The Birds* basically symbolized the more serious aspects of life." Such claims should be regarded as so much rot—a showman's con, according to Hunter. "I think Hitch is putting on the world when he pretends there is anything meaningful about *The Birds*," the writer countered in his own interviews. "We were trying to scare the hell out of people. Period."

After their relationship collapsed with *Marnie,* Hunter gave many interviews and then wrote a book in which he criticized the final form of *The Birds,* blaming Hitchcock for its supposed gaping faults. The writer admitted being offended by Hitchcock's equivocal comments—recycled in *Me and Hitch*—that Hunter may not have been "the ideal screenwriter [for *The Birds*]. You look around, you pick a writer, hoping for the best." He joined the faction of Hitchcock collaborators who couldn't accept the

* Yet Hitchcock had always sought out "serious" writers. A short list of such previous Hitchcock collaborators would include Sean O'Casey, John Galsworthy, John Steinbeck, Thornton Wilder, Ben Hecht, James Bridie, and Maxwell Anderson.

director's ultimate power over their work, becoming one of its loudest, most persistent voices.

As a follow-up to *Psycho,* as his most expensive film ever, and as Hitchcock's first film for Universal, *The Birds* had to succeed wildly to succeed at all.

When filming began in the Bay Area on March 5, Hitchcock found himself "pouring myself into 'the Girl,' " as he later told François Truffaut—and careening about in an unaccustomed "state of distress." He paged through the script at night after work, finding "deficiencies" at every turn. "This emotional siege that I had," he said later, "seemed to spark an extra creative thing in me."

At times, he said, he almost felt "lost." Time and again Hitchcock second-guessed his meticulous planning and went "off on a tangent," in production designer Robert Boyle's words.

For the film to succeed wildly, Tippi Hedren also had to succeed wildly. In later interviews, the director boasted with apparent arrogance that he had mapped out her "every expression—never a wasted one." But Rod Taylor, Suzanne Pleshette, and Jessica Tandy were seasoned players who could fend for themselves; Hedren, on the other hand, needed to be molded. She has never denied that he walked her through every expression.

As often happened, Hitchcock's technical achievements overshadowed his actors' performances—and Hedren's debut comes off as a remarkable triumph. In some scenes, she was surprisingly deft; in others, her acting was a master filmmaker's illusion. The scenes that really stick with people—those where Melanie suffers bird attacks, or fights them off—are pure cinema, pure Hitchcockery.

For example, the first gull that swoops down on Melanie as her boat docks at Bodega Bay. The boat docking was shot in the studio, against a blue screen over which a rear projection plate was later printed. For the long shots a gull was trained to land on Hedren's head, but for the close-ups the crew had planted a dummy seagull up in the rafters, attached to a wire on a pulley—and when the dummy gull was released it zoomed toward the actress. A pump hidden in her dress riffled her hair, and a trickle of blood was released by similar means.

Live birds were deployed for many scenes, however, and the winged creatures could be ruthless. The actors often had anchovies or ground meat smeared on their hands to attract the birds, and everyone suffered bites and scratches. According to trainer Ray Berwick, on the worst days a dozen crew members were sent to the hospital.

Hedren definitely had the worst of it, and the worst of the worst was the memorable sequence, in which the birds pour down the Brenner house

chimney and assault Melanie and the Brenner family. This was filmed at Universal in the first week of April, after cast and crew had returned from three weeks of location work around San Francisco and Bodega Bay. The location footage had revolved almost entirely around the actors; the birds shot on location were all trained, and then the swarms that appear on-screen were superimposed later by Ub Iwerks and his staff.

The live birds were trickiest on the soundstages, and the crescendo attack on the Brenner house, with birds funneling down the chimney, called for the largest number. The bird noises and sounds of fluttering wings would be amplified later, but on the set, as in silent film days, Hitchcock had a drummer and microphone making "a loud drum roll to help [the actors] react."

The living-room set had to be enclosed by a plastic wall so the birds couldn't escape. Opaque cages held hundreds of finches, sparrows, and other birds atop the prop chimney. "On cue," Kyle B. Counts reported in his definitive chronicle of the production, "trap doors were opened in the cages and, spotting the light below, the birds flew down the chimney. Air hoses handled by grips kept them from roosting."*

After surviving their ordeal, the exhausted Brenner family falls asleep. Melanie thinks she hears a peeping noise and heads upstairs, opening doors and looking for birds. Ambushed in the attic by a dive-bombing mass of birds, she stumbles against the door, trapping herself inside. The winged creatures envelop her fiercely, clawing and biting her.

Hedren had assumed that the bulk of the birds in this scene would be mechanical or optical creations, but Hitchcock decided at the last minute that the terror had to be real—for Melanie and the audience. It was one of the last scenes on the schedule, and the actress wasn't warned that she would be facing live gulls until the very morning of shooting.

Another special set had been built for the scene, surrounded by a huge cage to keep the birds from soaring into the rafters. Inside the cage were a crew of propmen, wearing thick leather gloves up to their elbows to protect themselves. Although the gulls were trained, they quickly learned to avoid Hedren, and had to be hurled at her by the propmen. Air jets kept the birds from flying into the camera lens. This extraordinary scene, which occupies roughly one minute of screen time, took an entire week to shoot, and it became a grueling physical ordeal for all involved—but especially for the leading lady.

Midweek during the filming of this scene Cary Grant visited the set, taking a break from Universal's *That Touch of Mink*. After watching a few

* Because Hitchcock wanted the effect of hundreds and hundreds of birds, Ub Iwerks later optically multiplied the number of birds in the living-room scene through quadruple printing.

takes, Grant told Hedren, "You're one brave lady." (The actress mused later: "I then considered the possibility that maybe this was one of the reasons why Hitchcock had chosen an unknown for the part.")

She had to be brave, for things were getting worse. "By Thursday," Hedren remembered, "I was noticeably nervous. By Friday they had me down on the floor with the birds tied loosely to me with elastic bands which were attached through the peck-hole in my dress. Well, one of the birds clawed my eye and that did it. I just sat and cried."

To be fair, even Hedren has said this week appeared to be an ordeal for Hitchcock, too. He sat in his office and wouldn't come out "until we were absolutely ready to shoot," according to Hedren; the very prospect of the scene was sobering, and the actual filming nightmarish.

And in the film the attic scene is followed by a sensitive moment. After rescuing her from the birds, Mitch brings Melanie downstairs and lays her on the couch. When she wakes up she recoils reflexively, hysterically batting away invisible birds until she is forced down and comforted by Mitch. Hitchcock said in interviews that this detail was inspired by his personal memories of feeling alone at Claridge's in London during World War II—hearing bombs fall, and shouts and noises, and not knowing what to do.

Following the final attack of the birds, the Brenners escape the house—a key scene with the principals that remained to be shot. Hitchcock was still pondering the film's ending. Should the birds keep up their attack? Why were the birds attacking? Why? The moron millions would want some answer, and he hated tidy answers.

It was during the last days of principal photography that Hitchcock decided to scrap Evan Hunter's ending, and excise several pages of dialogue and storyboarded visuals in favor of a single lengthy shot that would show Melanie and the Brenners slowly driving away in their sports car, crossing a bird-infested landscape as dawn breaks overhead. No final pursuit by the birds; no implication the attacks have spread—or have ended.

The future was left ambiguous. To Hunter Hitchcock's ending was a betrayal, yet its message was faithful to du Maurier's novella. More important, it was true to Hitchcock—the kind of open ending the director had always preferred, salvaging his characters without offering any false reassurance that evil had been entirely vanquished.

"Emotionally speaking," Hitchcock later said in defense of the controversial ending, "the movie was already over for the audience. The additional scenes would have been playing while everyone was leaving their seats and walking up the aisles."

The ending was also a technical accomplishment, weaving the actors together seamlessly with a horde of live, dummy, and optical-illusion birds, against a background which is one of Albert Whitlock's finest matte paintings. Thirty-two different exposures were required for the film's final

image, which remains stunning—"the most difficult single shot I've ever done," said Hitchcock.

The special-effects sequences, focusing primarily on Tippi Hedren, continued long after the rest of the cast had gone home. These included the scene with Melanie trapped in a telephone booth, assaulted by gulls—almost entirely a blue process shot blended with real and optical birds. The scoring, final optical effects, and other postproduction polishing on *The Birds* would occupy Hitchcock at least until midsummer, after which he had resolved to push ahead with *Marnie*.

Although Hitchcock and Evan Hunter had kidded themselves by calling "the Girl" Grace during their early work on *The Birds*, Hitchcock's next project thoroughly depended on the Princess of Monaco's repeated assurances that she would play the lead. From their very first discussions about *Marnie*, Hitchcock had referred to the character of Marnie as "HSH"—Her Serene Highness.

But Hitchcock made the mistake of announcing Grace Kelly's comeback prematurely, just as *The Birds* got under way on location. According to a March 18 press statement, *Marnie* was expected to begin filming in August on the East Coast, with Kelly in the title role.

In fact, Hitchcock had arranged the schedule to coincide with the royal family's annual summer visit to Philadelphia. Although for years Prince Rainier had opposed his wife's return to acting, now he was widely quoted as saying he would keep the princess company during filming. Prompted "both by concern for his wife's mental health and by his affection and respect for Alfred Hitchcock," according to one Grace Kelly biographer, Rainier approved of *Marnie* and, sensing his wife's equivocation, "kind of pushed her" into the project.

Yet the idea appears to have caught the populace of Monaco by surprise, and the news was met with a national outcry. For someone often described as a peerless manipulator of the press, Hitchcock made his share of blunders over the years, and he contributed to the brouhaha by giving an exclusive interview to London journalist Peter Evans of the *Daily Express* during the filming of *The Birds*, in which he celebrated Kelly's sex appeal as the "finest in the world." In a flood of letters and petitions, the citizens of Monaco protested the prospect of seeing their princess in Hollywood love scenes—not to mention the forcible variety called for in *Marnie*.

To add to the bad timing, Prince Rainier was currently locked in a dispute with France, which regarded Monaco's tax-free luring of French corporations as a violation of the treaty between the two nations. "Grace was going back to the movies, speculated newspapers from Nice to New Mex-

ico, to snub General de Gaulle, to prove Monaco's independence—and to raise much-needed money for her beleaguered husband," according to another Kelly biographer.*

Further complicating matters, Metro-Goldwyn-Mayer then stirred from its slumber and took notice of Kelly's announced comeback. The Princess of Monaco still had unfulfilled commitments on her MGM contract, and the current management wasn't going to stand idly by if the actress came out of retirement for another studio.

The unexpected entanglements and controversy took an emotional toll on Princess Grace, and by early June, according to Rainier's close aide Georges Lukamoski, she was "shocked beyond all measure," sequestered in her room in the palace, and "in grave danger of breaking down."

Soon it was clear that there was only one solution: Princess Grace had to withdraw from her commitment to *Marnie.* "It was heartbreaking for me," the Princess wrote to Hitchcock, explaining her decision. With impressive tact, he wrote back, "Yes, it was sad, wasn't it? . . . Without a doubt, I think you made not only the best decision, but the only decision, to put the project aside at this time. After all, it was only a movie."

His letter included "a small tape recording" that Hitchcock made especially for Prince Rainier, which he advised playing "privately. It is not for all ears." Its contents have never been divulged, but he told François Truffaut that Rainier "likes risqué stories so I sent him one on tape."

Whatever public face Hitchcock put on this setback, privately he was miserable. Kelly was lost to him, and Hollywood, forever. *Marnie* was the last film he would ever write for a real or imaginary "HSH." Evan Hunter was sent back to New York while Hitchcock pondered his next move. And *Marnie* was tabled, at least until the fall.

The same week that Grace Kelly resigned from *Marnie,* a letter arrived from François Truffaut, proposing to conduct a lengthy tape-recorded interview with Hitchcock, covering his entire career—the transcript of which would be published as a book, simultaneously in France and the United States. Although by now Hitchcock had been interviewed prolifically in newspapers and magazines, this was the first such comprehensive approach from a serious critic.

Truffaut's book project had its immediate impetus in an April 1962 trip to New York, where he attended a luncheon with Bosley Crowther, still the first-string reviewer of the *New York Times,* and Herman Weinberg,

* In fact, the Princess's announced eight-hundred-thousand-dollar salary had been earmarked for a state foundation for young athletes and deprived children.

an associate in the film department of the Museum of Modern Art. In conversation with these and other well-placed New Yorkers, Truffaut was "astounded by the American critics' deep disregard of Hitchcock's work," according to Truffaut biographers Antoine de Baecque and Serge Toubiana. "For them, he was merely a good technician, a cynical and clever 'master of suspense,' a 'moneymaker.' "

With Helen Scott, the press director of the French Film Office in New York, Truffaut developed the goal, as he stated in his book proposal, of changing "the idea Americans have of Hitchcock." His own notion was that Hitchcock deliberately disguised his art and genius with a self-deprecating public image, intended to ingratiate himself with audiences and the studios. In his book proposal, Truffaut suggested that Hitchcock was probably the "biggest liar in the world"—a Hitchcockian character haunted by his secret fears of being revealed.

"The man who excels at filming fear is himself a very fearful person," Truffaut theorized at the outset of the eventual book, "and I suspect that this trait of his personality has a direct bearing on his success. Throughout his entire career he has felt the need to protect himself from the actors, producers and technicians who, insofar as their slightest lapse or whim may jeopardize the integrity of his work, all represent as many hazards to a director. How better to defend oneself than to become the director no actor will question, to become one's own producer, and to know more about technique than technicians?"

His June 2, 1963, letter to Hitchcock was more diplomatic. Truffaut reminded his subject of their previous encounters, and of the fact that he himself was now a filmmaker whose *Les Quatre Cents Coups, Tirez sur le Pianiste,* and *Jules et Jim* had been "fairly well-received" by critics. Truffaut said his contacts with the foreign press and "particularly in New York" had taught him "that on the whole there is too often a superficial approach to your achievements. On the other hand, the propaganda we initiated in the *Cahiers du Cinéma,* while effective in France, carried no weight in America, because the arguments were over-intellectual. . . .

"Moreover," the letter continued, "now that I am a filmmaker, my admiration has, if anything, increased, strengthened by additional bases for appreciation. I've seen each of your pictures five or six times, now observing them primarily from the angle of construction."

Truffaut explained that he wanted to examine Hitchcock's life and career in detail, chronicling every period of activity, the cause and circumstances surrounding "the birth of each film, the development and construction of the scenario, problems of direction in respect to each picture, the situation of a film within the body of your work" and "your own evaluation of a film's artistic and commercial results, in relation to your intentions."

The edited manuscript would then be submitted to Hitchcock for his

approval and changes, and the final text prefaced by an introduction penned by Truffaut, "the essence of which can be summed up as follows: If cinema was to be deprived of sound overnight, and were once again to become a silent art, many directors would be doomed to unemployment. But among the survivors, the towering figure would be Alfred Hitchcock, who would inevitably be acknowledged as the best director in the world."

The amount of time Hitchcock would need to set aside was seven to ten days, Truffaut estimated; he hoped to arrange the sessions before September 15, when he was slated to embark on his next production, an adaptation of Ray Bradbury's *Fahrenheit 451.*

At the apogee of his fame and success, Hitchcock nonetheless had fresh cause to feel underappreciated and buffeted about by the exigencies of the film business, and on the heels of Princess Grace's defection from *Marnie,* he was all the more profoundly touched and flattered by Truffaut's overture. Inside of a week, he sent a night cable to Paris, declaring, "Your letter made me cry and how grateful I am to receive such a tribute from you." Hitchcock told Truffaut he needed to wait until he was through with the effects work for *The Birds,* but thought they might be able to get together at the end of August.

As he launched postproduction of *The Birds* in July, Hitchcock also devoted himself to preparing and shooting the one-hour "I Saw the Whole Thing"—the last television show he would ever direct, and the only one he made for the new *Alfred Hitchcock Hour.*

"I Saw the Whole Thing" was adapted from a story by Henry Cecil, the author of *No Bail for the Judge.* John Forsythe played an attorney defending himself against a felony hit-and-run charge. In the opening sequence, five different witnesses observe a car braking after hitting a motorcyclist, and each person's reaction to the incident is reconstructed in a short-story flashback. Forsythe's baffling decision to represent himself in court, while refusing to testify on his own behalf, is explained by a twist ending: he has been sheltering his wife, the actual driver, who was on her way to the hospital, pregnant with their child. "Although well-constructed," wrote J. L. Kuhns in his authoritative article on Hitchcock's TV work, the episode "lacks stylistic interest. The director was undoubtedly putting all his effort into *The Birds.*"

Not quite: *The Birds* had already been turned over to the special-effects wizards. What was preoccupying Hitchcock was *Marnie.* With a partial continuity under his belt and studio money already invested in the project, he was loath to quit. But who could ever replace Grace Kelly?

One candidate was Claire Griswold, who received special billing for her small role in "I Saw the Whole Thing." The character she played—a di-

vorcée distraught over having to give up her child for adoption—had psychological frailties reminiscent of Marnie's. Certainly "I Saw the Whole Thing" was a kind of tryout for Griswold: August was full of hair and costume appointments for the young actress, like Tippi Hedren under personal contract to Hitchcock. She looked more like Vera Miles than like Grace Kelly, so the director concentrated on reshaping her look.

Hitchcock also met with Miles, another possible Marnie, and mused about putting her in the part. And of course he saw Hedren nearly every day, having lunch with the actress between stints of dubbing and looping *The Birds*. But he couldn't make up his mind, and he didn't want to resume the script until he had decided on his lead.

François Truffaut and Helen Scott arrived in Hollywood on Sunday, August 12, 1962. Hitchcock, had arranged for them to stay at the Beverly Hills Hotel, though Truffaut later insisted on paying all his own bills, including the expensive lodgings—all except the limousine service that Hitchcock himself arranged. On Monday they plunged into work. In the morning, Truffaut and Scott watched the first rough cut of *The Birds* (still missing many of the optical effects, and with sound effects in place for only the final reel, the attack on the Brenner house). In the afternoon they turned on the tape recorder for the first time, then celebrated the Hitchcocks' sixty-third birthdays in the evening at Perrino's.

The Frenchman had prepared exhaustively, spending three days at the Royal Cinémathèque in Brussels watching all of Hitchcock's English films—including the rare silents, with which he "was ill acquainted," according to his biographers, "and liked only moderately." In spite of his winning smile and elfin looks (Scott dubbed him "Hitchcoquin," a pun meaning "little rascal"), Truffaut was a tough customer who took to heart his role of critical investigator. If necessary, he would extract the interview like a bad tooth.

Scott's excellent English made her involvement essential, for Truffaut's was only passable—like Hitchcock's command of French. Besides, Scott was feminine and charming, and Truffaut rightly anticipated that she would help put Hitchcock at ease. Scott often understood Hitchcock's anecdotes and bawdy jokes when Truffaut did not, but her diligent efforts to interpret and bridge the dialogue led to rushed or awkward translations during the conversations, some of which would survive into the book.

Truffaut had expected Hitchcock to be an elusive liar, an artist guarding precious secrets, a man as furtive and mysterious as his films. Yet the Frenchman learned what the working press already knew: Hitchcock was an articulate, conscious creator (the *New Yorker* "had the ridiculous effrontery," he scoffed at one point, "to say a picture like *North by North-*

west was unconsciously funny"), fundamentally open and truthful about his craft. "Everything happened as Truffaut and Scott had hoped," wrote de Baecque and Toubiana. "Hitchcock was specific, voluble, spirited, and delved willingly into the technical or interpretative details suggested by his interlocutors. He even discussed aspects of his childhood and adolescence, and his ambivalent relationships with actresses."

In spite of his suspicious nature, Truffaut was completely won over. Hitchcock was reaffirmed as his idol—and all hints of the grand, secretive liar disappeared from his introduction.

On August 18 Hitchcock left Los Angeles for London, where he conferred with Bernard Herrmann on the sound track–in–progress for *The Birds*. While overseas he also made an excursion to Paris, where Truffaut arranged a dinner with other Nouvelle Vague filmmakers. He didn't return to Los Angeles until September 11. But the interview talks with Truffaut and the three weeks of travel had reinvigorated him, and now, as he put the finishing touches on *The Birds* and began advance publicity for the film (including the famous portrait sessions with Philippe Halsman for *Life*), Hitchcock was ready to face *Marnie*.

Claire Griswold was still a long-shot contender for his leading lady, and in the fall of 1962 Hitchcock ordered that her hair be redone by experts, her wardrobe reorganized by Edith Head, her skin and makeup refined by beauticians. The actress ate lunch after lunch with the director, who rehearsed her in Grace Kelly's scenes from *Rear Window* and *To Catch a Thief,* first at Bellagio Road and then, at great expense, camera-testing her at the studio. Again and again she was tested, and the Hitchcocks and the production staff pored over the tests.

By November, Hitchcock was still unsure. The director took a day off to travel to Kansas City to attend to cattle shares he owned, while Mrs. Hitchcock traveled with Griswold to Bergdorf Goodman in New York for fresh fittings. The day before Thanksgiving, Hitchcock directed his last tests of Griswold—and by the following Monday he knew, painfully, that she would not be his Marnie.

All along, Tippi Hedren had been waltzing in and out of the office, keeping extremely busy with postproduction and prepublicity chores— and everyone who had seen the partial and advance screenings of *The Birds*, including Mrs. Hitchcock and Lew Wasserman, thought the first-time actress had shown tremendous poise, that she had given a remarkable performance. Everyone liked her personally—and, like Griswold, she was under contract.

Marnie was not so different from Melanie, who also bore a hint of frigidity and an emotionally scarred relationship with a callous mother.

Hitchcock himself had written the scene where Melanie articulates her psychological wounds, and that dialogue could have been written for either of the two films on his mind at the time, *The Birds* and *Marnie*. Hedren had substituted for Princess Grace once before; surely she could do so again. Less ceremoniously than before, Hitchcock told Hedren she would be Marnie—and gave her a hundred-dollar-weekly raise. When she voiced doubts over whether she could "play a part of this size, of this caliber," in her words, "once again Hitch gave me the assurance and never, ever, let me think that I couldn't do it."

Her casting, then, was almost circumstantial. During *The Birds*, no one had noticed any signs that the director was obsessed with his leading lady, that Hitchcock had fallen in love with Hedren—any of the preoccupation that has been alleged in the years since. Nor, as is alleged elsewhere, was there any evidence that he treated her with deliberate cruelty during the first film, though she suffered, in scenes calculated for their harshness and terror, just as Lillian Gish had, under D. W. Griffith, riding the ice floes for *Way Down East*.

The premiere of *The Birds* was still four months away. Evan Hunter came back from New York to work on *Marnie* until Christmas, when the Hitchcocks traveled to Paris and St. Moritz, and then Hunter returned to Universal in January and February for additional script conferences.

But Hunter wasn't the same eager receptacle for Hitchcock's ideas that he had been on *The Birds*. For one thing, the writer was disturbed by signs of what he considered artistic hubris. Taking his cue from François Truffaut, Hitchcock was now tape-recording all their script sessions, which were sometimes mysteriously attended by other people—Robert Boyle or Tippi Hedren. And the director didn't begin every meeting by asking Hunter, "Now, what is our story so far?" Now Hitchcock himself told the story, over and over.

But Hunter had been recruited at the very genesis of *The Birds*. He didn't know that Hitchcock had been pondering *Marnie* for two years, and had already developed a partial continuity with Joseph Stefano. The tape recordings attest that Hitchcock was racing ahead of the scriptwriter, dictating shots for scenes as yet unwritten, which Hunter would have little choice but to write just as the director prescribed.

"The film is going to open with a girl, back view, going to a railroad station at Hartford, Connecticut," Hitchcock announced at a February production conference. "At present, I don't know what time of the day we can shoot it because we don't want it full of crowds because it may cover her up. The essential part is that we follow her back view into the station as she goes to the desk or booking office. . . . We go close enough to her

to see the color of her hair, and finally she goes on to the platform down toward the train. And we end up with a CLOSE SHOT on a rather bulky handbag under her arm. So that would constitute the first scene."

But the script sessions were no less prolonged, with Hitchcock's customary anecdotes and digressions, and one day the increasingly weary Hunter interrupted to ask, "Shouldn't we get back to discussing *Marnie?*" The director raised an eyebrow, but said nothing.

After attending an early screening of *The Birds,* Hunter had quietly seethed over the changes Hitchcock had made to his script without his knowledge or approval, and he continued to seethe even after Hitchcock ordered that Hunter's screen credit be enlarged from 25 to 50 percent of the size of the title. Hunter wasn't that easily placated.

Above all, though he professed admiration for Winston Graham's novel, Hunter couldn't bring himself to write the scene from the book where Mark Rutland rapes Marnie after their wedding: "There was only the small pilot light shining in from the bathroom. Perhaps that prevented him from seeing the tears starting from my eyes. In the half-dark he tried to show me what love was, but I was stiff with repulsion and horror, and when at last he took me there seemed to come from my lips a cry of defeat that was nothing to do with physical pain."

It was a key scene for the director, who had spent much of his career fascinated with evil Prince Charmings who kissed sleeping beauties and aroused them to violence and dread—a director who, from *Spellbound* and *The Wrong Man* to *Vertigo* and *Psycho,* had found sex and love at the root of dysfunction. Hitchcock had underlined the scene in the book—and it was critical to his vision of the film.

"When I first read the book," Hunter recalled, the scene "disturbed me enormously." Then "when I [first] came to San Francisco to discuss it with Hitch, I told him that the psychological aspects of this woman really interested me, and I thought I could find out some things about that particular syndrome and we'd do something good with it. I said: But it really bothers me, the scene where he rapes her on their wedding night. He said: We'll talk about it later, don't worry about it. So I did the first draft and I grappled with that."

The grappling persisted throughout their story conferences. "Hitch," Hunter pleaded at another point, "I'm still having trouble with the scene, I don't understand why you want it in the movie. We're going to lose all sympathy for the lead character; no guy who claims to love a woman, [and] sees her cowering in the corner, is going to rape her."

Hitchcock gave Hunter a look: it was *supposed* to be disturbing. With relish, Hitchcock then recounted the scene in crude, excruciating detail, doing "the director's thing with his hands," in Hunter's words, "the way you frame a shot; he brought the camera in on my face that way," con-

cluding with, "Evan, when he sticks it in her, I want that camera right on her face."

Whooaa, thought Hunter.

Returning to New York for the actual writing, Hunter tried to give Hitchcock what he wanted—as well as another option. "I wrote the script two ways," Hunter recalled, "and I gave it my best shot. I wrote the scene where the camera's right on her face and he sticks it in her. And I wrote it as well as I know how to write any rapist. But then I wrote it another way, where he comes to her and says: All right, don't worry, we'll work this out, whatever it is, we'll work it out, I love you. That kind of scene. I wrote my scene on white paper within the body of the script. And I wrote the rape scene on yellow paper outside the script."

Attaching a note to his submission, Hunter said he firmly believed the rape scene was "out of place" in *Marnie,* and hoped Hitchcock would consider his alternative. His script arrived the first week of April; Hitchcock quickly read it, and responded that there was "still a lot of work to be done with it. Unfortunately, I feel that I have gone stale on it, and think it will have to be put aside for a little while until I can decide what to do about it. It may be it needs a fresh mind altogether, and this probably will have to be the next procedure."

Hunter wrote back, insisting he had done his best to comply with story directives and that he would like to have another try at the script after *The Birds* was released, when both of them could return to the subject refreshed. The writer stated that he would do his "utmost, as always" to complete the *Marnie* project "to our mutual satisfaction."

On May 1, however, Peggy Robertson called Hunter's agent to say that his services were no longer required. Hunter believes that he was fired for balking at the rape scene, although Hitchcock never named it as the cause.

And Hunter's anecdote, with Hitchcock salivating lasciviously as he describes how he intends to film the scene, is never compared to the way the marital rape was actually shot. It's certainly an unsettling scene, but it offers little of the patent ugliness that Hunter recalls from the script conference with Hitchcock. Photographed with little dialogue, as a progression of virtual close-ups, with Mark's face closing in fixedly on Marnie's, the rape scene has a formal beauty as well as an emotional delicacy. Marnie's expression is obviously traumatized, just as in the book; her eyes glisten with tears; and as she is forced to yield to her husband, the camera lifts up and glides silently away, panning across the cabin walls to rest, finally, on a porthole framing an absolutely flat gray sea.

It was typical of Hitchcock—Evan Hunter couldn't have known how typical—that he blamed himself for going "stale" on the script, even if they

had gone stale together. Now Hitchcock recognized that he needed a new writer to help him take *Marnie* across the finish line.

As the March release of *The Birds* approached, the director spent much of his time with his publicity team, preparing trailers, teasers, and radio spots for the film. (Hitchcock himself came up with the witty tag line: "*The Birds* Is Coming!") Hitchcock's private showing of the film, topped by a dinner at Chasen's, was held on Saturday, March 2. The New York premiere followed a week later, timed to coincide with a Museum of Modern Art retrospective prompted by American critic Peter Bogdanovich, who had followed Truffaut with his own extensive interviews with Hitchcock, initially for *Esquire*. The Hitchcocks and Tippi Hedren would travel to New York, Washington, D.C., Boston, Philadelphia, and Chicago, and literally dozens of other interviews were set up by phone: Atlanta, Pittsburgh, Denver, New Orleans, Dallas, Salt Lake City, Portland, and many more. In May, Hitchcock would escort his leading lady to Cannes, where he had regularly shown his films since the first festival in 1949, and make a red-carpet entrance for the opening night.

Such events were shrewdly incorporated into Hitchcock's publicity. But although he controlled the promotional campaigns as never before, and the combination of the television series, *Psycho*, and the Truffaut book made him all the more inviting an interview subject for intellectual critics as well as workaday journalists from all over the world, the scope and nature of the publicity was changing.

In the past, he had approached journalists as equals in related fields. *New York Herald Tribune* newspaperman Otis L. Guernsey Jr., who came up with the original idea for *North by Northwest*, met with the director frequently through the 1940s and 1950s, for example, and felt they had a warm, comfortable friendship. They talked easily about any subject, and not just films. Guernsey's opinions of Hitchcock's films never entered into their relationship, he said, and if you let him off the hook in a conversation, Hitchcock wouldn't dwell on his own films.

Ron Miller was an editor of the San Jose State College campus magazine *Lyke* when he sought to interview Hitchcock just before the release of *Psycho*. Later a Pulitzer Prize–winning journalist, Miller recalled that Hitchcock was "far from boastful and, in fact, suggested that many of the innovations he was credited with on screen were not original with him." Neither Miller nor the student photographer who accompanied him "ever felt he was talking down to us or showboating. I'd say he was actually more modest than vain." A "good-natured," even jolly man, "he took time out of his very busy schedule—at the very peak of his career—to sit for an interview with a couple of college journalists. He gave us no ground rules for the interview, no time limits and treated us as if we were distinguished guests."

After *Psycho,* the press was younger and younger, however, and no longer on any kind of equal footing with him. Like the actors in his films, they were increasingly aware of Hitchcock's mystique. His move to Universal obliged him to become an even more aggressive salesman for himself. It had been three years since the last Hitchcock film, and the budget for *The Birds* was so astronomical that it was crucial to promote the film to the hilt: Increasingly, the director felt compelled to posture in interviews, especially with the younger journalists. And some of them, without a close relationship or any long view of his career, sharpened their pencils to define Hitchcock according to their own presuppositions.

The most unfortunate example was Hitchcock's encounter with the well-known Italian journalist Oriana Fallaci at Cannes in 1963. Fallaci missed Hitchcock's sense of humor, and all his usual talk about sex and chastity and policemen and murderers disgusted her; he seemed nothing more than a swaggering old man. Besides the New Wave of filmmaking, the 1960s also saw the emergence of a blunt New Journalism, which allowed Fallaci to describe Hitchcock physically as never before: "ugly: bloated, purple, a walrus dressed as a man—all that was missing was the mustache. The sweat, copious and oily, was pouring out of all that walrus fat, and he was smoking a dreadfully smelly cigar."

In the end, the reviews for *The Birds* were generally better overseas ("brilliantly-handled," said the *Times* of London) than in America. The French fuss (and all of Hitchcock's carefully orchestrated publicity) may have backfired in the United States—in its Cannes coverage the *New York Times* questioned the "artistic" wisdom of even showing *The Birds* at the festival. The American reviews were surprisingly harsh, with *Newsweek* insisting the horror was "inexpertly handled," *Time* decrying its "silly plotboiling," and the *New Yorker* calling the film an outright "sorry failure." In the *Village Voice,* Andrew Sarris hailed the picture as "a major work of cinematic art," but his was a lonely voice.

Even though the grosses were respectable (its $5 million in rentals placed it in the top twenty in 1963), the expense of the film ate into the profits; and especially after *Psycho,* Hitchcock and Universal couldn't help but see it as a disappointment.

During the East Coast publicity swing for *The Birds,* Hitchcock and Robert Boyle also scouted Baltimore, where Marnie is said to have grown up, and Philadelphia, near where the Rutlands live. Tippi Hedren's briefings for the press tour alternated with costume, hair, and makeup appointments for *Marnie.* The director was very exacting about her look: for the riding scenes, Hedren's face must be "clean, with shine"; for the death of Forio (the horse), he advised "shadows above and below her eyes."

On May 29, Jay Presson Allen came to Santa Cruz to meet with Hitchcock for the first time. The important thing happened—they talked and laughed easily—and Allen was signed to write the final script for *Marnie*. A week later, she started work in Los Angeles.

Once again Hitchcock had lighted upon a talented unknown. In 1963, the forty-year-old Allen was something of a late bloomer: she had written an overlooked novel, a handful of television shows, one unproduced play, and another—*The Prime of Miss Jean Brodie*—that had just been announced for a 1966 opening in London, starring Vanessa Redgrave. Based on a Muriel Spark novel, set in the late 1930s, about the influence of a strong-minded Edinburgh schoolmistress on her pupils, *Brodie* was shown to Hitchcock by one of the New York agencies scrambling to find a successor to Evan Hunter.

A Texan transplanted to New York, Allen had performed on radio and in cabaret before turning to writing. A smart, fetching blonde, she was effortlessly amusing—and endlessly amused at life. Flattered to be writing a Hitchcock film, she was a novice wholeheartedly interested in the teaching he did "naturally, easily, and unselfconsciously," in her words.

"In that little bit of time that I worked for him, he taught me more about screenwriting than I learned in all the rest of my career," Allen recalled in an interview. "There was one scene in *Marnie*, for example, where this girl is forced into marriage with this guy. I only knew how to write absolutely linear scenes. So I wrote the wedding and the reception and leaving the reception and going to the boat and getting on the boat and the boat leaving. . . . I mean, you know, I kept plodding, plodding, plodding. Hitch said, 'Why don't we cut some of that out, Jay? Why don't we shoot the church and hear the bells ring and see them begin to leave the church. Then why don't we cut to a large vase of flowers, and there is a note pinned to the flowers that says, "Congratulations." And the water in the vase is sloshing, sloshing, sloshing.' "

The "little bit of time" they worked together ran from June through September—and for the first several weeks Hitchcock wouldn't even let Allen write a word. They "talked endlessly," Allen recalled, usually about the two main characters. "Characterization escaped him more than he would have wished it to," Allen said. "We just played and chatted, day after day after day," she said. "He got very involved in trying to get some reality in the relationship between [Marnie and Rutland]."

Virtually adopted by the Hitchcocks, Allen more or less moved into Bellagio Road, and spent long weekends with the couple up in Santa Cruz. As she later told author Tony Lee Moral, "I got to know him, personally, certainly as well, and much better, than most writers."

It may have been Alma who urged her husband to discharge Hunter and hire a woman for a story that needed feminine insight. Once again, it

seems, there were three Hitchcocks on the project. When Allen recalls her stint on *Marnie* she makes an occasional slip of the tongue, describing how *they*—not *he*—taught her how to write a film. Mrs. Hitchcock was "around a lot, though not for script sessions," Allen recalled. Yet "it was all very easy and open," the writer added. "Alma was knowledgeable, more sophisticated than Hitch. We were together all the time and got along well."

They got along so well that, one day, Hitchcock asked Allen to interpret a recurring dream he'd been having about his penis. In a moment's break from a script delving into sexual psychology, he told the writer that he often dreamed his penis was made of etched crystal—that it was extraordinarily beautiful and valuable. His main concern in the dream was to keep his penis hidden from the cook. "I just screeched," recalled Allen. "I mean it seemed so obvious [that] he was trying to keep his talent separate and safe from Alma, the cook, who had of course contributed greatly to his career, and who was, certainly by the time I came along, still enormously useful. When I told him that," Allen added, "he giggled."

Allen was even encouraged to suggest casting (Louise Latham, who made her screen debut as Marnie's mother, was an old Dallas chum of hers); later she was welcomed on the set during filming, then invited to watch edited scenes and offer postproduction advice. Many of her ideas were incorporated into *Marnie*'s final form.

And then, early in the summer, it was tacitly agreed that after she finished *Marnie* Allen would write the next Hitchcock film. And in mid-July, Mr. and Mrs. Hitchcock flew to Scotland for two weeks, visiting Glasgow, Mallaig, Kyle of Lochalsh, the Isle of Skye, Oban, Inverness, and Aberdeen—an informal location survey for Hitchcock's dream project, his long-mulled film of James M. Barrie's *Mary Rose*.

While the Hitchcocks were away, Allen was given her freedom, working off progress already made by Hunter—although the director didn't clarify the origins of the previous draft, any more than he had told Hunter about Joseph Stefano's earlier contribution. As always, Hitchcock was cultivating the script through different writers and progressive stages, melding and molding them to fit his final vision. "A direct comparison between Hunter's and Allen's scripts," wrote Tony Lee Moral in *Hitchcock: The Making of* Marnie, "shows a similarity of scenes which can only be attributed to Hitchcock's authorship."

Unlike Hunter, Allen felt no compunctions about the rape scene; it was she who penned the version that stands in the film. Making Rutland a would-be zoologist was also her idea. "I wanted him to be very knowledgeable about animal emotions," she explained. "Animals have the same emotions as we do, they're all from the same lower part of the brain." According to Moral, Allen also crucially developed the "themes of class dis-

tinction, religious transgression and Marnie's childlike mannerisms as a result of her trauma."

Ironically, Allen herself is not a particular fan of *Marnie*—a film hampered, she says, by her own shortcomings. "I think one of the reasons that Hitch was fond of me and filmed a lot of the stuff I wrote," the writer explained, "was that I am frequently almost crippled by making everything rational. There always has to be a reason for everything. And he loved that. Hitch was enormously permissive with me. He fell in love with my endless linear scenes. In point of fact, he loved what I wrote, he shot what I wrote, and he shouldn't have."

The first mystery concerning *Marnie* is what happened, during the summer of 1963, with the script. Allen's best explanation rings true: Hitchcock liked her so much that he shied away from tough editing of her work. He liked her so much that he asked her to write *Mary Rose;* after that, he suggested, maybe the three Hitchcocks would take a yearlong cruise, joined by her husband, producer Lewis Allen. Shades of *Rich and Strange:* Hitchcock told Allen the two couples would lead a merry shipboard life, anchoring in exotic ports, and in spare moments cook up a script about their capers. In the summer of 1963, before the filming of *Marnie* began, here was a happy, confident Hitchcock, dreaming up old and new ways to keep from going stale, and still making adventurous plans for the future.

As Jay Presson Allen wrote, the second unit raced ahead of her pages, shooting exteriors and process plates in Philadelphia, Baltimore, and Hartford, Connecticut. Already costly in preproduction, *Marnie* would be the first Hitchcock film in a decade to remain on the soundstage.

Meanwhile, the casting also raced ahead. Millions of moviegoers had been captivated by Sean Connery as the virile, indestructible Agent 007 of *Dr. No* and *From Russia with Love;* one avid follower of the James Bond series was Hitchcock, who had read the Ian Fleming books and considered filming them as far back as the early 1950s. He first considered Connery as Mitch for *The Birds;* busy then with the 007 series, Connery now was growing desperate to change his image, and had agreed to play Mark Rutland in *Marnie.*

The well-respected Diane Baker, who had just finished *Strait Jacket*—a horror film based on a Robert Bloch novel—would portray the scheming sister-in-law. Invited to brunch at Bellagio Road, the young actress was taken aback when Alma brought out a Grace Kelly layout and pointed out their resemblance—even though Baker was a brunette.

Mariette Hartley, a promising newcomer who had made an impression in Sam Peckinpah's *Ride the High Country,* would play an office mate of Marnie's. Bruce Dern, already specializing in offbeat, often psychotic

parts, was cast as the abusive sailor Marnie bludgeons to death in a child-hood flashback. Martin Gabel, who had started his career in Orson Welles's Mercury Theater, would play the first victim of Marnie's thievery.

Once again, as he had for the last ten years, Hitchcock would have Robert Burks as his cameraman, George Tomasini as his editor, Edith Head (with Virginia Darcy and Rita Riggs) as his wardrobe designer, and Bernard Herrmann as his composer. Hilton Green from *Psycho* was back as his assistant director. Tippi Hedren's hairdos were assigned to an assistant to Alexandre of Paris, who regularly styled Elizabeth Taylor, the wife of the Shah of Iran, and the Queen of England.

Between the second week of October, when Jay Presson Allen submitted her final script, and the last week of November, when principal photography began, Hitchcock turned his gaze—at first dotingly—to Tippi Hedren. The actress was still meeting with him regularly, but throughout the summer she had undertaken a grinding publicity schedule—including, for example, two weeks in London and Paris in August and September, where Peggy Robertson accompanied her on press appearances for foreign premieres of *The Birds*.

It wasn't until that publicity tour was concluded, and the script for *Marnie* was finished, that Hitchcock really focused on Hedren—and now, his attitude toward her seemed to change. As he had with other leading ladies, he began to behave as though he was enamored of her. He flattered her, gave her gifts of champagne and flowers. He even confessed to her that she had appeared in his dreams as his love object. As he had done with another nervous actress—Joan Fontaine during *Rebecca*—he tried to wall her off from other people, cocooning her while reinforcing the fragility that was Marnie's hallmark.

As a sign of the importance, and self-importance, now attached to everything he did, many of their talks were tape-recorded for posterity, and hours of these discussions are preserved in the Hitchcock archives at the Academy of Motion Picture Arts and Sciences.

Hitchcock went through every scene of *Marnie* with Hedren, "feeling by feeling, reaction by reaction," in the actress's words, functioning not merely as her director "but also my drama coach." *The Birds* had called for a "classic beauty," in Hitchcock's words, but the birds were the real stars of that film, and Hedren had received scant acting guidance. *Marnie,* on the other hand, called for a psychological complexity that Hitchcock was particularly anxious for the unschooled actress to absorb and convey.

Coming from a director known for his supposed taciturnity with actors, these were surprising, and impressive, tutorials from a master professor. For especially long, difficult passages, Hitchcock specified the tempo and

tone of her lines. He defined Marnie's dual nature, the contrast between her outward behavior and her emotions "underneath." He explored, according to these tape recordings, the character's torment "of being trapped and cautious and, shall we say, crestfallen" after being forced into marriage with Rutland. And he singled out particular instances in the story where the actress ought to transmit "strangely rather bewildered and pained" emotions.

Musing, for example, on the front Marnie must put up at her forced-wedding reception, Hitchcock explained to Hedren, "I think that [what] we should try and photograph, as subtly as we can, is the inner person and her outward behavior. And I think the way to do it is when she feels that no one is looking at her, although it's hard to discover what moment she would be left on her own, but her face would lapse into a mood, then brighten up when, say, Mr. Rutland kisses her—so that she isn't constantly in an apparently happy marital mood—that we see her now and again with the shadow over her face."

Discussing the scene with the free-association game, when a stunned Marnie lapses into childlike speech and screams out at past demons ("White! White! White!"), Hedren asked Hitchcock, "It's a very sad scene, isn't it?" and the director replied, "Yes, but it comes out of anger. It's a big—it's a helluva scene. If you can bring it off, that's one of the best scenes in the picture, because of the tremendous light and shade in it."

If she could bring it off: that was a thought Hitchcock had never needed to voice during *The Birds*. Then, Hitchcock had confidence enough to carry the day. Now, despite his own confident "outward behavior," he was harboring hidden doubts. As were others: Lew Wasserman, who never had liked the property but was seduced by the prospect of Grace Kelly, held his tongue; still, he hovered around the project with obvious concern. Anecdotes about Hitchcock grandly escorting Wasserman around the set, then inviting him to the screening room to observe "an Academy Award performance in the making," have been trotted out as evidence of Hitchcock's vanity, but there was also something poignant and defensive about the gesture.

Jay Presson Allen tried to conceal her skepticism. "I never thought Tippi was vulnerable," she said later. "The audience needed to have sympathy for the Marnie character. Hitchcock had a fancy for icy blondes, but for the lead character to be a liar and a cheat, [she] also needed to be deeply vulnerable to arouse sympathy in an audience, and Tippi Hedren doesn't have that quality. I thought he [Hitchcock] got a fairly effective performance out of her. I never thought she was right in the first place."

Also dubious was Bernard Herrmann, whose antipathy toward Hedren shaped, in the words of biographer Steven C. Smith, "an extremely romantic and aggressive score"—later criticized by some reviewers—"to overcompensate for a dearth of emotion in the film."

Hedren herself had more confidence than she had during *The Birds*. She

had just returned from a European tour where she was feted and praised everywhere she went. Other famous filmmakers had started inquiring about her availability. Passive, pliant, and grateful during *The Birds,* now she began to be discomfited by Hitchcock's tight leash, his smothering attention, endless patter, and off-putting gibes.

It didn't help the deteriorating dynamic between them that Hedren had just announced her engagement to her agent, Noel Marshall. "I never talked about my private life. Never! It used to drive him [Hitchcock] crazy," the actress noted in one interview. "He was almost obsessed with me and it's very difficult to be the object of someone's obsession. It's a very painful thing. That's the reason why I never talked about it for twenty years. I didn't want people to think about it in the wrong light. I felt such empathy for him. To have such strong feelings and to have them not returned is very difficult."

Hitchcock disliked the husband-to-be, and his muttered acerbity, his warnings to eschew marriage, fell on burning ears. His single-mindedness has been interpreted in other books as jealousy of Hedren, but it was also a knee-jerk reflex. Hitchcock was quite capable of *encouraging* the marriage of a close associate—he had thrown himself wholeheartedly, for example, into the Joan Harrison–Eric Ambler nuptials in 1958—but he had lost too many other leading ladies to marriages and motherhood.

Even so, in spite of all the pressures, everyone who was there agrees that the first half of filming was relatively trouble-free.

In the first half, Connery's professional amiability seemed to lighten the air. Hitchcock supplied the star with "very little direction, didn't even look through the viewfinder," Connery recalled. But every once in a while the director did venture minor "adjustments and suggestions" (Connery's words) in the rhythm of scenes—which, according to one Connery biographer, largely consisted of advising the actor to shut his mouth while listening for his cues, and inserting "dog's feet" into his lengthier speeches. "Dog's feet?" asked a mystified Connery. "Pawses," Hitchcock drawled.

Connery could grin at that (and whenever he liked)—but Hedren couldn't so much as smile without permission. Hitchcock watched closely over her scenes, hovered and stared, adopting the same inhibiting attitude toward her that Mark Rutland assumes toward Marnie in the film. The director always built up to the critical scenes during a production, so the first half of the filming was primarily groundwork. And the first half of filming went along fine—or were there certain warning signs?

Throughout his long career, Hitchcock had been a master of technical challenges; it was often the human challenges—the failures of an actor or actress to embody his vision sufficiently—that had stymied him. And now, realizing that his handpicked star was standing between him and his realization of *Marnie,* the director felt an unaccustomed, rising panic.

The first half of filming was done by Christmas, and it wasn't until after

the New Year that Hitchcock's attitude demonstrably changed. His good humor seemed to slip away, and he seemed sluggish on the set. Mariette Hartley recalled that the director, initially affable, ceased to take notice of her. Connery no longer amused him; in one later interview, Hitchcock said he would have preferred an older man as Rutland—perhaps Laurence Olivier.*

Hedren's performance was coming along, though ultimately she would prove somewhat inadequate in the role. The tension between her and the director had not dissipated—and now, worse, the actress seemed to be resisting him. The holiday break had allowed him time to brood over the rushes; now, with the darkest scenes coming up, it was make-or-break time.

Hitchcock tried any desperate means he could think of to rouse Hedren. Diane Baker, part of the film's on-screen triangle, was suddenly drafted into an offscreen one. Around Christmas Hitchcock began plying the third-billed actress with gifts, inviting her to lunch in his trailer, conspicuously flattering her. "I was embarrassed for Tippi," recalled Baker, "and feeling sorry that he was turning his attention onto me in front of Tippi, when Tippi was within ear range or sight."

In this and other ham-handed ways, Hitchcock tried to get a rise out of Hedren—tried to force her to *be* Marnie. As her resentment grew, so did his dismay. Even then, it wasn't until "the last quarter of the shoot," in Hedren's words, that the unthinkable happened.

In the last week of January 1964, Hedren asked to be excused for a few days to travel to New York to pick up a "Star of Tomorrow" award at a press function, and make an appearance on *The Tonight Show*. The director said no. Hedren was furious. "Not only would it be inconvenient, but he thought a break like that, taking her out of the mood they had created for the character (mainly by keeping her in virtual isolation during the shooting period), would harm her performance," wrote John Russell Taylor, defending Hitchcock.

In an ugly flare-up, the actress screamed at Hitchcock—reportedly calling her director a fat pig in front of other people on the set. "Afterwards," wrote Taylor, "all Hitch would volunteer was, 'She did what no one is permitted to do. She referred to my *weight*.'"

Afterward, Hedren angrily demanded to be released from her exclusive contract with Hitchcock. Every bit as angry, the director said he would destroy her career before he let her go.

Communication between the two all but broke down, with a few weeks

* When Connery was introduced at Hitchcock's American Film Institute Life Achievement Award dinner in 1978, the director was photographed turning to Cary Grant and clearly mouthing, "Who's that?"—perhaps a lead-footed joke, for even then Connery was under consideration to star in Hitchcock's unfinished fifty-fourth film, "The Short Night."

of photography remaining. Although John Russell Taylor, in his authorized account, and Donald Spoto, in his unauthorized version, give highly disparate accounts of this incident, they agree on one detail: that Hitchcock thereafter distanced himself from the film and spoke to his leading lady only through intermediaries. However, Tony Lee Moral's meticulous behind-the-scenes chronicle of the production insists upon a more tangled scenario—with Hitchcock, only momentarily defeated by his humiliation, springing back to life and trying to mend fences.

Hitchcock finished *Marnie* gamely, according to Moral's book, as he had always finished embattled films throughout an embattled career. In February, for example, the director supervised the highly emotional scenes in Rutland's car, where he grills Marnie about her true identity—"some of the best scenes in the finished film," as Moral points out.

That better explains the timing of what Hitchcock is alleged to have done extremely late in the schedule—some time after the "Star of Tomorrow" brouhaha. In "late February," according to *The Dark Side of Genius,* the director "finally lost any remnant of dignity and discretion. Alone with Hedren in her trailer after the day's work, he made an overt sexual proposition that she could neither ignore nor answer casually." Hitchcock had too long repressed his Victorian sexuality, Donald Spoto theorized, and "a healthy, active libido, earlier, would have prevented this entire chapter of his life."

Note that Hedren is not quoted directly in this account. According to Spoto, he did not quote "Hitch's vulgar proposition to her—because she did not repeat the words to me for decency's sake." "All I can say is demands of me were made that I couldn't acquiesce to," the star of *Marnie* explained in one interview. Hitchcock "didn't want me for a mistress," she said on another occasion.

So what happened exactly? What if this despicable secret would look merely foolish if explained in print? What if Hitchcock was thinking like Mark Rutland, telling Hedren how sexy and attractive she was, how much he wanted to sleep with her? What if he really *did* want to sleep with her? Or what if, while trying very hard to patch things up with his leading lady, he made one of his clumsiest attempts at tongue-kissing, or just as clumsy, a vulgar joke?

"I was with Tippi Hedren once on a CBS show," recalled actress Joan Fontaine, who could boast of surviving a similarly complicated relationship with Hitchcock, "when she said he had propositioned her. Well, what he did was to see her Achilles' heel, and, knowing that pretty young actresses wanted to feel that he was a dirty old man, he would play it up. 'Yes, I must get into your bloomers, young lady!' he would puff and growl. I can just see him leering at them in jest, but they never realized he was teasing them."

Something happened: nobody doubts it. Whatever happened, if it happened on the stage in her trailer, the worst thing of all was that Hitchcock broke his own inviolable rule of professionalism at work. And whatever happened, it was his miscalculation, his mistake, his failure. The filming of *Marnie* ended on an unfortunate note.

The very last shot, incidentally, was captured on March 14. At the San Jose railroad station, a depot familiar to Hitchcock from his commutes, the director and a small crew photographed the opening of *Marnie*, which Hitchcock had precisely outlined a year earlier: a tracking shot of Hedren, walking through the station, a close-up on her bulging handbag full of stolen cash.

Tippi Hedren was *not* nominated for Best Actress. Neither was anyone else associated with *Marnie*. Indeed, after *The Birds* (and its sole nomination for Ub Iwerks for Best Special Effects), no Hitchcock film would ever again be nominated for an Academy Award.

Considering the Sturm und Drang behind the scenes, it's ironic that *Marnie* has become, over time, the vital film for many Hitchcock cultists, who see in it the filmmaker's maturity of craft and persistence of vision. What happened between the director and his leading lady, in the view of Hitchcockians, mirrors the complex angst of the subject.

Robin Wood insists that *Marnie* is "one of Hitchcock's richest, most fully achieved and mature masterpieces." Donald Spoto agrees: "I think it's Hitch's last great masterpiece." Tony Lee Moral—noting that for Hitchcock's centenary "a panel of top directors" assembled by *Sight and Sound* ranked *Marnie* as number ten among Hitchcock's greatest films*— wrote that the film continues to develop followers who probe its meaning, and especially has "become a time capsule for gender representations and psychoanalytical ideas for key traumas and events."

Tippi Hedren would later tell interviewers that "for two years after *Marnie*" Hitchcock "cheated her out of a career" by refusing to release her from her contract, while informing other directors, including François Truffaut, that she was "busy." But the record is far from clear.

Donald Spoto wrote that the director refused ever again to speak the actress's name directly—ruefully referring to her, among friends and associates, as "that Girl." But then Hitchcock had always referred to Hedren,

* The other nine were (1) *Psycho*, (2) *Vertigo*, (3) *Notorious*, (4) *The Birds*, (5) *North by Northwest*, (6) *Shadow of a Doubt*, (7) *Foreign Correspondent*, (8) *Frenzy*, and (9) *The Lady Vanishes*.

outside her own presence, as "the Girl" (it was how many silent-film directors referred to the leading lady's role, and it was the established nickname of the character Hedren had played in *The Birds*).*

"Sometimes of course I have failed," Hitchcock admitted in one interview. "Tippi Hedren did not have the volcano." Yet his logbook indicates that he met with Hedren several times over the next year, trying to bridge the gulf between them. Neither party could muster the old goodwill, though Hitchcock continued to pay her salary of five hundred dollars weekly, or twenty-six thousand dollars per year.

Vera Miles had done television for Hitchcock after starring in *The Wrong Man* and *Psycho;* but for Hedren the last straw came when the director asked her to appear in a Universal telefilm, and she refused. That dissolved her contract, and by the fall of 1965, about a year and a half after completing *Marnie,* she was in London for a small role in *A Countess from Hong Kong*—Charles Chaplin's last film. "When Hitch heard I was going to do the Chaplin film," she boasted in a subsequent interview, "he almost had a heart attack, he was so upset."

But her future as an actress was not grand.

* The tape recordings affirm that when they were together, Hitchcock always addressed Tippi by her first name.

SEVENTEEN
1964–1970

As late as March 1964, even as he was finishing *Marnie,* Hitchcock was still looking forward to making *Mary Rose.* In the spring Jay Presson Allen delivered her second-draft script for a film that would have comprised an informal trilogy of dissimilar subjects linked by the same director and star: Hitchcock and Tippi Hedren. "This ghost story," Joseph McBride observed in his definitive article on the subject, "would have taken Hitchcock's characteristic mingling of eroticism and death into dimensions beyond which any he had explored on the screen."

Hitchcock never forgot his pleasure at watching the James Barrie play in 1920. Barrie's ghost story concerns a young girl who disappears while on holiday with her parents on a Scottish island, dubbed "The Island That Likes to Be Visited." When the girl returns after twenty days, she can't explain where she has been or what has happened to her. Later, at eighteen, Mary Rose gets married and bears a child; returning to the same island on her anniversary, once again she vanishes. This time she goes missing for many years, returning guiltily to look for her son only after he is fully grown into a man. She herself is unchanged—a young, innocent, still-beautiful ghost.

Hitchcock had tried over the years to interest various producers in a film of the play. He had pitched *Mary Rose* to Twentieth Century–Fox in

the 1940s, and mentioned it to Paramount as a possibility for Grace Kelly in the 1950s. He and Alma had discussed the adaptation and scouted the locations. He had invested his own money in preproduction, even contacting the original star, Fay Compton, about playing a small part.

Jay Presson Allen's draft modified the original play in intriguing ways. Hitchcock's *Mary Rose* would have been "more nightmarish than dreamlike," in McBride's words, "intensifying the anguish felt by the title character and her aged family members." In Hitchcock's version Mary Rose would discover that her son, Kenneth, who has enlisted in the U.S. Army during World War I, might be a prisoner of war. This "provokes a harrowing sequence using subjective camera and sound techniques to convey her overwhelming anguish," according to McBride. "The realization of this loss literally kills her (again). But worse is yet to come."

In the story's denouement, Kenneth, still an army officer, returns to his ancestral home, where he encounters the apparition of his mother. Failing to recognize him, she is convinced that he has stolen the young child she is seeking. Facing him with his army knife clutched in her hands, Mary Rose hisses, "Give him back!"—and Kenneth is forced to confess that, in a way, he is the very person who has stolen her child. Kenneth then offers Mary Rose "the forgiveness she seeks for having abandoned him," in McBride's words.

"Her hand falls to her side and she gives back the knife, finally freed to accept her death," McBride writes. "Barrie, too, flirted with this disturbing situation of a mother contemplating her own son's murder, but the playwright's Mary Rose, unlike Hitchcock's, never took the knife from behind her back."

McBride points out that the "poignant, blissful ending" of the play had "Mary Rose bidding her son farewell, hearing the call of her heavenly voices and returning to her island forever," leaving her fate ambiguous. But Hitchcock changed the ending so that in the last scene her husband would discover Mary Rose, sitting in a chair, dead. "He will touch her head," Hitchcock told a London newspaper, "and his hand will glow with blue powder, ectoplasm."

The final narration—by a local man named Cameron, who had accompanied Mary Rose and her husband to "The Island That Likes to Be Visited"—was written into the draft by Hitchcock himself.

> Once more THE ISLAND *as we saw it first, a sweetly solitary place, a promising place. And now again, we hear* CAMERON's *voice.*

CAMERON (O.S.)
Or if we do dare to visit such an island . . . we cannot come away again without . . .

(There is bitter humour in his voice)

. . . without *embarrassment.*

And it takes more than a bit of searching to find someone who will forgive us that.

(Cameron's voice changes now, becomes harder, matter-of-fact, and final.)

Well, that is it. Let's go back home now.

(Ironically)

There of course it's raining . . .

THE CAMERA *begins to retreat. The Island grows smaller, mistier.*

CAMERON (O.S.)

. . . as usual. And there's a naughty boy waiting for punishment and an old villager who had the fatal combination of weak heart and bad temper. *He's* waiting to be buried. All the usual, *dependable,* un-islandy things.

(He sighs deeply)

You understand.

As the Island becomes no more than a distant vision, CAMERON's *voice diminishes as well, until at last we have lost them both.*

FADE OUT.

Before Hitchcock could realize his dream project, however, *Mary Rose* was killed by Universal. "I don't know whether it was because it was costume stuff, maybe marginally intellectual, I have no idea," recalled Jay Presson Allen, "but Lew Wasserman was on record as not being interested in it to begin with. Hitch never had a green light for the project, never. He just went ahead on his own. By the time *Mary Rose* came up for greenlighting, Tippi was out of the picture, and I think that is possibly why Hitch didn't fight for it."

Hitchcock had done substantial preproduction work, along with his work with Allen on the script, and Albert Whitlock, who drew "a lot of sketches" for *Mary Rose* before it was canceled, asked the director why he had succumbed to front-office pressures and abandoned the project. "They believe it isn't what audiences expect of me," Hitchcock explained. "Not the kind of picture they expect of me," he repeated.

Later, Hitchcock would make a sad boast to interviewers: an actual clause had been inserted into his Universal contract, he said, stating that

he could make any film for the studio that he wanted, as long as it was budgeted under $3 million—and as long as it wasn't *Mary Rose*.

His contract was, in fact, amended around the time that *Mary Rose* was canceled. Officially *Marnie* had been a coproduction between Universal and "Geoffrey Stanley Inc."—a legal entity named for the Hitchcock family dogs—but all future Hitchcock films would be produced and owned outright by Universal. The salary and benefits guaranteed by the new contract of August 1964 reportedly made Hitchcock the highest-paid director in Hollywood history; but more important, the contract made him a part-owner of the studio. He and Alma became the third largest stockholders. In exchange for the stock transfer, Universal assumed ownership of Shamley Productions, including all rights to *Alfred Hitchcock Presents,* the reverted Paramount films, and future marketing of the name "Alfred Hitchcock."

Although it was immensely satisfying to become a part-owner of the Hollywood studio that first showed interest in bringing him to America, back in 1931—the studio, moreover, where he had made *Saboteur* and *Shadow of a Doubt*—there were still tensions in Hitchcock's relationship with Universal. While Lew Wasserman was trying to transform the once lowly studio into a first-class operation, it would prove a long, slow process, and Universal would cling to television and television-style filmmaking far into the 1970s. Hitchcock couldn't shake the feeling that Universal would always be more Woolworth than Cartier.

And while his amended contract was generous, friends say that both Hitchcocks resented its strictures and, in sour moments, complained that he had been robbed of his golden opportunity to film *Mary Rose*. Alma felt that it was worse for her husband to have been robbed of his name, even though in exchange he received the pleasure of lifetime security.

The personal bond between Hitchcock and Wasserman was transformed and aggravated by their professional realignment. Once Hitchcock's agent, Wasserman was now his employer. Hitchcock "resented it," said Jay Presson Allen. "I know he did." Universal had been forced by the U.S. Justice Department to divest itself of MCA in 1964, and Arthur Park was Hitchcock's main contact at the agency now; still, despite Wasserman's efforts to put intermediaries between himself and Hitchcock in the decision-making process, either at MCA or Universal, there was no question who was the boss of bosses.

The two strove to preserve their always equable personal relationship. The new contract made Hitchcock the undisputed king of the lot, and Wasserman paid court, visiting Hitchcock's office almost every day to gossip or talk about the stock market. They lunched privately once a week, and at night the Wassermans regularly dined out with the Hitchcocks.

While she was working on *Marnie* and *Mary Rose,* Jay Presson Allen

sometimes joined the pair for lunch. While Hitchcock and Wasserman gossiped, she listened, secretly amused, because she knew that the rest of the industry gossiped about them—the two most powerful men in Hollywood. According to the scuttlebutt she had heard, both men were sexually impotent. Hitchcock had confessed his impotence to Allen (one reason she never believed that he propositioned Hedren), and although Wasserman had a beautiful wife, he was a notorious workaholic who slept on the couch while his wife slept around.

Although Hitchcock had made *The Birds* and *Marnie* with little interference, the failure of *Marnie*—from the first puzzled reactions elicited at studio screenings—would haunt him at Universal. His new contract made him a bird in a gilded cage. At Universal he would be worry-free financially, but creatively he had sacrificed his power and freedom.

Before *Marnie* was released the Hitchcocks took a two-month vacation, stopping first in New York to see the hit musicals—*High Spirits* and *Hello, Dolly*—and rendezvous with François Truffaut, who was conducting follow-up interviews for his book-in-progress. Then they headed for the Villa d'Este at Lake Como, Italy, where they had shot location scenery for the first Hitchcock film. From there the couple followed a complicated itinerary that took them to favorite places (Paris, the south of France, Rome, Vienna, Munich, and, as always, London) as well as new places they had always wanted to explore—Belgrade, Dubrovnik, and Zagreb, Yugoslavia. A driver accompanied them, and as much as possible they journeyed by car.

Except when they stayed at the Villa d'Este, where they tried to blend in and relax, the Hitchcocks made business and public events part of their vacation. In Rome, for example, Hitchcock met with the Italian writers Agenore Incrocci and Furio Scarpelli; billed as "Age & Scarpelli," they had written *Big Deal on Madonna Street* as well as the successful Toto comedies, which Hitchcock had seen. He spoke of collaborating with them one day.

At the Belgrade Airport the Hitchcocks were greeted by journalists and fans, and the director drew and signed caricatures of himself. He was presented to Yugoslavian colleagues at the national film archives. The Kolarc's People's University organized an "Evening with Alfred Hitchcock," and afterward the couple dined with guests at a famous Serbian restaurant in the artists' quarter, celebrating publication of the first monograph in Serbo-Croatian extolling his career. Hitchcock ate heartily of the local cuisine; when he was on vacation on doctor's orders, he told people, he also vacationed *from* doctor's orders.

Their return to the United States coincided with publicity for the open-

ing of *Marnie*. The reviews were unusually inconclusive. The new Hitchcock film was "at once a fascinating study of a sexual relationship and the master's most disappointing film in years," observed Eugene Archer in the *New York Times*. Edith Oliver in the *New Yorker* described it as "an idiotic and trashy movie with two terrible performances," adding, "I had quite a good time watching it." Archer Winsten of the *New York Post* thought the film's "human warmth and sympathy" made it a "superior" Hitchcock production, while the usually admiring Philip K. Scheuer in the *Los Angeles Times* found the latest Hitchcock "naggingly improbable" and only "fitfully effective."

In America, *Marnie* would take in a $3.3 million gross (placing it below the top twenty), while in England it ranked as the twelfth most successful picture of the year. This, ironically, was due to Sean Connery's drawing power (*Goldfinger* was the number one film that year), although his salary also had escalated the budget. (Meeting with author Winston Graham, Hitchcock "complained bitterly about the cost of his two stars.") Although the box-office figures were modest, *Marnie* went into the black— outperforming *Vertigo*, for example.

As a man who prized box-office success above reviews and was accustomed to ups and downs, Hitchcock undoubtedly considered *Marnie* a momentary dip in his long career, to be erased by whatever he did next. Everything still seemed possible in the fall of 1964, even the idea that he might mend fences with Tippi Hedren and make another film with her.

On vacation he had talked things over with Alma, and he returned home with ambitious plans. As he often had before, he decided to launch several projects simultaneously. Whichever story came together easiest and fastest would be the film he made first.

He had two stories, both no further along than the idea stage. One was a picaresque yarn involving a family-run hotel in Italy, which is a disguised criminal operation. Another was a run-for-cover crime drama based on the exploits of a notorious English murderer—which one he hadn't decided— to be shot in a contemporary style, with explicit sex and violence.

But in the summer of 1964, Hitchcock couldn't possibly have predicted the run of bad luck and troubles that would begin to envelop his circle. Over the next three years he would suffer a series of dramatic losses from his valued production team—with whom, he had boasted on *The Birds*, he enjoyed "a sort of telepathic communication that sets us right."

The passing of his longtime editor George Tomasini was the first of several premature deaths to diminish his team. Tomasini, only fifty-five when felled by a heart attack in November 1964, had edited *Rear Window, To Catch a Thief, The Man Who Knew Too Much, The Wrong Man, Vertigo, North by Northwest, Psycho,* and *The Birds. Marnie* and a cocredit on *In Harm's Way* (released in 1965) were his last films.

Regardless of the cheerful mortician's mask (and uniform) that Hitchcock wore for public appearances, illness and death moved him. He visited old friends like cameraman Jack Cox in the hospital on their deathbeds, and was an inveterate attender of funerals; now the funerals were starting to accrue. He wept at the news of deaths, and his logbook scheduled his day around funerals; it was a point of honor to stand over the burial site of old friends like Edmund Gwenn. When he couldn't attend the funeral, he always sent flowers and a note.

Suddenly he seemed surrounded by death, and Hitchcock's own health began to preoccupy him, much earlier than has been reported. During the making of *Marnie,* he called Norman Lloyd in and told him that something was wrong with him. Dr. Ralph Tandowsky couldn't pinpoint a cause, but Hitchcock felt tired, with constant aches and pains. Though the director kept his concerns from the cast, he told Lloyd, "You might have to finish this one for me."

Everyone thought the usual vacation would do the trick. *Marnie* had been stressful, but Hitchcock always bounced back. Shortly after returning from abroad, though, he was still feeling poorly, and in mid-July he enlisted a crew of specialists to conduct tests. Again the diagnosis was elusive, and it's possible that it was all in his head. But Hitchcock was feeling his age, and it was quietly agreed that he would cancel his television series, now in its third season as an hourlong program (the half-hour show had run for seven seasons). Although it had been three years since he directed an episode, he couldn't let go of his pervasive involvement, and he took his role in approving the main elements and performing the lead-ins seriously.

Doctors advised him to slow down, restrict his activity, cut down on food and drink. His weight, which he had kept under control since *Lifeboat* two decades earlier, was rising.

So the summer of 1964 was a quiet one, by choice. Hitchcock held meetings with Norman Lloyd and Joan Harrison about the final television season, conducted a few interviews with journalists, spent long weekends in Santa Cruz. But he continued to feel anxious about his health, and initiated regular medical appointments, twice weekly. He had long taken vitamin B boosters, but it now appears that he began to receive cortisone shots as well.

Hitchcock was a lifelong devotee of studio screenings, and now he had his own private screening room. The films he watched had always run the gamut; he'd watch almost anything—except films that implied cruelty to animals. (He cut off *The Misfits* and walked out, and remained furious with Peggy Robertson all the rest of the day for booking it.) But once

Hitchcock had a definite project in mind, the roster homed in on similar subjects, and in the fall of 1964 he began watching a spate of recent films—*The Prize, Seven Days in May, Fail-Safe, The Manchurian Candidate*—that pointed in a new direction. To the hotel-of-crooks project and the run-for-cover about a serial murderer, Hitchcock now added a contemporary political thriller.

Briefly he had toyed with filming another John Buchan novel with Richard Hannay as its central character, but the book he considered, *The Three Hostages,* was set in the year of its publication, way back in 1924, and was hopelessly quaint. Rereading Buchan helped him recharge his batteries, however.

Though he was a fan of the James Bond films, Hitchcock resented how brazenly the 007 series appeared to be borrowing from *North by Northwest*. The duel between Cary Grant and a crop-spraying biplane had been shamelessly lifted and copied, Hitchcock believed, for the clash between Bond and a helicopter in *From Russia with Love*. In Hitchcock's estimation the Bond films had taken his vision one step further toward comic-book storytelling; the only way to compete, he felt, was to make a more "realistic Bond." After all, he had been making spy thrillers since *The Man Who Knew Too Much* and *The 39 Steps;* he had this branch of his reputation to uphold.

Besides the "realistic Bond," Hitchcock toyed with the possibility of shooting the hotel-of-crooks story on location in Italy. He watched the latest works by Luchino Visconti, Michelangelo Antonioni, and other Italian filmmakers, while returning to *Big Deal on Madonna Street,* a robbery-gone-wrong satire he liked for its sophisticated plot mechanics and ironic tone. (He also liked, according to Furio Scarpelli, the fact that it "somewhat mocked the film style of Hitchcock" himself.) Hitchcock inquired about the availability of the veteran Italian writers Agenore Incrocci and Furio Scarpelli, and then arranged a spate of meetings with other writers who might be right for one of his other future projects. He spoke with novelist Richard Condon, the author of *The Manchurian Candidate,* and with *Twilight Zone* creator Rod Serling, who had scripted *Seven Days in May*. He lunched with old *Vertigo* hands Alec Coppel and Sam Taylor, wondering if either of them might click with a run-for-cover crime picture or the political thriller.

But his days were uncrowded, and there was no urgency until after Thanksgiving—and George Tomasini's death. Then he struck out in several directions at once.

In early November, Hitchcock had registered "an untitled original story subject" with the Writers Guild, broadly outlining a sort of prequel that would "cover the events prior to the beginning of the story told in *Shadow of a Doubt*." Following "an attractive man" who murders rich widows

while on the run from police, the prequel would present "the events surrounding the killing and disposal of these various women." According to the outline, the story would draw on the facts of "famous English criminal cases" such as John Haigh, John Christie, or Neville Heath, while Americanizing the characters and situations.

Later that same month, Hitchcock invited *Psycho* author Robert Bloch, whom he didn't know very well (though Bloch had gone on to write multiple episodes of *Alfred Hitchcock Presents*), to a "gourmet luncheon accompanied by wines of appropriate bouquet and vintage," in Bloch's words.

At lunch, Hitchcock explained that he was mulling approaches to a run-for-cover crime film whose true inspiration harked back to Jack the Ripper. But he wanted to modernize the story by borrowing from public-domain accounts of more contemporary killers. He was thinking of adopting the stylistic methods of the Nouvelle Vague, or Italians like Antonioni.

The lunch was more of a monologue, all of it captured on tape—Hitchcock rambling on about the necrophile Christie ("a very sordid little man . . . almost like Hume Cronyn could be"), Heath the flagellator of women ("he always went beyond . . . the thing got to the point where he would push the crop up them and bite their breasts and all that kind of thing"), even bringing up Patrick Mahon ("I used some aspects of his case in *Rear Window* because he got a girl in the family way and he killed her— you know, all it is, is a matter of economics really"). The director said he could envision using another detail of the Mahon case in the new planned film: when Mahon tried to destroy the head of a victim by shoving it into a fireplace and lighting a fire, Hitchcock recalled, "the heat caused the eyes to open."

The theory was that Hitchcock would pay Bloch to write a novel based on an actual serial killer's exploits; then, after Bloch wrote the novel, the director would convert it to film—a plan that had worked for Hitchcock at least as far back as Dale Collins and *Rich and Strange*. The director recommended that Bloch read *Ten Rillington Place,* a nonfiction account of the Christie murders and trial by journalist Ludovic Kennedy, as the kind of realistically flavored narrative he wanted to sponsor. His story ideas were sketchy, Hitchcock admitted, and he wasn't sure which of the notorious murderers offered the best prototype. All that was up to Bloch.

And then, during same week he met with Bloch, Hitchcock wrote to Vladimir Nabokov in Montreux, Switzerland, following up on an earlier telephone call to the world-renowned author of *Laughter in the Dark* and *Lolita* (Nabokov had helped adapt the latter into a well-regarded Stanley Kubrick film). It is unclear whether Hitchcock knew the Russian-born author beforehand, whether he had met him in England (where Nabokov was educated after World War I), in the United States (where he had taught

college after World War II), or in Switzerland (where Nabokov moved in 1959). Whatever the case, the director addressed him formally as "Mr. Nabokov," and offered the world-class writer—as highbrow a candidate as Bloch was low—his pick of the two other competing projects.

The one he thought optimal for Nabokov was the political thriller, which was shaping up as a fictional riff on the defections of Guy Burgess and Donald Maclean. As Cambridge students in the 1930s, Burgess and Maclean had belonged to a circle of left-wing intellectuals, several of whom were recruited as Soviet spies. Later, as British diplomats, Burgess and Maclean funneled secrets to Russia during and after World War II, until their treachery was discovered and they fled from England in 1951. Hitchcock had long been fascinated by Burgess and Maclean, and discussed them with Angus MacPhail (another Cambridge graduate) while remaking *The Man Who Knew Too Much*.

The real-life Bonds were often shabby, cold-blooded ideologues, and the kind of political thriller Hitchcock had in mind would delve deeper into the women who attached themselves to such Cold War pawns—women not unlike Mrs. Drayton (Brenda de Banzie), the more sympathetic of the villains in the second *Man Who Knew Too Much*. The drama would focus on "the problem of the woman who is associated, either by marriage or engagement, to a defector," in his words.

A woman who loved such a Cold Warrior, Hitchcock explained in his letter, would share his fate. "We have, for example, the case of Burgess and Maclean, where Mrs. Maclean eventually followed her husband behind the Iron Curtain, and obviously Mrs. Maclean had no other loyalties."

As a "crude example" of the kind of story he was proposing, Hitchcock imagined the "very American" son of Werner Von Braun—an ingenious scientist like his father—taking a vacation to visit his father's relatives in East Germany. He might have a fiancée, who is "the daughter of a Senator," whom the CIA and other "security people" enlist to keep an eye on Von Braun Jr.—and report back to them on the young scientist's suspicious activities.

The plot would follow the "journey behind the Iron Curtain," but the emotional focus would be on the girl and her dawning realization that her lover might defect. "Maybe she goes over to the side of her fiancé. It would depend upon how her character is drawn. It is also possible if she did this, she might be making a terrible mistake—especially if her fiancé, after all, turned out to be a double agent."

Such a political thriller, the letter continued, should be "expressed in terms of action and movement and, naturally, one that would give me the opportunity to indulge in the customary Hitchcock suspense."

If the realistic Bond story didn't appeal to Nabokov, Hitchcock dangled another possibility, which he admitted might not be as attractive—"but on

the other hand, it might." This was the family of crooks in an Italian hotel, which, in an earlier incarnation, he explained, he intended to make for a studio in England. But he never completed a script "because I left to come to America." (If he had, the film would have starred Nova Pilbeam.)

"I wondered what would happen . . ." wrote Hitchcock, spinning the tale of a young girl, raised in a Swiss convent, who leaves college and moves in with her widowed father, who is acting as general manager of a large London hotel ("at the time I imagined it would be the Savoy," he noted). The father of "our young heroine" has one brother who is the concierge, another who is cashier, a third who is one of the chefs, a sister who is the housekeeper, "and a bedridden mother living in a penthouse in the hotel. The mother is about eighty years of age, a matriarch."

Unbeknownst to the innocent heroine, the whole family is "a gang of crooks," the hotel their headquarters. The "backstage" of the hotel, especially the kitchen and nightclub, would form an important part of the story. Hitchcock said he was seeking a film that would provide the colorful "details of a big hotel and not merely a film played in hotel rooms."

Hitchcock conceded that he had related only "the crudest conception" of his ideas, adding, "I haven't bothered to go into such details as characterizations or the psychological aspects of these stories.

"As I indicated to you on the telephone, screenplay writers are not the type of people to take such ideas as these and develop them into responsible story material. They are usually people who adapt other people's work. That is why I am by-passing them and coming direct to you—a storyteller."

For various reasons, the easier deal—the job-for-hire with Bloch—fell apart. Hitchcock had offered the author of *Psycho* $5,000 to write the novel, and another $20,000 if a film was produced. But Bloch's agent knew the score this time, and countered by asking for 5 percent of grosses over $5 million, along with other rights and bonuses linked to sequels and merchandising. The negotiations waxed and waned briefly, until Hitchcock decided that his "modest idea" had been inflated by Bloch's agent's demands, and that he was "willing to gamble a small sum for a small picture . . . not an elaborate one."

Bloch also didn't appreciate the fine print in Hitchcock's offer, which stipulated he wouldn't receive any compensation until the director had read a treatment and approved his approach. That would mean Hitchcock got to talk (and talk), then wait for a story to be written and accepted, before Block received a nickel. "Mr. Hitchcock was in a position to proceed at his leisure, but this was a luxury I just couldn't afford," Bloch said later.

Hitchcock could have afforded to be generous, but curiously—and perhaps more importantly—the director felt no rapport with the author of *Psycho;* after their lunch, he showed no inclination to bend his rules. As

for Bloch, he left his initial encounter with Hitchcock scratching his head. He phoned his agent and asked to be eased out of the deal.

But the more challenging deal, the one with the world-renowned litterateur, crumbled just as fast. It took Nabokov only a couple of days to respond to Hitchcock's letter. Although both stories were interesting, he said, the political thriller "would present many difficulties because I do not know enough about American security matters and methods, or how the several intelligence bureaus work." Surprisingly, he was interested in the family-of-crooks tale, a slice of life in a hotel setting. "Given a complete freedom (as I assume you intend to give me)," wrote Nabokov, "I think I could turn it into a screenplay."

Except for one tiny matter—"the matter of time," in Nabokov's words. At present he was extremely busy in Switzerland "winding up several things at once," and "I could devote some thought to the screenplay this summer but could hardly settle down to work on it yet."

But Hitchcock had just emerged from a long period of rest and reflection, and time was once more an urgent matter for him. By Christmas Nabokov was out of the picture, and Hitchcock had decided to engage the two Italians, Agenore Incrocci and Furio Scarpelli, for the hotel-of-crooks script. On New Year's Eve he hired an interpreter, and Age and Scarpelli arrived from Rome for their first Universal meeting on January 4, 1965.

The hotel was now going to be located in New York, he told the Italian writers. It would be a lavish hotel much like the Waldorf-Astoria, but the story would take place mainly in the kitchen and on the top floor, where a family of Italians live, dominated by a grandmother type. The family has been brought over from Sicily by the manager of the hotel, an immigrant who has worked his way up from being an elevator boy.

A valuable coin exhibition is taking place at the hotel, and an antique Roman coin is stolen. A homicide occurs. One of the family members, a beautiful maid ("a Sophia Loren–type," according to Scarpelli) must solve (and survive) the mysterious goings-on. "I'd show the whole workings of the hotel," Hitchcock explained in an interview, "the kitchen, the laundry etc." After he outlined his ideas, Age and Scarpelli went to New York to acquaint themselves with the Waldorf-Astoria.

Concurrently, Hitchcock decided to push ahead with the political thriller, asking Universal to recommend a sophisticated novelist to write the original script. The thriller was Lew Wasserman's favorite of the three projects, the one to which he felt he could make a contribution. Wasserman felt that Hitchcock should return to the Paramount formula of beautiful people and beautiful scenery—that coincided with Wasserman's vision of the program Universal should be developing.

Wasserman was a heavy supporter of the Democratic Party in the mid-1960s—the era of Lyndon Baines Johnson's presidency—and Hitchcock

was invited to visit the White House; he attended off-the-record meetings at the State Department, and was welcomed for private talks with Secretary of State Dean Rusk. All this was facilitated by Wasserman's high-level contacts; eager to discourage another *Psycho,* the studio head subtly encouraged Hitchcock's other projects, and now especially the realistic Bond.

Even though novelist Brian Moore said he didn't want to write a movie for Hitchcock, Universal flew him and his wife, Jean, out to Hollywood to discuss the spy thriller with the director. Moore's much-admired first novel, *The Lonely Passion of Judith Hearne,* portrayed the life of an alcoholic Belfast spinster. (On the basis of this and other works of spare, exquisite prose, Graham Greene called Moore "my favorite living novelist.") Born in Ireland, Moore had emigrated to Canada after World War II and become a citizen, but was now living in New York. In advance of meeting him, Hitchcock screened *The Luck of Ginger Coffey,* a film adapted by Moore from his own novel.

Their "cordiality and mutual understanding were instant," according to Donald Spoto. "Hitchcock confided that he understood Moore's Irish-Catholic background and that the religious-school setting of his novel *The Feast of Lupercal* was familiar to him from his own background." Still, Moore said no, and "typically," according to his wife, "the studio assumed he was wanting more money and upped the offer, whereupon our lawyer advised Brian that he needed the money and urged him to accept."

Early 1965 would be divided between these two projects. During January and February Hitchcock worked principally with Age and Scarpelli on the hotel-of-crooks script; after they returned to Italy in early March to begin the writing, the director rotated to story conferences with Moore on the realistic Bond that would eventually become *Torn Curtain.*

Hitchcock's script sessions with Age and Scarpelli were hampered by the language barrier and, as the director later insisted, by the Italians' "slipshod" story construction. Indeed, the Italians were daunted by the complicated mechanics of the story Hitchcock outlined. For these reasons, the hotel-of-crooks script, tentatively titled "RRRRR," was earmarked as the longer-term project.

On the other hand, Brian Moore's political thriller progressed with alacrity. Moore completed the synopsis by March 26, and a longer treatment by May 19. The first fifteen pages of script went to Hitchcock on May 25, and the remainder of the draft followed by June 21.

Moore's five-page synopsis concisely described key scenes of the eventual film. These included *Torn Curtain*'s opening aboard a cruise steamer in the Norwegian fjords, and the dispatch of the undercover agent Gromek by the American scientist and a farm woman "in a brutal and slow sort of

murder," in Moore's words—the writer's suggestion, and Hitchcock loved the idea, "and proceeded to act it out," according to Jean Moore. There was no hint of the seriocomic slant that the director would endeavor to bring to these scenes, but Hitchcock kept insisting that he would add his trademark comedy in the latter stages of the writing and in "the attitude of the direction."

Later, Hitchcock would say much the same to reassure Paul Newman, an early front-runner to play the scientist who pretends to embrace Communism in order to travel behind the Iron Curtain and investigate a secret formula for developing an "antimissile missile."

Moore would later charge Hitchcock with having "absolutely no concept of character—even of two-dimensional figures in a story. He kept switching from the woman's to the man's point of view, and the original story idea began to shift and fade uncontrollably." And it was true; Hitchcock kept shifting as he shopped for stars. The ones he trusted to bring their own dimensionality to his films were showing wrinkles, or threatening retirement.

In the spring of 1965 the director attended a Los Angeles Dodgers game with Cary Grant, and mused about strong-arming Grant into one last Hitchcock film. That would have turned *Torn Curtain* into more of a bookend with *North by Northwest,* and given the film a vastly different tone from what eventually resulted. But Grant had just agreed to star in a Universal picture shooting in Japan in the fall, and quite apart from the fact that this augured an irreconcilable scheduling conflict, Grant insisted he was going to retire after *Walk, Don't Run.*

And Hitchcock appreciated that Cary Grant's magical name meant less and less to increasingly younger movie audiences. By late spring, with the script just underway, Paul Newman and Julie Andrews had emerged as the likely leads. Lew Wasserman lobbied heavily for them, confident that they would contribute the glamour and prestige he wanted in a Hitchcock film.

Hitchcock had followed Newman's career from the beginning, admiring the actor's always conscientious choice of material. Back in the fall of 1964, Hitchcock had watched Newman in screenings of *The Outrage,* a Western remake of *Rashomon,* and *The Prize,* a political thriller which bore similarities to *Torn Curtain.*

Julie Andrews was another star he had been following. Hitchcock had enjoyed her as the original Eliza Doolittle in *My Fair Lady,* and with his soft spot for musicals, he had screened the blockbusters *The Sound of Music* and *Mary Poppins* before their release. Andrews's latest picture, *Hawaii,* was still in postproduction, and the trade papers were full of items about it. The director was open to Wasserman's touting of Newman, but he was warier of Andrews as the female lead of *Torn Curtain,* unsure that she could be "convincing as a scientist." But he debated Wasserman in

vain; the director was now beholden to Universal, and the studio "insisted she was great box-office," according to Hitchcock.

"Having had comparatively lesser known stars in the last three pictures," Hitchcock privately wrote to François Truffaut in the fall, "I have now consented to please the whim of the 'front office' and to use two well-known players." Andrews's manager was also Jimmy Stewart's, but Hitchcock didn't strike any bargain there: he had to pay the actress $750,000 against 10 percent of the gross—a higher salary than top-billed Newman.

"It would interest you to know that this [salary plus percentage] total of $1,500,000 is more than we have to pay for the cost of the rest of the picture," Hitchcock griped to Truffaut. "But that's the way the business is today. Names are wanted, [and] there is such a shortage that these 'cattle' are demanding astronomical figures."

Signing Newman and Andrews gave Hitchcock the opportunity to begin to integrate their personalities into the ongoing script development. But what *were* their personalities?

He met Andrews on April 3, well before the first draft was completed. She had always played goody-two-shoes characters in movies, and Hitchcock relished reversing her image in her very first scene, showing the scientist defector and his girlfriend undressed and under the covers in their ship's compartment, their lovemaking keeping them warm as their boat glides up a frigid fjord toward Copenhagen, broken heater and all.

Andrews was game for the scene and the role reversal. But what was the value in reversing an image if the audience was left with a veritable blank afterward? And Andrews seemed a blank to Hitchcock, even after they met. "Hitch speaks politely of her," wrote John Russell Taylor. "She speaks politely of him. But there was no spark of communication."

That may have not been the worst thing about Andrews. More inconvenient was the fact that the actress was in such demand ("Upfront they said, 'Oh, she's so hot!' " the director bitterly recalled) that Hitchcock would absolutely have to shoot *Torn Curtain* in the fall, or risk losing his leading lady to other commitments.

As for Paul Newman, to Hitchcock he was a strange type—and one who got off on the wrong footing with the director. "Hitch invited Newman to a small dinner party," wrote Taylor in his authorized biography. "The first thing Newman did was to take off his jacket at table and drape it over the back of his chair. Then he refused Hitch's carefully chosen vintage wine and asked for beer instead. And to make matters worse, he insisted on going and getting it himself out of the refrigerator in the kitchen and drinking it from the can."

Which of them—the ill-suited good girl with the bigger salary, or the star who drank beer from a can—should be the subjective focus of the

film? From the start, Hitchcock had favored making Andrews the lead, and Moore had begun his work on the script on that basis; he was hired expressly for his strength with female characters, and the film's opening scene was devised specifically to explode the image of Julie Andrews. But Andrews in person didn't excite Hitchcock, and after that opening scene the script began to back away from its intended focus on her. Originally envisioned as the story of a defecting scientist's wife, the script swung toward the defector—the star with the more legible personality. The defector became terse, moody, a tortured enigma—more like the Paul Newman of *Somebody Up There Likes Me, Cat on a Hot Tin Roof, The Hustler,* and *Hud* (all films Hitchcock watched).

At the start of the writing process, Hitchcock had talked about the characters as being interchangeable with the stars; now he openly expressed anxiety about the ones he was stuck with. The casting "inhibited" Hitchcock, said Moore. Losing interest in his leads boosted his preoccupation with the lesser characters, and with "the most trivial details of a story," in Moore's words, "such as what airline departs a city on a given day—but, oddly, this was his strength at the time, and it assured a wealth of accurate historical and social and cultural detail. But it also covered a profound ignorance of human motivation."

Perhaps the supporting cast could help him forget the stars. Lila Kedrova, a flamboyant Tallulah Bankhead type, born in Russia but a resident of France, had been Oscar-nominated as Best Supporting Actress for *Zorba the Greek;* now she would play the red-haired, French-accented Countess Kutchinska, who befriends the defectors on the outskirts of Berlin.

Moore later conceded that much of *Torn Curtain*'s script originated with Hitchcock. ("I told him," Moore recalled, "that for truth's sake the credits should read 'Screenplay by Alfred Hitchcock, assisted by Brian Moore,' but he said he never took writing credit.") But Countess Kutchinska was all Moore's, though the casting was Hitchcock's; the character derived from a brief story sketch Moore carried with him at the outset of their deliberations, which explained the Countess's desire to emigrate to the United States, and her hopes that the defector will help her. The sketch inspired the scene where the countess risks everything to help the scientist couple escape, even going so far as to tackle a pursuing policeman. She is left behind as they flee, crumpled on a stairwell, plaintively crying out, "My sponsor!"

Kedrova would become the director's favorite among the cast; he ate lunch with her several times during the filming, and brought her home to Bellagio Road for dinners with Mrs. Hitchcock. And in spite of the eventual rupture between Hitchcock and Moore, he let Moore's lengthy Countess Kutchinska scenes run intact in the final film.

* * *

Two more close Hitchcock associates died in first half of 1966. The first, in February, was James Allardice, only forty-six when he suffered a fatal heart attack. Allardice had been responsible for the pixie humor of Hitchcock's tag-end appearances on television, as well as the speeches he had been making at public events, and even the articles under his byline (Hitchcock's contribution to the *Encyclopaedia Britannica* on filmmaking). Norman Lloyd believed that Allardice's unexpected passing affected the director profoundly. Whenever Allardice dropped into the office, no matter what else was going on, Hitchcock's mood had always lightened. He would visit no more.

Without his favorite ghostwriter, Hitchcock cut back on all his speeches. He even dodged an invitation proffered by his old friend, the Catholic priest Father Thomas J. Sullivan, in the second half of 1966. Father Sullivan wanted him to speak for twelve minutes "on any topic" to a San Francisco group. When Hitchcock demurred, Sullivan pleaded with him, reminding him how well received his clever and amusing stump speech had been when he accepted an honorary degree at Santa Clara University in 1963. (Father Sullivan, who had promoted the degree, was in the audience.) "You'll never know what I went through before the Santa Clara speech," Hitchcock wrote Father Sullivan. "I was miserable for days and days before it came about. I know the speech got a lot of laughs and that sort of thing, but I personally get no satisfaction from it whatsoever. It's just the same when I make a picture. I go through hell and get no pleasure at all from the fact that it succeeds. I'm only relieved that it wasn't a complete failure." Without the safety net of James Allardice's wit, Hitchcock no longer enjoyed such public performances, and in the future his few addresses and bylined articles were ghosted by Universal publicists.

June brought the death of David O. Selznick. The career of Hitchcock's first Hollywood producer had ground to a virtual halt after *The Paradine Case*—and after Selznick's marriage to Jennifer Jones. Like his father before him, Selznick had become irrelevant in the film industry. But Hitchcock had kept in touch with him socially, and saw Selznick's death as symbolic of an era passing. He spoke graciously of Selznick at the time, telling *The Moguls* author, Norman Zierold, for example, that the producer used his notorious memos "as much to clear his own mind as much as to communicate with others."

In years to come, Hitchcock would wax nostalgic for the producers of old. "Are we missing some other stimulus that went with those earlier days," he asked an interviewer in 1969, "the great movie mogul, for example?" The same year, he told another journalist, "It was fun then. Now the industry's run by accountants and businessmen and agents. Agents are

the worst, because they've no interest in the film, only in getting work for their artists." (Never mind that he was employed by Universal, a studio run by his own former agent.)

With a heavy heart, Hitchcock attended Selznick's funeral, and then left for a long, purely social weekend in Santa Cruz with Brian and Jean Moore. Such weekends used to be reserved for close friends, but now his friends were scattered; the weekends were more like treats or outings for principals who worked on his films. When meeting with each other later, the guests would compare notes like children discussing a schoolmaster.

Besides getting Moore started on a second draft, Hitchcock welcomed Agenore Incrocci and Furio Scarpelli back to Hollywood. He met with them regularly until July 9, when he and other key personnel flew to Europe to scout *Torn Curtain* locations in Copenhagen and Frankfurt.

The European milieu called for changes in the team. Hein Heckroth, who had won an Oscar for Michael Powell's *The Red Shoes,* supplanted Robert Boyle as production designer. Hitchcock planned another one of his unusual color schemes—if possible, a shadowless monochrome. "We decided," the director explained later, "that after we leave Copenhagen, which is the last location in the picture before we go to East Germany, to go gray everywhere—gray and beige—so we have a mood, a depressed mood, a sinister mood, in the general tones of all the sets."

Bud Hoffman moved over from *Alfred Hitchcock Presents* to edit his first feature. Cameraman John F. Warren's feature credits included *The Country Girl* with Grace Kelly, but he had been on Hitchcock's crew as far back as *Rebecca,* and also served as a cameraman for *Alfred Hitchcock Presents.* Edith Head (who concentrated on Julie Andrews's hair and costumes) and Bernard Herrmann were the only key members of Hitchcock's long-established Paramount unit to carry over to the new film.

In Hollywood as in London, it was common policy to shoot films as much as possible inside the studio or in the near vicinity, to tuck costs into general overhead. The high cost of his two stars forced him into "cutting corners," as Hitchcock candidly admitted later; the decision to shoot *Torn Curtain* in its entirety at Universal may have saved a little budget money, but it also dictated, in the words of writer Keith Waterhouse, "the excessive use of (sometimes crude) back projection."

Any hopes for Eastern European flavor were dashed after the second unit returned from East Germany. For economic as well as surreptitious reasons, Hitchcock had hired a German crew to capture the sights and scenery while pretending to be shooting a travelogue. But their footage proved "inferior," according to John Russell Taylor, and there wasn't the time or money to send Americans back. In the end Hitchcock had no choice but to minimize the authenticity.

An airport in the San Fernando Valley stood in for East Berlin's Schöne-

feld. The farm on the outskirts of East Berlin was actually near Camarillo. The Swedish docks were faked in Long Beach Harbor, and the University of Southern California stood in for Karl Marx University. When Paul Newman walks through the Museen zu Berlin in *Torn Curtain,* only the floor is real: the galleries are paintings optically printed into the film. After ten years exploiting all manner of exotic locations, this was the second film in a row with Hitchcock stuck inside soundstages.

It's hard not to assume that Hitchcock's decision to stick close to home was also influenced by concerns about his health. But he continued his grueling pace: when he returned to the United States on July 15, Hitchcock went back to juggling two different projects, sometimes working on one script in the morning, then switching to the other in the afternoon.

Brian Moore was just a week away from finishing the second draft of *Torn Curtain,* and Age and Scarpelli were in and out of Hollywood all during the summer, still developing the "RRRRR" project. Along with the Italian writing team, Hitchcock interviewed a slew of performers, nobodies in Hollywood terms, who might be right to play the family of crooks: actors of different nationalities (one Argentinean), eccentric performers, even circus clowns.

After Moore finished his second draft, Hitchcock asked for rewrites and a third draft, which was delivered to him in the first week of August. The director was sufficiently pleased that he offered Moore a contract for another four Hitchcock films. But Moore was exhausted by the process, and said he'd rather return to novels; then, when Hitchcock summoned him to discuss additional "script fixes" in the third week of August, the increasingly impatient Moore forgot himself and savaged the project. Fed up, he told Hitchcock that the plotting was implausible and the characters cardboard, according to Donald Spoto; polishing the dialogue wouldn't solve anything. "I told him that if it were a book I were writing, I'd scrap it, or do a complete rewrite," Spoto quoted Moore as saying.

But a final polish was needed, Hitchcock insisted at the time in a letter to François Truffaut, because Moore had "a tendency to want to avoid all melodrama. This I was quite prepared to do, except that there was a tremendous risk of the story becoming flat and plausible, but unexciting." Hitchcock said people complained that the dialogue was too literary, that "the people did not talk like human beings."

After their unpleasant meeting, Moore had second thoughts, and two weeks later he wrote to Hitchcock, offering to accommodate any "rewrites or fixes," assuring the director that he "vastly enjoyed" working with him, Lucullan meals and all. But Hitchcock couldn't forget that Moore had disparaged the film on which he was pinning his hopes, and the director left him behind.

Wasting no time, Hitchcock contacted the English writing team of Keith Waterhouse and Willis Hall, authors of several West End hits including *Billy Liar* (which was also made into a successful film), and the duo agreed to come to Hollywood. They arrived "within a few days of rolling," according to Waterhouse, "so that we often found ourselves revising scenes only hours before they were to be shot, while on occasion a messenger would be waiting to rush our latest rewrites across to the *Torn Curtain* sound stage, where they would be thrust into the hands of the actors even as Hitchcock lit them for the scene."

The new writers were "treated to a crash course in filmmaking," hovering "close at hand on the set," according to Waterhouse, where Hitchcock would "only very occasionally" refer "to the shooting script being meticulously monitored by his longtime assistant Peggy Robertson, for by this stage in the game the whole film existed, frame by frame, as pictures in his head.

"There was a written part of this highly-paid seminar besides the valuable lectures both on and off the sound stage. Willis and I had been assigned a comfortable star dressing-room bungalow, just around the corner from Hitchcock's suite of offices at Universal City Studios. Every morning when the studio limo decanted us, there would be awaiting us a big buff envelope containing Hitchcock's notes on the current day's work, dictated between looking at the rushes the previous evening and going home to Bel Air to read that day's London *Times* before his customary dinner of Dover sole, both of them flown to him along with his breakfast kippers. I have kept over twenty close-typed pages of these ruminations. . . .

"Some of them show Hitchcock's almost fanatical obsession with accuracy: 'Scene 88. We should eliminate the Floor Concierge. My information is that they do not have these in East Berlin.' Others show his sense of meticulous cinematic detail: 'Scene 127C. I would like to discuss the place where the sausage is carved . . .' On Scene 139, where we had someone describing the Julie Andrews character as beautiful, Hitchcock comments: 'Not that I wish to cast any aspersions on Miss Andrews' physiognomy, but do you think beautiful is perhaps too much, and cannot we say lovely instead?'

"Above all, there are the notes that reveal the seething mind of Hitchcock at work as he jigsaws the pictures in his head into place. He takes two long paragraphs to detail how he envisages the reaction of refugees on a stolen bus as they witness the approach of the real bus that must give their game away. He wants one character to see the bus in the distance but keep it to himself . . . then someone else sees it, and someone else, until panic spreads through the bus: 'It would be rather like the play within a play in *Hamlet* which starts with the King and then spreads to the rest. Anyway, let's talk about this little moment.' There was nothing to talk about. He had already conceived the whole sequence exactly as he was to shoot it."

Hitchcock's copious notes included his cameo appearance, by now a treasured tradition of a Hitchcock film, but also a headache to think up and insert early enough in the story to satisfy the audience's expectations without impeding the momentum of the suspense. The director suggested inserting himself in the brief scene in the lounge of Copenhagen's five-star Hotel d'Angleterre, where Newman and Andrews stay in the film. Waterhouse was struck by how Hitchcock envisioned his cameo "not simply as an ego trip" but as a shot also supplying "valuable background information."

Hitchcock explained: "I should be seen sitting in an armchair in the lounge with a nine month old baby on my knee and I'm looking around rather impatiently for the mother to come back. This impatience could be underscored by shifting the baby from one knee to the other, and then with the free hand, surreptitiously wiping the thigh. Having this shot would enable us to show the sign announcing the presence of the convention members in the hotel. We might even show some of the delegates crowding around the elevator which, of course, would then lead us to the corridor scene on page 10."

Waterhouse found working with Hitchcock "an education and a joy"—an education entertainingly leavened by the director's reminiscences about his silent film days in London, by the long dinners at Chasen's and Bellagio Road, and by the surprise awaiting them when they returned to England for a play opening, and were feted at a first-night party in their honor, which Hitchcock had masterminded from Hollywood.

Truth to tell, the two Englishmen didn't think much of the film—or of Brian Moore's script, which would have ranked *Torn Curtain* "even lower in the oeuvre had we not been called in to improve the script and polish the dialogue," in Waterhouse's words. But the writing partners were limited in their contribution "apart from the odd scene . . . restricting ourselves to dialogue rewrites which we were doing on a day-by-day basis as the film was shot."

But a fair share of the film's flaws, Waterhouse reflected, should be blamed on Hitchcock. The master provocateur of *Psycho* and *The Birds* had begun making mistakes; he first turned old-fashioned, with *Marnie*; and now he was behaving cautiously, and worse. Hitchcock took out his resentment of the stars on the most vulnerable players; he fixated on irrelevant details; and the man who had always challenged audiences now seemed bent on pandering to the moron millions.

"We could not persuade him," Waterhouse remembered, "to let us get to work on an immortally bad line uttered by Julie Andrews: 'East Berlin? But—but—that's behind the Iron Curtain!' Mindful of geographically uncoordinated audiences in such centers of insularity as Dubuque, Mr. Hitchcock steadfastly refused to modify the line, not even to the extent of getting rid of the superfluous 'but' and its hesitant dash."

"Additional dialogue by" was a dubious credit that had been abolished by the Writers Guild, so when Hitchcock submitted "Story by Brian Moore, Screenplay by Brian Moore, and Keith Waterhouse & Willis Hall" as the film's official credits, the matter was automatically sent to arbitration.

Waterhouse reports that Hitchcock "campaigned valiantly" for his name and Hall's to be included, adding, "I hope it does not seem ungrateful when I reveal that we were campaigning just as vigorously to have our names kept out of it." Moore, "feeling that the script was not up to his standards and expectations," according to Jean Moore, tried just as hard to keep his name off. "However," said his wife, "our lawyer intervened again and strongly advised Brian not to remove his name." Ironically, Hitchcock's resistance to changes had limited the Englishmen's input, and after studying the drafts the Guild struck their names.

In spite of the script's defects, Hitchcock was still optimistic as the filming began; one might even say he was deluded. Sending a copy of the script to Truffaut for his opinion, he wrote, "In some respects it might have the feeling of *Notorious,* except that I have given it a little more movement than *Notorious* had. Anyway, read the script and then you can judge for yourself."

When Paul Newman and Julie Andrews read the script, however, they saw no resemblance to *Notorious.* In fact, it seemed substandard—nothing like the story they had agreed to star in. Andrews, whose role had mysteriously shrunk during the successive drafts, secretly despised the script, while Newman admitted later he "never felt comfortable" with it. But the clock was running, and both trusted in Hitchcock.

Apart from Lila Kedrova, most of the ensemble were known only to European filmgoers. Gisela Fischer (as Dr. Koska, the defector's pro-U.S. contact in East Germany) and Wolfgang Kieling (as Hermann Gromek, the "personal guide" who is actually a menacing undercover agent for the East German state) had both appeared in *Frau Cheneys Ende,* a 1961 German version of the chic English jewel-thief play *The End of Mrs. Cheyney.* Kieling's countercasting as the film's only true heavy—he was a frequent studio vocalist for hit Broadway shows rerecorded in German—was a joke only for diehard German fans.

Hansjoerg Felmy was cast as the chief of East German security, and Günter Strack as the East German scientist who abets the American scientist's defection. Tamara Toumanova, whose role as a ballerina wittily bookends the film, had been the supreme Russian ballerina of the 1930s and 1940s in Paris and New York. Ludwig Donath, a veteran of German and U.S. films, played the East German professor who has formulated a

sought-after mathematical theory to counteract nuclear weaponry. This, his final role before his death, brought Donath back from a long absence due to the blacklist.

On October 18, photography began on Stage 18 at Universal. From the outset Hitchcock got along politely—too politely—with Julie Andrews, while Paul Newman vexed him with his persistent Method questions, and his equally vexing script suggestions ("apparently," Hitchcock wrote Brian Moore earlier, passing along three pages of his ideas, this "comes from Paul Newman the author, and not Paul Newman the actor").

"One of our duties," recalled Keith Waterhouse, "was to keep Paul Newman out of our director's nonexistent hair, spelling out the thinking behind any scene or piece of dialogue that troubled him, and if necessary inventing far-fetched explanations for the characters' behavior. This we became quite good at."

One thoroughly minor scene, where Newman had to furtively meet Andrews and take a package from her, agonized the star; no matter how much the writers reassured him, Newman insisted on discussing it with Hitchcock at some length during the camera rehearsal. The star hemmed and hawed, finally asking how he should be *relating* to Andrews in the scene.

"Well, Mr. Newman," Hitchcock explained in his plummy accent. "I'll tell you exactly what I have in mind here. Miss Andrews will come down the stairs with the package, d'you see, when you, if you'll be so good, will glance just a little to the right of camera to take in her arrival; whereupon my audience will say, 'Hulloh! What's this fellow looking at?' And then I'll cut away, d'you see, and show them what you're looking at."*

But there was an unmistakable pall over the project, symbolized neatly by Hitchcock's gray-on-gray color scheme. Even the atmosphere on the set was "everywhere gray"—the color of indefiniteness, irresolution, and gloom. Regardless of his customary black or blue suits, the director himself now virtually embodied that color. "Hitchcock in action," reported one journalist to the set, "is mostly Hitchcockian inaction."

"We all knew we had a loser on our hands," Newman recalled afterward.

The director "just lost heart during the shooting," according to *Vertigo* writer Sam Taylor. "He just couldn't get a chemistry going with them [Newman and Andrews], and he got very depressed and just went through the motions."

In the end Hitchcock stared past the leads, but this time he ignored most of the supporting players, too. "Sometimes with actors it was a puzzling experience," recalled matte artist Albert Whitlock, "his lack of communication."

* "I have heard," concluded Waterhouse, "no better or more concise an analysis of what filmmaking is all about either before or since."

Instead, he took to yelling at the "rooks and pawns," according to Waterhouse. "It was painful, one day, to see a wretched bit player being harangued by the distinguished director for not jumping off a bus in the proper manner. Hitchcock made him do retake after retake, cruelly tormenting him for being unable to comprehend a simple note of direction when he called himself an actor. The poor fellow was jumping off the bus in what he must have firmly believed, from his own observation, was the way that people do jump off buses; unfortunately, this did not coincide with the picture in Mr. Hitchcock's mind. The director wanted the actor to emulate, to perfection, a photograph he had never seen."

Hitchcock went through the motions for more than three months, including two weeks of unscheduled hiatus when Newman incurred a chin infection, before filming was finally completed in mid-February 1966. Through most of that time the director visited his personal physician at least twice weekly at 8 A.M. before heading over to the set at Universal.

Bernard Herrmann was awaiting instructions in England, where he had moved in the midst of a fractious divorce. Now run by executives who started out in the music agency business, Universal insisted on a pop music score for *Torn Curtain*—preferably with a hit song performed by Julie Andrews—and Hitchcock didn't necessarily disagree. He had long recognized the value of music in his films.

Even by the time of *The Birds*, Hitchcock felt that Herrmann's music was becoming too predictable in its portentousness. Then Herrmann's score for *Joy in the Morning*, a sudsy MGM film that followed *Marnie*, particularly "disappointed" him. "NOT ONLY DID I FIND IT CONFORMING TO THE OLD PATTERN," Hitchcock bluntly wired Herrmann early in the filming of *Torn Curtain*, "BUT EXTREMELY REMINISCENT OF THE MARNIE MUSIC IN FACT THE THEME WAS ALMOST THE SAME.

"UNFORTUNATELY FOR WE ARTISTS WE DO NOT HAVE THE FREEDOM THAT WE WOULD LIKE TO HAVE BECAUSE WE ARE CATERING TO AN AUDIENCE AND THAT IS WHY YOU GET YOUR MONEY AND I GET MINE."

Trying to explain the the new direction he wanted Herrmann to adopt, the director explained that "catering to an audience" meant catering to increasingly younger audiences, staying hip to the Nouvelle Vague, and likewise to contemporary trends in film music.

"THIS AUDIENCE," he wrote, "IS VERY DIFFERENT FROM THE ONE TO WHICH WE USED TO CATER IT IS YOUNG VIGOROUS AND DEMANDING STOP IT IS THIS FACT THAT HAS BEEN RECOGNIZED BY ALMOST ALL OF THE EUROPEAN FILMMAKERS WHERE THEY HAVE SOUGHT TO INTRODUCE A BEAT AND A RHYTHM THAT IS MORE IN TUNE WITH THE REQUIREMENTS OF THE AFORESAID AUDIENCE STOP THIS IS WHY I AM ASKING YOU TO APPROACH THIS PROBLEM WITH A RECEPTIVE AND IF POSSIBLE ENTHUSIASTIC MIND STOP IF YOU CANNOT DO THIS

THEN I AM THE LOSER STOP I HAVE MADE UP MY MIND THAT THIS APPROACH TO THE MUSIC IS EXTREMELY ESSENTIAL."

Herrmann gave Hitchcock no cause for concern in his return telegram, which said, "DELIGHTED COMPOSE BEAT SCORE FOR TORN CURTAIN ALWAYS PLEASED HAVE YOUR VIEWS."

For whatever reasons, then, Hermann followed his own muse and wrote a score of instrumental extremes, with heavy emphasis on the bass, brass, and woodwinds, and almost no apparent melody. It may have been vintage Herrmann, but it wasn't the departure Hitchcock had asked for. Hitchcock wanted Herrmann to provide upbeat musical relief from a film that everybody—the director included—found flat and dull.

Both men were under great strain when Hitchcock kept an appointment with Herrmann in late March to listen to the first recording of the music. But the director didn't get very far, absorbing only the Prelude before shutting the recording off. Where was the pop sound he wanted? he demanded furiously.

Herrmann was just as angry. "Look Hitch," he said, "you can't out-jump your own shadow. And you don't make pop pictures. What do you want with me? I don't write pop music."

"I'm entitled to a great pop tune if I want one," replied Hitchcock sullenly.

"Hitch, what's the use of my doing more with you?" Herrmann said fatally. "I had a career before, and I will afterwards."

Those were their last words. Whether Hitchcock actually fired Herrmann is unclear—accounts differ—but according to Herrmann's own account, he *quit*. After which, British composer John Addison, who won an Oscar for the pastiche score of *Tom Jones* in 1963, was forced to play catch-up with a light score that was among the most forgettable Hitchcock ever used.

A few years later, Herrmann visited the director at Universal to pay his respects, and repair the damage. But Hitchcock refused even to come out of his office to greet his old comrade—refused ever to work again with the man who wrote the ultimate Hitchcockian music for *The Trouble with Harry, The Man Who Knew Too Much, The Wrong Man, Vertigo, North by Northwest, Psycho,* and *Marnie*.

"IF YOU CANNOT DO THIS," Hitchcock had predicted, "THEN I AM THE LOSER."

Before *Torn Curtain*'s midsummer opening Hitchcock conducted publicity on the East Coast, then met with François Truffaut in London for final editing of the interview book. Afterward he spent a week with Sidney Bernstein in Orbetello, Italy, returning to London in time to promote the film's

release in England. In England and America, reviewers struggled to detect some merit in the fiftieth Hitchcock film. "What went wrong here, one suspects," wrote Penelope Houston in *Sight and Sound,* "was something basic in the storyline." "Awful," "preposterous," and "irritatingly slack," Renata Adler concluded in the *New Yorker.* "Hitchcock is tired," declared Richard Schickel in *Life,* "to the point where what once seemed highly personal style is now merely repetition of past triumphs."

The best scene in the film—the only truly memorable one—dated back to the very first synopsis: Gromek's death. The East German undercover agent has followed the defector to an isolated farm outside Berlin, where he is making surreptitious contact with an American agent. Confronted in the kitchen by Gromek and threatened with arrest, the scientist and a farm woman accomplice have no choice but to fight back. First they attempt to strangle Gromek, and stab him with a butcher knife; then they try to bludgeon him with a shovel. But the tough villain keeps springing back to life. Finally they shove Gromek headfirst into a oven, turning on the gas and holding him inside—until he asphyxiates, his fingers twitching spasmodically. The struggle—as shot by Hitchcock, characteristically, without any real dialogue or music—is not only brutal but uncomfortably comical. Although Brian Moore complained to Donald Spoto that the director "went further than I think he should have in that case," it was the most Hitchcockian scene in *Torn Curtain*—and a last bitter allusion to the Holocaust. ("One couldn't help but think that here we are back at Auschwitz again and the gas ovens," Hitchcock told Richard Schickel.)

But in the end the only thing faintly *Notorious* about *Torn Curtain* was the Macguffin—the "antimissile missile" formula sought by Paul Newman. Hitchcock had anticipated the atomic bomb for his 1945 film, and Frances FitzGerald in her book *Way Out There in the Blue* makes a good case that *Torn Curtain* likewise anticipated war weaponry of the future. Ronald Reagan, an ex-client of Lew Wasserman's who now occupied the California governor's seat, watched the latest Hitchcock film and took note, according to FitzGerald. Years later, as president, Reagan was inspired by Hitchcock's Macguffin to propose his still-controversial, still-unrealized "Star Wars" missile-defense shield.

Despite initial crowds, *Torn Curtain* did less well than *Marnie* at the box office, making it a second, and more expensive, knockdown for Hitchcock. Though accustomed to such disappointments in his long career, he no longer had the resilience of the boy wonder who went to the studio bristling with energy, ideas, and mischief, who worked all day and then stayed after dark to shoot necessary scenes, who bounded up three flights

of steps when he came home late and then hosted a party, or attended a first night, or went dancing at a nightclub.

Marnie had been a setback, but *Torn Curtain* was a profound failure that indicated a more chronic condition—a malaise. Hitchcock's twice-weekly doctor appointments continued, and in September and October he and Alma took another monthlong vacation, hoping to restore his bounce, pausing again at the Villa d'Este before doing a little publicity and sightseeing in Tel Aviv, Copenhagen, Stockholm, Munich, and Paris.

When he returned to Hollywood, he seemed in better spirits. Yet this was a time for sober adjustments. The hotel-of-crooks story was the most ambitious of his future projects, the least run-for-cover, and as the one least likely to become a star vehicle, it was also the least palatable to Lew Wasserman and Universal. It was the kind of offbeat slice of life Hitchcock had always mused about filming, but in spite of working with Agenore Incrocci and Furio Scarpelli for over a year, he couldn't conjure any confidence in the project. "We had a friendly exchange of ideas and arguments," Scarpelli remembered. "Maybe it was our fault. Maybe it was his. He was tired, but we were tired too."

Every decision now was a marker on the road, and this step marked a departure from Hitchcock's lifelong practice: never again would two projects vie simultaneously for his attention.

At Christmas, the Hitchcocks flew with the Sam Taylors to St. Moritz. This must be the year, according to Donald Spoto's book, when Hitchcock organized his day around the cocktail hour, always with "gargantuan lunches and four-hour dinners" whose menus he "dictated." He waved from the balcony when Alma and the Taylors ventured outdoors; once again, on vacation, he took a vacation from doctor's orders.

This Christmas, according to Spoto, Hitchcock seemed fixated on necrophilia, demonstrating to Suzanne Taylor how a man might strangle a woman with only one hand. To Spoto, that seemed like evidence of an increasingly morbid bent, though Hitchcock had always fixated on murders—staging stranglings in his films at dinner parties, even posing as a strangler for publicity photos. Some of his favorite crimes involved strangling followed by necrophilia. And, it was at St. Moritz that the director decided on his next subject, one deeply rooted in his nationality, and his imagination: the story of a necrophiliac serial killer.

Such a project could become the ultimate run-for-cover, while also giving him a chance to acknowledge a debt to the Nouvelle Vague. Even before he started working with François Truffaut, Hitchcock had been conscientiously screening the works of the new generation of foreign-language filmmakers, especially those from France and Italy. The autobiographical, socially critical, sexually explicit, psychological and philosophically oriented, sometimes fantastical and often stylistically un-

orthodox films of these young directors had flavored his screening diet for nearly a decade.

Hitchcock watched all of Truffaut's films; he kept up loyally with the output of anyone with whom he was acquainted. Curiously, though, the pictures that really struck him—startled him, really, out of his rut—were those of Jean-Luc Godard and Michelangelo Antonioni. Again and again he screened their films—*Blow-Up, Red Desert, Masculine Feminine*—all of them innovative in format and intellectual in content, and almost anti-Hitchcockian in their antidramatic narratives. But he was fascinated by their visual adeptness; watching one Antonioni, he sat up straight at the sight of a man all in white in a white room. "White on white!" he exclaimed to Peggy Robertson. "There, you see! It *can* be done!"

Inspired by such experimentalists, Hitchcock decided to shoot his new psycho-killer film in a contemporary, pseudo-vérité style—as much as possible on actual locations, working with fast film stock and natural light, and a cast of cheap young unknowns.

He had the sentimental idea that an old friend might join him in tilting at this windmill, and mentioned the project with deliberate casualness to Sam Taylor and Charles Bennett, but he detected little appetite from them for his Nouvelle Vague shocker. Surprisingly, then, he contacted Benn Levy. Although Levy was principally a playwright and stage director, he also had a good track record in film—and he had contributed dialogue to the sound version of *Blackmail* and directed *Lord Camber's Ladies*, which Hitchcock produced in 1931. Hitchcock and Levy had quarreled disastrously during *Lord Camber's Ladies,* but had reconciled after being thrown together over the years in show business circles. For five years after World War II Levy had served as a respected Labour Party MP and emerged as an assertive voice on peace issues and the arts, but he also kept busy as a writer, and was excited by the prospect of reuniting with Hitchcock on a film that would draw from real life.

As part of his modernizing campaign, the director wanted the story to be based on a postwar Jack the Ripper, either John Haigh (the acid-bath murderer he had read about during the filming of *Stage Fright*) or Neville Heath (the earlier, brutal sexual mutilator). Both of these notorious London murderers were familiar to Levy, but one was preferable.

"It's got to be Heath, not Haigh," Levy wrote Hitchcock on January 18, 1967, shortly after agreeing to the assignment. "*Told forwards* the Heath story is a gift from heaven. You'd start with a 'straight' romantic meeting, handsome young man, pretty girl. Maybe he rescues her from the wild molestations of a drunken escort. 'I can't stand men who paw every girl they meet.' Get us rooting for them both. He perhaps unhappily married and therefore a model of screen-hero restraint. She begins to find him irresistibly 'just a little boy who can't cope with life'—least of all with do-

mestic problems such as he has described. She's sexually maternal with him, she'd give him anything—and we're delighted. Presently a few of us get tiny stirrings of disquiet at the physical love scenes but don't quite know why. By the time we see the climax of his love in action, and her murder, then even the slowest of us get it." Before the letter closed, Levy reiterated his Hitchcockian notion that the film should be "told forwards, i.e. more from the angle of the pursued than the pursuers." And he added: "At one point, if I know my Hitch, I don't doubt but that Heath with his maximum of charms will accost a policewoman."

Hitchcock liked that: not only was Levy spewing out ideas before his contract was finalized, but his tossed-off notion of Heath accosting a policewoman was reminiscent of *No Bail for the Judge,* offering Hitchcock a chance to recycle his idea of a lady barrister posing as a prostitute. In "Frenzy," as the project was tentatively titled, the near-victim would instead be an undercover policewoman.

"Supposing," Hitchcock replied, sparking off Levy's idea, "that the third woman* is a plant by the police so that you get the extreme suspense of watching the man fall into a trap—or does he fall? Supposing he nearly succeeds with the third woman, especially if he maneuvers her into some remote area which prohibits protective observation."

Hitchcock's chemistry with Levy convinced him to offer Levy a seventy-five-thousand-dollar deal for an outline, treatment, and first-draft script. (Note that these terms, for a friend and writer with a track record with Hitchcock, were substantially higher than the amount offered to Bloch for a book *and* film—higher, even, than the salary Brian Moore received for the bigger-budgeted *Torn Curtain.*) Arriving from London on February 18, 1967, Levy went straight to dinner at Bellagio Road; the next morning, he and Hitchcock commenced their discussions.

Levy was in the United States for the next two months, completing a treatment and developing a draft script that revolved around a young murderer of women, and a female police officer set up as a decoy. Although Neville Heath was the model for the killer, the story would be Americanized by virtue of its New York setting. Hitchcock supplied Levy with books about Heath, muscle magazines to help characterize the killer—a bodybuilder—and articles on hippies, who are among his victims. In April the director and writer traveled together to New York, staying at the St. Regis. Hitchcock gave Levy a tour of the city, and the film-to-be.

Life photographer Arthur Schatz was engaged to ride around with them and shoot color slides of prospective sites, including a few that were familiar from other Hitchcock films. Scenes were planned for the New Jersey flats (as in *Shadow of a Doubt*), and in front of the United Nations (as

* The "second woman" is the young man's second murder victim.

in *North by Northwest*). Hitchcock intended to use a Shea Stadium baseball game as one background, and Central Park as another. Unknown actors and models posed in the settings for Schatz. "As we reached the locations," the photographer recalled in Dan Auiler's book *Hitchcock's Notebooks,* Hitchcock "would tell me the story of what was happening in the film."

As Hitchcock told and retold the story, Levy wrote and rewrote. "Frenzy" evolved into an American manifesto—even offering a passing glimpse of the President of the United States himself. At the same time it was going to be a very personal Hitchcock film, a triumphant reprise of his signature themes. Hitchcock envisioned the mother of the killer as a professional actress, playing with the idea of the mother giving a Broadway performance, while suspecting her son of horrible deeds. (The police are slow to suspect the real killer, of course, although at one point a traffic cop pulls him over.) At the end of "Frenzy," the mother would agree to help the police trap her son—a kind of apologetic reversal of *Psycho*.

The "Frenzy" murders would all be triggered by proximity to water, which had been a source of danger in other Hitchcock films. The first victim (a UN employee) would be slain in broad daylight near a waterfall in a secluded patch of woods outside New York City; the second, an art student, would be wooed to a shipyard and viciously murdered amid abandoned World War II freighters. The "Mothball Fleet" sequence would be a nail-biting cinematic crescendo, a Hitchcockian tour de force.

The director's eagerness about the project, combined with the sudden fragility of his career after *Torn Curtain,* even lured Mrs. Hitchcock back into the script talks. Although Alma had been a silent partner for *Marnie,* she was instrumentally involved in "Frenzy." The participation of Levy, a mutual friend, lured her into helping—a by-product Hitchcock had counted on.

These were the last three Hitchcocks, and after Levy finished his tour of duty, leaving behind a solid treatment, the two Hitchcocks soldiered on together. In May 1966, they meticulously mapped out the shots for the "Mothball Fleet" sequence. As they had done since the silent era, the husband-and-wife team went over and over the crucial scene, debating the "maximum effect," in Hitchcock's words, "without being too horrifying and running into censorship problems." As usual, Hitchcock did most of the talking while Alma listened.

The shipyard sequence would be preceded by a scene in which Willie (the killer) and Patti (the second murder victim) dine in a country restaurant. When they depart for the shipyard, Hitchcock asked his wife, "Is his mind made up that he's going to kill her?" "Yes," Alma replied, after thinking it over. "He knows she's got a boyfriend and he may not get another chance. He goes to a lot of trouble to get her in the engine room."

After luring her onto one of the abandoned vessels, Willie begins to rip

her clothes off, but his frenzy is interrupted by a shipboard fire he must extinguish before it can alert people on shore. "I'm scared [that] if we make it too horrific, we'll get too much criticism," Hitchcock said. He outlined a strategy whereby Willie would attack and stab Patti, but she would break away, running up iron stairs ("shoot through grilles, etc. so the shadows cross her body and we don't have too much nudity")—but then what? He couldn't decide if there ought to be more stabbing, or perhaps a strangling. "The question is in tackling so much detail, how far can we go without the audience coming out of the theater, saying, 'It's too horrible, don't go.' "

Hitchcock pondered having the killer let her go "with a smile," and then having Patti just barely make it to the top of the stairs before fainting, and cracking her head as she falls. "Then there wouldn't be *two* murder charges against him," Alma noted, disputing his logic.

"How about if she gets away, and he chases her upstairs, and he kills her at the top of the stairs?" Hitchcock then mused. "We see her face, and she falls to the deck. We can use the shadows and the light carefully, so that we can get away with enough. We see the knife uplifted. Lots of inserts, rather like the shower sequence in *Psycho*. There will be many dark shadows and corners. We can build this in the studio so we can control it."

Alma wondered if that wouldn't seem like too much of "a repetition of *Psycho*," in her words. Now, after the knockdowns of *Marnie* and *Torn Curtain*, it seemed more important than ever that Hitchcock avoid obvious repetition and place a premium on novelty.

"No," Hitchcock insisted, "because it will emerge spontaneously by her running away." He visualized Patti running up only a short, cramped flight of steps—not higher than the ceiling of his study—before Willie catches her, "a montage of heads, knife, hands, body, then she falls in big head [close-up]. She hits her head on [something hard] enough to kill her. We have a moment for him in calm contemplation. Also, based on photos, we can construct a set with a grille on top, so that the moonlight streams through the top almost like zebra stripes."

Brainstorming aloud, Hitchcock got to a part of the story they hadn't decided on. What should happen next? The men on shore, he said, would have noticed the fire.

"Which is best for us?" asked Alma. "Does he [Willie] know the men are coming, or not?"

"Isn't it more suspenseful," Hitchcock said, picking up the thread, "to milk the situation so that only the audience know the men are coming—because, for some inexplicable reason, the audience are on the side of the criminal at this point. Like Tony in *Psycho*, putting the car in the swamp; then, when it stopped, the audience held their breath.

"We must milk the fact that there are so many ships, they don't know

which one to search first. We want to see the men coming from *HIGH*, so we know that they have got a long way to go. If we shoot high up like that, we could put mirrors in their flashlights so the sun reflects in them as we're shooting day for night."

That is how they left it for the time being. The Hitchcocks talked about "Frenzy" through June; the director himself revised Levy's treatment, with Peggy Robertson taking down his dictation. The Hitchcock version is the one Auiler calls brave and disturbing—"the best of all the versions." Hitchcock wrote the waterfall murder as a bucolic love scene that ends up as the shocking annihilation of an innocent. He planned ample nudity featuring both women *and* men ("an insistence on sex and nudity," Truffaut later pointed out), and a vignette where the killer's mother interrupts him masturbating in his bedroom.

By mid-July the project was ready for another writer, and since "Frenzy" was a Hitchcock original demanding the skills of a novelist, he hired Howard Fast. With a long, prolific career dating back to the Great Depression, Fast had seen his novel *Spartacus,* about a slave revolt in ancient Rome, made into a spectacular film by Stanley Kubrick. Although as a disaffected ex-Communist he might have seemed more appropriate for *Torn Curtain,* Fast was also was a reputable crime novelist with a series, under the pseudonym E. V. Cunningham, that featured a Japanese American detective in the Beverly Hills Police Department.

"My god, Howard!" Fast recalled Hitchcock exclaiming. "I've just seen Antonioni's *Blow-Up.* These Italian directors are a century ahead of me in terms of technique! What have I been doing all this time?"

Though Fast was treated to the usual mini–Hitchcock festival, the director himself now seemed fixated on Antonioni's films. And he commissioned Antonioni-style camera tests in New York, "primarily intended to compare different film stocks in low-light settings," wrote Dan Auiler, but with "full mockups of actual scenes from the screenplay, using unknown actors and models." According to Auiler, "nearly an hour of silent footage" was assembled.*

"The first scene," Auiler reports, "is of the young model getting up from bed in her New York apartment. She's nude as she rises in the scene—lit only by natural light—and walks to the bathroom. The camera remains fixed as it does a full 360-degree pan of the apartment—starting with her rise from the bed and following her around to her entry into the bathroom.

* At this stage the script had been retitled "Kaleidoscope," which was more Sixties-ish, but it kept shifting back and forth, and was generally known as "Frenzy."

"The second scene is at the artist's studio, where the young killer meets the nude model. There are several dollies and elaborate pans of the artists (including the young man intended as the killer) at work."

After a series of script conferences Fast was left alone to start writing, while the Hitchcocks spent the early fall on a South Sea cruise with the O'Connells, visiting Tahiti, Fiji, and New Zealand. "Hitchcock gave me a very free hand," the novelist recalled. "He seemed mostly interested in working out elaborate camera movements. By the time the script was finished he had specified over four hundred and fifty camera positions."

Returning in October, Hitchcock read Fast's draft and announced he was pleased by his progress. However, he decided, one more writer—and revision—was called for. That suggested the weight Hitchcock attached to "Frenzy," but it was also a sop to a growingly concerned Lew Wasserman. Universal was doing everything possible to dissuade Hitchcock from making the explicit film. The final script, Hitchcock assured Wasserman, would moderate the studio's censorship and adverse-publicity concerns. Meanwhile, he agreed to set it aside temporarily—permanently, Universal hoped.

And Hitchcock did set "Frenzy" aside for a month or two, which was always beneficial to a project. Throughout the fall he watched films, attended plays and concerts, kept up his medical appointments. At Christmas he took his annual trip with Alma, but this time to Hawaii, which was sunnier and closer than St. Moritz. Teresa Hitchcock and the O'Connells joined the Hitchcocks in Kamuela, where James Stewart had a ranch.

After New Year's, he returned with renewed zeal to "Frenzy." Playwright and novelist Hugh Wheeler, who wrote exceptional crime novels under various pseudonyms, but whose screen credits included *Five Miles to Midnight,* a murder mystery starring Anthony Perkins, arrived to spend two weeks in meetings with Hitchcock, pruning scenes and polishing dialogue for the shooting script. After that, "Frenzy"—with its extensive test footage, its script by several writers (including Mrs. Hitchcock) prepared over the course of a year, its subject the director's lifetime obsession—would be ready.

It was the greatest film Hitchcock never made.

Death and desertion continued to cull the Hitchcock circle.

The director's longtime physician, Dr. Ralph Tandowsky, died in January 1968. The death of the heart specialist who had treated Hitchcock for thirty years—who gave him his twice-weekly shots in 1966 and 1967—was a milestone followed closely in May by the death of cameraman Robert Burks and his wife in a freak house fire.* James Allardice, George

* Burks had not shot *Torn Curtain* because of its Eastern European flavor, but he was still a candidate for future Hitchcock films, including "Frenzy."

Tomasini, and Robert Burks, the core of Hitchcock's glorious Paramount years, were all gone.

And when he stopped producing *Alfred Hitchcock Presents* in 1968, it had the effect of removing two of his other chief lieutenants, Norman Lloyd and Joan Harrison, from regular counsel and contact with him. Pining for England, Harrison was on the verge of moving back there to live in quiet retirement with her husband, Eric Ambler.

Hitchcock might once have entertained hopes that Peggy Robertson, his production assistant in England on *Under Capricorn* and *Stage Fright,* and then in America on every film since *Vertigo,* would emerge as Harrison's successor. By 1968, Robertson was the last of the old guard, the gatekeeper to the master's presence, in the background of every production, a vital component at meetings and script conferences. But she had never graduated to being a writer, script editor, or producer; and when Robertson urged Hitchcock to reunite with John Michael Hayes—whom she herself had never met—tellingly he felt no compunction about ignoring her advice.

The flow of writers and stories had slowed to a trickle, worsened by the end of the TV series and the dwindling of staff, but also by the fact that Universal had a more provincial story department. Already feeling constricted by the studio's limitations, Hitchcock was nevertheless dependent on it for stories. Lew Wasserman, who thought that Hitchcock was pinning too much on "Frenzy," urged him to get working on another project, and shelve "Frenzy" until they could calmly review its prospects. Even though things had gone awry with *Torn Curtain,* Wasserman encouraged Hitchcock to have another try at similar spy-thriller material. In truth, Hitchcock hadn't lost the desire to produce a realistic Bond, and he wanted nothing more than to erase the memory of his previous failure.

He stayed home to reread John Buchan's gentleman-spy stories, and talked vaguely of making another Richard Hannay film. Once more the rights were elusive, and he seemed to have little recourse but to appeal to Universal's story department. The result was *Topaz*—a book he chose as his next project, after rummaging through the available properties, because it was "better than nothing," in the words of John Russell Taylor.

Yet there was also something about *Topaz* that appealed to Hitchcock. He had a penchant for Cold War stories based on reality, and author Leon Uris had based his lead character—French intelligence agent Andre Devereaux—on Philippe de Vosjoli, a Frenchman who had gathered information about Russian missiles in Cuba for the CIA, but who fell out of favor for refusing to identify his Cuban sources. (De Vosjoli feared that Soviet spies in France would pass the information along to Moscow.) One of de Vosjoli's sources was Fidel Castro's sister Juanita, whose identity is changed in the novel to Juanita de Cordoba—a onetime revolutionary who has become Devereaux's secret mistress.

An admirer of John F. Kennedy, Hitchcock was fascinated by the American president's showdown with Castro and Khrushchev in 1962. The island nation where Hitchcock had enjoyed vacationing (under the previous regime) would have to be re-created largely on the back lot of Universal, but Wasserman promised to let him shoot the last third of *Topaz,* which exposes Soviet moles in de Gaulle's government, on location in Paris.

A dense, labyrinthine novel, *Topaz* begins in Copenhagen with the defection of a KGB agent. Through the defector the Central Intelligence Agency learns of Soviet plans to place missiles in Cuba, and of a high-level French spy ring channeling classified information to Russia. An honorable French agent, working secretly with the Americans, agrees to a CIA mission in Cuba, and to try to prevent future leaks in Paris. The political allegiances of the characters are tangled up with their love stories. The widow of a onetime revolutionary now actively conspiring against Castro makes love to Devereaux whenever he is in Cuba on behalf of France, and Devereaux's wife is the secret mistress of a disloyal Parisian.

Topaz had been a best-seller a year earlier, but was overlooked by Hollywood—in large part, the author believed, because it had been stigmatized by lawsuit threats and U.S. government opposition. Hollywood producers shied away from the budgetary costs as much as the controversial politics. When Hitchcock contacted him, Uris was "shocked out of my wits" that such an important director had chosen to film *Topaz.* He was just as shocked to be asked to write the script.

On January 21, 1968, three days after attending Dr. Tandowsky's funeral, Hitchcock met Uris for the first time; the two launched into regular meetings in late April. Uris faced a man who was changed in every way for the worse from five years before. Hitchcock looked and acted defeated, sour and defensive. Photographs taken during the filming of *Marnie* show an almost trim and dapper man; in contrast, the director Uris greeted in 1968 was once again far overweight, pink-cheeked from drinking, and transparently depressed with the realization that time, always his cruelest enemy, was closing in.

Once, his office had bustled. Now there was something eerie about his streamlined operations, about Peggy Robertson's fierce guardianship, about her welcome to Uris: rubbing her hands together, she told him confidentially that *Topaz* was going to dust Hitchcock off and bring him out of the museum—that it would be his comeback to greatness.

Uris had hugely admired Hitchcock before they met. But Uris was a prickly, independent-minded writer, and from the first there were "bad vibes" between him and the famous director, he recalled. According to Uris, Hitchcock tried to lord over him, making it clear who was the boss and who was the underdog. On his very first day of work, Hitchcock escorted Uris to "a little office in his cottage," and said this was the writer's

niche; Uris demurred, saying he felt that he was entitled to a private office in the studio's Executive Building. "This miffed him, I'm sure," recalled Uris. Later, Hitchcock invited Uris to New York for a press conference announcing *Topaz*, booking the author into a suite adjacent to his at the St. Regis; but Uris offended the director by insisting on staying at his own favorite hotel. "I made a fight out of it," Uris recalled.

Hitchcock had spent his career turning writers into his friends and allies by keeping them in constant close proximity—huddling with them in offices, hotel rooms, or his own home, even taking them on vacations. Trying to win Uris over the same way, he scheduled regular lunches with the writer, but Uris resented being stuck in the office, eating every day in the private dining room, where Hitchcock presided oppressively over the menu and conversation. To Uris, lunch just seemed like an extra obligation. "I couldn't say no," Uris recalled. And Hitchcock, once such a proud wine connoisseur, now found his physical condition shaky enough that he couldn't handle even one glass of spirits at lunch without becoming slipshod in conversation—and two glasses would be a violation of doctor's orders.

Uris realized that he received a "classical education" from watching Hitchcock films, with the director sitting close to him and narrating aloud (recalling "every famous shot" all the way back to his first film, according to Uris). *Notorious* was the golden oldie to which Hitchcock kept referring, the kind of film he said he hoped *Topaz* might be—"espionage with an emotional relationship." After a while, however, Uris found the experience of watching Hitchcock films "a drill in self-aggrandizement. He wasn't trying to teach me anything. He was trying to show me how great he was." And when a Hitchcock film wasn't scheduled, they watched not Godard or Antonioni, but "some other Universal junk," in Uris's words.

Once a man of boundless energy who drew inspiration from scouting trips and social forays, Hitchcock now sat immobile behind his desk all day long, Uris reported. He seemed most interested in playing with his dogs, who rode in the car with him from Bellagio Road every morning to romp around the bungalow and wet the rugs. The director and writer would work, but mostly it was talk, hours of talk—fixated on the story's crescendo moments. Uris expected to discuss the political complexities of his story, but he decided that Hitchcock didn't have the slightest grasp of political complexities, and that all his ideas about espionage (as evidenced by his repeated references to *Notorious*) were outdated and quaint. He "didn't seem to understand how a real secret service worked," said Uris.

Hitchcock's personality assets—his insistence on intimacy with his collaborators, his love of gossip, his crude humor—failed to beguile Uris. When the director told Uris he "hadn't been laid" in twenty-five years, the

author thought that a tasteless confidence. Hitchcock proffered salacious tidbits about stars he had known, "but I didn't like that," recalled Uris.

The sexagenarian director, trying to craft a realistic Bond, was sadly out of touch with the real world, Uris thought. And Hitchcock seemed not only removed from, but contemptuous of, humanity. He was cold, morose. Hitchcock saw "the writer as his enemy." thought Uris.

Suffering from poor health, under mounting strain, and stuck with a challenge that eluded him, Hitchcock was grasping desperately at every strategy that had worked for him in the past, trying to impose his will on the film by establishing mutual ground with Uris. But nothing he did elicited any real engagement—or even sympathy—from the author.

In the end, they clung to their differences; Uris resisted doing Hitchcock's bidding. The director warned Uris, for example, to write the intelligence agents *and* the revolutionaries as human beings, without regard to politics. But Uris's treatment made Fidel's lieutenant Rico Parra "a cartoon sex maniac to whom Juanita finally offers herself to distract him while Devereaux is getting out of the country," in the words of Bill Krohn. "She then has rings inserted into her eyes to force her to watch while Parra is beaten to death, and is last seen with her breasts forcibly bared for carving by Havana's chief of police."

In the end, director and writer *did* become enemies. Uris lasted only until July, though he delivered a partial draft before moving on. After turning it in, according to Uris, he tried to contact Peggy Robertson about something, and she cut him off on the phone.

With *Topaz* in trouble, Hitchcock brought "Frenzy" back to the table. The director had valuable test footage, he had copious storyboards prepared, and he had a script all but finished. All he needed was one more writer and a final polish. He met with Herb Gardner, the playwright of *A Thousand Clowns,* and showed him the storyboards: the way Hitchcock explained it, what he was really looking for was someone to do the job that brought him into film, in 1921—a title writer, who would "caption" the drawn shots.

Gardner was tempted, until he saw in one storyboard a shot of a character being choked and pushed off the Verrazano-Narrows Bridge—and then, two frames later, the same man sitting at an outdoor café on Fifth Avenue. "How do we get from the guy being pushed off the Verrazano-Narrows Bridge to the same guy at a Fifth Avenue cafe?" he asked.

"The crew goes there," said Hitchcock, without cracking a smile.

"Wait a minute. How do we get the audience there, is what I mean."

"Mr. Gardner," said Hitchcock, "The audience will go wherever I take them and they'll be very glad to be there, I assure you."

When Gardner bowed out, Universal itself proved unwilling to go any further with the project. On July 10, 1968, Hitchcock met with Edd Henry and Lew Wasserman, presenting the "Frenzy" slides and test footage in a last-ditch attempt to make his case for the film. The result, as Donald Spoto wrote, was humiliating. Over the next week the three met several more times, but MCA and Universal had been opposed to "Frenzy" all along, and now these two executives—the head of MCA and the boss of Universal—forcefully reiterated their opposition.

"You may question my taste," Sir John tells Handel Fane in *Murder!*, describing his plans to mount a play based on the murder he suspects Fane himself of perpetrating, "but as an artist you'll understand my temptation." Now, in addition to the studio and agency that represented Hitchcock, other friends questioned his taste, and few understood his temptation.

Back at Paramount, when *Psycho* had encountered a wall of resistance inside his team, Hitchcock had proved everyone wrong. But that was ten years earlier, and Hitchcock was more vulnerable now. He had lunch with Herbert Coleman and Doc Ericksen, asking if they would come back to work for him, but Coleman expressed a distaste for the *Psycho*-like "Frenzy."

Even François Truffaut disappointed him. When Hitchcock sent him the script of "Frenzy," just after the U.S. publication of *Hitchcock/Truffaut,* he couldn't have predicted the reaction of his great champion. Truffaut was no Godard or Antonioni. He made humanist films, and he never intentionally shocked or alienated audiences. Although the Nouvelle Vague filmmaker strove to be diplomatic in his letter, praising certain scenes while stressing how much "I respect, admire, and esteem you," in his words, the Frenchman obviously recoiled from "Frenzy." He pointedly mentioned the pervasive nudity, sex, and violence ("It does not worry me too much because I know that you shoot such scenes with real dramatic power," he temporized, "and you never dwell on unnecessary detail"), and targeted several key scenes of the script as simplistic or implausible. More broadly, he diagnosed the entire second half as "a trifle banal."

Perhaps this stark but promising film might have remained in the director's sights if Mrs. Hitchcock had advised her husband to ignore the critics and go ahead with "Frenzy." But there is no evidence she said anything one way or another. Her deep involvement in the script may even have made her shy about pressing her opinion; after all, she had backed *Under Capricorn.* Although she supported Hitchcock's every move, the important moves were up to him. And perhaps he could have bucked Wasserman and Universal, insisting on making "Frenzy"—which, unlike *Mary Rose,* wasn't strictly precluded by his contract. But the united front wore him down—and Hitchcock was reluctant to spurn advice from Wasserman, a friend who had done so much for him.

"Frenzy" was indefinitely postponed—and before too long Hitchcock was referring to Antonioni in interviews as "pretentious." *Topaz* was swiftly given the green light.

After he'd lined up Herbert Coleman and Doc Ericksen, the director's attempt to recapture the halcyon days of the 1950s was symbolized by the eleventh-hour hiring of Sam Taylor—Hitchcock's greatest stooge of that era, a writer who *enjoyed* long lunches with him, who vacationed with the Hitchcocks, and even hosted them at his home in Maine.

Moving swiftly to make up for lost time, on July 21 Hitchcock, Coleman, and Ericksen left for England and the Continent. Taylor received a long phone call from Claridge's, getting him started on the new script. While scouting locations in Denmark and France, Hitchcock interviewed European actors and shot tests of Vienna-born Frederick Stafford at Cinecittà in Rome.

When Hitchcock returned to California by early August, the production was put on a pressure-cooker schedule. The director juggled script conferences with Taylor and staff meetings with costume designer Edith Head, art director Henry Bumstead, and editor William Ziegler—all veterans of Hitchcock films, adding to the déjà vu atmosphere. Even cameraman Jack Hildyard, who had won an Oscar for *The Bridge over the River Kwai,* was an old acquaintance, from his days at Elstree as a clapper boy.

Universal was pushing for a fall start, but give Lew Wasserman credit: he put his money where his mouth was, investing $4 million in *Topaz,* Hitchcock's biggest budget to date—his biggest ever, as it turned out. Universal figured that an international cast and exotic settings would serve as an antidote to the lure of watching free programming on a small living-room screen.

Although Taylor had finished off *Vertigo* in style, that script was also indebted to an excellent novel, and a series of capable writers who built on each other's drafts over a period of years. On *Topaz,* Taylor began with an unwieldy novel, one partial draft, and material alien to anything else he had ever written. Now, instead of *Notorious,* the script shifted toward a less romantic model: 1965's *The Spy Who Came In from the Cold,* a film Hitchcock and his staff watched several times. Taking Uris's criticisms to heart—that he was out of touch with spying—Hitchcock arranged for several briefings from intelligence officials, including George Horkan, former deputy inspector general of the CIA.

Taylor got rid of the World War II–French Resistance flashbacks, which the budget couldn't handle, and at Hitchcock's behest turned Rico Parra into a sympathetic, almost tragic figure—in truth, the film's most faceted character. Taylor also built up the Cuban scenes—his heavy rewriting

would make them among the best in the film—and radically altered the plotting of Uris's book.

One highlight, Juanita's death, was never fully described in the script, or even storyboarded, until it came up on the schedule. Though Hitchcock had mused about it endlessly—and built a floral motif into preceding scenes. As Bill Krohn observed, in the opening defection sequence Topaz "pauses to contemplate a ceramic flower being put together petal by petal"; later, when the American intelligence chief visits Devereaux in his hotel room, "he brings a grim-looking bouquet of yellow flowers as a pretext for screwing up a family vacation with an assignment"; and later still, there is "a dolly-in on a white funeral wreath" ending the sequence where the rogue employed by Devereaux sacrifices a Cuban informant.

Then when Juanita is shot to death at close range by Parra, her betrayed lover, the Cuban heroine collapses into Parra's arms and sinks to the floor, her purple dress spreading out over the black-and-white tiles like a gorgeous flower blossoming.* The director filmed this stunningly from high overhead; it is the one shot people always remember from *Topaz*. "This is the level on which the film took shape in Hitchcock's mind," wrote Krohn, "often without being set down on paper, in images that are also metaphors for its venomous beauty."

Hitchcock and Taylor weren't able to spend much time together, however, and the filming started without a complete script. Taylor had to rush pages over to Copenhagen and Paris during the location work in mid-September; then, at Universal in October and November, the remaining scenes were revised just days before they were shot. But a decent script eluded Hitchcock, and so did the right actors; certain roles were cast and recast. "An actor who, when he wasn't employed, operated a beauty parlor was cast in a small but significant role," recalled studio publicist Orin Borsten. "I watched as Mr. Hitchcock, walking over, the company within hearing distance, asked the actor to play the role in the acting style of Peter Lorre. Time was being lost as he worked with the actor, who either didn't understand the director's wishes or was incapable of satisfying him. That same day he was fired."

He collected actors, literally, from around the world. The cast included imposing Montreal-born John Vernon as Rico Parra, and the African American actor Roscoe Lee Browne as the operative hired to purloin in-

* Hitchcock loved to describe the shot for interviewers: "Just before John Vernon [who plays Rico Parra] kills her, the camera slowly travels up and doesn't stop until the moment she falls. I had attached to her gown five strands of thread held by five men off-camera. At the moment she collapses, the men pulled up the threads and her robe splayed out like a flower that was opening up. That was for contrast. Although it was a death scene, I wanted it to look very beautiful."

criminating documents from the Cuban delegation visiting New York. There were Danes, and there were Germans too. Two distinguished Frenchmen, Michel Piccoli and Philippe Noiret, had parts in the French section, as the Soviet moles. The only old Hitchcock hand was John Forsythe, as the American spy official probing the Cuban-Soviet-French connection.

To save money, and avoid coping with another quirky figure like Paul Newman, Hitchcock thought this time he would launch his own male star. Frederick Stafford was a virtual unknown; Hitchcock had spotted him in a French James Bond hand-me-down called *OSS 17,* about a CIA agent pursuing smugglers in Brazil. Just as he had tried to make Tippi Hedren into Grace Kelly, he would try to transform Stafford into a realistic Bond—"the director's approximation of a Cary Grant persona," in Borsten's words. But Hitchcock's casting judgment deserted him in his worst hour, and just as in days of yore he found himself stuck with a wooden, unsexy lead.

"One of the tragedies of *Topaz,*" Sam Taylor recalled in one interview, "was that Hitch was trying to make something as if he had Ingrid Bergman and Cary Grant in it."

Topaz featured several beautiful, competent women, but none of them compared to Ingrid Bergman, or the other great ladies of Hitchcock's past. Stafford's daughter was played by Claude Jade, who had appeared in Truffaut's *Stolen Kisses* and came recommended by the French filmmaker. Stafford's wife was played by the ex-ballerina Dany Robin.

The casting process was chaotic, and Juanita, the key role for an actress, wasn't filled until just days before her scenes had to be shot. Hitchcock had interviewed actress after actress, finding fault with each one. With the Cuban scenes fast approaching, there was anxiety among the staff. But the director seemed untroubled. "She will show up," he assured people.

So it came to pass: one day an agent brought in Karin Dor, a ravishingly Latinesque German actress who spoke flawless English. Even better, Dor had appeared in *You Only Live Twice;* how could Hitchcock resist adding an actual Bond girl to his realistic Bond film? Dor was handed a script, costumed, made up, and pushed in front of the cameras.

Alma shared her husband's instant infatuation with the German actress, and the Hitchcocks took Dor to Chasen's night after night. Her scenes got extra attention, though ultimately she disappointed Hitchcock, more off-camera than on. One day, during a break in filming, Borsten arranged for a photographic session with Dor and John Vernon, for advertising and promotion purposes. Hitchcock sat in, posing them sexily together. He zeroed in on Vernon's cigar, telling Dor, "Karin, put it in your mouth," according to Borsten—"innuendo manifest, a sly twinkle in the director's eyes."

Dor blushed, giggled, demurred. Hitchcock insisted: "Come on, Karin, you know you've had it in your mouth before. . . ." She pleaded, refused. Angrily, Hitchcock ended the session, but not before asking Borsten, "Now do you have all the art you need?" Borsten said he would like a few shots of Hitchcock with his brunet star, in contrast to all the photographs that existed of him with blondes. Still visibly deflated by Dor's refusal to play along with him, the director muttered, "I wouldn't want a picture with her." (Borsten recalled: "Only the night before the Hitchcocks had dined her at Chasen's.")

The actors resisted him, or they didn't fathom him. Hitchcock's sense of humor was off throughout the filming. His back-alley jokes, wasted earlier on Leon Uris, were really squandered on the French actors, according to Borsten; even the best English-to-French dictionary wouldn't have helped them decipher his Cockney slang and puns. "They gazed at him uncomprehendingly, the humor pointless to them."

But Hitchcock's biggest defeat was Dor's big love scene with Stafford, which all along Hitchcock had eagerly planned ("unknown to actors and [the] entire company," according to Borsten) as his first opportunity to thumb his nose at the fading Production Code; he'd show his lead actress and actor naked from the waist up. A wardrobe woman rushed up to him before the filming, wringing her hands. "Oh, Mr. Hitchcock, Mr. Hitchcock, Miss Dor can't do it. . . ." Dor's body was marked with scars from surgery. Then, almost laughably, Stafford followed a moment later to explain that he too had gone through lung surgery and now bore a livid scar from one side of his chest to the other. Hitchcock merely gulped, and said with a deep sigh, "Very well, we shall film the scene from the shoulders up."

From script to postproduction, *Topaz* was nothing but "a dreadful experience," in Taylor's words. Hitchcock rushed through all the planning. He shot backgrounds that weren't used, and scenes that were later dropped. At the same time he indulged in foolish extravagances over minute details: on the verge of shooting a French dinner scene, he held up filming until he could make contact with a Parisian restaurateur to confirm the precise amount in a single serving of pâté de foie gras.

He wasn't the same Hitchcock who could patch the flaws of *To Catch a Thief* into a sparkling film, regardless of trouble along the way. Ralph Tandowsky's longtime partner, Dr. Walter Flieg, had inherited the job of Hitchcock's physician, and for the first time a doctor attended the director on-set throughout the making of a film, hovering discreetly nearby even in Copenhagen and Paris. The obvious burden Hitchcock was under alarmed friends and associates. "He was no longer the great brain that sat in the chair watching 'round him," recalled John Forsythe, who had acted in *The Trouble with Harry* and on television for Hitchcock. "He would go away

for fifteen or twenty minutes and lie down if he could, and it was sad to see."

After finishing principal photography in March, the director took a short break, then returned to Paris in mid-April to shoot the grand climax of the film. This was to be the greatest of the film's choreographed crescendos—a scene not in the book, but in Hitchcock's mind from the beginning. It was an old-fashioned pistol duel between Devereaux (Stafford) and Granville (Piccoli), the "Topaz" mole and lover of Madame Devereaux, set at dawn in a deserted soccer stadium. During the duel, Topaz is shot in the back by a Russian sniper.

Hitchcock got only halfway through the weeklong shoot before he was forced to leave the set prematurely for entirely unexpected reasons. Whereas Forsythe and others had been holding their breath over the director's health, word came from America that Alma—invincible Alma—had been hospitalized. Distraught, Hitchcock told Herbert Coleman that he was unable to continue filming. *Topaz* didn't matter to him at all, he said, if Alma was in danger. He gave precise instructions to Coleman, who—just as he had done for Hitchcock on *To Catch a Thief*—finished the location work. The director left for Hollywood, where news of Alma's brief illness—vague and undiagnosable—was kept from the papers.

The film was jinxed to the end—and the editing of the duel sequence became a particular sore point.

The French government had objected to *Topaz,* with its portrait of Soviet sympathizers infiltrating their highest ranks. Permission to film in Paris was suspended until the U.S. ambassador to France, Sargent Shriver, arranged a meeting and reassured authorities of Hitchcock's honorable intentions. Although Hitchcock was perfectly capable of double-crossing the French, as he had fooled censors and studio officials throughout his career, the duel sequence was there partly to assuage them by exterminating the Soviet mole—punishing the villain, as in Production Code days of old.

But when the Hitchcock film was test-screened in San Francisco, the audience reaction was divided dramatically between people who thought *Topaz* was the best movie they had seen in years, and others who felt it ruined a great book. "Because the audience had been recruited from fans of the Leon Uris novel on which the film was based," wrote Bill Krohn, "outrage was in the majority." And the worst derisive laughter greeted the visually spectacular duel scene, which nonetheless struck many Americans as a ludicrous anachronism.

Although Hitchcock had always pooh-poohed previews, this time he

had to answer to Universal—and to his own nagging doubts about *Topaz*. Although he had always toyed with alternative endings, now, for the first time since *Suspicion,* he changed an ending purely to answer the preview cards. He hastily agreed to ditch the duel, and returned to France to film an alternative ending at Orly Airport, with Devereaux and the French traitor boarding plans for Washington and Moscow, respectively, and waving to each other cynically.

While it eliminated the old-fashioned duel, the trouble with this ending was that it revived the possibility of the French condemning the film. And Sam Taylor especially hated the idea that the traitor might be allowed to abscond, telling Hitchcock that the revised ending was too cynical—"a betrayal of the very story you have told. . . . Your point, that you have made so effectively, is that the Cold War, and spying, and power politics, destroys lives."

Taylor convinced Hitchcock to work from available footage to devise yet a third alternative, to be used only in case of "emergency," and even then solely in France: the audience hears the noise of a gunshot, followed by a freeze-frame of the front door of Topaz's house. This would hint at the traitor's suicide, along with "flashback shots of characters destroyed to achieve American goals superimposed over that image and one of a man reading a newspaper about the Cuban missile crisis," in Bill Krohn's words.

Over the summer, Hitchcock stubbornly maneuvered to keep one of his two replacement endings. He thought the Orly Airport one was the toughest, the most realistic, but Universal preferred the freeze-frame, which wouldn't offend anyone. Vacationing at the Villa d'Este in August, Hitchcock phoned editor William Ziegler to make a final decision. Orly Airport "is really the correct ending," he insisted. "In every case, whether it be Philby, Burgess [or] Maclean, they've all gotten away with it and they've all gone back to Russia."

There was internal debate right up to release, and then a compromise: different versions would be made available for different markets. It wasn't the first time the director had been obliged to offer different versions of Hitchcock films to different markets; it had been going on since Islington days. But it hadn't happened to him in a long time, and it was all the harder to swallow now, at the twilight of his career.

Topaz varied wherever it was shown. The Rank Organisation in England insisted on cutting at least twenty minutes out of the film, for example; in London, Universal showed the freeze-frame ending to critics at the premiere, and the Orly Airport version to the general public. American and French audiences got the freeze-frame. It was, Truffaut wrote later, "a solution of despair."

And what of the spectacular duel, doomed by preview audiences?

Hitchcock told film critic Penelope Houston, ruefully, "I'll probably let Langlois have it"—meaning Henri Langlois, the director of the renowned Paris Cinémathèque archive. After all the trouble with France, he probably meant it ironically. But after his death the duel sequence—which Hitchcock "smuggled out of Universal and kept in his garage," according to Krohn—was indeed donated to the library of the Academy of Motion Picture Arts and Sciences. Today it can be viewed, along with other cut scenes and ending variations, on the DVD edition of *Topaz*.

When *Topaz* was released at Christmas, 1969, the other films stirring excitement in theaters—*Easy Rider, Alice's Restaurant, Putney Swope, Midnight Cowboy, Take the Money and Run, Bob and Carol and Ted and Alice*—seemed to augur an American Nouvelle Vague. In contrast, Hitchcock's latest looked all the more creaky and lackluster.

Following so closely on the heels of the Truffaut book, *Topaz* should have offered a magnificent capstone to Hitchcock's career. But the film disappointed—and in some quarters even the book backfired. Truffaut was attacked in the influential *Film Quarterly* for his preoccupation with technique and form as opposed to substance, and the extravagant artistic claims he made for Hitchcock were unfavorably compared, by Gavin Millar in *Sight and Sound,* to the director's own relentless anecdote-telling and persistent self-deprecation. Truffaut's "twin assertions in the introduction that Hitchcock is a major influence on world cinema and that he is grossly underrated," asserted Millar, "seem to demand a level of response from Hitchcock himself beyond anything which the book gives us."

Although many young critics idolized Hitchcock, it was just as true—as it had been true even in the days of his earliest silent-film triumphs—that others were offended by the attention and adulation he received. The young detractors included such prominent critics as Pauline Kael of the *New Yorker* and Stanley Kauffmann of the *New Republic,* and they could be as extreme as the worshipers. (As far back as *Vertigo* Kauffmann had declared Hitchcock's career dead, and called the James Stewart—Kim Novak film "an asinine, unredeemed bore.") Richard Corliss in *Film Quarterly* now wrote that Hitchcock "is neither the Shakespeare of film, as Sarris and Robin Wood state, nor its Shadwell, as Pauline Kael might want us to believe." Corliss argued that *Topaz* was really two films: "inept and effable, poorly acted and well acted, shoddily shot and exquisitely shot, mediocre and transcendent."

Better on balance than *Torn Curtain,* with some genuinely worthwhile elements, *Topaz* has grown in critical estimation, just as the Truffaut interview book has come to be accepted as a model of its type. Bill Krohn,

for one, regards *Topaz* as "a chilling panorama of the human toll taken by Cold War politics." That's certainly what Hitchcock had hoped for— but he wouldn't have agreed with Krohn's verdict. He himself regarded *Topaz* as "a complete disaster," according to John Russell Taylor, "whatever some of his wilder admirers may say in its favor."

EIGHTEEN
1970–1980

Nineteen seventy went by in a blur of celluloid. Hitchcock continued his diet of French and Italian films, but also screened youth-exploitation movies about drugs and campus revolution (*Getting Straight,* Antonioni's *Zabriskie Point,* even *Woodstock*), and a surprising number of "blaxploitation" pictures (as if trying to puzzle out an audience he had virtually ignored in his own films). He kept up with the James Bonds, with the Academy Award contenders, with films made by old friends as well as autumnal works by colleagues like William Wyler and Billy Wilder. He rewatched *Citizen Kane* and *The Big Sleep.* He seemed never to miss a Walt Disney picture, and tried dutifully to sit through everything produced by Universal.

Old friends stopped by the office or came to dinner at Bellagio Road. Hugh Gray, Victor Saville, Charles Bennett, Joan Harrison, Whitfield Cook, Herbert Coleman, and Norman Lloyd stayed in touch. Once or twice a week Hitchcock had lunch with Lew Wasserman, usually joined by MCA agents Herman Citron or Edd Henry. Mrs. Hitchcock sometimes came to the office for lunch, though often Hitchcock ate alone—or, if he was in the mood to talk, with Peggy Robertson.

He still attended all the important stage shows at the downtown the-

aters. He still enjoyed horse racing, and several times accepted invitations to share a racetrack box with former MGM director Mervyn LeRoy, for whom he had a soft spot;* he and Alma were also hosted several times for dinner by onetime MGM executive Benny Thau.

Hitchcock was now without a new film, or even his television series, before him; his schedule was never more open-ended than at the dawn of the new decade. Some days he simply stayed home, "reading properties," according to the steady notation in his logbook. Getting in to see the legendary Alfred Hitchcock wasn't hard: writers from small film journals, college students running film societies, a collector of rare recordings by Eric Coates (often hailed as the British king of light music), all got appointments.

A lesser man, after the triple whammy of *Marnie, Torn Curtain,* and *Topaz,* might have elected to retire and rest on his laurels. But Hitchcock gave no hint of quitting. If anything, failure had made it all the more important for him to try again, and he spent most of 1970 resting, coaxing his body back into shape. The time off seemed to work, and when Hitchcock had a thorough physical on April 6, 1970, the results were positive.

It was a cautious year, spent close to home, Universal, and Dr. Walter Flieg. The director took a week in Hawaii, and a few days in Canada, but there were no quick hops to New York, no long trips abroad; even weekends in Santa Cruz were down to a handful.

"I am looking for a new film project," Hitchcock wrote Truffaut during the summer, "but it is very difficult. In the film industry here, there are so many taboos: We have to avoid elderly persons and limit ourselves to youthful characters; a film must contain some anti-establishment elements; no picture can cost more than two or three million dollars.

"On top of this, the story department sends me all kinds of properties which they claim are likely to make a good Hitchcock picture. Naturally, when I read them, they don't measure up to Hitchcock standards."

But the slow pace was tonic, and by January 1971 something new looked like it might measure up.

Arthur La Bern was a former Fleet Street reporter turned novelist and film writer whose long vitae included the acclaimed *It Always Rains on Sunday,* a 1947 film produced by Ealing from his novel. Angus MacPhail had been among the writers on that film, so Hitchcock knew all about La Bern—but it had taken him a while to get around to reading La

* LeRoy directed *I Am a Fugitive From a Chain Gang,* the only sound film Hitchcock listed in 1939 as among his ten favorite films.

Bern's 1966 novel *Goodbye Piccadilly, Farewell Leicester Square*. He must have smacked his lips as he read—the story was so Hitchcockian, like *The Lodger, Psycho,* and Hitchcock's abortive "Frenzy" rolled into one, that La Bern could be accused of having written it with the director in mind.

The story concerned a sexually impotent psycho killer who is preying on women in modern London. After his ex-wife and a barmaid girlfriend are murdered, an ex-RAF hero becomes the chief suspect. But he has a "rooted objection to being placed in a cell," in the words of the book, and goes on the run.

Here was the fiction, with real-life echoes, that he'd been looking for. Although he could describe the story as a run-for-cover, it combined his kind of wrong-man conceit with a fiendish, "Frenzy"-style killer. Indeed, La Bern's book directly likened the killer to Neville Heath; and in the film Hitchcock would add pointed comparisons to Jack the Ripper and John Christie—covering three of the psychopaths who had come up in Hitchcock's talks with Robert Bloch and Benn Levy.

Everyone around him had witnessed the depths of the director's despair after *Topaz,* and Lew Wasserman wanted to give his friend another chance. Now, suddenly, Hitchcock found Wasserman receptive to the project—all the more so because it was a London story that could be cheaply bought and filmed—even though the killer in La Bern's novel was so reminiscent of the despised "Frenzy" that Hitchcock could recycle its title for the new film: *Frenzy.*

But this was an English killer, not one that reflected on America, Wasserman reasoned; and indeed, Hitchcock would be permitted to shoot *Frenzy* almost entirely in London, which would be great publicity (while allowing him to escape Universal). Universal granted him a $2.8 million budget, small enough to minimize the studio's risk, though Hitchcock had always been clever about stretching money.

Time had moved on for Hitchcock since he had conceived the first "Frenzy" in a New Wave mold, with a modernist black-and-white camera style and a cast of young no-names. The new *Frenzy* would be brought more in line with traditional Universal productions; it would feature highly respected English stage players and old-fashioned color photography.

Hitchcock even had an English playwright with a tasteful stage hit lined up to execute the script. En route to Paris in mid-January, the director stopped in New York for his first meeting with Anthony Shaffer, a former lawyer and author of the long-running stage hit *Sleuth,* a thriller about a mystery writer who plots the perfect murder of his rival. Shaffer then accompanied Hitchcock to London, where both stayed at Claridge's while discussing the script and touring locations in Hyde Park, Leicester Square, Piccadilly, Oxford Street, and Bayswater, and on the Thames.

Hitchcock noted the proximity of Hammersmith Hospital to Worm-wood Scrubs prison, and decided to exploit that for the escape of the wronged man in the film's third act. The film was envisioned as a Hitchcock travelogue of London, but also a personal scrapbook of memories—starting with Covent Garden, where the psycho killer lives in the book. The venerable fruit and vegetable market was a place Hitchcock knew well from his father's trade, and now he laid plans to tie the setting even closer into the suspense by making the psychopath a produce wholesaler.

Hitchcock himself was more like the wronged man of the story—Blaney, a man out of step with fashion, wearing an outdated tweed jacket with leather patches on the shoulders and elbows. As he and Shaffer toured London, Hitchcock, chagrined by how things had changed, found himself dwelling on the past. He agreed to set a scene at the recently built Hilton Hotel and another at New Scotland Yard, but rejected other contemporary locations suggested by Shaffer. Looking for a model of the old-style pub where Blaney bartends in the film, he complained to reporters about the "psychedelic nature" of up-to-date pub interiors. "They look wrong," he said. "There's nothing like dark wood in a good pub."

But the two hadn't yet done any actual scriptwork, Hitchcock informed the press; they were merely working from three pages of notes from the book. "We haven't got a line of dialogue," Hitchcock said. Then, after meeting with old friends, including a lunch with Ingrid Bergman, Hitchcock flew to Paris, where he was installed as a Chevalier of the Legion of Honor. At his request, the ceremony was presided over by Henri Langlois of the Paris Cinémathèque, who had been fired in 1968 by André Malraux under Charles de Gaulle. (Only after international protests from prestigious filmmakers, including Hitchcock, had Langlois been reinstated.)

Shaffer met with the director back in Los Angeles on January 22, launching a month of talks. But on the first day, the writer remembered, "I nearly talked myself out of writing the film by accusing the great man of being illogical and of leaving holes in his plots between the famous set pieces." Lunch ensued "in arctic silence, Hitch thinking furiously throughout. At the end of it he said in his stertorous way, 'Dear boy, quite obviously you've never heard of the icebox syndrome.' " No, the screenwriter admitted, he had not.

"I leave holes in my films deliberately, so that the following scenario can take place in countless homes. The man of the house gets out of bed in the middle of the night, and goes down stairs and takes a chicken leg out of the icebox. His wife follows him down and asks what he's doing. 'You know,' he says, 'there's a hole in that film we saw tonight.' 'No there isn't,' she says, and they fall to arguing. As a result of which they go to see it again."

"Just how many holes do you want to leave in *Frenzy*?" Shaffer asked skeptically.

"I'm quite sure you won't leave any, dear boy," Hitchcock replied mischievously. "Just leave that to me."

Reconciled, the pair went back to work. To open the film, Hitchcock sketched an ambitious overhead shot, starting in midair above the Thames near his old neighborhood of Limehouse, then moving upriver and gliding under Tower Bridge Road, arriving to hover above County Hall, where a stuffy politician is making a speech about how the formerly polluted Thames has been thoroughly cleaned up (a bowler-hatted Hitchcock would be glimpsed amidst the onlookers). The politician's self-serving speech is interrupted by the naked body of a woman washing up on the nearby muddy shore (the buttocks shot Hitchcock had pursued since *Psycho*).

Covent Garden had been in La Bern's novel; so was the famous dead-body-in-a-potato-sack scene. But Hitchcock seized on these elements to weave a food motif throughout the film. Food would become a key to the main characters, hinting at their deeper urges. The psychopath, Rusk, likes to munch an apple after his nasty acts; Blaney (the wronged man) expresses his frustration in one scene by mangling a bag of grapes, in another by crushing a wineglass, cutting his hand (as Farley Granger does in *Rope*). The Chief Inspector meanwhile segues amiably from discussing criminal pathology to waxing euphoric over his office breakfast: bangers and mash.

It was steak and salad that linked Hitchcock and Shaffer as they steered their way through the script. That was the daily repast served for lunch in the director's bungalow—every day, without relief. One day, Shaffer dared to wonder aloud "very gently, about this monotony. I shouldn't have. Next day, a fifteen-course dinner arrived, catered by Chasen's, and was laid at my tableside. Hitch, of course, had his small steak and salad."

They were also linked by screenings: Shaffer was treated to the relevant Hitchcocks, and together they watched British psychopath films like *Twisted Nerve* (music by Bernard Herrmann) and *Ten Rillington Place*, about the Christie case. They perused medical literature on impotence and sexual pathology. They mulled the casting: Michael Caine was about to star in the film version of *Sleuth,* and Hitchcock had been following him since his debut in *Zulu*. The British actor's first Oscar nomination had come for his turn as the sexually predatory Cockney of *Alfie*, a part not too far from Rusk (with his "man-about-town appearance," in the book's words). Hitchcock had Caine to lunch in the bungalow, but the part was a hard sell, and Caine was heavily booked up; he became the latest in a long line to squirm away from Hitchcock. (Barry Foster, the lesser-known actor who ultimately got the part, bore an obvious resemblance.)

Hitchcock's drinking now seemed to be regulated, and he and Shaffer quit work every day at 4 P.M. for daiquiris and gossip. The director was,

Shaffer told Donald Spoto, "not only mythicized—he was also lugubrious," but never more so than when drinking. Because Shaffer was so professional, and because Hitchcock had been shaping and reshaping this kind of run-for-cover film all his life, the script advanced with remarkable ease. Although Arthur La Bern later denounced the film adapted from his novel as "distasteful," with "appalling" dialogue ("a curious amalgam of an old Aldwych farce, *Dixon of Deck Green* and that almost forgotten *No Hiding Place*," as the author grouched in a "Letter to the Editor" in the *Times*), his complaint is rather surprising, as the most distasteful scenes were culled straight from the book.*

The murders are extremely graphic in the novel. In one passage the first victim, Blaney's ex-wife, is slowly strangled, an act that follows Rusk's impotent attempts at lovemaking; afterward (in the film *and* book), the dead wife's bulging eyes stare lifelessly at the killer. Later, Rusk murders Blaney's barmaid girlfriend and stuffs her body in a potato sack, tossing the sack in the back of a lorry. He is forced to jump in and ride along, after he realizes she has an incriminating item in her grip; in order to retrieve it, he must bend back the dead woman's fingers until they break. This scene, too, is in the book, and Hitchcock earmarked it for one of his crescendos in the film.

In shrewd ways Hitchcock judiciously edited the book. Where the novel has lengthy courtroom scenes, the film conveys Blaney's guilty verdict in concise Hitchcockian fashion, when a bailiff guarding a courtroom door swings it open momentarily to eavesdrop. The film also excised Blaney's brief escape to Paris, saving further screen time and budget. Yet Hitchcock couldn't win with writers, who could be offended in so many ways.

It is true that the "appalling" dialogue wasn't all La Bern's. In subtle and unsubtle ways, Hitchcock was determined to make the film deliberately archaic—as, at the twilight of his career, he consciously sought to replicate his beginnings. "He was intractable about not modernizing the dialogue of the picture," Shaffer told Spoto, "and he kept inserting antique phrases I knew would cause the British public a hearty laugh or even some annoyance."

The film did boast one major innovation, on the other hand, that was entirely Hitchcock's, and entirely to the good; he elevated the minor character of Chief Inspector Oxford to importance, giving him a fluffy wife, and supper scenes revolving around the wife's experimentation with nou-

*"We *cleaned up* the story," Hitchcock shot back in one interview. "In the original [book], the murderer was found by fingerprints left on a potato. The potato had been stuffed into a questionable area of the victim's body."

velle cuisine. Like other Hitchcock detectives down through the years, the Chief Inspector has everything "ass about face," in Rusk's words; after convicting the wrong man, though, something nags at the Chief Inspector enough to convince him to pursue further investigation on his own. (La Bern particularly objected to the film's "grotesque misrepresentation of Scotland Yard.")

One thing nagging the Chief Inspector is his wife, with whom he discusses the case—and his misgivings—in a series of delightful interludes that were a transparent riff on Mr. and Mrs. Hitchcock. (The director, like the Chief Inspector, preferred his shepherd's pie—though Alma was a splendid cook in any cuisine; the Rusk case was an analogue for a script the Hitchcocks might have worked out at mealtimes.)

Leaving the script in Shaffer's hands, Hitchcock flew in and out of London during the first week of March to receive from Princess Anne an honorary membership in Britain's new Society for Film and Television Arts, at a public ceremony held at Royal Albert Hall. Shaffer returned to Los Angeles for more talks in April, but he and Hitchcock were in sync and the rewrites went quickly and smoothly. A rare Hitchcock film without multiple writers, *Frenzy* was ready, astonishingly, for preproduction in London on May 23.

Leaving his old Hollywood confreres behind, Hitchcock rounded up a British crew for *Frenzy*. Sound mixer Peter Handford had enjoyed a bonhomie, and long conversations about steam trains, with the director during *Under Capricorn,* but Handford was surprised to receive a call out of the blue from Hitchcock asking him to record *Frenzy*. "He'd taken the trouble to trace me," Handford remembered. "I thought that was the most wonderful thing, for such a famous man to take all that trouble over a sound recordist."

Gilbert Taylor had once been a clapper boy at Elstree, before becoming the virtuoso cameraman of *Dr. Strangelove, A Hard Day's Night, Repulsion, Cul-de-Sac,* and *Macbeth*. Hitchcock told Taylor he admired his camera work on those films, but before he took the job Taylor felt compelled to confess a youthful indiscretion: While shooting *Number Seventeen,* Hitchcock had subjected the clapper boy and others on the set to a barrage of pranks, including grabbing people and cutting off the ends of their ties. One day, in return, Hitchcock himself was lured into a darkened room and tackled by two people, who managed to cut off his tie and make their escape without his discovering their identities. Furious, the director convened cast and crew, threatening reprisals. No one stepped forward to confess. Now, Taylor did confess to pulling off that stunt with a friend. The cameraman noted Hitchcock's surprisingly earnest reaction—along

the lines of "Why pick on me?" But the director also said with a chuckle that it was a good thing Taylor hadn't come clean at the time, for undoubtedly he would have fired him.

Discussing the look he wanted for *Frenzy*, Taylor was cautioned that despite the gruesome story, Hitchcock had no desire to make a "Hammer horror."* He wanted a realistic nightmare—"a day in Covent Garden." Taylor, who grew close to the director during filming, thought *Frenzy* "was a boring film from his point of view. He didn't pretend that it would be anything more than it was. I think he would have liked to have been on something better."

Hitchcock took his customary care assembling the cast, small parts and all. He had known the onetime revue artist Elsie Randolph, a longtime song-and-dance partner of the debonair Jack Buchanan (whom Hitchcock had nearly directed in a film), for donkey's years; having played Elsie, the ship busybody in *Rich and Strange* in 1932, now she would play Elsie again—the receptionist at the hotel where Blaney and "Babs" have an afternoon delight.

Jon Finch (as Blaney), Barry Foster (Rusk), Barbara Leigh-Hunt (Brenda Blaney), Anna Massey (Barbara "Babs" Milligan), Clive Swift (Johnny Porter), Billie Whitelaw (Hetty Porter), Alec McCowen (Chief Inspector Oxford), and Vivien Merchant (Mrs. Oxford) were all well-regarded performers in England. Only McCowen (who had appeared in *A Night to Remember* and *Loneliness of the Long Distance Runner*), Merchant (Oscar-nominated for *Alfie*), and Finch (the dour star of Roman Polanski's bloody *Macbeth*) had any kind of profile in Hollywood, but their names wouldn't do much to add to the film's box-office prospects.

Although McCowen had appeared in films before, he was best known for Shakespearean leads with the Old Vic and the Royal Shakespeare Company. He was therefore surprised to be cast as a policeman; it wasn't his sort of territory. Similarly, Massey rang up Hitchcock to ask if he had her confused with someone else. "Don't worry," he replied, "it's only a mo-o-ovie." He had to adopt his best salesman's face for a long lunch with the skeptical Merchant, another thespian more accustomed to classical leads, assuring her that her part was most valuable. (Then, during filming, Merchant had so much fun getting into it that Hitchcock let her embroider her part with stage business and asides.)

Only Finch, who really had to carry *Frenzy* with his acting and personality, offended Hitchcock. The book's Blaney is quite a bit older than

* "Hammor horror"—as in the low-budget, blood-and-gore horror films in lurid color churned out to huge success by England's Hammer Films.

the actor, who had just turned thirty; La Bern's Blaney is closer to fifty, a World War II veteran, in fact—which figures into the plot connections and relationships. Hitchcock wanted a younger Blaney to attract younger audiences, but Finch was too young to play a man who is supposed to have been a squadron leader in Suez. Hitchcock was blithe as always about such trifling inconsistencies. But that wasn't the real problem with Finch.

Before the filming began, Finch earnestly told reporters that Hitchcock seemed past his prime, that the actors might have to improvise a little to improve the quaint script. If that wasn't bad enough, the actor also committed the mortal sin, for a man who had not yet proved himself, of giving Hitchcock a critique of his own dialogue. The director was not only flabbergasted; he was "very angry and he was thinking about recasting," recalled cameraman Taylor. "That's a fact."

In subtle ways and worse, Hitchcock never let Finch forget this transgression. More than once he pointedly stopped the actor before a take, asking if Finch was satisfied with his lines; when Finch once dared to suggest a minor word change, Hitchcock ceremoniously halted the photography until Anthony Shaffer could be found and consulted. Whenever Finch strayed by so much as a hem or haw, the script girl corrected him sharply.

Hitchcock gave Finch no warmth or support on the set, so the actor always remained off balance—just as Blaney is throughout the story. According to cameraman Gil Taylor, Hitchcock also "wasn't very kind to him in terms of shooting close-ups or reverses." If the cameraman suggested an over-the-shoulder shot to include Finch, Hitchcock was inclined to demur. "Of course," Taylor recalled, "Jon used to come to me to say, 'Where's my bloody close-up mate?' and I'd say, 'Well, the Governor doesn't want it.'"

Hitchcock's treatment of Finch was "an act of spite," cameraman Taylor reflected, exacerbating the film's aloofness toward Blaney—whom one critic has called "the least appealing hero" in the director's oeuvre. But Blaney gets no warmth or approval in La Bern's book, either, where he is every bit a loser, brusque and unpleasant even with his few friends. Although his ex-wife and girlfriend are murdered, in both film and book Blaney thinks only about himself; self-absorbed, he doesn't even pause to mourn them.

Up to a point, the film likes Rusk—and Barry Foster, the actor playing him—much better. "The real murderer is deliberately made so much more charming and agreeable than the rather unappetizing character he is framing for his crimes," John Russell Taylor wrote about *Frenzy,* "that all one's normal moral responses are thrown right off."

* * *

Before photography began, Hitchcock seemed ebullient, filming an entire production in London for the first time since *Stage Fright*. He and Alma got out to restaurants and plays; they went to see Ingrid Bergman on stage in *Captain Brassbound's Conversion,* and afterward went for drinks with her and other cast members. Hitchcock had everybody in stitches over what he'd said to Jessica Tandy on the set of *The Birds*. "Listen, Jessica," he warned the distinguished actress, just before releasing the birds for the worst attack scene, "if one of them gets up your skirt, grab it! Because a bird in the hand . . ."

The studio scenes would be shot at Pinewood in Buckinghamshire, the flagging command center of the J. Arthur Rank empire, where the James Bond series had been produced and Chaplin made his last picture—the London studio, where Hitchcock had shot *Young and Innocent*. His return to England was celebrated "in the nature of a triumphal entry," in the words of John Russell Taylor, with a lavish studio banquet where he was seated beside art director Alex Vetchinsky from *The Lady Vanishes*.

Each day by 8 or 8:30 A.M. during the filming in July and August, the director was driven in a Rolls-Royce through the front gates and directly onto the stage, within a few paces of his caravan, so he wouldn't have to walk very far. "Good morning, old bean," he'd invariably say, as he emerged with a smile, to assistant director Colin M. Brewer. "Is everything ready for me?" An honor guard of his staff awaited him: Brewer, Peggy Robertson, and cameraman Gil Taylor. Hitchcock always delegated liberally; besides policing the set, his assistant directors guided the second unit and minor bridge scenes.

Brewer would do especially heavy lifting on this film, for Hitchcock now stayed in his trailer until the set had been arranged and lit, the actors briefed. There, sipping coffee, he went over the day's plans with Brewer and Taylor, reviewing the shot list, which had been numbered and storyboarded. Only when everything was ready did he appear on the set.

By this time, nearly everyone treated him with undisguised awe, as though he were a walking Madame Tussaud's waxwork. His mystique was intimidating, but so was the man—slow, formal, pachydermous. "Hitchcock at work, for all his amiability and chattiness, is a remote and mysterious figure," wrote John Russell Taylor, "hedged about with etiquette."

In order to cope with anxious actors, he had to summon the old warmth and sense of humor. "He would always before a take tell you some dirty schoolboy joke," said Anna Massey, adding, "he did that to relax you because it relaxed him."

He saved his worst puns for one actor who couldn't get his lines straight, and faltered during repeated takes. Hitchcock asked, "Are you a Catholic?"

Yes, came the wary nod.

"I also am a Catholic, so now together let us celebrate the Feast of the Enunciation."

Another nervous actress Hitchcock scolded with a curious phrase: "Genuine chopper," he said.

"Genuine chopper?" she repeated, baffled.

"Real axe," he explained ponderously. "Say it quick!"

"Relax?"

"That's it, dear."

On one hand, Hitchcock felt at ease while making this run-for-cover film, away from Universal, back in the home of his youth and his heart. Yet he couldn't summon much affection for Pinewood, and London had changed in upsetting ways. The contrast was never greater between the legendary public figure and the human being, freighted now with melancholy and infirmities.

Asked by a reporter if he felt sentimental about returning to London, Hitchcock sighed. "One is preoccupied with one's work," he replied. "I get up at 6 A.M., come on the set at 7:45 and go home at 6:30. London is just work and a hotel room." "Just work" put him in mind of his father's profession. "No, my father was not a costermonger here. He was a wholesale cabbage buyer. He would buy acres of cabbage. *Acres.*"

Everyone asked the same thing—even François Truffaut, who visited him on the set and wondered if Hitchcock was suffering pangs of nostalgia. No, the director replied. "When I enter the studios—be it in Hollywood or in London—and the heavy doors close behind me, there is no difference. A salt mine is always a salt mine."

Whenever he appeared in public, Londoners swarmed and Fleet Street wrote about him. Influenced by the French, and led by influential British film scholars such as Robin Wood (whose 1965 book *Hitchcock's Films* rallied auteurists everywhere and proved nearly as important as Truffaut's), the local critics had swung back in his favor—and there was certainly a nostalgia for Hitchcock and his films.

The press flocked to the first day's filming at Covent Garden, where as a young boy Hitchcock had followed his father around as he purchased and sold comestibles. The exploding flashbulbs seemed to take Hitchcock by surprise as he emerged from his Rolls-Royce. He glanced around, looking for familiar faces, but soon was basking in the attention—even posing and "directing" the extraneous lenses.

"To anyone who would listen," wrote Donald Spoto, "Hitchcock spoke of his childhood in old London, and of the Moroccan tomatoes available at Covent Garden in both 1901 and 1971, and of the citrus fruits from Israel, the grapes from Spain, the vegetables from California, and the special produce from all over the world." According to Spoto,

the director even spoke a little of his long-dead father; when an old man came up to say that he remembered William Hitchcock, the director showed a flicker of sadness.

Mornings he was at his best, his most alert, and more work got done before lunch than after. Filming was tougher than writing, and it couldn't be broken up by long lunches, afternoon naps, or screenings. He couldn't take a few days off if he felt like it. As the days mounted, his energy sagged; starting at midday, Hitchcock would be tempted by orange juice and vodka.

He professed to hate teatime—that late-afternoon break unique to the English workday—except that now he made it the excuse for an orange-juice-and-vodka break, shared with the people on the set he liked best, cameraman Taylor and Barry Foster. By the time the assistant director nudged him to say that teatime was over, his mood sometimes had dipped, and he'd say, "You direct it." (Priding himself on his professionalism, though, he generally allowed himself to be coaxed back to his feet.)

Hitchcock started off "meticulously," recalled Shaffer, before losing steam. "Early on," Anna Massey agreed, "he was concerned about every detail—clothes and colors and set dressings. But then he got slow physically. Off the set, the only conversation that seemed to interest him was about food—he taught me how to make a good batter—and later I realized that this was apt at a time when we were making a film so crowded with food."

As rough as he might have been on Jon Finch, Hitchcock was gentle and generous to others in the cast—especially the two actresses playing the murder victims. He liked Barbara Leigh-Hunt better, even though Massey had the bigger part. Leigh-Hunt, however, was the one with the particularly degrading scene, in which she is abused, her clothes ripped off, before she is strangled. Hitchcock cleared the set of everyone except a handful of crew members when that difficult scene was filmed. The repeated takes seemed as painful for Hitchcock as for Leigh-Hunt. "He was trying all the time to spare the girl's modesty," recalled Taylor, "because she didn't like what she was doing, she didn't like exposing her breasts."

Hitchcock seemed to almost dote on Barry Foster.* He supplied the actor with books about Neville Heath from his private library; the two had long talks about Heath, and Hitchcock even ordered him to curl his hair to resemble Heath. The director shared his storyboards to show Foster how individual scenes would be shot, and when Foster suggested a bit

* The relatively obscure actor playing the psycho killer had caught his attention in *Twisted Nerve* (which also featured Billie Whitelaw) and, before making his final decision, Hitchcock attended the West End play Foster was appearing in.

of unplanned blocking for his scene with Blaney's ex-wife—he thought his character might wander angrily around the office, slamming drawers— Hitchcock accommodated the impromptu action.

He fine-tuned Foster's eerie performance right down to the film's very last scene, when Rusk enters his flat dragging a heavy trunk in which he intends to dump another body, and is caught flat-footed by Blaney and the Chief Inspector. That scene wasn't in La Bern's novel, which ends with Blaney alone in the flat, bludgeoning a person he thinks is Rusk—actually Rusk's latest victim, already dead. But Hitchcock's instinct for rounding things out brought Blaney, Rusk, and the Chief Inspector together for a better ending.

During the first takes, Foster reacted to the trap by dropping his head guiltily. The director took him aside and recommended that he smile nervously instead: a Hitchcockian nuance. And Alec McCowen's last line, after it is clear that the real killer finally has been caught—"Mr. Rusk, you're not wearing your necktie!"—also got massaged by the master. During the first takes, McCowen snapped it out in terse tough-guy fashion. Hitchcock pulled him aside. "Alec, if I was playing your part . . . which I'm not . . . but if I was playing your part I wouldn't say the line like that. It's the end of the movie. You've got your man. There's nothing else to worry about. If I was playing your part, I'd just lean against the door, and I'd sigh. . . . I might smile, even . . . and I'd say very quietly, 'You're not wearing your necktie . . .' But it's up to you—you're playing the part." One more time, and it was perfect.

The one character given short shrift in the scene, ironically, is Blaney, who, after having escaped a prison hospital, has just swung a crowbar against a sleeping form—startlingly revealed to be a fresh victim of Rusk's. Jon Finch is least important in the triangulated final shot; perhaps, after all his character has been through, he too could have used a touch of pity.

In early June Mr. and Mrs. Hitchcock had stolen a weekend in Scotland, where once again they found themselves dreaming forlornly of filming *Mary Rose*. When, after the first few weeks of shooting *Frenzy*, Hitchcock decided to assemble some footage and show it to a handful of privileged souls, he worried what Alma would think. He awaited her reaction "like a schoolboy," recalled Barry Foster, "showing his homework to the teacher."

Disaster struck shortly thereafter, when, on the eve of leaving for a vacation with her granddaughter, Mrs. Hitchcock suffered a paralyzing stroke. Fortunately Dr. Walter Flieg, in London throughout filming on *Frenzy* (though he didn't advertise his presence), was able to assist her. Alma was flown to a Los Angeles hospital, and Hitchcock didn't know

what to do; everyone told him there was nothing he could do. But he was frantic, distraught, and in the company of family or friends he overflowed with tears.

People wondered if he would make it through the film. But Hitchcock bucked up, as though it was more important than ever that he finish *Frenzy,* if only to please Alma. Still, the afternoons became endurance tests, with Hitchcock heading for his caravan by 4:30 P.M. to watch on video the last take of the day. Afterward he invited the cameraman and assistant director to join him for another juice and vodka. They still had work to do breaking down the set, so they humored him, taking sips but leaving most of their drinks behind.

He even excused himself and stayed in his caravan for the scene where Rusk, crouched in the back of the truck carrying Babs's body, has to break her fingers in order to dislodge her grip on his tiepin.* This scene, one of *Frenzy*'s most excruciating (and an uncomfortably funny moment), had been planned shot by shot and then carefully storyboarded—so much of it was easily delegated to the second unit while Hitchcock was dining in his caravan with two royal visitors, Princess Grace and Prince Rainier.

The nights were especially rough on Hitchcock as he waited for the regular reports from the States about Alma's prognosis. Her left side was frozen, her speech and walking erratic. Again and again he inveigled the cameraman and assistant director back to Claridge's so he wouldn't have to sit alone in his suite, arranging an elaborate dinner that he only picked at, drinking steadily while talking morosely about the two things he loved most in the world: film and his adored Alma. Dinner was interrupted by transatlantic calls.

Although he could present an icy, forbidding facade, Hitchcock was "an incredibly friendly, nice man," according to cameraman Taylor. He was also "incredibly generous" to the actors, Taylor noted, keeping certain ones on salary *after* their scenes in spite of pressure from the studio, saying, "The film is going to make $10 million, whether it's liked or disliked, and we've only spent two and a half million, so what are they complaining about?"**

After the principals were finished, the cameraman and a small crew were likewise kept on salary after their contracts ran out. Hitchcock had only one thing left to shoot: the trailer. He and Taylor went out for lunch

* In the book the incriminating clue is a spare room key. Hitchcock, sensitive to having used keys before, changed it to a tiepin for the film, and then linked the tiepin to Rusk's dandified appearance.

** Hitchcock wasn't far off. In February 1975, writing to Michael Balcon, he confided that *Frenzy* would end up grossing $16 million. "The London cost, including studio overhead, was $1,250,000. Of course, by the time the studio added the overhead of the cost of my office and staff here and my own salary we got up to $2,200,000. This picture, *Frenzy,* was also sold to television for $2 million, for three runnings."

and dinner again and again, with the director musing endlessly about the best possible trailer (and racking up lavish mealtime expenses while the studio's representatives fumed). After a while they got around to shooting a specially crafted dummy-Hitchcock for the trailer, which they shot floating on his back down the Thames. Then and only then did the director return to Hollywood.

Even before he returned. Alma was much improved, though she would suffer aftereffects, including the permanent paralysis of three fingers of her left hand ("in fact, I have to help 'do her up' every morning before I leave," Hitchcock wrote to a friend).

A few interiors, retakes, the special effects, and other postproduction took six months. Then Hitchcock returned to London early in 1972 to oversee the final dubbing and scoring.

Henry Mancini was the first man engaged to compose the music for *Frenzy*. But Hitchcock was enigmatic with his instructions to Mancini, giving the most garlanded light composer in Hollywood a seeming free hand. So Mancini delivered what he thought Hitchcock wanted—brooding, Herrmannesque music. Hitchcock listened to a recording of the pieces, saying nothing, nodding appreciatively. "Finally, when he was alone in the dubbing room," recalled Mancini, "he decided that it didn't work. The reason he sent forth—I never talked to him, he sent word through someone—he said the score was macabre."

The score was then reassigned to Ron Goodwin, a light composer from the British film industry. This time, Hitchcock articulated a comprehensive breakdown of his requisites. "Sparkling early-morning music for the opening—woodwinds and glockenspiel," Goodwin remembered. "If Hitchcock hadn't directed me, I would have written something with a macabre lilt to it. But he wanted no hint of the horror to come." ("I wish I had something like that to go by," said Mancini ruefully. "It might have been a different story.")

As usual, the film's visual crescendos involved meticulous planning— but also as usual, Hitchcock tinkered with them a fair amount during postproduction. Two of the most famous sequences were laboriously crafted Hitchcockery; one was heavily indebted to Soviet editing philosophies, the other every bit as influenced by German expressionism.

The ex-wife's rape and strangling was a truly disturbing scene, but like the shower-stabbing montage in *Psycho* it was also a magic act: quick cuts, body doubles (Barbara Leigh-Hunt's breasts were disallowed by contract), extreme distorted angles, even freeze-frames to disguise the actress's breathing. And after the "impotent frenzy of the killer and the hideous closeup of the strangling with a necktie," in Anthony Shaffer's words,

Hitchcock planned to conclude the montage with "a closeup of the dead woman's tongue dripping saliva," the decision that provoked the sharpest debate during postproduction.

Indeed, "Hitchcock filmed a pan down from her eyes to her tongue lolling out after she dies," according to Bill Krohn, "using a 250 mm lens equipped with a diopter—a filter that enhances the camera's ability to focus on tiny details—to show spittle collecting on her chin."

Shaffer, Peggy Robertson, and Universal officials, already thrown by the unseemly film, united against the tongue-dripping close-up, and at the eleventh hour Hitchcock "yielded to pressure," according to Shaffer. He took it out—but left it in for the British version, so his homeland's more conservative censors could take it out. For wasn't the chin spittle the last red herring of Hitchcock's career, allowing the censors to pass everything else? And wasn't that the idea—the decisively modern idea of *Frenzy*, which is indeed more lurid than any other Hitchcock film—that such a murder should be thoroughly explicit, thoroughly repulsive?

If the rape-strangling was bravura Russian-inspired editing (forty-three shots, according to Krohn's tally, with each shot preordained on a numbered yellow file card), another high point of the film was the Murnau-inspired floating camera movement that escorts Rusk and Babs up the stairs to his second-floor flat. As though sensing what is about to happen, Hitchcock's camera pauses outside the door; then, as they pass inside, it pulls back and glides away—a difficult, beautiful shot in those days—the sound track going silent as the camera descends the stairs alone.

Upstairs, behind closed doors, the murder takes place, but it is drowned out by the noise of the street welling up to blot out any struggle or scream.* The ex-wife's rape and strangling was the most brutal scene in the director's career, but Babs's was Hitchcock at his most discreet. The former was the gaze of a voyeur, the latter of a man turning away in disgust.

By the New Year, *Frenzy* was beginning to shape up coherently, darker and more gripping than anything Hitchcock had accomplished since *The Birds*. After several failures in a row, even those close to him were surprised by its riveting quality. One day, Hitchcock ran the finished *Frenzy* in the office projection room solely for Mrs. Hitchcock and Norman Lloyd. He sat in his office down the hall, his hands clasped at his desk, stoically awaiting their verdict. Lloyd deliberately sat by himself up front, while Mrs. Hitchcock sat where she liked to watch, from a back row. By the time *Frenzy* was over, Lloyd had grown so excited that he

* Movement *and* cutting: the staircase sequence was also a special effect. Indeed, it annoyed cameraman Gil Taylor that after all the bother necessary to create the shot on location in London (laying tracks, etc.), Hitchcock later insisted on reshooting part of the scene on a set back at Universal. The editing made it all look seamless.

leaped up and shouted, "It's the picture of a young man!" He glanced behind him and saw Mrs. Hitchcock weeping uncontrollably with pride in her husband.

Universal was at once proud and terrified—proud that it had such a sensational Hitchcock film to promote and distribute, but terrified that the nudity and violence might prove too much for provincial markets. The studio's editor in chief, William Hornbeck, was called in to consult with Hitchcock, helping to parse the differing versions that varied country by country, and sometimes even state by state in the United States. This—like censorship and back projection—was another constant of his long career, a necessary compromise he hated, but stoically accepted.

Universal in 1972 might not have been up to Hitchcock's standards in some categories, but its publicity department marched like Sherman's army—and now was able to tout the greatest Hitchcock film in a decade. The studio could offer for dozens of interviews—in person or by phone—with the living legend himself, who, rested and ready after a quiet spring, signed on for a grueling press campaign.

Everyone figured *Frenzy* would be the last Hitchcock film, and so there was a last-hurrah quality to all the hoopla. The bandwagon started in May with Cannes, where the new film was shown out of competition. François Truffaut met with Hitchcock before the festival, and thought the director looked "aged, tired and tense, for he was always very emotional before introducing a new picture, very much like a young man about to take a school examination." Hitchcock could be assured of appreciation from the French, however, and *Frenzy* was hailed in Cannes as a late-career masterpiece.

After staying overnight at the palace in Monaco, the Hitchcocks brought *Frenzy* to Paris for a screening, where Truffaut thought he looked "fifteen years younger" after the reception at Cannes. Now the director beamed with pleasure, admitting that he'd been scared beforehand.

Back in America by the first week of June, Hitchcock was interviewed by newspapers and magazines, and on radio and television. Still, though there are more on-the-record interviews with Hitchcock than with any other director of his generation, even his publicists said that after Truffaut's book, he was rarely asked a truly searching question. The interviewers now were almost fawning, the questions often repetitive or stupid. Herb Steinberg, who attended to Hitchcock's publicity at Paramount and Universal, recalled an eleven-city tour in the mid-1960s where in each city, a stream of journalists were ushered in to meet him all day long, bearing their tape recorders and cameras. "We played a game," recalled Steinberg, "and kept score of how many people asked him the same dumb question about the project. He enjoyed that, but it also bored him."

On the East Coast Hitchcock accepted a flurry of awards, including an

honorary doctor of humane letters at Columbia University. He attended press luncheons and wine tastings, and even cut cakes in the lobbies of newly built movie theaters that were opening up for business with *Frenzy*. Although the Atlantic tour touched down only in Boston and New York, back in California Universal took care of arranging even more in-person or phone appointments for regional media, as well as representatives of foreign markets.

Hitchcock hadn't seen reviews this good for years; even skeptics were won back. Jay Cocks wrote in *Time* that "in case there was any doubt, back in the dim days of *Marnie* and *Topaz,* Hitchcock is still in fine form. *Frenzy* is the dazzling proof." Richard Schickel said in *Life* that "Hitchcock superbly balances the ordinary and the extraordinary, thus reminding us how much he still deserves the name of master, and how well a master can entertain." Vincent Canby wrote in the *New York Times* that the film represented "Hitchcock in the dazzling lucid form that is as much the meaning as the method of his films."

With or without the spittle, the strangling scene was still shocking— "repulsive," in the words of Spoto, "unworthy of the ordinary Hitchcock restraint and indirectness"—and caused a brouhaha in America. "Does 'Frenzy' Degrade Women?" read the headline of a Sunday piece in the *New York Times,* and letters to the editor poured in. The National Organization for Women gave the film a "Keep Her in Her Place" Award. But the controversy only seemed to fan the box office, where *Frenzy* performed remarkably well.

Truffaut astutely described it as combination of two kinds of Hitchcock films: one half of *Frenzy* traced "the itinerary of a killer," the other "the troubles of an innocent man who is on the run," both set in a "nightmarish, stifling Hitchcockian universe" with "a world made up of coincidences so systematically organized that they cross-cut one another vertically and horizontally. *Frenzy* is a crossword puzzle on the leitmotif of murder."

"*Frenzy* isn't just a Hitchcock film," Jonathan Jones wrote in the *Guardian* almost thirty years later, on the occasion of the director's centenary. "It's Hitchcockian, a pastiche and reprise of his work, especially his British films, and a coded autobiography. London is the city of Hitchcock's imagination, and *Frenzy* is his last visit. It's Hitchcock's most insidiously personal film, the Catholic director's final confession."

Despite "up to the minute" violence, Jones wrote, the Hitchcock film was also "flamboyantly old-fashioned" both in its dialogue and its ways of depicting London, which harked back to the director's boyhood. Jones also saw it as two films—"an emigrant's view of home, at once nostalgic and angry," in his words; "what could be perceived as an old man's nostalgia," he added, "could equally be a disciplined and self-conscious piece of artistry."

Although in 1972 there were year-end plaudits from some critics,* Hitchcock's genuinely disturbing, pessimistic film was nevertheless ignored for Oscar nominations. He had always swung back and forth between styles and subjects, and prided himself on his body of work more than individual films. He disliked naming favorite pictures, or explaining symbolic ones. He already had ideas for future works that would further complicate his legacy. Although *Frenzy* resurrected his reputation in the twilight of his career, still Hitchcock would wince to hear it described—as critics routinely do—as his last dark testament.

After the East Coast publicity grind, Hitchcock's first appointment was with Dr. Walter Flieg; then his activity was scaled back for the summer, in preparation for the equally grueling push in Europe in the fall. In September, Hitchcock hosted similar events and press conferences in Germany, Switzerland, and Italy, giving numerous interviews along the way. This time he was accompanied by Alma, whose health once again had rebounded, although now there were weekly checkups for both husband and wife. Their nearly two months of travel and promotion was broken up twice by long interregnums at the Villa d'Este.

Back in Hollywood, on November 16, 1972, Hitchcock attended George Cukor's luncheon honoring the visiting Spanish filmmaker Luis Buñuel. Cukor threw such luncheons to bring together members of the directing profession, and he had remained friendly with Hitchcock since their Selznick days. Buñuel, who had just finished *The Discreet Charm of the Bourgeoisie* (which would win the Best Foreign-Language Film Oscar in 1973), was a rare filmmaker for whom, backed into a corner, Hitchcock admitted grudging admiration. ("He can barely speak the titles, but he manages to let *Tristana* and *That Obscure Object of Desire* pass from his lips," recalled writer David Freeman, who worked with Hitchcock in 1978–79. "He's a hard man. As far as I can see, no one else's work interests him.")

Dutifully, Hitchcock screened Buñuel films for weeks beforehand. The two aging provocateurs had several things in common: though Buñuel was a year younger, both were in their seventies, and still active. Both were educated by Jesuits. Both had worked with Salvador Dalí. Both liked subjects that undressed women, mingled fear and desire, dreams and reality. Yet Hitchcock scoffed at any deeper meaning in his films, while Buñuel was an intellectual who prided himself on his savaging of government, society, and the Church.

* *Frenzy* was named as one of the best pictures of the year by the National Board of Review and the Golden Globes, which also nominated Hitchcock as Best Director and Anthony Shaffer for Best Screenplay.

It's hard to imagine what some of the other Hollywood guests present might have had to say to Buñuel. "Cukor's famous charm glossed over the awkward pauses," wrote John Baxter in *Buñuel*. "Hitchcock in particular was genial, chuckling to Buñuel about Tristana's artificial leg."*

In a photograph taken that day, Hitchcock is seated next to Buñuel among the group that included Rouben Mamoulian, George Stevens, Billy Wilder, William Wyler, and Cukor. John Ford was too ill to stay for the photo, and Fritz Lang also left early. Unlike Cukor and Wilder, who were the only others still active as directors, Hitchcock and Buñuel had started out in the silent era; indeed, Hitchcock had preceded Buñuel in film by several years. For a man of his age, whose health was steadily deteriorating, Hitchcock looks almost serene, even radiant, in the picture.

The studio, the director's staff, and his close friends secretly believed that *Frenzy* would be the last Hitchcock film. But throughout the global publicity campaign, whenever journalists asked him if he was on the verge of retirement, his shock and displeasure were unfeigned. "Retire?" Hitchcock would protest. "What would I do? Sit in a corner and read a book?"

By now, however, his world was shrinking to include only his home and his office, and very often he did just that, stay home and read. Dr. Flieg didn't encourage travel, except for his annual vacation to Hawaii. He didn't go out at night, except for special occasions. Alma's health had stabilized, but her heart was weak, and Dr. Flieg ordered occasional bed rest for Mrs. Hitchcock. Thus, the Hitchcocks' Thursday nights at Chasen's became a special occasion, and it was a big deal when Alma came to lunch or showed up for the afternoon screening.

"Home reading" was what Hitchcock's logbook reported, increasingly, in 1972 and 1973. He had always prided himself on getting up early in the morning and going to work; now he showed up in the office most days after 10 A.M. Some days it wasn't until 12:30, and then the only thing on the schedule might be lunch with his agents, or with old friends like Norman Lloyd. Or it might be just him and Peggy Robertson. In the afternoons there were often showings of films by young directors, foreign and American, but just as often it was the latest musicals, Walt Disney, or James Bond.

He browsed crime and spy books forwarded by Universal's story department. Now his idée fixe became to do another realistic cold war thriller, to expunge the dishonor of *Torn Curtain* and *Topaz*. One day the studio arranged a lunch for Hitchcock with Secretary of State Henry Kissinger and the Soviet ambassador to the United States, Anatoly Do-

* Tristana (Catherine Deneuve) has an artificial leg, and at one point in the film she takes it—and everything else—off, displaying herself nude to her aged guardian Fernando Rey.

brynin. Hitchcock told Dobrynin he aspired to make a film set entirely in the Kremlin. He insisted such a film would be a "formidable success," recalled Dobrynin. Dobrynin probably wasn't aware of the anti-Soviet drift of *Torn Curtain* and *Topaz,* but nonetheless voiced "doubts that the Moscow leadership would fully appreciate the depth and originality of the idea."

The right spy thriller eluded him, and shortly after the Buñuel luncheon Hitchcock had another studio lunch with two young television writers on the lot, William Link and Richard Levinson, who had written for *Alfred Hitchcock Presents* and wanted to spend time with the great man. Over lunch the director talked about his ongoing search for story material, and afterward the writers recalled a book they had read that they thought might be of interest. It wasn't a political thriller—it was in a more familiar Hitchcock crime mode. They had it shipped up to Mrs. Hitchcock at the Santa Cruz house, which the couple was selling. Alma read *The Rainbird Pattern* by Victor Canning first, and recommended it to her husband.

Victor Canning was a thriller writer of considerable distinction (V. S. Pritchett was quoted on his dust jackets, hailing him as "a master of his craft"). Published in 1972, *The Rainbird Pattern* was a suspenseful double chase that on the surface seemed made to order for Hitchcock. One of the chases is quasi-comic, involving an oddball bunco clairvoyant and her out-of-work boyfriend, who are searching for a missing heir on behalf of a wealthy spinster (whose nickname in the book, oddly, is Tippy). The other chase pits hapless police against an archfiend who is plotting a high-level kidnapping. A stark climax, with the archcriminal revealed as the long-lost heir, unites the two story threads.

The novel takes place entirely in England, and involves the ransom of the Archbishop of Canterbury. Although the police bungle along, chasing the wrong couple (an element Hitchcock must have enjoyed), in the end they manage to trap their man, and the archcriminal and his wife meet an ugly demise. So do all the other main characters: the clairvoyant, the boyfriend, the elderly heiress. A chilling coda demonstrates the triumph of evil, fulfilling the genealogical "pattern" of the book's title.

After deciding on *The Rainbird Pattern,* the director offered the script assignment to Anthony Shaffer, who read the book but balked at "the sort of version that Hitch was describing—a sort of light, Noel Coward–Madame Arcati thing with Margaret Rutherford." (Thus, already, before there was any script, he was describing a Hitchcock film quite different from the book.) Shaffer agreed to think about it, but he had flashed the wrong signals, and Hitchcock phoned him a week later to say that his agent had made excessive

demands. Shaffer felt Hitchcock was dissembling in order to avoid a later confrontation over his approach.

In September 1973, Hitchcock recruited another familiar face: Ernest Lehman. Since *North by Northwest*, Lehman had written some of Hollywood's most prestigious films: *From the Terrace, West Side Story, The Prize, The Sound of Music, Who's Afraid of Virginia Woolf?*, and *Hello, Dolly!* He had produced the latter two films, as well as *Portnoy's Complaint*, his debut (and swan song) as a director.*

Except for *Sweet Smell of Success*, which was adapted from his novel (and coscripted by Clifford Odets), *North by Northwest* was the only original script on Lehman's filmography. But *The Rainbird Pattern* would also be an original once they had finished revamping the novel, Hitchcock assured him. With more than a touch of resentment—after all, he'd been stung by Arthur La Bern's poisonous "Letter to the Editor," and disapproved of the steep price he had had to pay for rights to Canning's novel—Hitchcock told Lehman, "I don't have any regard for the book. It's *our* story, not the book's. Canning's a very lucky man."

"What's he going to get out of this?" Lehman asked.

"A lot," Hitchcock replied rather uncharitably. "These fellows . . . you know what happens. They rerelease the book with our new title."**

The director told Lehman that he intended to keep Canning's basic premise, but part of their job would include moving the whole shebang to California because of Hitchcock's health concerns as well as budget considerations. Another part would be giving the material the Noel Coward tone Hitchcock envisioned.

The September 1973 start of Hitchcock's work with Lehman on "Deceit" (the first thing junked was Canning's title) came fifteen months after the release of *Frenzy*, and those months had been hard on Hitchcock. In January 1973 he spent two weeks in the hospital, fighting gout. In the spring he struggled with the flu. In June he attended the funeral of Dave Chasen, owner of his favorite restaurant. August brought a heart scare, a flurry of tests, and days at home.

There was something sad and beautiful about these two old warhorses reuniting, fifteen years after *North by Northwest*, each past his prime. "By now he was a legendary figure to me, too," recalled Lehman, "yet at first I felt very comfortable being back with him. However, before long I real-

* Like Hitchcock, Lehman never won a competitive Oscar, despite three nominations, and would have to wait for an honorary Oscar until age eighty-one, in 2001. His Oscar was the first ever voted to a screenwriter not for any individual film, but for his body of work.

** Actually, though La Bern's publisher did rerelease his book as *Frenzy*, Canning stuck with his title through all editions.

ized that our relationship was quite different. Many years had passed. We had both had successes and failures. We were different people now."

At first the Hitchcock who rolled up his sleeves for work seemed almost unchanged from the practical artist Lehman knew from long before—the man who had worked with writers on scripts for fifty years, in much the same way. No matter how early the writer arrived for their morning sessions, Hitchcock was already there waiting, sitting in "his favorite red leather chair beside the red leather sofa surrounded by beige and mahogany and brass in the tasteful, soothing, orderly office . . . smiling, hopeful, expectant, hands folded over a navy worsted suit and black tie."

"Good morning, old bean."

"Morning, Hitch."

Lehman arrived about ten, but by the time they started talking about the script it was getting close to eleven. "The first forty-five minutes," said the writer, "are always warm-up time, during which neither of you would dare commit the gross, unpardonable sin of mentioning the work at hand. There are more attractive matters to be discussed first . . . what dinner parties, if any, have been attended the night before, who was there and said what to whom? . . . or, if not a party, what about the movie that was seen last night and was now to be dissected, or how about those reviews in the morning trades, weren't they shocking? . . . and let's not forget the morning headlines and the stock market and the president and the secretary of state and Lew Wasserman and the Middle East and the sagging U.S. economy.

"How much more pleasurable, this sharing of the problems of others, than to have to sit there, sometimes in terribly long silences, trying to devise Hitchcockian methods of extricating fictional characters from the corners into which you painted them the day before."

Inevitably it fell to the writer to launch into script issues, usually by starting off with the previous day's problem—suggesting a solution he had cogitated overnight. With Hitchcock, that was often like loading a bullet into a revolver for a friendly game of Russian roulette.

"He looks at you with hope, or is it pity, and murmurs. Really?

"And you begin to talk, and he watches you, and he listens, and you watch him carefully, and you continue, and finally you've said it all. And then he does one of several things. His face lights up with enthusiasm. Good sign. Or his face remains unchanged. Question mark. Or he says absolutely nothing about what you have just told him, and talks about another aspect of the picture. Pocket veto. Or he looks at you with great sympathy and says, But Ernie, that's the way they do it in the *movies*."

If the writer stumbled, then implicitly it was Hitchcock's turn to venture an idea "bold and outrageous," in Lehman's words. "He knows that you understand the anything-goes rule of this moviemaking game that the two of you play in his office, otherwise neither of you would risk the embarrassment. So

you look at him steadily and give him your full attention and listen to all of his ideas, and when he has finished you respond with one of your own personal devices for dealing with this sensitive work relationship."

Either: "Hey, that's nifty, Hitch. I really like that," according to Lehman.

Or: "Hmmm . . . yes, that has possibilities . . ."

Or: "Very interesting . . . really interesting . . . I think we ought to throw it in the hopper with all the others . . ."

Or: "I don't know . . . I see what you mean . . . but I don't know."

"The rules—never acknowledged or articulated—are: I won't hurt you if you don't hurt me," reflected Lehman, "provided neither of us lets the other hurt the picture. I'll let you fight me if you let me fight you, provided neither of us forgets that the main fight is to entertain an audience."

At 12:30 P.M., the office door would burst open, heralding a studio waiter carrying two trays of New York steak and black coffee. On cue, the two would retreat to Hitchcock's private dining room. "The story problems can go to the devil," Lehman explained. "This is conversation time, much of it about rare dishes and vintage wines, because there are no calories in small talk, or in flashbacks to the triumphs and the defeats of yesteryear."

When Hitchcock lit a cigar and asked, "Shall we return to our toy trains?"—usually about 1:40 P.M.—it was the signal to amble back to the red leather chair and sofa.

"Now, where were we?"

Before lunch one day they had been discussing the kidnapping. Of course Hitchcock Americanized the victim *and* the scene of the crime. In the book the English archbishop is snatched during a country idyll; Hitchcock delighted in his substitution, which had "the special appeal of breaking a taboo," in John Russell Taylor's words. The film's kidnapping would take place at Grace Cathedral on Nob Hill in San Francisco, with the victim, an Episcopalian bishop, injected with Pentothal and dragged off during services ("depending of course on the slightly embarrassed sense of decorum which possesses those in church and makes them hesitate to act in what would otherwise be a natural fashion," observed Taylor).

Later, the kidnappers deposit the drugged bishop in their car on the way to making the ransom exchange. But just as they are about to leave their garage, the clairvoyant, with singular bad timing, turns up to identify the long-lost heir. As she is explaining her errand, however, a car door bulges open and the stupefied bishop pitches out the side. . . .

"But Hitch, I thought we had agreed that he can't open the back door if he's unconscious . . ."

"Well, if he doesn't open the back door and fall out, how will she be able to see him? . . ."

"She won't," said Lehman. "So we'll have to come up with another—"

"But think, when she sees the bishop's head fall out of the open back door? . . ."

"How can an unconscious man reach up and open a car door?"

"I'll shoot her point of view," said Hitchcock, "and the bishop's mouth will be hanging open like this, only upside down, of course . . ."

"But if he's unconscious . . ."

"Did I ever tell you," interrupted Hitchcock, "about the time I ran into Dorothy Hammerstein in a New York restaurant after having not seen her for thirty years?"

"No, please do . . ."

Daily at 3:15 P.M. sharp a secretary entered with two wineglasses of chilled Fresca over a single cube of ice. Thus refreshed, Hitchcock and Lehman continued their debate about the unconscious bishop, without resolution. After a short while, the director called out "loudly for another glass, this time with two blocks of ice, please." The secretary reentered, exited, "and this time," wrote Lehman, "she leaves the door slightly open."

"To this day," wrote Lehman, he hadn't "been able to figure out the signal, if indeed there is one." Was it the words "two blocks"? Or was it the mere request for another glass?

All he knew for sure was that the door was opening, and he was being ushered out.

"I think we did very well today," Hitchcock would say as Lehman departed, "don't you?"

"Terrific, Hitch. Very encouraging. And tomorrow will be even better."

"OK, old bean, see you in the morning."

It's "all a game leading nowhere," Lehman reflected, driving home; "you *know* it's just talk until you both throw in the towel, you know that you're never actually going to write a screenplay for a film called *Family Plot,* and even if you did, you know he has no intention of making it. Just as you knew there would never be a *North by Northwest.*"

Their talks were energized in the first months of 1974 by Watergate and the Patty Hearst affair. Hitchcock was fascinated by Nixon, a villainous president who "smiled" as he fended off impeachment, and by the headlines from San Francisco—the putative setting of his new film—about the newspaper heiress who enlisted in the very gang that kidnapped her. Somehow, he vowed, he would slip Nixon and Patty Hearst into "Deceit."*

By mid-April Lehman had finished an initial draft, which Hitchcock cri-

* The working title kept shifting between "Deceit" and "Deception."

tiqued in detail. "Attached to each page of Lehman's draft was an identical-size piece of paper, with Hitchcock's observations on each scene and each line of dialogue," according to Donald Spoto. "He added the opening shot of the picture in painstaking visual detail; made changes in major scenes; queried Lehman on motivations and major shots; altered a word or two; suggested clarifications; pointed out some problems of construction."

That same month the director went all out for a trip to New York, with a press conference, interviews, and a gala tribute sponsored by the Film Society of Lincoln Center. It must have been extremely gratifying for him; Princess Grace came from Monaco, and other veterans of his films stood at the podium, tweaking him with ironic praise. With a draft of his fifty-third feature in his pocket, Hitchcock was feeling almost buoyant. He also made a round of plays; watching old friends Hume Cronyn and Jessica Tandy in Noel Coward's *Suite in Two Keys* at the Ethel Barrymore Theater also gave him a chance to brush up on tone for *Family Plot*.

Returning to California, Hitchcock went to the racetrack, attended *Gypsy* at the Shubert and *Mack and Mabel* at the Chandler. He spent several days posing for Philippe Halsman for a special issue of French *Vogue*, and also for Maureen Lambray, who was compiling a book of photographs of film directors. (Universal erected a special set for her so that Hitchcock could be snapped reclining on a train seat.)

The summer of 1974 was capped by his (and Alma's) seventy-fifth-birthday party, which Lew Wasserman arranged and hosted at Chasen's. Cary Grant, Laraine Day, Paul Newman, and François Truffaut were among the luminaries who toasted the Hitchcocks' continued health and well-being, and ate cake with the director's frosting-embossed profile.

The second round of script meetings with Lehman, though, went less well. "I found myself refusing to accept Hitch's ideas (if I thought they were wrong)," Lehman recalled later, "merely because those ideas were coming from a legendary figure." The writer had grown weary of Hitchcock overanalyzing everything, and he simply wanted the go-ahead to finish. The silences between them grew longer, the disagreements awkward. Hitchcock seemed overly worried about plot logic. Lehman worried more about the characters. They pondered possible stars, which for Hitchcock could be a substitute for characterization.

All along Hitchcock "sort of dropped things in to pay lip service" to characterization, Lehman remembered, "but he really didn't want them in the picture. I pleaded with him, so he put them back in the script and shot them, then edited them out of the picture."

Privately Hitchcock had decided that Lehman was "a very nervous and edgy sort of man" who was deliberately giving him "a rather difficult time," as he complained in a letter to Michael Balcon in England. When

he suffered a heart attack in September, Hitchcock went so far as to blame the episode (only half kiddingly, it seems) on the constant "nervous state" induced by his arguments with Lehman. After dizzy spells, the director was taken in an ambulance to the UCLA hospital, to a special wing that had been built in part from his charitable donations, where a pacemaker to monitor his heart was installed under the skin of his shoulder blade. He took manifest pleasure in describing the operation later to friends and journalists; the device itself, he told Balcon, "looks like one of those old-fashioned watches that men used to wear in their waistcoats."

But Hitchcock's surgery was followed by complications—fever and pain, a severe bout with colitis, then a kidney stone operation and further complications in October. Over the Thanksgiving weekend, Hitchcock injured himself in the first of several falls connected to his arthritis, his medication, and his excessive drinking. At that point, few believed that "Deceit" would ever get made.

But Hitchcock was still a believer, and once again, miraculously, he bounced back. By the first week of January 1975 he was going to plays (Ingrid Bergman in *The Constant Wife*) and dinner parties (a guest of the Victor Savilles at Hillcrest Country Club), and holding meetings with Howard Kazanjian, the assistant director lined up by Universal; art director Henry Bumstead, who had worked with him as far back as *The Man Who Knew Too Much*; and cameraman Leonard South, who once was Robert Burks's assistant. By the end of the month he was watching casting reels; even Mrs. Hitchcock, drawn into the excitement, came into the office for lunch, screenings, and meetings, to help narrow down the casting.

Jack Nicholson was one possibility for George Lumley, the boyfriend of the spiritualist, Blanche. Hitchcock had watched *Easy Rider* and the explosion of Nicholson films that followed. But Nicholson was heavily committed, and busy with preproduction for *One Flew Over the Cuckoo's Nest*. More than ever, Hitchcock felt the need to move quickly. Once more forced to settle for a second choice, now he found a backup Nicholson: Bruce Dern, who had costarred memorably with Nicholson in *The King of Marvin Gardens* and other young-audience films. Of course Dern had cut his teeth as the sailor bludgeoned in *Marnie*, and Hitchcock fondly recalled his offbeat personality.

Universal recommended Liza Minnelli for the clairvoyant, but Hitchcock couldn't see her in the part, nor did he want to jack up the budget for her star salary. The New Hollywood theme continued with the casting of Barbara Harris, whom Hitchcock had watched in the film of *A Thousand Clowns;* though Harris was mainly a Broadway name, she had also played a psychic in *On a Clear Day You Can See Forever,* and had just finished a

major role in Robert Altman's *Nashville*. Hitchcock followed the career of Altman, who had worked for *Alfred Hitchcock Presents*—though, as he later told Penelope Gilliat, he didn't much like *Nashville,* with its loose episodes, so antithetical to his own tightly choreographed style.

Everyone warned him against Harris, a Method-trained improvisational talent regarded as intuitive but quirky (and not the slightest box-office draw). But Hitchcock thought her background was fine for the character she was playing, and he liked her temperament when he met her. (It didn't hurt that she physically resembled Alma in her younger days.)

Karen Black was also New Hollywood, a prominent player in the Nicholson films *Five Easy Pieces* and *Drive, He Said*. (She was also in Ernest Lehman's *Portnoy's Complaint* and Altman's *Nashville*.) Another free spirit, Black met Hitchcock in February, and on the spot he decided to cast her as the wife of the master villain, the Trader. During her crime sprees, however, Black would be disguised by an ugly wig and menswear, and thus all but unrecognizable. (She was meant to evoke Patty Hearst.)

But who should be the Trader, the coldhearted chief of the kidnapping scheme? Perhaps it should be someone from Old Hollywood; perhaps John Houseman, the director mused during one script session—for his friend from *Saboteur* days had now transformed himself into a portly but Oscar-winning actor, playing a Harvard law professor in *The Paper Chase*.

"What would John Houseman be doing as a resident of San Francisco?" a skeptical Ernest Lehman had asked.

"Well, he could be in clerical work," Hitchcock answered warily.

"I see him more as the owner of an art gallery," Lehman countered. "John Houseman would never lower himself to do clerical work."

"John Houseman, on the other hand, might not lower himself to do kidnapping either. I know he's a professor at Berkeley."

"He could be an impresario of the San Francisco Opera," mused Lehman.

"That's too high, isn't it?" wondered Hitchcock.

"Sounds like Houseman, doesn't it?" insisted Lehman.

But it was a subtext of Hitchcock's last several films that people from the old school were now simply *too* old to play leads for him. In the end, the Trader would be presented as neither an art gallery owner nor an opera impresario, but the master salesman of a jewelry store; Hitchcock accepted Universal's recommendation and cast a younger man named Roy Thinnes, the former star of TV's *The Invaders* who was under option and just finishing *The Hindenburg*.

The only old acquaintance who did get a plum part was Catherine Nesbitt, whom Hitchcock had admired in the 1920s as a leading lady in West End plays such as James Barrie's *Quality Street*. Nesbitt had made one of

her infrequent screen appearances in 1935's *The Passing of the Third Floor Back*—a rare non-Hitchcock written by Alma.

Nesbitt was cast as the elderly Julia Rainbird, who in Canning's novel is seeking her deceased sister's lost child, now a grown adult. Hitchcock told writer Joseph McBride that he had managed to sneak a little of his beloved *Mary Rose*—with a quintessential James Barrie actress—into his fifty-third film. In the first scene of *Family Plot,* Blanche would hold a séance with Mrs. Rainbird, who is guilt-ridden for having forced her sister to abandon an illegitimate baby forty years earlier. "Julia tells her sister's ghost," wrote McBride, "in words that could have been addressed to Mary Rose, 'If he's still alive, I'll find your son, and I'll take him in my arms and love him as if I were you.' "

There had been many grand dames in Hitchcock films over the years; Nesbitt was destined to be the last and most sympathetic, and her acting gave Hitchcock inestimable pleasure.

By the end of their collaboration, Hitchcock was no longer meeting—or even speaking—with Ernest Lehman. Instead the two wrote messages back and forth "almost on a daily basis," in Lehman's words. Why? The writer had been banished from the lot and the director's bungalow. "It's too difficult to get Ernie to agree with me," Hitchcock told a studio executive.

Hitchcock had insisted on purging almost everything from Victor Canning's book that seemed—at least to Lehman—Hitchcockian. Evil never had triumphed in a Hitchcock film, as it did in the second half of Canning's novel; so the second half of the book was simply jettisoned. The clairvoyant and her offbeat boyfriend became increasingly comic characters. Blanche's spiritual detection became a con game. The police detection, a crucial component of the novel, was completely marginalized; Hitchcock, at the end of his career, just didn't care about police, or even about punishing villains. Blanche, Lumley, Mrs. Rainbird, the Trader, and his wife are all slain violently in the novel; at the end of the film they're all alive and well. (Only one minor character dies.) Even the *Mary Rose* conceit grew so faint as to become, finally, almost irrelevant. "Hitchcock largely was content to treat the subject of occultism as an oddball jeu d'sprit," wrote Joseph McBride, "rather than the artistic testament *Mary Rose* might have been."

Reality, long an elaborate contrivance with Hitchcock anyway, was thrown out along with the book. British accents and quaint phrases like "village parson" would coexist in the film alongside hippie-era actors. In the end the director even shrank from San Francisco, saying he was tired of *Bullitt*-type car chases in the hilly city, so the Americanized settings of

Family Plot became generic California scenes—part San Francisco, part Los Angeles.

The film was still called "Alfred Hitchcock's Deceit" when it began shooting on May 12, 1975.

Not much filming got done that first day, however, for the studio threw a luncheon to introduce the cast and director, attended by dozens of journalists and critics. The luncheon was staged in a cemetery erected on the back lot, where each guest could read his (or her) name on a tombstone. "The reporters asked Hitchcock all the old questions," reported the *Los Angeles Times*, "so that he might respond with all the old answers."

"Hitchcock's 53rd" felt like the most publicized film since *Gone With the Wind*. Correspondents visited the set from all over the United States and around the globe, representing everything from major media outlets to small, elite film journals. On the schedule the first week—and once a week—was an 11:15 A.M. pacemaker phone call to UCLA. The journalists not only got interviews; they usually got Hitchcock lifting his shirt and displaying the scar of what François Truffaut called his miraculous "medical gadget."

The interviewers gaped at the scar—and deferred to the legend, who handled the press with the usual aplomb. "He had all [his] answers worked out," unit publicist Charles Lippincott recalled, "and made it seem like fresh material. He was a terrific actor."

Now and then Mrs. Hitchcock materialized on the set, and even she cooperated with a few interviews. "I suppose it's my own background in silent cinema, where a big crew was eight or nine, but I don't find it so enjoyable with sixty people around," Alma told one journalist. "I always find myself visualizing the finished films from Hitch's scripts before he starts shooting, and then I like to stay away until the rough cut to see how far my visualization corresponds with the film itself."

With his every move monitored by doctors, studio officials, and the press, Hitchcock was on his best behavior, drinking only moderately and then only at the end of the day. Most of the production took place on Universal soundstages; except between shots, when he hid out in his trailer—sometimes giving interviews, sometimes napping—Hitchcock seemed on constant display.

Right from the outset, he was openly irritated by Roy Thinnes, whom he mistakenly introduced as Roy Scheider (wishful thinking!) at the first-day press gala. Thinnes had sent him a letter with little ideas for his character (one was that the Trader ought to have perpetual shaving nicks on his face). Subsequently, Hitchcock found fault with Thinnes's performance. After filming the kidnapping of the bishop on location in San Fran-

cisco in early June, he decided the actor lacked strength in the part. He fired Thinnes and rushed another actor into the role, reshooting most of Thinnes's completed scenes. (Hedging from day one, though, Hitchcock had staged some of the action from behind Thinnes's back.)*

He chose William Devane as his new Trader. Devane might be considered Hitchcock's last stroke of countercasting, having risen to prominence playing President John F. Kennedy in the television miniseries *The Missiles of October;* Devane would play the Trader with a constant duplicitous smirk—like Kennedy with Nixon's smile. (Ironically, though, Devane proved no less annoying than Thinnes, for the new Trader was another Method actor with endless questions about his motivation.)

Although people had cautioned Hitchcock against Barbara Harris, he had more trouble with Karen Black, fighting the actress's temptation to tinker with her disguise, look her attractive self, and be more likable in her role. "Hitch chewed her out," recalled publicist Lippincott. " 'Miss Black,' he said, 'You are *bad* in this movie and you are to remember that from now on. I don't want you trying to change your character.' That was it, short and to the point."

John Russell Taylor, covering the production for the *London Times*, reported that Black seemed a different actress after the encounter from the one he had watched a year earlier during the making of *The Day of the Locust*. "There, in tune with the atmosphere of the production as a whole, she was playful, extrovert, kooky, and from time to time temperamental," Taylor observed. "Here, she is staid, deferential, eagerly concentrating on the purely technical problems of fitting into a staged action, referring to Hitchcock, rather like a good little girl who hopes for an approving pat on the head from her teacher."

At times Black got more than a pat. The actress insisted in subsequent interviews that Hitchcock ended up liking her so much that one day he impulsively gave her a kiss, thrusting his tongue into her mouth. "He was an exuberant spirit," she said. "I think he probably was born an exuberant spirit, and that's why he French-kissed me. He felt like it."

The two performers Hitchcock clearly liked best, however, were playing the characters he liked best. After shaking hands with all the principals on the first day of filming, he also gave Barbara Harris—who appeared scared—a buss on the cheek. As he did so, he whispered, "Barbara, *I'm* scared. Now go and act. Many are called but few are frozen." When Hitchcock noticed the actress still trembling, he ordered some brandy for her teacup.

* Aghast at being cornered by the unhappy Thinnes at Chasen's one night, Hitchcock had to tell the actor something by way of explanation. "You were too nice for the part, too *nice*," the director insisted.

Whenever Harris had trouble with a scene, she asked his advice. "All his suggestions would be very good and to the point and unconfusing," she recalled in one interview. "I call it Brechtian-type directing. Because he sees a scene, not so much for the subjective emotional intent that he's interested in, but what the scene is about. In the cab scene, I didn't know if I was supposed to be a sex-starved girl with my boyfriend, or what. He said it was a business scene. So then I became a businesswoman. Which is a Brechtian idea. Brecht would say, 'Well, what would Hamlet be like in the kitchen with the servants?' "

Hitchcock's other favorite was Bruce Dern. "Hours the two spent together," according to *Rolling Stone*, "Hitchcock telling him stories." Dern could be counted on to laugh at the director's jokes and jolly him along with his own banter. "I got to jack him up a little," Dern reported. "Get him ready for the day. He's bored with the whole fucking thing."

When Hitchcock was "feeling better," said Dern, "there was no one better on the set. He noticed everything—a shadow on a performer's face, a bad angle for a prop, a few seconds too long on a take. Just when we thought he had no idea what was going on, he'd snap us all to attention with the most incredible awareness of some small but disastrous detail that nobody would have noticed until it got on screen. And then he'd be bored again."

But when Hitchcock was feeling uncommunicative, or when he'd made up his mind about something, even the favorites could find him inflexible. "It's frustrating sometimes," Dern complained in an interview, "because you say, 'Let me do another take on that, I didn't go deep enough.' And he says, 'Bruuuuuce, they'll never know in Peoria.' "

Throughout the filming, Hitchcock's fifty-third continued to favor light over darkness. One planned highlight was the sequence that starts with Blanche (Harris) and Lumley (Dern) arriving to meet the Trader's henchman at a mountain roadside diner. They order beer and hamburgers. The diner is deserted except for a priest and his small catechism class. The henchman doesn't show up; Blanche and Lumley don't notice him outside, sabotaging their car.

Afterward, driving down the high, winding mountain road, they discover that their brakes have been disabled. Lumley, who is driving, frantically tries to keep his grip on the wheel as a hysterical Blanche grabs and climbs all over him. The screeching around curves and lurching back and forth are made worse by the fact that both have had too much beer, and Blanche, for one, feels like throwing up. The actors were encouraged to wildly embroider the humor. It was the silliest comedy of Hitchcock's career—a slapstick replay of the Corniche chase in *To Catch a Thief*—and in the film he allows it to go on . . . and on.

Gregg Kilday was on location—a dirt turnoff on a bend of the Angeles Crest Highway—for the filming that day, and watched Hitchcock shoot

parts of the scene. Hitchcock told Harris to go ahead and step on Dern's face. "It's a twisted mouth that we are playing for," he said. As Kilday noted in his account for the *Los Angeles Times,* although the scene had been storyboarded, Hitchcock egged the actors on, and incorporated their ideas.

After their car finally crashes, "I want them to climb out of the top of the car and slither down," Hitchcock told Leonard South, indicating where the camera should be positioned.

"I can crawl out like a worm" from under the car, Dern volunteered, and Hitchcock liked that image. "That's good, Bruce, very good," he responded, telling the cameraman to change the shot.

"As the sequence progresses," wrote Kilday, "Hitchcock even allows Dern to invent a piece of business. Free of the car, the actor and actress walk back toward the deserted road. Approaching a bit of rough ground, Dern picks Harris up and carries her the rest of the way.

"Watching the scene," Kilday mused in his article, "one can easily imagine the analysis that even such a tiny gesture will eventually receive. For when Hitchcock is working at top form, his films contain few, if any extraneous movements. Every camera angle, every action takes on a special significance. 'Each shot is like a line in a novel. It says something,' Hitchcock insists. Clearly, the director has his reasons for instructing Barbara Harris to step on Bruce Dern's face. Does Dern's carrying Harris then also contribute to that meaning?

"The master does little to encourage such speculation."

By the end, it was Harris's and Dern's film all the way. Hitchcock didn't even give the Trader and his wife a reaction shot after Blanche and Lumley slam the door on them in the basement—one last Hitchcock film to end with a cell door clanging. "The weakness of the villain was responsible for the weakness of the picture," Truffaut noted after Hitchcock's death—but it was also the director's weakness for the pair who made him chuckle.

In the film's coda, Lumley wonders where the missing diamonds are. Blanche consults her muse; then, to his surprise, she wafts into the atelier and halfway up the stairs, slowly whirling to stab her finger at gems glittering in the chandelier. Turning to face the camera, Blanche then does something as remarkable as proving her psychic prowess: she winks.

This final shot of the final Hitchcock film was the "main difference of opinion" between the director and Ernest Lehman, according to John Russell Taylor. After arguing about it at every stage, Hitchcock wrote the ultimate variation himself, and "submitted it to Lehman, listened to his objections (mainly that the medium is shown throughout as a complete fake, so to suggest at the last that maybe she has a touch of psychic power is disturbingly inconsistent), discussed his alternative solutions, and then went right ahead and used his own version." Hitchcock couldn't

be stopped from winking at the audience, just as he had been doing for fifty years.

Postproduction, wrote John Russell Taylor, was characterized by Hitchcock "still modifying, still worrying," especially about that "on-the-nose" final shot of Blanche winking.

Once, music had been paramount for Hitchcock; now it was almost an afterthought. "Evidently nothing in *Family Plot* or *Frenzy* had been planned in relation to the musical score," according to Taylor, "which was slotted into a relatively small, circumscribed place in Hitch's considerations, to be supplied when the rest of the film was nearing completion." John Williams, riding high at Universal on the tsunami of *Jaws*, was hired to write the score.

All the press attention had boosted Hitchcock's spirits, and he and Alma felt strong enough to travel to St. Moritz for Christmas. Speaking to reporters before the release of *Family Plot*, Hitchcock said he was optimistic about the new film's prospects. He said his wife no longer skied. "We spend most of our time sitting comfortably in the Palace Hotel," he said, "watching it from behind the window." They couldn't have known it would be the last time they would visit St. Moritz—indeed, their last time in Europe.

Before the film's national release, Universal sponsored a lavish premiere at FILMEX, the Los Angeles International Film Festival, replete with fireworks, dancing bears, and the film reels delivered in a hearse. In the theater they showed a clip of Hitchcock arriving at the theater and coming to the door; then, when the clip ended, the man himself strolled onstage. James Stewart was on hand to present him with a career achievement award. Although it was a black-tie event, bags of popcorn were handed out along with soft drinks.

One hundred journalists and movie critics congregated in Los Angeles, New York, Chicago, and Dallas for a closed-circuit press conference, just before Easter, 1976. "The general tenor of questioning was highly respectful," wrote Joseph McBride in *Variety*, although Hitchcock was subjected to "repeated, and sometimes silly, questions from critics about symbolism in his work." Asked, for example, if wall smudges around a light switch in *Family Plot* suggested any implied meaning, Hitchcock responded, "A switch is a symbol of light." But the train-tunnel ending of *North by Northwest* was consciously symbolic of intercourse. "I think that comes under the heading of pornography ahead of its time," Hitchcock gamely told the press, in a line he had used in numerous interviews over the years. Asked if *Family Plot* was his final film, he said no—no, he "definitely" had a fifty-fourth in the works.

When the reviews for *Family Plot* were toted up, they fell into three distinct categories. The older, more gentlemanly (and ladylike) critics found the new Hitchcock picture benign and entertaining; Vincent Canby of the *New York Times,* for example, described the film as "thoughtful, measured in tone and so courtly that we are well into the performance before we realize just how high he's sent us up, and with what good humor."

Younger, more aggressive reviewers generally thought *Family Plot* "vulgar, lifeless and maladroit," in the words of Jay Cocks in *Time,* or "less pretentious and preposterous than *Torn Curtain* and *Topaz,* less ludicrous than *Marnie* and less offensive than *Frenzy,*" while "still late Hitchcock and not very good," according to *New York* magazine's John Simon—who also, incidentally, dismissed Ernest Lehman as a "glorified hack."

The auteurists and cineastes who had grown to revere the director, and who saw nuances and symbolism in the least of his films (even when none was intended)—these scribes saw a pure, Hitchcockian *Family Plot,* "a marvelously fluid light comedy with scarcely a slack moment," in the words of Jonathan Rosenbaum, writing in *Sight and Sound.**

Today most find it a slight film, although its value to Hitchcock fans and scholars has only increased over time. Bill Krohn in his book described *Family Plot* as Hitchcockian precisely *because* the director rubbed out his usual realism and identifying marks while defying all expectations. "An exhilarating experiment in mise en scène from beginning to end," Krohn rhapsodized. "His characters, played by a new breed of actors, are freed from the often suffocating constraints of his highly composed frames, enabling them to move around in front of the camera and invent their lives in a visual universe made up of medium shots and medium closeups. (Hitchcock had never made a film with so few real closeups.)" In his last film, Krohn wrote, "Hitchcock overturns the principles of his cinema and makes a film that belongs to the cinema of the eternally young, along with *Seven Women* (1966), *A King in New York* (1957), and *La Petit Théâter de Jean Renoir* (1971)," late films by John Ford, Charles Chaplin, and Jean Renoir.

Shortly after *Family Plot* was released, Alma Reville suffered a severe stroke, crippling her and confining her to the house, under the care of round-the-clock nurses and several kinds of therapists. Although for a few months Hitchcock made the effort to take her to Chasen's once a week, she could not walk without strong aid, and he himself could no longer

*"What particularly appealed to Hitchcock," said François Truffaut, in his more oblique defense of the film, "was the passage from one geometric figure to another. First, two parallel stories are introduced, then the gap between them gradually narrows, and finally they mesh, winding up as a single story."

walk easily or far. Writing to intimates, Hitchcock was frank about Alma's condition, if uncomplaining about his own. There wasn't room in the house for all the nurses and a cook, so Chasen's began to deliver, and Hitchcock himself took over the cooking three times a week. "Little did I believe that after all these years and the accumulation of a little wealth that I should approach my 78th year being a cook in the kitchen!" he wrote Michael Balcon.

Most of the second half of 1976 was taken up with arranging Alma's medical care, so Hitchcock cut back on his office routine. By early 1977, Hitchcock was forced to accept that she was more or less permanently housebound, and he began to talk serously about getting started on a fifty-fourth film.

It was peculiarly ungratifying to him that the amorphous *Family Plot* had found its main audience among auteurists and cineastes. Hitchcock had always taken pride in his box-office numbers, yet *Family Plot* was his least successful picture since *The Trouble with Harry,* another bent comedy to which the fifty-third Hitchcock bore a fleeting resemblance. Its number twenty-six box-office ranking was an embarrassment, and to go out on top—with an audience winner—was one reason behind his seeming iron resolve to make yet one more film.

For a while he alighted on Elmore Leonard's *Unknown Man No. 89,* a hard-boiled crime novel set in Detroit. But after thinking it over, Hitchcock returned to his idée fixe of shooting a realistic James Bond to wash away the stain of his previous failures. He took up another Cold War novel Universal had acquired for him almost ten years before—a story that, like both *Torn Curtain* and *Topaz,* involved a double agent with a conflicted wife. Ronald Kirkbride's novel *The Short Night,* published in 1968, was loosely based on the true story of George Blake, a double agent who had worked for the British Foreign Office while betraying British agents; after being caught and convicted, Blake had made a daring escape from Wormwood Scrubs Prison in 1966, fleeing to the Soviet Union.

In the novel, the fugitive, while en route to Moscow stops at a secluded island in Finland, where his wife and children await him. An American agent, intending to avenge his brother (one of the double spy's victims), arrives first, and falls in love with the traitor's wife.

The Blake case had fascinated Hitchcock in real life, and to help with the authenticity of the film the director bought the rights to a second book, a nonfiction account of the prison escape called *The Springing of George Blake* by Sean Bourke, one of the accomplices.

In the first week of May 1977, Hitchcock launched into scriptwork with a writer Universal had recommended. James Costigan was a native Californian, and author of *Love Among the Ruins* (1975) and *Eleanor and Franklin* (1976), both Emmy-winning television films. (*Love Among the*

Ruins particularly intrigued Hitchcock, as it starred Laurence Olivier and Katharine Hepburn, and was directed by George Cukor.) Costigan entered the usual regimen: long talks, steak and coffee lunches, screenings of Hitchcock films, all of it at Universal, as Bellagio Road had become a virtual hospital ward.

In June, Hitchcock wrote to Balcon to decline an honorary doctorate from the Royal College of Art in England, explaining, without alluding to his own health problems, all the reasons that kept him from traveling overseas: Alma, the pending project, the troublesome writer. Although Costigan was highly regarded, Hitchcock explained that he had agreed to a contractual first payment of $150,000, which forced them to get along even if they didn't harmonize. Costigan, the director complained, is "noncinematic, in addition to which he is extremely obstinate, if you attempt to guide him away from the overemphasis on the verbal." Moreover, their "difficulties" involved "the interesting part of the story," the romance between the American revenge seeker and the escaped spy's wife. "He doesn't like the woman in the story," Hitchcock plaintively reported, "because she is married to Blake, even though she has two children by him. What about Philby? What about Burgess and Maclean? Didn't they have wives?"

Hitchcock's preferred way of making films (starting with a blank slate and painstakingly weaving in his ideas over a series of writers and drafts) had always been a function of the available time and money. But now the director was facing hard questions: Did he have enough time to start over with a new writer? Could he afford to alienate the studio by simply paying Costigan off?

Reviewing his personal dilemma, Hitchcock in his letter also reviewed the industry's. MCA, he noted, had $150 million in the bank at $40 a share, "higher than anyone else." *Jaws* had lifted Universal's stock, and now *Star Wars* was elevating Twentieth Century–Fox. "It seems like in making pictures we have to play a kind of roulette and hope that the balls fall in #35 instead of Zero, because that's how chancy the whole business has become," he observed. "You can see by the picture I draw," he stated glumly, "that it is one of preoccupation."

He and Costigan worked together just a short time, before Hitchcock gave up and paid the writer off; then followed a summer of chest colds, backaches, and cortisone shots (now applied directly into his knees), even as Hitchcock was coping with a sadly diminished Alma. Then, in mid-October, Ernest Lehman inherited "The Short Night." Better the devil you know, Hitchcock had decided, and so their previous disagreements over *Family Plot* were set aside.

Lehman gave this fifty-fourth Hitchcock a needed injection of hope and vitality. Now Hilton Green, Robert Boyle, Albert Whitlock, and Norman Lloyd began to show up for preproduction meetings, and Boyle, Lloyd,

and others flew to Finland to photograph settings. Hitchcock talked about filming part of "The Short Night" on location, but people wondered how he could possibly manage it, and indeed whether he could ever bring himself to leave the country without Alma. Lloyd was expected to fill in, directing the second unit.

Ever loyal, Princess Grace came to see the Hitchcocks in November, and again in February, but office visitors were discouraged because of the work, and most days the schedule simply read: "11 A.M., Ernie; 12:30, lunch." The first storyboards were executed, depicting a complicated crescendo at the end of the film, with the vengeance seeker chasing a train with the spy aboard. That would be arduous to shoot, and the prospect of it finally decided Hitchcock against going to Finland. So Lloyd agreed to direct the train scenes, too.

The talk turned to casting. Clint Eastwood, who had left Universal for a deal at Warner Bros., was a star the studio wished to lure back. Hitchcock had lunch with Eastwood, and the actor raised an eyebrow on hearing about a pending Hitchcock film with a Clint-type lead: an American on a revenge mission. But Eastwood was busy, involved with his own projects; in time the American intelligence agent would become a Scot, with Sean Connery penciled in to play the lead, and perhaps Liv Ullmann as the traitor's wife.

Hitchcock and Lehman got along well for a time, before optimism faded. The director had one sharp disagreement with Lehman over a scene in the novel, in which the Blake character rapes and murders a woman. Hitchcock wanted to retain the scene, but Lehman resisted writing it. (Later, at Hitchcock's behest, David Freeman would put it in.)

Then Hitchcock decided the script needed another writer—though he might have been stalling. "He couldn't lick the story," said Lloyd. "Nobody could lick the story. Nobody knew better than Hitch that it was old hat. He'd had it on his shelf for eleven years, and interestingly enough, while we were talking about doing it, we kept looking for something else."

In July 1978 Lloyd took over, meeting with Hitchcock on a daily basis to revise Lehman's draft and plot a fresh continuity, incorporating fresh research and location ideas. But Hitchcock's ailments were steadily mounting: lung congestion, dizzy spells, repeated falls. Some days, Lloyd recalled, Hitchcock could barely make it down the hallway to his office, lurching in pain, holding on to the wall. But still he refused to use a cane. One day Lloyd and Joseph Cotten spirited the director away for a rare lunch outside the studio, and it struck both of them that he wasn't eating like his old self. His appetite had vanished, and he'd even lost his taste for cigars, taking just two puffs of one before he set it down.

One day the director surprised Lloyd by saying, "You know, Norm, we're not ever going to make this picture."

"Why do you say that, Hitch?" Lloyd protested. "You've got a bunga-

low, you've got a driver, you've got a cutter, you've got a staff, you've got Bob Boyle working on sketches . . . why do you say that?"

"Because," Hitchcock answered flatly, "it's not *necessary*."

"He had reached a point in his life when he looked the fact right in the face," Lloyd recalled.

Even so, the script talks continued. But they had gotten only two-thirds of the way through a lengthy continuity when, in late September, Hitchcock surprised Lloyd by announcing they should launch into the actual script. It was as though that day Hitchcock suddenly realized that "The Short Night" might in fact never be made with such slow progress. Panicked, Lloyd said quickly, "Not me. I don't think we're ready"—and then he couldn't mistake the betrayed look in Hitchcock's face. "He just cut me off like I'd never known him," recalled Lloyd. "He had a right to."

The next day Lloyd showed up at the office, but Hitchcock's door was closed to him. For three or four days, nobody could convince the director to see Lloyd, until finally one day Hitchcock's door was open, and Lloyd walked in. He apologized, and told Hitchcock he had changed his mind. Hitchcock was sitting there with the script in his hands, pencil poised. "Hitch," said Lloyd, "I really would like to work on it with you." "Never mind," he said brusquely, "I can do it myself."

"I have never forgiven myself," said Lloyd.

But Hitchcock really didn't want to make a film by himself—a film without any involvement from Mrs. Hitchcock. On those days when she could, Alma sat up in a wheelchair, or was propped up on a window settee in the living room. She liked to read *Time* and *Newsweek* "and now and again a book," as Hitchcock informed one intimate in a letter. "Of course you can get awfully bored with reading, but she does have a little Sony color set about eight inches square. It works very well and she lets it run a good part of the day."

That was a sanguine version of the sad reality. Whenever he left for his office at Universal, Alma acted hurt and resentful at being abandoned, Hitchcock told actor Barry Foster, who stopped by to see him in October 1978. When he said good-bye to his wife at Bellagio Road, Alma aimed "a stream of invective and foul language" at him, according to Foster, "which, poor soul, she didn't know she was doing, and it puzzled him."

Writing to a relative in England, Hitchcock admitted, "I am preparing a film, but, as you can imagine, [Alma's] condition at the age of 78 makes everything melancholy." But he usually joked about his own "condition." Writing to his eighty-five-year-old sister, Nellie Ingram, at the end of November 1978, he described a recent fall in the bathroom, painting it with Hitchcockian details and comedy. He set the scene: the white marble floor,

the sheet of carpet he slipped on, the wild stumble, which propelled him backward against the shower door, his head and shoulders crashing against the wall as the rest of his body slammed down hard against the floor. The night nurse ("a very clean cut little woman") phoned for the paramedics, who arrived with a young man wearing a fire helmet ("so I was able to say to myself, 'What's he here for? I'm not on fire.' ").

An ambulance then whizzed the director to the hospital, where "in no time I was stripped, given a hospital gown and then taken into the X-ray room. I was given X-ray treatment but everything seemed to be all right. I actually hadn't broken my neck or anything, but I must tell you that the whole feeling of my head and shoulders and back was extremely painful."

Railings were now put up for him everywhere, at home and in the office. And he began to use a cane. The rest of the letter was as cheerful and affectionate as could be, under the circumstances: news about his dog (a West Highland terrier named Sarah), his granddaughters, and a long, funny anecdote about a monsignor making unpriestly comments. Hitchcock vowed not to mention dreadful current events and "all that stuff we read in the newspapers," and told Nellie he would send her an "emolument" shortly.

Three months went by between the departure of Norman Lloyd and the arrival of David Freeman, the next writer, who came to Hitchcock's office for lunch on December 7, 1978.

"Find me a younger man," the director had told Universal. Though he had tried writing the script on his own, it was lonely and unamusing to muse aloud, or to dictate to a young secretary, however pretty, who didn't appreciate all of his asides and references.

Born in Cleveland, Freeman was in his late thirties. He had been a magazine journalist before turning to play- and screenwriting. His *Jesse and the Bandit Queen* had been an off-Broadway hit in 1975–76, and he had done a fair amount of rewriting for studio films. "One Universal picture that I did, uncredited, had recently made a bundle," Freeman recalled. "Another, *First Love,* for Paramount, had recently been in the theaters."

When Freeman arrived, the secretaries were in a "tizzy," he remembered. "It seems that Mr. H. is not only expecting me, he's expecting Thom Mount, the head of production at the studio. Mount has not been informed of this. After much frantic buzzing about the lot, Mount is located and changes his plans at the last minute." Waiting for Mount, Freeman was introduced to Hitchcock, his first glimpse revealing a short man "with almost unwrinkled skin" who was "very fat. The famous deadpan eyes that stared out so opaquely, so unrevealingly on television, permitting only drollness to be perceived, seemed a little more relaxed

now, less guarded, less contrived. A hopeful sign. We shake hands and he immediately begins a monologue about prison breaks and South America. It makes very little sense."

After Mount arrived, the trio headed to the private dining room, several steps down. "Hitchcock remarks that he fell on these steps a few days ago. Now there are rails. He needs them." The table was set with steaks and coffee. "As we eat, he continues to deliver various monologues. It's all interesting, but the sort of stuff you read or hear if you spend any time in Hollywood. The truth is I'm starting to get uncomfortable. I begin to think he doesn't know why I'm here. Does he think I've come to interview him?"

Mount smoothly steered Hitchcock (who had been "going on about English pork butchers and how to best prepare pork cracklings") toward the film project. The talk narrowed. "He has ideas, I have ideas," recalled Freeman. "We agree here and disagree there. His face lights up and he sounds a hell of a lot better. It's amazing. A minute ago I was convinced this wasn't going to work, and now I can feel a script forming."

They agreed to meet again the following Monday, whereupon they began five months of collaboration on the fifty-fourth Hitchcock—a period Freeman chronicled in his book *The Last Days of Alfred Hitchcock*. Freeman forthrightly warned Hitchcock that he might write such a book, that he was keeping a journal. Imagine: Hitchcock knew his daily deterioration was being recorded for posterity. Although the director didn't acknowledge Freeman's comment, "I think he heard me," said Freeman—who suspected that some of what later transpired between them was *intended* for posterity.

The big difference between Ernest Lehman's draft and Freeman's was that Lehman's began after the jailbreak, according to Freeman, "focusing on the hero of the picture, an American who pursues Blake," while his started in England with the traitor and the prison escape. "The idea is to show how determined the hero's adversary is," said Freeman, "and because it follows a narrative device Hitchcock has used to good effect in the past: a story begins one way, proceeds, then stops abruptly, allowing the main story to begin."

Hitchcock showed his age-old appetite for researching all the physical details—"how high is the wall, what is the geography of the prison yard, what sort of uniforms do the convicts wear," in Freeman's words. (If the Blake character used a rope ladder to escape, for example, what kind of rope should it be? Jute?) Though he could no longer visit London, Hitchcock ordered up enlarged maps, positioned them on his belly, and studied them with a magnifying glass.

To Freeman, he seemed obsessed with such minutiae, "even if it's all to be shot on a soundstage. It reminds me of Stanislavski's dictum about stage sets: A living room might be all the audience sees, but the director

and the actors must know what's in the hypothetical offstage rooms, right down to what's in the linen closets." According to Freeman, "He's immersing himself in it, creating the density of felt detail, from which fine performances emerge. Hitchcock moves from the general to the particular in his script preparation exactly as he does in the celebrated sequences of his films." He was defining for himself "first the place (if it's unusual)," said Freeman, "then the people—much of the discussion wide-ranging and speculative—then the details about the people that will drive our story forward. Sure enough, the general to the particular, the farthest to the nearest."

If the detail-seeking was "compulsive and a little nuts," it was also, Freeman perceived, partly "to avoid actual script writing." When Hitchcock was bored or having a painful day, they switched to discussing "the nature of the love affair," which usually alleviated his bad mood. The vengeance seeker making love to the traitor's wife: that excited Hitchcock. When Freeman brought up his vision of "compulsive, life-changing, soul-altering sex—all to be made more explicit than any scenes in his previous films," Hitchcock responded, "Yes, yes. That will work, very exciting." ("It was as elaborate as praise ever got," Freeman recalled.)

One day, discussing the scene between the two lovers in a cabin on the Finnish island, Hitchcock visualized an X-rated interaction. "The lovers are seated across the room from each other," he intoned—with their robes *open*, he added. (Freeman: "He stopped, savoring the scene, repeating that the robes were open.") "Their robes open as they look at one another," Hitchcock continued, breaking into a lascivious grin. "Outside, on the bay, a tiny boat is approaching, coming over the horizon. The lovers know the husband is approaching. They can hear the sound of his boat's motor, growing louder as it comes over the horizon. They stare at each other and begin to masturbate, each of them. The camera moves closer to their eyes. The sound of the motor grows louder as their eyes fill the screen."*

As Hitchcock talked, he stretched his legs and his cane fell away, according to Freeman; then the director who had always styled the hair of leading ladies to his whim finished his depiction of the scene with a triple-X flourish. "Then after orgasm, the man must take an ivory comb and comb her pubic hair." Not really a scene intended for "The Short Night," this was, according to Freeman, "a private vision, playful and from the heart, a true home movie. This led to a general chat about pornography. I told him about the Pleasure Chest—a Hollywood shop

* Characteristically, Hitchcock had been dreaming of this scene for years, and had in fact described a variation to Truffaut almost fifteen years earlier: "There's just so much one can do with a love scene. Something I wish I could work out is a love scene with two people on each side of the room. It's impossible, I suppose, because the only way to suggest love would be to have them exposing themselves to each other, with the man opening his fly and the girl lifting her skirt, and the dialogue in counterpoint."

that sells sexual paraphernalia. I told him San Fernando Valley house-wives walk up and down the aisles with supermarket baskets buying vi-brators and dildoes. God knows if it's true, but it astonished him, and he loved being astonished."

This revealing incident, along with others, led the writer to believe that Hitchcock nurtured a Dionysian streak that "at least at the end of his life was trying to get out." Although he was not the first, he was probably the last confidant taken aback to hear Hitchcock confess that he and his wife didn't have "relations. Haven't for years." Freeman later reflected: "It's clear he wanted posterity to know that sex and passion, the absolute fun-dament of his work, was not a part of his marriage. Surely he was trying to say, 'I am my films, my films are me. If you want to know either, look at them, my spiritual legacy, not at my odd, misshapen corporeal presence. There is no other me.'"

Yet Hitchcock seemed ebullient one day when the two temporarily moved their sessions to Bellagio Road, and Alma agreed to sit in. Frail and twisted, Mrs. Hitchcock was helped by a nurse into the study. Freeman re-called how Alma looked "angry to be infirm." And that day the director came alive as never before in their script discussions. "He was showing off for her," Freeman recalled. "Strutting his stuff. He was saying, 'Look, I can still do it. There's a future. There's going to be another movie. It's worth it to go on.'"

Most days, though, Hitchcock and Freeman worked at the studio, usu-ally alone, although a pretty young secretary was sometimes there with them, taking notes, and now and then Peggy Robertson sat in. Hilton Green, Robert Boyle, and Albert Whitlock came to meetings, but other visitors were rare. Although he was friendly with his staff, they weren't close friends. In all the time he worked for Hitchcock, Boyle never spent much time at Bellagio Road, and Whitlock said, "I was known to some people as Hitchcock's friend, but this always left me feeling part of the 'friend enigma.' I am mentioned as an old friend and colleague in John Russell Taylor's biography, but I make no claim, although this assuredly came from Hitchcock, as did the rest of the quote about me. Hitch sent me an inscribed copy (with his caricature on the fly leaf) and marked also on the page."

In fact, many of his old, true friends had quit the business or moved away. "No one seems to have the nerve to call him and he's usually pleased when an old friend does," wrote Freeman.

Hitchcock showed Freeman something like fifty bottles of pills on a tray in his bedroom at home, and told the writer there were half as many more in the bathroom. His arthritis ("my friend Arthur," he dubbed

it) was growing worse, and now the director had to be helped in and out of chairs and cars. There were pills at the office, too, and booze everywhere.

His drinking had grown "seriously worse," in Freeman's words. There might be wine at lunch, and always vodka and orange juice at the afternoon break. Between times, Hitchcock kept a brandy bottle in a paper bag in the office bathroom "as if he were some wino on the street," Freeman remembered. "He'd always be shuffling off to have a little bit. That had a kind of sadness about it, as if he were ashamed to be doing it."

Too often, by the spring of 1979, Hitchcock seemed "adrift in senility and depression," and too often the production meetings had to be cut short, awkwardly, when he drifted off. The fifty-fourth Hitchcock film, too, was drifting away. Hitchcock was suffering feelings of embarrassment—and fear. But giving up on "The Short Night" and dying were interchangeable in his mind. Some mornings he wept with his pain, and the thought of dying: "When do you think I'll go?" he asked Peggy Robertson. "When?"

Not before two final honors: first, the American Film Institute in October 1978 had announced that the Master of Suspense would receive its prestigious Life Achievement Award, established in 1973 and thus far awarded to John Ford, James Cagney, Orson Welles, Henry Fonda, Bette Davis, and William Wyler.

Although Hitchcock agreed to be the AFI's honoree, the tribute dinner, scheduled for March 7, 1979, loomed before him like a sword he had to fall upon. He dreaded the upcoming ceremony, which had all the trappings of a public entombment. "He ignored it all, until the last week or so," according to Freeman. With the AFI date looming, wrote Freeman, the pain and drinking "seemed to be constant," and then the director "took to spending long, preposterously flirtatious sessions with a young secretary. When she walked past, he would crinkle his nose and give her little private waves. She always blushed."

He dodged the witty veteran writer Hal Kanter, assigned by the AFI to ghost his acceptance remarks. "He kept canceling dates with Kanter," recalled Freeman, "and denying any knowledge of the need to make a speech."

The day before the event his doctors forbade him to go, throwing AFI officials into a "panic," according to Joseph McBride. "As a precautionary measure," McBride reported, "his acceptance speech was taped in advance, on the afternoon of the event." Although Hitchcock mustered the courage to defy his doctors, the taped version was later intercut with the live version, to give television viewers "the illusion of an error-free delivery"—even though a close viewing shows him standing in the former and seated in the latter.

On the very day of the tribute, a telegram arrived from Frank Capra in Palm Springs, sending his regrets. "It was a message from one old lion to another," wrote Freeman. "Hitch held it in his hands, read it, reread it and cried. Not for the sentiment, I don't think, which was certainly genuine, but because he saw it as attesting to his own demise."

At the Beverly Hilton, where the event took place, Universal had reserved a suite for Hitchcock and then frantically contrived to keep liquor out of his hands until the dinner began.

The cohosts of the evening were Ingrid Bergman and François Truffaut. The glittering assemblage included many veterans of Hitchcock films: Dame Judith Anderson, Teresa Wright, Jane Wyman, John Forsythe, Vera Miles, Janet Leigh, Anthony Perkins, Rod Taylor, Sean Connery, Karen Black, and Tippi Hedren. There was also a sprinkling of younger Hollywood, including Barbra Streisand, Robin Williams, and Steve Martin.

All stood to cheer when the director entered the room, walking to his table—as he had insisted—without help. ("He might have as easily pole-vaulted his way," recalled Freeman.) Spotlights covered his "step by agonizing step, his face red and wheezing, his eyes straight ahead," said Freeman.

The honoree paused "gallantly" to kiss the hand of his daughter, Pat Hitchcock O'Connell, according to the *Los Angeles Times*, before arriving at his table, where he was ringed by Bergman, Cary Grant, James Stewart, Lew Wasserman, Lord and Lady Bernstein, and—"in her own show of gallantry"—Mrs. Hitchcock, even though it had been previously announced that she would be absent because of illness. (Like her husband, Alma hated the idea of appearing publicly in such condition, but at the last moment she decided to come.)

Each of the AFI tributes had its own "flavor," Charles Champlin wrote in the *Los Angeles Times*. "James Cagney's was a family picnic, a welcome home for a beloved and rascally uncle who had been away too long. Orson Welles' was a mixture of reverential awe and sadness, that the astonishing triumph of *Citizen Kane* was a peak he has not equaled since. The tributes to Henry Fonda and Bette Davis were warm with admiration for achievements and for lives lived to the full. William Wyler's night was touched with austere respect for a meticulous and demanding craftsman who was not a man you slapped on the back."

Yet Hitchcock's was undoubtedly "the most filmic of all," wrote Champlin, and also "one of the most melancholy." For it was obvious to everyone present—and then, when the tribute was broadcast one week later, to a national TV audience—that the unsmiling Master of Suspense was deeply mired in a private hell. No matter how merciful, the later crosscutting between clips and rehearsed speeches strained to find any expression in Hitchcock's blank, defeated face. He briefly rose to the occasion with a

subversive speech, which Kanter had cobbled together out of his own resourcefulness. He spoke almost with aplomb, although he couldn't stand and had trouble with the "idiot" cards. The audience "couldn't be sure whether he accidentally or intentionally alluded to the Life Amusement Award instead of the Life Achievement Award," according to the *Los Angeles Times*. "He said all a man required was affection, approval, encouragement and a hearty meal, and he was grateful for having received three out of the four this night."*

Then Hollywood, a den of iniquity for mistresses and divorce, heard something rare, as Hitchcock proceeded to rhapsodize about "the woman at my side" as the ultimate wife, mother, writer, editor, and cook. On the occasion of his last public appearance, he paid moving tribute to the lifelong partner who was still there with him.

When AFI director George Stevens Jr. came to his table to hand him the award, Hitchcock tried to stand up, but fell back into his chair—a moment briefly captured in the televised version. And then there was an especially heartbreaking moment at the end of the evening, when Ingrid Bergman came over to him and made a declaration of her gratitude, presenting Hitchcock with the prop key to the wine cellar, which had been tucked in her hand in a famous shot from *Notorious*. She and Cary Grant had shared custody of it, as a good luck charm, for thirty years. Now she was returning the key—and its luck—to him.

Totally out of character, Hitchcock embraced the actress, trembling. "Suddenly it was not a public show of affection," reported the *Los Angeles Times*, "it was a parting at the platform of two old and dear friends who could not be sure they would meet again." Grant, who typically had balked at rehearsing and saying anything lengthy at the podium, spontaneously jumped up and joined the embrace, ending the night on "a moment of high and genuine emotion whose honesty transcended the circumstances of a fundraising event," according to the *Los Angeles Times*, which added that there were moist eyes throughout the room.

His flirtations with the pretty young secretary worsened, and "soon enough she was spending time with him in his office, à deux," according to David Freeman. "No one but the two of them can say what went on, though I imagine it was something along the lines of Hitch posing her and gazing at her while she unbuttoned herself. Looking was a particular

* The menu featured lobster, wrote David Freeman in his book, and "Hitchcock hadn't eaten shellfish of any sort in fifty years. He claimed it made him ill to look at it. The lobster was taken away and they found him a steak, something he considered edible."

specialty of his. It's unlikely that Hitchcock was capable of much more than that."

The office rumor was that Hitchcock—on the pretext of considering the young secretary for a part in his fifty-fourth film—gave her a little money for posing. "To set this down makes it sound sleazier than it was," said Freeman. "The whole thing had a pathetic innocence about it." Then one day the secretary disappeared; the new rumor was that Lew Wasserman had found out about it and put an end to the matter. "I wouldn't be surprised if Lew Wasserman had paid her to go away," said Freeman, "if he thought Hitch's good name was at risk. He was Hitch's friend, but equally important, Hitch's name was an important studio asset."

The director and writer continued their work up until May 1979; as they left it, "The Short Night" would be polished enough to be published, after Hitchcock's death, along with Freeman's memoir. A short time after the draft was delivered, however, Hitchcock called in Hilton Green and asked him to notify Wasserman that his fifty-fourth film would never be made. Wasserman, a friend to the last, pretended it was a temporary decision. Hitchcock's office stayed open, and he still came in to work when he felt like it, sitting at his desk and dictating correspondence, or jotting fresh notes on "The Short Night." Whenever he was there in the afternoon, he watched a film in his private projection room—often alone.

Although he considered himself a Catholic, he had long since stopped going to church, and now the Jesuit father Thomas Sullivan, friendly with Hitchcock since 1947, insisted on coming to Bellagio Road once a week to say Mass for him and Alma.

He had also long since stopped going to Dr. Walter Flieg's office, asking apologetically if he might have his checkups at home, where the doctor was now his most regular visitor. Hitchcock enjoyed Dr. Flieg's company, among other reasons because they tended to talk about movies, not his health. Dr. Flieg loved Hitchcock's anecdotes and reminiscences. The checkups were brief and routine; the conversation and cocktails took longer.

Most of the time, in his last months, Hitchcock preserved his good humor, Dr. Flieg recalled. But the stretches of misery and depression also lengthened and worsened.

According to Donald Spoto's book, Ingrid Bergman paid Hitchcock a final visit, very close to his eightieth birthday, in August 1979. "He took both my hands," the actress informed Spoto, "and tears streamed down his face and he said, 'Ingrid, I'm going to die,' and I said, 'But of course you are going to die sometime, Hitch—we are all going to die.' And then I told him that I, too, had recently been very ill, and that I had thought about it, too. And for a moment the logic of that seemed to make him more peaceful."

Death surrounded him. It came in the newspapers; it came by mail and by phone. Michael Balcon: October 17, 1977. His sister, Nellie: January 30, 1979. Victor Saville, only a month after making an appearance at Hitchcock's American Film Institute tribute: May 8, 1979. Peggy Robertson had the sad task of bringing him the news each time. Besides Alma, these were the relatives and friends he had known the longest, back in his youth and the boy wonder days. Each death brought new outbursts of tears.

Hume Cronyn came to visit, trying be cheerful. Hitchcock held his hands, weeping, knowing that whichever one of them outlived the other, it would be the last time they met.

At the end of 1979, the last year of his life, came the second award: his listing on Queen Elizabeth's annual New Year's Honors as an honorary Knight Commander of the Order of the British Empire.

"The possibility of a knighthood, I suspect, played a larger part in Hitchcock's inner life than he acknowledged," wrote David Freeman. Officially an American citizen since 1955, Hitchcock was still British to the core, and knighthood allowed him to be known, in the last months of his life, as Sir Alfred. With a flash of the old Hitchcock, he irreverently dubbed himself "the short knight," and there was a brief flurry of attendant studio publicity and office activity resurrecting Hitchcock's fifty-fourth, "The Short Night." But that likelihood was as illusory as the fleeting notion that the director might somehow be able to travel to England for a formal ceremony at Buckingham Palace.

Instead, Lew Wasserman and Universal—which had cocooned Hitchcock for the last twenty years; which had made the studio a safe haven as well as gilded cage for him; which had kept up the pretense of preproduction on the fifty-fourth Hitchcock film in spite of internal certainty that the director was finished—performed one last act of corporate noblesse oblige by hastily rounding up old friends and associates for a knighthood luncheon.

Cary Grant and Janet Leigh, along with a phalanx of studio officials, came to honor Hitchcock, and photographs were taken of him looking all but gone. British consul general Thomas W. Aston bestowed the knighthood. Asked by a reporter why it had taken the queen so long, Hitchcock managed a winking reply. "I guess she forgot," he said.

Around this time, stopping by the office to say hello to the director, David Freeman found the staff in tears, and furniture movers streaming in and out, carrying boxes, files, books, old films—"the detritus of his business," in Freeman's words. Hitchcock had once and for all informed the front office that he couldn't—and wouldn't—make another film, and "the

studio jumped at the chance to close down, or at least reduce, his costly operation," according to Freeman.

"The staff was furious at him for not making an announcement to them himself," wrote Freeman, "and more importantly, not helping them look to their futures. His own sense of himself was so wrapped up in being a film maker that when he wasn't one anymore, he just closed up his shop and released his staff. The people around him had trouble seeing past his recent cruelties and drunken behavior; they saw venality where there was only human frailty. They left angry and hurt, and when they were gone, he came back."

Hitchcock then sat in the middle of his office, having the studio barber trim his sideburns as the workmen gradually emptied out the place. Even after that day, though, Hitchcock couldn't stay away. The director began showing up at the barren office, briefly aided by a temporary assistant. According to Freeman, Hitchcock "resumed his rituals, unencumbered by the fiction of being a film maker, or the trappings of power and authority. There was only one phone line left, and when it would ring, the bell would echo, oddly, off the walls."

In the afternoons he still ordered up screenings, although the logbook was no longer maintained, and there is no record of the last films he watched. A dog lover since boyhood, the director loved *Benji,* and watched the dog-thwarts-kidnappers film repeatedly. The New Wave had waned, and he no longer tried to keep up with youthful trends. He probably watched the latest Walt Disney and James Bond pictures, which always amused him. He would have forced himself to see Universal films because he was loyal, and a major stockholder. In the past his own films had always been on the schedule, whenever he had a writer to indoctrinate—and perhaps that was still true even now. Perhaps Hitchcock watched his own favorites—although he never much dwelled on favorites—reminding himself once and for all of the power and immortality of his life's work.

By late winter, however, he had stopped showing up at Universal. After one last act of duty and friendship (a taped introduction to the forthcoming American Film Institute Life Achievement Award tribute for James Stewart), he left Bellagio Road only once more, checking into Cedars Sinai for diagnostic tests in March. In his final weeks, he took to bed. Alma was incapacitated. His wife was adrift from reality, and he had watched and directed his last film. For Hitchcock, film had been friendship and society, as well as the work that consumed him. Film had been his entire world for all his adult life. Now, uncharacteristically, he even lost interest in the newspaper, in television, in industry or Hollywood gossip.

According to Dr. Flieg, Hitchcock suffered aches and pains, mild hypertension, a heart condition, kidney problems, and a general physical deterioration, but his constitution was strong and he was not dying. He could have lived out months, even years, with care and comfort, said Dr. Flieg. Yet always a man of tremendous willpower, now the director willed himself to die. A man who loved food and drink, now he refused either, taking only sips of water. He stopped getting out of bed; he refused to see or talk to friends; he stared coldly at the few who braved a visit, and more than once confronted them with irrational anger and epithets.

When Dr. Flieg stopped by, Hitchcock even screamed insults at his physician: he wasn't going to pay his medical bills anymore, Hitchcock said, so the doctor may as well leave. Dr. Flieg replied, "I love you, Hitch, and I don't care whether I'm paid or not. I'll still be coming to see you."

In his last days, Hitchcock virtually withered away, lying almost motionless in his bed. Then, at 9:17 A.M. on April 29, 1980, three months shy of his eighty-first birthday, he passed from this earth. A memorial Mass for Alfred Joseph Hitchcock was held at the Church of Good Shepherd in Beverly Hills, "on a bright sunswept day," in the words of the *New York Times,* with Father Thomas Sullivan conducting the service and Lew Wasserman delivering the eulogy. Father Sullivan comforted mourners by telling them that Hitchcock's films were the work of a man he personally knew to be unafraid of death, who "knew that we only live twice—and that the best is yet to come." Among the six hundred people gathered in the church were director Mel Brooks (who had lampooned Hitchcock to Hitchcock's great delight in *High Anxiety*), Louis Jourdan, Karl Malden, Tippi Hedren, Janet Leigh, François Truffaut, and "set workers from the director's studio days," according to the *New York Times.*

Up front, physically crippled and mentally impaired, sat Alma in a wheelchair. She is said to have had only the vaguest idea where she was, or what she was doing there. For the next two years, although she needed round-the-clock medical supervision, Alma Reville Hitchcock was generally "happy as a clam," in her daughter's words, and unaware that her husband was dead. "Hitch is in the next room," Alma would whisper to visitors, or, "He's at the studio. Don't worry, he'll be home soon." Surprising everyone, Mrs. Hitchcock lived until July 6, 1982.

CODA

No matter how much Alfred Joseph Hitchcock streaked his films with comedy and entertainment, they portrayed a world tilting toward madness and horror. The films tried to balance darkness and light, and the life was a similar balancing act. "Hitch had moments of delight and triumph," said Hume Cronyn, "and also moments of confusion, despair and failure."

Some film directors achieve their art by imagining their deepest, darkest fantasies; others do so by means that cannot be analyzed so simply or straightforwardly.

John Russell Taylor's authorized biography, *Hitch: The Life and Times of Alfred Hitchcock* was published in 1978, but its sympathetic portrait was challenged by Donald Spoto's *Alfred Hitchcock: The Dark Side of Genius,* published two years after Hitchcock's death. Spoto saw the director as an extreme example of a dark fantasist, "a macabre joker, a frightened child, and a tyrannical artist," whose obsessions led him toward a lifetime of bloody-minded crime films that trapped beautiful blondes squirming in his grip.

Some who knew Hitchcock tended to agree, based on Spoto's evidence. These, it must be said, were frequently those who knew the director least, or knew him last, during his most difficult years. Sam Taylor, his friend and the screenwriter of *Vertigo* and *Topaz,* annoyed some in the Hitchcock circle by praising the Spoto book, although he told this author that he read it only up to the pages where he and Hitchcock met.

After the book was published and received prominent acclaim in the *New York Times,* people who knew Hitchcock intimately sent protest letters, only a few of which were printed. Some of these people had excluded themselves from Spoto's research in a backdoor effort to unite against the emerging dark portrait.

A dismayed Hume Cronyn wrote the *Times* to say that Spoto's Hitchcock was not the Hitchcock he knew, and to emphasize instead "his generosity, kindness, professional courage, sympathy and the debt I owe him for support and opportunity." Publicist Albert Margolies ("with my knowledge of him based on twenty years as his press agent and forty as his friend") also chimed in. Whitfield Cook wrote too, and privately added in a note to Cronyn, "The author's surmises are often ridiculous. Difficult Hitch sometimes was, but never a monster."

John Houseman said the biography was melodramatic, simplified, and prurient in parts, but regardless "ends up as a serious book—one that will be of interest to scholars and film buffs." Norman Lloyd (who didn't cooperate with Spoto) and Herbert Coleman (who did, but insisted he was misquoted) hated the book, calling it false. Pat Hitchcock O'Connell, who has proved herself every bit her father's daughter in her shrewd management of his image and estate, also denounced the book, and has stated repeatedly that "Spoto took things and twisted them."

But the book sold well around the world, undoubtedly eclipsing François Truffaut's in its number of readers. And Spoto's portrait has stuck in people's minds, perhaps because it is easier to imagine a manipulative egoist and monster, a shriveled soul inside a grossly fat man, than to understand the practical artist who gave his life to film.

Some directors die penniless, few die wealthy, and almost none die owning their own films. Most of the directors of Hitchcock's generation are forgotten, their names and movies treasured by only a small audience of aficionados. Hitchcock was not only the ultimate film director; he also mastered the pitfalls and politics of studio filmmaking that dogged him both in England and America, and emerged as the industry's consummate professional.

Spoto was indeed "conservative" when he estimated Hitchcock's net worth, upon his death, at $20 million. His 150,000 shares of MCA stock alone were worth more than that, before the city and county bonds, the oil shares and other stocks (including his beloved cattle), and, most important, the rights and percentages attached to his post-Selznick films. Earnings from the films alone would add up, over time, to more than $20 million, although when the Hitchcock estate sold *Rope, Rear Window, The Man Who Knew Too Much, The Trouble with Harry,* and *Vertigo* to Universal (which already owned *Saboteur, Shadow of a Doubt,*

and all the late films starting with *Psycho*) in 1983, no price tag was announced.

The value can be guessed by the unusual campaign of restoration and rerelease of Hitchcock's best-known American films, along with the continued promotion of the video, laser-disc, and DVD reissues. Only a small fraction of older films ever undergo the expense of restoration and the gamble of theatrical rerelease; the expense is exorbitant, and the investment is too often impossible to justify. *Vertigo* reportedly cost an estimated $1.5 million when it was restored by Robert Harris and James Katz for Universal, *Rear Window* another $600,000. When the latter was rereleased in 1983, *before* restoration, it grossed $9.1 million. (Vincent Canby of the *New York Times* called it "the most elegantly entertaining American film now in first run.") *Vertigo* had a limited rerelease in 1996 and wasn't as profitable, but Universal's marketing ensures other dividends on Hitchcock's reputation.

Seeing *Vertigo* again reaffirmed that it was "as intensely personal as any entry at Sundance," wrote Kenneth Turan in the *Los Angeles Times*, "an audaciously, brilliantly twisted movie, infused with touches of genius and madness." In 2002, *Sight and Sound*, the film journal of the British Film Institute, conducted two international polls, one of critics and another of filmmakers, in order to compile Top Ten Lists of the all-time greatest movies. *Vertigo* was named by 144 critics as the second greatest film of all time (up from number 4 in 1992, the last such poll), and 108 directors gave it a sixth-place tie. (*Citizen Kane* was number 1 in both polls.)

There is no real U.S. equivalent of the British Film Institute, but in 1998 the American Film Institute canvassed "a blue-ribbon panel of leaders from across the film community" for the Top 100 American films of all time. Hitchcock boasted four among the top hundred. Billy Wilder also claimed four. Only Steven Spielberg, with five, had more. *Psycho* ranked the highest among Hitchcock's entries at number 18, but *North by Northwest* (number 40), *Rear Window* (number 42), and *Vertigo* (number 61) also made the list. (*Citizen Kane* also placed number 1 in the AFI's Top 100 poll.) Most, though not all, critics would agree that these are Hitchcock's four greatest films, though not necessarily in that order—and also not so far below certain other films on the AFI's highly controversial list.*

Three years later, when the AFI drew up another list of Top 100 Thrillers, *Psycho* was number 1; and Hitchcock had nine entries, three of them in the top seven (*North by Northwest* at number 4, *The Birds* at number 7). No other director came close.

* Hitchcock's pre-1939 films fared less well on the BFI's list of 100 Greatest British films of all time. *The 39 Steps* at number 4, and *The Lady Vanishes* at number 35, were the only ones that made the list.

He would have smiled to know, on the other hand, that when the Zagat organization conducted a survey of "thousands of avid moviegoers" to determine the "Fifty Greatest 'Feel Good' Movies of All Time," not a single Hitchcock film made the list. Hitchcock's goal was always to make his audiences *feel*—rarely to make them feel good.

Type "Alfred Hitchcock" into the Internet, and you will obtain thousands of hits, including posted articles, Web sites, chat rooms, fan clubs, and personal pages. Hitchcock courses are a phenomenon in colleges, and analyzing his films is a particular lunacy of academics. Starting with the modest Chabrol-Rohmer tome in 1958, there has been an avalanche of Hitchcock books. There are more books about him than any other film director, and in virtually any language (Persian, if you like, or Serbo-Croatian). In English there are at this writing somewhere in the neighborhood of two hundred Hitchcock books *in print* and available, everything from *Hitchcock: Poster Art* and *Alfred Hitchcock: Triviography and Quiz Book* to *In the Name of National Security: Hitchcock, Homophobia and the Political Construction of Gender in Postwar America* and *Hitchcock and Homosexuality: His 50-Year Obsession with Jack the Ripper and the Superbitch Prostitute: A Psychoanalytic View.*

In several countries (including the United States) you can buy postage stamps with his face on them, and anywhere in the world you can wear a T-shirt with his caricature (or "Bates Motel"), and be as identifiably hip as if you were wearing Che Guevara or Jimi Hendrix.

The Hitchcock name continues to sell, and his movies continue to make money. If, in this modern, callous world, his movies no longer shock, they still afford reliable pleasure, and if he is in heaven—he certainly believed in heaven—this news should afford him pleasure as well.

The centenary of Hitchcock's birth, in 1999, was an opportunity for worldwide symposia, museum retrospectives, nonstop television airings of the old films, new documentaries—and for reappraisal of a man who in his life sometimes struggled for critical respect.

By now it has become commonplace to rank Hitchcock "as a complex figure comparable with Shakespeare and Dickens," in the words of Philip French in the *Observer* (though French qualified his remark by adding, "Of all the great directors, Hitchcock's reputation is the most controversial").

"I rank him with Picasso, Stravinsky, Joyce and Proust," exclaimed the redoubtable Camille Paglia.

"Probably the dominant figure of the first half century of film," said the American critic Roger Ebert.

"You can watch Hitchcock's films over and over," American director

Martin Scorsese wrote in a moving tribute in *Sight and Sound*, "and find something new every time. There's always more to learn. And as you get older, the films change with you. After a while you stop counting the number of times you've seen them. I've looked at Hitchcock's films in sections. Just like the greatest music or painting, you can live with, or by, his films."

Indeed, his films were classed with great paintings in an exhibition entitled "Hitchcock and Art: Fatal Coincidence," which opened at the Montreal Museum of Fine Arts in 2000 before traveling to the Centre Pompidou in Paris in 2001. This show was the brainchild of the Montreal Museum's Guy Cogeval and Dominique Pacini of the Cinémathèque Française, the institution that had championed Hitchcock before any other. Aiming to reveal the wellsprings of his inspiration, the show offered provocative works in all mediums by diverse artists, which echoed the storyboards, publicity stills, costume designs, memorabilia, and excerpts from Hitchcock films. Museum visitors were led through a series of spaces—"some claustrophobic, others sweepingly spacious," in the words of one critic—in which material from Hitchcock's career was juxtaposed with works by Auguste Rodin, Edvard Munch, Max Ernst, Edward Hopper, and other important artists.

"His stature is irrefutably established," declared Peter Conrad in the *Observer*, joining praise of a show that found Hitchcock as at home in a museum as in living rooms.

Perhaps it is better to say as little as possible about the remakes, except that like everything else they add revenue and luster to the Hitchcock name.

A Perfect Murder (1998's loose remake of *Dial M for Murder*) and *Rear Window* (with Christopher Reeve, wheelchair-bound, for television) were solid, if not quite Hitchcockian, a comparison now slung around whenever a disappointing suspense film appears. Brace yourself: new takes on everything from *The 39 Steps* to *To Catch a Thief* are rumored to be in the works. But Gus Van Sant's "faithful" remake of *Psycho* (also 1998), made from Joseph Stefano's original script—only this time in color—illustrates that you can copy the script and style, even the exact shots, without getting close to the essence of Hitchcock.

Perhaps more than anything else, the remakes and "Hitchcock-style" films that Hollywood continues to manufacture remind us that he is gone, and that his life's work, even with the best of intentions, can never be replicated. Quite apart from their craftsmanship, we owe those films to the ceaseless strivings of a remarkable life—and to the spirit of a short, chubby boy, son of a greengrocer, who rose up to transform himself into the truest knight of film.

FILMOGRAPHY

Cast and crew are identified and listed in the order of the original credits, as the names appeared on the screen at the time of the film's initial release. "Unbilled" players and technical personnel are omitted. There are some exceptions, including Hitchcock's own cameo appearances, which were never officially credited. Various Web sites—including the Internet Movie Database (www.imdb.com)—feature more complete listings of cast and crew, including spelling variations and additional personnel.

1920

The Great Day
As title designer. Dir: Hugh Ford. Sc: Eve Unsell, from a play by Louis N. Parker and George R. Sims. Ph: Hal Young.

Cast: Arthur Bourchier, May Palfrey, Bertram Burleigh, Marjorie Hume, Adeline Hayden-Coffin, Meggie Albanesi, Percy Standing, Geoffrey Kerr, Lewis Dayton, L. Thomas, L. C. Carelli.

(Silent, B & W, Hugh Ford for Famous Players–Lasky British)

The Call of Youth
As title designer. Dir: Hugh Ford. Sc: Eve Unsell, from a play by Henry Arthur Jones. Ph: Hal Young.

Cast: Mary Glynne, Ben Webster, Jack Hobbs, Malcolm Cherry, Marjorie Hume, Gertrude Sterroll.

(Silent, B & W, Hugh Ford for Famous Players–Lasky British)

1921

Appearances
As title designer. Dir: Donald Crisp. Sc: Margaret Turnbull, from a play by Edward Knoblock. Ph: Hal Young.

Cast: Mary Glynne, David Powell, Langhorne Burton, Marjorie Hume, Mary Dibley, Percy Standing, Jane West.
(Silent, B & W, Donald Crisp for Famous Players–Lasky British)

The Princess of New York
As *title designer*. Dir: Donald Crisp. Sc: Margaret Turnbull, from a novel by Cosmo Hamilton. Ph: Joseph Rosenthal.
Cast: Mary Glynne, David Powell, Ivor Dawson, George Bellamy, Saba Raleigh, Dorothy Fane, Philip Hewland, Wyndham Guise, R. Heaton Grey.
(Silent, B & W, Donald Crisp for Famous Players–Lasky British)

Dangerous Lies
As *title designer*. Dir: Paul Powell. Sc: Mary O'Connor, from a novel by E. Phillips Oppenheim.
Cast: Mary Glynne, David Powell, Minna Grey, Warburton Gamble, Harry Ham, Clifford Grey, Arthur Cullin, Ernest A. Douglas, Daisy Sloane, Philip Hewland.
(Silent, B & W, Paul Powell for Famous Players–Lasky British)

The Mystery Road
As *title designer*. Dir: Paul Powell. Sc: Margaret Turnbull and Mary O'Connor, from a novel by E. Phillips Oppenheim. Ph: Claude McDonnell.
Cast: Mary Glynne, David Powell, Ruby Miller, Nadja Ostrovska, Irene Tripod, Percy Standing, Lewis Gilbert, Pardoe Woodman, Arthur Cullin, Lionel d'Aragon, Ralph Forster, R. Judd Green, F. Seager.
(Silent, B & W, Paul Powell for Famous Players–Lasky British)

Beside the Bonnie Brier Bush (U.S.: The Bonnie Brier Bush)
As *title designer*. Dir: Donald Crisp. Sc: Margaret Turnbull, from a novel by Ian Maclaren and plays by James McArthur and Augustus Thomas. Ph: Claude L. McDonnell.
Cast: Donald Crisp, Mary Glynne, Alec Fraser, Dorothy Fane, Langhorne Burton, Jerrold Robertshaw, Humbertson Wright, Adeline Hayden-Coffin, John M. East.
(Silent, B & W, Donald Crisp for Famous Players–Lasky British)

1922

Three Live Ghosts
As *title designer and art director*. Dir: George Fitzmaurice. Sc: Margaret Turnbull and Ouida Bergere, from a play by Frederic S. Isham and Max Marcin. Ph: Arthur C. Miller.
Cast: Anna Q. Nilsson, Norman Kerry, Cyril Chadwick, Edmund Goulding,

John Miltern, Clare Greet, Annette Benson, Dorothy Fane, Wyndham Guise. (Silent, B & W, George Fitzmaurice for Famous Players–Lasky British)

Perpetua (U.S.: Love's Boomerang)

As title designer and art director. Dir: John S. Robertson. Sc: Josephine Lovett, from the novel by Dion Clayton Calthrop. Ph: Roy Overbaugh.

Cast: Ann Forrest, David Powell, Geoffrey Kerr, Bunty Fosse, John Miltern, Florence Wood, Roy Byford, Lillian Walker, Lionel d'Aragon, Polly Emery, Amy Williard, Tom Volbecque, Frank Stanmore, Ida Fane, Sara Sample. (Silent, B & W, John S. Robertson for Famous Players–Lasky British)

The Man from Home

As title designer and art director. Dir: George Fitzmaurice. Sc: Ouida Bergere, from the play by Booth Tarkington and Harry Leon Wilson. Ph: Arthur C. Miller.

Cast: James Kirkwood, Anna Q. Nilsson, Geoffrey Kerr, Norman Kerry, Dorothy Cumming, José Ruben, Annette Benson, Edward Dagnall, John Miltern, Clifford Grey. (Silent, B & W, George Fitzmaurice for Famous Players-Lasky British)

The Spanish Jade

As title designer and art director. Dir: John S. Robertson. Sc: Josephine Lovett, from the play by Louis Joseph Vance and the novel by Maurice Hewlett. Ph: Roy Overbaugh.

Cast: David Powell, Evelyn Brent, Charles de Rochefort, Marc McDermott, Harry Ham, Roy Byford, Frank Stanmore, Lionel d'Aragon. (Silent, B & W, John S. Robertson for Famous Players–Lasky British)

Tell Your Children

As title designer and art director. Dir: Donald Crisp. Sc: Leslie Howard Gordon, from a novel by Rachel MacNamara.

Cast: Walter Tennyson, Doris Eaton, Margaret Halstan, Gertrude McCoy, Mary Rorke, Adeline Hayden-Coffin, Warwick Ward, Cecil Morton York, A. Harding Steerman. (Silent, B & W, Martin Sabine for International Artistes Film Co.)

Number Thirteen (unfinished; also referred to as Mrs. Peabody)

As director and producer. Sc: Anita Ross. Ph: Joseph Rosenthal.
Cast: Clare Greet, Ernest Thesiger.
"The picture dealt with London low-life, the 'Number Thirteen' of the title referring to the number of a tenement flat in a Peabody Building (a poor person's dwelling). In a letter . . . Ernest Thesiger comments on the fact that Clare Greet was persuaded to put up some of the money towards the making of the

picture, which was never eventually shown. Adrian Brunel, however, remembers Hitchcock showing it to him, in an incomplete state, in 1922."

Peter Noble, "An Index to the Work of Alfred Hitchcock," Special Supplement to *Sight and Sound,* May 1949

1923

Always Tell Your Wife
As production manager and codirector (with Hugh Croise). Sc: Seymour Hicks and Hugh Croise, from a one-act play by Hicks. Ph. Claude L. McDonnell.

Cast: Seymour Hicks, Ellaline Terriss, Stanley Logan, Gertrude McCoy, Ian Wilson.

(Silent, B & W, Seymour Hicks for Comedie-de-Lux, Seymour Hicks Productions)

"Only the first reel [of two] survives; and the narrative is well enough handled to leave you eager to know what happens next when it cuts off."

David Robinson, *18th Pordenone Silent Film Festival Catalogue,* 1999

Woman to Woman
As coscenarist, art director, and assistant director. Dir: Graham Cutts. Sc: Hitchcock and Michael Morton, from a play by Morton. Ph: Claude L. McDonnell. Editor and Second Asst Dir: Alma Reville.

Cast: Betty Compson, Clive Brook, Josephine Earle, Marie Ault, Myrtle Peter, A. Harding Steerman, Henry Vibart, Donald Searle.

(Silent, B & W, Michael Balcon for Balcon-Saville-Freedman)

"The film critic of the Daily Express *said . . . that it was the 'best American picture made in England.' . . . On* Woman to Woman *I was the general factotum. I wrote the script. I designed the sets, and I managed the production. It was the first film that I had really got my hands onto."*

Alfred Hitchcock, *Stage,* July 1936

1924

The White Shadow
As coscenarist, art director, and assistant director. Dir: Graham Cutts. Sc: Hitchcock and Michael Morton, from a story by Morton. Ph: Claude L. McDonnell. Editor and Second Asst Dir: Alma Reville.

Cast: Betty Compson, Clive Brook, Henry Victor, Daisy Campbell, Olaf Hytten, A. B. Imeson.

(Silent, B & W, Michael Balcon for Balcon-Saville-Freedman)

"Engrossed in our first production, we had made no preparations for the second. Caught on the hop, we rushed into production with a story called The White Shadow. *It was as big a flop as* Woman to Woman *had been a success."*

Michael Balcon, *Michael Balcon Presents . . . a Lifetime of Films,* 1969

The Passionate Adventure

As coscenarist, art director, and assistant director. Dir: Graham Cutts. Sc: Hitchcock and Michael Morton, based on the Frank Stayton novel. Ph: Claude L. McDonnell. Editor and Second Asst Dir: Alma Reville.

Cast: Alice Joyce, Clive Brook, Marjorie Daw, Lilian Hall-Davis, Victor McLaglen, Mary Brough, John Hamilton, Joseph R. Tozer.

(Silent, B & W, Michael Balcon for Gainsborough)

"Some of the sets in The Passionate Adventure *are unique, especially the large hall which is seen so many times and from so many different angles during the progress of the story. Graham Cutts tells me it was especially designed so as to give a minimum of two hundred different camera angles. The movie itself will doubtless be popular, for it is well acted, beautifully costumed and ably directed."*

Pictures and Picturegoer, October 1924

1925

The Blackguard (German: Die Prinzessin und der Geiger)

As scenarist, art director, and assistant director. Dir: Graham Cutts. Sc: Hitchcock, based on the Raymond Paton novel. Ph: Theodor Sparkuhl. Editor and Second Asst Dir: Alma Reville.

Cast: Jane Novak, Walter Rilla, Bernhard Goetzke, Frank Stanmore, Rosa Valetti, Martin Herzberg, Dora Bergner, Fritz Alberti.

(Silent, B & W, Michael Balcon for Gainsborough and Erich Pommer for Ufa)

"The producer who up to now has adhered to following the ordinary American feature productions has now gone over to the German idea of realism coupled with gigantic and, in some cases, almost unnatural settings. The result is that he has a picture which, whether it proves a showman's proposition or not, is miles above the average production."

Variety, May 27, 1925

The Prude's Fall (U.S.: Dangerous Virtue)

As scenarist, art director, and assistant director. Dir: Graham Cutts. Sc: Hitchcock, based on the Rudolf Besier and May Edginton play. Ph: Hal Young. Editor and Second Asst Dir: Alma Reville.

Cast: Jane Novak, Julanne Johnston, Warwick Ward, Miles Mander, Hugh Miller, Gladys Jennings, Henry Vibart, Marie Ault.

(Silent, B & W, Michael Balcon for Gainsborough)

Variety's *review of the U.S. version notes that no producer or director is named, but that Alfred J. Hitchcock is credited with editing and titling. The review goes on to say:* "Dangerous Virtue *is just a piece of film junk and nothing more. The answer is apparent that no producer or director is credited, and the note that American editing and titling were tried to whip it into shape, but even then there was nothing that could be done to save the picture. The* [Loew's]

New York's audience laughed at it and practically hooted it from the screen in derision."
 Variety, November 3, 1926

1926

The Pleasure Garden (German title: Irrgarten der Leidenschaft)

As director. Sc: Eliot Stannard, from the novel by Oliver Sandys. Ph: Baron (Gaetano di) Ventimiglia. Art Dir: Ludwig Reiber. Asst Dir: Alma Reville.

Cast: Virginia Valli, Carmelita Geraghty, Miles Mander, John Stuart, Georg H. Schnell, Karl Falkenberg, Ferdinand Martini, Florence Helminger.*
(Silent, B & W, Michael Balcon for Gainsborough and Münchener Lichtspielkunst, Emelka, original British running length:7,508 ft.)**

"It is improbable that Mr. Hitchcock chose this hectic story of his own accord, but the point is that he has produced it with remarkable power and imaginative resource. The technical skill revealed in this film is superior, I think, to that shown in any film yet made by a British producer, despite the fact that it was made under the difficult conditions, for an Englishman, of a German studio."
 G. A. Atkinson, *Daily Express,* February 14, 1926

The Mountain Eagle (German: Der Bergadler)

As director. Sc: Eliot Stannard, from an original story by Charles Lapworth (German version: Max Ferner). Ph: Baron Ventimiglia. Art Dir: Willy and Ludwig Reiber. Asst Dir: Alma Reville.

Cast: Bernhard Goetzke, Nita Naldi, Malcolm Keen, John Hamilton, Ferdinand Martini.
(Silent, B & W, Michael Balcon for Gainsborough–Münchener Lichtspielkunst Emelka, 7,503 ft.)

"The Mountain Eagle, is due in May and incidentally, is one of the finest pictures of the year."
 "Lolita" for "Film of the Week," *Modern,* February 19, 1927

* The identity of the actress who plays the native girl is unknown, although the listing of Nita Naldi is an error that appears in almost every filmography. Hitchcock in one acount said the part was played by a waitress in the Alassio hotel who was impressed into service when the scheduled German actress could not go into the water because of her menstrual cycle.

**Note on running time of silent films: Unlike a sound film, the running time of a silent film is not a meaningful description, for it is not an intrinsic property of the film itself, but only of a particular screening. The speed of projection (in frames per second) was selected at the whim of the projectionist. A silent film is characterized in this filmography by its length in feet. The relationship between speed, time, and length is that there are sixteen frames per foot in a 35 mm print. A simple example of the fact that the running time can vary drastically is that two video transfers of exactly the same print of *Easy Virtue* run at different times: one (Valencia) runs at sixty minutes, while another (Video Yesteryear) runs at eighty-seven minutes.

The Lodger: A Story of the London Fog (U.S.: The Case of Jonathan Drew)

As director. Sc: Eliot Stannard, from the novel by Mrs. Marie Adelaide Belloc Lowndes. Ph: Baron Ventimiglia. Art Dir: C. Wilfred Arnold, Bertram Evans. Asst Dir: Alma Reville. Editing and Titling: Ivor Montagu. Title Design: E. McKnight Kauffer.

Cast: Ivor Novello, June [Howard-Tripp], Marie Ault, Arthur Chesney, Malcolm Keen, and Alfred Hitchcock (a newsman on the phone, and, perhaps, in the crowd crying for the lodger's blood, toward the end).

(Silent, B & W, Michael Balcon and Carlyle Blackwell for Gainsborough, 7,503 ft.)

"The Lodger *is not an apprentice work but a thesis, definitively establishing Hitchcock's identity as an artist. Thematically and stylistically, it is fully characteristic of his filmic writing. By 'writing' I mean not what we ordinarily think of as a script but a film's construction as a succession of views, what is technically called its 'continuity' and in France its 'decoupage.' The writing of* The Lodger *in this sense is amazingly imaginative and complex. Every shot, every framing, reframing, and cut, is significant.*"

William Rothman, *Hitchcock—The Murderous Gaze*

1927

Downhill (U.S.: When Boys Leave Home)

As director. Sc: Eliot Stannard, from a play by David. L'Estrange (pseudonym of Ivor Novello and Constance Collier). Ph: Claude L. McDonnell. Art Dir: Bertram Evans. Asst Dir: Frank Mills. Ed: Ivor Montagu.

Cast: Ivor Novello, Robin Irvine, Isabel Jeans, Ian Hunter, Norman McKinnel, Annette Benson, Sybil Rhoda, Lilian Braithwaite, Violet Farebrother, Ben Webster, Hannah Jones, Jerrold Robertshaw, Barbara Gott, Alfred Goddard, J. Nelson.

(Silent, B & W, C. M. Woolf and Michael Balcon for Gainsborough, 7,803 ft.)

"Downhill *is slick, well photographed, neat—altogether a nicely turned-out piece of cinematography. . . . Mr Hitchcock, more perhaps than any of our directors, understands the significance of inanimate objects and the tremendous effects that the screen, alone of all the arts, can get out of them.*"

Beatrice Curtis Brown, *Graphic* (London), October 22, 1927

Easy Virtue

As director. Sc: Eliot Stannard, based on the play by Noel Coward. Ph: Claude L. McDonnell. Art Dir: Clifford Pember. Ed: Ivor Montagu. Asst Dir: Frank Mills.

Cast: Isabel Jeans, Franklin Dyall, Eric Bransby Williams, Ian Hunter, Robin Irvine, Violet Farebrother, Frank Elliott, Dacia Deane, Dorothy Boyd, Enid Stamp Taylor, Benita Hume, and Alfred Hitchcock (glimpsed leaving a tennis court through a side gate).

(Silent, B & W, C. M. Woolf and Michael Balcon for Gainsborough, 7,300 ft.)

"Seen in the context of the average British film of the day, Easy Virtue represents a tremendous step forward: not only is it inventive and cinematic, but it is obviously the work of a man who loves his medium and wants to do exciting things with it."

William K. Everson, "Rediscovery," *Films in Review* 26, no. 5 (1975)

The Ring

As scenarist and director. Ph: John J. Cox. Art Dir: C. Wilfred Arnold. Asst Dir: Frank Mills.

Cast: Carl Brisson, Lilian Hall-Davis, Ian Hunter, Forrester Harvey, Harry Terry, Gordon Harker, Clare Greet, Eugene Corri.

(Silent, B & W, John Maxwell for British International Pictures, 8,400 ft.)

"A great success in critical terms. Superlatives abounded in the press reviews and the film was hailed as 'the greatest production ever made in this country'; 'a devastating answer to those who disbelieved in the possibilities of a British film'; 'a triumph for the British film industry'; and a picture which 'challenges comparison with the best that America can produce.' The newspaper comment was so favorable that as part of the advance publicity for the film The Bioscope *included a double page spread which simply printed excerpts from 15 newspaper reviews under a banner headline which repeated the* Daily Mail's *judgment of the film as 'the greatest production ever made in this country.' "*

Tom Ryall, *Alfred Hitchcock and the British Cinema*

1928

The Farmer's Wife

As director. Sc: Eliot Stannard, based on the play by Eden Phillpotts. Ph: John J. Cox. Art Dir: C. Wilfred Arnold. Ed: Alfred Booth. Asst Dir: Frank Mills.

Cast: Jameson Thomas, Lilian Hall-Davis, Gordon Harker, Maud Gill, Louise Pounds, Olga Slade, Ruth Maitland, Antonia Brough, Gibb McLaughlin, Haward Watts, Mollie Ellis.

(Silent, B & W, John Maxwell for British International Pictures, 8,775 ft.)

"The cast works as an ensemble, immaculately controlled by Hitchcock, and the film remains genuinely funny and even a little bit touching: One of Hitchcock's rare out-and-out comedies, it reminds us of his great skills in the area, when he chose to exercise them."

John Russell Taylor, *18th Pordenone Silent Film Festival Catalogue* 1999

Champagne

As adapter and director. Sc: Eliot Stannard, from an original story by Walter C. Mycroft. Ph: John J. Cox. Art Dir: C. Wilfred Arnold. Asst Dir: Frank Mills. Titles: Arthur Wimperis.

Cast: Betty Balfour, Jean Bradin, Theo von Alten, Gordon Harker, Clifford Heatherley, Hannah Jones, Claude Hulbert.

(Silent, B & W, John Maxwell for British International Pictures, 8,038 ft.)

Hitchcock: ". . . probably the lowest ebb in my output." Truffaut: "That's not fair. I enjoyed it. Some of the scenes have the lively quality of the Griffith comedies."

François Truffaut, *Hitchcock*

1929

The Manxman

As director. Sc: Eliot Stannard, based on the novel by Sir Hall Caine. Ph: John J. Cox. Art Dir: C. Wilfred Arnold. Asst Dir: Frank Mills. Ed: Emile de Ruelle.

Cast: Carl Brisson, Malcolm Keen, Anny Ondra, Randle Ayrton, Clare Greet.

(Silent, B & W, John Maxwell for British International Pictures, 8,163 ft.)

"A plot such as this, melodramatic in its premises, can only achieve the sublime if the filmmaker dares to meet the challenge head-on. For the first time, Hitchcock penetrated a domain that has since become dear to him— vertigo. The situation in The Manxman *is sublime because it is insoluble and rejects all artifice. It is insoluble because it does not depend upon the evilness of the characters or the relentlessness of fate. Hitchcock gave himself up to a minute, complete, and unflinching description of the moral conflict opposing three people whose behavior is practically beyond reproach."*

Eric Rohmer and Claude Chabrol, *Hitchcock—The First Forty-four Films*

Blackmail (silent)

As scenarist and director. From the play by Charles Bennett. Ph: John J. Cox. Art Dir: C. Wilfred Arnold. Asst Dir: Frank Mills. Ed: Emile de Ruelle.

Cast: Same as for the sound version, except for Phyllis Konstam (gossiping neighbor) and Sam Livesey (Chief Inspector).

(Silent, B & W, John Maxwell for British International Pictures, 6,750 ft.)

"The silent version of this fine drama brings the directorial art of Alfred Hitchcock into still greater prominence, and proves . . . that he has succeeded to a superlative degree in combining the advantages of the medium of the screen with those of the spoken drama. Without its dialogue and very effectively subtitled, Blackmail *is likely to achieve equal success on the silent screen."*

The Bioscope, August 21, 1929

Blackmail (sound)

As adapter and director. Adaptation: Hitchcock, from the play by Charles Bennett. Sound Dialogue: Benn W. Levy. Ph: John J. Cox. Art Dir: C. Wilfred

Arnold. Asst Dir: Frank Mills. Ed: Emile de Ruelle. Music: Campbell and Connelly. Score: Henry Stafford. Arranger: Hubert Bath. Musical Director: John Reynders.

Cast: Anny Ondra [Joan Barry, voice double for Anny Ondra], Cyril Ritchard, John Longden, Donald Calthrop, Sara Allgood, Charles Paton, Phyllis Monkman, Harvey Braban, Hannah Jones, and Alfred Hitchcock (on the train, being pestered by a small boy).

(Sound, B & W, John Maxwell for British International Pictures, 86 mins.)*

"Not just a talker, but a motion picture that talks. Alfred J. Hitchcock has solved the problem of making a picture which does not lose any film technique and gains effect from dialog. Silent, it would be an unusually good film; as it is, it comes near to being a landmark."

Variety (London correspondent), July 1, 1929

Juno and the Paycock (U.S.: The Shame of Mary Boyle)

As adapter and director. Sc: Alma Reville, from the play by Sean O'Casey. Ph: John J. Cox. Art Dir: J. Marchant. Asst Dir: Frank Mills. Sound: Cecil V. Thornton. Ed: Emile de Ruelle.

Cast: Sara Allgood, Edward Chapman, John Laurie, Maire O'Neill, Sidney Morgan, John Longden, Denis Wyndham, Kathleen O'Regan, Barry Fitzgerald, Dave Morris, Fred Schwartz, Donald Calthrop.

(B & W, John Maxwell for British International Pictures, 99 mins.)

"Though crudely made in that early sound era, it is far superior and truer than the John Ford version of another O'Casey play The Plough and the Stars *(1936). Hitchcock loved the play with its morally marginal message which pussyfoots around the* Irish Uprising *and oppressed Catholic theme."*

Kevin Lewis, *Irish America Magazine,* August–September 1999

1930

An Elastic Affair (short subject)

As director. Ten-minute black-and-white film starring scholarship winners in *Film Weekly*'s acting competition.

Cast: Aileen Despard, Cyril Butcher.

Elstree Calling

As director of "sketches and other interpolated items." Dir: Adrian Brunel. Sc: Adrian Brunel, Walter C. Mycroft, Val Valentine. Ph: Claude Friese-Greene. Sound Recordist: Alec Murray. Prod Mgr: J. Sloan. Ed: A. C. Hammond, under supervision of Emile de Ruelle. Music: Reg Casson, Vivian Ellis, Chick Endor, Ivor Novello, Jack Strachey. Lyrics: Douglas Furber, Rowland

* Henceforth all listings are sound films, and will be listed according to approximate running time in minutes.

Leigh, Donovan Parsons, Jack Hulbert, Paul Murray, André Charlot. Conductors: Teddy Brown, Sydney Baynes, John Reynders.

Cast: Cicely Courtneidge, Jack Hulbert, Tommy Handley, Lily Morris, Helen Burnell, the Berkoffs, Bobbie Comber, Lawrence Green, Ivor McLaren, Anna May Wong, Jameson Thomas, John Longden, Donald Calthrop, Will Fyffe, Gordon Harker, Hannah Jones, Teddy Brown, the Three Eddies, the Balalaika Choral Orchestra, supported by the Adelphi Girls and the Charlot Girls.

(B & W, John Maxwell for British International Pictures, 86 mins.)

Elstree Calling *was produced as a multilingual in ten languages—including Flemish! And there was a color version. It is a matter of some interest what exactly was Hitchcock's participation in the film. The best analytical work on this problem is by James M. Vest, who wrote: "Thus it appears that casual dismissals of* Elstree Calling *on the part of the director, his biographers, and some commentators stand in need of revision. In all likelihood Hitchcock's role in this film is considerably greater than generally acknowledged."*

James M. Vest, "Alfred Hitchcock's Role in Elstree Calling," *Hitchcock Annual,* 2000–2001

Murder!

As coadapter and director. Sc: Alma Reville. Coadaptation: Walter Mycroft, from *Enter Sir John* by Clemence Dane and Helen Simpson. Ph: John J. Cox. Art Dir: John F. Mead, Peter Proud. Asst Dir: Frank Mills. Sound Recordist: Cecil V. Thornton. Music Dir: John Reynders. Ed: Rene Marrison, under supervision of Emile de Ruelle.

Cast: Herbert Marshall, Norah Baring, Edward Chapman, Phyllis Konstam, Miles Mander, Esmé Percy, Donald Calthrop, Esme V. Chaplin, Amy Brandon Thomas, Joynson Powell, S. J. Warmington, Marie Wright, Hannah Jones, Una O'Connor, R. E. Jeffrey; Jury: Alan Stainer, Kenneth Kove, Guy Pelham Boulton, Violet Farebrother, Clare Greet, Drusilla Wills, Robert Easton, William Fazan, George Smythson, Ross Jefferson, Picton Roxborough, and Alfred Hitchcock (walking past the scene of the crime).

(B & W, John Maxwell for British International Pictures, 108 mins.)

"Looked at as a thriller, it is less thrilling than 'The Perfect Alibi' and looked at as a piece of analysis, it lacks the true psychology which distinguishes many less valuable German pictures; but it sets out to be neither of these things. After you have seen it several times, you think of it, with its strong shafts of sound and wedges of visual continuity, as an abstract film on a gigantic and really for once modern scale."

Robert Herring, *London Mercury,* November 1930

Mary! (German version of Murder!)

As director. Ph: John J. Cox. German adaptation: Herbert Juttke and Georg C. Klaren.

Cast: Alfred Abel, Olga Tschechowa, Paul Graetz, Lotte Stein, Ekkehard Arendt, Jack Mylong-Münz, Louis Ralph, Hermine Sterler, Fritz Alberti, Miles Mander (in his original role).

(B & W, German-English coproduction with British International Pictures, 80 mins.)

"Mary *is a neat little potboiler, efficient but rather empty, precisely because all the elements of 'fun,' the play on spectacle, dressing-up and pretending, which make* Murder! *so messy, have gone."*

Richard Combs, "Murder II/Hitchcock's German Double," *Sight and Sound,* Autumn 1990

1931

The Skin Game

As adapter and director. Sc: Alma Reville, from the play by John Galsworthy. Ph: John J. Cox. Art Dir: J. B. Maxwell. Asst Dir: Frank Mills. Sound Recordist: Alec Murray. Ed: Rene Marrison, A. R. Cobbett,

Cast: Edmund Gwenn, Helen Haye, C. V. France, Jill Esmond, John Longden, Phyllis Konstam, Frank Lawton, Herbert Ross, Dora Gregory, Edward Chapman, R. E. Jeffrey, George Bancroft, Ronald Frankau.

(B & W, John Maxwell for British International Pictures, 88 mins.)

"Far more skilled and delicate than the original stage version."

John Grierson, *Everyman,* November 5, 1931 (*Grierson on the Movies*)

Rich and Strange (U.S. title: East of Shanghai)

As coscenarist and director. Sc: Alma Reville and Val Valentine, from a theme by Dale Collins. Ph: John J. Cox, Charles Martin. Art Dir: C. Wilfred Arnold. Asst Dir: Frank Mills. Music: Hal Dolphe. Musical Direction: John Reynders. Sound Recordist: Alec Murray. Ed: Winifred Cooper, Rene Marrison.

Cast: Henry Kendall, Joan Barry, Percy Marmont, Betty Amann, Elsie Randolph, Aubrey Dexter, Hannah Jones.

(B & W, John Maxwell for British International Pictures, 87 mins.)

"In a sense it is Hitchcock's subtlest, most far-reaching film [of the early years]. Since it is an early sound film, it does not have the defining style that would give it real greatness, but it has a great deal of quality and remains a very remarkable film."

Kirk Bond, "The Other Alfred Hitchcock," *Film Culture,* Summer 1966

1932

Number Seventeen

As coscenarist and director. Sc: Alma Reville and Rodney Ackland, from the play by J. Jefferson Farjeon. Ph: John J. Cox, Bryan Langley. Art Dir:

C. Wilfred Arnold. Asst Dir: Frank Mills. Music: A. Hallis. Musical Direction: John Reynders. Sound Recordist: A. D. Valentine. Ed: A. C. Hammond.

Cast: Leon M. Lion, Anne Grey, John Stuart, Donald Calthrop, Barry Jones, Ann Casson, Henry Caine, Herbert Langley, Garry Marsh.

(B & W, John Maxwell for British International Pictures, 64 mins.)

"The movie has all it takes to become a camp cult, and something more, something strangely precious, distilling a kind of essence of childhood pulp."
Raymond Durgnat, *The Strange Case of Alfred Hitchcock*

Lord Camber's Ladies

As producer. Dir: Benn W. Levy. Sc: Edwin Greenwood and Gilbert Wakefield, based on the play *The Case of Lady Camber* by H. A. Vachell. Additional Dialogue: Benn W. Levy. Ph: James Wilson. Asst Dir: Frank Mills. Art Dir: David Rawnsley. Sound Recordist: Alec Murray.

Cast: Gerald du Maurier, Gertrude Lawrence, Benita Hume, Nigel Bruce, Clare Greet, A. Bromley Davenport, Hal Gordon, Molly Lamont, Betty Norton, Hugh E. Wright, Harold Meade.

(B & W, Hitchcock for British International Pictures, 80 mins.)

"Although basically a crime drama, there is a great preponderance of comedy in this picture, which is at times so facetious that it takes the punch out of the dramatic moments."
Picturegoer Weekly, March 18, 1933

1934

Waltzes from Vienna (U.S.: Strauss' Great Waltz/The Strauss Waltz)

As director. Sc: Guy Bolton and Alma Reville, from the play *Walzerkrieg* by Heinz Reicherts, Dr. A. M. Willner, and Ernst Marischka. Music: Julius Bittner and E. W. Korngold, featuring the works of Johann Strauss Sr. and Johann Strauss, as adapted for the screen by Hubert Bath. Musical Director: Louis Levy. Ph: Glen MacWilliams. Art Dir: Alfred Junge, Oscar Werndorff. Set Dec: Peter Proud. Asst Dir: Richard Beville. Editor: Charles Frend. Sound Recordist: Alfred Birch.

Cast: Jessie Matthews, Edmund Gwenn, Fay Compton, Esmond Knight, Frank Vosper, Robert Hale, Charles Heslop, Hindle Edgar, Marcus Barron, Betty Huntley Wright, Sybil Grove, Bill Shine, Bertram Dench, B. M. Lewis, Cyril Smith.

(B & W, Tom Arnold for Tom Arnold Productions/Gaumont-British, 81 mins.)

"It has a rhythm not unlike that of Lubitsch's silent The Student Prince, *and Hitchcock often uses his music track in satiric counterpoint to the action. . . . Despite his own repudiation of the film, there is too much vintage Hitchcock in the film for his claims of disinterest and frustration to hold water completely."*
W. K. Everson, "Jessie Matthews," *Films in Review,* December 1975

The Man Who Knew Too Much

As director Sc: A. R. Rawlinson and Edwin Greenwood, from a story by Charles Bennett and D. B. Wyndham-Lewis. Additional Dialogue: Emlyn Williams. Ph: Curt Courant. Art Dir: Alfred Junge. Set Dec: Peter Proud. Ed: H. (Hugh) St. C. Stewart. Sound Recordist: F. McNally. Music: Arthur Benjamin. Musical Dir: Louis Levy. Prod Mgr: Richard Beville.

Cast: Leslie Banks, Edna Best, Peter Lorre, Frank Vosper, Hugh Wakefield, Nova Pilbeam, Pierre Fresnay, Cicely Oates, D. A. Clarke Smith, George Curzon, Henry Oscar, Clare Greet.

(B & W, Michael Balcon with Ivor Montagu for Gaumont-British, 75 mins.)

"Critics who elevate the second Man Who Knew Too Much, *the Hollywood film of the 50s, over the bouncing, bounding, sharp-shooting original, seem to be preferring technique to pristine zest, sentiment to humor, exploitation of star appeal (James Stewart and Doris Day) to fast story-telling, and an American tourist's scenery to seedily persuasive sets like the run-down little chapel and the gang's murky hideout. . . . There is less danger and less surprise [in the second version]. . . . one suspects that the critics who prefer it feel there is something a bit lowering and demeaning about the thriller from as such. Their request to Hitchcock is always to transcend it."*

Penelope Houston, *Cinema: A Critical Dictionary,* Volume One

1935

The 39 Steps

As director. Sc: Charles Bennett, based on the novel by John Buchan. Dialogue: Ian Hay. Continuity: Alma Reville. Ph: Bernard Knowles. Art Dir: Oscar Werndorff. Ed: Derek N. Twist. Sound Recordist: A. Birch. Musical Dir: Louis Levy. Wardrobe: Marianne. Dress Designer: J. Strassner.

Cast: Robert Donat, Madeleine Carroll, Lucie Mannheim, Godfrey Tearle, Peggy Ashcroft, John Laurie, Helen Haye, Frank Cellier, Wylie Watson, Gus MacNaughton, Jerry Verno, Peggy Simpson, and Alfred Hitchcock (litterer, as Donat and Mannheim leave the Music Hall).

(B & W, Michael Balcon with Ivor Montagu for Gaumont-British, 87 mins.)

"This is Hitchcock's most virtuoso and most famous work during his English period. Its chase is handled with great technical finesse and with marvelous touches of macabre humor and banter, moving the hero from a train to a leap from a bridge, across the nicely observed Scottish landscape to a party in a large house (whose owner turns out to be the chief of the spy ring), to a political meeting, to a Salvation Army rally, through yet another flight across the landscape handcuffed to a girl, and finally to a musical hall in London. Though its plot is unbelievable, Hitchcock's continual mastery of suspense keeps it alive."

Georges Sadoul, *Dictionary of Films*

1936

Secret Agent

As director. Sc: Charles Bennett, from the Campbell Dixon play and based on the Ashenden novel by W. Somerset Maugham. Dialogue: Ian Hay. Continuity: Alma Reville. Additional Dialogue: Jesse Lasky Jr. Ph: Bernard Knowles. Art Dir: Oscar Werndorff. Set Dec: Albert Julian. Ed: Charles Frend. Recordist: Philip Dorté. Dresses: J. Strassner. Musical Dir: Louis Levy.

Cast: John Gielgud, Madeleine Carroll, Peter Lorre, Robert Young, Percy Marmont, Florence Kahn, Lilli Palmer, Charles Carson.

(B & W, Michael Balcon with Ivor Montagu for Gaumont-British, 86 mins.)

"The privileged moments are all incidental to the ultimate intrigue—a box of chocolates, a secret message on an assembly line, a dead man's head pressing an eerie note on a church organ, a convenient train wreck to sort out the active sinners from the not-so-innocent bystanders. Despite the relative fastidiousness of its two leads, Secret Agent *remains one of Hitchcock's most engaging films from his British period."*

Andrew Sarris, *You Ain't Heard Nothin' Yet:* The American Talking Film: History and Memory, 1927–1949

Sabotage (U.S.: The Woman Alone)

As director. Sc: Charles Bennett, from the novel *The Secret Agent* by Joseph Conrad. Dialogue: Ian Hay, Helen Simpson. Continuity: Alma Reville. Additional Dialogue: E. V. H. (Ted) Emmett. Ph: Bernard Knowles. Ed: Charles Frend. Art Dir: Oscar Werndorff. Set Dec: Albert Julian. Sound: A. Cameron. Dresses: J. Strassner. Wardrobe: Marianne. Music Dir: Louis Levy. Cartoon Sequence: By arrangement with Walt Disney.

Cast: Sylvia Sidney, Oscar Homolka, Desmond Tester, John Loder, Joyce Barbour, Matthew Boulton, S. J. Warmington, William Dewhurst, Peter Bull, Torin Thatcher, Austin Trevor, Clare Greet.

(B & W, Michael Balcon with Ivor Montagu for Gaumont-British, 76 mins.)

"Mr. Hitchcock keeps perfectly within the bounds of the movie art. He knows exactly what a movie should be and do; so exactly, in fact, that a live wire seems to run backward from any of his films to all the best films one can remember, connecting them with it in a conspiracy to shock us into a special state of consciousness with respect to the art."

Mark Van Doren, *The Nation,* March 13, 1937

1937

Young and Innocent (U.S.: The Girl Was Young)

As director. Sc: Charles Bennett, Edwin Greenwood, and Anthony Armstrong, based on the novel *A Shilling for Candles* by Josephine Tey. Continuity: Alma Reville. Dialogue: Gerald Savory. Ph: Bernard Knowles. Sound: A. O'Donoghue.

Ed: Charles Frend. Art Dir: Alfred Junge. Music Dir: Louis Levy. Wardrobe: Marianne. Song: Lerner, Goodhart and Hoffman.

Cast: Nova Pilbeam, Derrick de Marney, Percy Marmont, Edward Rigby, Mary Clare, John Longden, George Curzon, Basil Radford, Pamela Carme, George Merritt, J. H. Roberts, Jerry Verno, H. F. Maltby, John Miller, and Alfred Hitchcock (photographer with tiny camera, as de Marney escapes from the courthouse).

(B & W, Edward Black for Gaumont-British, 84 mins.)

"I like it best of all his pictures. It may not be, academically speaking, the cleverest. The adepts who go to a Hitchcock film to grub out bits of montage may be disappointed. . . . The real charm of the film is its eye for human values. Hitchcock seems to know, with a certainty that has sometimes evaded him, what is important and what is immaterial to a person in certain circumstances, just how far emotion can affect behavior."

C. A. Lejeune, *Observer,* January 3, 1938 (*The C. A. Lejeune Film Reader*)

1938

The Lady Vanishes

As director. Sc: Sidney Gilliat and Frank Launder, based on the novel *The Wheel Spins* by Ethel Lina White. Continuity: Alma Reville. Ph: John J. Cox. Ed: R. E. Dearing. Cutting: Alfred Roome. Sound: S. Wiles. Settings: Alex Vetchinsky. Music Dir: Louis Levy.

Cast: Margaret Lockwood, Michael Redgrave, Paul Lukas, Dame May Whitty, Cecil Parker, Linden Travers, Naunton Wayne, Basil Radford, Mary Clare, Emile Boreo, Googie Withers, Sally Stewart, Philip Leaver, Zelma Vas Dias, Catherine Lacey, Josephine Wilson, Charles Oliver, Kathleen Tremaine, and Alfred Hitchcock (at Victoria Station, near the end, crossing the screen and smoking a cigarette).

(B & W, Edward Black for Gainsborough, 97 mins.)

"Hitchcock builds suspense on suspense, deception on revelation, like a maestro playing the fifty-two card trick. With the heroine, we cannot believe the evidence of her eyes. Miss Froy's handwriting on the window, the only surety of her existence, disappears like the Uncertainty Principle on the moment of its discovery. The bandaged patient may contain the vanished lady, or a corpse, or anyone. As for the nun in high heels, she is the stuff of dream as well as deception. And the illusion of the moving train itself, though filmed in a small studio, hustles us towards an excitement, a denouement, and explosions of laughter to relieve the suspense. The Lady Vanishes is Hitchcock at his most worldly and assured. Yet beneath the entertainment, there is the menace of a Europe about to be plunged into the horror of war."

Andrew Sinclair, *Masterworks of the British Cinema*

1939

Jamaica Inn

As director. Sc: Sidney Gilliat and Joan Harrison, based on the novel by Daphne du Maurier. Dialogue: Sidney Gilliat. Additional Dialogue: J. B. Priestley. Continuity: Alma Reville. Ph: Harry Stradling, Bernard Knowles. Settings: Tom Morahan. Costumes: Molly McArthur Ed: Robert Hamer. Music: Eric Fenby. Musical Director: Frederic Lewis. Special Effects: Harry Watt. Sound: Jack Rogerson. Makeup: Ern Westmore. Prod Mgr: Hugh Perceval.

Cast: Charles Laughton, Maureen O'Hara, Leslie Banks, Robert Newton, Marie Ney, Emlyn Williams, Wylie Watson, Horace Hodges, Hay Petrie, Frederick Piper, Herbert Lomas, Clare Greet, William Devlin, Jeanne de Casalis, Bromley Davenport, Mabel Terry-Lewis, George Curzon, Basil Radford, Morland Graham, Edwin Greenwood, Mervyn Johns, Stephen Haggard.

(B & W, Erich Pommer and Charles Laughton for Mayflower Pictures, 98 mins.)

"It has suspense and a good run of motion. It has a fine tone—the Inn and the doings there, the coaches and night roads, the English types Hitchcock knows so well how to keep both vivid and credible. . . . What it is above everything else is true to its form, without pretensions but without fawning. Better movies can be made, and have been; more ambitious movies are being made all over the place without half the honest picture skill, consequently without half the audience satisfaction and freedom from pose."

Otis Ferguson, *The New Republic,* September 6, 1939

1940

Rebecca

As director. Sc: Robert E. Sherwood, Joan Harrison. Adaptation: Philip MacDonald and Michael Hogan, from the novel by Daphne du Maurier. Ph: George Barnes. Music: Franz Waxman. Music Assoc: Lou Forbes. Art Dir: Lyle Wheeler. Interiors: Joseph B. Platt. Special Effects: Jack Cosgrove. Interior Dec: Howard Bristol. Supervising Ed: Hal Kern. Assoc. Ed: James E. Newcom. Scenario Asst: Barbara Keon. Recorder: Jack Noyes. Asst Dir: Edmond Bernoudy.

Cast: Laurence Olivier, Joan Fontaine, George Sanders, Judith Anderson, Gladys Cooper, Nigel Bruce, Reginald Denny, C. Aubrey Smith, Florence Bates, Leo G. Carroll, Melville Cooper, Leonard Carey, Edward Fielding, Lumsden Hare, Forrester Harvey, Philip Winter, and Alfred Hitchcock (passerby outside phone booth, toward the end of the film).

(B & W, David O. Selznick for Selznick International Pictures, 130 mins.)
"One feels the genuine chill when watching Rebecca.*"*
Peter Cowie, *Fifty Major Filmmakers*

Foreign Correspondent

As director. Sc: Charles Bennett, Joan Harrison. Dialogue: James Hilton, Robert Benchley. Music: Alfred Newman. Art Dir: Alexander Golitzen. Assoc Art Dir: Richard Irvine. Ph: Rudolph Maté. Special Photographic Effects: Paul Eagler. Supervising Ed: Otho Lovering. Ed: Dorothy Spencer. Interior Dec: Julia Heron. Costumes: I. Magnin & Co. Asst Dir: Edmond Bernoudy. Sound: Frank Maher. Special Production Effects: William Cameron Menzies.

Cast: Joel McCrea, Laraine Day, Herbert Marshall, George Sanders, Albert Basserman, Robert Benchley, Edmund Gwenn, Eduardo Ciannelli, Harry Davenport, Martin Kosleck, Frances Carson, Ian Wolfe, Charles Wagenheim, Edward Conrad, Charles Halton, Barbara Pepper, Emory Parnell, Roy Gordon, Gertrude Hoffman, Martin Lamont, Barry Bernard, Holmes Herbert, Leonard Mudie, John Burton, Jane Novak, and Alfred Hitchcock (pedestrian reading a newspaper as he strolls past McCrea's hotel early in the film).

(B & W, Walter Wanger for Walter Wanger Productions, 119 mins.)

"With so much that is brilliant—the realism of the wrecked plane, the beautiful scenes in the darkness of the windmill amid the turning wheels, the superb melodramatic shot of the torturers' faces seen by the victim under the arc-lamps—I scarcely noticed the blemishes. This film is worth fifty Rebeccas.*"*
Dilys Powell, *Sunday Times,* October 10, 1940

1941

Mr. and Mrs. Smith

As director. Sc: Norman Krasna, based on his original story. Music: Edward Ward. Ph: Harry Stradling. Art Dir: Van Nest Polglase. Assoc Art Dir: L. P. Williams. Gowns: Irene. Set Dec: Darrell Silvera. Sound: John E. Tribby. Special Effects: Vernon L. Walker. Ed: William Hamilton. Asst Dir: Dewey Starkey.

Cast: Carole Lombard, Robert Montgomery, Gene Raymond, Jack Carson, Philip Merivale, Lucile Watson, William Tracy, Charles Halton, Esther Dale, Emma Dunn, Betty Compson, Patricia Farr, William Edmunds, Adele Pearce, and Alfred Hitchcock (passing Robert Montgomery in front of his building).

(B & W, Harry E. Edington for RKO-Radio Pictures, 95 mins.)

"It swings along a merry path with only a smattering of dull episodes, providing many marital pyrotechnics and maneuvers familiar to most couples. Story, as is the case with most marital farces, is not too solidly set up, but its deficiencies in this regard will easily be overlooked in the general humorous melee."
Variety, January 22, 1941

Suspicion

As director. Sc: Samson Raphaelson, Joan Harrison, and Alma Reville, from the novel *Before the Fact* by Francis Iles. Music: Franz Waxman. Ph:

Harry Stradling. Special Effects: Vernon L. Walker. Art Dir: Van Nest Polglase. Assoc. Art Dir: Carroll Clark. Gowns: Edward Stevenson. Set Dec: Darrell Silvera. Sound: John E. Tribby. Ed: William Hamilton. Asst Dir: Dewey Starkey.

Cast: Cary Grant, Joan Fontaine, Cedric Hardwicke, Nigel Bruce, Dame May Whitty, Isabel Jeans, Heather Angel, Auriol Lee, Reginald Sheffield, Leo G. Carroll, and Alfred Hitchcock (posting a letter at the village postbox).

(B & W, Harry E. Edington for RKO-Radio Pictures, 99 mins.)

"Suspicion, *while seeming to gratify the commonplace desire for a romantic thriller, simultaneously urges us to take a closer look and thereby to become self-conscious viewers, aware that the commercial spectacle can entertain us only by entrapping us. Like all of Hitchcock's most successful films,* Suspicion *invites us to penetrate its surface, to cease watching as escapists and attempt an unflinching (and still generally unheard-of) critical spectatorship, one that might enable us to grasp, not just the exquisite strategies of spectacles far more suasive than* Suspicion *seems even to its most credulous viewers. That is,* Suspicion *asks us to become aware of the manipulations made routine by the very industry that produced it."*

Mark Crispin Miller, "Hitchcock's Suspicions and *Suspicion,*" *Boxed In: The Culture of TV*

1942

Saboteur

As director. Sc: Peter Viertel, Joan Harrison, and Dorothy Parker. Ph: Joseph Valentine. Art Dir: Jack Otterson. Assoc. Art Dir: Robert Boyle. Ed: Otto Ludwig. Asst Dir: Fred Frank. Set Dec: R. A. Gausman. Set Continuity: Adele Cannon. Music Dir: Charles Previn. Music: Frank Skinner. Sound: Bernard B. Brown. Sound Technician: William Hedgcock. Special Effects: John P. Fulton.

Cast: Priscilla Lane, Robert Cummings, Otto Kruger, Alan Baxter, Clem Bevans, Norman Lloyd, Alma Kruger, Vaughan Glaser, Dorothy Peterson, Ian Wolfe, Frances Carson, Murray Alper, Kathryn Adams, Pedro de Cordoba, Billy Curtis, Marie Le Deaux, Anita Bolster, Jeanne Romer, Lynn Romer, and Alfred Hitchcock (standing in front of Cut-Rate Drugs in New York).

(B & W, Jack H. Skirball for Frank Lloyd Productions–Universal, 108 mins.)

"To *put it mildly, Mr. Hitchcock and his writers have really let themselves go. Melodramatic action is their forte, but they scoff at speed limits this trip. All the old master's experience at milking thrills has been called upon. As a consequence—and according to Hitchcock custom—*Saboteur *is a swift, high-tension film which throws itself forward so rapidly that it permits slight opportunity for looking back. And it hurtles the holes and bumps which plague it with a speed that forcefully tries to cover them up."*

Bosley Crowther, *New York Times,* May 8, 1942

1943

Shadow of a Doubt

As director. Sc: Thornton Wilder, Sally Benson, and Alma Reville, from a story by Gordon McDonell. Ph: Joseph Valentine. Music: Dimitri Tiomkin. Art Dir: John B. Goodman. Assoc Art Dir: Robert Boyle. Sound: Bernard B. Brown. Sound Technician: Robert Pritchard. Set Dec: R. A. Gausman. Assoc Set Dec: E.R. Robinson. Musical Dir: Charles Previn. Set Continuity: Adele Cannon. Ed: Milton Carruth. Asst Dir: William Tummell. Teresa Wright's Gowns: Adrian. Costumes: Vera West.

Cast: Teresa Wright, Joseph Cotten, MacDonald Carey, Henry Travers, Patricia Collinge, Hume Cronyn, Wallace Ford, Edna May Wonacott, Charles Bates, Irving Bacon, Clarence Muse, Janet Shaw, Estelle Jewell, and Alfred Hitchcock (on the train to Santa Rosa, holding thirteen spades in a bridge game).

(B & W, Jack H. Skirball for Universal-Skirball Productions, 108 mins.)

"Very rarely have I seen a picture where it ceases to be a picture and you are sitting there in the theatre not realizing you are, transported completely into the life which is there upon the screen. Never before has such an experience happened to me in a murder picture. I do think it is a masterpiece which you have created."

From a letter from Gordon McDonell to Hitchcock upon seeing *Shadow of a Doubt,* January 10, 1943

1944

Lifeboat

As director. Sc: Jo Swerling, from a story by John Steinbeck. Ph: Glen MacWilliams. Art Dir: James Basevi, Maurice Ransford. Set Dec: Thomas Little. Assoc Set Dec: Frank E. Hughes. Ed: Dorothy Spencer. Costumes: René Hubert. Makeup: Guy Pearce. Special Photographic Effects: Fred Sersen. Technical Adviser: Thomas Fitzsimmons. Sound: Bernard Freericks, Roger Heman. Music: Hugo W. Friedhofer. Musical Dir: Emil Newman.

Cast: Tallulah Bankhead, William Bendix, Walter Slezak, Mary Anderson, John Hodiak, Henry Hull, Heather Angel, Hume Cronyn, Canada Lee, and Alfred Hitchcock (seen in Reduco newspaper advertisement).

(B & W, Kenneth MacGowan for Twentieth Century–Fox, 96 mins.)

"Lifeboat is not only an extraordinary film, it is also an extraordinary Hitchcock film. Here, he has expanded his mathematical formula of mere suspense until it fully exploits a pathos that never becomes sleek or slick. Despite the fact that only nine characters carry the action which is laid entirely within the confines of a life-craft, there is no strain in the development, no sense of the mechanical ingenuity necessary to keep the events taut and moving. The characters are dimensional, fresh and human, all quite free of the formula

quality with which Hollywood habitually endows a collection of antitheticals in group-dramas."
Herb Sterne, *Rob Wagner's Script,* January 22, 1944

Bon Voyage
As director. Sc: J. O. C. Orton and Angus MacPhail, from a story by Arthur Calder-Marshall. Ph: Günther Krampf. Prod Design: Charles Gilbert. Music: Benjamin Frankel. Technical Adviser: Claude Dauphin.
Cast: John Blythe, the Molière Players.
(B & W, British Ministry of Information for Phoenix Films, 26 mins.)
". . . earnestly and somewhat melodramatically unmasks the dastardly duplicity of the fascists."
Sidney Gottlieb, *"Bon Voyage* and *Aventure Malgache,"* Hitchcock Annual, 1994

Aventure Malgache
As director. Sc: J. O. C. Orton and Angus MacPhail. Ph: Günther Krampf. Prod Design: Charles Gilbert.
Cast: the Molière Players.
(B & W, British Ministry of Information for Phoenix Films, 31 mins.)
". . . focuses on the shrewd, witty, and endearing theatricality of a Resistance fighter."
Sidney Gottlieb, *"Bon Voyage* and *Aventure Malgache,"* Hitchcock Annual, 1994

1945
Spellbound
As director. Sc: Ben Hecht. Adaptation: Angus MacPhail, suggested by the novel *The House of Dr. Edwardes* by Francis Beeding. Ph: George Barnes. Music: Miklós Rózsa. Art Dir: James Basevi. Assoc Art Dir: John Ewing. Supervising Ed: Hal C. Kern. Assoc Ed: William H. Ziegler. Prod Asst: Barbara Keon. Special Effects: Jack Cosgrove. Interior Dec: Emile Kuri. Asst Dir: Lowell J. Farrell. Sound: Richard DeWeese. Dream Sequence Designs: Salvador Dalí. Psychiatric Adviser: May E. Romm.
Cast: Ingrid Bergman, Gregory Peck, Michael Chekhov, Leo G. Carroll, John Emery, Norman Lloyd, Steven Geray, Wallace Ford, Regis Toomey, Bill Goodwin, Donald Curtis, Art Baker, Rhonda Fleming, and Alfred Hitchcock (carrying a violin case and smoking a cigar as he emerges from the Empire Hotel elevator).
(B & W, David O. Selznick for Selznick International Pictures, 111 mins.)
"A frantic chase through hospitals, hotels, stations, trains and consulting rooms, culminating on a ski run, is the route Alfred Hitchcock takes, armed

with Ben Hecht's Freud-slanted script. It is very simplified Freud, to be sure—simplified to the point of being rather incredible if you can stop long enough to think about it. But Hitchcock doesn't give much time for critical contemplation, what with his dazzling use of pace, mood, camera and detail."

Arthur Beach, *New Movies*, November 1945

Memory of the Camps (unfinished)

As treatment adviser and director. Sc: Richard Crossman and Colin Wills. Ph: Service cameramen with the British, American, and Russian armies. Ed: Stewart McAllister, Peter Tanner.

(Sidney Bernstein and Sergei Nolbandov for Supreme Headquarters Allied Expeditionary Force, 55 mins.)

"I got Hitchcock over—he was a great friend of mine—because I wanted somebody to compile it together. There was a very good man called [Peter] Tanner, and a number of good editors, but I wanted the imaginative touch that somebody like Hitchcock could give."

Lord Bernstein to Elizabeth Sussex, "The Fate of F3080,"*
Sight and Sound, Spring 1984

1946

Notorious

As director and producer. Sc: Ben Hecht. Prod Asst: Barbara Keon. Ph: Ted Tetzlaff. Special Effects: Vernon L. Walker, Paul Eagler. Art Dir: Carroll Clark, Albert S. D'Agostino. Set Dec: Darrell Silvera, Claude Carpenter. Music: Roy Webb. Musical Dir: C. Bakaleinikoff. Orchestral Arr: Gil Grau. Ed: Theron Warth. Sound: John E. Tribby, Terry Kellum. Miss Bergman's Gowns: Edith Head. Asst Dir: William Dorfman.

Cast: Cary Grant, Ingrid Bergman, Claude Rains, Louis Calhern, Madame Leopoldine Konstantin, Reinhold Schünzel, Moroni Olsen, Ivan Triesault, Alex Minotis, Lester Dorr, Eberhard Krumschmidt, Charles Mendl, and Alfred Hitchcock (drinking champagne at the party at the mansion).

(B & W, Alfred Hitchcock for RKO Radio, 101 mins.)

"Notorious lacks many of the qualities which made the best of Alfred Hitchcock's movies so good, but it has more than enough good qualities of its own. Hitchcock has always been as good at domestic psychology as at thrillers, and many times here he makes a moment in a party, or a lovers quarrel, or a mere interior shrewdly exciting in ways that few people in film seem to know. His great skill in directing women, which boggled in Spellbound, *is*

* Title assigned by the Imperial War Museum to edited footage unreleased in 1945. First shown in the United States as part of PBS's *Frontline* series, on May 7, 1985, with Trevor Howard reading from the narration from the original script.

functioning beautifully again: I think that Ingrid Bergman's performance here is the best of hers that I have seen. One would think that the use of the camera subjectively—that is, as one of the characters—would for many years have been as basic a movie device as the close-up, but few people try it and Hitchcock is nearly the only living man I can think of who knows just when and how to."

James Agee, *The Nation*, August 17, 1946

1947

The Paradine Case

As director. Sc: David O. Selznick. Adaptation: Alma Reville, from the novel by Robert Hichens. Ph: Lee Garmes. Music: Franz Waxman. Prod Design: J. McMillan Johnson. Art Dir: Thomas Morahan. Costumes: Travis Banton. Supervising Ed: Hal C. Kern. Assoc Ed: John Faure. Scenario Asst: Lydia Schiller. Sound Dir: James G. Stewart. Sound Recording: Richard Van Hessen. Interiors: Joseph B. Platt. Set Dec: Emile Kuri. Asst Dir: Lowell J. Farrell. Unit Mgr: Fred Ahern. Special Effects: Clarence Slifer. Hair Styles: Larry Germain.

Cast: Gregory Peck, Ann Todd, Charles Laughton, Charles Coburn, Ethel Barrymore, Louis Jourdan, Alida Valli, Leo G. Carroll, Joan Tetzel, Isobel Elsom, and Alfred Hitchcock (carrying a cello and getting off the train at Cumberland Station).

(B & W, David O. Selznick for Selznick International Pictures, 116 mins.)

"The film is a study in sexual obsession, flawed by certain compromises (Hitchcock wanted the lover to be played by Robert Newton, as a squalid lower class type), but nevertheless underrated and stunningly beautiful as an example of Hitchcock's visual bravura. The camerawork by Lee Garmes is probably the greatest ever seen in a Hitchcock film. Incomparable are the circling, sinuous movement around Mrs. Paradine as she is arrested at the outset, the shadowy prison cell interview, and the almost incredible Old Bailey sequences, transcendently brilliant in terms of cutting, lighting and direction."

Charles Higham, "Program Notes: Vintage Hitchcock," August 14–15, 1972

1948

Rope

As director and coproducer. Sc: Arthur Laurents. Adaptation: Hume Cronyn, from the play *Rope's End* by Patrick Hamilton. Ph: Joseph Valentine, William V. Skall. Technicolor Dir: Natalie Kalmus. Technicolor Assoc: Robert Brower. Art Dir: Perry Ferguson. Set Dec: Emile Kuri, Howard Bristol. Prod Mgr: Fred Ahern. Ed: William H. Ziegler. Asst Dir: Lowell J. Farrell. Makeup: Perc Westmore. Sound: Al Riggs. Operators of Camera Movement: Edward Fitzgerald, Richard Emmons, Paul G. Hill, Morris Rosen. Lighting Technician:

Jim Potevin. Music Dir: Leo F. Forbstein. Miss Chandler's Dress: Adrian. Radio Sequence: the Three Suns.

Cast: James Stewart, John Dall, Farley Granger, Cedric Hardwicke, Constance Collier, Douglas Dick, Edith Evanson, Dick Hogan, Joan Chandler, and Alfred Hitchcock (glimpsed on a neon sign).

(Color, Hitchcock and Sidney Bernstein for Transatlantic Pictures, 80 mins.)

. . . a quintessentially Hitchcockian thriller. For, in addition to the suspense implicit in its plot (a pair of Nietzschean dandies murder a close personal friend merely to demonstrate their own intellectual superiority), it generates an even more powerful meta-suspense *through the very technique by which Hitchcock has opted to film it.* How long is this shot going to last? *we nail-bitingly ask ourselves.* Surely a cut is due any second now? *And (even if common sense tells us that nothing of the kind can possibly occur in a completed film)* is one of the performers about to make a wrong move? *The paradox of a shot as emblematically cinematic as the ten-minute take is that what it ultimately mimics are the tensions of the real, of the live experience."*

Gilbert Adair, *Flickers: An Illustrated Celebration of 100 Years of Cinema*

1949

Under Capricorn

As director and coproducer. Sc: James Bridie and Hume Cronyn, based on the novel by Helen Simpson. Ph: Jack Cardiff. Technicolor Consultants: Natalie Kalmus, Joan Bridge. Prod Design: Thomas Morahan. Ed: A. S. Bates. Costumes: Roger Furse. Asst Dir: C. Foster Kemp. Script Supervisor: Peggy Singer. Sound: Peter Handford. Makeup: Charles E. Parker. Set Dec: Philip Stockford. Music: Richard Addinsell. Prod Mgr: Fred Ahern. Music Dir: Louis Levy.

Cast: Ingrid Bergman, Joseph Cotten, Michael Wilding, Margaret Leighton, Cecil Parker, Denis O'Dea, Jack Watling, Harcourt Williams, John Ruddock, Bill Shine, Victor Lucas, Ronald Adam, Francis De Wolff, G. H. Mulcaster, Olive Sloane, Maureen Delaney, Julia Lang, Betty McDermott, and Alfred Hitchcock (twice, early in the film wearing a coat and hat in Sydney town square, and, later, among the men on the steps of Government House).

(B & W, Hitchcock and Sidney Bernstein for Transatlantic Pictures, 117 mins.)

"Ranks among Hitchcock's "astonishing achievements . . . a rich account of emotional self-sacrifice."

David Thomson, *A Biographical Dictionary of Film*

1950

Stage Fright

As director and producer. Sc: Whitfield Cook. Adaptation: Alma Reville, based on the novel *Outrun the Constable* by Selwyn Jepson. Ph: Wilkie

Cooper. Art Dir: Terence Verity. Ed: E. B. Jarvis. Sound: Harold King. Makeup: Colin Garde. Prod Supervisor: Fred Ahern. Music: Leighton Lucas. Music Dir: Louis Levy.

Cast: Jane Wyman, Marlene Dietrich, Michael Wilding, Richard Todd, Alastair Sim, Sybil Thorndike, Kay Walsh, Miles Malleson, Hector MacGregor, Joyce Grenfell, André Morell, Patricia Hitchcock, Ballard Berkeley, and Alfred Hitchcock (man on street who passes Wyman, rehearsing her part before entering Dietrich's apartment, notices her, then walks away puzzled).

(B & W, Hitchcock for Warner Bros., 110 mins.)

"Never a man to make things easy for himself, director Hitchcock has tried in Stage Fright *to work within the discipline of a tricky story conceit: his heroine (Jane Wyman) plays romantic nip and tuck simultaneously with a suspected murderer (Richard Todd) and the Scotland Yard man (Michael Wilding) who is tracking him down. Hitchcock exploits the situation as much for chuckles as for chills. The result is an entertaining show handsomely produced against a London background, studded with effective scenes and enlivened by an excellent cast."*

Time, March 13, 1950

1951

Strangers on a Train

As director and producer. Sc: Raymond Chandler and Czenzi Ormonde. Adaptation: Whitfield Cook, from the novel by Patricia Highsmith. Ph: Robert Burks. Art Dir: Edward S. Haworth. Ed: William Ziegler. Sound: Dolph Thomas. Set Dec: George James Hopkins. Wardrobe: Leah Rhodes. Makeup: Gordon Bau. Special Effects: H. F. Koenekamp. Assoc Prod: Barbara Keon. Musical Direction: Ray Heindorf. Music: Dimitri Tiomkin.

Cast: Farley Granger, Robert Walker, Ruth Roman, Leo G. Carroll, Patricia Hitchcock, Laura Elliott, Marion Lorne, Jonathan Hale, Howard St. John, John Brown, Norma Varden, Robert Gist, and Alfred Hitchcock (man boarding train carrying double bass).

(B & W, Hitchcock for Warner Bros., 101 mins.)

"A dual figure again, with the extravagant notion of the exchange murders speaking the language of desire and repression, within the context of a morbid dream where the tennis game is a clear metaphor for the exchange."

Jean-André Fieschi, "Alfred Hitchcock," *Cinema: A Critical Dictionary*

1953

I Confess

As director and producer. Sc: George Tabori and William Archibald, from a play by Paul Anthelme. Ph: Robert Burks. Art Dir: Edward S. Haworth. Ed: Rudi Fehr. Sound: Oliver S. Garretson. Set Dec: George James Hopkins.

Wardrobe: Orry-Kelly. Prod Supervisor: Sherry Shourds. Prod Assoc: Barbara Keon. Makeup: Gordon Bau. Asst Dir: Don Page. Technical Adviser: Father Paul LaCouline. Musical Direction: Ray Heindorf. Music: Dimitri Tiomkin.

Cast: Montgomery Clift, Anne Baxter, Karl Malden, Brian Aherne, O. E. Hasse, Roger Dann, Dolly Haas, Charles Andre, Judson Pratt, Ovila Légaré, Gilles Pelletier, and Alfred Hitchcock (man crossing top of stairs during opening credits).

(B & W, Hitchcock for Warner Bros., 95 mins.)

"The real star is Hitchcock himself. Few directors move their cameras so daringly, frame their action so expertly, or know so well the precise moment to cut from action to reaction. Few directors have his flair for staging a scene to give the almost newsreel quality of reality caught by chance."

Arthur Knight, *Saturday Review*, February 21, 1953

1954

Dial M for Murder

As director and producer. Sc: Frederick Knott, as adapted from his play. Ph: Robert Burks. Art Dir: Edward Carrere. Ed: Rudi Fehr. Sound: Oliver S. Garretson. Set Dec: George James Hopkins. Wardrobe: Moss Mabry. Makeup: Gordon Bau. Asst Dir: Mel Dellar. Music: Dimitri Tiomkin.

Cast: Ray Milland, Grace Kelly, Robert Cummings, John Williams, Anthony Dawson, Leo Britt, Patrick Allen, George Leigh, George Alderson, Robin Hughes, and Alfred Hitchcock (in college reunion photograph).

(Color, Hitchcock for Warner Bros., 105 mins.)

"I should mention that this is one of the pictures I see over and over again. I enjoy it more every time I see it. Basically, it's a dialogue picture, but the cutting, the rhythm, and the direction of the players are so polished that one listens to each sentence religiously. It isn't all that easy to command the audience's undivided attention for a continuous dialogue. I suspect that here again the real achievement is that something very difficult has been carried out in a way that makes it seem very easy."

François Truffaut, *Hitchcock*

Rear Window

As director and producer. Sc: John Michael Hayes, based on a short story by Cornell Woolrich. Ph: Robert Burks. Technicolor Consultant: Richard Mueller. Art Dir: Hal Pereira, Joseph MacMillan Johnson. Special Photographic Effects: John P. Fulton. Set Dec: Sam Comer, Ray Moyer. Asst Dir: Herbert Coleman. Ed: George Tomasini. Costumes: Edith Head. Technical Adviser: Bob Landry. Makeup: Wally Westmore. Sound Dir: Loren L. Ryder. Sound Recording: Harry Lindgren, John Cope. Music: Franz Waxman.

Cast: James Stewart, Grace Kelly, Wendell Corey, Thelma Ritter, Raymond Burr, Judith Evelyn, Ross Bagdasarian, Georgine Darcy, Sara Berner, Frank

Cady, Jesslyn Fax, Rand Harper, Irene Winston, Havis Davenport, and Alfred Hitchcock (man winding clock in songwriter's apartment).

(Color, Hitchcock for Paramount, 112 mins.)

"*In an impressive oeuvre,* Rear Window *is arguably the most exquisitely handcrafted feature. . . . [It] has often been described as Hitchcock's testament because it sums up so many of his ideas about filmmaking: His fascination with voyeurism, his love of technical restrictions (which had also motivated* Lifeboat *and* Rope), *and his cultivation of certain stars—it was the second time he'd used Stewart* (Rope) *and Kelly* (Dial M for Murder). *It also sums up his ideas about editing, especially as a means for soliciting the audience's involvement in the action.*"

Jonathan Rosenbaum, *Chicago Reader,* February 25, 2000

1955

To Catch a Thief

As director and producer. Sc: John Michael Hayes, from the novel by David Dodge. Ph: Robert Burks. Technicolor Consultant: Richard Mueller. Art Dir: Hal Pereira, Joseph MacMillan Johnson. Second Unit Ph: Wallace Kelley. Special Photographic Effects: John P. Fulton. Process Photography: Farciot Edouart. Set Dec: Sam Comer, Arthur Krams. Ed: George Tomasini. Asst Dir: Daniel J. McCauley. Makeup: Wally Westmore. Sound: Harold Lewis, John Cope. Music: Lynn Murray. Second Unit Dir: Herbert Coleman. Costumes: Edith Head. Dialogue Coach: Elsie Foulstone.

Cast: Cary Grant, Grace Kelly, Jessie Royce Landis, John Williams, Charles Vanel, Brigitte Auber, Jean Martinelli, Georgette Anys, and Alfred Hitchcock (man on bus seated next to Cary Grant).

(Color, Hitchcock for Paramount, 106 mins.)

"*A remarkable film, and in it Alfred Hitchcock has managed to surpass himself. His favorite themes, which the young Hitchcock-Hawksian French critics seem to have revealed to him, are very much in evidence here. Despite his claim of not having gotten deeply involved in this film, Hitchcock's themes, treated in a relatively formal and externalized way, are clearly stated—especially the primary one, which François Truffaut has extricated in a fairly irrefutable way: that of the identification of one character with another, a kind of ontological identification which is the ulterior motive for the action.*"

André Bazin, *L'Observateur,* December 29, 1955, *The Cinema of Cruelty*

The Trouble with Harry

As director and producer. Sc: John Michael Hayes, based on the novel by Jack Trevor Story. Ph: Robert Burks. Technicolor Consultant: Richard Mueller. Art Dir: Hal Pereira, John Goodman. Ed: Alma Macrorie. Special Photographic Effects: John P. Fulton. Set Dec: Sam Comer, Emile Kuri. Asst Dir: Howard Joslin. Costumes: Edith Head. Makeup: Wally Westmore. Sound:

Harold Lewis, Winston Leverett. Music: Bernard Herrmann. Song: "Flaggin' the Train to Tuscaloosa" by (lyrics) Mack David and (music) Raymond Scott. Associate Prod: Herbert Coleman.

Cast: Edmund Gwenn, John Forsythe, Mildred Natwick, Mildred Dunnock, Jerry Mathers, Royal Dano, Parker Fennelly, Barry Macollum, Dwight Marfield, Shirley MacLaine, and Alfred Hitchcock (walking past limousine of art collector).

(Color, Hitchcock for Paramount, 99 mins.)

"This little gem of black comedy—alive with the sort of wry, sparkling wit we associate with Punch *or* New Yorker *cartoons in their heyday—was a flop in 1956 America, but a huge hit in Europe, playing to packed houses at a Champs Élysées theater for over half a year. It is one of Hitchcock's great personal favorites, a mine of his special, sophisticated, larkily evil brand of humor."*

Michael Wilmington, *L.A. Weekly*, April 20–26, 1984

1956

The Man Who Knew Too Much

As director and producer. Sc: John Michael Hayes, based on a story by Charles Bennett and D. B. Wyndham-Lewis. Ph: Robert Burks. Technicolor Consultant: Richard Mueller. Art Dir: Hal Pereira, Henry Bumstead. Special Photographic Effects: John P. Fulton. Process Photography: Farciot Edouart. Set Dec: Sam Comer, Arthur Krams. Technical Advisers: Constance Willis, Abdelhaq Chraibi. Ed: George Tomasini. Asst Dir: Howard Joslin. Costumes: Edith Head. Asst Dir: Howard Joslin. Makeup: Wally Westmore. Sound: Paul Franz, Gene Garvin. Music: "Storm Cloud Cantata" by Arthur Benjamin and D. B. Wyndham-Lewis, performed by London Symphony Orchestra, conducted by Bernard Herrmann, with Covent Garden Chorus, Barbara Howitt, soloist. Score: Bernard Herrmann. Songs: "Whatever Will Be" and "We'll Love Again" by Jay Livingston and Ray Evans. Associate Prod: Herbert Coleman.

Cast: James Stewart, Doris Day, Brenda de Banzie, Bernard Miles, Ralph Truman, Daniel Gelin, Mogens Wieth, Alan Mowbray, Hillary Brooke, Christopher Olsen, Reggie Nalder, Richard Wattis, Noel Willman, Alix Talton, Yves Brainville, Carolyn Jones, Bernard Herrmann (the Conductor), and Alfred Hitchcock (man with back to camera watching acrobats in Moroccan marketplace).

(Color, Hitchcock for Paramount, 120 mins.)

"This film by a supposedly misogynous director has as its sole mainspring—assuming one resolutely rejects metaphysics—feminine intuition. It is, like his preceding films, without self-indulgence, but the better displays its moments of grace and liberty. Sometimes, like the little boy held prisoner in the

embassy who hears his mother's voice as she sings in the salon, we are touched in the work of this caustic and brilliant man by a grace which may only come to us in snatches from afar, but which minds more immediately lyrical are incapable of dispensing with such delicacy. Let us love Hitchcock when, weary of passing simply for a master of taut style, he takes us the longest way around."

Jean-Luc Godard, *Godard on Godard*

The Wrong Man

As director and producer. Sc: Maxwell Anderson and Angus MacPhail. Story: Maxwell Anderson, based on a true case of mistaken identity. Ph: Robert Burks. Art Dir: Paul Sylbert. Ed: George Tomasini. Asst Dir: Daniel J. McCauley. Sound: Earl Crain Sr. Set Dec: William L. Kuehl. Makeup: Gordon Bau. Music: Bernard Herrmann. Technical Advisers: Frank D. O'Connor, George Groves. Associate Prod: Herbert Coleman.

Cast: Henry Fonda, Vera Miles, Anthony Quayle, Harold J. Stone, Charles Cooper, John Heldabrand, Esther Minciotti, Doreen Lang, Laurinda Barrett, Norma Connolly, Nehemiah Persoff, Lola D'Annunzio, Kippy Campbell, Robert Essen, Richard Robbins, Dayton Lummis, Peggy Webber, and Alfred Hitchcock (narrating the prologue).

(B & W, Hitchcock for Warner Bros., 105 mins.)

"First part of the picture, in which Fonda is arrested outside his home, questioned, fingerprinted, paraded in front of witnesses, and tossed into jail, is masterfully directed with a sense of precision that's even above Hitchcock's usual standards. It perfectly illustrates Hitchcock's lifelong terror of being arrested for a crime he knew nothing about. This Kafkaesque sequence is so frightening that everything that comes afterward seems anticlimatic.... I think this picture is of special significance because Fonda represents the most extreme example of the initially dull Hitchcockian hero whose every minute is planned out and whose life doesn't vary at all from day to day—he is the one hero without any sense of humor."

Danny Peary, *Guide for the Film Fanatic*

1958

Vertigo

As director and producer. Sc: Alec Coppel and Samuel Taylor, based upon the novel *D'Entre les Morts* by Pierre Boileau and Thomas Narcejac. Ph: Robert Burks. Art Dir: Hal Pereira, Henry Bumstead. Technicolor Consultant: Richard Mueller. Special Photographic Effects: John P. Fulton. Process Photography: Farciot Edouart, Wallace Kelley. Set Dec: Sam Comer, Frank Mc-Kelvy. Title Design: Saul Bass. Ed: George Tomasini. Asst Dir: Daniel J. McCauley. Makeup: Wally Westmore. Hairstyle Supervision: Nellie Manley.

Sound: Harold Lewis, Winston Leverett. Costumes: Edith Head. Special Sequence: John Ferren. Music: Bernard Herrmann, conducted by Muir Mathieson. Prod Mgr: C. O. (Doc) Ericksen. Associate Prod: Herbert Coleman.

Cast: James Stewart, Kim Novak, Barbara Bel Geddes, Tom Helmore, Henry Jones, Raymond Bailey, Ellen Corby, Konstantin Shayne, Lee Patrick, and Alfred Hitchcock (walking past shipyard).

(Color, Hitchcock for Paramount, 128 mins.)

"Think seriously about Vertigo *and* Psycho, *and you will find themes of profound and universal significance; think again, and you will find these themes expressed in the form and style of the film as much as in any extractable 'content.' The subject matter of Hitchcock's* Vertigo *(as distinct from Boileau and Narcejac's) is no longer a matter of mere mystery thriller trickery: it has close affinities with, on the one hand, Mizoguchi's* Ugetsu Monogatari, *and on the other, Keats's 'Lamia.' To adduce these generally accepted works is not to try to render* Vertigo *respectable by means of them—there is no sleight-of-hand involved of the 'A is like B so A is as good as B' variety.* Vertigo *needs no such dishonest apologia, having nothing to fear from comparison with either work."*

Robin Wood, *Hitchcock's Films,* Introduction to 1965 edition

1959

North by Northwest

As director and producer. Sc: Ernest Lehman. Ph: Robert Burks. Music: Bernard Herrmann. Prod Design: Robert Boyle. Art Dir: William A. Horning, Merrill Pye. Set Dec: Henry Grace, Frank McKelvy. Special Effects: A. Arnold Gillespie, Lee LeBlanc. Title Design: Saul Bass. Ed: George Tomasini. Color Consultant: Charles K. Hagedorn. Recording Supervisor: Franklin Milton. Hairstyles: Sydney Guilaroff. Makeup: William Tuttle. Asst Dir: Robert Saunders. Associate Prod: Herbert Coleman.

Cast: Cary Grant, Eva Marie Saint, James Mason, Jessie Royce Landis, Leo G. Carroll, Josephine Hutchinson, Philip Ober, Martin Landau, Adam Williams, Edward Platt, Robert Ellenstein, Les Tremayne, Philip Coolidge, Patrick McVey, Edward Binns, Ken Lynch, and Alfred Hitchcock (missing bus during opening titles).

(Color, Hitchcock for Metro-Goldwyn-Mayer, 136 mins.)

"Taken seriously, the plot makes no sense whatsoever. This is fortunate, because, taken seriously, its implications about the heroine's morals, the methods of American intelligence agencies and sundry other matters are alarming to say the least. It is amazing, nevertheless, how entertaining the picture is as it unreels."

Moira Walsh, *America,* August 22, 1959

1960

Psycho

As director and producer. Sc: Joseph Stefano, from the novel by Robert Bloch. *Ph:* John L. Russell. *Art Dir:* Joseph Hurley, Robert Clatworthy. Set Dec: George Milo. Unit Manager: Lew Leary. Title Design: Saul Bass. Ed: George Tomasini. Costume Supervisor: Helen Colvig. Wardrobe: Rita Riggs. Makeup: Jack Barron, Robert Dawn. Hairstylist: Florence Bush. Special Effects: Clarence Champagne. Sound: Waldon O. Watson, William Russell. Asst Dir: Hilton A. Green. Pictorial Consultant: Saul Bass. Music: Bernard Herrmann.

Cast: Anthony Perkins, Vera Miles, John Gavin, Martin Balsam, John McIntire, Simon Oakland, Frank Albertson, Patricia Hitchcock, Vaughn Taylor, Lurene Tuttle, John Anderson, Mort Mills, Janet Leigh, and Alfred Hitchcock (man in cowboy hat outside realtor's office).

(B & W, Hitchcock for Paramount-Shamley Productions, 109 mins.)

After confessing that he was one of "four lonely souls" who ranked Psycho *among the all-time 'Top Ten' for* Sight and Sound's *poll of eighty-nine critics, in 1972, Richard Corliss recalls the roots of his affection for the film. "From the first time I saw* Psycho, *at age sixteen in the Avalon Theatre on the South Jersey coast, the film admirably fulfilled its Saturday-matinee horror-movie function: it scared the shit out of me. And it still does. Whatever academic pleasure I might have derived from analyzing* Psycho's *shower sequence on a movieola for this essay was overwhelmed by a purely physical discomfort at reliving an experience that still sets my stomach seismograph aquiver every time I step into a strange shower stall."*

Richard Corliss, *"Psycho Therapy,"* Favorite Movies: Critics' Choices

1963

The Birds

As director and producer. Sc: Evan Hunter, from the story by Daphne du Maurier. Ph: Robert Burks. Prod Design: Robert Boyle. Ed: George Tomasini. Miss Hedren's Costumes: Edith Head. Prod Mgr: Norman Deming. Special Photographic Adviser: Ub Iwerks. Special Effects: Lawrence A. Hampton. Pictorial Designs: Albert Whitlock. Sound: Waldon O. Watson, William Russell. Makeup: Howard Smit. Hairstylist: Virginia Darcy. Asst to Mr. Hitchcock: Peggy Robertson. Asst Dir: James H. Brown. Set Dec: George Milo. Script Supervisor: Lois Thurman. Wardrobe Supervisor: Rita Riggs. Trainer of the Birds: Ray Berwick. Titles: James S. Pollak. Electronic Sound Production and Composition: Remi Gassmann, Oskar Sala. Sound Consultant: Bernard Herrmann.

Cast: Rod Taylor, Jessica Tandy, Suzanne Pleshette, Tippi Hedren, Veronica Cartwright, Ethel Griffies, Charles McGraw, Ruth McDevitt, Lonny Chap-

man, Joe Mantell, Doodles Weaver, Malcolm Atterbury, John McGovern, Karl Swenson, Richard Deacon, Elizabeth Wilson, William Quinn, Doreen Lang, and Alfred Hitchcock (leaving the pet store with his own dogs, Geoffrey and Stanley, on a leash).

(Color, Hitchcock for Universal, 120 mins.)

"The apocalyptic overtones of The Birds, *which most critics at the time saw as a startling departure from Hitchcock's usual register, were only an intensification of the disruptive tendency at work in all his films. Tumultuously chaotic conditions have always been a specialty of his. Hitchcock loves engineering cataclysmic clashes, precipitating people and things into abysses or engulfing elements. Shipwrecks, derailments, plane crashes, car accidents punctuate his work. Vehicles are bombed, blown up, sunk, hurled into one another, airplanes splash into the ocean, automobiles are swallowed up into mines and swamps, or hurtle along brakeless or with drunken drivers at the wheel. Everything that moves seems destined for destruction, as though motion itself were a hazard. For Hitchcock, nothing is safe, because nothing is stable."*

Jean-Pierre Coursodon, *American Directors*

1964

Marnie

As director and producer. Sc: Jay Presson Allen, from the novel by Winston Graham. Ph: Robert Burks. Prod Design: Robert Boyle. Asst Dir: James H. Brown. Unit Mgr: Hilton A. Green. Miss Hedren's and Miss Baker's Costumes: Edith Head. Miss Hedren's Hairstyles: Alexandre of Paris. Ed: George Tomasini. Pictorial Design: Albert Whitlock. Sound: Waldon O. Watson, William Russell. Makeup: Jack Barron, Howard Smit, Robert Dawn. Hairstylist: Virginia Darcy. Asst to Mr. Hitchcock: Peggy Robertson. Set Dec: George Milo. Script Supervisor: Lois Thurman. Camera Operator: Leonard South. Costume Supervisor: Vincent Dee. Women's Costumes: Rita Riggs. Men's Costumes: James Linn. Music: Bernard Herrmann.

Cast: Tippi Hedren, Sean Connery, Diane Baker, Martin Gabel, Louise Latham, Bob Sweeney, Milton Selzer, Mariette Hartley, Alan Napier, Bruce Dern, Henry Beckman, S. John Launer, Edith Evanson, Meg Wyllie, and Alfred Hitchcock (furtive man in hotel corridor).

(Color, Hitchcock for Universal, 129 mins.)

"I find that Marnie *grows in stature with repeated viewings. . . . In ways, it is a lesser achievement—cinematically, philosophically, mythically—than* The Birds, *which itself grows more impressive over the years. Yet just as clearly, it forms a late-period diptych with* The Birds, *not least because of Tippi Hedren's presence in both as the embodiment of some of Hitchcock's most melancholic thoughts on femininity and its place in the world."*

David Sterritt, *The Films of Alfred Hitchcock*

1966

Torn Curtain

As director and producer. Sc: Brian Moore. Ph: John F. Warren. Prod Design: Hein Heckroth. Art Dir: Frank Arrigo. Prod Mgr: Jack Corrick. Pictorial Designs: Albert Whitlock. Sound: Waldon O. Watson, William Russell. Ed: Bud Hoffman. Asst Dir: Donald Baer. Set Dec: George Milo. Makeup: Jack Barron. Costumes: Grady Hunt. Asst to Mr. Hitchcock: Peggy Robertson. Camera Operator: Leonard South. Script Supervisor: Lois Thurman. Miss Andrews' Hairstylist: Hal Saunders. Hair Stylist: Lorraine Roberson. Miss Andrews' Costumes: Edith Head. Music: John Addison.

Cast: Paul Newman, Julie Andrews, Lila Kedrova, Hansjörg Felmy, Tamara Toumanova, Wolfgang Kieling, Ludwig Donath, Günter Strack, David Opatoshu, Gisela Fischer, Mort Mills, Carolyn Conwell, Arthur Gould-Porter, Gloria Gorvin, and Alfred Hitchcock (man holding baby in hotel lobby).

(Color, Hitchcock for Universal, 128 mins.)

"Arabesques without great consequences? No doubt the leaden skies of The Birds *or the wan false hopes of* Marnie *troubled us in quite a different fashion. But is it really limitation of ambition or impoverishment of Hitchcock to want today to renew the bond, through his films, with the fantastic round trips and adventurous itineraries, no less authentic a vein of his work, from* The Lady Vanishes *to* The Man Who Knew Too Much?*"*

Jean Narboni, "Defense of *Torn Curtain,*" *Cahiers du Cinéma in English,* no. 10 (1966)

1969

Topaz

As director and producer. Sc: Samuel Taylor, from the novel by Leon Uris. Ph: Jack Hildyard. Prod Design: Henry Bumstead. Ed: William H. Ziegler. Photographic Consultant: Hal Mohr. Sound: Waldon O. Watson, Robert A. Bertrand. Prod Mgr: Wallace Worsley. Asst Dirs: Douglas Green, James Westman. Special Photographic Effects: Albert Whitlock. Set Dec: John Austin. Script Supervisor: Trudy Von Trotha. Makeup: Bud Westmore, Leonard Engelman. Hair Styles: Larry Germain, Nellie Manley. Asst to Mr. Hitchcock: Peggy Robertson. Camera Operator: William Dodds. Men's Costumes: Peter Saldutti. Cuban Technical Adviser: J. P. Mathieu. French Technical Adviser: Odette Ferry. Costumes: Edith Head. Costumes (Paris): Pierre Balmain. Music: Maurice Jarre. Assoc Prod: Herbert Coleman.

Cast: Frederick Stafford, Dany Robin, John Vernon, Karin Dor, Michel Piccoli, Philippe Noiret, Claude Jade, Michel Subor, Per-Axel Arosenius, Roscoe Lee Browne, Edmon Ryan, Sonja Kolthoff, Tina Hedstrom, John Van Dreelen, Don Randolph, Roberto Contreras, Carlos Rivas, Roger Til, Lewis Charles, Sandor Szabo, Anna Navarro, Lew Brown, John Roper,

George Skaff, John Forsythe, and Alfred Hitchcock (man in wheelchair at airport).

(Color, Hitchcock for Universal, 127 mins.)

"The film is so free of contemporary cinematic cliches, so reassuring in its choice of familiar espionage gadgetry (remote control cameras, geiger counters), that it tends to look extremely conservative, politically. Topaz, however, is really above such things. It uses politics the way Hitchcock uses actors—for its own ends, without making any real commitments to them. Topaz is not only most entertaining. It is, like so many Hitchcock films, a cautionary fable by one of the most moral cynics of our time."

Vincent Canby, "Alfred Hitchcock at His Best," *New York Times*, December 20, 1969

1972

Frenzy

As director and producer. Sc: Anthony Shaffer, from the novel *Goodbye Picadilly, Farewell Leicester Square* by Arthur La Bern. Ph: Gil Taylor. Prod Design: Syd Cain. Art Dir: Bob Laing. Prod Mgr: Brian Burgess. Camera Operator: Paul Wilson. Continuity: Angela Martelli. Sound Mixer: Peter Handford. Sound Recordist: Gordon K. McCallum. Sound Editor: Rusty Coppelman. Wardrobe Supervisor: Dulcie Midwinter. Asst to Mr. Hitchcock: Peggy Robertson. Casting: Sally Nicholl. Special Photographic Effects: Albert Whitlock. Makeup: Harry Frampton. Hairdresser: Pat McDermott. Set Dresser: Simon Wakefield. Asst Dir: Colin M. Brewer. Assoc Prod: William Hill. Ed: John Jympson. Music: Ron Goodwin.

Cast: Jon Finch, Alec McCowen, Barry Foster, Billie Whitelaw, Anna Massey, Barbara Leigh-Hunt, Bernard Cribbins, Vivien Merchant, Michael Bates, Jean Marsh, Clive Swift, John Boxer, Madge Ryan, George Tovey, Elsie Randolph, Jimmy Gardner, Gerald Sim, Noel Johnson, and Alfred Hitchcock (man in crowd on Thames embankment).

(Color, Hitchcock for Universal, 116 mins.)

"This is the kind of thriller Hitchcock was making in the 1940s, filled with macabre details, incongruous humor, and the desperation of a man convicted of a crime he didn't commit. The only 1970s details are the violence and the nudity (both approached with a certain grisly abandon that has us imagining Psycho *without the shower curtain). There is suspense and local color ("It's been too long since the Christie murders; a good colorful crime spree is good for tourism") and, always, Hitchcock smacking his lips and rubbing his hands and delighting in his naughtiness."*

Roger Ebert, *Roger Ebert's Video Companion*

1976

Family Plot

As director and producer. Sc: Ernest Lehman, based on *The Rainbird Pattern* by Victor Canning. Ph: Leonard J. South. Prod Design: Henry Bumstead. Costumes: Edith Head. Ed: J. Terry Williams. Sound: James R. Alexander, Robert L. Hoyt. Makeup: Jack Barron. Set Dec: James W. Payne. Asst Dir: Howard G. Kazanjian. Second Asst Dir: Wayne A. Farlow. Asst to Mr. Hitchcock: Peggy Robertson. Sound Editor: Roger Sword. Script Supervisor: Lois Thurman. Prod Mgr: Ernest B. Wehmeyer. Special Effects: Albert Whitlock. Production Illustrator: Thomas J. Wright. Music: John Williams.

Cast: Karen Black, Bruce Dern, Barbara Harris, William Devane, Ed Lauter, Cathleen Nesbitt, Katherine Helmond, Warren J. Kemmerling, Edith Atwater, William Prince, Nicolas Colasanto, Marge Redmond, John Lehne, Charles Tyner, Alexander Lockwood, Martin West, and Alfred Hitchcock (in silhouette at Registrar of Births and Deaths).

(Color, Hitchcock for Universal, 120 mins.)

"With his last film, Hitchcock made a triumphant return to form in the comic thriller. His most relaxed, witty and urbane movie since North by Northwest *(also scripted by Ernest Lehman), it's a dense but extremely entertaining collection of symmetric patterns, doubles, and rhymes. . . . Beneath all the fun, there's a vision of humans as essentially greedy and dishonest, presented with a gorgeously amoral wink from Hitchcock, and performed to perfection by an excellent cast."*

Geoff Andrew, *Time Out Film Guide*

TELEVISION CREDITS

Only the episodes directed by Hitchcock are listed.

1955–56 SEASON

Revenge

As director and producer. Broadcast: October 2, 1955. Sc: Francis Cockrell, from a story by Samuel Blas. Ph: John L. Russell, Jr.

Cast: Ralph Meeker, Vera Miles, Frances Bavier.

(With Joan Harrison for *Alfred Hitchcock Presents*, Shamley Productions, 25 mins.)

Breakdown

As director and producer. Broadcast: November 13, 1955. Sc: Francis Cockrell and Louis Pollock, from a story by Louis Pollock. Ph: John L. Russell, Jr.

Cast: Joseph Cotten, Raymond Bailey, Forrest Stanley, Harry Shannon, Lane Chandler, James Edwards, Murray Alper, Aaron Spelling.

(With Joan Harrison for *Alfred Hitchcock Presents,* Shamley, 25 mins.)

The Case of Mr. Pelham

As director and producer. Broadcast: December 4, 1955. Sc: Francis Cockrell, from a story by Anthony Armstrong. Ph: John L. Russell, Jr.

Cast: Tom Ewell, Raymond Bailey, Justice Watson.

(With Joan Harrison for *Alfred Hitchcock Presents,* Shamley, 25 mins.)

Back for Chrismas

As director and producer. Broadcast: March 4, 1956. Sc: Francis Cockrell, from a story by John Collier. Ph: John L. Russell, Jr.

Cast: John Williams, Isobel Elsom, A. E. Gould-Porter, Lily Kemble-Cooper.
(With Joan Harrison for *Alfred Hitchcock Presents,* Shamley, 25 mins.)

1956–57 SEASON
Wet Saturday
As director and producer. Broadcast: September 30, 1956. Sc: Marian Cockrell, from a story by John Collier. Ph: John L. Russell, Jr.
Cast: Cedric Hardwicke, John Williams, Tita Purdom, Kathryn Givney, Jerry Barclay.
(With Joan Harrison for *Alfred Hitchcock Presents,* Shamley, 25 mins.)

Mr. Blanchard's Secret
As director and producer. Broadcast: December 23, 1956. Sc: Sarett Rudley, from a story by Emily Neff. Ph: John L. Russell, Jr.
Cast: Mary Scott, Robert Horton, Meg Mundy, Dayton Lummis.
(With Joan Harrison for *Alfred Hitchcock Presents,* Shamley, 25 mins.)

One More Mile to Go
As director and producer. Broadcast: April 7, 1957. Sc: James P. Cavanagh, from a story by George F. J. Smith. Ph: John L. Russell, Jr.
Cast: David Wayne, Louise Larabee, Steve Brodie, Norman Leavitt.
(With Joan Harrison for *Alfred Hitchcock Presents,* Shamley, 25 mins.)

1957–58 SEASON
Four O'Clock
As director and producer. Broadcast: September 30, 1957. Sc: Francis Cockrell, from a story by Cornell Woolrich. Ph: John L. Russell, Jr.
Cast: E. G. Marshall, Nancy Kelly, Richard Long.
(With Joan Harrison for *Suspicion,* Shamley, 50 mins.)

The Perfect Crime
As director and producer. Broadcast: October 20, 1957. Sc: Stirling Silliphant, from a story by Ben Ray Redman. Ph: John L. Russell, Jr.
Cast: Vincent Price, James Gregory.
(Joan Harrison with Norman Lloyd for *Alfred Hitchcock Presents,* Shamley, 25 mins.)

Lamb to the Slaughter
As director and producer. Broadcast: April 13, 1958. Sc: Roald Dahl, from his story. Ph: John L. Russell, Jr.
Cast: Barbara Bel Geddes, Allan Lane, Harold J. Stone.

(Joan Harrison with Norman Lloyd for *Alfred Hitchcock Presents,* Shamley, 25 mins.)

A Dip in the Pool

As director and producer. Broadcast: June 1, 1958. Sc: Robert C. Dennis and Francis Cockrell, from a story by Roald Dahl. Ph: John F. Warren.

Cast: Keenan Wynn, Louise Platt, Philip Bourneuf, Fay Wray, Doreen Lang.

(Joan Harrison with Norman Lloyd for *Alfred Hitchcock Presents,* Shamley, 25 mins.)

1958–59 SEASON

Poison

As director and producer. Broadcast: October 5, 1958. Sc: Casey Robinson, based on a story by Roald Dahl. Ph: John L. Russell, Jr.

Cast: Wendell Corey, James Donald, Arnold Moss.

(Joan Harrison with Norman Lloyd for *Alfred Hitchcock Presents,* Shamley, 25 mins.)

Banquo's Chair

As director and producer. Broadcast: May 3, 1959. Sc: Francis Cockrell, from a story by Rupert Croft-Cooke. Ph: John L. Russell, Jr.

Cast: John Williams, Reginald Gardiner, Kenneth Haigh.

(Joan Harrison with Norman Lloyd for *Alfred Hitchcock Presents,* Shamley, 25 mins.)

1959–60 SEASON

Arthur

As director and producer. Broadcast: September 27, 1959. Sc: James P. Cavanagh, from a story by Arthur Williams. Ph: John L. Russell, Jr.

Cast: Laurence Harvey, Hazel Court, Robert Douglas, Patrick Macnee.

(Joan Harrison with Norman Lloyd for *Alfred Hitchcock Presents,* Shamley, 25 mins.)

The Crystal Trench

As director and producer. Broadcast: October 4, 1959. Sc: Stirling Silliphant, from a story by A. E. W. Mason. Ph: John F. Warren.

Cast: James Donald, Patricia Owens, Werner Klemperer, Patrick Macnee.

(Joan Harrison with Norman Lloyd for *Alfred Hitchcock Presents,* Shamley, 25 mins.)

Incident at a Corner

As *director and producer.* Broadcast: April 5, 1960. Sc: Charlotte Armstrong, from her novel. Ph: John L. Russell, Jr.

Cast: Vera Miles, George Peppard, Paul Hartman, Bob Sweeney, Leora Dana, Philip Ober.

(Joan Harrison, Shamley, for *Ford-Startime,* 50 mins.)*

1960–61 SEASON

Mrs. Bixby and the Colonel's Coat

As *director and producer.* Broadcast: September 27, 1960. Sc: Halsted Wells, from a story by Roald Dahl. Ph: John L. Russell, Jr.

Cast: Audrey Meadows, Les Tremayne, Sally Hughes, Stephen Chase.

(Joan Harrison and Norman Lloyd for *Alfred Hitchcock Presents,* Shamley, 25 mins.)

The Horseplayer

As *director and producer.* Broadcast: March 14, 1961. Sc: Henry Slesar, from his story. Ph: John L. Russell, Jr.

Cast: Claude Rains, Ed Gardner, Kenneth MacKenna.

(Joan Harrison and Norman Lloyd for *Alfred Hitchcock Presents,* Shamley, 25 mins.)

1961–62 SEASON

Bang! You're Dead

As *director and producer.* Broadcast: October 17, 1961. Sc: Harold Swanton, from a story by Margery Vosper. Ph: John L. Russell, Jr.

Cast: Steve Dunne, Biff Elliott, Lucy Prentiss, Billy Mumy, Juanita Moore.

(Joan Harrison and Norman Lloyd for *Alfred Hitchcock Presents,* Shamley, 25 mins.)

1962–63 SEASON

I Saw the Whole Thing

As *director and producer.* Broadcast: October 11, 1962. Sc: Henry Slesar, from a story by Henry Cecil. Ph: Benjamin H. Kline.

Cast: John Forsythe, Kent Smith, Evans Evans, Billy Wells, Claire Griswold, Philip Ober, William Newell.

(Joan Harrison for *The Alfred Hitchcock Hour,* Shamley, 50 mins.)

* "Incident at a Corner" is the only Hitchcock-directed television show filmed in color.

SOURCES AND ACKNOWLEDGMENTS

Queries and correspondence: Jonathan Balcon (son of Michael Balcon), David Bernstein (son of Sidney Bernstein), Orin Borsten, Colin M. Brewer, Amanda Cockrell (daughter of Francis and Marian Cockrell), Dr. Ambrose King, Herbert Coleman, Chris Coppel (son of Alec Coppel), Hume Cronyn, Constance Cummings, David Freeman, Winston Graham, Barbara T. Gray (Mrs. Hugh Gray), Rita Landale, Arthur Laurents, Jay Livingston, James Mavor (grandson of James Bridie), Jean Moore, Evelyn Mumm (daughter of Alex Ardrey), Pat Hitchcock O'Connell, Czenzi Ormonde, Bernard Parkin, S.J., Nova Pilbeam, John E. Pommer (son of Erich Pommer), Oliver Pritchett (son of V. F. Pritchett), Jessica Rains (daughter of Claude Rains), Esmé Surman, George Tabori, Peter Tanner, Sam Taylor, Peter Viertel, Keith Waterhouse, Albert Whitlock, Fay Wray.

Interviews: Jay Presson Allen, Roy Ward Baker, Ray Bradbury, Jack Cardiff, Herbert Coleman, Whitfield Cook, Laraine Day, Bob Dunbar, C. O. "Doc" Ericksen, Rudi Fehr, Dr. Walter Flieg, Otis C. Guernsey Jr., Val Guest, John Michael Hayes, Bryan Langley, William Link, Norman Lloyd, Ron Miller, Ronald Neame, Czenzi Ormonde, Alfred Roome, Jeremy M. Saunders, Julian Spiro, George Stevens Jr., Hugh Stewart, Richard Todd, Leon Uris, Peter Viertel.

Hitchcock family members in England and South Africa: Jeanette and Chris Albert, John Albert, Rodney Cooper (S.A.), Winnie Curtis, John "Jack" Lee, Mrs. E. J. (Betty) Sparks (S.A.).

Mary Troath interviewed Jeanette and Chris Albert, John Albert, Winnie Curtis, Dr. Ambrose King (with daughter Mary Taylor), Jack Lee, and Jennia Reissar in England. Fiona Eakins interviewed Furio Scarpelli in Rome. John Baxter interviewed Charles Lippincott in Los Angeles and Brigitte Auber in Paris.

I was kindly supplied interview transcripts pertaining to Hitchcock and his films from among the numerous subjects in the oral history archives of DeGolyer Library, Southern Methodist University, Texas. (I have drawn especially from the Doris Day, Joan Fontaine, Tippi Hedren, and Gregory Peck interviews.) Tim Kirby furnished transcripts of over forty interviews with key cast and crew members of Hitchcock films conducted for his 1999 two-part documentary *Hitch* ("Alfred the Great" and "Alfred the Auteur"), part of the *Reputations* series for the British Broadcasting Corporation, and other BBC staff forwarded many tapes and transcripts of earlier radio and television shows pertaining to Hitchcock. (Besides in general supplying invaluable detail and background, the BBC interviews I have quoted from include Whitfield Cook, Farley Granger, John Russell Taylor, Joseph Stefano, and Herb Steinberg.) Through the intercession of Roy A. Fowler I was allowed access to the many Hitchcock-related interviews among those conducted for the Broadcasting, Entertainment, Cinematograph & Theatre Union (BECTU) oral history project. (I particularly drew from the Sidney Gilliat and Alfred Roome oral histories.) Barbara Hall guided my research into the many oral histories conducted for the Academy of Motion Picture Arts and Sciences and the Margaret Herrick Library. (I have cited the Robert Boyle and Peggy Robertson transcripts.)

Wendy Daniell in Milwaukee translated French and Italian articles, while Kristi Jaas in Paris translated an excerpt from Michel Piccoli's *Dialogues egoistes* pertaining to *Topaz*.

Collegial advice and assistance from outside the United States: In Australia: Howard Gelman and Ken Mogg. In Britain: Geoff Brown, Kevin Brownlow, Walter Donohue, David Eldridge, Laurence Geary, Gary Giblin, Mark Glancy, Bernie Gollogly, Philip Kemp, Kevin Macdonald, Tony Lee Moral, Geoffrey Parry, Peter Graham Scott, Otto R. Snel, and especially Roy A. Fowler and Bernard Lewis (a.k.a. Colin Belfrage). In Canada: Yves Laberge. In Germany: Thomas David, Joseph Garncarz, and especially Werner Sudendorf. In Italy: Lorenzo Codelli and Giuliana Muscio. In Sweden: Michael Tapper. In Yugoslavia: Dejan Kosanovic.

Collegial advice and assistance in the United States: Richard Allen, Matthew Bernstein, Connie Bruck, Paul Buhle, Robert L. Carringer, William G. Contento, Scott Curtis, James V. D'Arc, Ronald L. Davis, Jim Drake, Scott Eyman, David Fantle, Volney P. Gay, Hal Gefsky, David Goodrich, Sidney Gottlieb, Charles Higham, Anne Holliday, Helen Imburgia, David Kalat, Leonard Leff, Vinny LoBrutto, Glenn Lovell, Leonard Maltin, Dave Martin, Joseph McBride, Dennis McDougal, Paul Gregory Nagle, James Robert Parish, Gerald Peary, Gene D. Phillips, S.J., Arnie Reisman, Kristina Ropella, Nat Segaloff, Michael Sragow, Charles Stecy, Tom Stempel, Lynissa Stokes, Barry Strugatz, David Thomson, Duane Wright, Annie Yang.

Screenings: Charles Barr and Mary Sandra Lindner for *Mary;* Tag Gal-

lagher and Bill Krohn for *Waltzes from Vienna* and *Memory of the Camps*; Bill Krohn and Leonard Maltin for radio recordings; David Miller for episodes of *Alfred Hitchcock Presents*; the Museum of Broadcasting, Chicago, and the Museum of Television and Broadcasting, New York, for various television shows.

Special thanks to Lorenzo Codelli for inviting me to the Eighteenth Pordenone Silent Film Festival, October 9–16, 1999, in Sacile, Italy, where I enjoyed screenings of Hitchcock's rarest silent films, and to Richard Allen for inviting me to the "Hitchcock: A Centennial Celebration" in New York City on October 13–17, 1999, where I met scholars and enthusiasts who aided my work.

Archives and organizations outside the United States: In England: Army Medical Services Museum; Chris Lloyd, Bancroft Library, Tower Hamlets; A. J. Gammon, Sanctions Emergency Unit, Bank of England; the British Film Institute (BFI) Library and Special Collections; British Library (Colindale); Roy A. Fowler, Rick Harley, Alan Lawson, and Stephen Peet, Broadcasting, Entertainment, Cinematograph & Theatre Union (BECTU); F. H. Trimmer, Registrar, Brompton Oratory, South Kensington; Cartoon Art Trust; Wills & Probate Centre of the Court Service; Cripplegate Institute; Curtis Brown Literary Agency; Sister Mary Rose McCabe of Sisters, Faithful Companions of Jesus; Goldsmiths' College Library; David Oliver, W.T. Henley, Ltd.; (AEI Cables Limited) Imperial War Museum; Lincolns Inn Library; Laurence Evans, MCA (London); Colin McLaughlin, James Bridie Papers, National Library of Scotland, Edinburgh; Peabody Trust; Public Records Office, Kew; Richmond upon Thames Local Studies Library; Royal London Hospital Archives; Colin Hinton, editor of the parish magazine for Our Lady of St. Thomas of Canterbury, Harrow; St. Hugh's College, Oxford; Michael Blundell, Headmaster, St. Ignatius College, Enfield, and Jim Garvey, Old Ignatian Association; St. Francis Roman Catholic Church, Stratford; Graham Collyer, *Surrey Advertiser*; Theatre Museum, London; John Rylands University Library, University of Manchester; Vestry House Museum, Walthamstow.

In Canada: Heather Wilson, Toronto Reference Library, Ontario; the Brian Moore Collection at the University of Calgary, Alberta. In Germany: Dr. Torsten Musial, Stiftung Archiv der Akademie der Künste, Berlin; Silke Ronneburg and Werner Sudendorf, Stiftung Deutsche Kinemathek, Berlin. In South Africa: Elaine Pearson, the National English Literary Museum, Grahamstown; Sibuse Mgquba, the National Library of South Africa, Cape Town Division.

Archives and organizations in the United States: the Hitchcock Collection at the Margaret Herrick Library, the Academy of Motion Picture Arts and Sciences, Los Angeles; the American Cancer Society; Kevin Wilcox, American Society of Newspaper Editors; Sean D. Noel, Special Collections (including the Robert Benchley, Whitfield Cook, Arthur Laurents, Claude Rains, Basil Rath-

bone, and Ouida Bergere papers), Boston University; Judith Goodstein and Bonnie Ludt, the Robert A. Millikan Papers, Caltech Archives, California Institute of Technology; the Samson Raphaelson Papers at Butler Library, Columbia University; Armand Gagne, Diocese de Quebec; Hume Cronyn Papers, Manuscript Division, Library of Congress; Dr. Errol Stevens, Department of Archives and Special Collections, and Brother Daniel Peterson, S.J., Archivist, Loyola Marymount University, Los Angeles; Jane Klain, Museum of Television and Radio, New York; Collier County Public Library, Naples, Florida; National Archives and Records Administration (Ship Passenger Arrival Records), Washington, D.C.; National Archives (Immigration Records), Pacific Southwest Region; Margaret Kulis, Newberry Library, Chicago; S. Flannery, Reference, Newton Free Library, Newton Center (Mass.); Shari West Twitero, Reference, Rapid City Public Library (S.D.); Steve Groth, Special Collections, San Jose State University Library (Calif.); Donna Swedberg, Reference, Santa Cruz Public Library (Calif.); Roxanne Wilson and Audrey Herman, Local History, Sonoma County Public Library (Calif.); Kay Bost and Ronald L. Davis, the Oral History Project, DeGolyer Library, Southern Methodist University, Texas; Sara Timby, Special Collections (the John Galsworthy Papers), Stanford University; Cecily Hilsdale, Erika Young, Betsy Bernard, and Ellen M. Gameral, Twentieth Century–Fox; the Kenneth MacGowan Papers and Twentieth Century–Fox Collection, Special Collections, University of California at Los Angeles (UCLA); UCLA Emeriti Service Center; Jim Burns, Public Information, and Paul Stubbs, Special Collections, University Library, University of California at Santa Cruz; Paula Contreras, Regenstein Library Reference, University of Chicago; William J. Maher, Samson Raphaelson Collection, University Library, University of Illinois, Urbana-Champaign; the Universal and Warner Bros. Studio Collections in the Cinema-Television Archives of the University of Southern California, Los Angeles; the Maxwell Anderson, Ernest Lehman, Brian Moore, David O. Selznick and Myron Selznick Collections in the archives of the Harry Ransom Humanities Research Center, the University of Texas, Austin; the Edward R. Stettinius Papers in the Albert H. Small Special Collections, Alderman Library, University of Virgina, Charlottesville; the Leo Mishkin Collection in the American Heritage Center, University of Wyoming; Molly Dohrmann, Special Collections (the Delbert Mann Papers), Jean and Alexander Heard Library, Vanderbilt University; Paul Donovan, Department of Libraries, State of Vermont; Local Reference, Watertown Free Library, Watertown (Mass.); the Thornton Wilder Collection, Yale Collection of American Literature, the Beinecke Rare Book and Manuscript Library, Yale University.

Special thanks to Ned Comstock of the University of Southern California Archives, and the extraordinarily helpful librarians of the Memorial Library Reference Department, Marquette University, Milwaukee, Wisconsin.

Major Hitchcock interviews quoted in text: "A Talk with Alfred Hitchcock" by Bob Thomas, *Action* (May-June 1968); "Alfred Hitchcock: The Ger-

man Years" by Bob Thomas, *Action* (Feb. 1973); Charles Higham and Joel Greenberg's interview in *The Celluloid Muse: Hollywood Directors Speak* (Henry Regnery, 1969); "Hitchcock On Style" in *Cinema* (Aug.-Sept. 1962); Oriana Fallaci's interview in *The Egotists* (Henry Regnery, 1968); "Alfred Hitchcock" interviewed by Charles Thomas Samuels in *Encountering Directors* (G. P. Putnam's, 1972); "Hitchcock and the Dying Art" in *Film* (summer 1966); "It's the Manner of Telling: An Interview with Alfred Hitchcock" by F. Anthony Macklin, *Film Heritage* (spring 1976); "The Man Behind the Body" by John D. Weaver, *Holiday* (Sept. 1964); "Q. & A.: Alfred Hitchcock" by Digby Diehl, *Los Angeles Times* (*West* magazine, June 25, 1972); Richard Schickel's interview in *The Men Who Made the Movies* (Atheneum, 1975); Ian Cameron and V. F. Perkins's interview in *Movie* (Jan. 1963); "Core of the Movie—The Chase," an interview by David Brady in the *New York Times Magazine* (Oct. 29, 1950); "Conversation with Alfred Hitchcock" in *Oui* (Feb. 1973); "The Americanisation of Alfred Hitchcock . . . and Vice Versa" by John C. Mahoney, *Performing Arts* (Feb. 1973); "I Call on Alfred Hitchcock" by Pete Martin in the *Saturday Evening Post* (July 27, 1957); "Surviving: Alfred Hitchcock" by John Russell Taylor in *Sight and Sound* (summer 1977); Peter Bogdanovich's interview in *Who the Devil Made It* (Knopf, 1997).

Key books: Dan Auiler, *Hitchcock's Notebooks* (Avon Books, 1999); David Freeman, *The Last Days of Alfred Hitchcock* (Overlook Press, 1999); Sidney Gottlieb, ed., *Alfred Hitchcock: Interviews* (University Press of Mississippi, 2003); Sidney Gottlieb, ed., *Hitchcock on Hitchcock: Selected Writings and Interviews* (University of California Press, 1995); Robert E. Kapsis, *Hitchcock: The Making of a Reputation* (University of Chicago Press, 1992); Bill Krohn, *Hitchcock at Work* (Phaidon, 2000); Albert J. LaValley, ed., *Focus on Hitchcock*, (Prentice-Hall, 1972); Leonard J. Leff, *Hitchcock and Selznick: The Rich and Strange Collaboration of Alfred Hitchcock and David O. Selznick in Hollywood* (Weidenfeld & Nicholson, 1987); Dennis McDougal, *The Last Mogul: Lew Wasserman, MCA, and the Hidden History of Hollywood* (Crown, 1998); Jane E. Sloan, *Alfred Hitchcock: The Definitive Filmography* (University of California Press, 1993); David Thomson, *Showman: The Life of David O. Selznick* (Knopf, 1992).

Especially: Donald Spoto's *The Dark Side of Genius: The Life of Alfred Hitchcock* (Little, Brown, 1983), John Russell Taylor's *Hitch* (Pantheon, 1978), and François Truffaut's *Hitchcock* (Simon & Schuster, 1967). This book started in part as an effort to take stock of all the new Hitchcock findings of the last twenty years. But every Hitchcockian—fan, scholar, or biographer—must begin with, draw from, and repeatedly reference these three groundbreaking books. The Truffaut interview is frequently cited in the text, and especially with actors or writers who have died, or no longer grant interviews, I have also often quoted people from the Taylor and Spoto books.

Every book project has its special angels who prod it along with encouragement and insights. Bill Fagelson was a researcher whom I learned to trust not only in the vast Harry Ransom Humanities Research Library, but in the equally forbidding Margaret Herrick Library in Los Angeles. Charles Barr, whose own *English Hitchcock* (Cameron & Hollis, 1999) is indispensable, read drafts and traded views. Anthony Slide and David Thomson did likewise in the United States, with similar patience. Bill Krohn did not see me as a rival, though he is one of the leading Hitchcock scholars with his own important book and continues writing on the Hitchcock films. J. Lary Kuhns sweated blood over the filmography, and overflowed with information and opinions on every film. Mary Troath in London is an author's dream of an intelligent, tireless researcher, and, thank you, Mary, she even kept a tab when funds ran low. John Baxter in Paris again and again came to my rescue. I feel blessed by the support of my long time agent, Gloria Loomis. Calvert Morgan Jr. took this book from St. Martin's Press to Regan Books at HarperCollins, for which I am grateful; he also took the subject to heart, and the manuscript to hand, shaping it, with his always discerning editing, into a better life story.

NOTES

Only key sources not *listed in* Sources *are noted.*

ONE: 1899–1913

Hitchcock talked about his boyhood with Fred Jones in "The Master of the Macabre, Who Is 70 Today, Talks to Fred Jones . . ." in the *Guardian* (Aug. 23, 1969), in "Alfred Hitchcock: 'This Age of Violence is Nothing New' " in the *Sunday Express* (April 24, 1966), and with Hugh Whelon for "Alfred Hitchcock on His Films," in the *Listener* (Aug. 6, 1964). "A smartly dressed . . ." is the reminiscence of a cousin quoted in *The Alfred Hitchcock Quote Book* by Laurent Bouzereau (Citadel, 1993). He recalled being an altar boy in "Tourists in Quebec Throng to See Hitchcock Make Movie" by Marjory Adams in the *Boston Globe* (Sept. 16, 1953). He reminisced about growing up with Dick Cavett on *The Dick Cavett Show* (broadcast in 1972), and with Tom Snyder on the *Tomorrow* show (broadcast in 1973). The Faithful Companions of Jesus' pamphlet "Good Example Does Much Good" described their religious order and Howrah House, while the Vestry House Museum pamphlet "Alfred Hitchcock: From Leytonstone to Hollywood" by Nigel Sadler and Victoria Coxon supplied local color. I have also cited Raymond Fielding, "Hale's Tours: Ultrarealism in the Pre-1910 Motion Picture" in the *Smithsonian Journal of History* (winter 1968–69) and Charles Musser (in collaboration with Carol Nelson), *High-Class Moving Pictures: Lyman H. Howe and the Forgotten Era of Traveling Exhibition, 1880–1920* (Princeton University Press, 1991). The correspondence and a transcript of Hitchcock's filmed address to the Westcliff Cine Club is in the Margaret Herrick Library.

My research into St. Ignatius College was buoyed by a visit to that institution, examining the school records and memorabilia, and reading old issues of the *Ignatian Record* (the parish newsletter). The *St. Ignatius Silver Jubilee Magazine (1894–1919)* contains "Reminiscences, 1909–1915" by Reginald

Dunn, and other school background. The Reverend Bernard Parkins's *St. Ignatius College, 1894–1994* (St. Ignatius College, 1994) was a vital resource, which Parkins augmented with other material supplied to the author. John O'Riordan interviewed Hitchcock for the *Ignatian* (summer 1973). Neil P. Hurley's *Souls in Suspense: Hitchcock's Fright and Delight* (Scarecrow, 1983) goes into depth about Hitchcock's Jesuit upbringing and related Catholic motifs in his films. Cardinal John C. Heenan is quoted from *Not the Whole Truth* (Hodder & Stoughton, 1971). Besides an interview with Dr. Ambrose King, I drew on his book *Strong Medicine: Brothers at Home and Abroad* by A. C. King and A. J. King (Churchman, 1990).

Robert Goold's letter to the BBC was shown to me, courtesy of Tim Kirby.

Robert Boyle is quoted here and elsewhere from his oral history in the Margaret Herrick Library, but also from other published and archival sources.

Other books: Peter Ackroyd, *London: The Biography* (Chatto & Windus, 2000); Grace Goakes, *My Part of the River* (Shepheard-Walwyn, 1974); Harry Grant-Whyte, *Between Life and Death* (Shuter & Shooter, 1976); George Orwell, "Decline of the English Murder," in *Shooting an Elephant, and Other Essays* (Secker & Warburg, 1970); Roy Plomley, *Desert Island Discs* (William Kimber, 1975); W. H. Weston, *The Story of Leyton and Leytonstone* (Exeter, 1921).

TWO: 1913–1921

The Henley's years were greatly informed by Ernest Slater's *One Hundred Years: The Story of Henley's* (Henley's, 1937) and by pamphlets and background furnished by David Oliver, a current W. T. Henley's official. Oliver also retrieved original back issues of the *Henley Telegraph,* leading to the important discovery of additional Hitchcock stories besides "Gas," the only one heretofore known. W. A. Moore is quoted from issues of the *Henley Telegraph.*

"The worst thing was chemistry . . ." is from "With *Family Plot* . . ." by Penelope Gilliatt in the *Observer* (Aug. 8, 1976). Andrew Sarris is quoted from *The American Cinema: Directors and Directions, 1929–1968* (Dutton, 1968). I am indebted to Charles Higham for the bosun's chair anecdote.

THREE: 1921–1925

My research into Islington and Hitchcock's earliest silent film work was aided by reading the *Bioscope* and the *Kinematograph Weekly* in the microforms room of the Golda Meir Library of the University of Wisconsin–Milwaukee. J. Lary Kuhns supplied many clippings from these and other British screen publications of the early 1920s, from his own private collection.

"Birds flying, hearts breaking . . ." and "I was given odd jobs of going out to shoot . . ." are from *Dialogue on Film* (American Film Institute publication, no.1, 1972).

Arthur C. Miller is quoted from *One Reel a Week* (University of California Press, 1967). Seymour Hicks is quoted from *Hail Fellow Well Met* (Staples Press, 1949). Michael Balcon is quoted from *Michael Balcon Presents . . . a Lifetime of Films* (Hutchinson, 1969), but I also explored his papers at the British Film Institute (BFI), and cite from the Hitchcock-Balcon letters. Victor Saville is quoted from *Evergreen: Victor Saville in His Own Words* with Roy Moseley (Southern Illinois University Press, 2000), but I also drew from his papers at the BFI.

My information on Alma Reville's career is culled from a number of publicity releases, interviews, and bylined articles, some in archives as unsourced clippings. These include "Two New British Production Units" by P. L. Mannock, *Kinematograph Weekly* (Oct. 8, 1925); "Alma in Wonderland," *Picturegoer* (Dec. 1925); "Hitchcock's Wife a Bit Player, Too" by Wm. Michelfelder, *New York World Telegram* (Aug. 9, 1954); "Effects by Hitchcock" by Elaine Lane, *New York Post* (June 21, 1959); "I Don't Scare Easily, Says Mrs. Hitchcock" by Rita Grosvenor, *Sunday Express* (Jan. 30, 1972); "One Woman Who Has Never Been Frightened by Mr. Hitchcock" by Ivor Davis, *Daily Express* (Aug. 4, 1976); and "Mr. and Mrs. Hitchcock" by Joseph McBride, *Sight and Sound* (autumn 1976).

"All I can remember . . ." is from "My Horrifying Husband" by Alma Hitchcock, parts 1 and 2 (undated clipping, *TV Times*). "He strolled across the set . . ." is from "My Husband Alfred Hitchcock Hates Suspense" by Mrs. Alfred Hitchcock as told to Martin Abrams, *Coronet* (Aug. 1964), which also includes her version of the night Hitchcock proposed marriage. "The Woman Who Knows Too Much" by Alfred Hitchcock in *McCall's* (March 1956) contains his alternative account. "I married her because . . ." is from *The Egotists*. "If I hadn't met Alma . . ." is John Russell Taylor from the *E! Hollywood True Story* documentary about Hitchcock (first broadcast in 1999). "It didn't stick . . ." is from Hitchcock's February 20, 1975, letter to Michael Balcon.

Pat Hitchcock O'Connell's book *Alma Hitchcock: The Woman Behind the Man* (Berkley Books, 2003), written with Laurent Bouzereau, was a recent addition to Hitchcock literature, shedding important light on her mother's life and career.

All material pertaining to Hitchcock's relationship with the Joyce-Selznick Agency, later the Selznick Agency—including correspondence and business memoranda involving Harry Ham, Noll Gurney, Dan Winkler, Sig Marcus, Carl Laemmle Jr., Sam Goldwyn, David O. Selznick, and Myron Selznick—comes from the Myron Selznick Collection in the archives of the Harry Ransom Research Center of the University of Texas, Austin. This material is heavily utilized in chapters 7–10.

Other articles and books: Charles Barr, ed., *All Our Yesterdays: 90 Years of British Cinema* (BFI, 1986); Colin Belfrage (pseudonym for Bernard Lewis),

All Is Grist (Parallax Press, 1988); *Eighteenth Pordenone Silent Film Festival Catalogue;* Clive Brook, *The Eighty-four Ages* (unpublished manuscript, BFI); M. Danischewsky, ed., *Michael Balcon's Twenty-five Years in Films* (World Film Publications, 1947); Joseph Garncarz, "The German Hitchcock," *Hitchcock Annual* (2000–2001); *Michael Balcon: The Pursuit of British Cinema* (Museum of Modern Art, 1984); Peter Noble, "Index to the Work of Alfred Hitchcock," Special Supplement to *Sight and Sound* (May 1949); Duncan Petrie, *The British Cinematographer* (BFI, 1996); John Stuart, *Caught in the Act* (Silent Picture, 1971); Patricia Warren, *British Film Studios: An Illustrated History* (B. T. Batsford, 1995); Herbert Wilcox, *Twenty-five Thousand Sunsets* (Bodley Head, 1967). I am especially indebted to J. Lary Kuhn's definitive article about *The Mountain Eagle*, which appeared in the 1998–99 *Hitchcock Annual*.

FOUR: 1925–1929

"Two peas in a pod . . ." is from "On Suspense and Other Film Matters," *Films in Review* (April 1950), and "I more or less base my idea of sexuality . . ." is from *Oui* (Feb. 1973).

June is quoted from *The Glass Ladder* (Heinemann, 1960). Ivor Montagu is quoted from his papers at the BFI, *The Youngest Son: Autobiographical Sketches* (Lawrence & Wishart, 1970) and "Working with Hitchcock" in *Sight and Sound* (summer 1980). Angus MacPhail is quoted here and elsewhere from his correspondence to Sidney Bernstein at the BFI, and to Hitchcock in the Hitchcock Collection. Cedric Belfrage is quoted from his unfinished autobiography and from his *New York Herald Tribune* columns of the 1920s, among the Belfrage Papers in the Tamiment Library of New York University.

"Top money . . ." is from Sidney Gilliat's BECTU transcript.

Alfred Roome is quoted from my interview but I also referred to his BECTU transcript.

Other books: Adrian Brunel, *Nice Work* (Forbes Robertson, 1949); Pam Cook, *Gainsborough Pictures* (Cassell, 1997); James Hardin, *Ivor Novello* (W. H. Allen, 1987); Mark Haworth-Booth, *E. McKnight Kauffer: A Designer and His Public* (G. Fraser, 1979); Ivor Montagu, *Film World* (Pelican, 1964); Tom Ryall, *Alfred Hitchcock and the British Cinema* (Croom Helm, 1986).

FIVE: 1929–1933

George Pearson is quoted from *Flashback: The Autobiography of a British Film-maker* (Allen & Unwin, 1957). The Eliot Stannard anecdote pertaining to *The Ring* comes from Gavin Lambert's *Mainly About Lindsay Anderson: A Memoir* (Knopf, 2000). Michael Powell is quoted from *A Life in Movies* (Knopf, 1987) and *Million Dollar Movie* (Random House, 1992). Freddie Young is quoted from *Seventy Light Years* (Faber & Faber, 1999).

"It was almost a matter of committing . . ." is from George Angell's "The

Time of My Life" interview with Hitchcock for the BBC Home Service (July 30, 1966).

Charles Landstone is quoted from *I Gate-Crashed* (Stainer & Bell, 1976).

Hitchcock's reflections on actors, "Actors Aren't REALLY Cattle," comes from a typed transcript in a file of ghostwritten publicity articles in the Hitchcock Collection.

Sean O'Casey is quoted from "A Long Ashwednesday" in *Rose and Crown* (Macmillan, 1952). Hitchcock is photographed bartending in *Juno and the Paycock* in the *Picturegoer* (Jan. 1930).

Henry Kendall is quoted from *I Remember Romano's* (Macdonald, 1960). Esmond Knight is quoted from *Seeking the Bubble* (Hutchinson, 1943). Rodney Ackland is quoted from *The Celluloid Mistress* with Elspeth Grant (Allan Wingate, 1954).

Other articles and books: Charles Barr, "*Blackmail*: Silent and Sound," *Sight and Sound* (spring 1983); Daphne du Maurier, *Gerald: A Portrait* (Victor Gollancz, 1934); Maud Gill, *See the Players* (Hutchinson, 1938); James Hardin, *Gerald du Maurier: The Last Actor-Manager* (Hodder & Stoughton, 1989); David Krause, *The Letters of Sean O'Casey,* vol. 3, *1955–58* (Catholic University of America Press, 1989); Jessie Matthews, *Over My Shoulder* (W. H. Allen, 1974); Sheridan Morley, *Gertrude Lawrence* (McGraw-Hill, 1981); Sean O'Casey, *The Green Crow* (George Braziller, 1956); Garry O'Connor, *Sean O'Casey: A Life* (Hodder & Stoughton, 1988); Tom Ryall, *Blackmail* (BFI Film Classics, 1993); Michael Thornton, *Jessie Matthews* (Hart-Davis, 1974); Asher Boldon Wilson, *John Galsworthy's Letters to Leon Lion* (Mouton, 1968).

SIX: 1933–1937

Hitchcock's "possessory" deposition was reprinted in *In Their Own Words: The Battle over the Possessory Credit, 1966–1968* (Directors Guild of America booklet).

The relationship between Hitchcock and Charles Bennett is reconstructed from Bennett's unpublished memoirs, as well as several lengthy interviews with Bennett: my own interview with Bennett, published in *Backstory: Interviews with Screenwriters of Hollywood's Golden Age* (University of California Press, 1986); Lee Server's in *Screenwriter: Words Become Pictures* (Main Street Press, 1987); and Matthew Bernstein's unpublished interview with Bennett for his book *Walter Wanger: Hollywood Independent* (University of California Press, 1994).

My portrait of Joan Harrison was informed by numerous clippings, frequently unsourced or undated, from the BFI, the University of Southern California, and the Margaret Herrick Library files. The more extensive articles included "Joan Harrison Worrying About Butter" by Florabel Muir, "It's a Woman's World Too" by Ann Daggett, "Specialty: Murder" (no date or

by-line), and "Murder, She Says," by Jerry D. Lewis in *Collier's* (Aug. 14, 1943).

"He's a master of well thought out effects . . ." is from Richard Overstreet's interview in *George Cukor: Interviews,* ed. Robert Emmet Long (University Press of Mississippi, 2001).

Peggy Robertson is quoted here and elsewhere in the book from her oral history in the Margaret Herrick Library.

Datas is quoted from *Datas: The Memory Man* (Wright & Brown, 1932).

Stephen D. Youngkin's *The Lost One: A Biography of Peter Lorre* (forthcoming, University of California Press) informed my chronicle of the making of *The Man Who Knew Too Much* and *Secret Agent.*

I read Robert Donat's correspondence with Hitchcock courtesy of the John Rylands University Library, University of Manchester, and quoted from Kenneth Barrow's *Mr. Chips: The Life of Robert Donat* (Methuen, 1985). Sylvia Sidney is quoted from Gregory J. M. Catsos's interview in *FILMFAX* (Nov. 1990) and Jeff Laffel's interview in *Films in Review* (Sept.-Oct. 1994). Brian McFarlane's excellent oral history *Sixty Voices* (BFI Publishing, 1992) was reissued in expanded form as *The Autobiography of British Cinema* (Methuen, 1997); I have particularly drawn from his interviews with Nova Pilbeam and Desmond Tester.

Other articles and books: John Belton, "Charles Bennett and the Typical Hitchcock Scenario," *Film History* 9, no. 3 (1998); T. E. B. Clarke, *This Is Where I Came In* (Michael Joseph, 1974); Jonathan Croall, *Gielgud: A Theatrical Life, 1902–2000* (Continuum, 2001); John Gielgud (with John Miller and John Powell), *An Actor and His Time* (Applause, 1979); Graham Greene, *The Pleasure Dome: The Collected Film Criticism, 1935–40* (Martin Secker & Warburg, 1972); Val Guest, *So You Want to Be in Pictures* (Reynolds & Hearn, 2001); James Hardin, *Emlyn Williams: A Life* (Weidenfeld & Nicolson, 1993); Ronald Hayman, *John Gielgud* (Heinemann, 1971); Louis Levy, *Music for the Movies* (Sampson Low, Marston, 1948); Sheridan Morley, *John Gielgud: The Authorized Biography* (Simon & Schuster, 2002); Garry O'Connor, *The Secret Woman: A Life of Peggy Ashcroft* (Weidenfeld & Nicolson, 1997); C. T., *Penrose Tennyson* (A. S. Atkinson, 1943); J. C. Trewin, *Robert Donat: A Biography* (Heinemann, 1968); Emlyn Williams, *Emlyn: An Early Autobiography, 1927–1935* (Bodley Head, 1973).

SEVEN: 1937–1939

Hitchcock's article "Search for the Sun" appeared in the *New York Times* (Feb. 7, 1937), though it is actually a rewrite of "Why Britain's Countryside Is Not Filmed," *Film Pictorial* (Dec. 5, 1936). "The sky was always gray . . ." is from part 1 ("It's Only a Movie . . .") of a two-part BBC *Omnibus* documentary about Hitchcock (broadcast in 1986).

My account of Hitchcock's first visit to America is culled from "Falstaff in Manhattan" in the *New York Times* (Sept. 5, 1937), "The Hitchcock Formula" in the *New York Times* (Feb. 13, 1938), "*39 Steps* Jolly Good, Hitchcock Discovers" by William Boehnel in the *New York World-Telegram* (Sept. 1, 1937), "Hitchcock Likes to Smash Cups" by H. Allen Smith in the *New York World-Telegram* (undated clipping), "Picture Parade" by Janet White (unsourced clipping, 1937), and "London Talk" in the *Hollywood Reporter* (Oct. 2, 1937).

Sidney Gilliat and Frank Launder are quoted from *Launder and Gilliat* by Geoff Brown (BFI, 1977), but also from Gilliat's unpublished memoirs (a portion of which was provided to the author by Charles Barr), Gilliat's BECTU interview transcript, and "The Early Life of a Screenwriter II," Kevin Macdonald's extensive interview in *Projections 2* (Faber, 1997).

Michael Redgrave is quoted from *In My Mind's I: An Actor's Autobiography* (Viking, 1983). Margaret Lockwood is quoted from *Lucky Star* (Odhams Press, 1955).

My account of Hitchcock's first trip to Hollywood is drawn largely from the Myron Selznick Collection, with other details collected from "Hitchcock for Hollywood and the Experience Will Probably Do Him Good" by Herbert Thompson in *Film Weekly* (July 16, 1938), "Alfred Hitchcock: England's Best and Biggest Director Goes to Hollywood" by Geoffrey T. Hellman in *Life* (Nov. 29, 1940), "Picture Plays and Players: Alfred Hitchcock, English Director, to Take a Look at Hollywood" by Eileen Creelman in the *New York Sun* (June 15, 1938), and "What Happens After That," Russell Maloney's profile of the director in the *New Yorker* (Sept. 10, 1938). Hitchcock muses about American trains in "Hitchcock Steps Off Deadly Trains" by Art Buchwald in the *New York Herald Tribune* (Jan. 16, 1955). "A long-felt desire . . ." and "I once thought of opening a film . . ." are from the *New York Times* (Feb. 13, 1938).

"If I do go to Hollywood . . ." is from "The Censor and Sydney Street" by Leslie Perkoff, *World Film News* (March 1938). I am grateful to Charles Barr for his research and insights into " 'A Marvelously Dramatic Subject': Hitchcock's *Titanic* Project" from the *Hitchcock Annual* (2000–2001). The Charles Laughton anecdotes are from Andy Warhol's interview with Hitchcock in *Interview* (Sept. 1974) and the director's dialogue with Pia Lindstrom, one of two *Camera Three* episodes known as "The Illustrated Hitchcock" (broadcast in 1972).

Books: Simon Callow, *Charles Laughton: A Difficult Actor* (Methuen, 1987); Charles Higham, *Charles Laughton: An Intimate Biography* (W. H. Allen, 1976); Paul Macnamara, *Those Were the Days, My Friend: My Life in Hollywood with David O. Selznick and Others* (Scarecrow Press, 1993); Leo Rosten, *Hollywood: The Movie Colony, the Movie Makers* (Harcourt, Brace, 1941); Kurt Singer, *The Laughton Story* (John C. Winston, 1954); Hilton

Tims, *Once a Wicked Lady: A Biography of Margaret Lockwood* (Virgin, 1989).

EIGHT: 1939–1941

"My Ten Favorite Pictures" is from the *New York Sun* (March 15, 1939). "Naturally, Selznick dominated the scene . . ." is from "Hitchcock: In the Hall of Mogul Kings" in the *London Times* (June 23, 1969).

Joan Fontaine is quoted from *No Bed of Roses* (William Morrow, 1978), but also from her Southern Methodist University oral history and published interviews, including Brian McFarlane's in *Cinema Papers* (Australia, June 1982), Robert Kendall's in *Hollywood Studio Magazine*, no. 3 (1990), and Gregory Speck's in *Interview* (Feb. 1987). Speck's interview was recycled for *Hollywood Royalty: Hepburn, Davis, Stewart and Friends at the Dinner Party of the Century* (Birch Lane Press, 1992). "We all could see precisely . . ." is from the BBC documentary "It's Only A Movie . . . "

H. Mark Glancy's *When Hollywood Loved Britain: The Hollywood 'British' Film, 1939–45* (Manchester University Press, 1999) greatly enhanced my understanding of Hitchcock's wartime filmmaking, and the author also corresponded with me, filling in gaps.

Matthew Bernstein's *Walter Wanger: Hollywood Independent* was my primary source on the film producer. I consulted George Turner's well-researched "*Foreign Correspondent*—The Best Spy Thriller of All" from *American Cinematographer* (Aug. 1995). Joel McCrea is quoted on Hitchcock from my interview with him in *Film Crazy* (St. Martin's Press, 2000). Michael Balcon's attack on Hitchcock was published in the *London Sunday Dispatch* (Aug. 25, 1940), Hitchcock's reply came in the *New York World-Telegram* (Aug. 27, 1940), and the British anti–*Foreign Correspondent* broadside appeared in the *Documentary News Letter* (Dec. 1940).

Hitchcock discusses the possibilities of color in "Cinema Matters" by Virginia Wright, an undated *Hollywood Citizen-News* article in the *Suspicion* microfiche at the Margaret Herrick Library.

Bill Krohn supplied me with his illuminating piece about *Suspicion*, "Ambivalence," which appeared in French in *Trafic* (spring 2002), and in English in the *Hitchcock Annual* (2003–4).

Samson Raphaelson's anecdote about the benzedrine dinner party comes from the *Spellbound* publicity file in the Margaret Herrick Library.

Cary Grant gave few substantive interviews in his career, but for this book I have drawn on "Notorious Gentleman" by Ruth Waterbury in *Photoplay* (Jan. 1947), "Cary Grant—Indestructible Pro" by Richard G. Hubler in *Coronet* (Aug. 1957), "The Riddle of Cary Grant" by Eleanor Harris in *McCall's* (Sept. 1958), "What It Means to Be a Star" by Grant himself in *Films and Filming* (July 1961), and Kent Schuelke's interview in *Interview* (Jan. 1987). I have also cited from Maureen Donaldson and William Royce, *An Affair to Re-*

member: My Life with Cary Grant (G. K. Hall, 1990), Charles Higham and Roy Moseley, *Cary Grant: The Lonely Heart* (Harcourt Brace, 1989), and Nancy Nelson, *Evenings with Cary Grant* (William Morrow, 1991).

For details of the Santa Cruz residence, I have relied on two excellent articles: "Hitchcock Had Link to Santa Cruz" by Ross Eric Gibson in the *San Jose Mercury News* (Nov. 19, 1994) and Catherine Graham's "Hitch's Retreat" in the *Santa Cruz County Sentinel* (Aug. 13, 1999).

Hitchcock's tribute to Ford is reprinted in Galyn Studlar and Matthew Bernstein, eds., *John Ford Made Westerns: Filming the Legend in the Sound Era* (Indiana University Press, 2001).

My account of Hitchcock's relationship with the Film Censor in England and the Production Code in Hollywood was aided by Gerald Gardner's *The Censorship Papers: Movie Censorship Letters from the Hays Office, 1934–1968* (Dodd, Mead., 1987); Raymond Moley's *The Hays Office* (Bobbs-Merrill, 1945); Jeffrey Richards's "The British Board of Film Censors and Content Control in the 1930s: Images of Britain," *Historical Journal of Film, Radio and Television* 1, no. 2 (1981); Murray Schumach's *The Face on the Cutting Room Floor* (William Morrow, 1964); Anthony Slide's *'Banned in the U.S.A.': British Films in the United States and Their Censorship, 1933–1960* (I. B. Tauris, 1998); and Frank Walsh's *Sin and Censorship: The Catholic Church and the Motion Picture Industry* (Yale University Press, 1996).

Other articles and books: Billy Altman, *Laughter's Gentle Soul: The Life of Robert Benchley* (W. W. Norton, 1997); Osmond Borradaile (with Anita Borradaile Hadley), *Life Through a Lens: Memoirs of a Cinematographer* (McGill–Queen's University Press, 2001); Roland Flamini, *Scarlett, Rhett, and a Cast of Thousands: The Filming of* Gone With the Wind (Macmillan, 1975); Susan Lowndes, ed., *Diaries and Letters of Marie Belloc Lowndes, 1911–1947* (Chatto & Windus, 1971); Miklós Rózsa, *Double Life: The Autobiography of Miklos Rozsa* (Midas Books, 1982); Donald Spoto, *Laurence Olivier: A Biography* (HarperCollins, 1992); Donald Spoto, *Notorious: The Life of Ingrid Bergman* (HarperCollins, 1997); Bob Thomas, *Selznick* (Doubleday, 1970).

NINE: 1941–1944

John Houseman is quoted from *Unfinished Business: Memoirs, 1902–1988: Run-Through, Front and Center,* and *Final Dress* (Applause, 1989). The strawberries Romanoff anecdote is from " 'Hitch' Tops, Flagg Says" by James Montgomery Flagg in the *Hollywood Citizen-News* (Nov. 6, 1941). Priscilla Lane is quoted from Doug McClelland's *Forties Film Talk* (McFarland, 1992). Norman Lloyd is quoted from my interview with him, but also from *Stages of Life in Theatre, Film and Television* (Limelight, 1993), and from other published interviews, including "Norman Lloyd: Working with Hitch" by Tom Weaver in *Classic Images* (April 2000) and "The Man on the Statue of Liberty" by Ira Sandler in FILMFAX (April-May, 2003).

My account of the making of *Shadow of a Doubt* is drawn from the Universal Studio Collection and Jack Skirball's Papers in the USC archives, and from Thornton Wilder's Papers at Yale. I have cited *The Enthusiast: A Life of Thornton Wilder* by Gilbert A. Harrison (Ticknor & Fields, 1983), and quoted Wilder from *The Letters of Alexander Woollcott*, eds. Beatrice Kaufman and Joseph Hennessey (Viking, 1944). Hitchcock recalls Wilder borrowing from Hemingway in "In Charge," *New Yorker* (March 30, 1963). The Gordon McDonell background of the original story is related in *Hitchcock's Notebooks*. Joseph Cotten is quoted from *Vanity Will Get You Somewhere* (Mercury House, 1987). Teresa Wright is quoted from "Teresa Wright on *Shadow of a Doubt*" in *Projections 7* (Faber, 1997).

All the treatments and drafts of *Lifeboat*, the studio memoranda, legal depositions, and court papers relating to the case of *Sidney Easton v. Twentieth Century–Fox Film Corp.* were furnished by Twentieth Century–Fox. Kenneth MacGowan's Papers at the University of California at Los Angeles provided additional documentation.

Hume Cronyn is quoted from his correspondence with me, his papers at the Library of Congress, "Melodrama Maestro" by Cronyn in *Maclean's* (Nov. 1, 1944), and *A Terrible Liar* (William Morrow, 1991). Walter Slezak is quoted from *What Time's the Next Swan?* (Doubleday, 1962).

Philip Kemp wrote about *Aventure Malgache* and *Bon Voyage* in *Sight and Sound* (Nov. 1993).

Other articles and books: Jackson J. Benson, *The True Adventures of John Steinbeck, Writer* (Viking Press, 1984); Dennis Brian, *Tallulah, Darling* (Macmillan, 1980); MacDonald Carey, *The Days of My Life* (St. Martin's Press, 1991); Martin Grams Jr., *Suspense: Twenty Years of Thrills and Chills* (Morris Publishing, 1993); Robert E. Morseberger, "Adrift in Steinbeck's *Lifeboat*," *Literature/Film Quarterly* (fall 1976); Roy Simmonds, *John Steinbeck: The War Years, 1939–1945* (Bucknell University Press, 1996); George Turner, "*Saboteur*: Hitchcock Set Free," *American Cinematographer* (Nov.-Dec. 1993); George Turner, "Hitchcock's Mastery Is Beyond Doubt in *Shadow*," *American Cinematographer* (May 1993); Bret Wood, "Foreign Correspondence: The Rediscovered War Films of Alfred Hitchcock," *Film Comment* (July-Aug. 1993).

TEN: 1944–1947

Alan Osbiston's anecdote about Hecht and Hitchcock playacting Cary Grant and Ingrid Bergman comes from the unpublished version of *All Is Grist*. I have relied upon "The Unknown Hitchcock: *Watchtower over Tomorrow*" by Sidney Gottlieb from the *Hitchcock Annual* (1996–97), but augmented Gottlieb's research with my delvings into the Edward R. Stettinius Papers. Ben Hecht is quoted from his papers and from *A Child of the Century* (Simon

& Schuster, 1954). Hitchcock refers to "a fascinating day at California Institute of Technology trying to get data on the atomic bomb" in "A Liberated Hitchcock Dreams Gaudy Dreams of Technicolor" by Thornton Delehanty, *New York Herald Tribune* (April 22, 1945). Frank Nugent mentions the visit to Dr. Millikan in "Assignment in Hollywood," *Good Housekeeping* (Nov. 1945).

Ingrid Bergman is quoted from *My Story* (Delacorte Press, 1980) and Laurence Leamer's *As Time Goes By* (Harper & Row, 1986). Gregory Peck is quoted from *Hollywood Royalty*, and the Krohn, Spoto, and Taylor books, but I also drew on his Southern Methodist University oral history. Salvador Dalí is quoted from Meredith Etherington-Smith's *The Persistence of Memory: A Biography of Dalí* (Random House, 1992). James Bigwood's definitive "Solving a *Spellbound* Puzzle," re-creating the Hitchcock–Salvador Dalí collaboration, appeared in *American Cinematographer* (June 1991).

Edith Head is quoted from *Edith Head's Hollywood* with Paddy Calistro (E. P. Dutton, 1983) and *The Dress Doctor* with Jane Kesner Ardmore (Little, Brown, 1959).

I have drawn extensively from the Sidney Bernstein Papers at the War Museum (which contains material relating to all the wartime information films) as well as Bernstein's holdings at the BFI (relating to Transatlantic and other projects). I have consulted the extensive Warner Bros. Collection in the USC archives. These archives yielded background, information, financial details, publicity material, and memoranda and correspondence between Bernstein and Hitchcock, and others associated with their mutual endeavors. I have also cited Caroline Moorehead's excellent *Sidney Bernstein* (Jonathan Cape, 1984).

The making of "F3080," or "Memories of the Camp," is recounted in "Out of the Archives: The Horror Film that Hitchcock Couldn't Bear to Watch" by Norman Lebrecht in the *Sunday Times* (Feb. 17, 1984).

Bess Taffel is quoted from my interview with her in *Tender Comrades* (St. Martin's Press, 1997).

"I even knew what lens I would use . . ." is from "Hitchcockney from Hollywood" by John Barber, *Leader Magazine* (May 25, 1946).

Hitchcock is quoted on the subject of *Under Capricorn* in *Hollywood Talks Turkey*. Jack Cardiff is quoted from my interview with him and from *Magic Hour* (Faber, 1996). Ann Todd is quoted from *The Eighth Veil* (William Kimber, 1980).

Other articles and books: Jack Cardiff, "The Problems of Lighting and Photographing *Under Capricorn*," *American Cinematographer* (Oct. 1949); Doug Fetherling, *The Five Lives of Ben Hecht* (Lester and Orpen, 1977); Leonard Leff, "Cutting *Notorious*," *Film Comment* (Mar-Apr. 1999); Herb A. Lightman, "Cameraman's Director," *American Cinematographer* (April 1947); William MacAdams, *Ben Hecht: The Man Behind the Legend* (Scrib-

ner's, 1990); Ronald Mavor, *Dr. Mavor and Mr. Bridie* (Canongate and the National Library of Scotland, 1988).

ELEVEN: 1947–1950

Arthur Laurents is quoted from *Original Story By* (Knopf, 2000). Laurents declined to be interviewed for this book, but I consulted other interviews with him, including my own from *Backstory 2* (University of California Press, 1991). Laurents answered a handful of questions by E-mail. Farley Granger is quoted from his BBC transcript, "Out into the World" by Gordon Gow in *Films and Filming* (Oct. 1973), and "Granger on a Train," Jessie Lilley's interview in *Scarlet Street* (winter 1996).

I consulted numerous interviews and articles about James "Jimmy" Stewart. These include "The Many Splendored Actor: An Interview With Jimmy Stewart" by Neil P. Hurley in the *New Orleans Review* (spring 1983), "James Stewart: It's a Wonderful Life" by Ray Comiskey in *Cinema Papers* (Jan. 1986), David Denicolo's interview in *Interview* (Apr. 1990), "Small-Town Guy" by Mike Wilmington in *Film Comment* (Mar.-Apr. 1990), and Gregory Solman's interview in *Projections 5* (Faber, 1996). I also referred to the biography *Pieces of Time: The Life of James Stewart* by Gary Fishgall (Scribner's, 1997).

Whitfield Cook is quoted from his journal, from his interview with me, and from his BBC transcript.

Michael Wilding is quoted from *The Wilding Way* (St. Martin's Press, 1982). I have quoted correspondence from the Marlene Dietrich Papers in Berlin, and from the actress's autobiography, *Marlene* (Weidenfeld & Nicholson, 1989), Steven Bach's biography *Marlene Dietrich: Life and Legend* (Morrow, 1992), and her daughter Maria Riva's *Marlene Dietrich* (Knopf, 1993). "The heroine's mother was like mother . . ." is from *Films in Review* (Apr. 1950).

Other books: Sean French, *Patrick Hamilton: A Life* (Faber, 1993); Bruce Hamilton, *The Light Went Out: The Life of Patrick Hamilton* (Constable, 1972); Margaret Case Harriman, *Take Them Up Tenderly* (Knopf, 1944); Joe Morella and Edward Z. Epstein, *Jane Wyman* (Delacorte Press, 1985); Graham Payn and Sheridan Morley, *The Noel Coward Diaries* (Weidenfeld and Nicholson, 1982); Dimitri Tiomkin and Prosper Buranelli, *Please Don't Hate Me* (Doubleday, 1959); Virginia Yates, "*Rope* Sets a Precedent," *American Cinematographer* (July 1948).

TWELVE: 1950–1953

Hitchcock's February 20, 1974, letter rejecting Alma's participation in a book about "The Women Who Wrote the Movies" is in the Hitchcock Collection. William K. Everson's interview was one of the "Illustrated Hitchcock" episodes for *Camera Three*.

To trace the collaboration between Hitchcock and Raymond Chandler, and the script evolution of *Strangers on a Train,* I have drawn on my interviews with Whitfield Cook and Czenzi Ormonde, and cited Chandler's correspondence from *Raymond Chandler Speaking,* ed. Dorothy Gardiner and Kathrine Sorley Walker (Houghton Mifflin, 1970) and *Selected Letters of Raymond Chandler,* ed. Frank MacShane (Delta, 1987). Robert C. Carringer's article about the political subtext of *Strangers on a Train,* "Collaboration and Concepts of Authorship," appeared in *PMLA* (Mar. 2001). I also referred to Al Clark's *Raymond Chandler in Hollywood* (Proteus, 1983), Gene D. Phillips's *Creatures of Darkness: Raymond Chandler, Detective Fiction and Film Noir* (University Press of Kentucky, 2000), and Jon Tuska's *In Manors and Alleys: A Casebook on the American Detective Film* (Greenwood Press, 1988).

"Afraid of any brush . . ." is from Alma Reville's notes in the publicity file of *Suspicion* in the Hitchcock Collection.

The Laura Elliott (a.k.a. Kasey Rogers) anecdote is from Tom Weaver's interview with the actress in *Science Fiction Confidential: Interviews with Twenty-three Monster Stars and Filmmakers* (McFarland, 2002).

Brian Aherne is quoted from *A Proper Job* (Houghton Mifflin, 1969). Karl Malden is quoted from *When Do I Start?* (Simon & Schuster, 1997). Bill Krohn augmented my account of *I Confess* with background on "Paul Anthelme," his own research from the USC files, and insights into the film.

The anecdote about Hitchcock at the Canadian premiere of *I Confess* comes from Giles Pelletier's interview in *Le Soleil* (Quebec, Aug. 14, 1999), while other background comes from "Hitchcock's Quebec Shoot" by Jean-Claude Marineau in *Cinéma Canada* (Mar. 1985).

Peter Bordanaro's illuminating article about *Dial M for Murder,* "A Play by Frederick Knott/A Film by Alfred Hitchcock," appeared in *Sight and Sound* (summer 1976).

Grace Kelly is quoted from the Taylor and Spoto books, as well as from several biographies about her, including Steven England, *Grace of Monaco* (Doubleday, 1984); Robert Lacey, *Grace* (G. P. Putnam's, 1994); Joshua Logan, *Movie Stars, Real People and Me* (Delacorte Press, 1978); James Spada, *Grace: The Secret Lives of a Princess* (Doubleday, 1987).

Other books: Patricia Bosworth, *Montgomery Clift* (Harcourt, 1978); Merv Griffin, *Merv: An Autobiography* (Simon & Schuster, 1980).

THIRTEEN: 1953–1955

"We can all be millionaires . . ." is from Hitchcock's December 7, 1978, letter to Lawrence Read, in the Hitchcock Collection. Bill Krohn wrote about Hitchcock's art collection in "Le musée secret de M. Hitchcock" in *Cahiers du Cinéma,* no. 559 (July-Aug. 2001).

My understanding of Hitchcock's Paramount period was enhanced by Her-

bert Coleman's *The Hollywood I Knew, A Memoir: 1916–1988* (Scarecrow Press, 2003), portions of which I read in draft form. I also conducted several interviews with Coleman, and he answered brief queries by mail. *Variety* is quoted on Don Hartman and Y. Frank Freeman from Hartman's obituary in the March 26, 1958, issue.

John Michael Hayes has been extensively interviewed, but I also interviewed him for this biography. Other Hayes interviews I have drawn upon include Susan Green's in *Backstory;* "Setting the Record Straight" by Steve Cohen in *Columbia Film View* (winter/spring 1990); and "The Hayes Office" by Richard Valley in *Scarlet Street,* nos. 21 and 22 (winter 1996). Steven DeRosa's *Writing with Hitchcock: The Collaboration of Alfred Hitchcock and John Michael Hayes* (Faber, 2001) focuses on the complicated relationship between the two men.

The making of *Rear Window* is well reported in *"Rear Window"* by Arthur E. Gavin in *American Cinematographer* (Feb. 1954) and "Hitchcock's Techniques Tell *Rear Window* Story" by David Atkinson in *American Cinematographer* (Jan. 1990). I drew from *"Rear Window:* The Untold Story" by Steve Cohen in *Columbia Film View* (winter/spring 1990); Michael R. Dilberto's "Looking Through *Rear Window:* A Review of the United States Supreme Court Decision in *Stewart vs. Abend"* in *Loyola of Los Angeles Entertainment Law Journal* 12, no. 2 (1992); and John Belton's *Alfred Hitchcock's* Rear Window (Cambridge University Press, 2000)—especially Scott Curtis's piece, "The Making of *Rear Window.*" Francis M. Nevins Jr.'s *Cornell Woolrich: First You Dream, Then You Die* (Mysterious Press, 1988) supplied vital background on Woolrich and astutely analyzed the adaptation of the novella into the film.

John M. Woodcock writes about the editing of *To Catch a Thief* in "The Name Dropper," *American Cinemeditor* (summer 1990). Lynn Murray is quoted from *Musician: A Hollywood Journal* (Lyle Stuart, 1987).

"It's important that filmmakers . . ." is from "Conversations with Hitchcock" by Catherine de la Roche, *Sight and Sound* (winter 1955).

Shirley MacLaine is quoted from *"Don't Fall Off the Mountain"* (W. W. Norton, 1970).

My portrait of the relationship between Hitchcock and Bernard Herrmann was greatly informed by *Bernard Herrmann: Film Music and Narrative* by Graham Bruce (UMI Research Press, 1985) and *A Heart at Fire's Center: The Life and Music of Bernard Herrmann* by Steven C. Smith (University of California Press, 1991). I have cited "Herrmann, Hitchcock, and the Music of the Irrational" by Royal S. Brown, *Cinema Journal* (spring 1982) and "Herrmann and the Politics of Film Music" by Steven C. Smith in *Schwann Opus* (summer 1996). I also consulted Royal S. Brown's interview with Herrmann in *High Fidelity* (Sept. 1976) and "The Colour of the Music," Ted Gilling's interview in *Sight and Sound* (winter 1971–72).

André Bazin writes about visiting the *To Catch a Thief* set in Nice in

"Hitchcocks versus Hitchcock" in *Cahiers du Cinéma* (Oct. 1954), which was translated and reprinted in the Bazin collection *The Cinema of Cruelty: From Buñuel to Hitchcock* (Seaver Books, 1982).

Doris Day is quoted from *Doris Day, Her Own Story* by A. E. Hotchner (William Morrow, 1975) but I also consulted her Southern Methodist University oral history.

Hitchcock first talked about his television series in "Hitchcock, Master of Suspense, Turns to TV" by Cecil Smith in the *Los Angeles Times* (Sept. 11, 1955). As well as viewing all the television episodes Hitchcock directed, I have drawn on the research and scholarship of other authors. Key sources include "The Television Films of Alfred Hitchcock" by Steve Mamber in *Cinema* (fall 1971), "Hitchcock's TV Films" by Jack Edmund Nolan in *Film Fan Monthly* (June 1968), "Hitchcock's Forgotten Films: The Twenty Teleplays" by Gene D. Phillips in the *Journal of Popular Film and Television* (summer 1982), and, especially, John McCarty and Brian Kelleher's *Alfred Hitchcock Presents* (St. Martin's Press, 1985) and "Hitchcock's Television Work" by J. L. Kuhns, from *The Alfred Hitchcock Story*, ed. Ken Mogg (Titan Books, 1999).

Starting with the year 1956, the chronological detail of my life story is drawn largely from logbooks of the director's schedule and appointments in the Hitchcock Collection.

Other books: David Dodge, *The Rich Man's Guide to the Riviera* (Little, Brown, 1962); Oleg Cassini, *In My Own Fashion* (Simon & Schuster, 1987); François Truffaut, *Correspondence: 1945–1984* (Farrar, Straus, and Giroux, 1989); Paul Henreid (with Julius Fast), *Ladies Man: An Autobiography* (St. Martin's Press, 1984).

FOURTEEN: 1956–1958

Hitchcock is quoted on *Flamingo Feather* in South Africa's *Cape Times* (July 5, 1956).

For the section on *Vertigo*, I have cited and referred repeatedly to Dan Auiler's indispensable chronicle, Vertigo: *The Making of a Hitchcock Classic* (St. Martin's Press, 1998).

Vera Miles did not reply to letters requesting an interview for this book. Background about the actress was drawn in part from "Hitchcock's New Star" by Robert W. Marks, *McCall's (*May 1957), "The New Grace Kellys," *Mademoiselle* (Dec. 1959), and "I Walked Away from Fear" by Carl Clement, *Photoplay* (Sept. 1957). Henry Fonda is quoted from Lawrence Grobel's interview in *Playboy* (Dec. 1981). Harold J. Stone is quoted from Harvey F. Chartrand's interview with him in *FILMFAX* (Apr.-May 2002).

Sam Taylor is quoted from the Auiler, Krohn, Spoto, and Taylor books, as well as other published interviews and my own phone conversation with him.

The Balcon-Hitchcock correspondence can be found among the Balcon Papers at the BFI. The director's May 1, 1957, letter to Anita Colby is in the Hitchcock Collection.

I consulted numerous articles and interviews with Kim Novak to depict her relationship with Hitchcock. My key sources include Peter Harry Brown, *Kim Novak, Reluctant Goddess* (St. Martin's Press, 1986), "Dream Date: Kim Novak" by John Calendo, *Interview* (Mar. 1981), "Looking Back at *Vertigo*" by Roger Ebert in the *Chicago Sun-Times* (Oct. 17, 1996), and Beauregard Houston-Montgomery's interview with the actress in *Interview* (Dec. 1986).

Other books: Charles Barr, *Vertigo* monograph (BFI, 2002).

FIFTEEN: 1958–1960

My account of the evolution of *North by Northwest,* and Hitchcock's relationship with Ernest Lehman, is drawn from Lehman's papers in the Harry Ransom Library, and from several Lehman interviews, including those in the Spoto and Taylor books, and: "Ernest Lehman: An American Film Institute Seminar on His Work" (1977), John Brady's interview in *The Craft of the Screenwriter* (Simon & Schuster, 1981), Joel Engel's interview in *Screen Writers on Screen Writing* (Hyperion, 1995), and "The View from Here: A Conversation with Ernest Lehman" by Susan Bullington Katz, in the *Journal* (of Writers Guild–West) (June 1995). Gregg Garrett's "The Men Who Knew Too Much: The Unmade Films of Hitchcock and Lehman" in the *North Dakota Quarterly* (spring 1993) added intriguing information about the "unmade" Hitchcock-Lehman projects that followed *North by Northwest.*

Truffaut writes about Stewart being "too old to play the lead" in Hitchcock films after *Vertigo* in "Slow Fade: The Declining Years of Alfred Hitchcock," *American Film* (Jan.-Feb. 1985).

James Mason is quoted from *Before I Forget* (Hamish Hamilton, 1981). Hitchcock describes Eva Marie Saint's costuming in "Alfred Hitchcock Talking," *Films and Filming* (July 1959). "Hitchcock gave me three directions . . ." is from "Five of Hitchcock's Leading Ladies Speak Up for the Great Director" by Robert Blanco, *Pittsburgh Post-Gazette* (1997 syndicated article). The Styrofoam cup anecdote comes from "Reel to Real," David Fantle and Thomas Johnson's interview with Eva Marie Saint in *Senior Highlights* (Nov. 1996).

Cary Grant and Hitchcock are quoted during location filming in New York from "Excitement at the Plaza: Hitchcock, Cary Grant" by Richard C. Wald in the *New York Herald Tribune* (Sept. 7, 1958). "Alfred Hitchcock's 'Expedient Exaggerations' and the Filming of *North by Northwest* at Mount Rushmore" by Todd David Epp in *South Dakota History* (fall 1993) recounts what transpired on location at Mount Rushmore.

Again and again I drew and quoted from Stephen Rebello's invaluable *Alfred Hitchcock and the Making of Psycho* (Dembner Books, 1990). Other key books that informed this section include Robert Bloch's *Once Around the Bloch: An Unauthorized Autobiography* (Tor, 1993) and *Filmguide to Psycho* by James Naremore (Indiana University Press, 1973). I also consulted *"Psycho*: The Making of Alfred Hitchcock's Masterpiece" by Rebello in *Cinefan-*

tastique (Oct. 1986); this *Cinefantastique* special issue is somewhat different from Rebello's later book, and includes the Saul Bass interview where Bass claims to have directed the shower sequence.

Besides the Rebello book, Joseph Stefano is quoted from his BBC transcript and "An Interview with Joseph Stefano" by Sylvia Caminer and John Andrew Gallagher in *Films in Review* (Jan.-Feb. 1996). Janet Leigh is quoted from the Rebello book, but I also consulted numerous interviews and quoted the actress from her memoir *There Really Was a Hollywood* (Doubleday, 1984) and her book *Behind the Scenes of* Psycho with Christopher Nickens (Harmony, 1995).

To report how the Production Code censors handled *Psycho,* I drew on "Hays Code: Out-Psyched by Hitch" by Jerry Drucker in the *Los Angeles Times* Calendar section (Oct. 28, 1979).

SIXTEEN: 1960–1964

The Tel Aviv and Copenhagen incidents were recounted for *Camera Three.*

Philip K. Scheuer handicapped Hitchcock's Oscar odds in "Scheuer's Forecast of Oscar Winners" in the *Los Angeles Times* (Apr. 16, 1961). "We're on dangerous ground . . ." is from George Angell's BBC interview. "The studios run those things . . ." and Hitchcock's recollection of seeing pornographic movies and a live sex act in Japan are from *Interview* (Sept. 1974). "Oscars aren't the end-all . . ." is from "The Old Wrangler Rides Again" in the book *John Ford Made Westerns: Fiming the Legend in the Sound Era.*

Ron Miller's interview with Alfred Hitchcock appeared in San Jose State College's *Lyke* magazine (spring 1960). Miller also answered queries by E-mail.

For the section on *The Birds,* I drew extensively on Kyle B. Counts's definitive "The Making of Alfred Hitchcock's *The Birds*" in *Cinefantastique* (fall 1980).

Evan Hunter has been interviewed numerous times, and is quoted mainly from his book *Me and Hitch* (Faber, 1997) but also from *Cinefantastique* and his BBC transcript. I have also drawn from "Jay Presson Allen and Evan Hunter," *On Writing,* a publication of the Writers Guild–East (Mar. 24, 1993), "Writing *The Birds*: An Interview with Evan Hunter," *Scenario* 5, no. 2, "Writing for Hitch: An Interview with Evan Hunter" by Charles L.P. Silet; *Hitchcock Annual* (1994–95); "Words of the Week" (Hunter's talk before London's National Film Theatre) in the *Independent* (June 14, 1997).

Tippi Hedren is quoted from various published and unpublished interviews, including the *Cinefantastique* article, Tony Lee Moral's *Hitchcock and the Making of* Marnie (Scarecrow Press, 2002), her Southern Methodist University oral history, her BBC transcript, and her interview in 2000 with journalist Scott Eyman, a copy of which was supplied to the author. The "three golden birds with seed pearls" anecdote is from "Tippi Hedren—From

The Birds to the Roar of the Lions" by Marianne Gray in *Photoplay* (May 1982).

"Never dared face them . . ." and "Almost as though she were cleansing herself . . ." are from "Art Is Immersion," Fletcher Markle's interview with Hitchcock for the CBC *Telescope* series (broadcast in 1964).

"Your letter made me cry . . ." is from a June 11, 1962, cable from Hitchcock to Truffaut. All the cited Hitchcock-Truffaut correspondence, the original tape recordings, and the complete transcript of the interview sessions are in the Hitchcock Collection. I have also relied upon the biography *Truffaut* by Antoine de Baecque and Serge Toubiana (Knopf, 1999).

For the section on *Marnie,* I referred repeatedly to the authoritative book *Hitchcock and the Making of* Marnie, and author Tony Lee Moral generously consulted with me on findings and interpretations.

Hitchcock discussed Grace Kelly's casting in *Marnie* in "Grace Kelly . . . Ice That Burns Your Hands" with Peter Evans in the *Daily Express* (Mar. 24, 1962). Mariette Hartley is quoted from *Breaking the Silence* with Anne Commire (Putnam's, 1988), and from "20 Questions" in *Playboy* (Aug. 1982). Sean Connery is quoted from Andrew Yule's *Sean Connery: From 007 to Hollywood Icon* (Donald I. Fine, 1992). Joan Fontaine is quoted about Tippi Hedren from *Hollywood Royalty*. "He almost had a heart attack . . ." is from Scott Eyman's interview.

Other articles and books: Alfred Hitchcock, "It's a Bird, It's a Plane, It's . . . The Birds!" in *Take One* 1, no. 10 (1968); Camille Paglia, *The Birds* (BFI Film Classics, 1998).

SEVENTEEN: 1964–1970

Joseph McBride graciously supplied clippings from his own Hitchcock file, as well as many insights from his personal study of Hitchcock films. His definitive "Alfred Hitchcock's *Mary Rose*: An Old Master's Unheard Cri de Coeur" appeared in *Cineaste* 26, no. 2 (2001).

The transcript of a "taped conversation between Mr. Hitchcock and Mr. Robert Bloch on Friday, November 20, 1964" and the Hitchcock-Nabokov correspondence are in the Hitchcock Collection.

"You'll never know what I went through . . ." is from Hitchcock's October 20, 1966, letter to the Reverend Thomas J. Sullivan, S.J., in the Hitchcock Collection. "It was fun then . . ." is from "Hitch His Own Star" by Margaret Hinxman in the *Daily Telegraph* (Oct. 5, 1969).

"I just never believed Julie Andrews . . ." is from "Hitchcock Still Fighting Hard to Avoid the Conventional" by Joyce Haber, *Los Angeles Times* (Feb. 7, 1973). "Gray everywhere . . ." is from "Hitch: I Wish I Didn't Have to Shoot the Picture," *Take One* 1, no. 1 (1966). Keith Waterhouse is quoted from his correspondence with me and from *Streets Ahead* (Hodder & Stoughton, 1995).

The Herb Gardner anecdote is from the William Friedkin interview in *Dialogue on Film* (American Film Institute, Feb.-Mar. 1974). Hitchcock disparages Antonioni in the *Daily Telegraph* (Oct. 5, 1969): "It's easy to make a pretentious film. Pop in quite unnecessary images to baffle people. Like that Italian chap, Antonioni." Penelope Houston's "Hitch on *Topaz*" appeared in *Sight and Sound* (winter 1969). Bill Krohn's article about *Topaz*, "A Venomous Flower," appeared in *Video Watchdog* (Aug. 2001).

Other articles and books: Anatoly Dobrynin, *In Confidence: Moscow's Ambassador to America's Six Cold War Presidents, 1962–1986* (Times Books, 1995); Frances FitzGerald, *Way Out There in the Blue: Reagan, Star Wars and the End of the Cold War* (Simon & Schuster, 2000); Herb A. Lightman, "Hitchcock Talks About Lights, Camera, Action," *American Cinematographer* (May 1967); Charles Loring, "Filming *Torn Curtain* by Reflected Light," *American Cinematographer* (Oct. 1966); *Vladimir Nabokov: Selected Letters, 1940–1977*, eds. Dimitri Nabokov and Matthew J. Bruccoli (Harcourt, 1989); Bob Rains, *Beneath the Tinsel: The Human Side of Hollywood Stars* (Three Lions, 1999); Robert Windeler, *Julie Andrews: A Life on Stage and Screen* (Birch Lane Press, 1997); Norman Zierold, *The Moguls* (Coward-McCann, 1969).

EIGHTEEN: 1970–1980

Anthony Shaffer is quoted from the Spoto book, "The Wicker Man and Others" in *Sight and Sound* (Aug. 1995), and his posthumously published *So What Did You Expect?* (Picador, 2001). "I'm a bit disturbed at their psychedelic nature . . ." is from "Chilling Chevalier" in the *Evening Standard* (Jan. 12, 1971). "We cleaned up the story . . ." is from "Hitchcock Turns 73, Basks in Praise for Latest Thriller" by Orin Borsten in the *Birmingham News* (Aug. 25, 1973). Henry Mancini is quoted from the American Film Institute publication *Dialogue on Film* (Jan. 1974).

Key articles which informed my account of the making of *Frenzy*: "Hitch . . . But That's No Head in His Pocket" by Shaun Usher in the *Daily Sketch* (Jan. 13, 1971); "A Dream—Is It the Vital Clue to Hitchcock?" by Geoffrey Matthews in the *Evening News* (Sept. 30, 1971); "Why Hitchcock Treats His Women Rough" by Clive Hirschhorn in the *Sunday Express* (March 7, 1971); and "Hitchcock's Finest Hour" by Paul Sargent Clark in *Today's Filmmaker* (Nov. 1972). "One is preoccupied . . ." and "No, my father was not . . ." are from "Thrillers by an Innocent" by Peter Lennon in the *Sunday Times* (Aug. 1, 1971). Jonathan Jones's perceptive "He Travelled Every Tram Route" appeared in the *Guardian* (Aug. 14, 1991).

Alec McCowen is quoted from "Shooting Stars: Alec McCowen Remembers . . ." from the *Sunday Times* (Dec. 5, 1985). I consulted several Jon Finch interviews, including the one that appeared in *Interview* (Apr. 31, 1973), "On Film Violence and Mrs. Mary Ding-a-Ling" in the *Morning Star* (June 1, 1973), and "Technical Hitch" in *Films Illustrated* 1, no. 3 (1971).

Truffaut writes about the screening of *Frenzy* at Cannes in *American Film* (Nov. 1984). Herb Steinberg is quoted from his BBC transcript. The Buñuel anecdotes are from *My Last Sigh: The Autobiography of Luis Buñuel* (Knopf, 1983), and from Buñuel biographer John Baxter. Hitchcock's February 20, 1975, letter to Michael Balcon is in the Balcon Papers.

The transcript of the *Family Plot* script sessions is among the Ernest Lehman Papers at the University of Texas. The "typical day" section about working on *Family Plot* is quoted with permission from the "Lehman at Large" column, "He Who Gets Hitched," in *American Film* (May 1978).

Although I spent several days on the set of *Family Plot* in 1975, interviewing Hitchcock, Bruce Dern, Karen Black, William Devane, and others, I also consulted numerous articles on the production, including "The 'Plot' Thickens" by Andrew Meyer in *Film Comment* (Sept.-Oct. 1975), "Plots and Patterns" by Roger Greenspun in *Film Comment* (May-June 1976), and "Alfred Hitchcock on the set of 'Family Plot' " by Larry Salvato in *Millimeter* (Jan. 1976).

"I think that comes under the heading . . ." is from "Alf Hitchcock Fields Critics' Questions, Some Pretty Silly" by Joseph McBride in *Variety* (Mar. 31, 1976), John Russell Taylor wrote about Karen Black in "Hitchcock's Fifty Years in Films" in the *London Times* (July 19, 1975). Bruce Dern is quoted from "Muuuurder by the Babbling Brook" by Chris Hodenfeld in *Rolling Stone* (July 29, 1976). "Barbara, I'm scared . . ." and the reference to *Nashville* are in "With *Family Plot* . . ." by Penelope Gilliatt in the *Observer* (Aug. 8, 1976). Gregg Kilday's "Steel-Belted Playfulness at Work" was published in the *Los Angeles Times* (July 27, 1975).

David Freeman is quoted from his generous correspondence by E-mail and letter with me, and from his invaluable book *The Last Days of Alfred Hitchcock* (Overlook Press, 1984).

Charles Champlin reported "A Big Hollywood Turnout for Alfred Hitchcock" in the *Los Angeles Times* (Mar. 12, 1979). I reviewed numerous other accounts of the AFI event, including "An Homage to 'King Alfred' " by Champlin in the *Los Angeles Times* (Mar. 7, 1979), " 'Half of Hollywood' Salutes Filmmaker Hitchcock" by Glenn Lovell in the *Fort Lauderdale Sun-Sentinel* (Mar. 12, 1979), and Joseph McBride's contribution to "Buts and Rebuts—Hitchcock: A Defense and an Update" in *Film Comment* (May-June 1979).

I have at points quoted Karen Black, Dr. Walter Flieg, John Forsythe, Barry Foster, David Freeman, and Anna Massey from the *E! Hollywood True Story* documentary about Hitchcock. I have also quoted Foster from his BBC interview.

Hitchcock's June 10, 1977, letter to Michael Balcon, at the BFI, describes Alma's illness and relates his "difficulties" with writer James Costigan. Hitchcock's June 15, 1978, letter to Mrs. Gladys Hitching; his November 29, 1978, letter to his sister, Mrs. Nellie Ingram; his December 6, 1978, letter to Elsie Randolph; and his December 20, 1978, letters to Irene Selznick and to Mr. and

Mrs. Hume Cronyn, describing his and his wife's deteriorating health, are in the Hitchcock Collection.

Other books: Hal Kanter, *So Far, So Funny: My Life in Show Business* (Mc-Farland, 1995); Kenneth Williams, *The Kenneth Williams Diaries* (Harper-Collins, 1993).

CODA

Albert Margolies, Whitfield Cook, and Hume Cronyn are quoted from the Cronyn Papers at the Library of Congress. "Donald Spoto took things and twisted them . . ." is from "Dizzy Heights," an interview with Pat Hitchcock O'Connell by Tom Charity in *Time Out* (Apr. 16–23, 1997). John Houseman's reaction to the Spoto book is quoted from his collection *Entertainers and the Entertained* (Simon & Schuster, 1986).

Grateful acknowledgment is made for permission to reprint from the following:

UNPUBLISHED BOOKS

Cedric Belfrage, *A Gent in Hollywood*, courtesy of Mary Belfrage, from the Cedric Belfrage papers, Tamiment Library, New York University; Charles Bennett, *The Man Who Knew Too Much: The Memoirs of Screenwriter-Laureate Charles Bennett* ed. John Charles Bennett, courtesy of John Charles Bennett; Colin Belfrage, *All Is Grist* (unpublished version), courtesy of Bernard Lewis.

EXCERPTS

David Freeman, *The Last Days of Hitchcock*, copyright © 1984, quoted with permission of the author; Evan Hunter, *Me and Hitch*, copyright © 1997, excerpted by arrangement with the author; Ernest Lehman, professional papers and *North by Northwest*.

ORAL HISTORIES

Sidney Gilliat, courtesy of Caroline Brown (née Gilliat) and Edward Russell, BECTU Collection, London; Samson Raphaelson, courtesy of Joel Raphaelson, from the Samson Raphaelson Collection, University of Illinois, Champaign-Urbana; Robert Boyle and Peggy Robertson, courtesy of Margaret Herrick Library, Academy of Motion Picture Arts and Sciences.

CORRESPONDENCE AND JOURNALS

Robert Benchley, used by permission of his estate, Nathaniel Robert Benchley, Executor, from the Robert Benchley papers, Special Collections, Boston University; James Bridie, courtesy of James Mavor; Whitfield Cook (5-Year Journal, 1945–1949), Special Collections, Boston University; Marlene Dietrich, courtesy of the Berlin Kinemathek; Ben Hecht papers, courtesy of The Newberry Library, Chicago; Brian Moore, with the permission of the estate of Brian Moore, and courtesy of the Brian Moore fonds, Special Collections, University of Calgary Library, and Harry Ransom Humanities Research Center, the University of Texas at Austin; V. S. Pritchett letters, courtesy of Oliver Pritchett; Myron Selznick papers, courtesy of Daniel Selznick, and Harry Ransom Humanities Research Center, the University of Texas at Austin; Edward R. Stettinius papers, courtesy of Wallace Stettinius and the Albert and Shirley Small Special Collections Library, University of Virginia; Thornton Wilder, courtesy of A. Tappan Wilder, and the Thornton Wilder Papers, Yale Collection of American Literature, Beinecke Rare Book and Manuscript Library, Yale University.

PHOTOGRAPHS

Individuals: John Baxter; Claire Brandt (Eddie Brandt's Saturday Matinee); Ned Comstock (Cinema-Television Library, University of Southern California);

Sidney Gottlieb; Michael Rhodes (family photos); David Oliver (Henley's); Esmé Surman (American scrapbook); Betty and Louisa Ware (Shoreham photos). **Organizations:** Eddie Brandt's Saturday Matinee; Special Collections, Boston University; Getty Images; Time-Life; Photofest; Vestry House Museum; *Hitchcock Annual;* and the author's personal collection. Endpapers: Getty Images.

The author welcomes corrections. Special thanks to eagle-eyed readers W. C. Clogston, David Freeman, Dean Goodman, J. Lary Kuhns, John Kennedy Melling, Ken Mogg, Hubert Niogret, and Mary Troath, who spotted typos and mistakes in the hardcover biography. We have endeavored to correct known errors for this paperback edition.

INDEX